NATIONAL PORTRAIT GALLERY
Complete Illustrated Catalogue

NATIONAL PORTRAIT GALLERY

Complete Illustrated Catalogue
1856–1979

Compiled by K.K. Yung

Edited by Mary Pettman

St Martin's Press
NEW YORK

Contents

© National Portrait Gallery, London 1981
First published by the National Portrait Gallery,
London WC2H OHE, England
This edition published by St Martin's Press,
New York
ISBN 0-312-15777-0

Typeset by Tek-art Ltd
Printed in Great Britain by The Anchor Press Ltd
and bound by William Brendon & Son Ltd
both of Tiptree, Essex

REF.
708.2074
N

Foreword

This is the first comprehensively illustrated catalogue of the National Portrait Gallery's collection to have been published since Sir Lionel Cust's lavish two-volume set of 1901-2. Since then the collection has more than trebled in size, and the problems of bringing it together in manageable form within the confines of a single volume have been considerable.

The concise catalogue performs an invaluable function as the basic reference book of the Gallery's collection. The inclusion of illustrations of almost every portrait listed has added immeasurably to the value of the catalogue, which is now a complete National Portrait Gallery in miniature form. The illustrations are necessarily small, and of limited use for study purposes; the degree of reduction has unfortunately meant some loss of detail and definition in the fainter drawings. Nevertheless, they convey the character and 'look' of each image.

Building on the work of previous cataloguers, and especially on Maureen Hill's 1970 Concise Catalogue, the present Registrar, Kai Kin Yung, has carried out the onerous task of compilation with skill and perseverance. Not only has he had to check the accuracy of all existing entries, but he has added a considerable amount of new information, especially with regard to dating. An illustrated catalogue of this size would have been beyond the resources of this Gallery had it not been for the flair and energy of Roger Sheppard, the Publications Manager, who secured outside support. Finally, the catalogue was edited and seen through the press by the Gallery Editor, Mary Pettman, with her usual painstaking care and efficiency.

Richard Ormond
Deputy Director

Introduction

This catalogue lists all registered portraits in the Gallery's permanent collection at December 1979, including those of foreign figures and those which were originally accepted for reference but were given a register number. It includes those portraits on long-term loan to the Gallery (often with numbers preceded by L) which are likely to remain so for a considerable period by arrangement with the lenders. It also includes, for the first time, original photographs in the collection (numbers preceded by P). In all, it would not be an exaggeration to say that the Gallery, founded in 1856, now holds around eight thousand portraits, thus making it the most comprehensive collection of its kind in the world. The entire collection, including those portraits which are not on view, is accessible to the public, but intending viewers are advised to contact the Registry in advance, as portraits may be away for conservation or exhibitions, or on long-term loan. Photographic reproductions are available from the Publications Department, which also supplies current price lists and information regarding copyright and reproduction fees.

Not included in this edition is the small but steadily growing Contemporary Portraits Collection. This collection of portraits of living people was formed in 1972 'to widen the representation, but without prejudice to the judgement of posterity'. It is therefore 'an interim collection, with a separate numbering system; the portraits are submitted to the Trustees for inclusion in the main collection at such time after the sitter's death as the Director shall consider appropriate'. (*Annual Report*, 1967-75, p.26.)

Acknowledgements

The first debt of anyone attempting a catalogue of the Gallery collections must be to the Gallery staff, both past and present, whose researches and work have helped to create the records. My more immediate debt is to Richard Ormond, Deputy Director, who first suggested this project to me, and has given it his continuous encouragement and support. To him also, and to Richard Walker, I am grateful for generously allowing me access to their draft entries and notes for their forthcoming catalogues raisonnés of, respectively, *Late Victorian Portraits* and *Regency Portraits*. They and my other colleagues, Angela Cox, Elspeth Evans (now retired), Colin Ford, Robin Gibson, John Kerslake, Terence Pepper, Kate Poole and Malcolm Rogers, have kindly answered questions relating to their specialist knowledge. Sarah Wimbush has often very kindly pointed out errors or given me new information not consistent with old records. My former colleague, Kathy Lockley, has

done the basic work on the entries for photographs, and she and Tessa Kaye have largely compiled the Index. For fifteen months Tessa Kaye also undertook, with patient charm and readiness, the unenviable task of collecting, sorting and arranging all the illustrations, and of photocopying the entries for printing. Her excellent work was continued by Carol Scott Fox for another three months. Finally, to all those public and private owners of copyright, far too many to name individually, the Gallery is grateful for permission to reproduce portraits in this catalogue.

Structure of the sections

1. *Single and Double Portraits*: Arranged alphabetically and illustrated. When a sitter is represented by more than one portrait, the entries are arranged, as far as possible, in chronological order. Undated portraits, or portraits impossible to date either by evidence available or by appearance, are placed at the end. Such cases are fortunately infrequent, and are almost entirely restricted to drawings by Sir Francis Carruthers Gould or Harry Furniss.

2. *Groups*: Arranged numerically and illustrated, beginning with non-prefixed numbers, followed by numbers with the prefix P (photograph), and then by numbers with the prefix L (loan). Wherever possible, the sitters are listed, with cross-references in the other sections of the catalogue.

3. *Collections* (portraits which form a set, or are by a single artist and originally acquired as a set): Arranged numerically, beginning with non-prefixed numbers, followed by numbers with the prefix P (photograph), and then by numbers with the prefix L (loan). Sitters represented in this section are listed in full, with cross-references in the other sections of the catalogue. These portraits are illustrated only if the sitters are not otherwise represented, or if the image is of particular interest; the illustrations are incorporated in the section *Single and Double Portraits.*

4. *Unknown Sitters*: Arranged chronologically in four groups, and numerically within each group. Not illustrated.

5. *Index of Artists, Engravers and Photographers*: With references to register numbers.

Structure of the entries

1. *Names or titles*: Each entry in the section *Single and Double Portraits* begins with the name, dates and profession of the sitter; entries in the *Groups* and *Collections* sections begin with the title of the group or collection. Noblemen are catalogued under their last title, with their surname given as a cross-reference. Except for theatrical women, married women are generally catalogued under their last known married name.

2. *Register number*

3. *Support or medium*: Paintings in oils are described in terms of their support (eg canvas, panel, millboard); drawings in terms of their medium (eg water-colour, pastel, chalk).

4. *Sizes*: Given in centimetres and (in brackets) inches, height before width.

5. *Artist and date*: Whenever possible, the name of the artist is given in full. Dates (in brackets) refer to the originals, or, if specified, to the dates when the portraits were first engraved, first exhibited or first published (eg in *Punch, Vanity Fair*).

6. *Source and year of acquisition*

7. *Reference*: The locations of long-term loans from the Gallery, except those to the National Trust for display at Beningbrough Hall and Montacute House (indicated by *Beningbrough* or *Montacute* after the year of acquisition), are not noted, since these loans are subject to recall or change. Where a sitter, group or collection is fully discussed in one of the Gallery catalogues raisonnés, this is indicated at the end of the entry (eg Strong, Piper, etc. See *Abbreviations*, overleaf).

Abbreviations

b	born
BM	British Museum
Beningbrough	On long-term loan to the National Trust for display at Beningbrough Hall, Beningbrough, near York
d	died
eng	first engraved
exh	first exhibited
Ford *Album*	Colin Ford, *An Early Victorian Album. The photographic masterpieces (1843-1847) of David Octavius Hill and Robert Adamson,* Alfred A. Knopf, 1976
Ford *Carroll*	Colin Ford, *Lewis Carroll at Christ Church,* National Portrait Gallery, 1974
Ford *Herschel*	Colin Ford, *The Cameron Collection. An Album of Photographs By Julia Margaret Cameron Presented to Sir John Herschel,* Van Nostrand Reinhold in association with the National Portrait Gallery, 1975
Harris	Eileen Harris, *The Townshend Album*, HMSO, 1974
Kerslake	John Kerslake, *Early Georgian Portraits*, HMSO, 1977
Montacute	On long-term loan to the National Trust for display at Montacute House, Montacute, near Yeovil, Somerset
NACF	National Art-Collections Fund
NG	National Gallery, London
Ormond	Richard Ormond, *Early Victorian Portraits*, HMSO, 1973
Ormond *VF*	Richard Ormond, *Original Vanity Fair Cartoons in the National Portrait Gallery*, National Portrait Gallery,1976
Piper	David Piper, *Seventeenth Century Portraits in the National Portrait Gallery,* Cambridge University Press, 1963
pub	first published
Strong	Roy Strong, *Tudor and Jacobean Portraits*, HMSO, 1969
VF	*Vanity Fair*

K. K. Yung
August 1980

Single and Double Portraits

ABBOT, George (1562-1633)
Archbishop of Canterbury

2160 Canvas 121.9 x 96.2
(48 x 37$\frac{7}{8}$)
Unknown artist, after a portrait
of 1623
Purchased, 1927. *Montacute*

Strong

ABBOT-ANDERSON, Edward
See AYNESWORTH, Allan

ABBOTT, Charles, 1st Baron
Colchester *See* COLCHESTER

ABBOTT, Charles, 1st Baron
Tenterden *See* TENTERDEN

ABBOTT, Sir James (1807-96)
General

4532 Water-colour 20.3 x 15.2
(8 x 6)
B. Baldwin, 1841
Given by Miss E. Werge Thomas,
1967

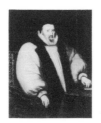

ABDUL AZIZ (1830-76)
Sultan of Turkey

4707(1) Water-colour 29.8 x 18.1
(11$\frac{3}{4}$ x 7$\frac{1}{8}$)
James Jacques Tissot, signed *Coïdé*
(VF 30 Oct 1869)
Purchased, 1934
See Collections: Vanity Fair
cartoons, 1869-1910, by various
artists, **2566-2606,** etc

A BECKETT, Arthur William
(1844-1909) Humorist

3619 *See Collections:* Prominent
Men, c. 1880-c. 1910, by Harry
Furniss, **3337-3535** and **3554-3620**

A BECKETT, Gilbert Abbott
(1811-56) Comic writer

1362 Miniature over a photograph,
oval 11.1 x 8.3 (4$\frac{3}{8}$ x 3¼)
Attributed to Charles Couzens,
1855
Given by the sitter's son, Arthur A
Beckett, 1904

Ormond

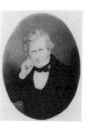

ABEL, Carl Friedrich (1725-87)
Musician

5081 Black chalk and stump
and white chalk 32.4 x 25.4
(12¾ x 10)
Thomas Gainsborough, c.1763
Purchased, 1976

5178 Pen and ink and wash
17.8 x 13.8 (7 x 5⅜)
John Nixon, signed in monogram
and dated 1787, inscribed below
image
Purchased, 1978

ABEL, Sir Frederick Augustus
(1827-1902) Chemist

4926 Canvas 119.8 x 99.1
(47⅛ x 39)
Frank Bramley, signed and dated
1900
Purchased, 1973

ABERCORN, James Hamilton,
1st Duke of (1811-85)
Lord-Lieutenant of Ireland

1834(a) Pencil 20.3 x 13 (8 x 5⅛)
Frederick Sargent, signed and
inscribed
Given by A. C. R. Carter, 1919
See Collections: Members of the
House of Lords, c.1870-80, by
Frederick Sargent, **1834**
(a-z and aa-hh)

ABERCORN, Louisa Jane (née
Russell), Duchess of (1812-1902)
Wife of 1st Duke of Abercorn

316a(104, 105) Pencil, two
sketches, each 34 x 27.9
(13⅜ x 11)
Sir Francis Chantrey, inscribed
Given by Mrs George Jones, 1871
See Collections: Preliminary
drawings for busts and statues by
Sir Francis Chantrey, **316a(1-202)**

ABERCROMBY, James, 1st Baron
Dunfermline *See* DUNFERMLINE

ABERCROMBY, Sir Ralph
(1734-1801) General

1538 Canvas 93.3 x 76.8
(36¾ x 30¼)
After John Hoppner (eng 1799)
Given by Alfred Jones, 1909

ABERDARE, Henry Austin Bruce,
1st Baron (1815-95) Statesman

5116 *See Groups:* Gladstone's
Cabinet of 1868, by Lowes Cato
Dickinson

ABERDEEN, George Hamilton
Gordon, 4th Earl of (1784-1860)
Prime Minister

793 *See Groups:* Four studies for
Patrons and Lovers of Art, c.1826,
by Pieter Christoph Wonder, **792-5**

54 *See Groups:* The House of Com-
mons, 1833, by Sir George Hayter

2789 *See Groups:* Members of the
House of Lords, c.1833, attributed
to Isaac Robert Cruikshank

342, 343a-c *See Groups:* The Fine
Arts Commissioners, 1846, by
John Partridge

750 Canvas 115.6 x 144.8
(45½ x 57)
John Partridge, c.1847
Given by Henry Willett, 1886

1125 *See Groups:* The Coalition
Ministry, 1854, by Sir John Gilbert

Ormond

ABERDEEN AND TEMAIR, John
Campbell Gordon, 1st Marquess of
(1847-1934) Statesman

3845 *See Groups:* Dinner at Haddo
House, 1884 by Alfred Edward
Emslie

ABERDEEN AND TEMAIR,
Ishbel Maria (Marjoribanks),
1st Marchioness of (1857-1939)
Promoter and patron of social
service enterprises

3845 *See Groups:* Dinner at Haddo
House, 1884, by Alfred Edward
Emslie

ABERNETHY, John (1764-1831)
Surgeon and teacher

1253 Pencil 31.1 x 22.2
(12¼ x 8¾)
George Dance, signed and dated
1793
Purchased, 1900

ABINGDON, Montague Bertie,
6th Earl of (1808-84) MP for
Oxfordshire

54 *See Groups:* The House of Com-
mons, 1833, by Sir George Hayter

ACHESON, Archibald, 2nd Earl of
Gosford *See* GOSFORD

ACLAND, Sir Thomas Dyke,
Bt (1787-1871) Philanthropist

316a(1) Pencil 47.2 x 32.4
(18⅝ x 12¾)
Sir Francis Chantrey, inscribed
Given by Mrs George Jones, 1871
See Collections: Preliminary
drawings for busts and statues by
Sir Francis Chantrey, **316a(1-202)**

ACTON, John Acton, 1st Baron
(1834-1902) Historian

4083 Canvas 64.8 x 52.1
(25½ x 20½)
Franz Seraph von Lenbach, c.1879
Purchased, 1958

ACTON, Sir John Frances Edward,
Bt (1736-1811) Prime Minister of
Naples

4082 Miniature on ivory, octagonal
9.8 x 7.6 (3⅞ x 3)
Peter Eduard Ströhling, signed and
inscribed
Purchased, 1958

ADAM, Professor
American slavery abolitionist

599 *See Groups:* The Anti-Slavery
Society Convention, 1840, by
Benjamin Robert Haydon

ADAM, Sir Charles (1790-1853)
Admiral

54 *See Groups:* The House of Com-
mons, 1833, by Sir George Hayter

ADAM, Sir Frederick (1781-1853)
General

3689 Canvas 53.3 x 43.2 (21 x 17)
William Salter, 1830-40
Bequeathed by W.D.Mackenzie,
1929
See Collections: Studies for The
Waterloo Banquet at Apsley House,
1836, by William Salter, **3689-3769**

ADAM, John (1721-92)
Architect; eldest of the Adam
brothers

4612 Medallion 7.6 (3) high
James Tassie, incised and dated
1791
Given by Hugh Leggatt through
NACF, 1968

ADAM, Robert (1728-92)
Architect

2953 Canvas 127 x 101.6
(50 x 40)
Attributed to George Willison,
c. 1770-5
Purchased, 1938

ADAMS, Edward Hamlyn
(1777-1842) MP for Carmarthenshire

54 *See Groups:* The House of Com-
mons, 1833, by Sir George Hayter

ADAMS, John Couch (1819-92)
Astronomer and mathematician

1842 Canvas 59.7 x 39.4
(23½ x 15½)
Sir Hubert von Herkomer, 1888
Bequeathed by the sitter's
widow, 1910

ADAMS, Sarah Flower (1805-48)
Poet and hymn-writer

1514 Photograph of drawing,
touched with chalk 24.5 x 19.7
($9\frac{5}{8}$ x 7¾)
After Margaret Gillies
Given by wish of George Fox, 1908

ADAMS, William (1772-1851)
Lawyer

1695(h) *See Collections:* Sketches
for The Trial of Queen Caroline,
1820, by Sir George Hayter,
1695(a-x)

2662(10) *See Collections:* Book of
sketches, mainly for The Trial of
Queen Caroline, 1820, by Sir
George Hayter, **2662(1-38)**

999 *See Groups:* The Trial of
Queen Caroline, 1820, by Sir
George Hayter

ADAMSON, Alexander
Brother of Robert Adamson

P6(153) *See Collections:* The Hill
and Adamson Albums, 1843-8,
by David Octavius Hill and
Robert Adamson, **P6(1-258)**

ADAMSON, John (1810-70)
Chemist and brother of Robert
Adamson

P6(153) *See Collections:* The Hill
and Adamson Albums, 1843-8,
by David Octavius Hill and
Robert Adamson, **P6(1-258)**

ADAMSON, Mrs John

P6(153) *See Collections:* The Hill
and Adamson Albums, 1843-8,
by David Octavius Hill and
Robert Adamson, **P6(1-258)**

ADAMSON, Melville
Sister of Robert Adamson

P6(153) *See Collections:* The Hill
and Adamson Albums, 1843-8,
by David Octavius Hill and
Robert Adamson, **P6(1-258)**

ADAMSON, Robert (1821-48)
Pioneer photographer

P6(181) Photograph: calotype
20.1 x 14.4 ($7\frac{7}{8}$ x $5\frac{5}{8}$)
David Octavius Hill and Robert
Adamson, 1843-8
Given by an anonymous donor,
1973
See Collections: The Hill and
Adamson Albums, 1843-8,
by David Octavius Hill and
Robert Adamson, **P6(1-258)**

P6(153) *See Collections:* The Hill
and Adamson Albums, 1843-8,
by David Octavius Hill and
Robert Adamson, **P6(1-258)**

ADAMSON, William (1863-1936)
Chairman of the Parliamentary
Labour Party

4529(1) *See Collections:* Working
drawings by Sir David Low,
4529(1-401)

ADDINGTON, Henry, 1st Viscount
Sidmouth *See* SIDMOUTH

ADDISON, Joseph (1672-1719)
Essayist and poet

3193 Canvas 91.4 x 71.1
(36 x 28)
Sir Godfrey Kneller, signed, eng
before 1717
Kit-cat Club portrait
Given by NACF, 1945

283 Canvas 88.9 x 67.3 (35 x 26½)
After Sir Godfrey Kneller (the Kit-
cat Club portrait)
Purchased, 1869

714 Canvas 102.9 x 79.4
(40½ x 31¼)
Michael Dahl, signed, inscribed and
dated 1719
Purchased, 1884

Piper

ADELAIDE Amelia Louisa Theresa
Caroline of Saxe-Coburg Meiningen
(1792-1849) Queen of William IV

1533 Canvas 91.4 x 70.5
(36 x 27¾)
Sir William Beechey, c. 1831
Purchased, 1909

Ormond

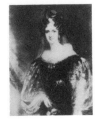

ADEY, Edward
Slavery abolitionist

599 *See Groups:* The Anti-Slavery
Society Convention, 1840,
by Benjamin Robert Haydon

ADYE, Stephen Galway (d.1838)
General

3690 *See Collections:* Studies for
The Waterloo Banquet at Apsley
House, 1836, by William Salter,
3689-3769

AELFRED (849-901)
King of the West Saxons

4269 Silver penny 1.9 (¾) diameter
Unknown artist, c. 887
Purchased with help from the
Rev A. C. Don, 1962

Strong

AFFLECK, Philip (1729-99)
Admiral

1579 Canvas 76.8 x 63.8
(30¼ x 25⅛)
Attributed to Edward Penny,
c.1789
Given by H. J. Pfungst, 1910

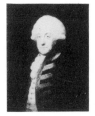

AGAR, James Ellis, 3rd Earl of
Normanton *See* NORMANTON

AGAR, John Samuel (1770-1858)
Engraver

2560 Pencil 19.7 x 15.9 (7¾ x 6¼)
Self-portrait
Given by Athill Cruttwell, 1933

AGAR-ELLIS, George, 1st Baron
Dover *See* DOVER

AGLIONBY, Henry Aglionby
(1790-1854) MP for Cockermouth

54 *See Groups:* The House of Com-
mons, 1833, by Sir George Hayter

AGNEW, Sir Andrew, Bt
(1793-1849) Sabbatarian

54 *See Groups:* The House of Com-
mons, 1833, by Sir George Hayter

AGNEW, Sir William, Bt
(1825-1910) Art dealer

3413 *See Collections:* Prominent
Men, c. 1880-c.1910, by Harry
Furniss, **3337-3535** and **3554-3620**

1833 *See Groups:* Private View of
the Old Masters Exhibition, Royal
Academy, 1888, by Henry Jamyn
Brooks

AIKEN, Arthur (1773-1854)
Chemist and geologist

2515(9) Pencil and black chalk
39.4 x 27.8 (15½ x 10⅞)
William Brockedon, dated 1826
Lent by NG, 1959
See Collections: Drawings of
Prominent People, 1823-49, by
William Brockedon, **2515(1-104)**

Ormond

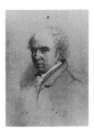

AILESBURY, Charles Brudenell-
Bruce, 1st Marquess of (1773-1856)

999 *See Groups:* The Trial of
Queen Caroline, 1820, by Sir
George Hayter

AILESBURY, Ernest Augustus
Charles Brudenell-Bruce, 3rd
Marquess of (1811-86) MP for
Marlborough

54 *See Groups:* The House of Commons, 1833, by Sir George Hayter

AINGER, Alfred (1837-1904)
Writer, humorist and divine

2660 Water-colour 30.5 x 22.9
(12 x 9)
George du Maurier, signed
Given by the artist's son, Sir Gerald
du Maurier, 1934

AINLEY, Henry Hinchliffe
(1879-1945) Actor

3414 Ink 38.7 x 31.8 (15¼ x 12½)
Harry Furniss, signed with initials,
1905
Purchased, 1947
See Collections: Prominent Men,
c.1880-c.1910, by Harry Furniss,
3337-3535 and **3554-3620**

AINSWORTH, William Harrison
(1805-82) Novelist

3655 Canvas 91.4 x 70.5
(36 x 27¾)
Daniel Maclise, c.1834
Given by Mrs L. A. Crocker Fox,
1949

Ormond

AIRD, Sir John (1833-1911)
Contractor

5014 Water-colour 35.6 x 22.9
(14 x 9)
Sir Leslie Ward, signed *Spy*
(VF 20 June 1891)
Purchased, 1974

AIRLIE, Henrietta Blanche (née
Stanley), Countess of (1830-1921)
Wife of 7th Earl of Airlie

1833 *See Groups:* Private View of
the Old Masters Exhibition, Royal
Academy, 1888, by Henry Jamyn
Brooks

AISLABIE, John (1670-1742)
Chancellor of the Exchequer

1754 *See Unknown Sitters III*

AITKEN, William Maxwell, 1st
Baron Beaverbrook
See BEAVERBROOK

AKERS-DOUGLAS, Aretas, 1st
Viscount Chilston *See* CHILSTON

ALANBROOKE, Alan Brooke,
1st Viscount (1883-1963)
Field-Marshal

4346 Chalk 49.5 x 32.4
(19½ x 12¾)
Juliet Pannett, signed and inscribed,
1961
Purchased, 1964

ALAVA, Don Miguel
Spanish ambassador

3691 *See Collections:* Studies for
The Waterloo Banquet at Apsley
House, 1936, by William Salter,
3689-3769

ALBANY, Prince Leopold,
Duke of (1853-84) Fourth and
youngest son of Queen Victoria

P26 *See Groups:* The Royal
Family . . . , by L. Caldesi

P22(2,3,7) *See Collections:* The
Balmoral Album, 1854-68,
by George Washington Wilson,
W. & D. Downey, and Henry
John Whitlock, **P22(1-27)**

4711 Water-colour 35.6 x 20
(14 x 7⅞)
Sir Leslie Ward, signed *Spy*
(VF 21 April 1877)
Purchased, 1970

ALBANY, Louisa Maria von Stolberg, Countess of (1753-1824) Wife of Prince Charles Edward Stuart ('The Young Pretender')

377 *See Unknown Sitters III*

ALBEMARLE, George Monck, 1st Duke of (1608-70) Soldier and statesman

154 Canvas 76.5 x 63.5 (30⅛ x 25) After Samuel Cooper (c.1660) Purchased, 1863

833 Line engraving 31.8 x 21.9 (12½ x 8⅝) David Loggan, signed, inscribed, and dated on plate 1661 Purchased, 1890

423 Canvas 124.5 x 99.1 (49 x 39) Studio of Sir Peter Lely (c. 1665-6) Purchased, 1876

1927 *See Unknown Sitters II*

Piper

ALBEMARLE, Arnold Joost van Keppel, 1st Earl of (1669-1718) General

1625 Canvas 64.8 x 55.9 (25½ x 22) Sir Godfrey Kneller, c.1700 Purchased, 1911

Piper

ALBEMARLE, William Charles Keppel, 4th Earl of (1772-1849) Master of the Horse

999 *See Groups:* The Trial of Queen Caroline, 1820, by Sir George Hayter

316a(2) Pencil 41.9 x 35.3 (16½ x 13⅞) Sir Francis Chantrey, inscribed and dated 1840 Given by Mrs George Jones, 1871 *See Collections:* Preliminary drawings for busts and statues by Sir Francis Chantrey, **316a(1-202)**

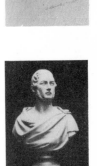

ALBERT of Saxe-Coburg-Gotha, Prince (1819-61) Prince Consort of Queen Victoria

1736 Plaster cast of bust, now painted black 79.4 (31¼) high John Francis, incised and dated 1844 Given by J. A. Gowland, 1914

342,343a-c *See Groups:* The Fine Arts Commissioners, 1846, by John Partridge

P26 *See Groups:* The Royal Family . . . , by L.Caldesi

237 Canvas 241.3 x 156.8 (95 x 61¾) Francis Xavier Winterhalter, signed and dated 1867, replica (1859) Given by Queen Victoria, 1867

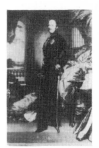

4969 *See Groups:* Queen Victoria presenting a Bible in the Audience Chamber at Windsor, c. 1861, by Thomas Jones Barker

2023A(3,4) *See Collections:* Queen Victoria, Prince Albert and members of their family, by Susan D. Durant, **2023A(1-12)**

1199 Cream painted plaster cast of bust 73.7 (29) high George Gammon Adams, incised Purchased, 1899

Ormond

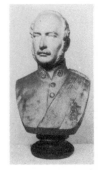

ALCOCK, Sir John William
(1892-1919) Airman; made first
non-stop flight across Atlantic

1894 Canvas 149.9 x 101.6
(59 x 40)
Ambrose McEvoy, signed, 1919
Given by Messrs Rolls-Royce, 1921

ALDER, Joshua (1792-1867)
Zoologist; friend of Thomas Bewick

P120(17) Photograph: albumen
print, arched top 19.7 x 14.6
(7¾ x 5¾)
Maull & Polyblank, inscribed on
mount, 1855
Purchased, 1979
See Collections: Literary and
Scientific Men, 1855, by Maull
& Polyblank, **P120(1-54)**

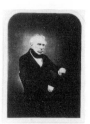

ALDINI, Giovanni (1762-1834)
Italian experimental philosopher
and writer

2515(19) *See Collections:*
Drawings of Prominent People,
1823-49, by William Brockedon,
2515(1-104)

ALEXANDER II (1818-81)
Tsar of Russia

4707(2) Water-colour 30.1 x 18.1
(11$\frac{7}{8}$ x 7$\frac{1}{8}$)
James Jacques Tissot, signed *Coïdé*
(*VF* 16 Oct 1869)
Purchased, 1934
See Collections: Vanity Fair
cartoons, 1869-1910, by various
artists, **2556-2606**, etc

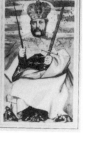

ALEXANDER, Harold Alexander,
Earl (1891-1969) Field-Marshal

4689 Oil on paper 42.5 x 29.8
(16¾ x 11¾)
John Gilroy, signed, 1957
Given by the artist, 1969

ALEXANDER, Daniel Asher
(1786-1846) Architect

4827 Canvas 54 x 40.6
(21¼ x 16)
John Partridge, signed with initials,
inscribed, c.1818
Purchased, 1970

ALEXANDER, Sir George (George
Samson)(1858-1918) Actor-manager

4095(1) Ink 38.4 x 31.8
(15$\frac{1}{8}$ x 12½)
Harry Furniss, signed with initials,
1905
Purchased, 1959
See Collections: The Garrick
Gallery of Caricatures, 1905,
by Harry Furniss, **4095(1-11)**

3663 Water-colour 47 x 23.5
(18½ x 9¼)
Sir Bernard Partridge, signed,
inscribed and dated 1909
Purchased, 1949

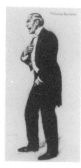

ALEXANDER, George William
(1802-90) Treasurer of the British
and Foreign Anti-Slavery Society

599 *See Groups:* The Anti-Slavery
Society Convention, 1840, by
Benjamin Robert Haydon

ALEXANDER, Samuel
(1859-1938) Philosopher

4422 Chalk 38.1 x 27.9
(15 x 11)
Francis Dodd, signed and dated
1932
Purchased, 1964

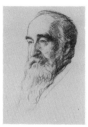

ALEXANDER-SINCLAIR,
Sir Edwyn Sinclair (1865-1945)
Admiral

1913 *See Groups:* Naval Officers
of World War I, by Sir Arthur
Stockdale Cope

ALEXANDRA of Denmark
(1844-1925) Queen of Edward VII

3059 Marble bust 57.2 (22½) high
H. Garland, incised, c.1883
Given by the Alexandra Club, 1939

1889 Canvas 128.3 x 102.9
(50½ x 40½)
Sir Luke Fildes, replica (1884)
Given by King George V, 1920

ALFRED, Prince, Duke of
Edinburgh *See* EDINBURGH

ALICE Maud Mary, Princess
(1843-78) Third child of Queen
Victoria

P26 *See Groups:* The Royal
Family . . . , by L. Caldesi

P27 *See Groups:* Royal mourning
group, 1862, by W. Bambridge

2023A(7-10) *See Collections:*
Queen Victoria, Prince Albert and
members of their family, by Susan
D. Durant, **2023A(1-12)**

ALLAN, Ann (née Nicholson)
(1741-87) First wife of George Allan

4308 *See under* George Allan,
no.**4307**

ALLAN, George (1763-1800)
Antiquary and topographer

4307 Pastel 58.4 x 47 (23 x 18½)
Unknown artist
Given by Mr and Mrs C. J. Duveen,
1963 (A pastel portrait by
unknown artist of the sitter's first
wife, Ann, given by the same
donors, is no.**4308**)

ALLAN, Sir William (1782-1850)
Painter; President of the Royal
Scottish Academy

P6(9) Photograph: calotype
20.3 x 14.3 (8 x 5⅝)
David Octavius Hill and
Robert Adamson, 1844
Given by an anonymous donor, 1973
See Collections: The Hill and
Adamson Albums, 1843-8, by
David Octavius Hill and Robert
Adamson, **P6(1-258)**

P6(35,55) *See Collections:* The
Hill and Adamson Albums, 1843-8,
by David Octavius Hill and
Robert Adamson, **P6(1-258)**

ALLEN, Joshua William Allen,
6th Viscount (1791-1845)
Soldier

4026(1,2) *See Collections:*
Drawings of Men about Town,
1832-48, by Alfred, Count D'Orsay
4026(1-61)

ALLEN, Charles Grant Blairfindie
(1848-99) Writer

3998 Lithograph 45.7 x 28.6
(18 x 11¼)
Sir William Rothenstein, signed and
inscribed, and dated on stone 1897
Purchased, 1956

ALLEN, John (1771-1843)
Historian

384 Panel 61 x 45.1 (24 x 17¾)
Sir Edwin Landseer, 1835
Given by Mrs C. R. Fox, 1873

ALLEN, Ralph (1694-1763)
Philanthropist; 'The Man of Bath'

1580 *See Unknown Sitters III*

ALLEN, Richard (1787-1873)
Slavery abolitionist

599 *See Groups:* The Anti-Slavery
Society Convention, 1840, by
Benjamin Robert Haydon

ALLEN, Stafford (1806-89)
Slavery abolitionist

599 *See Groups:* The Anti-Slavery
Society Convention, 1840, by
Benjamin Robert Haydon

ALLEN, William (1770-1843)
Chemist and philanthropist

1075, 1075a and **b** *See Groups:*
Men of Science Living in 1807-8,
by Sir John Gilbert and others

599 *See Groups:* The Anti-Slavery
Society Convention, 1840, by
Benjamin Robert Haydon

ALLEN, William (1793-1864)
Rear-Admiral

2515(68) Black and red chalk
35.2 x 26.3 (13$\frac{7}{8}$ x 10$\frac{3}{8}$)
William Brockedon, dated 1834
Lent by NG, 1958
See Collections: Drawings of
Prominent People, 1823-49, by
William Brockedon, **2515(1-104)**

Ormond

ALLENBY, Edmund Allenby,
1st Viscount (1861-1936)
Field-Marshal

2908(10,12) *See Collections:*
Studies, mainly for General Officers
of World War I, by John Singer
Sargent, **2908(1-18)**

1954 *See Groups:* General
Officers of World War I, by
John Singer Sargent

2906 Pastel 44.5 x 33.7
(17½ x 13¼)
Eric Kennington, pub 1926
Given by A. W. Lawrence, 1936

ALLESTREE, Richard (1619-81)
Royalist divine

629 Line engraving 28.3 x 22.2
(11$\frac{1}{8}$ x 8¾)
David Loggan, signed and inscribed
on plate
Purchased, 1881

ALLINGHAM, William (1824-89)
Poet

1647 Water-colour 29.2 x 23.5
(11½ x 9¼)
Helen Allingham (his wife), signed
with initials and dated 1876
Given by the artist, 1912

ALLIX, Charles (1787-1862)
Colonel

3692 *See Collections:* Studies for
The Waterloo Banquet at Apsley
House, 1836, by William Salter,
3689-3769

ALMA-TADEMA, Laura (née Epps),
Lady (d.1909) Second wife of Sir
Lawrence Alma-Tadema

1833 *See Groups:* Private View of
the Old Masters Exhibition, Royal
Academy, 1888, by Henry Jamyn
Brooks

ALMA-TADEMA, Sir Lawrence
(1836-1912) Painter

1833 *See Groups:* Private View of
the Old Masters Exhibition, Royal
Academy, 1888, by Henry Jamyn
Brooks

2820 *See Groups:* Conversazione
at the Royal Academy, 1891, by
G. Grenville Manton

4245 *See Groups:* Hanging
Committee, Royal Academy, 1892,
by Reginald Cleaver

4404 *See Groups:* The St John's
Wood Arts Club, 1895, by Sydney
Prior Hall

4388 Pencil 22.9 x 18.1 (9 x 7⅛)
Sydney Prior Hall, signed with
initials, c. 1895
Purchased, 1964

3946 Pencil 31.8 x 23.2
(12½ x 9⅛)
Flora Lion, signed, 1912
Purchased, 1955

ALTEN, Sir Charles, Count von
(1764-1840) Hanoverian general

1914(1) Water-colour 20.3 x 16.5
(8 x 6½)
Thomas Heaphy, 1813-14
Purchased, 1921
See Collections: Peninsular and
Waterloo Officers, 1813-14, by
Thomas Heaphy, **1914(1-33)**

ALVANLEY, Richard Pepper
Arden, 1st Baron (1744-1804)
Judge

745 *See Groups:* William Pitt
addressing the House of Commons
. . . 1793, by Karl Anton Hickel

ALVANLEY, William Arden, 2nd
Baron (1789-1849) Soldier

999 *See Groups:* The Trial of
Queen Caroline, 1820, by Sir
George Hayter

4918 *See Collections:* Caricatures
of Prominent People, c. 1835, by
Sir Edwin Landseer, **4914-22**

ALVERSTONE, Richard Everard
Webster, Viscount (1842-1915)
Lord Chief Justice

2698 Water-colour 31.1 x 18.1
(12¼ x 7⅛)
François Verheyden
(*VF* 26 May 1883)
Purchased, 1934

2300 *See Collections:* Drawings of
Members of Parliament, etc,
c.1886-1903, by Sydney Prior Hall,
2282-2348 and **2370-90**

2233 *See Collections:* The Parnell
Commission, 1888-9, by Sydney
Prior Hall, **2229-72**

4337 Chalk 48.9 x 38.7
(19¼ x 15¼)
John Seymour Lucas, signed and
dated 1902
Given by the Royal Borough of
Kensington, 1963

AMELIA Sophia Eleanora, Princess
(1711-86) Second daughter of
George II

1556 *See Groups:* Frederick,
Prince of Wales, and his sisters
(The Music Party), by Philip Mercier

AMERY, Leopold Stennett
(1873-1955) Secretary of State for
India

4300 Canvas 74.9 x 62.2
(29½ x 24½)
Sir James Gunn, signed 1942
Purchased, 1963

AMHERST of Arracan, William Pitt
Amherst, 1st Earl (1773-1857)
Statesman; Governor-General
of India

1546 Canvas 107.6 x 83.1
(42⅜ x 32¾)
After Arthur William Devis (1803)
Bequeathed by Earl Egerton, 1909

2662(20) *See Collections:* Book
of sketches, mainly for The Trial
of Queen Caroline, 1820, by Sir
George Hayter, **2662(1-38)**

999 *See Groups:* The Trial of
Queen Caroline, 1820, by Sir
George Hayter

AMHERST, Jeffrey Amherst,
1st Baron (1717-97) Field-Marshal

150 Canvas, feigned oval 76 x 63.1
(29⅞ x 24⅞)
Thomas Gainsborough, c.1780
Purchased, 1862

ANCASTER, Gilbert Henry Heathcote-Drummond-Willoughby, 1st Earl of (1830-1910) Politician

4712 Water-colour 31.1 x 17.1 (12¼ x 6¾)
Sir Leslie Ward, signed *Spy*
(*VF* 30 July 1881)
Purchased, 1970

ANDERSON, Sir Edmund (1530-1605) Lord Chief Justice

2148 Panel 90.8 x 74.9 (35¾ x 29½)
Unknown artist, c.1590-1600
Purchased, 1927. *Montacute*

456 Water-colour 23.2 x 20.6 ($9\frac{1}{8}$ x $8\frac{1}{8}$)
Manner of George Perfect Harding after unknown artist
Given by the Society of Judges and Serjeants-at-Law, 1877

Strong

ANDERSON, John, 1st Viscount Waverley *See* WAVERLEY

ANDERSON, Professor

P106(1) *See Collections:* Literary and Scientific Portrait Club, by Maull & Polyblank, **P106(1-20)**

ANDERSON, Mary (Mrs de Navarro) (1859-1940) Actress

2820 *See Groups:* Conversazione at the Royal Academy, 1891, by G. Grenville Manton

ANDERSON, Stella (née Benson)
See BENSON

ANGELL, Sir Norman (1874-1967) Writer

5129 Ink 22.9 x 17.1 (9 x 6¾)
Edmond Xavier Kapp, signed and dated 1914, and inscribed below image
Purchased, 1977

ANGELO, Henry Charles (d.c.1854) Fencing master

2009A Pencil 19.3 x 13.6 ($7\frac{5}{8}$ x $5\frac{3}{8}$)
W. H. Nightingale, signed with initials and dated 1839
Given by R. Farquharson Sharp, 1923

ANGLESEY, Arthur Annesley, 1st Earl of (1614-86) Politician and book collector

3805 Canvas 127 x 101 (50 x 39¾)
After John Michael Wright (1676)
Given by Miss Mary Annesley, 1951

Piper

ANGLESEY, Henry William Paget, 1st Marquess of (1768-1854) Field-Marshal; Lord-Lieutenant of Ireland

313 Water-colour 47 x 34.3 (18½ x 13½)
Henry Edridge, signed and dated 1808
Purchased, 1870

1581 Canvas 76.2 x 63.5 (30 x 25)
Unknown artist, c.1817
Purchased, 1910

999 *See Groups:* The Trial of Queen Caroline, 1820, by Sir George Hayter

54 *See Groups:* The House of Commons, 1833, by Sir George Hayter

3693 Canvas 53.3 x 43.2 (21 x 17)
William Salter, 1834-40
Bequeathed by W. D. Mackenzie,
1929
See Collections: Studies for The
Waterloo Banquet at Apsley House,
1836, by William Salter, **3689-3769**

5270 Wax medallion, oval
17.1 x 14.9 (6¾ x 5⅞)
Richard Cockle Lucas, incised
and dated 1851
Purchased, 1979

ANGLESEY, Marjorie,
Marchioness of (d.1946) Wife of
6th Marquess of Anglesey

1833 *See Groups:* Private View of
the Old Masters Exhibition, Royal
Academy, 1888, by Henry Jamyn
Brooks

ANNE of Bohemia (1366-94)
Queen of Richard II

331 Electrotype of effigy in
Westminster Abbey 73.7 (29) high
After Nicholas Broker and Godfrey
Prest (c.1395-7)
Purchased, 1871

Strong

ANNE BOLEYN (1507-36)
Second Queen of Henry VIII

668 Panel 54.3 x 41.6
(21⅜ x 16⅜)
Unknown artist
Purchased, 1882

4980(15) *See Collections:* Set of
16 early English Kings and Queens
formerly at Hornby Castle,
Yorkshire, **4980(1-16)**

Strong

ANNE of Denmark (1574-1619)
Queen of James I

4010 Miniature on vellum, oval
5.1 x 4.1 (2 x 1⅝)
Isaac Oliver, signed in monogram
Purchased with help from NACF,
1957

4656 Panel 57.2 x 43.8
(22½ x 17¼)
Attributed to William Larkin,
c. 1612
Purchased, 1969

127 Canvas, feigned oval
62.9 x 53.3 (24¾ x 21)
After Paul van Somer (c.1617)
Purchased, 1861. *Montacute*

Strong

ANNE, Queen (1665-1714)
Reigned 1702-14

1616 Canvas 233.7 x 142.9
(92 x 56¼)
Attributed to Sir Godfrey Kneller,
c. 1690
Purchased, 1911. *Beningbrough*

5227 With her son, William,
Duke of Gloucester
Canvas 125.1 x 102.2 (49¼ x 40¼)
Studio of Sir Godfrey Kneller
(c.1694)
Bequeathed by Mrs I. H. Wilson,
1978

325 With her son, William,
Duke of Gloucester
Canvas 121.9 x 100.3 (48 x 39½)
After Sir Godfrey Kneller (c.1694)
Purchased, 1871

Continued overleaf

215 Canvas 125.1 x 102.9
(49¼ x 40½)
Studio of John Closterman (c.1702)
Purchased, 1866

L152(20) Enamel miniature, oval
4.4 x 3.8 (1¾ x 1½)
Charles Boit, signed
Lent by NG (Alan Evans Bequest),
1975

624 *See Groups:* Queen Anne and
the Knights of the Garter, by
Peter Angelis

1674 *See Unknown Sitters II*

Piper

ANNE, Princess (1636-40) Third
daughter of Charles I

267 *See Groups:* Five Children of
Charles I, 1637, after Sir Anthony
van Dyck

ANNE, Princess Royal (1709-59)
Daughter of George II; Princess
of Orange

1556 *See Groups:* Frederick,
Prince of Wales, and his sisters
(The Music Party), by Philip Mercier

ANNESLEY, Arthur, 1st Earl of
Anglesey *See* ANGLESEY

ANSDELL, Richard (1815-85)
Painter

P89 Photograph: albumen print
21.3 x 16.1 (8⅜ x 6⅜)
David Wilkie Wynfield, 1860s
Given by H. Saxe Wyndham, 1937
See Collections: The St John's
Wood Clique, by David Wilkie
Wynfield, **P70-100**

P70 *See Collections:* The St
John's Wood Clique, by David
Wilkie Wynfield, **P70-100**

ANSON, George Anson,
1st Baron (1697-1762) Admiral

518 Canvas 127 x 101.6 (50 x 40)
After Sir Joshua Reynolds (1755)
Transferred from BM, 1879

Kerslake

ANSON, Sir George (1769-1849)
MP for Lichfield

54 *See Groups:* The House of Com-
mons, 1833 by Sir George Hayter

ANSON, George (1797-1857)
General

999 *See Groups:* The Trial of
Queen Caroline, 1820, by Sir
George Hayter

54 *See Groups:* The House of Com-
mons, 1833, by Sir George Hayter

ANSTEY, Christopher (1724-1805)
Poet

3084 With his daughter, Mary
Canvas 126 x 99.7 (49⅝ x 39¼)
William Hoare, c. 1779
Bequeathed by Mrs C. M.
Sambourne-Palmer, 1940.
Beningbrough

1339 *See Unknown Sitters III*

ANSTRUTHER, Sir William
Carmichael, Bt (1793-1869)

P6(43) *See Collections:* The Hill
and Adamson Albums, 1843-8,
by David Octavius Hill and
Robert Adamson, **P6(1-258)**

ARABELLA Stuart *See* STUART

ARBLAY, Frances ('Fanny Burney')
Madame D' (1752-1840) Diarist
and novelist

2634 Canvas 76.2 x 63.5 (30 x 25)
Edward Francis Burney (her
cousin), c. 1784-5
Purchased with help from NACF,
1933

ARBUTHNOT, Charles
(1767-1850) Diplomat

2662(14) *See Collections:* Book
of sketches, mainly for The Trial of
Queen Caroline, 1820, by Sir
George Hayter, **2662(1-38)**

999 *See Groups:* The Trial of
Queen Caroline, 1820, by Sir
George Hayter

ARBUTHNOT, Hugh (1780-1868)
MP for Kincardine

54 *See Groups:* The House of Com-
mons, 1833, by Sir George Hayter

ARBUTHNOT, Sir Robert Keith,
Bt (1864-1916) Rear-Admiral

1913 *See Groups:* Naval Officers
of World War I, by Sir Arthur
Stockdale Cope

ARCHER, Frederick (1857-86)
Jockey

2648 Water-colour 50.8 x 69.9
(20 x 27½)
Otto Brower, signed, inscribed and
dated 1878
Purchased, 1933

2649 Water-colour 50.8 x 69.9
(20 x 27½)
Otto Brower, signed, inscribed and
dated 1878
Purchased, 1933

3961 Chalk 57.8 x 41.3
(22¾ x 16¼)
Unknown artist, signed *D.W.S.* and
dated 1888
Given by A. C. Möller, 1955

ARDEN, Richard Pepper, 1st Baron
Alvanley *See* ALVANLEY

ARDEN, William, 2nd Baron
Alvanley *See* ALVANLEY

AREMBERG, Charles de Ligne,
Count of
Delegate at the Somerset House
Conference
665 *See Groups:* The Somerset
House Conference, 1604, by an
unknown Flemish artist

ARGYLL, John Campbell, 2nd
Duke of, and Duke of Greenwich
(1680-1743) Field-Marshal and
statesman

737 Canvas 125.7 x 101
(49½ x 39¾)
William Aikman, inscribed, c.1720-5
Purchased, 1885

3110 Canvas 139.7 x 111.8
(55 x 44)
Thomas Bardwell, signed in
monogram, inscribed and dated 1740
Purchased, 1942

Piper

ARGYLL, George William
Campbell, 6th Duke of (1768-1839)

999 *See Groups:* The Trial of
Queen Caroline, 1820, by Sir
George Hayter

ARGYLL, George Douglas
Campbell, 8th Duke of (1823-1900)
Liberal statesman

1125,1125a *See Groups:* The
Coalition Ministry, 1854, by Sir
John Gilbert

1263 Panel 59.7 x 49.5
(23½ x 19½)
George Frederic Watts, c. 1860
Given by the artist, 1900

5116 *See Groups:* Gladstone's
Cabinet of 1868, by Lowes Cato
Dickinson

2338 *See Collections:*
Miscellaneous drawings . . . by
Sydney Prior Hall, **2282-2348**
and **2370-90**

ARGYLL, John Campbell, 9th Duke
of (1845-1914) Governor-General
of Canada

4629 Water-colour 29.8 x 18.4
(11¾ x 7¼)
Carlo Pellegrini, signed *Ape*
(*VF* 19 Nov 1870)
Purchased, 1968

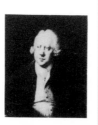

ARGYLL, Archibald Campbell,
9th Earl of (1629-85) Statesman

3902 With his first or second wife
Canvas 110.1 x 163.2
(43⅜ x 64¼)
Unknown artist, 1660-70
Purchased, 1954

630 Line engraving 30.5 x 20.3
(12 x 8)
David Loggan (c.1680)
Purchased, 1881

Piper

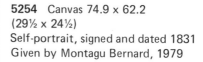

ARGYLL, Archibald Campbell,
1st Marquess of (1607-61)
Statesman

3109 Canvas, feigned oval
74.3 x 63.5 (29¼ x 25)
After David Scougall, inscribed
Purchased, 1942

Piper

ARKLEY, Margaret
(née McCandlish)

P6 (176, 177) *See Collections:* The
Hill and Adamson Albums, 1843-8,
by David Octavius Hill and
Robert Adamson, **P6 (1-258)**

ARKWRIGHT, Sir Richard
(1732-92) Engineer and inventor

136 Canvas 75.6 x 63.5
(29¾ x 25)
Studio of Joseph Wright (1790)
Purchased, 1861

ARLINGTON, Henry Bennet, 1st
Earl of (1618-85) Politician

1853 Canvas 121.3 x 95.9
(47¾ x 37¾)
After Sir Peter Lely (c.1665-70)
Purchased, 1919

Piper

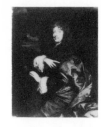

ARMSTRONG, William George
Armstrong, Baron (1810-1900)
Inventor

L161 Canvas 60.7 x 53
(23⅞ x 20⅞)
Mary Lemon Waller, signed and
dated 1882
Lent by the Institution of Civil
Engineers, 1975

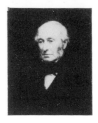

ARNALD, George (1763-1841)
Marine and landscape painter

1967A Sepia and wash 34.3 x 22.9
(13½ x 9)
John Thomas Smith, signed and
inscribed, c. 1830
Purchased, 1922

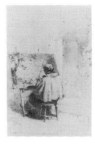

5254 Canvas 74.9 x 62.2
(29½ x 24½)
Self-portrait, signed and dated 1831
Given by Montagu Bernard, 1979

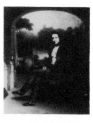

ARNE, Thomas Augustine
(1710-78) Composer

1130 Etching with water-colour
27.9 x 22.2 (11 x 8¾)
After Francesco Bartolozzi
(c.1770), inscribed below print
Given by Sir Lionel Cust, 1898

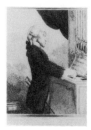

ARNOLD, Sir Edwin (1832-1904)
Poet and journalist

2455 Pencil 30.8 x 21.6
(12⅛ x 8½)
Alphaeus Philemon Cole, signed
by artist and sitter, and dated 1903
Purchased, 1930

ARNOLD, Matthew (1822-88)
Poet and critic

1000 Canvas 66 x 52.1 (26 x 20½)
George Frederic Watts, 1880
Given by the artist, 1895

ARNOLD, Samuel (1740-1802)
Composer

1135 Pencil 25.4 x 19.1 (10 x 7½)
George Dance, signed and dated 1795
Purchased, 1898

ARNOLD, Thomas (1795-1842)
Headmaster of Rugby School

1998 Canvas 121.9 x 99.1 (48 x 39)
Thomas Phillips, 1839
Given by Viscountess Sandhurst
and Mrs Whitridge, 1923

168 Marble bust 76.2 (30) high
William Behnes, incised and
dated 1849
Given by Bishop James Lee, 1864

Ormond

ARNOLD-FOSTER, Hugh Oakeley
(1855-1909) Politician

2328 *See Collections:*
Miscellaneous drawings . . . by
Sydney Prior Hall, **2282-2348**
and **2370-90**

ARTAUD, William (1763-1823)
Portrait painter

4863 With two children (reverse:
unknown lady with a child)
Pencil 15.9 x 11.8 (6¼ x 4⅝)
Self-portrait, c. 1800
Given by Kenneth Tayler, 1972

4862 Pastel, oval, 36.8 x 29.2
(14½ x 11½)
Self-portrait, c. 1822
Given by Kenneth Tayler, 1972

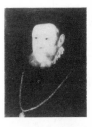

ARTHUR, Prince, Duke of
Connaught and Strathearn
See CONNAUGHT

ARUNDEL, Henry Fitzalan, 12th
Earl of (1511?-80) Soldier and
courtier

4693 Panel 53.3 x 42.5
(21 x 16¾)
Studio of Steven van der Meulen
Purchased, 1969

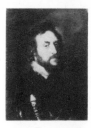

ARUNDEL AND SURREY, Thomas
Howard, 2nd Earl of (1585-1646)
Art patron and collector

2391 Canvas 68.6 x 53.3 (27 x 21)
Sir Peter Paul Rubens, 1629
Purchased, 1929

Piper

519 Panel 14.6 x 12.7 (5¾ x 5)
After Sir Anthony van Dyck
(c. 1635)
Transferred from BM, 1879

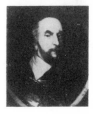

ARUNDELL, Francis Vyvyan Jago
(1780-1846) Traveller and antiquary

2515(36) *See Collections:* Drawings
of Prominent People, 1824-49, by
William Brockedon, **2515(1-104)**

ASHBOURNE, Edward Gibson, 1st Baron (1837-1913) Lord Chancellor of Ireland

3932 Water-colour 30.5 x 18.1 (12 x 7⅛)
Sir Leslie Ward, signed *Spy* (*VF* 4 July 1885)
Purchased, 1955

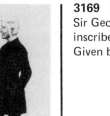

ASHBURNHAM, George Ashburnham, 3rd Earl of (1760-1830)

999 *See Groups:* The Trial of Queen Caroline, 1820, by Sir George Hayter

ASHBURNHAM, John (1603-71) Royalist

1243 *See Unknown Sitters II*

ASHBURTON, John Dunning, 1st Baron (1731-83) Solicitor-General

102 Canvas 74.3 x 61 (29¼ x 24)
Studio of Sir Joshua Reynolds, 1768-73
Given by Thomas Baring, 1860

ASHBURTON, Alexander Baring, 1st Baron (1774-1848) Financier

54 *See Groups:* The House of Commons, 1833, by Sir George Hayter

342, 343a-c *See Groups:* The Fine Arts Commissioners, 1846, by John Partridge

ASHBURTON, William Baring, 2nd Baron (1799-1864) Statesman

54 *See Groups:* The House of Commons, 1833, by Sir George Hayter

ASHBY, Thomas (1874-1931) Archaeologist

4281 Bronze head 40.6 (16) high
David Evans, incised and dated 1925
Given by the artist's widow, Mrs Y. L. Evans, 1962

3169 Pencil 22.9 x 20.3 (9 x 8)
Sir George Clausen, signed, inscribed and dated 1925
Given by the sitter's widow, 1943

ASHLEY-COOPER, Anthony, 7th Earl of Shaftesbury
See SHAFTESBURY

ASHLEY-COOPER, Anthony Henry (1807-58) MP for Dorchester

54 *See Groups:* The House of Commons, 1833, by Sir George Hayter

ASHMOLE, Elias (1617-92) Antiquary

1602 Canvas 74.3 x 62.2 (29¼ x 24½)
After John Riley (1687-9)
Purchased, 1911

Piper

ASKEW, Sir Henry (1775-1847) Lieutenant-General

3694 *See Collections:* Studies for The Waterloo Banquet at Apsley House, 1836, by William Salter, **3689-3769**

ASQUITH, Helen Violet Bonham Carter, Baroness (1887-1969) Patron of the arts, writer and woman of affairs

4963 Bronze bust 26.4 (10⅜) high
Oscar Nemon, incised, 1960-9
Purchased, 1973

ASQUITH, Herbert Henry, 1st Earl of Oxford and Asquith
See OXFORD AND ASQUITH

ASTLEY, Jacob, 16th Baron Hastings *See* HASTINGS

ASTLEY, Sir John Dugdale, Bt
(1828-94) Sportsman

2775 Water-colour 31.8 x 18.4
(12½ x 7¼)
John Flatman, signed with initials
Purchased, 1935

3173 Silhouette 17.5 x 11.1
(6⅞ x 4⅜)
Phil May, signed,
inscribed and dated 1889
Purchased, 1944

3173A Silhouette 16.1 x 10.2
(6⅜ x 4)
Phil May, signed,
inscribed and dated 1889
Purchased, 1944. *Not illustrated*

ASTLEY, Rhoda (née Delaval)
(1731-57) Pastellist

5253 Canvas 76.8 x 68.6
(30¼ x 27)
Unknown artist
Given by Montagu Bernard, 1979

ASTON, Harvey (d.1839)

1818B *See Collections:* Drawings
by John Linnell, **1812-18B**

ASTON, William George
(1841-1911) Japanese scholar

1775 Crayon 45.7 x 32.1
(18 x 12⅝)
Minnie Agnes Cohen, signed, 1911
Given by the sitter's sister,
Mary Aston, 1916

ASTOR, Nancy Viscountess
(1880-1964) First woman MP

4885 Chalk 55.9 x 38.1 (22 x 15)
John Singer Sargent, signed and
dated 1923
Given by the sitter's son, the Hon
Michael Astor, 1972

ASTOR, David (b.1912) Journalist

4529(3-6) *See Collections:* Working
drawings by Sir David Low,
4529(1-401)

ATHLONE, Alexander Cambridge,
Earl of (1874-1957) Governor-
General of the Union of South
Africa and of Canada

4441 *See Groups:* The Duke and
Duchess of Teck receiving Officers
of the Indian Contingent, 1882, by
Sydney Prior Hall

ATHOLL, John Murray, 4th Duke
of (1755-1830)

999 *See Groups:* The Trial of
Queen Caroline, 1820, by Sir
George Hayter

ATHOLL, Anne, Duchess of
(1814-97) Wife of 6th Duke of
Atholl

P22(2,3,24) *See Collections:* The
Balmoral Album, 1854-68, by
George Washington Wilson, W. & D.
Downey, and Henry John Whitlock,
P22(1-27)

ATKINSON, James (1780-1852)
Army surgeon and Oriental scholar

930 Millboard 22.9 x 18.4 (9 x 7¼)
Self-portrait, c. 1845
Given by the sitter's son, Canon
J.A. Atkinson, 1892

Ormond

ATTERBURY, Francis (1662-1732)
Bishop of Rochester

2024A Miniature on ivory, oval
8.9 x 7.3 (3½ x 2⅞)
After Sir Godfrey Kneller, eng 1718
Given by Alfred Jones, 1924

ATTLEE, Clement Attlee, 1st Earl
(1883-1967) Prime Minister

P16 With Arthur Greenwood
See Collections: Prominent men,
c.1938-43, by Felix H.Man,**P10-17**

4593 Canvas 79.4 x 62.9
(31¼ x 24¾)
George Harcourt, signed and dated
1946
Bequeathed by Edric William Hoyer
Millar, 1967

4601 Bronze head 35.8 (13⅞) high
David McFall, incised, 1965
Purchased, 1968

ATTWOOD, Thomas (1783-1856)
Political reformer

54 *See Groups:* The House of Com-
mons, 1833, by Sir George Hayter

AUCHINLECK, Sir Claude (b.1884)
Field-Marshal

4639 Canvas board 50.8 x 40.6
(20 x 16)
Reginald Grenville Eves, signed and
dated 1940
Given by the artist's son, Grenville
Eves, 1968

AUCKLAND, William Eden, 1st
Baron (1744-1814) Statesman

122 Pencil and water-colour
28.3 x 23.5 (11⅛ x 9¼)
Henry Edridge, signed with initials
and dated 1809
Given by Earl Stanhope, 1861

AUCKLAND, George Eden, 2nd
Baron and 1st Earl of (1784-1849)
Governor-General of India

999 *See Groups:* The Trial of
Queen Caroline, 1820, by Sir
George Hayter

AUDEN, Wystan Hugh (1907-73)
Poet

4677 Pen and ink 73.7 x 58.4
(29 x 23)
Don Bachardy, signed, inscribed
and dated 1967
Purchased, 1969

AUGUSTA of Saxe-Gotha, Princess
of Wales (1719-72) Mother of
George III

2093 Canvas 127.6 x 101.6
(50¼ x 40)
Charles Philips, c.1736
Purchased, 1925

Kerslake

AUGUSTUS GEORGE, Margrave
of Baden (1706-71)

4855(36) *See Collections:* The
Townshend Album, **4855(1-73)**

AUMALE, Henri d'Orleans, Duc d'
(1822-97) Son of Louis Philippe

4707(3) *See Collections:*
Vanity Fair cartoons, 1869-1910,
by various artists, **2566-2606,** etc

AUMONIER, Stacy (1887-1928)
Writer

2777 Pencil 34 x 26.3 (13⅜ x 10⅜)
Emmanuel Henry Horwitz, signed
and dated 1926
Given by the artist, 1934

AUSTEN, Jane (1775-1817)
Novelist

3181 *Identity uncertain*
Hollow-cut silhouette 10.2 x 8
(4 x 3⅛)
Perhaps by Mrs Collins, c. 1801
Purchased, 1944

3630 Pencil and water-colour
11.4 x 8 (4½ x 3⅛)
Cassandra Austen (her sister), c.1801
Purchased with help from Friends
of the National Libraries, 1948

AUSTIN, Alfred (1835-1913)
Poet Laureate

1768 Water-colour 30.5 x 17.5
(12 x 6⅞)
Sir Leslie Ward, signed *Spy*
(*VF* 20 Feb 1896)
Given by Ernest E. Leggatt, 1916

4845 Water-colour 33 x 25.4
(13 x 10)
Sir Leslie Ward, signed
(variant of cartoon for *VF* of 20 Feb
1896)
Acquired, 1971

AUSTIN, Sir Horatio Thomas
(1801-65) Admiral and explorer

1218 Canvas 39 x 32.4 (15⅜ x 12¾)
Stephen Pearce, 1860
Bequeathed by John Barrow, 1899
See Collections: Arctic explorers,
1850-86, by Stephen Pearce,
905-24 and **1209-27**

Ormond

AUSTIN, Sarah (née Taylor)
(1793-1867) Translator

672 Chalk and pencil 52.1 x 41.6
(20½ x 16⅜)
John Linnell, signed and dated 1834
Given by the sitter's granddaughter,
Mrs Janet Ross, 1883

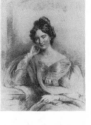

598 Panel 18.1 x 14.3 (7⅛ x 5⅝)
Lady Arthur Russell, c. 1867
Given by the artist, 1879

Ormond

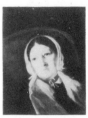

AVEBURY, Sir John Lubbock, 1st
Baron (1834-1913) Banker,
scientist and writer

4869 Chalk 61 x 45.7 (24 x 18)
George Richmond, signed and
dated 1869
Purchased, 1972

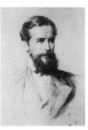

AVELAND, Gilbert John
Heathcote, 1st Baron (1795-1867)
MP for Lincolnshire

54 *See Groups:* The House of Com-
mons, 1833, by Sir George Hayter

AVERY, John (1807-55) Surgeon

1893 Miniature on ivory
20.3 x 14.6 (8 x 5¾)
Attributed to Henry Collen
Given by Macleod Yearsley, 1921

Ormond

AVON, Robert Anthony Eden, 1st
Earl of (1897-1977) Prime Minister

4907 Lithographic chalk
43.2 x 31.8 (17 x 12½)
Edmond Xavier Kapp, signed and
dated 1935
Purchased, 1972

4529(120-2) *See Collections:*
Working drawings by Sir David
Low, **4529(1-401)**

AVORY, Sir Horace Edmund
(1851-1935) Judge

3415 *See Collections:* Prominent
Men, c.1880-c.1910, by Harry
Furniss, **3337-3535** and **3554-3620**

AYLESBURY, Sir Thomas
(1576-1657) Patron of
mathematical learning

615 *See Unknown Sitters II*

AYLESFORD, Heneage Finch, 5th
Earl of (1786-1859)

999 *See Groups:* The Trial of
Queen Caroline, 1820, by Sir
George Hayter

1695(n) *See Collections:* Sketches
for The Trial of Queen Caroline,
1820, by Sir George Hayter,
1695(a-x)

AYNESWORTH, Allan (Edward
Abbot-Anderson),(1864-1959) Actor

3416 *See Collections:* Prominent
Men, c.1880-c.1910, by Harry
Furniss, **3337-3535** and **3554-3620**

AYRTON, Acton Smee (1816-86)
Politician

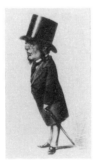

4713 Water-colour 30.5. x 17.8
(12 x 7)
Carlo Pellegrini, signed *Ape*
(*VF* 23 Oct 1869)
Purchased, 1970

AYSCOUGH, Francis (1700-63)
Dean of Bristol; tutor to George III

1165 *See Groups:* Francis
Ayscough with the Prince of Wales
and the Duke of York and Albany,
by Richard Wilson, c. 1749

AYTOUN, James
Chartist and manufacturer

P6(36) *See Collections:* The Hill
and Adamson Albums, 1843-8, by
David Octavius Hill, **P6(1-258)**

AYTOUN, William Edmondstoune
(1813-65) Poet

1544 Plaster cast of bust, painted
black 82.6 (32½) high
Patric Park, c. 1851
Given by Andrew Kay, 1909

AZEGLIO, Marchesi d'
Italian diplomat

4714 *See Collections: Vanity Fair*
cartoons, 1869-1910, by various
artists, **2566-2606**, etc

BABBAGE, Charles (1791-1871)
Mathematician

2515(33) *See Collections:* Drawings
of Prominent People, 1823-49, by
William Brockedon, **2515(1-104)**

414 Canvas 127 x 101.6 (50 x 40)
Samuel Laurence, 1845
Bequeathed by Sir Edward Ryan,
1876

P28 Photograph: daguerreotype
7 x 6 (2¾ x 2⅜)
Antoine Claudet, c. 1847-51
Purchased, 1977

Ormond

BABER, Henry Hervey (1775-1869)
Philologist

591 Canvas 76.8 x 63.5
(30¼ x 25)
Unknown artist, c. 1830
Transferred from BM, 1879

BABINGTON, Charles Cardale
(1809-95) Botanist and
archaeologist

P106(10) Photograph: albumen
print, arched top 20 x 14.6
(7⅞ x 5¾)
Maull & Polyblank, c. 1855
Purchased, 1978
See Collections: Literary and
Scientific Portrait Club, by Maull &
Polyblank, **P106(1-20)**

BACK, Sir George (1796-1878)
Admiral

2515(46) Black and red chalk
36.2 x 25.4 (14¼ x 10)
William Brockedon, dated 1833
Lent by NG, 1959
See Collections: Drawings of
Prominent People, 1823-49, by
William Brockedon, **2515(1-104)**

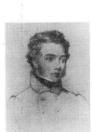

1208 *See Groups:* The Arctic
Council, 1851, by Stephen Pearce

Ormond

BACKHOUSE, Sir John
(1582-1649) An original director of
the New River Company

2183 Canvas 128.3 x 104.1
(50½ x 41)
Unknown artist, signed *VM,* dated
1637
Purchased, 1928. *Montacute*

Piper

BACON, Francis, Baron Verulam
and Viscount St Alban (1561-1626)
Philosopher; Lord Chancellor

1904 Canvas 127.6 x 102.6
(50¼ x 40⅜)
John Vanderbank, 1731, copy
(c. 1618)
Bequeathed by Mrs A. H. S.
Wodehouse, 1921

520 Canvas 76.5 x 63.2
(30⅛ x 24⅞)
John Vanderbank, 1731?, copy
Transferred from BM, 1879

1288 Canvas 200 x 127 (79 x 50)
Unknown artist, after 1731
Purchased, 1900. *Montacute*

408 Electrotype of effigy in St
Michael's Church, St Albans
152.4 (60) high
After unknown artist
Purchased, 1875

Strong

BACON, Frances (b. 1909) Artist

5135 Board 45.1 x 37.1
(17¾ x 14⅝)
Reginald Gray, signed and
dated 1960
Given by Aubrey Beese, 1975

BACON, Sir James (1798-1895)
Judge

2173(3) Pen and ink 20 x 14.9
(7⅞ x 5⅞)
Sebastian Evans, signed in
monogram, inscribed and dated 1877
Given by George Hubbard, 1927
See Collections: Book of sketches
by Sebastian Evans, **2173(1-70)**

BACON, John (1740-99) Sculptor

L152(27) Enamel miniature, oval
5.7 x 4.4 (2¼ x 1¾)
William Bate after Mason
Chamberlin (1785), signed with
initials
Lent by NG (Alan Evans Bequest),
1975

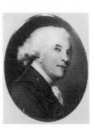

BACON, Sir Nathaniel (1585-1627)
Country gentleman and painter

2142 Panel, feigned oval
57.5 x 44.5 (22⅝ x 17½)
Self-portrait, c. 1625
Purchased, 1926. *Montacute*

Strong

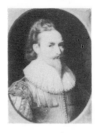

BACON, Sir Nicholas (1509-79)
Lord Keeper of the Great Seal

164 Panel 62.5 x 48.3 (24⅝ x 19)
Unknown artist, dated 1579
Purchased, 1863. *Montacute*

Strong

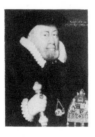

BADDELEY, Angela (1904-76)
Actress

P59 *See Collections:* Prominent
people, c. 1946-67, by Angus
McBean, **P56-67**

BADDELEY, Robert (1733-94)
Comedian

2541 Water-colour, feigned oval
38.1 x 25.4 (15. x 10)
Sylvester Harding, inscribed (below
image), eng 1794
Purchased, 1932

BADEN-POWELL, Robert Baden-
Powell, 1st Baron (1857-1941)
Founder of the Boy Scouts and
Girl Guides

4100 Chalk 34.3 x 27.6
(13½ x 10⅞)
Shirley Slocombe, signed and dated
1916
Purchased, 1959

BAGOT, William Bagot, 2nd Baron
(1773-1856) Agriculturalist

999 *See Groups:* The Trial of
Queen Caroline, 1820, by Sir
George Hayter

BAGSTER, Samuel, the Elder
(1772-1851) Publisher

1816 Pencil and white chalk
44.2 x 27.9 (17⅜ x 11)
John Linnell, inscribed and dated
(below mount) c. 1852
Purchased, 1918
See Collections: Drawings by
John Linnell, **1812-18B**

BAILLIE, Grizel (1822-91)

P6(207) *See Collections:* The Hill
and Adamson Albums, 1843-8, by
David Octavius Hill and Robert
Adamson, **P6(1-258)**

BAILY, Edward Hodges
(1788-1867) Sculptor

1456(1) Pencil and black chalk
11.7 x 12.1 (4⅝ x 4¾)
Charles Hutton Lear, inscribed,
c.1846
Given by John Elliot, 1907
See Collections: Drawings of
artists, c. 1845, by Charles Hutton
Lear, **1456(1-27)**

Ormond

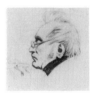

BAILY, Francis (1774-1844)
Astronomer

1075, 1075a and **b** *See Groups:*
Men of Science Living in 1807-8,
by Sir John Gilbert and others

BAINES, Sir Edward (1800-90)
Journalist

599 *See Groups:* The Anti-Slavery
Society Convention, 1840, by
Benjamin Robert Haydon

BAIRD, Sir David, Bt (1757-1829)
General

2195 Canvas 125.7 x 100.3
(49½ x 39½)
Attributed to Sir John Watson-
Gordon, c. 1820
Purchased, 1928

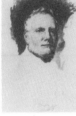

1825 Water-colour 54.3 x 43.2
(21⅜ x 17)
Sir David Wilkie, c.1834
Purchased, 1918

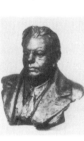

BAIRD, John Logie (1888-1946)
Television pioneer

4125 Bronze bust 45.1 (17¾) high
Donald Gilbert, incised and dated
1943
Purchased, 1959

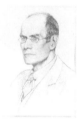

BAKER, Charles Henry Collins
(1880-1959) Art historian

4355 Chalk 38.1 x 27.9 (15 x 11)
Francis Dodd, signed, inscribed and
dated 1932
Given by Mrs Barbara Isherwood
Kay, 1964

BAKER, Sir Herbert (1862-1946)
Architect

4763 Chalk 32.4 x 35.2
(12¾ x 13⅞)
Sir William Rothenstein, signed with
initials and dated 1925
Purchased, 1970

BAKER, William (1841-1905)
Headmaster of Merchant Taylors'
School

3300 Water-colour 35.2 x 25.4
(13⅞ x 10)
A.G.Witherby, signed *w.a.g.*
(*VF* 21 March 1901)
Purchased, 1934

BALCHIN, Nigel (1908-70)
Novelist

4529(7-11) *See Collections:*
Working drawings by Sir David
Low, **4529(1-401)**

BALDWIN, Stanley Baldwin, 1st
Earl (1867-1947) Prime Minister

5030 *See Collections:* Miniatures,
1920-30, by Winifred Cécile
Dongworth, **5027-36**

3866 Chalk 22.9 x 16.5 (9 x 6½)
Sir William Rothenstein, signed
with initials and dated 1928
Given by the Rothenstein Memorial
Trust, 1953

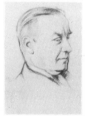

3551 Canvas 78.1 x 66 (30¾ x 26)
Reginald Grenville Eves, signed
with initials, c. 1933
Given by the Contemporary
Portraits Fund, 1948

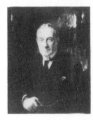

4425 Chalk 55.9 x 38.1 (22 x 15)
Francis Dodd, inscribed, 1942
Purchased, 1964

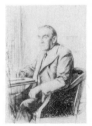

4529(12) *See Collections:* Working
drawings by Sir David Low,
4529(1-401)

BALDWIN, Lucy (née Ridsdale),
Countess (d. 1945) Wife of 1st
Earl Baldwin

5034 *See Collections:* Miniatures,
1920-30, by Winifred Cécile
Dongworth, **5027-36**

BALDWIN, Edward
Slavery abolitionist

599 *See Groups:* The Anti-
Slavery Society Convention,
1840, by Benjamin Robert Haydon

BALDWIN, Robert (1804-58)
Canadian statesman

1721 Oil on paper 21.6 x 16.5
(8½ x 6½)
Thomas Waterman Wood, signed
and dated 1855
Given by A. G. Ross, 1914

Ormond

BALFE, Michael William (1808-70)
Composer

1450 *See Unknown Sitters IV*

BALFOUR, Arthur James Balfour,
1st Earl of (1848-1930)
Prime Minister

4987 Chalk 43.5 x 31.5 (17⅛ x 12⅜)
George Richmond, signed and
dated 1877
Purchased, 1974

2949 Canvas 127 x 92.1 (50 x 36¼)
Sir Lawrence Alma-Tadema, signed,
exh 1891
Given by Viscount Hambledon, 1938

3337, 3338 *See Collections:*
Prominent Men, c.1880-c.1910, by
Harry Furniss, **3337-3535** and
3554-3620

5114 With Joseph Chamberlain (left)
Canvas 61 x 91.8 (24 x 36⅛)
Sydney Prior Hall
Purchased, 1976

2331 *See Collections:*
Miscellaneous drawings . . . by
Sydney Prior Hall, **2282-2348**
and **2370-90**

2497 Canvas 108 x 76.2 (42½ x 30)
Philip de Laszlo, signed
Given by the Countess of Wemyss,
1931

2463 *See Groups:* Statesmen of
World War I, by Sir James Guthrie

2864, 2864a, 2866 *See Collections:*
Caricatures of Politicians, by Sir
Francis Carruthers Gould, **2826-74**

BALFOUR, Jabez Spencer
(1843-1916) Radical politician

4606 Water-colour 34.9 x 25.4
(13¾ x 10)
Sir Leslie Ward, signed *Spy*
(*VF* 19 March 1892)
Purchased, 1968

BALFOUR, John Hutton (1808-84)
Botanist

P120(43) Photograph: albumen
print, arched top 19.7 x 14.6
(7¾ x 5¾)
Maull & Polyblank, inscribed on
mount, 1855
Purchased, 1979
See Collections: Literary and
Scientific Men, 1855, by Maull &
Polyblank, **P120(1-54)**

BALL, Albert (1896-1917)
Fighter-pilot

2277 Bronze cast of statuette
60.3 (23¾) high
Henry Poole, incised
Given by the sitter's father, Sir
Albert Ball, 1929

BALL, Sir Robert Stawell
(1840-1913) Astronomer and
mathematician

4544 Water-colour 36.8 x 24.8
(14½ x 9¾)
Sir Leslie Ward, signed *Spy*
(*VF* 13 April 1905)
Purchased, 1967

3417 *See Collections:* Prominent
Men, c.1880-c.1910, by Harry
Furniss, **3337-3535** and **3554-3620**

BALLANTINE, James (1808-77)
Stained glass artist and writer

P6(82) Photograph: calotype
21 x 15.6 (8¼ x 6⅛)
David Octavius Hill and Robert
Adamson, 1843-8
Given by an anonymous donor, 1973
See Collections: The Hill and
Adamson Albums, 1843-8, by
David Octavius Hill and Robert
Adamson, **P6(1-258)**

P6(95,141,143) *See Collections:*
The Hill and Adamson Albums,
1843-8, by David Octavius Hill and
Robert Adamson, **P6(1-258)**

BALLANTYNE, Robert Michael
(1825-94) Author of stories for boys

4128 Canvas 64.8 x 50.8 (25½ x 20)
John Ballantyne (his brother),c.1855
Given by the sitter's daughter,Mrs I.
McK.Dobson, and family, 1959

BANCROFT, George Pleydell
(1868-1956) Lawyer and writer

3418 *See Collections:* Prominent
Men, c.1880-c.1910, by Harry
Furniss, **3337-3535** and **3554-3620**

BANCROFT, Marie Effie (née
Wilton), Lady (1839-1921) Actress

2122 Canvas 90.2 x 69.9
(35½ x 27½)
Thomas Jones Barker
Bequeathed by the sitter's husband,
Sir Squire Bancroft Bancroft, 1926

BANCROFT, Richard (1544-1610)
Archbishop of Canterbury

945 Panel 57.5 x 44.2 (22$\frac{5}{8}$ x 17$\frac{3}{8}$)
Unknown artist
Purchased, 1893. *Montacute*

Strong

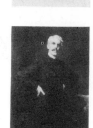

BANCROFT, Sir Squire Bancroft
(1841-1926) Actor-manager

5072 Water-colour 56.2 x 34.3
(22$\frac{1}{8}$ x 13½)
Carlo Pellegrini, signed *Ape*
Acquired, 1976

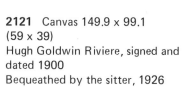

2121 Canvas 149.9 x 99.1
(59 x 39)
Hugh Goldwin Riviere, signed and
dated 1900
Bequeathed by the sitter, 1926

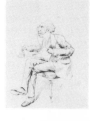

4095(2) Ink 38.7 x 31.4
(15¼ x 12$\frac{3}{8}$)
Harry Furniss, signed with initials
Purchased, 1959
See Collections: The Garrick Gallery
of Caricatures, 1905, by Harry
Furniss, **4095(1-11)**

BANKES, Sir John (1589-1644)
Judge

1069 Canvas 127 x 101.6 (50 x 40)
After Gilbert Jackson(?) (c.1641)
Given by Walter Ralph Bankes,1896

Piper

BANKES, William John (d.1855)
Traveller in the East

54 *See Groups:* The House of Commons, 1833, by Sir George Hayter

BANKS, Sir Joseph, Bt (1743-1820)
Explorer and botanist

853 Pencil 24.8 x 20.3 (9¾ x 8)
Sir Thomas Lawrence, probably
c. 1806
Purchased, 1891

1075, 1075a and **b** *See Groups:*
Men of Science Living in 1807-8,
by Sir John Gilbert and others

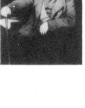

885 Canvas 141.9 x 111.8
(55⅞ x 44)
Thomas Phillips, inscribed, 1810
Purchased, 1892

BANNERMAN, Sir Alexander
(1788-1864) MP for Aberdeen

54 *See Groups:* The House of Commons, 1833, by Sir George Hayter

BANNISTER, Elizabeth (née
Harpur) (1752-1844) Singer

1770 Pastel 61.6 x 46.4 (24¼ x 18¼)
John Russell, signed and dated 1799
Given by the sitter's great-granddaughter, Grace Hilda Bannister,
1916

BANNISTER, John (1760-1836)
Comedian

1769 Pastel 61 x 45.7 (24 x 18)
John Russell, signed and dated 1799
Given by the sitter's great-granddaughter, Grace Hilda Bannister,
1916

1136 Pencil 25.4 x 19.7 (10 x 7¾)
George Dance, signed and dated 1800
Purchased, 1898

BANNISTER, Saxe (1790-1877)
Pamphleteer

599 *See Groups:* The Anti-Slavery
Society Convention, 1840, by
Benjamin Robert Haydon

BANTOCK, Sir Granville
(1868-1946) Composer

4457 Canvas 64.8 x 55.9
(25½ x 22)
George Herbert Buckingham
Holland, signed and dated 1933
Given by the Council of the
Birmingham and Midland Institute,
1965

BARBAULD, Anna Letitia
(1743-1825) Poet and writer

4905 *See Groups:* The Nine
Living Muses of Great Britain,
by Richard Samuel

BARETTI, Joseph (Giuseppe)
(1719-89) Writer and friend of
Dr Johnson

3024 *See Unknown Sitters III*

BARHAM, Richard Harris
(1788-1845) Author of *Ingoldsby
Legends*

2922 Pencil 24.1 x 19.1 (9½ x 7½)
Richard James Lane, 1842-3
Given by wish of the sitter's granddaughter, Mrs M. B. Platt, 1937

Ormond

BARING, Alexander, 1st Baron
Ashburton *See* ASHBURTON

BARING, Evelyn, 1st Earl of
Cromer *See* CROMER

BARING, Sir Francis, Bt
(1740-1810) Merchant banker

1256 Enamel 30.5 x 22.9 (12 x 9)
Charles Muss after Sir Thomas
Lawrence (exh 1807)
Given by the sitter's great-grandson,
the Earl of Northbrook, 1900

BARING, Francis, 1st Baron
Northbrook *See* NORTHBROOK

BARING, Henry Bingham (1804-69)
MP for Marlborough

54 *See Groups:* The House of Com-
mons, 1833, by Sir George Hayter

BARING, Maurice (1874-1945)
Man of letters

3654 *See Groups:* Conversation
Piece . . . , by Sir James Gunn

BARING, William, 2nd Baron
Ashburton *See* ASHBURTON

BARING-GOULD, Sabine
(1834-1924) Divine and writer

4353 Pencil 20.3 x 14.6 (8 x 5¾)
Constance Mortimore, signed and
dated 1896
Given by the artist's niece, Miss
Barbara Shaw, 1964

BARKER, Harley Granville
Granville- *See* GRANVILLE-
BARKER

BARKER, Sir Herbert Atkinson
(1869-1950) Manipulative surgeon

4189 Canvas 91.4 x 73.7 (36 x 29)
Augustus John, 1916
Given by the Maharajah Kumar of
Kutch and other patients, 1960

BARKER, Mrs (? Jane Sophia
Barker, née Harden)

P6(123) *See Collections:* The Hill
and Adamson Albums, 1843-8, by
David Octavius Hill and Robert
Adamson, **P6(1-258)**

BARLOW, Sir George (1762-1846)
Governor-General of India

4988 Canvas 213.5 x 140.3
(84 x 55¼)
Unknown artist, c. 1840
Given by the sitter's great-great-
grandson, C. M. Barlow, 1974

BARLOW, J.

P120(6) *See Collections:* Literary
and Scientific Men, 1855, by
Maull & Polyblank, **P120(1-54)**

BARLOW, Thomas Oldham
(1824-98) Mezzotint engraver

P90 Photograph: albumen print
21.3 x 16.2 (8⅜ x 6⅜)
David Wilkie Wynfield, 1860s
Given by H. Saxe Wyndham, 1937
See Collections: The St John's
Wood Clique, by David Wilkie
Wynfield, **P70-100**

P71 *See Collections:* The St John's
Wood Clique, by David Wilkie
Wynfield, **P70-100**

BARNARD, Sir Andrew Francis
(1773-1855) General

982a Panel 14.6 x 11.8 (5¾ x 4⅝)
George Jones, signed and inscribed,
c. 1815
Given by the artist's widow, 1871

3695 *See Collections:* Studies for
The Waterloo Banquet at Apsley
House, 1936, by William Salter,
3689-3769

4026(3) *See Collections:* Drawings
of Men about Town, 1832-48, by
Alfred, Count D'Orsay, **4026(1-61)**

Ormond

BARNARD, Frederick (1846-96)
Humorous artist

3419 *See Collections:* Prominent
Men, c. 1880-c.1910, by Harry
Furniss, **3337-3535** and **3554-3620**

BARNATO, Barnett Isaacs
(1852-97) Financier

3431 *See Collections:* Prominent
Men, c. 1880-c. 1910, by Harry
Furniss, **3337-3535** and **3554-3620**

BARNES, Sir Edward (1776-1838)
Lieutenant-General

1914(2) Water-colour 19.1 x 15.9
(7½ x 6¼)
Thomas Heaphy, 1813-14
Purchased, 1921
See Collections: Peninsular and
Waterloo Officers, 1813-14, by
Thomas Heaphy, **1914(1-32)**

1914(3) *See Collections:* Peninsular
and Waterloo Officers, 1813-14, by
Thomas Heaphy, **1914(1-32)**

3696 Canvas 53.3 x 43.2 (21 x 17)
William Salter, 1834-40
Bequeathed by W.D.Mackenzie
(d. 1928), 1950
See Collections: Studies for The
Waterloo Banquet at Apsley House,
1836, by William Salter, **3689-3769**

BARNES, George Nicoll
(1859-1940) Statesman

2463 *See Groups:* Statesmen of
World War I, by Sir James Guthrie

BARNES, Thomas (1785-1841)
Editor of *The Times*

999 *See Groups:* The Trial of
Queen Caroline, 1820, by Sir
George Hayter

BARNES, William (1801-86)
Dorsetshire poet

3332 Canvas 68.6 x 51.4
(27 x 20¼)
George Stuckey, c. 1870
Given by the sitter's granchildren,
A. H. Baxter and the Misses G. and
E. Baxter, 1947

Ormond

BARNETT, Charles James
(c. 1797-1882) MP for Maidstone

54 *See Groups:* The House of Com-
mons, 1833, by Sir George Hayter

BARNETT, John (1802-90)
Composer

1587 Canvas 76.8 x 63.2
(30¼ x 24$\frac{7}{8}$)
Charles Baugniet, c. 1839
Given by the sitter's surviving
children and R.E.Francillon,1910

Ormond

BARNETT, Samuel Augustus
(1844-1913) Social reformer

2893 Canvas 76.2 x 63.5 (30 x 25)
George Frederic Watts, 1887
Bequeathed by the sitter's widow,
1936

4419 Chalk 38.1 x 27.9 (15 x 11)
Francis Dodd, signed and inscribed
Purchased, 1964

BARON, Bernard (1696-1762)
Engraver

1384 *See Groups:* A Conversation
of Virtuosis . . . at the Kings Armes
(A Club of Artists), by Gawen
Hamilton

BARON, John (1786-1851)
Physician

4548 Chalk 38.1 x 27.9 (15 x 11)
Unknown artist, inscribed, c.1850
Given by A. Yakovleff, 1967

BARRAS
Prior of the monastery on the Great
St Bernard Pass

2515(77) *See Collections:* Drawings
of Prominent People, 1823-49, by
William Brockedon, **2515(1-104)**

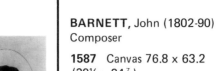

BARRÉ, Isaac (1726-1802)
Soldier and politician

1191 Canvas, feigned oval
76.2 x 63.5 (30 x 25)
Gilbert Stuart, c. 1785
Purchased, 1899

BARRET, George (1728?-84)
Landscape painter

1437,1437a *See Groups:* The
Academicians of the Royal
Academy, 1771-2, by John
Sanders and Johan Zoffany

BARRETT, Edward
An emancipated slave, and a
slavery abolitionist

599 *See Groups:* The Anti-Slavery
Society Convention, 1840, by
Benjamin Robert Haydon

BARRETT, Richard
Slavery abolitionist

599 *See Groups:* The Anti-Slavery
Society Convention, 1840, by
Benjamin Robert Haydon

BARRIE, Sir James Matthew, Bt
(1860-1937) Writer; author of
Peter Pan

3420 Ink 31.4 x 15.6 ($12\frac{3}{8}$ x $6\frac{1}{8}$)
Harry Furniss, signed with initials
and inscribed
Purchased, 1947
See Collections: Prominent Men,
c. 1880-c.1910, by Harry Furniss,
3337-3535 and **3554-3620**

4557 Chalk 43.2 x 30.2 (17 x $11\frac{7}{8}$)
Sir David Low, signed and inscribed,
pub 1928
Purchased, 1967

3539 Pencil 32.4 x 22.9 ($12\frac{3}{4}$ x 9)
Sir Walter Thomas Monnington,
signed and dated 1932
Given by the Contemporary
Portraits Fund, 1947

BARRINGTON, Samuel
(1729-1800) Admiral

740 Canvas 77.5 x 60.3 (30½ x 23¾)
Unknown artist, inscribed
Given by the sitter's great-great-
nephew, Viscount Barrington, 1885

BARRINGTON, Shute (1734-1826)
Bishop of Durham

999 *See Groups:* The Trial of
Queen Caroline, 1820, by Sir
George Hayter

316a(3) (unfinished sketch on
reverse)
Pencil 41.9 x 25.4 (16½ x 10)
Sir Francis Chantrey, inscribed,
1824
and
316a(4) Pencil 42.5 x 33
(16¾ x 13)
Sir Francis Chantrey, inscribed, 1824
Given by Mrs George Jones, 1871
See Collections: Preliminary
drawings for busts and statues by
Sir Francis Chantrey, **316a(1-202)**

BARRON, Sir Henry Winston, Bt
(1795-1872) MP for Waterford

54 *See Groups:* The House of Com-
mons, 1833, by Sir George Hayter

BARROW, Isaac (1630-77)
Master of Trinity College, Dublin

1876 Plumbago on vellum
12.9 x 10.8 ($5\frac{1}{8}$ x 4¼)
David Loggan, signed with initials
and dated 1676
Purchased, 1920

Piper

BARROW, Sir John, Bt
(1764-1848) Writer; founder of
the Royal Geographical Society

769 Miniature on ivory, oval
4.4 x 3.5 (1¾ x 1⅜)
Unknown artist, c. 1795
Given by the sitter's son,
Col John Barrow, 1887

886 Canvas 76.8 x 63.5
(30¼ x 25)
John Jackson, c. 1810
Purchased, 1892

1208 *See Groups:* The Arctic
Council, 1851, by Stephen Pearce

BARROW, John (1808-98)
Archivist to the Admiralty

905 (study for *Groups,* **1208**)
Millboard 37.8 x 31.8 (14⅞ x 12½)
Stephen Pearce, c. 1850
Bequeathed by Lady Franklin, 1892
See Collections: Arctic Explorers,
1850-86, by Stephen Pearce,
905-24 and **1209-27**

1208 *See Groups:* The Arctic
Council, 1851, by Stephen Pearce

Ormond

BARRY, Sir Charles (1795-1860)
Architect

342,343a-c *See Groups:* The Fine
Arts Commissioners, 1846, by
John Partridge

1272 Canvas 144.8 x 111.8
(57 x 44)
John Prescott Knight, c. 1851
Given by the sitter's son, Bishop
A. Barry, 1900

Ormond

BARRY, Sir Gerald (1898-1968)
Journalist

4529(13-15) *See Collections:*
Working drawings by Sir David
Low, **4529(1-401)**

BARRY, James (1741-1806)
Painter

213 With James Paine the
Younger and Dominique Lefevre
Canvas 60.7 x 50.5 (23⅞ x 19⅞)
Self-portrait, 1767
Purchased, 1866

441 Chalk 15.2 x 10.2 (6 x 4)
William Evans, c. 1806, eng 1809
Purchased, 1877

BARTOLOZZI, Francesco
(1727-1815) Engraver

1437,1437a *See Groups:* The
Academicians of the Royal
Academy, 1771-2, by John Sanders
after Johan Zoffany

3186 *See Groups:* Francesco
Bartolozzi, Giovanni Battista
Cipriani and Agostino Carlini,
1777, by John Francis Rigaud

222 Canvas 90.2 x 69.9
(35½ x 27½)
John Opie, c. 1785
Given by G. P. Everett Green, 1866

BARTON, Sir Dunbar Plunkett, Bt
(1853-1937) Lawyer

3421 *See Collections:* Prominent
Men, c. 1880-c.1910, by Harry
Furniss, **3337-3535** and **3554-3620**

BASKERVILLE, John (1706-75)
Printer and type-designer

1394 Canvas 73 x 59.7
(28¾ x 23½)
After James Millar (1774)
Purchased, 1905

Kerslake

BASS, Isaac (1782-1855)
Slavery abolitionist

599 *See Groups:* The Anti-Slavery Society Convention, 1840, by Benjamin Robert Haydon

BASS, Michael Arthur, 1st Baron Burton *See* BURTON

BATEMAN, Kate *See* CROWE

BATES, Herbert Ernest (1905-74)
Writer and novelist

4529(16) Pencil 18.4 x 12.1 (7¼ x 4¾)
Sir David Low, inscribed
Purchased, 1967
See Collections: Working drawings by Sir David Low, **4529(1-401)**

4529(17-19) *See Collections:* Working drawings by Sir David Low, **4529(1-401)**

BATES, Thomas (d. 1606)
Conspirator

334A *See Groups:* The Gunpowder Plot Conspirators, 1605, by an unknown artist

BATESON, Sir Robert, Bt (1782-1863) MP for County Londonderry

54 *See Groups:* The House of Commons, 1833, by Sir George Hayter

BATESON, William (1861-1926)
Biologist

4379 Pencil 35.6 x 25.4 (14 x 10)
Sir William Rothenstein, signed with initials, inscribed and dated 1917
Purchased, 1964

2147 Chalk 33.3 x 22.9 (13⅛ x 9)
William Edward Arnold-Forster, signed in monogram and dated 1923
Given by the sitter's widow, 1927

BATH, William Pulteney, 1st Earl of (1684-1764) Statesman

3194 Canvas 91.4 x 71.1 (36 x 28)
Sir Godfrey Kneller, signed in monogram, inscribed and dated 1717
Kit-cat Club portrait
Given by NACF, 1945

Piper

35 Canvas 127 x 101.6 (50 x 40)
After Sir Joshua Reynolds
(c. 1755-7)
Purchased, 1858

337 Canvas 154.9 x 147.3 (61 x 58)
Sir Joshua Reynolds, inscribed, 1761
Purchased, 1872. *Beningbrough*

Kerslake

BATH, Thomas Thynne, 2nd Marquess of (1765-1837)

999 *See Groups:* The Trial of Queen Caroline, 1820, by Sir George Hayter

BATHURST, Henry Bathurst, 3rd Earl (1762-1834) Statesman

999 *See Groups:* The Trial of Queen Caroline, 1820, by Sir George Hayter

3697 *See Collections:* Studies for The Waterloo Banquet at Apsley House, 1836, by William Salter, **3689-3769**

BATHURST, George Henry
Bathurst, 4th Earl (1790-1866)
MP for Cirencester
54 *See Groups:* The House of Commons, 1833, by Sir George Hayter

BATHURST, Henry (1744-1837)
Bishop of Norwich

883(1) Pencil 12.1 x 9.5 (4¾ x 3¾)
Sir George Hayter, inscribed, c.1816
Purchased, 1891
See Collections: Studies for
miniatures by Sir George Hayter,
883(1-21)

BAUER, Franz Andreas
(1758-1840) Botanist

2515(63) *See Collections:* Drawings
of Prominent People, 1823-49, by
William Brockedon, **2515(1-104)**

BAX, Sir Arnold (1883-1953)
Composer

4400 Ink 33.7 x 25.4
(13¼ x 10)
Powys Evans, signed and inscribed,
pub 1931
Purchased, 1964

BAXTER, Richard (1615-91)
Puritan divine

521 Canvas 72.4 x 61.6
(28½ x 24¼)
After Robert White (1670)
Transferred from BM, 1879

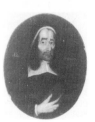

875 Miniature on brass, oval
9.9 x 8.3 (3⅞ x 3¼)
After Robert White (1670),
inscribed
Bequeathed by Thomas Kerslake,
1891

Piper

BAYLEY, Sir John, Bt
(1763-1841) Judge

457 Canvas 124.5 x 100.3
(49 x 39½)
William Russell, c.1808
Given by the Society of Judges
and Serjeants-at-Law, 1877

BAYLY, Thomas Haynes
(1797-1839) Popular song-writer

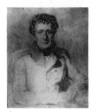

2647 Pencil and chalk 29.8 x 22.9
(11¾ x 9)
Frederick Richard Say, inscribed,
eng 1831
Purchased, 1933

BAYNE, Thomas Vere (1829-1908)
Censor, Christ Church, Oxford

P7(18) *See Collections:* Lewis
Carroll at Christ Church, by Charles
Lutwidge Dodgson, **P7(1-37)**

BAYNING, Charles Powlett
Townshend, 2nd Baron (1785-1823)

1695(u) *See Collections:* Sketches
for The Trial of Queen Caroline,
1820, by Sir George Hayter,
1695(a-x)

999 *See Groups:* The Trial of
Queen Caroline, 1820, by Sir
George Hayter

BAZLEY, Sir Thomas, Bt
(1797-1885) Manufacturer and
politician

2566 Water-colour 30.5 x 17.8
(12 x 7)
Carlo Pellegrini
(*VF* 21 Aug 1875)
Purchased, 1933

Ormond

BEACH, Thomas (1738-1806)
Portrait painter

3143 Canvas, feigned oval
74.9 x 61 (29½ x 24)
Self-portrait, signed, inscribed and
dated 1802
Purchased, 1943

BEACH, Thomas Miller (1841-94)
Government spy, known as 'Major
Le Caron'

2237 Pencil 25.1 x 19.7 (9⅞ x 7¾)
Sydney Prior Hall, inscribed and
dated *Feb 5* (1889)
Given by the artist's son, Harry
Reginald Holland Hall, 1928
See Collections: The Parnell
Commission, 1888-9, by Sydney
Prior Hall, **2229-72**

2236, 2238, 2239, 2244 *See
Collections:* The Parnell Commission,
1888-9, by Sydney Prior Hall,
2229-72

BEACONSFIELD, Benjamin
Disraeli, Earl of (1804-81) Prime
Minister and novelist

3093 Pen and ink 24.8 x 18.8
(9¾ x 7⅜)
By or after Daniel Maclise, c.1833
Purchased, 1940

4893 *See Groups:* The Derby
Cabinet of 1867, by Henry Gales

652 Plaster cast of statuette
70.5 (27¾) high
Lord Ronald Sutherland Gower,
incised and dated 1878-9
Given by the artist, 1882

4671 Plaster cast of statuette
81.9 (32¼) high
Sir William Hamo Thornycroft
incised and dated 1881
Given by the artist's daughter,
Mrs A.E.Popham, 1969

3241 Canvas 127.6 x 93.1
(50¼ x 36⅝)
Sir John Everett Millais, signed in
monogram and dated 1881
Given by Viscount Hambleden,1945

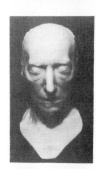

925 Canvas 127 x 91.4 (50 x 36)
W. Lockhart Bogle after Sir John
Everett Millais, 1892 (1881)
Given by the Beaconsfield Memorial
Committee, 1892

2655 Wax cast of death-mask
36.8 (14½) long
R. Glassby, inscribed (1881)
Given by J.T.Tussaud, 1934

1760 Plaster cast of statuette
69.9 (27½) high
Sir Joseph Edgar Boehm, incised
and dated 1881
Given by Lord Redesdale, 1915

860 Plaster cast of bust 55.9
(22) high
Sir Joseph Edgar Boehm, c. 1881
Purchased, 1891

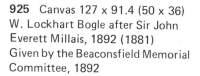

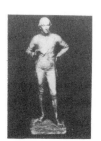

Continued overleaf

3031 Chalk 12.1 x 7.3 (4¾ x 2⅞)
Randolph Caldecott
Given by Marion Harry Spielmann,
1939

3339-42 *See Collections:*
Prominent Men, c.1880-c.1910, by
Harry Furniss, **3337-3535** and
3554-3620

4503 *See Unknown Sitters IV*

1293 *See Unknown Sitters IV*

BEADON, Richard (1737-1824)
Bishop of Bath and Wells

4901 Plaster statuette 23.5
(9¼) high
Lucius Gahagan, incised and
dated 1823
Given by Cyril Humphris, 1972

BEALE, Charles, the Elder
(1632-1705) Husband of Mary Beale

1279 Canvas, octagonal
24.1 x 21 (9½ x 8¼)
Mary Beale, c. 1663
Purchased, 1900

Piper

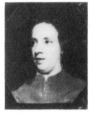

BEALE, Mary (née Cradock)
(1633-99) Portrait painter

1687 Canvas 109.2 x 87.6
(43 x 34½)
Self-portrait, c. 1665
Purchased, 1912

Piper

BEALE, William (1784-1854)
Musician

5265 Miniature on ivory
13.3 x 9.8 (5¼ x 3⅞)
Charles John Robertson, inscribed
and dated on backing card 1815
Purchased, 1979

BEARDSLEY, Aubrey Vincent
(1872-98) Illustrator

P43 Photograph: albumen cabinet
print 14.3 x 10.2 (5⅝ x 4)
James Russell & Sons, c. 1890s
Purchased, 1977

P114 Photograph: platinum print
13 x 9.8 (5⅛ x 3⅞)
Frederick Henry Evans, inscribed
and dated on mount 1895
Given by Dr Robert Steele, 1939

P115 Photograph: platinum print
14.9 x 10.5 (5⅞ x 4⅛)
Frederick Henry Evans, inscribed
and dated on mount 1895
Given by Dr Robert Steele, 1939

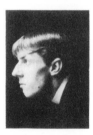

1991 Canvas 90.2 x 71.8
(35½ x 28¼)
Jacques-Emile Blanche, signed
and dated 1895
Purchased, 1923

1967 Pen and ink 24.1 x 22.9
(9½ x 9)
Walter Richard Sickert, inscribed
Purchased, 1922

BEATRICE, Princess (1857-1944)
Fifth and youngest daughter of
Queen Victoria

P26 *See Groups:* The Royal
Family. . . , by L. Caldesi

P27 *See Groups:* Royal mourning
group, 1862, by W. Bambridge

P22(8) Photograph: albumen print
14 x 9.8 (5½ x 3⅞)
W. & D. Downey, May 1868
Purchased, 1975
See Collections: The Balmoral
Album, 1854-68, by George
Washington Wilson, W. & D. Downey,
and Henry John Whitlock, **P22(1-27)**

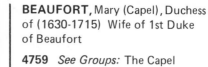

P22(1-3) *See Collections:* The
Balmoral Album, 1854-68, by
George Washington Wilson, W. & D.
Downey, and Henry John Whitlock,
P22(1-27)

5166 Canvas 128.9 x 97.5
(50¾ x 38⅜)
Joaquin Sorolla y Bastida, 1908
Given by Kensington and Chelsea
and Westminster Health Authority,
1977

BEATTY, David Beatty, 1st Earl
(1871-1936) Admiral

1913 *See Groups:* Naval Officers
of World War I, by Sir Arthur
Stockdale Cope

BEAUCHAMP, Henry Beauchamp
Lygon, 4th Earl (1784-1863)
MP for Worcestershire West

54 *See Groups:* The House of Com-
mons, 1833, by Sir George Hayter

BEAUCLERK, Lord Frederick
(1808-65) Son of 8th Duke of
St Albans

883(2) *See Collections:* Studies
for miniatures by Sir George
Hayter, **883(1-21)**

BEAUCLERK, William, 8th Duke
of St Albans *See* ST ALBANS

BEAUCLERK, William Aubrey de
Vere, 10th Duke of St Albans
See ST ALBANS

BEAUFORT, Mary (Capel), Duchess
of (1630-1715) Wife of 1st Duke
of Beaufort

4759 *See Groups:* The Capel
Family, by Cornelius Johnson

BEAUFORT, Henry Somerset, 2nd
Duke of (1684-1714) Tory politician

624 *See Groups:* Queen Anne and
the Knights of the Garter, by
Peter Angelis

BEAUFORT, Henry Charles
Somerset, 6th Duke of (1766-1835)

999 *See Groups:* The Trial of
Queen Caroline, 1820, by Sir
George Hayter

BEAUFORT, Henry Somerset, 7th
Duke of (1792-1853) Sportsman

999 *See Groups:* The Trial of
Queen Caroline, 1820, by Sir
George Hayter

4026(5) *See Collections:* Drawings
of Men about Town, 1832-48, by
Alfred, Count D'Orsay, **4026(1-61)**

2806 Canvas 26.7 x 22.2
(10½ x 8¾)
Henry Alken, signed and dated 1845
Purchased, 1936

Ormond

BEAUFORT, Daniel Augustus
(1739-1821) Geographer

5255 Pencil 10.5 x 8.9
(4⅛ x 3½) *sight*
Unknown artist, inscribed
Given by Robert Bayne-Powell, 1979

BEAUFORT, Sir Francis
(1774-1857) Rear-Admiral and
hydrographer

2515(90) Black and red chalk
35.6 x 26 (14 x 10¼)
William Brockedon, dated 1838
Lent by NG, 1959
See Collections: Drawings of
Prominent People, 1823-49, by
William Brockedon, **2515(1-104)**

918 (study for *Groups,* **1208**)
Millboard 50.5 x 40.6 ($19\frac{7}{8}$ x 16)
Stephen Pearce, 1850
Bequeathed by Lady Franklin, 1892
See Collections: Arctic Explorers,
1850-86, by Stephen Pearce,
905-24 and **1209-27**

1208 *See Groups:* The Arctic
Council, 1851, by Stephen Pearce

Ormond

BEAUFORT, Lady Margaret
(1443-1509) Mother of Henry VII

551 Panel 68.6 x 54.9 (17 x $21\frac{5}{8}$)
Unknown artist
Transferred from BM, 1879

356 Electrotype of effigy in
Westminster Abbey 88.9 (35) high
After Pietro Torrigiano (c. 1514)
Purchased, 1875

BEAUMONT, Abraham
(1782-1848) Slavery abolitionist

599 *See Groups:* The Anti-Slavery
Society Convention, 1840, by
Benjamin Robert Haydon

BEAUMONT, Sir George Howland,
Bt (1753-1827) Connoisseur, art
patron and landscape painter

3157 Water-colour 18.4 x 15.2
(7¼ x 6)
J. Wright after John Hoppner
(c. 1803), eng 1812
Purchased, 1943

1137 Pencil 23.5 x 18.4 (9¼ x 7¼)
George Dance, signed in monogram
and dated 1807
Purchased, 1898

BEAUMONT, Hugh ('Binkie')
(1908-73) Theatrical manager

P59 *See Collections:* Prominent
people, c. 1946-64, by Angus
McBean, **P56-67**

BEAUMONT, John (1788-1862)
Slavery abolitionist

599 *See Groups:* The Anti-Slavery
Society Convention, 1840, by
Benjamin Robert Haydon

BEAUMONT, Mrs John
(1790-1853) Slavery abolitionist

599 *See Groups:* The Anti-Slavery
Society Convention, 1840, by
Benjamin Robert Haydon

BEAVERBROOK, William Maxwell
Aitken, 1st Baron (1879-1964)
Statesman and newspaper proprietor

5173 Canvas 176.2 x 107.3
($69\frac{3}{8}$ x 42¼)
Walter Richard Sickert, signed and
dated 1935
Given by the Beaverbrook
Foundation, 1977

5195 Canvas 46 x 38.1 ($18\frac{1}{8}$ x 15)
Graham Sutherland, signed with
initials and dated 1952
Purchased, 1978

BECHE, Sir Henry Thomas de la
(1796-1855) Geologist

2515(94) *See Collections:* Drawings
of Prominent People, 1823-49, by
William Brockedon, **2515(1-104)**

BECHER, Eliza (née O'Neill), Lady
(1791-1872) Actress

445 Canvas 76.2 x 63.5 (30 x 25)
John James Masquerier, c. 1815
Given by the Hon Percy Wyndham,
1877

Ormond

BECKETT, Samuel (b. 1906)
Playwright and writer

5100 Pencil 24.1 x 15.9 (9½ x 6¼)
Avigdor Arikha, signed and dated
1971
Purchased, 1976

BECKFORD, Henry
Emancipated slave, and slavery
abolitionist

599 *See Groups:* The Anti-Slavery
Society Convention, 1840, by
Benjamin Robert Haydon

BEDDOES, Thomas (1760-1808)
Physician

5070 Miniature on ivory, oval
6 x 4.8 (2 $\frac{3}{8}$ x 1 $\frac{7}{8}$)
Sampson Towgood Roch(e), signed
and dated 1794
Purchased, 1976

BEDFORD, William Russell, 1st
Duke of (1613-1700)
Soldier; Privy Councillor

298 Canvas 245.1 x 153.7
(96½ x 60½)
Sir Godfrey Kneller, signed in
monogram, c. 1692
Purchased, 1870

1824 Chalk on copper 38.1 x 30.5
(15 x 12)
Edward Lutterel, signed and dated
1698
Purchased, 1918

Piper

BEDFORD, John Russell, 4th Duke
of (1710-71) Statesman

755 Canvas feigned oval
74.9 x 62.2 (29½ x 24½)
Thomas Gainsborough, c. 1770
Purchased, 1866. *Beningbrough*

BEDFORD, Francis Russell, 5th
Duke of (1765-1802)
Politician and agriculturalist

L152(34) Miniature on ivory, oval
12.4 x 9.5 (4 $\frac{7}{8}$ x 3¾) *sight*
William Grimaldi after John
Hoppner (1796-7)
Lent by NG (Alan Evans Bequest),
1975

1830 Chalk 40 x 32.1 (15¾ x 12 $\frac{5}{8}$)
William Lane, c. 1798
Given by Ernest E. Leggatt, 1919

BEDFORD, John Russell, 6th Duke
of (1766-1839)
Lord-Lieutenant of Ireland

883(3) Pen and sepia wash
16.5 x 11.8 (6½ x 4 $\frac{5}{8}$)
Sir George Hayter, inscribed,
c. 1815-20
Purchased, 1891
See Collections: Studies for
miniatures by Sir George Hayter
883(1-21)

999 *See Groups:* The Trial of
Queen Caroline, 1820, by Sir
George Hayter

54 *See Groups:* The House of Com-
mons, 1833, by Sir George Hayter

BEDFORD, Georgina, Duchess of (1781-1853) Second wife of 6th Duke of Bedford

883(4) Pencil, feigned oval 8.6 x 6.4 ($3\frac{3}{8}$ x 2½) Sir George Hayter, c. 1819 Purchased, 1891

and

883(5) Ink 8.6 x 7.4 ($3\frac{3}{8}$ x $2\frac{7}{8}$) Sir George Hayter Purchased, 1891 *See Collections:* Studies for miniatures by Sir George Hayter, **883(1-21)**

BEDFORD, Francis Russell, 7th Duke of (1788-1861) Statesman

54 *See Groups:* The House of Commons, 1833, by Sir George Hayter

BEDFORD, William Russell, 8th Duke of (1809-72) MP for Tavistock

54 *See Groups:* The House of Commons, 1833, by Sir George Hayter

BEDFORD, Herbrand Arthur Russell, 11th Duke of (1858-1940) Zoologist

2337 *See Collections:* Miscellaneous drawings . . . by Sydney Prior Hall, **2282-2348** and **2370-90**

BEDFORD, John Russell, 1st Earl of (1486?-1556) Lord High Admiral

4165 *See Groups:* Edward VI and the Pope, by an unknown artist

BEDFORD, Grosvenor

217 *See under* Francis Hayman

BEDFORD, Paul (1792?-1871) Comedian

2449 Water-colour 32.4 x 20.3 (12¾ x 8) Alfred Bryan Purchased, 1930

Ormond

BEECHAM, Sir Thomas (1879-1961) Conductor

4975(11) Pencil 27 x 20.3 ($10\frac{5}{8}$ x 8) Ernest Procter, 1929 Purchased, 1974 *See Collections:* Rehearsals for *A Mass of Life,* 1929, by Ernest Procter, **4975(1-36)**

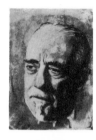

L106 Board 15.6 x 11.4 ($6\frac{1}{8}$ x 4½) Gordon Thomas Stuart, 1953-4 Lent by the Sir Thomas Beecham Society, 1977

4221 Bronze head and separate hands 54.6 (21½) high David Wynne, incised and dated on support 1957 Purchased, 1961

BEECHEY, Frederick William (1796-1856) Rear-Admiral and geographer

911 (study for *Groups,* **1208**) Millboard 38.1 x 32.1 (15 x $12\frac{5}{8}$) Stephen Pearce, 1850 Bequeathed by Lady Franklin,1892 *See Collections:* Arctic Explorers, 1850-86, by Stephen Pearce, **905-24** and **1209-27**

1208 *See Groups:* The Arctic Council, 1851, by Stephen Pearce

P120(44) Photograph: albumen print, arched top 19.7 x 14.6 (7¾ x 5¾) Maull & Polyblank, 1855 Purchased, 1979 *See Collections:* Literary and Scientific Men, 1855, by Maull & Polyblank, **P120(1-54)**

Ormond

BEECHEY, Sir William
(1753-1839) Portrait painter

3158 Pencil 24.5 x 20.7 ($9\frac{5}{8}$ x $8\frac{1}{8}$)
William Evans after Sir William
Beechey (1799), signed, inscribed
and dated 1809
Purchased, 1943

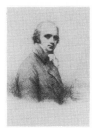

5169 Marble bust 57 ($22\frac{3}{8}$) high
Edward Hodges Baily, incised and
dated 1826
Purchased, 1977

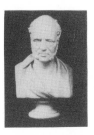

614 Canvas 76.2 x 62.9
(30 x 24¾)
Sir William Beechey and John
Wood, c. 1836
Purchased, 1880

BEERBOHM, Sir Max (Henry
Maximilian) (1872-1956)
Writer and caricaturist

4330 Lithograph 51.4 x 34
(20¼ x $13\frac{3}{8}$)
Charles Haslewood Shannon,
signed, inscribed, and signed on
stone with initials
Purchased, 1963

3850 Canvas 50.2 x 40 (19¾ x 15¾)
Sir William Nicholson, signed with
initials, 1905
Bequeathed by Mrs G. Kinnell, 1953

5107 Water-colour 23.9 x 31.1
($9\frac{3}{8}$ x 12¼)
Self-portrait, signed *Max,* inscribed
and dated 1923
Purchased, 1976

4141 Pencil 42.5 x 34 ($16\frac{3}{4}$ x $13\frac{3}{8}$)
Sir William Rothenstein, signed and
dated 1928
Given by the Rothenstein Memorial
Trust, 1960

4000 Pencil 31.1 x 21.9 (12¼ x $8\frac{5}{8}$)
Reginald Grenville Eves, signed
and dated 1936
Given by the Contemporary
Portraits Fund, 1956

BEESLY, Edward Spencer
(1831-1915) Historian and Latin
scholar

2304 *See Collections:* Miscellaneous
drawings . . . by Sydney Prior Hall,
2282-2348 and **2370-90**

BEETON, Isabella Mary (née
Mayson) (1836-65) 'Mrs Beeton'
author of the *Book of Household
Management*

P3 (formerly no. 2539) Photograph:
hand-tinted albumen print
18.4 x 14.9 (7¼ x $5\frac{7}{8}$)
Maull & Co
Given by the sitter's son, Sir
Mayson Beeton, 1932

Ormond

BEGG, James (1808-83)

P6(105) *See Collections:* The
Hill and Adamson Albums,
1843-8, by David Octavius Hill
and Robert Adamson, **P6(1-258)**

BEHAN, Brendan (1923-64)
Writer

4529(20) Pencil 20.3 x 15.5
(8 x $6\frac{1}{8}$)
Sir David Low, inscribed
Purchased, 1967
See Collections: Working drawings
by Sir David Low, **4529(1-401)**

Continued overleaf

4529(21,22) *See Collections:* Working drawings by Sir David Low, **4529(1-401)**

BELCHER, Sir Edward (1799-1877) Admiral

1217 Canvas 39.4 x 33.3 (15½ x 13$\frac{1}{8}$) Stephen Pearce, c.1859 Bequeathed by Col John Barrow, 1899 *See Collections:* Arctic Explorers, 1850-86, by Stephen Pearce, **905-24** and **1209-27**

BELCHER, James (1781-1811) Pugilist

5214 Canvas 76.2 x 63.8 (30 x 25$\frac{1}{8}$) Unknown artist, c. 1800 Purchased, 1978

BELL, Miss

P6(170) *See Collections:* The Hill and Adamson Albums, 1843-8, by David Octavius Hill and Robert Adamson, **P6(1-258)**

BELL, Mrs Sister of Robert Adamson

P6(119,153) *See Collections:* The Hill and Adamson Albums, 1843-8, by David Octavius Hill and Robert Adamson, **P6(1-258)**

BELL, Sir Charles (1774-1842) Neurologist

446a Canvas 127.3 x 101.3 (50$\frac{1}{8}$ x 37$\frac{7}{8}$) John Stevens, c. 1821 Given by the sitter's widow, 1876

BELL, Clive (1881-1964) Writer on art

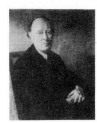

4967 Canvas 73.4 x 60 (28$\frac{7}{8}$ x 23$\frac{5}{8}$) Roger Fry, c. 1924 Given by Mrs Barbara Bagenal, 1973

BELL, George William Physician and social reformer

P6(70,141,143) *See Collections:* The Hill and Adamson Albums, 1843-8, by David Octavius Hill and Robert Adamson, **P6(1-258)**

BELL, Gertrude (1868-1926) Traveller and archaeologist

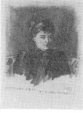

4385 Water-colour 25.4 x 17.8 (10 x 7) Flora Russell, signed, inscribed and dated 1887 Given by the artist, 1964

BELL, John (1763-1820) Surgeon

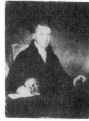

1983 Panel 29.5 x 21 (11$\frac{5}{8}$ x 8¼) Unknown artist, c. 1801 Purchased, 1923

BELL, Thomas (1792-1880) Dental surgeon and zoologist

P120(42) Photograph: albumen print, arched top 19.7 x 14.6 (7¾ x 5¾) Maull & Polyblank, inscribed on mount, 1855 Purchased, 1979 *See Collections:* Literary and Scientific Men, 1855, by Maull & Polyblank, **P120(1-54)**

BELL, Thomas Blizzard (1815-66) Brother of George William Bell

P6(64,97) *See Collections:* The Hill and Adamson Albums, 1843-8, by David Octavius Hill and Robert Adamson, **P6(1-258)**

BELL, Vanessa (née Stephen)
(1879-1961) Painter; sister of
Virginia Woolf

4331 Canvas 94 x 60.6
(37 x 23⅞)
Duncan Grant, c. 1918
Purchased, 1963

4349 Lead cast of bust
47 (18½) high
Marcel Gimond, c. 1922-6
Purchased, 1964

BELLOC, Hilaire (1870-1953)
Writer

P21 Photograph: gelatine print
13.3 x 10.2 (5¼ x 4)
T. & R. Annan & Sons, inscribed
and dated by sitter, 1910
Purchased, 1975

4341 Millboard 40 x 30.5
(15¾ x 12)
Unknown artist, signature
indecipherable
Purchased, 1963

3664 Pencil 37.8 x 27.6
(14⅞ x 10⅞)
Sir Bernard Partridge, signed
and inscribed
(*Punch* 17 Aug 1927)
Purchased, 1949
See Collections: Mr Punch's
Personalities, 1926-9, by Sir
Bernard Partridge, **3664-6,** etc

4008 Chalk 31.8 x 24.1 (12½ x 9½)
Daphne Pollen, signed with initials,
1932
Purchased, 1956

3654 *See Groups:* Conversation
Piece . . . , by Sir James Gunn

BELLOT, Joseph René (1826-52)
French Arctic explorer

1227 Canvas 38.7 x 31.8
(15¼ x 12½)
Stephen Pearce, 1851
Bequeathed by Col John Barrow,
1899
See Collections: Arctic Explorers,
1850-86, by Stephen Pearce,
905-24 and **1209-27**

Ormond

BELLWOOD, Bessie (d. 1896)
Music-hall comedienne

3968 Ink 15.5 x 9.2 (6⅛ x 3⅝)
Unknown artist
Given by Cyril Hughes Hartmann,
1955

BELZONI, Giovanni Battista
(1778-1823) Actor, engineer
and traveller

829 Canvas 86.7 x 69.9
(34⅛ x 27½)
Attributed to William Brockedon,
c. 1820
Given by Humphrey Wood, 1890

2515(1) Pencil and chalk 33 x 21
(13 x 8¼)
William Brockedon, dated 1823
Lent by NG, 1959
See Collections: Drawings of
Prominent People, 1823-49, by
William Brockedon, **2515(1-104)**

BENBOW, John (1653-1702)
Vice-Admiral

2950 Chalk 28.9 x 22.9
(11$\frac{3}{8}$ x 9)
After Sir Godfrey Kneller (1701)
Given by John Warwick, 1865

BENETT, John (1773-1852)
MP for Wiltshire South

54 *See Groups:* The House of Commons, 1833, by Sir George Hayter

BENNET, Charles Augustus, 6th
Earl of Tankerville
See TANKERVILLE

BENNET, Henry, 1st Earl of
Arlington *See* ARLINGTON

BENNETT, Arnold (1867-1931)
Novelist

3422-4 *See Collections:* Prominent
Men, c.1880-c.1910, by Harry
Furniss, **3337-3535** and **3554-3620**

2043 *See Collections:* Medallions
of Writers, c. 1922, by Theodore
Spicer-Simson, **2043-55**

2664 Pencil 26.7 x 20.3 (10½ x 8)
Walter Ernest Tittle, signed,
inscribed and dated 1923
Purchased, 1934

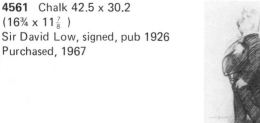

4561 Chalk 42.5 x 30.2
(16¾ x 11$\frac{7}{8}$)
Sir David Low, signed, pub 1926
Purchased, 1967

4075 Chalk and wash 37.8 x 27
(14$\frac{7}{8}$ x 10$\frac{5}{8}$)
Sir Bernard Partridge, signed
(*Punch* 27 April 1927)
Given by D. Pepys Whiteley,1958
See Collections: Mr Punch's
Personalities, 1926-9, by Sir
Bernard Partridge, **3364-6,** etc

BENNETT, George
Slavery abolitionist

599 *See Groups:* The Anti-Slavery
Society Convention, 1840, by
Benjamin Robert Haydon

BENSON, Edward White (1829-96)
Archbishop of Canterbury

2058 Plaster cast of bust 63.5
(25) high
Albert Bruce-Joy, incised
Given by the artist, 1924

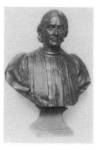

2058a Bronze cast of no.**2058**
Purchased, 1924. *Not illustrated*

2870,2871 *See Collections:*
Caricatures of Politicians, by Sir
Francis Carruthers Gould,
2826-74

2353 Plaster cast of death-mask
24.1(9½) long
Unknown artist
Given by Archbishop Davidson,
1928

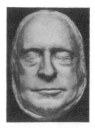

BENSON, Sir Frank Robert
(1858-1939) Actor-manager

3777 Canvas 74.3 x 62.2
(29¼ x 24½)
Reginald Grenville Eves, signed
and dated 1924
Transferred from Tate Gallery,1957

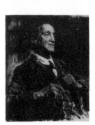

BENSON, Richard Meux
(1824-1915) Divine; founder of
Society of St John the Evangelist

P7(13) Photograph: albumen print
14 x 12.1 (5½ x 4¾)
Charles Lutwidge Dodgson,
inscribed below image, c. 1856
Purchased with help from Kodak
Ltd, 1973
See Collections: Lewis Carroll at
Christ Church, by Charles Lutwidge
Dodgson, **P7(1-37)**

BENSON, Stella (Mrs Anderson)
(1892-1933) Novelist

3321 Water-colour 38.7 x 33.7
(15¼ x 13¼)
Cuthbert Julian Orde, posthumous
Given by wish of the sitter's
husband, 1947

BENTHAM, Jeremy (1748-1832)
Social philosopher

196 Canvas 183 x 119.4 (71 x 47)
Thomas Frye, inscribed and dated
on reverse 1760
Given by Sir John Bowring, 1865

3068 Silhouette 7.9 x 6.4
($3\frac{1}{8}$ x 2½)
John Field, c. 1823
Transferred from BM, 1939

413 Canvas 204.4 x 138.4
(80½ x 54½)
Henry William Pickersgill,
exh 1829
Purchased, 1875

BENTHAM, Samuel (1757-1831)
Naval architect

3069 Miniature on ivory, oval
6 x 4.8 ($2\frac{3}{8}$ x $1\frac{7}{8}$)
Henry Edridge
Transferred from BM, 1939

1075,1075a and **b** *See Groups:* Men
of Science Living in 1807-8, by Sir
John Gilbert and others

BENTINCK, Lord George Cavendish
(1802-48) Statesman and sportsman

1515 Canvas 128.3 x 101.6
(50½ x 40)
Samuel Lane, c.1836 (after 1834
full-length)
Given by F. Cavendish Bentinck,
1908

134 Marble bust 78.7 (31) high
Thomas Campbell, incised and
dated 1848
Purchased, 1861

Ormond

BENTINCK, Lord Henry William
(1804-70) Politician; son of 4th
Duke of Portland

3553 Water-colour 27.5 x 18.4
($10\frac{7}{8}$ x 7¼)
Joshua Dighton
Purchased, 1947

BENTINCK, Lord William Cavendish
(1774-1839) Governor-General of
India; son of 3rd Duke of Portland

848 Pencil, pen and ink
22.6 x 16.2 ($8\frac{7}{8}$ x $6\frac{3}{8}$)
James Atkinson, inscribed, c.1833
Given by the artist's son, Canon
J. A. Atkinson, 1890

BENTINCK, William, 1st Earl of
Portland *See* PORTLAND

BENTINCK, William Cavendish
Scott-, 4th Duke of Portland
See PORTLAND

BENTLEY, Edmund Clerihew
(1875-1956) Writer

4931 Charcoal 58.4 x 45.7
(23 x 18)
Hugh Goldwin Riviere, signed with
initials and dated 1915
Given by the sitter's son, Nicholas
Bentley, 1973

BENTLEY, John Francis
(1839-1902) Architect

4479 Canvas 126.7 x 101.6
(48$\frac{7}{8}$ x 40)
William Christian Symons, signed
and dated 1902
Given by the sitter's daughter, Miss
M. M. Bentley, 1966

BENTLEY, Richard (1662-1742)
Classical scholar; Master of Trinity
College, Cambridge

851 Canvas 127 x 102.2
(50 x 40¼)
After Sir James Thornhill (1710),
inscribed
Purchased, 1890

Piper

BENTLEY, Thomas (1731-80)
Potter; partner of Josiah Wedgwood

1949 Modern cast from Wedgwood
medallion, oval 12.7 x 10.2 (5 x 4)
Joachim Smith (c. 1773)
Given by J. Wedgwood & Sons Ltd,
1922

BERESFORD, William Carr
Beresford, Viscount (1768-1854)
General

1914(4) *See Collections:* Peninsular
and Waterloo Officers, 1813-14, by
Thomas Heaphy, **1914(1-32)**

1180 Oil on paper 12.4 x 10.5
(4$\frac{7}{8}$ x 4$\frac{1}{8}$)
E. (probably Elizabeth) Beresford
after Sir William Beechey (c.1814),
inscribed and dated on reverse 1815
Given by the Rev Francis Warre,
1898

300 Canvas 91 x 70.8 (35$\frac{7}{8}$ x 27$\frac{7}{8}$)
Richard Rothwell, c. 1831
Given by the sitter's stepson,
A. J. B. Beresford Hope, 1870

BERESFORD, Charles William de
la Poer Beresford, Baron
(1846-1919) Admiral

1935 Canvas 122.6 x 97.2
(48¼ x 38¼)
Charles Wellington Furse, exh 1903
Given by the artist's widow, 1922

BERESFORD, Sir John Poo, Bt
(1766-1844) Admiral; MP for
Coleraine

54 *See Groups:* The House of Com-
mons, 1833, by Sir George Hayter

BERKELEY, James Berkeley, 3rd
Earl of (1680-1736) Admiral

3195 Canvas 91.4 x 71.1
(36 x 28)
Sir Godfrey Kneller, signed in
monogram, c. 1710
Kit-cat Club portrait
Given by NACF, 1945

Piper

BERKELEY, George (1685-1753)
Philosopher; Bishop of Cloyne

653 Canvas 101.6 x 74.9 (40 x 29½)
John Smibert, 1730
Given by the Rev William Josiah
Irons, 1882

Kerslake

BERKELEY, George Charles
Grantley Fitzhardinge (1800-81)
Writer and sportsman

54 *See Groups:* The House of Commons, 1833, by Sir George Hayter

BERKELEY, Sir Lennox (b.1903)
Composer

5232 Canvas 65.1 x 50.5
($25\frac{5}{8}$ x $19\frac{7}{8}$)
Caroline Hill, inscribed and
dated 1972
Purchased, 1978

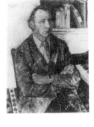

BERNAL, Ralph (d. 1854)
Collector

54 *See Groups:* The House of Commons, 1833, by Sir George Hayter

BERNAYS, Albert James (1823-92)
Chemist

2515(102) Pencil and chalk
35.6 x 26.3 (14 x $10\frac{3}{8}$)
William Brockedon
Lent by NG, 1959
See Collections: Drawings of
Prominent People, 1823-49, by
William Brockedon, **2515(1-104)**

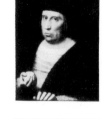

BERNERS, John Bourchier, 2nd
Baron (1467-1533) Statesman
and writer

4953 Panel 49.5 x 39.4
(19½ x 15½)
Unknown Flemish artist, 1520-6
Purchased with help from NACF
and H. M. Government, 1973

BERNERS, Gerald Tyrwhitt-Wilson,
14th Baron (1883-1950) Musician,
artist and writer

4380 Sanguine and white chalk
45.5 x 36 ($17\frac{7}{8}$ x $14\frac{1}{8}$)
Sir William Rothenstein, 1923
Purchased, 1964

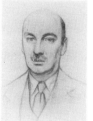

5050 Canvas 40.2 x 32.9
($15\frac{7}{8}$ x 13)
Rex Whistler, 1929
Purchased, 1975

BERRY, Sir Edward (1768-1831)
Rear-Admiral

5259 Pencil and white chalk
16.5 x 12.1 (6½ x 4¾)
George Jones, inscribed
Purchased, 1979

BERTIE, Montagu, 6th Earl of
Abingdon *See* ABINGDON

BERTIE, Montague, 2nd Earl
of Lindsey *See* LINDSEY

BESANT, Sir Walter (1836-1901)
Novelist

2280 With James Rice (seated)
Canvas 140.3 x 181.6 (55¼ x 71½)
Archibald James Stuart Wortley,
signed in monogram and dated 1882
Given by T. Chatto, 1929

BESSBOROUGH, Frederick
Ponsonby, 3rd Earl of (1758-1844)

2076 *See Groups:* Whig Statesmen
and their Friends, c.1810, by
William Lane
999 *See Groups:* The Trial of
Queen Caroline, 1820, by Sir
George Hayter

BESSBOROUGH, John William
Ponsonby, 4th Earl of (1781-1847)
Statesman

54 *See Groups:* The House of Commons, 1833, by Sir George Hayter

Continued overleaf

4915 Pen and wash 23.8 x 18.7
($9\frac{3}{8}$ x $7\frac{3}{8}$)
Sir Edwin Landseer, c. 1835
Purchased, 1972
See Collections: Caricatures of
Prominent People, c. 1832-5, by
Sir Edwin Landseer, **4914-22**

BESSBOROUGH, John Ponsonby,
5th Earl of (1809-80) Man of affairs

4026(6) Pencil and red chalk
28.2 x 15.6 ($11\frac{1}{8}$ x $6\frac{1}{8}$)
Alfred, Count D'Orsay, signed,
inscribed and dated 1834
Purchased, 1957
See Collections: Drawings of Men
about Town, 1832-48, by Alfred,
Count D'Orsay, **4026(1-61)**

BEST, William Thomas (1826-97)
Organist

1455 Bronze relief 14.3 x 13.3
($5\frac{5}{8}$ x 5¼)
Charles J. Praetorius, incised,
embossed and dated 1898
Given by J. M. Levien, 1907

BETHELL, Richard (1772-1864)
MP for Yorkshire East Riding

54 *See Groups:* The House of Com-
mons, 1833, by George Hayter

BETHELL, Richard, Baron
Westbury *See* WESTBURY

BETTERTON, Thomas (1635-1710)
Actor

752 Canvas 76.2 x 64.8 (30 x 25½)
Studio of Sir Godfrey Kneller
(c. 1690-1700)
Purchased, 1886

Piper

BETTS, Miss
Singer
1962(j) With Miss H. Cause
See Collections: Opera singers and
others, c. 1804-c. 1836, by Alfred
Edward Chalon, **1962(a-l)**

BETTY, William Henry West
(1791-1874)
Actor; 'the Young Roscius'

1392 Canvas 198.1 x 149
(78 x $58\frac{5}{8}$)
John Opie, 1804
Bequeathed by the sitter's son,
Henry Thomas Betty, 1905

1333 Pencil and chalk 57.2 x 47
(22½ x 18½)
George Henry Harlow, signed (?),
inscribed and dated 1810
Purchased, 1902

BEUST, Friedrich Ferdinand,
Count von (1809-86)
Austrian statesman

4707(4) *See Collections: Vanity
Fair* cartoons, 1869-1910, by
various artists, **2566-2606**, etc

BEVAN, Aneurin (1897-1960)
Statesman

4529(23) *See Collections:* Working
drawings by Sir David Low,
4529(1-401)

4993 Bronze cast of head 40
(15¾) high
Peter Lambda, dated 1945
Purchased, 1974

BEVAN, Robert Polhill (1865-1925)
Painter

5201 Canvas 45.7 x 35.6 (18 x 14)
Self-portrait, 1913-14
Purchased, 1978

BEVAN, Stanislawa (née de Karlowska) (1876-1952) Painter; wife of Robert Polhill Bevan

5202 Canvas 46 x 38.4 (18⅛ x 15⅛) Robert Polhill Bevan, 1920 Purchased, 1978

BEVAN, William Slavery abolitionist

599 *See Groups:* The Anti-Slavery Society Convention, 1840, by Benjamin Robert Haydon

BEVERIDGE, William Henry Beveridge, 1st Baron (1879-1963) Administrator

P11 *See Collections:* Prominent men, c. 1938-43, by Felix H. Man, **P10-17**

BEVIN, Ernest (1881-1951) Statesman

4558 Chalk 45.7 x 29.5 (18 x 11⅝) Sir David Low, signed, pub 1933 Purchased, 1967

P12 Photograph: bromide print 35.2 x 30.2 (13⅞ x 11⅞) Felix H. Man, signed, inscribed and dated on reverse 1939-40 Given by the photographer, 1975 *See Collections:* Prominent men, c. 1938-43, by Felix H. Man, **P10-17**

3921 Canvas 109.9 x 85.1 (43¼ x 33½) Thomas Cantrell Dugdale, signed, c. 1945 Purchased, 1954

BEWICK, Thomas (1753-1828) Wood engraver

319 Canvas 74.9 x 62.2 (29½ x 24½) James Ramsay, inscribed and dated on reverse 1823 Purchased, 1871

971 *See Unknown Sitters IV*

BEXLEY, Nicholas Vansittart, Baron (1766-1851) Chancellor of the Exchequer

641 Chalk 55.5 x 43.2 (21⅞ x 17) Georgiana Margaretta Zornlin, inscribed and dated (by sitter) 1848 Given by the artist, 1881

BHOWNAGGREE, Sir Mancherjee Merwanjee (1851-1933) Lawyer and politician

4241 Water-colour 37.2 x 17 (14⅝ x 10⅝) Sir Leslie Ward, signed *Spy* (*VF* 18 Nov 1897) Given by Jocelyn Oliver, 1961

BICKERSTETH, Henry, Baron Langdale *See* LANGDALE

BIDDER, George Parker (1806-78) Engineer

2515(15) Black chalk and wash 38.7 x 28.6 (15¼ x 11¼) William Brockedon, c. 1825 Lent by NG, 1959 *See Collections:* Drawings of Prominent People, 1823-49, by William Brockedon, **2515(1-104)**

5163 Marble bust 79 (31⅛) high Edward William Wyon, inscribed, c. 1855 Purchased, 1977

Ormond

BIDDULPH, Sir Michael Anthony
Shrapnel (1823-1904) General

3931 Water-colour 34 x 21.6
($13\frac{3}{8}$ x 8½)
Sir Leslie Ward, signed *Spy*
(*VF* 21 Nov 1891)
Purchased, 1955

BIGGAR, Joseph Gillis (1828-90)
Irish politician

2282 *See Collections:*
Miscellaneous drawings by Sydney
Prior Hall, **2282-2348** and **3270-90**

BIKANER, The Maharaja of
(1880-1943) Statesman and general

4188 Canvas 76.2 x 63.5 (30 x 25)
Sir William Orpen, 1919
Given by wish of Viscount
Wakefield, 1960

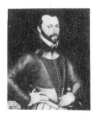

2463 *See Groups:* Statesmen of
World War I, by Sir James Guthrie

BINGHAM, Sir Richard (1528-99)
Soldier and Governor of Connaught

3793 Panel 58.4 x 49.5 (23 x 19½)
Unknown artist, inscribed and
dated 1564
Purchased, 1951. *Montacute*

Strong

BINNEY, Thomas (1798-1874)
Nonconformist divine

599 *See Groups:* The Anti-Slavery
Society Convention, 1840, by
Benjamin Robert Haydon

2182 Water-colour 29.8 x 18.4
(11¾ x 7¼)
Charles Auguste Loye (alias
Montbard), signed in monogram *MD*
(*VF* 12 Oct 1872)
Given by W. H. Fairbairns, 1928

Ormond

BINYON, Laurence (1869-1943)
Poet and art historian

3185 Pencil 32.4 x 24.8
(12¾ x 9¾)
William Strang, signed and dated
1901
Purchased, 1944

BIRCH, Lamorna (1869-1955)
Artist

5084 Pastel 59.4 x 45.4
($23\frac{3}{8}$ x $17\frac{7}{8}$)
James Ardern Grant, signed and
dated 1946
Given by the artist's son,
Ian Grant, 1976

BIRCH, Thomas (1705-66)
Historian

522 Canvas 90.8 x 70.5
(35¾ x 27¾)
Unknown artist, c. 1735
Transferred from BM, 1879

Kerslake

BIRD, Cyril Kenneth (1887-1965)
'Fougasse'; caricaturist

4529(24-7) *See Collections:*
Working drawings by Sir David
Low, **4529(1-401)**

BIRD, Edward (1772-1819)
Painter

3648 Pencil 23.5 x 17.1
(9¼ x 6¾)
Sir Francis Chantrey, signed,
inscribed and dated 1816
Given by Thomas Balston, 1949

986 Plaster cast of bust 60.3
(23¾) high
Sir Francis Chantrey, incised and
dated 1816
Given by the executors of
George Wallis, 1895

BIRD, Edward Joseph (1799-1881)
Admiral

1208 *See Groups:* The Arctic
Council, 1851, by Stephen Pearce

BIRD, Henry Edward (1830-1908)
Chess player

3060 *See Groups:* Chess players,
by A. Rosenbaum

BIRDWOOD, William Riddell
Birdwood, 1st Baron (1865-1951)
Field-Marshal

2908(1) *See Collections:* Studies,
mainly for General Officers of World
War I, by John Singer Sargent,
2908(1-18)

4186 Chalk 59.1 x 48.3
(23¼ x 19)
John Singer Sargent, signed,
inscribed and dated 1916
Given by wish of Viscount
Wakefield, 1960

1954 *See Groups:* General Officers
of World War I, by John Singer
Sargent

BIRKENHEAD, Frederick Edwin
Smith, 1st Earl of (1872-1930)
Lord Chancellor

2552 Canvas 132.1 x 99.1
(52 x 39)
Sir Oswald Birley, signed and dated
1932, replica (c.1922)
Given by Francis Howard, 1932

5224(4) *See Collections:* Cartoons,
c.1928-c.1936, by Robert Stewart
Sherriffs, **5224(1-8)**

BIRKETT, William Norman Birkett,
1st Baron (1883-1962) Judge

4529(28-31) *See Collections:*
Working drawings by Sir David
Low, **4529(1-401)**

BIRNEY, James Gillespie
(1792-1857) American
slavery abolitionist

599 *See Groups:* The Anti-Slavery
Society Convention, 1840, by
Benjamin Robert Haydon

BIRRELL, Augustine (1850-1933)
Man of letters and politician

3343, 3344 *See Collections:*
Prominent Men, c.1880-c.1910,
by Harry Furniss, **3337-3535** and
3554-3620

3126 Water-colour 36.5 x 26.7
(14⅜ x 10½)
Sir Leslie Ward, signed *Spy*
(*VF* 18 Jan 1906)
Purchased, 1942

2791 Chalk 48.3 x 35.6 (19 x 14)
Sir William Orpen, signed and dated
1909
Purchased, 1935

4431 Chalk 45.7 x 63.5 (18 x 25)
Randolph Schwabe, signed and
dated 1927
Given by Sir Charles Tennyson, 1965

4529(32) *See Collections:* Working
drawings by Sir David Low,
4529(1-401)

BIRT, John
American slavery abolitionist

599 *See Groups:* The Anti-Slavery
Society Convention, 1840, by
Benjamin Robert Haydon

BISH, Thomas (1780-1843)
MP for Leominster

54 *See Groups:* The House of Commons, 1933, by Sir George Hayter

BISHOP, Sir Henry Rowley
(1786-1855) Composer of operas
and glees

617 Canvas 22.9 x 17.8 (9 x 7)
Attributed to George Henry Harlow,
c. 1810
Purchased, 1880

275 Canvas 76.2 x 63.5 (30 x 25)
Attributed to Isaac Pocock, 1813
Given by Mrs C. H. Smith, 1869

BLACHFORD, Frederic Rogers,
Baron (1811-89) A founder of
the *Guardian* newspaper

3810 Pencil 16.5 x 11.4
(6½ x 4½)
Frederick Sargent, signed and
inscribed
Purchased, 1951

BLACK Joseph (1728-99)
Chemist and physician

3238 Paste medallion 8.9 x 6.4
(3½ x 2½)
James Tassie, incised and dated 1788
Purchased, 1945

BLACKBURNE, Joseph Henry
(1841-1924) Chess player

3060 *See Groups:* Chess players,
by A. Rosenbaum

BLACKETT, Sir Basil Phillott
(1882-1935) Financial administrator

4529(33) *See Collections:* Working
drawings by Sir David Low,
4529(1-401)

BLACKETT, Patrick Maynard
Stuart Blackett, 1st Baron
(1897-1974) Physicist

P127 *See Collections:* Prominent
People, 1935-8, by Lucia Moholy,
P127-33

4529(34-9) *See Collections:* Working
drawings by Sir David Low,
4529(1-401)

4565 Chalk 43.8 x 31.5
(17¼ x 12⅜)
Sir David Low, signed, inscribed
and dated 1949
Purchased, 1967

5010 Board 78.7 x 61 (31 x 24)
Emmanuel Levy, signed, 1956
Purchased, 1974

BLACKHOUSE, Jonathan
Slavery abolitionist

599 *See Groups:* The Anti-Slavery
Society Convention, 1840, by
Benjamin Robert Haydon

BLACKIE, John Stuart (1809-95)
Classical scholar and teacher

2670 Canvas 64.8 x 49.5
(25½ x 19½)
Somerled Macdonald
Bequeathed by Archibald Stodart
Walker, 1934

BLACKSTONE, Sir William
(1723-80) Jurist

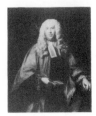

388 Canvas 124.5 x 99.7 (49 x 39¼)
Attributed to Sir Joshua Reynolds
Purchased, 1874

BLACKSTONE, William Seymour (1809-81) MP for Wallingford

54 *See Groups:* The House of Commons, 1833, by Sir George Hayter

BLAIR, W. T.
Slavery abolitionist

599 *See Groups:* The Anti-Slavery Society Convention, 1840, by Benjamin Robert Haydon

BLAKE, William (1757-1827)
Visionary poet and painter

212 Canvas 92.1 x 72 (36¼ x 28⅜)
Thomas Phillips, initialled *P* and dated 1807
Purchased, 1866

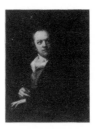

2146 Water-colour 22.9 x 17.8 (9 x 7)
John Linnell, signed, inscribed and dated 1861, replica (1821)
Given by A. S. Bradby, 1927

1809 Plaster head 29.2 (11½) high
James S. Deville, incised and dated 1823
Purchased, 1953

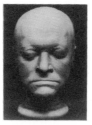

1809a Bronze cast of no. **1809**
Purchased, 1953

BLESSINGTON, Charles John Gardiner, 1st Earl of (1782-1829)
Man of fashion

1523 Oil on silver 15 x 11.8 (5⅞ x 4⅝)
James Holmes, c. 1812
Purchased, 1908

999 *See Groups:* The Trial of Queen Caroline, 1820, by Sir George Hayter

BLESSINGTON, Marguerite, Countess of (1789-1849)
Novelist and beauty

1309 Water-colour 26 x 21 (10¼ x 8¼)
By or after Alfred Edward Chalon, c. 1834
Given by Alfred Jones, 1902

1645a Pencil 19.7 x 14.3 (7¾ x 5⅝)
Charles Martin, signed with initials, inscribed and dated 1844
Purchased, 1912

Ormond

BLIGH, John, 4th Earl of Darnley *See* DARNLEY

BLIGH, John Stuart, 6th Earl of Darnley *See* DARNLEY

BLIGH, William (1754-1817)
Admiral and explorer; captain of the *Bounty*

1138 Pencil 25.4 x 19.1 (10 x 7½)
George Dance, signed and dated 1794
Purchased, 1898

4317 Pencil and water-colour 14.6 x 8.3 (5¾ x 3¼)
John Smart, eng 1803
Purchased, 1963

BLISS, Sir Arthur (1891-1975)
Composer

5055 Chalk 36.8 x 31.8
(14½ x 12½)
Richard Stone, signed, 1969-70
Given by the artist, 1975

BLIZARD, Sir William (1743-1835)
Surgeon

316a(5) Pencil and brown ink
40.6 x 28.6 (16 x 11¼)
Sir Frances Chantrey, inscribed,
1815
Given by Mrs George Jones, 1871
See Collections: Preliminary
drawings for busts and statues by
Sir Francis Chantrey, **316a(1-202)**

BLOMFIELD, Charles James
(1786-1857) Bishop of London

4166 *See Groups:* Charles James
Blomfield, Cardinal Manning and
Sir John Gurney, by George
Richmond

BLOMFIELD, Sir Reginald
Theodore (1856-1942) Architect

4764 Sanguine 31.1 x 35.9
(12¼ x 14⅛)
Sir William Rothenstein, 1923
Purchased, 1970

3929 Bronze bust 43.8 (17¼) high
Sir William Reid Dick, incised
and dated 1927
Bequeathed by the sitter, 1955

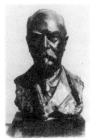

BLOOD, Thomas (1618?-80)
Adventurer; attempted to steal
Crown jewels

418 *See Unknown Sitters II*

BLOODWORTH, Thomas
Groom of the bedchamber to
Frederick Lewis, Prince of Wales

1164 *See under* Frederick Lewis,
Prince of Wales

BLOOMFIELD, John Arthur
Douglas Bloomfield, 2nd Baron
(1802-79) Diplomat

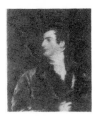

1408 Canvas 75.6 x 63.8
(29¾ x 25⅛)
Sir Thomas Lawrence, 1819
Bequeathed by the sitter's widow,
1905

Ormond

BLOOMFIELD, Robert
(1766-1823) Poet

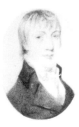

1644 Miniature on ivory, oval
5.4 x 4.1 (2⅛ x 1⅝)
Henry Bone after Richard Cosway,
signed in monogram *HB*, c. 1800
Purchased, 1912

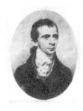

2926 Water-colour, oval 8.3 x 6.4
(3¼ x 2½)
Henry Edridge, inscribed on mount,
c. 1805
Purchased, 1937

BLORE, Edward (1787-1879)
Architect and antiquary

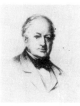

3163 Chalk 66 x 54 (26 x 21¼)
George Koberwein, signed and
dated 1868
Given by the sitter's great-grand-
daughter, Mrs A. H. Walker, 1943

Ormond

BLOUNT, Charles, Earl of
Devonshire *See* DEVONSHIRE

BLOUNT, Mountjoy, Earl of
Newport *See* NEWPORT

BLUNDELL, Sir Michael (b.1907)
Politician in Kenya

4529(40-2) *See Collections:*
Working drawings by Sir David
Low, **4529(1-401)**

BLUNDEN, Edmund (1896-1974)
Poet, writer and teacher

4976 Pencil 27.6 x 21.6
($10\frac{7}{8}$ x $8\frac{1}{2}$)
Ralph Hodgson, signed with initials,
inscribed and dated 1921
Given by the sitter's wife, 1973

4977 Chalk 29.5 x 25
($11\frac{5}{8}$ x $9\frac{7}{8}$) *sight*
Sir William Rothenstein, signed
and dated 1922
Given by Kenneth Guichard, 1974

BODICHON, Barbara Leigh Smith
(1827-91) Benefactress of Girton
College, Cambridge

P137 Photograph: ambrotype,
oval 8.3 x 6.4 ($3\frac{1}{4}$ x $2\frac{1}{2}$)
Unknown photographer
Given by Mrs Elizabeth Malleson,
1912

BODKIN, Thomas (1887-1961)
Teacher and writer on art

5015 Terracotta bust 33.7
($13\frac{1}{4}$) high
Sir Charles Wheeler, incised with
initials and dated 1955
Given by the artist's widow,
Lady Muriel Wheeler, 1975

BODLEY, John Edward Courtney
(1853-1925) Historian and writer

2278 Pen and ink 27.3 x 24.1
($10\frac{3}{4}$ x $9\frac{1}{2}$)
Robert Kastor, signed, inscribed
and dated 1903
Given by the Hon Mrs Eustace
Hills, 1929

BODMER, Johann Jakob
(1698-1783) Tutor of Henry Fuseli

3027 (formerly called Henry Fuseli)
Pencil 38.7 x 30.5 ($15\frac{1}{4}$ x 12)
Henry Fuseli
Given by Marion Harry Spielmann,
1939

BOEHM, Sir Joseph Edgar, Bt
(1834-90) Sculptor

1833 *See Groups:* Private View of
the Old Masters Exhibition, Royal
Academy, 1888, by Henry Jamyn
Brooks

5273 Bronze medallion 11.4
($4\frac{1}{2}$) diameter
Edouard Lanteri, incised, embossed
and dated 1891
Purchased, 1979

BOLEYN, Queen Anne
See ANNE

BOLINGBROKE, Henry St John,
1st Viscount (1678-1751)
Statesman and writer

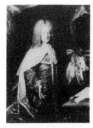

593 Canvas 143.5 x 111.8
($56\frac{1}{2}$ x 44)
Attributed to Alexis Simon Belle,
1712(?)
Purchased, 1879

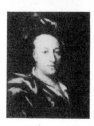

1493 Canvas 57.2 x 48.3
($22\frac{1}{2}$ x 19)
Attributed to Jonathan Richardson,
c. 1730(?)
Purchased, 1908

Continued overleaf

3067 Enamel miniature on copper, oval 4.1 x 3.5 ($1\frac{5}{8}$ x $1\frac{3}{8}$)
Artist unknown, c. 1740-50
Transferred from BM, 1939

Piper

BOLLAND,Sir William (1772-1840)
Judge and bibliophile

730 Canvas 76.2 x 63.1 (30 x $24\frac{7}{8}$)
James Lonsdale, c. 1830
Given by Sir Augustus Stephenson, 1884

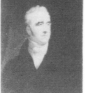

BOLT, Robert (b. 1924)
Playwright

4529(43,44) *See Collections:* Working drawings by Sir David Low, **4529(1-401)**

BOLTON, William Henry Orde-Powlett, 3rd Baron (1818-95)
Representative peer

1834(b) *See Collections:* Members of the House of Lords, c. 1870-80, by Frederick Sargent, **1834(a-z and aa-hh)**

BOMBERG, David (1890-1957)
Painter

4522 Chalk 55.9 x 38.1 (22 x 15)
Self-portrait, signed, 1913-14
Purchased, 1956

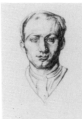

4821 Charcoal and wash 49.5 x 32.4 (19½ x 12¾)
Self-portrait, signed, 1937
Purchased, 1970

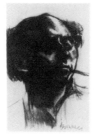

BONDFIELD, Margaret Grace (1873-1953) Politician; first woman cabinet minister

3966 Miniature on ivory, oval 7.6 x 6 (3 x $2\frac{3}{8}$)
W. Milner Knight, signed, and on reverse signed, inscribed and dated 1937
Purchased, 1955

BONE, Henry (1755-1834)
Enamel painter

869 Canvas 76.2 x 63.5 (30 x 25)
John Opie, inscribed and dated on reverse 1799
Purchased, 1891

3155 Pencil and water-colour 24.5 x 20.6 ($9\frac{5}{8}$ x $8\frac{1}{8}$)
John Jackson, c. 1814
Purchased, 1943

316a(13b) Pencil 51 x 33 ($20\frac{1}{8}$ x 13)
Sir Francis Chantrey, inscribed, c. 1816
Given by Mrs George Jones, 1871
See Collections: Preliminary drawings for busts and statues by Sir Francis Chantrey, **316a(1-202)**

BONE, James (1872-1962)
Journalist

4529(45-51) *See Collections:* Working drawings by Sir David Low, **4529(1-401)**

BONE, Sir Muirhead (1876-1953)
Draughtsman, etcher and painter

4428 Chalk 37.8 x 27.9 ($14\frac{7}{8}$ x 11)
Francis Dodd, signed, inscribed and dated 1931
Purchased, 1964

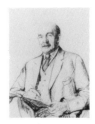

3079 Etching (first state)
30.5 x 22.9 (12 x 9)
Francis Dodd, signed and dated
1931 on plate
Purchased, 1954

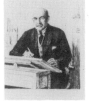

3079a Etching (second state)
30.5 x 22.9 (12 x 9)
Francis Dodd, signed and dated
1931 on plate, and signed and
inscribed below plate
Purchased, 1965

4453 Pencil 35.6 x 25.4 (14 x 10)
Sir Stanley Spencer, signed and
inscribed
Purchased, 1965

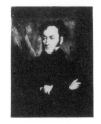

BONE, Robert Trewick (1790-1840)
History painter

4233 Millboard 24.8 x 20 (9¾ x 7⅞)
John Partridge, 1836
Bequeathed by the widow of the
artist's nephew, Sir Bernard
Partridge, 1961

Ormond

BONHAM CARTER, Helen Violet,
Baroness Asquith *See* ASQUITH

BONINGTON, Richard Parkes
(1802-28) Painter

1729 Water-colour 19.1 x 11.8
(7½ x 4⅝)
Self-portrait, c. 1820-5
Given by Ernest E. Leggatt, 1914

492 Chalk 44.5 x 33 (17½ x 13)
Margaret Carpenter, c.1827
Given by William Callow, 1877

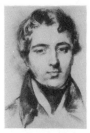

444 Canvas 76.2 x 63.5 (30 x 25)
Margaret Carpenter, c. 1827
Purchased, 1877

BONOMI

3089(2) *See Collections:* Tracings
of drawings by George Dance,
3089(1-12)

BONOMI, Joseph (1739-1808)
Architect

3089(1) Pencil 25.4 x 20 (10 x 7⅞)
William Daniell after George Dance
(1793), inscribed
Purchased, 1940
See Collections: Tracings of drawings
by George Dance, **3089(1-12)**

BONOMI, Joseph, the Younger
(1796-1878) Sculptor and
draughtsman

1477 Canvas 50.2 x 40.3
(19¾ x 15⅞)
Matilda Sharpe, signed, inscribed
and dated on reverse 1868
Given by the artist and her sister,
Miss E. Sharpe, 1907

Ormond

BOOLE, George (1815-64)
Mathematician

4411 Pencil 12.4 x 8.9 (4⅞ x 3½)
Unknown artist, inscribed, 1847
Given by Sir Geoffrey Taylor,
grandson of the sitter's widow, 1964

Ormond

BOOTH, Dr

P120(18) *See Collections:* Literary and Scientific Men, 1855, by Maull & Polyblank, **P120(1-54)**

BOOTH, Charles (1840-1916)
Shipowner and sociologist

4131 Canvas 74.6 x 61.9 (29$\frac{3}{8}$ x 24$\frac{3}{8}$)
George Frederic Watts, c. 1901
Given under the terms of the artist's will, 1959

4765 Pencil 39.4 x 28.3 (15½ x 11$\frac{1}{8}$)
Sir William Rothenstein, inscribed, 1910
Purchased, 1970

BOOTH, William (1829-1912)
'General Booth'; founder of the Salvation Army

2383 *See Collections:* Miscellaneous drawings . . . by Sydney Prior Hall, **2282-2348** and **2370-90**

2275 Pen and ink 27.9 x 21 (11 x 8¼)
Stephen Reid, signed, inscribed and dated 1906
Given by Irving Taylor, 1928

1783A Etching 29 x 25.4 (11$\frac{3}{8}$ x 10)
Francis Dodd, signed on and outside plate
Given by Dugald Sutherland MacColl through NACF, 1916

2042 Canvas 89.5 x 69.2 (35¼ x 27¼)
David N. Ingles, signed
Given by the sitter's granddaughter, Catherine Bramwell-Booth, 1961

2932 Pen and ink 15.9 x 10.2 (6¼ x 4)
Colin Campbell, signed
Given by the artist, 1938

BOOTLE-WILBRAHAM, Edward, 1st Earl of Lathom *See* LATHOM

BORDEN, Sir Robert Laird (1854-1937) Prime Minister of Canada

2463 *See Groups:* Statesmen of World War I, by Sir James Guthrie

BORGO, Count Pozzi di
Russian ambassador

3699 *See Collections:* Studies for The Waterloo Banquet at Apsley House, 1836, by William Salter, **3689-3769**

BORLASE, Sir John (1576-1648)
General of the Ordnance and Governor of Ireland

4933 Panel 113 x 91.1 (44½ x 35$\frac{7}{8}$)
Michael Jansz. van Miereveldt, signed and dated 1625
Purchased, 1973. *Montacute*

BORUWLASKI, Joseph (1739-1837) Dwarf

3097(8) *See Collections:* Caricatures, c. 1825-c.1835, by Sir Edwin Landseer, **3097(1-10)**

BORRER, William (1781-1862)
Botanist

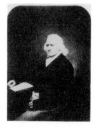

P106(2) Photograph: albumen print, arched top 20 x 14.6 (7$\frac{7}{8}$ x 5¾)
Maull & Polyblank, c. 1855
Purchased, 1978
See Collections: Literary and Scientific Portrait Club, by Maull & Polyblank, **P106(1-20)**

BORRER, William, Junior

P106(3) *See Collections:* Literary
and Scientific Portrait Club, by
Maull & Polyblank, **P106(1-20)**

BORROW, George (1803-81)
Philologist and writer

1651 Canvas 80 x 71.1 (31½ x 28)
John Borrow (his brother), c. 1821
or c. 1824
Purchased, 1912

1841 Canvas 48.3 x 36.8 (19 x 14½)
Henry Wyndham Phillips, small
replica (1843)
Given by Mrs Smith-Stanier, 1919

Ormond

BORTHWICK, Algernon, 1st Baron
Glenesk *See* GLENESK

BOSCAWEN, Edward (1711-61)
Admiral

44 Canvas 74.9 x 62.2 (29½ x 24½)
After Sir Joshua Reynolds (c.1755)
Given by Viscount Falmouth, 1858

Kerslake

BOSCAWEN, Edward, 1st Earl of
Falmouth *See* FALMOUTH

BOSWELL, James (1740-95)
Biographer of Dr Johnson

4452 Canvas 76.2 x 63.5 (30 x 25)
Sir Joshua Reynolds, 1785
Purchased, 1965

1675 Canvas 72.4 x 60.3
(28½ x 23¾)
Studio of Sir Joshua Reynolds, 1785
Transferred from Tate Gallery, 1957

1139 Pencil 25.4 x 18.4 (10 x 7¼)
George Dance, signed and dated
1793
Purchased, 1898

2755 Pencil 15.9 x 12.1 (6¼ x 4¾)
Sir Thomas Lawrence, inscribed,
c. 1790-5
Given by Harold Hartley, 1935

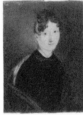

BOSWELL, Mary (née Lear) (d.1861)
Sister of Edward Lear and wife of
Richard Boswell

1759B Miniature on ivory 8.3 x 6.4
(3¼ x 2½)
Unknown artist
Given by Francis Adeney Allen,
1915

BOTHA, Louis (1862-1919)
South African statesman

2908(8) *See Collections:* Studies,
mainly for General Officers of
World War I, by John Singer
Sargent, **2908(1-18)**

1954 *See Groups:* General Officers
of World War I, by John Singer
Sargent

2463 *See Groups:* Statesmen of
World War I, by Sir James Guthrie

BOTTOMLEY, Anna (née
Thomson) (1820-56) Sister of
William Thomson, Baron Kelvin

1708(d) *See Collections:* Lord
Kelvin and members of his family,
by Elizabeth King and Agnes
Gardner King, **1708(a-h)**

BOTTOMLEY, Gordon (1874-1948)
Poet and dramatist

4150 Chalk 17.5 x 15.9 (6$\frac{7}{8}$ x 6¼)
Charles Haslewood Shannon, signed
with initials, inscribed and dated
1924
Given by the sitter's executors, 1960

BOUCICAULT, Dion (1820-90)
Actor and dramatist

3554 *See Collections:* Prominent
men, c.1880-c.1910, by Harry
Furniss, **3337-3535** and **3554-3620**

BOUGHTON, George Henry
(1833-1905)
Painter and illustrator

2612 Pencil, two heads 9.5 x 14.6
(3¾ x 5¾)
Alfred Lys Baldry, 1889
Given by the artist, 1933

BOUGHTON, Rutland (1878-1960)
Composer

4932 Pencil 37.5 x 29.2 (14¾ x 11½)
Christina Walshe, signed and dated
1911
Given by Mrs Fiona Gibson at the
wish of her mother, Mrs Estelle
Fletcher, 1973

P111 Photograph: bromide print
15.5 x 21.6 (6$\frac{1}{8}$ x 8½)
Herbert Lambert, 1921
Given by the photographer's
daughter, Mrs Barbara Hardman,
1978
See Collections: Musicians and
Composers, by Herbert Lambert,
P107-11

BOULT, Sir Adrian (b. 1899)
Conductor

5130 Lithograph 53.7 x 39
(21$\frac{1}{8}$ x 15$\frac{3}{8}$)
Edmond Xavier Kapp, signed and
inscribed, and initialled on stone,
c.1932
Purchased, 1977

4906 Chalk 38.1 x 27.3 (15 x 10¾)
Richard Stone, signed and dated
1972
Given by the artist, 1972

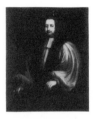

BOULTBEE, William
Slavery abolitionist

599 *See Groups:* The Anti-Slavery
Society Convention, 1840, by
Benjamin Robert Haydon

BOULTER, Hugh (1672-1742)
Archbishop of Armagh

502 Canvas 124.2 x 100.3
(48$\frac{7}{8}$ x 39½)
After Francis Bindon (1742?)
Purchased, 1878

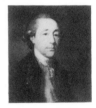

Kerslake

BOULTON, Matthew (1728-1809)
Engineer; worked with James Watt

1532 Canvas 57.8 x 49.5
(22¾ x 19½)
Unknown artist
Purchased, 1909

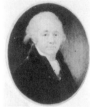

1595 Miniature on ivory, oval
7.9 x 6.4 (3$\frac{1}{8}$ x 2½)
After Sir William Beechey (1799)
Purchased, 1911

1451 Paste medallion 7.6 x 5.7
(3 x 2¼)
S. Brown, incised and dated 1807
Purchased, 1906

1075,1075a and **b** *See Groups:* Men
of Science living in 1807-8, by Sir
John Gilbert and others

BOURCHIER, John, 2nd Baron
Berners *See* BERNERS

BOURCHIER, Sir Thomas
(1791-1849) Captain in Royal Navy

720 Canvas 40.6 x 32.7 (16 x 12$\frac{7}{8}$)
Samuel Laurence, inscribed and
dated on stretcher 1846
Bequeathed by the sitter's widow,
1884

Ormond

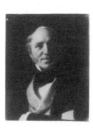

BOURGEOIS, Sir Peter Francis
(1756-1811) Landscape painter;
founder of Dulwich College Picture
Gallery

231 Canvas 76.2 x 63.5 (30 x 25)
Sir William Beechey, c. 1810
Purchased, 1867

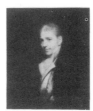

BOURKE, Henry Lorton
(1840-1911) Socialite

3276 Water-colour 34.6 x 21
(13$\frac{5}{8}$ x 8¼)
Sir Francis Carruthers Gould,
signed *FCG*
(*VF* 30 Aug 1890)
Purchased, 1934

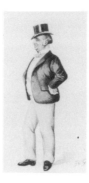

BOURKE, Richard Southwell,
6th Earl of Mayo *See* MAYO

BOURNE, Francis Alphonsus
(1861-1935) Cardinal Archbishop
of Westminster

4592 Water-colour 40.6 x 25.4
(16 x 10)
Sir Leslie Ward, signed and dated
1910
Purchased, 1967

BOWATER, Sir Edward
(1787-1861) Lieutenant-General

3700 *See Collections:* Studies for
The Waterloo Banquet at Apsley
House, 1836, by William Salter,
3689-3769

BOWEN, Elizabeth (1899-1973)
Novelist and writer

5134 Canvas 101.6 x 91.4 (40 x 36)
André Durand, signed and dated
1969
Given by Miss Elizabeth Ritchie,
1973

BOWERBANK, James Scott
(1797-1877) Geologist

P106(4) Photograph: albumen
print, arched top 20 x 14.6
(7$\frac{7}{8}$ x 5¾)
Maull & Polyblank, inscribed on
mount, c. 1855
Purchased, 1978
See Collections: Literary and
Scientific Portrait Club, by Maull &
Polyblank, **P106(1-20)**

P120(1) *See Collections:* Literary
and Scientific Men, 1855, by Maull
& Polyblank, **P120(1-54)**

BOWLY, Samuel (1802-84)
Quaker and anti-slavery agitator

599 *See Groups:* The Anti-Slavery
Society Convention, 1840, by
Benjamin Robert Haydon

BOWMAN, Sir James (1898-1978)
Mineworkers' administrator

4529(52-5) *See Collections:*
Working drawings by Sir David Low,
4529(1-401)

BOWRA, Sir Maurice (1898-1971)
Classical scholar and writer

4667 Chalk 35.3 x 25.1
(13$\frac{7}{8}$ x 9$\frac{7}{8}$)
Henry Lamb, 1952
Purchased, 1969

BOWRING, Sir John (1792-1872)
Linguist and traveller

1113 Canvas 92.1 x 71.1
(36¼ x 28)
John King, inscribed and dated 1826
Given by the sitter's widow, 1898

Continued overleaf

2515(56) *See Collections:*
Drawings of Prominent People,
1823-49, by William Brockedon,
2515(1-104)

1082 Bronze medallion 16.5
(6½) diameter
Pierre David D'Angers, incised and
dated 1832
Given by Sir Lionel Cust, 1897

599 *See Groups:* The Anti-Slavery
Society Convention, 1840, by
Benjamin Robert Haydon

2550 Pencil 19.1 x 23.5 (7½ x 9¼)
Unknown artist, inscribed and
dated 1854
Given by W. C. Edwards, 1932

Ormond

BOXALL, Sir William (1800-79)
Painter; Director of the National
Gallery

937 Canvas 69.2 x 60 (27¼ x 23⅝)
Michel Angelo Pittatore, 1870
Purchased, 1892

Ormond

BOYCE, William (1710-79)
Composer and organist; wrote
Hearts of Oak

4212 Pastel 60.3 x 47.9
(23¾ x 18⅞)
John Russell, signed and dated 1776
Purchased, 1961

BOYD, Sir Robert (1710-94)
General

1752 *See Groups:* The Siege of
Gibraltar, 1782, by George Carter

BOYDELL, John (1719-1804)
Engraver

934 Panel 52.1 x 41.9 (20½ x 16½)
Attributed to Sir William Beechey,
reduced version (1801)
Bequeathed by Henry Graves, 1892

BOYLE, Charles, 4th Earl of Orrery
See ORRERY

BOYLE, Lady Jane
2495 *See under* 3rd Earl of
Burlington

BOYLE, John, 5th Earl of Cork and
Orrery *See* CORK AND ORRERY

BOYLE, Richard, 1st Earl of
Burlington and 2nd Earl of Cork
See BURLINGTON

BOYLE, Richard, 3rd Earl of
Burlington *See* BURLINGTON

BOYLE, Richard, 1st Earl of Cork
See CORK

BOYLE, Richard, 2nd Viscount
Shannon *See* SHANNON

BOYLE, Richard Edmund St
Lawrence, 9th Earl of Cork and
Orrery *See* CORK AND ORRERY

BOYLE, Robert (1627-91)
Chemist and natural philosopher

734 Canvas, feigned oval
75.6 x 62.2 (29¾ x 24½)
After Johann Kerseboom
(c. 1689-90)
Purchased, 1885

3930 Canvas 127 x 103.5 (50 x 40¾)
After Johann Kerseboom
(c. 1689-90)
Given by Eric Bullivant in memory
of his wife, Kate, 1955

Piper

BOYS, Thomas Shotter (1803-74)
Water-colourist and lithographer

4820 Ceramic plaque 20.3 (8)
diameter
Emile Aubert Lessore, signed, and
inscribed and dated on reverse 1856
Purchased, 1970

Ormond

BRABAZON of Tara, John Moore-
Brabazon, 1st Baron (1884-1964)
Statesman and sportsman

4442 Pastel 45.7 x 33 (18 x 13)
Alfred Egerton Cooper, signed with
initials, 1958
Purchased, 1965

BRABAZON, Hercules Brabazon
(1821-1906) Painter

L168(1) Sanguine and black
25.4 x 20.3 (10 x 8)
Sir William Rothenstein, c. 1895
Lent by the artist's son, Sir John
Rothenstein, 1977
See Collections: Prominent men,
1895-1930, by Sir William
Rothenstein, **L168(1-11)**

BRABAZON, Reginald, Earl of
Meath *See* MEATH

BRACKEN, Brendan Bracken,
Viscount (1901-58) Statesman

4529(56,57) *See Collections:*
Working drawings by Sir David
Low, **4529(1-401)**

BRACKLEY, Sir Thomas Egerton,
1st Baron Ellesmere and 1st
Viscount (1540?-1617)
Lord Chancellor

3783 Panel 114.3 x 88.9 (45 x 35)
Unknown artist
Given in memory of A. C. J. Borrett
by his parents, 1950. *Montacute*

Strong

BRADBURN, George
American slavery abolitionist

599 *See Groups:* The Anti-Slavery
Society Convention, 1840, by
Benjamin Robert Haydon

BRADFORD, Orlando Bridgeman,
1st Earl of (1762-1825)

999 *See Groups:* The Trial of
Queen Caroline, 1820, by Sir
George Hayter

BRADFORD, Samuel (1652-1731)
Bishop of Rochester

2416 Water-colour, feigned oval
12.3 x 10.5 ($4\frac{7}{8}$ x $4\frac{1}{8}$)
George Perfect Harding (eng 1822)
after an unknown artist, signed
Purchased, 1929
See Collections: Copies of early
portraits, by George Perfect Harding
and Sylvester Harding, **1492,
1492(a-c)** and **2394-2419**

BRADLAUGH, Charles (1833-91)
Radical politician

5256 *See Groups:* The Lobby of
the House of Commons, 1886, by
Liberio Prosperi

2313, 2314, 2316, 2332 *See
Collections:* Miscellaneous drawings
. . . by Sydney Prior Hall, **2282-2348**
and **2370-90**

2206 Pencil 18.4 x 17.1 (7¼ x 6¾)
Walter Richard Sickert, signed,1890
Given by Lady Gosse and family,
1928

2868 *See Collections:*
Caricatures of Politicians, by Sir
Francis Carruthers Gould, **2826-74**

3555 *See Collections:* Prominent
Men, c. 1880-c.1910, by Harry
Furniss, **3337-3535** and **3554-3620**

BRADLEY, James (1693-1762)
Astronomer Royal

1073 Panel, feigned oval
26 x 21.3 (10¼ x 8⅜)
After Thomas Hudson (c.1742-7)
Purchased, 1896

Kerslake

BRADSHAW, George (1801-53)
Originator of railway guides

2201 Canvas 91.4 x 71.1 (36 x 28)
Richard Evans, 1841
Bequeathed by the sitter's son,
Christopher Bradshaw, 1928

Ormond

BRADSHAW, John (1602-59)
Regicide

2131 *See Unknown Sitters II*

BRAGG, Sir William Henry
(1862-1942) Physicist and
crystallographer

3255 Pencil 29.2 x 20.6 (11½ x 8⅛)
Randolph Schwabe, signed and
dated 1932
Given by the Contemporary
Portraits Fund, 1945

BRAHAM, John (1777-1856)
Singer

1637 Water-colour 22.6 x 18.2
(8⅞ x 7⅛)
Richard Dighton, 1819
Purchased, 1911

1870 Miniature on ivory 9.8 x 7.4
(3⅞ x 2⅞)
Unknown artist, c. 1834
Given by Sir Edward Tyas Cook in
memory of his brother, Sir Charles
Cook, 1920

BRAHAM, Joseph (1748-1814)
Inventor

1075, 1075a and **b** *See Groups:*
Men of Science living in 1807-8,
by Sir John Gilbert and others

BRAMPTON, Henry Hawkins, 1st
Baron (1817-1907) Judge

3466 *See Collections:* Prominent
Men, c. 1880-c.1910, by Harry
Furniss, **3337-3535** and **3554-3620**

BRAMSTON, Sir John (1577-1654)
Judge

462 Canvas 75.6 x 62.9 (29¾ x 24¾)
Unknown artist, inscribed
SR RANDH CREWE (sic)
Given by the Society of Judges and
Serjeants-at-Law, 1877

Piper

BRANCKER, Sir William Sefton
(1877-1930) Major-General and
Air Vice-Marshal

3665 Chalk 37.5 x 30.5 (14¾ x 12)
Sir Bernard Partridge, signed and
inscribed
(*Punch* 3 July 1929)
Purchased, 1949
See Collections: Mr Punch's
Personalities, 1926-9, by Sir Bernard
Partridge, **3664-6**, etc

BRAND, Thomas, 20th Baron
Dacre *See* DACRE

BRANDE, William Thomas
(1788-1866) Chemist

4819 Plaster medallion, oval
9.5 x 8.3 (3¾ x 3¼)
Incised *Troye,* c. 1820
Purchased, 1970

P120(45) Photograph: albumen
print, arched top 19.7 x 14.6
(7¾ x 5¾)
Maull & Polyblank, inscribed, 1855
Purchased, 1979
See Collections: Literary and
Scientific Men, 1855, by Maull &
Polyblank, **P120(1-54)**

Ormond

BRANDON, Charles, 1st Duke of
Suffolk *See* SUFFOLK

BRANGWYN, Sir Frank
(1867-1956) Painter

4057 Chalk 16. 5 x 13.3 (6½ x 5¼)
Phil May
Purchased, 1958

4041(5) Pencil and wash
43.2 x 30.5 (17 x 12)
Walker Hodgson, signed with initials,
inscribed and dated 1892
Purchased, 1957
See Collections: Drawings, 1891-5,
by Walker Hodgson, **4041(1-5)**

5194 Chalk 25.1 x 18.2 (9⅞ x 7⅛)
Louis Ginnett, signed and dated
1936
Given by John Bluet Denman, 1978

4374 Sanguine 27.9 x 22.6
(11 x 8⅞)
Arthur Henry Knighton-Hammond,
signed, inscribed and dated 1937
Given by the artist, 1964

4373 Etching 20 x 25.1 (7⅞ x 9⅞)
Arthur Henry Knighton-Hammond,
signed, inscribed, and dated outside
plate 1939
Given by the artist, 1964

BRAY, Anna Eliza (née Kempe)
(1790-1883) Novelist

2515(71) *See Collections:* Drawings
of Prominent People, 1823-49, by
William Brockedon, **2515(1-104)**

BRAYTON, Lily (1876-1953)
Actress

5032 Miniature on ivory, oval
3.8 x 2.8 (1½ x 1⅛) *sight*
Winifred Cécile Dongworth, signed
and dated 1921
Bequeathed by the artist, 1975
See Collections: Miniatures, 1920-30,
by Winifred Cécile Dongworth,
5027-36

5033 *See Collections:* Miniatures,
1920-30, by Winifred Cécile
Dongworth, **5027-36**

BREADALBANE, John Campbell,
2nd Marquess of (1796-1862)
Politician

2510 (study for *Groups,* 54)
Millboard 34 x 26.3 (13⅜ x 10⅜)
Sir George Hayter, 1834
Given by Queen Mary, 1931

54 *See Groups:* The House of Com-
mons, 1833, by Sir George Hayter

P6(104) *See Collections:* The Hill
and Adamson Albums, 1843-8, by
David Octavius Hill and Robert
Adamson, **P6(1-258)**

Ormond

BRENAN, Gerald (b.1894)
Writer

5197 Canvas 49.5 x 40.6 (19½ x 16)
Dora Carrington, c. 1921
Given by John Wolfers, 1978

P134(21) Photograph: platinum
print 10.5 x 8 (4⅛ x 3⅛)
John Hope-Johnstone, 1922
Purchased, 1979
See Collections: Gerald Brenan
Album, by John Hope-Johnstone,
P134(1-25)

P134(20) *See Collections:* Gerald
Brenan Album, by John Hope-
Johnstone, **P134(1-25)**

BRETT, Henry (d.1724) Colonel

L152(43) Miniature on vellum, oval 8.6 x 7 ($3\frac{3}{8}$ x $2\frac{3}{4}$) Lawrence Crosse, signed in monogram, and on backcard signed in monogram, inscribed and dated 1703 Lent by NG (Alan Evans Bequest), 1975

BREWSTER, Sir David (1781-1868) Scientist and writer; invented kaleidoscope

P6(10) Photograph: calotype 19.4 x 14.9 ($7\frac{5}{8}$ x $5\frac{7}{8}$) David Octavius Hill and Robert Adamson, 1843 Given by an anonymous donor, 1973 *See Collections:* The Hill and Adamson Albums, 1843-8, by David Octavius Hill and Robert Adamson, **P6(1-258)**

P6(104) *See Collections:* The Hill and Adamson Albums, 1843-8, by David Octavius Hill and Robert Adamson, **P6(1-258)**

691 Canvas 127 x 101 (50 x 39¾) Sir John Watson Gordon, signed and dated 1864 Transferred from Tate Gallery, 1957

Ormond

BREWSTER, James (1777-1847) Elder brother of Sir David Brewster

P6(54) *See Collections:* The Hill and Adamson Albums, 1843-8, by David Octavius Hill and Robert Adamson, **P6(1-258)**

BRIDGEMAN, Charles (d. 1738) Landscape gardener

1384 *See Groups:* A Conversation of Virtuosis . . . at the Kings Armes, by Gawen Hamilton

BRIDGEMAN, Orlando, 1st Earl of Bradford *See* BRADFORD

BRIDGES, Robert (1844-1930) Poet Laureate

2773 Gold-point 30.5 x 20.3 (12 x 8) William Strang, eng 1898 Purchased, 1935

2044 Plasticine medallion 10.2 (4) diameter Theodore Spicer-Simson, incised and dated 1922 Given by the artist, 1924 *See Collections:* Medallions of Writers, c. 1922, by Theodore Spicer-Simson, **2043-55**

BRIDGEWATER, Francis Egerton, 3rd Duke of (1736-1803) Pioneer of inland waterways

4276 Wax medallion 7 x 6.4 (2¾ x 2½) Peter Rouw, incised and dated 1803 Purchased, 1963

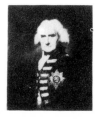

BRIDGEWATER, John William Egerton, 7th Earl of (1752-1823)

999 *See Groups:* The Trial of Queen Caroline, 1820, by Sir George Hayter

BRIDPORT, Alexander Hood, 1st Viscount (1726-1814) Admiral

745 *See Groups:* William Pitt addressing the House of Commons . . . 1793, by Karl Anton Hickel

138 Canvas 74. 3 x 61.6 Lemual Francis Abbott, 1795 (29¼ x 24¼) Lemuel Francis Abbott, 1795 Purchased, 1862

BRIGHT, John (1811-89) Statesman and orator

5116 *See Groups:* Gladstone's Cabinet of 1868, by Lowes Cato Dickinson

3808 Pencil 20.3 x 12.7 (8 x 5)
Frederick Sargent, signed by sitter
Purchased, 1951

817 Canvas 127.6 x 101.6
(50¼ x 40)
Walter William Ouless, signed and
dated 1879
Given by Leopold Salomons, 1889

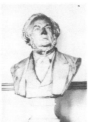

868 Plaster cast of bust 71.1
(28) high
Sir Joseph Edgar Boehm, incised
and dated 1881
Purchased, 1891

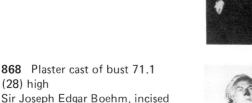

5256 *See Groups:* The Lobby of
the House of Commons, 1886, by
Liberio Prosperi

2332 *See Collections:*
Miscellaneous drawings . . . by
Sydney Prior Hall, **2282-2348**
and **2370-90**

3345 *See Collections:* Prominent
Men, c. 1880-c.1910, by Harry
Furniss, **3337-3535** and **3554-3620**

Ormond

BRISTOL, George William Hervey,
2nd Earl of (1721-75) Politician

4855(7) *See Collections:* The
Townshend Album, **4855(1-73)**

BRISTOL, Augustus John Hervey,
3rd Earl of (1724-79) Admiral

1835 Canvas 124.5 x 100.3
(49 x 39½)
After Sir Joshua Reynolds
Purchased, 1919

BRISTOL, Frederick Augustus
Hervey, 4th Earl of (1730-1803)
Bishop of Derry

3895 Marble bust 64.8 (25½) high
Christopher Hewetson, incised
Purchased, 1953

BRISTOL, Frederick William
Hervey, 2nd Marquess of (1800-64)
MP for Bury St Edmunds

54 *See Groups:* The House of Com-
mons, 1833, by Sir George Hayter

BRITTEN, Benjamin Britten,
Baron (1913-76) Composer

5137 Water-colour, oval 18.4 x 13
(7¼ x $5\frac{1}{8}$)
Sarah Fanny Hockey (his aunt),
c. 1920
Bequeathed by William Plomer,
1973

5136 With Sir Peter Pears
Canvas 71.5 x 96.9 ($28\frac{1}{8}$ x $38\frac{1}{8}$)
Kenneth Green, signed and dated
1943
Given by Mrs Behrend, 1973

4529(62) Pencil 18.1 x 12.7
($7\frac{1}{8}$ x 5)
Sir David Low, inscribed
Purchased, 1967
See Collections: Working drawings
by Sir David Low, **4529(1-401)**

4529(58-61) *See Collections:*
Working drawings by Sir David
Low, **4529(1-401)**

BRITTON, John (1771-1857)
Antiquary and topographer

2515(44) Black and red chalk
33.7 x 25.1 (13¼ x $9\frac{7}{8}$)
William Brockedon, dated 1831
Lent by NG, 1959
See Collections: Drawings of
Prominent People, 1823-49, by
William Brockedon, **2515(1-104)**

Continued overleaf

667 Canvas 44.2 x 35.6 (17$\frac{3}{8}$ x 14)
John Wood, signed and dated 1845
Given by the sitter's widow, 1882

Ormond

BRITTON, Thomas (1644-1714)
'The musical small-coal man'

523 Canvas 74.3 x 62.2 (29¼ x 24½)
John Wollaston, signed and dated
1703
Transferred from BM, 1879

Piper

BROCK, Sir Osmond de Beauvoir
(1869-1947) Admiral

1913 *See Groups:* Naval Officers
of World War I, by Sir Arthur
Stockdale Cope

BROCK, Sir Thomas (1847-1922)
Sculptor

4245 *See Groups:* Hanging
Committee, Royal Academy, 1892,
by Reginald Cleaver

BROCK, William (1807-75)
Dissenting divine

599 *See Groups:* The Anti-Slavery
Society Convention, 1840, by
Benjamin Robert Haydon

BROCKEDON, William (1787-1854)
Painter, writer and inventor

4653 Pencil, coloured chalk and
stump 34.3 x 23.8 (13½ x 9$\frac{3}{8}$)
Clarkson Stanfield, inscribed
Purchased, 1968

Ormond

BRODIE, Sir Benjamin Collins, Bt
(1783-1862) Surgeon

316a(6) Pencil, two sketches
47.3 x 70.2 (18$\frac{5}{8}$ x 27$\frac{5}{8}$)
Sir Francis Chantrey, inscribed,
c. 1839
Given by Mrs George Jones, 1871
See Collections: Preliminary
drawings for busts and statues by
Sir Francis Chantrey, **316a(1-202)**

BRODIE, William Bird (1780-1863)
MP for Salisbury

54 *See Groups:* The House of Com-
mons, 1833, by Sir George Hayter

BRODRICK, George Charles
(1831-1903) Political writer

2271 *See Collections:* The Parnell
Commission, 1888-9, by Sydney
Prior Hall, **2229-72**

BRODSKY, Adolf (1851-1929)
Violinist and music teacher

4766 Pencil 30.5 x 24.8 (12 x 9¾)
Sir William Rothenstein, signed and
dated 1899
Purchased, 1970

BROMLEY, Henry, Baron Montfort
of Horseheath *See* MONTFORT
of Horseheath

BRONTË, Anne (1820-49)
Novelist

1725 *See Groups:* The Brontë
Sisters, by Patrick Branwell Brontë

BRONTË, Charlotte (Mrs A. B.
Nicholls) (1816-55) Novelist

1725 *See Groups:* The Brontë
Sisters, by Patrick Branwell Brontë

1452 Chalk 60 x 47.6 (23⅝ x 18¾)
George Richmond, signed and
dated 1850
Bequeathed by the sitter's husband,
the Rev A.B.Nicholls, 1906

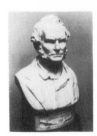

1444 *See Unknown Sitters IV*

Ormond

BRONTË, Emily (1818-48)
Novelist

1724 Canvas 51.4 x 32.4
(20¼ x 12¾)
Patrick Branwell Brontë, c.1833
Purchased, 1914

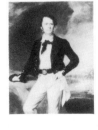

1725 *See Groups:* The Brontë
Sisters, by Patrick Branwell Brontë

Ormond

BROOK, Peter (b. 1925)
Producer

4529(63-6) *See Collections:*
Working drawings by Sir David
Low, **4529(1-401)**

P58 *See Collections:* Prominent
people, c. 1946-64, by Angus
McBean, **P56-67**

BROOKE, Alan, 1st Viscount
Alanbrooke *See* ALANBROOKE

BROOKE, Sir James (1803-68)
Rajah of Sarawak

1559 Canvas 142.9 x 111.1
(56¼ x 43¾)
Sir Francis Grant, 1847
Bequeathed by Sir Spenser St John,
1910

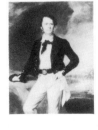

1426 Marble bust 68.6 (27) high
Thomas Woolner, incised and dated
1858
Bequeathed by Mrs Totern Knox,
1906

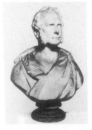

1200 Plaster cast of bust 74.9
(29½) high
George Gammon Adams, incised
and dated 1868
Purchased, 1899

Ormond

BROOKE, Rupert (1887-1915)
Poet

4911 Canvas 54.6 x 73.7 (21½ x 29)
Clara Ewald, 1911
Given by the artist's son, Prof P. P.
Ewald, 1972

P101(b) Photograph: glass positive
30.5 x 25.4 (12 x 10)
Sherrill Schell (1913)
Given by Emery Walker Ltd, 1956

and

P101(f) Photograph: glass positive
30.5 x 25.4 (12 x 10)
Sherrill Schell (1913)
Given by Emery Walker Ltd, 1956
See Collections: Rupert Brooke,
1913, by Sherrill Schell, **P101(a-g)**

P101(a,c-e,g) *See Collections:*
Rupert Brooke, 1913, by Sherrill
Schell, **P101(a-g)**

2448 Pencil 42.5 (16¾) diameter
James Harvard Thomas, posthumous
(based on no.**P101(b)**)
Given by Lascelles Abercrombie,
Walter de la Mare, Wilfred Gibson
and Sir Edward Marsh, 1930

BROOKE, Stopford Augustus
(1832-1916) Writer and divine

3077 Canvas 66.7 x 51.4 (26¼ x 20¼)
George Frederic Watts, 1871
Given by the sitter's grandson,
Somerset Stopford Brooke, 1939

4767 Pencil 35.6 x 25.2 (14 x 9⅞)
Sir William Rothenstein, inscribed
and dated 1917-18
Purchased, 1970

4774 Pencil 19.1 x 28.6 (7½ x 11¼)
Sir William Rothenstein, inscribed
Sir Francis Darwin (sic), 1917-18
Purchased, 1970

BROOKES, Joshua (1761-1833)
Anatomist

5002 Canvas 141.6 x 113
(55¾ x 44½)
Thomas Phillips, 1815
Purchased, 1974

BROOKFIELD, William Henry
(1809-74) Queen Victoria's
Chaplain-in-Ordinary

P18(17) *See Collections:* The
Herschel Album, by Julia Margaret
Cameron, **P18(1-92b)**

BROOKS, Henry Jamyn (d. 1925)
Painter

1833 *See Groups:* Private View of
the Old Masters Exhibition, Royal
Academy, 1888, by Henry Jamyn
Brooks

BROTHERTON, Joseph
(1783-1857) Parliamentary
reformer

54 *See Groups:* The House of Com-
mons, 1833, by Sir George Hayter

BROUGH, Lionel (1836-1909)
Actor

3556 *See Collections:* Prominent
Men, c.1880-c.1910, by Harry
Furniss, **3337-3535** and **3554-3620**

BROUGHAM AND VAUX, Henry
Brougham, 1st Baron (1778-1868)
Lord Chancellor

999 *See Groups:* The Trial of
Queen Caroline, 1820, by Sir
George Hayter

5038 Chalk 52.1 x 41.9 (20½ x 16½)
James Lonsdale, inscribed, c. 1821
Purchased, 1975

361 Canvas 114.3 x 85.1
(45 x 33½)
James Lonsdale, 1821, replica
Given by the artist's son, James
John Lonsdale, 1873

3136 Panel 114.3 x 81.9
(45 x 32¼)
Sir Thomas Lawrence, 1825
Purchased with help from NACF,
1943

2772 *See Collections:* The Clerk
family, Sir Robert Peel, Samuel
Rogers, and others, 1833-57, by
Jemima Wedderburn

1457a Pen and ink 14.6 x 14.9
(5¾ x 5⅞)
Charles Hutton Lear, inscribed, 1857
Given by John Elliot, 1907

1457b Pen and ink 17.8 x 11.4
(7 x 4½)
Charles Hutton Lear, 1857
Given by John Elliot, 1907

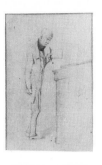

1588 Plaster bust 63.5 (25) high
John Adams-Acton, incised, 1867
Given by the artist's widow, 1910

2004 Marble bust 62 (24) high
John Adams-Acton, incised and
dated 1867
Bequeathed by Edmund Knowles
Muspratt, 1923

1203 Plaster cast of bust 61(24)high
George Gammon Adams, c.1869
Purchased, 1899. *Destroyed, 1940*

BROUGHAM AND VAUX, William
Brougham, 2nd Baron (1795-1886)
Master in Chancery

54 *See Groups:* The House of Commons, 1833, by Sir George Hayter

BROUGHTON, Jack (1705-89)
Pugilist

4855(29) *See Collections:* The
Townshend Album, **4855(1-73)**

BROUGHTON de Gyfford, John
Cam Hobhouse, Baron (1786-1869)
Statesman; friend of Byron

54 *See Groups:* The House of Commons, 1833, by Sir George Hayter

BROUNCKER, William Brouncker,
2nd Viscount (1620-84)
Mathematician; first President of
the Royal Society

1567 Canvas 125.1 x 101.6
(49¼ x 40)
After Sir Peter Lely(?) (c.1674?)
Purchased, 1910

Piper

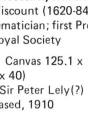

BROUNCKER, Henry Brouncker,
3rd Viscount (1624/5-88) Courtier

1590 Canvas 114.9 x 101.6
(45¼ x 40)
After Sir Peter Lely (c.1675)
Purchased, 1910

Piper

BROWN, Mrs
Maid and housekeeper of Elizabeth,
Lady Holland

4914 *See Collections:* Caricatures
of Prominent People, c. 1832-5, by
Sir Edwin Landseer, **4914-22**

BROWN, Ernest (1881-1962)
Statesman and Free Churchman

4529(67) Pencil 17.8 x 10.8
(7 x 4¼)
Sir David Low, inscribed
Purchased, 1967
See Collections: Working drawings
by Sir David Low, **4529(1-401)**

BROWN, Ford Madox (1821-93)
Painter

1021 Pencil 17.1 x 11.4 (6¾ x 4½)
Dante Gabriel Rossetti, signed in
monogram and dated 1852
Given by the sitter's son-in-law,
William Michael Rossetti, 1895

Continued overleaf

4041(4) Pencil and water-colour 37.5 x 26.4 (14¾ x 10⅜) Walker Hodgson, signed with initials, inscribed and dated 1892 Purchased, 1957 *See Collections:* Drawings, 1891-5, by Walker Hodgson, **4041(1-5)**

BROWN, Frederick (1851-1941) Painter and teacher

2816 Chalk 22.2 x 18.4 (8¾ x 7¼) Philip Wilson Steer Purchased, 1936

2556 *See Groups:* The Selecting Jury of the New English Art Club, 1909, by Sir William Orpen

2663 *See Groups:* Some members of the New English Art Club, by Donald Graeme MacLaren

BROWN, Ivor (1891-1974) Drama critic and writer

P57 Photograph: bromide print 47 x 38.1 (18½ x 15) Angus McBean, c. 1950 Purchased, 1977 *See Collections:* Prominent people, c. 1946-64, by Angus McBean, **P56-67**

BROWN, John (1826-83) Gillie and personal servant of Queen Victoria

P22(4) *See under* Queen Victoria

P22(9,17) *See Collections:* The Balmoral Album, 1854-68, by George Washington Wilson, W. & D. Downey, and Henry John Whitlock, **P22(1-27)**

BROWN, Lancelot (1715-83) 'Capability Brown'; landscape gardener

L107 Canvas 76.8 x 64.1 (30¼ x 25¼) Nathaniel Dance, c. 1770? Lent by Mrs M. Morrice, 1961

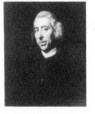

1490 Canvas, oval 61 x 50.8 (24 x 20) Nathaniel Dance, c. 1770? Purchased, 1908. *Beningbrough*

BROWN, Riches Repps (d. 1767)

4855(54) *See Collections:* The Townshend Album, **4855(1-73)**

BROWN, Robert (1773-1858) Botanist

1075,1075a and **b** *See Groups:* Men of Science Living in 1807-8, by Sir John Gilbert and others

2515(100) Black and red chalk 38.1 x 27 (15 x 10⅝) William Brockedon, dated 1849 Lent by NG, 1959 *See Collections:* Drawings of Prominent People, 1823-49, by William Brockedon, **2515(1-104)**

P120(41) Photograph: albumen print, arched top 19.7 x 14.6 (7¾ x 5¾) Maull & Polyblank, inscribed on mount, 1855 Purchased, 1979 *See Collections:* Literary and Scientific Men, 1855, by Maull & Polyblank, **P120(1-54)**

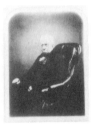

Ormond

BROWNE, Sir Anthony (d. 1548) Politician

5186 Panel 92.4 x 74.9 (36⅝ x 29½) Unknown artist, inscribed Purchased, 1978

BROWNE, Anthony, 1st Viscount Montague *See* MONTAGUE

BROWNE, Dominick, 1st Baron Oranmore and Browne *See* ORANMORE AND BROWNE

BROWNE, Sir Richard, Bt (d. 1669)
Parliamentary general

2109 Canvas 73 x 61.6 (28¾ x 24¼)
Unknown artist, inscribed
Purchased, 1925

Piper

BROWNE, Sir Thomas (1605-82)
Physician; author of *Religio Medici*
and *Urn Burial*

2062 With his wife, Dorothy (née
Mileham) (1621-85)
Panel 18.4 x 22.9 (7¼ x 9)
Attributed to Joan Carlile, c.1641-50
Purchased, 1924

1969 Plumbago on vellum
10.5 x 9.2 (4$\frac{1}{8}$ x 3$\frac{5}{8}$)
After Robert White
Purchased, 1922

Piper

BROWNE, Valentine, 6th Earl of
Kenmare *See* KENMARE

BROWNE, Valentine Augustus, 4th
Earl of Kenmare *See* KENMARE

BROWNING, Elizabeth Barrett
(1806-61) Poet; wife of Robert
Browning

3165 Bronze cast of her right
hand clasping that of her husband
21 (8¼) long
Harriet Hosmer, incised and dated
1853
Given by Mrs Richard Fuller, 1953

1899 Canvas 73.7 x 58.4 (29 x 23)
Michele Gordigiani, signed, 1858
Given by Mrs Florence Barclay, 1921

322 Chalk 60.3 x 44.8 (23¾ x 17$\frac{5}{8}$)
Field Talfourd, signed and dated
1859
Given by Miss Ellen Heaton, 1871

Ormond

BROWNING, Sir Montague Edward
(1863-1947) Admiral

1913 *See Groups:* Naval Officers
of World War I, by Sir Arthur
Stockdale Cope

BROWNING, Robert (1812-89)
Poet

3165 *See under* Elizabeth Barrett
Browning

1898 Canvas 72.4 x 58.7
(28½ x 23$\frac{1}{8}$) Michele Gordigiani,
signed, 1858
Given by Mrs Florence Barclay,1921

1269 Chalk 63.2 x 44.8
(24$\frac{7}{8}$ x 17$\frac{5}{8}$)
Field Talfourd, signed and dated
1859, and inscribed by sitter
Purchased, 1900

1001 Canvas 66 x 53.3 (26 x 21)
George Frederic Watts, 1866
Given by the artist, 1895

Continued overleaf

839 Canvas 94 x 71.1 (37 x 28)
Rudolph Lehmann, signed
monogram and dated 1884
Given by the artist, 1890

Ormond

BROWNLOW, John Cust, 1st Earl
(1779-1853)

999 *See Groups:* The Trial of
Queen Caroline, 1820, by Sir
George Hayter

BRUCE of Kinloss, Edward Bruce,
1st Baron (1549?-1611) Judge

2401 Water-colour 19.7 x 14
(7¾ x 5½)
George Perfect Harding after a
painting of 1604, signed, inscribed
and dated 1843
Purchased, 1929
See Collections: Copies of early
portraits, by George Perfect Harding
and Sylvester Harding, **1492,**
1492(a-c) and **2394-2419**

BRUCE, Henry Austin, 1st Baron
Aberdare *See* ABERDARE

BRUCE, James (1730-94)
Explorer

100 Canvas 73.7 x 62.2
(29 x 24½)
Unknown artist
Purchased, 1860

5008 Miniature on ivory, oval
3.8 x 3.2 (1½ x 1¼)
John Smart, signed with initials
and dated 1776
Purchased, 1975

BRUCE, Sir James Lewis Knight-
(1791-1866) Judge

1576c Pencil 23.5 x 18.1 (9¼ x 7⅛)
Unknown artist, inscribed
Given by Lord De Mauley, 1910

BRUCE, Victor Alexander, 9th Earl
of Elgin *See* ELGIN

BRUDENELL, James Thomas, 7th
Earl of Cardigan *See* CARDIGAN

BRUDENELL-BRUCE, Charles, 1st
Marquess of Ailesbury
See AILESBURY

BRUDENELL-BRUCE, Ernest
Augustus Charles, 3rd Marquess of
Ailesbury *See* AILESBURY

BRUNEL, Isambard Kingdom
(1806-59) Civil engineer

979 Canvas 91.4 x 70.5
(36 x 27¾)
John Callcott Horsley, signed and
dated 1857
Given by the sitter's son, Isambard
Brunel, 1895

P112 Photograph: albumen print
28.6 x 22.5 (11¼ x 8⅞)
Robert Howlett, November 1857
Given by Mr Vaughan, 1972

Ormond

BRUNEL, Sir Marc Isambard
(1769-1849) Civil engineer

1075,1075a and **b** *See Groups:* Men
of Science Living in 1807-8, by Sir
John Gilbert and others

978 Canvas 125.1 x 99.1
(49¼ x 39)
James Northcote, signed, 1812-13
Given by the sitter's grandson,
Henry March Brunel, 1895

2515(28) *See Collections:* Drawings of Prominent People, 1823-49, by William Brockedon, **2515(1-104)**

89 Canvas 127 x 101.6 (50 x 40)
Samuel Drummond, c. 1835
Purchased, 1859

BRYCE, James Bryce, 1st Viscount (1838-1922) Jurist, historian and statesman

2249 *See Collections:* The Parnell Commission, 1888-9, by Sydney Prior Hall, **2229-72**

1970 Canvas 80 x 65.4 (31½ x 25¾)
Ernest Moore, signed, 1907
Given by Viscount Wakefield, 1923

3425, 3557 *See Collections:* Prominent Men, c. 1880-c. 1910, by Harry Furniss, **3337-3535** and **3554-3620**

4551 With 'Uncle Sam' (right)
Ink 48.3 x 38.1 (19 x 15)
Boardman Robinson, signed and inscribed, 1913
Given by A. Yakovleff, 1967

BRYDGES, James, 1st Duke of Chandos *See* CHANDOS

BRYDGES, Sir Samuel Egerton, Bt (1762-1837) Genealogist

2393 Chalk 22.5 x 17.5 ($8\frac{7}{8}$ x $6\frac{7}{8}$)
Benjamin Burnell, signed, inscribed and dated 1817
Purchased, 1929

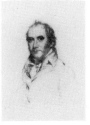

2394 *See Collections:* Copies of early portraits, by George Perfect Harding and Sylvester Harding, **1492, 1492(a-c)** and **2394-2419**

BRYSON, Robert (1778-1852)
Watchmaker to Queen Victoria; founder of Mechanics Institute

P6(38,80) *See Collections:* The Hill and Adamson Albums, 1843-8, by David Octavius Hill and Robert Adamson, **P6 (1-258)**

BUCHAN, John, Baron Tweedsmuir *See* TWEEDSMUIR

BUCHANAN, George (1506-82)
Historian and scholar

524 Panel 34.9 x 27.9 (13¾ x 11)
Unknown artist after Arnold van Brounckhorst, inscribed and dated 1581 (1580)
Transferred from BM, 1879

Strong

BUCKINGHAM, George Villiers, 1st Duke of (1592-1628) Courtier; favourite of James I

3840 Canvas 205.7 x 119.4 (81 x 47)
Attributed to William Larkin, inscribed, c. 1616
Given in memory of Benjamin Seymour Guinness, 1952

711 *See Groups:* The Duke of Buckingham and his Family, 1628, after Gerard Honthorst

1346 *See Unknown Sitters II*
Piper

BUCKINGHAM, Katharine, Duchess of (d. 1649) Wife of 1st Duke of Buckingham

711 *See Groups:* The Duke of Buckingham and his Family, 1628, after Gerard Honthorst

BUCKINGHAM, George Villiers, 2nd Duke of (1628-87) Statesman and dramatist

711 *See Groups:* The Duke of Buckingham and his Family, 1628, after Gerard Honthorst

Continued overleaf

279 Canvas 76.2 x 63.5 (30 x 25)
Sir Peter Lely, c. 1675
Purchased, 1869

Piper

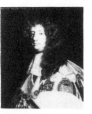

BUCKINGHAM, George Nugent-
Temple-Grenville, 1st Marquess of
(1753-1813) Statesman

5168 Canvas 237 x 146.4
(93½ x 57⅝)
Unknown artist, after 1786
Purchased, 1977

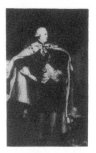

BUCKINGHAM, James Silk
(1786-1855) Writer and traveller

5003 Miniature on ivory 14 x 11.8
(5½ x 4⅝)
Edwin Dalton Smith, signed, and
dated on reverse 1837
Purchased, 1974

2368 Canvas, feigned oval
20.3 x 17.5 (8 x 6⅞)
Attributed to Clara Lane, initialled
C. S. L., c. 1850
Given by Mrs Cecil Burns, 1929

Ormond

BUCKINGHAM AND CHANDOS,
Richard Grenville, 1st Duke of
(1776-1839)
Statesman and print collector

999 *See Groups:* The Trial of
Queen Caroline, 1820, by Sir
George Hayter

BUCKINGHAM AND CHANDOS,
Richard Grenville, 2nd Duke of
(1797-1861) Writer

54 *See Groups:* The House of Com-
mons, 1833, by Sir George Hayter

BUCKINGHAM AND CHANDOS,
Richard Grenville, 3rd Duke of
(1823-89) Statesman

4893 *See Groups:* The Derby
Cabinet of 1867, by Henry Gales

BUCKINGHAM AND NORMANBY,
John Sheffield, Duke of (1648-1721)
Statesman and writer

1779 Canvas 125.1 x 100.3
(49¼ x 39½)
After Sir Godfrey Kneller (c.1685-6)
Purchased, 1916

Piper

BUCKINGHAMSHIRE, Robert
Hobart, 4th Earl of (1760-1816)
Statesman

3892 Canvas 127 x 101.6 (50 x 40)
John Hoppner, inscribed
Lent by Ian Hope-Morley, 1963

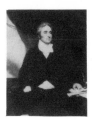

BUCKINGHAMSHIRE, George
Robert Hobart, 5th Earl of
(1789-1849)

999 *See Groups:* The Trial of
Queen Caroline, 1820, by Sir
George Hayter

BUCKLAND, William (1784-1856)
Geologist

2515(87) *See Collections:* Drawings
of Prominent People, 1823-49, by
William Brockedon, **2515(1-104)**

1275 Canvas 75.6 x 62.5
(29¾ x 24⅝)
Thomas Phillips
Given by the sitter's daughter,
Mrs G.C.Bompas, and her
husband, 1900

255 Electrotype bronze cast of
bust 74.9 (29½) high
Henry Weekes, incised, 1858
Given by the artist, 1860

Ormond

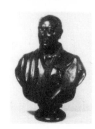

BUCKMASTER, Stanley Owen
Buckmaster, 1st Viscount
(1861-1934) Lord Chancellor

3426, 3427 *See Collections:*
Prominent Men, c. 1880-c.1910,
by Harry Furniss, **3337-3535** and
3554-3620

BUCKSTONE, John Baldwin
(1802-79) Comedian and writer

2087 Canvas 43.8 x 34.9
(17¼ x 13¾)
Daniel Maclise, c. 1836
Bequeathed by John Lane, 1925

3071 Water-colour 26 x 16.5
(10¼ x 6½)
Alfred Bryan
Purchased, 1939

Ormond

BUCKTON, Woodyerill

P106(5) *See Collections:* Literary
and Scientific Portrait Club, by
Maull & Polyblank, **P106(1-20)**

BUIST, George (1805-60)
Journalist and man of science

P6(41) Photograph: calotype
20.3 x 14 (8 x 5½)
David Octavius Hill and Robert
Adamson, 1845
Given by an anonymous donor,
1973
See Collections: The Hill and
Adamson Albums, 1843-8, by
David Octavius Hill and Robert
Adamson, **P6(1-258)**

BULL, John (1563?-1628)
Composer

4873 *See Unknown Sitters I*

BULLER, Sir Francis, Bt
(1746-1800) Judge

458 Canvas 125.1 x 99.1
(49¼ x 39)
Mather Brown, exh 1792
Given by the Society of Judges and
Serjeants-at-Law, 1877

BULLEY, Thomas
Slavery abolitionist

599 *See Groups:* The Anti-Slavery
Society Convention, 1840, by
Benjamin Robert Haydon

BULLOCK, William (1657-1740?)
Comedian

2540 Water-colour 20.3 x 16.5
(8 x 6½)
Attributed to Sylvester Harding
after Thomas Johnson (c.1710-20)
Purchased, 1932

Piper

BULLOUGH, Mrs
See ELSIE, Lily

BULWER, William, Baron Dalling
and Bulwer *See* DALLING AND
BULWER

BUNBURY, Henry William
(1750-1811) Artist and caricaturist

4696 Pastel, oval 31.5 x 26.4
(12⅜ x 10⅜)
Sir Thomas Lawrence, inscribed,
c.1788
Purchased, 1969

BUNTING, Jabez (1779-1858)
Wesleyan Methodist

P6(47) Photograph: calotype
20.3 x 15.2 (8 x 6)
David Octavius Hill and Robert
Adamson, 1843-8
Given by an anonymous donor,
1973
See Collections: The Hill and
Adamson Albums, 1843-8, by
David Octavius Hill and Robert
Adamson, **P6(1-258)**

P6(46) *See Collections:* The Hill
and Adamson Albums, 1843-8, by
David Octavius Hill and Robert
Adamson, **P6(1-258)**

4880 Bronze cast of relief 22.2
(8¾) diameter
William Behnes, embossed and
dated 1852
Given by William Redford, 1972

BUNYAN, John (1628-88)
Author of *Pilgrim's Progress*

1311 Canvas 74.9 x 63.5 (19½ x 25)
Thomas Sadler, inscribed, 1684-5
Purchased, 1902

Piper

BURCH, Edward (fl.1771)
Painter

1437,1437a *See Groups:* The
Academicians of the Royal
Academy, 1771-2, by John Sanders
after Johan Zoffany

BURDETT, Mr

883(6) *See Collections:* Studies
for miniatures by Sir George Hayter,
883(1-21)

BURDETT, Sir Francis, Bt
(1770-1844) Parliamentary reformer

3820 Canvas 250.2 x 143.5
(98½ x 56½)
Sir Thomas Lawrence, inscribed,
begun 1793
Bequeathed by the Rt Hon William
Ashmead Bartlett Burdett-Coutts,
1952

1229 Water-colour, oval
19.5 x 16.2 (7⅝ x 6⅜)
Adam Buck, c. 1810
Purchased, 1899

999 *See Groups:* The Trial of
Queen Caroline, 1820, by Sir
George Hayter

54 *See Groups:* The House of Com-
mons, 1833, by Sir George Hayter

34 Canvas 76.2 x 62.9 (30 x 24¾)
Thomas Phillips, signed with initials
and dated 1834
Given by the sitter's daughter,
Baroness Burdett-Coutts, 1858

2056 Miniature on ivory
39.4 x 34.3 (15½ x 13½)
Sir William Charles Ross, inscribed,
c. 1840
Transferred from Tate Gallery, 1957

3140 Canvas 24.4 x 9.2 (9⅝ x 3⅝)
Sir Edwin Landseer, c. 1840
Given by Percy Moore Turner, 1943

432 Canvas 76.8 x 63.9 (30¼ x 25⅛)
Sir Martin Archer Shee, 1843
Given by the sitter's daughter, Mrs
Susan Trevanion, 1876

BURDETT, Sophia, Lady
(1775-1844) Wife of Sir Francis
Burdett

3821 Canvas 237.5 x 143.5
(93½ x 56½)
Sir Thomas Lawrence, begun 1793
Bequeathed by the Rt Hon William
Ashmead Bartlett Burdett-Coutts,
1952

BURDETT-COUTTS, Angela
Georgina Burdett-Coutts, Baroness
(1814-1906) Philanthropist

2057 Miniature on ivory
41.9 x 29.2 (16½ x 11½)
Sir William Charles Ross, c. 1847
Transferred from Tate Gallery, 1957

Ormond

BURDON-SANDERSON, Sir John
Scott, Bt (1828-1905)
Physiologist and pathologist

4297 Canvas 66 x 55.9 (26 x 22)
Walter William Ouless, signed with
initials and dated 1886
Given by the sitter's great-nephew,
Prof J. D. S. Haldane, 1963

BURGESS, John Bagnold (1830-97)
Painter

4404 *See Groups:* The St John's
Wood Arts Club, 1895, by
Sydney Prior Hall

BURGESS, Thomas (1756-1837)
Bishop of Salisbury

999 *See Groups:* The Trial of
Queen Caroline, 1820, by Sir
George Hayter

BURGH, Ulick de, 5th Earl and
Marquess of Clanricarde
See CLANRICARDE

BURGH, Ulick de, 1st Marquess of
Clanricarde *See* CLANRICARDE

BURGHLEY, William Cecil, 1st
Baron (1520-98) Lord High
Treasurer

2184 Panel 95.3 x 71.8
(37½ x 28¼)
By or after Arnold von
Brounckhorst, inscribed, c.1560-70
Purchased, 1928

715 Panel 90.5 x 73.3
(35⅝ x 28⅞)
Unknown artist, after 1572
Given by Barnard's Inn, 1884

604 Panel 47.9 x 33.7 (18⅞ x 13¼)
Unknown artist, after 1572
Purchased, 1880. *Montacute*

362 Panel 113 x 91.1 (44½ x 35⅞)
Attributed to Marcus Gheeraerts
the Younger, after 1585
Purchased, 1873

1905 Panel 54.6 x 44.5 (21½ x 17½)
Unknown artist, after 1585
Bequeathed by Mrs A. H. S.
Wodehouse, 1921

525 Panel 55.9 x 41.3 (22 x 16¼)
Unknown artist, after 1580
Transferred from BM, 1879

Continued overleaf

4881 Canvas 223. 6 x 140.3
(88¼ x 55¼)
Unknown artist
Purchased, 1972. *Montacute*

Strong

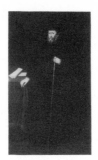

BURGOYNE, John (1722-92)
'Gentleman Johnny'; soldier and
dramatist

4158 Canvas 50.8 x 35.6 (20 x 14)
After Allan Ramsay (1756-8)
Purchased with help from NACF,
1960

BURGOYNE, Sir John Fox, Bt
(1782-1871) Military engineer

1914(5) Pencil and water-colour
19.1 x 15.9 (7½ x 6¼)
Thomas Heaphy, c.1813
Purchased, 1921
See Collections: Peninsular and
Waterloo Officers, 1813-14, by
Thomas Heaphy, **1914(1-32)**

4321 *See Unknown Sitters IV*

BURKE, Edmund (1729-97)
Statesman

655 Canvas 75.6 x 62.9
(29¾ x 24¾)
Studio of Sir Joshua Reynolds, 1771
Purchased, 1882

854 Miniature on ivory 6.4 x 5.1
(2½ x 2)
After James Barry (1774)
Purchased, 1891

1607 Wax medallion 11.4 (4½)
diameter
Thomas R. Poole, incised and
dated 1791
Given by Lt-Col G. B. Croft-Lyons,
1911

BURLINGTON, Richard Boyle, 1st
Earl of, and 2nd Earl of Cork
(1612-98) Magnate

893 Canvas 50.8 x 38.1 (20 x 15)
After Sir Anthony van Dyck(?)
(c. 1640)
Purchased, 1892

Piper

BURLINGTON, Richard Boyle, 3rd
Earl of, and 4th Earl of Cork
(1694-1753) Patron of the arts

2495 With his sister, Lady Jane
Boyle
Panel 37.5 x 24.8 (14¾ x 9¾)
After Sir Godfrey Kneller (c.1700)
Bequeathed by Edmund Montagu
Boyle, 1931. *Beningbrough*

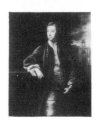

4818 Canvas 146.1 x 116.8
(57½ x 46)
Attributed to Jonathan Richardson,
inscribed, c. 1717-19
Purchased with help from NACF
and Dr D. M. McDonald, 1970

Kerslake

BURLTON, Philip (d. 1790)
Army surgeon and patron of the turf

4855(41) *See Collections:* The
Townshend Album, **4855(1-73)**

BURNABY, Frederick Gustavus
(1842-85) Soldier, traveller
and balloonist

2642 Panel 49.5 x 59.7
(19½ x 23½)
James Jacques Tissot, signed and
dated 1870
Purchased, 1933

3428 *See Collections:* Prominent
Men, c.1880-c.1910, by Harry
Furniss, **3337-3535** and **3554-3620**

BURNAND, Sir Francis Cowley
(1836-1917) Editor of *Punch*

3429, 3430 *See Collections:*
Prominent Men, c.1880-c.1910,
by Harry Furniss, **3337-3535** and
3554-3620

BURNE-JONES, Sir Edward Coley, 1st Bt (1833-98) Painter and designer

5276 Pencil 21.6 x 14 (8½ x 5½) George Howard, c. 1875 Purchased, 1979

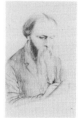

2287 *See Collections:* Miscellaneous drawings . . . by Sydney Prior Hall, **2282-2348** and **2370-90**

2820 *See Groups:* The Royal Academy Conversazione, 1891, by G. Grenville Manton

1864 Canvas 74.9 x 53.3 (29½ x 21) Sir Philip Burne-Jones (his son), signed and dated 1898 Given by the artist, 1920

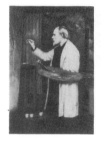

3432 *See Collections:* Prominent Men, c.1880-c.1910, by Harry Furniss, **3337-3535** and **3554-3620**

BURNE-JONES, Sir Philip, 2nd Bt (1861-1926) Painter

1833 *See Groups:* Private View of the Old Masters Exhibition, Royal Academy, 1888, by Henry Jamyn Brooks

BURNES, Sir Alexander (1805-41) Indian political officer

2515(20) *See Collections:* Drawings of Prominent People, 1823-49, by William Brockedon, **2515(1-104)**

BURNET, Gilbert (1643-1715) Bishop of Salisbury; historian

159 Canvas, feigned oval 74.3 x 62.9 (29¼ x 24¾) After John Riley (c.1689-91) Purchased, 1863

Piper

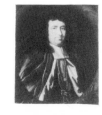

BURNET, John (1784-1868) Painter and engraver

935 Canvas 91.4 x 70.5 (36 x 27¾) William Simson, signed and dated 1841 Bequeathed by Henry Graves, 1892

Ormond

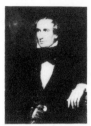

BURNET, John Slavery abolitionist

599 *See Groups:* The Anti-Slavery Society Convention, 1840, by Benjamin Robert Haydon

BURNET, Thomas (1635?-1715) Writer and divine; Master of the Charterhouse

526 Canvas, oval 74.3 x 58.4 (29¼ x 23) Probably by Ferdinand Voet, inscribed and dated 1675 Transferred from BM, 1879

Piper

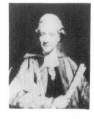

BURNEY, Sir Cecil, 1st Bt (1858-1929) Admiral

1913 *See Groups:* Naval Officers of World War 1, by Sir Arthur Stockdale Cope

BURNEY, Charles (1726-1814) Musician and historian of music

3884 Canvas 74.9 x 61 (19½ x 24) Sir Joshua Reynolds, 1781 Purchased, 1953

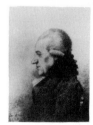

1140 Pencil 24.8 x 17.8 (9¾ x 7) George Dance, signed and dated 1794 Purchased, 1898

BURNEY, Charles Rousseau
(1747-1819) Musician; nephew and
son-in-law of Charles Burney

1860 Water-colour 17.8 x 17.1
(7 x 6¾)
Edward Francis Burney (his cousin)
Given by G. Bellingham-Smith, 1920

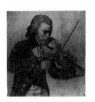

BURNEY, Frances ('Fanny'),
Madame D'Arblay *See* ARBLAY

BURNHAM, Edward Levy-Lawson,
1st Baron (1833-1916)
Newspaper proprietor

3433 *See Collections:* Prominent
Men, c.1880-c.1910, by Harry
Furniss, **3337-3535** and **3554-3620**

BURNS, James Glencairn
(1794-1865) Colonel; youngest son
of Robert Burns

P6(50) *See Collections:* The Hill
and Adamson Albums, 1843-8, by
David Octavius Hill and Robert
Adamson, **P6(1-258)**

BURNS, John (1858-1943) Labour
leader and politician

3170 Canvas 124.5 x 92.1
(49 x 36¼)
John Collier, signed and dated 1889
Given by the sitter's family, 1943

2290 *See Collections:*
Miscellaneous drawings . . . by
Sydney Prior Hall, **2282-2348**
and **2370-90**

5124 Sanguine 47.6 x 36.5
(18¾ x 14⅜)
Harold Speed, signed, inscribed and
dated 1907
Purchased, 1977

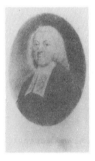

2826 *See Collections:* Caricatures
of Politicians, by Sir Francis
Carruthers Gould, **2826-74**

3851 Ink and wash 24.1 x 17.5
(9½ x 6⅞)
Sir Max Beerbohm, signed *Max* and
inscribed
Purchased, 1953
See Collections: Caricatures
1897-1932, by Sir Max Beerbohm,
3851-8

3346 *See Collections:* Prominent
Men, c. 1880-c.1910, by Harry
Furniss, **3337-3535** and **3554-3620**

BURNS, Robert (1759-96) Poet

46 Canvas feigned oval 31.8 x 24.1
(12½ x 9½)
Alexander Nasmyth, c. 1792
replica (1787)
Given by John Dillon, 1858

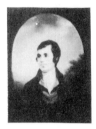

BURNS, William Hamilton
(1779-1859)

P6(86) *See Collections:* The Hill
and Adamson Albums, 1843-8, by
David Octavius Hill and Robert
Adamson, **P6(1-258)**

BURROUGHS-PAULET, Charles
Ingoldsby, 13th Marquess of
Winchester *See* WINCHESTER

BURROW, Sir James (1701-82)
Editor of law reports

3090(8) Pencil, oval 21.9 x 13.3
(8⅝ x 5¼)
After Arthur Devis, inscribed
Purchased, 1940

BURTON, Michael Arthur Bass, 1st
Baron (1837-1909) Brewer

1833 *See Groups:* Private View of
the Old Masters Exhibition, Royal
Academy, 1888, by Henry Jamyn
Brooks

BURTON, Mr

316a(7) *See Collections:*
Preliminary drawings for busts and
statues by Sir Francis Chantrey,
316a(1-202)

BURTON, Sir Frederick William
(1816-1900) Painter; Director
of the National Gallery

1701 Canvas 76.2 x 63.8
(30 x 25⅛)
Henry Tanworth Wells, signed in
monogram and dated 1863
Given by the artist's daughters,
Mrs A. E. Street and Mrs W. J.
Hadley, 1913

1833 *See Groups:* Private View of
the Old Masters Exhibition, Royal
Academy, 1888, by Henry Jamyn
Brooks

BURTON, Sir Richard Francis
(1821-90) Explorer and writer

1070 Canvas 59.7 x 49.5
(23½ x 19½)
Frederic Leighton, Baron Leighton,
c. 1872-5
Given by the artist's sisters, at his
wish, 1896

3148 Pencil 17.8 x 11.4 (7 x 4½)
Marian Collier, signed in monogram,
inscribed and dated 1878
Purchased, 1943

BURTON, William Shakespeare
(1824-1916) Painter

3042 Chalk 36.8 x 26.7 (14½ x 10½)
Self-portrait, 1899
Given by Marion Harry Spielmann,
1939

BURY, Charles William, 2nd Earl
of Charleville *See* CHARLEVILLE

BUSBY, Richard (1606-95)
Headmaster of Westminster School

419 Canvas 74.9 x 62.2
(19½ x 24½)
Unknown artist
Purchased, 1876

Piper

BUSHE, John

4026(7) *See Collections:* Drawings
of Men about Town, 1832-48, by
Alfred, Count D'Orsay, **4026(1-61)**

BUTCHER, John George, Baron
Danesfort *See* DANESFORT

BUTE, John Stuart, 3rd Earl of
(1713-92) Statesman

3938 Canvas 236.9 x 144.8
(93¼ x 57)
Sir Joshua Reynolds, 1773
Purchased with help from NACF
1958

BUTLER, Charles (1822-1910)

1833 *See Groups:* Private View of
the Old Masters Exhibition, Royal
Academy, 1888, by Henry Jamyn
Brooks

BUTLER, Henry Montagu
(1833-1918) Master of Trinity
College, Cambridge

3277 Water-colour 36.8 x 22.9
(14½ x 9)
Hay, signed
(*VF* 18 May 1889)
Purchased, 1934

4768 Pencil 35.6 x 25.4 (14 x 10)
Sir William Rothenstien, 1916
Purchased, 1970

BUTLER, James, 1st Duke of Ormonde *See* ORMONDE

BUTLER, James 2nd Duke of Ormonde *See* ORMONDE

BUTLER, Josephine Elizabeth (née Grey) (1828-1906) Social reformer

L172 Pastel 58.1 x 44.5 (22⅞ x 17½) *sight*
George Richmond, signed and dated 1851
Lent by the G. G. Butler Will Trust, 1979

2194 Canvas 74.9 x 62.2 (29½ x 24½)
George Frederic Watts, 1894
Given under the terms of the artist's will, 1935

BUTLER, Samuel (1612-80) Author of *Hudibras*

2468 Canvas 121.3 x 102.9 (47¾ x 40½)
Gerard Soest, c. 1670-80
Purchased, 1930

248 Gouache and pastel on panel 33 x 22.9 (13 x 9)
Edward Lutterel, c.1680
Purchased, 1867

Piper

BUTLER, Samuel (1835-1902) Author of *Erewhon* and *The Way of All Flesh*

1599 Canvas 68.6 x 52.1 (17 x 20½)
Charles Gogin, inscribed and dated 1896
Given by the artist, 1911

BUTLER, Thomas, Earl of Ossory *See* OSSORY

BUTLIN, Sir William ('Billy') (1899-1980) Founder of Butlin holiday camps

4529(68-71) *See Collections:* Working drawings by Sir David Low, **4529(1-401)**

BUTT, Isaac (1813-79) Founder of the Irish Home Rule Party

3831 Chalk 42.5 x 34.9 (16¾ x 13¾)
John Butler Yeats
Given by the sitter's granddaughter, Lady Ball, 1952

BUTTS, Sir William (d. 1545) Physician

210 Panel 47 x 37.5 (18½ x 14¾)
After Hans Holbein (c. 1540-3)
Purchased, 1866. *Montacute*

Strong

BUXTON, Sir Thomas Fowell, Bt (1786-1845) Philanthropist

54 *See Groups:* The House of Commons, 1833, by Sir George Hayter

3782 (study for *Groups*, **599**)
Chalk 52.4 x 40.6 (20⅝ x 16)
Benjamin Robert Haydon, inscribed, 1840
Purchased, 1950

599 *See Groups:* The Anti-Slavery Society Convention, 1840, by Benjamin Robert Haydon

Ormond

BYNG, of Vimy, Julian Byng, 1st Viscount (1862-1935) Field-Marshal

2908(5) *See Collections:* Studies, mainly for General Officers of World War I, by John Singer Sargent, **2908(1-8)**

1954 *See Groups:* General Officers of World War I, by John Singer Sargent

3666 Pencil 35.9 x 25.7
($14\frac{1}{8}$ x $10\frac{1}{8}$)
Sir Bernard Partridge, signed
(variant for cartoon in *Punch*
8 Dec 1926)
Purchased, 1949
See Collections: Mr Punch's
Personalities, 1926-9, by Sir
Bernard Partridge, **3664-6,** etc

3786 Canvas 119.4 x 91.1
(47 x 36¼)
Philip de Laszlo, signed and dated
on reverse 1933
Bequeathed by the sitter's widow,
1951

BYNG, Frederick (d. 1871)
Son of 5th Viscount Torrington

4026(8,9) *See Collections:*
Drawings of Men about Town,
1832-48, by Alfred, Count D'Orsay,
4026(1-61)

BYNG, George, Viscount Torrington
See TORRINGTON

BYNG, George (1784-1847)
MP for Middlesex

54 *See Groups:* The House of Commons, 1833, by Sir George Hayter

BYNG, George Henry Charles, 3rd
Earl of Strafford *See* STRAFFORD

BYNG, George Stevens, 2nd Earl
of Strafford *See* STRAFFORD

BYNG, John, 1st Earl of Strafford
See STRAFFORD

BYRNE, Patrick (1797?-1863)
Blind Irish harpist

P6(146,148,150,152) *See
Collections:* The Hill and Adamson
Albums, 1843-8, by David Octavius
Hill and Robert Adamson, **P6(1-258)**

BYRON, George Gordon Byron,
6th Baron (1788-1824) Poet

4243 Canvas 91.4 x 71.1 (36 x 28)
Richard Westall, signed, inscribed
and dated 1813
Purchased, 1961

1047 Canvas 76.2 x 63.5 (30 x 25)
By or after Richard Westall (1813)
Purchased, 1896

142 Canvas 76.5 x 63.9
($30\frac{1}{8}$ x $25\frac{1}{8}$)
Thomas Phillips, signed in
monogram, 1813
Purchased, 1862

1367 Marble bust 59.7 (23½) high
Lorenzo Bartolini, incised, 1822
Purchased, 1904

BYRON, Anne Isabella (née
Milbanke), Lady (1792-1860)
Wife of Lord Byron

599 *See Groups:* The Anti-Slavery
Society Convention, 1840, by
Benjamin Robert Haydon

CADBURY, Tapper (1768-1860)
Birmingham manufacturer; slavery
abolitionist

599 *See Groups:* The Anti-Slavery
Society Convention, 1840, by
Benjamin Robert Haydon

CADELL, Robert (1788-1849)
Publisher

P6(139) *See Collections:* The Hill
and Adamson Albums, 1843-8, by
David Octavius Hill and Robert
Adamson, **P6(1-258)**

CADOGAN, William Cadogan, 1st Earl (1675-1726) General

18 Canvas 158.8 x 118.1 (62½ x 46½)
Attributed to Louis Laguerre, c.1716
Purchased, 1857

Piper

CADORNA, Chevalier Carlo
Italian statesman

4635 *See Collections: Vanity Fair* cartoons, 1869-1910, by various artists, **2566-2606,** etc

CAESAR, Sir Charles (1590-1624) Judge

2402 Water-colour, feigned oval 13 x 10.2 (5$\frac{1}{8}$ x 4)
George Perfect Harding after a painting of 1624, signed, inscribed and dated
Purchased, 1929
See Collections: Copies of early portraits, by George Perfect Harding and Sylvester Harding, **1492, 1492(a-c)** and **2394-2419**

Strong

CAESAR, Sir Julius (1558-1636) Judge

527 *See Unknown Sitters I*

CAINE, Sir Hall (1853-1931) Novelist

3667 Water-colour 38.1 x 26.7 (15 x 10½)
Sir Bernard Partridge, signed *J:P:B.* (*VF* 2 July 1896)
Purchased, 1949

3434-6 *See Collections:* Prominent Men, c.1880-c.1910, by Harry Furniss, **3337-3535** and **3554-3620**

CAITHNESS, James Sinclair, 14th Earl of (1821-81) Scientist

1834(c) Pencil 20.6 x 13 (8$\frac{1}{8}$ x 5$\frac{1}{8}$)
Frederick Sargent, signed and inscribed
Given by A. C. R. Carter, 1919
See Collections: Members of the House of Lords, c.1870-80, by Frederick Sargent, **1834(a-z and aa-hh)**

CALABRELLA, Mrs Thomas Jenkins, Baroness de
Wife of Lady Blessington's first protector

4026(19) *See Collections:* Drawings of Men about Town, 1832-48, by Alfred, Count D'Orsay, **4026(1-61)**

CALCRAFT, John Hales (1796-1880) MP for Wareham

54 *See Groups:* The House of Commons, 1833, by Sir George Hayter

CALDERON, Philip Hermogenes (1833-98) Painter

P72 Photograph: albumen print 20 x 16.2 (7$\frac{7}{8}$ x 6$\frac{3}{8}$)
David Wilkie Wynfield, 1860s
Purchased, 1929
See Collections: The St John's Wood Clique, by David Wilkie Wynfield, **P70-100**

1833 *See Groups:* Private View of the Old Masters Exhibition, Royal Academy, 1888, by Henry Jamyn Brooks

2820 *See Groups:* The Royal Academy Conversazione, 1891, by G. Grenville Manton

CALLCOTT, Sir Augustus Wall (1779-1844) Landscape painter

361a(8) Pencil 47.3 x 35.2 (18$\frac{5}{8}$ x 13$\frac{7}{8}$)
Sir Francis Chantrey, c.1830
Given by Mrs George Jones, 1871
See Collections: Preliminary drawings for busts and statues by Sir Francis Chantrey, **316a(1-202)**

3336 Millboard 35.6 x 25.1
(14 x 9⅞)
Sir Edwin Landseer, 1833
Purchased, 1947

CALLCOTT, Maria (née Dundas),
Lady (1785-1842) Writer

954 Canvas 59.7 x 49.5
(23½ x 19½)
Sir Thomas Lawrence, 1819
Bequeathed by Elizabeth, Lady
Eastlake, 1894

CALLOW, William (1812-1908)
Water-colour painter

2356 Water-colour, oval
12.1 x 10.2 (4¾ x 4)
Unknown artist
Given by the sitter's widow, 1929

2937 Pastel 52.1 x 43.2 (20½ x 17)
Edward Robert Hughes, signed and
inscribed
Bequeathed by the sitter's widow,
1937

CALTHORPE, George Gough-
Calthorpe, 3rd Baron (1787-1851)

999 *See Groups:* The Trial of
Queen Caroline, 1820, by Sir
George Hayter

CALTHROP, Dion Clayton
(1878-1937) Artist and writer

3437 *See Collections:* Prominent
Men, c.1880-c.1910, by Harry
Furniss, **3337-3535** and **3554-3620**

CALVERT, Felix (1790-1857)
Colonel

3701 *See Collections:* Studies for
The Waterloo Banquet at Apsley
House, 1836, by William Salter,
3689-3769

CAMBRIDGE, George William
Frederick Charles, 2nd Duke of
(1819-1904)
Commander-in-Chief of the Army

1834(d) Pencil 20 x 12.4
(7⅞ x 4⅞)
Frederick Sargent, signed and
inscribed
Given by A. C. R. Carter, 1919
See Collections: Members of the
House of Lords, c.1870-80, by
Frederick Sargent, **1834(a-z and
aa-hh)**

CAMBRIDGE, Alexander, Earl
of Athlone *See* ATHLONE

CAMDEN, Charles Pratt, 1st
Earl (1714-94) Lord Chancellor

459 Canvas 90.2 x 69.9
(35½ x 27½)
After Sir Joshua Reynolds (1764)
Given by the Society of Judges and
Serjeants-at-Law, 1877

336 Canvas 123.2 x 99.1
(48½ x 39)
Nathaniel Dance, 1767-9
Purchased, 1872

CAMDEN, John Jeffreys Pratt, 1st
Marquess of (1759-1840) Statesman

745 *See Groups:* William Pitt
addressing the House of Commons
. . . 1793, by Karl Anton Hickel

999 *See Groups:* The Trial of
Queen Caroline, 1820, by Sir
George Hayter

316a(9) (study for no.**5241**)
Pencil, two sketches 47 x 70.5
(18½ x 27¾)
Sir Francis Chantrey, inscribed and
dated (on separate slip) 1830
Given by Mrs George Jones, 1871
See Collections: Preliminary
drawings for busts and statues by
Sir Francis Chantrey, **316a(1-202)**

Continued overleaf

5241 Marble bust 62.6 (24⅝) high
Sir Francis Chantrey, incised and
dated 1835
Purchased, 1979

CAMDEN, William (1551-1623)
Antiquary and historian

528 Panel 56.5 x 41.9 (22¼ x 16½)
By or after Marcus Gheeraerts the
Younger, inscribed and dated 1609
Transferred from BM, 1879.
Montacute

Strong

CAMERON, Anne (née Chinery)
Wife of Ewen Wrottesley Hay
Cameron

P18(78) *See Collections:* The
Herschel Album, by Julia Margaret
Cameron, **P18(1-92b)**

CAMERON, Eugene Hay (1840-85)
Soldier; eldest son of Julia Margaret
Cameron

P18(89) *See Collections:* The
Herschel Album, by Julia Margaret
Cameron, **P18(1-92b)**

CAMERON, Ewen Wrottesley Hay
(1843-88) Youngest son of Julia
Margaret Cameron

P18(22) *See Collections:* The
Herschel Album, by Julia Margaret
Cameron, **P18(1-92b)**

CAMERON, Julia Margaret
(1815-79) Pioneer photographer

5046 Canvas 61 x 50.8 (24 x 20)
George Frederic Watts, 1850-2
Purchased, 1975

CAMPBELL, John Campbell, 1st
Baron (1779-1861)
Lord Chancellor

54 *See Groups:* The House of Com-
mons, 1833, by Sir George Hayter

460 Canvas 141 x 110.5
(55½ x 43½)
Sir Francis Grant, 1850
Given by the Society of Judges and
Serjeants-at-Law, 1877

375 Canvas 121.9 x 88.9 (48 x 35)
Thomas Woolnoth, c. 1851
Purchased, 1873

Ormond

CAMPBELL, Archibald, 9th Earl
of Argyll *See* ARGYLL

CAMPBELL, Archibald, 1st
Marquess of Argyll *See* ARGYLL

CAMPBELL, C.
Queen Victoria's gillie

P22(10) *See Collections:* The
Balmoral Album, 1854-68, by
George Washington Wilson, W. & D.
Downey, and Henry John Whitlock,
P22(1-27)

CAMPBELL, Sir Colin (1776-1847)
Governor of Nova Scotia and of
Ceylon

4320 Pencil and water-colour
14.6 x 12.1 (5¾ x 4¾)
Thomas Heaphy, inscribed, 1813
Purchased, 1963

3702 *See Collections:* Waterloo
Officers, 1834-40, by William
Salter, **3689-3769**

CAMPBELL, Colin, 1st Baron
Clyde *See* CLYDE

CAMPBELL, Gertrude Elizabeth (née Blood), Lady Colin (1858-1911) Journalist and socialite

1630 Canvas 182.2 x 117.5 (71¾ x 46¼)
Giovanni Boldini, signed, c.1897
Given by the sitter's wish, 1911

CAMPBELL, George Douglas, 8th Duke of Argyll *See* ARGYLL

CAMPBELL, George William, 6th Duke of Argyll *See* ARGYLL

CAMPBELL, H.

2242 *See Collections:* The Parnell Commission, 1888-9, by Sydney Prior Hall, **2229-72**

2286 *See Collections:* Miscellaneous drawings . . . by Sydney Prior Hall, **2282-2348** and **2370-90**

CAMPBELL, John, 2nd Duke of Argyll and Duke of Greenwich *See* GREENWICH

CAMPBELL, John, 9th Duke of Argyll *See* ARGYLL

CAMPBELL, John, 2nd Marquess of Breadalbane
See BREADALBANE

CAMPBELL, John (1817-1904) Army surgeon

2523 Canvas 76.2 x 63.5 (30 x 25)
John Robertson Reid, signed, inscribed and dated 1893
Bequeathed by the sitter's niece, Marion Isabella Campbell, 1931

CAMPBELL, Sir Malcolm (1885-1948) Racing motorist

4195 Resin and bronze mask 27 (10⅝) high
H. A. Stermann, incised with initials, c. 1935
Given by George Henry Clarke, 1960

CAMPBELL, Thomas (1777-1844) Poet

1429 Pencil 15.2 x 12.7 (6 x 5)
John Henning, signed and dated 1813
Given by Miss Joanna Horner and Mrs Katharine M. Lyell (née Horner), 1906

198 Canvas 91.4 x 71.1 (36 x 28)
Sir Thomas Lawrence, c.1820
Given by the Duke of Buccleuch, 1865

4026(10) *See Collections:* Drawings of Men about Town, 1832-48, by Alfred, Count D'Orsay, **4026(1-61)**

2515(93) Black and red chalk 36.8 x 27.3 (14½ x 10¾)
William Brockedon, dated 1842
Lent by NG, 1959
See Collections: Drawings of Prominent People, 1823-49, by William Brockedon, **2515(1-104)**

CAMPBELL-BANNERMAN, Sir Henry (1836-1908) Prime Minister

3537 Water-colour 21.6 x 17.8 (8½ x 7)
Sir Francis Carruthers Gould, signed with initials
Given by the artist's son, N. Carruthers Gould, 1946

2830-2, 2866 *See Collections:* Caricatures of Politicians, by Sir Francis Carruthers Gould, **2826-74**

Continued overleaf

5120 Sanguine 47.3 x 36.8
(18⅝ x 14½)
Harold Speed, signed and dated by
artist and sitter, 1907
Purchased, 1977

CANNING, Charles John Canning,
Earl (1812-62)
Governor-General of India

P119 Photograph: 9th plate
daguerreotype 5.1 x 3.2
(2 x 1¼) *sight*
Studio of Richard Beard, 1840s
Purchased, 1979

342,343a-c *See Groups:* The Fine
Arts Commissioners, 1846, by
John Partridge

1057 Chalk 61.6 x 47.9
(24¼ x 18⅞)
George Richmond, signed and
inscribed, 1851
Purchased, 1896

Ormond

CANNING, George (1770-1827)
Prime Minister

745 *See Groups:* William Pitt
addressing the House of Commons
. . . 1793, by Karl Anton Hickel

316a(10) Pencil 40.9 x 26.7
(16⅛ x 10½)
Sir Francis Chantrey, inscribed,
c. 1818
Given by Mrs George Jones, 1871
See Collections: Preliminary
drawings for busts and statues by
Sir Francis Chantrey, **316a(1-202)**

282 Marble bust 69.9 (17½) high
Sir Francis Chantrey, incised and
dated 1821
Purchased, 1869

1338 Canvas 91.4 x 60.3 (36 x 23¾)
Sir Thomas Lawrence and
(completed by) Richard Evans,
c. 1825
Purchased, 1903

1832 Canvas 238. 1 x 147.3
(93¾ x 58)
Sir Thomas Lawrence, 1825
Given by the Earl of Harewood,
1919

CANNING, Sir Samuel
(1823-1908) Civil engineer; pioneer
of submarine telegraphy

4925 Canvas 108.3 x 93.3
(42⅝ x 36¾)
Beatrice Bright, signed and dated
1897
Purchased, 1973

CANNING, Stratford, 1st Viscount
Stratford de Redcliffe
See STRATFORD DE REDCLIFFE

CANNIZZARO, Duchess of
(d. 1841) Society hostess

3097(5) *See Collections:*
Caricatures, c. 1825-c.1835, by
Sir Edwin Landseer, **3097(1-10)**

CANOVA, Antonio (1757-1822)
Italian sculptor and painter

2515(2) *See Collections:* Drawings
of Prominent People, 1823-49, by
William Brockedon, **2515(1-104)**

CANT, Andrew
Piper

3845 *See Groups:* Dinner at
Haddo House, 1884, by Alfred
Edward Emslie

CANTERBURY, Charles Manners Sutton, 1st Viscount (1780-1845) Speaker of the House of Commons

1987 Canvas 134.6 x 109.2 (53 x 43) Henry William Pickersgill,1833 Given by the sitter's grandson, Canon Edward Manners-Sanderson, 1923

54 *See Groups:* The House of Commons, 1833, by Sir George Hayter

4026(11) *See Collections:* Drawings of Men about Town, 1832-48, by Alfred, Count D'Orsay, **4026(1-61)**

CANTON, John (1718-72) Electrician

809 Canvas 48.9 x 39.4 (19¼ x 15½) Unknown artist, inscribed Given by the sitter's great-grandson, Robert Canton, 1888

Kerslake

CAPADOSE, Abraham (1795-1874) Physician and Calvinist writer

P6(26) Photograph: calotype 20.1 x 14.9 (7$\frac{7}{8}$ x 5$\frac{7}{8}$) David Octavius Hill and Robert Adamson, 1843-8 Given by an anonymous donor,1973 *See Collections:* The Hill and Adamson Albums, 1843-8, by David Octavius Hill and Robert Adamson, **P6(1-258)**

CAPEL, Arthur Capel, 1st Baron (1604-49) Royalist

4759 *See Groups:* The Capel Family, by Cornelius Johnson

1520 Canvas 124.5 x 100.3 (49 x 39½) Henry Paert after a painting of c.1645, inscribed Purchased, 1908

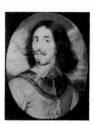

L152(13) Miniature on vellum, oval 7.6 x 6.4 (3 x 2½) Presumably after John Hoskins, initialled *JH* and dated 1647 Lent by NG (Alan Evans Bequest), 1975

CAPEL, Elizabeth (née Morrison), Lady (d. 1661) Wife of 1st Baron Capel

4759 *See Groups:* The Capel Family, by Cornelius Johnson

CAPEL, Sir Henry Capel, Baron (1638-96) Lord-Lieutenant of Ireland

4759 *See Groups:* The Capel Family, by Cornelius Johnson

CAPEL, Algernon, 2nd Earl of Essex *See* ESSEX

CAPEL, Charles (d. 1656/7)

4759 *See Groups:* The Capel Family, by Cornelius Johnson

CAPEL, Thomas John (1836-1911) Roman Catholic prelate

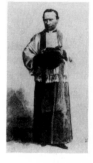

2567 Water-colour 30.5 x 17.8 (12 x 7) Charles Auguste Loye, signed in monogram *MD* (*VF* 7 Sept 1872) Purchased, 1933

CAPEL-CONINGSBY, George, 5th Earl of Essex *See* ESSEX

CARBERY, John Vaughan, 3rd Earl of (1639-1713) Politician and courtier

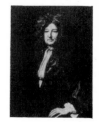

3196 Canvas 90.8 x 71.1 (35¾ x 28) Sir Godfrey Kneller, signed, c. 1700-10 Kit-cat Club portrait Given by NACF, 1945. *Beningbrough*

Piper

CARDEN, Sir Robert Walter, Bt (1801-88) Lord Mayor of London

2568 Water-colour 27.9 x 17.8 (11 x 7)
Sir Leslie Ward, signed *Spy*
(*VF* 11 Dec 1880)
Purchased, 1933

CARDIGAN, James Thomas Brudenell, 7th Earl of (1797-1868) General

54 *See Groups:* The House of Commons, 1833, by Sir George Hayter

CARDWELL, Edward Cardwell, Viscount (1813-86) Statesman

767 Canvas 125.7 x 100.3 (49½ x 39½)
George Richmond
Given by the family of Viscountess Cardwell, 1887

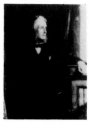

5116 *See Groups:* Gladstone's Cabinet of 1868, by Lowes Cato Dickinson

2569 Water-colour 30.5 x 17.8 (12 x 7)
Carlo Pellegrini, signed *Ape*
(*VF* 3 April 1869)
Purchased, 1933

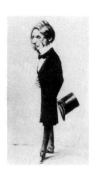

1834(e) *See Collections:* Members of the House of Lords, c.1870-80, by Frederick Sargent, **1834(a-z and aa-hh)**

CAREW, Sir Benjamin Hallowell (1760-1834) Admiral

316a(64) Pencil 42.5 x 28.2 (16¾ x 11⅛)
Sir Francis Chantrey, inscribed and dated 1815
Given by Mrs George Jones, 1871
See Collections: Preliminary drawings for busts and statues by Sir Francis Chantrey, **316a(1-202)**

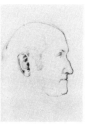

373 Canvas 77.5 x 63.8 (30½ x 25⅛)
John Hayter, c. 1833
Given by William Smith, 1873

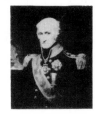

CAREW, George, Earl of Totnes
See TOTNES

CAREY, Henry, 2nd Earl of Monmouth *See* MONMOUTH

CAREY, Robert, 1st Earl of Monmouth *See* MONMOUTH

CAREY, Thomas (1597-1634) Younger son of 1st Earl of Monmouth

5246 *See Groups:* 1st Earl of Monmouth and his family, attributed to Paul van Somer

CARLETON, Hugh Carleton, Viscount (1739-1826) Irish judge

3089(3) Pencil 25.4 x 19.7 (10 x 7¾)
William Daniell after George Dance, inscribed
Purchased, 1940
See Collections: Tracings of drawings by George Dance, **3089(1-12)**

CARLETON, Anne (née Gerrard), Lady (1585?-1627) Connoisseur

111 Panel 63.5 x 53.3 (25 x 21)
Studio of Michael Jansz. van Miereveldt, c. 1625
Given by Felix Slade, 1860

Piper

CARLETON, Dudley, Viscount Dorchester *See* DORCHESTER

CARLILE, James (1784-1854) Divine

599 *See Groups:* The Anti-Slavery Society Convention, 1840, by Benjamin Robert Haydon

CARLILE, Richard (1790-1843)
Free-thinker

1435 Canvas 76.2 x 62.9 (30 x 24¾)
Unknown artist
Bequeathed by G.L.Holyoake,1906
Ormond

CARLINGFORD, Chichester
Samuel Fortescue (afterwards
Parkinson-Fortescue), Baron
(1823-98) Statesman

5116 *See Groups:* Gladstone's
Cabinet of 1868, by Lowes Cato
Dickinson

CARLINI, Agostino (d. 1790)
Sculptor

1437,1437a *See Groups:* The
Academicians of the Royal
Academy, 1771-2, by John Sanders
after Johan Zoffany

3186 *See Groups:* Francesco
Bartolozzi,Giovanni Batista Cipriani
and Agostino Carlini, 1777, by
John Francis Rigaud

CARLISLE, James Hay, 1st Earl
of (c.1580-1636) Courtier;
favourite of James I and Charles I

5210 Canvas 194.6 x 120
(76⅝ x 47¼)
Unknown artist, inscribed and
dated 1628
Purchased, 1978. *Montacute*

CARLISE, Charles Howard, 3rd
Earl of (1669-1738) Statesman

3197 Canvas 90.8 x 71.1
(35¾ x 28)
Sir Godfrey Kneller, signed in
monogram, c. 1700-10
Kit-cat Club portrait
Given by NACF, 1945
Beningbrough

Piper

CARLISLE, Henry Howard, 4th
Earl of (1684-1758) Politician

926 *See Groups:* The Committy
of the house of Commons (the
Gaols Committee), by William
Hogarth

CARLISLE, George William
Frederick Howard, 7th Earl of
(1802-64) Viceroy of Ireland

999 *See Groups:* The Trial of
Queen Caroline, 1820, by Sir
George Hayter

54 *See Groups:* The House of Com-
mons, 1833, by Sir George Hayter

342,343a-c *See Groups:* The Fine
Arts Commissioners, 1846, by
John Partridge

CARLOS, Don (1848-1909)
Pretender to the Spanish throne
as Carlos VII

4707(6) Water-colour 30.8 x 18.1
(12⅛ x 7⅛)
Sir Leslie Ward, signed *Spy*
(*VF* 29 April 1876)
Purchased, 1938
See Collections: Vanity Fair
cartoons, 1869-1910, by various
artists, **2566-2606,** etc

CARLOS, William (d. 1689)
Royalist soldier

5248,5249 *See Collections:*
Charles II's escape after the Battle
of Worcester, 1651, by Isaac
Fuller, **5247-51**

CARLYLE, Jane Baillie (née Welsh)
(1801-66) Letter writer; wife of
Thomas Carlyle

1175 Canvas 20 x 15.2 (7⅞ x 6)
Samuel Laurence, c. 1852
Given by Maj-Gen Stirling, 1898

Ormond

CARLYLE, Thomas (1795-1881)
Historian and essayist

1241 Plaster cast of medallion, painted black 21.6 (8½) diameter
Thomas Woolner, 1855
Given by Sir James Caw, 1899

2520 Pen and ink 16.8 x 11.1 ($6\frac{5}{8}$ x $4\frac{3}{8}$)
Charles Bell Birch, signed with initials, inscribed and dated 1859
Given by the artist's nephew, George von Pirch, 1931

P18(2) Photograph: albumen print 33.7 x 27.9 (13¼ x 11)
Julia Margaret Cameron, 1867
Purchased with help from public appeal, 1975
See Collections: The Herschel Album, by Julia Margaret Cameron, **P18(1-92b)**

P18(4) *See Collections:* The Herschel Album, by Julia Margaret Cameron, **P18(1-92b)**

P122 Photograph: albumen print 33.3 x 24.1 (13$\frac{1}{8}$ x 9½)
Julia Margaret Cameron, 1867
Purchased, 1911

P123 Photograph: albumen print, printed in reverse 33.7 x 28.6 (13¼ x 11¼)
Julia Margaret Cameron, 1867
Given by Alfred Jones, 1922

1002 Canvas 66 x 53.3 (26 x 21)
George Frederic Watts, 1868-77
Given by the artist, 1895

2794 Pen and ink 17.8 x 11.1 (7 x $4\frac{3}{8}$)
Sir George Scharf, signed with initials, inscribed and dated 1874
Bequeathed by the artist, 1895

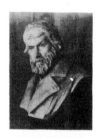

658 Terracotta cast of bust 55.9 (22) high
Sir Joseph Edgar Boehm, incised, c. 1875
Given by the artist, 1882

1623 Plaster cast of hands 25.4 x 21.6 (10 x 8½)
Brucciani & Co after Sir Joseph Edgar Boehm, incised, 1875
Given by the makers, 1911

968 Canvas 116.8 x 88.3 (46 x 34¾)
Sir John Everett Millais, 1877
Purchased, 1894

1361 Plaster cast of death-mask 26 (10¼) long
Sir Alfred Gilbert, 1881
Given by Mrs W.E.H.Lecky, 1904

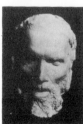

2894 Pen and ink 10.2 x 6.4
(4 x 2½)
Edward Matthew Ward, inscribed
Given by Walter Bennett, 1936

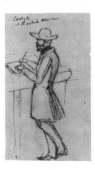

3558 Pen and ink 14.9 x 22.2
($5\frac{7}{8}$ x 8¾)
Harry Furniss, signed with initials
Purchased, 1948
See Collections: Prominent Men,
c. 1880-c.1910, by Harry Furniss,
3337-3535 and **3554-3620**

Ormond

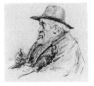

CARNAC, Sir James Rivett, 1st
Bt (1785-1846)
Governor of Bombay

316a(11,12) Pencil, two sketches,
each 51 x 34 ($20\frac{1}{8}$ x $13\frac{3}{8}$)
Sir Francis Chantrey, inscribed and
dated 1839
Given by Mrs George Jones, 1871
See Collections: Preliminary
drawings for busts and statues by
Sir Francis Chantrey, **316a(1-202)**

5128 Marble bust 81.3 (32) high
Patrick MacDowell, exh 1844
Purchased, 1977

CARNAC, John (1716-1800)
Soldier

L152(22) Miniature on ivory,
oval 5.1 x 4.1 (2 x $1\frac{5}{8}$)
Ozias Humphry, signed with initials
and dated on back card, 1786
Lent by NG (Alan Evans Bequest),
1975

CARNARVON, Elizabeth (née
Capel), Countess of (1633-78)
Wife of 2nd Earl of Carnarvon

4759 *See Groups:* The Capel
Family, by Cornelius Johnson

CARNARVON, Henry George
Herbert, 2nd Earl of (1772-1833)

999 *See Groups:* The Trial of
Queen Caroline, 1820, by Sir
George Hayter

CARNOT, Sadi (1837-94)
President of the French Republic

4707(7) *See Collections: Vanity
Fair* cartoons, 1869-1910, by
various artists, **2566-2606,** etc

CAROLINE Wilhelmina of
Brandenburg-Ansbach (1683-1737)
Queen of George II

529 Canvas 97.5 x 61.9
($38\frac{3}{8}$ x $24\frac{3}{8}$)
After Sir Godfrey Kneller (1716)
Transferred from BM, 1879

369 Canvas 218.5 x 127.6
(86 x 50¼)
Studio of Charles Jervas, c. 1727
Purchased, 1873

4332 Canvas 243.9 x 152.4
(96 x 60)
Jacopo Amigoni, inscribed, 1735
Purchased, 1963

Kerslake

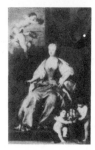

CAROLINE Amelia Elizabeth of Brunswick (1768-1821) Queen of George IV

244 Canvas 140.3 x 111.8 (55¼ x 44) Sir Thomas Lawrence, 1804 Purchased, 1867

498 Canvas 76.2 x 64.1 (30 x 25¼) James Lonsdale, c. 1820 Given by the artist's son, James John Lonsdale, 1873

1695(a,b) *See Collections:* Sketches for The Trial of Queen Caroline, 1820, by Sir George Hayter, **1695(a-x)**

2662(1-6,8) *See Collections:* Book of sketches, mainly for The Trial of Queen Caroline, 1820, by Sir George Hayter, **2662(1-38)**

4940 (study for *Groups,* **999**) Panel 34.9 x 29.2 (13¾ x 11½) Sir George Hayter, c.1820 Purchased, 1973

999 *See Groups:* The Trial of Queen Caroline, 1820, by Sir George Hayter

CAROLINE, Elizabeth, Princess (1713-57) Daughter of George II

1556 *See Groups:* Frederick, Prince of Wales, and his sisters (The Music Party), by Philip Mercier

CARPENTER, Alfred Francis Blakeney (1881-1955) Vice-Admiral

3971 Canvas 72.4 x 59.7 (28½ x 23½) Sir Arthur Stockdale Cope, signed and dated 1918 Bequeathed by the sitter's father, Alfred Carpenter, 1956

CARPENTER, Edward (1844-1929) Sociologist

2447 Canvas 74.9 x 43.8 (29½ x 17¼) Roger Fry, exh 1894 Given by the artist, 1930

P48 Photograph: gum-platinum print 28.3 x 22.2 ($11\frac{1}{8}$ x 8¾) Alvin Langdon Coburn, signed and dated on mount 1905 Given by Dr F. Severne Mackenna, 1977

3832 Canvas 47.3 x 43.8 ($18\frac{5}{8}$ x 17¼) Henry Bishop, signed and dated 1907 Given by Richard Hawkin, 1952

CARPENTER, William Benjamin (1813-85) Naturalist

P120(35) Photograph: albumen print, arched top 19.7 x 14.6 (7¾ x 5¾) Maull & Polyblank, inscribed on mount, 1855 Purchased, 1979 *See Collections:* Literary and Scientific Men, 1855, by Maull & Polyblank, **P120(1-54)**

CARR, John (1723-1807) Architect

4062 Canvas 126.7 x 100.6 ($49\frac{7}{8}$ x $39\frac{5}{8}$) Sir William Beechey, inscribed, 1791 or after Purchased,1958. *Beningbrough*

CARR, Sir John (1772-1832) Traveller

2515(42) *See Collections:* Drawings of Prominent People, 1823-49, by William Brockedon, **2515(1-104)**

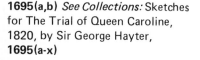

CARR, Joseph William Comyns
(1849-1916) Critic and dramatist

2263 *See Collections:* The Parnell
Commission, 1888-9, by Sydney
Prior Hall, **2229-72**

2286 *See Collections:*
Miscellaneous drawings . . . by
Sydney Prior Hall, **2282-2348**
and **2370-90**

3438 *See Collections:* Prominent
Men, c.1880-c.1910, by Harry
Furniss, **3337-3535** and **3554-3620**

CARR, Robert, Earl of Somerset
See SOMERSET

CARR, William Holwell
See HOLWELL-CARR

CARRINGTON, Charles Wynn-
Carrington, Earl (1843-1928)
Politician

5121 Sanguine 46.4 x 36.5
(18¼ x 14 $\frac{3}{8}$)
Harold Speed, signed and dated
1909, and autographed by sitter
1910
Purchased, 1977

CARRINGTON, Robert Smith, 1st
Baron (1752-1838) Politician

999 *See Groups:* The Trial of
Queen Caroline, 1820, by Sir
George Hayter

CARRINGTON, Robert John
(Smith) Carrington, 2nd Baron
(1796-1868)
MP for Chipping Wycombe

999 *See Groups:* The Trial of
Queen Caroline, 1820, by Sir
George Hayter

54 *See Groups:* The House of Com-
mons, 1833, by Sir George Hayter

CARRINGTON, Noel Thomas
(1777-1830) Poet

1797b Pencil 17.8 x 15.2 (7 x 6)
Unknown artist, inscribed, c.1815-20
Given by Alfred Jones, 1917

CARROLL, Lewis
See DODGSON, Charles Lutwidge

CARSON, Edward Carson, 1st Baron
(1854-1935)
Ulster leader and advocate

3347 *See Collections:* Prominent
Men, c.1880-c.1910, by Harry
Furniss, **3337-3535** and **3554-3620**

3852 Pencil and wash 31.1 x 19.4
(12¼ x 7 $\frac{5}{8}$)
Sir Max Beerbohm, signed Max,
inscribed and dated 1912
Purchased, 1953
See Collections: Caricatures,
1897-1932, by Sir Max Beerbohm,
3851-8

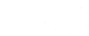

2916 Etching 22.9 x 17.8 (9 x 7)
John George Day, signed on plate
with symbol, and signed, inscribed
and dated below plate 1914
Purchased, 1937

CARTAGENA, Don Pablo Morillo,
Comte de (1777-1838)
Spanish Major-General

1914(23) *See Collections:*
Peninsular and Waterloo Officers,
1813-14, by Thomas Heaphy,
1918(1-32)

CARTER, Elizabeth (1717-1806)
Scholar and writer

4905 *See Groups:* The Nine
Living Muses of Great Britain, by
Richard Samuel

Continued overleaf

28 Pastel, oval 31.1 x 27.3
(12¼ x 10¾)
Sir Thomas Lawrence, exh 1790
Purchased, 1858. *Beningbrough*

CARTER, Robert Brudenell
(1828-1918) Ophthalmic surgeon

3298 Water-colour 36.2 x 22.2
(14¼ x 8¾)
(Possibly H.C.Sepping) Wright
signed *STUFF*
(*VF* 8 April 1892)
Purchased, 1934

CARTERET, John, 2nd Earl
Granville *See* GRANVILLE

CARTWRIGHT, Edmund
(1743-1823) Inventor

1075,1075a and **b** *See Groups:* Men
of Science Living in 1807-8, by Sir
John Gilbert and others

CARTWRIGHT, Samuel
(1788-1864) Dentist

4983 Marble bust 42.9 (16⅞)high
Benedetto Pistrucci, incised
Given by Dr C. Bowdler Henry,1974

CARTWRIGHT, Thomas (1634-89)
Bishop of Chester

1090 Canvas 74.9 x 62.2
(29½ x 24½)
After Gerard Soest (c. 1680)
Purchased, 1897

1613 Canvas 92.1 x 76.8
(36¼ x 30¼)
Unknown artist (c. 1686-9)
Purchased, 1911

Piper

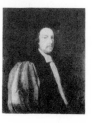

CARTWRIGHT, William Ralph
(1771-1847)
MP for Northamptonshire South

54 *See Groups:* The House of Com-
mons, 1833, by Sir George Hayter

CARY, Francis Stephen (1808-80)
Painter and teacher of art

3896 Pencil and chalk, octagonal
16.8 x 14.3 (6⅝ x 5⅝)
James Hayllar, signed and dated
1851
Purchased, 1953

Ormond

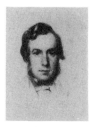

CARY, Joyce (1888-1957)
Novelist and poet

4822 Pen and ink 33.3 x 23.8
(13⅛ x 9⅜)
Katerina Wilczynski, signed with
initials and dated 1954, and
autographed by the sitter
Purchased, 1970

4113 Lithograph 27.9 x 20.3
(11 x 8)
Self-portrait, signed on stone with
initials, and signed and numbered 4
Given by the sitter's son, Michael
Cary, 1959

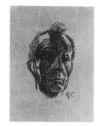

CARY, Lucius, 2nd Viscount
Falkland *See* FALKLAND

CASAUBON, Isaac (1559-1614)
Classical scholar and theologian

1776 Panel 35.6 x 25.7 (14 x 10⅛)
Unknown artist, inscribed
Purchased, 1916

Strong

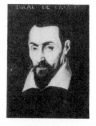

CASEMENT, Roger David
(1864-1916) Irish rebel

3867 Pencil 18.7 x 28.6 (7⅜ x 11¼)
Sir William Rothenstein, 1911
Given by the Rothenstein Memorial
Trust, 1953

3867A Pencil 28.6 x 20 (11¼ x 7⅞)
Sir William Rothenstein, inscribed
and dated 1911
Given by the Rothenstein Memorial
Trust, 1953

CASIMIR-PERIER, Jean Paul
Pierre (1847-1907)
President of the French Republic

4707(8) *See Collections: Vanity
Fair* cartoons, 1869-1910, by
various artists, **2566-2606,** etc

CASSEL, Sir Ernest Joseph
(1852-1921) Financier and
philanthropist



3995 Etching 19.7 x 14.9
(7¾ x 5⅞)
Anders Leonard Zorn, signed in
monogram and dated 1909 on plate
Purchased, 1956

CASSON, Ann
Daughter of Dame Sybil Thorndike

5036 *See Collections:* Miniatures,
1920-30, by Winifred Cécile
Dongworth, **5027-36**

CASSON, Mary
Daughter of Dame Sybil Thorndike

5036 *See Collections:* Miniatures,
1920-30, by Winifred Cécile
Dongworth, **5027-36**

CASTEL-CICALA, Prince
Neapolitan ambassador

3703 *See Collections:* Studies for
The Waterloo Banquet at Apsley
House, 1836, by William Salter,
3689-3769

CASTLEMAINE, Richard
Handcock, 4th Baron (1826-92)
Representative peer

1834(f) *See Collections:* Members
of the House of Lords, c.1870-80,
by Frederick Sargent, **1834(a-z and
aa-hh)**

CASTLEREAGH, Viscount
See LONDONDERRY, 2nd
Marquess of

CATALANI, Angelica
(1780-1849) Singer

1962(a) Pen and ink 12.4 x 8
(4⅞ x 3⅛)
Alfred Edward Chalon, inscribed
and dated 1814
Purchased, 1922
See Collections: Opera singers
and others, c.1804-c.1836, by
Alfred Edward Chalon, **1962(a-l)**

5039 Marble bust 48.3 (19) high
L. Alexander Goblet, incised and
dated 1820
Purchased, 1975

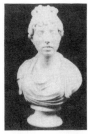

CATES, William Leist Readwin
(1821-95) Chronologist

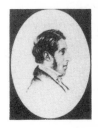

3078 Charcoal 12.7 x 11.4 (5 x 4½)
Charlotte Pearson, signed with
initials and dated on reverse 1848
Given by the sitter's son, Herbert
Cates, 1939

CATESBY, Robert (1573-1605)
Conspirator

334A *See Groups:* The Gunpowder
Plot Conspirators, 1605, by an
unknown artist

CATHCART, Miss

P22(24) *See Collections:* The
Balmoral Album, 1854-68, by
George Washington Wilson, W. & D.
Downey, and Henry John Whitlock,
P22(1-27)

CATHERINE of Aragon
(1485-1536) First Queen of
Henry VIII

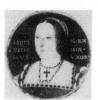

4682 Miniature on vellum
3.8 (1½) diameter
Attributed to Lucas Hornebolte,
inscribed, c.1525
Purchased, 1969

163 Panel 55.9 x 44.5 (22 x 17½)
Unknown artist (c. 1530)
Purchased, 1863

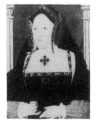

2421 *See Unknown Sitters I*

Strong

CATHERINE Howard (d.1542)
Fifth Queen of Henry VIII

1119 *See Unknown Sitters I*

CATHERINE Parr (1512-48)
Sixth Queen of Henry VIII

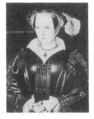

4618 Panel 63.5 x 50.8 (25 x 20)
Unknown artist, inscribed, c.1545
Purchased with help from NACF,
the Pilgrim Trust, H.M. Government,
and Messrs Gooden & Fox Ltd

Strong

CATHERINE of Braganza
(1638-1705) Queen of Charles II

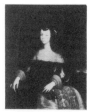

2563 Canvas 123.2 x 100.3
(48½ x 39½)
By or after Dirk Stoop, c.1660-1
Bequeathed by Viscount Dillon,
1933

353 Canvas 62.2 x 55.2
(24½ x 21¾)
After Dirk Stoop (c.1660-1)
Purchased, 1872

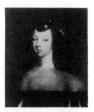

597 Canvas 73.7 x 62.2 (29 x 24½)
Studio of Jacob Huysmans (?)
(c.1670)
Purchased, 1879

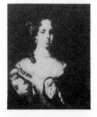

623 *See Unknown Sitters II*

Piper

CATTERMOLE, George (1800-68)
Painter

4579 Pencil and crayon 38.7 x 31.5
(15¼ x 12⅜)
Unknown artist, inscribed
Given by K.M.Guichard, 1967

Ormond

CATTON, Charles, the Elder
(1728-98) Painter

1437,1437a *See Groups:* The
Academicians of the Royal
Academy, 1771-2, by John Sanders
after Johan Zoffany

CAULFIELD, Charles, 1st Earl of
Charlemont *See* CHARLEMONT

CAVALLO, Tiberius (1749-1809)
Scientist and inventor

1412 Panel 59.1 x 48.9 (23¼ x 19¼)
Unknown artist, c.1790
Purchased, 1905

CAVAN, Frederick Lambart, 10th
Earl of (1865-1946) Field-Marshal

2908(3,9) *See Collections:* Studies,
mainly for General Officers of
World War I, by John Singer
Sargent **2908(1-18)**

1954 *See Groups:* General Officers
of World War I, by John Singer
Sargent

CAVE, George Cave, Viscount
(1856-1928) Statesman

4421 Chalk 38.1 x 17.9 (15 x 11)
Francis Dodd, signed, inscribed and
dated 1925
Purchased, 1964

CAVENDISH, Charles Compton,
1st Baron Chesham *See* CHESHAM

CAVENDISH, Henry (1731-1810)
Physicist

1075, 1075a and **b** *See Groups:* Men of Science Living in 1807-8, by Sir John Gilbert and others

CAVENDISH, Spencer, 8th Duke of Devonshire *See* DEVONSHIRE

CAVENDISH, Victor, 9th Duke of Devonshire *See* DEVONSHIRE

CAVENDISH, William, 2nd Duke of Devonshire *See* DEVONSHIRE

CAVENDISH, William, 5th Duke of Devonshire *See* DEVONSHIRE

CAVENDISH, William, 6th Duke of Devonshire *See* DEVONSHIRE

CAVENDISH, William, 7th Duke of Devonshire *See* DEVONSHIRE

CAVOUR, Camille, Count (1810-61) Italian statesman

2515(75) *See Collections:* Drawings of Prominent People, 1823-49, by William Brockedon, **2515(1-104)**

CAWSE, Miss H.
Singer

1962(j) With Miss Betts
See Collections: Opera singers and others, c.1804-c.1836, by Alfred Edward Chalon, **1962(a-l)**

CAYLEY, Edward Stillingfleet (1802-62)
MP for Yorkshire North Riding

54 *See Groups:* The House of Commons, 1833, by Sir George Hayter

CAYLEY, Sir George, Bt (1773-1857) Pioneer of aviation

54 *See Groups:* The House of Commons, 1833, by Sir George Hayter

3977 Canvas 91.2 x 70.8 (35$\frac{7}{8}$ x 27$\frac{7}{8}$)
Henry Perronet Briggs, signed and dated 1840
Given by Sir Kenelm Cayley, Bt, 1956
Ormond

CECIL, Edgar Gascoyne-Cecil, 1st Viscount (1864-1958)
Statesman; President of the League of Nations

2827, 2865 *See Collections:* Caricatures of Politicians, by Sir Francis Carruthers Gould, **2826-74**

4184 Canvas 91.4 x 76.2 (36 x 30)
Sir William Orpen, 1919
Given by wish of Viscount Wakefield, 1960

4769 Chalk 29.2 x 37.1 (11½ x 14$\frac{5}{8}$)
Sir William Rothenstein, 1922
Purchased, 1970

4112 Canvas 89.5 x 69.9 (35¼ x 27½)
John Mansbridge, c.1931
Given by A.K.S. Lambton, 1959

CECIL, Brownlow, 2nd Marquess of Exeter *See* EXETER

CECIL, Edward, Viscount Wimbledon *See* WIMBLEDON

CECIL, Robert, 1st Earl of Salisbury *See* SALISBURY

CECIL, Robert Gascoyne-, 3rd Marquess of Salisbury *See* SALISBURY

CECIL, Thomas, 1st Earl of Exeter
See EXETER

CECIL, William, 1st Baron Burghley
See BURGHLEY

CERVETTO, James (1747-1837)
Violoncellist and composer

5179 *See Groups:* A Bravura at
the Hanover Square Concert, by
John Nixon

CETEWAYO (or Cettiwayo)
(d. 1883) King of Zululand

2699 *See Collections: Vanity Fair*
cartoons, 1869-1910, by various
artists, **2566-2606,** etc

CHADWICK, Sir Edwin (1801-90)
Sanitary reformer

849 Marble bust 75.6 (29¾) high
Adam Salomon, c.1863
Given by the sitter's widow, 1890

Ormond

CHALMERS, George (1742-1825)
Scottish antiquary

2196 Pencil and water-colour
24.8 x 20.3 (9¾ x 8)
Henry Edridge, signed with initials
and dated 1809
Purchased, 1928

CHALMERS, Thomas (1780-1847)
First Moderator of the Free Church

P6(6) Photograph: calotype
15.2 x 12.7 (6 x 5)
David Octavius Hill and Robert
Adamson, 1843-7
Given by an anonymous donor, 1973
See Collections: The Hill and
Adamson Albums, 1843-8, by
David Octavius Hill and Robert
Adamson, **P6(1-258)**

P6(5) *See Collections:* The Hill
and Adamson Albums, 1843-8, by
David Octavius Hill and Robert
Adamson, **P6(1-258)**

CHALON, Alfred Edward
(1780-1860) Portrait and subject
painter

3260 *See Unknown Sitters IV*

CHALON, John James (1778-1854)
Landscape and genre painter

4230 Millboard 25.1 x 20.3
(9⅞ x 8)
John Partridge, 1836
Bequeathed by the widow of the
artist's nephew, Sir Bernard
Partridge, 1961

Ormond

CHALONER, Sir Thomas
(1521-65) Diplomat

2445 Panel 71.1 x 54.6
(28 x 21½)
Unknown Flemish artist, inscribed
and dated 1559
Purchased, 1929. *Montacute*

1274 Canvas 75.6 x 55.9
(29¾ x 22)
Unknown artist, after no.**2445**
Given by E.A.Maund, 1900

Strong

CHAMBERLAIN, Arthur Neville
(1869-1940) Prime Minister; son
of Joseph Chamberlain

4268 Bronze medal 7 (2¾) diameter
Victor Demanet, incised and dated
1938
Given by Marion Harry Spielmann,
1939

4279 Canvas 129.5 x 94 (51 x 37)
Henry Lamb, c.1939
Purchased, 1962

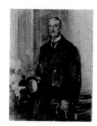

4413 Lithograph 48.3 x 38.4
(19 x 15⅛)
Andrew MacLaren, signed by
artist and sitter, inscribed, 1940
Given by the artist, 1964

4529(73) *See Collections:* Working
drawings by Sir David Low,
4529(1-401)

CHAMBERLAIN, Joseph
(1836-1914) Statesman

1604 Canvas 115.6 x 86.4
(45½ x 34)
Frank Holl, signed and dated 1886
Bequeathed by Sir Charles
Wentworth Dilke, Bt, 1911

5256 *See Groups:* The Lobby of
the House of Commons, 1886, by
Liberio Prosperi

2307 *See Collections:*
Miscellaneous drawings . . . by
Sydney Prior Hall, **2282-2348**
and **2370-90**

4030 Canvas 161.9 x 91.4
(63¾ x 36)
John Singer Sargent, signed and
dated 1896
Bequeathed by the sitter's widow,
Mrs Mary Endicott Carnegie, 1957

5114 *See under* 1st Earl of Balfour

3020 Pen and ink 13.3 x 13.7
(5¼ x 5⅜)
Phil May, signed and dated 1902
Given by Lady Forbes-Robertson,
1939

2779 Chalk 55.9 x 36.8
(22 x 14½)
Sir Hubert von Herkomer, signed
with initials and dated 1903
Given by J.Whiteley Wilkin, 1935

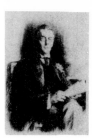

2330 *See Collections:*
Miscellaneous drawings . . . by
Sydney Prior Hall, **2282-2348**
and **2370-90**

3096 Plaster cast of bust
40.6 (16) high
Courtenay Pollock, incised, c.1912
Given by wish of the sitter's son,
Neville Chamberlain, 1941

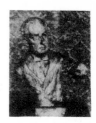

2829,2864 *See Collections:*
Caricatures of Politicians, by Sir
Francis Carruthers Gould,**2826-74**

CHAMBERLAIN, Sir Joseph
Austen (1863-1937) Statesman; son
of Joseph Chamberlain

4562 Chalk 43.2 x 29.5 (17 x 11⅝)
Sir David Low, signed, inscribed
and dated 1926
Purchased, 1967

5059 Bronze bust 59.1 (23¼)high
Sigismund de Strobl, 1935
Given by the artist's daughter,
Dr Eva Visy-Strobl, 1975

CHAMBERLAIN, Thomas
(1810-92) Honorary Canon of
Christ Church, Oxford

P7(3) *See Collections:* Lewis
Carroll at Christ Church, by Charles
Lutwidge Dodgson, **P7(1-37)**

CHAMBERLIN, Mason (d. 1787)
Portrait painter

1437,1437a *See Groups:* The
Academicians of the Royal
Academy, 1771-2, by John Sanders
after Johan Zoffany

2653 Marble relief 38.1
(15) diameter
John Bacon the Elder, incised and
dated 1785
Purchased, 1934

CHAMBERS, Sir Edmund Kerchever
(1866-1954) English scholar

4139 Pencil and chalk 51.4 x 34.9
(20¼ x 13¾)
Sir William Rothenstein, 1924
Given by the Rothenstein Memorial
Trust, 1960

CHAMBERS, Sir William (1726-96)
Architect

27 Canvas 88.9 x 68.6 (35 x 27)
Sir Joshua Reynolds, c.1751-60
Purchased, 1858

4044 Miniature on ivory, oval
4.1 x 3.2 (1⅝ x 1¼)
Jeremiah Meyer, after 1770
Bequeathed by Miss E.F.E.Pebardy,
1958

1437,1437a *See Groups:* The
Academicians of the Royal
Academy, 1771-2, by John Sanders
after Johan Zoffany

3159 Wash 21.6 x 17.8 (8½ x 7)
After Sir Joshua Reynolds
(exh 1780)
Purchased, 1943

987 *See Groups:* Sir Joshua
Reynolds, Sir William Chambers,
and Joseph Wilton, 1782, by John
Francis Rigaud

CHANCELLOR, Sir Christopher
(b. 1904)
Journalist and administrator

4529(74-7) *See Collections:*
Working drawings by Sir David
Low, **4529(1-401)**

CHANDOS, James Brydges, 1st
Duke of (1674-1744)
Patron of the arts

530 Canvas 174.3 x 123.8
(68⅝ x 48¾)
Herman van der Myn, 1725 or
before
Transferred from BM, 1879.
Beningbrough

Kerslake

CHANDOS, Oliver Lyttelton, 1st
Viscount (1893-1972) Politician

4529(78,79) *See Collections:*
Working drawings by Sir David
Low, **4529(1-401)**

CHANTREY, Sir Francis Leggatt
(1781-1841) Sculptor

2103A Pencil and wash
13.6 x 14.3 (5⅜ x 5⅝)
Self-portrait, inscribed, c.1800
Given by the Misses Frere, 1925

654 Chalk 47.6 x 35.3
(18¾ x 13⅞)
Self-portrait, signed with initials,
c.1802
Given by William Overend, 1882

86 Panel 91.4 x 77.2 (36 x 30⅜)
Thomas Phillips, signed in
monogram, 1818
Given by the sitter's widow, 1859

1731 Chalk 38.7 x 33.7 (15¼ x 13¼)
Eden Upton Eddis, signed,
inscribed and dated 1838
Given by the artist's daughter, Mrs
Henry Powell, 1914

CHAPLIN, Henry Chaplin, 1st
Viscount (1840-1923)
Sportsman and politician

3189 Water-colour 30.5 x 17.8
(12 x 7)
Carlo Pellegrini, signed *Ape*
(*VF* 5 Dec 1874)
Purchased, 1945

5256 *See Groups:* The Lobby of
the House of Commons, 1886, by
Liberio Prosperi

4865 Canvas 127 x 96.5 (50 x 38)
Sir Arthur Stockdale Cope, signed
and dated 1908
Given by 3rd Viscount Chaplin, 1972

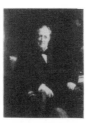

3853 Ink, water-colour and wash
32 x 18.4 (12⅝ x 7¼)
Sir Max Beerbohm, signed and
inscribed
Purchased, 1953
See Collections: Caricatures,
1897-1932, by Sir Max Beerbohm,
3851-8

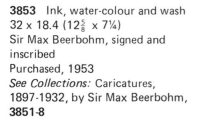

2828 *See Collections:* Caricatures
of Politicians, by Sir Francis
Carruthers Gould, **2826-74**

3439, 3440 *See Collections:*
Prominent Men, c. 1880-c.1910,
by Harry Furniss, **3337-3535** and
3554-3620

CHAPLIN, Sir Charles (1889-1977)
Actor and producer

5224(9) Ink 12.1 x 9.5 (4¾ x 3¾)
Robert Stewart Sherriffs, signed
Purchased, 1978
See Collections: Cartoons,
c. 1928-c.1936, by Robert Stewart
Sherriffs, **5224(1-9)**

CHAPMAN, William (1749-1832)
Civil engineer

1075a,1075b *See Groups:* Men of
Science Living in 1807-8, by Sir
John Gilbert and others

CHARDIN, Sir John (1643-1712)
Merchant-adventurer and orientalist

5161 Canvas 135.2 x 134.9
(53¼ x 53⅛)
Unknown artist
Purchased, 1977

CHARLEMONT, James Caulfield,
1st Earl of (1728-99)
Irish statesman

176 Canvas 67.3 x 49.5
(26½ x 19½)
Richard Livesay, c. 1783
Purchased, 1864

CHARLES I (1600-49)
Reigned 1625-49

3064 Miniature on vellum, oval
4.8 x 3.8 (1⅞ x 1½)
Studio of Isaac Oliver, c.1612
Transferred from BM, 1939

1112 Canvas 200.7 x 115.6
(79 x 45½)
Attributed to Abraham van
Blyenberch (c.1617-20)
Purchased from a fund given by the
Stuart Exhibition Committee, 1897

Montacute

Continued overleaf

4444 Canvas 76.2 x 64.1 (30 x 25¼)
Gerard Honthorst, 1628
Purchased with help from NACF, 1965

1246 Canvas 215.9 x 134.6 (85 x 53)
Daniel Mytens, signed, inscribed and dated 1631
Purchased, 1899

297 Bronze cast of bust
76.2 (30) high
After(?) Hubert Le Sueur (c.1635)
Purchased, 1870

843 Canvas 124.5 x 100.3
(49 x 39½)
After Sir Anthony van Dyck
(c. 1635-6)
Purchased, 1890

2137 Canvas 123.2 x 99.1 (48½ x 39)
After Sir Anthony van Dyck
(c. 1635-7)
Bequeathed by Mrs Penelope Isabella Christie, 1926

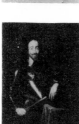

1906 Canvas 113 x 96.5 (44½ x 38)
After Sir Anthony van Dyck
(c. 1635-7)
Bequeathed by Mrs A. H. S. Wodehouse, 1921

4516 Panel 25.7 x 33.3 (10⅛ x 13⅛)
Unknown artist (c.1630-40)
Purchased, 1966

1924 Miniature on vellum, oval
8.3 x 6.4 (3¼ x 2½)
David Des Granges after John Hoskins, signed in monogram
(c. 1645)
Bequeathed by G. Milner-Gibson-Cullum, 1922

1961 With Sir Edward Walker
Canvas 151.1 x 226.1 (59½ x 89)
Unknown artist
Purchased, 1922

4836 Canvas 83.8 x 73.7 (33 x 29)
Unknown artist, related to engraving by Faber of 1717
Given by Mme Jean Hugo in memory of Hedley Hope Nicholson, 1971

2189A Pencil 13.3 x 11.1 (5¼ x 4⅜)
Sir Henry Halford, Bt, 1813
Purchased, 1928

1910 *See Unknown Sitters II*

Piper

CHARLES II (1630-85)
Reigned 1660-85

267 *See Groups:* Five Children of Charles I, 1637, after Sir Anthony van Dyck

5103 Canvas 29 x 20 (11⅜ x 7⅞)
Cornelius Johnson, signed with initials, 1639
Purchased, 1975
See Collections: Three eldest children of Charles I, by Cornelius Johnson, **5103-5**

L152(14) Miniature on vellum, oval 4.8 x 3.8 ($1\frac{7}{8}$ x 1½) David Des Granges after Adriaen Hanneman (c.1648), signed in monogram
Lent by NG (Alan Evans Bequest), 1975

1499 Canvas 74.9 x 64.8 (29½ x 25½)
After Adriaen Hanneman (c.1648)
Purchased, 1908

5247 With Richard Penderel (right) Canvas 213.3 x 185.4 (84 x 73) Isaac Fuller, signed with initials
Purchased, 1979
See Collections: Charles II's escape after the Battle of Worcester, 1651, by Isaac Fuller, **5247-51**

5248-51 *See Collections:* Charles II's escape after the Battle of Worcester, 1651, by Isaac Fuller, **5247-51**

531 Canvas 126.4 x 101 (49¾ x 39¾)
Studio of(?) John Michael Wright, c. 1660-5
Transferred from BM, 1879

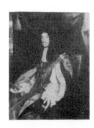

1313 Canvas 69.9 x 56.5 (27½ x 22¼)
Unknown artist, c. 1665
Purchased, 1902

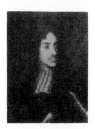

153 Canvas, feigned oval 74.9 x 62.9 (29½ x 24¾)
After Sir Peter Lely (c. 1675)
Purchased, 1863

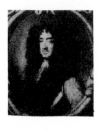

4691 Canvas 226.7 x 135.6 ($89\frac{1}{4}$ x $53\frac{3}{8}$)
Attributed to Thomas Hawker, c. 1680
Purchased, 1969

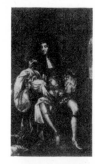

3798 Canvas 72.4 x 57.8 (28½ x 22¾)
Studio of John Riley, c.1680-5
Purchased, 1951

137 Oil on copper 13.6 x 11.5 ($5\frac{3}{8}$ x 4½)
James Parmentier, signed
Bequeathed by the Rev Peter Spencer, 1862

Piper

CHARLES Edward Stuart, Prince (1720-88) Grandson of James II; 'Bonnie Prince Charlie'

434 Canvas, feigned oval 63.5 x 48.3 (25 x 19)
Studio of Antonio David, c.1729?
Purchased, 1876

1052 Bronze medal 4.1 ($1\frac{5}{8}$) diameter
Attributed to Thomas Pingo, embossed and dated 1745
Given by Lord Edmond Fitzmaurice, 1896

2161 Pastel 57.2 x 42.2 (22½ x $16\frac{5}{8}$)
After Maurice Quentin de la Tour (1748)
Given by L. M. Fischel, 1927

Continued overleaf

376 Canvas, feigned oval
25.1 x 22.2 (9$\frac{7}{8}$ x 8¾)
Attributed to Hugh Douglas
Hamilton, c.1785
Purchased, 1873. *Beningbrough*

1929 *See Unknown Sitters III*

Kerslake

CHARLES Louis, Prince, Count
Palatine (1617-80) Eldest son of
Elizabeth, Queen of Bohemia

L125 Canvas 214 x 132.4
(84¼ x 52$\frac{1}{8}$)
Ascribed to the studio of Sir
Anthony van Dyck
Lent by NG, 1965

CHARLEVILLE, Charles William
Bury, 2nd Earl of (1801-51)
MP for Penryn

54 *See Groups:* The House of Com-
mons, 1833, by Sir George Hayter

4026(12) *See Collections:* Drawings
of Men about Town, 1832-48, by
Alfred, Count D'Orsay, **4026(1-61)**

CHARLOTTE Sophia of
Mecklenburg-Strelitz (1744-1818)
Queen of George III

224 Canvas 147.3 x 106.7 (58 x 42)
Studio of Allan Ramsay, c.1762
Purchased, 1866

L152(28) Enamel miniature on
copper, oval 7 x 5.7 (2¾ x 2¼)
Henry Bone, signed, and on reverse
inscribed and dated 1801
Lent by NG (Alan Evans Bequest),
1975

2788 Wash 15.9 x 12.7 (6¼ x 5)
Isaac Robert Cruikshank
Given by Godfrey Brennan, 1935

CHARLOTTE Augusta of Wales,
Princess (1796-1817)
Daughter of George IV

3086 Coloured wax relief
20.3 x 17.8 (8 x 7)
Samuel Percy, signed and dated 1814
Purchased, 1940

1914(19) Water-colour 49.5 x 38.1
(19½ x 15)
Thomas Heaphy, 1815
Purchased, 1921
See Collections: Peninsular and
Waterloo Officers, 1813-14, by
Thomas Heaphy, **1914(1-32)**

4470 Marble bust 72.4 (28½) high
Peter Turnerelli, incised and dated
1816
Bequeathed by Rupert Gunnis, 1965

206 Water-colour, oval 18.7 x 14.9
(7$\frac{3}{8}$ x 5$\frac{7}{8}$)
Richard Woodman, c.1816
Given by Frederic Bulley by wish
of his brother, 1866

51 Canvas 139.7 x 108 (55 x 42½)
George Dawe, 1817
Purchased, 1858

With her husband, Prince Leopold
(Leopold I)

1530 Coloured engraving
44.5 x 35.6 (17½ x 14)
William Thomas Fry after George
Dawe (1817)
Purchased, 1909

CHARLOTTE Augusta Matilda,
Princess Royal (1766-1828)
Eldest daughter of George III;
Queen of Würtemberg

2174 Wax relief, oval 11.4 x 10.2
(4½ x 4)
Attributed to Peter Rouw
Purchased, 1927

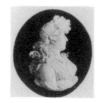

CHARTERIS, Francis (1844-70)
MP and collector; son of 10th
Earl of Wemyss

P18(85) *See Collections:* The
Herschel Album, by Julia Margaret
Cameron, **P18(1-92b)**

CHATFIELD, Alfred Chatfield, 1st
Baron (1873-1967)
Admiral of the Fleet

4602 Canvas 61 x 50.8 (24 x 20)
Reginald Grenville Eves, signed and
dated 1937
Given by the artist's son, Grenville
Eves, 1968

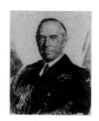

CHATHAM, William Pitt, 1st Earl
of (1708-78) Prime Minister

1050 Canvas 126.4 x 101
(49¾ x 39¾)
Studio of William Hoare, inscribed,
c.1754
Purchased, 1896

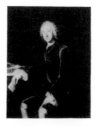

259 Canvas 116.2 x 85.7
(45¾ x 33¾)
After Richard Brompton (1772)
Given by the 5th Earl Stanhope,
1868

Kerslake

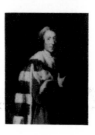

CHATHAM, John Pitt, 2nd Earl of
(1756-1835) General

999 *See Groups:* The Trial of
Queen Caroline, 1820, by Sir
George Hayter

CHAUCER, Geoffrey (1340?-1400)
Poet

532 Panel 30.5 x 27.3 (12 x 10¾)
Unknown artist, posthumous
Transferred from BM, 1879

Strong

CHEESMAN, Thomas (1760-1835)
Engraver

780 Canvas, feigned oval
31.8 x 25.4 (12½ x 10)
Francesco Bartolozzi, signed and
dated on reverse 1777
Given by T. Humphry Ward, 1888

CHEKE, Sir John (1514-57)
Greek scholar

1988 Electrotype of medal
5.4 ($2\frac{1}{8}$) diameter
After a medal attributed to Lodovico
Leoni (1555?), inscribed
Given by Sir George Francis Hill,
1923

Strong

CHELMSFORD, Frederick Thesiger,
1st Baron (1794-1878)
Lord Chancellor

4893 *See Groups:* The Derby
Cabinet of 1867, by Henry Gales

1834(g) Pencil 20 x 12.7 ($7\frac{7}{8}$ x 5)
Frederick Sargent, signed and
inscribed
Given by A. C. R. Carter, 1919
See Collections: Members of the
House of Lords, c.1870-80, by
Frederick Sargent, **1834(a-z and
aa-hh)**

CHESELDEN, William (1688-1752)
Surgeon and anatomist

4995 Pencil 14 x 11.8 (5½ x 4⅝)
Jonathan Richardson
Purchased, 1974. *Beningbrough*

CHESHAM, Charles Compton
Cavendish, 1st Baron (1793-1863)
MP for Sussex East

54 *See Groups:* The House of Commons, 1833, by Sir George Hayter

CHESNEY, Francis Rawdon
(1789-1872) General and explorer

2659 Oil over a photograph
22.2 x 17.5 (8¾ x 6⅞)
Unknown artist
Given by the sitter's grandson,
R. E. Charlewood, 1934

Ormond

CHESTERFIELD, Philip Dormer
Stanhope, 4th Earl of (1694-1773)
Statesman

158 Canvas 92.1 x 69.2 (36¼ x 27¼)
After William Hoare (c.1742),
inscribed
Purchased, 1863

533 Canvas 74. 9 x 62.9
(29½ x 24¾)
Allan Ramsay, signed, inscribed and
dated 1765
Transferred from BM, 1879

Kerslake

CHESTERTON, Gilbert Keith
(1874-1936) Poet, novelist and
critic

2045 *See Collections:* Medallions
of Writers, c. 1922, by Theodore
Spicer-Simson, **2043-55**

3240 Bronze cast of bust
58.4 (23) high
Maria Petrie, 1926
Purchased, 1945

4529(80-3) *See Collections:*
Working drawings by Sir David
Low, **4529(1-401)**

3984 (study for *Groups,* **3654**)
Chalk 37.8 x 30.2 (14⅞ x 11⅞)
Sir James Gunn, signed, inscribed
and dated 1932
Purchased, 1956

3985 (study for *Groups,* **3654**)
Chalk 61.9 x 46.4 (24⅝ x 18¼)
Sir James Gunn, signed with initials,
inscribed and dated 1932
Purchased, 1956

3654 *See Groups:* Conversation
Piece . . . , by Sir James Gunn

CHETWYND, William Fawkener
(1788-1873) MP for Stafford

54 *See Groups:* The House of Commons, 1833, by Sir George Hayter

CHICHESTER, George Hamilton,
3rd Marquess of Donegall
See DONEGALL

CHIFFINCH, Thomas (1600-66)
Keeper of the Privy Closet and the
King's Jewels to Charles II

816 Canvas 113 x 93.3 (44½ x 36¾)
Attributed to Sebastien Bourdon,
c. 1655-60
Purchased, 1889

Piper

CHIFFINCH, William (1602-88)
Keeper of the Privy Closet and the
King's Jewels to Charles II; brother
of Thomas Chiffinch

1091 Canvas, oval 53.3 x 42.5
(21 x 16¾)
After John Riley (c. 1670-80)
Purchased, 1897

Piper

CHILD, Sir Francis, the Younger
(1684?-1740) Banker

926 *See Groups:* The Committy of
the house of Commons (the Gaols
Committee), by William Hogarth

CHILDERS, Hugh Culling Eardley
(1827-96) Statesman

5116 *See Groups:* Gladstone's
Cabinet of 1868, by Lowes Cato
Dickinson

1631 Canvas 90.2 x 69.9
(35½ x 27½)
Emily Maria Eardley Childers (his
daughter), signed and dated 1891
Given by the sitter's son, Charles
E. Eardley Childers, 1911

CHILDERS, John Walbanke
(1789-1886) MP for Cambridgeshire

54 *See Groups:* The House of Com-
mons, 1833, by Sir George Hayter

CHILDREN, George (1742-1818)
Electrician

5150 Canvas 76.2 x 63.5 (30 x 25)
Archer James Oliver, 1806
Given by John C. Children, 1977

CHILDREN, John George
(1777-1852) Chemist, mineralogist
and natural scientist; only son of
George Children

5151 Canvas 76.2 x 63.5 (30 x 25)
Benjamin Rawlinson Faulkner, 1826
Given by John C. Children, 1977

CHILSTON, Aretas Akers-Douglas,
1st Viscount (1851-1926)
Statesman

4991 Water-colour 21.6 x 9.5
(8½ x 3¾)
Phil May, signed and inscribed
Purchased, 1974

CHINNERY, George (1774-1852)
Painter

4096 Pencil 19.7 x 13.3 (7¾ x 5¼)
Self-portrait, inscribed and dated
1832
Given by Bertram Seton, 1959

779 Canvas 71.1 x 54 (28 x 21¼)
Self-portrait, c. 1840
Given by John Dent on behalf of
his uncle, Lancelot Dent, 1888

Ormond

CHIROL, Sir Ignatius Valentine
(1852-1929)
Traveller, journalist and writer

4271 Canvas 61 x 50.8 (24 x 20)
John Collier, signed and dated 1909
Given by the artist's son, Sir
Laurence Collier, 1962

CHOLMLEY, Sir George
See STRICKLAND, Sir George

CHOLMLEY, John (d. 1693)
Brother of Nathaniel Cholmley,
merchant of London

2105 Canvas 74.9 x 62.2 (29½ x 24½)
Attributed to Jacob Huysmans,
c. 1680, inscribed *BUTLER* (*sic*)
Purchased, 1925

Piper (see under Samuel Butler)

CHOLMONDELEY, George James
Cholmondeley, 1st Marquess of
(1749-1827)
Chamberlain to the Prince of Wales

2076 *See Groups:* Whig Statesmen
and their Friends, c. 1810, by
William Lane

CHORLEY, Henry Fothergill
(1808-72) Music critic

4026(13) Pencil and chalk
16.2 x 12.1 (6⅜ x 4¾)
Alfred, Count D'Orsay, signed,
inscribed and dated 1841
Purchased, 1957
See Collections: Drawings of Men
about Town, 1832-48, by Alfred,
Count D'Orsay, **4026(1-61)**

Ormond

CHUBB, Thomas (1679-1747)
Theologian and philosopher

1122 Canvas 75.6 x 62.2
(29¾ x 24½)
George Beare, signed and dated 1747
Purchased, 1898

Kerslake

CHURCHILL, Lord Randolph
(1849-94) Statesman

5256 *See Groups:* The Lobby of
the House of Commons, 1886, by
Liberio Prosperi

5113 Canvas 127.4 x 101.6
(50⅛ x 40)
Edwin Long, exh 1888
Purchased, 1976

3351, 3352, 3559 *See Collections:*
Prominent Men, c. 1880-c.1910, by
Harry Furniss, **3337-3535** and
3554-3620

3032 Pen and ink 13 x 9.8 (5⅛ x 3⅞)
Phil May, signed and inscribed
Given by Marion Harry Spielmann,
1939

CHURCHILL, Charles (1731-64)
Satirist

162 Canvas, feigned oval
73 x 62.2 (28¾ x 24½)
J. S. C. Schaak, c.1763-4
Purchased, 1863

Kerslake

CHURCHILL, John, 1st Duke of
Marlborough
See MARLBOROUGH

CHURCHILL, John, 6th Duke of
Marlborough
See MARLBOROUGH

CHURCHILL, Sarah, Duchess of
Marlborough
See MARLBOROUGH

CHURCHILL, Sarah (b.1914)
Writer; daughter of Sir Winston
Churchill

5184 *See under* Baroness Spencer-
Churchill

CHURCHILL, Sir Winston Spencer
(1874-1965) Prime Minister

2463 *See Groups:* Statesmen of
World War I, by Sir James Guthrie

4529(84) *See Collections:* Working
drawings by Sir David Low,
4529(1-401)

4438 Canvas 45.7 x 30.5 (18 x 12)
Walter Richard Sickert, 1927
Given by NACF, 1965

4458 Chalk 44.5 x 30.5
(17½ x 12)
Bernard Hailstone, signed, inscribed
and dated 1956
Given by the artist, 1965

4474 Pencil 22.9 x 15.2 (9 x 6)
Juliet Pannett, signed and dated
1964
Purchased, 1966

CIBBER, Colley (1671-1757)
Dramatist and actor

1045 Painted plaster bust 67.3
(26½) high
Workshop of the Cheeres(?), c. 1740
Purchased, 1896

Kerslake

CIBBER, Susannah Maria (née Arne)
(1714-66) Actress and singer

1984 Ivory medallion, oval
3.5 x 2.8 ($1\frac{3}{8}$ x $1\frac{1}{8}$)
Unknown artist, inscribed
Purchased, 1923

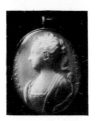

4526 Canvas, feigned oval
76.2 x 62.9 (30 x 24¾)
Thomas Hudson, eng 1749
Purchased, 1967. *Beningbrough*

Kerslake

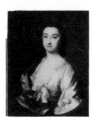

CIPRIANI, Giovanni Battista
(1727-85) Painter and engraver

1437, 1437a *See Groups:* The
Academicians of the Royal
Academy, 1771-2, by John Sanders
after Johan Zoffany

3186 *See Groups:* Francesco
Bartolozzi, Giovanni Battista
Cipriani and Agostino Carlini,
1777, by John Francis Rigaud

CLANCARTY, Richard Le Poer
Trench, 2nd Earl of and 1st
Viscount (1767-1837) Diplomatist

5252 Canvas 77.3 x 63.8
($30\frac{3}{8}$ x $25\frac{1}{8}$)
Joseph Paelinck, signed and dated
1817
Purchased, 1979

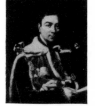

CLANRICARDE, Ulick de Burgh,
5th Earl and Marquess of (1604-57)
Irish politician

1841A Oil on iron, oval 8.9 x 7.6
(3½ x 3)
Unknown artist, signed *H.H*
Given by Viscount Lascelles, 1919

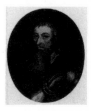

CLANRICARDE, Ulick de Burgh,
1st Marquess of (1802-74) Statesman

4026(14) *See Collections:*
Drawings of Men about Town,
1832-48, by Alfred, Count D'Orsay
4026(1-61)

CLANWILLIAM, Richard Meade
3rd Earl of (1795-1879) Diplomat

999 *See Groups:* The Trial of
Queen Caroline, 1820, by Sir
George Hayter

CLARE, John Fitzgibbon, 2nd Earl
of (1792-1851)

999 *See Groups:* The Trial of
Queen Caroline, 1820 by Sir
George Hayter

CLARE, Richard Hobart
Fitzgibbon, 3rd Earl of
(1793-1864)
MP for County Limerick

54 *See Groups:* The House of Com-
mons, 1833, by Sir George Hayter

CLARE, John (1792-1864) Poet

1469 Canvas 76.2 x 63.5 (30 x 25)
William Hilton, 1820
Purchased, 1907

3843 *See Unknown Sitters IV*

CLARE, Peter (1781-1851)
Slavery abolitionist

599 *See Groups:* The Anti-Slavery
Society Convention, 1840, by
Benjamin Robert Haydon

CLARENDON, Edward Hyde, 1st
Earl of (1609-74) Statesman

773 Canvas, hexagonal 90.2 x 72.4
(35½ x 28½)
After Adriaen Hanneman
(c. 1648-55)
Purchased, 1887

4361 Silver medal 4.4 (1¾) diameter
Thomas Simon, incised, 1662
Purchased, 1964

645 Line engraving 29.5 x 20
($11\frac{5}{8}$ x $7\frac{7}{8}$)
David Loggan, signed and inscribed
on plate, 1666
Purchased, 1881

Piper

CLARENDON, George Villiers,
4th Earl of (1800-70) Diplomat

1125, 1125a *See Groups:* The
Coalition Ministry, 1854, by Sir
John Gilbert

5116 *See Groups:* Gladstone's
Cabinet of 1868, by Lowes Cato
Dickinson

CLARK, Kenneth Clark, Baron
(b. 1903) Art historian

5244 Canvas 14.3 x 10.2 ($5\frac{5}{8}$ x 4)
Graham Sutherland, signed with
initials
Purchased, 1979

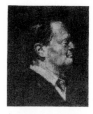

5243 Canvas 54.6 x 45.7
(21½ x 18)
Graham Sutherland, signed with
initials and dated 1963-4
Purchased, 1979

CLARK, Sir Andrew, Bt (1826-93)
Physician

1003 Canvas 64.8 x 51.4
(25½ x 20¼)
George Frederic Watts, signed with
initials and dated 1893
Given by the artist, 1895

CLARKE, Sir Casper Purdon
(1846-1911) Director of the
Metropolitan Museum of Art,
New York

3441 *See Collections:* Prominent
Men, c. 1880-c.1910, by Harry
Furniss, **3337-3535** and **3554-3620**

CLARKE, Charles Cowden
(1787-1877) Writer and lecturer

4506 Water-colour on marble
30.2 x 25.1 ($11\frac{7}{8}$ x $9\frac{7}{8}$)
Unknown artist
Given by members of the Gigliucci
family, 1966

CLARKE, Sir Charles Mansfield,
Bt (1782-1857) Obstetrician

316a(16) Pencil 42.8 x 30.5
($16\frac{7}{8}$ x 12)
Sir Francis Chantrey, inscribed and
dated (on separate label) 1833
Given by Mrs George Jones, 1871
See Collections: Preliminary
drawings for busts and statues by
Sir Francis Chantrey, **316a(1-202)**

316a(15) *See Collections:*
Preliminary drawings for busts and
statues by Sir Francis Chantrey,
316a(1-202)

CLARKE, Edward Daniel
(1769-1822) Mineralogist

813 *See Unknown Sitters III*

CLARKE, Sir Edward George
(1841-1931) Lawyer and politician

2700 Water-colour 30.5 x 18.7
(12 x 7⅜)
Sir Leslie Ward, signed *Spy*
(*VF* 11 June 1903)
Purchased, 1934

3442 *See Collections:* Prominent
Men, c. 1880-c.1910, by Harry
Furniss, **3337-3535** and **3554-3620**

CLARKE, Mary Anne
(née Thompson) (1776-1852)
Mistress of the Duke of York

2793 Miniature on ivory
10.2 x 8.3 (4 x 3¼)
Adam Buck, signed and dated 1803
Purchased, 1935

4436 Marble bust 64.1 (25¼) high
Lawrence Gahagan, incised and
dated 1811
Purchased, 1965

CLARKE, Samuel (1675-1729)
Metaphysician

4838 Platinated lead bust
60 (23⅝) high
Jamé Verhych, incised and dated
(on base) 1719
Purchased, 1971. *Beningbrough*

266 Canvas 167.6 x 120.7
(66 x 47½)
Unknown artist, c. 1720
Purchased, 1868

Piper

CLARKSON, Mary
Daughter-in-law of Thomas
Clarkson (1760-1846)

599 *See Groups:* The Anti-Slavery
Society Convention, 1840, by
Benjamin Robert Haydon

CLARKSON, Thomas (1760-1846)
Philanthropist

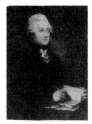

235 Canvas 90.8 x 70.5
(35¾ x 27¾)
Carl Frederik von Breda, inscribed,
eng 1789
Bequeathed by Henry Crabb
Robinson, 1867

599 *See Groups:* The Anti-Slavery
Society Convention, 1840, by
Benjamin Robert Haydon

CLARKSON, Thomas
Grandson of Thomas Clarkson
(1760-1846)

599 *See Groups:* The Anti-Slavery
Society Convention, 1840, by
Benjamin Robert Haydon

CLARKSON, Willie
Wigmaker and costumier

4529(86) *See Collections:*
Working drawings by Sir David Low,
4529(1-401)

CLAUSEN, Sir George (1852-1944)
Painter

3041 Pen and ink 17.1 x 12.4
(6¾ x 4⅞)
Self-portrait, signed with initials
and dated 1895
Given by Marion Harry Spielmann,
1939

CLAVERING Charles

883(7) *See Collections:* Studies
for miniatures by Sir George
Hayter, **883(1-21)**

CLAY, Sir William, Bt (1791-1869)
Politician

54 *See Groups:* The House of Com-
mons, 1833, by Sir George Hayter

CLAYPOLE, Elizabeth
(née Cromwell) (1629-58)
Daughter of Oliver Cromwell

952 Panel 54 x 45.1 (21¼ x 17¾)
John Michael Wright, signed in
monogram, inscribed and dated
1658
Purchased, 1893

Piper

CLAYPOLE, John (d. 1688)
Parliamentarian; married Cromwell's
daughter, Elizabeth

4673 Canvas 72.4 x 57.2
(28½ x 22½)
Unknown artist
Purchased, 1969

CLAYTON, Sir Oscar (1816-92)
Surgeon and socialite

3265 Water-colour 30.5 x 17.8
(12 x 7)
Carlo Pellegrini, signed *Ape*
(*VF* 12 Sept 1874)
Purchased, 1934

CLAYTON, Sir William Robert, Bt
(1786-1866) MP for Great Marlow

54 *See Groups:* The House of Com-
mons, 1833, by Sir George Hayter

CLEASBY, Sir Anthony (1804-79)
Judge

2897 (study in reverse for no.**2701**)
Water-colour 31.8 x 20.3 (12½ x 8)
Sir Leslie Ward, 1876
Given by Viscount Ullswater, 1936

2701 Water-colour 30.5 x 18.4
(12 x 7¼)
Sir Leslie Ward, signed *Spy*
(*VF* 5 Feb 1876)
Purchased, 1934

Ormond

CLERK-MAXWELL, James
(1831-79) Physicist

1189 Water-colour on china, oval
17.8 x 13.3 (7 x 5¼)
Unknown artist after a photograph
Purchased, 1899

CLEVELAND, Barbara Palmer,
Duchess of (1640-1709)
Mistress of Charles II

2564 (as Madonna and Child)
Canvas 175.2 x 114.3 (69 x 45)
After Sir Peter Lely (c.1665-75)
Bequeathed by Viscount Dillon,
1933

387 Canvas 124.5 x 101
(49 x 39¾)
After Sir Peter Lely (c. 1666)
Purchased, 1874

427 Canvas 124.5 x 101
(49 x 39¾)
After Sir Godfrey Kneller (c. 1705)
Purchased, 1876

Piper

CLEVELAND, William Harry Vane, 1st Duke of (1766-1842)
Sportsman and patron of the turf

316a(17) Pencil, two sketches 50.8 x 64.8 (20 x 25½)
Sir Francis Chantrey, inscribed, c. 1802
Given by Mrs George Jones, 1871
See Collections: Preliminary drawings for busts and statues by Sir Francis Chantrey, **316a(1-202)**

CLEVELAND, Henry Vane, 2nd Duke of (1788-1864)
MP for Salop South

54 *See Groups:* The House of Commons, 1833, by Sir George Hayter

CLIFDEN, Henry Welbore Agar-Ellis, 2nd Viscount (1761-1836)

999 *See Groups:* The Trial of Queen Caroline, 1820, by Sir George Hayter

CLIFFORD of Chudleigh, Thomas Clifford, 1st Baron (1630-73)
Statesman

204 Canvas 76.2 x 64.1 (30 x 25¼)
After Sir Peter Lely (c. 1672)
Purchased, 1865

Piper

CLIFFORD, Anne
See PEMBROKE AND MONTGOMERY

CLIFFORD, George, 3rd Earl of Cumberland *See* CUMBERLAND

CLIFFORD, John (1836-1923)
Baptist leader

2037 Canvas 59.7 x 49.5 (23½ x 19½)
John Collier, reduced replica (1906) signed
Given by the Baptist Union, 1924

CLIFFORD, William Kingdon (1845-79)
Mathematician and metaphysician

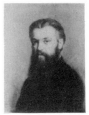

1231 Canvas 59.7 x 47.6 (23½ x 18¾)
John Collier, signed, reduced replica
Given by the artist, 1899

CLIFTON, Sir Arthur (1772-1869)
Lieutenant-General

3704 *See Collections:* Studies for The Waterloo Banquet at Apsley House, 1836, by William Salter, **3689-3769**

CLINE, Henry (1750-1827)
Surgeon

316a(18) Pencil 46.1 x 37.8 (18 x 14$\frac{7}{8}$)
Sir Francis Chantrey, inscribed
Given by Mrs George Jones, 1871
See Collections: Preliminary drawings for busts and statues by Sir Francis Chantrey, **316a(1-202)**

CLINT, Alfred (1807-83)
Etcher and marine painter; son of George Clint

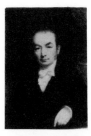

4616 Miniature on ivory 11.8 x 8.9 (4$\frac{5}{8}$ x 3½)
Attributed to himself
Purchased, 1968

Ormond

CLINT, George (1770-1854)
Portrait painter and engraver

2064 Canvas 76.2 x 63.5 (30 x 25)
Self-portrait, c. 1800
Purchased, 1924

CLINTON, Robert St John Trefusis, 18th Baron (1787-1832)

999 *See Groups:* The Trial of Queen Caroline, 1820, by Sir George Hayter

CLINTON, Edward Fiennes de, 1st Earl of Lincoln *See* LINCOLN

CLINTON, Henry, 7th Earl of
Lincoln *See* LINCOLN

CLINTON, Henry, 2nd Duke of
Newcastle *See* NEWCASTLE

CLINTON, Henry, 4th Duke of
Newcastle *See* NEWCASTLE

CLINTON, Henry, 5th Duke of
Newcastle *See* NEWCASTLE

CLIVE, Robert Clive, 1st Baron
(1725-74) Governor of Bengal

5263 *See Groups:* Robert Clive
and Mir Jaffier after the Battle of
Plassey, 1757, by Francis Hayman

1688 Silver medal 4.4 (1¾) diameter
John van Noost the Younger and
'C.G.', inscribed and dated 1766
Purchased, 1912

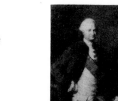

39 Canvas 127.6 x 102.2
(50¼ x 40¼)
Studio of (?) Nathaniel Dance
(1772-3)
Purchased, 1858

Kerslake

CLIVE, Edward Bolton
(after 1763-1845) MP for Hereford

54 *See Groups:* The House of Commons, 1833, by Sir George Hayter

CLIVE, Robert Henry (1789-1854)
MP for Salop South

54 *See Groups:* The House of Commons, 1833, by Sir George Hayter

CLODD, Edward (1840-1930)
Banker and writer

P103 Photograph: bromide print
24.4 x 18 (9⅝ x 7⅛)
Emil Otto Hoppé, signed, c.1909
Purchased, 1978

2749 Chalk 47 x 34.3 (18½ x 13½)
Helen Bedford, signed and dated
1928
Given by the sitter's widow, 1934

CLOTWORTHY, John, 1st Viscount
Massereene *See* MASSEREENE

CLOUGH, Arthur Hugh (1819-61)
Poet

3314 Chalk 54.6 x 43.2 (21½ x 17)
Samuel Rowse, 1860
Given by the sitter's daughter, Miss
B.A. Clough, 1946

1694 Plaster cast of bust 63.5
(25) high
Thomas Woolner, incised, c.1863
Purchased, 1913

Ormond

CLUTTON-BROCK, Arthur
(1868-1924) Essayist, critic and
journalist

4770 Pencil 36.5 x 26.3
(14⅜ x 10⅜)
Sir William Rothenstein, signed
with initials and dated 1916
Purchased, 1970

CLYDE, Colin Campbell, 1st Baron
(1792-1863) Field-Marshal

P20 Photograph: salt print
24.8 x 21 (9¾ x 8¼)
Roger Fenton, 1855
Purchased, 1975

1201 Plaster cast of bust 83.8
(33) high
George Gammon Adams, incised
and dated 1855
Purchased, 1899

619 Pen and ink and water-colour
25.4 x 12.7 (10 x 5)
Sir Francis Grant, c.1860
Given by Viscount Hardinge, 1881

Ormond

COBB, John (1756-1818)
Playwright

3900 Pencil 24.8 x 19.1 (9¾ x 7½)
George Dance
Purchased, 1954

COBBETT, William (1762-1835)
Writer, politician and agriculturalist

2877 Water-colour 21.6 x 17.8
(8½ x 7)
Unknown artist, c. 1805
Purchased, 1936

1549 Canvas 91.4 x 71.1 (36 x 28)
Unknown artist, possibly George
Cooke, c. 1831
Purchased, 1909

54 *See Groups:* The House of Com-
mons, 1833, by Sir George Hayter

COBDEN, Richard (1804-65)
Statesman

201 Canvas 102.2 x 80.6
(40¼ x 31¾)
Giuseppe Fagnani, inscribed, replica,
1865 (1860-1)
Purchased , 1865

316 Canvas 183.5 x 121.9
(72¼ x 48)
Lowes Cato Dickinson, signed
in monogram and dated 1870
(from photographs and drawing of
1861)
Given by the Reform Club, 1870

219 Marble bust 69.9 (17½) high
Thomas Woolner, incised and dated
1866
Given by the sitter's widow, 1868

Ormond

COBHAM, Richard Temple, 1st
Viscount (1675-1749)
Field-Marshal and politician

3198 Canvas 91.4 x 71.1 (36 x 28)
Sir Godfrey Kneller, signed in
monogram, c. 1710
Kit-cat Club portrait
Given by NACF, 1945

Continued overleaf

286 Canvas 75.6 x 62.9
(29¾ x 24¾)
After Jean Baptiste van Loo
(c. 1740)
Purchased, 1869. *Beningbrough*

Piper

COBHAM, Sir Alan (1894-1973)
Pioneer aviator

5018 Canvas 109.9 x 84.8
(43¼ x 33⅜)
Frank O. Salisbury, signed and
dated 1926
Given by the sitter's sons, Michael
and Geoffrey Cobham, 1975

COCHRAN, Sir Charles Blake
(1872-1951) Theatrical manager

4460 Pencil 25.4 x 19.1 (10 x 7½)
Powys Evans
Purchased, 1965

5224(5) *See Collections:* Cartoons,
c. 1928-c.1936, by Robert Stewart
Sherriffs, **5224(1-8)**

COCHRANE, Colonel

1752 *See Groups:* The Siege of
Gibraltar, 1782, by George Carter

COCHRANE, Archibald, 9th Earl
of Dundonald *See* DUNDONALD

COCK, Alfred (1851-98) Lawyer

3297 Water-colour 34 x 21
(13⅜ x 8¼)
(Possibly H.C.Sepping) Wright, signed
Stuff Gownsman
(*VF* 17 Jan 1891)
Purchased, 1934

COCKBURN, Henry Cockburn,
Lord (1779-1854) Scottish judge

4700 Marble bust 55.2 (21¾) high
Alexander Handyside Ritchie,
incised and dated 1848
Given by the sitter's great-grandson,
Reginald S.Cockburn, 1970

COCKBURN, Miss
Daughter of Lord Henry Cockburn

P6(151,158) *See Collections:*
The Hill and Adamson Albums,
1843-8, by David Octavius Hill
and Robert Adamson, **P6(1-258)**

COCKBURN, Sir Alexander, Bt
(1802-80) Judge

933 Canvas 41.9 x 34.9
(16½ x 13¾)
Alexander Davis Cooper
Given by Baron Northbourne, 1892

Ormond

COCKCROFT, Sir John
(1897-1967) Nuclear physicist

4812 Chalk 42.5 x 32.7
(16¾ x 12⅞)
H. Andrew Freeth, signed and
inscribed, 1957
Purchased, 1970

COCKER, Edward (1631-75)
Pedagogue

274 Canvas, feigned oval
37.5 x 29.8 (14¾ x 11¾)
Unknown artist, based on engraving
by Richard Gaywood (1657)
Purchased, 1868

Piper

COCKERELL, Sir Charles, Bt
(1755-1837) MP for Evesham

999 *See Groups:* The Trial of
Queen Caroline, 1820, by Sir
George Hayter

54 *See Groups:*The House of Com-
mons, 1833, by Sir George Hayter

COCKERELL, Charles Robert
(1788-1863) Architect

5096 Water-colour 25.4 x 20
(10 x 7$\frac{7}{8}$)
Attributed to Alfred Edward
Chalon
Purchased, 1976

COCKERELL, Sir Sydney
(1867-1962) Director of the
Fitzwilliam Museum, Cambridge

4325 Pencil 26.4 x 16.5 (10$\frac{3}{8}$ x 6½)
Dorothy Hawksley, signed and
dated 1952
Purchased, 1963

4324 Water-colour 25.4 x 35.6
(10 x 14)
Dorothy Hawksley, 1960
Given by the artist, 1963

COCKS, Charles Somers, 3rd Earl
Somers *See* SOMERS

COCKS, John Somers, 2nd Earl
Somers *See* SOMERS

CODRINGTON, Sir Edward
(1770-1851) Admiral

54 *See Groups:* The House Com-
mons, 1833, by Sir George Hayter

721 Panel 53.3 x 42.9 (21 x 16$\frac{7}{8}$)
Henry Perronet Briggs, 1843
Bequeathed by the sitter's daughter,
Lady Bouchier, 1884

Ormond

CODRINGTON, Sir William John
(1804-84) General

883(8) *See Collections:* Studies
for miniatures by Sir George
Hayter, **883(1-21)**

COHEN, Lionel Leonard Cohen,
Baron (1888-1973) Judge

4529(87-9) *See Collections:*
Working drawings by Sir David
Low, **4529(1-401)**

COKAYNE, Brien, 1st Baron
Cullen of Ashbourne
See CULLEN of Ashbourne

COKE, Thomas (1747-1814)
Methodist

1434a Wash and pencil 17.5 x 13.7
(6$\frac{7}{8}$ x 5$\frac{3}{8}$)
Henry Edridge, signed with initial
and dated 1799
Purchased, 1906

COKE, Thomas William, 1st Earl of
Leicester *See* LEICESTER

COLBORNE, Nicholas William
Ridley-Colborne, 1st Baron
(1779-1854)
Statesman and financier

342,343a-c *See Groups:* The Fine
Arts Commissioners, 1846, by
John Partridge

COLBORNE, John, 1st Baron
Seaton *See* SEATON

COLBY, Thomas Frederick
(1784-1852) Director of the
Ordnance Survey

2515(82) Chalk 36 x 26
(14$\frac{1}{8}$ x 10¼)
William Brockedon, dated 1837
Lent by NG, 1959
See Collections: Drawings of
Prominent People, 1823-49, by
William Brockedon, **2515(1-104)**

Ormond

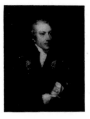

COLCHESTER, Charles Abbott,
1st Baron (1757-1829)
Speaker of the House of Commons

1416 Canvas 76.2 x 63.5 (30 x 25)
John Hoppner, c. 1802
Bequeathed by George Bramwell,
1905

COLE, Arthur Henry (1780-1844)
MP for Enniskillen

54 *See Groups:* The House of Com-
mons, 1833, by Sir George Hayter

COLE, Sir Galbraith Lowry
(1772-1842) General

946 Canvas 141 x 110.5
(55½ x 43½)
William Dyce, c. 1834-5
Purchased, 1893

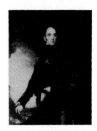

COLE, Sir Henry (1808-82)
Secretary of the Department of
Science and Art

1698 Chalk 63.5 x 49.5 (25 x 19½)
Samuel Laurence, signed and dated
1865
Given by the sitter's son, Alan S.
Cole, 1913

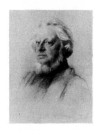

865 Plaster cast of bust 72.4
(28½) high
Sir Joseph Edgar Boehm, incised
and dated 1875
Purchased, 1891

Ormond

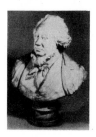

COLE, John Willoughby, 2nd Earl
of Enniskillen *See* ENNISKILLEN

COLE, Thomas
Divine

1719A Water-colour, oval
21 x 17.1 (8¼ x 6¾)
John Downman, signed with
initials and dated 1780
Bequeathed by the sitter's great-
grandson, William Comyns Clifton,
1913

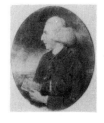

COLE, William Willoughby, 3rd
Earl of Enniskillen
See ENNISKILLEN

COLEBROOKE, Henry Thomas
(1765-1837) Sanskrit scholar;
founder of the Royal Asiatic
Society

316a(19) Pencil 37.5 x 22.2
(14¾ x 8¾)
Sir Francis Chantrey, c.1820
Given by Mrs George Jones, 1871
See Collections: Preliminary
drawings for busts and statues by
Sir Francis Chantrey, **316a(1-202)**

COLENSO, John William (1814-83)
Bishop of Natal

1080 Canvas 141 x 110.5
(55½ x 43½)
Samuel Sidley, signed and dated
1866
Given by the artist's family, 1897

COLEPEPER, John Colepeper, 1st
Baron (d. 1660) Politician

2666 Sepia and wash 34.9 x 27
(13¾ x 10⅝)
Attributed to George Perfect
Harding, inscribed below image, copy
Acquired, 1934

COLERIDGE, John Duke Coleridge,
1st Baron (1820-94) Judge

2702 Water-colour 30.5 x 18.1
(12 x 7⅛)
Carlo Pellegrini, signed *Ape*
(*VF* 5 March 1887)
Purchased, 1934

COLERIDGE, Bernard John
Seymour Coleridge, 2nd Baron
(1851-1927) Judge

3281 Water-colour 47 x 30.8
(18½ x 12⅛)
Sir Leslie Ward, signed *Spy*
(*VF* 13 Jan 1900)
Purchased, 1934

COLERIDGE, Samuel Taylor
(1772-1834) Poet

192 Canvas 55.9 x 45.7 (22 x 18)
Peter Vandyke, 1795
Purchased, 1865

452 Pencil and wash 17.8 x 15.6
(7 x $6\frac{1}{8}$)
Robert Hancock, 1796
Purchased, 1877

184 Canvas 114.3 x 87.6
(45 x 34½)
Washington Allston, signed and
dated 1814
Purchased, 1864

COLERIDGE, Sara (1802-52)
Writer; daughter of Samuel Taylor
Coleridge

4029 With her cousin, Edith May
Warter (right)
Miniature on ivory 14.3 x 10.2
($5\frac{5}{8}$ x 4)
Edward Nash, 1820
Bequeathed by Edith May Warter's
granddaughter, Mrs E. A. Boult, 1957

Ormond

COLET, John (1467?-1519)
Founder of St Paul's School

4823 Plaster cast of bust 83.8
(33) high
After Pietro Torrigiano
Purchased, 1970

COLLET, Joseph (1673-1725)
Merchant and administrator in
Sumatra and Madras

4005 Painted plaster statuette
83.8 (33) high
Amoy Chinqua, incised and dated
(on base)1716
Given by the sitter's descendant,
W.P.G Collet, 1956

Kerslake

COLLIER, John (1850-1934)
Painter and writer on art

4390 (possibly a sketch for
Groups, **4404**)
Pencil and chalk 26 x 19.7
(10¼ x 7¾)
Sydney Prior Hall, signed with
initials, c. 1895
Purchased, 1964

4404 *See Groups:* The St John's
Wood Arts Club, 1895, by Sydney
Prior Hall

COLLIER, Robert, Baron
Monkswell *See* MONKSWELL

COLLINGWOOD, Cuthbert
Collingwood, Baron (1750-1810)
Admiral

1496 Canvas 127 x 101.6 (50 x 40)
Henry Howard, 1828 (based on
painting of 1807 by Giuseppe Politi)
Purchased, 1908

1296 Marble bust 81.3 (32) high
Attributed to John Graham Lough,
c. 1845
Purchased, 1901

COLLINS, Mr

P22(2,24) *See Collections:* The
Balmoral Album, 1854-68, by
George Washington Wilson, W. & D.
Downey, and Henry John Whitlock,
P22(1-27)

COLLINS, Norman Richard
(b. 1907) Television administrator
and writer

4529(90-2) *See Collections:*
Working drawings by Sir David Low,
4529(1-401)

COLLINS, William (1788-1847)
Landscape and genre painter

1643 Chalk 51.4 x 39.4
(10¼ x 15½)
Charles Allston Collins (his son),
1846
Purchased, 1912

COLLINS, William Wilkie (1824-89)
Novelist

967 Panel 26.7 x 17.8 (10½ x 7)
Sir John Everett Millais, signed in
monogram and dated 1850
Purchased, 1894

2703 Water-colour 30.5 x 18.1
(12 x 7⅛)
Adriano Cecioni
(*VF* 3 Feb 1872)
Purchased, 1934

3333 Canvas 66.7 x 54 (26¼ x 21¼)
Rudolph Lehmann, signed in
monogram and dated 1880
Given by Mrs R.C.Lehmann, 1947

COLLINSON, Peter (1694-1768)
Naturalist and antiquary

L152(21) Miniature on ivory, oval
3.5 x 2.5 (1⅜ x 1)
Nathaniel Hone, signed in
monogram and dated 1765
Lent by NG (Alan Evans Bequest),
1975

COLLINSON, Sir Richard (1811-83)
Admiral

1221 Canvas 39.4 x 33 (15½ x 13)
Stephen Pearce, 1855
Bequeathed by John Barrow, 1899
See Collections: Arctic Explorers,
1850-86, by Stephen Pearce,
904-24 and **1209-27**

914 *See Collections:* Arctic
Explorers, 1850-86, by Stephen
Pearce, **904-24** and **1209-27**

COLMAN, George (1732-94)
Playwright

1364 Canvas 73.7 x 62.2
(29 x 24½)
Studio of Sir Joshua Reynolds,
c.1770
Purchased, 1904

59 Canvas 72.4 x 59.1
(28½ x 23¼)
Thomas Gainsborough, c.1778
Purchased, 1859

COLONSAY AND ORONSAY,
Duncan McNeill, Baron
(1793-1874) Judge

2627 Water-colour 27.9 x 17.1
(11 x 6¾)
Sir Leslie Ward, signed *Spy*
(*VF* 13 Sept 1873)
Purchased, 1933

Ormond

COLOROSSI, Alessandro
Italian model

P18(69) *See Collections:* The
Herschel Album, by Julia Margaret
Cameron, **P18(1-92b)**

COLQUHOUN, Robert (1914-62)
Painter

4872 Pencil 34.9 x 24.8
(13¾ x 9¾)
Self-portrait, inscribed and dated
1940
Purchased, 1972

COLVER, Nathaniel
American slavery abolitionist

599 *See Groups:* The Anti-Slavery
Society Convention, 1840, by
Benjamin Robert Haydon

COLVILLE, Charles John Colville,
1st Viscount (1818-1903)
Representative peer

1834(h) *See Collections:* Members
of the House of Lords, c. 1870-80,
by Frederick Sargent, **1834(a-z** and
aa-hh)

COLVILLE, John Colville, 10th
Baron (1768-1849)

999 *See Groups:* The Trial of
Queen Caroline, 1820, by Sir
George Hayter

1695(n) *See Collections:* Sketches
for The Trial of Queen Caroline,
1820, by Sir George Hayter,
1695(a-x)

COLVIN, Sir Sidney (1845-1927)
Literary critic and art historian

3999 Lithograph 27 x 19.7
($10\frac{5}{8}$ x 7¾)
Sir William Rothenstein, signed,
and on stone signed with initials
and dated 1897
Purchased, 1966

COMBE, George (1788-1858)
Phrenologist

P6(87) Photograph: calotype
20.3 x 15.2 (8 x 6)
David Octavius Hill and Robert
Adamson, 1843-8
Given by an anonymous donor,
1973
See Collections: The Hill and
Adamson Albums, 1843-8, by
David Octavius Hill and Robert
Adamson, **P6(1-258)**

COMBE, William (1741-1823)
Author of *Doctor Syntax*

2029 Pencil 29.8 x 22.5
(11¾ x $8\frac{7}{8}$)
George Dance, signed and dated
1793
Given by John Lane, 1924

COMBERMERE, Stapleton Cotton,
1st Viscount (1773-1865)
Field-Marshal

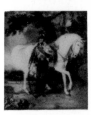

4177 Water-colour 59.7 x 53.3
(23½ x 21)
Thomas Heaphy, signed and dated
1817
Given by Edward Peter Jones, 1960

351 Canvas 127.6 x 102.2
(50¼ x 40¼)
Mary Martha Pearson, signed and
dated 1825
Given by the sitter's widow, 1872

COMMERELL, Sir John Edmund
(1829-1901) Admiral

4060 Water-colour 30.2 x 18.7
($11\frac{7}{8}$ x $7\frac{3}{8}$)
Théobald Chartran, signed . *T.*
(*VF* 24 Dec 1881)
Purchased, 1958

COMMYNS, A.
MP for Roscommon

2259 *See Collections:* The Parnell
Commission, 1888-9, by Sydney
Prior Hall, **2229-72**

COMPER, Sir John Ninian
(1864-1960) Church architect

4808 Canvas 61 x 50.8 (24 x 20)
Beatrice Bright, 1930s
Given by the sitter's son, J.Sebastian
Comper, 1970

COMPTON, Lord Alwyne
(1825-1906) Bishop of Ely

2369 *See Groups:* The Education
Bill in the House of Lords, by
Sydney Prior Hall

COMPTON, Henry (1632-1713)
Bishop of London

152a *See Groups:* Medal depicting
Henry Compton, Bishop of London,
and the Seven Bishops Committed
to the Tower in 1688, by George
Bower

2952 Canvas 75.6 x 63.5
(29¾ x 25)
Sir Godfrey Kneller, signed in
monogram, c. 1700
Purchased, 1936

Piper

COMPTON, Spencer, 2nd Earl of
Northampton
See NORTHAMPTON

COMPTON, Spencer, Earl of
Wilmington
See WILMINGTON

COMPTON, Spencer Joshua
Alwyne, 2nd Marquess of
Northampton
See NORTHAMPTON

COMPTON, Sir William (1625-63)
Royalist commander

1522 Canvas 125.1 x 101
(49¼ x 39¾)
Henry Paert after Sir Peter Lely
(c. 1655), inscribed
Purchased, 1908

Piper

CONDER, Charles (1868-1909)
Painter

2558 Pencil 26.4 x 36.2
(10⅜ x 14¼)
Sir William Rothenstein, 1896
Purchased, 1932

4556 Chalk 38.7 x 27 (15¼ x 10⅝)
Self-portrait, 1905
Purchased, 1967

CONDER, Josiah (1789-1855)
Bookseller

599 *See Groups:* The Anti-Slavery
Society Convention, 1840, by
Benjamin Robert Haydon

CONGREVE, William (1670-1729)
Dramatist

3199 Canvas 91.4 x 71.1 (36 x 28)
Sir Godfrey Kneller, signed and
dated 1709
Kit-cat Club portrait
Given by NACF, 1945

67 Canvas, feigned oval
76.2 x 62.2 (30 x 24½)
Studio of Sir Godfrey Kneller,
c.1709
Purchased, 1859. *Beningbrough*

Piper

CONGREVE, Sir William, Bt
(1772-1828) Military inventor

1075,1075a and **b** *See Groups:*
Men of Science Living in 1807-8,
by Sir John Gilbert and others

982f Canvas 75.6 x 62.9
(29¾ x 24¾)
James Lonsdale, c.1812
Acquired before 1896

CONINGSBY, Sir Thomas
(1551-1625) Soldier

4348 Panel 94 x 69.9 (37 x 27½)
Attributed to George Gower,
inscribed and dated 1572
Purchased, 1964. *Montacute*

Strong

CONNARD, Philip (1875-1958)
Painter

4702 Hardboard 50 x 40
(19⅝ x 15¾)
Self-portrait
Given by Miss Gabrielle Cross,
1970

**CONNAUGHT AND
STRATHEARN,** Arthur, 1st Duke
of (1850-1942) Field-Marshal;
son of Queen Victoria

P26 *See Groups:* The Royal
Family . . . , by L. Caldesi

3083 *See Groups:* The Opening
of the Royal Albert Infirmary at
Bishop's Waltham, 1865, by FW

P22(2,3) *See Collections:* The
Balmoral Album, 1854-68, by
George Washington Wilson, W. & D.
Downey, and Henry John Whitlock,
P22(1-27)

CONNORS, Patrick
Soldier

P18(30) *See Collections:* The
Herschel Album, by Julia Margaret
Cameron, **P18(1-92b)**

CONOLLY, Arthur (1807-42)
Asiatic traveller

825 Water-colour 24.1 x 16.5
(9½ x 6½)
James Atkinson, inscribed, c.1840
Given by the artist's son, Canon
J.A.Atkinson, 1889

Ormond

CONOLLY, Edmund Michael
(1786-1848)
 MP for County Donegal

54 *See Groups:* The House of Com-
mons, 1833, by Sir George Hayter

CONRAD, Joseph (1857-1924)
Novelist

2097 Pastel 21.6 x 19.7 (8½ x 7¾)
Sir William Rothenstein, 1903
Given by Mrs Emile Mond, 1925

2207 Pencil 34.6 x 24.1
(13⅝ x 9½)
Sir William Rothenstein, signed
with initials and dated 1916
Given by Lady Gosse and family,
1928

1985 Chalk and wash 30.5 x 22.9
(12 x 9)
Percy Anderson, signed in
monogram and dated 1918
Given by Sir Sidney Colvin, 1923

2220 Canvas 85.1 x 69.9
(33½ x 27½)
Walter Tittle, signed, 1923-4
Given by Lord Duveen, 1931

2482 Etching 18.4 x 14.9
(7¼ x 5⅞)
Walter Tittle, signed below plate,
and signed and dated 1924 on plate
Purchased, 1930

4159 Bronze cast of bust 43.2
(17) high
Sir Jacob Epstein, 1924
Purchased, 1960

4529(93,94) *See Collections:*
Working drawings by Sir David
Low, **4529(1-401)**

CONROY, Sir John, Bt
(1786-1854) Man of fashion

2175 Miniature on ivory
15.5 x 11.4 (6⅛ x 4½)
Alfred Tidey, inscribed and dated
on backcard 1836
Purchased, 1927
Ormond

CONSTABLE, John (1776-1837)
Landscape painter

1786 Canvas 76.2 x 63.8
(30 x 25⅛)
Ramsay Richard Reinagle, c. 1799
Given by NACF, 1917

901 Pencil and chalk 24.8 x 19.4
(9¾ x 7⅝)
Self-portrait, c. 1800
Purchased, 1892

1458 Pencil 14.9 x 11.4
(5⅞ x 4½)
Daniel Maclise, c. 1831
Purchased, 1907

4063 Bronze cast of death-mask
25.4 (10) long
Samuel Joseph
Given by the President and Council
of the Royal Academy, 1958

CONSTABLE, William George
(1887-1976) Art critic and historian

5090 Canvas 62.2 x 76.2
(24½ x 30)
Elizabeth Polunin, signed, c. 1936
Bequeathed by the sitter, 1976

CONWAY, William Conway, 1st
Baron (1856-1937) Mountaineer,
writer and critic

4019 Medallion 9.8 (3⅞) diameter
Edward Onslow Ford, inscribed and
dated 1893
Given by wish of Charles ffoulkes,
1957

CONWAY, Henry Seymour
(1721-95) Field-Marshal

1757 Wax medallion 10.2 x 7.6
(4 x 3)
Isaac Gosset, 1760
Purchased, 1915

COOK, George (1772-1845)
Philosopher

P6(13) *See Collections:* The Hill
and Adamson Albums, 1843-8, by
David Octavius Hill and Robert
Adamson, **P6(1-258)**

COOK, James (1728-79)
Circumnavigator

26 Canvas, feigned oval
36.8 x 29.2 (14½ x 11½)
John Webber, 1776
Purchased, 1858

984 Marble bust 58.4 (23) high
Lucien Le Vieux, incised and dated
1790
Purchased, 1895

COOK, Sir Joseph (1860-1947)
Prime Minister of Australia

2463 *See Groups:* Statesmen of
World War I, by Sir James Guthrie

COOPER, Abraham (1787-1868)
Painter

1456(2) Pencil 8.3 x 8.6 (3¼ x 3⅜)
Charles Hutton Lear, inscribed,1845
Given by John Elliot, 1907
See Collections: Drawings of Artists,
c. 1845, by Charles Hutton Lear,
1456(1-27)

3182(1,19) *See Collections:*
Drawings of Artists, c. 1862, by
Charles West Cope, **3182(1-19)**

Ormond

COOPER, Sir Alfred (1838-1908)
Surgeon

5013 Water-colour 39.4 x 25.7
(15½ x 10⅛)
Sir Leslie Ward, signed *Spy*
(*VF* 30 Dec 1897)
Purchased, 1974

COOPER, Alfred Duff, 1st Viscount
Norwich *See* NORWICH

COOPER, Anthony Ashley, 1st
Earl of Shaftesbury
See SHAFTESBURY

COOPER, Sir Astley Paston, Bt
(1768-1841) Surgeon

316a(20) Pencil, two sketches
50.8 x 68.6 (20 x 27)
Sir Francis Chantrey, inscribed,
c. 1825
Given by Mrs George Jones, 1871
See Collections: Preliminary
drawings for busts and statues by
Sir Francis Chantrey, **316a(1-202)**

316a(21) *See Collections:*
Preliminary drawings for busts and
statues by Sir Francis Chantrey,
316a(1-202)

COOPER, Cropley Ashley, 6th Earl
of Shaftesbury
See SHAFTESBURY

COOPER, Lady Diana
See NORWICH, Viscountess

COOPER, Joseph (1800-81)
Slavery abolitionist

599 *See Groups:* The Anti-Slavery
Society Convention, 1840, by
Benjamin Robert Haydon

COOPER, Samuel (1609-72)
Miniature painter

2891 Wash 15.9 x 11.7 (6¼ x 4⅝)
After a self-portrait, inscribed
below drawing
Purchased, 1936

Piper

COOPER, Sidney

1841B *See Groups:* Four men at
cards, by Fred Walker

COOPER, Thomas Sydney
(1803-1902) Animal painter

3236 Canvas 61 x 50.8 (24 x 20)
Walter Scott, 1841
Purchased, 1945

Ormond

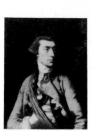

COOTE, Sir Charles Henry, Bt
(1802-64) MP for Queen's County

54 *See Groups:*The House of Com-
mons, 1833, by Sir George Hayter

COOTE, Sir Eyre (1726-83)
General

124 Canvas 74.9 x 61.6
(29½ x 24¼)
Henry Morland, c. 1763
Purchased, 1861

COPE, Sir John (1690-1760)
Military commander

4855(46,47) *See Collections:*
The Townshend Album, **4855(1-73)**

COPLEY, John Singleton
(1737-1815) Painter

2143 Canvas, oval 67.3 x 56.5
(26½ x 22¼)
Gilbert Stuart, c. 1784
Bequeathed by Lady Lyndhurst,
1927

COPLEY, John Singleton, Baron
Lyndhurst *See* LYNDHURST

CORAM, Thomas (1668?-1751)
Philanthropist

2427 Pencil(?) and wash, feigned
irregular oval 22.9 x 19.1 (9 x 7½)
After William Hogarth (1740)
Purchased, 1927

2351 *See Unknown Sitters III*

Kerslake

CORBET, Mathew Ridley
(1850-1902) Painter

1867 Canvas 44.5 x 59.7
(17½ x 23½)
John McLure Hamilton, signed,
inscribed and dated 1893
Given by the artist, 1920

CORBOULD, Alfred Chantrey
(d. 1920) Painter and illustrator

2436 Oil on paper 34 x 24.4
(13⅜ x 9⅝)
Phil May, 1897
Given by Mrs Gabrielle Enthoven,
1926

CORELLI, Marie
See MACKAY, Mary

CORFE, Charles William (1814-83)
Organist at Christ Church, Oxford;
composer

P7(9) Photograph: albumen print
14.3 x 12.1 (5⅝ x 4¾)
Charles Lutwidge Dodgson,
inscribed below image, c. 1856
Purchased with help from Kodak
Ltd, 1973
See Collections: Lewis Carroll at
Christ Church, by Charles Lutwidge
Dodgson, **P7(1-37)**

CORK, Richard Boyle, 1st Earl of
(1566-1643) Irish statesman

2494 Miniature on vellum, oval
4.8 x 3.8 (1⅞ x 1½)
Isaac Oliver
Bequeathed by Edmund Montagu
Boyle, 1931

Strong

CORK AND ORRERY, John Boyle,
5th Earl of (1707-62) Politician
and man of letters

4621 Canvas 62.9 x 50.8
(24¾ x 20)
Attributed to Isaac Seeman
Given by Hugh Leggatt, 1968

Kerslake

CORK AND ORRERY, Richard
Edmund St Lawrence Boyle, 9th
Earl of (1829-1904)
Representative peer

1823(i) *See Collections:* Members
of the House of Lords, c. 1870-80,
by Frederick Sargent, **1834(a-z and
aa-hh)**

CORNEWALL, Folliott Herbert
Walker (1754-1831)
Bishop of Worcester

999 *See Groups:* The Trial of
Queen Caroline, 1820, by Sir
George Hayter

CORNWALLIS, Charles Cornwallis,
1st Marquess (1738-1805)
General and diplomat

281 Canvas, feigned oval
74.9 x 62.2 (29½ x 24½)
Thomas Gainsborough, inscribed
and dated 1783
Purchased, 1869

4316 Pencil and wash, feigned
oval 18.4 x 16.8 (7¼ x 6⅝)
John Smart, signed, inscribed and
dated 1792
Purchased, 1963

CORNWALLIS, Charles Cornwallis, 2nd Marquess (1774-1823) Sportsman

999 *See Groups:* The Trial of Queen Caroline, 1820, by Sir George Hayter

CORNWALLIS, Charles Cornwallis, 4th Baron (1675-1722) Whig politician

3200 Canvas 91.4 x 71.1 (36 x 28) Sir Godfrey Kneller, signed in monogram, c. 1705-15 Kit-cat Club portrait Given by NACF, 1945. *Beningbrough*

Piper

CORNWALLIS, Sir Charles (d. 1629) Diplomat

4867 Panel 113 x 83.2 (44½ x 32¾) Unknown artist, inscribed Purchased, 1972. *Montacute*

CORRIE, George Elwes (1793-1885) Anglican divine and theologian

2173(20,21) *See Collections:* Book of sketches by Sebastian Evans, **2173(1-70)**

CORRY, Henry Thomas Lowry (1803-73)

54 *See Groups:*The House of Commons, 1833, by Sir George Hayter

4893 *See Groups:* The Derby Cabinet of 1867, by Henry Gales

COSTER, Howard (1885-1959) Photographer

5196 Pencil 37.5 x 27.3 (14¾ x 10¾) Eric Gill, signed and dated 1931 Purchased, 1978

COSWAY, Richard (1740-1821) Miniature painter

1437, 1437a *See Groups:* The Academicians of the Royal Academy, 1771-2, by John Sanders after Johan Zoffany

304 Pencil and wash, oval 10.5 x 7.9 (4⅛ x 3⅛) Self-portrait Given by Miss G.M.Zornlin, 1870

1678 Panel, oval 15.6 x 13.3 (6⅛ x 5¼) Self-portrait Given by Heber Mardon, 1912

COTMAN, John Sell (1782-1842) Landscape painter

1372 Pencil and wash 27.3 x 21 (10¾ x 8¼) Horace Beevor Love, signed and dated 1830 Purchased, 1904

COTTENHAM, Charles Pepys, 1st Earl of (1781-1851) Lord Chancellor

54 *See Groups:*The House of Commons, 1833, by Sir George Hayter

5149 Canvas 102.2 x 78.7 (40¼ x 31) Charles Robert Leslie, exh 1840 Purchased, 1977

COTTESLOE, Thomas Francis
Fremantle, 1st Baron (1798-1890)
Politician

54 *See Groups:* The House of Commons, 8133, by Sir George Hayter

3190 Water-colour 30.8 x 18.1
($12\frac{1}{8}$ x $7\frac{1}{8}$)
Sir Leslie Ward, signed *Spy*
(*VF* 22 July 1876)
Purchased, 1945

Ormond

COTTINGTON, Francis Cottington,
1st Baron (1578-1652) Politician

605 Canvas 73 x 58.4 (28¾ x 23)
Unknown artist, inscribed and
dated 1634?
Purchased, 1880

Piper

COTTLE, Amos Simon (1766-1800)
Translator and poet

2470 Canvas 40.6 x 33 (16 x 13)
William Palmer, 1787
Purchased, 1930

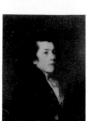

COTTON, Captain

316a(22) *See Collections:*
Preliminary drawings for busts and
statues by Sir Francis Chantrey,
316a(1-202)

COTTON, Sir Henry (1821-92)
Judge

4240 Chalk 48.9 x 37.5
(19¼ x 14¾)
George Richmond, 1875
Given by Kenneth Guichard,1961

2704 Water-colour 30.2 x 18.1
($11\frac{7}{8}$ x $7\frac{1}{8}$)
Sir Leslie Ward, signed *Spy*
(*VF* 19 May 1888)
Purchased, 1934

COTTON, Sir Henry James
Stedman (1845-1917)

P18(65,80,88) *See Collections:*
The Herschel Album, by Julia
Margaret Cameron, **P18(1-92b)**

COTTON, Jack (1903-64)
Property entrepreneur

4529(95-7) *See Collections:*
Working drawings by Sir David Low,
4529(1-401)

COTTON, Mary (née Ryan), Lady
(1848-1914) Wife of Sir Henry
James Stedman Cotton

**P18(28,48,51,55,65,66,77,80,86,
92)** *See Collections:* The Herschel
Album, by Julia Margaret Cameron,
P18(1-92b)

COTTON, Richard Lynch
(1794-1880) Provost of Worcester
College, Oxford

4541(9) *See Collections:* The
Pusey family and their friends,
c.1856, by Clara Pusey, **4541(1-13)**

COTTON, Sir Robert Bruce
(1571-1631) Antiquary

534 Canvas 76.2 x 63.5 (30 x 25)
After Cornelius Johnson (1629),
inscribed
Transferred from BM, 1879

4270 *See Unknown Sitters I*

Strong

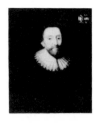

COTTON, Stapleton, 1st Viscount
Combermere *See* COMBERMERE

COTTON, Sir William (1822-1902)
Lord Mayor of London

3282 Water-colour 30.5 x 18.1
(12 x 7$\frac{1}{8}$)
Sir Leslie Ward, signed *Spy*
(*VF* 5 Sept 1885)
Purchased, 1934

COTTON, Sir Willoughby
(1783-1860) General

824 Water-colour 24.1 x 16.5
(9½ x 6½)
James Atkinson, inscribed, c.1838
Given by the artist's son, Canon
J.A.Atkinson, 1889

4026(15) *See Collections:*
Drawings of Men about Town,
1832-48, by Alfred, Count D'Orsay,
4026(1-61)

Ormond

COURAYER, Pierre François Le
(1681-1776) French divine

5177 Canvas, painted cartouche
76.2 x 63.2 (30 x 24$\frac{7}{8}$)
Unknown artist, inscribed
Purchased, 1978

COURTNEY of Penwith, Leonard
Courtney, 1st Baron (1832-1918)
Politician

4633 Water-colour 30.8 x 18.1
(12$\frac{1}{8}$ x 7$\frac{1}{8}$)
Théobald Chartran
(*VF* 25 Sept 1880)
Purchased, 1968

2321 *See Collections:*
Miscellaneous drawings . . . by
Sydney Prior Hall, **2282-2348**
and **2370-90**

COURTNEY, William Leonard
(1850-1928)
Philosopher and journalist

3443 *See Collections:* Prominent
Men, c. 1880-c.1910, by Harry
Furniss, **3337-3535** and **3554-3620**

COUSINS, Samuel (1801-87)
Engraver

1447 Canvas 91.4 x 71.1 (36 x 28)
James Leakey, inscribed, 1843
Given by the artist's daughter,
Emily Leakey, 1906

3182(3) *See Collections:* Drawings
of Artists, c. 1862, by Charles West
Cope, **3182(1-19)**

1751 Pen and wash 16.2 x 14
(6$\frac{3}{8}$ x 5½)
Frank Holl, 1879
Given by Ernest E. Leggatt, 1915

Ormond

COUTTS, Charlie
Queen Victoria's gillie

P22(10,17) *See Collections:* The
Balmoral Album, 1854-68, by
George Washington Wilson, W. & D.
Downey, and Henry John Whitlock,
P22(1-27)

COVENTRY, George William
Coventry, 7th Earl of (1758-1831)

999 *See Groups:* The Trial of
Queen Caroline, 1820, by Sir
George Hayter

COVENTRY, George William
Coventry, 8th Earl of (1784-1843)

999 *See Groups:* The Trial of
Queen Caroline, 1820, by Sir
George Hayter

COVENTRY, Thomas Coventry, 1st
Baron (1578-1640) Lord Keeper

716 Canvas 76.2 x 63.5 (30 x 25)
After Cornelius Johnson (c. 1634)
Given by Barnard's Inn, 1884

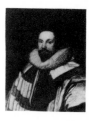

Continued overleaf

4815 Canvas 126.4 x 100.3
(49¾ x 39½)
Cornelius Johnson, signed with
initials and dated 1639
Purchased, 1970. *Montacute*

Piper

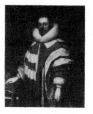

COWAN, Henry Vivian (1854-1918)
Colonel

4039(1) Water-colour and pencil
29.8 x 24.1 (11¾ x 9½)
Inglis Sheldon-Williams, signed,
inscribed and dated by artist and
sitter 1900
Purchased, 1957
See Collections: Boer War Officers,
1900, by Inglis Sheldon-Williams,
4039(1-7)

COWAN, Sir Walter Henry
(1871-1958) Admiral

1913 *See Groups:* Naval Officers
of World War I, by Sir Arthur
Stockdale Cope

COWANS, Sir John Steven
(1862-1921) General

1954 *See Groups:* General Officers
of World War I, by John Singer
Sargent

COWARD, Sir Noel (1899-1973)
Actor and playwright

4950 Canvas 51 x 41 (20⅛ x 16⅛)
Clemence Dane, signed, before 1939
Bequeathed by the sitter, 1973

4951 Bronze bust 56.5 (22¼) high
Clemence Dane, c. 1939
Bequeathed by the sitter, 1973

COWLEY, Abraham (1618-67)
Poet

74 Canvas 74.9 x 62.9
(29½ x 24¾)
After Sir Peter Lely (c. 1660)
Purchased, 1859

4215 Canvas 121.9 x 101.6
(48 x 40)
Sir Peter Lely, inscribed, c.1666-7
Purchased, 1961

659 *See Unknown Sitters II*

Piper

COWPER, William Cowper, 1st
Earl (1665?-1723) Lord Chancellor

736 Canvas 74. 9 x 52.7
(29½ x 20¾)
By or after Jonathan Richardson,
c. 1710?
Purchased, 1885

1228 Canvas 75.6 x 62.9
(29¾ x 24¾)
Sir Godfrey Kneller, signed,
inscribed and dated 1722
Given by Earl Cowper, 1899

Piper

COWPER, Peter Nassau Cowper,
5th Earl (1778-1837)

999 *See Groups:* The Trial of
Queen Caroline, 1820, by Sir
George Hayter

COWPER, Charles Spencer
(1816-79) Son of 5th Earl Cowper

4026(16) *See Collections:*
Drawings of Men about Town,
1832-48, by Alfred, Count D'Orsay,
4026(1-61)

COWPER, Henry (1758-1840)
Lawyer

999 *See Groups:* The Trial of
Queen Caroline, 1820, by Sir
George Hayter

316a(23) Pencil, two sketches
41.1 x 63.2 (16$\frac{1}{8}$ x 24$\frac{7}{8}$)
Sir Francis Chantrey, inscribed,
1823-7
Given by Mrs George Jones, 1871
See Collections: Preliminary
drawings for busts and statues by
Sir Francis Chantrey, **316a(1-202)**

COWPER, William (1731-1800)
Poet

2783 Canvas 127 x 101.6 (50 x 40)
Lemuel Francis Abbott, 1792
Purchased, 1935

806 Water-colour and pencil
26.3 x 17.5 (10$\frac{3}{8}$ x 6$\frac{7}{8}$)
William Harvey after Lemuel
Francis Abbott, inscribed
Given by W.J.Loftie, 1888

1423 Pastel 57.2 x 47 (22½ x 18½)
George Romney, 1792
Purchased, 1905

972 *See Unknown Sitters III*

COX, David (1783-1859)
Landscape painter

1403 Canvas 76.5 x 63.5
(30$\frac{1}{8}$ x 25)
William Radclyffe, 1830
Purchased, 1905

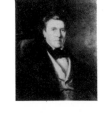

1074 Pencil 13.3 x 10.2 (5¼ x 4)
Unknown artist, inscribed and
dated 1855
Purchased, 1896

1986 Canvas 61 x 50.8 (24 x 20)
Sir William Boxall, 1856
Bequeathed by the sitter's son,
David Cox, 1923

Ormond

COX, Francis Augustus (1783-1853)
Baptist preacher

599 *See Groups:* The Anti-Slavery
Society Convention, 1840, by
Benjamin Robert Haydon

COX, Harold (1859-1936)
Economist and journalist

3560 *See Collections:* Prominent
Men, c. 1880-c. 1910, by Harry
Furniss, **3337-3535** and **3554-3620**

COX, Joseph R.
MP for East Clare

2246 *See Collections:* The Parnell
Commission, 1888-9, by Sydney
Prior Hall, **2229-72**

COXE, William (1747-1828)
Historian

3911 Water-colour 18.4 x 14.9
(7¼ x 5$\frac{7}{8}$)
Unknown artist, c. 1820
Purchased, 1954

CRABBE, George (1754-1832)
Poet

1495 Canvas 75.9 x 63.5
(29$\frac{7}{8}$ x 25)
Henry William Pickersgill, c.1818-19
Purchased, 1908

Continued overleaf

316a(24a) Pencil 44.5 x 32.4
(17½ x 12¾)
Sir Francis Chantrey, inscribed and
dated 1821
Given by Mrs George Jones, 1871

and

316a(24b) (reverse of preceding)
Pencil 44.5 x 32.4 (17½ x 12¾)
Sir Francis Chantrey, inscribed and
dated 1821
Given by Mrs George Jones, 1871
See Collections: Preliminary
drawings for busts and statues by
Sir Francis Chantrey, **316a(1-202)**

CRADOCK, Sir Christopher
(1862-1914) Admiral

1913 *See Groups:* Naval Officers
of World War I, by Sir Arthur
Stockdale Cope

CRAGGS, James, the Elder
(1657-1721) Financier

1733 Canvas 127 x 101.6 (50 x 40)
Attributed to John Closterman,
inscribed, c.1710
Purchased, 1914

Piper

CRAGGS, James, the Younger
(1686-1721) Secretary of State

1134 Canvas 123.2 x 100.3
(48½ x 39½)
Studio of Sir Godfrey Kneller,
inscribed (c. 1708)
Purchased, 1898

Piper

CRAIG, Edward Gordon
(1872-1966) Actor, producer-
designer and writer

5224(6) *See Collections:*
Cartoons, c.1928-c.1936, by Robert
Stewart Sherriffs, **5224(1-9)**

CRAIG, Colonel P.

1752 *See Groups:* The Siege of
Gibraltar, 1782, by George Carter

CRAIK, Dinah Maria (née Mulock)
(1826-87) Novelist; author of
John Halifax, Gentleman

2544 (With another sketch of
Mrs Craik on reverse)
Pencil 17.1 x 13.3 (6¾ x 5¼)
Amelia Robertson Hill (née Paton),
signed, inscribed and dated 1845
Given by J.K.Richardson, 1932

3304 Canvas 120.7 x 92.7
(47½ x 36½)
Sir Hubert von Herkomer, signed
with initials and dated 1887
Given by wish of the sitter's
husband, 1946

CRAMER, Johann Baptist
(1771-1858) Pianist

5190 Miniature on ivory
15.5 x 12.4 ($6\frac{1}{8}$ x $4\frac{7}{8}$)
George Lethbridge Saunders, signed,
inscribed and dated on backing
paper 1827
Purchased, 1978

CRAMER, John Anthony
(1793-1848) Historian

2515(72) Chalk 35.3 x 26
($13\frac{7}{8}$ x 10¼)
William Brockedon, dated 1834
Lent by NG, 1959
See Collections: Drawings of
Prominent People, 1823-49, by
William Brockedon, **2515(1-104)**

Ormond

CRANBOURNE, Viscount
See SALISBURY, 1st Earl of

CRANBROOK, Gathorne Gathorne-
Hardy, 1st Earl of (1814-1906)
Statesman

1449 Pencil and chalk 78.7 x 63.5
(31 x 25)
George Richmond, signed and
dated 1857
Given by the sitter's son, the Earl
of Cranbrook, 1906

4893 *See Groups:* The Derby Cabinet of 1867, by Henry Gales

2173(46) Pencil 8.9 x 6 (3½ x 2⅜)
Sebastian Evans, inscribed and dated 1883
Given by George Hubbard, 1927
See Collections: Book of sketches by Sebastian Evans, **2173(1-70)**

3353 *See Collections:* Prominent Men, c. 1880-c.1910, by Harry Furniss, **3337-3535** and **3554-3620**

CRANE, Walter (1845-1915)
Decorative artist

1750 Canvas 64.8 x 54.6 (25½ x 21½)
George Frederic Watts, 1891
Given by wish of the artist, 1915

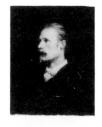

CRANMER, Thomas (1489-1556)
Archbishop of Canterbury

535 Panel 98.4 x 76.2 (38¾ x 30)
Gerlach Flicke, signed, inscribed and dated 1546
Transferred from BM, 1879

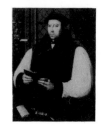

4165 *See Groups:* Edward VI and the Pope, by an unknown artist

Strong

CRANWORTH, Robert Monsey Rolfe, Baron (1790-1868)
Lord Chancellor

1125,1125a *See Groups:* The Coalition Ministry, 1854, by Sir John Gilbert

285 Canvas 139.7 x 109.9 (55 x 43¼)
George Richmond, 1860-2
Bequeathed by the sitter, 1869

Ormond

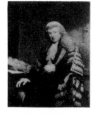

CRAVEN, William Craven, 1st Earl of (1606-97)
Soldier and Royalist

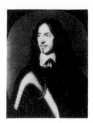

4517 Canvas, feigned oval 73 x 59.7 (28¾ x 23½)
Attributed to Princess Louise, dated 1647
Purchased, 1966

3018 Ink and wash 13.3 x 9.8 (5¼ x 3⅞)
George Perfect Harding after a portrait of c.1650, signed and inscribed
Purchased, 1938

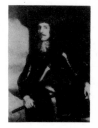

270 Canvas 114.3 x 90.2 (45 x 35½)
Unkown artist
Given by the Earl of Craven, 1868

Piper

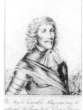

CRAVEN, William Craven, 2nd Earl of (1809-66) Lord-Lieutenant of Warwickshire

4026(17) *See Collections:* Drawings of Men about Town, 1832-48, by Alfred, Count D'Orsay **4026(1-61)**

CRAVEN, Keppel Richard (1779-1851) Traveller

4026(18) Pencil and chalk 16.5 x 12.7 (6½ x 5)
Alfred, Count D'Orsay, signed, inscribed and dated 1832
Purchased, 1957
See Collections: Drawings of Men about Town, 1832-48, by Alfred, Count D'Orsay, **4026(1-61)**

CRAWFORD, James Lindsay,
26th Earl of (1847-1913)
Scientist

2705 Water-colour 33.7 x 21.9
(13¼ x 8⅝)
Sir Leslie Ward, signed *Spy*
(*VF* 11 May 1878)
Purchased, 1934

CRAWFORD, David Lindsay,
27th Earl of (1871-1940)
Politician and connoisseur

4771 Chalk 38.7 x 28.9
(15¼ x 11⅜)
Sir William Rothenstein, c.1938
Purchased, 1970

3088 Canvas 127 x 101.6 (50 x 40)
Sir James Gunn, signed, 1939
Purchased, 1940

CREALOCK, Henry Hope
(1831-91) Soldier, artist
and writer

2191 Millboard, oval 41.9 x 34.3
(16½ x 13½)
Robert Russ, signed and dated 1869
Given by the sitter's niece, Miss
Edith Price, 1928

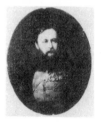

2898 Water-colour 34.9 x 22.9
(13¾ x 9)
Sir Leslie Ward
(study for *VF* 15 March 1879)
Given by Viscount Ullswater,
1936

CREIGHTON, Mandell (1843-1901)
Bishop of London

2706 Water-colour 35.3 x 23.5
(13⅞ x 9¼)
F.T. Dalton, signed *F.T.D.*
(*VF* 22 April 1897)
Purchased, 1934

1335 Canvas 120.7 x 96.5
(47½ x 38)
Sir Hubert von Herkomer, signed
with initials and dated 1902
Given by Creighton Memorial
Committee, 1902

CRESWICK, William (1813-88)
Actor

2450 Water-colour 35.6 x 24.1
(14 x 9½)
Alfred Bryan, signed with initials
Purchased, 1930

CREW, Nathaniel Crew, 3rd Baron
(1633-1722) Bishop of Durham

656 Canvas 76.2 x 62.9
(30 x 24¾)
After an unknown artist
(1675-85)
Purchased, 1882

Piper

CREWDSON, Isaac (1780-1844)
Writer

599 *See Groups:* The Anti-Slavery
Society Convention, 1840, by
Benjamin Robert Haydon

CREWDSON, William Dillworth
Slavery abolitionist

599 *See Groups:* The Anti-Slavery
Society Convention, 1840, by
Benjamin Robert Haydon

CREWE, Robert Crewe-Milnes, 1st Marquess of (1858-1945) Statesman

3849 Canvas 125.7 x 100.3 (49½ x 39½)
Walter Frederick Osborne, signed, before 1903
Given by members of the Crewe family, 1953

3354 *See Collections:* Prominent Men, c. 1880-c.1910, by Harry Furniss, **3337-3535** and **3554-3620**

4772 Pencil 38.1 x 27.6 (15 x 10⅞)
Sir William Rothenstein, 1918
Purchased, 1970

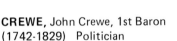

CREWE, John Crewe, 1st Baron (1742-1829) Politician

2076 *See Groups:* Whig Statesmen and their Friends, c. 1810, by William Lane

CRIGHTON, David Maitland McGill (1801-44?) Landowner; a lay leader of the Free Church

P6(81) *See Collections:* The Hill and Adamson Albums, 1843-8, by David Octavius Hill and Robert Adamson, **P6(1-258)**

CRIPPS, Joseph (1765-1847) MP for Cirencester

54 *See Groups:* The House of Commons, 1833, by Sir George Hayter

CRIPPS, Sir Stafford (1889-1952) Statesman

4672 Canvas 76.2 x 63.5 (30 x 25)
Isaac Michael Cohen, signed, exh 1931
Given by the sitter's widow, Dame Isobel Cripps, 1969

CRISTALL, Joshua (1767-1847) Painter and water-colourist

3944(55) *See Collections:* Artists, 1825, by John Partridge and others, **3944(1-55)**

1456(3) Chalk 8.3 x 7.9 (3¼ x 3⅛)
Charles Hutton Lear, inscribed and dated 1846
Given by John Elliot, 1907
See Collections: Drawings of Artists, c. 1845, by Charles Hutton Lear, **1456(1-27)**

Ormond

CROFT, William (c. 1677-1727) Musician

1192 Canvas 76.8 x 63.5 (30¼ x 25)
Unknown artist, c. 1690?
Purchased, 1899

Piper

CROKER, John Wilson (1780-1857) Politician and essayist

355 Canvas 76.2 x 63.5 (30 x 25)
William Owen, c. 1812
Given by Frederick Locker (afterwards Locker-Lampson),1872

CROKER, Thomas Crofton (1798-1854) Irish antiquary

4555 Millboard 35.6 x 25.4 (14 x 10)
Unknown artist, c.1849
Purchased, 1967

Ormond

CROLY, George (1780-1860) Writer and divine

2515(31) *See Collections:* Drawings of Prominent People, 1823-49, by William Brockedon, **2515(1-104)**

CROME, John (1768-1821)
Landscape painter and founder
of the Norwich School

1900 Plaster cast of bust, painted
black 66.7 (26¼) high
Pellegrino Mazzotti, c.1820
Given by Sir Charles Scott
Sherrington, 1921

2061 Water-colour and pencil
21.9 x 18.4 (8⅝ x 7¼)
Denis Brownell Murphy, exh 1821
Purchased, 1924

CROMER, Evelyn Baring, 1st Earl
of (1841-1917) Consul-General
in Egypt

2901 Canvas 165.1 x 91.4 (65 x 36)
John Singer Sargent, signed and
dated 1902
Purchased, 1977

CROMPTON, Samuel (1753-1827)
Inventor

1075,1075a and **b** *See Groups:*
Men of Science Living in 1807-8,
by Sir John Gilbert and others

CROMWELL, Elizabeth (née
Steward) (d.1654)
Mother of Oliver Cromwell

1771 *See Unknown Sitters II*

CROMWELL, Oliver (1599-1658)
Lord Protector of England

536 Canvas 125.7 x 101.6
(49½ x 40)
Robert Walker, c. 1649
Transferred from BM, 1879

4365 Silver medal, oval 3.5 x 2.8
(1⅜ x 1⅛)
Thomas Simon, inscribed and dated
1650
The Dunbar Medal
Given by the Cromwell Association,
in memory of the Rt Hon Isaac
Foot, 1964

747 Electrotype of the Dunbar
Medal (see no. **4365**)
Given by Herbert Appold Grueber,
1885. *Not illustrated*

1486 Electrotype from a silver
medal 3.5 (1⅜) diameter
Thomas Simon, inscribed, c. 1651
The Lord General Medal
Given by M.W.Fawcus, 1908

4366 Silver medal 3.8 (1½)
diameter
Thomas Simon, inscribed, 1653
The Lord Protector Medal
Given by the Cromwell Association,
in memory of the Rt Hon Isaac
Foot, 1964

5274 Miniature on vellum, oval
6 x 4.8 (2⅜ x 1⅞)
Attributed to Samuel Cooper,
c. 1655
Purchased, 1979

4068 Gold broad 2.8 (1⅛) diameter
Coined by Peter Blondeau from
designs by Thomas Simon,
inscribed and dated 1656
Purchased, 1958

3065 Miniature on vellum, oval
7 x 5.7 (2¾ x 2¼)
Samuel Cooper, signed in
monogram and dated 1656
Transferred from BM, 1939

514 Canvas, feigned oval
75.6 x 62.9 (29¾ x 24¾)
After Samuel Cooper (1656)
Purchased, 1879

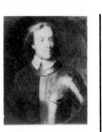

588 Canvas, feigned oval
22.2 x 16.5 (8¾ x 6½)
After Samuel Cooper (1656)
Transferred from BM, 1879

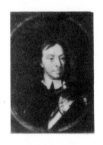

2426 Chalk and water-colour
14.6 x 12.1 (5¾ x 4¾)
Robert Hutchinson after a drawing
attributed to Samuel Cooper
Given by Miss Marshall, 1927

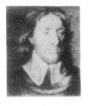

4025 Plaster cast of death-mask
28.6 (11¼) long
Unknown artist
Given by the Frankland family,
1957

3014 Plaster cast of death-mask,
with a bronze glaze
Unknown artist
(related to the Ashmolean Museum
death-mask)
Given by Miss Clare Atwood, 1939

1665 Plaster cast of death-mask
Unknown artist
(related to the Ashmolean Museum
death-mask)
Purchased, 1912

1238a Plaster cast of death-mask
D.Brucciani & Co, from the
Ashmolean Museum death-mask
Not illustrated

1238 Plaster cast of mask
From bust in Museo Nazionale,
Florence
Purchased, 1899

132 Terracotta bust 41.9 (16½) high
Unknown artist, based on a bust by
Edward Pierce
Purchased, 1861

438 Bronze cast of bust 63.5
(25) high
From a bust by Edward Pierce
Purchased, 1877

3087 Plaster cast of mask
Probably related to a bust by
Edward Pierce (see no.**438**)
Given anonymously, c.1920

982(g) *See Unknown Sitters II*

1517 *See Unknown Sitters II*
Piper

CROMWELL, Richard (1626-1712)
Lord Protector of England

4350 Miniature on vellum, oval
5.4 x 4.4 (2⅛ x 1¾)
Unknown artist
Purchased, 1964

1334 *See Unknown Sitters II*
Piper

CROMWELL, Thomas, Earl of
Essex *See* ESSEX

CROOKES, Sir William (1832-1919)
Chemist

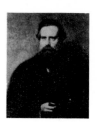

1846 Canvas 75.6 x 62.2
(29¾ x 24½)
Albert Ludovici, exh 1885
Given by the sitter's family, 1919

CROOKS, William (1852-1921)
Socialist politician

3561 *See Collections:* Prominent
Men, c. 1880-c.1910, by Harry
Furniss, **3337-3535** and **3554-3620**

CROPPER, John
Slavery abolitionist

599 *See Groups:* The Anti-Slavery
Society Convention, 1840, by
Benjamin Robert Haydon

CROSDILL, John (1751-1825)
Violoncellist

3089(4) Pencil 25.5 x 19.7
(10 x 7¾)
William Daniell after George Dance,
inscribed
Purchased, 1940
See Collections: Tracings of
drawings by George Dance,
3089(1-12)

CROSS, Richard Cross, 1st Viscount
(1823-1914) Statesman

2946 Canvas 134 x 99.1
(52¾ x 39)
Sir Hubert von Herkomer, signed
with initials and dated 1882
Given by Viscount Hambleden,1938

CROSS, John Green (1790-1850)
Surgeon

2083A Chalk and pencil
25.1 x 21 (9⅞ x 8¼)
Frederick Sandys
Given by the sitter's grandson,
Herbert Green, 1925

CROSS, Mary Ann (née Evans)
(1819-80) 'George Eliot' ; novelist

2645 Silhouette 11.4 x 7
(4½ x 2¾)
Unknown artist
Given by Miss Elsie Druce in
memory of her uncle, John Walter
Cross (the sitter's husband), 1933

1232 Water-colour 17.8 x 14.6
(7 x 5¾)
Caroline Bray, inscribed and dated
1842
Given by the artist, 1899

1405 Canvas 34.3 x 26.7
(13½ x 10½)
François D'Albert Durade, replica
(1849)
Purchased, 1905

669 Chalk 51.4 x 38.1 (20¼ x 15)
Sir Frederick William Burton,
signed, 1865
Given by the sitter's husband and
Charles Lee Lewis, 1883

4961 Ink 19.1 x 9.5 (7½ x 3¾)
Lowes Cato Dickinson, inscribed
and dated 1872
Bequeathed by Mrs M.E.L.
Brownlow, 1973

2211 Pencil 12.7 x 11.4 (5 x 4½)
Laura Theresa, Lady Alma-Tadema,
initialled (by artist's husband),
c. 1877
Given by Lady Gosse and family,
1928

1758 Pencil 10.2 x 11.4 (4 x 4½)
Laura Theresa, Lady Alma-Tadema,
inscribed and dated 1877
Given by Sir Edmund Goose, 1915

2210 *See Unknown Sitters IV*

CROTCH, William (1775-1847)
Musician

1812 Water-colour 45.7 x 35.6
(18 x 14)
John Linnell, signed, inscribed
and dated 1839
Purchased, 1918
and

1813 Water-colour
45.4 x 34.9 (17⅞ x 13¾)
John Linnell, inscribed, c.1839
Purchased, 1918
See Collections: Drawings by
John Linnell, **1812-18B**

Ormond

CROWE, Sir Joseph Archer
(1825-96) Journalist and
art critic

4329 Canvas 78.1 x 66 (30¾ x 26)
Louis Kolitz, signed and dated 1877
Given by the sitter's great-grand-
daughter, Miss Aldred Brown, 1963

CROWE, Kate Josephine (née
Bateman) (1842-1917) Actress

2620 Pencil 10.2 x 10.2 (4 x 4)
Unknown artist, 1904
Given by Miss Gwen John, 1933

CRUIKSHANK, Eliza
Sister of George and Isaac Robert
Cruikshank

4259 *See Collections:* George
Cruikshank and others, by George
Cruikshank

CRUIKSHANK, George
(1792-1878) Caricaturist and
illustrator

5170 Pencil 30.8 x 23.8
(12⅛ x 9⅜)
Daniel Maclise, signed in monogram
and *A Croquis*, inscribed, and dated
1833
(*Fraser's Magazine* VIII, 1833)
Purchased, 1977

1385 Canvas 33 x 27.3 (13 x 10¾)
Unknown artist, 1836
Purchased, 1904

4259 *See Collections:* George
Cruikshank and others, by George
Cruikshank

1300 Plaster cast of bust 76.2
(30) high
William Behnes, incised, c.1855
Purchased, 1901

3150 Water-colour 25.4 x 21.9
(10 x 8⅝)
Unknown artist, based on
photograph by Elliot & Fry (c.1872)
Given by Percy Moore Turner, 1943

Ormond

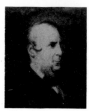

CRUIKSHANK, Isaac Robert
(1789-1856) Caricaturist and
miniature-painter

4259 *See Collections:* George
Cruikshank and others, by George
Cruikshank

CUBBON, Sir Mark (1784-1861)
Commissioner of Mysore

4250 Water-colour and pencil
28.6 x 23.5 (11¼ x 9¼)
Captain Martin, inscribed, c.1856-61
Purchased, 1962

Ormond

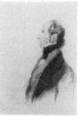

CUBITT, Lewis (1799-1883)
Architect

4099 Panel 61 x 44.8 (24 x 17⅝)
Sir William Boxall, 1845
Purchased, 1959

Ormond

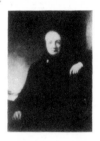

CUBITT, Thomas (1788-1855)
Builder

4613 Canvas 127 x 101.3
(50 x 39⅞)
Unkown artist
Given by Cubitt Estates Ltd,1968

Ormond

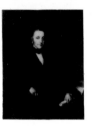

CUDLIPP, Percy (1905-62)
Journalist

4529(98-108) *See Collections:*
Working drawings by Sir David
Low, **4529(1-401)**

CULLEN of Ashbourne, Brien
Cokayne, 1st Baron (1864-1932)
Governor of the Bank of England

4773 Chalk 42.9 x 34 (16⅞ x 13⅜)
Sir William Rothenstein, c.1928
Purchased, 1970

CUMBERLAND, William Augustus,
Duke of (1721-65) General;
third son of George II

802 Canvas 147.3 x 111.8
(58 x 44)
Charles Jervas, c. 1728
Given by the Earl of Chichester,
1888. *Beningbrough*

L152(23) Enamel miniature on
copper, oval 3.8 x 3.2 (1½ x 1¼)
Attributed to Christian Friedrich
Zincke
Lent by NG (Alan Evans Bequest),
1975

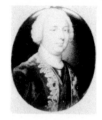

537 Canvas 74.9 x 61 (29½ x 24)
Studio of David Morier, c.1748-9
Transferred from BM, 1879

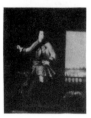

4855(37-9) *See Collections:* The
Townshend Album, **4855(1-73)**

625 Canvas 74.9 x 62.2
(29½ x 24½)
Studio of Sir Joshua Reynolds,
c. 1758-60
Purchased, 1881

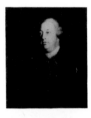

229 Canvas 87.6 x 59.1
(34½ x 23¼)
After Sir Joshua Reynolds
(c. 1758-60)
Purchased, 1867

Kerslake

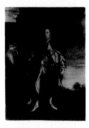

CUMBERLAND, Ernest Augustus,
Duke of, and King of Hanover
(1771-1851) Son of George III

3309 Canvas 94 x 76.2 (37 x 30)
George Dawe, c. 1828
Purchased, 1946

L167 With William Frederick, 2nd
Duke of Gloucester
Plaster statuette 33 x 44.8 x 35.6
(13 x 17⅝ x 14)
Jean-Pierre Danton, incised and
dated 183(4?)
Lent by H.M. the Queen, 1977

CUMBERLAND, George Clifford,
3rd Earl of (1558-1605)
Naval commander

L152(11) Miniature on vellum,
oval 4.8 x 3.8 ($1\frac{7}{8}$ x 1½)
Nicholas Hilliard, inscribed,
c. 1580-94
Lent by NG (Alan Evans Bequest),
1975

277 Canvas 75.9 x 61 ($29\frac{7}{8}$ x 24)
After Nicholas Hilliard (c. 1590)
Purchased, 1869

1492(c) Water-colour 19.1 x 12.5
($7\frac{1}{2}$ x $4\frac{7}{8}$)
George Perfect Harding after
Nicholas Hilliard (c.1590), signed
in monogram
Bequeathed by Henry Callcott
Brunning, 1908
See Collections: Copies of early
portraits, by George Perfect
Harding and Sylvester Harding,
1492, 1492(a-c) and **2394-2419**

Strong

CUMBERLAND, Margaret (née
Russell), Countess of (1560?-1616)
Wife of 3rd Earl of Cumberland

415 Panel 54 x 43.2 (21¼ x 17)
Unknown artist, after a portrait
of 1585
Given by Sir George Scharf, 1876

Strong

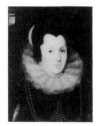

CUMBERLAND, George
(1754-1847) Writer on art

5162 Enamel miniature 4.1
($1\frac{5}{8}$) diameter
Unknown artist
Purchased, 1977

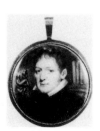

CUMBERLAND, Richard
(1732-1811) Playwright

19 Canvas 124.5 x 99.1 (49 x 39)
George Romney, c.1776
Purchased, 1857

**CUMBERLAND AND
STRATHEARN,** Henry Frederick,
Duke of (1725-90)
Brother of George III

5179 *See Groups:* A Bravura at
the Hanover Square Concert, by
John Nixon

CUMING, Hugh (1791-1865)
Naturalist

P106(6) Photograph: albumen
print, arched top, 20 x 14.6
($7\frac{7}{8}$ x 5¾)
Maull & Polyblank, c.1855
Purchased, 1978
See Collections: Literary and
Scientific Portrait Club, by Maull &
Polyblank, **P106(1-20)**

CUMMING-BRUCE, Charles
Lennox (1790-1875)
MP for Inverness

54 *See Groups:* The House of Com-
mons, 1833, by Sir George Hayter

CUMMINGS, Constance (b.1910)
Actress

P63 *See Collections:* Prominent
people, c. 1946-64, by Angus
McBean, **P56-67**

CUNNINGHAM, Allan (1784-1842)
Writer

2515(39) *See Collections:*
Drawings of Prominent People,
1823-49, by William Brockedon,
2515(1-104)

Continued overleaf

1823 Canvas 91.4 x 71.1 (36 x 28)
Henry Room, c. 1840
Purchased, 1918

Ormond

CUNNINGHAM, Peter (1816-69)
Antiquary

1645 Chalk 59.1 x 43.2
(23¼ x 17)
Charles Martin, exh 1859
Purchased, 1912

Ormond

CUNNINGHAM, William (1805-61)

P6(105) *See Collections:* The Hill
and Adamson Albums, 1843-8, by
David Octavius Hill and Robert
Adamson, **P6(1-258)**

CUNNINGHAM, William
(1848-1919)
Historian of economics

4021 Canvas 90.2 x 69.9
(35½ x 27½)
Eric Henri Kennington, signed and
dated 1908
Purchased, 1957

CUNNINGHAME, Mr

2252 *See Collections:* The Parnell
Commission, 1888-9, by Sydney
Prior Hall, **2229-72**

CURETON, William (1808-64)
Syriac scholar

3164 Chalk 60.3 x 45.7
(23¾ x 18)
George Richmond, signed and
dated 1861
Given by the sitter's granddaughter,
Mrs A.H.Walker, 1943

Ormond

CURLING, T. B.

P120(5) *See Collections:* Literary
and Scientific Men, 1855, by Maull
& Polyblank, **P120(1-54)**

CURRAN, John Philpot
(1750-1817) Irish judge

379 Canvas 74. 3 x 61.6
(29¼ x 24¼)
Unknown artist
Purchased, 1873

CURREY, Benjamin
Clerk

999 *See Groups:* The Trial of
Queen Caroline, 1820, by Sir
George Hayter

CURRIE, Sir Arthur William
(1875-1933) Canadian general

1954 *See Groups:* General Officers
of World War I, by John Singer
Sargent

CURRIE, Sir Donald (1825-1909)
Shipowner

2707 Water-colour 30.5 x 18.1
(12 x 7⅛)
Carlo Pellegrini, signed *Ape*
(*VF* 21 June 1884)
Purchased, 1934

CURSETJEE, Manockjee
(1808-87) Parsee merchant;
judge and sheriff of Bombay

2515(92) *See Collections:*
Drawings of Prominent People,
1823-49, by William Brockedon,
2515(1-104)

CURTIS, John (1791-1862)
Entomologist

P120(36) Photograph: albumen
print, arched top 19.7 x 14.6
(7¾ x 5¾)
Maull & Polyblank, inscribed on
mount, 1855
Purchased, 1979
See Collections: Literary and
Scientific Men, 1855, by Maull &
Polyblank, **P120(1-54)**

CURTIS, Sir William, Bt
(1752-1829) Lord Mayor of London

316a(25) Pencil 43.8 x 37.8
(17¼ x 14⅞)
Sir Francis Chantrey, inscribed,1827
Given by Mrs George Jones, 1871
and
316a(26) Pencil 46.7 x 30.2
(18⅜ x 11⅞)
Sir Francis Chantrey, inscribed,1827
Given by Mrs George Jones, 1871
See Collections: Preliminary
drawings for busts and statues by
Sir Francis Chantrey, **316a(1-202)**

CURWEN, John (1816-80)
Writer on music

1066 Canvas 88.9 x 69.2
(35 x 27¼)
William Gush, c. 1857
Given by the sitter's daughter,
Mrs Lewis Banks, 1896

CURZON of Kedleston, George
Curzon, Marquess (1859-1925)
Statesman; Viceroy of India

3355 Pen and ink 38.7 x 19.1
(15¼ x 7½)
Harry Furniss, signed with initials
Purchased, 1947
See Collections: Prominent Men,
c. 1880-c.1910, by Harry Furniss,
3337-3535 and **3554-3620**

2534 Canvas 104.1 x 81.3 (41 x 32)
John Cooke after John Singer
Sargent (1914)
Given by the sitter's widow, 1932

CURZON, Robert, 14th Baron
Zouche *See* ZOUCHE

CUST, John, 1st Earl Brownlow
See BROWNLOW

CUTTS, John Cutts, Baron
(1661-1707) Soldier

515 Canvas, feigned oval
74.9 x 62.2 (29½ x 24½)
Studio of William Wissing (c. 1685)
Purchased, 1879

L152(19) Miniature on vellum,
oval 6.4 x 5.4 (2½ x 2⅛)
Nicholas Dixon, signed in monogram
Lent by NG (Alan Evans Bequest),
1975

Piper

D'ABERNON, Edgar Vincent, 1st
Viscount (1857-1941) Diplomat

3862 Pencil 37.5 x 27.3
(14¾ x 10¾)
Francis Dodd, signed, inscribed and
dated 1931
Given by the Contemporary
Portraits Fund, 1953

DACRE, Thomas Brand, 20th Baron (1774-1851)

999 *See Groups:* The Trial of Queen Caroline, 1820, by Sir George Hayter

DADD, Richard (1817-86)
Painter

5181 Etching 14.9 x 11.4 ($5\frac{7}{8}$ x 4½)
Self-portrait, in reverse pose, signed and dated on plate 1841
Purchased, 1978

DAHL, Michael (1659?-1743)
Portrait painter

3822 Canvas 124.5 x 99.1 (49 x 39)
Self-portrait, signed and dated 1691
Purchased, 1952

1384 *See Groups:* A Conversation of Virtuosis . . . at the Kings Armes (A Club of Artists), by Gawen Hamilton

Piper

DAIKENHAUSEN, Colonel

1752 *See Groups:* The Siege of Gibraltar, 1782, by George Carter

DALGLEISH, Charlotte (née Hill) (1839-62) Only child of David Octavius Hill

P6(175) *See Collections:* The Hill and Adamson Albums, 1834-8, by David Octavius Hill and Robert Adamson, **P6(1-258)**

DALGLISH, Robert (1808-80)
Politician

3283 Water-colour 26.7 x 17.1 (10½ x 6¾)
Sir Leslie Ward, signed *Spy*
(*VF* 7 June 1873)
Purchased, 1934

DALHOUSIE, James Ramsay, 10th Earl and 1st Marquess of (1812-60) Governor-General of India

188 Canvas 242.5 x 151.1 (95½ x 59½)
Sir John Watson-Gordon, signed and dated 1847
Given by the artist's brother, H.G.Watson, 1865

Ormond

DALHOUSIE, Fox Maule-Ramsay, 11th Earl of (1801-74) Statesman

2537 Wash 23.8 x 14.9 ($9\frac{3}{8}$ x $5\frac{7}{8}$)
Thomas Duncan, inscribed, c.1838
Given by Iolo A. Williams, 1932

Ormond

DALLAS, Sir Robert (1756-1824)
Judge

999 *See Groups:* The Trial of Queen Caroline, 1820, by Sir George Hayter

DALLING AND BULWER, William Bulwer, Baron (1801-72) Diplomat

852 Canvas 76.2 x 63.5 (30 x 25)
Giuseppe Fagnani, signed and dated 1865
Given by the artist's daughter, Emma Fagnani, 1891

3969 Pencil 33 x 27 (13 x $10\frac{5}{8}$)
Carlo Pellegrini signed; also signed *Ape* and inscribed
(study for *VF* 27 Aug 1870, in reverse pose)
Purchased, 1955

Ormond

DALRYMPLE, John, 8th Earl of Stair *See* STAIR

DALTON, John (1766-1844)
Chemist; pioneer in nuclear physics

1075,1075a and **b** *See Groups:*
Men of Science Living in 1807-8,
by Sir John Gilbert and others

316a(29) Pencil 47.6 x 35.2
(18¾ x 13⅞)
Sir Francis Chantrey, inscribed and
dated 1834
Given by Mrs George Jones, 1971
See Collections: Preliminary
drawings for busts and statues by
Sir Francis Chantrey, **316a(1-202)**

316a(27,28,30) *See Collections:*
Preliminary drawings for busts and
statues by Sir Francis Chantrey,
316a(1-202)

1102 Embossed paper medallion,
oval 2.2 x 1.9 (⅞ x ¾)
Charles Frederick Carter, inscribed
and dated 1842
Given by Richard J. Greene, 1897

DAMER, Anne Seymour (née
Conway) (1749-1828) Sculptor

594 Canvas 54 x 44.5
(21¼ x 17½)
Studio of Sir Joshua Reynolds, 1772
Purchased, 1879

5236 Miniature on ivory, oval
6 x 4.8 (2⅜ x 1⅞)
Richard Cosway, signed in
monogram, and on back of frame
incised and dated 1785
Purchased, 1979

DAMPIER, William (1651-1715)
Circumnavigator and hydrographer

538 Canvas 74.9 x 62.9
(29½ x 24¾)
Thomas Murray, signed with
initials, c.1697-8
Transferred from BM, 1879

Piper

DANCE, Sir Charles Webb (d.1844)
Colonel

3706 *See Collections:* Studies for
The Waterloo Banquet at Apsley
House, 1836, by William Salter,
3689-3769

DANCE, George (1741-1825)
Architect and portrait draughtsman

2812 Pencil and chalk 23.5 x 19.7
(9¼ x 7¾)
Self-portrait, signed and dated 1814
Purchased, 1936

DANCE, William (1755-1840)
Musician; founder of the Royal
Philharmonic Society

3058 Pencil 25.7 x 19.4
(10⅛ x 7⅝)
George Dance, signed and dated
1880
Given by Marion Harry Spielmann,
1939

DANCE-HOLLAND, Sir Nathaniel,
Bt (1725-1811) Painter

3626 Canvas 73.7 x 61 (29 x 24)
Self-portrait, c. 1773
Bequeathed by the sitter's great-
grand-niece, Miss Mary Sibyll
Dance, 1948

DANCER, Daniel (1716-94)
Miser

4369 Pencil and chalk 14.9 x 12.4
(5⅞ x 4⅞)
Attributed to Robert Cooper
Given by J.J.Byam Shaw, 1964

DANE, Clemence (Winifred Ashton)
(1888-1965) Novelist and
playwright

4490 Pastel 61 x 50.8 (24 x 20)
Frederic Yates, inscribed, c.1917
Given by the artist's daughter,
Miss Mary Yates, 1966

DANESFORT, John George
Butcher, Baron (1853-1935)
Lawyer

2657 Water-colour 31.1 x 19.4
(12¼ x 7⅝)
Sir Leslie Ward, signed *Spy*
(*VF* 7 Nov 1901)
Purchased, 1934

DANIEL, Sir William (d.1610)
Judge

717 Panel 114.3 x 83.2
(45 x 32¾)
Unknown artist, inscribed c.1604
Given by Barnard's Inn, 1884

Strong

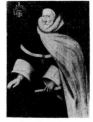

DARBY, John Nelson (1800-82)
Plymouth Brother and founder of
the Darbyites

4870 Water-colour 22.9 x 17.1
(9 x 6¾)
Edward Penstone, signed in
monogram and inscribed
Purchased, 1972

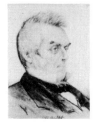

DARLING, Charles John Darling,
1st Baron (1849-1936) Judge

3546 Canvas 135.9 x 90.2
(53½ x 35½)
Charles Wellington Furse, signed
and dated 1890
Given by the sitter's grandson,
Lord Darling, 1947

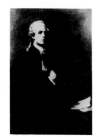

2708 Water-colour 27.3 x 21.6
(10¾ x 8½)
Sir Leslie Ward
Purchased, 1934

DARLING, Grace (1815-42)
Heroine of a sea rescue

1663 Water-colour and pencil
24.8 x 20 (9¾ x 7⅞)
Henry Perlee Parker, signed,
inscribed and dated 1838
Purchased, 1912

1662 Water-colour and pencil
31.1. x 22.9 (12¼ x 9)
Henry Perlee Parker, signed by artist
and sitter, inscribed and dated 1838
Purchased, 1912

998 Marble bust 63.5 (25) high
David Dunbar, incised, 1838
Transferred from Tate Gallery, 1957

Ormond

DARNLEY, Henry Stuart, Lord
(1545-67) Second Consort of
Mary, Queen of Scots

359 Electrotype from figure on
the tomb of his mother, Margaret,
Countess of Lennox, in Westminster
Abbey 68.6 (27) high
Purchased, 1872

Strong

DARNLEY, John Bligh, 4th Earl
of (1767-1831)

999 *See Groups:* The Trial of
Queen Caroline, 1820, by Sir
George Hayter

DARNLEY, John Stuart Bligh,
6th Earl of (1827-96)

1833 *See Groups:* Private View
of the Old Masters Exhibition,
Royal Academy, 1888, by Henry
Jamyn Brooks

DARTIQUENAVE, Charles
(1664-1737) Epicure and wit

3239 Canvas 108 x 80
(42½ x 31½)
Sir Godfrey Kneller, signed and
dated 1702
Purchased, 1945

3201 Canvas 96.5 x 81.3 (38 x 32)
After Sir Godfrey Kneller (1702)
Kit-cat Club portrait
Given by NACF, 1945.
Beningbrough

Piper

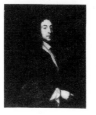

DARTMOUTH, William Legge, 4th
Earl of (1784-1853)

999 *See Groups:* The Trial of
Queen Caroline, 1820, by Sir
George Hayter

DARTMOUTH, George Legge, 1st
Baron (1648-91) Admiral

664 Canvas 123.2 x 100.3
(48½ x 39½)
After John Riley (c.1685-90)
Given by the Earl of Dartmouth,
1882. *Beningbrough*

Piper

DARTREY, Richard Dawson, 1st
Earl of (1817-97)
Landowner and chess player

3060 *See Groups:* Chess players,
by A. Rosenbaum

DARWIN, Bernard (1876-1961)
Writer and golfer

4462 Pen and ink 38.1 x 29.8
(15 x 11¾)
Powys Evans, pub 1930
Purchased, 1965

DARWIN, Charles Robert
(1809-82) Naturalist; evolved
theory of evolution; grandson of
Erasmus Darwin

P106(7) Photograph: albumen
print, arched top 20 x 14.6
(7⅞ x 5¾)
Maull & Polyblank, c. 1855
Purchased, 1978
See Collections: Literary and
Scientific Portrait Club, by Maull &
Polyblank, **P106(1-20)**

P8 Photograph: albumen print
33 x 25.6 (13 x 10⅛)
Julia Margaret Cameron,1868-9
Purchased, 1974

3144 Pencil 18.1 x 12.4 (7⅛ x 4⅞)
Marian Collier (née Huxley), signed
in monogram *MH*, 1878
Purchased, 1943

1024 Canvas 125.7 x 96.5
(49½ x 38)
John Collier, signed and dated
1883, amended version (1881)
Given by the sitter's son, William
Edward Darwin, 1896

761 Terracotta bust 61 (24) high
Sir Joseph Boehm, incised
Given by the artist, 1887

Continued overleaf

1395 Terracotta bust 69.9
(27½) high
Horace Montford, incised,
posthumous
Given by the artist, 1905

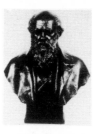

DARWIN, Erasmus (1731-1802)
Physician and poet

88 Canvas 76 x 63.5 (19⅞ x 25)
Joseph Wright, 1770
Purchased, 1859

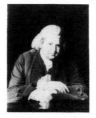

DARWIN, Sir George Howard
(1845-1912) Mathematician and
astronomer; son of Charles Darwin

2101 Drawing on canvas
34.9 x 25.4 (13¾ x 10)
Gwendolen Raverat (his daughter)
Given by the sitter's widow, 1925

1999 Canvas 90.2 x 59.7
(35½ x 23½)
Mark Gertler, inscribed and dated
on reverse 1912
Given by the sitter's widow, 1923

DASHWOOD, Francis, 15th Baron
Le Despencer
See LE DESPENCER

DASHWOOD, Sir George Henry, Bt
(1790-1862)
MP for Buckinghamshire

54 *See Groups:* The House of Com-
mons, 1833, by Sir George Hayter

DAUNCEY, Elizabeth (née More)
(b. 1506) Second daughter of
Sir Thomas More

2765 *See Groups:* Sir Thomas
More, his Father, his Household
and his Descendants, by Rowland
Lockey

DAVIDSON of Lambeth, Randall
Thomas Davidson, Baron
(1848-1930)
Archbishop of Canterbury

2369 *See Groups:* The Education
Bill in the House of Lords, by
Sydney Prior Hall

2956 Water-colour 45.7 x 34.3
(18 x 13½)
Sir Leslie Ward, signed; also signed
Spy and dated 1910
Purchased, 1938

2863 *See Collections:* Caricatures
of Politicians, by Sir Francis
Carruthers Gould, **2826-74**

DAVIDSON, Samuel (1806-98)
Theologian

1539 Chalk 38.1 x 30.5 (15 x 12)
Matilda Sharpe
Given by the artist, 1909

DAVIES, Randall Robert Henry
(1866-1946) Critic, writer
and collector

3621 Chalk 35.9 x 29.2
(14⅛ x 11½)
Randolph Schwabe, signed with
initials, inscribed and dated 1939
Given by Malcolm Stearns, 1948

DAVIES, William Henry
(1871-1940) Poet

3885 Bronze cast of head 31.1
(12¼) high
Sir Jacob Epstein, 1916
Purchased, 1953

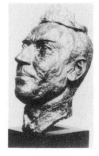

3149 Pencil 29.2 x 22.9 (11½ x 9)
Augustus John, signed, inscribed
and dated 1918
Purchased, 1943

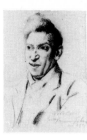

4396 Pen and ink 24.4 x 18.4
(9⅝ x 7¼)
Powys Evans, c. 1922
Purchased, 1964

2046 *See Collections:* Medallions
of Writers, c.1922, by Theodore
Spicer-Simson, **2043-55**

4194 Canvas 54.6 x 58.4
(21½ x 23)
Sir William Nicholson, 1927-8
Purchased, 1961

DAVIS, Mr

316a(31) *See Collections:*
Preliminary drawings for busts and
statues by Sir Francis Chantrey,
316a(1-202)

DAVIS, Mrs

316a(32) *See Collections:*
Preliminary drawings for busts and
statues by Sir Francis Chantrey,
316a(1-202)

DAVIS, Mary (fl.1663-9) Actress

253 *See Unknown Sitters II*

DAVITT, Michael (1846-1906)
Irish revolutionary and labour
agitator

2250 *See Collections:* The Parnell
Commission, 1888-9, by Sydney
Prior Hall, **2229-72**

DAVY, Sir Humphry, Bt
(1778-1829) Chemist

4591 Canvas 128.3 x 102.9
(50½ x 40½)
Henry Howard, inscribed and dated
1803
Purchased, 1867

1075, 1075a and **b** *See Groups:*
Men of Science Living in 1807-8,
by Sir John Gilbert and others

1794 Water-colour 22.5 x 20.3
(8⅞ x 8)
John Jackson, c. 1820
Given by the sitter's great-niece,
Miss Helen Mary Davy, and his
great-nephew, Sir Humphry Davy
Rolleston, Bt, 1917

2546 Canvas 91.4 x 71.1 (36 x 28)
Thomas Phillips, signed in
monogram, 1821
Purchased, 1932

1573 Canvas 142.2 x 111.8
(56 x 44)
After Sir Thomas Lawrence (c.1821)
Purchased, 1910

1273 Plaster medallion, oval
30.5 x 22.9 (12 x 9)
Albert Bruce-Joy, 1876
Given by J. Wilcox Edge, 1900

DAWBER, Sir Edward Guy
(1861-1938) Architect

4168 Board 38.1 x 27.9 (15 x 11)
Fred Roe, inscribed and dated (by
donor on reverse) 1926
Given by the artist's son, F. Gordon
Roe, 1960

Continued overleaf

4529(109) *See Collections:*
Working drawings by Sir David
Low, **4529(1-401)**

DAWES, William
American slavery abolitionist

599 *See Groups:* The Anti-Slavery
Society Convention, 1840, by
Benjamin Robert Haydon

DAWKINS, F. (1796-1847)
Colonel

3707 *See Collections:* Studies for
The Waterloo Banquet at Apsley
House, 1836, by William Salter,
3689-3769

DAWSON, Geoffrey (1874-1944)
Journalist; editor of *The Times*

L168(8) *See Collections:*
Prominent men, 1895-1930, by Sir
William Rothenstein, **L168(1-11)**

DAWSON, Richard, 1st Earl of
Dartrey *See* DARTREY

DAWSON DAMER, George Lionel
(1788-1856) Colonel

3705 *See Collections:* Studies for
The Waterloo Banquet at Apsley
House, 1836, by William Salter,
3689-3769

DAY, Alexander (1773-1841)
Medallion painter and picture
importer

3113 Pencil 26 x 18.4 (10¼ x 7¼)
Unknown artist, inscribed, c.1800
Given by Iolo A. Williams, 1942

DAY, John
Sportsman

2776 Water-colour 37.5 x 28.9
(14¾ x 11⅜)
John Flatman, signed and inscribed
Purchased, 1935

DAY, Sir John (1826-1908)
Judge

2249 *See Collections:* The
Parnell Commission, 1888-9, by
Sydney Prior Hall, **2229-72**

2285,2296 *See Collections:*
Miscellaneous drawings . . . by
Sydney Prior Hall, **2282-2348**
and **2370-90**

DAY, Thomas (1748-89)
Author of *Sandford and Merton*

2490 Canvas 121.9 x 97.8
(48 x 38½)
Joseph Wright
Purchased, 1931

DAYES, Edward (1763-1804)
Water-colour painter and mezzotint
engraver

2091 Canvas 61 x 50.8 (24 x 20)
Self-portrait, inscribed and dated
on reverse 1801
Purchased, 1925

DAY-LEWIS, Cecil (1904-72)
Poet Laureate

5068 Bronze bust 37.5
(14¾) high
Franta Belsky, incised and dated
1952
Purchased, 1976

DEAKIN, Arthur (1890-1955)
Politician

4529(110-15) *See Collections:*
Working drawings by Sir David
Low, **4529(1-401)**

DEAN, James
American slavery abolitionist

599 *See Groups:* The Anti-Slavery
Society Convention, 1840, by
Benjamin Robert Haydon

DEAN, John (d. 1747)
Shipwrecked mariner

949 Canvas 125.7 x 100.3
(49½ x 39½)
William Verelst, signed and dated
1743
Lent by Ministry of Works, 1968

DEANE, Sir Anthony
(c. 1638-1721) Shipbuilder

2124 Canvas 74.3 x 62.9
(29¼ x 24¾)
Sir Godfrey Kneller, 1690
Purchased, 1926

Piper

DEANE, H.

P120(37) *See Collections:*
Literary and Scientific Men, 1855,
by Maull & Polyblank, **P120(1-54)**

DEANE, Sir Henry Bargrave
(1846-1919) Judge

3284 Water-colour 35.3 x 21
(13$\frac{7}{8}$ x 8¼)
Sir Leslie Ward, signed *Spy*
(*VF* 4 Aug 1898)
Purchased, 1934

DE BEGNIS, Claudine (née Ronzi)
(1800-53) Actress and singer

1328 Water-colour 43.8 x 30.5
(17¼ x 12)
Alfred Edward Chalon, c. 1823
Purchased, 1902

Ormond

DE CLIFFORD, Edward Southwell,
18th Baron (1767-1832)

999 *See Groups:* The Trial of
Queen Caroline, 1820, by Sir
George Hayter

DEEPING, Warwick (1877-1950)
Novelist

5142 Chalk 38.1 x 29.5
(15 x 11$\frac{5}{8}$)
Kathleen Shackleton, signed,
inscribed and dated 1936
Given by Desmond Flower, 1977

DEFOE, Daniel (1660-1731)
Novelist and journalist; author of
Robinson Crusoe

3960 Line engraving 27.3 x 18.4
(10¾ x 7¼)
Michiel van der Gucht after
J. Taverner, signed and inscribed on
plate, 1706
Transferred from NPG Library, 1955

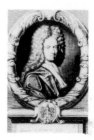

DE GREY, Thomas Philip de Grey,
Earl (1781-1859) Statesman

999 *See Groups:* The Trial of
Queen Caroline, 1820, by Sir
George Hayter

DE GREY, Thomas, 6th Baron
Walsingham *See* WALSINGHAM

DE HOCHEPIED, George Porter,
6th Baron (1760-1828) General

745 *See Groups:* William Pitt
addressing the House of
Commons . . . 1793, by Karl
Anton Hickel

DE KEYSER, Sir Polydore
(1832-97) Lord Mayor of London

2570 Water-colour 31.4 x 18.7
(12$\frac{3}{8}$ x 7$\frac{3}{8}$)
Sir Leslie Ward, signed *Spy*
(*VF* 26 Nov 1887)
Purchased, 1933

DE LA BECHE, Sir Henry Thomas
(1796-1855) Geologist

2515(94) *See Collections:*
Drawings of Prominent People,
1823-49, by William Brockedon,
2515(1-104)

DE LA MARE, Walter (1873-1956)
Poet and novelist

2047 Plasticine medallion 8.9
(3½) diameter
Theodore Spicer-Simson, incised,
c. 1922
Given by the artist, 1924
See Collections: Medallions of
Writers, c.1922, by Theodore
Spicer-Simson, **2043-55**

4529(231) *See Collections:*
Working drawings by Sir David Low,
4529(1-401)

4142 Chalk 45.1 x 33 (17¾ x 13)
Sir William Rothenstein, c. 1929
Given by the Rothenstein Memorial
Trust, 1960

4473 Chalk 35.6 x 31.1 (14 x 12¼)
Augustus John, signed and dated
1950
Purchased with help from the
Beatrice Mary Raine Harrop
Bequest, 1966

DE LA MOTTE, Major-General

1752 *See Groups:* The Siege of
Gibraltar, 1782, by George Carter

DELANE, John Thadeus (1817-79)
Editor of *The Times*

1593 Canvas 74.9 x 62.2
(29½ x 24½)
Heinrich August Georg Schiött,
signed and dated 1862
Given by the sitter's nephew,
Arthur Irwin Dasent, 1911

DELANEY, Shelagh (b. 1939)
Playwright

P45 Photograph: bromide print
34.6 x 23.5 (13⅝ x 9¼)
Arnold Newman, 1961
Purchased, 1976

DELANY, Mary (née Granville)
(1700-88) Memoir and letter writer

1030 Canvas, feigned oval
74.9 x 62.2 (29½ x 24½)
John Opie, 1782
Bequeathed by the Baroness
Llanover, 1896. *Beningbrough*

DE LA RAMÉE, Marie Louise
(1839-1908) 'Ouida'; novelist

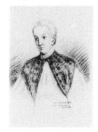

1508 Chalk, oval 30.5 x 24.8
(12 x 9¾)
Visconde Georgio de Moraes
Sarmento, signed, inscribed and
dated 1904
Given by the artist, 1908

DE LA RUE, Warren (1815-89)
Inventor

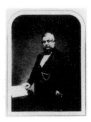

P120(38) Photograph: albumen
print, arched top 19.7 x 14.6
(7¾ x 5¾)
Maull & Polyblank, inscribed on
mount, 1855
Purchased, 1979
See Collections: Literary and
Scientific Men, 1855, by Maull &
Polyblank, **P120(1-54)**

DE LASZLO, Philip (Philip Alexius
László de Lombos) (1869-1937)
Portrait painter

4529(207) *See Collections:*
Working drawings by Sir David Low,
4529(1-401)

DELAWARR, George John
Sackville-West, 5th Earl (1791-1869)

2662(20) *See Collections:* Book
of sketches, mainly for The Trial
of Queen Caroline, 1820, by Sir
George Hayter, **2662(1-38)**

999 *See Groups:* The Trial of
Queen Caroline, 1820, by Sir
George Hayter

DELIUS, Frederick (1862-1934)
Composer

4975(1) Pencil 26.4 x 19.7
(10⅜ x 7¾)
Ernest Procter, 1929
Purchased, 1974
See Collections: Rehearsals for
A Mass of Life, 1929, by Ernest
Procter, **4975(1-36)**

3861 Millboard 31.8 x 25.4
(12½ x 10)
Ernest Procter, signed and dated
1929
Purchased, 1953

DE LOUTHERBOURG, Philip
James (1740-1812) Painter

2493 Canvas 127 x 101.6 (50 x 40)
Self-portrait, 1805-10
Purchased, 1931

DE LUC (probably Jean André,
1763-1847) Swiss geologist
and meteorologist

2515(78) *See Collections:*
Drawings of Prominent People,
1823-49, by William Brockedon,
2515(1-104)

DE MAULEY, William Ponsonby,
1st Baron (1787-1855)
MP for Dorset

999 *See Groups:* The Trial of
Queen Caroline, 1820, by Sir
George Hayter

54 *See Groups:* The House of Com-
mons, 1833, by Sir George Hayter

DE MORGAN, William Frend
(1839-1917) Artist, potter
and novelist

2116 Pencil 29.2 x 20.3
(11½ x 8)
James Kerr-Lawson, signed and
dated 1908
Purchased, 1926

DE NAVARRO, Mary
See ANDERSON, Mary

DENBIGH, William Feilding,
7th Earl of (1796-1865)

1695(u) *See Collections:* Sketches
for The Trial of Queen Caroline,
1820, by Sir George Hayter,
1695(a-x)

999 *See Groups:* The Trial of
Queen Caroline, 1820, by Sir
George Hayter

DENBIGH, Rudolph William
Feilding, 8th Earl of (1823-92)
Representative peer

1834(j) *See Collections:* Members
of the House of Lords, c. 1870-80,
by Frederick Sargent, **1834(a-z and
aa-hh)**

DENHAM, Dixon (1786-1828)
Soldier and traveller

2441 Canvas 76.2 x 63.5
(30 x 25)
Thomas Phillips, 1826
Given by John Murray, 1929

DENHAM, Sir James Steuart, Bt
(1744-1839) General

2756 Water-colour 27.3 x 21.6
(10¾ x 8½)
Richard Dighton, signed and
inscribed, 1836-7
Given by W.M.Campbell Smyth,
1935

DENISON, Edward (1840-70)
Philanthropist

4480 With his sister, Louisa Mary
Chalk 62.2. x 47 (24½ x 18½)
John Hayter, signed and dated 1845
Given by Lt-Col Vivian Seymer,
1966

DENISON, John Evelyn, 1st Viscount
Ossington *See* OSSINGTON

DENISON, Louisa Mary
(1841-1919)

4480 *See under* Edward Denison

DENMAN, Thomas Denman, 1st
Baron (1779-1854)
Lord Chief Justice

372 Canvas 76.2 x 63.5 (30 x 25)
John James Halls, exh 1819
Given by John Herman Merivale,
1873

463 Canvas 236.2 x 144.8
(93 x 57)
Sir Martin Archer Shee, c. 1832
Given by the Society of Judges and
Serjeants-at-Law, 1877

DENMAN, George (1819-96)
Judge

3299 Water-colour 36. 2 x 21.3
(14¼ x 3⅜)
(Possibly H.C.Sepping) Wright,
signed *STUFF*
(*VF* 19 Nov 1892)
Purchased, 1934

DENNING, Inspector

5256 *See Groups:* The Lobby
of the House of Commons, 1886,
by Liberio Prosperi

DENON, Dominique Vivant, Baron
(1747-1825) French painter,
archaeologist and traveller

2515(3) *See Collections:* Drawings
of Prominent People, 1823-49, by
William Brockedon, **2515(1-104)**

DE QUINCEY, Thomas
(1785-1859) Writer; author of
Confessions of an Opium Eater

189 Canvas 127.3 x 101.3
(50⅛ x 39⅞)
Sir John Watson-Gordon, c.1845
Given by the artist's brother,
Henry George Watson, 1865

822 Plaster cast of bust, painted
black 66.7 (26¼) high
Sir John Robert Steell, incised
and dated 1875
Given by William Bell Scott, 1889

Ormond

DERBY, Henry Stanley, 4th Earl
of (1531-93) Statesman

L152(40) Miniature on vellum,
oval 5.1 x 4.2 (2 x 1⅝)
Isaac Oliver
Lent by NG (Alan Evans Bequest),
1975

DERBY, James Stanley, 7th Earl
of (1607-51) Royalist

90 Canvas, feigned oval
73.7 x 60.3 (29 x 23¾)
After Sir Anthony van Dyck
(c. 1636-7)
Given by the Earl of Derby, 1860

Piper

DERBY, Charlotte (de la Trémoille),
Countess of (1599-1664) Royalist;
wife of 7th Earl of Derby

4296 Canvas 121.9 x 98.8
(48 x 38⅞)
Unknown artist (1657)
Purchased, 1963

DERBY, Edward Smith Stanley,
12th Earl of (1752-1834)

999 *See Groups:* The Trial of
Queen Caroline, 1820, by Sir
George Hayter

DERBY, Elizabeth (Farren),
Countess of (1759?-1829) Actress;
wife of 12th Earl of Derby

2652 Chalk, oval 20.3 x 17.1
(8 x 6¾)
John Downman, signed and dated
1787
Given by Mrs D. E.Knollys, 1934

4469 Marble bust 59.7 (23½) high
Anne Seymour Damer, incised,
c. 1789
Given by Rupert Gunnis, 1965

DERBY, Edward Stanley, 14th
Earl of (1799-1869) Prime Minister

54 *See Groups:* The House of Commons, 1833, by Sir George Hayter

2789 *See Groups:* Members of the
House of Lords, c. 1835, by Isaac
Robert Cruikshank

1806 Canvas 142.2 x 111.8
(56 x 44)
Frederick Richard Say, 1844
Given by the sitter's grandson, the
Earl of Derby, 1918

4893 *See Groups:* The Derby
Cabinet of 1867, by Henry Gales

Ormond

DERBY, Edward Stanley,
15th Earl of (1826-93)
Foreign Secretary

4893 *See Groups:* The Derby
Cabinet of 1867, by Henry Gales

948 Chalk 47.6 x 40 (18¾ x 15¾)
Samuel Laurence
Given by the sitter's widow, 1893

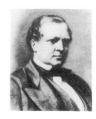

3356 *See Collections:*
Proment Men, c.1880-c.1910, by
Harry Furniss, **3337-3535** and
3554-3620

DERBY, Edward Stanley, 17th Earl
of (1865-1948)
Secretary of State for War

4039(2) Water-colour and pencil
29.5 x 24.1 (11$\frac{5}{8}$ x 9½)
Inglis Sheldon-Williams, signed,
inscribed, and dated by artist and
sitter, 1900
Purchased, 1957
See Collections: Boer War Officers,
1900, by Inglis Sheldon-Williams,
4039(1-7)

4185 Canvas 76.2 x 64.9
(30 x 25½)
Sir William Orpen, signed and dated
1919
Given by wish of Viscount
Wakefield, 1960

DE ROBECK, Sir John Michael, Bt
(1862-1928) Admiral

1913 *See Groups:* Naval Officers
of World War I, by Sir Arthur
Stockdale Cope

DE SAUMAREZ, James Saumarez,
1st Baron (1757-1836) Admiral

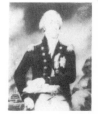

2549 Miniature on ivory
22.9 x 22.9 (9 x 9)
Philip Jean, signed with initials and
dated 1801
Given by Lord de Saumarez, 1932

DESCAZEAUX DU HALLY, Michel
(1710-75) Adventurer

4855(9) *See Collections:* The
Townshend Album, **4855(1-73)**

DESMOND, Catherine (Fitzgerald),
Countess of (d. 1604) Centenarian

2039 *See Unknown Sitters I*

DESPARD, Charlotte (née French)
(1844-1939) Suffragette and
social worker

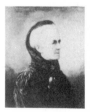

4345 Canvas 61 x 50.8 (24 x 20)
Attributed to Charles Horsfall
Given by Miss Marian Lawson, 1964

Continued overleaf

5007 Canvas 68.9 x 55.9
($27\frac{1}{8}$ x 22)
Mary Edis (afterwards Lady
Bennett), signed, exh 1916
Given by the artist, 1974

DETMOLD, Charles Maurice
(1883-1908) Illustrator

3036 Pencil 31.4 x 24.8
($12\frac{3}{8}$ x 9¾)
Edward Julius Detmold (his
brother), signed and dated 1899
Given by Marion Harry Spielmann,
1939

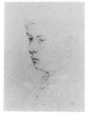

DETMOLD, Edward Julius
(1883-1957) Painter, etcher
and illustrator

3037 Pencil 25.8 x 17.5
($10\frac{1}{8}$ x $6\frac{7}{8}$)
Charles Maurice Detmold (his
brother), signed in monogram and
dated 1899
Given by Marion Harry Spielmann,
1939

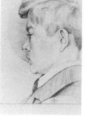

DE VALOIS, Dame Ninette
(Mrs A.B.Connell) (b.1898)
Director of the Royal Ballet

4679 Bronze cast of head 53.3
(21) high
Frederick Edward McWilliam,
incised and dated 1964
Given by the sitter, 1969

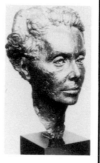

DEVENPORT, Hudson Kearley,
1st Viscount (1856-1934)
Man of business

4483 Pencil 27.9 x 22.5 (11 x $8\frac{7}{8}$)
Frederick Sargent, signed and dated
1893, autographed by sitter
Purchased, 1966

DE VERE, Aubrey Thomas
(1814-1902) Poet, critic and
writer on church matters

P18(15) Photograph: albumen
print, arched top, 23.9 x 18.4
($9\frac{3}{8}$ x 7¼)
Julia Margaret Cameron, 1864
Purchased with help from public
appeal, 1975
See Collections: The Herschel
Album, by Julia Margaret Cameron,
P18(1-92b)

DEVEREUX, Henry, 14th
Viscount Hereford
See HEREFORD

DEVEREUX, Robert, 2nd Earl of
Essex *See* ESSEX

DEVEREUX, Robert, 3rd Earl
of Essex *See* ESSEX

DEVEREUX, Walter, 1st Earl
of Essex *See* ESSEX

DEVONSHIRE, William Cavendish,
2nd Duke of (1673-1729)
Whig leader

3202 Canvas 91.4 x 71.1 (36 x 28)
Sir Godfrey Kneller, signed in
monogram, c.1710 or c. 1714-16
Kit-cat Club portrait
Given by NACF,1945.*Beningbrough*

Piper

DEVONSHIRE, William Cavendish,
5th Duke of (1748-1811)
Lord High Treasurer of Ireland

2076 *See Groups:* Whig Statesmen
and their Friends, c. 1810, by
William Lane

DEVONSHIRE, Georgiana
(Spencer), Duchess of (1757-1806)
Beauty and leader of Whig society;
first wife of 5th Duke of Devonshire

1041 Canvas, feigned oval
58.4 x 47 (23 x 18½)
Sir Joshua Reynolds, c. 1761
Given by the sitter's great-grandson,
Lord Ronald Sutherland-Gower,
1896. *Beningbrough*

DEVONSHIRE, Elizabeth (Hervey),
Duchess of (1759-1824)
Famous beauty; second wife of 5th
Duke of Devonshire

2355 Canvas 125.7 x 95.9
(49½ x 37¾)
John Westbrooke Chandler, c.1790
Bequeathed by Lord Revelstoke,
1929

DEVONSHIRE, William Cavendish,
6th Duke of (1790-1858)
Lord Chamberlain

999 *See Groups:* The Trial of
Queen Caroline, 1820, by Sir
George Hayter

4916 Pen and wash 22.6 x 18.8
($8\frac{7}{8}$ x $7\frac{3}{8}$)
Sir Edwin Landseer, inscribed,
c.1832
Purchased, 1972
See Collections: Caricatures of
Prominent People, c.1832-5, by
Sir Edwin Landseer, **4914-22**

DEVONSHIRE, William Cavendish,
7th Duke of (1808-91) Promotor
of science and industry

54 *See Groups:* The House of Com-
mons, 1833, by Sir George Hayter

DEVONSHIRE, Spencer Cavendish,
8th Duke of (1833-1908)
Liberal statesman

5116 *See Groups:* Gladstone's
Cabinet of 1868, by Lowes Cato
Dickinson

4715 Water-colour 30.5 x 17.5
(12 x $6\frac{7}{8}$)
Carlo Pellegrini, signed *Ape* and
C Pellegrini
(*VF* 27 March 1869)
Purchased, 1970

5256 *See Groups:* The Lobby of
the House of Commons, 1886, by
Liberio Prosperi

3191 Water-colour 33.7 x 18.1
(13¼ x $7\frac{1}{8}$)
Sir Leslie Ward, signed *Spy*
(*VF* 21 July 1888)
Purchased, 1945

1598 Water-colour 60.6 x 50.5
($23\frac{7}{8}$ x $19\frac{7}{8}$)
Julia, Lady Abercromby, signed in
monogram and dated 1894 (*sic*),
1888
Given by the Earl of Camperdown,
1911

1545 Canvas 139.7 x 109.2
(55 x 43)
Sir Hubert von Herkomer, signed
with initials and dated 1897
Given by Sir William Cuthbert
Quilter, Bt, 1909

2335 *See Collections:*
Miscellaneous drawings . . . by
Sydney Prior Hall, **2282-2348**
and **2370-90**

2833,2834 *See Collections:*
Caricatures of Politicians, by Sir
Francis Carruthers Gould, **2826-74**

DEVONSHIRE, Victor Cavendish, 9th Duke of (1868-1938) Governor-General of Canada

3562 *See Collections:* Prominent Men, c. 1880-c.1910, by Harry Furniss, **3337-3535** and **3554-3620**

4775 Pencil 35.6 x 25.1 (14 x 9$\frac{7}{8}$) Sir William Rothenstein, 1916 Purchased, 1970

DEVONSHIRE, Charles Blount, Earl of (1563-1606) Soldier

665 *See Groups:* The Somerset House Conference, 1604, by an unknown Flemish artist

DEWAR, Sir James (1842-1923) Chemist

2118 Bronze statuette 35.6 (14) high Cernigliari Melilli, incised and dated 1906 Given by the sitter's widow, 1926

2119 Bronze cast of bust 71.8 (28¼) high George D.MacDougald, incised and dated 1910 Given by the sitter's widow, 1926

DE WIART, Sir Adrian Carton (1880-1963) General

4651 Canvas 91.4 x 76.2 (36 x 30) Sir William Orpen, signed, 1919 Given by wish of Viscount Wakefield, 1968

D'EYNCOURT, Charles Tennyson (1784-1861) Politician

54 *See Groups:* The House of Commons, 1833, by Sir George Hayter

DIBDIN, Charles (1745-1814) Songwriter and dramatist

103 Canvas 73.7 x 62.2 (29 x 24½) Thomas Phillips, signed with initials and dated 1799 Purchased, 1860

DICK, Quintin (1777-1858) MP for Maldon

54 *See Groups:* The House of Commons, 1833, by Sir George Hayter

DICK, Sir Robert Henry (1785?-1846) Major-General

3708 *See Collections:* Studies for the Waterloo Banquet at Apsley House, 1836, by William Salter, **3689-3769**

DICK, Sir William Reid (1879-1961) Sculptor

4809 Canvas 127 x 101.6 (50 x 40) Philippe Ledoux, signed, exh 1934 Given by the sitter's widow, 1970

DICKENS, Charles (1812-70) Novelist

5207 Chalk 51.7 x 36.4 (20$\frac{3}{8}$ x 14$\frac{3}{8}$) Samuel Laurence, signed and dated 1838, autographed *Boz* by sitter Purchased, 1978

1172 Canvas 91.4 x 71.4 (36 x 28$\frac{1}{8}$) Daniel Maclise, signed and dated 1839 Lent by Tate Gallery, 1954

315 Canvas 94.3 x 62.9 (37$\frac{1}{8}$ x 24¾) Ary Scheffer, signed and dated 1855 Purchased, 1870

3445,3446,3563-6 *See Collections:* Prominent Men, c. 1880-c.1910, by Harry Furniss, **3337-3535** and **3554-3620**

Ormond

DICKENS, Sir Henry Fielding (1849-1933)
Lawyer; son of Charles Dickens

3285 Water-colour 36.2 x 22.5 (14¼ x 8⅞)
Sir Leslie Ward, signed *Spy* (*VF* 13 May 1897)
Purchased, 1934

DICKINSON, Goldsworthy Lowes (1862-1932) Philosopher

4293 Canvas, feigned circle 45.7 x 45.7 (18 x 18)
Lowes Cato Dickinson (his father), signed with initial and dated 1869
Given by the sitter's niece, Mrs Brownlow, 1962

3151 Chalk 49.5 x 40.3 (19½ x 15⅞)
Roger Fry, signed in monogram and dated 1893
Given by wish of the sitter's sister, Miss Lowes Dickinson, 1943

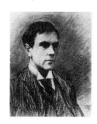

DICKONS, Maria (née Poole) (c. 1770-1833) Opera and sacred music soprano

1962(c) Ink 15 x 12.7 (5⅞ x 5)
Alfred Edward Chalon, inscribed and dated 1815
See Collections: Opera singers and others, c. 1804-c. 1836, by Alfred Edward Chalon, **1962(a-l)**

DICKSON, Sir Alexander (1777-1840) Major-General

3709 *See Collections:* Studies for The Waterloo Banquet at Apsley House, 1836, by William Salter, **3689-3769**

DIGBY, Edward Digby, 2nd Earl (1773-1856)

999 *See Groups:* The Trial of Queen Caroline, 1820, by Sir George Hayter

DIGBY, Sir Kenelm (1603-65)
Naval commander, diplomat and scientist

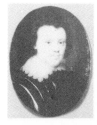

L152(12) Miniature on vellum, oval 7 x 5.5 (2¾ x 2⅛)
Peter Oliver, signed and dated 1627
Lent by NG (Alan Evans Bequest), 1975

486 Canvas 117.2 x 91.7 (46⅛ x 36⅛)
After Sir Anthony van Dyck (?) (c. 1640)
Purchased, 1877

Piper

DIGHTON, Richard (1795-1880)
Portraitist and caricaturist

1836a *See Unknown Sitters IV*

DIGHTON, Robert (1752?-1814)
Portrait painter, caricaturist and actor

2815 Pen and sepia wash 14.6 x 11.4 (5¾ x 4½)
Self-portrait, signed with initials, c. 1787
Purchased, 1936

DILKE, Sir Charles Wentworth, Bt (1843-1911) Politician and writer

1827 Canvas 62.2 x 52.1 (24½ x 20½)
George Frederic Watts, 1873
Given by the sitter's executors, 1919

1883 Bronze plaque 7.6 x 5.1 (3 x 2)
Oscar Roty, incised and dated 1900
Given by the sitter's executors, 1920

Continued overleaf

5154 Pencil 21.6 x 13 (8½ x 5⅛)
Edward Tennyson Reed, signed
with initials, c. 1902
Purchased, 1977

3819 Pencil 41 x 29.8 (16⅛ x 11¾)
William Strang, signed and dated
1908, autographed by sitter
Bequeathed by the sitter's niece,
Mrs Gertrude Mary Tuckwell,1952

5122 Sanguine 46 x 35.2
(18⅛ x 13⅞)
Harold Speed, signed and dated
1908, autographed by sitter
Purchased, 1977

DILKE, Emilia Frances, Lady
(1840-1904) Philanthropist
and writer on art

1828A Millboard 25.4 x 18.1
(10 x 7⅛) *sight*
Pauline, Lady Trevelyan, and
Laura Capel Lofft (afterwards
Lady Trevelyan), signed *L. Capel
Lofft,* c. 1864
Bequeathed by the sitter's husband,
1919

1828 Miniature on ivory 14 x 9.5
(5½ x 3¾)
Charles Camino, signed and dated
1882
Bequeathed by the sitter's husband,
1919

5288 Canvas 139.7 x 109.2
(55 x 43)
Sir Hubert von Herkomer, signed
with initials and dated 1887
Purchased, 1980

DILLON, Harold Lee-Dillon, 17th
Viscount (1844-1932) Antiquary

4834 Water-colour 28.2 x 24.1
(11⅛ x 9½)
Sir George Scharf
Acquired, 1970

2623 Canvas 76.2 x 63.5 (30 x 25)
Georgina Brackenbury, signed in
monogram and dated 1894
Given by the sitter's family, 1933

3259 Lead cast of medallion 7.9
(3⅛) diameter
Sydney William Carline, incised
and dated 1913
Purchased, 1913

DILLON, John (1851-1927)
Irish politician

2872 Pencil, chalk and wash
29 x 26.7 (11⅜ x 10½)
Sir Francis Carruthers Gould,
signed with initials
Purchased, 1936
See Collections: Caricatures of
Politicians, by Sir Francis
Carruthers Gould, **2826-74**

2835 *See Collections:* Caricatures
of Politicians, by Sir Francis
Carruthers Gould, **2826-74**

DILLON, Wentworth, 4th Earl
of Roscommon
See ROSCOMMON

DILLWYN, Lewis Weston
(1778-1855) Naturalist

54 *See Groups:* The House of Commons, 1833, by Sir George Hayter

DINWIDDIE, Robert (1693-1770)
Lieutenant-Governor of Virginia

1640 Canvas 75.6 x 63.5
(29¾ x 25)
Unknown artist
Purchased, 1912

Kerslake

DISRAELI, Benjamin, Earl of
Beaconsfield
See BEACONSFIELD

D'ISRAELI, Isaac (1766-1848)
Writer

4079 Pencil 39.6 x 32.1
(15⅝ x 12⅝)
John Downman, signed and dated
1804 by sitter
Purchased, 1958

3092 Pen and ink 25.1 x 18.4
(9⅞ x 7¼)
After Daniel Maclise, signed by
sitter, c. 1832
Purchased, 1939

3772 Pencil and wash 27.9 x 20.3
(11 x 8)
Alfred, Count D'Orsay, signed,
inscribed and dated 1839
Purchased, 1950

DIVETT, Edward (1797-1864)
MP for Exeter

54 *See Groups:* The House of Commons, 1833, by Sir George Hayter

DIXON, Richard Watson
(1833-1900) Historian, poet
and divine

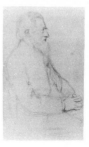

3171 Lithographic chalk
32.1 x 25.1 (12⅝ x 9⅞)
Sir William Rothenstein, signed and
dated 1897
Purchased, 1943

DOBELL, Sir Charles Macpherson
(1869-1954) General

2908(6,7) *See Collections:* Studies,
mainly for General Officers of
World War I, by John Singer
Sargent, **2908(1-18)**

1954 *See Groups:* General Officers
of World War I, by John Singer
Sargent

DOBELL, Sidney Thompson
(1824-74) Poet and critic

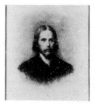

2060 Pencil 41.9 x 36.8
(16½ x 14½)
Briton Riviere
Given by the sitter's sister, Alice
Riviere (the artist's widow), 1924

DOBSON, Austin (1840-1921)
Poet and man of letters

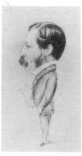

2208 Chalk 40.6 x 23.8 (16 x 9⅜)
A.R.Fairfield, signed and dated 1874
Given by Lady Gosse and family,
1928

1964 Canvas 29.2 x 22.2
(11½ x 8¾)
Sylvia Gosse, signed and dated 1908
Given by Sir Edmund Gosse, 1922

2176 Canvas 59.7 x 50.2
(23½ x 19¾)
Frank Brooks, signed and dated
1911
Bequeathed by the sitter's widow,
1928

DOBSON, William (1610-46)
Portrait painter

302 Canvas 71.1 x 59.7
(28 x 23½)
After a self-portrait (c. 1642-6)
Purchased, 1870

Piper

DOBSON, William Charles Thomas
(1817-98) Painter

2820 *See Groups:* The Royal
Academy Conversazione, 1891, by
G. Grenville Manton

DODD, William (1729-77)
Parson and forger

251 Canvas 121.9 x 97.2
(48 x 38¼)
John Russell, signed, inscribed
and dated 1769
Purchased, 1867

DODDRIDGE (or Doderidge),
Sir John (1555-1628) Judge

539 Canvas, feigned oval
76.2 x 62.9 (30 x 24¾)
Unknown artist
Transferred from BM, 1879

Strong

DODDRIDGE, Philip (1702-51)
Dissenting minister

2007 *See Unknown Sitters III*

DODGSON, Charles (1800-68)
Archdeacon; father of 'Lewis
Carroll'

P31 *See Collections:* Prints from
two albums, 1952-60, by Charles
Lutwidge Dodgson and others,
P31-40

DODGSON, Charles Lutwidge
(1832-98) 'Lewis Carroll';
photographer and author of *Alice
in Wonderland*

P7(26) Photograph: albumen print
14 x 11.7 (5½ x 4⅝)
Possibly by Reginald Southey,
c. 1856
Purchased with help from Kodak
Ltd, 1973
See Collections: Lewis Carroll at
Christ Church, by Charles Lutwidge
Dodgson, **P7(1-37)**

P38 Photograph: albumen print
7.9 x 5.4 (3⅛ x 2⅛)
Unknown photographer
Purchased, 1977
See Collections: Prints from two
albums, 1852-60, by Charles
Lutwidge Dodgson and others,
P31-40

P32, P39 *See Collections:* Prints
from two albums, 1852-60, by
Charles Lutwidge Dodgson and
others, **P31-40**

2609 Pen and ink 21 x 13.3
(8¼ x 5¼)
Harry Furniss, inscribed
Given by Harold Hartley, 1933

3629 Pen and ink 18.4 x 10.2
(7¼ x 4)
Harry Furniss, signed with initials
Given by Theodore Cluse, 1948

DODGSON, George Haydock
(1811-80) Water-colour painter

1456(4) Chalk 6 x 6 (2⅜ x 2⅜)
Charles Hutton Lear, inscribed,
c. 1845
Given by John Elliot, 1907
See Collections: Drawings of
Artists, c. 1845, by Charles
Hutton Lear, **1456(1-27)**

DODINGTON, George Bubb,
Baron Melcombe
See MELCOMBE

DODSLEY, Robert (1703-64)
Poet, dramatist and bookseller

1436 Oil on tin, oval 28.9 x 24.8
(11⅜ x 9¾)
Attributed to Edward Alcock,
1760(?)
Given by Alfred Jones, 1906

Kerslake

DOLLAND, Peter (1730-1820)
Optician

1075,1075a and **b** *See Groups:*
Men of Science Living in 1807-8,
by Sir John Gilbert and others

DOLMETSCH, Arnold (1858-1940)
Musician and historian of music

4641 Chalk 16.2 x 25.4 (6⅜ x 10)
Sir William Rothenstein, signed and
inscribed, 1895
Given by the Rothenstein Memorial
Trust, 1968

4642 Chalk, two sketches
23. 8 x 28.3 (9⅜ x 11⅛)
Sir William Rothenstein, signed and
inscribed, 1895
Given by the Rothenstein Memorial
Trust, 1968

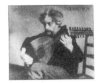

P108 Photograph: bromide print
14.9 x 17.5 (5⅞ x 6⅞)
Herbert Lambert
Given by the photographer's
daughter, Mrs Barbara Hardman,
1978
See Collections: Musicians and
Composers, by Herbert Lambert,
P107-11

DON, Alan Campbell (1885-1966)
Dean of Westminster

4539 Chalk 38.1 x 27.3 (15 x 10¾)
Francis Dodd, signed and inscribed
Purchased, 1967

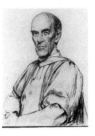

DONEGALL, George Hamilton
Chichester, 3rd Marquess of
(1797-1883)
MP for County Antrim

54 *See Groups:* The House of Com-
mons, 1833, by Sir George Hayter

DONKIN, Bryan (1768-1855)
Civil engineer

1075,1075a and **b** *See Groups:*
Men of Science Living in 1807-8,
by Sir John Gilbert and others

DONKIN, Sir Rufane Shaw
(1773-1841) General

54 *See Groups:* The House of Com-
mons, 1833, by Sir George Hayter

DONNE, John (c. 1572-1631)
Poet and divine

1849 Canvas 53.3 x 44.5
(21 x 17½)
After Isaac Oliver (1616)
Purchased, 1919

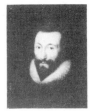

Strong

DONOUGHMORE, Richard Hely-
Hutchinson, 1st Earl of
(1756-1825) Advocate of Catholic
emancipation

2662(29) *See Collections:* Book
of sketches, mainly for The Trial of
Queen Caroline, 1820, by Sir
George Hayter, **2662(1-38)**

999 *See Groups:* The Trial of
Queen Caroline, 1820, by Sir
George Hayter

DORAN, John (1807-78) Writer

1648 Water-colour 30.5 x 17.5
(12 x 6⅞)
Sir Leslie Ward, signed *Spy*
(*VF* 6 Dec 1873)
Given by Sir Edmund Gosse, 1912

Ormond

DORCHESTER, Catherine (Sedley),
Countess of (1657-1717)
Mistress of James II

36 Canvas 125.7 x 100.3
(49½ x 39½)
Studio of Sir Peter Lely (c.1675)
Purchased, 1858

1696 Miniature on vellum, oval
7.9 x 6 ($3\frac{1}{8}$ x $2\frac{3}{8}$)
Lawrence Crosse, signed in
monogram, c.1685-90
Purchased, 1913

Piper

DORCHESTER, Dudley Carleton,
Viscount (1574-1632) Diplomat

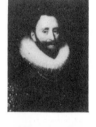

3684 Panel 63.5 x 50.2 (25 x 19¾)
Michael Jansz. van Miereveldt,
c. 1620
Given by Mrs Harry Burton, in
memory of her husband, 1950.
Montacute

110 Panel 63.5 x 53.3 (25 x 21)
Studio of Michael Jansz. van
Miereveldt (1625)
Given by Felix Slade, 1860

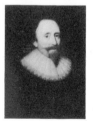

Piper

DORE, Kate

P18(35) *See Collections:* The
Herschel Album, by Julia Margaret
Cameron, **P18(1-92b)**

DORMER, John (1669-1719)
Country gentleman

3203 Canvas 90.8 x 70.5
(35¾ x 27¾)
Sir Godfrey Kneller, signed in
monogram, c. 1710
Kit-cat Club portrait
Given by NACF, 1945.
Beningbrough

Piper

D'ORSAY, Alfred, Count (1801-52)
Amateur artist and man of fashion

4922 *See Collections:* Caricatures
of Prominent People, c. 1832-5,
by Sir Edwin Landseer, **4914-22**

5061 Canvas 127.3 x 101.6
($50\frac{1}{8}$ x 40)
Sir George Hayter, 1839
Purchased, 1975

4540 Chalk and pencil
22.2 x 16.5 (8¾ x 6½)
Richard James Lane, signed with
initials and dated 1841
Purchased, 1967

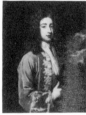

3548 Marble bust 83.8 (33) high
Self-portrait
Lent by Lady Teresa Agnew, 1968

Ormond

DORSET, Lionel Sackville, 1st
Duke of (1688-1765) Courtier

3205 Canvas 91.4 x 71.1
(36 x 28)
Sir Godfrey Kneller, signed in
monogram, c. 1710
Kit-cat Club portrait
Given by NACF, 1945

Piper

DORSET, Thomas Sackville, 1st
Earl of (1536-1608)
Poet and Lord Treasurer

4024 Panel 110.5 x 87.6
(43½ x 34½)
Attributed to John de Critz the
Elder, dated 1601
Purchased, 1957

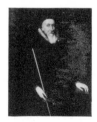

665 *See Groups:* The Somerset House Conference, 1604, by an unknown Flemish artist

DORSET, Anne (Clifford), Countess of *See* PEMBROKE AND MONTGOMERY

DORSET, Charles Sackville, 6th Earl of (1638-1706)
Poet and courtier

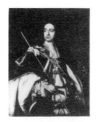

250 Canvas 126.4 x 101 (49¾ x 39¾)
Studio of Sir Godfrey Kneller (1694)
Purchased, 1867

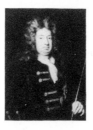

3204 Canvas 91.4 x 71.1 (36 x 28)
Sir Godfrey Kneller, signed, c.1697
Kit-cat Club portrait
Given by NACF, 1945.
Beningbrough
Piper

DOUGHTY, Charles Montagu (1843-1926) Poet and traveller

2113 Pastel 48.3 x 36.8 (19 x 14½)
Eric Kennington, signed and dated 1921
Transferred from Tate Gallery, 1926

DOUGHTY, William (1757-82)
Portrait painter and mezzotint engraver

2513 Canvas, feigned oval 22.9 x 19.1 (9 x 7½)
Self-portrait, c. 1776
Purchased, 1931

DOUGLAS, Sir Howard, Bt (1776-1861) General

316a(33) Pencil, two sketches 47.3 x 66.4 ($18\frac{5}{8}$ x $26\frac{1}{8}$)
Sir Francis Chantrey, inscribed, 1837-41
Given by Mrs George Jones, 1871
See Collections: Preliminary drawings for busts and statues by Sir Francis Chantrey, **316a(1-202)**

DOUGLAS, John Sholto, 8th Marquess of Queensberry
See QUEENSBERRY

DOUGLAS, Norman (1868-1952)
Novelist

4146 Ink and wash 35.6 x 27.9 (14 x 11)
Michael Ayrton, signed, inscribed and dated 1948
Given by W.A.Evill, 1960

DOUGLAS, Sholto John, 20th Earl of Morton *See* MORTON

DOUGLAS, William, 4th Duke of Queensberry
See QUEENSBERRY

DOUGLAS-PENNANT, Edward, 1st Baron Penrhyn
See PENRHYN

DOVER, George-Agar Ellis, 1st Baron (1797-1833)
A founder of the National Gallery

999 *See Groups:* The Trial of Queen Caroline, 1820, by Sir George Hayter

794 *See Groups:* Four studies for Patrons and Lovers of Art, c.1826, by Pieter Christoph Wonder, **792-5**

DOWNEY, Richard Joseph (1881-1953)
Archbishop of Liverpool

5023 Canvas 60.3 x 50.2 (23¾ x 19¾)
Stanley Reed, signed, 1949-50
Given by the artist, 1975

DOWNSHIRE, Wills Hill, 1st Marquess of (1718-93)
Statesman

L160 *See Groups:* 1st Marquess of Downshire and his family, by Arthur Devis

DOWNSHIRE, Arthur Hill, 2nd
Marquess of (1753-1801)

L160 *See Groups:* 1st Marquess
of Downshire and his family, by
Arthur Devis

DOWNSHIRE, Arthur Trumbull
Hill, 3rd Marquess of (1788-1845)

999 *See Groups:* The Trial of
Queen Caroline, 1820, by Sir
George Hayter

DOWSON, Ernest (1867-1900)
Poet

2209 Pencil 14.9 x 12.7
($5\frac{7}{8}$ x 5)
Charles Conder, signed and inscribed
Given by Lady Gosse and family,
1928

DOYLE, Sir Arthur Conan
(1859-1930) Novelist

3668 With figure of Sherlock
Holmes (left)
Pencil, ink and wash 37.2 x 28.2
($14\frac{5}{8}$ x $11\frac{1}{8}$)
Sir Bernard Partridge, signed
(*Punch* 12 May 1926)
Purchased, 1949
See Collections: Mr Punch's
Personalities, 1926-9, by Sir
Bernard Partridge, **3664-6,** etc

4115 Canvas 73.7 x 62.2
(29 x 24½)
Henry L. Gates, signed, 1927
Given by the sitter's daughter, Jean
Conan Doyle, 1959

DOYLE, Sir Charles Hastings
(1805-83) General

2709 Water-colour 30.5 x 18.1
(12 x $7\frac{1}{8}$)
Sir Leslie Ward, signed *Spy*
(*VF* 23 March 1878)
Purchased, 1934

Ormond

DOYLE, Sir Francis, Bt (1810-88)
Poet and civil servant

2710 Water-colour 38.1 x 20.3
(15 x 8)
Sir Leslie Ward, signed *Spy*
(*VF* 24 Nov 1877)
Purchased, 1934

DOYLE, Henry Edward (1827-92)
Director of the National Gallery
of Ireland

1833 *See Groups:* Private View of
the Old Masters Exhibition, Royal
Academy, 1888, by Henry Jamyn
Brooks

DOYLE, John (1797-1868)
Caricaturist; 'HB'

2130 Chalk 57.5 x 45.7 ($22\frac{5}{8}$ x 18)
Henry Edward Doyle (his son),
signed
Given by the sitter's grandson, Sir
Arthur Conan Doyle, 1926

Ormond

D'OYLY, Henry (1780-1855)
Major-General

3710 *See Collections:* Studies for
The Waterloo Banquet at Apsley
House, 1836, by William Salter,
3689-3769

DRAKE, Sir Francis (1540?-96)
Admiral and circumnavigator

4851 Miniature on vellum 2.8
($1\frac{1}{8}$) diameter
Studio of (?) Nicholas Hilliard,
inscribed and dated 1581
Purchased with help from NACF
and H.M.Government, 1971

4032 Panel 181.3 x 113
($71\frac{3}{8}$ x 44½)
Unknown artist, c. 1580-5
Purchased, 1957. *Montacute*

3905 Engraving 39.4 x 30.5
(15½ x 12)
Attributed to Jodocus Hondius,
finished by George Vertue, c.1583
Acquired originally for reference

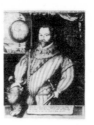

1627 Panel 31.8 x 32.4
(12½ x 12$\frac{3}{8}$)
After engraving attributed to
Jodocus Hondius
Purchased, 1911

Strong

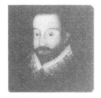

DRAYTON, Michael (1563-1631)
Poet

2528 Water-colour 37.1 x 26
(14$\frac{5}{8}$ x 10¼)
Attributed to George Vertue,
inscribed
Bequeathed by Richard William
Goulding, 1931

776 *See Unknown Sitters I*

DREW, George A.

4529(116-19) *See Collections:*
Working drawings by Sir David
Low, **4529(1-401)**

DRINKWATER, John (1882-1937)
Poet and playwright

L168(9) Canvas 76.5 x 63.5
(30$\frac{1}{8}$ x 25)
Sir William Rothenstein, c.1918
Lent by the artist's son, Sir
John Rothenstein, 1977
See Collections: Prominent men,
1895-1930, by Sir William
Rothenstein, **L168(1-11)**

4094 Chalk 33 x 24.1 (13 x 9½)
Joyce Wansey Thompson, signed,
inscribed and dated 1935
Purchased, 1959

DRUMMOND, Berkeley
(1796-1860)
Lieutenant-Colonel

3711 *See Collections:* Studies for
The Waterloo Banquet at Apsley
House, 1836, by William Salter,
3689-3769

DRUMMOND, D.T.K.(1799-1888)
Episcopalian minister

P6(39) *See Collections:* The Hill
and Adamson Albums, 1843-8, by
David Octavius Hill and Robert
Adamson, **P6(1-258)**

DRUMMOND, Henry (1851-97)
Theological writer

3845 *See Groups:* Dinner at
Haddo House, 1884, by Alfred
Edward Emslie

DRUMMOND, James, 4th Earl
of Perth *See* PERTH

DRUMMOND, James (1816-77)
Painter

P6(34) Photograph: calotype
20 x 14.3 (7$\frac{7}{8}$ x 5$\frac{5}{8}$)
David Octavius Hill and Robert
Adamson, 1843-8
Given by an anonymous donor, 1973
See Collections: The Hill and
Adamson Albums, 1843-8, by
David Octavius Hill and Robert
Adamson, **P6(1-258)**

DRUMMOND, Samuel (1765-1844)
Portrait and historical painter

4216 Pen and ink 14.6 x 12.1
(5¾ x 4¾)
George Harlow White, signed,
inscribed and dated 1842
Given by E.E.Leggatt, 1910
See Collections: Drawings, c.1845,
by George Harlow White, **4216-18**

Ormond

DRUMMOND, of Hawthornden,
William (1585-1649) Poet

1195 *See Unknown Sitters I*

DRUMMOND-BURRELL, Peter
Robert, 2nd Baron Gwydyr
See GWYDYR

DRUMMOND-WILLOUGHBY,
Peter Robert, 19th Baron
Willoughby de Eresby
See WILLOUGHBY DE ERESBY

DRURY, Sir William (1527-79)
Soldier

1911 Panel 48.9 x 38.1 (19¼ x 15)
Unknown artist
Purchased, 1921

1492b *See Collections:* Copies of
early portraits, by George Perfect
Harding and Sylvester Harding,
1492,1492(a-c) and **2394-2419**

Strong

DRYBURGH, Margaret

P6(202, 204) *See Collections:* The
Hill and Adamson Albums, 1843-8,
by David Octavius Hill and Robert
Adamson, **P6(1-258)**

DRYDEN, John (1631-1700)
Dramatist and Poet Laureate

2083 Canvas 124.5 x 101
(49 x 39¾)
Sir Godfrey Kneller, signed and
inscribed, 1693
Purchased, 1925

57 Panel, feigned oval 30.5 x 25.4
(12 x 10)
After Sir Godfrey Kneller (1698)
Purchased, 1858

1133 Canvas 57.2 x 50.2
(22½ x 19¾)
James Maubert, inscribed
Purchased, 1898. *Beningbrough*

Piper

DU CANE, Alice Mary (b.1860)
Daughter of Sir Edmund Du Cane

P18(16) *See Collections:* The
Herschel Album, by Julia Margaret
Cameron, **P18(1-92b)**

DUCIE, Thomas Reynolds Moreton,
1st Earl of (1776-1840)

1695(u) *See Collections:* Sketches
for The Trial of Queen Caroline,
1820, by Sir George Hayter,
1695(a-x)

999 *See Groups:* The Trial of
Queen Caroline, 1820, by Sir
George Hayter

DUCK, Stephen (1705-56)
Poet

4493 Miniature on vellum, oval
5.1 x 4.1 (2 x 1⅝)
Attributed to Christian Richter
Given by John L.Nevinson, 1968

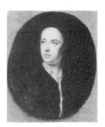

DUCKWORTH, Julia (née Jackson)
See STEPHEN, Julia, Lady

DUDLEY, Lady Jane (née Grey)
(1537-54)
Proclaimed Queen 1553

4451 Panel 180.3 x 94 (71 x 37)
Attributed to Master John, c.1545
Purchased with help from the
Gulbenkian Foundation, 1965

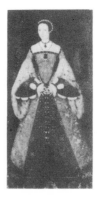

764 *See Unknown Sitters I*

Strong

DUDLEY, John, Duke of
Northumberland
See NORTHUMBERLAND

DUDLEY, Rachel (née Gurney), Countess of (d. 1920)
Wife of 2nd Earl of Dudley

2820 *See Groups:* The Royal Academy Conversazione, 1891, by G. Grenville Manton

DUDLEY, Robert, Earl of Leicester
See LEICESTER

DUFFERIN AND AVA, Frederick Hamilton-Temple-Blackwood, 1st Marquess of (1826-1902)
Diplomat and administrator

1315 Canvas 64.8 x 52.1 (25½ x 20½)
George Frederic Watts, signed, 1881
Given by the artist, 1902

DUGDALE, Thomas Cantrell (1880-1952) Painter

3919 With unknown lady
Canvas 63.2 x 76 (24$\frac{7}{8}$ x 29$\frac{7}{8}$)
Self-portrait, signed
Given by the artist's widow, 1954

DUGDALE, Sir William (1605-86)
Scholar and herald

540 Canvas 61 x 48.9 (24 x 19¼)
Unknown artist, c. 1675
Transferred from BM, 1879

Piper

DUGDALE, William Stratford (1800-71)
MP for Warwickshire North

54 *See Groups:* The House of Commons, 1833, by Sir George Hayter

DUKES, Dame Marie
See RAMBERT

DU MAURIER, George (1834-96)
Novelist and illustrator

3656 Canvas 45.7 x 37.5 (18 x 14¾)
Self-portrait, c. 1879
Given by members of the sitter's family, 1949

2899 Pen and ink 12.7 x 7.6 (5 x 3)
Edward Joseph Sullivan, signed and dated 1891
Given by A.F.U.Green, 1936

2711 Water-colour 32.4 x 19.7 (12¾ x 7¾)
Sir Leslie Ward, signed *Spy*
(*VF* 23 Jan 1896)
Purchased, 1934

3568, 3569 *See Collections:* Prominent Men, c. 1880-c.1910, by Harry Furniss, **3337-3535** and **3554-3620**

DU MAURIER, Sir Gerald (1873-1934) Actor-manager

4095(3) Pen and ink 39.4 x 31.4 (15½ x 12$\frac{3}{8}$)
Harry Furniss, signed with initials, pub 1905
Purchased, 1959
See Collections: The Garrick Gallery of Caricatures, 1905, by Harry Furniss, **4095(1-11)**

DUNCAN, Adam Duncan, 1st Viscount (1731-1804) Admiral

1084 Canvas 76.2 x 62.2 (30 x 24½)
Henri Pierre Danloux, 1792
Purchased, 1879

L152(8) Wedgwood medallion, oval 10.5 x 7.9 (4$\frac{1}{8}$ x 3$\frac{1}{8}$)
John de Vaere, 1798
Lent by NG (Alan Evans Bequest), 1974

Continued overleaf

1839 Canvas 74.9 x 62.2
(29½ x 24½)
John Hoppner, c. 1798
Given by Henry A. Warriner, 1919

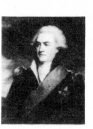

4315 Pencil and wash, feigned oval
18.1 x 16.2 ($7\frac{1}{8}$ x $6\frac{3}{8}$)
John Smart, signed, inscribed and
dated 1798
Purchased, 1963

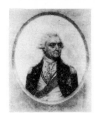

DUNCAN, Mrs

P22(21) *See Collections:* The
Balmoral Album, 1854-68, by
George Washington Wilson, W. & D.
Downey, and Henry John Whitlock,
P22(1-27)

DUNCAN, Henry (1774-1846)
Founder of savings banks

P6(88) Photograph: calotype
20.3 x 14.9 (8 x $5\frac{7}{8}$)
David Octavius Hill and Robert
Adamson, 1843-6
Given by an anonymous donor,
1973
See Collections: The Hill and
Adamson Albums, 1843-8, by
David Octavius Hill and Robert
Adamson, **P6(1-258)**

DUNCAN, James

P6(142) *See Collections:* The Hill
and Adamson Albums, 1843-8, by
David Octavius Hill and Robert
Adamson, **P6(1-258)**

DUNCAN, John
Music master; brother of Thomas
Duncan

P6(56, 69) *See Collections:* The
Hill and Adamson Albums, 1843-8,
by David Octavius Hill and Robert
Adamson, **P6(1-258)**

DUNCAN, Thomas (1807-45)
Painter

P6(84) Photograph: calotype
14.3 x 10.8 ($5\frac{5}{8}$ x 4¼)
David Octavius Hill and Robert
Adamson, 1843-5
Given by an anonymous donor, 1973
See Collections: The Hill and
Adamson Albums, 1843-8, by
David Octavius Hill and Robert
Adamson, **P6(1-258)**

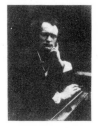

P6(20,72,142,227) *See Collections:*
The Hill and Adamson Albums,
1843-8, by David Octavius Hill
and Robert Adamson, **P6(1-258)**

DUNCH, Edmund (1657-1719)
Politician

3206 Canvas 91.4 x 71.8
(36 x 28¼)
Sir Godfrey Kneller, c. 1700-10
Kit-cat Club portrait
Given by NACF, 1945.
Beningbrough

Piper

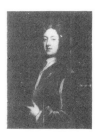

DUNCOMBE, Thomas Slingsby
(1796-1861) Radical politician

1651a Pencil and water-colour
27 x 20.7 ($10\frac{5}{8}$ x $8\frac{1}{8}$)
James Warren Childe, signed, and
autographed and dated 1836 by
sitter
Given by Claud Lovat Fraser, 1912

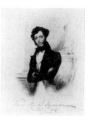

4026(20) *See Collections:*
Drawings of Men about Town,
1832-48, by Alfred, Count D'Orsay,
4026(1-61)

Ormond

DUNCOMBE, William, 2nd Baron
Feversham *See* FEVERSHAM

DUNCOMBE, William Ernest,
1st Earl of Feversham
See FEVERSHAM

DUNDAS, Thomas Dundas, 1st
Baron (1741-1820) Vice-Admiral
of Orkney and Shetland

316a(39) Pencil 43.8 x 27.9
(17¼ x 11)
Sir Francis Chantrey, inscribed,
1819-20
Given by Mrs George Jones, 1871
See Collections: Preliminary
drawings for busts and statues by
Sir Francis Chantrey, **316a(1-202)**

DUNDAS, Sir David (1735-1820)
General

982d Coloured etching 27.7 x 19.7
(10⅞ x 7¾)
Robert Dighton, signed, inscribed
and dated 1810 on plate
Acquired before 1896

316a(38) (With another drawing
of Dundas on reverse)
Pencil 45.4 x 32.8 (17⅞ x 12⅞)
Sir Francis Chantrey, c. 1818
Given by Mrs George Jones, 1871
See Collections: Preliminary
drawings for busts and statues by
Sir Francis Chantrey, **316a(1-202)**

DUNDAS, Henry, 1st Viscount
Melville *See* MELVILLE

DUNDAS, Sir James Whitley
Deans (1785-1862) Admiral

54 *See Groups:* The House of Com-
mons, 1833, by Sir George Hayter

DUNDAS of Arniston, Robert
(1758-1819) Judge and Chief
Baron of the Exchequer Court in
Scotland

745 *See Groups:* William Pitt
addressing the House of Commons
. . . 1793, by Karl Anton Hickel

316a(40) Pencil 43.8 x 28.6
(17¼ x 11¼)
Sir Francis Chantrey, inscribed,
1817-19
Given by Mrs George Jones, 1871
See Collections: Preliminary
drawings for busts and statues by
Sir Francis Chantrey, **316a(1-202)**

DUNDAS, Robert, 2nd Viscount
Melville *See* MELVILLE

DUNDAS, Sir Robert Lawrence
(1780-1844)
MP for Richmond, Yorkshire

54 *See Groups:* The House of Com-
mons, 1833, by Sir George Hayter

DUNDONALD, Archibald Cochrane,
9th Earl of (1747/8-1831) Chemist

1075 *See Groups:* Men of Science
Living in 1807-8, by Sir John
Gilbert and others

DUNEDIN, Andrew Graham
Murray, 1st Viscount (1849-1942)
Lord of Appeal

3935 Ink and chalk 24.1 x 22.2
(9½ x 8¾)
Robin Guthrie, signed, 1937
Purchased, 1955

DUNFERMLINE, James
Abercromby, 1st Baron
(1776-1858) Politician

54 *See Groups:* The House of Com-
mons, 1833, by Sir George Hayter

DUNK, George Montagu, 2nd
Earl of Halifax *See* HALIFAX

DUNLOP, James (1769?-1841)

316a(41) *See Collections:*
Preliminary drawings for busts and
statues by Sir Francis Chantrey,
316a(1-202)

DUNLOP, William (1792-1848)
Army surgeon and writer; pioneer
in Canada

3029 Pencil and water-colour
22.5 x 17.5 (8⅞ x 6⅞)
Daniel Maclise, 1833
Given by Marion Harry Spielmann,
1939

Ormond

DUNNING, John, 1st Baron
Ashburton *See* ASHBURTON

DUNSANY, Edward John Moreton
Drax Plunkett, 18th Baron
(1878-1957) Writer

2048 Plasticine medallion 10.5
($4\frac{1}{8}$) diameter
Theodore Spicer-Simson, incised
and dated 1922
Given by the artist, 1924
See Collections: Medallions of
writers, c.1922, by Theodore
Spicer-Simson, **2043-55**

DURAND, Sir Henry Mortimer
(1850-1924) Diplomat

2128 Canvas 61 x 49.5 (24 x 19½)
W. Thomas Smith, 1903-4
Given by subscribers, 1926

DURHAM, John George Lambton,
1st Earl of (1792-1840)
Governor-General of Canada

2547 Canvas 91.4 x 71.1 (36 x 28)
Thomas Phillips, replica (1819)
Purchased, 1932

999 *See Groups:* The Trial of
Queen Caroline, 1820, by Sir
George Hayter

Ormond

DURRANT, Davy (1704-59)

4855(1) *See Collections:* The
Townshend Album, **4855(1-73)**

DUVEEN, Joseph Duveen, Baron
(1869-1939)
Art dealer and benefactor

2484 Pencil 29.2 x 22.2
(11½ x 8¾)
Walter Tittle, signed by artist and
sitter
Purchased, 1930

3062 Stone bust 69.9 (27½) high
Sir William Reid Dick, exh 1934
Given by the sitter's widow, 1939

DYCE, William (1806-64)
Pre-Raphaelite painter

3944(30) Pencil 24.1 x 18.4
(9½ x 7¼)
John Partridge, 1825
Purchased, 1955
See Collections: Artists, 1825, by
John Partridge and others,
3944(1-55)

Ormond

DYER, Sir James (1512-82)
Judge

1294 Panel 53.3 x 42.2 (21 x $16\frac{5}{8}$)
Unknown artist, after a portrait of
1575
Purchased, 1901

Strong

DYER, Joseph Chessborough
(1780-1871) Inventor

2515(55) *See Collections:*
Drawings of Prominent People,
1823-49, by William Brockedon,
2515(1-104)

DYKES, Fretchville Lawson
Ballantine (1800-66)
MP for Cockermouth

54 *See Groups:* The House of Com-
mons, 1833, by Sir George Hayter

DYNEVOR, George Rice, 4th
Baron (1795-1869)
MP for Carmarthenshire

54 *See Groups:* The House of Com-
mons, 1833, by Sir George Hayter

DYNEVOR, Francis William Rice,
5th Baron (1804-78)
Representative peer

1834(k) *See Collections:* Members
of the House of Lords, c.1870-80,
by Frederick Sargent, **1834(a-z** and
aa-hh)

EARLE, Sir James (1755-1817)
Surgeon

3089(5) Pencil 25.4 x 19.7
(10 x 7¾)
William Daniell after George
Dance, inscribed
Purchased, 1940
See Collections: Tracings of
drawings by George Dance,
3089(1-12)

EARLE, John (1601-65)
Divine and writer; author of
Microcosmographie

1531 Canvas, feigned irregular
oval 73.7 x 62.2 (29 x 24½)
Unknown artist, c. 1660
Purchased, 1909

Piper

EAST, Sir Alfred (1849-1913)
Painter and etcher

4826 Canvas 101.6 x 128.3
(40 x 50½)
Sir Frank Brangwyn
Purchased, 1970

EAST, Sir Edward Hyde, Bt
(1764-1847)
Chief Justice of Calcutta

316a(42) Pencil, two sketches
42.5 x 64.1 (16¾ x 25¼)
Sir Francis Chantrey, inscribed,
1829
Given by Mrs George Jones, 1871
See Collections: Preliminary
drawings for busts and statues by
Sir Francis Chantrey, **316a(1-202)**

EASTLAKE, Sir Charles Lock
(1793-1865) PRA and Director
of the National Gallery

3944(22) Pencil 24.1 x 18.4
(9½ x 7¼)
John Partridge, 1825
Purchased, 1955
See Collections: Artists, 1825, by
John Partridge and others,
3944(1-55)

2515(16) *See Collections:*
Drawings of Prominent People,
1823-49, by William Brockedon,
2515(1-104)

342,343a-c *See Groups:* The Fine
Arts Commissioners, 1846, by
John Partridge

953 Marble bust 58.4 (23) high
John Gibson, incised, 1840s
Bequeathed by the sitter's widow,
1894

2477, 2478 *See Collections:*
Drawings of Royal Academicians,
c. 1858, by Charles Bell Birch,
2473-9

3182(5,12) *See Collections:*
Drawings of Artists, c. 1862, by
Charles West Cope

Ormond

EASTLAKE, Elizabeth (née Rigby),
Lady (1809-93) Writer; wife of Sir
Charles Lock Eastlake

P6(124) Photograph: calotype
20.6 x 15.6 ($8\frac{1}{8}$ x $6\frac{1}{8}$)
David Octavius Hill and Robert
Adamson, 1843-8
Given by an anonymous donor,1973
See Collections: The Hill and
Adamson Albums, 1843-8, by
David Octavius Hill and Robert
Adamson, **P6(1-258)**

P6 (125, 130, 134, 136, 163)
See Collections: The Hill and
Adamson Albums, 1843-8, by
David Octavius Hill and Robert
Adamson, **P6(1-258)**

Continued overleaf

2533 Water-colour 12.1 x 10.8
(4¾ x 4¼)
Coke Smyth
Purchased, 1932

Ormond

EATON, Sir Frederick (1838-1913)
Secretary of the Royal Academy

1833 *See Groups:* Private View of
the Old Masters Exhibition, Royal
Academy, 1888, by Henry Jamyn
Brooks

4245 *See Groups:* Hanging
Committee, Royal Academy, 1892,
by Reginald Cleaver

EATON, Joseph (1793-1858)
Slavery abolitionist

599 *See Groups:* The Anti-Slavery
Society Convention, 1840, by
Benjamin Robert Haydon

EBURY, Lord Robert Grosvenor,
1st Baron (1801-93) Politician

54 *See Groups:* The House of Com-
mons, 1833, by Sir George Hayter

EDDINGTON, Sir Arthur
(1882-1944) Astronomer

4646 Chalk 41.9 x 33.7
(16½ x 13¼)
Sir William Rothenstein, 1928-9
Given by the Rothenstein Memorial
Trust, 1968

EDEN, George, 1st Earl of
Auckland *See* AUCKLAND

EDEN, Robert Anthony, 1st Earl
of Avon *See* AVON

EDEN, William, 1st Baron
Auckland *See* AUCKLAND

EDGAR, Mrs William
Mother of Lady Peek

4441 *See Groups:* The Duke and
Duchess of Teck receiving Officers
of the Indian Contingent, 1882, by
Sydney Prior Hall

EDGEWORTH, Maria (1769-1849)
Novelist; daughter of Richard
Lovell Edgeworth

P5 Photograph: daguerreotype
5.4 x 4.4 (2⅛ x 1¾) *sight*
Studio of Richard Beard, 1841
Given by the Misses Butler, 1968

EDGEWORTH, Richard Lovell
(1744-1817) Writer and inventor

5069 Miniature on ivory, oval
7.6 x 6 (3 x 2⅜)
Horace Hone, signed in monogram
and dated 1785
Purchased, 1976

EDINBURGH, Prince Alfred, Duke
of (1844-1900)
Second son of Queen Victoria

P26 *See Groups:* The Royal
Family . . . , by L. Caldesi

P27 *See Groups:* Royal mourning
group, 1862, by W. Bambridge

EDMONDES, Sir Thomas
(1563?-1639) Diplomat

4652 Canvas 128.3 x 101.6
(50½ x 40)
Daniel Mytens, c. 1620
Purchased, 1968. *Montacute*

Strong

EDWARD (d.1066)
'The Confessor'; reigned 1043-66

4048 Silver penny 1.9 (¾) diameter
Manwine from a die attributed to
Theodoric, 1065
Purchased, 1958

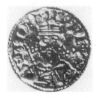

4049 Silver penny 1.9 (¾) diameter
Iocetel from a die attributed to
Theodoric, 1065
Purchased, 1958

Strong

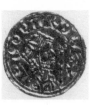

EDWARD II (1284-1327)
Reigned 1307-27

439 Electrotype of effigy in
Gloucester Cathedral 198.1 (78) long
Purchased, 1877

Strong

EDWARD III (1312-77)
Reigned 1327-77

332 Electrotype of effigy in
Westminster Abbey 111.8 (44) long
Unknown artist (c.1377-80)
Purchased, 1871

4980(7) Panel 58.1 x 44.8
($22\frac{7}{8}$ x $17\frac{5}{8}$)
Unknown artist, inscribed
Purchased, 1974. *Montacute*
See Collections: Set of 16 early
English Kings and Queens formerly
at Hornby Castle, Yorkshire,
4980(1-16)

Strong

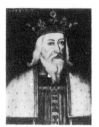

EDWARD IV (1442-83)
Reigned 1461-83

4980(10) Panel 57.2 x 44.8
(22½ x $17\frac{5}{8}$)
Unknown artist, inscribed
Purchased, 1974. *Montacute*
See Collections: Set of 16 early
English Kings and Queens formerly
at Hornby Castle, Yorkshire,
4980(1-16)

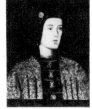

3542 Panel 33 x 27.3 (13 x 10¾)
Unknown artist, inscribed on frame
Purchased, 1947

Strong

EDWARD V (1470-83)
Reigned 1483

4980(11) *See Collections:* Set of
16 early English Kings and Queens
formerly at Hornby Castle,
Yorkshire, **4980(1-16)**

EDWARD VI (1537-53)
Reigned 1547-53

1132 Panel 43.8 x 31.1
(17¼ x 12¼)
After Hans Holbein (c.1542)
Purchased, 1898. *Montacute*

1299 Panel 42.5 x 160 (16¾ x 63)
William Scrots, inscribed and
dated 1546
Anamorphosis
Purchased, 1898

442 Panel 47.3 x 27.9 ($18\frac{5}{8}$ x 11)
Studio of William Scrots, c. 1546
Purchased, 1877

Strong

EDWARD VII (1841-1910)
Reigned 1901-10

P26 *See Groups:* The Royal
Family . . . , by L. Caldesi

5217 Pastel 59.7 x 45.1
(23½ x 17¾)
George Richmond, signed and
dated 1858
Purchased, 1978

P22(5) Photograph: albumen print
14 x 9.8 (5½ x 3⅞)
W. & D. Downey, 25 May 1868
Purchased, 1975
See Collections: The Balmoral
Album, 1854-68, by George
Washington Wilson, W. & D. Downey,
and Henry John Whitlock,
P22(1-27)

P22(2,3) *See Collections:* The
Balmoral Album, 1854-68, by
George Washington Wilson, W. & D.
Downey, and Henry John Whitlock,
P22(1-27)

3983 Chalk 58.4 x 48.3 (23 x 19)
George Frederic Watts, c.1874
Purchased, 1956

4536 *See Groups:* Four
Generations . . . , by Sir William
Quiller Orchardson

2019 Bronze cast of bust 40.6
(16) high
Sydney March, incised and dated
1901
Given by Viscount Dillon, 1924

1691 Canvas 275.6 x 180.3
(108½ x 71)
Sir Luke Fildes, replica (1902)
Given by King George VI, 1912

4367 Pencil 15.9 x 13 (6¼ x 5⅛)
Fred Roe, inscribed, 1905-6
Given by the artist's son, F. Gordon
Roe, 1964

3967 Water-colour 11.4 x 7.9
(4½ x 3⅛)
Mrs M.A.Barnett, signed with
initials, inscribed and dated 1908
Given by the artist's grandson, John
Steegman, 1955

EDWARD VIII
See WINDSOR

EDWARD, Prince of Wales
(1330-76) 'The Black Prince';
son of Edward III

396 Electrotype of effigy in
Canterbury Cathedral 119.4
(47) high
Unknown artist, c.1377-80
Purchased, 1875

Strong

EDWARD, Duke of Kent and
Strathearn *See* KENT

EDWARD Augustus, Duke of
York and Albany
See YORK AND ALBANY

EDWARDES
A son of William Edwardes, 2nd
Baron Kensington

4026(21) *See Collections:*
Drawings of Men about Town,
1832-48, by Alfred, Count D'Orsay,
4026(1-61)

EDWARDES, Sir Herbert (1819-68)
Major-General

1391 Canvas 251.5 x 161.9
(99 x 63¾)
Henry Moseley, inscribed, c.1850
Bequeathed by the sitter's widow,
1905

Ormond

EDWARDS, Amelia Ann (1831-92)
Novelist and Egyptologist

929 Marble bust 63.5 (25) high
Percival Ball, 1873
Bequeathed by the sitter, 1892

EDWARDS, George (1694-1773)
Naturalist

1576A Pencil and wash, oval
11.7 x 9.2 (4⅝ x 3⅝)
After Isaac Gosset
Given by S. Edwards, 1910

EDWARDS, John Passmore
(1823-1911)
Newspaper editor and philanthropist

3958 Canvas 70.2 x 57.5
(27⅝ x 22⅝)
George Frederic Watts, 1894
Given under the terms of the
artist's will, 1955

EFFINGHAM, Kenneth Alexander
Howard, 1st Earl of (1767-1845)

999 *See Groups:* The Trial of
Queen Caroline, 1820, by Sir
George Hayter

EGERTON, Francis, 3rd Duke of
Bridgewater *See* BRIDGEWATER

EGERTON, Francis, 1st Earl of
Ellesmere *See* ELLESMERE

EGERTON, John William, 7th Earl
of Bridgewater
See BRIDGEWATER

EGERTON, Sir Philip de Malpas
Grey- (1806-81) Palaeontologist

P120(39) Photograph: albumen
print, arched top 19.7 x 14.6
(7¾ x 5¾)
Maull & Polyblank, inscribed on
mount , 1855
Purchased, 1979
See Collections: Literary and
Scientific Men, 1855, by Maull &
Polyblank, **P120(1-54)**

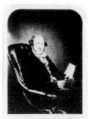

EGERTON, Richard (1783-1854)
Colonel

3712 *See Collections:* Studies for
The Waterloo Banquet at Apsley
House, 1836, by William Salter,
3689-3769

EGERTON, Sir Thomas, 1st
Baron Ellesmere and 1st Viscount
Brackley *See* BRACKLEY

EGG, Augustus Leopold (1816-63)
Subject painter

1456(5) Chalk 7 x 4.4 (2¾ x 1¾)
Charles Hutton Lear, inscribed and
dated 1845
Given by John Elliot, 1907
See Collections: Drawings of
Artists, c. 1845, by Charles Hutton
Lear, **1456(1-27)**

Ormond

EGMONT, John Perceval, 1st
Earl of (1683-1748) President
of the Trustees of Georgia

1956 Marble bust 83.8 (33) high
Vincenzo Felici, incised and dated
1707
Given by Sir Eric MacLagan through
NACF, 1922. *Beningbrough*

926 *See Groups:* The Committy
of the house of Commons (the Gaols
Committee), by William Hogarth

Kerslake

EGMONT, John Perceval, 2nd Earl of (1711-70) Statesman

2481 Canvas 124.5 x 99.1 (49 x 39)
Thomas Hudson, inscribed
Purchased, 1930. *Beningbrough*

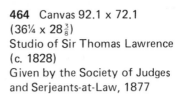

EGREMONT, Charles Wyndham, 2nd Earl of (1710-63) Statesman

4589 Canvas 127 x 101.6 (50 x 40)
Attributed to William Hoare, inscribed and dated 1762
Purchased, 1967

EGREMONT, George Wyndham, 3rd Earl of (1751-1837)
Patron of art

999 *See Groups:* The Trial of Queen Caroline, 1820, by Sir George Hayter

3323 Canvas 43.2 x 31.8 (17 x 12½)
Thomas Phillips, inscribed, 1823
Lent by Lady Teresa Agnew, 1968

795 *See Groups:* Four studies for Patrons and Lovers of Art, c.1826, by Pieter Christoph Wonder, **792-5**

316a(43) Pencil, two sketches 48.9 x 63.5 (19¼ x 25)
Sir Francis Chantrey, inscribed, 1829
Given by Mrs George Jones, 1871
See Collections: Preliminary drawings for busts and statues by Sir Francis Chantrey, **316a(1-202)**

ELDON, John Scott, 1st Earl of (1751-1838) Lord Chancellor

1695(k,l,s) *See Collections:* Sketches for The Trial of Queen Caroline, 1820, by Sir George Hayter, **1695(a-x)**

999 *See Groups:* The Trial of Queen Caroline, 1820, by Sir George Hayter

464 Canvas 92.1 x 72.1 (36¼ x 28⅜)
Studio of Sir Thomas Lawrence (c. 1828)
Given by the Society of Judges and Serjeants-at-Law, 1877

181 Marble bust 78.7 (31) high
Frederick Tatham, incised, 1830
Purchased, 1864

ELEANOR of Castile (d. 1290)
Queen of Edward I

345 Electrotype of effigy in Westminster Abbey 108 (42½) high
After William Torel (1291-3)
Purchased, 1872

Strong

ELGAR, Sir Edward, Bt (1857-1934) Composer

3868 Chalk 27.9 x 29.5 (11 x 11⅝)
Sir William Rothenstein, inscribed, 1917
Given by the Rothenstein Memorial Trust, 1953

2219 Bronze cast of bust 47 (18½) high
Percival Hedley, incised and dated 1927
Bequeathed by Leo F. Schuster, 1928

P107 Photograph: bromide print 15.2 x 20 (6 x 7⅞)
Herbert Lambert, 1933
Given by the photographer's daughter, Mrs Barbara Hardman, 1978
See Collections: Musicians and Composers, by Herbert Lambert, **P107-11**

ELGIN, Victor Alexander Bruce,
9th Earl of (1849-1917)

3845 *See Groups:* Dinner at
Haddo House, 1844, by Alfred
Edward Emslie

ELGIN, Constance (née Carnegie),
Countess of (d.1909)
Wife of 9th Earl of Elgin

3845 *See Groups:* Dinner at
Haddo House, 1884, by Alfred
Edward Emslie

ELIOT, George
See CROSS, Mary Ann

ELIOT, John, 1st Earl of St
Germans *See* ST GERMANS

ELIOT, Thomas Stearns
(1888-1965) Poet

4467 Canvas 76.2 x 62.9
(30 x 24¾)
Patrick Heron, signed and dated
1949
Purchased with help from the
Contemporary Art Society, 1965

4440 Plaster cast of bust 48.3
(19) high
Sir Jacob Epstein, 1951
Given by the Trustees of the
Epstein Estate, 1965

ELIOTT, George, Baron
Heathfield *See* HEATHFIELD

ELIZABETH of York (1465-1503)
Queen of Henry VII

311 Panel 56.5 x 41.6
(22¼ x 16⅜)
Unknown artist, inscribed
Purchased, 1870

291 Electrotype of effigy in
Westminster Abbey 86.4 (34) high
After Pietro Torrigiano (c.1512-18)
Purchased, 1869

Strong

ELIZABETH I (1533-1603)
Reigned 1558-1603

5175 Panel 127.3 x 99.7
(50⅛ x 39¼)
Unknown artist
Purchased, 1978

4449 Panel 39.4 x 27.3
(15½ x 10¾)
Unknown artist, c.1560
Purchased, 1965

4294 Lead medal 4.8
(1⅞) diameter
Steven van Herwijck, inscribed,1565
Purchased, 1962

108 Miniature on vellum 5.1 x 4.8
(2 x 1⅞)
Nicholas Hilliard, inscribed and
dated 1572
Purchased, 1860

190 Panel 78.7 x 61 (31 x 24)
Attributed to Nicholas Hilliard,
c.1575
Purchased, 1865

Continued overleaf

2082 Panel 113 x 78.7 (44½ x 31)
Unknown artist, c.1575
Purchased, 1925

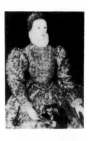

200 Panel 65.4 x 48.3 (25¾ x 19)
Unknown artist, c.1575-80
Given by the Mines Royal, Mineral
and Battery Societies, 1865

541 Panel 97.8 x 72.4 (38½ x 28½)
By or after George Gower, c.1588
Transferred from BM, 1879.
Montacute

2471 Panel 95.3 x 81.9
(37½ x 32¼)
Unknown artist, c.1585-90
Given by wish of Sir Aston Webb,
1930. *Montacute*

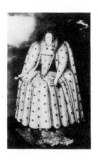

2561 Panel 241.3 x 152.4
(95 x 60)
Marcus Gheeraerts the Younger,
inscribed, c.1592
Bequeathed by Viscount Dillon,
1932

L155 Gold medal 2.5 (1) diameter
Attributed to Charles Anthony,
inscribed, 1601
Lent by the Trustees of
Clonterbrook House, 1975

357 Electrotype of effigy in
Westminster Abbey 96.5 (38) high
After Maximilian Colte (c.1605-7)
Purchased, 1872

542 Panel 85.1 x 67 (33½ x 26⅜)
Unknown artist, posthumous
Transferred from BM, 1879

446 Electrotype of so-called
pattern for a gold sovereign
2.5 x 1.3 (1 x ½) irregular
Unknown artist
Given by Sir George Scharf, 1877

2825 *See Unknown Sitters I*

Strong

ELIZABETH, The Queen Mother
(b. 1900)
Queen of George VI

4145 Canvas 60.7 x 50.8
(23⅞ x 20)
Reginald Grenville Eves, signed,
1924
Given by the artist's son, Grenville
Eves, 1960

4962 Canvas 98.4 x 78.1
(38¾ x 30¾)
Sir Gerald Kelly, c.1938
Purchased, 1973

3778 *See Groups:* Conversation
Piece at the Royal Lodge, Windsor,
1950, by Sir James Gunn

ELIZABETH II (b.1926)
Queen regnant

3778 *See Groups:* Conversation Piece at the Royal Lodge, Windsor, 1950, by Sir James Gunn

4830 (sketch for no.**4706**)
Chalk and wash 56.5 x 39.4
(22¼ x 15½)
Pietro Annigoni, 1969
Given by Roy Strong, 1970

4706 Panel 198.1 x 177.8
(78 x 70)
Pietro Annigoni, signed, 1969
Given by Hugh Leggatt, 1970

ELIZABETH, Queen of Bohemia
(1596-1662)
Daughter of James I

71 Panel 69.9 x 59.7 (27½ x 23½)
Studio of Michael Jansz. van Miereveldt (c.1623)
Purchased, 1859. *Montacute*

L123 Canvas 205.1 x 130.8
(80¾ x 51½)
Gerard Honthorst, signed, inscribed and dated 1642
Lent by NG, 1965

511 Panel, feigned oval 66.7 x 54.6
(26¼ x 21½)
Studio of Gerard Honthorst, reduced version (c.1642)
Purchased, 1878

Piper

ELIZABETH, Princess (1635-50)
Daughter of Charles I

267 *See Groups:* Five Children of Charles I, after Sir Anthony van Dyck

ELIZABETH, Princess Palatine
(1618-80) Daughter of Frederick V, King of Bohemia

340 Panel, feigned oval 71.1 x 59.4
(28 x 23⅜)
After Gerard Honthorst
Purchased, 1872

Piper

ELLENBOROUGH, Edward Law,
1st Earl of (1790-1871)
Governor-General of India

999 *See Groups:* The Trial of Queen Caroline, 1820, by Sir George Hayter

2789 *See Groups:* Members of the House of Lords, c.1835, by Isaac Robert Cruikshank

1805 Canvas 142.2 x 111.8
(56 x 44)
Frederick Richard Say, c.1845
Given by H.G.Boston, 1918

Ormond

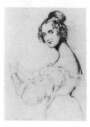

ELLENBOROUGH, Jane Elizabeth
(Digby), Countess of (1807-81)
Famous beauty; wife of 1st Earl of Ellenborough

883(10) Pencil and water-colour
15.2 x 11.4 (6 x 4½)
Sir George Hayter, inscribed, c.1825
Purchased, 1891
See Collections: Studies for miniatures by Sir George Hayter, **883(1-21)**

Ormond

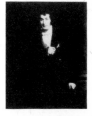

ELLENBOROUGH, Edward Law,
1st Baron (1750-1818)
Lord Chief Justice

1123 Canvas 66 x 54.6 (26 x 21½)
Samuel Drummond, exh and eng 1816
Purchased, 1898

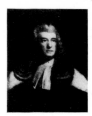

ELLENBOROUGH, Anne (Towry),
Lady (1769-1843)
Wife of 1st Baron Ellenborough

883(9) *See Collections:* Studies
for miniatures by Sir George Hayter,
883(1-21)

ELLENBOROUGH, Charles
Edmund Law, 3rd Baron (1820-90)
Soldier

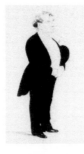

3286 Water-colour 31.8 x 18.4
(12½ x 7¼)
Sir Leslie Ward, signed *Spy*
(*VF* 16 Sept 1886)
Purchased, 1934

ELLESMERE, Francis Egerton,
1st Earl of (1800-57)
Statesman and poet

2203 Marble bust 17.3 (10¾) high
Matthew Noble, incised, c.1858
Given by Mrs L.B.Jameson,1928

Ormond

ELLESMERE, Sir Thomas Egerton,
1st Baron
See BRACKLEY, 1st Viscount

ELLEY, Sir John (d.1839)
Lieutenant-General

3713 *See Collections:* Studies for
The Waterloo Banquet at Apsley
House, 1836, by William Salter,
3689-3769

ELLICE, Edward (1781-1863)
Politician

54 *See Groups:* The House of Com-
mons, 1833, by Sir George Hayter

ELLIOT, Sir George (1784-1863)
Admiral

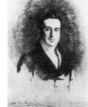

2511 Millboard 34 x 26.7
(13⅜ x 10½)
Sir George Hayter, signed and
dated 1834
Given by Queen Mary, 1931

Ormond

ELLIS, Charles

316a(45) *See Collections:*
Preliminary drawings for busts and
statues by Sir Francis Chantrey,
316a(1-202)

ELLIS, Frederick Augustus
Son of Charles Ellis

316a(44) *See Collections:*
Preliminary drawings for busts and
statues by Sir Francis Chantrey,
316a(1-202)

ELLIS, George Agar-, 1st Baron
Dover *See* DOVER

ELLIS, Havelock (1859-1939)
Physician and psychologist

3177 Chalk 29.2 x 24.1
(11½ x 9½)
Sir William Rothenstein, signed
with initials and dated 1931
Given by the artist, 1944

5242 Canvas 45.1 x 54.3
(17¾ x 21⅜)
Edmond Xavier Kapp, signed and
dated 1937
Purchased, 1979

ELLIS, Henry Wilbore Agar-, 2nd
Viscount Clifden *See* CLIFDEN

ELLIS, John (1789-1862)
Railway promotor

599 *See Groups:* The Anti-Slavery
Society Convention, 1840, by
Benjamin Robert Haydon

ELLIS, Welbore, Baron Mendip
See MENDIP

ELLIS, Sir William Henry
(1860-1945)
Civil engineer and steel maker

4927 Canvas 127 x 102.9
(50 x 40½)
Ernest Moore, signed
Purchased, 1973

ELLISTON, Robert William
(1774-1831) Actor

2136 Canvas 78.1 x 64.8
(30¾ x 25½)
George Henry Harlow, eng 1808
Bequeathed by the sitter's daughter,
Miss Mary Anne Elliston, 1926

ELPHINSTONE, Colonel (possibly
Sir Howard Crawfurd Elphinstone,
1829-90)

P22(2,24) *See Collections:* The
Balmoral Album, 1854-68, by
George Washington Wilson, W.& D.
Downey, and Henry John Whitlock,
P22(1-27)

ELPHINSTONE, William
(1782-1842) Major-General

3714 *See Collections:* Studies
for The Waterloo Banquet at Apsley
House, 1836, by William Salter,
3689-3769

ELSIE, Lily (Mrs Bullough)
(1886-1962) Actress

4322 Canvas 85.1 x 69.9
(33½ x 27½)
Sir James Jebusa Shannon, signed,
c.1916
Bequeathed by the sitter, 1963

ELWIN, Mr

316a(46) *See Collections:*
Preliminary drawings for busts and
statues by Sir Francis Chantrey,
316a(1-202)

EMERY, John (1777-1822)
Actor

1661 Oil on papier mâché 9.9
($3\frac{7}{8}$) diameter
Samuel Raven, signed and inscribed
on reverse, c.1819
Purchased, 1912

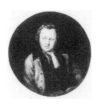

ENDERLEY, Charles (1797-1876)
South Sea whaler

2515(104) *See Collections:*
Drawings of Prominent People,
1823-49, by William Brockedon,
2515(1-104)

ENGLEFIELD, Sir Henry, Bt
(1752-1822)
Natural philosopher and antiquary

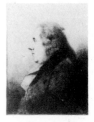

1142 Pencil and chalk 25.4 x 19.1
(10 x 7½)
George Dance, signed and dated
1794
Purchased, 1898

4659 Panel 32.1 x 25.1 ($12\frac{5}{8}$ x $9\frac{7}{8}$)
Thomas Phillips, signed in
monogram and dated 1815
Purchased, 1969

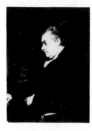

2000 Ivory disc 1.9 (¾) diameter,
irregular
Attributed to Henry Moses,
inscribed and dated on verso 1817
Given on behalf of Miss J.B.Horner,
1923

ENGLEHEART, George
(1752-1839) Miniature painter

2753 Water-colour, oval
12.7 x 10.2 (5 x 4)
Self-portrait, c.1803
Bequeathed by his great-great-
nephew, Henry L. D.
Engleheart, 1935

ENGLEHEART, John Cox Dillman
(1783-1862) Miniature painter

2754 Miniature on ivory 7.9 x 7
($3\frac{1}{8}$ x 2¾)
Self-portrait, c.1810
Bequeathed by his grandson,
Henry L.D. Engleheart, 1935

Ormond

ENNISKILLEN, John Willoughby Cole, 2nd Earl of (1768-1840)
Representative peer

999 *See Groups:* The Trial of Queen Caroline, 1820, by Sir George Hayter

ENNISKILLEN, William Willoughby Cole, 3rd Earl of (1807-86)
MP for County Fermanagh

54 *See Groups:* The House of Commons, 1833, by Sir George Hayter

EPSTEIN, Sir Jacob (1880-1959)
Sculptor

4119 Chalk 27.3 x 19.4 (10¾ x 7⅝)
Augustus John, signed, c.1900
Given by NACF, 1959

4126 Bronze cast of head 50.2 (19¾) high
Self-portrait, c.1912
Purchased, 1959

4397 Pen and ink 25.4 x 19.7 (10 x 7¾)
Powys Evans, signed, pub 1925
Purchased, 1964

P15 With Hewlett Johnson left
Photograph: bromide print 38.7 x 28.6 (15¼ x 11¼)
Felix H. Man, c.1940
Given by the photographer, 1975
See Collections: Prominent men, c.1938-43, by Felix H. Man, **P10-17**

ERLE, Sir William (1793-1880)
Judge

464a Water-colour 29.2 x 23.5 (11½ x 9¼)
F.A.Tilt, signed and dated 1868
Given by the Society of Judges and Serjeants-at-law, 1877

ERROL, Lady

316a(47) *See Collections:* Preliminary drawings for busts and statues by Sir Francis Chantrey, **316a(1-202)**

ERSKINE, Thomas Erskine, 1st Baron (1750-1823)
Lord Chancellor

745 *See Groups:* William Pitt addressing the House of Commons ... 1793, by Karl Anton Hickel

999 *See Groups:* The Trial of Queen Caroline, 1820, by Sir George Hayter

960 Canvas 75.2 x 62.9 (29⅝ x 24¾)
Sir William Charles Ross, inscribed and dated 1823
Purchased, 1894

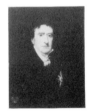

ERSKINE, James St Clair, 2nd Earl of Rosslyn *See* ROSSLYN

ERVINE, St John Greer (1883-1971) Playwright and writer

2049 Plasticine medallion 8.9 (3½) diameter
Theodore Spicer-Simson, incised, c.1922
Given by the artist, 1924
See Collections: Medallions of writers, c.1922, by Theodore Spicer-Simson, **2043-55**

4529(123) Pencil 18.4 x 11.1
(7¼ x 4⅜)
Sir David Low, inscribed
Purchased, 1967
See Collections: Working drawings
by Sir David Low, **4529(1-401)**

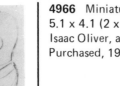

ESDAILE, William (1758-1837)
Banker and print collector

4660 Pastel 26 x 21.6 (10¼ x 8½)
George Sharples, eng 1826
Purchased, 1969

ESSEX, Thomas Cromwell, 1st
Earl of (1485?-1540) Statesman

1727 Panel 78.1 x 61.9
(30¾ x 24⅜)
After Hans Holbein, inscribed
Purchased, 1914

1083 Panel 43.8 x 32.4
(17¼ x 12¾)
After Hans Holbein
Purchased, 1896. *Montacute*

Strong

ESSEX, Walter Devereux, 1st
Earl of (1541?-76) Military
commander; Earl-Marshal of Ireland

4984 Panel 108.9 x 79
(42⅞ x 31⅛)
Unknown artist, dated 1572
Purchased, 1974. *Montacute*

ESSEX, Robert Devereux, 2nd Earl
of (1566-1601) Soldier; favourite
of Elizabeth I

180 Canvas 63.5 x 50.8 (25 x 20)
After Marcus Gheeraerts the
Younger (c.1596)
Purchased, 1864. *Montacute*

4966 Miniature on vellum, oval
5.1 x 4.1 (2 x 1⅝)
Isaac Oliver, after 1596
Purchased, 1973

4985 Canvas 218 x 127.2
(85⅞ x 54)
Marcus Gheeraerts the Younger,
c.1597
Purchased, 1974

Strong

ESSEX, Robert Devereux, 3rd Earl
of (1591-1646)
Parliamentary general

L115 Canvas 203.2 x 121.9
(80 x 48)
Attributed to Daniel Mytens
Lent by the Duke of Portland,
1964. *Montacute*

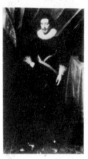

ESSEX, Arthur Capel, Earl of
(1631-83) Soldier

4759 *See Groups:* The Capel
Family, by Cornelius Johnson

ESSEX, Algernon Capel, 2nd Earl
of (1670-1710) General

143 Canvas 123.2 x 109.2
(48½ x 43)
After Sir Godfrey Kneller (c.1700)
Purchased, 1862

3207 Canvas 91.4 x 71.1
(36 x 28)
Sir Godfrey Kneller, signed, 1705
Kit-cat Club portrait
Given by NACF, 1945.
Beningbrough

Piper

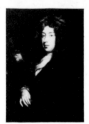

ESSEX, George Capel-Coningsby,
5th Earl of (1757-1839)
Lord-Lieutenant of Hereford

999 *See Groups:* The Trial of
Queen Caroline, 1820, by Sir
George Hayter

3097(6) *See Collections:*
Caricatures, c.1825-c.1835, by Sir
Edwin Landseer, **3097(1-10)**

ESSEX, Catherine (Stephens),
Countess of (1794-1882)
Actress and singer; wife of 5th
Earl of Essex

702 Canvas, feigned oval
76.8 x 64.1 (30¼ x 25¼)
John Jackson, inscribed, c.1822
Transferred from Tate Gallery,1957

Ormond

ESSLEMONT, Peter
Politician and merchant

3845 *See Groups:* Dinner at
Haddo House, 1884, by
Alfred Edward Emslie

ETTY, William (1787-1849)
Painter

P6(7) Photograph: calotype
20 x 14.3 (7⅞ x 5⅝)
David Octavius Hill and Robert
Adamson, October 1844
Given by an anonymous donor,1973
See Collections: The Hill and
Adamson Albums, 1843-8, by
David Octavius Hill and Robert
Adamson, **P6(1-258)**

1368 Millboard 41.3 x 31.8
(16¼ x 12½)
After photograph by David Octavius
Hill and Robert Adamson (1844)
(no. **P(7)**)
Purchased, 1904

1456(6) Black chalk 25.2 x 14
(6 x 5½)
Charles Hutton Lear, inscribed
and dated 1845
Given by John Elliot, 1907
See Collections: Drawings of
Artists, c.1845, by Charles Hutton
Lear, **1456(1-27)**

1456(7,8) *See Collections:*
Drawings of Artists, c.1845, by
Charles Hutton Lear, **1456(1-27)**

595 Marble bust 79.4 (31¼) high
Matthew Noble, incised and dated
1850
Purchased, 1879

Ormond

ETWALL, Ralph (1804-82)
MP for Andover

54 *See Groups:*The House of Com-
mons, 1833, by Sir George Hayter

EVAN-THOMAS, Sir Hugh
(1862-1928) Admiral

1913 *See Groups:* Naval Officers
of World War I, by Sir Arthur
Stockdale Cope

EVANS, Sir Arthur John
(1851-1941) Archaeologist

3540 Pencil 35.9 x 26.3
(14⅛ x 10⅜)
Francis Dodd, signed and dated
1935
Given by the Contemporary
Portraits Fund, 1947

EVANS, Dame Edith (1888-1976)
Actress

P64 *See Collections:* Prominent
people, c.1946-64, by Angus
McBean, **P56-67**

EVANS, Sir George de Lacy
(1787-1870) General

2158 Miniature on ivory, oval
9.2 x 7 ($3\frac{5}{8}$ x $2\frac{3}{4}$)
Sir William Charles Ross, signed
on backing paper
Given by Bernard Falk, 1927

Ormond

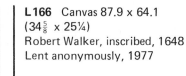

EVANS, Sir John (1823-1908)
Archaeologist and numismatist

5006 Plated copper medal 5.7
($2\frac{1}{4}$) diameter
John H. Pinches, inscribed and
dated 1887
Given by Mrs M.S.G.MacLeod, 1974

EVANS, Robert (1773-1849)
Estate agent; father of 'George
Eliot'

1232a Water-colour 18.4 x 14.3
($7\frac{1}{4}$ x $5\frac{5}{8}$)
Caroline Bray, 1841, after a
miniature by an unknown artist
Given by the artist, 1899

Ormond

EVANS, Sir Samuel Thomas
(1859-1918)
Judge and politician

3991 Ink, water-colour and wash
29.2 x 19.7 ($11\frac{1}{2}$ x $7\frac{3}{4}$)
Charles Pascoe Hawkes, signed and
inscribed
Bequeathed by Noel Middleton,
1956

EVANS, Thomas (d.1767)
Soldier

4855(13) *See Collections:* The
Townshend Album, **4855(1-73)**

EVELYN, John (1620-1706)
Diarist and virtuoso

L148 Canvas 76.8 x 64.1
($30\frac{1}{4}$ x $25\frac{1}{4}$)
Henrick van der Borcht, 1641
Lent by Patrick Evelyn, 1976

L166 Canvas 87.9 x 64.1
($34\frac{5}{8}$ x $25\frac{1}{4}$)
Robert Walker, inscribed, 1648
Lent anonymously, 1977

3258 Engraving, feigned oval
23.8 x 16.5 ($9\frac{3}{8}$ x $6\frac{1}{2}$)
Robert Nanteuil, signed and
inscribed on plate, 1650
Acquired before 1947

Piper

EVEREST, Sir George (1790-1866)
Surveyor-General of India

2553 Pencil 25.1 x 20.3 ($9\frac{7}{8}$ x 8)
Attributed to William Tayler,
inscribed and dated 1843
Given by the sitter's son,
L.F.Everest, 1932

Ormond

EVERSHED, Francis Evershed, 1st
Baron (1899-1966)
Judge and Master of the Rolls

4678 Canvas 76.2 x 50.8 (30 x 20)
Norman Hepple, signed and dated
1958
Given by the sitter's widow, 1969

EVERSLEY, Charles Shaw-Lefevre,
Viscount (1794-1888)
Speaker of the House of Commons

54 *See Groups:* The House of Com-
mons, 1833, by Sir George Hayter

342,343a-c *See Groups:* The Fine
Arts Commissioners, 1846, by
John Partridge

EVES, Reginald Grenville
(1876-1941) Portrait painter

3826 Canvas 58.4 x 42.5
(23 x $16\frac{3}{4}$)
Self-portrait, signed and dated 1908
Given by his widow, 1952

EWART, William (1798-1869)
Reformer and politician

54 *See Groups:* The House of Commons, 1833, by Sir George Hayter

EXETER, Thomas Cecil, 1st Earl of (1542-1623)
Soldier and statesman

567 Panel 55.9 x 43.8 (22 x 17¼)
Unknown artist, inscribed
Transferred from BM, 1879

Strong

EXETER, Brownlow Cecil, 2nd Marquess of (1795-1867)

999 *See Groups:* The Trial of Queen Caroline, 1820, by Sir George Hayter

EXMOUTH, Edward Pellew, 1st Viscount (1757-1833) Admiral

140 Canvas 127 x 101.6 (50 x 40)
James Northcote, signed and dated 1804
Given by the sitter's son, George Pellew, 1862

999 *See Groups:* The Trial of Queen Caroline, 1820, by Sir George Hayter

EYRE, Major

1752 *See Groups:* The Siege of Gibraltar, 1782, by George Carter

FAED, Thomas (1826-1900)
Painter

P73 Photograph: albumen print 20.6 x 16.2 ($8\frac{1}{8}$ x $6\frac{3}{8}$)
David Wilkie Wynfield, inscribed on separate label, 1860s
Purchased, 1979
See Collections: The St John's Wood Clique, by David Wilkie Wynfield, **P70-100**

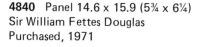

4840 Panel 14.6 x 15.9 (5¾ x 6¼)
Sir William Fettes Douglas
Purchased, 1971

2820 *See Groups:* The Royal Academy Conversazione, 1891, by G. Grenville Manton

FAIRBAIRN, James

P6(206) *See Collections:* The Hill and Adamson Albums, 1843-8, by David Octavius Hill and Robert Adamson, **P6(1-258)**

FAIRBANK, William (1771-1846)
Slavery abolitionist

599 *See Groups:* The Anti-Slavery Society Convention, 1840, by Benjamin Robert Haydon

FAIRFAX of Cameron, Thomas Fairfax, 3rd Baron (1612-71)
Parliamentary Commander-in-Chief

3624 Line engraving, feigned oval 17.3 x 19.1 (10¾ x 7½)
William Faithorne after Robert Walker, inscribed and signed on plate
Acquired before 1948

4624 Gold medal 2.5 x 1.9 (1 x ¾)
Thomas Simon, inscribed and dated 1645
Purchased, 1968

Piper

FAIRFAX of Emley, William Fairfax, 3rd Viscount (1620?-48)

754 With his wife, Elizabeth, afterwards Lady Goodricke
Canvas 139.1 x 174.6 (54¾ x 68¾)
Gerard Soest, signed and inscribed, c.1645-8
Purchased, 1886

Piper

FAIRLIE, John

4026(22) *See Collections:*
Drawings of Men about Town,
1832-48, by Alfred, Count D'Orsay,
4026(1-61)

FAITHORNE, William (1616?-91)
Draughtsman and engraver

618 *See Unknown Sitters II*

Piper

FALKLAND, Lucius Cary, 2nd
Viscount (1610?-43) Courtier

L 152(42) Miniature on vellum,
oval 5.1 x 4.1 (2 x 1⅝)
Initialled *JH,* attributed to John
Hoskins
Lent by NG (Alan Evans Bequest),
1975

FALMOUTH, Edward Boscawen,
1st Earl of (1787-1841)
Recorder of Truro

999 *See Groups:* The Trial of
Queen Caroline, 1820, by Sir
George Hayter

FANCOURT, Charles St John
(1804-75)
MP for Barnstaple

54 *See Groups:* The House of Commons, 1833, by Sir George Hayter

FANE, John, 10th Earl of
Westmorland
See WESTMORLAND

FANE, John, 11th Earl of
Westmorland
See WESTMORLAND

FARADAY, Michael (1791-1867)
Scientist

2515(24) *See Collections:*
Drawings of Prominent People,
1823-49, by William Brockedon,
2515(1-104)

269 Canvas 90.8 x 71.1
(35¾ x 28)
Thomas Phillips, signed in
monogram and dated 1842
Purchased, 1868

748 Marble bust 81.3 (32) high
Sir Thomas Brock after John Henry
Foley, 1886(1877)
Given by a Committee of
Gentlemen, 1886

Ormond

FARINGTON, Joseph (1747-1821)
Landscape painter and diarist

L 152(44) Miniature on ivory, oval
5.7 x 4.4 (2¼ x 1¾)
James Nixon, 1765
Lent by NG (Alan Evans Bequest),
1975

FARMER, George (1732-79)
Naval captain

2149 Canvas 91.4 x 69.2
(36 x 27¼)
Charles Grignion
Bequeathed by Henry Taylor, 1927

FARMER-ATKINSON, Henry John
(1828-1913) Founder and first
President of the Chamber of
Shipping

3536 Chalk 33.7 x 26.7
(13¼ x 10½)
Sir Francis Carruthers Gould, signed
with initials and inscribed
Given by the artist's son,
N. Carruthers Gould, 1946

FARNBOROUGH, Charles Long,
1st Baron (1760-1838) Paymaster-
General and connoisseur

4046 Pencil and wash 33.4 x 23.8
(13⅛ x 9⅜)
Henry Edridge, signed and dated
1805
Purchased, 1958

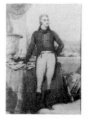

Continued overleaf

316a(79) Pencil 42.9 x 29.8
(16⅞ x 11¾)
Sir Francis Chantrey, inscribed,
1819
Given by Mrs George Jones, 1871

and

316a(80) Pencil 42.9 x 27
(16⅞ x 10⅝)
Sir Francis Chantrey, inscribed,
1819
Given by Mrs George Jones, 1871
See Collections: Preliminary
drawings for busts and statues by
Sir Francis Chantrey, **316a(1-202)**

2090 Marble bust 74.9 (29½) high
Sir Francis Chantrey, incised and
dated 1820
Purchased, 1925

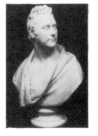

999 *See Groups:* The Trial of
Queen Caroline, 1820, by Sir
George Hayter

793 *See Groups:* Four studies for
Patrons and Lovers of Art, c.1826,
by Pieter Christoph Wonder, **792-5**

FARNBOROUGH, Thomas Erskine
May, 1st Baron (1815-86) Jurist

2712 Water-colour 29.8 x 18.1
(11¾ x 7⅛)
Carlo Pellegrini, signed *Ape*
(*VF* 6 May 1871)
Purchased, 1934

FARNEY, Annie

P6(161,162,165) *See Collections:*
The Hill and Adamson Albums,
1843-8, by David Octavius Hill
and Robert Adamson, **P6(1-258)**

FARNHAM, Henry Maxwell, 7th
Baron (1799-1868)
MP for County Cavan

54 *See Groups:* The House of Com-
mons, 1833, by Sir George Hayter

FARQUARSON, F.

P22(17) *See Collections:* The
Balmoral Album, 1854-68, by
George Washington Wilson, W. & D.
Downey, and Henry John Whitlock,
P22(1-27)

FARQUARSON, Peter
Queen Victoria's gamekeeper

P22(10,18) *See Collections:*
The Balmoral Album, 1854-68, by
George Washington Wilson, W.& D.
Downey, and Henry John Whitlock,
P22(1-27)

FARQUHARSON, Robert
(1836-1918)
MP for West Aberdeenshire

3845 *See Groups:* Dinner at Haddo
House, 1884, by Alfred Edward
Emslie

FARRAR, Frederick William
(1831-1903) Dean of Canterbury;
author of popular moral tales

3447 *See Collections:* Prominent
Men, c. 1880-c.1910, by Harry
Furniss, **3337-3535** and **3554-3620**

FARREN, Elizabeth
See DERBY, Countess of

FARREN, Ellen (1848-1904)
'Nellie Farren'; actress

3133 Canvas 77.5 x 61 (30½ x 24)
Walford Graham Robertson, signed
in monogram, inscribed and dated
1902
Given by the artist, 1943

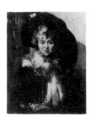

FARREN, William (1786-1861)
Actor

1440 Canvas 91.4 x 71.8
(36 x 28¼)
Richard Rothwell, c. 1829(?)
Purchased, 1906

Ormond

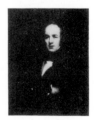

FARWELL, Sir George (1845-1915)
Judge

3273 Water-colour 33.3 x 20.6
($13\frac{1}{8}$ x $8\frac{1}{8}$)
F.T.Dalton, signed *FTD*
(*VF* 15 Nov 1900)
Purchased, 1934

FAUCIT, Helena, Lady Martin
See MARTIN

FAUSSETT, Robert Godfrey
(1827-1908)
Mathematician and divine

P7(16) *See Collections:* Lewis
Carroll at Christ Church, by Charles
Lutwidge Dodgson, **P7(1-37)**

FAWCETT, Henry (1833-84)
Political economist

1603 With his wife, Millicent
Canvas 108.6 x 83.8 (42¾ x 33)
Ford Maddox Brown, signed in
monogram, inscribed and dated
1872
Bequeathed by Sir Charles
Wentworth Dilke, Bt, 1911

1086 Plaster medallion, oval
48.3 x 45.7 (19 x 18)
Mary Grant, incised and dated 1886
Purchased, 1897

1418 Plaster cast of bust 65.4
(25¾) high
Henry Richard Hope-Pinker
Given by the artist, 1905

FAWCETT, John (1768-1837)
Actor and dramatist

692 Panel 76.2 x 62.2
(30 x 24½)
Begun by Sir Thomas Lawrence,
c.1818
Transferred from Tate Gallery, 1957

FAWCETT, Sir Luke (1881-1960)
Socialist and trade unionist

4529(124) *See Collections:*
Working drawings by Sir David Low,
4529(1-401)

FAWCETT, Dame Millicent (née
Garrett) (1847-1929) A leader
of the women's suffrage movement

1603 *See under* Henry Fawcett

FAWKES, Ayscough (1831-99)

1833 *See Groups:* Private View of
the Old Masters Exhibition, Royal
Academy, 1888, by Henry Jamyn
Brooks

FAWKES, Guy (1570-1606)
Conspirator

334A *See Groups:* The Gunpowder
Plot Conspirators, 1605, by an
unknown artist

FAY, Gerard (1913-68)
Journalist and writer

4529(125,126) *See Collections:*
Working drawings by Sir David Low,
4529(1-401)

FAZAKERLEY, John Nicholas
(1787-1852)
MP for Peterborough

54 *See Groups:* The House of Com-
mons, 1833, by Sir George Hayter

FEILDING, Rudolph William, 8th
Earl of Denbigh *See* DENBIGH

FEILDING, William, 7th Earl of
Denbigh *See* DENBIGH

FEILDON, Sir William, Bt
(1772-1859) MP for Blackburn

54 *See Groups:* The House of Com-
mons, 1833, by Sir George Hayter

FELLOWES, Robert (1770-1847)
Philanthropist

L152(36) Miniature on ivory, oval
6 x 4.8 ($2\frac{3}{8}$ x $1\frac{7}{8}$)
Henry Edridge
Lent by NG (Alan Evans Bequest),
1975

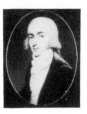

FELLOWS, Sir Charles (1799-1860)
Archaeologist and traveller

2515(97) Chalk 38.1 x 27.3
(15 x 10¾)
William Brockedon, dated 1845
Lent by NG, 1959
See Collections: Drawings of
Prominent People, 1823-49, by
William Brockedon, **2515(1-104)**

Ormond

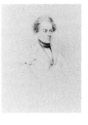

FENNER, Captain

3090(2) Sepia and wash
38.1 x 27.3 (15 x 10¾)
Unknown artist after an early
painting
Purchased, 1940

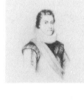

FENNER, Sir Edward (d.1612)
Judge

4958 Panel 52.4 x 35.9
($20\frac{5}{8}$ x $14\frac{1}{8}$)
Unknown artist, dated 1608
Purchased, 1973

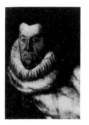

FENTON, John (c.1791-1863)
MP for Rochdale

54 *See Groups:* The House of Commons, 1833, by Sir George Hayter

FERGUSON, Robert (before
1773-1840) MP for Kirkcaldy

54 *See Groups:* The House of Commons, 1833, by Sir George Hayter

FERGUSON, Sir Ronald Craufurd
(1773-1841) General

316a(48) Pencil 45.4 x 33.3
($17\frac{7}{8}$ x $13\frac{1}{8}$)
Sir Francis Chantrey, inscribed,
c.1830
Given by Mrs George Jones, 1871
See Collections: Preliminary
drawings for busts and statues by
Sir Francis Chantrey, **316a(1-202)**

54 *See Groups:* The House of Commons, 1833, by Sir George Hayter

FERGUSSON, Robert Cutlar
(1768-1838) Judge

54 *See Groups:* The House of Commons, 1833, by Sir George Hayter

FERMOR, George, 3rd Earl of
Pomfret *See* POMFRET

FERNELEY, John (1782-1860)
Animal painter

2024 Canvas 76.2 x 63.5 (30 x 25)
Henry Johnson, inscribed and dated
on reverse 1838
Given by Alfred Jones, 1924

Ormond

FERRIER, Kathleen (1912-53)
Singer

5040(3) Chalk 27.6 x 14.3
($10\frac{7}{8}$ x $5\frac{5}{8}$)
Bernard Dunstan, signed with
initials, inscribed and dated 1950
Given by the artist, 1975
See Collections: Studies for portraits
of Kathleen Ferrier singing, by
Bernard Dunstan, **5040(1-8)**

5040(1,2,4-8) *See Collections:*
Studies for portraits of Kathleen
Ferrier singing, by Bernard Dunstan,
5040(1-8)

5043 *See Groups:* Kathleen Ferrier
at a concert, by Bernard Dunstan

FEUILLET DE COUCHE, F.
(probably Baron Felix, 1798-1887)
Master of Ceremonies to
Napoleon III

2515(65) *See Collections:*
Drawings of Prominent People,
1823-49, by William Brockedon,
2515(1-104)

FEVERSHAM, William Ernest
Duncombe, 1st Earl of (1829-1915)
Representative peer

1834(1) *See Collections:* Members
of the House of Lords, c.1870-80,
by Frederick Sargent, **1834(a-z and
aa-hh)**

FEVERSHAM, William Duncombe,
2nd Baron (1798-1867)
MP for Yorkshire, North Riding

54 *See Groups:* The House of Com-
mons, 1833, by Sir George Hayter

FIELD, William Ventris Field,
Baron (1813-1907) Judge

2713 Water-colour 31.1 x 18.7
(12¼ x 7⅜)
Sir Leslie Ward, signed *Spy*
(*VF* 30 April 1887)
Purchased, 1934

FIELDEN, John (1784-1849)
Reforming manufacturer

54 *See Groups:* The House of Com-
mons, 1833, by Sir George Hayter

FIELDING, Antony Vandyke
Copley (1787-1855)
Water-colourist

601 Canvas 61 x 46 (24 x 18⅛)
Sir William Boxall, exh 1843
Given by the artist's niece,
Mrs Longland, 1880

Ormond

FIELDING, Sir John (d.1780)
Magistrate and social reformer

3834 Canvas 124.5 x 100.3
(49 x 39½)
Nathaniel Hone, signed and dated
1762
Given by friends of Charles F.Bell,
1952

FILDES, Sir Luke (1843-1927)
Painter

3570 *See Collections:*
Prominent Men, c.1880-c.1910, by
Harry Furniss, **3337-3535** and
3554-3620

4960 Board 74.6 x 66 (29⅜ x 26)
Philip de Laszlo, signed, inscribed
and dated 1914
Given by the sitter's granddaughter,
Mrs B.L.Myers, and her husband,
1973

FILDES, Sir Paul (1882-1971)
Pathologist; son of Sir Luke Fildes

4843 Canvas 76.8 x 57.2
(30¼ x 22½)
Sir Luke Fildes, signed and dated
1919
Bequeathed by the sitter, 1971

FILLANS, James (1808-52)
Sculptor

P6(120) With his two daughters
(one is Wilhelmina)
See Collections: The Hill and
Adamson Albums, 1843-8, by
David Octavius Hill and Robert
Adamson, **P6(1-258)**

FINCH, John Finch, 1st Baron
(1584-1660)
Speaker of the House of Commons

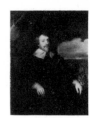

2125 Canvas 127 x 101.6
(50 x 40)
After Sir Anthony van Dyck(?)
(c.1640)
Purchased, 1926

Piper

FINCH, Anne, Countess of
Winchilsea *See* WINCHILSEA

FINCH, Daniel, 2nd Earl of
Nottingham and 7th Earl of
Winchilsea *See* WINCHILSEA

FINCH, Daniel, 8th Earl of
Winchilsea *See* WINCHILSEA

FINCH, George (1794-1870)
MP for Stamford

54 *See Groups:* The House of Commons, 1833, by Sir George Hayter

FINCH, Sir Heneage (1580-1631)
Speaker of the House of Commons

4552 Panel 68.6 x 54.6 (27 x 21½)
Unknown artist
Purchased, 1967. *Montacute*

Strong

FINCH, Heneage, 5th Earl of
Aylesford *See* AYLESFORD

FINCH, Heneage, 1st Earl of
Nottingham
See NOTTINGHAM

FINCH-HATTON, George,
11th Earl of Winchilsea
See WINCHILSEA

FINET, Sir John (1571-1641)
Master of the Ceremonies

2404 Water-colour 28.2 x 21.6
(11$\frac{1}{8}$ x 8½)
George Perfect Harding after an
unknown artist, signed and
inscribed
Purchased, 1929
See Collections: Copies of early
portraits, by George Perfect Harding
and Sylvester Harding, **1492,
1492(a-c)** and **2394-2419**

Strong

FINLAY, Robert Finlay, 1st
Viscount (1842-1929)
Lord Chancellor

2836 *See Collections:*
Caricatures of Politicians, by Sir
Francis Carruthers Gould, **2826-74**

FINLAY
A deerstalker from Colonsay

P6(96) *See Collections:* The Hill
and Adamson Albums, 1843-8, by
David Octavius Hill and Robert
Adamson, **P6(1-258)**

FINLAY, Grace
Fisherwoman

P6(202,204) *See Collections:* The
Hill and Adamson Albums, 1843-8,
by David Octavius Hill and Robert
Adamson, **P6(1-258)**

FINLAY, John Hope (1839-1907)
Lawyer

P6(174) *See Collections:* The Hill
and Adamson Albums, 1843-8, by
David Octavius Hill and Robert
Adamson, **P6(1-258)**

FINLAY, Marion
Fisherwoman

P6(202,204) *See Collections:* The
Hill and Adamson Albums, 1843-8,
by David Octavius Hill and Robert
Adamson, **P6(1-258)**

FINLAY, Sophia (née Morris)
Niece of David Octavius Hill

P6(118) *See Collections:* The Hill
and Adamson Albums, 1843-8, by
David Octavius Hill and Robert
Adamson, **P6(1-258)**

FINLAY, Sophia

P6(161,165) *See Collections:* The
Hill and Adamson Albums, 1843-8,
by David Octavius Hill and Robert
Adamson, **P6(1-258)**

FIRBANK, Ronald (1886-1925)
Novelist

4600 Pencil 33 x 31.8 (13 x 12½)
Augustus John, signed
Purchased, 1968

FISHER, John Fisher, 1st Baron
(1841-1920) Admiral

2805 Canvas 172.7 x 119.4
(68 x 47)
Sir Hubert von Herkomer, signed
with initials and dated 1911
Given by the sitter's son, Lord
Fisher, 1936

3080 Etching 34.3 x 25.4
(13½ x 10)
Francis Dodd, signed, inscribed and
dated 1916 on plate, and signed
and inscribed below plate
Purchased, 1940

FISHER, Catherine Maria (d.1767)
'Kitty Fisher'; courtesan

2354 Canvas 74.9 x 62.2
(29½ x 24½)
Nathaniel Hone, signed and dated
1765
Bequeathed by Lord Revelstoke,
1929

Kerslake

FISHER, Jane (née Lane), Lady
(d.1689) Stuart loyalist

5251 See Collections: Charles II's
escape after the Battle of Worcester,
1651, by Isaac Fuller, **5247-51**

1798 Canvas 108 x 91.4
(42½ x 36)
Unknown artist, inscribed, c.1660
Bequeathed by Miss Adelaide Julia
Darnbrough, 1917

Piper

FISHER, John (1469-1535)
Bishop of Rochester; canonized
1935

2821 Oil on paper 21 x 19.1
(8¼ x 7½)
After Hans Holbein (c.1528)
Purchased, 1936

Strong

FISHER, John (1748-1825)
Bishop of Salisbury

3089(6) Pencil 25.4 x 19.7
(10 x 7¾)
William Daniell after George
Dance, inscribed
Purchased, 1940
See Collections: Tracings of
drawings by George Dance,
3089(1-12)

FITZALAN, Henry, 12th Earl of
Arundel See ARUNDEL

FITZCLARENCE, Lord Frederick
(1799-1855)
Illegitimate son of William IV

4026(23) See Collections:
Drawings of Men about Town,
1832-48, by Alfred, Count D'Orsay,
4026(1-61)

FITZGERALD, Lord Edward
(1763-98) Irish patriot

3815 Canvas 71.8 x 61.6
(28¼ x 24¼)
Studio of Hugh Douglas Hamilton,
reduced version, inscribed and
dated 1796 (sic), 1798
Lent by Lady Teresa Agnew, 1968

FITZGERALD, Augustus Frederick,
3rd Duke of Leinster
See LEINSTER

FITZGERALD, Edward (1809-83)
Poet; translator of *Rubaiyat of Omar Khayyám*

1342 *Miniature on ivory, oval*
6.4 x 5.1 (2½ x 2)
Eva, Lady Rivett-Carnac, after a photograph of 1873, signed with initials
Purchased, 1903

Ormond

FITZGERALD, Percy (1834-1925)
Writer

3571 *See Collections:*
Prominent Men, c.1880-c.1910, by Harry Furniss, **3337-3535** and **3554-3620**

FITZGIBBON, John, 2nd Earl of Clare *See* CLARE

FITZGIBBON, Richard Hobart, 3rd Earl of Clare *See* CLARE

FITZHERBERT, Alleyne, Baron St Helens *See* ST HELENS

FITZHERBERT, Maria Anne (née Smythe) (1756-1837)
Famous beauty and morganatic wife of Geroge IV

L162 Canvas 91.4 x 7.1 (36 x 28)
Sir Joshua Reynolds, c.1788
Lent by the Earl of Portarlington, 1976

FITZMAURICE, Sir Maurice (1861-1924) Chief engineer to London County Council

4928 Canvas 127 x 101.6 (50 x 40)
George Harcourt, signed, exh 1924
Purchased, 1973

FITZMAURICE-KELLY, James
See KELLY

FITZPATRICK, Sir Dennis (1837-1920)
Lieutenant-Governor of the Punjab

4038 Canvas 27.9 x 22.9 (11 x 9)
James D.Costa, signed and dated 1891
Given by Francis F.Madan, 1957

FITZPATRICK, John, 2nd Earl of Upper Ossory
See UPPER OSSORY

FITZPATRICK, Richard (1747-1813) General and politician

2076 *See Groups:* Whig Statesmen and their Friends, c.1810, by William Lane

FITZROY, Lord Charles
Soldier

4318 *See Unknown Sitters IV*

FITZROY, Lord John Edward (1785-1856) MP for Thetford

999 *See Groups:* The Trial of Queen Caroline, 1820, by Sir George Hayter

FITZROY, Augustus Henry, 3rd Duke of Grafton *See* GRAFTON

FITZROY, Charles, 2nd Duke of Grafton *See* GRAFTON

FITZROY, George Henry, 4th Duke of Grafton *See* GRAFTON

FITZROY, Henry, 1st Duke of Grafton *See* GRAFTON

FITZROY, Richard Henry, 2nd Baron Raglan *See* RAGLAN

FITZWILLIAM, William
Wentworth Fitzwilliam, 2nd Earl
(1748-1833)
Lord-Lieutenant of Ireland

2076 *See Groups:* Whig Statesmen
and their Friends, c.1810, by
William Lane

4979 Canvas 127 x 101.6 (50 x 40)
William Owen, inscribed, exh 1817
Purchased, 1974

FLAMSTEED, John (1646-1719)
The first Astronomer Royal

1855 Canvas, oval 74.9 x 62.2
(29½ x 24½)
Unknown artist, inscribed, c.1680?
Lent by the Royal Society, 1920

Piper

FLATMAN, Thomas (1635-88)
Miniature painter and poet

1051 Canvas 57.2 x 46.4
(22½ x 18¼)
Attributed to himself, c.1660
Purchased, 1896

Piper

FLAXMAN, Anne (née Denman)
(d.1820)
Artist; wife of John Flaxman

2488 Companion to no.**2487**,
John Flaxman
Plaster medallion 14.9 (5$\frac{7}{8}$)
diameter
John Flaxman, 1790-5
Purchased, 1931

675 Companion to no.**674**,
John Flaxman
Panel 19.4 x 15.2 (7$\frac{5}{8}$ x 6)
Henry Howard, c.1797
Given by Sir Theodore Martin,
1883

FLAXMAN, John (1755-1826)
Sculptor

877 Canvas 74.3 x 60.3
(29¼ x 23¾)
Guy Head, inscribed, 1792
Given by T.R.Wilkinson, 1891

2487 Companion to no.**2488**,
Anne Flaxman
Plaster medallion 14.9
(5$\frac{7}{8}$) diameter
Self-portrait, 1790-5
Purchased, 1931

101 With Thomas Alphonso Hayley
(centre) and bust of William Hayley
Canvas 76.2 x 63.5 (30 x 25)
George Romney, 1795
Given by Henry Crabb Robinson,
1860

674 Companion to no.**675**,
Anne Flaxman
Panel 19.4 x 15.2 (7$\frac{5}{8}$ x 6)
Henry Howard, c.1797
Given by Sir Theodore Martin, 1883

4913(4) *See Collections:* Four
studies from a sketchbook, by
Thomas Cooley, **4913(1-4)**

2525(32) *See Collections:*
Drawings of Prominent People,
1823-49, by William Brockedon,
2515(1-104)

823 Pencil, ink and wash
16.2 x 11.4 (6$\frac{3}{8}$ x 4½)
James Atkinson, inscribed, 1826
Given by the artist's son, Canon
J.A.Atkinson, 1890

FLAXMAN, Mary Ann (1768-1833)
Painter and wax-modeller; half-
sister of John Flaxman

1715 Miniature on ivory, oval
7 x 5.4 (2¾ x 2⅛)
Attributed to herself
Purchased, 1913

FLECK, Alexander Fleck, Baron
(1889-1968) Chemist; FRS

4662 Canvas 101.6 x 87
(40 x 34¼)
Lawrence Gowing, signed and dated
1957
Bequeathed by the sitter, 1969

FLEETWOOD, George
(1622?- after 1664) Regicide

1925 Miniature on vellum, oval
5.7 x 4.4 (2¼ x 1¾)
Samuel Cooper, signed with initials
and dated 1647
Bequeathed by G. Milner-Gibson-
Cullum, 1922

Piper

FLEETWOOD, Sir Peter Hesketh,
1st Bt (1801-66) Founder of the
town of Fleetwood

54 *See Groups*: The House of Com-
mons, 1833, by Sir George Hayter

FLEETWOOD, William
(1656-1723) Bishop of Ely

5118 Miniature on ivory, oval
7.9 x 6.4 (3⅛ x 2½)
Bernard Lens, based on a drawing
by Robert White (of before 1705),
signed in monogram
Purchased, 1977

5119 Miniature on ivory, oval
7.9 x 6.7 (3⅛ x 2⅝)
Bernard Lens, signed in monogram
Purchased, 1977

FLEMING, Sir Alexander
(1881-1955) Discoverer of
penicillin

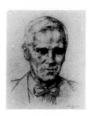

3988 Pencil 26 x 21.6 (10¼ x 8½)
Helen McDougall Campbell, signed
and dated 1944
Given by George S. Sandilands,
1956

5085 Lithograph 65 x 49.5
(25⅝ x 19½)
James Ardern Grant, signed
inscribed and dated 1944
Given by the artist's son, Ian Grant,
1976

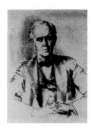

4238 Bronze medallion 15.6 (6⅛)
diameter
Frank Kovacs, incised, 1955
Purchased, 1961

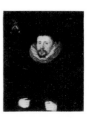

FLEMING, Charles Elphinstone
(1774-1840) MP for Stirlingshire

54 *See Groups*: The House of Com-
mons, 1833, by Sir George Hayter

FLEMING, Sir Thomas (1544-1613)
Judge; tried Guy Fawkes

1799 Panel 74.9 x 60
(29½ x 23⅝)
Circle of Hieronimo Custodis,
inscribed and dated 1596
Given by Walter Strachan, 1917
Montacute

Strong

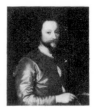

FLETCHER, John (1579-1625)
Dramatist

420 Canvas 73.7 x 36.8 (29 x 14½)
Unknown artist
Purchased, 1876. *Montacute*

Strong

FLINDERS, Matthew (1774-1814)
Hydrographer; inventor of the
Flinders Bar

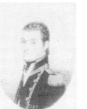

1844 Miniature on ivory, oval
6.4 x 5.1 (2½ x 2)
Helena G. de Courcy
Jones, inscribed, and (on reverse)
signed, after an unknown artist
Given by the sitter's grandson, Sir
William Matthew Flinders Petrie,
1919

FLUCKER, Barbara
Oysterwoman

P6(196, 197) *See Collections*:
The Hill and Adamson Albums,
1843-8, by David Octavius Hill and
Robert Adamson, **P6(1-258)**

FOLEY, John Henry (1818-74)
Sculptor

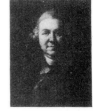

1541 Plaster medallion 26.7 (10½)
diameter
Charles Bell Birch, incised, c.1876
Purchased, 1909

Ormond

FOLEY, Sir Thomas (1757-1833)
Admiral

1459 Pencil and water-colour
35.2 x 24.4 (13⅞ x 9⅝)
Henry Edridge, signed and dated
1807
Purchased, 1907

FOLKES, Martin (1690-1754)
Antiquary

1926 Miniature on ivory 8.3 x 6.4
(3¼ x 2½)
Bernard Lens, signed in monogram
Bequeathed by G. Milner-Gibson-
Cullum, 1922

Kerslake

FOLKES, Sir William John Henry
Browne, Bt (1786-1860) MP for
Norfolk West

54 *See Groups*:The House of Com-
mons, 1833, by Sir George Hayter

FOLLETT, Sir William (1798-1845)
Attorney-General

1442 Canvas 42.9 x 31.1
(16⅞ x 12¼)
Sir Martin Archer Shee, c.1820
Purchased, 1906

Ormond

FOOT, Michael (b.1913) Politician

4529(127-31) *See Collections*:
Working drawings by Sir David Low,
4529(1-401)

FOOTE, Samuel (1720-77) Actor
and dramatist

4904 Canvas 55.9 x 45.7 (22 x 18)
Jean François Colson, signed and
dated 1769
Purchased, 1972

FORBES, Archibald (1838-1900)
War correspondent

2931 *See Groups*: Archibald
Forbes and others, by Frederic
Villiers

FORBES, C.
316a(50) *See Collections*:
Preliminary drawings for busts and
statues by Sir Francis Chantrey,
316a(1-202)

FORBES, Sir Charles, Bt
(1774-1849) Politician

316a(49) Pencil, two sketches
48 x 69.9 (18⅞ x 27½)
Sir Francis Chantrey, inscribed and
dated 1839
Given by Mrs George Jones, 1871
See Collections: Preliminary
drawings for busts and statues by
Sir Francis Chantrey, **316a(1-202)**

FORBES of Culloden, Duncan
(1685-1747) Lord President of the
Court of Session

61 Canvas, feigned oval
75.6 x 62.9 (29¾ x 24¾)
After Jeremiah Davison (c.1737?)
Given by Sir John Forbes, 1859

Kerslake

FORBES, Edward (1815-54)
Naturalist

1609 Bronze medal 5.1 (2)
diameter
Leonard Charles Wyon, based on a
marble bust by John Graham Lough
(1856), inscribed
Given by Miss J.B. Horner, 1911

Ormond

FORBES, James Staats (1823-1904)
Railway manager and art
connoisseur

3572 Pen and ink 12.4 x 18.8
($4\frac{7}{8}$ x $7\frac{3}{8}$)
Harry Furniss, signed with initials
and inscribed
Purchased, 1948
See Collections: Prominent Men,
c.1880-c.1910, by Harry Furniss,
3337-3535 and **3554-3620**

FORBES-ROBERTSON, Sir
Johnston *See* ROBERTSON,
Sir Johnston Forbes-

FORD, Edward Onslow
(1852-1901) Sculptor

2384, 2385 *See Collections*:
Miscellaneous drawings . . . by
Sydney Prior Hall, **2282-2384** and
2370-90

2820 *See Groups*: The Royal
Academy Conversazione, 1891, by
G. Grenville Manton

4391 (study for no. **1866**)
Pencil 44.8 x 56.5 ($17\frac{5}{8}$ x 22¼)
John McLure Hamilton, 1893
Purchased, 1964

1866 Canvas 44.5 x 59.7
(17½ x 23½)
John McLure Hamilton, signed and
dated 1893
Given by the artist, 1920

4404 *See Groups*: The St John's
Wood Arts Club, 1895, by Sydney
Prior Hall

FORD, Ford Madox (1873-1939)
Writer and critic

4454 Pen and ink 35.6 x 25.4
(14 x 10)
Alfred Wolmark, signed and dated
1927, and autographed by sitter
Purchased, 1965

FORD, Richard (1796-1858)
'Spanish Ford'; critic and traveller

1888 Canvas 30.5 x 25.4 (12 x 10)
After Antonio Chatelain (1840)
Purchased, 1920

Ormond

FORDHAM, George (1837-87)
Jockey

2629 Water-colour 30.5 x 18.1
(12 x $7\frac{1}{8}$)
Sir Leslie Ward, signed *Spy*
(*VF* 2 Sept 1882)
Purchased, 1934

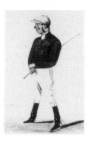

FORESTER, George Cecil Weld
Weld-Forester, 3rd Baron
(1807-86) General and politician

54 *See Groups*:The House of Com-
mons, 1833, by Sir George Hayter

4026(24) *See Collections*:
Drawings of Men about Town,
1832-48, by Alfred, Count D'Orsay,
4026(1-61)

1834(m) *See Collections*:
Members of the House of Lords,
c.1870-80, by Frederick Sargent,
1834(a-z and **aa-hh)**

FORESTER, Charles Robert Weld
(1811-52) Son of 1st Baron
Forester

4026(25) *See Collections*:
Drawings of Men about Town,
1832-48, by Alfred, Count D'Orsay,
4026(1-61)

FORESTIER-WALKER, Sir
Frederick (1844-1910) General

4716 Water-colour 36.8 x 27
(14½ x 10⅝)
Sir Leslie Ward, signed *Spy* and
inscribed
(*VF* 25 Dec 1902)
Purchased, 1970

FORSTER, Edward Morgan
(1879-1970) Novelist

4698 Canvas 50.8 x 40.6 (20 x 16)
Dora Carrington, 1920
Given by Mrs Frances Partridge,
1969

FORSTER, Josiah (1782-1870)
Slavery abolitionist

599 *See Groups*: The Anti-Slavery
Society Convention, 1840, by
Benjamin Robert Haydon

FORSTER, Robert (1792-1871)
Slavery abolitionist

599 *See Groups*: The Anti-Slavery
Society Convention, 1840, by
Benjamin Robert Haydon

FORSTER, William (1784-1854)
Quaker and reformer

599 *See Groups*: The Anti-Slavery
Society Convention, 1840, by
Benjamin Robert Haydon

FORSTER, William Edward
(1818-86) Statesman

5153 Water-colour 30.2 x 17.8
(11⅞ x 7)
Carlo Pellegrini, signed *Pellegrini*
and *Ape*
Purchased, 1977

1917 Canvas 124.5 x 99.1
(49 x 39)
Henry Tanworth Wells, signed and
dated 1875
Given by the sitter's adopted son,
E.R. Arnold-Forster, 1921

3358 *See Collections*: Prominent
Men, c.1880-c.1910, by Harry
Furniss, **3337-3535** and **3554-3620**

FORTESCUE, Hugh Fortescue,
1st Earl of (1753-1841)

999 *See Groups*: The Trial of
Queen Caroline, 1820, by Sir
George Hayter

FORTESCUE, Hugh Fortescue,
2nd Earl (1783-1861) MP for
Devonshire North

54 *See Groups*: The House of Com-
mons, 1833, by Sir George Hayter

FORTESCUE, Hugh Fortescue,
4th Earl (1854-1932) Sportsman
and MP

3266 Water-colour 30.5 x 18.4
(12 x 7¼)
Carlo Pellegrini, signed *Ape*
(*VF* 19 Feb 1887)
Purchased, 1934

FORTESCUE, Matthew Fortescue,
2nd Baron (1719-85) Politician

4855(4) *See Collections*: The
Townshend Album, **4855(1-73)**

FORTESCUE (afterwards
Parkinson-Fortescue), Chichester
Samuel, Baron Carlingford
See CARLINGFORD

FORTESCUE, Mathew (1754-1842)
Naval captain; second son of 2nd
Baron Fortescue

2885 Pencil, oval 15 x 11.7
(5⅞ x 4⅝)
Unknown artist
Purchased, 1936

FORTIA D'URBAIN, Agricole, Marquis de (1736-1843) French antiquary and patron of letters

2515(49) *See Collections*: Drawings of Prominent People, 1823-49, by William Brockedon, **2515(1-104)**

FORTNUM, Charles Drury Edward (1820-99) Art collector

1833 *See Groups*: Private View of the Old Masters Exhibition, Royal Academy, 1888, by Henry Jamyn Brooks

FOSTER, Sir Michael (1836-1907) Physiologist

1869 Canvas 141 x 102.9 (55½ x 40½)
John Collier, signed, inscribed and dated 1907
Given by the sitter's son, Michael Foster, 1920

FOSTER, Myles Birket (1825-99) Water-colourist

P99 Photograph: albumen print 21.3 x 16.2 ($8\frac{3}{8}$ x $6\frac{3}{8}$)
David Wilkie Wynfield, 1860s
Given by H. Saxe Wyndham, 1937
See Collections: The St John's Wood Clique, by David Wilkie Wynfield, **P70-100**

4041(1) Pencil and wash 32.7 x 22.9 ($12\frac{7}{8}$ x 9)
Walker Hodgson, signed with initials and dated 1891, and autographed by sitter
Purchased, 1957
See Collections: Drawings, 1891-5, by Walker Hodgson, **4041(1-5)**

FOUNTAINE, Sir Andrew (1676-1753) Collector

926 *See Groups*: The Committy of the House of Commons (the Gaols Committee), by William Hogarth

FOURDRINIER, Henry (1766-1854) Inventor

1075, 1075a and **b** *See Groups*: Men of Science Living in 1807-8, by Sir John Gilbert and others

FOWLER, Henry, Viscount Wolverhampton
See WOLVERHAMPTON

FOWLER, Sir Robert, Bt (1828-91) Lord Mayor of London

2571 Water-colour 31.1 x 18.1 (12¼ x $7\frac{1}{8}$)
Théobald Chartran, signed.*T.*
(*VF* 25 June 1881)
Purchased, 1933

FOX, Charles James (1749-1806) Whig statesman

L152(30) Miniature on ivory, oval 6.7 x 5.1 ($2\frac{5}{8}$ x 2)
Thomas Day, signed with initials and dated 1787
Lent by NG (Alan Evans Bequest), 1975

139 Terracotta bust 52.7 (20¾) high
Joseph Nollekens, c.1791
Purchased, 1862

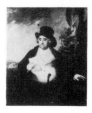

743 Canvas 132.1 x 113 (52 x 44½)
Karl Anton Hickel, c.1793
Purchased, 1885

745 *See Groups*: William Pitt addressing the House of Commons ... 1793, by Karl Anton Hickel

3887 Marble bust 67.3 (26½) high
Joseph Nollekens, incised and dated
1805
Given by P. Leigh-Smith, 1953

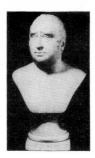

1310a Chalk 15.9 x 11.4
(6¼ x 4¼)
Unknown artist, inscribed
Given by Lord Weardale, 1902

1310b Chalk 14 x 11.4 (5½ x 4½)
Unknown artist, inscribed
Given by Lord Weardale, 1902

FOX, Charles Richard (1796-1873)
Numismatist

54 *See Groups*:The House of Commons, 1833, by Sir George Hayter

FOX, Elizabeth Vassall, Lady
Holland *See* HOLLAND

FOX, George Lane (c.1790-1848)
MP for Beverley

999 *See Groups*: The Trial of
Queen Caroline, 1820, by Sir
George Hayter

FOX, Henry, 1st Baron Holland
See HOLLAND

FOX, Henry Edward (1755-1811)
General

745 *See Groups*: William Pitt
addressing the House of Commons
. . . 1793, by Karl Anton Hickel

FOX, Henry Edward, 4th Baron
Holland *See* HOLLAND

FOX, Henry Richard Vassall, 3rd
Baron Holland *See* HOLLAND

FOX, Sackville Walter Lane
(1800-74) MP for Helston

54 *See Groups*:The House of Commons, 1833, by Sir George Hayter

FOX, Samuel (1781-1868)
Slavery abolitionist

599 *See Groups*: The Anti-Slavery
Society Convention, 1840, by
Benjamin Robert Haydon

FOX, Sir Stephen (1627-1716)
Financier

2077 Canvas 123.2 x 100.3
(48½ x 39½)
Sir Peter Lely, inscribed, c.1670
Lent by Lady Teresa Agnew, 1968
Piper

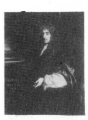

FOX, William Johnson (1786-1864)
Preacher, politician and journalist

1374 Canvas 61.3 x 50.8
(24⅛ x 20)
Eliza Florence Bridell (his
daughter), signed, c.1863
Given by the artist's second
husband, George Fox, 1904

Ormond

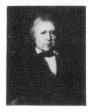

FOXE, John (1516-87)
Martyrologist

24 Panel 35.6 x 30.2 (14 x 11⅞)
Unknown artist, inscribed and
dated probably incorrectly 1587
Given by J.Y. Akerman, 1858

Strong

FOXE, Richard (1446/7-1528)
Bishop and statesman

874 Panel 66.7 x 45.7 (26¼ x 18)
After Johannes Corvus, inscribed
Bequeathed by Thomas Kerslake,
1891

Strong

FRAMPTON, Sir George
(1860-1928) Sculptor

3043 Pencil 43.8 x 36.8
(17¼ x 14½)
Self-portrait, signed and dated 1894
Given by Marion Harry Spielmann,
1939

3669 Pencil and wash 37.1 x 27.6
(14⅝ x 10⅞)
Sir Bernard Partridge, signed and
inscribed
(*Punch* 19 Jan 1927)
Purchased 1949
See Collections: Mr Punch's
Personalities, 1926-9, by Sir
Bernard Partridge, **3664-6**, etc

FRAMPTON, Tregonwell
(1641-1727) 'Father of the turf'

4312 Canvas 31.4 x 24.1
(12⅜ x 9½)
By or after John Wootton
Purchased, 1963

FRANCIS, Sir Philip (1740-1818)
Politician and pamphleteer

334 Canvas 74.9 x 61 (29½ x 24)
James Lonsdale, eng 1810
Purchased, 1871

FRANKLAND, Sir Edward
(1825-99) Chemist

4017 Plaster medallion 43.2 (17)
diameter
John Adams-Acton, c.1896
Given by the sitter's granddaughters,
the Misses Marjory S. and Elsa West,
1957

FRANKLIN, Benjamin (1706-90)
American statesman

722 Terracotta medallion 12.1
(4¾) diameter
Jean Baptiste Nini, inscribed and
dated 1777
Given by Charles Seidler, 1884

327 Canvas 71.1 x 57.2 (28 x 22½)
After Joseph Siffred Duplessis
(1783)
Purchased, 1871

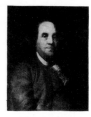

FRANKLIN, Jane (née Griffin),
Lady (1792-1875) Traveller;
second wife of Sir John Franklin

904 Chalk, oval 15.9 x 13.3
(6¼ x 5¼)
Amélie Romilly, 1816
Bequeathed by the sitter's niece,
Miss Sophia Cracroft, 1892

Ormond

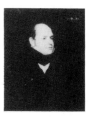

FRANKLIN, Sir John (1786-1847)
Arctic explorer

903 Canvas 76.8 x 51.4
(30¼ x 20¼)
Thomas Phillips, replica, signed in
monogram and dated 1828
Bequeathed by Lady Franklin's
niece, Miss Sophia Cracroft, 1892

2515(81) *See Collections*:
Drawings of Prominent People,
1823-49, by William Brockedon,
2515(1-104)

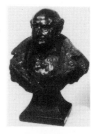

1230 Bronze cast of bust 40.3
(15⅞) high
Andrea Carlo Lucchesi, inscribed
and dated 1898
Given by the sitter's godson and
great-nephew, Willingham Franklin
Rawnsley, 1899

Ormond

FRANKS, Sir Augustus Wollaston
(1826-97) Antiquary

1584 Bronze plaque 15.2 x 14
(6 x 5½)
Charles J. Praetorius, inscribed
Given by Viscount Dillon, 1910

FRASER, Alexander, 16th Baron
Saltoun *See* SALTOUN

FRASER, Alexander Campbell
(1819-1914) Philosopher

P6(51) Photograph: calotype
19.4 x 14.3 ($7\frac{5}{8}$ x $5\frac{5}{8}$)
David Octavius Hill and Robert
Adamson, 1843-8
Purchased, 1973
See Collections: The Hill and
Adamson Albums, 1943-8, by
David Octavius Hill and Robert
Adamson, **P6(1-258)**

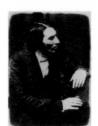

FRASER, James (1783-1856)
Traveller and writer

2515(48) *See Collections*:
Drawings of Prominent People,
1823-49, by William Brockedon,
2515(1-104)

FRASER, James Keith (1832-95)
Lieutenant-General

2572 Water-colour 30.5 x 17.8
(12 x 7)
Sir Leslie Ward, signed *Spy*
(*VF* 6 March 1880)
Purchased, 1933

FRASER, Sir William Augustus, Bt
(1826-98) Politician

2573 Water-colour 30.5 x 18.1
(12 x $7\frac{1}{8}$)
Carlo Pellegrini, signed *Ape*
(*VF* 9 Jan 1875, published in
reverse)
Purchased, 1933

FRAZER, Sir James George
(1854-1941) Social anthropologist

2099 Bronze cast of bust 67.9
(26¾) high
Emile Antoine Bourdelle, incised
and dated 1922
Given by the sitter's widow, 1949

L168(2) Sanguine, black and
white 40.9 x 30.5 ($16\frac{1}{8}$ x 12)
Sir William Rothenstein, signed and
dated 1925
Lent by the artist's son, Sir John
Rothenstein, 1977
See Collections: Prominent men,
1895-1930, by Sir William
Rothenstein, **L168(1-11)**

FREAKE, Sir Charles James, Bt
(1814-84) Builder and benefactor

2574 Water-colour 30.5 x 18.1
(12 x $7\frac{1}{8}$)
Théobald Chartran, signed *.T.*
(*VF* 31 March 1883)
Purchased, 1933

FREDERICK V, King of Bohemia
(1596-1632) Calvinist son-in-law
of James I

1973 Canvas 73.7 x 57.2
(29 x 22½)
Gerard Honthorst, c.1630(?)
Purchased, 1923

Piper

FREDERICK, Duke of York and
Albany *See* YORK AND ALBANY

FREDERICK Lewis, Prince of Wales
(1707-51) Son of George II; father
of George III

1164 With an attendant, possibly
his groom of the bedchamber,
Captain Thomas Bloodworth (left)
Canvas 123.2 x 100.3 (48½ x 39½)
Bartholomew Dandridge, signed,
c.1732
Purchased, 1898

1556 *See Groups*: Frederick,
Prince of Wales, and his sisters,
(The Music Party), by Philip
Mercier

2501 Canvas 123.8 x 100.3
(48¾ x 39½)
Philip Mercier, signed, c.1736(?)
Bequeathed by Miss Lillie B.
Randell, 1931. *Beningbrough*

Kerslake

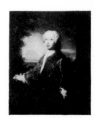

FREEMAN, John (1880-1929)
Poet

4040 Charcoal 37.2 x 27.3
(14⅝ x 10¾)
Dame Laura Knight, signed, pub
1928
Purchased, 1957

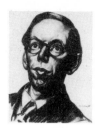

FREEMAN-MITFORD, Algernon,
Baron Redesdale
See REDESDALE

FREEMAN-MITFORD, John,
Baron Redesdale
See REDESDALE

FREMANTLE, John
Colonel

3715 *See Collections*: Studies for
The Waterloo Banquet at Apsley
House, 1836, by William Salter,
3689-3769

FREMANTLE, Thomas Francis,
1st Baron Cottesloe
See COTTESLOE

FRENCH, Fitzstephen (1801-73)
MP for County Roscommon

54 *See Groups*:The House of Com-
mons, 1833, by Sir George Hayter

FRENCH, John, 1st Earl of Ypres
See YPRES

FRERE, Sir Henry Bartle, Bt
(1815-84) Administrator in India
and South Africa

1670 Plaster cast of bust 69.9
(27½) high
Thomas Woolner, incised and dated
1868
Purchased, 1912

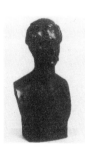

2669 Canvas 129.5 x 96.5
(51 x 38)
Sir George Reid, signed *R* and
dated 1881
Bequeathed by the sitter's son,
Sir Bartle C.A.Frere, Bt, 1934

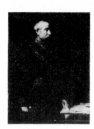

4441 *See Groups*: The Duke and
Duchess of Teck receiving Officers
of the Indian Contingent, 1882, by
Sydney Prior Hall

FRERE, John Hookham
(1769-1846) Diplomat and writer

1473 Pencil and chalk 38.1 x 26
(15 x 10¼)
Henry Edridge, c.1800
Purchased, 1907

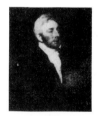

316a(51) *See Collections*:
Preliminary drawings for busts and
statues by Sir Francis Chantrey,
316a(1-202)

3326 Canvas 76.2 x 63.5 (30 x 25)
Sir Martin Archer Shee, c.1822
Lent by Lady Teresa Agnew, 1968

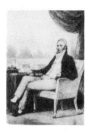

FREUD, Lucian (b. 1922)
Painter

5199 Bronze cast of head 40
(15¾) high
Sir Jacob Epstein, incised, 1949
(related to bust of 1947)
Purchased, 1978

5205 Canvas 30.5 x 25.1 (12 x 9⅞)
Self-portrait, 1962
Purchased, 1978

FREYCINET, Charles Louis de
Saulces de (1828-1923)
French politician

4707(9) *See Collections*: *Vanity
Fair* cartoons, 1869-1910, by
various artists, **2566-2606**, etc

FRIAS, Juan de Velasco, Duke of
Constable of Castile; delegate at the
Somerset House Conference

665 *See Groups*: The Somerset
House Conference, 1604, by an
unknown Flemish artist

FRITH, William Powell (1819-1909)
Painter

2139 Canvas 59.7 x 49.5
(23½ x 19½)
Self-portrait, 1838
Given by the artist's daughters, the
Misses Frith, 1926

1738 With an unidentified model
Canvas 61 x 46.4 (24 x 18¼)
Self-portrait, signed and dated 1867
Purchased, 1914

1833 *See Groups*: Private View of
the Old Masters Exhibition, Royal
Academy, 1888, by Henry Jamyn
Brooks

2820 *See Groups*: The Royal
Academy Conversazione, 1891, by
G. Grenville Manton

5058 Chalk 36.8 x 26.7
(14½ x 10½)
Mabel D. Lapthorn, signed and
dated 1909
Given by the artist's sister,
Miss G.E. Lapthorn, 1975

FRODSHAM, William James
(1778-1850) Chronometer maker

1075a, 1075b *See Groups*: Men of
Science Living in 1807-8, by Sir
John Gilbert and others

FROST, William Edward (1810-77)
Painter

4303 Pencil and water-colour
21.6 x 16.5 (8½ x 6½)
Self-portrait, 1839
Given by Tom Pocock, 1963

FROUDE, James Anthony
(1818-94) Historian

4990 Canvas 34.6 x 23.5
(13⅝ x 9¼)
Sir George Reid, signed *R* and
dated 1881
Purchased, 1974

1439 Chalk 49.5 x 39.4
(19½ x 15½)
John Edward Goodall, signed,
c.1890
Purchased, 1906

3448, 3449 *See Collections*:
Prominent Men, c.1880-c.1910, by
Harry Furniss, **3337-3535** and
3554-3620

FROUDE, Robert H. (1771?-1859)
Divine; father of J.A., R.H. and W.
Froude

2515(35) *See Collections*:
Drawings of Prominent People,
1823-49, by William Brockedon,
2515(1-104)

FRY, Christopher (b.1907)
Playwright

P67 *See Collections*: Prominent
people, c.1946-64, by Angus
McBean, **P56-67**

FRY, Sir Edward (1827-1918)
Judge

2466 Canvas 90.2 x 74.9
(35½ x 29½)
Frank Holl, signed and dated 1883
Given by wish of the sitter's widow,
1930

FRY, Elizabeth (1780-1845)
Prison reformer

118 Miniature on ivory 11.4 x 8.3
(4½ x 3¼)
Samuel Drummond, c.1815
Purchased, 1861

898 Panel 23.8 x 17.5 (9⅜ x 6⅞)
After Charles Robert Leslie (1823)
Purchased, 1892

FRY, Roger (1866-1934)
Critic and painter

4570 Chalk 25.4 x 21.6 (10 x 8½)
Jean Marchand, 1913
Purchased, 1967

3833 Canvas 59.7 x 49.5
(23½ x 19½)
Self-portrait, 1930-4
Given by his sister, Sara Margery
Fry, 1952

3858 Pen and water-colour
31.1 x 21.3 (12¼ x 8⅜)
Sir Max Beerbohm, signed,
inscribed and dated 1931
Purchased, 1953
See Collections: Caricatures,
1897-1932, by Sir Max Beerbohm,
3851-8

FRY, Ruth (1878-1962)
Quaker and writer

P129 Photograph: bromide print
40 x 31.1 (15¾ x 12¼)
Lucia Moholy, 1936
Purchased, 1979
See Collections: Prominent People,
1935-8, by Lucia Moholy, **P127-33**

FRY, Sara Margery (1874-1958)
Social and penal reformer; sister of
Roger Fry

5240 Canvas 27.9 x 24.4 (11 x 9⅝)
Claude Rogers, inscribed and dated
(on back of frame) 1939
Purchased, 1979

FULLER, Isaac (1606?-72)
Painter

2104 With unknown boy
Canvas 125.7 x 100.3 (49½ x 39½)
Self-portrait, c.1670
Purchased, 1925

Piper

FULLER, John

316a(52) *See Collections*:
Preliminary drawings for busts and
statues by Sir Francis Chantrey,
316a(1-202)

FURNISS, Harry (1854-1925)
Caricaturist

2386 *See Collections*:
Miscellaneous drawings. . . by
Sydney Prior Hall, **2282-2348** and
2370-90

2900 Pen and ink 12.7 x 7.6
(5 x 3)
Edward Joseph Sullivan, signed,
inscribed and dated 1891
Given by A.F.U. Green, 1936

3039 Pen and ink 25.4 x 19.1
(10 x 7½)
Self-portrait
Given by Marion Harry Spielmann,
1939

3567, 3599 *See Collections*:
Prominent Men, c.1880-c.1910, by
Harry Furniss, **3337-3535** and
3554-3620

FURNIVALL, Frederick James
(1825-1910) English scholar and
oarsman

3172 Pencil 17.8 x 15.2 (7 x 6)
Sir William Rothenstein, inscribed
and dated 1901
Given by Robert Steele, 1943

1577 Pencil and chalk 48.9 x 35.6
(19¼ x 14)
Charles Haslewood Shannon, signed
and inscribed, 1901
Given by Robert Steele, 1910

3450 *See Collections:* Prominent
Men, c.1880-c.1910, By Harry
Furniss, **3337-3535** and **3554-3620**

FUSELI, Henry (1741-1825)
Painter

L173 Canvas, feigned incomplete
oval 77.8 x 64.5 ($30\frac{5}{8}$ x $25\frac{3}{8}$)
James Northcote, signed and dated
1778
Lent anonymously, 1979

4538 Pencil 32.4 x 50.2
(12¾ x 19¾)
Self-portrait, inscribed, c.1779
Purchased, 1967

744 Canvas, feigned oval
76.2 x 63.5 (30 x 25)
John Opie, exh 1794
Given by J.S. North and Lord
North, 1885

4913(2) *See Collections*: Four
studies from a sketchbook, by
Thomas Cooley, **4913(1-4)**

FYVIE, Graham

P6(139) *See Collections*: The Hill
and Adamson Albums, 1843-8, by
David Octavius Hill and Robert
Adamson, **P6(1-258)**

GAGE, Sir Henry (1597-1645)
Royalist

2279 Canvas 127.6 x 99.1
(50¼ x 39)
Perhaps after William Dobson
Transferred from Tate Gallery, 1957

Piper

GAGE, Thomas (1721-87)
General

4070 Miniature on ivory, oval
4.8 x 3.8 ($1\frac{7}{8}$ x 1½)
Jeremiah Meyer
Given by Edward Peter Jones,1958

GAINSBOROUGH, Thomas
(1727-88)
Portrait and landscape painter

4446 Canvas 76.2 x 63.5 (30 x 25)
Self-portrait, c.1759
Acquired by H.M.Government,
1965, and allocated to NPG

3913 Canvas, oval 19.4 x 16.8
($7\frac{5}{8}$ x $6\frac{5}{8}$)
Johan Zoffany, c.1772
Lent by Tate Gallery, 1954

1107 Pencil, feigned oval
21 x 16.5 (8¼ x 6½)
Francesco Bartolozzi after a
self-portrait (1787)
Purchased, 1897

928 *See Unknown Sitters III*

GAIRDNER, James (1828-1912)
Historian

2021 Plaster bust 49.5 (19½) high
Frank Baxter, incised and dated
1900
Given by the artist, 1926.
Not illustrated

Continued overleaf

2021a Bronze cast of no.**2021**
Given by the sitter's family,1926

GAITSKELL, Hugh (1906-63)
Chancellor of the Exchequer

4923 Canvas 91.4 x 75.6
(36 x 29¾)
Judy Cassab, signed, 1957
Given by Lady Gaitskell,1972

4530 Bronze cast of head 41.3
(16¼) high
Leslie Cubitt Bevis, 1963
Purchased, 1967

GALE, William (1823-1909)
Painter

P100 Photograph: albumen print
21.3 x 16.2 (8⅜ x 6⅜)
David Wilkie Wynfield, 1860s
Given by H.Saxe Wyndham, 1937
See Collections: The St John's
Wood Clique, by David Wilkie
Wynfield, **P70-100**

GALLIE, Justine (née Monro)

P6(110,117) *See Collections:*
The Hill and Adamson Albums,
1843-8, by David Octavius Hill
and Robert Adamson, **P6(1-258)**

GALLOWAY, George Stewart, 8th
Earl of (1768-1834)

999 *See Groups:* The Trial of
Queen Caroline, 1820, by Sir
George Hayter

GALLOWAY, Alan Stewart, 10th
Earl of (1835-1901)
Conservative MP

3274 Water-colour 31.8 x 20
(12½ x 7⅞)
Melchiorre Delfico
(*VF* 1 Feb 1873)
Purchased, 1934

GALSWORTHY, John (1867-1933)
Novelist

3649 Bronze medallion 9.5
(3¾) diameter
Theodore Spicer-Simson, inscribed
and dated 1921
Purchased, 1949

4208 Bronze cast of bust 38.1
(15) high
David Evans, incised, 1929
Purchased, 1961

4529(132-40) *See Collections:*
Working drawings by Sir David
Low, **4529(1-401)**

GALT, John (1779-1839)
Novelist

2515(37) Chalk 36.5 x 25.7
(14⅜ x 10⅛)
William Brockedon, dated 1834
Lent by NG, 1959
See Collections: Drawings of
Prominent People, 1823-49, by
William Brockedon, **2515(1-104)**

Ormond

GALTON, Sir Francis (1822-1911)
Founder of the science of eugenics

3923 Water-colour 33.7 x 26.7
(13¼ x 10½)
Octavius Oakley, 1840
Purchased, 1955

1997 Panel 69.9 x 54 (27½ x 21¼)
Gustav Graef, inscribed and dated
1882 on reverse
Purchased, 1924

3916 Canvas 76.2 x 75.3
(30 x 29⅝)
Charles Wellington Furse, inscribed
and dated 1903 on reverse
Given by the widow of a nephew of
the sitter, Mrs J.Wheler-Galton,
1954

3095 Chalk 22.9 x 17.8 (9 x 7)
Janet Caroline Fisher
Bequeathed by the artist's sister,
Miss M.C.Fisher, 1940

GALUSHA, Eton
Americal Baptist minister and
slavery abolitionist

599 *See Groups:* The Anti-Slavery
Society Convention, 1840, by
Benjamin Robert Haydon

GALVIN, George (1860-1904)
'Dan Leno'; comedian

2750 Pen and ink 5.7 x 15.9
(2¼ x 6¼)
Self-portrait, signed
Given by Rathmell Wilson, 1934

GAMBIER, James Gambier, 1st
Baron (1756-1833) Admiral

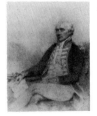

1982 Pencil and chalk 34.3 x 27.6
(13½ x 10⅞)
Joseph Slater, signed and dated
1813
Purchased, 1923

GARDINER, Charles John, 1st Earl
of Blessington
See BLESSINGTON

GARDINER, Harriet
Daughter of Col Thomas Gardiner

883(11) *See Collections:* Studies
for miniatures by Sir George Hayter,
883(1-21)

GARDINER, Louisa
Daughter of Col Thomas Gardiner

883(11) *See Collections:* Studies
for miniatures by Sir George Hayter,
883(1-21)

GARDINER, Mary
Daughter of Col Thomas Gardiner

883(11) *See Collections:* Studies
for miniatures by Sir George Hayter,
883(1-21)

GARDINER, Sir Robert William
(1781-1864)
Governor of Gibraltar

3716 *See Collections:* Studies
for The Waterloo Banquet at
Apsley House, 1836, by William
Salter, **3689-3769**

GARDNER, Alan Gardner, 1st
Baron (1742-1809) Admiral

2103 Canvas 74.9 x 62.2
(29½ x 24½)
Theophilus Clarke, exh and
eng 1799
Purchased, 1925

GARDNER, Alan Legge Gardner,
3rd Baron (1810-83) Held various
court appointments; sportsman

4026(27) *See Collections:*
Drawings of Men about Town,
1832-48, by Alfred, Count D'Orsay,
4026(1-61)

3287 Water-colour 30.5 x 18.1
(12 x 7⅛)
Sir Leslie Ward, signed *Spy*
(*VF* 21 July 1883)
Purchased, 1934

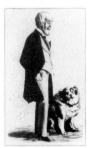

GARDNER, Daniel (1750?-1805)
Portrait painter

1971 Canvas 75.2 x 57.5
($29\frac{5}{8}$ x $22\frac{5}{8}$)
Self-portrait, c.1770
Given by his great-great-grand-
daughter, Miss Frances Baker, 1923

GARGRAVE, Sir Thomas
(1495-1579)
Speaker of the House of Commons

1928 Panel 42.5 x 34.3
(16¾ x 13½)
Unknown artist, inscribed, after a
portrait of 1570
Bequeathed by G.Milner-Gibson-
Cullum, 1922

Strong

GARNETT, Edward (1868-1937)
Writer and publisher

P132 Photograph: bromide print
40 x 31.1 (15¾ x 12¼)
Lucia Moholy, 1936
Purchased, 1979
*See Collections: Prominent People,
1935-8, by Lucia Moholy,* **P127-33**

GARNETT, Richard (1835-1906)
Writer and poet; Keeper of Printed
Books, BM

3451 Pen and ink 28.2 x 15.2
($11\frac{1}{8}$ x 6)
Harry Furniss, inscribed
Purchased, 1947
*See Collections: Prominent Men,
c.1880-c.1910, by Harry Furniss,*
3337-3535 and **3554-3620**

GARNIER, Thomas (1776-1873)
Dean of Winchester

4844 Wax medallion, oval
17.8 x 13.3 (7x 5¼)
Richard Cockle Lucas, incised and
dated 1850
Acquired, 1971

Ormond

GARRICK, David (1717-79)
Actor, playwright and theatre
manager

707a Plaster bust 63.5 (25) high
Attributed to Louis François
Roubiliac, 1758
Given by Sir Theodore Martin, 1883

1167 Canvas, feigned oval
75.2 x 63.2 ($29\frac{5}{8}$ x $24\frac{7}{8}$)
Studio of Johan Zoffany, c.1763
Transferred from Tate Gallery,
1957. *Beningbrough*

4504 Canvas 76.2 x 63.5 (30 x 25)
After Sir Joshua Reynolds (1768)
Given by Mrs Jenny Wolff, 1966

5054 Canvas 75.6 x 63.2
(29¾ x $24\frac{7}{8}$)
Thomas Gainsborough, exh 1770
Purchased, 1975

3639 Pencil 13.6 x 11.4 ($5\frac{3}{8}$ x 4½)
Nathaniel Dance, 1771
Given by Miss Katharine R. Image,
1948

1187 Pencil, oval 8.9 x 7 (3½ x 2¾)
John Keyse Sherwin, signed and
inscribed
Purchased, 1899

82 Canvas 88.9 x 71.1 (35 x 28)
Robert Edge Pine, inscribed,
eng 1776
Purchased, 1859

GARRICK, Eva Maria (née Veigel)
(1724-1822)
Dancer; wife of David Garrick

3640 Companion to no.**3639,**
David Garrick
Pencil 19.7 x 16.2 (7¾ x 6⅜)
Nathaniel Dance, 1771
Given by Miss Katharine R. Image,
1948. *Stolen, 1968*

GARROW, Sir William
(1760-1840) Lawyer

1695(s) *See Collections:* Sketches
for The Trial of Queen Caroline,
1820, by Sir George Hayter,
1695(a-x)

999 *See Groups:* The Trial of
Queen Caroline, 1820, by Sir
George Hayter

GARTH, Samuel (1661-1719)
Physician and poet

1076 Canvas, oval 73.7 x 62.2
(29 x 24½)
Unknown artist, c.1705-10
Purchased, 1896

3208 Canvas 90.2 x 70.5
(35½ x 27¾)
Sir Godfrey Kneller, signed, c.1710
Kit-cat Club portrait
Given by NACF, 1945

Piper

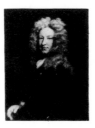

GARVIN, James Louis
(1868-1947) Journalist

3670 Pencil 41 x 31.5 (16⅛ x 12⅜)
Sir Bernard Partridge, signed and
inscribed
(*Punch* 25 April 1928)
Purchased, 1949
See Collections: Mr Punch's
Personalities, 1926-9, by Sir
Bernard Partridge, **3664-6,** etc

GASKELL, Daniel (1782-1875)
MP for Wakefield

54 *See Groups:* The House of Com-
mons, 1833, by Sir George Hayter

GASKELL, Elizabeth Cleghorn
(née Stevenson) (1810-65) Novelist;
biographer of Charlotte Brontë

1720 Chalk 61.6 x 47.6
(24¼ x 18¾)
George Richmond, signed and
dated 1851
Bequeathed by the sitter's daughter,
Miss Margaret Gaskell, 1913

Ormond

GASKELL, James Milnes (1810-73)
MP for Wenlock

54 *See Groups:* The House of Com-
mons, 1833, by Sir George Hayter

GASKOIN, J.

P120(40) *See Collections:*
Literary and Scientific Men, 1855,
Maull & Polyblank, **P120(1-54)**

GASSIOT, John Peter (1797-1877)
Scientific writer

P106(8) Photograph: albumen
print, arched top 20 x 14.6
(7⅞ x 5¾)
Maull & Polyblank, c.1855
Purchased, 1978
See Collections: Literary and
Scientific Portrait Club, by Maull &
Polyblank, **P106(1-20)**

GATHORNE-HARDY, Gathorne,
1st Earl of Cranbrook
See CRANBROOK

GAUDIER-BRZESKA, Henri
(1891-1915)
Sculptor and draughtsman

4814 Pencil 55.9 x 39.4 (22 x 15½)
Self-portrait, signed, inscribed and
dated 1912
Purchased, 1970

GAY, John (1685-1732)
Poet and dramatist

622 *See Unknown Sitters II*

GEDDES, Sir Eric Campbell
(1875-1937) Minister of Transport

2463 *See Groups:* Statesmen of
World War I, by Sir James Guthrie

GELL, Frederick (1820-1902)
Bishop of Calcutta

4550 Water-colour 37.5 x 19.7
(14¾ x 7¾)
Signed *JEJ.* and dated 1855,
inscribed
Given by A. Yakovleff, 1967

GELL, Sir William (1777-1836)
Archaeologist

5086 Pencil 50.2 x 34.6
(19¾ x 13$\frac{5}{8}$)
Cornelius Varley, signed, inscribed
and dated 1816
Purchased, 1976

1491 Pencil 21.3 x 18.7 (8$\frac{3}{8}$ x 7$\frac{3}{8}$)
Thomas Uwins, signed and dated
1830; autographed by sitter (on
separate label)
Purchased, 1908

GENNADIUS, John
Greek minister in London

4707(10) *See Collections:*
Vanity Fair cartoons, 1869-1910,
by various artists, **2566-2606,** etc

GENT-THARP, William Montagu
(1837-99) Sportsman

2990 Water-colour 35.6 x 21.9
(14 x 8$\frac{5}{8}$)
Sir Leslie Ward, signed *Spy*
(*VF* 21 June 1894)
Purchased, 1938

GEOFFREY (1158-86)
Fourth son of Henry II; Count of
Brittany

1301 Coloured facsimile from an
enamel at Le Mans 30.5 x 18.4
(12 x 7¼)
Unknown artist
Given by Goupil & Co, 1901

GEORGE I (1660-1727)
Reigned 1714-27

4223 Canvas, feigned oval
75.6 x 63.5 (29$\frac{7}{8}$ x 25)
Studio of Sir Godfrey Kneller
(c.1714), facsimile of signature
Purchased, 1961

544 Canvas 192.4 x 137.2
(75¾ x 54)
Studio of Sir Godfrey Kneller
(c.1714)
Transferred from BM, 1879

5174 Canvas 247 x 151.8
(97¼ x 59¾)
Sir Godfrey Kneller, signed and
dated 1716, replica (1714)
Purchased, 1978. *Beningbrough*

488 Oil on copper, oval 16.8 x 14.3
(6⅝ x 5⅝)
After Sir Godfrey Kneller (c.1714)
Purchased, 1877

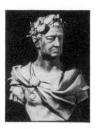

4156 Terracotta bust 62.9
(24¾) high
John Michael Rysbrack
Purchased, 1960

Kerslake

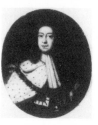

GEORGE II (1683-1760)
Reigned 1727-60

205 Canvas 155.6 x 59.7
(61¼ x 23½)
After Sir Godfrey Kneller (1716)
Purchased, 1865

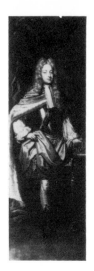

368 Canvas 219.7 x 128.3
(86½ x 50½)
Studio of Charles Jervas (c.1727)
Purchased, 1873

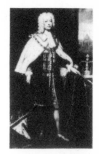

670 Canvas 218.8 x 146.7
(94 x 57¾)
Thomas Hudson, signed, 1744
Given by H.M.Office of Works, 1883

1356 *See Groups:* Groups
associated with the Moravian
Church, c.1752-4, attributed to
Johann Valentin Haidt, **624A** and
1356

256 Canvas 125.7 x 99.7
(49½ x 39¼)
By or after Thomas Worlidge,
c.1753
Purchased, 1868

4855(5) Ink 8.3 x 7 (3¼ x 2¾)
George Townshend, 4th Viscount
and 1st Marquess Townshend,
inscribed
Bequeathed by R. W. Ketton-
Cremer, 1971
See Collections: The Townshend
Album, **4855(1-73)**

4855(2) *See Collections:* The
Townshend Album, **4855(1-73)**

Kerslake

GEORGE III (1738-1820)
Reigned 1760-1820

1165 *See Groups:* Francis
Ayscough with the Prince of Wales
(later George III) and the Duke of
York and Albany, by Richard Wilson

223 Canvas 147.3 x 106.7
(58 x 42)
Studio of Allan Ramsay (c.1767)
Purchased, 1866

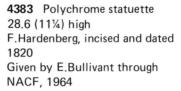

2502 Canvas 233.7 x 144.8
(92 x 57)
Studio of Sir William Beechey
(c.1800)
Bequeathed by Miss Lillie Belle
Randell, 1931

3903 Marble bust 42.5 (16¾) high
Peter Turnerelli, incised and dated
1809
Purchased, 1954

L152(26) Miniature on ivory, oval
3.2 x 2.2 (1¼ x $\frac{7}{8}$)
Unknown artist, signed in
monogram (?*JG*, possibly James
Gillray)
Lent by NG (Alan Evans Bequest),
1975

4383 Polychrome statuette
28.6 (11¼) high
F.Hardenberg, incised and dated
1820
Given by E.Bullivant through
NACF, 1964

GEORGE IV (1762-1830)
Regent 1811-20; reigned 1820-30

1761 Miniature on ivory 6 (2$\frac{3}{8}$)
diameter
H.de Janvry, signed in monogram
and dated 1793
Given by Francis Wellesley, 1915

3308 With his brother, Duke of
York and Albany (left)
Wax relief 10.2 x 14.6 (4 x 5¾)
Thomas R.Poole, inscribed and
dated 1795 (on backing paper)
Given by Mrs Frances E.Jerdein,
1946

123 Canvas 91.4 x 71.1 (36 x 28)
Sir Thomas Lawrence, c.1814
Purchased, 1861

2503 Canvas 241.3 x 154.9
(95 x 61)
After Sir Thomas Lawrence (1815)
Bequeathed by Miss Lillie Belle
Randell, 1931

L152(33) Miniature on ivory, oval
7.6 x 6.4 (3 x 2½)
Paul Fischer
Lent by NG (Alan Evans Bequest),
1975

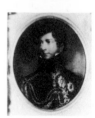

316a(54) Pencil 45.7 x 32.4
(18 x 12¾)
Sir Francis Chantrey, inscribed,
c.1821
Given by Mrs George Jones, 1871
See Collections: Preliminary
drawings for busts and statues by
Sir Francis Chantrey, **316a(1-202)**

316a(53,56,57) *See Collections:*
Preliminary drawings for busts and
statues by Sir Francis Chantrey,
316a(1-202)

1691a With his brother, Duke of
York and Albany (left)
Silhouette 31.8 x 23.8 (12½ x 9⅜)
Crowhurst of Brighton, c.1827
Purchased, 1905

GEORGE V (1865-1936)
Reigned 1910-36

4536 *See Groups:* Four
Generations . . . , by Sir William
Quiller Orchardson

1745 *See Groups:* The Royal
Family at Buckingham Palace, 1913,
by Sir John Lavery

4604 Canvas, oval 76.2 x 63.5
(30 x 25)
Lance Calkin, signed, reduced
version (c.1914)
Given by the artist's great-nephew,
Robert R.Calkin, 1968

4013 Canvas 59.1 x 42.9
(23¼ x 16⅞)
Sir Oswald Birley, signed with
initials
Purchased, 1957

2796 Bronze bust 83.8 (33) high
Felix Weiss, incised and dated 1935
Given by the artist, 1935

5094 Canvas 132.7 x 122.6
(52¼ x 48¼)
Frederic Whiting, signed, exh 1936
Bequeathed by Mrs L. G.
Maconochie, 1976

GEORGE VI (1895-1952)
Reigned 1936-52

4144 Canvas 61 x 50.8 (24 x 20)
Reginald Grenville Eves, signed,
1924
Given by the artist's son, Grenville
Eves, 1960, incised and dated 1945

4114 Bronze cast of bust 38.7
(15¼) high
Sir William Reid Dick, incised and
dated 1945
Purchased, 1959

3778 *See Groups:* Conversation
Piece at the Royal Lodge, Windsor,
1950, by Sir James Gunn

GEORGE of Denmark, Prince
(1653-1708)
Consort of Queen Anne

326 Canvas 124.5 x 101.6
(49 x 40)
After John Riley (1687?)
Purchased, 1871

Continued overleaf

4163 Canvas 125.7 x 102.9
(49½ x 40½)
By or after Michael Dahl, c.1705
Purchased, 1960

Piper

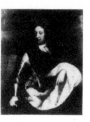

GEORGE Frederick William
Charles, 2nd Duke of Cambridge
See CAMBRIDGE

GERARD, Charles, 1st Earl of
Macclesfield
See MACCLESFIELD

GERARD, John (1545-1612)
Herbalist

1306 *See Unknown Sitters I*

GERMAIN, George Sackville,
1st Viscount Sackville
See SACKVILLE

GERMAN, Sir Edward (1862-1936)
Composer

3951 Lithograph 29.5 x 24.1
(11$\frac{5}{8}$ x 9½)
Flora Lion, inscribed on stone and
below plate, c.1912
Purchased, 1955

GIBBON, Edward (1737-94)
Historian; author of *Decline and
Fall of the Roman Empire*

1443 Canvas, oval 22.9 x 16.5
(9 x 6½)
Henry Walton, c.1773
Purchased, 1906

4854 Chalk 18.4 x 14.6 (7¼ x 5¾)
Unknown artist
Bequeathed by R.W.Ketton-Cremer,
1971

3317 Water-colour 15.2 x 11.4
(6 x 4½)
Unknown artist, inscribed,
posthumous
Purchased, before 1945

GIBBONS, Grinling (1648-1720)
Woodcarver and sculptor

2925 Canvas 123.2 x 99.1
(48½ x 39)
After Sir Godfrey Kneller (c.1690)
Purchased, 1937. *Beningbrough*

Piper

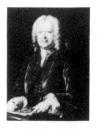

GIBBS, James (1682-1754)
Architect

1384 *See Groups:* A Conversation
of Virtuosis at the Kings Armes (A
Club of Artists), by Gawen Hamilton

504 Canvas 90.8 x 70.5
(35¾ x 27¾)
John Michael Williams, signed and
inscribed, c.1752(?)
Purchased, 1878. *Beningbrough*

Kerslake

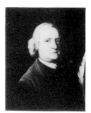

GIBBS, Joseph (1699-1788)
Organist and composer

2179 Canvas 60.6 x 50.2
(23$\frac{7}{8}$ x 19¾)
Thomas Gainsborough, inscribed,
c.1755
Purchased, 1928. *Beningbrough*

Kerslake

GIBSON, Edward (1668-1701)
Portrait draughtsman

1880 Chalk 27 x 19.4 (10$\frac{5}{8}$ x 7$\frac{5}{8}$)
Self-portrait, signed and dated
169(0?)
Given by Francis Wellesley, 1920.
Beningbrough

Piper

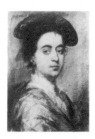

GIBSON, Edward, 1st Baron
Ashbourne *See* ASHBOURNE

GIBSON, Eliza (née Walker)
(d.1856) Daughter of Adam Walker

1106 *See Groups:* Adam Walker
and his family, by George Romney

GIBSON, John (1790-1866)
Sculptor

3944(32) Pencil 23.8 x 18.4
(9¾ x 7¼)
John Partridge, 1825
Purchased, 1955
See Collections: Artists, 1825, by
John Partridge and others,
3944(1-55)

2515(96) Black and red chalk
37.5 x 26.7 (14¾ x 10½)
William Brockedon, dated 1844
Lent by NG, 1959
See Collections: Drawings of
Prominent People, 1823-49, by
William Brockedon, **2515(1-104)**

232 Canvas 92.1 x 71.1
(36¼ x 28)
Margaret Sarah Carpenter, signed
and dated 1857
Purchased, 1867

1370 Pencil 30.5 x 21.6 (12 x 8½)
Unknown artist (formerly attributed
to Henry Hoppner Meyer), inscribed,
c. 1860
Purchased, 1904

1795 Marble bust 43.2 (17) high
William Theed, incised, c.1868
Given by Sir Thomas Devitt, Bt,
1917

Ormond

GIBSON, John (1799-1871)
Inspector for schools in Scotland

P6(42,154) *See Collections:* The
Hill and Adamson Albums, 1843-8,
by David Octavius Hill and Robert
Adamson, **P6(1-258)**

GIBSON, Richard (1615-90)
Miniature painter

1975 Canvas 125.7 x 101.6
(49½ x 40)
After Sir Peter Lely (1658)
Purchased, 1923

Piper

GIELGUD, Sir John (b.1904)
Actor and director

P60 Photograph: bromide print
60.3 x 48.6 (23¾ x 19⅛)
Angus McBean, 1959
Purchased, 1977
See Collections: Prominent people,
c.1946-64, by Angus McBean,
P56-67

GIFFARD, Hardinge Stanley, 1st
Earl of Halsbury *See* HALSBURY

GIFFORD, Robert Gifford, 1st
Baron (1779-1826) Judge

1695(e,i) *See Collections:* Sketches
for The Trial of Queen Caroline,
1820, by Sir George Hayter,
1695(a-x)

999 *See Groups:* The Trial of
Queen Caroline, 1820, by Sir
George Hayter

GIFFORD, William (1756-1826)
First editor of the *Quarterly
Review*

1017 Canvas 76.2 x 63.5 (30 x 25)
John Hoppner, replica
Given by Francis Turner Palgrave,
1895

GILBERT, Sir Alfred (1854-1934)
Sculptor

1865 Chalk 44.5 x 57.2
(17½ x 22½)
John McLure Hamilton, signed
and dated 1887
Given by the artist, 1920

4076 Pencil and chalk 38.1 x 27.9
(15 x 11)
Sir Bernard Partridge, signed and
inscribed
(*Punch* 8 May 1929)
Given by D.Pepys Whiteley, 1958
See Collections: Mr Punch's
Personalities, 1926-9, by Sir
Bernard Partridge, **3664-6**,etc

GILBERT, Ann *See* TAYLOR

GILBERT, Davies (1767-1839)
Scientist and antiquary; PRS

1075,1075a and **b** *See Groups:*
Men of Science Living in 1807-8,
by Sir John Gilbert and others

2515(88) Chalk 34.9 x 25.1
(13¾ x 9⅞)
William Brockedon, dated 1838
Lent by NG, 1959
See Collections: Drawings of
Prominent People, 1823-49, by
William Brockedon, **2515(1-104)**

GILBERT, Sir John (1817-97)
Painter and illustrator

3573 *See Collections:* Prominent
Men, c.1880-c.1910, by Harry
Furniss, **3337-3535** and **3554-3620**

GILBERT, Sir Joseph Henry
(1817-1901) Agricultural chemist

2472 Canvas 68.6 x 55.9 (27 x 22)
Josiah Gilbert (his brother), c.1840
Given by the sitter's nephew,
Charles Humphrey Gilbert, 1930

GILBERT, Mary Anne (née Hillier)
(1847-1936)

**P18(12,13,25,36,37,40,43-7,50,
52-5,61,62)** *See Collections:*
The Herschel Album, by Julia
Margaret Cameron, **P18(1-92b)**

GILBERT, Sir William Schwenk
(1836-1911) Poet, dramatist and
librettist of the 'Savoy' operas

2911 Canvas 100.3 x 125.7
(39½ x 49½)
Frank Holl, signed and dated
1886
Bequeathed by the sitter, 1937

3452,3453,3574 *See Collections:*
Prominent Men, c.1880-c.1910, by
Harry Furniss, **3337-3535** and
3554-3620

GILCHRIST, John Borthwick
(1759-1841) Orientalist

4064 Bronze medal 5.7
(2¼) diameter
Carl Friedrich Voigt, inscribed,
1841
Given by Sir Geoffrey Keynes,
1958

GILL, Eric (1882-1940)
Sculptor and typographer

4647 Pencil 38.7 x 28.6
(15¼ x 11¼)
Sir William Rothenstein, 1921
Given by the Rothenstein Memorial
Trust, 1968

4661 Pencil 28.3 x 24.1
(11⅛ x 9½)
Self-portrait, signed and dated 1927
Given by Prudence, Lady Maufe,
1969

3957 Pencil 31.1 x 23.8
(12¼ x 9⅜)
Desmond Chute, signed in
monogram, inscribed and dated
c.1938
Purchased, 1955

GILLRAY, James (1756-1815)
Caricaturist

83 Miniature on ivory 7.6 x 6.4
(3 x 2½) (oval mount)
Self-portrait, c.1800
Given by Charles Bagot, 1859

GILPIN, Sawrey (1733-1807)
Painter of horses

4328 Water-colour, oval
14 x 12.1 (5½ x 4¾)
William Sherlock
Given by A.A.Appleby, 1963

GILPIN, William (1724-1804)
Writer; exponent of 'the
picturesque'

4418 Panel, feigned oval
25.4 x 20.3 (10 x 8)
Henry Walton, signed and dated
1781
Purchased, 1964

GINNER, Charles (1878-1952)
Painter

4992 Pen, ink and water-colour
28.6 x 20.3 (11¼ x 8)
Self-portrait, signed, 1940s
Purchased, 1974

GIRDLESTONE, Gathorne Robert
(1881-1950) Orthopaedic surgeon

4801 Sanguine and white chalk
39.4 x 28.6 (15½ x 11¼)
Sir William Rothenstein
Purchased, 1970

GIRTIN, Thomas (1775-1802)
Water-colourist

882 Canvas 76.2 x 63.5 (30 x 25)
John Opie, c.1800
Purchased, 1891

GLADSTONE, Herbert Gladstone,
1st Viscount (1854-1930)
High Commissioner of Union of
South Africa

3288 Water-colour 29.8 x 18.1
(11¾ x 7⅛)
Sir Leslie Ward, signed *Spy*
(*VF* 6 May 1882)
Purchased, 1934

GLADSTONE, Colonel

1752 *See Groups:* The Siege of
Gibraltar, 1782, by George Carter

GLADSTONE, Catherine (née
Glynne) (d.1900)
Wife of William Ewart Gladstone

3845 *See Groups:* Dinner at
Haddo House, 1884, by Alfred
Edward Emslie

GLADSTONE, Helen (1849-1925)
Daughter of William Ewart
Gladstone; Vice-Principal of
Newnham College, Cambridge

3845 *See Groups:* Dinner at
Haddo House, 1884, by Alfred
Edward Emslie

GLADSTONE, Sir John
(1764-1851)
Merchant and politician

5042 Canvas 91.4 x 71.1
(36 x 28)
Thomas Gladstones (his nephew),
c. 1830
Given by the Royal Society of Arts,
1975

GLADSTONE, Sir Thomas, Bt
(1804-89)
MP for Portarlington

54 *See Groups:* The House of Com-
mons, 1833, by Sir George Hayter

GLADSTONE,William Ewart
(1809-98) Prime Minister

54 *See Groups:* The House of Commons, 1833, by Sir George Hayter

4034 Chalk 27.6 x 22.5
($10\frac{7}{8}$ x $8\frac{7}{8}$)
Heinrich Müller, signed and dated
1839
Purchased, 1957

1125,1125a *See Groups:* The
Coalition Ministry, 1854, by
Sir John Gilbert

1126 Panel 63.5 x 54.6 (25 x 21½)
George Frederic Watts, 1859
Given by the artist, 1898

5116 *See Groups:* Gladstone's
Cabinet of 1868, by Lowes Cato
Dickinson

1978 Water-colour 30.2 x 17.8
($11\frac{7}{8}$ x 7)
Carlo Pellegrini, signed *C Pellegrini*
and *Singe*
(*VF* 6 Feb 1869)
Given anonymously, 1923

3637 Canvas 125.7 x 91.4
(49½ x 36)
Sir John Everett Millais, signed in
monogram and dated 1879
Transferred from Tate Gallery,
1957

2167 Bronze bust 22.9 (9) high
Thomas Woolner, incised and dated
1882
Given by Alfred Jones, 1927

3845 *See Groups:* Dinner at
Haddo House, 1884, by Alfred
Edward Emslie

5256 *See Groups:* The Lobby of
the House of Commons, 1886, by
Liberio Prosperi

5057 Water-colour 32.4 x 19.7
(12¾ x 7¾)
Sir Leslie Ward, signed *Spy*
(*VF* 5 Nov 1887)
Purchased, 1975

1833 *See Groups:* Private View of
the Old Masters Exhibition, Royal
Academy, 1888, by Henry Jamyn
Brooks

3898 Canvas 48.3 x 38.1 (19 x 15)
Alfred Edward Emslie, signed,
inscribed and dated 1890
Given by the artist's daughter, Miss
Rosalie Emslie, 1954

2308-12, 2318,2319,2323-5
See Collections: Miscellaneous
drawings . . . by Sydney Prior
Hall, **2282-2348** and **2370-90**

2159 Millboard 26 x 19.1
(10¼ x 7½)
Prince Pierre Troubetskoy, signed,
inscribed and dated 1893
Purchased, 1927

3183 Pencil 35.6 x 25.4 (14 x 10)
George R.Halkett, signed, inscribed
and dated 1893
Given by the artist's widow, 1944

2819 Pen and ink 17.8 x 21.6
(7 x 8 ½)
Phil May, signed and dated 1893
Purchased, 1936

P54 Photograph: platinum print
31.1 x 24.1 (12¼ x 9½)
Eveleen Myers, 1890s
Purchased, 1977

3641 Canvas 62.2 x 48.9
(24½ x 19¼)
Sydney Prior Hall, signed
Given by wish of Mrs G.R.Rudolph,
1948

2227 Millboard 53.3 x 36.8
(21 x 14½)
Sydney Prior Hall, signed
Given by the artist's son, Harry
Reginald Holland Hall, 1928

3359-87, 3575 *See Collections:*
Prominent Men, c.1880-c.1910, by
Harry Furniss, **3337-3535** and
3554-3620

3319 Pencil 18.4 x 22.9 (7¼ x 9)
Sir William Blake Richmond, signed,
inscribed and dated May 21, 1898
Given by wish of H.A.Clifton Harris,
1947

GLADSTONE, William Henry
(1840-91) Politician; son of
William Ewart Gladstone

3289 Water-colour 32.1 x 18.4
(12⅝ x 7¼)
Sir Leslie Ward, signed *Spy*
(*VF* 11 Feb 1882)
Purchased, 1934

GLAISHER, James (1809-1903)
Astronomer and meteorologist

P120(53) Photograph: albumen
print, arched top 19.7 x 14.6
(7¾ x 5¾)
Maull & Polyblank, inscribed on
mount, 1855
Purchased, 1979
See Collections: Literary and
Scientific Men, 1855, by Maull &
Polyblank, **P120(1-54)**

GLANVILLE, Sir John (1586-1661)
Speaker of the Short Parliament

876 Canvas 124.5 x 99.1 (49 x 39)
Unknown artist, inscribed, and
falsely signed *C.Jansens*
Purchased, 1891

Piper

GLENESK, Algernon Borthwick,
1st Baron (1830-1908)
Newspaper proprietor

3454 *See Collections:* Prominent
Men, c.1880-c.1910, by Harry
Furniss, **3337-3535** and **3554-3620**

GLOUCESTER, Henry, Duke of
(1640-60) Third son of Charles I

1932 Canvas 104.8 x 85.7
(41¼ x 33¾)
After Johann Boeckhorst (c.1659)
Given by Viscount Dillon, 1922

Piper

GLOUCESTER, William, Duke of
(1689-1700) Son of Queen Anne

325 *See under* Queen Anne

5227 *See under* Queen Anne

5228 Canvas, oval 62.9 x 51.1
(24¾ x 20⅛)
Studio of Sir Godfrey Kneller
(c.1699)
Bequest of Mrs I.H.Wilson, 1978

Piper

GLOUCESTER, William Frederick,
2nd Duke of (1776-1834)
Field-Marshal

999 *See Groups:* The Trial of
Queen Caroline, 1820, by Sir
George Hayter

L167 *See under* Ernest Augustus,
Duke of Cumberland

GLOUCESTER, Prince William of
See WILLIAM

GLYN, Edward Carr (1844-1928)
Bishop of Peterborough

3845 *See Groups:* Dinner at
Haddo House, 1884, by Alfred
Edward Emslie

GLYN, Elinor (née Sutherland)
(1864-1943) Novelist

4283 Canvas 63.5 x 76.2 (25 x 30)
Arnold Mason, signed and dated
1942
Purchased, 1962

GLYN, Lady Mary (née Campbell)
(d.1947) Wife of Edward Carr Glyn

3845 *See Groups:* Dinner at
Haddo House, 1884, by Alfred
Edward Emslie

GLYNN, John (1722-79)
Politician and lawyer

1944 *See Groups:* John Glynn,
John Wilkes and John Horne Tooke,
by Richard Houston

GLYNNE, Sir Stephen, Bt
(1807-74) Antiquary

54 *See Groups:* The House of Com-
mons, 1833, by Sir George Hayter

GODFREY, Sir Edmund Berry
(1621-78) Magistrate

L126 Canvas, feigned oval
76.2 x 63.5 (30 x 25)
Unknown artist, inscribed,
c.1678
Lent by the City of Westminster,
1965

1101 Chalk, feigned oval
45.7 x 32.4 (18 x 12¾)
Unknown artist, inscribed,
c.1678
Purchased, 1897

Piper

GODOLPHIN, Sidney Godolphin,
1st Earl of (1645-1712) Financier

1800 Canvas, feigned oval
90.2 x 69.9 (35½ x 27½)
After Sir Godfrey Kneller (c.1705),
inscribed
Given by Baroness Lucas, 1917

Piper

GODOLPHIN, Francis Godolphin,
2nd Earl of (1678-1766)
Lord Privy Seal

3209 Canvas 90.8 x 70.5
(35¾ x 27¾)
Sir Godfrey Kneller, signed, c.1710
Kit-cat Club portrait
Given by NACF, 1945.
Beningbrough

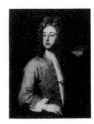

889 Canvas 76.2 x 62.9 (30 x 24¾)
Perhaps after Jean Baptiste van Loo
(c.1740)
Given by the Earl of Chichester,
1892

Piper

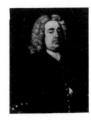

GODWIN, B.
Baptist preacher and slavery
abolitionist

599 *See Groups:* The Anti-Slavery
Society Convention, 1840, by
Benjamin Robert Haydon

GODWIN, Francis (1562-1633)
Bishop of Llandaff and Hereford

4371 Water-colour 17.8 x 13.7
(7 x 5⅜)
Unknown artist, after a portrait of
1613
Given by J.J.Byam Shaw, 1964

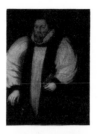

GODWIN, Mary (née
Wollstonecraft) (1759-97)
Writer and feminist; wife of
William Godwin

1237 Canvas 76.8 x 64.1
(30¼ x 25¼)
John Opie, c.1797
Bequeathed by Jane, Lady Shelley,
1899

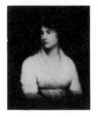

GODWIN, William (1756-1836)
Philosopher and novelist

1236 Canvas 74.9 x 62.2
(29½ x 24½)
James Northcote, 1802
Bequeathed by Jane, Lady Shelley,
1899

411 Canvas, feigned oval
69.9 x 63.2 (27½ x 24⅞)
Henry William Pickersgill, 1830
Purchased, 1875

2515(29) *See Collections:*
Drawings of Prominent People,
1823-49, by William Brockedon,
2515(1-104)

GOLDIE, Sir George Dashwood
Taubman (1846-1925)
Founder of Nigeria

2512 Canvas 140.3 x 109.9
(55¼ x 43¼)
Sir Hubert von Herkomer, signed
with initials and dated 1898
Given by the sitter's family, 1931

GOLDSMITH, Oliver (1728-74)
Writer

130 Canvas 73.7 x 62.2 (29 x 24½)
Studio of Sir Joshua Reynolds
(c.1770)
Purchased, 1861

828 Canvas 74.9 x 58.4
(29½ x 23)
After Sir Joshua Reynolds (c.1770)
Bequeathed by Dr Leifchild, 1890

676 Silhouette 11.4 x 8.9
(4½ x 3½)
Unknown artist
Given by Sir Theodore Martin,
1883

GOMM, Sir William Maynard
(1784-1875) Field-Marshal

3717 *See Collections:* Waterloo
Officers, 1834-40, by William
Salter, **3689-3769**

1071 Oil over a photograph
33 x 25.4 (13 x 10)
James Bowles, 1873-4
Given by Francis Carr-Gomm, 1896

Continued overleaf

2715 Water-colour 25.7 x 15.2
($10\frac{1}{8}$ x 6)
Sir Leslie Ward, signed *Spy*
(*VF* 30 Aug 1873)
Purchased, 1934

Ormond

GOOCH, Sir Daniel (1816-89)
Railway pioneer and inventor

5080 Canvas 142.2 x 111.8
(56 x 44)
Sir Francis Grant, dated 1872
Purchased, 1976

GOODALL, Frederick (1822-1904)
Painter

3257 Pen and ink 17.8 x 12.7
(7 x 5)
Joseph Barnard Davis, signed
Purchased, 1945

GOODENOUGH, Sir William
Edmund (1867-1945) Admiral

1913 *See Groups:* Naval Officers
of World War I, by Sir Arthur
Stockdale Cope

GOODFORD, Charles Old
(1812-84) Provost of Eton

2716 Water-colour 29.2 x 13.6
($11\frac{1}{2}$ x $5\frac{3}{8}$)
Sir Leslie Ward, signed *Spy*
(*VF* 22 Jan 1876)
Purchased, 1934

GOODMAN, Gabriel (1529?-1601)
Dean of Westminster

2414 12.4 x 10.5 ($4\frac{7}{8}$ x $4\frac{1}{8}$)
George Perfect Harding after
an unknown artist, signed
Purchased, 1929
See Collections: Copies of early
portraits, by George Perfect Harding
and Sylvester Harding, **1492**,
1492(a-c) and **2394-2419**

GOODRICKE, Elizabeth (née
Smith) (d.1692) Married first
3rd Viscount Fairfax of Emley,
and second Sir John Goodricke, Bt

754 *See under* 3rd Viscount
Fairfax of Emley

GOODRICKE, Sir Henry James,
Bt (d.1833) Hunting squire

4026(29) *See Collections:*
Drawings of Men about Town,
1832-48, by Alfred, Count D'Orsay,
4026(1-61)

GORDON, George Gordon, 5th
Duke of (1770-1836)
Raised the Gordon Highlanders

999 *See Groups:* The Trial of
Queen Caroline, 1820, by Sir
George Hayter

GORDON, Lord George (1751-93)
Agitator

4603 Glass intaglio 8.9 (3½) high
James Tassie, incised and dated 1781
Purchased, 1968

GORDON of Bavaglie
Queen Victoria's gillie

P22(10) *See Collections:* The
Balmoral Album, 1854-68, by
George Washington Wilson, W.& D.
Downey, and Henry John Whitlock,
P22(1-27)

GORDON, Sir Alexander
(1786-1815)
ADC to the Duke of Wellington

1801 Paste medallion 8.3 x 7
(3¼ x 2¾)
John Henning, incised and dated
1809
Given by Francis Wellesley,1917

GORDON, Charles George
(1833-85)
General; 'Chinese Gordon'

2575 Water-colour 30.2 x 17.8
(11⅞ x 7)
Carlo Pellegrini, signed *Ape*
(*VF* 19 Feb 1881)
Purchased, 1933

1479 Pencil 64.8 x 52.1
(25½ x 20½)
Edward Clifford, inscribed and
dated 1882
Given by the artist's brother, the
Bishop of Ludlow, 1907

864 Plaster cast of bust 73.7
(29) high
Sir Joseph Edgar Boehm, incised
Purchased, 1891

3576 *See Collections:* Prominent
Men, c.1880-c.1910, by Harry
Furniss, **3337-3535** and **3554-3620**

1772 Water-colour 59.7 x 49.5
(23½ x 19½)
Julia, Lady Abercromby,
posthumous
Given by wish of the artist, 1916

1474 *See Unknown Sitters IV*

GORDON, George, 9th Marquess
of Huntly *See* HUNTLY

GORDON, George Hamilton, 4th
Earl of Aberdeen *See* ABERDEEN

GORDON, John Campbell, 1st
Marquess of Aberdeen and Temair
See ABERDEEN AND TEMAIR

GORDON, Osborne (1813-83)
Divine; censor at Christ Church,
Oxford

P7(5) Photograph: albumen print
14 x 11.7 (5½ x 4⅝)
Charles Lutwidge Dodgson, c.1856
Purchased with help from Kodak
Ltd, 1973
See Collections: Lewis Carroll at
Christ Church, by Charles Lutwidge
Dodgson, **P7(1-37)**

GORDON, William (1784-1858)
MP for Aberdeenshire

54 *See Groups:* The House of Com-
mons, 1833, by Sir George Hayter

GORDON-CUMMING, Sir William,
Bt (1848-1930) Soldier

4631 Water-colour 30.5 x 17.8
(12 x 7)
Carlo Pellegrini, signed *Ape*
(*VF* 5 June 1880)
Purchased, 1968

GORDON-LENNOX, Charles
Henry, 6th Duke of Richmond and
1st Duke of Gordon
See RICHMOND

GORE, Charles (1853-1932)
Bishop

2611 Pencil 27.3 x 19.7
(10¾ x 7¾)
John Mansbridge, signed
Given by the sitter's brother, Sir
Francis Gore, 1933

GORE, Robert (1810-54)
Brother of 4th Earl of Arran; naval
captain and politician

4026(30,31) *See Collections:*
Drawings of Men about Town,
1832-48, by Alfred, Count D'Orsay,
4026(1-61)

GORE, Spencer Frederick
(1878-1914) Painter

3320 Canvas 43.2 x 34.9
(17 x 13¾)
Albert Rutherston, signed with
initials and dated 1902
Given by the Contemporary Art
Society, 1947

4981 Canvas 41 x 30.5 (16⅛ x 12)
Self-portrait, studio stamp, 1914
Purchased, 1974

GORING, George Goring, Baron
(1608-57) Royalist

762 *See under* Mountjoy Blount,
Earl of Newport

GORST, Sir John Eldon
(1835-1911) Solicitor-General

2839 *See Collections:* Caricatures
of Politicians, by Sir Francis
Carruthers Gould, **2826-74**

GOSCHEN, George Goschen,
1st Viscount (1831-1907)
Chancellor of the Exchequer

5116 *See Groups:* Gladstone's
Cabinet of 1868, by Lowes Cato
Dickinson

2307 *See Collections:*
Miscellaneous drawings . . . by
Sydney Prior Hall, **2282-2348** and
2370-90

3854 Ink, water-colour and wash
30.8 x 17.8 (12⅛ x 7)
Sir Max Beerbohm, signed *Max*, and
inscribed, c.1898
Purchased, 1953
See Collections: Caricatures,
1897-1932, by Sir Max Beerbohm,
3851-8

2838 *See Collections:* Caricatures
of Politicians, by Sir Francis
Carruthers Gould, **2826-74**

3577 *See Collections:* Prominent
Men, c.1880-c.1910, by Harry
Furniss, **3337-3535** and **3554-3620**

GOSFORD, Archibald Acheson,
2nd Earl of (1776-1849)

999 *See Groups:* The Trial of
Queen Caroline, 1820, by Sir
George Hayter

GOSS, Sir John (1800-80)
Composer

3019 Canvas 35.6 x 30.2
(14 x 11⅞)
Unknown artist, c.1835
Given by the sitter's great-grand-
daughter, Miss L.E.Speth, 1939

Ormond

GOSSE, Sir Edmund (1849-1928)
Poet and writer

2205 Canvas 54.6 x 44.5
(21½ x 17½)
John Singer Sargent, 1886
Given by Clement Valentine
Parsons, 1928

2359 Pencil 22.9 x 22.9 (9 x 9)
Sir William Rothenstein, signed and
dated 1928
Given by the artist, 1929

4529(141) *See Collections:*
Working drawings by Sir David
Low, **4529(1-401)**

GOSSE, Philip Henry (1810-88)
Zoologist

2367 Miniature on ivory 6.4 x 5.1
(2½ x 2)
William Gosse (his brother),
inscribed and dated 1839 on reverse
Given by the sitter's grandson,
Philip Gosse, 1929

P120(51) Photograph: albumen
print, arched top 19.7 x 14.6
(7¾ x 5¾)
Maull & Polyblank, inscribed on
mount, 1855
See Collections: Literary and
Scientific Men, 1855, by Maull &
Polyblank, **P120(1-54)**

GOSSETT, Ralph Allen
Deputy Serjeant-at-Arms at the
House of Commons

5256 *See Groups:* The Lobby of
the House of Commons, 1886, by
Liberio Prosperi

GOUGH, Hugh Gough, 1st Viscount
(1779-1869) Field-Marshal

1202 Plaster cast of bust 78.1
(30¾) high
George Gammon Adams, incised
and dated 1850
Purchased, 1899

805 Pen and ink 17.8 x 13.6
(7 x 5⅜)
Sir Francis Grant, c.1853
Given by 2nd Viscount Hardinge,
1888

Ormond

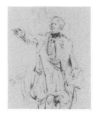

GOUGH, Sir Hubert (1870-1963)
General

4776 Chalk 31.1 x 25.4 (12¼ x 10)
Sir William Rothenstein, signed and
dated (twice) 1932
Purchased, 1970

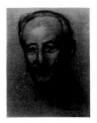

4477 Ciment fondu head 34.9
(13¾) high
Patricia Kahn, 1961-2
Purchased, 1966

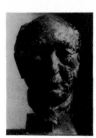

GOUGH-CALTHORPE, George,
3rd Baron Calthorpe
See CALTHORPE

GOULBURN, Henry (1784-1856)
MP for Cambridge University

54 *See Groups:* The House of Com-
mons, 1833, by Sir George Hayter

GOULD, Sir Francis Carruthers
(1844-1925)
Cartoonist and journalist

3278 Water-colour 36.5 x 20.6
($14\frac{3}{8}$ x $8\frac{1}{8}$)
Liberio Prosperi, signed *Lib*
(*VF* 22 Feb 1890)
Purchased, 1934

3315 Chalk 25.4 x 18.1 (10 x $7\frac{1}{8}$)
Edmond Xavier Kapp, signed,
inscribed and dated 1919
Purchased, 1946

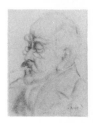

GOULD, William Frederick (b.1861)
Son of William Gould

P18(14,39-41,50, 55,60,81,92b)
See Collections: The Herschel
Album, by Julia Margaret Cameron,
P18(1-92b)

GOUPY, Joseph (d.1763)
Water-colourist

1384 *See Groups:* A Conversation
of Virtuosis at the Kings Armes
(A Club of Artists), by Gawen
Hamilton

GOVAN, William (1804-75)
Free Church missionary

P6(62) *See Collections:* The Hill
and Adamson Albums, 1843-8, by
David Octavius Hill and Robert
Adamson, **P6(1-258)**

GOW, Tammie

P22(20) *See Collections:* The
Balmoral Album, 1854-68, by
George Washington Wilson, W. & D.
Downey, and Henry John Whitlock,
P22(1-27)

GOWER, Lord Ronald Sutherland
(1845-1916)
Dilettante, sculptor and writer

4841 Canvas 61 x 50.8 (24 x 20)
Henry Scott Tuke, signed, inscribed
and dated 1897
Purchased, 1971

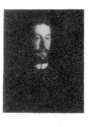

GOWING, Lawrence (b.1918)
Painter and art historian

5266 Canvas 76.2 x 63.5 (30 x 25)
Rodrigo Moynihan, signed and
dated 1979
Purchased, 1979

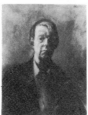

GRACE, William Gilbert
(1848-1915) Cricketer

2112 Canvas 90.2 x 69.9
(35½ x 27½)
Unknown artist
Given by MCC and other cricket
clubs, 1926

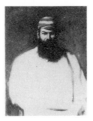

GRAFTON, Henry Fitzroy, 1st
Duke of (1663-90) Sailor and
soldier; son of Charles II

2915 Chalk 26.7 x 20.6 (10½ x 8⅛)
After Sir Peter Lely(?) (c.1678)
Purchased, 1937

Piper

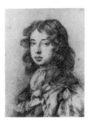

GRAFTON, Charles Fitzroy,
2nd Duke of (1683-1757)
Lord Chamberlain

3210 Canvas 91.4 x 71.1
(36 x 28)
Sir Godfrey Kneller, signed, c.1705
Kit-cat Club portrait
Given by NACF, 1945

Piper

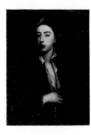

723 Canvas 151.8 x 125.1
(59¾ x 49¼)
Attributed to William Hoare
Given by Sir Richard Wallace,
Bt, 1884

Kerslake

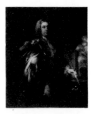

GRAFTON, Augustus Henry
Fitzroy, 3rd Duke of (1735-1811)
Statesman

4899 Canvas, feigned oval
76.2 x 61 (30 x 24)
Pompeo Batoni, 1762
Purchased, 1972. *Beningbrough*

GRAFTON, George Henry Fitzroy,
4th Duke of (1760-1844)
Politician

999 *See Groups:* The Trial of
Queen Caroline, 1820, by Sir
George Hayter

GRAHAM, Douglas, 5th Duke of
Montrose *See* MONTROSE

GRAHAM, James, 1st Marquess
of Montrose *See* MONTROSE

GRAHAM, Sir James, Bt
(1792-1861)
First Lord of the Admiralty

54 *See Groups:* The House of Com-
mons, 1833, by Sir George Hayter

342, 343 *See Groups:* The Fine
Arts Commissioners, 1846, by John
Partridge

1125, 1125a *See Groups:* The
Coalition Ministry, 1854, by Sir
John Gilbert

GRAHAM, Sir James Robert
George, Bt (1792-1861)
MP for Cumberland East

54 *See Groups:* The House of Commons, 1833, by Sir George Hayter

GRAHAM, Robert Bontine
Cunninghame (1852-1936)
Traveller and writer

3444 *See Collections:* Prominent
Men, c.1880-c.1910, by Harry
Furniss, **3337-3535** and **3554-3620**

4846 Pencil 56.2 x 33.4
($22\frac{1}{8}$ x $13\frac{1}{8}$)
George Washington Lambert,
stamped and certified
Acquired, 1971

2212 Chalk, oval 32.7 x 25.1
($12\frac{7}{8}$ x $9\frac{7}{8}$)
Theodore Blake Wirgman, signed
and dated 1918, autographed by
sitter
Given by Lady Gosse and family,
1928

4220 Bronze head 36.8 (14½) high
Sir Jacob Epstein, 1923
Purchased, 1961

4626 Canvas 129.5 x 97.8
(51 x 38½)
James McBey, signed and dated 1934
Given by the artist's widow, 1968

GRAHAM, Sir Sandford, Bt
(1788-1852) FSA

316a(58) *See Collections:*
Preliminary drawings for busts and
statues by Sir Francis Chantrey,
316a(1-202)

GRAHAM, Thomas (1805-69)
Chemist

2164 Canvas 81.3 x 67.6
(32 x $26\frac{5}{8}$)
Wilhelm Trautschold
Purchased, 1927

P120(54) Photograph: albumen
print, arched top 19.7 x 14.6
(7¾ x 5¾)
Maull & Polyblank, inscribed on
mount, 1855
Purchased, 1979
See Collections: Literary and
Scientific Men, 1855, by Maull &
Polyblank, **P120(1-54)**

P106(9) *See Collections:* Literary
and Scientific Portrait Club, by
Maull & Polyblank, **P106(1-20)**

Ormond

GRAHAM, Thomas, Baron
Lynedoch *See* LYNEDOCH

GRAHAM, William (1838-c.1900)
Counsel for *The Times* at the
Parnell Commission

2294 *See Collections:*
Miscellaneous drawings . . . by
Sydney Prior Hall, **2282-2348**
and **2370-90**

GRAIN, Richard Corney (1844-95)
Entertainer and song writer

3455 *See Collections:* Prominent
Men, c.1880-c.1910, by Harry
Furniss, **3337-3535** and **3554-3620**

GRAINGER, Percy (1882-1961)
Composer

3137a *See under* Henry Tonks

GRAMMONT, Elizabeth
(Hamilton), Countess of
(1641-1708) Courtier;
'La Belle Hamilton'

20 Canvas, oval 76.2 x 62.2
(30 x 24½)
John Giles Eccardt after Sir Peter
Lely (c.1663)
Purchased, 1957

509 *See Unknown Sitters II*

Piper

GRANBY, John Manners, Marquess
of (1721-70) Commander-in-Chief
of the British Army

1186 Chalk 53 x 38.7 (20 $\frac{7}{8}$ x 15¼)
After Sir Joshua Reynolds (c.1759)
Purchased, 1899

Kerslake

GRANGER, James (1723-76)
Biographer and print collector

2961 Copper 15.9 x 14 (6¼ x 5½)
John Cornish, 1765
Given by Henry T.Lunn, 1938

GRANT, Mrs
Mother of John Grant

P22(19) *See Collections:* The
Balmoral Album, 1854-68, by
George Washington Wilson, W.& D.
Downey, & Henry John Whitlock,
P22(1-27)

GRANT, Sir Archibald, Bt
(1696-1778)
MP for Aberdeenshire

926 *See Groups:* The Committy
of the House of Commons (the
Gaols Committee) by William
Hogarth

GRANT, Colquhoun (1780-1829)
Lieutenant-Colonel

5261 Pencil 10.8 x 10.5 (4¼ x 4$\frac{1}{8}$)
George Jones, inscribed
Purchased, 1979

GRANT, Duncan (1885-1978)
Artist

5131 Canvas 54.3 x 41.9
(21$\frac{3}{8}$ x 16½)
Self-portrait, c.1909
Purchased, 1977

GRANT, Sir Francis (1803-78)
Portrait painter and PRA

1286 Canvas 75.9 x 63.1
(29$\frac{7}{8}$ x 24$\frac{7}{8}$)
Self-portrait, c.1845
Given by his daughter, Miss
Elizabeth Catherine Grant, 1901

P6(25) Photograph: calotype
20 x 14.3 (7$\frac{7}{8}$ x 5$\frac{5}{8}$)
David Octavius Hill and Robert
Adamson, September 1845
Given by an anonymous donor,
1973
See Collections: The Hill and
Adamson Albums, 1843-8, by
David Octavius Hill and Robert
Adamson, **P6(1-258)**

1088 Plaster cast of bust 67.3
(26½) high
Mary Grant (his niece), incised and
dated 1866
Purchased, 1897

5239 Canvas 71.1 x 92.1
(28 x 36¼)
John Ballantyne, signed and dated
1866
Purchased, 1979

2521 With Sir Edwin Landseer
(right)
Pencil 18.4 x 14.9 (7¼ x 5$\frac{7}{8}$)
Charles Bell Birch, inscribed,
c.1870
Given by the artist's nephew,
George von Pirch, 1931

Ormond

GRANT, James (d.1852)
Colonel

3718 *See Collections:* Studies
for The Waterloo Banquet at
Apsley House, 1836, by William
Salter, **3689-3769**

GRANT, Sir James Hope (1808-75)
General; brother of Sir Francis
Grant

783 Canvas 213.6 x 134
(84⅛ x 52¾)
Sir Francis Grant, c.1861(?)
Purchased, 1888

Ormond

GRANT, John
Queen Victoria's head forester

P22(12,13) *See Collections:* The
Balmoral Album, 1854-68, by
George Washington Wilson, W.& D.
Downey, and Henry John Whitlock,
P22(1-27)

GRANT, Sir John Peter (1807-93)
Governor of Jamaica

1127 Canvas 66 x 53.6 (26 x 21⅛)
George Frederic Watts, after 1873
Given by the artist, 1898

Ormond

GRANT, Sir Patrick (1804-95)
Field-Marshal

4251 Water-colour 24.1 x 18.1
(9½ x 7⅛)
Captain Martin, inscribed, c.1856-61
Purchased, 1962

1454 Canvas 43.2 x 30.8
(17 x 12⅛)
E.J.Turner after photograph by
Maull & Fox (after 1883)
Given by the sitter's family, 1907

Ormond

GRANT, Sir Robert (1779-1838)
Governor of Bombay

54 *See Groups:* The House of Com-
mons, 1833, by Sir George Hayter

GRANT, Sir William (1752-1832)
Master of the Rolls

671 Canvas 237.5 x 146.1
(93½ x 57½)
Sir Thomas Lawrence, 1817
Given by the Master of the Rolls,
1883

GRANTHAM, Thomas Robinson,
1st Baron (1695-1770) Diplomat

1586 Chalk 45.7 x 34.6 (18 x 13⅝)
Unknown artist
Given by Alfred Jones, 1910

Kerslake

GRANVILLE, John Carteret, 2nd
Earl (1690-1763)
Secretary of State

1778 Canvas 125.7 x 101
(49½ x 39¾)
Studio of William Hoare, c.1750-2
Purchased, 1916

Kerslake

GRANVILLE, Granville Leveson-
Gower, 1st Earl (1773-1846)
Diplomat

2662(20) *See Collections:* Book
of sketches, mainly for The Trial of
Queen Caroline, 1820, by Sir George
Hayter, **2662(1-38)**

999 *See Groups:* The Trial of
Queen Caroline, 1820, by Sir
George Hayter

GRANVILLE, Granville Leveson-
Gower, 2nd Earl (1815-91)
Secretary of State for the Colonies

1125, 1125a *See Groups:* The
Coalition Ministry, 1854, by Sir
John Gilbert

Continued overleaf

5116 *See Groups:* Gladstone's Cabinet of 1868, by Lowes Cato Dickinson

4900 Chalk 56.9 x 44.5 (22⅜ x 17½)
George Richmond, 1876
Purchased, 1972

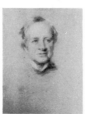

3809 Pencil 19.1 x 12.1 (7½ x 4¾)
Frederick Sargent, signed by artist and sitter
Purchased, 1951

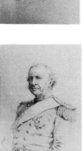

GRANVILLE-BARKER, Harley (1877-1946) Actor, producer, dramatist and critic

4178 Chalk 61.6 x 47.6 (24¼ x 18¾)
John Singer Sargent, signed and dated 1900
Given by wish of George Bernard Shaw, 1960

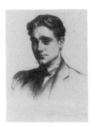

3842 Canvas 103.8 x 106.4 (40⅞ x 41⅞)
Jacques-Emile Blanche, signed and dated 1930
Given by Constant Huntington, 1952

GRATTAN, Henry (1746-1820)
Irish statesman

790 Panel 28.6 x 24.4 (11¼ x 9⅝)
Francis Wheatley, eng 1782
Given by the executors of Doyne Courtenay Bell, 1888

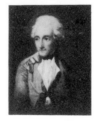

1341 Plaster cast of bust 55.9 (22) high
Peter Turnerelli, incised and dated 1812
Given by William Edward Hartpole Lecky, 1903

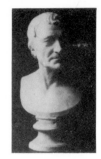

GRAVES, Algernon (1845-1922)
Art historian

1937 Plaster cast of bust 67.3 (26½) high
Alexander Zeitlin, incised and dated 1901
Bequeathed by the sitter, 1922

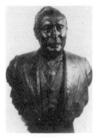

GRAVES, Henry (1806-92)
Printseller and publisher

1774b Chalk 61.6 x 49.2 (24¼ x 19⅜)
Frederick Sandys
Given by the sitter's son, Algernon Graves, 1916

Ormond

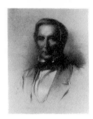

GRAVES, Robert (b.1895)
Poet and writer

4683 Canvas 61 x 50.8 (24 x 20)
John Aldridge, signed and dated 1968
Purchased, 1969

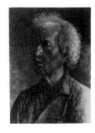

GRAY, Andrew (1805-61)
Presbyterian minister

P6(85) *See Collections:* The Hill and Adamson Albums, 1843-8, by David Octavius Hill and Robert Adamson, **P6(1-258)**

GRAY, John (1866-1934)
Roman Catholic priest, poet and
writer

3844 Lithograph 25.4 x 21
(10 x 8¼)
Raymond Savage, signed and
inscribed
Given by Sir John Rothenstein,
1952

GRAY, John Edward (1800-75)
Naturalist

P120(52) Photograph: albumen
print, arched top 19.7 x 14.6
(7¾ x 5¾)
Maull & Polyblank, inscribed on
mount, 1855
Purchased, 1979
See Collections: Literary and
Scientific Men, 1855, by Maull &
Polyblank, **P120(1-54)**

GRAY, Thomas (1716-71)
Classical scholar and poet

989 Canvas 40.3 x 32.7
(15⅞ x 12⅞)
John Giles Eccardt, 1747-8
Purchased, 1895

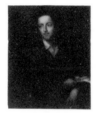

425 Pencil 26 x 20.3 (10¼ x 8)
James Basire after William Mason
(c.1771), signed
Purchased, 1876

781 Plaster bust 54.6 (21½) high
Unknown artist, posthumous
Given by Joshua W.Butterworth,
1888

Kerslake

GREAVES, Walter (1846-1930)
Painter

3179 Pencil 36.8 x 29.8
(14½ x 11¾)
Sir William Rothenstein, 1915
Given by the artist, 1944

4394 Pen and ink 35.6 x 25.4
(14 x 10)
Powys Evans, signed and inscribed,
pub 1928
Purchased, 1964

GREEN, Sir William, Bt
(1725-1811) General

1752 *See Groups:* The Siege of
Gibraltar, 1782, by George Carter

GREEN, Charles (1785-1870)
Balloonist

2557 Panel 35.9 x 28.9
(14⅛ x 11⅜)
Hilaire Ledru, signed, inscribed
and dated 1835
Purchased, 1932

4710 *See Groups:* A Consultation
prior to the Aerial Voyage to
Weilburg, 1836, by John Hollins

Ormond

GREEN, Mary Ann Everett (née
Wood) (1818-95) Historian

1438 Chalk 36.8 x 26.7
(14½ x 10½)
George Pycock Green (her husband)
Given by the sitter's daughter, Mrs
James Gow, 1906

GREEN, Valentine (1739-1813)
Mezzotint engraver

1260 Canvas 74.9 x 62.2
(29½ x 24½)
Lemuel Francis Abbott, eng 1788
Purchased, 1900

GREENE, Graham (b.1904)
Novelist

4529(147) Pencil 22.9 x 14
(9 x 5½)
Sir David Low
Purchased, 1967
See Collections: Working drawings
by Sir David Low, **4529(1-401)**

Continued overleaf

4529(145, 146, 148-51)
See Collections: Working drawings
by Sir David Low, **4529(1-401)**

GREENE, Sir Hugh Carleton
(b.1910)
Director of the BBC; writer

4529(142-4) *See Collections:*
Working drawings by Sir David
Low, **4529(1-401)**

GREENE, Maurice (1695-1755)
Composer

2106 With John Hoadly (right)
Canvas 69.9 x 90.2 (27½ x 35½)
Francis Hayman, signed, inscribed
and dated 1747
Purchased, 1925

2085 *See Unknown Sitters III*

Kerslake

GREENE, Thomas (1794-1872)
MP for Lancaster

54 *See Groups:* The House of Com-
mons, 1833, by Sir George Hayter

GREENWOOD, Arthur (1880-1954)
Politician

P16 *See Collections:* Prominent
men, c.1938-43, by Felix H. Man,
P10-17

GREENWOOD, Frederick
(1830-1909) Journalist

2714 Water-colour 30.5 x 17.8
(12 x 7)
Carlo Pellegrini, signed *Ape*
(*VF* 18 June 1880)
Purchased, 1934

GREGORY, Edward John
(1850-1909) Painter

2621 Water-colour 35.6 x 35.6
(14 x 14)
Self-portrait, signed, inscribed and
dated 1879
Given by Harold Hartley, 1933

GREGORY, Isabella Augusta, Lady
(1852-1932) Playwright

4676 *See Groups:* Lady Gregory,
Sir Hugh Lane, J.M.Synge and
W.B.Yeats, by Sir William Orpen

3950 Lithograph 35.6 x 26
(14 x 10¼)
Flora Lion, signed on stone,
inscribed, 1913
Purchased, 1955

GREGORY, Sir Richard Arman
(1864-1952) Scientific writer
and journalist

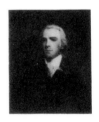

5117 Canvas 76.8 x 63.8
(30¼ x 25$\frac{1}{8}$)
Henry Raeburn Dobson, signed,
1929
Given by the sitter's granddaughter,
Mrs J.S.Knight, 1977

GREIFFENHAGEN, Maurice
William (1862-1931)
Painter and illustrator

4405 *See Groups:* Primrose Hill
School, 1893, by unknown artist

GRENVILLE, William Wyndham
Grenville, 1st Baron (1759-1834)
Prime Minister

318 Canvas 76.8 x 63.5
(30¼ x 25)
John Hoppner, c.1800
Purchased, 1871

999 *See Groups:* The Trial of
Queen Caroline, 1820, by Sir
George Hayter

GRENVILLE, George Nugent-
Temple-, 1st Marquess of
Buckingham *See* BUCKINGHAM

GRENVILLE, Sir Richard
(1541?-91) Naval commander

1612 Canvas 106 x 73.3
(41¾ x 28⅞)
Unknown artist, after a portrait
of 1571, inscribed
Purchased, 1911. *Montacute*

Strong

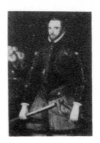

GRENVILLE, Richard, 1st Duke of
Buckingham and Chandos
See BUCKINGHAM AND
CHANDOS

GRENVILLE, Richard, 2nd Duke
of Buckingham and Chandos
See BUCKINGHAM AND
CHANDOS

GRENVILLE, Richard. 3rd Duke
of Buckingham and Chandos
See BUCKINGHAM AND
CHANDOS

GRENVILLE, Thomas (1755-1846)
Book collector and diplomat

517 Miniature on ivory, oval
12.7 x 7.6 (5 x 3)
Camille Manzini, signed and dated
1841
Purchased, 1879

GRENVILLE-TEMPLE, Richard,
2nd Earl Temple *See* TEMPLE

GRESHAM, Sir Thomas (1519?-79)
Founder of the Royal Exchange

352 Panel 100.3 x 72.4
(39½ x 28½)
Unknown Flemish artist, inscribed,
c.1565
Purchased, 1872

Strong

GRESSE, John Alexander
(1741-94) Painter and royal
drawing-master

4196 Chalk 28.3 x 21.9 (11⅛ x 8⅝)
Unknown artist, inscribed, c.1770
Given by E.Daly Lewis, 1947

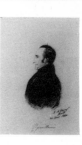

GREVILLE, Algernon Greville,
2nd Baron (1841-1910)
Landowner and politician

2576 Water-colour 29.8 x 18.7
(11¾ x 7⅜)
Sir Leslie Ward, signed *Spy*
(*VF* 31 Dec 1881)
Purchased, 1933

GREVILLE, Charles Cavendish
Fulke (1794-1864)
Diarist; clerk to the council

3773 Red and black chalk and
pencil 27.9 x 20.6 (11 x 8⅛)
Alfred, Count D'Orsay, signed and
dated 1840, autographed by sitter
Purchased, 1950

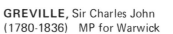

GREVILLE, Sir Charles John
(1780-1836) MP for Warwick

54 *See Groups:* The House of Commons, 1833, by Sir George Hayter

GREVILLE, Henry Richard, 3rd
Earl of Warwick *See* WARWICK

GREVILLE, Robert Kaye
(1794-1866) Botanist

599 *See Groups:* The Anti-Slavery
Society Convention, 1840, by
Benjamin Robert Haydon

GRÉVY, Jules (1807-91)
President of the French Republic

4707(11) *See Collections: Vanity
Fair* cartoons, 1869-1910, by
various artists, **2566-2606,** etc

GREY, Charles Grey, 2nd Earl
(1764-1845) Prime Minister

999 *See Groups:* The Trial of
Queen Caroline, 1820, by Sir
George Hayter

4137 Canvas 127.6 x 101
(50¼ x 39¾)
Attributed to Thomas Phillips,
c.1820
Purchased, 1960

1190 Canvas 76.2 x 62.9
(30 x 24¾)
After Sir Thomas Lawrence (c.1828)
Purchased, 1899

316a(59) Pencil 43.2 x 31.1
(17 x 12¼)
Sir Francis Chantrey, inscribed,
after 1830
Given by Mrs George Jones, 1871
See Collections: Preliminary
drawings for busts and statues by
Sir Francis Chantrey, **316a(1-202)**

54 *See Groups:* The House of Com-
mons, 1833, by Sir George Hayter

3784 Pencil 53 x 42.2 (20⅞ x 16⅝)
Benjamin Robert Haydon, inscribed
and dated 1834
Given by A.T.Playfair, 1951

Ormond

GREY, Henry George Grey, 3rd
Earl (1802-94)
Secretary for the Colonies

54 *See Groups:* The House of Com-
mons, 1833, by Sir George Hayter

GREY of Fallodon, Edward Grey,
1st Viscount (1862-1933)
Foreign Secretary and President of
the League of Nations

3388,3578 *See Collections:*
Prominent Men, c.1880-c.1910, by
Harry Furniss, **3337-3535** and
3554-3620

3869 Sanguine and white chalk
33.7 x 23.2 (13¼ x 9⅛)
Sir William Rothenstein, signed
with initials, inscribed and dated
1920
Given by the Rothenstein Memorial
Trust, 1953

3545 (study for *Groups,* **2463**)
Canvas 85.1 x 72.4 (33½ x 28½)
Sir James Guthrie
Bequeathed by Sir Frederick
C.Gardiner, 1947

2463 *See Groups:* Statesmen of
World War I, by Sir James Guthrie

3120 Canvas 130.8 x 105.4
(51½ x 41½)
Harold Speed, signed
Purchased, 1942

GREY, Charles (1804-70) General

P22(24) *See Collections:* The
Balmoral Album, 1854-68, by
George Washington Wilson, W.& D.
Downey, and Henry John Whitlock,
P22(1-27)

GREY, Sir George, Bt (1799-1882)
Home Secretary

1125,1125a *See Groups:* The
Coalition Ministry, 1854, by Sir
John Gilbert

GREY, Sir George (1812-98)
Colonial governor

1290 Canvas 88.9 x 73.7 (35 x 29)
Sir Hubert von Herkomer, signed
with initials and dated 1901
Given by a Memorial Committee,
1901

GREY, Henry, 1st Duke of Kent
See KENT

GREY, Lady Jane *See* DUDLEY

GRIERSON, Master

P6(179) *See Collections:* The Hill and Adamson Albums, 1843-8, by David Octavius Hill and Robert Adamson, **P6(1-258)**

GRIERSON, The Misses

P6(168,173) *See Collections:* The Hill and Adamson Albums, 1843-8, by David Octavius Hill and Robert Adamson, **P6(1-258)**

GRIEVE, Christopher Murray ('Hugh MacDiarmid') (1892-1978)
Poet

5230 Bronze cast of head 33.7 (13¼) high
Alan Thornhill, incised and dated 1974
Purchased, 1978

GRIEVE, Thomas (1799-1882) or William (1800-44)
Scene-painters

4026(32) Pencil and black chalk 27.6 x 20.6 (10⅞ x 8⅛)
Alfred, Count D'Orsay, signed, inscribed and dated 1836
Purchased, 1957
See Collections: Drawings of Men about Town, 1832-48, by Alfred, Count D'Orsay, **4026(1-61)**

GRIFFITH, Elizabeth (1720?-93)
Playwright and novelist

4905 *See Groups:* The Nine Living Muses of Great Britain, by Richard Samuel

GRIMALDI, Joseph (1778-1837)
Entertainer

827 Canvas 74.9 x 62.2 (29½ x 24½)
John Cawse, 1807
Purchased, 1889

GRIMALDI, William (1751-1830)
Miniature painter

3114 Pen and pencil 23.2 x 31.8 (9⅛ x 12½)
Mary Grimaldi after Louisa Edmeads (his daughter), inscribed
Purchased, 1941

GRIMOND, Joseph (Jo) (b.1913)
Liberal politician

4529(152-5) *See Collections:* Working drawings by Sir David Low, **4529(1-401)**

GRIMSTON, Sir Harbottle, Bt (1603-85)
Speaker of the House of Commons

381 Canvas 125.1 x 101.6 (49¼ x 40)
Unknown artist, c.1660-70
Given by the Earl of Verulam, 1873

Piper

GRIMSTON, James Walter, 1st Earl of Verulam *See* VERULAM

GRIMSTON, James Walter, 2nd Earl of Verulam *See* VERULAM

GRONOW, Rees Howell (1794-1865) MP for Stafford

54 *See Groups:* The House of Commons, 1833, by Sir George Hayter

GROSSMITH, George (1847-1912)
Entertainer

3456,3457 *See Collections:* Prominent Men, c.1880-c.1910, by Harry Furniss, **3337-3535** and **3554-3620**

GROSSMITH, George (1874-1935)
Actor, manager and playwright

5224(7) *See Collections:* Cartoons, c.1928-c.1936, by Robert Stewart Sherriffs, **5224(1-9)**

GROSSMITH, Weedon (d.1919)
Actor, artist and writer

3458 *See Collections:* Prominent
Men, c.1880-c.1910, by Harry
Furniss, **3337-3535** and **3554-3620**

GROSVENOR, Cyrus Pitt
American slavery abolitionist

599 *See Groups:* The Anti-Slavery
Society Convention, 1840, by
Benjamin Robert Haydon

GROSVENOR, Robert, 1st Baron
Ebury *See* EBURY

GROSVENOR, Robert, 1st
Marquess of Westminster
See WESTMINSTER

GROSVENOR, Thomas
(1764-1851) Field-Marshal

3982 Panel 26.7 x 20 (10½ x 7⅞)
Unknown artist, c.1820
Purchased, 1956

GROTE, George (1794-1871)
Historian

365 Canvas 90.8 x 71.1
(35¾ x 28)
Thomas Stewardson, 1824
Given by the sitter's widow, 1873

54 *See Groups:* The House of Com-
mons, 1833, by Sir George Hayter

GROVE, Major

1752 *See Groups:* The Siege of
Gibraltar, 1782, by George Carter

GROVE, Sir Coleridge (1839-1920)
Major-General

2420 Canvas 29.2 x 21.6
(11½ x 8½)
Fred Roe, signed
Given by Reginald Grundy, 1921

GROVE, Sir William Robert
(1811-96) Scientist and judge

2717 Water-colour 26 x 17.8
(10¼ x 7)
Sir Leslie Ward, signed *Spy*
(*VF* 8 Oct 1887)
Purchased, 1934

1478 Canvas 61 x 50.8 (24 x 20)
Helen Donald-Smith, posthumous
Given by the sitter's son, Sir
Coleridge Grove, 1907

GROVES, Sarah (1772-1865)

P18(33) *See Collections:* The
Herschel Album, by Julia Margaret
Cameron, **P18(1-92b)**

GUEDALLA, Philip (1889-1944)
Historian and essayist

4802 (With drawing of head on
reverse)
Chalk 39.4 x 31.1 (15½ x 12¼)
Sir William Rothenstein, signed
with initials
Purchased, 1970

GUEST, Sir Josiah John, Bt
(1785-1852) Ironmaster

54 *See Groups:* The House of Com-
mons, 1833, by Sir George Hayter

GUICCIOLI, Countess Teresa
(1801-73) Byron's mistress

2515(61) *See Collections:*
Drawings of Prominent People,
1823-49, by William Brockedon,
2515(1-104)

GUILFORD, Frederick North, 2nd
Earl of (1732-92) Prime Minister

3627 Canvas 125.1 x 100.3
(49¼ x 39½)
Nathaniel Dance, eng 1775
Purchased, 1948

276 Pastel, oval 24.8 x 19.1
(9¾ x 7½)
After Nathaniel Dance
Purchased, 1869

GUILFORD, Francis North, 1st
Baron (1637-85) Lord Chancellor

632 Line engraving, feigned oval
37.1 x 27.3 (14⅝ x 10¾)
David Loggan, signed and inscribed
on plate
Given by the Society of Judges and
Serjeants-at-Law, 1877

4708 Canvas 127 x 101.6 (50 x 40)
Attributed to John Riley
Purchased, 1970

GUINNESS, Sir Alec (b.1914)
Actor

4529(156-60) *See Collections:*
Working drawings by Sir David
Low, **4529(1-401)**

GULL, Sir William Withey, Bt
(1816-90) Physician

2909 Pencil 34.3 x 24.1
(13½ x 9½)
Carlo Pellegrini, signed *C Pellegrini*
and *Ape,* inscribed
(study for *VF* 18 Dec 1875)
Purchased, 1937

GULLY, John (1783-1863)
Prize-fighter and race-horse owner

4817 Board 43.2 x 34.9
(17 x 13¾)
Samuel Drummond, 1805-8
Lent by the sitter's great-great-
great-grandson, Brian Belk, 1970

54 *See Groups:* The House of Com-
mons, 1833, by Sir George Hayter

GUMPEL, Charles Godfrey
Creator of 'Mephisto', a chess-
playing automaton

3060 *See Groups:* Chess players,
by A.Rosenbaum

GUNN, George (d.1859)
Factor to the Duke of Sutherland

P6(44,78) *See Collections:* The
Hill and Adamson Albums, 1843-8,
by David Octavius Hill and Robert
Adamson, **P6(1-258)**

GUNNING, Elizabeth, Duchess
of Hamilton and of Argyll
See HAMILTON AND OF ARGYLL

GUNTHER, Albert (1830-1914)
Zoologist

4965 Water-colour 22.9 x 21.3
(9 x 8⅜)
Lucy Gee, 1900
Purchased, 1973

GURNEY, Sir John (1768-1845)
Judge

4166 *See Groups:* Charles James
Blomfield, Cardinal Manning and
Sir John Gurney, by George
Richmond

GURNEY, Samuel (1786-1856)
'The Banker's Banker';
philanthropist

599 *See Groups:* The Anti-Slavery
Society Convention, 1840, by
Benjamin Robert Haydon

GURNEY, William Brodie
(1777-1855) Shorthand writer
and philanthropist

999 *See Groups:* The Trial of
Queen Caroline, 1820, by Sir
George Hayter

GURWOOD, John (1790-1845)
Colonel; editor of the 'Wellington Despatches'

3719 *See Collections:* Studies for The Waterloo Banquet at Apsley House, 1836, by William Salter, **3689-3769**

GUTHRIE, George James (1785-1856) Surgeon

932 Miniature on ivory 9.8 x 7.6 ($3\frac{7}{8}$ x 3)
Reginald Easton
Given by the sitter's daughter, Miss Guthrie, 1892

Ormond

GUTHRIE, Thomas (1803-73)
Preacher and philanthropist; author of *Plea for Ragged Schools*

P6(29) Photograph: calotype 20 x 14.6 ($7\frac{7}{8}$ x 5¾)
David Octavius Hill and Robert Adamson, 1843-8
Given by an anonymous donor, 1973
See Collections: The Hill and Adamson Albums, 1843-8, by David Octavius Hill and Robert Adamson, **P6(1-258)**

P6(105) *See Collections:* The Hill and Adamson Albums, 1843-8, by David Octavius Hill and Robert Adamson, **P6(1-258)**

GUTHRIE, Thomas Anstey (1856-1934)
'F.Anstey'; author of *Vice Versa*

4507 Chalk 42.5 x 32.4 (16¾ x 12¾)
Laura Anning-Bell, signed
Bequeathed by the sitter's nephew, Eric Millar, 1966

GWYDYR, Peter Robert Drummond-Burrell, 2nd Baron (1782-1865)
Lord High Chamberlain

999 *See Groups:* The Trial of Queen Caroline, 1820, by Sir George Hayter

GWYN, Nell (1650-87)
Mistress of Charles II

3976 Canvas 127 x 101.6 (50 x 40)
Studio of Sir Peter Lely, c.1675
Purchased, 1956

3811 Line engraving 34.9 x 25.4 (13¾ x 10)
Gerard Valck after Sir Peter Lely
Purchased, 1950

2496 *See Unknown Sitters II*

Piper

GWYNN, John (1713-86)
Architect

1437 *See Groups:* The Academicians of the Royal Academy, 1771-2, by John Sanders after Johan Zoffany

4680 Canvas 91.4 x 74.3 (36 x 29¼)
Unknown artist
Purchased, 1969

GWYNN, Mary (née Horneck) (1754/5-1840)
Goldsmith's 'Jessamy Bride'

3152 Miniature on ivory, oval 6.4 x 4.8 (2½ x $1\frac{7}{8}$)
Henry Edridge
Purchased, 1943

GWYNN, Stephen Lucius (1864-1950)
Writer and Irish nationalist

4777 Chalk 35.3 x 25.2 ($13\frac{7}{8}$ x $9\frac{7}{8}$)
Sir William Rothenstein, signed and dated 1915
Purchased, 1970

HACKER, Arthur (1858-1919)
Painter

4389 (study for *Groups,* **4404**)
Pencil and chalk 22.9 x 19.4
(9 x 7⅞)
Sydney Prior Hall, signed with
initials
Purchased. 1964

4404 *See Groups*: The St John's
Wood Arts Club, 1895, by Sydney
Prior Hall

HADEN, Sir Francis Seymour
(1818-1910) Surgeon and engraver

1826 Canvas 74.3 x 50.2
(29¼ x 19¾)
George Percy Jacomb-Hood, signed
G.P. JACOMB-HOOD and in
monogram, inscribed, and dated
1892
Purchased, 1918

3870 Pencil 34.9 x 28.2
(13¾ x 11⅛)
Sir William Rothenstein, 1897
Given by the Rothenstein Memorial
Trust, 1953

HAGGARD, Sir Henry Rider
(1856-1925) Novelist

2350 Canvas 90.2 x 59.7
(35½ x 23½)
Leon Little, signed, and inscribed
and dated 1886 on reverse
Given by Lady Gosse and family,
1928

2801 Canvas 76.2 x 63.5 (30 x 25)
John Pettie, signed and dated 1889
Given by the sitter's widow, 1936

3459-61 *See Collections*:
Prominent Men, c.1880-c.1910, by
Harry Furniss, **3337-3535** and
3554-3620

HAIG, Douglas Haig, 1st Earl
(1861-1928) Field-Marshal

1801A Water-colour 28.6 x 22.5
(11¼ x 8⅞)
Mrs Graham Smith, inscribed and
dated 1894
Given by John Lane, 1917

2908(17) *See Collections*: Studies,
mainly for General Officers of
World War I, by John Singer
Sargent, **2908(1-18)**

1954 *See Groups:* General
Officers of World War I, by John
Singer Sargent

HAILEY, William Malcolm Hailey,
1st Baron (1872-1969)
Colonial administrator and writer

4529 (**161, 161a** and **b, 162**)
See Collections: Working drawings
by Sir David Low, **4529(1-401)**

HALDANE, Richard Burdon
Haldane, Viscount (1856-1928)
Statesman and philosopher

5125 Water-colour 40 x 18.4
(13⅜ x 7¼)
Sir Leslie Ward, signed *Spy*
(*VF* 13 Feb 1896)
Purchased, 1977

3855 Ink and wash 30.8 x 19.7
(12⅛ x 7¾)
Sir Max Beerbohm, pub 1912
Purchased, 1953
See Collections: Caricatures,
1897-1932, by Sir Max Beerbohm,
3851-8

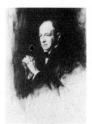

2364 Millboard 97.2 x 73
(38¼ x 28¾)
Philip de Laszlo, signed and dated
1928
Purchased, 1929

Continued overleaf

2840 *See Collections*: Caricatures of Politicians, by Sir Francis Carruthers Gould, **2826-74**

HALDANE, George (1722-59) Brigadier-General
4855(60) *See Collections*: The Townshend Album, **4855(1-73)**

HALDIMAND, Sir Frederick (1718-91) Governor and Commander-in-Chief of Canada

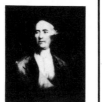

4974 Canvas 76.2 x 63.5 (30 x 25) Studio of Sir Joshua Reynolds, c.1778
Purchased, 1972

HALE, Sir Matthew (1609-76) Lord Chief Justice

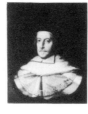

465 Canvas, feigned oval 73.7 x 61 (29 x 24)
After John Michael Wright (c.1670), inscribed
Given by the Society of Judges and Serjeants-at-Law, 1877

Piper

HALES, Stephen (1677-1761) Physiologist and inventor

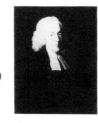

1861 Canvas, feigned oval 76.5 x 63.5 (30$\frac{1}{8}$ x 25)
Studio(?) of Thomas Hudson, c.1759
Purchased, 1920

Kerslake

HALE-WHITE, Sir William (1857-1949) Physician

L168(4) *See Collections*: Prominent men, 1895-1930, by Sir William Rothenstein, **L168(1-11)**

HALFORD, Sir Henry, Bt (1766-1844) Physician

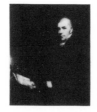

1068 Panel 106 x 89.5 (41¾ x 35¼)
Sir William Beechey, signed in monogram, inscribed, 1809
Given by the sitter's nephew, Edward Thomas Vaughan, 1896

HALIFAX, Charles Montagu, 1st Earl of (1661-1715) Financier

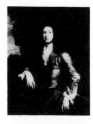

800 Canvas 125.1 x 100.3 (49¼ x 39½)
Sir Godfrey Kneller, c.1690-5
Purchased, 1888. *Beningbrough*

3211 Canvas 91.4 x 71.1 (36 x 28)
Sir Godfrey Kneller, signed in monogram, c.1703-10
Kit-cat Club portrait
Given by NACF, 1945

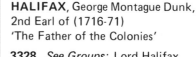

Piper

HALIFAX, George Montague Dunk, 2nd Earl of (1716-71)
'The Father of the Colonies'

3328 *See Groups*: Lord Halifax and his secretaries, attributed to Daniel Gardner, after Hugh Douglas Hamilton

HALIFAX, Edward Wood, 1st Earl of (1881-1959) Viceroy of India

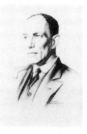

4214 Chalk 42.5 x 28.2 (16¾ x 11$\frac{1}{8}$)
Stanley Anderson, signed and dated 1932
Given by the Contemporary Portraits Fund, 1961

HALIFAX, George Savile, Marquess of (1633-95) Political philosopher

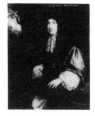

2962 Canvas 124.5 x 100.3 (49 x 39½)
Attributed to Mary Beale, inscribed
Purchased, 1938

Piper

HALIFAX, Charles Wood, 1st Viscount (1800-85)
Chancellor of the Exchequer

54 *See Groups*: The House of Commons, 1833, by Sir George Hayter

1125, 1125a *See Groups*: The Coalition Ministry, 1854, by Sir John Gilbert

1677 Canvas 91.4 x 70.2
(36 x 27⅝)
Anthony de Brie after George
Richmond (1873)
Given by the sitter's son, the 2nd
Viscount Halifax, 1912

Ormond

HALIFAX, Charles Lindley Wood,
2nd Viscount (1839-1934)
President of English Church Union;
supporter of reunion of Anglicans
and Roman Catholics

2376 *See Collections*:
Miscellaneous drawings . . . by
Sydney Prior Hall, **2282-2348** and
2370-90

HALKETT, Sir Colin (1774-1856)
General

3720 *See Collections*: Studies for
The Waterloo Banquet at Apsley
House, 1836, by William Salter,
3689-3769

HALL, Basil (1788-1844)
Naval captain

316a(62) Pencil 49.8 x 33.7
(19⅝ x 13¼)
Sir Francis Chantrey, inscribed
Given by Mrs George Jones, 1871
See Collections: Preliminary
drawings for busts and statues by
Sir Francis Chantrey, **316a(1-202)**

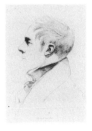

HALL, Sir Edward Marshall
(1858-1929) Advocate

3462 *See Collections:* Prominent
Men, c.1880-c.1910, by Harry
Furniss, **3337-3535** and **3554-3620**

HALL, John (1738-97)
Engraver

3992 Pastel, feigned oval
57.2 x 44.5 (22½ x 17½)
Attributed to William Lawranson,
c.1777
Given by the sitter's great-great-
granddaughter, Miss Margaret
J.M. Grubbe (afterwards Mrs
Hubbard), 1956

693 Canvas 90.2 x 70.2
(35½ x 27⅝)
Gilbert Stuart, 1785
Transferred from Tate Gallery, 1957

HALL, Margaret (née Hunter)
(d.1876) Wife of Basil Hall

316a(63) *See Collections*:
Preliminary drawings for busts and
statues by Sir Francis Chantrey,
316a(1-202)

HALL, Marguerite Radclyffe
(c.1886-1943) Novelist

4347 Canvas 91.4 x 71.1 (36 x 28)
Charles Buchel, signed and dated
1918
Bequeathed by Una, Lady
Troubridge, 1963

HALL, Sir Peter (b.1930)
Director of plays, films and operas

4529(163, 164) *See Collections*:
Working drawings by Sir David Low,
4529(1-401)

HALL, Robert (1764-1831)
Baptist divine

5066 Wax medallion 11.1 (4⅜)
diameter, *sight*
Thomas R. Poole, incised and dated
1814
Purchased, 1976

HALL, Sydney Prior (1842-1922)
Portrait painter

4405 *See Groups*: Primrose Hill
School, 1893, by an unknown artist

HALLAM, Henry (1777-1859)
Historian

2810 Chalk 22.5 x 17.1 (8⅞ x 6¾)
Attributed to Gilbert Stuart
Newton, inscribed
Purchased, 1936

Continued overleaf

5139 Chalk 61 x 43.8 (24 x 17¼) *sight*
George Richmond, signed and dated 1843
Purchased, 1977

342, 343 *See Groups*: The Fine Arts Commissioners, 1846, by John Partridge

3119 Wax relief, oval 19.7 x 14.6 (7¾ x 5¾)
Richard Cockle Lucas, incised and dated 1851
Purchased, 1942

1608 Bronze medal 6.4 (2½) diameter
Leonard Charles Wyon, inscribed, c.1859
Given by Miss J.B. Horner, 1911

Ormond

HALLÉ, Sir Charles (1819-95)
Conductor and founder of the Hallé Orchestra

1004 Canvas 74.3 x 48.9 (29¼ x 19¼)
George Frederic Watts, c.1870
Given by the artist, 1895

HALLEY, Edmund (1656-1742)
Astronomer

4393 Canvas, feigned oval 74.9 x 62.2 (29½ x 24½)
Richard Phillips, inscribed, 1721 or before
Purchased, 1964

Kerslake

HALLIWELL-PHILLIPPS, James Orchard (1820-89)
Biographer of Shakespeare

3859 Silhouette 28.6 x 15.9 (11¼ x 6¼)
Unknown artist, inscribed and dated on reverse 1839
Given by Iolo A. Williams, 1953

HALLOWELL, Sir Benjamin
See CAREW, Sir Benjamin Hallowell

HALLYBURTON, Lord Douglas Gordon (1777-1841)
MP for Forfarshire

54 *See Groups*: The House of Commons, 1833, by Sir George Hayter

HALSBURY, Hardinge Stanley Giffard, 1st Earl of (1823-1921)
Lord Chancellor

3290 Water-colour 30.5 x 18.4 (12 x 7¼)
Sir Leslie Ward, signed *Spy*
(*VF* 22 June 1878)
Purchased, 1934

4547 Ink 21.6 x 14 (8½ x 5½) irregular
Joseph Simpson, signed and inscribed
Purchased, 1967

2336 *See Collections*: Miscellaneous drawings. . . by Sydney Prior Hall, **2282-2348** and **2370-90**

3393, 3394 *See Collections*: Prominent Men, c.1880-c.1910, by Harry Furniss, **3337-3535** and **3554-3620**

HAMILTON, William Hamilton, 2nd Duke of (1616-51) Royalist

2120 Canvas 127 x 101 (50 x 39¾)
After Adriaen Hanneman (1650)
Purchased, 1926

Piper

HAMILTON, Alexander Hamilton, 10th Duke of (1767-1852)
Diplomat

999 *See Groups*: The Trial of Queen Caroline, 1820, by Sir George Hayter

HAMILTON, Lady Anne (1766-1846)
Lady-in-waiting to Queen Caroline

999 *See Groups*: The Trial of Queen Caroline, 1820, by Sir George Hayter

HAMILTON, Anthony (1646?-1719) Writer and soldier

1467 Canvas, oval 73.7 x 62.2 (29 x 24½)
Unknown artist (copy)
Purchased, 1907

Piper

HAMILTON, Charles
Suggested painting the House of Commons to Hayter

54 *See Groups*:The House of Commons, 1833, by Sir George Hayter

HAMILTON, Emma, Lady (1765-1815)
Mistress of Lord Nelson

294 Canvas 73.7 x 59.7 (29 x 23½)
George Romney, c.1785
Purchased, 1870

4448 Canvas 62.2 x 54.6 (24½ x 21½)
George Romney, c.1785
Purchased with help from NACF, 1965

2941 Pencil and water-colour 22.2 x 14 (8¾ x 5½)
Richard Cosway, c.1800
Bequeathed by H.W. Murray, 1938

HAMILTON, Gavin (1730-97)
Painter and excavator

3089(7) Pencil 25.4 x 20 (10 x 7$\frac{7}{8}$)
William Daniell after George Dance, inscribed
Purchased, 1940
See Collections: Tracings of drawings by George Dance, **3089(1-12)**

HAMILTON, Gawen (1697?-1737)
Portrait painter

1384 *See Groups*: A Conversation of Virtuosis at the Kings Armes (A Club of Artists), by Gawen Hamilton

HAMILTON, Sir George, Count (d.1679) Soldier

1468 Canvas, oval 73 x 62.2 (28¾ x 24½)
Unknown artist (copy)
Purchased, 1907

Piper

HAMILTON, Sir Ian (1853-1947)
General

4039(3) Water-colour and pencil 29.5 x 24.8 (11$\frac{5}{8}$ x 9¾)
Inglis Sheldon-Williams, signed and dated by artist and sitter, 1900
Purchased, 1957
See Collections: Boer War Officers, 1900, by Inglis Sheldon-Williams, **4039(1-7)**

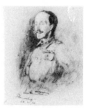

Continued overleaf

4609 Water-colour 36.8 x 26.7
(14½ x 10½)
Sir Leslie Ward, signed *Spy*
(*VF* 2 May 1901)
Purchased, 1968

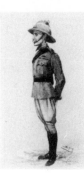

3871 Pencil 36.5 x 26.3
(14⅜ x 10⅜)
Sir William Rothenstein, signed
with initials and dated 1916
Given by the Rothenstein Memorial
Trust, 1953

HAMILTON, Dr (?James Hamilton,
1814-67)

P120(47) *See Collections*:
Literary and Scientific Men, 1855,
by Maull & Polyblank, **P120(1-54)**

HAMILTON, James, 1st Duke of
Abercorn *See* ABERCORN

HAMILTON, John (1799-1851)

P6(104, 105) *See Collections*:
The Hill and Adamson Albums,
1843-8, by David Octavius Hill and
Robert Adamson, **P6(1-258)**

HAMILTON, John Andrew,
Viscount Sumner *See* SUMNER

HAMILTON, Richard (b.1922)
Painter
5278 Screen/collotype 54.6 x 49.8
(21½ x 19⅝)
Self-portrait, signed, inscribed and
numbered 133/140 below plate,
1970
Purchased, 1979

5279 Aquatint 34 x 26.7
(13⅜ x 10½)
David Hockney, inscribed and
dated on plate 1971, and signed,
dated 1971, and numbered 30/30
below plate
Purchased, 1979

HAMILTON, Sir William
(1730-1803)
Diplomat and archaeologist
589 Canvas 226 x 180.3 (89 x 71)
David Allan, signed, inscribed and
dated 1775
Transferred from BM, 1879

680 Canvas 255.3 x 175.2
(100½ x 69)
Studio of Sir Joshua Reynolds, 1777
Transferred from Tate Gallery,
1957

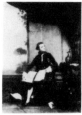

HAMILTON, William Alexander
Baillie (1803-81) Admiral

908 (study for *Groups*, **1208**)
Millboard 38.7 x 32.4 (15¼ x 12¾)
Stephen Pearce, inscribed, 1850
See Collections: Arctic Explorers,
1850-86, by Stephen Pearce,
905-24 and **1209-27**

1208 *See Groups*: The Arctic
Council, 1851, by Stephen Pearce

Ormond

HAMILTON AND OF ARGYLL,
Elizabeth (Gunning), Duchess of
(1734-90) Famous beauty

4890 Pastel 59.1 x 43.8
(23¼ x 17¼)
Francis Cotes, signed and dated
1751
Purchased, 1972

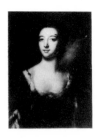

HAMILTON-GORDON, Caroline
(née Herschel), Lady (1830-1909)
A lady of the Queen's Bedchamber

P18(64) *See Collections*: The
Herschel Album, by Julia Margaret
Cameron, **P18(1-92b)**

HAMMOND, John Lawrence Le
Breton (1872-1949)
Journalist and historian

4778 Chalk 39.4 x 19.1
(15½ x 7½)
Sir William Rothenstein, 1923
Purchased, 1970

HAMPDEN, Thomas Hampden,
2nd Viscount (1746-1824)

999 *See Groups*: The Trial of
Queen Caroline, 1820, by Sir
George Hayter

HAMPDEN, John (1594-1643)
Politician
146, 1600 *See Unknown Sitters II*

Piper

HAMPDEN, John, the Younger
(1656-96) Politician

3057 Canvas, oval 72.4 x 61.4
(28½ x 24¼)
Unknown artist, inscribed, falsely
signed *G. Kneller*, c.1690
Purchased, 1939

Piper

HAMPTON, John Somerset
Pakington, 1st Baron (1799-1880)
Politician

4893 *See Groups*: The Derby
Cabinet of 1867, by Henry Gales

2628 Water-colour 29.8 x 18.4
(11¾ x 7¼)
Alfred Thompson, inscribed
(*VF* 12 Feb 1870)
Purchased, 1933

Ormond

HANBURY, Robert William
(1845-1903) President of the
Board of Agriculture

2327 *See Collections*:
Miscellaneous drawing . . . by
Sydney Prior Hall, **2282-2348** and
2370-90

HANDCOCK, Richard, 4th Baron
Castlemaine *See* CASTLEMAINE

HANDEL, George Frederick
(1685-1759) Composer

1976 Canvas, feigned oval
74.9 x 62.6 (29½ x 24⅝)
Attributed to Balthasar Denner,
1726-8
Given by Arthur F. Hill, 1923.
Beningbrough

2152 Canvas, feigned oval
19.4 x 16.8 (7⅝ x 6⅝)
Francis Kyte, signed and dated
1742
Bequeathed by William Barclay
Squire, 1927

3970 Canvas 238.8 x 146.1
(94 x 57½)
Thomas Hudson, signed and dated
1756
Purchased with help from the
Handel Appeal Fund and a
Government Grant, 1968

8 Canvas 124.2 x 101.3
(48⅞ x 39⅞)
After Thomas Hudson (1756)
Purchased, 1857

Continued overleaf

2151 Panel 27.9 x 21.6 (11 x 8½)
Unknown artist
Bequeathed by William Barclay
Squire, 1927

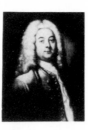

878 Terracotta bust 43.8 (17¼)
high
Unknown artist
Given by W.H. Withall, 1891

Kerslake

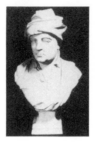

HANKEY, Maurice Hankey,
1st Baron (1877-1963) Statesman

4650 Canvas 91.4 x 76.2 (36 x 30)
Sir William Orpen, signed and
dated 1919
Given by wish of Viscount
Wakefield, 1968

HANKEY, J.A. (?John Alexander
Hankey, d.1882)

P120(34) *See Collections*:
Literary and Scientific Men, 1955,
by Maull & Polyblank, **P120(1-54)**

HANLEY, James (b. 1901)
Novelist

5231 Canvas 48.3 x 38.1 (19 x 15)
Sydney Earnshaw Greenwood,
signed, 1930s
Purchased, 1978

HANMER, John Hanmer, 1st Baron
(1809-81) Poet

54 *See Groups*:The House of Com-
mons, 1833, by Sir George Hayter

1834(n) Pencil 19.4 x 12.7
($7\frac{5}{8}$ x 5)
Frederick Sargent, signed by artist
and sitter
Given by A.C.R. Carter, 1919
See Collections: Members of the
House of Lords, c.1870-80, by
Frederick Sargent, **1834(a-z** and
aa-hh)

Ormond

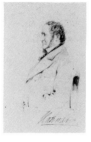

HANNEN, James Hannen, Baron
(1821-94) Judge

2232 *See Collections*: The Parnell
Commission, 1888-9, by Sydney
Prior Hall, **2229-72**

2296, 2305 *See Collections*:
Miscellaneous drawings . . . by
Sydney Prior Hall, **2282-2348** and
2370-90

HANOTAUX, Albert Auguste
Gabriel (1853-1944)
French historian and politician

4707(12) *See Collections*: *Vanity
Fair* cartoons, 1869-1910, by
various artists, **2566-2606**, etc

HANSARD, Mr

5256 *See Groups*: The Lobby of
the House of Commons, 1886, by
Liberio Prosperi

HANWAY, Jonas (1712-86)
Philanthropist

4301 Canvas 76.2 x 63.5 (30 x 25)
James Northcote, c.1785
Bequeathed by Sir Orme Sargent,
1963. *Beningbrough*

Kerslake

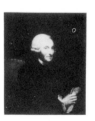

HARCOURT, William Harcourt,
3rd Earl (1743-1830)
Field-Marshal

999 *See Groups*: The Trial of
Queen Caroline, 1820, by Sir
George Hayter

HARCOURT, Lewis Harcourt,
1st Viscount (1863-1922)
Politician

3389 *See Collections*: Prominent
Men, c.1880-c.1910, by Harry
Furniss, **3337-3535** and **3554-3620**

HARCOURT, Edward (1757-1847)
Archbishop of York

1695(t) *See Collections*: Sketches
for The Trial of Queen Caroline,
1820, by Sir George Hayter,
1695(a-x)

999 *See Groups*: The Trial of
Queen Caroline, 1820, by Sir
George Hayter

HARCOURT, Lady Elizabeth
(née Bingham) (d.1838) Wife of
G.G. Harcourt, MP for Nuneham
Courtenay

883(12) *See Collections*: Studies
for miniatures by Sir George Hayter,
883(1-21)

HARCOURT, George (1868-1947)
Portrait and figure painter

3045 Pencil 37.8 x 31.1
$(14\frac{7}{8} \times 12\frac{1}{4})$
Self-portrait, signed and dated 1896
Given by Marion Harry Spielmann,
1939

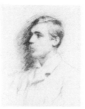

HARCOURT, George Granville
(1785-1861) MP for Oxfordshire

54 *See Groups*:The House of Com-
mons, 1833, by Sir George Hayter

HARCOURT, Sir William
(1827-1904) Statesman

5256 *See Groups*: The Lobby of
the House of Commons, 1886, by
Liberio Prosperi

2307, 2315, 2317 *See Collections*:
Miscellaneous drawings . . . by
Sydney Prior Hall, **2282-2348** and
2370-90

1461 Plaster cast of bust 101.6
(40) high
Waldo Story, 1899
Given by the artist, 1907

2844 Pen and ink 18.4 x 14
$(7\frac{1}{4} \times 5\frac{1}{2})$
Sir Francis Carruthers Gould,
signed with initials and inscribed
Purchased 1936
See Collections: Caricatures of
Politicians, by Sir Francis
Carruthers Gould, **2826-74**

2841-3, 2845 *See Collections*:
Caricatures of Politicians, by Sir
Francis Carruthers Gould, **2826-74**

3390-2 *See Collections*:
Prominent Men, c.1880-c.1910 by
Harry Furniss, **3337-3535** and
3554-3620

HARDEN, John (1772-1847)
Painter

P6(71) *See Collections*: The
Hill and Adamson Albums, 1943-8,
by David Octavius Hill and Robert
Adamson, **P6(1-258)**

HARDIE, James Keir (1856-1915)
Socialist leader

2542 Pencil 20.3 x 15.2 (8 x 6)
Cosmo Rowe after photograph by
George Charles Beresford (1905)
signed
Given by Mrs Walter Coates, 1932

4456 Water-colour 36.8 x 26.7
(14½ x 10½)
Sir Leslie Ward, signed *Spy*,
inscribed
(*VF* 8 Feb 1906)
Given by Francis Johnson, 1965

Continued overleaf

3979 Water-colour 37.1 x 26.7
(14⅝ x 10½)
Sylvia Pankhurst, before 1910
1910
Given by the artist, 1956

3978 Chalk 57.8 x 42.5
(22¾ x 16¾)
Sylvia Pankhurst, signed in
monogram, c.1910
Given by the artist, 1956

2846 *See Collections*: Caricatures
of Politicians, by Sir Francis
Carruthers Gould, **2826-74**

3579 *See Collections*: Prominent
Men, c.1880-c.1910, by Harry
Furniss, **3337-3535** and **3554-3620**

HARDING, George Perfect
(1781-1853)
Portrait painter, copyist and
antiquary

4615 Miniature on card, oval
8.3 x 7 (3¼ x 2¾)
Self-portrait, inscribed and dated
1804 on reverse
Purchased, 1968

HARDING, James Duffield
(1798-1863)
Landscape artist and lithographer

3125 Water-colour and pencil
38.4 x 28.2 (15⅛ x 11⅛)
Laurence Theweneti, inscribed
and dated 1825
Purchased, 1942

1781 Canvas 75.6 x 63.2
(29¾ x 24⅞)
Henry Perronet Briggs, c.1840
Given by the sitter's grandchildren,
1916

Ormond

HARDING, Mary Ann
Wife of George Perfect Harding

4615a Miniature on card, oval
7.9 x 6.4 (3⅛ x 2½)
Sylvester Harding, inscribed and
dated 1803 on reverse
Purchased, 1968

HARDINGE of Lahore, Henry
Hardinge, 1st Viscount (1785-1856)
Governor-General of India

54 *See Groups*:The House of Com-
mons, 1833, by Sir George Hayter

3721 *See Collections*: Studies for
The Waterloo Banquet at Apsley
House, 1836, by William Salter,
3689-3769

1207a Plaster cast of medallion,
oval 54 x 47 (21¼ x 18½)
George Gammon Adams, incised
and dated 1845
Purchased, 1899

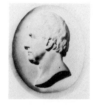

508 (study for portrait of 1849)
Millboard 26.x7 x 21.6 (10½ x 8½)
Sir Francis Grant, c.1849
Given by the 2nd Viscount
Hardinge, 1878

437 Canvas 127.3 x 101.6
(50⅛ x 40)
Sir Francis Grant, replica (1849)
Given by the artist, 1876

Ormond

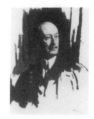

HARDINGE of Penshurst, Charles
Hardinge, 1st Baron (1858-1944)
Diplomat and Viceroy of India

4179 Canvas 63.5 x 50.8 (25 x 20)
Sir William Orpen, signed and dated
1919
Given by wish of Viscount
Wakefield, 1960

HARDINGE, Sir Richard, Bt
(1756-1826)

3089(8) *See Collections*: Tracings
of drawings by George Dance,
3089(1-12)

HARDWICKE, Philip Yorke,
1st Earl of (1690-1764)
Lord Chancellor

798 *See Groups*: The Court of
Chancery, by Benjamin Ferrers

872 Canvas 125.7 x 100.3
(49½ x 39½)
Studio of (?) Michael Dahl
Purchased, 1891

466 Water-colour 26.7 x 21.6
(10½ x 8½)
William Nelson Gardiner after
William Hoare, c.1800 (1763)
Given by the Society of Judges and
Serjeants-at-Law, 1877.
Beningbrough

Kerslake

HARDWICKE, Charles Philip
Yorke, 4th Earl of (1799-1873)
Admiral

54 *See Groups*: The House of Com-
mons, 1833, by Sir George Hayter

HARDWICKE, Charles Philip
Yorke, 5th Earl of (1836-97)
Sportsman

4717 Water-colour 29.8 x 17.8
(11¾ x 7)
Carlo Pellegrini, signed *Ape*
(*VF* 9 May 1873)
Purchased, 1970

1834(o) Pencil 20.6 x 12.7
(8⅛ x 5)
Frederick Sargent, signed and dated
1876, autographed by sitter
Given by A.C.R. Carter, 1919
See Collections: Members of the
House of Lords, c.1870-80, by
Frederick Sargent, **1834(a-z** and
aa-hh)

HARDY, John (1773-1855)
MP for Bradford

54 *See Groups*: The House of Com-
mons, 1833, by Sir George Hayter

HARDY, Thomas (1840-1928)
Novelist and poet

2929 Panel 43.2 x 38.1 (17 x 15)
William Strang, signed and dated
1893
Bequeathed by the sitter's widow,
1938

3463, 3464, 3580-3 *See
Collections*: Prominent Men,
c.1880-c.1910, by Harry Furniss,
3337-3535 and **3554-3620**

2156 Bronze head 34.9 (13¾)
high
Sir William Hamo Thornycroft,
incised and dated 1917
Given by the artist's widow, 1927

1922 Pencil 33 x 25.4 (13 x 10)
William Strang, signed and dated
1919, autographed by sitter
Given, through NACF, by the Earl
of Crawford and Balcarres, 1928

2050 *See Collections*: Medallions
of Writers, c.1922, by Theodore
Spicer-Simson, **2043-55**

Continued overleaf

2181 Canvas, oval, 74.9 x 62.2
(29½ x 24½)
Walter William Ouless, signed and
dated 1922
Bequeathed by the sitter, 1928

2498 Canvas 50.8 x 40.6 (20 x 16)
Reginald Grenville Eves, signed and
dated 1923
Purchased, 1931

HARE, Sir John (1844-1921)
Actor-manager

4095(5) Pen and ink 39.4 x 31.4
(15½ x 12⅜)
Harry Furniss, signed with initials
Purchased, 1959
See Collections: The Garrick
Gallery of Caricatures, by Harry
Furniss, **4095(1-11)**

HARE, Thomas (1806-91)
Political reformer

1819 Canvas, feigned oval
79.4 x 62.2 (31¼ x 24½)
Lowes Cato Dickinson, signed in
monogram and dated 1867
Given by the sitter's daughter,
Mrs Alice Westlake, 1918

1820 Pencil 44.5 x 31.8
(17½ x 12½)
Alice Westlake (his daughter),
c.1885
Given by the artist, 1918

HAREWOOD, Henry Lascelles,
2nd Earl of (1767-1841) Politician

1695(p) *See Collections*:
Sketches for The Trial of Queen
Caroline, 1820, by Sir George
Hayter, **1695(a-x)**

999 *See Groups*: The Trial of
Queen Caroline, 1820, by Sir
George Hayter

HARGREAVES, John (1839-95)
Sportsman

4718 Water-colour 31.1 x 18.7
(12¼ x 7⅜)
Sir Leslie Ward, signed *Spy*
(*VF* 11 June 1887)
Purchased, 1970

HARINGTON, Sir John
(1561-1612) Wit and writer;
translator of *Orlando Furioso*

3121 Panel 57.2 x 46 (22½ x 18⅛)
Attributed to Hieronimo Custodis
Purchased, 1942. *Montacute*

Strong

HARLAND, William Charles
(1804-63) MP for Durham

54 *See Groups*:The House of Com-
mons, 1833, by Sir George Hayter

HARLEY, Edward, 2nd Earl of
Oxford *See* Oxford

HARLEY, Robert, 1st Earl of
Oxford *See* Oxford

HARLOW, George Henry
(1787-1819) Portrait painter

782 Pencil 19.7 x 13.6
(7¾ x 5⅜)
John Jackson after a self-portrait,
inscribed
Bequeathed by the sitter's nephew,
George Harlow White, 1888

HARMAN, Sir John (1625?-73)
Admiral

1419 Canvas 124.5 x 101.6
(49 x 40)
Studio of Sir Peter Lely (c.1666),
inscribed
Purchased, 1905

Piper

HARMSWORTH, Alfred,
1st Viscount Northcliffe
See NORTHCLIFFE

HAROLD, King (1022?-66)
Reigned 1066

4050 Silver penny 1.9 (¾) diameter
Design attributed to Theodoric,
inscribed and dated 1066
Purchased, 1958

Strong

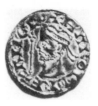

HARRINGTON, William Stanhope,
1st Earl of (1683?-1756)
Diplomat and statesman

4376 Canvas 95.9 x 125.1
(37¾ x 49¼)
James Worsdale, signed and
inscribed, 1746-50
Purchased, 1964

Kerslake

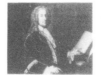

HARRINGTON, James (1611-77)
Political theorist

513 Canvas, feigned oval 80 x 69.2
(31½ x 27¼)
Unknown artist, inscribed, c.1635
Purchased, 1878

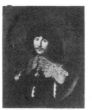

4109 Canvas 76.2 x 60.7
(30 x 23$\frac{7}{8}$)
After Sir Peter Lely (c.1658?),
inscribed
Purchased, 1959

Piper

HARRIS, William George Harris,
2nd Baron (1782-1845)
Lieutenant-General

3722 *See Collections*: Studies
for The Waterloo Banquet at
Apsley House, 1836, by William
Salter, **3689-3769**

HARRIS, George Francis Robert
Harris, 3rd Baron (1810-72)
Governor of Madras and of Trinidad

P117 Photograph: 9th plate
daguerreotype 5.1 x 3.8 (2 x 1½)
sight
Studio of Richard Beard, 1840s
Purchased, 1979

HARRIS, Sir Augustus (1852-96)
Actor, impresario and dramatist

3584 *See Collections*: Prominent
Men, c.1880-1910, by Harry
Furniss, **3337-3535** and **3554-3620**

HARRIS, James (1709-80)
Philosopher and critic

186 Canvas 125.7 x 100.3
(49½ x 39½)
Unknown artist, inscribed
Given by the Earl of Malmesbury,
1965

HARRIS, James, 1st Earl of
Malmesbury
See MALMESBURY

HARRIS, James Howard,
3rd Earl of Malmesbury
See MALMESBURY

HARRIS, James Thomas ('Frank')
(1856-1931)
Writer, editor and adventurer

L168(3) *See Collections*:
Prominent men, 1895-1930, by Sir
William Rothenstein, **L168(1-11)**

4883 Brush and ink 33.7 x 27.6
(13¼ x 10$\frac{7}{8}$)
John Duncan Fergusson, 1911-13
Purchased, 1972

HARRIS, John

P120(48) *See Collections*:
Literary and Scientific Men, 1855,
by Maull & Polyblank, **P120(1-54)**

HARRIS, Mat

2268 *See Collections*: The Parnell
Commission, 1888-9, by Sydney
Prior Hall, **2229-72**

HARRIS, Sir William Cornwallis
(1807-48)
Engineer and traveller

4098 Canvas 75.9 x 62.9
(29⅞ x 24¾)
Attributed to Ramsay Richard
Reinagle, c.1823
Purchased, 1959

Ormond

HARRISON, Frederic (1831-1923)
Writer and positivist

2718 Water-colour 30.5 x 18.1
(12 x 7⅛)
Carlo Pellegrini, signed *Ape*
(*VF* 23 Jan 1886)
Purchased, 1934

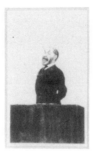

2214 Pencil 18.4 x 10.8 (7¼ x 4¼)
Walter Richard Sickert, signed, and
autographed and dated by sitter
1912
Given by Lady Gosse and family,
1928

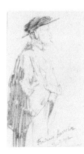

HARRISON, Jane Ellen
(1850-1928) Classical scholar

5220 Pencil 28.2 x 24.8
(11⅛ x 9¾)
Theo van Rysselberghe, signed in
monogram and dated 1925
Bequeathed by Helen Hope Mirrlees,
1978

HARRISON, John (1693-1776)
Horologist

4599 Paste medallion 8.3 (3¼)
high
James Tassie, incised
Purchased, 1968

HARRISON, Robert (1715-1802)
Mathematician and linguist

4898 Canvas 90.8 x 71.1
(35½ x 28)
William Bell, c.1791
Purchased, 1972

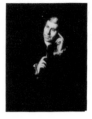

HARROWBY, Dudley Ryder,
1st Earl of (1762-1847)
Statesman

745 *See Groups*: William Pitt
addressing the House of Commons
. . . 1793, by Karl Anton Hickel

999 *See Groups*: The Trial of
Queen Caroline, 1820, by Sir
George Hayter

HARROWBY, Dudley Ryder,
2nd Earl of (1798-1882)
Statesman

54 *See Groups*:The House of Com-
mons, 1833, by Sir George Hayter

HARROWBY, Dudley Ryder,
3rd Earl of (1831-1900)
Educationalist

4226 Chalk 61 x 46.4 (24 x 18¼)
George Richmond, signed and
dated 1860
Given by the Earl of Harrowby,
1961

2577 Water-colour 30.2 x 18.1
(11⅞ x 7⅛)
Carlo Pellegrini, signed *Ape*
(*VF* 28 Nov 1885)
Purchased, 1933

HART, Solomon Alexander
(1806-81) Painter

1456(9) Black chalk 6 x 5.7
(2⅜ x 2¼)
Charles Hutton Lear, inscribed,
1845
Given by John Elliot, 1907
See Collections: Drawings of
Artists, c.1845, by Charles Hutton
Lear, **1456(1-27)**

2479 Pencil and water-colour
14.9 x 9.2 ($5\frac{7}{8}$ x $3\frac{5}{8}$)
Charles Bell Birch, dated 1853
Given by the artist's nephew,
George von Pirch, 1930
See Collections: Drawings of
Royal Academicians, c.1858, by
Charles Bell Birch, **2473-9**

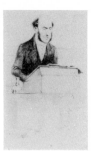

2476 *See Collections*: Drawings
of Royal Academicians, c.1858, by
Charles Bell Birch, **2473-9**

3182(3) *See Collections*:
Drawings of Artists, c.1862, by
Charles West Cope, **3182(1-19)**

Ormond

HARTRICK, Archibald Standish
(1864-1950) Painter

4193 Board 36.2 x 30.5
(14¼ x 12)
Self-portrait, exh 1913
Given by subscribers, 1961

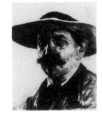

HARVEY, Daniel Whittle
(1786-1863) Politician; founder
of *The Sunday Times*

54 *See Groups*: The House of Com-
mons, 1833, by Sir George Hayter

HARVEY, William (1578-1657)
Physician; discovered the
circulation of the blood

5115 Canvas, oval 72.4 x 61
(28½ x 24)
Unknown artist, inscribed, c.1627
Purchased with help from the
Department of the History of
Medicine, University of British
Columbia, Jacob Zeitlin, and
Gonville and Caius College,
Cambridge, 1976

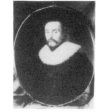

60 Canvas 97.8 x 79.4
(38½ x 31¼)
After etching attributed to Richard
Gaywood (c.1649)
Purchased, 1859

Piper

HASELDEN, Thomas (d.1740)
Mathematician

4122 Ink and wash, feigned oval
21.6 x 17.1 (8½ x 6¾)
After engraving by John Faber
(1740)
Given by Miss Vera Schanche, 1959

HASTINGS, Francis Rawdon-
Hastings, 1st Marquess of, and 2nd
Earl of Moira (1754-1826)
Soldier and statesman

2696 Panel 73 x 58.4 (28¾ x 23)
Unknown artist, c.1800
Purchased, 1934

L152(31) Miniature on ivory, oval
6.4 x 5.1 (2½ x 2)
Thomas Mitchell, signed and
inscribed on reverse
Lent by NG (Alan Evans Bequest),
1975

837 Pen and ink 15.2 x 11.4
(6 x 4½)
James Atkinson, inscribed and
dated 1820
Given by the artist's son,
J.A.Atkinson, 1890

HASTINGS, George Rawdon-
Hastings, 2nd Marquess of (1808-44)

4026(33) *See Collections:*
Drawings of Men about Town,
1832-48, by Alfred, Count D'Orsay,
4026(1-61)

HASTINGS, Henry, 3rd Earl of
Huntingdon *See* HUNTINGDON

HASTINGS, Jacob Astley, 16th
Baron (1797-1859)
MP for Norfolk West

3645 Pencil and red chalk
22.2 x 18.4 (8¾ x 7¼)
Joseph Slater, signed and dated
1830
Given by John Farrow, 1948

54 *See Groups:* The House of Com-
mons, 1833, by Sir George Hayter

HASTINGS, Sir Patrick
(1880-1952) Barrister and writer

4339 Ink and pencil 25.4 x 19.7
(10 x 7¾)
Nicolas Clerihew Bentley (his
son-in-law), signed, pub 1948
Given by the artist, 1963

HASTINGS, Selina, Countess of
Huntingdon *See* HUNTINGDON

HASTINGS, Warren (1732-1818)
Governor-General of India

4445 Canvas 126.4 x 101
(49¾ x 39¾)
Sir Joshua Reynolds, inscribed,
1766-8
Acquired by H.M.Government and
allocated to the Gallery, 1965

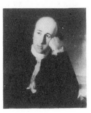

81 Canvas 68.6 x 57.2 (27 x 22½)
Tilly Kettle, c.1775
Purchased, 1859

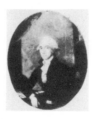

3823 Pastel, oval 31.8 x 26.7
(12½ x 10½)
Sir Thomas Lawrence, 1786
Purchased, 1952

L152(24) Miniature on ivory, oval
5.7 x 4.8 (2¼ x1⅞)
Richard Cosway, signed and dated
on backing card 1787
Lent by NG (Alan Evans Bequest),
1975

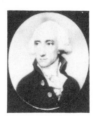

209 Bronze cast of bust 69.9
(27½) high
Thomas Banks, incised and dated
1794
Purchased, 1866

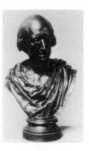

1845 Canvas 73.7 x 62.2
(29 x 24½)
Lemuel Francis Abbott, 1795-6
Bequeathed by Miss Marian Winter,
1919

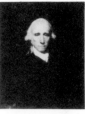

5065 Wax medallion 8.3
(3¼) diameter
Peter Rouw, incised and dated 1806
Purchased, 1976

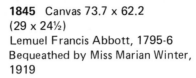

390 Canvas 90.2 x 69.9
(35½ x 27½)
Sir Thomas Lawrence, exh 1811
Purchased, 1874

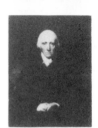

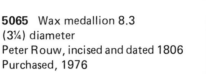

HATCHETT, Charles (1765?-1847)
Chemist

1075,1075a and **b** *See Groups:*
Men of Science Living in 1807-8,
by Sir John Gilbert and others

316a(65) Pencil 45.7 x 22.4
(18 x 8⅞)
Sir Francis Chantrey, inscribed and
dated 1820
Given by Mrs George Jones, 1871
See Collections: Preliminary
drawings for busts and statues by
Sir Francis Chantrey, **316a(1-202)**

HATHERLEY, William Wood,
Baron (1801-81) Lord Chancellor

5116 *See Groups:* Gladstone's
Cabinet of 1868, by Lowes Cato
Dickinson

646 Canvas 237.5 x 146.1
(93½ x 57½)
George Richmond, signed and
dated 1872
Bequeathed by the sitter, 1881

HATHERTON, Edward Littleton,
3rd Viscount (1842-1930)
Military Secretary to Governor-
General of Canada

4605 Water-colour 40.6 x 26.4
(16 x 10⅜)
(Possibly H.C.Sepping) Wright
signed *STUFF*
(*VF* 23 May 1895)
Purchased, 1968

HATHERTON, Edward John
Littleton, 1st Baron (1791-1863)
Politician

4658 (study for *Groups,* **54**)
Millboard 35.6 x 30.5 (14 x 12)
Sir Geroge Hayter, signed and
dated 1834
Purchased, 1969

54 *See Groups:* The House of Com-
mons, 1833, by Sir George Hayter

Ormond

HATHERTON, Edward Richard
Littleton, 2nd Baron (1815-88)
Representative peer

1834(p) *See Collections:* Members
of the House of Lords, c.1870-80,
by Frederick Sargent, **1834(a-z and
aa-hh)**

HATSELL, John (1743-1820)
Clerk of the House of Commons

745 *See Groups:* William Pitt
addressing the House of
Commons . . . 1793, by Karl
Anton Hickel

HATTON, Sir Christopher
(1540-91) Lord Chancellor

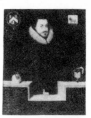

1518 Panel 78.7 x 63.5 (31 x 25)
Unknown artist, inscribed,
c.1588-91
Purchased, 1908

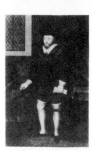

2413 Water-colour 30.5 x 23.5
(12 x 9¼)
Attributed to Sylvester Harding
after Nicholas Hilliard, 1848
(c.1588-91)
Purchased, 1929
See Collections: Copies of early
portraits, by George Perfect Harding
and Sylvester Harding, **1492,
1492(a-c) and 2394-2419**

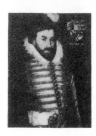

2162 Panel 78.1 x 65.4
(30¾ x 25¾)
Possibly after Cornelius Ketel,
inscribed
Purchased, 1927. *Montacute*

Strong

HAVELOCK, Sir Henry, Bt
(1795-1857) General

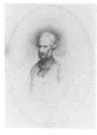

4835 Pencil and wash 52.4 x 41
(20⅝ x 16⅛)
Frederick Goodall, signed and
inscribed, c.1857
Acquired, 1970

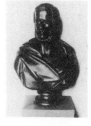

1204 Plaster cast of bust 83.8
(33) high
George Gammon Adams, 1858
Purchased, 1899

Ormond

HAWARD, Francis (1759-97)
Engraver

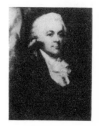

1233 Pastel 57.8 x 45.1
(22¾ x 17¾)
Ozias Humphry
Bequeathed by Charles Drury
Edward Fortnum, 1899

HAWEIS, Hugh Reginald
(1838-1901)
Preacher and writer on music

2719 Water-colour 30.5 x 18.1
(12 x 7$\frac{1}{8}$)
Carlo Pellegrini, signed *Ape*
(*VF* 22 Sept 1888)
Purchased, 1934

4107 Canvas 62.9 x 41
(24¾ x 16$\frac{1}{8}$)
Frederick Howard Lewis, signed,
inscribed and dated 1913
Bequeathed by the sitter's daughter,
Miss Hugolin Haweis, 1959

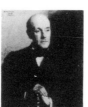

HAWES, Sir Benjamin (1797-1862)
Politician and advocate for the arts

342,343 *See Groups:* The Fine
Arts Commissioners, 1846, by John
Partridge

HAWKINS, Sir Anthony Hope
(1863-1933)
'Anthony Hope'; novelist

3974 Canvas 74.9 x 62.2
(29½ x 24½)
Alfred Wolmark, signed and dated
1908
Purchased, 1956

3456 *See Collections:* Prominent
Men, c.1880-c.1910, by Harry
Furniss, **3337-3535** and **3554-3620**

4529(172) *See Collections:*
Working drawings by Sir David
Low, **4529(1-401)**

HAWKINS, Caroline

P18(28) *See Collections:* The
Herschel Album, by Julia Margaret
Cameron, **P18(1-92b)**

HAWKINS, Henry, 1st Baron
Brampton *See* BRAMPTON

HAWKINS, Sir John (1719-89)
Writer

5020 Silhouette 6.4 (2½) high
Unknown artist, c.1781
Given by Mrs Edna Gray, 1975

HAWKSLEY, Thomas (1807-93)
Civil engineer

4973 Canvas 122.6 x 99.4
(48¼ x 39$\frac{1}{8}$)
Sir Hubert von Herkomer, signed
with initials and dated 1887
Bequeathed by the sitter's son,
Charles Hawksley, 1974

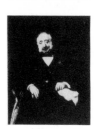

HAWKSMOOR, Nicholas
(1661-1736) Architect

4261 Bronze cast of bust 54.6
(21½) high
After bust attributed to Sir Henry
Cheere, 1962 (1736)
Given by the Warden and Fellows
of All Souls College, Oxford, 1962

Kerslake

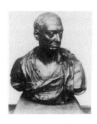

HAY, Sir Andrew Leith
(1785-1862) Soldier and writer

54 *See Groups:* The House of Com-
mons, 1833, by Sir George Hayter

HAY, James, 1st Earl of Carlisle
See CARLISLE

HAY, James (d.1854)
Major-General

3723 *See Collections:* Studies for
The Waterloo Banquet at Apsley
House, 1836, by William Salter,
3689-3769

HAY, Sir John, Bt (1788-1838)
MP for Peeblesshire

54 *See Groups:* The House of Com-
mons, 1833, by Sir George Hayter

HAY, William Montagu, 10th
Marquess of Tweeddale
See TWEEDDALE

HAYASHI, Viscount Tadasu
(1850-1913)
Japanese minister in London

4707(13) *See Collections: Vanity Fair* cartoons, 1869-1910, by various artists, **2566-2606,** etc

HAYDON, Benjamin Robert
(1786-1846)
History painter and diarist

1505 Black and white chalk
12.7 x 19.7 (5 x 7¾)
Sir David Wilkie, inscribed and dated 1815
Given, through NACF, by Frederick Anthony White, 1908

3250 (over 7 sketches: Haydon centre; the artist, profile, between pillars)
Pen and ink 31.8 x 20.3 (12½ x 8)
John Keats, inscribed, 1816
Purchased, 1945

2802 Plaster cast of life-mask
25.1 x 16.5 (9⅞ x 6½)
Unknown artist, c.1820
Given by Maurice Buxton Forman, 1936

2172 Plaster cast of life-mask
17.1 x 14 (6¾ x 5½)
Unknown artist, c.1820
Given by Sir Herbert Richmond, 1927

510 Canvas 68.6 x 57.2 (27 x 22½)
Georgiana Margaretta Zornlin, signed and dated on stretcher 1825
Given by the artist, 1878

268 Millboard 22.9 x 17.5 (9 x 6⅞)
Self-portrait, signed on reverse, c.1845
Purchased, 1868

HAYES, Sir Edmund Samuel, Bt
(1806-60) MP for County Donegal

54 *See Groups:* The House of Commons, 1833, by Sir George Hayter

HAYLEY, Thomas Alphonso
(1780-1800) Sculptor; natural son of William Hayley

101 *See under* John Flaxman

HAYLEY, William (1745-1820)
Poet and biographer

662 Panel 19.1 x 14.9 (7½ x 5⅞)
Henry Howard, c.1800
Given by Sir Theodore Martin, 1882

HAYMAN, Francis (1708-76)
Painter

217 With Grosvenor Bedford? (seated)
Canvas 71.8 x 91.4 (28¼ x 36)
Self-portrait, c.1740-5
Purchased, 1866

1437 *See Groups:* The Academicians of the Royal Academy, 1771-2, by John Sanders after Johan Zoffany

Kerslake

HAYTER, Charles (1761-1835)
Miniature painter

2617 Pencil and wash 23.5 x 16.5 (9¼ x 6½)
Sir George Hayter (his son), signed with initials, inscribed and dated 1811
Given by Iolo A.Williams, 1933

999 *See Groups:* The Trial of Queen Caroline, 1820, by Sir George Hayter

HAYTER, Sir George (1792-1871)
Portrait and history painter; son of
Charles Hayter

3104 Panel 51.4 x 52.1
(20¼ x 20½)
Self-portrait, signed and dated 1820
Given by NACF, 1941

999 *See Groups:* The Trial of
Queen Caroline, 1820, by Sir
George Hayter

3082(1-7) *See Collections:*
Drawings by Sir George Hayter,
illustrating his riding accident
in 1821

1103 (sheet of 3 studies for
Groups, **54**)
Pen and ink 22.2 x 28.2 (8¾ x 11⅛)
Self-portrait, signed with initials,
inscribed and dated 1843
Given by Major Harrel, 1897

54 *See Groups:* The House of Com-
mons, 1833, by Sir George Hayter

Ormond

HAYWARD, Abraham (1801-84)
Essayist; translated Goethe's *Faust*

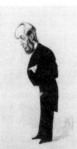

4072 Water-colour 30.5 x 17.8
(12 x 7)
Carlo Pellegrini, signed *Ape*
(*VF* 17 Nov 1875)
Given by Joseph Hayward, 1958

Ormond

HAYWARD, John (1905-65)
Anthologist, critic and editor

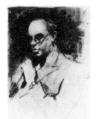

4475 Ink, crayon and wash
51.4 x 38.1 (20¼ x 15)
Anthony Devas, c.1950
Purchased, 1966

HAZLEDINE, Mr (probably
William Hazeldine, ironfounder,
1763-1840)

316a(66,67) *See Collections:*
Preliminary drawings for busts
and statues by Sir Francis Chantrey,
316a(1-202)

HAZLITT, William (1788-1830)
Essayist, journalist and critic

2697 Chalk 57.5 x 37.5
(22⅝ x 14¾)
William Bewick, replica, signed
with initials and dated 1825
Purchased, 1934

HEAD, George Head
Slavery abolitionist

599 *See Groups:* The Anti-Slavery
Society Convention, 1840, by
Benjamin Robert Haydon

HEADLEY, Charles Mark Allanson
Winn, 4th Baron (1845-1913)
Representative peer

3585 *See Collections:* Prominent
Men, c.1880-c.1910, by Harry
Furniss, **3337-3535** and **3554-3620**

HEALY, Timothy Michael
(1855-1931) Irish politician; first
Governor-General of Irish Free State

2319 *See Collections:*
Miscellaneous drawings . . . by
Sydney Prior Hall, **2282-2348**
and **2370-90**

3620 *See Collections:* Prominent
Men, c.1880-c.1910, by Harry
Furniss, **3337-3535** and **3554-3620**

HEAPHY, Thomas Frank (1813-73)
Painter

4016 Water-colour 25.4 x 24.1
(10 x 9½)
Self-portrait, c.1831
Given by his granddaughter, Miss E.
Desse Morris, 1957

Ormond

HEARNE, Thomas (1744-1817)
Water-colourist

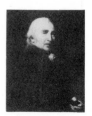

1653 Pastel 68.6 x 55.2 (27 x 21¾)
Henry Monro
Purchased, 1912

HEATH, James (1757-1834)
Engraver

771 Canvas 76.2 x 64.1 (30 x 25¼)
James Lonsdale, inscribed and dated
1830 on reverse
Bequeathed by the artist's son,
J. J. Lonsdale, 1887

HEATH, Nicholas (1501?-78)
Archbishop of York and Lord
Chancellor

1388 Panel 62.5 x 45.7 (24⅝ x 18)
Hans Eworth, inscribed and dated
1566
Purchased, 1904

Strong

HEATHCOTE, Gilbert John, 1st
Baron Aveland *See* AVELAND

HEATHCOTE, Sir T.

316a(68) *See Collections:*
Preliminary drawings for busts and
statues by Sir Francis Chantrey,
316a(1-202)

**HEATHCOTE-DRUMMOND-
WILLOUGHBY,** Gilbert Henry,
1st Earl of Ancaster
See ANCASTER

HEATHFIELD, George Eliott,
Baron (1717-90)
General; defender of Gibraltar

1752 *See Groups:* The Siege of
Gibraltar, 1782, by George Carter

170 Canvas 67.3 x 58.4
(26½ x 23)
John Singleton Copley, 1787
Purchased, 1864

HEBER, Richard (1773-1833)
Book collector

4886 Pencil 22.6 x 17.1 (8⅞ x 6¾)
John Harris, signed and inscribed,
c.1830
Purchased, 1972

HEINZ, Henry John (b.1908)
Chairman of H.J.Heinz Company

4529(165-7) *See Collections:*
Working drawings by Sir David
Low, **4529(1-401)**

HELENA Augusta Victoria, Princess
Christian (1846-1923)
Daughter of Queen Victoria

P26 *See Groups:* The Royal
Family . . . , by L.Caldesi

3083 *See Groups:* The Opening of
the Royal Albert Infirmary . . . ,
by an unkown artist

2023A(11 and 12) *See Collections:*
Queen Victoria, Prince Albert and
members of their family, by Susan
D. Durant, **2023A(1-12)**

HELLST, Colonel

1752 *See Groups:* The Siege of
Gibraltar, 1782, by George Carter

HELPMANN, Robert (b.1909)
Ballet dancer, choreographer, actor
and producer

P61 Photograph: bromide print
50.8 x 40.3 (20 x 15⅞)
Angus McBean, 1950
Purchased, 1977
See Collections: Prominent
people, c.1946-64, by Angus
McBean, **P56-67**

HELPS, Sir Arthur (1813-75)
Essayist and historian

2027 Chalk 59.4 x 45.1
(23⅜ x 17¾)
George Richmond, signed and
dated 1858
Bequeathed by the sitter's daughter,
Miss Alice Helps, 1924

Continued overleaf

3083 *See Groups:* The Opening
of the Royal Albert Infirmary . . . ,
by an unknown artist

Ormond

HELY-HUTCHINSON, Richard,
1st Earl of Donoughmore
See DONOUGHMORE

HEMANS, Felicia Dorothea
(1793-1835) Poet

1046 Plaster bust 70.5 (27¾) high
Angus Fletcher, 1829
Purchased, 1896

5198 Marble bust 63.1 (24$\frac{7}{8}$) high
Angus Fletcher, incised, c.1829
Purchased, 1978

HENDERSON, Arthur (1863-1935)
Labour leader and statesman

2067 Miniature on ivory, oval
11.4 x 8.9 (4½ x 3½)
Lilian Mary Mayer
Given by the artist's husband,
Sylvain Mayer, 1954

HENDERSON, John (1747-85)
Actor

1919 Pastel, oval 45.1 x 41.3
(17¾ x 16¼)
Robert Dunkarton, signed and
dated 1776
Given by Ernest E. Leggatt, 1921

980 Canvas 74.3 x 61.6
(29¼ x 24¼)
Thomas Gainsborough, c.1777
Given by the sitter's granddaughter,
Miss Julia Carrick Moore, 1895

HENDERSON MERCER, Douglas
See MERCER

HENDY, Sir Philip (1900-80)
Art historian; Director of the
National Gallery

4529(168-70) *See Collections:*
Working drawings by Sir David
Low, **4529(1-401)**

HENEAGE, Edward Heneage, 1st
Baron (1840-1922) Politician

4719 Water-colour 31.1 x 18.7
(12¼ x 7$\frac{3}{8}$)
Sir Leslie Ward, signed *Spy*
(*VF* 17 Dec 1887)
Purchased, 1970

HENEAGE, George Fieschi
(1800-64) MP for Lincoln

54 *See Groups:*The House of Com-
mons, 1833, by Sir George Hayter

HENFREY, Arthur (1819-59)
Botanist

P120(49) Photograph: albumen
print, arched top 19.7 x 14.6
(7¾ x 5¾)
Maull & Polyblank, inscribed on
mount, 1855
Purchased, 1979
See Collections: Literary and
Scientific Men, 1855, by Maull &
Polyblank, **P120(1-54)**

HENLEY, Robert, 1st Earl of
Northington *See* NORTHINGTON

HENLEY, William Ernest
(1849-1903) Poet and writer

1697 Bronze cast of bust 39.4
(15½) high
Auguste Rodin, c.1882
Given by the sitter's widow, 1913

4420 Pastel 27.9 x 22.5 (11 x 8$\frac{7}{8}$)
Francis Dodd, signed and dated
1900, autographed by sitter
Purchased, 1964

3586 *See Collections:* Prominent
Men, c.1880-c.1910, by Harry
Furniss, **3337-3535** and **3554-3620**

HENNIKER, John Henniker-Major,
4th Baron (1801-70)
MP for Suffolk East

54 *See Groups:* The House of Commons, 1833, by Sir George Hayter

HENNIKER, John Henniker-Major,
5th Baron (1842-1902)
Representative peer

1834(q) *See Collections:* Members
of the House of Lords, c.1870-80,
by Frederick Sargent, **1834(a-z** and
aa-hh)

HENNING, John (1771-1851)
Sculptor

P6(32) Photograph: calotype
20.7 x 15.5 (8$\frac{1}{8}$ x 6$\frac{1}{8}$)
David Octavius Hill and Robert
Adamson, 1843-8
Given by an anonymous donor,
1973
See Collections: The Hill and
Adamson Albums, 1843-8, by David
Octavius Hill and Robert Adamson,
P6(1-258)

P6(24,92,98,151,158,237,238)
See Collections: The Hill and
Adamson Albums, 1843-8, by
David Octavius Hill and Robert
Adamson, **P6(1-258)**

HENRIETTA Anne, Princess
See ORLEANS

HENRIETTA MARIA (1609-69)
Queen of Charles I

227 Canvas 109.2 x 82.6
(43 x 32½)
After Sir Anthony van Dyck
(c.1632-5)
Purchased, 1867

1247 Canvas 215.9 x 135.2
(85 x 53¼)
Unknown artist, background
probably by Hendrik van Steenwyck
the Younger, c.1635?
Given by Henry Louis
Bischoffsheim, 1899

Piper

HENRY I (1068-1135)
Reigned 1100-35

4980(2) *See Collections:* Set of
16 early English Kings and Queens
formerly at Hornby Castle,
Yorkshire, **4980(1-16)**

HENRY II (1133-89)
Reigned 1154-89

4980(4) *See Collections:* Set of
16 early English Kings and Queens
formerly at Hornby Castle,
Yorkshire, **4980(1-16)**

HENRY III (1207-72)
Reigned 1216-72

341 Electrotype of effigy in
Westminster Abbey 111.8 (44) high
After William Torel, c.1291
Purchased, 1870

4980(6) *See Collections:* Set of
16 early English Kings and Queens
formerly at Hornby Castle,
Yorkshire, **4980(1-16)**

Strong

HENRY IV (1367-1413)
Reigned 1399-1413

397 Electrotype of effigy in
Canterbury Cathedral 109.2
(43) high
After an unknown artist, c.1408-27
Purchased, 1875

4980(9) *See Collections:* Set of
16 early English Kings and Queens
formerly at Hornby Castle,
Yorkshire, **4980(1-16)**

310 *See Unknown Sitters I*

Strong

HENRY V (1387-1422)
Reigned 1413-22

545 Panel 72.4 x 41 (28½ x 16$\frac{1}{8}$)
Unknown artist
Transferred from BM, 1879

Strong

HENRY VI (1421-71)
Reigned 1422-61 and 1470-1

2457 Panel 31.8 x 25.4 (12½ x 10)
Unknown artist, inscribed on frame
Purchased, 1930

546 Panel 53.3 x 44.5 (21 x 17½)
Unknown artist, inscribed
Transferred from BM, 1879

Strong

HENRY VII (1457-1509)
Reigned 1485-1509

4980(13) Panel 56.8 x 44.5
(22$\frac{3}{8}$ x 17½)
Unknown artist, inscribed (c.1500)
Purchased, 1974
See Collections: Set of 16 early
English Kings and Queens formerly
at Hornby Castle, Yorkshire,
4980(1-16)

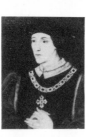

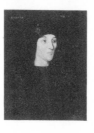

416 Panel, arched top 42.5 x 30.5
(16¾ x 12)
Michiel Sittow, inscribed and dated
1505
Purchased, 1876

290 Electrotype of effigy in
Westminster Abbey 86.4 (34) high
After Pietro Torrigiano (c.1512-19)
Purchased, 1869

Strong

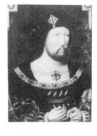

4027 *See under* Henry VIII

HENRY VIII (1491-1547)
Reigned 1509-47

4690 Panel 50.8 x 38.1 (20 x 15)
Unknown artist, c.1520
Purchased, 1969

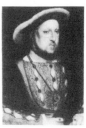

157 Copper 27.9 x 20 (11 x 7$\frac{7}{8}$)
After Hans Holbein (c.1536)
Purchased, 1863

4027 With Henry VII (right)
Ink and water-colour 257.8 x 137.2
(101½ x 54)
Hans Holbein, 1536-7
Acquired by H.M.Government and
allocated to the Gallery, 1957

324 Panel 48.3 x 34.3 (19 x 13½)
After Hans Holbein (c.1536-7),
inscribed
Purchased, 1871

1376 Panel 57.2 x 42.5
(22½ x 16¾)
Unknown artist, inscribed,
c.1535-40
Purchased, 1904

3638 Panel 58.4 x 44.5 (23 x 17½)
Unknown artist, c.1535-40
Given by Sir Geoffrey Keynes,
1948. *Montacute*

496 Panel 88.9 x 66.7 (35 x 26¼)
Unknown artist (c.1542)
Purchased, 1878. *Montacute*

4980(14) *See Collections:* Set of
16 early English Kings and Queens
formerly at Hornby Castle,
Yorkshire, **4980(1-16)**

4165 *See Groups:* Edward VI and
the Pope, by an unknown artist

Strong

HENRY, Prince of Wales
(1594-1612) Eldest son of James I

2562 Canvas 161.9 x 116.8
(63¾ x 46)
Marcus Gheeraerts the Younger,
c.1603
Bequeathed by Viscount Dillon,
1933. *Montacute*

4515 Canvas 172.7 x 113.7
(69 x 44¾)
Robert Peake, c.1610
Purchased with help from NACF,
1966

1572 Miniature on vellum, oval
5.1 x 4.1 (2 x 1⅝)
Studio of Isaac Oliver, c.1610
Purchased, 1910

407 Canvas 74 x 52.7 ($29\frac{1}{8}$ x 20¾)
After Isaac Oliver, inscribed
(c.1610)
Purchased, 1875

Strong

HENRY, Duke of Gloucester
See GLOUCESTER

HENRY Benedict Stuart, Cardinal
York *See* YORK

HENRY FREDERICK, Duke of
Cumberland and Strathearn
See CUMBERLAND AND
STRATHEARN

HENRY, Matthew (1662-1714)
Commentator

982(i) *See Unknown Sitters II*

HENRY, William (1774-1836)
Chemist

1075, 1075a and **b** *See Groups:*
Men of Science Living in 1807-8,
by Sir John Gilbert and others

HENSCHEL, Sir George
(1850-1934)
Musician; founder and conductor
of London symphony concerts

4935 Canvas 71.1 x 52.7
(28 x 20¾)
Philip de Laszlo, signed, inscribed
and dated 1917
Purchased, 1973

HENTY, George Alfred
(1832-1902)
Writer of books of adventure

3467 *See Collections:* Prominent
Men, c.1880-c.1910, by Harry
Furniss, **3337-3535** and **3554-3620**

HERBERT of Cherbury, Edward
Herbert, 1st Baron (1583-1648)
Diplomat and writer

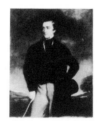

487 Canvas, feigned oval
73.7 x 61 (29 x 24)
Perhaps after Isaac Oliver,
inscribed (c.1603-5)
Purchased, 1877. *Montacute*

Piper

HERBERT of Lea, Sidney Herbert,
1st Baron (1810-61)
War Secretary

54 *See Groups:* The House of Com-
mons, 1833, by Sir George Hayter

1639 Canvas 142.9 x 111.8
(56¼ x 44)
Sir Francis Grant, 1847
Given by the sitter's son, the
Earl of Pembroke, 1912

1125, 1125a *See Groups:* The
Coalition Ministry, 1854, by Sir
John Gilbert

Ormond

HERBERT, Sir Alan Patrick
(1890-1971)
Humorist and politician

4894 Canvas 76.2 x 63.5 (30 x 25)
Ruskin Spear, signed
Purchased, 1972

HERBERT, Edward, 2nd Earl of
Powis *See* POWIS

HERBERT, George (1812-38)
Grandson of 1st Earl of Carnarvon;
soldier

4026(34) *See Collections:*
Drawings of Men about Town,
1832-48, by Alfred, Count D'Orsay,
4026(1-61)

HERBERT, Henry George, 2nd
Earl of Carnarvon
See CARNARVON

HERBERT, John (1723-99)
Governor of Balambangan

547 Canvas 73.7 x 61 (29 x 24)
Arthur William Devis, inscribed and
dated 1791
Transferred from BM, 1879

HERBERT, John Rogers (1810-90)
History and portrait painter

1456(10) Chalk 9.2 x 7.3
($3\frac{5}{8}$ x $2\frac{7}{8}$)
Charles Hutton Lear, inscribed,
c.1845
Given by John Elliot, 1907
See Collections: Drawings of
Artists, c.1845, by Charles Hutton
Lear, **1456(1-27)**

Ormond

HERBERT, Philip, 4th Earl of
Pembroke and 1st Earl of
Montgomery *See* PEMBROKE

HERBERT, Thomas, 8th Earl of
Pembroke *See* PEMBROKE

HEREFORD, Henry Devereux,
14th Viscount (1777-1843)

999 *See Groups:* The Trial of
Queen Caroline, 1820, by Sir
George Hayter

HERKOMER, Sir Hubert von
(1849-1914) Painter

2720 Water-colour 32.1 x 18.1
($12\frac{5}{8}$ x $7\frac{1}{8}$)
F.Goedecker, signed in monogram
(*VF* 26 Jan 1884)
Purchased, 1934

2820 *See Groups:* The Royal
Academy Conversazione, 1891, by
G. Grenville Manton

3175 Millboard 34 x 23.5
($13\frac{3}{8}$ x 9¼)
Ernest Borough Johnson, signed,
inscribed and dated 1892
Given by the artist, 1944

2461 Bronze cast of bust 71.1
(28) high
Edward Onslow Ford, c.1897
Purchased, 1930

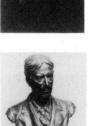

HERON, Cecily (née More) (b.1507)
Youngest daughter of Sir Thomas
More

2765 *See Groups:* Sir Thomas
More, his Father, his Household
and his Descendants, by Rowland
Lockey after Hans Holbein

HERON, Sir Robert, Bt
(1765-1854) Politician

54 *See Groups:* The House of Com-
mons, 1833, by Sir George Hayter

HERRIES, John Charles
(1778-1855)
Statesman and financier

54 *See Groups:* The House of Com-
mons, 1833, by Sir George Hayter

HERRING, Ann (née Harris)
(1795-1838)
First wife of John Frederick Herring

4903 Water-colour 21.6 x 18.4
(8½ x 7¼)
Edward Heaton, signed with initials
and dated 1825
Bequeathed by the sitter's great-
granddaughter, Miss Mabel Herring,
1972

HERRING, John Frederick
(1795-1865) Animal painter

4902 Water-colour 19.7 x 18
($7\frac{3}{4}$ x $7\frac{1}{8}$)
G.Jackson, signed and dated 1822
Bequeathed by the sitter's great-
granddaughter, Miss Mabel Herring,
1972

HERRING, Thomas (1693-1757)
Archbishop of Canterbury

4895 Canvas 109.9 x 92.1
(43¼ x 36¼)
Attributed to Thomas Hudson,
inscribed, c.1748
Purchased, 1972

Kerslake

HERSCHEL, Sir John, Bt
(1792-1871) Astronomer;
son of Sir William Herschel

4148 Silhouette, oval 10.2 x 8.9
(4 x 3½)
Unknown artist
Given by A. Parker Smith, 1960

1386 Pencil 33 x 25.4 (13 x 10)
Henry William Pickersgill, c.1835
Purchased, 1904

4056 Plaster cast of bust 80
(31½) high
Edward Hodges Baily, 1850
Purchased, 1958

Continued overleaf

P18(1) Photograph: albumen print
33.3 x 27.9 (13$\frac{1}{8}$ x 11)
Julia Margaret Cameron, April 1867
Purchased with help from public
appeal, 1975
See Collections: The Herschel
Album, by Julia Margaret Cameron,
P18(1-92b)

Ormond

HERSCHEL,Sir William
(1738-1822) Astronomer

98 Canvas 76.2 x 63.5 (30 x 25)
Lemuel Francis Abbott, 1785
Purchased, 1860

4055 Plaster cast of bust 82.6
(32½) high
John Charles Locheé, 1787
Purchased, 1958

1075,1075a and **b** *See Groups:*
Men of Science Living in 1807-8,
by Sir John Gilbert and others

HERSCHELL, Farrar Herschell,
1st Baron (1837-99)
Lord Chancellor

2721 Water-colour 30.5 x 18.1
(12 x 7$\frac{1}{8}$)
Sir Leslie Ward, signed *Spy*
(*VF* 19 March 1881)
Purchased, 1934

2343-5 *See Collections:*
Miscellaneous drawings . . . by
Sydney Prior Hall, **2282-2348**
and **2370-90**

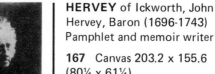

HERVEY of Ickworth, John
Hervey, Baron (1696-1743)
Pamphlet and memoir writer

167 Canvas 203.2 x 155.6
(80¼ x 61¼)
Studio of Jean Baptiste van Loo,
c.1740-1
Given by the Marquess of Bristol,
1863

Kerslake

HERVEY, Augustus John, 3rd
Earl of Bristol *See* BRISTOL

HERVEY, Frederick Augustus,
4th Earl of Bristol *See* BRISTOL

HERVEY, Frederick William,
2nd Marquess of Bristol
See BRISTOL

HERVEY, George William, 2nd
Earl of Bristol *See* BRISTOL

HESELTINE, Philip Arnold
(1894-1930)
Composer and writer on music

4975(8) *See Collections:*
Rehearsals for *A Mass of Life,*
1929, by Ernest Procter, **4975(1-36)**

HESSE-DARMSTADT, Louis IV,
Grand Duke of *See* LOUIS

HEWART, Gordon Hewart, 1st
Viscount (1870-1943)
Lord Chief Justice

4529(171) *See Collections:*
Working drawings by Sir David
Low, **4529(1-401)**

HEWITT, James, 1st Viscount
Lifford *See* LIFFORD

HEWITT, James, 4th Viscount
Lifford *See* LIFFORD

HEWLETT, Hilda Beatrice (née Herbert) Wife of Maurice Hewlett

3264 *See Groups:* Mrs Hewlett, Mrs Kerr-Lawson and Maurice Hewlett, by James Kerr-Lawson

HEWLETT, Maurice (1861-1923) Novelist

2213 Chalk 28.9 x 21.6 (11$\frac{3}{8}$ x 8½) Sir William Rothenstein, signed with initials and dated 1898 Given by Lady Gosse and family, 1928

3263 (study for no.**2800**) Pencil 35.9 x 49.8 (14$\frac{1}{8}$ x 19$\frac{5}{8}$) James Kerr-Lawson, 1904 Given by the artist's widow, before 1945

2800 Canvas 37.5 x 51.4 (14¾ x 20¼) James Kerr-Lawson, signed with initials, 1904 Purchased, 1935

3264 *See Groups:* Mrs Hewlett, Mrs Kerr-Lawson and Maurice Hewlett, by James Kerr-Lawson

HICHENS, Mary Emily (née Prinsep) (1853-1931)

P18(25, 49, 54, 63, 83, 87) *See Collections:* The Herschel Album, by Julia Margaret Cameron, **P18(1-92b)**

HICKEY, William (1749-1830) Attorney in India and memoirist

3249 With an Indian youth (left) Canvas 111.8 x 86.4 (44 x 34) William Thomas, 1819 Purchased, 1945

HICKS, Sir Edward Seymour (1871-1949) Actor-manager

3468 *See Collections:* Prominent Men, c.1880-c.1910, by Harry Furniss, **3337-3535** and **3554-3620**

HICKS-BEACH, Michael, 1st Earl St Aldwyn *See* ST ALDWYN

HIGGINS, Matthew James (1810-68) 'Jacob Omnium'; journalist

2433 Chalk 61.9 x 48.3 (24$\frac{3}{8}$ x 19) Samuel Laurence, signed and inscribed Given by Henrietta Maria, Lady Stanley of Alderley, 1884

HIGHMORE, Nathaniel (1613-85) Physician

4069 Canvas, oval 75.2 x 62.5 (29$\frac{5}{8}$ x 24$\frac{5}{8}$) Unknown artist, c.1660-5(?) Bequeathed by Sir Nathaniel Highmore, 1958

Piper

HILDERSHAM, Arthur (1563-1632) Puritan divine

1575 Panel 58.1 x 44.7 (22$\frac{7}{8}$ x 17$\frac{5}{8}$) Unknown artist, inscribed and dated 1619 Purchased, 1910

Strong

HILL, Rowland Hill, 1st Viscount (1772-1842) General

1914(6) Water-colour and pencil 19.1 x 16.2 (7½ x 6$\frac{3}{8}$) Thomas Heaphy, 1813-14 Purchased, 1921 *See Collections:* Peninsular and Waterloo Officers, 1813-14, by Thomas Heaphy, **1914(1-32)**

1914(7) *See Collections:* Peninsular and Waterloo Officers, 1813-14, by Thomas Heaphy, **1914(1-32)**

999 *See Groups:* The Trial of Queen Caroline, 1820, by Sir George Hayter

Continued overleaf

1055 Water-colour and pencil
20.3 x 15.9 (8 x 6¼)
George Richmond, 1834
Purchased, 1896

3724 *See Collections:* Studies
for The Waterloo Banquet at
Apsley House, 1836, by William
Salter, **3689-3769**

HILL, Rowland Hill, 2nd Viscount
(1800-75) MP for Salop North

54 *See Groups:* The House of Commons, 1833, by Sir George Hayter

HILL, Lord Arthur William
(1846-1931) Politician

5256 *See Groups:* The Lobby
of the House of Commons, 1886,
by Liberio Prosperi

HILL, Archibald Vivian
(1886-1977) Physiologist

4813 Water-colour 31.1 x 37.5
(12¼ x 14¾)
H. Andrew Freeth, signed, 1957
Purchased, 1970

HILL, Arthur, 2nd Marquess of
Downshire *See* DOWNSHIRE

HILL, Arthur Trumbull, 3rd
Marquess of Downshire
See DOWNSHIRE

HILL, Clement (1781-1845)
Major-General

3725 *See Collections:* Studies
for The Waterloo Banquet at Apsley
House, 1836, by William Salter,
3689-3769

HILL, David Octavius (1802-70)
Landscape and portrait painter;
pioneer photographer

5049 Canvas 77.5 x 64.1
(30½ x 25¼)
Robert Scott Lauder, 1829
Purchased, 1975

P6(1) Photograph: calotype
19.7 x 13.7 (7¾ x 5⅜)
David Octavius Hill and Robert
Adamson, c.1843
Given by an anonymous donor,
1973
See Collections: The Hill and
Adamson Albums, 1843-8, by
David Octavius Hill and Robert
Adamson, **P6(1-258)**

**P6(2, 98, 100, 103, 141, 143, 155,
221, 227, 228, 237, 238)**
See Collections: The Hill and
Adamson Albums, 1843-8, by
David Octavius Hill and Robert
Adamson, **P6(1-258)**

HILL, Edward (1809-1900)
Honorary Canon of St Albans
Cathedral

P7(4) *See Collections:* Lewis
Carroll at Christ Church, by Charles
Lutwidge Dodgson, **P7(1-37)**

HILL, Mary Amelia, 1st Marchioness
of Salisbury *See* SALISBURY

HILL, Octavia (1838-1912)
Social reformer

3804 Pencil 12.7 x 12.1
(5 x 4¾)
A member of the Barton family,
c.1864
Purchased, 1951

1746 Canvas 101 x 77.5
(39¾ x 30½)
John Singer Sargent, signed,
exh 1899
Bequeathed by the sitter, 1915

HILL, Sir Richard, 2nd Bt
(1732-1808)
Writer of religious pamphlets

1465 Pastel 31.1 x 24.8
(12¼ x 9¾)
John Russell
Given by Sir Edwin Durning-
Lawrence, Bt, 1907

HILL, Rowland (1744-1833)
Evangelical preacher

1464 Pastel 31.1 x 24.8
(12¼ x 9¾)
John Russell, inscribed
Given by Sir Edwin Durning-
Lawrence, Bt, 1907

1401 Plaster cast of bust 50.8
(20) high
Unknown artist
Given by Francis Draper, 1905

HILL, Sir Rowland (1795-1879)
Initiator of penny post

838 Canvas 126.4 x 101.6
(49¾ x 40)
John Alfred Vinter, after a
photograph of c.1879, signed
Given by the sitter's son, Pearson
Hill, 1890

Ormond

HILL, Wills, 1st Marquess of
Downshire *See* DOWNSHIRE

HILLARY, Richard (1919-43)
Spitfire pilot; author of *The
Last Enemy*

5167 Pastel 50.8 x 45.1 (20 x 17¾)
Eric Henri Kennington, signed with
initials and dated 1942
Bequeathed by the sitter's father,
Michael Hillary, 1977

HILLINGDON, Charles Henry Mills,
1st Baron (1830-98) Banker

1833 *See Groups:* Private View of
the Old Masters Exhibition, Royal
Academy, 1888, by Henry Jamyn
Brooks

HILLSBOROUGH, Margaretta,
Countess of (1729-66) First wife
of 1st Marquess of Downshire

L160 *See Groups:* 1st Marquess of
Downshire and his family, by
Arthur Devis

HILTON, William (1786-1839)
History painter

1456(11) Pencil 9.8 x 7.6 ($3\frac{7}{8}$ x 3)
Charles Hutton Lear, inscribed,
c.1839
Given by John Elliot, 1907
See Collections: Drawings of Artists,
c.1845, by Charles Hutton Lear,
1456(1-27)

Ormond

HINTON, John Howard
(1791-1873) Baptist minister

599 *See Groups:* The Anti-Slavery
Society Convention, 1840, by
Benjamin Robert Haydon

HIPKINS, Alfred James
(1826-1903)
Musician and antiquary

2129 Canvas 67.3 x 80
(26½ x 31½)
Edith J.Hipkins (his daughter),
signed, inscribed and dated 1898
Given by the artist, 1926

HIRSCHEL, Solomon (1761-1842)
Chief Rabbi in London

1343 Canvas 127 x 101.6 (50 x 40)
Frederick Benjamin Barlin, c.1802
Given by Archibald Ramsden,1903

HITCHAM, Sir Robert
(1572?-1636) Judge

467 Canvas 109.2 x 87.6
(43 x 34½)
Unknown artist
Given by the Society of Judges
and Serjeants-at-Law, 1877

Strong

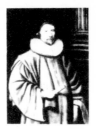

HITCHENS, Ivon (1893-1979)
Painter

P135 Photograph: bromide print
27.6 x 20 (10$\frac{7}{8}$ x 7$\frac{7}{8}$)
John Somerset Murray, c.1933
Purchased, 1979

HOADLY, Benjamin (1676-1761)
Bishop of Winchester and
controversialist

31 Canvas 124.5 x 99.1 (49 x 39)
Sarah Hoadly (his wife)
Purchased, 1858

Kerslake

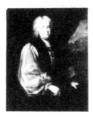

HOADLY, John (1711-76)
Dramatist and chaplain to
Frederick, Prince of Wales

2106 *See under* Maurice Greene

HOARE, Prince (1755-1834)
Painter and dramatist; son of
William Hoare

2515(27) Chalk 37.5 x 27
(14¾ x 10$\frac{5}{8}$)
William Brockedon, dated 1831
Lent by NG, 1959
See Collections: Drawings of
Prominent People, 1823-49, by
William Brockedon, **2515(1-104)**

HOARE, William (1707?-92)
Portrait painter

1437 *See Groups:* The
Academicians of the Royal
Academy, 1771-2, by John Sanders
after Johan Zoffany

HOBART, George Robert, 5th Earl
of Buckinghamshire
See BUCKINGHAMSHIRE

HOBART, Sir Henry, Bt (d.1625)
Chief Justice of Common Pleas

468 Canvas 74.9 x 61 (29½ x 24)
Unknown artist (copy)
Given by the Society of Judges
and Serjeants-at-Law, 1877

Strong

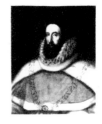

HOBART, Robert, 4th Earl of
Buckinghamshire
See BUCKINGHAMSHIRE

HOBBES, Thomas (1588-1679)
Social philosopher

225 Canvas 66 x 54.6 (26 x 21½)
John Michael Wright, c.1669-70
Given by Sir Walter Trevelyan,
1866

106 Canvas 75.6 x 64.1
(29¾ x 25¼)
After John Michael Wright
(c.1699-70), inscribed
Purchased, 1860

Piper

HOBBS, Sir Jack (1872-1951)
Cricketer

5224(8) Ink 36.5 x 23.5
(14$\frac{3}{8}$ x 9¼)
Robert Stewart Sherriffs, signed,
inscribed and dated 1936
Purchased, 1978
See Collections: Cartoons,
c.1928-c.1936, by Robert Stewart
Sherriffs, **5224(1-9)**

HOBHOUSE, Sir Benjamin, Bt
(1757-1831) Politician

316a(69) Pencil, two sketches
45.1 x 58.4 (17¾ x 23)
Sir Francis Chantrey, inscribed,
1818
Given by Mrs George Jones, 1871
See Collections: Preliminary
drawings for busts and statues by
Sir Francis Chantrey, **316a(1-202)**

HOBHOUSE, John Cam, Baron
Broughton de Gyfford
See BROUGHTON de Gyfford

HOBSON, Thomas (1544?-1631)
The Cambridge Carrier; perpetrator
of 'Hobson's choice'

1972 Canvas 79.7 x 63.2
(31⅜ x 24⅞)
Unknown artist, inscribed
Purchased, 1923. *Montacute*

Strong

HOBSON, William Robert (1831-80)
Naval lieutenant

910 Canvas 39.1 x 32.4
(15⅜ x 12¾)
Stephen Pearce, c.1860
Bequeathed by Lady Franklin, 1892
See Collections: Arctic Explorers,
1850-86, by Stephen Pearce,
905-24 and **1209-27**

Ormond

HOBY, Sir Edward (1560-1617)
Scholar; favourite of James I

1974 Panel 95.3 x 75.6
(37½ x 29¾)
Unknown artist, dated 1583
Purchased, 1923. *Montacute*

Strong

HOCKNEY, David (b.1937)
Artist

5280 With head of Pablo Picasso
(right)
Etching 57.2 x 43.5 (22½ x 17⅛)
Self-portrait, signed, numbered
9/15, and dated 1973 below plate
Purchased, 1979

HODGES, Thomas Law
(1776-1857) MP for Kent West

54 *See Groups:* The House of Com-
mons, 1833, by Sir George Hayter

HODGSON, Brian Houghton
(1800-94) Orientalist and
Indian administrator

1707 Canvas 76.2 x 63.8
(30 x 25⅛)
Louisa Starr-Canziani, exh 1872
Bequeathed by the sitter's widow,
1913

Ormond

HODGSON, Isaac (1783-1847)
Slavery abolitionist

599 *See Groups:* The Anti-Slavery
Society Convention, 1840, by
Benjamin Robert Haydon

HODGSON, John Evan (1831-95)
Painter

P74 Photograph: albumen print
18.7 x 15.2 (7⅜ x 6)
David Wilkie Wynfield, 1860s
Purchased, 1929
See Collections: The St John's
Wood Clique, by David Wilkie
Wynfield, **P70-100**

P91 *See Collections:* The St John's
Wood Clique, by David Wilkie
Wynfield, **P70-100**

1833 *See Groups:* Private View of
the Old Masters Exhibition, Royal
Academy, 1888, by Henry Jamyn
Brooks

HODGSON, Ralph (1871-1962)
Poet

4704 Plaster mould for medallion
10.2 (4) diameter
Theodore Spicer-Simson, inscribed
and dated 1922 on reverse
Purchased, 1970

4704A Bronze cast of no.**4704**
Commissioned, 1970

HOFFMEISTER, Dr

P22(2,24) *See Collections:* The
Balmoral Album, 1854-68, by
George Washington Wilson, W.& D.
Downey, and Henry John Whitlock,
P22(1-27)

HOGARTH, William (1697-1764)
Painter and engraver

121 Terracotta bust 71.1 (28) high
Louis François Roubiliac,c.1741
Purchased, 1861

289 Canvas 45.1 x 42.5
(17¾ x 16¾)
Self-portrait, c.1757
Purchased, 1869

Kerslake

HOGG, James (1770-1835)
Poet; 'The Ettrick Shepherd'

426 Water-colour 23.5 x 21
(9¼ x 8¼)
Charles Fox, 1830
Purchased, 1876

2515(41) Pencil 35.9 x 25.1
(14⅛ x 9⅞)
William Brockedon, dated 1832
Lent by NG, 1959
See Collections: Drawings of
Prominent People, 1823-49, by
William Brockedon, **2515(1-104)**

HOGG, John (1800-69)
Scholar and naturalist

P120(50) Photograph: albumen
print, arched top 19.7 x 14.6
(7¾ x 5¾)
Maull & Polyblank, inscribed on
mount, 1855
Purchased, 1979
See Collections: Literary and
Scientific Men, 1855, by Maull &
Polyblank, **P120(1-54)**

HOGG, Maybird

3845 *See Groups:* Dinner at
Haddo House, 1884, by Alfred
Edward Emslie

HOLCROFT, Thomas (1745-1809)
Dramatist and writer

3130 Canvas 76.2 x 63.5 (30 x 25)
John Opie, c.1782
Bequeathed by Sir Henry Miers,
1943

512 Canvas 76.2 x 63.5 (30 x 25)
John Opie, c.1804
Purchased, 1878

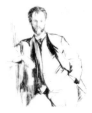

HOLDEN, Charles (1875-1960)
Architect

4427 (study for no.**4173**)
Chalk 38.1 x 27.6 (15 x 10⅞)
Francis Dodd, signed and inscribed,
1915
Purchased, 1964

4173 Etching 31.1 x 24.1
(12¼ x 9½)
Francis Dodd, signed and dated
1915 on plate
Given by relatives and executors of
the sitter, 1960

HOLDSWORTH, Arthur Howe
(1780-1860)
Last governor of Dartmouth

2515(80) *See Collections:*
Drawings of Prominent People,
1823-49, by William Brockedon,
2515(1-104)

HOLKER, Sir John (1828-82)
Judge

2722 Water-colour 35.2 x 18.7
(13⅞ x 7⅜)
Sir Leslie Ward, signed *Spy*
(*VF* 9 Feb 1878)
Purchased, 1934

HOLL, Francis (1815-84)
Engraver

2530 Canvas 83.8 x 71.1 (33 x 28)
Frank Holl (his son)
Given by the sitter's daughter-in-law
and granddaughter, Mrs Edgar Holl
and Mrs Constance M.Baker, 1932

HOLL, Francis Montague (Frank)
(1845-88)
Painter; son of Francis Holl

2531 Canvas 50.8 x 40.6 (20 x 16)
Self-portrait, dated on reverse 1863
Given by the sitter's sister-in-law
and niece, Mrs Edgar Holl and Mrs
Constance M. Baker, 1932

1833 *See Groups:* Private View of
the Old Masters Exhibition, Royal
Academy, 1888, by Henry Jamyn
Brooks

HOLL, William (1771-1838)
Engraver; father of William and
Francis Holl

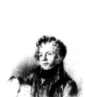

2912 Pencil 22.5 x 18.7 (8⅞ x 7⅜)
Unknown artist, c.1830
Given by the sitter's granddaughter-
in-law and her daughter, Mrs Edgar
Holl and Mrs Constance M. Baker,
1937

HOLL, William (1807-71)
Engraver

2913 Chalk 20.3 x 17.1 (8 x 6¾)
T.W.Harland, signed and dated 1830
Given by the widow of the sitter's
nephew and her daughter, Mrs Edgar
Holl and Mrs Constance M. Baker,
1937

Ormond

HOLLAND, Henry Rich, 1st Earl
of (1590-1649) Courtier

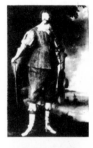

3770 Canvas 221 x 134.6 (87 x 53)
Studio of Daniel Mytens, inscribed,
c.1632-3
Purchased, 1950

1654 Canvas, feigned oval
73.7 x 62.2 (29 x 24½)
After Sir Anthony van Dyck(?)
(c.1640)
Purchased, 1912

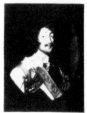

Piper

HOLLAND, Henry Fox, 1st Baron
(1705-74) Whig statesman

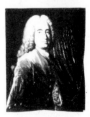

2078 Canvas 75.6 x 62.9
(29¾ x 24¾)
John Giles Eccardt after Jean
Baptiste van Loo
Lent by Lady Teresa Agnew, 1968

2075 Canvas 126.4 x 101
(49¾ x 39¾)
After Sir Joshua Reynolds (c.1762)
Purchased, 1924

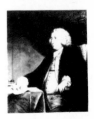

Kerslake

HOLLAND, Henry Richard Vassall
Fox, 3rd Baron (1773-1840)
Whig statesman and patron of art
and letters

3660 Canvas 104.8 x 83.8
(41¼ x 33)
François Xavier Fabre, signed and
dated 1795
Purchased, 1949

2076 *See Groups:* Whig Statesmen
and their Friends, c.1810, by
William Lane

1695(g) *See Collections:* Sketches
for The Trial of Queen Caroline,
1820, by Sir George Hayter,
1695(a-x)

5192 (study for *Groups,* **999**)
Panel 42.9 x 29.5 (16⅞ x 11⅝)
Sir George Hayter, 1820
Given by William Drummond,
Covent Garden Gallery, 1978

999 *See Groups:* The Trial of
Queen Caroline, 1820, by Sir
George Hayter

382 Canvas, oval 75.6 x 63.5
(29¾ x 25)
John Simpson after Charles Robert
Leslie (c.1829)
Given by the sitter's daughter-in-
law, Mrs C.R.Fox, 1873

54 *See Groups:* The House of Com-
mons, 1833, by Sir George Hayter

4914 *See Collections:*
Caricatures of Prominent People,
c.1832-5, by Sir Edwin Landseer,
4914-22

1382 *See Unknown Sitters III*

HOLLAND, Elizabeth Vassall
Fox, Lady (1770-1845)
Wife of 3rd Baron Holland

4914 *See Collections:* Caricatures
of Prominent People, c.1832-5, by
Sir Edwin Landseer, **4914-22**

HOLLAND, Henry Edward Fox,
4th Baron (1802-59) Diplomat

4026(26) *See Collections:*
Drawings of Men about Town,
1832-48, by Alfred, Count D'Orsay,
4026(1-61)

HOLLAND, Charles (1733-69)
Actor

L152(25) Miniature on ivory, oval
4.1 x 3.2 (1⅝ x 1¼)
J.Hutchinson, signed with initials
and dated 1760
Lent by NG (Alan Evans Bequest),
1975

HOLLAND, Sir Henry, Bt
(1788-1873) Physician

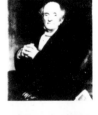

1656 Canvas 76.2 x 63.2
(30 x 24⅞)
Thomas Brigstocke, exh 1860
Given by the sitter's son, Viscount
Knutsford, 1912

1067 Marble bust 70.5 (27¾) high
William Theed, incised and dated
1873
Given by the sitter's son, Viscount
Knutsford, 1896

Ormond

HOLLAND, Henry Thurstan,
1st Viscount Knutsford
See KNUTSFORD

HOLLAND, Sir Nathaniel Dance
See DANCE-HOLLAND

HOLLAR, Wenceslaus (1607-77)
Engraver

1617 *See Unknown Sitters II*

HOLLES, Denzil Holles, 1st Baron
(1599-1680) Statesman

L116 Canvas 75.9 x 63.8
($29\frac{7}{8}$ x $25\frac{1}{8}$)
Unknown artist, inscribed
Lent by the Duke of Portland
1964

HOLLINS, John (1798-1855)
Painter

4710 *See Groups:* A Consultation
prior to the Aerial Voyage to
Weilburg, 1836, by John Hollins

HOLLOND, Robert (1808-77)
Lawyer, politician and aeronaut

4710 *See Groups:* A Consultation
prior to the Aerial Voyage to
Weilburg, 1836, by John Hollins

HOLLOWAY, Sir Charles
(1749-1827) Major-General

1752 *See Groups:* The Siege of
Gibraltar, 1782, by George Carter

HOLMAN, James (1786-1857)
Blind traveller

2515(69) Chalk 35.9 x 26.3
($14\frac{1}{8}$ x $10\frac{3}{8}$)
William Brockedon, dated 1834
Lent by NG, 1959
See Collections: Drawings of
Prominent People, 1823-49, by
William Brockedon, **2515(1-104)**

P106(11) Photograph: albumen
print, arched top 20 x 14.6
($7\frac{7}{8}$ x 5¾)
Maull & Polyblank, c.1855
Purchased, 1978
See Collections: Literary and
Scientific Portrait Club, by Maull &
Polyblank, **P106(1-20)**

HOLMES, Sir Charles John
(1868-1936) Painter and critic;
Director successively of the National
Portrait Gallery and the National
Gallery

3307 Pen and ink 50.8 x 35.2
(20 x $13\frac{7}{8}$)
Powys Evans, pub 1926
Purchased, 1946

3549 Canvas 80.6 x 64.8
(31¾ x 25½)
George Herbert Buckingham
Holland, signed and dated 1934
Purchased, 1947

HOLMES, John (1800-54)
Antiquary

1781A Photograph: daguerreotype
5.7 x 5.1 (2¼ x 2)
After wax medallion by Richard
Cockle Lucas (1849-50)
Given by the sitter's grandson,
Sir Charles John Holmes, 1916

HOLROYD, John, 1st Earl of
Sheffield *See* SHEFFIELD

HOLST, Gustav Theodore
(1874-1934) Composer

4273 Canvas 43.2 x 53.3 (17 x 21)
Millicent Woodforde, 1910
Given by the sitter's widow and
daughter, Mrs Gustav Hoist and
Miss Imogen Holst, 1962

P109 Photograph: bromide print
11.1 x 12.1 ($4\frac{3}{8}$ x 4¾)
Herbert Lambert, autographed on
mount by the sitter
Given by the photographer's
daughter, Mrs Barbara Hardman,
1978
See Collections: Musicians and
Composers, by Herbert Lambert,
P107-11

HOLT, Sir John (1642-1710)
Judge

3101 Canvas 124.5 x 99.7
(49 x 39¼)
Richard van Bleeck, signed and
inscribed, c.1700
Purchased, 1941

Piper

HOLWELL-CARR, William
(1758-1830) Connoisseur

792 *See Groups:* Four studies for
Patrons and Lovers of Art, c.1826,
by Pieter Christoph Wonder, **792-5**

HOLYOAKE, George Jacob
(1817-1906) Secularist,
journalist and lecturer

1810 Canvas 72.4 x 57.8
(28½ x 22¾)
Walter Richard Sickert, signed,
exh 1892
Given by the artist, 1918

HOME, Sir Everard, Bt (1756-1832)
Surgeon

316a(70) Pencil 43.2 x 28.6
(17 x 11¼)
Sir Francis Chantrey, inscribed,
1815-16
Given by Mrs George Jones, 1871
See Collections: Preliminary
drawings for busts and statues by
Sir Francis Chantrey, **316a(1-202)**

HOME, John (1722-1808)
Scottish minister and dramatist

320 Canvas 73.7 x 61 (29 x 24)
Sir Henry Raeburn
Purchased, 1871

HOME, Robert (1752-1834)
Portrait painter

3162 Canvas 76.2 x 65.7
(30 x 25$\frac{7}{8}$)
Self-portrait
Given by his great-great-grand-
daughters, Mrs Ethel Lawrence
and Mrs Ella Day, 1934

HONE, Horace (1756-1825)
Miniaturist; son of Nathaniel Hone

1879 Miniature on ivory, oval
6.7 x 5.1 (2$\frac{5}{8}$ x 2)
Self-portrait, signed in monogram
and dated 1795
Bequeathed by H.V.Metcalfe, 1920

HONE, Nathaniel (1718-84)
Portrait painter and miniaturist

1878 Enamel miniature on copper,
oval 3.2 x 2.8 (1¼ x 1$\frac{1}{8}$)
Self-portrait, signed on reverse
Bequeathed by H.V.Metcalfe, 1920

177 Canvas 74.9 x 61 (29½ x 24)
Self-portrait
Purchased, 1864

1437 *See Groups:* The
Academicians of the Royal
Academy, 1771-2, by John Sanders
after Johan Zoffany

HONE, William (1780-1842)
Bookseller, pamphleteer and
writer

1183 Canvas 75.6 x 63.5
(29¾ x 25)
George Patten, eng 1818
Given by the sitter's daughter,
Mrs Ellen H. Soul, 1899

4259 *See Collections:* George
Cruikshank and others, by George
Cruikshank

HOOD, Samuel Hood, 1st Viscount
(1724-1816) Admiral

745 *See Groups:* William Pitt
addressing the House of Commons
. . . 1793, by Karl Anton Hickel

628 Canvas 127 x 101.6 (50 x 40)
Lemuel Francis Abbott, 1795,
reduced version
Purchased, 1881

HOOD, Alexander, 1st Viscount
Bridport *See* BRIDPORT

HOOD, Sir Horace (1870-1916)
Rear-Admiral

1913 *See Groups:* Naval Officers
of World War I, by Sir Arthur
Stockdale Cope

HOOD, Jane (née Reynolds)
Wife of Thomas Hood

856 (Companion to no.**855**,
Thomas Hood)
Millboard 30.5 x 22.9 (12 x 9)
Unknown artist, c.1832-4
Purchased, 1891

HOOD, Thomas (1799-1845)
Poet and humorist

855 Millboard 30.5 x 22.9 (12 x 9)
Unknown artist, c.1832-4
Purchased, 1891

Ormond

HOOK, James (1746-1827)
Musician

2519 Canvas 76.8 x 64.1
(30¼ x 25¼)
Lemuel Francis Abbott, c.1800
Given by Edward Rimbault Dibdin,
1931

HOOK, James Clarke (1819-1907)
Painter

1456(13) Chalk 4.4 x 5.4
(1¾ x 2⅛)
Charles Hutton Lear, inscribed, 1845
Given by John Elliot, 1907
See Collections: Drawings of Artists,
c.1845, by Charles Hutton Lear,
1456(1-27)

Ormond

HOOK, Theodore Edward
(1788-1841) Novelist and wit

37 Canvas 73.7 x 64.1 (29 x 25¼)
Eden Upton Eddis, eng 1839
Purchased, 1858

2515(101) *See Collections:*
Drawings of Prominent People,
1823-49, by William Brockedon,
2515(1-104)

Ormond

HOOKE, Nathaniel (d.1763)
Historian and writer

68 Canvas 125.7 x 100.3
(49½ x 39½)
Bartholomew Dandridge, signed
Given by Lord Boston, 1859

Kerslake

HOOKER, Sir Joseph Dalton
(1817-1911) Botanist

P106(12) Photograph: albumen
print, arched top 20 x 14.6
(7⅞ x 5¾)
Maull & Polyblank, c.1855
Purchased, 1978
See Collections: Literary and
Scientific Portrait Club, c.1855,
by Maull & Polyblank, **P106(1-20)**

2276 Silvered copper medal 7.6
(3) diameter
Frank Bowcher, inscribed and
dated 1897
Given by the artist, 1929

2033 Wedgwood medallion, oval
9.5 x 6.4 (3¾ x 2½)
Frank Bowcher, incised and dated
1897
Purchased, 1924

4199 Pencil 25.4 x 19.1 (10 x 7½)
Sir William Rothenstein, signed with
initials, inscribed and dated 1903
Given by Sir Geoffrey Keynes, 1961

HOOKER, Richard (1554?-1600)
Theologian

844 *See Unknown Sitters I*

HOOKER, Sir William Jackson
(1785-1865) Botanist

1673 Plaster cast of bust 62.9
(24¾) high
Thomas Woolner, incised and
dated 1859
Purchased, 1912

1032 Wedgwood medallion, oval
32.4 x 27 (12¾ x 10⅝)
Thomas Woolner, incised on reverse,
1866
Given by the sitter's nephew,
Francis Turner Palgrave, 1896

Ormond

HOOLE, John (1727-1803)
Writer and translator

1143 Pencil 30.5 x 22.2 (12 x 8¾)
George Dance, signed and dated
1793
Purchased, 1898

3089(9) *See Collections:* Tracings
of drawings by George Dance,
3089(1-12)

HOPE, Anthony
See HAWKINS, Sir Anthony Hope

HOPE, Thomas (1770-1831)
Collector, virtuoso and writer

4574 Canvas 221.6 x 168.9
(87¼ x 66½)
Sir William Beechey, exh 1799
Purchased, 1967

HOPKINS, Arthur (1848-1930)
Illustrator; landscape and coastal
painter

4405 *See Groups:* Primrose Hill
School, 1893, by an unknown
artist

4404 *See Groups:* The St John's
Wood Arts Club, 1895, by Sydney
Prior Hall

HOPKINS, Gerard Manley
(1845-89) Poet

4264 Water-colour 21.6 x 17.8
(8½ x 7)
Anne Eleanor Hopkins (his aunt),
signed with initials and dated 1859
Given by Edward Manley Hopkins,
1962

HOPKINS, Thomas (d.1720)
Financier

3212 Canvas 91.4 x 71.1 (36 x 28)
Sir Godfrey Kneller, signed and
dated 1715
Kit-cat Club portrait
Given by NACF, 1945.
Beningbrough

Piper

HOPKINSON, Sir Alfred
(1851-1939) Lawyer,
educationalist and politician

4779 Lithographic chalk
29.8 x 24.4 (11¾ x 9⅝)
Sir William Rothenstein, c.1899
Purchased, 1970

P130 Photograph: bromide print
40 x 31.1 (15¾ x 12¼)
Lucia Moholy, 1937
Purchased, 1979
See Collections: Prominent People,
1935-8, by Lucia Moholy, **P127-33**

HOPTON of Stratton, Ralph
Hopton, 1st Baron (1598-1652)
Royalist general

494 Canvas 127 x 102.9
(50 x 40½)
After an unknown artist (c.1637),
inscribed
Purchased, 1877

Piper

HORE-BELISHA, Leslie
Hore-Belisha, Baron (1893-1957)
Politician

4860 Canvas 88.9 x 73.7 (35 x 29)
Clarence White, signed and dated
1936
Purchased, 1972

HORN, Charles Edward
(1786-1849) Singer and composer

5189 Canvas 85.9 x 59.3
($33\frac{7}{8}$ x $23\frac{3}{8}$)
Peter Eduard Ströhling, inscribed
Purchased, 1978

HORNBY, Charles Harry St John
(1867-1946)
Printer and connoisseur

3872 Sanguine and white chalk
51.1 x 38.1 ($20\frac{1}{8}$ x 15)
Sir William Rothenstein, signed and
dated 1923
Given by the Rothenstein Memorial
Trust, 1953

HORNBY, James John (1826-1909)
Headmaster and Provost of Eton

3105 Water-colour 36.5 x 20.3
($14\frac{3}{8}$ x 8)
Sir Leslie Ward, signed *Spy*
(*VF* 31 Jan 1901)
Purchased, 1942

HORNE, Henry Sinclair Horne,
Baron (1861-1929) General

2908(4) *See Collections:* Studies,
mainly for General Officers of
World War I, by John Singer
Sargent, **2908(1-8)**

1954 *See Groups:* General Officers
of World War I, by John Singer
Sargent

HORNE, Richard Henry
(or Hengist) (1803-84) Writer

2168 Panel 30.5 x 24.1 (12 x 9½)
Margaret Gillies, c.1840
Given by Mrs Henry Buxton
Forman and Maurice Buxton
Forman, 1934

2682 Plaster cast of medallion
22.9 (9) diameter
Charles Summers
Given by Maurice Buxton Forman,
1934

Ormond

HORNE, Sir William (1774-1860)
Master in Chancery and politician

54 *See Groups:* The House of Commons, 1833, by Sir George Hayter

HORNER, Francis (1778-1817)
Political economist

2677 Pencil and chalk 35.6 x 31.8
(14 x 12½)
John Henning, c.1806
Given by wish of the sitter's great-
nephew, Francis Horner Lyell, 1934

2678 Wax medallion 14 (5½)
diameter
John Henning, incised and dated
1806
Given by wish of the sitter's great-
nephew, Francis Horner Lyell, 1934

485 Canvas 128.9 x 101.6
(50¾ x 40)
Sir Henry Raeburn, 1812
Given by wish of the sitter's
brother, Leonard Horner, 1877

HORNIMAN, Annie Elizabeth
Fredericka (1860-1937)
Pioneer of repertory theatre

3973 Chalk 28.6 x 21
(11¼ x 8¼)
Flora Lion, signed and inscribed
Purchased, 1956

HORSLEY, John Callcott
(1817-1903) Painter

3182(2) *See Collections*:
Drawings of Artists, c.1862, by
Charles West Cope, **3182(1-19)**

1833 *See Groups*: Private View
of the Old Masters Exhibition,
Royal Academy, 1888, by Henry
Jamyn Brooks

4245 *See Groups*: Hanging
Committee, Royal Academy, 1892,
by Reginald Cleaver

HORSLEY, Samuel (1733-1806)
Bishop of St Asaph; Secretary of
the Royal Society

155 Miniature on ivory, oval
8.6 x 6.7 (3⅜ x 2⅝)
Walter Stephens Lethbridge
Purchased, 1863

HORSLEY, William (1774-1858)
Composer, organist and founder of
the Philharmonic Society

1655 Canvas 92.1 x 71.1
(36¼ x 28)
William Owen, c.1801
Bequeathed by the sitter's son,
John Callcot Horsley, 1912

HORWITZ, Bernhard (1807-85)
Chess player

3060 *See Groups*: Chess players,
by A. Rosenbaum

HOSTE, Sir George Charles
(1786-1845) Colonel

3726 *See Collections*: Studies for
The Waterloo Banquet at Apsley
House, 1836, by William Salter,
3689-3769

HOTHAM, Beaumont Hotham,
3rd Baron (1794-1870) General

54 *See Groups*:The House of Com-
mons, 1833, by Sir George Hayter

3727 *See Collections*: Studies for
The Waterloo Banquet at Apsley
House, 1836, by William Salter,
3689-3769

HOTHAM, Sir John, Bt (d.1645)
Parliamentarian

4364 Silver medal 3.2 (1¼)
diameter
Probably by Thomas Simon,
inscribed, 1645
Purchased, 1964

HOUGH, John (1651-1743)
Bishop of Worcester

3685 Miniature on vellum, oval
7.9 x 6.4 (3⅛ x 2½)
Simon Digby
Given by Winchester Museums and
Library Committee, 1950

Kerslake

HOUGHTON, Richard Monckton
Milnes, 1st Baron (1809-85)
Politician and poet

3824 Chalk 62.9 x 47.6
(24¾ x 18¾)
George Richmond, c.1844
Given by the sitter's daughter-in-
law, the Marchioness of Crewe,
1952

2723 Water-colour 29.8 x 18.1
(11¾ x 7⅛)
Carlo Pellegrini, signed *Ape*
(*VF* 3 Sept 1870)
Purchased, 1934

HOUSMAN, Alfred Edward
(1859-1936)
Poet and classical scholar

3873 Sanguine and black chalk
38.1 x 27.6 (15 x 10⅞)
Sir William Rothenstein, signed
with initials and dated 1906
Given by the Rothenstein Memorial
Trust, 1953

2051 *See Collections*: Medallions
of Writers, c.1922, by Theodore
Spicer-Simson, **2043-55**

3075 Pencil 37.5 x 27.3
(14¾ x 10¾)
Francis Dodd, signed, inscribed and
dated 1926
Purchased, 1939

HOUSMAN, Laurence (1865-1959)
Writer

4816 Wooden bust 17.8 (7) high
Alec Miller, c.1924
Given by the artist's widow, 1970

HOWARD of Effingham, Lord
See NOTTINGHAM

HOWARD, Charles, 3rd Earl of
Carlisle See CARLISLE

HOWARD, Edward Charles
(1774-1816) Sugar refiner

1075, 1075a and **b** See Groups:
Men of Science Living in 1807-8,
by Sir John Gilbert and others

HOWARD, Frances, Countess of
Somerset See SOMERSET

HOWARD, George William
Frederick, 7th Earl of Carlisle
See CARLISLE

HOWARD, Henrietta, Countess of
Suffolk See SUFFOLK

HOWARD, Henry, 4th Earl of
Carlisle See CARLISLE

HOWARD, Henry, 6th Duke of
Norfolk See NORFOLK

HOWARD, Henry, 1st Earl of
Northampton
See NORTHAMPTON

HOWARD, Henry, Earl of Surrey
See SURREY

HOWARD, Henry Charles,
13th Duke of Norfolk
See NORFOLK

HOWARD, John (1726?-90)
Prison reformer

97 Canvas, feigned oval
70.5 x 58.4 (27¾ x 23)
Mather Brown
Purchased, 1860

HOWARD, Kenneth Alexander,
1st Earl of Effingham
See EFFINGHAM

HOWARD, Leslie (1893-1943)
Actor

3827 Canvas 49.5 x 39.4
(19½ x 15½)
Reginald Grenville Eves, signed
Purchased, 1952

HOWARD, Philip Henry (1801-83)
MP for Carlisle

54 See Groups: The House of Com-
mons, 1833, by Sir George Hayter

HOWARD, Philip Thomas
(1629-94) Cardinal

245 Copper miniature, oval
9.8 x 7.3 ($3\frac{7}{8}$ x $2\frac{7}{8}$)
Unknown artist (copy)
Purchased, 1867

Piper

HOWARD, Thomas, 2nd Earl of
Arundel and Surrey
See ARUNDEL AND SURREY

HOWARD, Thomas, 4th Duke of
Norfolk See NORFOLK

HOWARD, Thomas, 1st Baron
Howard de Walden and 1st Earl of
Suffolk See SUFFOLK

HOWARD, William, 1st Viscount Stafford *See* STAFFORD

HOWE, Richard Howe, 1st Earl (1725-99) Admiral

3313 Wax relief 10.2 x 7.6 (4 x 3) After John de Vaere (1798), incised Purchased, 1946

75 Canvas 56.5 x 39.4 (22½ x 15½) Henry Singleton, eng 1799 Purchased, 1859

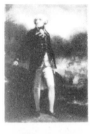

HOWE, John (1630-1705 Puritan divine

265 Canvas, feigned oval 74.9 x 62.2 (29½ x 24½) After Sir Godfrey Kneller, inscribed (c.1690-1700) Purchased, 1868

Piper

HOWELLS, Herbert (b.1892) Composer

5209 Canvas 101.3 x 75.9 (39$\frac{7}{8}$ x 29$\frac{7}{8}$) Howard Morgan, signed and dated 1978 Given by the Royal College of Music, 1978

HOWLEY, William (1766-1848) Archbishop of Canterbury

999 *See Groups*: The Trial of Queen Caroline, 1820, by Sir George Hayter

1552 Canvas 125.1 x 99.7 (49¼ x 39¼) William Owen, c.1823-5 Purchased, 1909

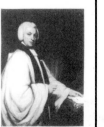

54 *See Groups*: The House of Commons, 1833, by Sir George Hayter

HOWORTH, Sir Henry Hoyle (1842-1923) Historian and archaeologist

3469 *See Collections*: Prominent Men, c.1880-c.1910, by Harry Furniss, **3337-3535** and **3554-3620**

HUCKS, William (d.1740) Brewer; MP for Wallingford

926 *See Groups*: The Committy of the house of Commons (the Gaols Committee), by William Hogarth

HUDDART, Joseph (1741-1816) Hydrographer and manufacturer

1075, 1075a and **b** *See Groups*: Men of Science Living in 1807-8, by Sir John Gilbert and others

HUDDLESTON, Sir John Walter (1815-90) Judge

2724 Water-colour 28.9 x 17.5 (11$\frac{3}{8}$ x 6$\frac{7}{8}$) Carlo Pellegrini, signed *Ape* (*VF* 28 Feb 1874) Purchased, 1934

1410 Canvas 125.1 x 99.7 (49¼ x 39¼) Frank Holl, signed and dated 1888 Bequeathed by the sitter's widow, 1905

2173(9) *See Collections*: Book of sketches by Sebastian Evans, **2173(1-70)**

HUDSON, Jeffrey (1619?-82) Dwarf; favourite of Queen Henrietta Maria

1591 *See Unknown Sitters II*

HUDSON, Robert

P106(13) *See Collections*:
Literary and Scientific Portrait
Club, by Maull & Polyblank,
P106(1-20)

HUDSON, Thomas (1772-1852)
MP for Evesham

54 *See Groups*:The House of Com-
mons, 1833, by Sir George Hayter

HUDSON, William Henry
(1841-1922)
Ornithologist and writer

1965 Canvas 54.1 x 41.3
(20¼ x 16¼)
Sir William Rothenstein
Given by a Memorial Committee,
1923

2052 *See Collections*: Medallions
of Writers, c.1922, by Theodore
Spicer-Simson, **2043-55**

HUGGINS, Sir William
(1824-1910) Astronomer

1682 Canvas 90.2 x 69.9
(35½ x 27½)
John Collier, signed, inscribed and
dated 1905, replica
Given by the sitter's widow, 1912

HUGHES, Arthur (1832-1915)
Painter

2759 Millboard 15.2 x 12.7 (6 x 5)
Self-portrait, inscribed and dated
1851
Given by his daughter, Miss E.
Hughes, 1935

P30 Photograph: albumen print
20.6 x 14.9 ($8\frac{1}{8}$ x $5\frac{7}{8}$)
Possibly by W. & D. Downey,
autographed by sitter on separate
label, c.1860s
Purchased, 1977

HUGHES, Christopher
316a(71) *See Collections*:
Preliminary drawings for busts and
statues by Sir Francis Chantrey,
316a(1-202)

HUGHES, Edward Hughes Ball
(d. 1863) Gamester; known as
'Golden Ball'

4026(36) Pencil and chalk
17.88 x 13.3 (7 x 5¼)
Alfred, Count D'Orsay, signed and
inscribed
Purchased, 1957
See Collections: Drawings of Men
about Town, 1832-48, by Alfred,
Count D'Orsay, **4026(1-61)**

Ormond

HUGHES, Sir Edwin (1832-1904)
MP for Woolwich

2390 *See Collections*:
Miscellaneous drawings . . . by
Sydney Prior Hall, **2282-2348** and
2370-90

HUGHES, Seymour Ball
Son of Edward Hughes Ball Hughes

4026(35) *See Collections*:
Drawings of Men about Town,
1832-48, by Alfred, Count D'Orsay,
4026(1-61)

HUGHES, Thomas (1822-96)
Author of *Tom Brown's Schooldays*

L122 Plaster statuette 76.2 (30)
high
Sir Joseph Edgar Boehm, incised,
exh 1871
Lent by Mrs Brinsley Ford, 1964

HUGHES, William Morris
(1864-1952)
Prime Minister of Australia

2463 *See Groups*: Statesmen of
World War I, by Sir James Guthrie

HUGO, Colonel

1752 *See Groups*: The Siege of Gibraltar, 1782, by George Carter

HULL, Thomas (1728-1808)
Actor and playwright

4625 Canvas 76.5 x 61.6 (30⅛ x 24¼)
Unknown artist, inscribed
Purchased, 1977

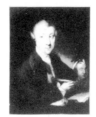

3899 Pencil 25.4 x 19.1 (10 x 7½)
George Dance, signed and dated 1799
Purchased 1954

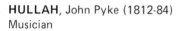

HULLAH, John Pyke (1812-84)
Musician

1348 Pencil 20.3 x 15.9 (8 x 6¼)
Sir William Blake Richmond, signed and dated 1859
Given by the sitter's son, Francis Hullah, and family, 1903

HUMBOLDT, Friedrich Heinrich Alexander, Baron (1769-1859)
German naturalist

2515(38) *See Collections*:
Drawings of Prominent People, 1823-49, by William Brockedon, **2515(1-104)**

HUME, Sir Abraham, Bt (1749-1838) Connoisseur

793 *See Groups*: Four studies for Patrons and Lovers of Art, by Pieter Christoph Wonder, **792-5**

HUME, David (1711-76)
Philosopher and historian

4897 Glass paste medallion, oval 10.2 x 7.6 (4 x 3)
James Tassie, incised *T* and
DAVID HUME
Purchased, 1972

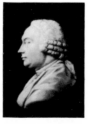

HUME, Joseph (1777-1855)
Leader of the Radical Party

54 *See Groups*:The House of Commons, 1833, by Sir George Hayter

1098 Chalk 47.3 x 37.5 (18⅝ x 14¾)
Charles Blair Leighton, signed, 1849-50
Given by Edward Hutchins, 1897

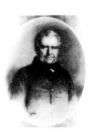

713 Canvas 155.3 x 113.7 (61⅛ x 44¾)
John Whitehead Walton, signed and dated 1854
Bequeathed by the sitter's nephew, Joseph Glen, 1884

Ormond

HUMPHERY, John (1794-1863)
MP for Southwark

54 *See Groups*:The House of Commons, 1833, by Sir George Hayter

HUMPHERY, Mary Catherine (née Alderson), Lady

P18(92a) *See Collections*: The Herschel Album, by Julia Margaret Cameron, **P18(1-92b)**

HUNT, Henry (1773-1835)
Radical politician and demagogue

956 Water-colour 21 x 16.2 (8¼ x 6⅜)
Adam Buck, c.1810
Given by Henry Willett, 1894

957 Water-colour 31.5 x 23.2 (12⅜ x 9⅛)
J. Wiche, eng 1822
Given by Henry Willett, 1894

HUNT, James Henry Leigh
(1784-1859) Poet, essayist and critic

293 Canvas 61 x 50.2 (24 x 19¾)
Benjamin Robert Haydon, c.1811
Purchased, 1869

4505 Pencil 21 x 16.5 (8¼ x 6½)
Thomas Charles Wageman, 1815
Given by members of the Gigliucci
family, 1966

2508 Canvas 111.8 x 90.5
(44 x 35⅝)
Samuel Laurence, c.1837
Given by Mrs M.E. Leigh Hunt,
widow of the sitter's great-grandson,
1931

1267 Miniature on ivory
22.5 x 14.9 (8⅞ x 5⅞)
Margaret Gillies, 1838 (completed
1846)
Given by Alfred Ainger, 1900

HUNT, Robert (d. 1850)
Journalist, artist and actor; brother
of James Henry Leigh Hunt

4523 Pencil 23.2 x 18.4
(9⅛ x 7¼)
John Linnell, signed, inscribed and
dated 1819
Given by Sir Geoffrey Keynes,
1966

HUNT, Thornton Leigh (1810-73)
Journalist; son of James Henry
Leigh Hunt

4686 *See Groups*: Mr and Mrs
George Henry Lewes with
Thornton Leigh Hunt, by William
Makepeace Thackeray

HUNT, William Henry (1790-1864)
Painter and water-colourist

2636 Water-colour 37.5 x 27.9
(14¾ x 11)
Self-portrait
Bequeathed by Henry Sutton
Palmer, 1933

768 Oil on paper 13.3 x 10.8
(5¼ x 4¼)
Self-portrait, signed
Given by the Earl of Leven and
Melville, 1887

Ormond

HUNT, William Holman
(1827-1910) Pre-Raphaelite painter

P75 Photograph: albumen print
21.3 x 16.2 (8⅜ x 6⅜)
David Wilkie Wynfield, 1860s
Purchased, 1979
See Collections: The St John's
Wood Clique, by David Wilkie
Wynfield, **P70-100**

P18(11) Photograph: albumen
print 26 x 20.6 (10¼ x 8⅛)
Julia Margaret Cameron, May 1864
Purchased with help from public
appeal, 1975
See Collections: The Herschel
Album, by Julia Margaret Cameron,
P18(1-92b)

P18(23) *See Collections*: The
Herschel Album, by Julia Margaret
Cameron, **P18(1-92b)**

2555 Canvas 61 x 71.1 (24 x 28)
John Ballantyne, signed, 1865
Purchased, 1932

1901 Canvas 59.7 x 48.9
(23½ x 19¼)
Sir William Blake Richmond,
c.1877
Bequeathed by the artist, 1922

1833 *See Groups*: Private View of
the Old Masters Exhibition, Royal
Academy, 1888, by Henry Jamyn
Brooks

Continued overleaf

2803 Canvas 61 x 50.8 (24 x 20)
Sir William Blake Richmond,
c.1897
Given by the sitter's daughter,
Mrs Michael Joseph, 1936

HUNTER, Sir Archibald
(1856-1936) General

5126 Water-colour 38.1 x 27.6
(15 x 10$\frac{7}{8}$)
Sir Leslie Ward, signed *Spy* and
inscribed
(*VF* 27 April 1899)
Purchased, 1977

HUNTER, John (1728-93)
Surgeon and anatomist

1712 Plaster cast of life-mask
21.6 (8½) long
After an unknown artist (c.1785)
Given by Brucciani & Co, 1913

4288 Bronze cast of no.**1712**
Given by the Royal College of
Surgeons of England, 1962.
Not illustrated

77 Canvas 141 x 190.9
(55½ x 43¼)
John Jackson after Sir Joshua
Reynolds (1786)
Purchased, 1859

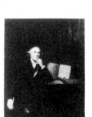

HUNTER, William (1718-83)
Anatomist

1437 *See Groups*: The
Academicians of the Royal
Academy, 1771-2, by John Sanders
after Johan Zoffany

HUNTER-BLAIR, Thomas
(d. 1849) Colonel

3698 *See Collections*: Studies for
The Waterloo Banquet at Apsley
House, 1836, by William Salter,
3689-3769

HUNTINGDON, Henry Hastings,
3rd Earl of (1536-95) Statesman

1574 Panel 55.9 x 42.2 (22 x 16$\frac{5}{8}$)
Unknown artist, inscribed
Purchased, 1910

Strong

HUNTINGDON, Selina Hastings,
Countess of (1707-91) Friend and
benefactor of Methodist movement

4224 Oil on card 56.5 x 43.8
(22¼ x 17¼)
Unknown artist
Given by John St C.Elkington, 1961

HUNTINGTON, William
(1745-1813) Coalheaver and
eccentric preacher

141 Canvas 128 x 102.2
(50$\frac{3}{8}$ x 40¼)
Domenico Pellegrini, signed and
dated 1803
Given by William Stevens, 1862

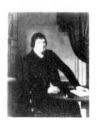

95 *See Unknown Sitters III*

HUNTLY, George Gordon,
9th Marquess of (1761-1853)
Lieutenant-Colonel

999 *See Groups*: The Trial of
Queen Caroline, 1820, by Sir
George Hayter

HUSKISSON, William (1770-1830)
Statesman

21 Canvas 91.4 x 71.1 (36 x 28)
Richard Rothwell, replica (1830)
Purchased, 1857

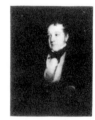

HUTCHINSON, Henry Doveton
(1827-1924) Lieutenant-General
and military historian

4607 Water-colour 36.8 x 26.3
(14½ x 10$\frac{3}{8}$)
Sir Leslie Ward, signed *Spy*
(*VF* 8 Sept 1904)
Purchased, 1968

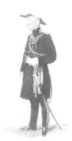

HUTTON, Henry (1760-1836)
Barrister; Recorder of Lincoln

2768 Canvas 74.6 x 60.3
(29⅜ x 23¾)
Sir William Beechey
Given by J. Kent Richardson, 1934

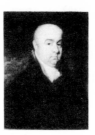

HUXLEY, Aldous (1894-1963)
Novelist

4485 Ink 35.6 x 25.4 (14 x 10)
Alfred Wolmark, signed, inscribed
and dated 1928
Purchased, 1966

4529(175) Pencil 23.2 x 17.8
(9⅛ x 7)
Sir David Low, c.1933
Purchased, 1967
See Collections: Working drawings
by Sir David Low, **4529(1-401)**

4529(173, 174, 176) *See
Collections*: Working drawings by
Sir David Low, **4529(1-401)**

HUXLEY, Sir Julian (1887-1975)
Biologist and writer

5041 Chalk 58.1 x 38.9
(22⅞ x 15⅜)
Rupert Shephard, signed, inscribed
and dated 1960
Purchased, 1975

HUXLEY, Thomas Henry (1825-95)
Scientist and educationalist

1528 Pencil 22.9 x 26 (9 x 10¼)
Theodore Blake Wirgman, signed
and dated 1882
Given by the artist, 1909

3168 Canvas 127 x 101.6 (50 x 40)
John Collier (his son-in-law), signed
and dated 1883
Given by the sitter's son, Henry
Huxley, 1943

3145 Pencil 19.1 x 12.7 (7½ x 5)
Marian Collier (his daughter)
Purchased, 1943

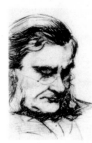

3147 Pencil 17.8 x 12.7 (7 x 5)
Marian Collier (his daughter),
signed with initials
Purchased, 1943

1330 Plaster cast of bust 76.2
(30) high
Edward Onslow Ford
Purchased, 1902

HYDE, Anne, Duchess of York
See YORK

HYDE, Catherine, Duchess of
Queensberry *See* QUEENSBERRY

HYDE, Edward, 1st Earl of
Clarendon *See* CLARENDON

HYDE, Laurence, 1st Earl of
Rochester *See* ROCHESTER

HYDE, Sir Nicholas (d. 1631)
Chief Justice of England

461 *See Unknown Sitters I*

HYLTON, William Joliffe,
1st Baron (1800-76) Politician

54 *See Groups*: The House of Com-
mons, 1833, by Sir George Hayter

HYLTON, Jack (1892-1965)
Impresario

4529(177-80) *See Collections*:
Working drawings by Sir David
Low, **4529(1-401)**

HYNDMAN, Henry Mayers
(1842-1921) Socialist leader

1947 Bronze cast of bust 51.4
(20¼) high
Edward Hill Lacey, 1922
Given by a Memorial Committee,
1922

HYSING, Hans (1678-1752/3)
Portrait painter

1384 *See Groups*: A Conversation
of Virtuosis at the Kings Armes (A
Club of Artists), by Gawen
Hamilton

IBBETSON, Bella (née Thompson)
(c.1782-1839) Second wife of
Julius Caesar Ibbetson

L152(6) (Companion to no.
L152(5), Julius Caesar Ibbetson)
Panel 35.6 x 27.3 (14 x 10¾)
Julius Caesar Ibbetson, 1803
Lent by NG (Alan Evans Bequest),
1974

IBBETSON, Julius Caesar
(1759-1817) Landscape painter

L152(5) Canvas 36.5 x 27.3
$(14\frac{3}{8} \times 10\frac{3}{4})$
Self-portrait, signed and dated 1804
Lent by NG (Alan Evans Bequest),
1974

IDDESLEIGH, Stafford Henry
Northcote, 1st Earl of (1818-87)
Statesman

4893 *See Groups*: The Derby
Cabinet of 1867, by Henry Gales

2944 Canvas 125.7 x 91.4
(49½ x 36)
Edwin Long, signed in monogram
and dated 1882
Given by Viscount Hambleden,
1938

820 Canvas 120 x 80 (47½ x 31½)
Edwin Long, signed in monogram
and dated 1889, replica (c.1882)
Given by a Memorial Committee,
1889

861 Plaster cast of bust 47 (18½)
high
Sir Joseph Edgar Boehm, 1887
Purchased, 1891

3396 *See Collections*: Prominent
Men, c.1880-c.1910, by Harry
Furniss, **3337-3535** and **3554-3620**

ILBERT, Sir Courtenay Peregrine
(1841-1924) Parliamentary
draftsman

2245 Pencil 16.5 x 12.4 $(6\frac{1}{2} \times 4\frac{7}{8})$
Sydney Prior Hall, inscribed, 1889
Given by the artist's son, Harry
Reginald Holland Hall, 1928
See Collections: The Parnell
Commission, 1888-9, by Sydney
Prior Hall, **2229-72**

IMPEY, Sir Elijah (1732-1809)
Chief Justice of Bengal

335 Canvas 123.8 x 97.8
(48¾ x 38½)
Johan Zoffany
Bequeathed by the sitter's godson,
Sir Roderick Impey Murchison, Bt,
1872

821 Pastel, oval 30.5 x 25.4
(12 x 10)
Sir Thomas Lawrence, 1786
Given by William Hartree and
family, 1889

INCHBALD, Elizabeth (1753-1821)
Actress and writer

1144 Pencil 25.4 x 19.1 (10 x 7½)
George Dance, signed and dated
1794
Purchased, 1898

INCHCAPE, James Lyle Mackay,
1st Earl of (1852-1932)
Shipowner and company director

3470 *See Collections*: Prominent
Men, c.1880-c.1910, by Harry
Furniss, **3337-3535** and **3554-3620**

INCLEDON, Charles (1763-1826)
Singer and actor

1145 Pencil and red chalk
25.4 x 19.7 (10 x 7¾)
George Dance, signed and dated
1798
Purchased, 1898

INGE, William Ralph (1860-1954)
Dean of St Paul's

4529(181, 182) *See Collections*:
Working drawings by Sir David Low,
4529(1-401)

3920 Canvas 109.9 x 85.1
(43¼ x 33½)
Arthur Norris, signed, exh 1934
Purchased, 1954

4856 Canvas 92.1 x 71.8
(36¼ x 28¼)
Philip de Laszlo, signed and dated
1934
Given by wish of the sitter, 1971

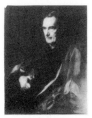

INGHAM, Sir James Taylor
(1805-90) Police magistrate

2247 Pencil 20 x 25.1 ($7\frac{7}{8}$ x $9\frac{7}{8}$)
Sydney Prior Hall, inscribed and
dated *Feb 13* (1889)
Given by the artist's son, Harry
Reginald Holland Hall, 1928
See Collections: The Parnell
Commission, 1888-9, by Sydney
Prior Hall, **2229-72**

INGHAM, Robert (1793-1875)
MP for South Shields

54 *See Groups*:The House of Com-
mons, 1833, by Sir George Hayter

INGLEFIELD, Sir Edward
Augustus (1820-94) Admiral

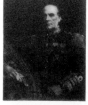

1223 Canvas 39.1 x 33.7
($15\frac{3}{8}$ x 13¼)
Stephen Pearce, signed on reverse,
exh 1853
Bequeathed by John Barrow, 1899
See Collections: Arctic Explorers,
1850-86, by Stephen Pearce,
905-24 and **1209-27**

921 *See Collections*: Arctic
Explorers, 1850-86, by Stephen
Pearce, **905-24** and **1209-27**

2500 Canvas 96.5 x 79 (38 x $31\frac{1}{8}$)
John Collier, signed, 1897
Bequeathed by the sitter's son,
Henry Beaufort Inglefield, 1931

Ormond

INGLIS, Charles (1734-1816)
First Bishop of Nova Scotia

1023 Canvas 109.2 x 88.9
(43 x 35)
Robert Field, signed, inscribed and
dated 1810
Given by the sitter's grandson,
Thomas Cochran Inglis, 1895

INGLIS, James (1813-51)
Physician

P6(37) *See Collections*: The Hill
and Adamson Albums, 1843-8, by
David Octavius Hill and Robert
Adamson, **P6(1-258)**

INGLIS, Sir Robert, Bt
(1786-1855) Tory politician

4968 (study for *Groups*, **54**)
Board 40 x 34.6 (15¾ x 13⅝)
Sir George Hayter
Purchased, 1974

54 *See Groups*:The House of Commons, 1833, by Sir George Hayter

1062 Chalk 61.3 x 47 (24⅛ x 18½)
George Richmond, signed and
inscribed, 1845
Purchased, 1896

Ormond

INNES, James Dickson (1887-1914)
Landscape painter

3054 Pencil 19.7 x 17.1 (7¾ x 6¾)
Albert Rutherston, signed,
inscribed and dated 1908
Purchased, 1939

4382 Pencil 22.9 x 21.6 (9 x 8½)
Ian Strang, signed and dated 1913
Purchased, 1964

INNES-KER, Lord Charles John
(1842-1919) Son of Duke of
Roxburghe

4721 Water-colour 31.8 x 18.1
(12½ x 7⅛)
Sir Leslie Ward, signed *Spy*
(*VF* 20 March 1886)
Purchased, 1970

IRELAND, John (1761-1842)
Dean of Westminster

316a(72) *See Collections*:
Preliminary drawings for busts and
statues by Sir Francis Chantrey,
316a(1-202)

IRELAND, John (1879-1962)
Composer

P105 Photograph: bromide print
15.9 x 11.4 (6¼ x 4½)
Herbert Lambert, inscribed on
print, c.1920
Purchased, 1978

4290 Canvas 66.3 x 50.8
(26⅛ x 20)
Guy Lindsay Roddon, signed and
dated 1960
Purchased, 1962

IRELAND, Samuel (d. 1800)
Writer and engraver

4302 Pastel, oval 26.7 x 21
(10½ x 8¼)
Hugh Douglas Hamilton, 1776
Purchased, 1963

IRETON, Henry (1611-51)
Parliamentary general

3301 Canvas 124.5 x 100.3
(49 x 39½)
Attributed to Robert Walker after
Samuel Cooper and Sir Anthony
van Dyck
Purchased, 1945

33 *See Unknown Sitters II*

Piper

IRVING, David (1778-1860)
Biographer

P6(77) Photograph: calotype
20 x 13.6 (7⅞ x 5⅜)
David Octavius Hill and Robert
Adamson, 1843-8
Given by an anonymous donor,
1973
See Collections: The Hill and
Adamson Albums, 1843-8, by
David Octavius Hill and Robert
Adamson, **P6(1-258)**

IRVING, Edward (1792-1834)
Scottish minister

2757 Water-colour 72.4 x 53.3
(28½ x 21)
Unknown artist, c.1823
Given by the sitter's granddaughter,
Miss Margaret Gardiner, 1935

424 Pencil 22.6 x 17.5 ($8\frac{7}{8}$ x $6\frac{7}{8}$)
Joseph Slater, c.1825
Purchased, 1876

1689 Wax relief, oval 13 x 11.4
($5\frac{1}{8}$ x 4½)
Unknown artist
Purchased, 1912

IRVING, Sir Henry (1838-1905)
Actor-manager

1560 Canvas 43.2 x 45.7 (17 x 18)
Jules Bastien-Lepage, 1880
Given by Dame Ellen Terry, 1910

5073 Water-colour 56.2 x 34
($22\frac{1}{8}$ x $13\frac{3}{8}$)
Carlo Pellegrini, signed *Ape*
Acquired, 1976

1453 Canvas 109.2 x 78.7
(43 x 31)
Harry Allen after Sir John Everett
Millais (c.1884)
Given by the Garrick Club, 1907

2820 *See Groups*: The Royal
Academy Conversazione, 1891, by
G. Grenville Manton

3679 Pencil 14.6 x 18.7 ($5\frac{3}{4}$ x $7\frac{3}{8}$)
Phil May, signed, inscribed and
dated 1899
Given by Miss Margaret Shields,
1949

3680 Pencil 14 x 8.9 (5½ x 3½)
Phil May, signed, 1899
Given by Miss Margaret Shields,
1949

3681 Pencil 14 x 8.9 (5½ x 3½)
Phil May, signed, 1899
Given by Miss Margaret Shields,
1949

1611 Pen and ink 21 x 12.7
(8¼ x 5)
Phil May, signed
Given by Messrs Ernest Brown &
Phillips, 1911

4095(6) Pen and ink 38.7 x 31.4
(15¼ x $12\frac{3}{8}$)
Harry Furniss, signed with initials
Purchased, 1959
See Collections: The Garrick
Gallery of Caricatures, 1905, by
Harry Furniss, **4095(1-11)**

3538 Silhouette 33 x 21.6
(13 x 8½)
Sir Francis Carruthers Gould,
signed with initials
Given by the artist's son, Norman
Carruthers Gould, 1946

3471 *See Collections*: Prominent
Men, c.1880-c.1910, by Harry
Furniss, **3337-3535 and 3554-3620**

IRVING, Henry Brodribb
(1870-1919) Actor-manager; son
of Sir Henry Irving

4095(7) Pen and ink 38.7 x 31.4
(15¼ x 12⅜)
Harry Furniss, signed with initials
Purchased, 1959
See Collections: The Garrick
Gallery of Caricatures, 1905, by
Harry Furniss, **4095(1-11)**

IRVING, Sir Henry Turner
(1833-1923) Colonial governor

1841B *See Groups*: Four men at
cards, by Fred Walker

IRVING, Washington (1783-1859)
American biographer and novelist

2515(6) Pencil and chalk
37.8 x 27 (14⅞ x 10⅝)
William Brockedon, dated 1824
Lent by NG, 1959
See Collections: Drawings of
Prominent People, 1823-49, by
William Brockedon, **2515(1-104)**

IRWIN, Sir John (1722-88)
General

682 *See Groups*: A Review of
Troops in Phoenix Park, Dublin,
1781, by Francis Wheatley

ISAACS, Rufus, Marquess of
Reading *See* READING

ISAMBERT, M.M.
French slavery abolitionist

599 *See Groups*: The Anti-Slavery
Society Convention, 1840, by
Benjamin Robert Haydon

ISHERWOOD, Christopher
(b. 1904) Novelist

P41 Photograph: bromide print
21 x 14.6 (8¼ x 5¾)
Humphrey Spender, 1935
Purchased, 1977

ISMAY, Hastings Ismay, 1st Baron
(1887-1965) General

4537 Canvas 76.2 x 55.9 (30 x 22)
Allan Gwynne-Jones, signed with
initials and dated 1958
Purchased, 1967

JACKSON, Barbara Jackson (née
Ward), Baroness (b.1914) Writer

4529(379-83) *See Collections:*
Working drawings by Sir David
Low, **4529(1-401)**

JACKSON, Frederick George
(1860-1938) Explorer and soldier

4611 Water-colour 36.5 x 23.5
(14⅜ x 9¼)
Sir Leslie Ward, signed *Spy*
(*VF* 16 Dec 1897)
Purchased, 1968

JACKSON, Henry (1839-1921)
Classical scholar

5045 Canvas 92.1 x 71.1
(36¼ x 28)
Charles Wellington Furse, signed,
1889
Given by John Loch, 1975

JACKSON, John (1778-1831)
Portrait painter

443 Canvas 74.3 x 61.6
(29¼ x 24¼)
Self-portrait, c.1823
Purchased, 1877

L152(37) Miniature on card
8.3 x 7 (3¼ x 2¾)
William Mulready after a
self-portrait (c.1823)
Lent by NG (Alan Evans Bequest),
1975

JACKSON, John (1804-87)
Physician

P18(18) *See Collections:* The
Herschel Album, by Julia Margaret
Cameron, **P18(1-92b)**

JACOB, Edgar (1844-1920)
Bishop of St Albans

2369 *See Groups:* The Education
Bill in the House of Lords, by
Sydney Prior Hall

JACOB, John (1812-58)
Brigadier-General

2186A Engraving 52.7 x 41.3
(20¾ x 16¼)
Thomas Lewis Atkinson after an
unknown artist, inscribed and dated
1859 on plate
Purchased, 1928

JACOBS, William Wymark
(1863-1943) Novelist

3472 *See Collections:* Prominent
Men, c.1880-c.1910, by Harry
Furniss, **3337-3535** and **3554-3620**

3178 Canvas 67.3 x 53.3
(26½ x 21)
Carton Moore-Park, signed and
dated 1910
Given by the sitter's executors,
1944

4529(309) *See Collections:*
Working drawings by Sir David Low,
4529(1-401)

JACOBSON, William (1803-84)
Bishop of Chester

P7(1) Photograph: albumen print
14.3 x 11.7 ($5\frac{5}{8}$ x $4\frac{5}{8}$)
Charles Lutwidge Dodgson, c.1856
Purchased with help from Kodak
Ltd, 1973
See Collections: Lewis Carroll at
Christ Church, by Charles Lutwidge
Dodgson, **P7(1-37)**

JAMES I of England and VI of
Scotland (1566-1625)
Reigned, Scotland from 1567,
England 1603-25

63 Canvas 118.1 x 73 (46½ x 28¾)
Attributed to Rowland Lockey after
Arnold van Brounckhorst (1574),
inscribed
Purchased, 1859. *Montacute*

1188 Panel 20.3 x 14.3 (8 x $5\frac{5}{8}$)
Unknown artist
Purchased, 1899

548 Panel 57.2 x 41.9 (22½ x 16½)
After John de Critz the Elder
Transferred from BM, 1879.
Montacute

549 Panel 45.1 x 35.9 (17¾ x $14\frac{1}{8}$)
Unknown artist
Transferred from BM, 1879

Continued overleaf

109 Canvas 148.6 x 100.6
(58½ x 39⅝)
Daniel Mytens, inscribed and
dated 1621
Purchased, 1860

Strong

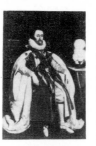

JAMES II (1633-1701)
Reigned 1685-8

5104 Panel 28.9 x 20 (11⅜ x 7⅞)
Cornelius Johnson, signed with
initials and dated 1639
Purchased, 1976
See Collections: Three eldest
children of Charles I, by Cornelius
Johnson, **5103-5**

5211 Canvas 51.4 x 45.1
(20¼ x 17¾)
Sir Peter Lely
Purchased, 1978

5077 With Anne Hyde, his first
Duchess
Canvas 139.7 x 192 (55 x 75⅛)
Sir Peter Lely, 1660s
Purchased, 1976

666 Canvas 245.6 x 144.1
(92¾ x 56¾)
Sir Godfrey Kneller, 1684-5
Purchased, 1882

L152(15) Miniature on ivory, oval
8.9 x 7.3 (3½ x 2⅞)
After Sir Godfrey Kneller (1684-5)
Lent by NG (Alan Evans Bequest),
1975

366 Canvas 120.7 x 98.4
(47½ x 38¾)
Unknown artist, c.1690?
Purchased, 1873. *Beningbrough*

Piper

JAMES Francis Edward Stuart,
Prince (1688-1766)
Son of James II; 'The Old Pretender'

976 With his sister, Louisa Maria
Theresa
Canvas 190.5 x 143.5 (75 x 56½)
Nicolas de Largillière, inscribed
and dated 1695
Bequeathed by the 4th Earl of
Orford, 1895

348 Canvas 80.6 x 62.9
(31¾ x 24¾)
Studio of Alexis Simon Belle, c.1712
Purchased, 1872

273 Minature on copper, oval
6.7 x 5.4 (2⅝ x 2⅛)
After Alexis Simon Belle (c.1712)
Purchased, 1868

433 Canvas 74.9 x 61 (29½ x 24)
Unknown artist
Purchased, 1876

4535 Pen and ink 20.3 x 16.5
(8 x 6½)
By or after Francesco Ponzone,
c.1741
Purchased, 1967. *Beningbrough*

Kerslake

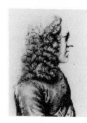

JAMES, Henry James, 1st Baron
(1828-1911)
Barrister and politician

2725 Water-colour 29.8 x 17.5
(11¾ x 6⅞)
Carlo Pellegrini, signed *Ape*
(*VF* 7 March 1874)
Purchased, 1934

2239, 2250, 2254, 2272
See Collections: The Parnell
Commission, 1888-9, by Sydney
Prior Hall, **2229-72**

2307 *See Collections:*
Miscellaneous drawings . . . by
Sydney Prior Hall, **2282-2348** and
2370-90

JAMES, David (1839-93) Actor

2374 *See Collections:*
Miscellaneous drawings . . . by
Sydney Prior Hall, **2282-2348** and
2370-90

JAMES, George Payne Rainsford
(1799-1860)
Novelist and historical writer

1259 Millboard 21 x 18.1
(8¼ x 7⅛)
Stephen Pearce, 1846
Given by the artist, 1900

Ormond

JAMES, Henry (1843-1916)
American-born novelist

1767 Canvas 85.1 x 67.3
(33½ x 26½)
John Singer Sargent, signed and
dated 1913
Bequeathed by the sitter, 1916

JAMES, John Angell (1785-1859)
Independent minister

599 *See Groups:* The Anti-Slavery
Society Convention, 1840, by
Benjamin Robert Haydon

JAMES, William (1791-1861)
MP for Carlisle

54 *See Groups:* The House of Com-
mons, 1833, by Sir George Hayter

JAMES, William
Slavery abolitionist

599 *See Groups:* The Anti-Slavery
Society Convention, 1840, by
Benjamin Robert Haydon

JAMES, Sir William Milbourne
(1807-81) Lord justice of appeal

4710 *See Groups:* A Consultation
prior to the Aerial Voyage to
Weilburg, 1836, by John Hollins

JAMESON, Anna Brownell
(1794-1860) Writer

P6(112) 20.3 x 13.7 (8 x 5⅜)
David Octavius Hill and Robert
Adamson, 1843-8
Given by an anonymous donor, 1973
See Collections: The Hill and
Adamson Albums, 1843-8, by David
Octavius Hill and Robert Adamson,
P6(1-258)

689 Marble bust 60 (23⅝) high
John Gibson, incised, 1862
Transferred from Science Museum,
1883

Ormond

JAMESON, Sir Leander Starr, Bt
(1853-1917)
South African statesman

2804 Canvas 27.9 x 35.6 (11 x 14)
Middleton Jameson (his brother)
Given by the sitter's nephew,
R.W. Jameson, 1936

JANSON, T.C. (?Thomas Corbyn
Janson, 1809-63)

P120(46) *See Collections:* Literary
and Scientific Men, 1855, by Maull
& Polyblank, **P120(1-54)**

JAY, William (1769-1853)
Dissenting minister

4892 Canvas 43.5 x 30.2
($17\frac{1}{8}$ x $11\frac{7}{8}$)
Unknown artist, 1800-10
Given by the Deacons of Argyle
Congregational Church, Bath, 1972

1793 Wax medallion, oval
10.5 x 8.6 ($4\frac{1}{8}$ x $3\frac{3}{8}$)
Miss S.E.Covell, incised and dated
1812
Given by Francis Wellesley, 1917

JAYNE, Francis John (1845-1921)
Bishop of Chester

2369 *See Groups:* The Education
Bill in the House of Lords, by
Sydney Prior Hall

JEFFERIES, Richard (1848-87)
Novelist and naturalist

1097 Plaster cast of bust 33 (13)
high
Margaret Thomas, incised
Given by the artist, 1897

JEFFERYS, James (1751-84)
Historical painter

4669 Pen and ink, feigned irregular
oval 49.5 x 42.5 ($19\frac{1}{2}$ x $16\frac{3}{4}$)
Self-portrait, inscribed
Purchased, 1969

JEFFREY, Francis Jeffrey, Lord
(1773-1850)
Scottish judge, critic and editor of
The Edinburgh Review

1628 Canvas 144.1 x 112.1
($56\frac{3}{4}$ x $44\frac{1}{8}$)
Andrew Geddes, signed with
initials and dated 182(0 or 6)
Purchased, 1911

54 *See Groups:* The House of Com-
mons, 1833, by Sir George Hayter

1815 Pencil 45.7 x 35.9 (18 x $14\frac{1}{8}$)
John Linnell, c.1840
Purchased, 1918

133 Marble bust 74.9 (29½) high
Patric Park, exh 1840
Purchased, 1861

JEFFREYS, George Jeffreys,
1st Baron (1645-89) Judge

56 Canvas 126.4 x 102.2
(49¾ x 40¼)
Attributed to William Claret,
inscribed, c.1678-80
Purchased, 1858

Piper

JEFFREYS, John Gwyn (1809-85)
Conchologist

P120(16) Photograph: albumen
print, arched top 19.7 x 14.6
(7¾ x 5¾)
Maull & Polyblank, inscribed on
mount, 1855
Purchased, 1979
See Collections: Literary and
Scientific Men, 1855, by Maull &
Polyblank, **P120(1-54)**

JEKYLL, Gertrude (1843-1932)
Horticulturalist and writer

3334 Canvas 76.2 x 76.2 (30 x 30)
Sir William Nicholson, signed and
dated 1920
Given by Sir Edwin Lutyens, 1947

JEKYLL, Joseph (1753-1837)
Wit and politician

1146 Pencil 25.4 x 19.1 (10 x 7½)
George Dance, signed and dated
1796
Purchased, 1898

JELLICOE, John Rushworth
Jellicoe, 1st Earl (1859-1935)
Admiral

1913 *See Groups:* Naval Officers
of World War I, by Sir Arthur
Stockdale Cope

2799 Canvas 60.3 x 49.5
(23¾ x 19½)
Reginald Grenville Eves, signed and
dated 1935
Purchased, 1935

4529(183,184) *See Collections:*
Working drawings by Sir David Low,
4529(1-401)

JENKINS, John Edward
(1838-1910) Politician and writer

2578 Water-colour 31.4 x 19.4
($12\frac{3}{8}$ x $7\frac{5}{8}$)
Sir Leslie Ward, signed *Spy*
(*VF* 31 Aug 1878)
Purchased, 1933

JENKINS, Sir Leoline (1623-85)
Diplomat and Secretary of State

92 Canvas 122.6 x 94 (48¼ x 37)
Herbert Tuer, signed, inscribed and
dated 1679
Given by John M.Traherne, 1860

Piper

JENKINS, Thomas (1722-98)
Painter, art dealer and banker
in Rome

5044 With his niece, Anna Maria
Canvas 129.5 x 94.6 (51 x 37¼)
Angelica Kauffmann, signed and
dated 1790
Purchased, 1975

JENKINS, Mrs Thomas, Baroness
de Calabrella *See* CALABRELLA

JENKINSON, Charles, 1st Earl of
Liverpool *See* LIVERPOOL

JENKINSON, Sir George Samuel,
Bt (1817-92)
High Sheriff of Gloucestershire

2579 Water-colour 30.5 x 18.1
(12 x $7\frac{1}{8}$)
Carlo Pellegrini, signed *Ape*
(*VF* 24 April 1875)
Purchased, 1933

JENKINSON, Robert, 2nd Earl of
Liverpool *See* LIVERPOOL

JENNER, Edward (1749-1823)
Discoverer of vaccination

62 Canvas 127 x 101.6 (50 x 40)
James Northcote, signed, inscribed
and dated 1803
Given by the sitter's friend, James
Carrick Moore, 1859

1075,1075a and **b** *See Groups:*
Men of Science Living in 1807-8,
by Sir John Gilbert and others

JENNINGS, Frances, Duchess of
Tyrconnel *See* TYRCONNEL

JERDAN, William (1782-1869)
Journalist

3028 Water-colour 22.2 x 20
(8¾ x $7\frac{7}{8}$)
Daniel Maclise
(*Fraser's Magazine* I, 1830)
Given by Marion Harry Spielmann,
1939

Ormond

JEREMIE, Sir John (1795-1841)
Colonial judge

599 *See Groups:* The Anti-Slavery
Society Convention, 1840, by
Benjamin Robert Haydon

JEROME, Jerome Klapka
(1859-1927) Writer; author of
Three Men in a Boat

4492 Panel 24.1 x 14.9 (9½ x 5$\frac{7}{8}$)
Solomon Joseph Solomon, c.1889
Bequeathed by the sitter's widow,
1966

4491 Canvas 91.4 x 71.1 (36 x 28)
Philip de Laszlo, signed and dated
1921
Bequeathed by the sitter's widow,
1966

JERROLD, Douglas William
(1803-57)
Journalist and playwright

292 Canvas 91.4 x 71.1 (36 x 28)
Sir Daniel Macnee, signed and
dated 1853
Given by William Hepworth Dixon,
1869

942 Marble bust 60.7 (23$\frac{7}{8}$) high
Edward Hodges Baily, incised and
dated 1853
Given by the sitter's daughter-in-
law, Mrs William Blanchard Jerrold,
1893

Ormond

JERSEY, George Child-Villiers, 5th
Earl of (1773-1859) Master of the
Horse to Queen Victoria

1695(u) *See Collections:* Sketches
for The Trial of Queen Caroline,
1820, by Sir George Hayter,
1695(a-x)

999 *See Groups:* The Trial of
Queen Caroline, 1820, by Sir
George Hayter

54 *See Groups:* The House of Com-
mons, 1833, by Sir George Hayter

JERSEY, Sarah Sophia, Countess
of (d.1867)
Wife of 5th Earl of Jersey

883(14) *See Collections:* Studies
for miniatures by Sir George Hayter,
883(1-21)

JERSEY, George Augustus
Frederick Child-Villiers, 6th Earl
of (1808-59) MP for Honiton

54 *See Groups:* The House of Com-
mons, 1833, by Sir George Hayter

JERSEY, Victor Child-Villiers, 7th
Earl of (1845-1915)
Colonial governor

1834(r) Pencil 20.3 x 12.4 (8 x 4$\frac{7}{8}$)
Frederick Sargent, signed with
initials and inscribed
Given by A.C.R.Carter, 1919
See Collections: Members of the
House of Lords, c.1870-80, by
Frederick Sargent, **1834(a-z and
aa-hh)**

1833 *See Groups:* Private View of
the Old Masters Exhibition, Royal
Academy, 1888, by Henry Jamyn
Brooks

JERSEY, Margaret Elizabeth (née
Leigh), Countess of (1849-1945)
Wife of 7th Earl of Jersey; writer
for children

1833 *See Groups:* Private View of
the Old Masters Exhibition, Royal
Academy, 1888, by Henry Jamyn
Brooks

JERVIS, John, Earl of St Vincent
See ST VINCENT

JESSE, Edward (1780-1868)
Natural historian

2453 Chalk 38.1 x 27.9 (15 x 11)
Daniel Macdonald, signed, inscribed
and dated 1844
Purchased, 1930

Ormond

JESSE, John Heneage (1815-74)
Historical writer

4026(37) Pencil and black chalk
29.2 x 22.9 (11½ x 9)
Alfred, Count D'Orsay, autographed
by sitter
Purchased, 1957
See Collections: Drawings of Men
about Town, 1832-48, by Alfred,
Count D'Orsay, **4026(1-61)**

Ormond

JESSOP, William (1745-1814)
Civil engineer

1147 Pencil 25.4 x 19.1 (10 x 7½)
George Dance, signed and dated
1796
Purchased, 1898

1075, 1075a and **b** *See Groups:*
Men of Science Living in 1807-8,
by Sir John Gilbert and others

JEWEL, John (1522-71)
Bishop of Salisbury

242 Panel 54.6 x 26.3 (21½ x 10⅜)
Unknown artist, inscribed
Purchased, 1867

Strong

JOACHIM, Joseph (1831-1907)
Violinist

4930 Water-colour 36.2 x 26.7
(14¼ x 10½)
Sir Leslie Ward, signed *Spy*
(*VF* 5 Jan 1905)
Purchased, 1973

JOANNA of Navarre (1370?-1437)
Queen of Henry IV

398 Electrotype of effigy in
Canterbury Cathedral 109.2 (43)
high
Unknown artist
Purchased, 1875

Strong

JOCELYN, Robert Jocelyn,
Viscount (1816-54)
Soldier and politician

4026(38) *See Collections:*
Drawings of Men about Town,
1832-48, by Alfred, Count D'Orsay,
4026(1-61)

JOCELYN, Robert, 4th Earl of
Roden *See* RODEN

JOHN (1167?-1216)
Reigned 1199-1216

4980(5) *See Collections:* Set of
16 early English Kings and Queens
formerly at Hornby Castle,
Yorkshire, **4980(1-16)**

JOHN, Prince (1905-19)
Youngest son of George V

5144 Miniature on card 9.2 x 8.3
(3⅝ x 3¼)
Vere Temple, signed and dated 1909
Given by Winifred A. Myers
(Autographs) Ltd, 1977

JOHN, Augustus (1878-1961)
Painter

4252 Canvas 99.1 x 94 (39 x 37)
Sir William Orpen, exh 1900
Given by NACF, 1962

Continued overleaf

4577 Chalk 26 x 17.8 (10¼ x 7)
Self-portrait, c.1901
Purchased, 1967

2556 *See Groups:* The Selecting
Jury of the New English Art Club,
1909, by Sir William Orpen

2663 *See Groups:* Some Members
of the New English Art Club, by
Donald Graeme MacLaren

4295 Bronze cast of head 35.6 (14)
high
Sir Jacob Epstein, 1916
Purchased, 1962

P134(25) Photograph: platinum
print 11.1 x 8.3 (4⅜ x 3¼)
John Hope-Johnstone, 1922
Purchased, 1979
See Collections: Gerald Brenan
Album, by John Hope-Johnstone,
P134(1-25)

P134(10,18) *See Collections:*
Gerald Brenan Album, by John
Hope-Johnstone, **P134(1-25)**

4246 Sanguine and white chalk
28.9 x 35.6 (11⅜ x 14)
Sir William Rothenstein, signed with
initials, inscribed and dated 1924
Given by the Rothenstein Memorial
Trust, 1961

4529(185) *See Collections:*
Working drawings by Sir David Low,
4529(1-401)

JOHN, Gwendolen Mary (Gwen)
(1876-1939) Painter; sister of
Augustus John

4439 Canvas 61 x 37.8 (24 x 14⅞)
Self-portrait, c.1900
Given by NACF, to mark Sir Alec
Martin's forty years' service to the
Fund, 1965

JOHN, Sir William Goscombe
(1860-1952)
Sculptor and medallist

5102 Panel 60 x 39.4 (23⅝ x 15½)
Erich Wolfsfeld, signed, c.1944
Purchased, 1976

JOHNSON, Amy (Mrs Mollison)
(1903-41) Airwoman

4201 Canvas 69.2 x 57.2
(27¼ x 22½)
Sir John Longstaff, signed
Given by L.C.Sedon-Thompson,
1961

JOHNSON, Cornelius (1593-1661)
Portrait painter

1887 *See Unknown Sitters II*

JOHNSON, Frederick Piggott
(1826-82) Divine

P7(12) *See Collections:* Lewis
Carroll at Christ Church, by Charles
Lutwidge Dodgson, **P7(1-37)**

JOHNSON, Hewlett (1874-1966)
Dean of Canterbury

P15 *See under* Sir Jacob Epstein

4585 Metal bust 68.6 (27) high
Vera Mukhina, 1945
Given by the sitter's widow, 1967

JOHNSON, J. H.
Slavery abolitionist

599 *See Groups:* The Anti-Slavery
Society Convention, 1840, by
Benjamin Robert Haydon

JOHNSON, Maurice (1688-1755)
Antiquary

4684 Miniature on vellum, oval
4.8 x 4.1 (1⅞ x 1⅝)
George Vertue, signed in monogram,
and inscribed and dated on reverse
1731
Given by C.V.Marsden, 1969

Kerslake

JOHNSON, Samuel (1709-84)
Poet, critic and lexicographer

1597 Canvas 127.6 x 101.6
(50¼ x 40)
Sir Joshua Reynolds, c.1756
Given anonymously, 1911

1445 Canvas 45.1 x 38.7
(17¾ x 15¼)
After Sir Joshua Reynolds, reduced
copy (c.1769)
Given by T.Humphry Ward, 1906

996 Marble bust 68.6 (27) high
Edward Hodges Baily after Joseph
Nollekens, incised and dated 1828
(1777)
Transferred from Tate Gallery,
1957. *Beningbrough*

1185 Canvas, oval 60.6 x 53
(23⅞ x 20⅞)
James Barry, c.1777
Purchased, 1899

L142 Canvas 75.6 x 62.2
(29¾ x 24½)
Sir Joshua Reynolds c.1778
Lent by Tate Gallery, 1968

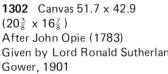

1302 Canvas 51.7 x 42.9
(20⅜ x 16⅞)
After John Opie (1783)
Given by Lord Ronald Sutherland
Gower, 1901

4685 Plaster cast of bust
incorporating death-mask 62.2
(24½) high
After William Cumberland
Cruikshank (1784)
Given by the Royal Literary Fund,
1969

498A Plaster cast of bust, identical
to no.**4685**, 64.8 (25½) high
Purchased, 1878. *Not illustrated*

498B Plaster cast of bust, identical
to no.**4685**, 62.2 (24½) high
Purchased, 1878. *Not illustrated*

621 Terracotta bust 43.2 (17) high
Sir Joseph Edgar Boehm, incised,
posthumous
Given by the artist, 1881

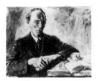

621a Clay bust 28.6 (11¼) high
Sir Joseph Edgar Boehm,
posthumous
Given by the artist, 1881.
Not illustrated

JOHNSTON, Edward (1872-1944)
Calligrapher

4375 Canvas 71.1 x 91.4 (28 x 36)
Arthur Henry Knighton-Hammond,
signed, exh 1937
Given by the artist, 1964

Continued overleaf

3330 Pencil 40.3 x 32.4
($15\frac{7}{8}$ x 12¾)
Edmond Xavier Kapp, signed and
dated 1940
Purchased, 1947

JOHNSTON, Sir Harry Hamilton
(1858-1927)
Explorer and administrator

2902 Pencil 21.6 x 19.7 (8½ x 7¾)
Theodore Blake Wirgman, signed
and dated 1894
Given by the sitter's brother
Philip M.Johnston, 1936

3473 *See Collections:* Prominent
Men, c.1880-c.1910, by Harry
Furniss, **3337-3535** and **3554-3620**

JOHNSTON, James (1721-97)
General

4855(6) *See Collections:* The
Townshend Album, **4855(1-73)**

JOHNSTONE, Elizabeth
Fisherwoman

P6(193,195,203) *See Collections:*
The Hill and Adamson Albums,
1843-8, by David Octavius Hill and
Robert Adamson, **P6(1-258)**

JOHNSTONE, James (1815-78)
Newspaper proprietor

2726 Water-colour 29.8 x 17.5
(11¾ x $6\frac{7}{8}$)
Carlo Pellegrini, signed *Ape*
(*VF* 14 Feb 1874)
Purchased, 1934

JOHNSTONE, Sir John Vanden
Bempde, Bt (1799-1869)
MP for Scarborough

54 *See Groups:*The House of Com-
mons, 1833, by Sir George Hayter

JOHNSTONE, William Borthwick
(1804-68)
Landscape and historical painter

P6(100,144) *See Collections:* The
Hill and Adamson Albums, 1843-8,
by David Octavius Hill and Robert
Adamson, **P6(1-258)**

JOLLIFFE, William, 1st Baron
Hylton *See* HYLTON

JONES, George (1786-1869)
Painter

1456(14) Chalk 10.2 x 11.4
(4 x 4½)
Charles Hutton Lear, inscribed and
dated 1845
Given by John Elliot, 1907
See Collections: Drawings of
Artists, c.1845, by Charles Hutton
Lear, **1456(1-27)**

Ormond

JONES, Henry Arthur (1851-1929)
Dramatist

3474 *See Collections:* Prominent
Men, c.1880-c.1910, by Harry
Furniss, **3337-3535** and **3554-3620**

4239 Lithograph 32.1 x 23.8
($12\frac{5}{8}$ x $9\frac{3}{8}$)
Walter Tittle, signed by artist and
autographed by sitter on stone, 1924
Purchased, 1961

4482 Pen and ink 35.6 x 25.4
(14 x 10)
Alfred Wolmark, signed and dated
1928, and autographed and dated
by sitter 1928
Purchased, 1966

JONES, Inigo (1573-1652)
Architect

603 Canvas, feigned oval
64.1 x 53.3 (25¼ x 21)
After Sir Anthony van Dyck
Given by J.Fuller Russell, 1880

3128 Brown wash 25.1 x 18.7
(9⅞ x 7⅜)
After etching by Robert van Voerst
after Sir Anthony van Dyck
Given by Geoffrey E.Lloyd-Wilson,
1942

Piper

JONES, John (1705-69)

4855(43) *See Collections:*
The Townshend Album, **4855(1-73)**

JONES, John Paul (1747-92)
Seaman adventurer

4022 Bronze medallion 5.7
(2¼) diameter
Augustin Dupré after bust by
Jean Antoine Houdon, inscribed
and dated 1789
Given by Cyril Hughes Hartmann,
1957

JONES, Peter ('Kahkewaquonaby')
(1802-56) Missionary

P6(83,94,145) *See Collections:*
The Hill and Adamson Albums,
1843-8, by David Octavius Hill
and Robert Adamson, **P6(1-258)**

JONES, Philip

316a(73,74) *See Collections:*
Preliminary drawings for busts and
statues by Sir Francis Chantrey,
316a(1-202)

JONES, Thomas (1752-1845)
Evangelical divine

4828 Canvas 74.9 x 62.9
(29½ x 24¾)
George Clint, c.1814
Given by the British and Foreign
Bible Society, 1970

JONES, Thomas (1870-1955)
Public administrator and writer

4780 Sanguine and white chalk
36.5 x 28.9 (14⅜ x 11⅜)
Sir William Rothenstein, 1924
Purchased, 1970

JONES, Thomas Henshaw
(1796-1860) Free Church minister

P6(73) *See Collections:* The Hill
and Adamson Albums, 1843-8, by
David Octavius Hill and Robert
Adamson, **P6(1-258)**

JONES, Thomas Heron, 7th
Viscount Ranelagh
See RANELAGH

JONSON, Benjamin (1573?-1637)
Poet and dramatist

2752 Canvas 47 x 41.9
(18½ x 16½)
After Abraham van Blyenberch
Purchased, 1935

363 Panel 36.8 x 28.9 (14½ x 11⅜)
After Abraham van Blyenberch
Purchased, 1873. *Montacute*

Strong

JORDAN, Dorothy (1762-1816)
Actress

L174 Canvas 74.9 x 62.2
(29½ x 24½)
John Hoppner, exh 1791
Lent by Tate Gallery (Stern
Bequest), 1979

JOWETT, Benjamin (1817-93)
Master of Balliol College, Oxford

2389 *See Collections:*
Miscellaneous drawings . . . by
Sydney Prior Hall, **2282-2348** and
2370-90

3475 *See Collections:* Prominent
Men, c.1880-c.1910, by Harry
Furniss, **3337-3535** and **3554-3620**

JOYCE, James (1882-1941)
Novelist, poet and playwright

3883 Canvas 125.1 x 87.6
(49¼ x 34½)
Jacques-Emile Blanche, signed and
dated 1935
Purchased, 1953

JUNG, Sir Salar (1829-83)
Prime Minister of Hyderabad

2580 *See Collections: Vanity Fair*
cartoons, 1869-1910, by various
artists, **2566-2606,** etc

JUXON, William (1582-1663)
Archbishop of Canterbury

500 Canvas 125.7 x 101.6
(49½ x 40)
Unknown artist (copy) (c.1640)
Purchased, 1878

Piper

KARLOWSKA, Stanislawa de
See BEVAN

KARSLAKE, Sir John Burgess
(1821-81) Lawyer

2581 Water-colour 29.5 x 17.1
(11⅝ x 6¾)
W.Vine, signed in monogram
(*VF* 22 Feb 1873)
Purchased, 1933

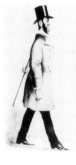

KATER, Henry (1777-1835)
Scientist

1075, 1075a and **b** *See Groups:*
Men of Science Living in 1807-8,
by Sir John Gilbert and others

2165 Black and red wash, oval
25.4 x 20.3 (10 x 8)
George Richmond, signed with
initials and dated 1831
Given by the sitter's great-grandson,
Sir Norman Kater, 1927

KAUFFER, Edward McKnight
(1891-1954) Artist and designer

4947A (study for no.**4947**)
Pencil 21 x 20 (8¼ x 7⅞)
Maxwell Armfield, signed *K* and
dated 1915
Purchased, 1973

4947 Canvas 29.2 x 34.3
(11½ x 13½)
Maxwell Armfield, 1915
Purchased, 1973

KAUFFMANN, Angelica
(1741-1807) Painter

430 Canvas 73.7 x 61 (29 x 24)
Self-portrait, c.1770-5
Purchased, 1876. *Beningbrough*

4905 *See Groups:* The Nine
Living Muses of Great Britain, by
Richard Samuel

KAY, Sir Edward Ebenezer
(1822-97) Judge

2173(15) *See Collections:* Book
of sketches by Sebastian Evans,
2173(1-70)

2727 Water-colour 30.5 x 20
(12 x 7⅞)
Sir Leslie Ward, signed *Spy*
(*VF* 7 Jan 1888)
Purchased, 1934

KAY, William
Slavery abolitionist

599 *See Groups:* The Anti-Slavery
Society Convention, 1840, by
Benjamin Robert Haydon

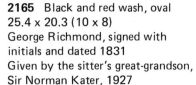

KEAN, Charles John (1811-68)
Actor; second son of Edmund Kean

1249 Canvas 126.4 x 101
(49¾ x 39¾)
Samuel John Stump, signed, c.1830
Purchased, 1900

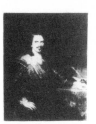

2524 Chalk 31.1 x 26 (12¼ x 10¼)
Attributed to Rose Myra
Drummond, c.1838
Given by Harley Granville Barker,
1932

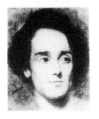

1307 Chalk, oval 66.7 x 50.8
(26¼ x 20)
E. Goodwyn Lewis, signed
Purchased, 1901

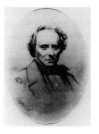

2772(p.33) *See Collections:* The
Clerk family, Sir Robert Peel,
Samuel Rogers and others, 1833-57,
by Jemima Wedderburn, **2772**

Ormond

KEAN, Edmund (1787-1833)
Actor

1829 (With engraving, right, and
theatre ticket)
Pencil, oval 9.5 x 7 (3¾ x 2¾)
Samuel Cousins, 1814
Given by Ernest E.Leggatt, 1919

4623 Pencil 21 x 14.6 (8¼ x 5¾)
Attributed to Thomas Wageman,
inscribed and dated 1827
Purchased, 1968

KEARLEY, Hudson, 1st Viscount
Devonport *See* DEVENPORT

KEATE, John (1773-1852)
Headmaster of Eton

1116 Etching 23.8 x 19.1
(9⅜ x 7½)
Richard Dighton, signed and
inscribed on plate
Given by Sir Lionel Cust,1898

KEATING, Sir Henry Sheehy
(1775-1847) General

1895 Canvas 88.9 x 68.6
(35 x 27)
Andrew Morton, exh 1839
Given by the sitter's granddaughter,
Miss Agnes Mary Keating, 1921

KEATS, John (1795-1821)
Poet

3250 *See under* Benjamin Robert
Haydon

3251 Pen and ink 31.8 x 20.3
(12½ x 8)
Benjamin Robert Haydon, signed,
inscribed and dated 1816
Purchased, 1945

686 Plaster cast of life-mask 23.5
(9¼) long
Benjamin Robert Haydon, 1816
Given by Miss Charlotte Reynolds,
1883

686b Electrotype of no.**686**
23.5 (9¼) long
After Benjamin Robert Haydon,
1884 (1816)
Commissioned, 1884

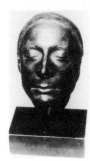

Continued overleaf

686a Canvas 29.2 x 24.1
(11½ x 9½) *sight*
T.Sampson after Benjamin Robert
Haydon, signed, inscribed and
dated 1828 (1816)
Given by the Earl of Derby, 1888

1605 Miniature, oil on ivory
10.8 x 7.9 (4¼ x 3⅛)
Joseph Severn, 1819
Given by the executors of Sir
Charles Wentworth Dilke, Bt, 1919

194 Canvas 76.2 x 63.5 (30 x 25)
William Hilton after Joseph Severn
(1819)
Purchased, 1865

1963 Pencil 22.9 x 21.6 (9 x 8½)
Charles Armitage Brown, 1819
Given by the artist's granddaughter,
Mona M.Brown, 1922

4031 Plaster cast of death-mask
23.5 (9¼) long
Unknown artist, 1821
Lent by Mrs Olivia Sowerby, 1957

58 Canvas 56.5 x 41.9
(22¼ x 16½)
Joseph Severn, signed and dated
1821
Given by S.Smith Travers, 1859

KEBLE, John (1792-1866)
Poet and divine

1043 Chalk 71.8 x 52.1
(28¼ x 20½)
George Richmond, dated 1863
Bequeathed by the artist, 1896

Ormond

KEELEY, Mary Ann (née Goward)
(1805?-99) Actress

1558 Canvas, feigned oval
48.9 x 38.7 (19¼ x 15¼)
Julia Bracewell Folkard, signed,
inscribed and dated 1898
Given by the artist, 1909

KEENE, Charles Samuel (1823-91)
Illustrator

P92 Photograph: albumen print
20.7 x 16.2 (8⅛ x 6⅜)
David Wilkie Wynfield, 1860s
Given by H.Saxe Wyndham, 1937
See Collections: The St John's
Wood Clique, by David Wilkie
Wynfield, **P70-100**

P76 *See Collections:* The St John's
Wood Clique, by David Wilkie
Wynfield, **P70-100**

2771 Pencil 13.3 x 8.3 (5¼ x 3¼)
Alfred William Cooper, signed with
initials, inscribed and dated 1866
Given by T.E.Lowinsky, 1935

1337 Water-colour 60.3 x 37.5
(23¾ x 14¾)
Walton Corbould, signed
Given by Thomas G.Bain, 1903

2817 Pen and ink 13.3 x 7.6
(5¼ x 3)
Self-portrait, c.1885
Purchased, 1936

3476,3477 *See Collections:*
Prominent Men, c.1880-c.1910, by
Harry Furniss, **3337-3535** and
3554-3620

KEEP, John
American slavery abolitionist

599 *See Groups:* The Anti-Slavery
Society Convention, 1840, by
Benjamin Robert Haydon

KEILIN, David (1888-1963)
Biologist

4811 Ink and wash 52.7 x 38.4
(20¾ x 15⅛)
H.Andrew Freeth, signed, inscribed
and dated 1952
Purchased, 1970

KEITH, Alexander (1791-1880)
Writer on prophecy

P6(12) Photograph: calotype
20 x 13 (7⅞ x 5⅛)
David Octavius Hill and Robert
Adamson, 1843-8
Given by an anonymous donor, 1973
See Collections: The Hill and
Adamson Albums, 1843-8, by
David Octavius Hill and Robert
Adamson, **P6(1-258)**

P6(30,48) *See Collections:* The
Hill and Adamson Albums, 1843-8,
by David Octavius Hill and Robert
Adamson, **P6(1-258)**

KEITH, Sir Arthur (1866-1955)
Anatomist and anthropologist

4140 Pencil 39.4 x 29.2
(15½ x 11½)
Sir William Rothenstein, signed
with initials and dated 1928
Given by the Rothenstein Memorial
Trust, 1960

3986 Chalk 33.3 x 25.4 (13⅛ x 10)
Juliet Pannett, signed, 1954
Given by George S. Sandilands, 1956

KEITH, George, 10th Earl Marischal
See MARISCHAL

KEITH-FALCONER, Algernon,
9th Earl of Kintore *See* KINTORE

KELLAWAY, Mary

P18(55,77) *See Collections:*
The Herschel Album, by Julia
Margaret Cameron, **P18(1-92b)**

KELLETT, Sir Henry (1806-75)
Vice-Admiral

1222 Canvas 39.4 x 33 (15½ x 13)
Stephen Pearce, exh 1856
Bequeathed by John Barrow,1899
See Collections: Arctic Explorers,
1850-86, by Stephen Pearce,
905-24 and **1209-27**

915 *See Collections:* Arctic
Explorers, 1850-86, by Stephen
Pearce, **905-24** and **1209-27**

Ormond

KELLY, Frances Maria (1790-1882)
Actress and singer

1791 Chalk 38.4 x 33 (15⅛ x 13)
Thomas Uwins, signed, inscribed
and dated 1822
Given by Henry Pfungst, 1917

Ormond

KELLY, Sir Gerald (1879-1972)
Painter and PRA

4529(186) Pencil 20.3 x 15.6
(8 x 6⅛)
Sir David Low, inscribed
Purchased, 1967
See Collections: Working drawings
by Sir David Low, **4529(1-401)**

4529(187,188) *See Collections:*
Working drawings by Sir David Low,
4529(1-401)

KELLY, James Fitzmaurice
(1857-1923)
Historian of Spanish literature

2018 Canvas 125.7 x 100.3
(49½ x 39½)
Sir John Lavery, signed and dated
1898
Given by the sitter's widow, 1924

KELVIN, William Thomson, Baron
(1824-1907) Scientist and inventor

1708(f) Pencil 20.6 x 16.5
(8⅛ x 6½)
Elizabeth King (his sister), dated
1840
Given by the artist's daughter,
Agnes Gardner King, 1913
See Collections: Lord Kelvin and
members of his family, by Elizabeth
King and Agnes Gardner King,
1708(a-h)

1708 Canvas 52.1 x 40
(20½ x 15¾)
Elizabeth King (his sister), 1886-7
Given by the artist's daughter,
Agnes Gardner King, 1913

1708(a) *See Collections:* Lord
Kelvin and members of his family,
by Elizabeth King and Agnes
Gardner King, **1708(a-h)**

1896a Plaster for no.**1896**
Given by the artist, 1921

1896 Wax medallion 11.4 (4½)
diameter
Margaret M. Giles, incised
Given by the artist, 1921.
Not illustrated

3005 Water-colour 36.2 x 24.1
(14¼ x 9½)
Sir Leslie Ward, signed *Spy* and
inscribed
(*VF* 29 April 1897)
Purchased, 1938

3587 *See Collections:* Prominent
Men, c.1880-c.1910, by Harry
Furniss, **3337-3535** and **3554-3620**

KELWAY, Joseph (d.1782)
Organist and composer

4213 Pastel, oval 61 x 47.6
(24 x 18¾)
John Russell, signed, 1776?
Purchased, 1961. *Beningbrough*

KEMBLE

1962(d) *See Collections:* Opera
singers and others, c.1804-c.1836,
by Alfred Edward Chalon, **1962(a-l)**

KEMBLE, John Philip (1757-1823)
Actor

49 Canvas, feigned oval 74.9 x 62.2
(29½ x 24½)
Gilbert Stuart, c.1785
Given by John Thaddeus Delane,
1858

2616 Pencil 27.9 x 17.8 (11 x 7)
Attributed to Sir Thomas Lawrence,
c.1800
Bequeathed by Richard Henry Bath,
1933

149 Bronze cast of bust 34.3
(13½) high
John Gibson, incised and dated 1814
Given by the artist, 1862

KEMBLE, Maria Theresa
(1774-1838)
Actress; wife of Charles Kemble

1962(b) *See Collections:* Opera
singers and others, c.1804-c.1836,
by Alfred Edward Chalon, **1962(a-l)**

KEMP, Miss
Sister of George Meikle Kemp

P6(121) *See Collections:* The Hill
and Adamson Albums, 1843-8,
by David Octavius Hill and Robert
Adamson, **P6(1-258)**

KEMP, George Meikle (1795-1844)
Architect of the Scott monument,
Edinburgh

P6(234) *See Collections:* The Hill
and Adamson Albums, 1843-8, by
David Octavius Hill and Robert
Adamson, **P6(1-258)**

KEMP, Thomas Read (1781?-1844)
Founder of Kemp Town, Brighton

54 *See Groups:* The House of Com-
mons, 1833, by Sir George Hayter

KEMPENFELT, Richard (1718-82)
Admiral

1641 Canvas 127 x 99.1 (50 x 39)
Ralph Earl, signed and dated 1783
Purchased, 1912

KEMPT, Sir James (1764-1854)
Governor-General of Canada

3728 *See Collections:* Studies for
The Waterloo Banquet at Apsley
House, 1836, by William Salter,
3689-3769

KEN, Thomas (1637-1711)
Bishop of Bath and Wells

79,152a *See Groups:* The Seven
Bishops Committed to the Tower in
1688, by an unknown artist and
George Bower

1821 Canvas, feigned oval
75.6 x 62.9 (29¾ x 24¾)
Attributed to F.Scheffer, c.1700
Given by James D.C.Wickham,1918

Piper

KENEALY, Edward Vaughan Hyde
(1819-80) Barrister

2685 Water-colour 29.8 x 18.1
(11¾ x $7\frac{1}{8}$)
Sir Leslie Ward, signed *Spy*
(*VF* 1 Nov 1873)
Purchased, 1934

KENMARE, Valentine Augustus
Browne, 4th Earl of (1825-1905)
Landowner

4720 Water-colour 31.4 x 17.5
($12\frac{3}{8}$ x $6\frac{7}{8}$)
Sir Leslie Ward, signed *Spy*
(*VF* 26 Feb 1881)
Purchased, 1970

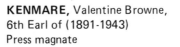

KENMARE, Valentine Browne,
6th Earl of (1891-1943)
Press magnate

4529(72) *See Collections:*
Working drawings by Sir David
Low, **4529(1-401)**

KENNARD, Howard John
(1829-96) Financier

2988 Water-colour 39.1 x 26.3
($15\frac{3}{8}$ x $10\frac{3}{8}$)
Liberio Prosperi, signed *Lib*
(*VF* 6 Dec 1890)
Purchased, 1938

KENNAWAY, Sir John Henry, Bt
(1837-1919) Politician

2582 Water-colour 34 x 18.1
($13\frac{3}{8}$ x $7\frac{1}{8}$)
Sir Leslie Ward, signed *Spy*
(*VF* 10 April 1886)
Purchased, 1933

KENNEDY, D.

P22(17) *See Collections:* The
Balmoral Album, 1854-68, by
George Washington Wilson, W.& D.
Downey, and Henry John Whitlock,
P22(1-27)

KENNEDY, J.

P22(10) *See Collections:* The
Balmoral Album, 1854-68, by
George Washington Wilson, W.& D.
Downey, and Henry John Whitlock,
P22(1-27)

KENNEDY, Thomas Francis
(1788-1879) Politician

54 *See Groups:* The House of Com-
mons, 1833, by Sir George Hayter

KENNEDY, William (1813-90)
Sailor

1225 Canvas 38.7 x 32.4
(15¼ x 12¾)
Stephen Pearce, 1853
Bequeathed by John Barrow, 1899
See Collections: Arctic Explorers,
1850-86, by Stephen Pearce,
905-24 and **1209-27**

917 *See Collections:* Arctic
Explorers, 1850-86, by Stephen
Pearce, **905-24** and **1209-27**

Ormond

KENNET, Edward Hilton Young,
1st Baron (1879-1960)
Journalist and politician

4800 Sanguine and black chalk
39.4 x 24.1 (15½ x 9½)
Sir William Rothenstein, signed
with initials and dated 1924
Purchased, 1970

4529(398) *See Collections:*
Working drawings by Sir David
Low, **4529(1-401)**

KENNEY, James (1780-1849)
Dramatist

4263 Chalk 46 x 33.7 ($18\frac{1}{8}$ x 13¼)
Samuel Laurence, c.1840-9
Given by Miss Elizabeth Newmarch,
1962

KENNION, George Wyndham
(1845-1922)
Bishop of Bath and Wells

2369 *See Groups:* The Education
Bill in the House of Lords, by
Sydney Prior Hall

KENT, Henry Grey, 1st Duke of
(1664-1740) A lord justice

624 *See Groups:* Queen Anne and
the Knights of the Garter, 1713, by
Peter Angelis

KENT, William (1685?-1748)
Architect

1384 *See Groups:* A Conversation
of Virtuosis at the Kings Armes (A
Club of Artists), by Gawen Hamilton

1557 *Identity provisionally
accepted*
Canvas 88.9 x 71.8 (35 x 28¼)
Bartholomew Dandridge, signed
Purchased, 1909. *Beningbrough*

Kerslake

KENT AND STRATHEARN,
Edward, Duke of (1767-1820)
Son of George III

207 Wax relief, oval 11.4 x 8.9
(4½ x 3½)
Thomas Engleheart, 1786
Given by Edmund Christy, 1866.
Stolen, 1968. Not illustrated

647 Canvas 74.3 x 61.6
(29¼ x 24¼)
Sir William Beechey, 1818
Bequeathed by Lord Hatherley,
1881

KENT AND STRATHEARN,
Victoria, Duchess of (1786-1861)
Mother of Queen Victoria

2554 Canvas, oval 61 x 50.8
(24 x 20)
Franz Xavier Winterhalter, reduced
version (1857)
Purchased, 1932

KENTISH, John (1768-1853)
Unitarian divine

4971 Canvas 91.8 x 71.4
(36⅛ x 28⅛)
Thomas Phillips, signed in
monogram, inscribed and dated
1840
Purchased, 1974

KENYON, Lloyd Kenyon, 1st Baron
(1732-1802) Lord Chief Justice

469 Canvas 74.9 x 62.2
(29½ x 24½)
William Davison after George
Romney and Sir Martin Archer
Shee, reduced copy
Given by the Society of Judges and
Serjeants-at-Law, 1877

KENYON, George Kenyon, 2nd
Baron (1776-1855)

999 *See Groups:* The Trial of
Queen Caroline, 1820, by Sir
George Hayter

KEOGH, William Nicholas
(1817-78) Irish judge

3395 *See Collections:* Prominent
Men, c.1880-c.1910, by Harry
Furniss, **3337-3535** and **3554-3620**

KEOWN, Alice Jessie (b.1861)

P18(12,36,43,44,53,57,58)
See Collections: The Herschel
Album, by Julia Margaret Cameron,
P18(1-92b)

KEOWN, Elizabeth (b.1859)

P18(14,36,41,43,51,53,56,86)
See Collect' ns: The Herschel
Album, by Julia Margaret Cameron,
P18(1-92b)

KEOWN, Kate (b.1857)

P18(56,86) *See Collections:*
The Herschel Album, by Julia
Margaret Cameron, **P18(1-92b)**

KEOWN, Percy Seymour (b.1864)

P18(46,57,58) *See Collections:*
The Herschel Album, by Julia
Margaret Cameron, **P18(1-92b)**

KEPPEL, Augustus Keppel,
Viscount (1725-86) Admiral

179 Canvas 123.2 x 100.3
(48½ x 39½)
Studio of Sir Joshua Reynolds
(1779)
Purchased, 1864

KEPPEL, Arnold Joost van,
1st Earl of Albemarle
See ALBEMARLE

KEPPEL, William Charles,
4th Earl of Albemarle
See ALBEMARLE

KER, John, 3rd Duke of Roxburghe
See ROXBURGHE

KER, William Paton (1855-1923)
Scholar and writer

4803 Sanguine and white chalk
39.4 x 28.6 (15½ x 11¼)
Sir William Rothenstein, 1923
Purchased, 1970

KÉROUALLE, Louise de, Duchess
of Portsmouth
See PORTSMOUTH

KERR, Philip Henry, 11th Marquess
of Lothian *See* LOTHIAN

KERR, William, 6th Marquess of
Lothian *See* LOTHIAN

KERRISON, Sir Edward, Bt
(1774-1853) General

54 *See Groups:* The House of Com-
mons, 1833, by Sir George Hayter

3729 *See Collections:* Studies for
The Waterloo Banquet at Apsley
House, 1836, by William Salter,
3689-3769

KERR-LAWSON, Caterina
Wife of James Kerr-Lawson

3264 *See Groups:* Mrs Hewlett,
Mrs Kerr-Lawson and Maurice
Hewlett, by James Kerr-Lawson

KERRY, William Thomas Petty-
Fitzmaurice, Earl of (1811-36)
MP for Calne

54 *See Groups:* The House of Com-
mons, 1833, by Sir George Hayter

KETLEY, Joseph
Slavery abolitionist

599 *See Groups:* The Anti-Slavery
Society Convention, 1840, by
Benjamin Robert Haydon

KETTLE, Sir Rupert Alfred
(1817-94)
Judge; 'Prince of Arbitrators'

2173(14) Pen and ink 16.2 x 14.9
($6\frac{3}{8}$ x $5\frac{7}{8}$)
Sebastian Evans, inscribed
Given by George Hubbard, 1927
See Collections: Book of sketches
by Sebastian Evans, **2173(1-70)**

KEYES, Roger Keyes, 1st Baron
(1872-1945) Admiral

1913 *See Groups:* Naval Officers
of World War I, by Sir Arthur
Stockdale Cope

KEYNES, John Maynard Keynes,
Baron (1883-1946) Economist

4553 Water-colour 27.9 x 36.8
(11 x 14½)
Gwen Raverat, c.1908
Given by the sitter's sister, Mrs
Margaret Hill, 1967

4529(189-91) *See Collections:*
Working drawings by Sir David Low,
4529(1-401)

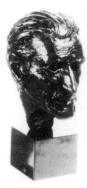

KEYNES, Sir Geoffrey (b.1887)
Surgeon and scholar; brother of
Baron Keynes

5182 Bronze cast of head 29.8
(11¾) high
Nigel Boonham, incised, 1976
Given by Prof Peter Daniel, 1978

KILLIGREW, Sir Thomas (1612-83)
Dramatist and courtier

892 Canvas 105.4 x 83.8
(41½ x 33)
After Sir Anthony van Dyck
(c.1635), inscribed
Purchased, 1892

3795 Canvas 124.5 x 96.5
(49 x 38)
William Sheppard, signed, inscribed
and dated 1650
Purchased, 1951

Piper

KIMBERLEY, John Wodehouse,
1st Earl of (1826-1902) Statesman

5116 *See Groups:* Gladstone's
Cabinet of 1868, by Lowes Cato
Dickinson

KING of Ockham, Peter King, 1st
Baron (1669-1734)
Lord Chancellor

470 Canvas 195.6 x 127 (77 x 50)
Daniel de Coning, signed and dated
1720
Given by the Society of Judges and
Serjeants-at-Law, 1877

Piper

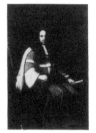

KING of Ockham, Peter King, 7th
Baron (1775-1833)
Authority on currency

2662(20) *See Collections:* Book
of sketches, mainly for The Trial of
Queen Caroline, 1820, by Sir
George Hayter, **2662(1-38)**

999 *See Groups:* The Trial of
Queen Caroline, 1820, by Sir
George Hayter

4020 Panel 36.2 x 29.8
(14¼ x 11¾)
John Linnell, signed and dated 1832
Purchased, 1957

KING, Cecil Harmsworth (b.1901)
Newspaper magnate and writer

4529(192-5) *See Collections:*
Working drawings by Sir David
Low, **4529(1-401)**

KING, Charles (d.1844) Colonel

3730 *See Collections:* Studies
for The Waterloo Banquet at
Apsley House, 1836, by William
Salter, **3689-3769**

KING, David (1806-83)
Scottish Presbyterian divine

1708(g) Pencil 12.1 x 11.1
(4¾ x 4⅜)
Elizabeth King (his wife), 1842
Given by their daughter, Agnes
Gardner King, 1913
See Collections: Lord Kelvin and
members of his family, by Elizabeth
King and Agnes Gardner King,
1708(a-h)

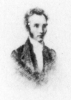

KING, Edward Bolton (1800-78)
MP for Warwick

54 *See Groups:* The House of Com-
mons, 1833, by Sir George Hayter

KING, Eliza (née Young)
(1786?-1847)
Mother of David King

1708(h) *See Collections:* Lord
Kelvin and members of his family,
by Elizabeth King and Agnes
Gardner King, **1708(a-h)**

KING, Elizabeth (née Thomson)
(1818-96) Sister of Baron Kelvin;
wife of David King

1708(a,c) *See Collections:* Lord
Kelvin and members of his family,
by Elizabeth King and Agnes
Gardner King, **1708(a-h)**

KING, John (1559?-1621)
Bishop of London

657 Panel, feigned oval
77.5 x 59.7 (30½ x 23½)
Attributed to Nicholas Lockey,
dated 1620
Purchased, 1882. *Montacute*

Strong

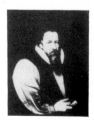

KING, Sir John (1639-77)
Lawyer

66 Canvas 90.8 x 73 (35¾ x 28¾)
Unknown artist, c.1674
Purchased, 1859

Piper

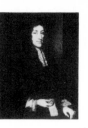

KING-HALL, William Stephen
Richard King-Hall, Baron
(1893-1966)
Sailor, writer and commentator

4529(196,196a) *See Collections:*
Working drawings by Sir David
Low, **4529(1-401)**

KINGLAKE, Alexander William
(1809-91) Historian

1903 Canvas 62.2 x 53.3
(24½ x 21)
Harriet M.Haviland, inscribed and
dated on reverse 1863
Purchased, 1921

KINGSCOTE, Sir Robert Nigel
Fitzhardinge (1830-1908)
Soldier and agriculturalist

4723 Water-colour 30.5 x 17.8
(12 x 7)
Sir Leslie Ward, signed *Spy*
(*VF* 14 Feb 1880)
Purchased, 1970

KINGSLEY, Charles (1819-75)
Novelist and divine

2525 Canvas, painted area 90.2
(35½) diameter
Lowes Cato Dickinson, signed with
initials and dated 1862
Given by George A.Macmillan,1932

1939 Water-colour 30.5 x 18.1
(12 x 7⅛)
Adriano Cecioni
(*VF* 30 March 1872)
Purchased, 1922

1284 Pen and ink 27.3 x 20.3
(10¾ x 8)
William S.Hunt after a photograph
(c.1874)
Given by the artist, 1901

1666 Plaster cast of bust 69.9
(27½) high
Thomas Woolner, incised and dated
1875, posthumous
Purchased, 1912

KINGSLEY, Henry (1830-76)
Novelist; brother of Charles Kingsley

1285 Pen and ink 26.7 x 20.3
(10½ x 8)
William S.Hunt after a photograph
(c.1874)
Given by the artist, 1901

KINGSTON, Evelyn Pierrepont, 1st
Duke of (1665-1726)
Whig magnate

3213 Canvas 91.4 x 71.1 (36 x 28)
Sir Godfrey Kneller, signed, 1709
Kit-cat Club portrait
Given by NACF, 1945

Piper

KINNAIRD, Douglas James William
(1788-1830)
Writer and friend of Byron

999 *See Groups:* The Trial of
Queen Caroline, 1820, by Sir
George Hayter

KINNERSLEY, Mr

316a(76) *See Collections:*
Preliminary drawings for busts and
statues by Sir Francis Chantrey,
316a(1-202)

KINNERSLEY, G.R.

316a(75) *See Collections:*
Preliminary drawings for busts and
statues by Sir Francis Chantrey,
316a(1-202)

KINTORE, Algernon Keith-
Falconer, 9th Earl of (1852-1930)
Governor of South Australia

4722 Water-colour 31.1 x 18.4
(12¼ x 7¼)
Sir Leslie Ward, signed *Spy*
(*VF* 27 March 1880)
Purchased, 1970

KIPLING, Rudyard (1865-1936)
Writer and poet

2919 Pencil 31.8 x 22.2
(12½ x 8¾)
William Strang, signed and inscribed,
c.1898
Purchased, 1937

1863 Canvas 74.9 x 62.2
(29½ x 24½)
Sir Philip Burne-Jones, signed and
dated 1899
Bequeathed by the artist's mother,
1920

3478,3588 *See Collections:*
Prominent Men, c.1880-c.1910, by
Harry Furniss, **3337-3535** and
3554-3620

3874 Sanguine and black chalk
34.6 x 28.6 (13⅝ x 11¼)
Sir William Rothenstein, c.1932
Given by the Rothenstein Memorial
Trust, 1953

2955 Bronze cast of head 58.4
(23) high
Ginette Bingguely-Lejeune, incised
and dated 1936-7
Given by the Kipling Society, 1938

KIRBY, John Joshua (1716-74)
Student of linear perspective;
artist and friend of Gainsborough

1421 With his wife, Sarah
Canvas 74.3 x 61.6 (29¼ x 24¼)
Thomas Gainsborough, c.1751-2
Purchased, 1905

Kerslake

KIRBY, Sarah (née Bull) (d.1775)
Wife of John Joshua Kirby

1421 *See under* John Joshua Kirby

KIRK, Sir John (1832-1922)
Naturalist and administrator

1936 Water-colour 36.8 x 27.9
(14½ x 11)
Alexander H. Kirk (his nephew),
signed and dated 1915
Given by the artist, 1922

KIRKWOOD, David Kirkwood,
1st Baron (1872-1955)
Socialist leader

4529(197) *See Collections:*
Working drawings by Sir David
Low, **4529(1-401)**

KITCHENER of Khartoum, Horatio
Herbert Kitchener, 1st Earl
(1850-1916) Field-Marshal

1782 Canvas 139.7 x 109.2
(55 x 43)
Sir Hubert von Herkomer and
(background) Frederick Goodall,
signed *HH* and dated 1890
Given by Pandeli Ralli, 1916

Continued overleaf

2684 Water-colour 36.8 x 18.4
(14½ x 7¼)
Sir Leslie Ward, signed *Spy*
(*VF* 23 Feb 1899)
Purchased, 1934

1780 Pastel, octagonal 48.3 x 39.4
(19 x 15½)
Charles Mendelssohn Horsfall,
signed and dated 1899
Given by Sir Lees Knowles, Bt,1916

4549 Chalk and wash 34.9 x 25.1
(13¾ x $9\frac{7}{8}$)
Unknown artist, signed *G.R.H.*,
inscribed
Given by A.Yakovleff, 1967

2463 *See Groups:* Statesmen of
World War I, by Sir James Guthrie

KITCHENER, William
(1775?-1827) Writer on science
and music

2515(14) Chalk 38.4 x 27.9
($15\frac{1}{8}$ x 11)
William Brockedon
Lent by NG, 1959
See Collections: Drawings of
Prominent People, 1823-49, by
William Brockedon, **2515(1-104)**

KITCHIN, George William
(1827-1912) Dean of Winchester

P7(14) Photograph: albumen print
14.3 x 12.1 ($5\frac{5}{8}$ x 4¾)
Charles Lutwidge Dodgson, c.1856
Purchased with help from Kodak
Ltd, 1973
See Collections: Lewis Carroll at
Christ Church, by Charles Lutwidge
Dodgson, **P7(1-37)**

KLEIN, Melanie (1882-1960)
Psychoanalyst and writer

5108 Pencil 35.2 x 25.4
($13\frac{7}{8}$ x 10)
Ishbel McWhirter, signed and
inscribed
Purchased, 1976

KNATCHBULL, Sir Edward, Bt
(1781-1849) Statesman

54 *See Groups:* The House of Com-
mons, 1833, by Sir George Hayter

KNATCHBULL, Sir John, Bt
(1637-96)

3090(6) Wash 38.1 x 27.3
(15 x 10¾)
After an early painting
Purchased, 1940

KNATCHBULL, Sir Thomas, Bt
(d.1703) Recorder of Maidstone

3090(7) Wash 32.7 x 24.1
($12\frac{7}{8}$ x 9½)
After Samuel van Hoogstraeten
(1667)
Purchased, 1940

KNELLER, Sir Godfrey, Bt
(1646-1723) Portrait painter

3794 Canvas, feigned oval
75.6 x 62.9 (29¾ x 24¾)
Self-portrait, signed and dated 1685
Purchased, 1951

1740 Ivory medallion 9.5 (3¾)
diameter
Jean Cavalier(?), signed *I.C.*,
inscribed, c.1690
Purchased, 1914

3214 Canvas 46.4 x 35.6
(18¼ x 14)
Self-portrait, signed
Kit-cat Club portrait
Given by NACF, 1945.
Beningbrough

1365 *See Unknown Sitters II*

Piper

KNIBB, William (1803-45)
Missionary and slavery abolitionist

599 *See Groups:* The Anti-Slavery
Society Convention, 1840, by
Benjamin Robert Haydon

4957 Colour print 27.5 x 22.5
(10⅞ x 8⅞)
George Baxter, inscribed on plate,
1847
Purchased, 1973

KNIGHT, Ann (1792-1868)
Slavery abolitionist

599 *See Groups:* The Anti-Slavery
Society Convention, 1840, by
Benjamin Robert Haydon

KNIGHT, Charles (1791-1873)
Writer and publisher

393 Marble bust 64.5 (25⅜) high
Joseph Durham, incised and dated
1874
Given by the sitter's grandchildren,
1874

Ormond

KNIGHT, Harold (1874-1961)
Artist

4831 Canvas 91.4 x 71.1 (36 x 28)
Self-portrait, signed, c.1923
Bequeathed by his widow, Dame
Laura Knight, 1970

KNIGHT, Henry Gally (1786-1846)
Writer on architecture

342,343c *See Groups:* The Fine
Arts Commissioners, 1846, by John
Partridge, **342**and **343(a-c)**

KNIGHT, John Prescott (1803-81)
Portrait painter

3182(6) *See Collections:* Drawings
of Artists, c.1862, by Charles
West Cope, **3182(1-19)**

KNIGHT, Joseph (1829-1907)
Drama critic

3479,3480 *See Collections:*
Prominent Men, c.1880-c.1910, by
Harry Furniss, **3337-3535** and
3554-3620

KNIGHT, Dame Laura (1877-1970)
Artist

4839 With nude model
Canvas 152.4 x 127.6 (60 x 50¼)
Self-portrait, signed, 1913
Purchased, 1971

KNIGHT, Richard Payne
(1750-1824) Numismatist

4887 Marble and bronze bust
57.2 (22½) high
John Bacon the Younger, incised
and dated 1814
Purchased, 1972

KNIGHTLEY, Rainald Knightley,
1st Baron (1819-95) Politician

4026(39) *See Collections:*
Drawings of Men about Town,
1832-48, by Alfred, Count D'Orsay,
4026(1-61)

KNOBLOCK, Edward (1874-1945)
Playwright

3481 *See Collections:* Prominent
Men, c.1880-c.1910, by Harry
Furniss, **3337-3535** and **3554-3620**

KNOWLES, James Sheridan
(1784-1862) Dramatist

2003 Canvas 113 x 88 (44½ x 34⅝)
Wilhelm Trautschold, exh 1849
Bequeathed by Edmund Knowles
Muspratt, 1923

Ormond

KNOX, John (1505-72)
Scottish reformer and historian

72 *See Unknown Sitters I*

KNOX, Ronald Arbuthnot
(1888-1957) Roman Catholic
churchman, scholar and writer

4403 Pen and ink 35.6 x 25.4
(14 x 10)
Powys Evans, pub 1926
Purchased, 1964

KNUTSFORD, Henry Thurstan
Holland, 1st Viscount (1825-1914)
Secretary of State for the Colonies

2947 Canvas 124.5 x 89.5
(49 x 35¼)
Sir Arthur Stockdale Cope, signed
and dated 1906
Given by Viscount Hambleden, 1938

KNYPHAUSEN, Dodo Heinrich
Freiherr von (1729-89)
Ambassador to England

4855(57,59) *See Collections:* The
Townshend Album, **4855(1-73)**

KNYVETT, William (1779-1856)
Composer and singer

3089(10) Pencil 25.5 x 19.6
(10 x 7¾)
William Daniell after George Dance
Purchased, 1940
See Collections: Tracings of
drawings by George Dance,
3089(1-12)

KOESTLER, Arthur (b.1905)
Writer

4529(198,199) *See Collections:*
Working drawings by Sir David
Low, **4529(1-401)**

KOKOSCHKA, Oskar (1886-1980)
Artist and writer

5156 Lithograph 98.7 x 65.4
(38⅞ x 25¾)
Self-portrait, signed with initials on
stone, and signed and numbered
12/50, 1965
Purchased, 1977

KRAMER, Jacob (1892-1962)
Artist

4871 Lithograph 38.1 x 27.3
(15 x 10¾)
Self-portrait, signed, inscribed and
dated 1930
Purchased, 1972

KRATZER, Nicholas (1487-?1550)
Mathematician and astronomer

5245 Panel 81.9 x 64.8
(32¼ x 25½)
After Hans Holbein, inscribed and
dated 1528
Purchased, 1979

KUO SUNG TAO (d.1877)
Chinese minister in London

4707(14) Water-colour 30.5 x 18.4
(12 x 7¼)
Sir Leslie Ward, signed *Spy*
(*VF* 16 June 1877)
Purchased, 1938
See Collections: Vanity Fair
cartoons, 1869-1910, by various
artists, **2566-2606,** etc

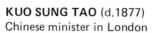

LABOUCHERE, Henry, 1st Baron
Taunton *See* TAUNTON

LABOUCHERE, Henry du Pré
(1831-1912)
Journalist and politician

5256 *See Groups:* The Lobby of
the House of Commons, 1886, by
Liberio Prosperi

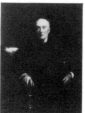

2248 *See Collections:* The Parnell Commission, 1888-9, by Sydney Prior Hall, **2229-72**

2283,2284 *See Collections:* Miscellaneous drawings . . . by Sydney Prior Hall, **2282-2348** and **2370-90**

2848,2867 *See Collections:* Caricatures of Politicians, by Sir Francis Carruthers Gould, **2826-74**

3589 *See Collections:* Prominent Men, c.1880-c.1910, by Harry Furniss, **3337-3535** and **3554-3620**

LACAITA, Sir James Philip (1813-95)
Italian scholar and politician

5272 Bronze statuette 32.1 ($12\frac{5}{8}$) high
Georgio Matarrese, incised and dated 1894
Purchased, 1979

LAFAYETTE, Marie Joseph, Marquis de (1757-1834)
French general and statesman

2515(57) *See Collections:* Drawings of Prominent People, 1823-49, by William Brockedon, **2515(1-104)**

LAIRD, John (1805-74)
Shipbuilder

2686 Pencil, three sketches 17.5 x 22.6 ($6\frac{7}{8}$ x $8\frac{7}{8}$)
Charles Samuel Keene, inscribed, c.1872
Given by George Stewart Bowles, 1934

Ormond

LAKE, John (1624-89)
Bishop of Chester

79,152a *See Groups:* The Seven Bishops Committed to the Tower in 1688, by an unknown artist and George Bower

LAMB, Lady Caroline (1785-1828)
Novelist

3312 Canvas 114.9 x 140.3 (45¼ x 55¼)
Eliza H.Trotter, exh 1811
Given by Lady Lett, 1946

LAMB, Charles (1775-1834)
Essayist and poet

449 Pencil and chalk 17.1 x 14.6 (6¾ x 5¾)
Robert Hancock, 1798
Purchased, 1877

507 Canvas 76.2 x 62.2 (30 x 24½)
William Hazlitt, 1804
Purchased, 1878

1312 Canvas 33 x 26.7 (13 x 10½)
After Henry Hoppner Meyer (1826)
Purchased, 1902

1019 With his sister, Mary
Canvas 113 x 85.1 (44½ x 33½)
Francis Stephen Cary, signed, 1834
Given by Edward Robert Hughes, 1895

LAMB, Frederick James, 3rd Viscount Melbourne
See MELBOURNE

LAMB, Henry (1883-1960)
Painter

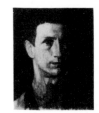

4432 (With sketch of coastal scene at Doelan near Finisterre on reverse)
Panel 36.8 x 31.8 (14½ x 12½)
Self-portrait, signed, inscribed and dated 1914
Given by Darsie Japp, 1965

Continued overleaf

4401 Pen and ink 35.6 x 28.6
(14 x 11¼)
Powys Evans, signed and inscribed,
pub 1928
Purchased, 1964

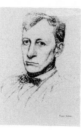

4257 Pencil 35.6 x 25.4 (14 x 10)
Self-portrait, c.1950
Purchased, 1962

4256 Pencil and red chalk
38.7 x 27.9 (15¼ x 11)
Self-portrait, dated 1951
Purchased, 1962

LAMB, Mary (1764-1847) Sister
and collaborator of Charles Lamb

1019 *See under* Charles Lamb

LAMB, William, 2nd Viscount
Melbourne *See* MELBOURNE

LAMBARDE, William (1536-1601)
Historian and lawyer

4489 Panel 57.2 x 44.5
(22½ x 17½)
Unknown artist, inscribed
Purchased, 1966

Strong

LAMBART, Frederick, 10th Earl
of Cavan *See* CAVAN

LAMBERT, Constant (1905-51)
Composer, conductor and critic

4443 Canvas 91.4 x 55.9 (36 x 22)
Christopher Wood, 1926
Purchased, 1965

LAMBERT, George Washington
(1873-1930) Artist

3115 Canvas 45.7 x 36.8
(18 x 14½)
Self-portrait, c.1900-1
Given by his widow, 1942

LAMBERT, John (1619-84)
Parliamentary general

252 Canvas, oval 74.3 x 61.6
(29¼ x 24¼)
After Robert Walker (c.1650-5)
Purchased, 1867

982(h) *See Unknown Sitters II*
Piper

LAMBERT, Sir John (1772-1847)
General

3731 *See Collections:* Studies for
The Waterloo Banquet at Apsley
House, 1836, by William Salter,
3689-3769

LAMBTON, John George, 1st Earl
of Durham *See* DURHAM

LAMPSON, Frederick Locker
See LOCKER-LAMPSON

LANCASTER, Joseph (1778-1838)
Educationalist

99 Canvas 74.3 x 61.6
(29¼ x 24¼)
John Hazlitt
Given by Samuel Sharwood, 1860

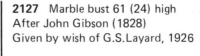

LANCE, George (1802-64)
Painter of still-life

1713 Pencil and water-colour
22.9 x 18.4 (9 x 7¼)
Self-portrait
Given by his daughter-in-law,
Mrs Lance, 1913

Ormond

LANDER, John (1807-39)
Explorer

2515(64) Black and red chalk
36.2 x 25.7 (14¼ x 10⅛)
William Brockedon, dated 1834
Lent by NG, 1959
See Collections: Drawings of
Prominent People, 1823-49, by
William Brockedon, **2515(1-104)**

Ormond

LANDER, Richard Lemon
(1804-34) Explored the course of
the Niger

2515(47) *See Collections:*
Drawings of Prominent People,
1823-49, by William Brockedon,
2515(1-104)

2442 Canvas 74.9 x 62.2
(29½ x 24½)
William Brockedon, c.1835
Given by Sir John Murray, 1929

Ormond

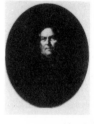

LANDON, Letitia Elizabeth (Mrs
Maclean) (1802-38)
Poet and novelist

1953 Pencil, black chalk and
stump 27.3 x 21.6 (10¾ x 8½)
Daniel Maclise, c.1830-5
Purchased, 1922

LANDOR, Walter Savage
(1775-1864) Writer; author of
Imaginary Conversations

1950 Plaster cast of bust 58.4
(23) high
John Gibson, incised, 1828
Given by the sitter's grandson,
Walter Savage Landor, 1922

2127 Marble bust 61 (24) high
After John Gibson (1828)
Given by wish of G.S.Layard, 1926

236 Canvas 89.5 x 69.9 (35¼ x 27½)
William Fisher, exh 1840
Bequeathed by Henry Crabb
Robinson, 1867

2658 Pastel, oval 76.2 x 63.5
(30 x 25)
Robert Faulkner
Given by the Marquess of Crewe,
1934

LANDSEER, Sir Edwin Henry
(1802-73) Painter of animals

4267 Pencil 20 x 15.5 (7⅞ x 6⅛)
Self-portrait, signed with initials
and dated 1818
Purchased, 1962

436 Sepia ink 15.2 x 11.1 (6 x 4⅜)
Sir Francis Grant, signed and dated
1852
Given by the 2nd Viscount
Hardinge, 1876

1018 Board 30.2 x 25.4
(11⅞ x 10)
Sir Francis Grant, inscribed on
reverse, c.1852
Given by Sir Richard Quain, Bt,
1895

Continued overleaf

834 Canvas 114.3 x 89.2
(45 x 35⅛)
Sir Francis Grant, 1852
Given by the Marquis de Rochefort-
Luçay, 1890

835 Canvas 80 x 113 (31½ x 44½)
John Ballantyne, signed, c.1865
Given by William Agnew, 1890

2521 *See under* Sir Francis Grant

Ormond

LANDSEER, John (1769-1852)
Engraver

1843 Canvas 91.4 x 70.5
(36 x 27¾)
Sir Edwin Henry Landseer (his son)
Transferred from Tate Gallery, 1919

LANDSEER, Thomas (1795-1880)
Engraver; brother of Sir Edwin
Henry Landseer

1120 Chalk 35.2 x 25.4
(13⅞ x 10)
Charles Landseer (his brother),
signed with initials
Purchased, 1898

Ormond

LANE, Mr (?John Lane)

P6(149,157,159) *See Collections:*
The Hill and Adamson Albums,
1843-8, by David Octavius Hill
and Robert Adamson, **P6(1-258)**

LANE, Sir Allen (1902-70)
Founder of Penguin Books

4529(200-4) *See Collections:*
Working drawings by Sir David
Low, **4529(1-401)**

LANE, Edward William (1801-76)
Arabic scholar

940 Plaster statue 95.3 (37½) high
Richard James Lane (his brother),
1829
Given by the sitter's great-nephew,
Stanley Lane Poole, 1893

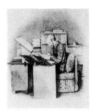

3099 Water-colour 23.5 x 19.1
(9¼ x 7½)
Clara S.Lane (his niece), signed
with initials and dated 1850
Purchased, 1941

Ormond

LANE, Sir Hugh (1875-1915)
Art collector and critic

4676 *See Groups:* Lady Gregory,
Sir Hugh Lane, J.M.Synge and
W.B.Yeats, by Sir William Orpen

LANE, Jane *See* FISHER

LANE, Sir William Arbuthnot, Bt
(1856-1943) Surgeon

4484 Pen and ink 35.6 x 25.4
(14 x 10)
Alfred Wolmark, signed, inscribed
and dated 1926
Purchased, 1966

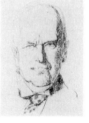

4529(109) *See Collections:*
Working drawings by Sir David
Low, **4529(1-401)**

LANG, Andrew (1844-1912)
Poet, scholar and writer

3482,3483 *See Collections:*
Prominent Men, c.1880-c.1910,
by Harry Furniss, **3337-3535** and
3554-3620

LANGDALE, Henry Bickersteth,
Baron (1783-1851)
Master of the Rolls

1773 Miniature on ivory
12.4 x 9.8 (4⅞ x 3⅞)
Henry Collen, signed and dated 1829
Given by A.Heathcote Long, 1916

Ormond

LANGTON, William Gore
(1760-1847) MP for Somerset East

54 *See Groups:* The House of Commons, 1833, by Sir George Hayter

LANKESTER, Edwin (1814-74)
Scientist

P120(15) Photograph: albumen
print, arched top 19.7 x 14.6
(7¾ x 5¾)
Maull & Polyblank, inscribed on
mount, 1855
Purchased, 1979
See Collections: Literary and
Scientific Men, 1855, by Maull &
Polyblank, **P120(1-54)**

LANKESTER, Sir Edwin Ray
(1847-1929) Zoologist; son
of Edwin Lankester

3006 Water-colour 36.2 x 26.4
(14¼ x 10⅜)
Sir Leslie Ward, signed *Spy*
(*VF* 12 Jan 1905)
Purchased, 1938

4378 Sanguine and white chalk
39.4 x 31.4 (15½ x 12⅜)
Sir William Rothenstein, signed and
dated 1922
Purchased 1964

4781 Sanguine 36.8 x 25.7
(14½ x 10⅛)
Sir William Rothenstein, signed with
initials, inscribed and dated 1925
Purchased, 1970

LANSBURY, George (1859-1940)
Labour leader and pacifist

3775 Canvas 52.1 x 34.3
(20½ x 13½)
Sylvia Gosse, signed, 1939
Purchased, 1950

LANSDOWNE, William Petty, 1st
Marquess of (Lord Shelburne)
(1737-1805)
Statesman and patron of the arts

43 Canvas 74.9 x 62.2
(29½ x 24½)
After Sir Joshua Reynolds, reduced
copy (1764)
Given by the sitter's son, the
Marquess of Lansdowne, 1858

LANSDOWNE, Henry Petty-
Fitzmaurice, 3rd Marquess of
(1780-1863) Statesman

178 Canvas, feigned oval
75.9 x 63.2 (29⅞ x 24⅞)
Henry Walton, c.1805
Purchased, 1864

999 *See Groups:* The Trial of
Queen Caroline, 1820, by Sir
George Hayter

54 *See Groups:* The House of Commons, 1833, by Sir George Hayter

1383 Chalk and stump 28.2 x 21
(11⅛ x 8¼)
Edmund Thomas Parris, signed with
initials, inscribed and dated 1838
Purchased, 1904

342,343 *See Groups:* The Fine
Arts Commissioners, 1846, by John
Partridge

1125,1125a *See Groups:* The
Coalition Ministry, 1854, by Sir
John Gilbert

Ormond

LANSDOWNE, Henry Petty-
Fitzmaurice, 5th Marquess of
(1845-1927) Viceroy of
India and Foreign Secretary

2625 Water-colour 30.5 x 17.8
(12 x 7)
Carlo Pellegrini, signed *Ape*
(*VF* 4 April 1874)
Purchased, 1933

Continued overleaf

3590 *See Collections:* Prominent
Men, c.1880-c.1910, by Harry
Furniss, **3337-3535** and **3554-3620**

2180 Canvas 90.2 x 59.7
(35½ x 23½)
Philip de Laszlo, signed and dated
1920
Given by the sitter's son, the
Marquess of Lansdowne, 1928

LARDNER, Dionysius (1793-1859)
Scientific writer

1039 Panel, oval 12.1 x 9.5
(4¾ x 3¾)
Edith Fortunée Tita de Lisle,
signed
Given by the sitter's son,
G.D.Lardner, 1896

Ormond

LARKING, Cuthbert (b.1842)
Sportsman and royal official

4724 Water-colour 31.1 x 18.1
(12¼ x $7\frac{1}{8}$)
Carlo Pellegrini, signed *Ape*
(*VF* 11 Aug 1888)
Purchased, 1970

LARPENT, Charlotte Rosamund
(née Arnold) (d.1879) Second
wife of Francis Seymour Larpent

3806 *See under* Francis Seymour
Larpent

LARPENT, Francis Seymour
(1776-1845) Civil servant

3806 With his second wife,
Charlotte Rosamund
Canvas 74.9 x 62.2 (29½ x 24½)
Unknown artist, after 1829
Given by Francis Beaufort-Palmer,
1951

LASCELLES, Mrs

4855(14) *See Collections:* The
Townshend Album, **4855(1-73)**

LASCELLES, Sir Frank Cavendish
(1841-1920) Diplomat

5083 Water-colour 56.2 x 25.4
(22$\frac{1}{8}$ x 10)
Unknown artist, signed *K*
(*VF* 23 Oct 1912)
Given by J.Vassall Adams, 1976

LASCELLES, Henry, 2nd Earl of
Harewood *See* HAREWOOD

LASKI, Harold (1893-1950)
Political theorist

4529(205,205a,206) *See
Collections:* Working drawings by
Sir David Low, **4529(1-401)**

LASZLO de Lombos, Philip Alexius
See DE LASZLO, Philip

LATHOM, Edward Bootle-
Wilbraham, 1st Earl of (1837-98)
Representative peer

1834(s) *See Collections:* Members
of the House of Lords, c.1870-80,
by Frederick Sargent, **1834(a-z
and aa-hh)**

LATIMER, Hugh (1485?-1555)
Bishop of Worcester

295 Panel 55.9 x 41.9 (22 x 16½)
Unknown artist, inscribed and
dated 1555
Purchased, 1870

Strong

LATROBE, Charles Joseph
(1801-75) Australian governor
and traveller

2515(45) Black, red and brown
chalk 34.9 x 26.7 (13¾ x 10½)
William Brockedon, dated 1835
Lent by NG, 1959
See Collections: Drawings of
Prominent People, 1823-49, by
William Brockedon, **2515(1-104)**

1672 Bronze cast of medallion
7.6 (3) diameter
Thomas Woolner, reduced version,
c.1853
Purchased, 1912

Ormond

LATTAS, Michael
See OMAR PASHA

LAUD, William (1573-1645)
Archbishop of Canterbury

171 Canvas 123.2 x 94 (48½ x 37)
After Sir Anthony van Dyck
(c.1636?)
Purchased, 1864

Piper

LAUDERDALE, John Maitland,
1st Duke of (1616-82) Politician;
supporter of Charles II

4198 Miniature on vellum, oval
8.6 x 7 ($3\frac{3}{8}$ x 2¾)
Samuel Cooper, signed in
monogram and dated 1664
Purchased with help from NACF,
Pilgrim Trust, and H.M.Government,
1961

2084 Canvas 127 x 99.7
(50 x 39¼)
Jacob Huysmans, c.1665-70
Purchased, 1925

4362 Silver medal 2.5 (1) diameter
John Roettier, incised and dated
1672
Purchased, 1964

Piper

LAUDERDALE, James Maitland,
8th Earl of (1759-1839) Author of
*Inquiry into the Nature and Origin
of Public Wealth*

999 *See Groups:* The Trial of
Queen Caroline, 1820, by Sir
George Hayter

LAURIER, Sir Wilfrid (1841-1919)
Canadian statesman

2382 *See Collections:*
Miscellaneous drawings . . . by
Sydney Prior Hall, **2282-2348** and
2370-90

LAVERY, Sir John (1856-1941)
Portrait painter

3671 Pencil and chalk 37.5 x 27
(14¾ x $10\frac{5}{8}$)
Sir Bernard Partridge, signed
(*Punch* 30 March 1927)
Purchased, 1949
See Collections: Mr Punch's
Personalities, 1926-9, by Sir
Bernard Partridge, **3664-6,** etc

LAW, Andrew Bonar (1858-1923)
Prime Minister

2358 Pencil 15.2 x 11.4 (6 x 4½)
Minnie Agnes Cohen, signed and
dated 1890
Given by the artist, 1929

2847 *See Collections:* Caricatures
of Politicians, by Sir Francis
Carruthers Gould, **2828-74**

2463 *See Groups:* Statesmen of
World War I, by Sir James Guthrie

LAW, Charles Edmund, 3rd Baron
Ellenborough
See ELLENBOROUGH

LAW, Edward, 1st Earl of
Ellenborough
See ELLENBOROUGH

LAW, Edward, 1st Baron
Ellenborough
See ELLENBOROUGH

LAW, George Henry (1761-1845)
Bishop of Bath and Wells

1695(n) *See Collections:* Sketches
for The Trial of Queen Caroline,
1820, by Sir George Hayter

Continued overleaf

999 *See Groups:* The Trial of
Queen Caroline, 1820, by Sir
George Hayter

LAW, John (1671-1729)
Financier and speculator

191 Canvas, oval 81.3 x 63.5
(32 x 25)
Attributed to Alexis Simeon Belle,
c.1715-20?
Purchased, 1865

Piper

LAWES, Sir John Bennet, Bt
(1814-1900) Agriculturalist

2643 Water-colour 30.5 x 18.1
(12 x 7$\frac{1}{8}$)
Théobald Chartran, signed .*T.*
(*VF* 8 July 1882)
Purchased, 1933

LAWLEY, Beilby, 3rd Baron
Wenlock *See* WENLOCK

LAWRENCE, John Laird Mair
Lawrence, 1st Baron (1811-79)
Governor-General of India

1005 Panel 62.2 x 50.5
(24½ x 19$\frac{7}{8}$)
George Frederic Watts, signed
with initials and dated 1862
Given by the artist, 1895

2610 Coloured chalk 59.1 x 46.7
(23¼ x 18$\frac{3}{8}$)
E.Goodwyn Lewis, signed, 1872
Given by the sitter's great-nephew,
Lt-Col H.Lawrence, 1933

2111 Marble bust 82.6 (32½) high
Thomas Woolner, incised and dated
1882
Given by the sitter's son, Sir
Herbert Lawrence, 1926

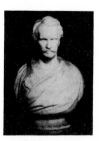

766 Plaster cast of bust 65.4
(25¾) high
Sir Joseph Edgar Boehm, c.1882
Given by the artist, 1885

Ormond

LAWRENCE, David Herbert
(1885-1930) Novelist and poet

4036 Canvas 38.7 x 29.8
(15¼ x 11¾)
Jan Juta, signed and dated 1920
Purchased, 1957

5098 Chalk 32.4 x 25.4 (12¾ x 10)
Maria Hubrecht, signed in
monogram, 1920-1
Purchased, 1976

4035 Chalk 44.5 x 38.4
(17½ x 15$\frac{1}{8}$)
Edmond Xavier Kapp, signed and
dated 1923
Purchased, 1957

4015 Oil on card 16.5 x 14
(6½ x 5½)
The Hon Dorothy Eugénie Brett,
signed and dated 1925
Purchased, 1957

LAWRENCE, Sir Henry
Montgomery (1806-57) General

1990 Canvas 43.2 x 32.4
(17 x 12¾)
Unknown artist, c.1827
Given by the sitter's grandson,
Sir Alexander Lawrence, Bt, 1923

727 Miniature on ivory 11.4 x 8.7
(4½ x 3⅜)
Unknown artist, c.1847
Given by the 2nd Viscount
Hardinge, 1884

1989 Marble bust 78.1 (30¾) high
Thomas Campbell, incised and
dated 1849
Given by the sitter's grandson, Sir
Alexander Lawrence, Bt, 1923

Ormond

LAWRENCE, Stringer (1697-1775)
'Father of the Indian army'

777 Canvas, feigned oval
75.9 x 62.6 (29⅞ x 24⅝)
Thomas Gainsborough
Given by Sir Henry Yule, 1888

Kerslake

LAWRENCE, Sir Thomas
(1769-1830) Portrait painter,
collector and PRA

2515(21) Pencil 37.5 x 24.5
(14¾ x 9⅝)
William Brockedon, inscribed,
1820-30
Lent by NG, 1959
See Collections: Drawings of
Prominent People, 1823-49, by
William Brockedon, **2515(1-104)**

260 Canvas 92.1 x 71.1 (36¼ x 28)
Richard Evans after a self-portrait
(c.1825)
Purchased, 1868

1634 Plaster cast of death-mask
44.5 x 31.5 (17½ x 12⅜) and right
hand 21 (8¼) long
Unknown artist, 1830
Given by the daughters of Archibald
Keightley, the sitter's sole executor,
1911

239 Marble bust 69.9 (27½) high
Edward Hodges Baily, incised and
dated 1830
Purchased, 1867

1507 Bronze medallion 36.5
(14⅜) diameter
Samuel Parker after Edward Hodges
Baily, incised, 1830
Given by Alfred Jones, 1908

4278 Copper medal 4.1 (1⅝)
diameter
Scipio Clint after Samuel Joseph
(obverse; *above*) and Scipio Clint
after Edward Hodges Baily (reverse;
below), incised and dated 1830
Given by the Royal College of
Surgeons of England, 1962

LAWRENCE, Thomas Edward
(1888-1935) Soldier and writer;
'Lawrence of Arabia'

3187 Pencil 35.6 x 25.4 (14 x 10)
Augustus John, 1919
Given by George Bernard Shaw,
1944

4298 Bronze cast of bust 41.3
(16¼) high
Eric Henri Kennington, incised with
initials and numbered 9, 1926
Purchased, 1963

5016 Marble head 28.6 (11¼) high
Sir Charles Wheeler, incised and
dated 1929
Given by Lady Muriel Wheeler, the
artist's widow, 1975

3188 Pencil 40.6 x 30.5 (16 x 12)
Augustus John, c.1929
Given by George Bernard Shaw,
1944

2910 Chalk 33.7 x 26 (13¼ x 10¼)
Augustus John, signed, c.1929
Given by Eric Henri Kennington,
1937

LAWRIE, Hugh Richard
See SHEPPARD

LAWSON, Cecil Gordon (1849-82)
Landscape painter

2797 Pencil 14.9 x 10.2 (5$\frac{7}{8}$ x 4)
Francis Wilfrid Lawson (his
brother), signed with initials,
c.1865
Given by the sitter's niece, Miss
M. Winifrid Lawson, 1935

3889 Water-colour 49.5 x 34.3
(19½ x 13½)
Sir Hubert von Herkomer, signed
with initials, inscribed and dated
1877
Given by the sitter's son, Cecil
Lawson, 1953

LAWSON, Malcolm Leonard
(1847-1918) Composer

2798 Pencil 14.3 x 11.1 (5$\frac{5}{8}$ x 4$\frac{3}{8}$)
Francis Wilfrid Lawson (his
brother), signed with initials,
c. 1865
Given by the sitter's niece, Miss
M.Winifrid Lawson, 1935

LAWSON, Sir Wilfrid, Bt
(1829-1906) Politician

2728 Water-colour 30.8 x 18.4
(12$\frac{1}{8}$ x 7¼)
Thomas Nast
(*VF* 11 May 1872)
Purchased, 1934

LAYARD, Sir Austen Henry
(1817-94)
Diplomat and archaeologist

2515(103) Pencil and chalk
37.5 x 27 (14¾ x 10$\frac{5}{8}$)
William Brockedon
Lent by NG, 1959
See Collections: Drawings of
Prominent People, 1823-49, by
William Brockedon, **2515(1-104)**

3787 Black chalk 58.4 x 48.3
(23 x 19)
George Frederic Watts, signed, 1848
Given by the sitter's grand-niece,
Miss Barbara Murray, 1951

1006 Black chalk 59.7 x 49.5
(23½ x 19½)
George Frederic Watts. c.1851
Given by the artist, 1895

1797 Water-colour 60.3 x 45.1
(23¾ x 17¾)
Ludwig Johann Passini, signed and
dated 1891
Bequeathed by the sitter's widow,
1917

LEACH, Sir George Archibald
(1820-1913) Secretary to the
Board of Agriculture

2974 Water-colour 33 x 25.4
(13 x 10)
F.T. Dalton, signed *FTD*
(*VF* 21 Dec 1896)
Purchased, 1938

LEAF, Walter (1852-1927)
Classical scholar and banker

4782 Black crayon 39.4 x 28.6
(15½ x 11¼)
Sir William Rothenstein, 1910
Purchased, 1970

LEAN, David (b.1908)
Film director

4529(208, 209) *See Collections*:
Working drawings by Sir David
Low, **4529(1-401)**

LEAR, Ann (1791-1861)
Eldest sister of Edward Lear

1759A Miniature on ivory 9.8 x 7.6
($3\frac{7}{8}$ x 3)
Unknown artist
Given by Francis Adeney Allen,
1915

LEAR, Catherine
Youngest sister of Edward Lear

1759C Silhouette 7 x 2.8
(2¾ x $1\frac{1}{8}$)
Unknown artist
Given by Francis Adeney Allen,
1915

LEAR, Edward (1812-88)
Artist and author of the *Book of
Nonsense*

1759 Silhouette 6.4 x 2.8
(2½ x $1\frac{1}{8}$)
Unknown artist
Given by Francis Adeney Allen,
1915

3055 Pencil 17.8 x 10.8 (7 x 4¼)
Wilhelm Nicolai Marstrand, inscribed
and dated 1840
Purchased, 1939

4351 Pen and ink 14 x 17.5
(5½ x $6\frac{7}{8}$)
Self-portrait, inscribed, 1862-3
Purchased, 1964

LEATHAM, William (1783-1842)
Slavery abolitionist

599 *See Groups*: The Anti-Slavery
Society Convention, 1840, by
Benjamin Robert Haydon

LECESNE, L.C.
Slavery abolitionist

599 *See Groups*: The Anti-Slavery
Society Convention, 1840, by
Benjamin Robert Haydon

LECHMERE, Sir Edmund, Bt
(1826-94) Pioneer of Red Cross
Society

4628 Water-colour 30.5 x 18.1
(12 x 7⅛)
Théobald Chartran, signed .*T*.
(*VF* 23 June 1883)
Purchased, 1968

LECKY, William Edward Hartpole
(1838-1903) Historian and essayist

3146 Pencil 12.7 x 8.9 (5 x 3½)
Marian Collier, signed with initials
and dated 1877
Purchased, 1943

1350 Canvas 64.8 x 52.1
(25½ x 20½)
George Frederic Watts, 1878
Given by the artist, 1903

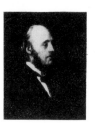

5165 Water-colour 35.6 x 25.4
(14 x 10)
Sir Leslie Ward, inscribed
(study in reversed pose for
VF 27 May 1882)
Given by James Byam Shaw, 1977

1360 Terracotta bust 63.5 (25)
high
Sir Joseph Edgar Boehm, c.1890
Given by the sitter's widow, 1904

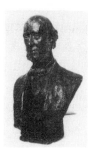

LE DESPENCER, Francis
Dashwood, 15th Baron (1708-81)
Chancellor of the Exchequer;
founder of the Hell-fire Club

1345 Canvas 73.7 x 61 (29 x 24)
Attributed to Nathaniel Dance,
inscribed, c.1776
Purchased, 1903

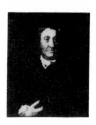

LEE, Dr

P120(14) *See Collections*:
Literary and Scientific Men, 1855,
by Maull & Polyblank, **P120(1-54)**

LEE, Sir Henry (1533-1611)
Master of the Ordnance

2095 Panel 64.1 x 53.3 (25¼ x 21)
Antonio Mor, signed and dated
1568
Given by Viscount Dillon, 1925

Strong

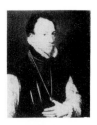

LEE, Sir Sidney (1859-1926)
Shakespearian scholar; editor of the
Dictionary of National Biography

4423 Black chalk 38.1 x 27.9
(15 x 11)
Francis Dodd
Purchased, 1964

LEE, Sir William (1688-1754)
Judge

471 Canvas 237.5 x 146.7
(93½ x 57¾)
C.F. Barker after John Vanderbank,
1845 (1738)
Given by the Society of Judges and
Serjeants-at-Law, 1877

Kerslake

LEECH, John (1817-64)
Illustrator and caricaturist

899 Water-colour 40 x 25.4
(13⅜ x 10)
Sir John Everett Millais, signed in
monogram and dated 1854
Purchased, 1892

866 Plaster cast of bust 62.2
(24½) high
Sir Joseph Edgar Boehm, c.1865
Purchased, 1891

Ormond

LEEDS, Thomas Osborne, 1st Duke
of (1631-1712) Statesman

1472 Canvas 236.2 x 146.1
(93 x 57½)
Studio of Sir Peter Lely, inscribed,
c.1680(?)
Purchased, 1907

631 Engraving 38.1 x 27.3
(15 x 10¾)
Robert White, signed and inscribed
on plate, c.1694
Purchased, 1881

Piper

LEEDS, Francis Osborne, 5th Duke
of (1751-99) Foreign Secretary

801 Canvas 69.2 x 88.9 (27½ x 35)
Attributed to Benjamin West
Given by the Earl of Chichester,
1888

LEEKE, Robert (d.1762) Divine

4855(16) *See Collections*: The
Townshend Album, **4855(1-73)**

LEESON, Edward Nugent, 6th Earl
of Milltown *See* MILLTOWN

LE FANU, Joseph Thomas
Sheridan (1814-73)
Novelist and journalist

4864 Water-colour 19.4 x 14.6
($7\frac{5}{8}$ x 5¾)
Unknown artist, inscribed and
dated 1842
Given by Lord Kenyon, 1972

LEFEVRE Dominique (1737-69)
French artist

213 *See under* James Barry

LEFROY, Anthony (1800-90)
MP for County Longford

54 *See Groups*:The House of Commons, 1833, by Sir George Hayter

LEFROY, Thomas Langlois
(1776-1869) Irish judge

54 *See Groups*:The House of Commons, 1833, by Sir George Hayter

LEGGE, George, 1st Baron
Dartmouth *See* DARTMOUTH

LEGGE, William (1609-72)
Soldier and Royalist

505 Canvas 110.5 x 95.3
(43½ x 37½)
After Jacob Huysmans (c.1670?)
Given by the Earl of Dartmouth,
1878

Piper

LEGGE, William, 4th Earl of
Dartmouth *See* DARTMOUTH

LEGROS, Alphonse (1837-1911)
Painter, sculptor and etcher

2551 Canvas 91.4 x 67. 3
(36 x 26½)
Charles Haslewood Shannon,
signed and dated 1899
Given by Francis Howard, 1932

LEHMANN, Liza (Mrs H. Bedford)
(1862-1918) Singer and composer

4118 Lithograph 35.6 x 25.4
(14 x 10)
Flora Lion, signed, autographed by
sitter, and dated on stone 1915
Purchased, 1959

LEICESTER, Robert Dudley, Earl of (1532?-88) Favourite of Elizabeth I

447 Panel 108 x 82.6 (42½ x 32½)
Unknown artist, c.1575
Purchased, 1877

4197 Miniature on vellum 4.4 (1¾) diameter
Nicholas Hilliard, inscribed and dated 1576
Purchased with help from NACF, Pilgrim Trust, H.M. Government and an anonymous donor, 1961

247 Panel 96.5 x 68.6 (38 x 27)
Unknown artist, c.1575-80
Purchased, 1867. *Montacute*

Strong

LEICESTER, Robert Sidney, 1st Earl of (1563-1626) Soldier; second son of Sir Henry Sidney

1862 Canvas 99.1 x 79.4 (39 x 31¼)
Unknown artist, inscribed, c.1588
Purchased, 1920. *Montacute*

Strong

LEICESTER, Thomas William Coke, 1st Earl of (1752-1842) Agriculturalist

316a(77) Pencil 48.6 x 33.3 ($19\frac{1}{8}$ x $13\frac{1}{8}$)
Sir Francis Chantrey, inscribed
Given by Mrs George Jones, 1871
and

316a(78) Pencil 48.3 x 33 (19 x 13)
Sir Francis Chantrey, inscribed
Given by Mrs George Jones, 1871
See Collections: Preliminary drawings for busts and statues by Sir Francis Chantrey, **316a(1-202)**

LEIGH, Anthony (d.1692) Comedian

1280 Canvas 231.8 x 142.2 (91¼ x 56)
Sir Godrey Kneller, signed, inscribed and dated 1689
Given by Mrs Charles James Wylie, 1900

Piper

LEIGH, Vivien (née Hartley) (1913-67) Actress

P62 Photograph: bromide print 50.5 x 40 ($19\frac{7}{8}$ x 15¾)
Angus McBean c.1949
Purchased 1977
See Collections: Prominent people, c.1946-64, by Angus McBean, **P57-67**

LEIGHTON, Frederic Leighton, Baron (1830-96) Painter and PRA

2141 Pencil 19.7 x 15.2 (7¾ x 6)
Self-portrait, signed, 1845-50
Given by Miss Caroline Nias, 1926
See Collections: Lord Leighton and his family, by Frederic, Lord Leighton, and Edward(?) Foster, **2141,2141(a-d)**

P93 Photograph: albumen print 21.3 x 16.2 ($8\frac{3}{8}$ x $6\frac{3}{8}$)
David Wilkie Wynfield, 1860s
Given by H. Saxe Wyndham, 1937
See Collections: The St John's Wood Clique, by David Wilkie Wynfield, **P70-100**

P77 *See Collections*: The St John's Wood Clique, by David Wilkie Wynfield, **P70-100**

1049 Canvas 97.8 x 74.9 (38½ x 29½)
George Frederic Watts, signed and dated 1881
Given by the artist, 1896

1833 *See Groups*: Private View of the Old Masters Exhibition, Royal Academy, 1888, by Henry Jamyn Brooks

2262 *See Collections*: The Parnell Commission, 1888-9, by Sydney Prior Hall, **2229-72**

2820 *See Groups*: The Royal Academy Conversazione, 1891, by G. Grenville Manton

4245 *See Groups*: Hanging Committee, Royal Academy, 1892, by Reginald Cleaver

1957 Plaster cast of bust 82.6 (32½) high
Sir Thomas Brock, incised and dated 1892
Given by wish of the sculptor, 1922.
Not illustrated

1957a Bronze cast of no. **1957**
Purchased, 1923

2016 Miniature on ivory
12.7 x 9.8 (5 x 3⅞)
Rosa Carter, signed with initials, 1896
Purchased, 1924

3484 *See Collections*: Prominent Men, c.1880-c.1910, by Harry Furniss, **3337-3535** and **3554-3620**

LEIGHTON, Augusta (née Nash) (1804-65) Mother of Lord Leighton

2141(d) *See Collections*: Lord Leighton and his family, by Frederic, Lord Leighton, and Edward(?) Foster, **2141,2141(a-d)**

LEIGHTON, Frederic Septimus (1800-92) Physician; father of Lord Leighton

2141(c) *See Collections*: Lord Leighton and his family, by Frederic, Lord Leighton, and Edward(?) Foster, **2141, 2141(a-d)**

LEINSTER, Augustus Frederick Fitzgerald, 3rd Duke of (1791-1874)

999 *See Groups*: The Trial of Queen Caroline, 1820, by Sir George Hayter

LEITCH, William Leighton (1804-83) Painter

P6(144, 147) *See Collections*: The Hill and Adamson Albums, 1843-8, by David Octavius Hill and Robert Adamson, **P6(1-258)**

LEITH, John Farley (1808-87) Lawyer and politician

4725 Water-colour 30.5 x 17.8 (12 x 7)
Sir Leslie Ward, signed *Spy*
(*VF* 21 June 1879)
Purchased, 1970

LELY, Sir Peter (1618-80) Portrait painter

3897 108 x 87.6 (42½ x 34½)
Self-portrait, signed in monogram, c.1660
Purchased, 1954

951 Canvas 46.4 x 36.8 (18¼ x 14½)
After a self-portrait (c.1670)
Purchased, 1893

Piper

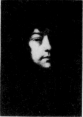

LENNOX, Margaret Douglas, Countess of (1515-78) Mother of Lord Darnley

358 Electrotype of effigy in Westminister Abbey 96.5 (38) high Unknown artist Purchased, 1872

401 *See Unknown Sitters I*

Strong

LENNOX, Charles, 1st Duke of Richmond and Lennox *See* RICHMOND AND LENNOX

LENNOX, Charles, 3rd Duke of Richmond and Lennox *See* RICHMOND AND LENNOX

LENNOX, Charles, 4th Duke of Richmond and Lennox *See* RICHMOND AND LENNOX

LENNOX, Charles Gordon-, 5th Duke of Richmond and Lennox *See* RICHMOND AND LENNOX

LENNOX, Charlotte (1720-1804) Writer

4905 *See Groups*: The Nine Living Muses of Great Britain, by Richard Samuel

LENO, Dan *See* GALVIN

LENS, Bernard (1682-1740) Miniaturist

1624 Miniature on vellum, oval 4.4 x 3.5 (1¾ x 1⅜) Self-portrait, signed in monogram and dated 1721 Purchased, 1911

Kerslake

LENTHALL, William (1591-1662) Speaker of the House of Commons

12 Canvas 143.5 x 114.3 (56½ x 45) Unknown artist Purchased, 1857

2766 Miniature on vellum, oval 5.4 x 4.4 (2⅛ x 1¾) Samuel Cooper, signed in monogram and dated 1652 Bequeathed by Emslie John Horniman, 1935

Piper

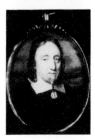

LEOPOLD I (1790-1865) King of the Belgians; uncle of Queen Victoria

2422 Miniature on ivory, oval portrait 8.6 x 6.7 (3⅜ x 2⅝) Unknown artist, 1815 Given by Thomas Wright, 1892

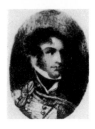

1530 *See under* Princess Charlotte Augusta

LEOPOLD, Prince, Duke of Albany *See* ALBANY

LESLIE, Charles Robert (1794-1859) Painter and writer

2618 Canvas 75.9 x 62.9 (29⅞ x 24¾) Self-portrait, signed and dated 1814 Given by his grandson, Sir Bradford Leslie, 1933

4232 Millboard 20 x 25.4 (7⅞ x 10) John Partridge, 1836 Bequeathed by the widow of the artist's nephew, Sir Bernard Partridge, 1961

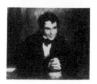

1456(15) Black chalk 8.6 x 8.6 (3⅜ x 3⅜) Charles Hutton Lear, inscribed and dated 1846 Given by John Elliot, 1907 *See Collections*: Drawings of Artists, c.1845, by Charles Hutton Lear, **1456(1-27)**

3182(4, 5) *See Collections*: Drawings of Artists, c.1862, by Charles West Cope, **3182(1-19)**

Ormond

LESLIE, George Dunlop (1835-1921) Painter and writer; son of Charles Robert Leslie

2477 *See Collections*: Drawings of Royal Academicians, c.1858, by Charles Bell Birch, **2473-9**

LESLIE, Henry David (1822-96) Conductor and composer

2522 Pen and ink 17.8 x 11.4 (7 x 4½) Thomas George Cooper, signed, c.1868-72 Given by the sitter's son, John H. Leslie, 1931

LESLIE, Sir John (1766-1832) Scientist and mathematician

1075, 1075a and b *See Groups*: Men of Science Living in 1807-8, by Sir John Gilbert and others

316a(64a) *See Collections*: Preliminary drawings for busts and statues by Sir Francis Chantrey, **316a(1-202)**

LESLIE-MELVILLE, Alexander, 12th Earl of Leven and Melville *See* LEVEN AND MELVILLE

LESTER, Benjamin Lester (c.1780-1838) MP for Poole

54 *See Groups*:The House of Commons, 1833, by Sir George Hayter

LESTER, C. Edwards American slavery abolitionist

599 *See Groups*: The Anti-Slavery Society Convention, 1840, by Benjamin Robert Haydon

L'ESTRANGE, Sir Roger (1616-1704) Royalist and journalist

3771 Canvas 127 x 102.2 (50 x 40¼) Attributed to John Michael Wright, inscribed, c.1680(?) Purchased, 1950

Piper

LE SUEUR, Hubert (1580-1670) Sculptor

939 Electrotype cast of medal, oval 6.4 x 5.1 (2½ x 2) Attributed to Claude Warin, inscribed (1635) Given by Sir Lionel Cust, 1893

Piper

LEVEN AND MELVILLE, Alexander Leslie-Melville, 12th Earl of (1817-89) Banker

4726 Water-colour 30.5 x 18.1 (12 x 7⅛) Sir Leslie Ward, signed *Spy* (*VF* 17 Dec 1881) Purchased, 1970

LEVESON, Sir Arthur Cavenagh (1868-1929) Admiral

1913 *See Groups*: Naval Officers of World War I, by Sir Arthur Stockdale Cope

LEVESON GOWER, Sir George (1858-1951) Politician

5256 *See Groups*: The Lobby of the House of Commons, 1886, by Liberio Prosperi

LEVESON-GOWER, George Granville, 1st Duke of Sutherland *See* SUTHERLAND

LEVESON-GOWER, George Granville Sutherland, 2nd Duke of Sutherland *See* SUTHERLAND

LEVESON-GOWER, Granville,
1st Earl Granville
See GRANVILLE

LEVESON-GOWER, Granville
George, 2nd Earl Granville
See GRANVILLE

LEVY, Joseph Moses (1812-88)
Founder of the *Daily Teleghraph*

4760 Canvas 122.6 x 99.1
(44¼ x 39)
Sir Hubert von Herkomer, exh
1888
Purchased, 1970

LEVY-LAWSON, Edward, 1st
Baron Burnham *See* BURNHAM

LEWES, Agnes (née Jervis)
(d. 1902) Wife of George Henry
Lewes

4686 *See Groups*: Mr and Mrs
George Henry Lewes with
Thornton Leigh Hunt, by William
Makepeace Thackeray

LEWES, George Henry (1817-78)
Writer

1373 Pencil 19.1 x 17.1 (7½ x 6¾)
Anne Gliddon, signed, inscribed
and dated 1840
Given by wish of the sitter's widow,
1904

4686 *See Groups*: Mr and Mrs
George Henry Lewes with
Thornton Leigh Hunt, by William
Makepeace Thackeray

LEWES, Sir Watkin (1736-1821)
Politician; Lord Mayor of London

2439 Pastel, irregular oval
31.1 x 25.1 (12¼ x 9⅞)
By or after Daniel Dodd, inscribed,
eng 1791
Acquired, 1929

LEWIS, Lieutenant-Colonel

1752 *See Groups*: The Siege of
Gibraltar, 1782, by George Carter

LEWIS, Charles George (1808-80)
Engraver

890 Water-colour and pencil
17.8 x 12.7 (7 x 5)
Marshall Claxton, signed with
initials, inscribed and dated 1864
Given by Algernon Graves, 1892

LEWIS, George (1803-79)

P6(99) *See Collections*: The Hill
and Adamson Albums, 1843-8, by
David Octavius Hill and Robert
Adamson, **P6(1-258)**

LEWIS, Sir George Cornewall, Bt
(1806-63) Chancellor of the
Exchequer; editor of the *Edinburgh
Review*

1063 Black and white chalk
58.4 x 43.2 (23 x 17)
George Richmond, signed with
initials and inscribed
Purchased, 1896

Ormond

LEWIS, Sir George Henry, Bt
(1833-1911) Solicitor

2258 Pencil 20 x 14.6 ($7\frac{7}{8}$ x 5¾)
Sydney Prior Hall, inscribed and
dated *Feb 21* (1889)
Given by the artist's son, Harry
Reginald Holland Hall, 1928
See Collections: The Parnell
Commission, 1888-9, by Sydney
Prior Hall, **2229-72**

2243, 2244, 2250 *See Collections*:
The Parnell Commission, 1888-9,
by Sydney Prior Hall, **2229-72**

2282, 2292, 2299 *See Collections*:
Miscellaneous drawings . . . by
Sydney Prior Hall, **2282-2348** and
2370-90

LEWIS, John Frederick (1805-76)
Painter

1470 Panel 45.7 x 35.2 (18 x 13$\frac{7}{8}$)
Sir William Boxall, 1832
Given by wish of the sitter's widow,
1907

Ormond

LEWIS, Matthew Gregory
(1775-1818) Writer

2171 Miniature on ivory
11.4 x 9.2 (4½ x 3$\frac{5}{8}$)
George Lethbridge Saunders,
signed, copy (c.1790-1800)
Given by Bernard Falk, 1927

421 Canvas 74.3 x 61.6
(29¼ x 24¼)
Henry William Pickersgill, eng
1809
Purchased, 1876

LEWIS, William Thomas
(1748-1811) Actor

5148 Canvas, feigned oval
73.3 x 63.5 (28$\frac{7}{8}$ x 25)
Gainsborough Dupont, c.1795
Purchased, 1977

LEWIS, Wyndham (1882-1957)
Painter and novelist

4528 Ink and wash 25.4 x 19.7
(10 x 7¾) *sight*
Self-portrait, signed with initials
and dated 1932
Purchased, 1968

LEY, Jacob (1803-81)
Censor of Christ Church, Oxford

P7(2) *See Collections*: Lewis
Carroll at Christ Church, by
Charles Lutwidge Dodgson,
P7(1-37)

LEY, James, 1st Earl of
Marlborough
See MARLBOROUGH

LEY, John Henry (d.1850)
First Clerk of the House of
Commons

54 *See Groups*:The House of Com-
mons, 1833, by Sir George Hayter

LEY, William (c.1817-47)
Assistant Clerk of the House of
Commons

54 *See Groups*:The House of Com-
mons, 1833, by Sir George Hayter

LIDDELL, Adolphus George
Charles (1846-1920) Lawyer;
cousin of Alice Liddell

P18(91) *See Collections*: The
Herschel Album, by Julia Margaret
Cameron, **P18(1-92b)**

LIDDELL, Henry George
(1811-98) Dean of Christ Church;
father of Alice Liddell

1871 Marble bust 70.2 (27$\frac{5}{8}$) high
Henry Richard Hope-Pinker, incised
and dated 1888
Given by the artist, 1920

LIDDON, Henry Parry (1829-90)
Canon of St Paul's Cathedral

P7(22) Photograph: albumen print
14 x 11.7 (5½ x 4$\frac{5}{8}$)
Charles Lutwidge Dodgson, c.1856
Purchased with help from Kodak
Ltd, 1973
See Collections: Lewis Carroll at
Christ Church, by Charles Lutwidge
Dodgson, **P7(1-37)**

1060 Chalk 72.4 x 53.3 (28½ x 21)
George Richmond, signed with
initials and dated 1860
Purchased, 1896

LIFFORD, James Hewitt, 1st
Viscount (1709-89) Lord
Chancellor of Ireland

4249 Pencil, irregular oval
14 x 10.5 (5½ x 4⅛)
Samuel Lover, copy
Purchased, 1961

LIFFORD, James Hewitt, 4th
Viscount (1811-87)
Representative peer

1834(t) *See Collections*: Members
of the House of Lords, c.1870-80,
by Frederick Sargent, **1834(a-z and
aa-hh)**

LIGHT, William (1786-1839)
Surveyor-General of South
Australia

982(c) Panel 14.3 x 11.4 (5⅝ x 4½)
George Jones, signed and inscribed
Given by the artist's widow, 1871

LIGONIER, John Ligonier, 1st Earl
(1680-1770 Field-Marshal

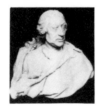

2013 Terracotta bust 45.7 (18)
high
Louis François Roubiliac, c.1761(?)
Purchased, 1924

Kerslake

LIMERICK, Edmund Henry Pery,
1st Earl of (1758-1844)

999 *See Groups*: The Trial of
Queen Caroline, 1820, by Sir
George Hayter

LINCOLN, Edward Fiennes de
Clinton, 1st Earl of (1512-85)
Lord High Admiral

2918 Panel 45.7 x 34.3 (18 x 13½)
Unknown artist, c.1560-5
Purchased, 1937

900 Panel 92.1 x 74.9 (36½ x 29½)
Unknown artist, inscribed and
dated 1584
Purchased, 1892. *Montacute*

Strong

LINCOLN, Henry Clinton, 7th Earl
of (1684-1728) Magnate

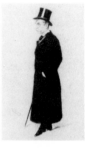

3215 With his brother-in-law,
Thomas Pelham-Holles, 1st Duke of
Newcastle (left)
Canvas 127 x 149.2 (50 x 58¾)
Sir Godfrey Kneller, signed, c.1721
Kit-cat Club portrait
Given by NACF, 1945

Piper

LINCOLNSHIRE, Charles Robert
Wynn-Carrington, 1st Marquess of
(1843-1928) Governor of New
South Wales

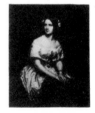

3111 Water-colour 45.1 x 31.4
(17¾ x 12⅜)
Sir Leslie Ward, signed *Spy*
(*VF* 11 Sept 1907)
Purchased, 1941

LIND, Johanna Maria (Jenny)
(1820-87) Singer; 'the Swedish
nightingale'

3801 Canvas 118.1 x 94.6
(46½ x 37¼)
Eduard Magnus, c.1861, replica
(1846)
Bequeathed by the sitter's
daughter-in-law, Mrs Helen
Goldschmidt, 1951

2204 Canvas 44.5 x 34.3
(17½ x 13½)
Alfred, Count D'Orsay, 1847
Given by the sitter's daughter,
Mrs Raymond Maude, 1928

LINDLEY, Robert (1776-1855)
Violoncellist

1952 Canvas 127 x 100.3
(50 x 39½)
William Davison, exh 1826
Purchased, 1922

1962(e) Water-colour 14.6 x 10.5
(5¾ x 4⅛)
Alfred Edward Chalon
Purchased, 1922
See Collections: Opera singers and
others, c.1804-c.1836, by Alfred
Edward Chalon, **1962(a-l)**

LINDSAY, Catherine Hepburne
(b.1822) Daughter of the Hon
Charles Lindsay

3791 With her sister, Alexina
Nesbit, afterwards Mrs Sandford
(seated)
Canvas 213.3 x 148.9 (84 x 58⅝)
Andrew Geddes, signed, exh 1838
Given by Lady Wavertree, 1951

Ormond (under Caroline, Lady
Stirling-Maxwell)

LINDSAY, Sir Coutts, 2nd Bt
(1824-1913) Artist

P52 Photograph: albumen print
25.4 x 20 (10 x 7⅞)
Julia Margaret Cameron, signed and
inscribed below image, c.1865
Purchased, 1975

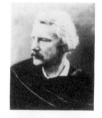

2729 Water-colour 31.4 x 18.1
(12⅜ x 7⅛)
Joseph Middleton Jopling, inscribed
(*VF* 3 Feb 1883, omitting
background)
Purchased, 1934

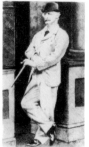

LINDSAY, David, 27th Earl of
Crawford *See* CRAWFORD

LINDSAY, Lady Harriet

3845 *See Groups:* Dinner at
Haddo House, 1884, by Alfred
Edward Emslie

LINDSAY, James, 26th Earl of
Crawford *See* CRAWFORD

LINDSAY, Robert James
(afterwards Loyd-Lindsay), 1st
Baron Wantage *See* WANTAGE

LINDSEY, Montague Bertie, 2nd
Earl of (1608-66) Royalist soldier

1124 *See Unknown Sitters II*

LINGARD, John (1771-1851)
Roman Catholic historian

4304 Miniature on ivory,
oval portrait 11.1 x 8.6
(4⅜ x 3⅜)
Thomas Skaife, signed and dated
1848
Purchased, 1963

LINNELL
One of the sons of the painter
John Linnell

1456(16) *See Collections*:
Drawings of Artists, c.1845, by
Charles Hutton Lear, **1456(1-27)**

LINNELL
One of the sons of the painter
John Linnell

1456(17) *See Collections*:
Drawings of Artists, c.1845, by
Charles Hutton Lear, **1456(1.27)**

LINNELL, John (1792-1882)
Painter

1811 Canvas 91.1 x 70.2
(35⅞ x 27⅝)
Self-portrait, c.1860
Given by Edward Vicars, 1918

Ormond

L'INSTANT, M.
Slavery abolitionist from Haiti

599 *See Groups*: The Anti-Slavery
Society Convention, 1840, by
Benjamin Robert Haydon

LINTON, Annie

P6(200) *See Collections*: The Hill and Adamson Albums, 1943-8, by David Octavius Hill and Robert Adamson, **P6(1-258)**

LINTON, James ('Sandy')
Fisherman

P6(199) *See Collections:* The Hill and Adamson Albums, 1843-8, by David Octavius Hill and Robert Adamson, **P6(1-258)**

LINTON, Sir William (1801-80)
Army physician

2939A *See Groups*: Study for Florence Nightingale at Scutari, by Jerry Barrett

4305 *See Groups*: Sketch for Florence Nightingale at Scutari, by Jerry Barrett

LISGAR, John Young, Baron (1807-76)
Governor-General of Canada

54 *See Groups:* The House of Commons, 1833, by Sir George Hayter

LISTER, Joseph Lister, Baron (1827-1912)
Founder of antiseptic surgery

1897a Plaster for no. **1897**
Given by the artist, 1921

1897 Wax medallion 11.4 (4½) diameter
Margaret M. Giles
incised *M.M.Giles,* 1898
Given by the artist, 1921.
Not illustrated

1958 Plaster cast of bust 74.9 (29½) high
Sir Thomas Brock, c.1913
Given by wish of the artist, 1922

1958a Bronze cast of no.**1958**
Sir Thomas Brock
Purchased, 1922. *Not illustrated*

LISTON, John (1776?-1846)
Comedian

3098 Silhouette 23.5 x 16.5 (9¼ x 6½)
By or after Augustin Edouart, c.1826
Purchased, 1941

LISTON, John
Fisherman

P6(215) *See Collections:* The Hill and Adamson Albums, 1843-8, by David Octavius Hill and Robert Adamson, **P6(1-258)**

LISTON, Robert (1794-1847)
Surgeon

P6(19) Photograph: calotype 20.3 x 14.9 (8 x 5$\frac{7}{8}$)
David Octavius Hill and Robert Adamson, 1843-7
Given by an anonymous donor, 1973
See Collections: The Hill and Adamson Albums, 1843-8, by David Octavius Hill and Robert Adamson, **P6(1-258)**

P6(18,91) *See Collections:* The Hill and Adamson Albums, 1843-8, by David Octavius Hill and Robert Adamson, **P6(1-258)**

LISTON, Willie

P6(217) *See Collections:* The Hill and Adamson Albums, 1843-8, by David Octavius Hill and Robert Adamson, **P6(1-258)**

LITTLETON, Edward Littleton, 1st Baron (1589-1645) Lawyer

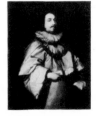

473 Canvas 125.7 x 100.3 (49½ x 39½)
Copy (?after Sir Anthony van Dyck), (1640)
Given by the Society of Judges and Serjeants-at-Law, 1877

Piper

LITTLETON, Edward, 3rd Viscount
Hatherton *See* HATHERTON

LITTLETON, Edward John, 1st
Baron Hatherton
See HATHERTON

LITTLETON, Edward Richard, 2nd
Baron Hatherton
See HATHERTON

LITTLETON, William Francis
(1847-89) Barrister

2271 *See Collections:* The Parnell
Commission, 1888-9, by Sydney
Prior Hall, **2229-72**

LIVERPOOL, Charles Jenkinson,
1st Earl of (1727-1808) Statesman

5206 Canvas 149.9 x 114.3
(59 x 45)
George Romney, inscribed, c.1786
Purchased, 1978

LIVERPOOL, Robert Jenkinson,
2nd Earl of (1770-1828)
Prime Minister

745 *See Groups:* William Pitt
addressing the House of Commons
. . . 1793, by Karl Anton Hickel

1695(m and **s)** *See Collections:*
Sketches for The Trial of Queen
Caroline, 1820, by Sir George
Hayter, **1695(a-x)**

5257 Study for *Groups,* **999**
Panel 33 x 25.8 (13 x 10$\frac{1}{8}$)
Sir George Hayter, signed and
dated 1823
Purchased, 1979

999 *See Groups:* The Trial of
Queen Caroline, 1820, by Sir
George Hayter

1804 Canvas 233.7 x 142.2
(92 x 56)
Sir Thomas Lawrence, inscribed,
exh 1827
Given through NACF, 1918

LIVINGSTONE, David (1813-73)
Missionary and explorer

386 Black chalk 19.9 x 16.7
(7$\frac{7}{8}$ x 6$\frac{5}{8}$)
Joseph Bonomi, signed, inscribed
and dated 1857
Given by William Smith, 1874

1040 Canvas 112.1 x 86.4
(44$\frac{1}{8}$ x 34)
Frederick Havill, posthumous
Given by John Lillie, 1896

Ormond

LLEWELLYN, Sir William
(1858-1941) Artist and PRA

5064 Chalk 37.2 x 30.2
(14$\frac{5}{8}$ x 11$\frac{7}{8}$)
Sir Bernard Partridge, signed
(*Punch* 19 Dec 1928)
Given by J.Vassall Adams, 1975

LLOYD, Major

1752 *See Groups:* The Siege of
Gibraltar, 1782, by George Carter

LLOYD, Clifford

2262 *See Collections:* The Parnell
Commission, 1888-9, by Sydney
Prior Hall, **2229-72**

LLOYD, William (1627-1717)
Bishop of Worcester

633 Engraving 29.2 x 20.7
(11½ x 8$\frac{1}{8}$)
David Loggan, signed and inscribed
on plate, c.1680
Purchased, 1881

79,152a *See Groups:* The Seven
Bishops Committed to the Tower
in 1688, by an unknown artist and
George Bower

LLOYD-BAKER, Mary (née Sharp)
(d.1812) Daughter of William
Sharp (1729-1820)

L169 *See Groups:* The Sharp
Family, by Johan Zoffany

LLOYD-GEORGE, David Lloyd
George, 1st Earl (1863-1945)
Prime Minister

3252 Pencil and wash 31.8 x 23.5
(12½ x 9¼)
Sir Max Beerbohm, signed *Max* and
inscribed, c.1908
Purchased, 1945

3397,3398 *See Collections:*
Prominent Men, c.1880-c.1910, by
Harry Furniss, **3337-3535** and
3554-3620

4340 Millboard 41.9 x 31.8
(16½ x 12½)
Unknown artist (after photograph
of c.1917), signed illegibly
Purchased, 1963

2463 *See Groups:* Statesmen of
World War I, by Sir James Guthrie

2837,2874 *See Collections:*
Caricatures of Politicians, by Sir
Francis Carruthers Gould, **2826-74**

3244 Canvas 88.9 x 94 (35 x 37)
Sir William Orpen, signed and
inscribed, 1927
Purchased, 1945

3261 Chalk 32.4 x 26.4
(12¾ x 10⅜)
Robin Guthrie, 1934
Given by the artist, 1936

P10 Photograph: bromide print
38.7 x 29.2 (15¼ x 11½)
Felix H.Man, c.1940
Given by the photographer, 1975
See Collections: Prominent men,
c.1938-43, by Felix H.Man, **P10-17**

LLUELLYN, Sir Richard
(1783-1867) Colonel

3732 *See Collections:* Studies for
The Waterloo Banquet at Apsley
House, 1836, by William Salter,
3689-3769

LOCH, James (1780-1855)
Economist

54 *See Groups:* The House of Commons, 1833, by Sir George Hayter

LOCKE, John (1632-1704)
Philosopher

3912 Canvas, oval 56.2 x 47
(22⅛ x 18½)
John Greenhill, c.1672-6
Purchased, 1954. *Beningbrough*

4061 Plumbago, oval 11.1 x 8.6
(4⅜ x 3⅜)
Sylvester Brounower, signed with
initials and inscribed, c.1685(?)
Purchased, 1958

3846 Canvas, oval 90.2 x 75.6
(35½ x 29¾)
Herman Verelst, signed and dated
1689
Purchased with help from NACF,
1953

114 Canvas, oval 74.9 x 61
(29½ x 24)
Michael Dahl, c.1696
Purchased, 1860

550 Canvas, feigned oval
74.9 x 62.2 (29½ x 24½)
After Sir Godfrey Kneller (1704)
Transferred from BM, 1879

Piper

LOCKE, Wadham (1779-1835)
MP for Devizes

54 *See Groups:* The House of Commons, 1833, by Sir George Hayter

LOCKE, William John (1863-1930)
Novelist

3262 Chalk 29.2 x 25.4 (11½ x 10)
James Montgomery Flagg, signed,
inscribed and dated 1909
Given by A.Yakovleff, 1945

3485,3486 *See Collections:*
Prominent Men, c.1880-c.1910, by
Harry Furniss, **3337-3535** and
3554-3620

LOCKER-LAMPSON, Frederick
(Frederick Locker) (1821-95)
Poet and writer

P102 Photograph: albumen print
24.8 x 19.4 (9¾ x 7$\frac{5}{8}$)
Julia Margaret Cameron, c.1867
Purchased, 1978

LOCKHART, Sir William (1621-76)
Soldier and diplomat

2444 *See Unknown Sitters II*

LOCKWOOD, Sir Frank (1846-97)
Solicitor-General

2253 *See Collections:* The Parnell
Commission, 1888-9, by Sydney
Prior Hall, **2229-72**

2298,2306,2307 *See Collections:*
Miscellaneous drawings . . . by
Sydney Prior Hall, **2282-2348** and
2370-90

3487 Pen and ink 38.7 x 31.4
(15¼ x 12$\frac{3}{8}$)
Harry Furniss, signed with initials
Purchased, 1947
See Collections: Prominent Men,
c.1880-c.1910, by Harry Furniss,
3337-3535 and **3554-3620**

LODGE, Edmund (1756-1839)
Historian

1411 Canvas 73.7 x 61.6
(29 x 24¼)
Lemuel Francis Abbott
Bequeathed by William Guy, 1905

LODGE, Sir Oliver Joseph
(1851-1940) Scientist

3952 Canvas 73.7 x 55.9 (29 x 22)
Sir George Reid, signed *R*, inscribed,
c.1907
Given by the sitter's children and
grandchildren, 1955

3875 Crayon 35.3 x 25.1
(13$\frac{7}{8}$ x 9$\frac{7}{8}$)
Sir William Rothenstein, signed
with initials and dated 1916
Given by the Rothenstein Memorial
Trust, 1953

4077 Black chalk 36.2 x 25.7
(14¼ x 10$\frac{1}{8}$)
Sir Bernard Partridge, signed
(*Punch* 24 Nov 1926)
Given by D.Pepys Whiteley, 1958
See Collections: Mr Punch's
Personalities, 1926-9, by Sir
Bernard Partridge, **3644-6,** etc

3856 Water-colour 32.1 x 21
(12$\frac{5}{8}$ x 8¼)
Sir Max Beerbohm, signed *Max*,
inscribed, and dated 1932
Purchased, 1953
See Collections: Caricatures,
1897-1932, by Sir Max Beerbohm,
3851-8

LOGAN, Elizabeth (1811-62)

P6(169,172,178) *See Collections:*
The Hill and Adamson Albums,
1843-8, by David Octavius Hill
and Robert Adamson, **P6(1-258)**

LONDONDERRY, Robert Stewart, 2nd Marquess of (Lord Castlereagh) (1769-1822) Statesman

1141 Pencil 25.4 x 18.4 (10 x 7¼) George Dance, signed and dated 1794
Purchased, 1898

891 Canvas 74.3 x 61.6 (29¼ x 24¼)
Sir Thomas Lawrence, exh 1810
Purchased, 1892

999 *See Groups:* The Trial of Queen Caroline, 1820, by Sir George Hayter

316a(13,14) *See Collections:* Preliminary drawings for busts and statues by Sir Francis Chantrey, **316a(1-202)**

687 Marble bust 78.7 (31) high
Sir Francis Chantrey, eng 1822
Purchased, 1883

4384 Wax relief 8.9 (3½) diameter
Unknown artist, incised and dated 1822
Given by Stephen C.Grimes through NACF, 1964

LONDONDERRY, Charles William Vane-Stewart, 3rd Marquess of (1778-1854) Soldier and diplomat

2789 *See Groups:* Members of the House of Lords, c.1835, attributed to Isaac Robert Cruikshank

LONDONDERRY, Frederick William Robert Stewart, 4th Marquess of (1805-72)
MP for County Down

54 *See Groups:*The House of Commons, 1833, by Sir George Hayter

LONDONDERRY, George Vane-Tempest, 5th Marquess of (1821-84) Landowner and politician

4429 Water-colour 30.8 x 18.4 (12⅛ x 7¼)
Sir Leslie Ward, signed *Spy* (*VF* 11 Nov 1876)
Purchased, 1965

LONDONDERRY, Charles Stewart Vane-Tempest-Stewart, 6th Marquess of (1852-1915) Viceroy of Ireland

2964 Water-colour 31.1 x 18.8 (12¼ x 7⅜)
F.T.Dalton, signed *FTD* (*VF* 6 Feb 1896)
Purchased, 1938

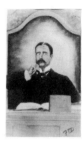

4545 Water-colour 46 x 30.1 (18⅛ x 11⅞)
W.W.Hodgson, signed *Eye* and *W W Hodgson,* inscribed
Given by A.Yakovleff, 1967

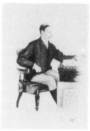

LONDONDERRY, Charles Vane-Tempest-Stewart, 7th Marquess of (1878-1949) Politician

4529(210) *See Collections:* Working drawings by Sir David Low, **4529(1-401)**

LONG, Charles, 1st Baron Farnborough
See FARNBOROUGH

LONG, Edwin Longsden (1829-91) Painter

2474 Pencil 14 x 8.3 (5½ x 3¼)
Charles Bell Birch, inscribed and dated 1858
Given by the artist's nephew, George von Pirch, 1930
See Collections: Drawings of Royal Academicians, c.1858, by Charles Bell Birch, **2473-9**

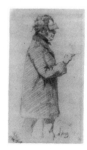

Ormond

LONG, Sir James, Bt (1617-92)
Royalist, soldier and antiquary;
nephew of Sir Robert Long

4638 Canvas, feigned oval
76.2 x 62.2 (30 x 24½)
Unknown artist, inscribed
Given by wish of Miss Dorothy
Long, 1968

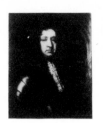

LONG, Sir Robert (d.1673)
Auditor of the Exchequer

4637 Canvas, feigned oval
76.2 x 63.5 (30 x 25)
After Sir Peter Lely, reduced copy
Given by wish of Miss Dorothy
Long, 1968

LONG, William (fl.1821-55)
Painter

1456(18) Black chalk 8.6 x 7.3
$(3\frac{3}{8} \times 2\frac{7}{8})$
Charles Hutton Lear, inscribed,
c.1845
Given by John Elliot, 1907
See Collections: Drawings of
Artists, c.1845, by Charles Hutton
Lear, **1456(1-27)**

LONGLEY, Charles Thomas
(1794-1868)
Archbishop of Canterbury

1056 Black and white chalk
64.1 x 51.4 (25¼ x 20¼)
George Richmond, inscribed,
c.1862
Purchased, 1896

Ormond

LONGSTAFF, Sir John
(1862-1941) Painter

4392 Pencil 25.1 x 22.9 ($9\frac{7}{8}$ x 9)
Phil May, signed, inscribed and
dated 1901
Purchased, 1964

LONSDALE, James (1777-1839)
Portrait painter

1854 Oil miniature 7.3 x 5.7
$(2\frac{7}{8} \times 2\frac{1}{4})$
Self-portrait, c.1810
Bequeathed by his grandson,
Horatio Walter Lonsdale, 1920

770 Marble bust 66 (26) high
Edward Hodges Baily, incised and
dated 1844
Bequeathed by the sitter's son,
James John Lonsdale, 1887

LOPES, Henry Charles, 1st Baron
Ludlow *See* LUDLOW

LOPES, Sir Ralph, Bt (1788-1854)
MP for Westbury

54 *See Groups:* The House of Com-
mons, 1833, by Sir George Hayter

LOREBURN, Robert Threshie
Reid, Earl (1846-1923)
Lord Chancellor

2301 *See Collections:*
Miscellaneous drawings . . . by
Sydney Prior Hall, **2282-2348**
and **2370-90**

LOTHIAN, William Kerr, 6th
Marquess of (1763-1824)

999 *See Groups:* The Trial of
Queen Caroline, 1820, by Sir
George Hayter

LOTHIAN, Philip Henry Kerr,
11th Marquess of (1882-1940)
Journalist and statesman

3245 Plaster cast of death-mask
27.9 (11) long
Unknown artist
Given by Sir James Gunn, 1945

LOTI, Pierre *See* VIAUD, Julien

LOUDEN, Mr

2255,2268 *See Collections:* The Parnell Commission, 1888-9, by Sydney Prior Hall, **2229-72**

LOUIS, Prince (1837-92)
Louis IV, Grand Duke of Hesse-Darmstadt; husband of Princess Alice

2023A(10) *See Collections:* Queen Victoria, Prince Albert and members of their family, by Susan D.Durant, **2023A(1-12)**

LOUISA Maria Theresa Stuart, Princess (1692-1712)
Daughter of James II

976 *See under* Prince James Francis Edward Stuart

1658 Canvas 75.3 x 62.5 (29$\frac{5}{8}$ x 24$\frac{3}{8}$)
Unknown artist
Given by George Harland Peck, 1912. *Beningbrough*

Kerslake

LOUISE Caroline Alberta, Princess, Duchess of Argyll (1848-1939)
Daughter of Queen Victoria

P26 *See Groups:* The Royal Family . . . , by L.Caldesi

3083 *See Groups:* The Opening of the Royal Albert Infirmary at Bishop's Waltham . . . 1865, by an unknown artist

P22(6) Photograph: albumen print 14 x 9.8 (5½ x 3$\frac{7}{8}$)
W. & D.Downey, May 1868
Purchased, 1975
See Collections: The Balmoral Album, by George Washington Wilson, W. & D.Downey, and Henry John Whitlock, **P22(1-27)**

P22(1-3,7) *See Collections:* The Balmoral Album, by George Washington Wilson, W.&.D.Downey, and Henry John Whitlock, **P22(1-27)**

4455 Terracotta bust 63.5 (25) high
Attributed to herself
Given by Miss Kathleen Parbury, 1965

LOUISE Victoria Alexandra Dagmar, Princess (1867-1931)
Third child of Edward VII; wife of 6th Earl of Fife

4471 *See Groups:* The three daughters of Edward VII and Queen Alexandra, by Sydney Prior Hall

LOVAT, Simon Fraser, 11th Baron (1667?-1747) Jacobite

216 Canvas 65.4 x 41.3 (25¾ x 16¼)
After William Hogarth (1746)
Purchased, 1866

Kerslake

LOVELL, Sir Bernard (b.1913)
Radio astronomer

4529(211-14) *See Collections:* Working drawings by Sir David Low, **4529(1-401)**

LOVELL, Sir Thomas (d.1524)
Chancellor of the Exchequer

1565 Plaster relief 67.3 (26½) diameter
After bronze relief by Pietro Torrigiano in Westminster Abbey (c.1518)
Purchased, 1910

Strong

LOVER, Samuel (1797-1868)
Song-writer, novelist and painter

627 Marble bust 74.3 (29¼) high
Edward Arlington Foley, incised and dated 1839
Purchased, 1881

Ormond

LOW, Sir David (1891-1963)
Cartoonist

4512 Canvas 61 x 45.7 (24 x 18)
Self-portrait, 1924-5
Purchased, 1966

LOWE, Robert, 1st Viscount
Sherbrooke *See* SHERBROOKE

LOWENTHAL, Johann Jakob
(1810-76) Chess player

3060 *See Groups:* Chess players,
by A.Rosenbaum

LOWRY, Laurence Stephen
(1887-1976) Painter

5091 Bronze cast of bust 35.6
(14) high
Samuel Tonkiss, incised and dated
1971
Purchased, 1976

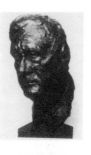

LOWRY, Wilson (1762-1824)
Engraver

2875 Water-colour 17.1 x 14
(6¾ x 5½)
Attributed to Matilda Heming
(his daughter)
Purchased, 1936

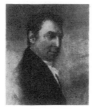

LOWTHER, Henry Cecil
(1790-1867)
MP for Westmorland

54 *See Groups:* The House of Com-
mons, 1833, by Sir George Hayter

LOWTHER, James (1840-1904)
Politician

3615 *See Collections:* Prominent
Men, c.1880-c.1910, by Harry
Furniss, **3337-3535** and **3554-3620**

LOWTHER, James William,
Viscount Ullswater
See ULLSWATER

LUBBOCK, Sir John, 1st Baron
Avebury *See* AVEBURY

LUCAS, David (1802-81)
Engraver

3070 Miniature on ivory, oval
6.7 x 4.4 (2⅝ x 1¾)
Attributed to Robert William
Satchwell, c.1820
Transferred from BM, 1939

1353 Chalk 19.1 x 15.5 (7½ x 6⅛)
Thomas H.Hunn, signed and dated
1902
Given by Ernest E.Leggatt, 1904

Ormond

LUCAS, Edward Verrall
(1868-1938) Essayist and literary
scholar

3934 Pen and ink 24.1 x 18.4
(9½ x 7¼)
Robin Guthrie, signed and inscribed,
1937
Purchased, 1965

LUCAS, John Seymour
(1849-1923) Painter

3040 Pencil 26.7 x 17.8 (10½ x 7)
Self-portrait, signed, inscribed and
dated 1887
Given by Marion Harry Spielmann,
1939

2820 *See Groups:* The Royal
Academy Conversazione, 1891,
by G.Grenville Manton

5219 Canvas 69.8 x 54.9
(27⅛ x 21⅝)
John Singer Sargent, signed,
inscribed and dated 1905
Given by the sitter's granddaughter,
Mrs Margaret Hubbard, 1978

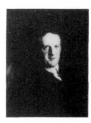

LUCAS, Richard Cockle (1800-83) Sculptor

1651B Etching, pen and wash 14.3 x 10.2 (5$\frac{5}{8}$ x 4) Self-portrait, signed, inscribed and dated on plate 1858 Given by William Burrough Hill, 1912

1783 Plaster cast of bust 65.4 (25¾) high Self-portrait, incised and dated 1868 Given by John Lane, 1916

Ormond

LUCAS, Samuel Slavery abolitionist

599 *See Groups:* The Anti-Slavery Society Convention, 1840, by Benjamin Robert Haydon

LUCY, Sir Henry William (1845-1924) Journalist

2333,2334 *See Collections:* Miscellaneous drawings . . . by Sydney Prior Hall, **2282-2348** and **2370-90**

2930 Canvas 72.4 x 53.3 (28½ x 21) John Singer Sargent, signed and dated 1905 Bequeathed by the sitter, 1938

LUDLOW, Henry Charles Lopes, 1st Baron (1828-99) Judge

2173(7) Pen and ink 18.1 x 14 (7$\frac{1}{8}$ x 5½) Sebastian Evans, signed in monogram, inscribed and dated 1877 Given by George Hubbard, 1927 *See Collections:* Book of sketches by Sebastian Evans, **2173(1-70)**

LUGARD, Frederick Lugard, 1st Baron (1858-1945) Soldier, administrator, colonial governor and writer

3305 Miniature on ivory, oval 7.6 x 6.4 (3 x 2½) Charlotte E.Howard (later Mrs Lugard, his sister-in-law), signed with initials, 1893 Given by the sitter's brother, E.J.Lugard, 1946

3306 Canvas 48.9 x 38.7 (19¼ x 15¼) W.J.Carrow, 1936 (after a photograph of 1929) Given by the sitter's brother, E.J.Lugard, 1946

4289 Plaster cast of bust 91.4 (36) high Charles d'Orville Pilkington Jackson, inscribed and dated 1960 Purchased, 1962

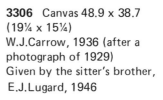

4289A Polyester bronze cast of no.**4289** Purchased, 1962. *Not illustrated*

LUKIN, Sir Henry Timson (1860-1925) Major-General

1954 *See Groups:* General Officers of World War I, by John Singer Sargent

LUMLEY, John Lumley, 5th (or 6th) Baron (1493-1544) A leader in the Pilgrimage of Grace

2491 *See Unknown Sitters I*

2693 *See Unknown Sitters I*

LUMLEY, Ralph (b.1529)

2492 Water-colour 21 x 15.9
(8¼ x 6¼)
Attributed to George Perfect
Harding, after unknown artist,
inscribed and dated 1567
Bequeathed by Frederick Louis
Lucas, 1931

LUMLEY, Richard, 2nd Earl of
Scarborough
See SCARBOROUGH

LUMLEY-SAVILE, John, 2nd
Baron Savile *See* SAVILE

LUPTON, Thomas Goff
(1791-1873) Engraver

1619 Canvas 48.6 x 38.4
(19⅛ x 15⅛)
George Clint
Bequeathed by the sitter's son,
Thomas Lupton, 1911

Ormond

LUSH, Sir Robert (1807-81)
Judge

2730 Water-colour 29.5 x 18.4
(11⅝ x 7¼)
Sir Leslie Ward, signed *Spy*
(*VF* 31 May 1873)
Purchased, 1934

LUSHINGTON, Stephen
(1782-1873) Judge

1695(i) *See Collections:* Sketches
for The Trial of Queen Caroline,
1820, by Sir George Hayter,
1695(a-x)

999 *See Groups:* The Trial of
Queen Caroline, 1820, by Sir
George Hayter

599 *See Groups:* The Anti-Slavery
Society Convention, 1840, by
Benjamin Robert Haydon

1646 Canvas 81.9 x 64.8
(32¼ x 25½)
William Holman Hunt, signed in
monogram and dated 1862
Given by the sitter's granddaughter,
Miss Susan Lushington, 1912

Ormond

LUSTY, Sir Robert (b.1909)
Journalist and publisher

4529(215-20) *See Collections:*
Working drawings by Sir David
Low, **4529(1-401)**

LUTYENS, Sir Edwin (1869-1944)
Architect and PRA

3876 Sanguine, black and white
chalk 34.6 x 29.2 (13⅝ x 11½)
Sir William Rothenstein, signed
with initials and dated 1922
Given by the Rothenstein Memorial
Trust, 1953

3672 Ink and wash 24.1 x 18.7
(9½ x 7⅜)
Sir Bernard Partridge, signed with
initials
(study for *Punch* 20 July 1927)
Purchased, 1949
See Collections: Mr Punch's
Personalities, 1926-9, by Sir
Bernard Partridge, **3664-6**, etc

3192 Bronze cast of death-mask
29.8 (11¾) long
Unknown artist
Given by the sitter's son, Robert
Lutyens, 1944

4481 Panel 25.4 x 22.9 (10 x 9)
Robert Lutyens (his son), signed
and dated 1959
Given by the artist, 1966

LUXMOORE, John (1756-1830)
Bishop of St Asaph

999 *See Groups:* The Trial of
Queen Caroline, 1820, by Sir
George Hayter

LYALL, Sir Alfred Comyn
(1835-1911) Administrator in
India and writer

2170 Canvas 59.1 x 49.5
(23¼ x 19½)
Henry John Hudson after Sir
James Jebusa Shannon (1890)
Given by the sitter's son,
R.A.Lyall, 1927

LYELL, Sir Charles, Bt (1797-1875)
Geologist

1064 Black and white chalk
43.2 x 35.6 (17 x 14)
George Richmond, inscribed,c.1853
Purchased, 1896

P120(13) Photograph: albumen
print, arched top 19.7 x 14.6
(7¾ x 5¾)
Maull & Polyblank, inscribed on
mount, 1855
Purchased, 1979
See Collections: Literary and
Scientific Men, 1855, by Maull &
Polyblank, **P120(1-54)**

1387 Canvas 122.2 x 88.9
(48⅛ x 35)
Lowes Cato Dickinson, 1883,
replica (c.1870)
Given by the sitter's sister-in-law,
Mrs Katherine Lyell, 1904

Ormond

LYGON, Edward Pyndar
(c.1786-1860) Major-General

3733 *See Collections:* Studies for
The Waterloo Banquet at Apsley
House, 1836, by William Salter,
3689-3769

LYGON, Henry Beauchamp, 4th
Earl Beauchamp
See BEAUCHAMP

LYNCH, Sir William (d.1785)
Privy-Councillor

3090(9) Wash 38.3 x 28.1
(15⅛ x 11⅛)
After an unknown artist, inscribed
Purchased, 1940

LYND, Robert (1879-1949)
Journalist

4529(221) *See Collections:*
Working drawings by Sir David
Low, **4529(1-401)**

4666 Black and red chalk
31.1 x 24.1 (12¼ x 9½)
Henry Lamb
Purchased, 1969

LYNDHURST, John Singleton
Copley, Baron (1772-1863)
Lord Chancellor; son of the painter
John Singleton Copley

1695(i) *See Collections:* Sketches
for The Trial of Queen Caroline,
1820, by Sir George Hayter,
1695(a-x)

2662(7) *See Collections:* Book of
sketches, mainly for The Trial
of Queen Caroline, 1820, by Sir
George Hayter, **2662(1-38)**

999 *See Groups:* The Trial of
Queen Caroline, 1820, by Sir
George Hayter

54 *See Groups:* The House of Com-
mons, 1833, by Sir George Hayter

472 Canvas 236.2 x 146.1
(93 x 57½)
Thomas Phillips, signed in
monogram and dated 1836
Given by the Society of Judges
and Serjeants-at-Law, 1877

4121 Water-colour, octagonal
22.2 x 17.5 (8¾ x 6⅞)
F.Roffe, c.1836
Given by Messrs F.D.Daniell, 1959

342,343 *See Groups:* The Fine
Arts Commissioners, 1846, by John
Partridge

2144 Chalk 62.6 x 47.3
(24⅝ x 18⅝)
George Richmond, signed, inscribed
and dated 1851
Bequeathed by the sitter's widow,
1927

683 Panel 61 x 50.2 (24 x 19¾)
George Frederic Watts, signed, 1862
Given by the artist, 1883

Ormond

LYNEDOCH, Thomas Graham,
Baron (1748-1843) General

1037 Canvas 90.2 x 69.9
(35½ x 27½)
Sir George Hayter, inscribed and
dated 1832, replica (1822)
Given by the Earl of Bradford, 1896

LYONS, Richard Bickerton Pemell
Lyons, Earl (1817-87) Diplomat

1995 Water-colour 30.5 x 18.1
(12 x 7⅛)
Carlo Pellegrini, signed *Ape*
(*VF* 6 April 1878)
Purchased, 1923

LYONS, Edmund Lyons, 1st
Baron (1790-1858) Admiral

685 Canvas 61 x 50.5 (24 x 19⅞)
George Frederic Watts, signed,
1856-7
Given by the artist, 1883

Ormond

LYSONS, Samuel (1763-1819)
Antiquary

5078 Pencil 15.2 x 12.7 (6 x 5)
Sir Thomas Lawrence, 1790s
Purchased, 1976

3089(11) Pencil 25.7 x 19.7
(10⅛ x 7¾)
William Daniell after George Dance,
inscribed
Purchased, 1940
See Collections: Tracings of
drawings by George Dance,
3089(1-12)

LYSTER, John (d.1840)
Soldier

4026(40) *See Collections:*
Drawings of Men about Town,
1832-48, by Alfred, Count D'Orsay,
4026(1-61)

LYTE, Sir Henry Churchill Maxwell
(1848-1940) Historian

3937 Canvas 101.6 x 76.2
(40 x 30)
Samuel Melton Fisher, signed and
dated 1933
Given by the artist's son, F. Melton
Fisher, 1955

LYTTELTON, George Lyttelton,
1st Baron (1709-73)
Chancellor of the Exchequer and
scholar

128 Canvas 74.9 x 62.9
(29½ x 24¾)
Unknown artist
Given by Lord Lyttelton, 1861

Continued overleaf

4855(49) *See Collections:* The Townshend Album, **4855(1-73)**

Kerslake

LYTTELTON, Thomas Lyttelton, 2nd Baron (1744-79) Politician and profligate

1446 Canvas 73.4 x 62.9 $(28\frac{7}{8}$ x 24¾) After Thomas Gainsborough Given by Viscount Cobham, 1906

LYTTELTON, William Henry Lyttelton, 3rd Baron (1782-1837) Politician

883(15) Pencil and wash 13 x 10 $(5\frac{1}{8}$ x $4\frac{7}{8}$) Sir George Hayter, inscribed Purchased, 1891 *See Collections:* Studies for miniatures by Sir George Hayter, **883(1-21)**

Ormond

LYTTELTON, Edward (1855-1942) Schoolmaster, divine and cricketer

4783 Sanguine 34 x 28.6 $(13\frac{3}{8}$ x 11¼) Sir William Rothenstein, 1923 Purchased, 1970

LYTTELTON, Oliver, 1st Viscount Chandos *See* CHANDOS

LYTTON, Edward Bulwer-Lytton, 1st Earl of (1831-91) Viceroy of India

1007 Canvas 64.8 x 52.1 (25½ x 20½) George Frederic Watts, 1884 Given by the artist, 1895

3488 *See Collections:* Prominent Men, c.1880-c.1910, by Harry Furniss, **3337-3535** and **3554-3620**

LYTTON, Neville Stephen Lytton, 3rd Earl of (1879-1951) Painter and journalist

4784 Sanguine 38.4 x 28.3 $(15\frac{1}{8}$ x $11\frac{1}{8}$) Sir William Rothenstein, 1906 Purchased, 1970

LYTTON, Edward Bulwer-Lytton, 1st Baron (1803-73) Novelist

1277 Canvas 91.4 x 71.5 $(36$ x $28\frac{1}{8}$) Henry William Pickersgill, c.1831 Purchased, 1900

1099 *See Unknown Sitters IV*

Ormond

LYVEDEN, Robert Vernon Smith, 1st Baron (1800-73) MP for Northampton

54 *See Groups:* The House of Commons, 1833, by Sir George Hayter

McADAM, John Loudon (1756-1836) The 'macadamiser' of roads

3686 Canvas 89.5 x 69.2 (35¼ x 27¼) Unknown artist Given by the sitter's descendant, Mrs Katharine L.Scott, 1950

MacALLISTER, J.Finlay (1805-66)

P6(75) *See Collections:* The Hill and Adamson Albums, 1843-8, by David Octavius Hill and Robert Adamson, **P6(1-258)**

MACARDELL, James (1729?-65)
Mezzotint engraver

3123 Canvas 74.9 x 62.2
(29½ x 24½)
Sir Joshua Reynolds, c.1756-60
Given by NACF, 1942
Beningbrough

Kerslake

MACARTNEY, George Macartney,
1st Earl (1737-1806)
Diplomat and colonial governor

329 With his secretary, Sir George
Leonard Staunton (right)
Canvas 99.1 x 124.5 (39 x 49)
Lemuel Francis Abbott, 1784
Purchased, 1871

745 *See Groups:* William Pitt
addressing the House of Commons
. . . 1793, by Karl Anton Hickel

MACAULAY, Thomas Babington
Macaulay, Baron (1800-59)
Historian, poet and statesman

54 *See Groups:* The House of Com-
mons, 1833, by Sir George Hayter

342,343 *See Groups:* The Fine
Arts Commissioners, 1846, by John
Partridge

257 Bronze medallion 24.5 (9⅝)
diameter
Baron Carlo Marochetti, incised and
dated 1848
Purchased, 1868

1564 Canvas 94 x 74.3 (37 x 29¼)
John Partridge, c.1849-53
Given by Viscount Knutsford,
1910

4882 Canvas 63.5 x 76.2 (25 x 30)
Edward Matthew Ward, 1853
Purchased, 1972

453 Canvas 29.8 x 25.4 (11¾ x 10)
Sir Francis Grant, 1853
Given by Sir William Stirling-
Maxwell, Bt, 1877

2689 *See Groups:* The Funeral of
Lord Macaulay, by Sir George Scharf

Ormond

MACAULAY, Catherine (1731-91)
Historian

1357 Canvas, feigned oval
74.3 x 62.2 (29¼ x 24½)
By or after Mason Chamberlin,
inscribed, c.1774
Purchased, 1904

4905 *See Groups:* The Nine Living
Muses of Great Britain, by Richard
Samuel

MACBETH, Robert Walker
(1848-1910) Painter

2820 *See Groups:* The Royal
Academy Conversazione, 1891, by
G.Grenville Manton

McBEY, James (1883-1959)
Etcher and painter

4463 (With water-colour sketch of
a boy on reverse)
Pencil 31.8 x 24.5 (12½ x 9⅝)
Martin Hardie, signed, inscribed and
dated 1919
Given by the artist's son, Frank
Hardie, 1965

MacCARTHY, Sir Desmond
(1877-1952) Writer and critic

3936 Pencil 39.7 x 35.2
(15⅝ x 13⅞)
Robin Guthrie, 1938
Purchased, 1955

Continued overleaf

4468 Pencil 29.2 x 21.9
(11½ x 8⅝)
Duncan Grant, inscribed, c.1938
Given by the artist, 1965

5024 Canvas 25.4 x 20.3 (10 x 8)
Duncan Grant, c.1942
Bequeathed by Ava, Viscountess
Waverley, 1975

4842 Canvas 91.4 x 84.5
(36 x 33¼)
Duncan Grant, signed and dated
1944
Purchased, 1971

McCARTHY, Justin (1830-1912)
Politician and writer

2284,2387,2388 *See Collections:*
Miscellaneous drawings . . . by
Sydney Prior Hall, **2282-2384** and
2370-90

3591,3620 *See Collections:*
Prominent Men, c.1880-c.1910, by
Harry Furniss, **3337-3535** and
3554-3620

MACCLESFIELD, Charles Gerard,
1st Earl of (d.1694)
Royalist soldier

2406 *See Collections:* Copies of
early portraits, by George Perfect
Harding and Sylvester Harding,
1492,1492(a-c) and **2394-2419**

MACCLESFIELD, Thomas Parker,
1st Earl of (1666-1732)
Lord Chancellor

799 Canvas 125.7 x 99.1
(49½ x 39)
After Sir Godfrey Kneller (1712)
Purchased, 1888

798 *See Groups:* The Court of
Chancery, by Benjamin Ferrers

Piper

MACCLESFIELD, Thomas
Augustus Wolstenholme Parker, 9th
Earl of (1811-96) Landowner

4727 Water-colour 30.8 x 18.4
(12⅛ x 7¼)
Sir Leslie Ward, signed *Spy*
(*VF* 22 Oct 1881)
Purchased, 1970

McCLINTOCK, Sir Francis Leopold
(1819-1907) Admiral

1226 Millboard 38.4 x 32.4
(15⅛ x 12¾)
Stephen Pearce, 1856
Bequeathed by John Barrow, 1899
See Collections: Arctic Explorers,
1850-86, by Stephen Pearce,
905-24 and **1209-27**

919 *See Collections:* Arctic
Explorers, 1850-86, by Stephen
Pearce, **905-24** and **1209-27**

1211 Canvas 127 x 101.9
(50 x 40⅛)
Stephen Pearce, 1859
Bequeathed by John Barrow, 1899
See Collections: Arctic Explorers,
1850-86, by Stephen Pearce,
905-24 and **1209-27**

Ormond

McCLURE, Sir Robert (1807-73)
Vice-Admiral

1210 Canvas 127.3 x 101.6
(50⅛ x 40)
Stephen Pearce, 1855
Bequeathed by John Barrow, 1899
See Collections: Arctic Explorers,
1850-86, by Stephen Pearce,
905-24 and **1209-27**

Ormond

MacCOLL, Dugald Sutherland
(1859-1948) Critic, painter
and gallery director

4857 Silverpoint 34.9 x 25.4
(13¾ x 10)
Alphonse Legros, signed and dated
1897
Bequeathed by the sitter's son,
René MacColl, through NACF, 1971

2556 *See Groups:* The Selecting
Jury of the New English Art Club,
1909, by Sir William Orpen

2663 *See Groups:* Some Members
of the New English Art Club, by
Donald Graeme MacLaren

4424 Chalk 37.8 x 27.9
(14⅞ x 11)
Francis Dodd, signed, inscribed and
dated 1939
Purchased, 1964

McCORMICK, Robert (1809-90)
Naval surgeon and naturalist

1216 Canvas 39.4 x 32.7
(15½ x 12⅞)
Stephen Pearce, c.1856
Bequeathed by John Barrow, 1899
See Collections: Arctic Explorers,
1850-86, by Stephen Pearce,
905-24 and **1209-27**

Ormond

McCULLOCH, John Ramsay
(1789-1864)
Statistician and economist

677 Canvas 143.5 x 112.4
(56½ x 44¼)
Sir Daniel Macnee, exh 1840
Bequeathed by the sitter's daughter,
Mrs Margaret Cox, 1883

Ormond

MACDIARMID, Hugh
See GRIEVE, Christopher Murray

MACDONA, John Cumming
(1836-1907)
President of the Kennel Club

2973 Water-colour 35.3 x 26.7
(13⅞ x 10½)
Sir Leslie Ward, signed *Spy*
(*VF* 8 Feb 1894)
Purchased, 1938

MACDONALD, Mr
Queen Victoria's tagger

P22(10,11,23) *See Collections:*
The Balmoral Album, 1854-68, by
George Washington Wilson, W.& D.
Downey, and Henry John Whitlock,
P22(1-27)

MacDONALD, George (1824-1905)
Poet and novelist

P36 Photograph: albumen print
14.9 x 10.2 (5⅞ x 4)
Possibly by Charles Lutwidge
Dodgson
Purchased, 1977
See Collections: Prints from two
albums, 1852-60, by Charles
Lutwidge Dodgson and others,
P31-40

2011 Canvas 55.9 x 45.7 (22 x 18)
Sir George Reid, signed in
monogram and dated 1868
Given by the sitter's son, Greville
MacDonald, 1924

MACDONALD, James Ramsay
(1866-1937) Prime Minister

3890 Canvas 90.2 x 72.4
(35½ x 28½)
Solomon Joseph Solomon, signed
in monogram, c.1910
Given by the sitter's daughter, Mrs
Ishbel Peterkin, 1953

2066 Miniature on ivory, oval
11.4 x 8.6 (4½ x 3⅜)
Lilian Mary Mayer
Given by the artist's husband,
Sylvain Mayer, 1954

Continued overleaf

5029 *See Collections:* Miniatures, 1920-30, by Winifred Cécile Dongworth, **5027-36**

4529(222) *See Collections:* Working drawings by Sir David Low, **4529(1-401)**

2959 Canvas 95.3 x 69.9 (37½ x 27½) Sir John Lavery, signed, and inscribed and dated 1931 on reverse Given by the artist, 1938

4665 Chalk 33 x 22.2 (13 x 8¾) Sir Max Beerbohm, signed *Max,* inscribed and dated 1931 Purchased, 1969

2934 Bronze cast of bust 61 (24) high Sir Jacob Epstein, 1934 Purchased, 1938

MACDONALD, Sir John Alexander (1815-91) Prime Minister of Canada

1550 Plaster cast of statuette 80 (31½) high Charles Bell Birch, incised Purchased, 1909

MACDONALD, R.

1841B *See Groups:* Four men at cards, by Fred Walker

MACDONALD, Sir Reginald (1820-99) Admiral

2583 Water-colour 30.5 x 17.8 (12 x 7) Sir Leslie Ward, signed *Spy* (*VF* 7 Feb 1880) Purchased, 1933

MACDONALD, Reginald Ranald (d.1845) Colonel

3734 *See Collections:* Studies for The Waterloo Banquet at Apsley House, 1836, by William Salter, **3689-3769**

MACDONELL, Sir James (d.1857) General

2656 Miniature on ivory, oval 16.8 x 12.7 ($6\frac{5}{8}$ x 5) Unknown artist Purchased, 1934

3753 *See Collections:* Studies for The Waterloo Banquet at Apsley House, 1836, by William Salter, **3689-3769**

Ormond

MacDONNELL, George Alcock (1830-99) Chess player and columnist

3060 *See Groups:* Chess players, by A.Rosenbaum

MACDONNELL, John J. (1825-1900) Lieutenant-General

2584 Water-colour 30.8 x 18.4 ($12\frac{1}{8}$ x 7¼) Sir Leslie Ward, signed *Spy* (*VF* 7 Oct 1882) Purchased, 1933

McDONNELL, T.M. Slavery abolitionist

599 *See Groups:* The Anti-Slavery Society Convention, 1840, by Benjamin Robert Haydon

McEVOY, Ambrose (1878-1927)
Painter

3056 Chalk 44.5 x 29.8
(17½ x 11¾)
Augustus John, signed
Given by Stevenson Scott, through
NACF, 1939

2556 *See Groups:* The Selecting
Jury of the New English Art Club,
1909, by Sir William Orpen

2790 Pencil 20.3 x 14 (8 x 5½)
Self-portrait, c.1912
Given by the sitter's widow, 1935

2958 Bronze cast of bust 59.7
(23½) high
Francis Derwent Wood, 1915
Given by the sitter's widow, 1938

2663 *See Groups:* Some Members
of the New English Art Club, by
Donald Graeme MacLaren

MACFARLANE, Charles (d.1858)
Historian

2515(60) *See Collections:*
Drawings of Prominent People,
1823-49, by William Brockedon,
2515(1-104)

MacGREGOR, Miss

P22(2,24) *See Collections:* The
Balmoral Album, 1854-68, by
George Washington Wilson, W.& D.
Downey, and Henry John Whitlock,
P22(1-27)

MACGREGOR, William Gordon
(d.1840) Lieutenant-Colonel

999 *See Groups:* The Trial of
Queen Caroline, 1820, by Sir
George Hayter

McGRIGOR, Sir James, Bt
(1771-1858) Army surgeon

1914(8) Water-colour and pencil
19.4 x 16.2 (7⅝ x 6⅜)
Thomas Heaphy
Purchased, 1921
See Collections: Peninsular and
Waterloo Officers, 1813-14, by
Thomas Heaphy, **1914(1-32)**

MACKAY, James Lyle, 1st Earl
of Inchcape *See* INCHCAPE

MACKAY, Mary ('Marie Corelli')
(1855-1924) Novelist

4891 Canvas 92.7 x 71.1
(36½ x 28)
Helen Donald-Smith, 1897
Acquired, 1972

McKENNA, Stephen (1888-1967)
Novelist

3489 *See Collections:* Prominent
Men, c.1880-c.1910, by Harry
Furniss, **3337-3535** and **3554-3620**

MACKENZIE, Colonel

1752 *See Groups:* The Siege of
Gibraltar, 1782, by George Carter

MACKENZIE, Sir Alexander
Campbell (1847-1935) Composer

3490 *See Collections:* Prominent
Men, c.1880-c.1910, by Harry
Furniss, **3337-3535** and **3554-3620**

3972 Pencil and chalk 24.1 x 19.1
(9½ x 7½)
Flora Lion, signed and inscribed
Purchased, 1956

MACKENZIE, Sir Compton
(1883-1972) Writer and novelist

4948 Pastel 57.2 x 42.5
(22½ x 16¾)
Helen Wilson, signed and dated 1963
Purchased, 1973

MACKENZIE, Henry (1745-1831)
Novelist

455 Canvas 74.9 x 62.9
(29½ x 24¾)
Sir Henry Raeburn
Purchased, 1877

MACKINDER, Sir Halford John
(1861-1947)
Geographer and politician

4785 (With drawing of head of
unidentified man on reverse)
Sanguine, black and white chalk
51.7 x 34 (20$\frac{3}{8}$ x 13$\frac{3}{8}$)
Sir William Rothenstein
Purchased, 1970

MACKINLAY, Antoinette (née
Stirling) (1843-1904) Singer

2774 Chalk 36.8 x 31.8
(14½ x 12½)
Louise Virenda Blandy, signed and
dated 1880
Given by Mrs Charles Edward
Barrett-Lennard, 1935

MACKINTOSH, Lieutenant-
Colonel

1752 *See Groups:* The Siege of
Gibraltar, 1782, by George Carter

MACKINTOSH, Sir James
(1765-1832) Philosopher

45 Canvas 93.3 x 73.7 (36¾ x 29)
Sir Thomas Lawrence, exh 1804
Given by the sitter's son, Robert
James Mackintosh, 1858

MACKLIN, Charles (1699?-1797)
Actor-manager and dramatist

1319 Canvas 90.8 x 70.5
(35¾ x 27¾)
John Opie, c.1792
Purchased, 1902

Kerslake

MACLAGAN, William Dalrymple
(1826-1910) Archbishop of York

2369 *See Groups:* The Education
Bill in the House of Lords, by
Sydney Prior Hall

MACLEAY, Kenneth (1802-78)
Miniaturist; founder member of
Royal Scottish Academy

P6(101) Photograph: calotype
15.5 x 10.8 (6$\frac{1}{8}$ x 4¼)
David Octavius Hill and Robert
Adamson, 1843-8
Given by an anonymous donor, 1973
See Collections: The Hill and
Adamson Albums, 1843-8, by
David Octavius Hill and Robert
Adamson, **P6(1-258)**

MACLEOD, Roderick (1768-1853)
MP for Sutherland

54 *See Groups:* The House of Com-
mons, 1833, by Sir George Hayter

MACLISE, Daniel (1806-70)
History and portrait painter

1456(19) Black chalk 7.9 x 7.9
(3$\frac{1}{8}$ x 3$\frac{1}{8}$)
Charles Hutton Lear, inscribed and
dated 1845
Given by John Elliot, 1907
and
1456(20) Black chalk 8.9 x 9.8
(3½ x 3$\frac{7}{8}$)
Charles Hutton Lear, inscribed and
dated 1845
Given by John Elliot, 1907
See Collections: Drawings of Artists,
c.1845, by Charles Hutton Lear,
1456(1-27)

616 Panel 45.7 x 35.2 (18 x 13$\frac{7}{8}$)
Edward Matthew Ward, signed and
dated 1846
Given by Sir George Scharf, 1880

2476 *See Collections:* Drawings of
Royal Academicians, c.1858, by
Charles Bell Birch, **2473-9**

Ormond

MACMILLAN, Harold (b.1894)
Prime Minister

P44 Photograph: bromide print
33.7 x 26.3 (13¼ x 10$\frac{3}{8}$)
Arnold Newman, 1954
Purchased, 1976

5133 Bronze cast of bust 34.3
(13½) high
Angela Conner, incised and dated
1973
Given anonymously, 1973

MACNAGHTEN, Sir William Hay,
Bt (1793-1841)
Diplomat and orientalist

749 Water-colour 18.4 x 14.9
(7¼ x 5$\frac{7}{8}$)
James Atkinson, 1841
Given by the artist's son,
J.A.Atkinson, 1885

Ormond

MACNAMARA, Thomas James
(1861-1931) Politician

2975 Water-colour 50.2 x 33.7
(19¾ x 13¼)
Sir Leslie Ward, signed *Spy*
(*VF* 9 Oct 1907)
Purchased, 1938

McNEILL, Duncan, Baron
Colonsay and Oronsay
See COLONSAY AND ORONSAY

McNEILL, Sir John (1795-1883)
Surgeon and Crimean commissioner

P6(11) Photograph: calotype
20.3 x 14.9 (8 x 5$\frac{7}{8}$)
David Octavius Hill and Robert
Adamson, 1845
Given by an anonymous donor,1973
See Collections: The Hill and
Adamson Albums, 1843-8, by
David Octavius Hill and Robert
Adamson, **P6(1-258)**

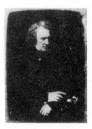

MACPHERSON, James (1736-96)
Poet

983 Canvas 74.3 x 62.2
(29¼ x 24½)
After Sir Joshua Reynolds (1772)
Given by Henry Willett, 1895

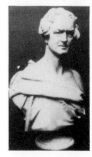

MACREADY, William Charles
(1793-1873) Actor

1503 Canvas 91.4 x 61.6
(36 x 24¼)
John Jackson, 1821
Bequeathed by the sitter, 1908

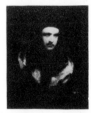

1504 Marble bust 81.3 (32) high
William Behnes, exh 1844
Bequeathed by the sitter, 1908

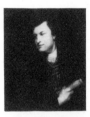

3329 Water-colour 108 x 68.2
(42½ x 26$\frac{7}{8}$)
Attributed to Daniel Maclise
Purchased, 1947

Continued overleaf

3017 Water-colour 21 x 16.5
(8¼ x 6½)
Unknown artist, c.1870
Purchased, 1939

Ormond

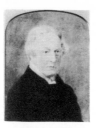

MACSWINNY (or Swinny), Owen
(d.1754) Playwright

1417 Canvas 76.8 x 63.8
(30¼ x 25⅛)
After Peter van Bleeck (1737)
Bequeathed by George Bramwell,
1905

Kerslake

McTAGGART, William (1835-1910)
Painter

4041(2) Pencil and black wash
38.7 x 31.8 (15¼ x 12½)
Walker Hodgson, signed with
initials, inscribed and dated 1892
Purchased, 1957
See Collections: Drawings, 1891-5,
by Walker Hodgson, **4041(1-5)**

MADDEN, Sir Charles Edward, Bt
(1862-1935) Admiral

1913 *See Groups:* Naval Officers
of World War I, 1914-18, by Sir
Arthur Stockdale Cope

MADDEN, Sir Frederic (1801-73)
Antiquary and palaeographer

1979 Wax medallion, oval
18.4 x 14.3 (7¼ x 5⅝)
Richard Cockle Lucas, incised and
dated 1849
Given by the sitter's grandson,
Frederic Madden, 1923

Ormond

MADDEN, Richard Robert
(1798-1886) Miscellaneous writer

4026(41) Pencil and black chalk
16.5 x 12.1 (6½ x 4¾)
Alfred, Count D'Orsay, inscribed
and dated 1828
Purchased, 1957
See Collections: Drawings of Men
about Town, 1832-48, by Alfred,
Count D'Orsay, **4026(1-61)**

599 *See Groups:* The Anti-Slavery
Society Convention, 1840, by
Benjamin Robert Haydon

Ormond

MADOCKS, John (1786-1837)
MP for Denbigh

54 *See Groups:* The House of Com-
mons, 1833, by Sir George Hayter

MAGEE, William (1766-1831)
Archbishop of Dublin

5213 Silhouette 7.6 x 6 (3 x 2⅜)
sight
John Field
Purchased, 1978

MAGEE, William Connor (1821-91)
Archbishop of York

1994 Water-colour 29.5 x 18.1
(11⅝ x 7⅛)
Carlo Pellegrini, signed *Ape*
(*VF* 3 July 1869)
Purchased, 1923

MAGUIRE, Rochfort (d.1867)
Naval commander

1214 Canvas 38.7 x 32.4
(15¼ x 12¾)
Stephen Pearce, 1860
Bequeathed by John Barrow, 1899
See Collections: Arctic Explorers,
1850-86, by Stephen Pearce,
905-24 and **1209-27**

Ormond

MAHON, Charles James Patrick
(1800-91) Irish politician;
'The O'Gorman Mahon'

4584 Water-colour 47.6 x 35.9
($18\frac{3}{4}$ x $14\frac{1}{8}$)
Probably by Thomas Bridgford,
signature partially visible
Acquired, 1967

MAINWARING, William
MP for Middlesex

745 *See Groups:* William Pitt
addressing the House of Commons
. . . 1793, by Karl Anton Hickel

MAITLAND, John Maitland, Baron
(1545?-95)
Lord High Chancellor of Scotland

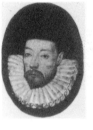

2769 Tempera on card, oval
3.8 x 2.8 ($1\frac{1}{2}$ x $1\frac{1}{8}$)
Unknown artist, c.1590
Given by Hugh Cobb, 1935

Strong

MAITLAND, Frederic William
(1850-1906) Historian of law

1966 Canvas 59.7 x 49.5
($23\frac{1}{2}$ x $19\frac{1}{2}$)
Beatrice Lock, signed and dated
1906
Purchased, 1922

MAITLAND, James, 8th Earl of
Lauderdale *See* LAUDERDALE

MAITLAND, John, 1st Duke of
Lauderdale *See* LAUDERDALE

MAITLAND, Sir Peregrine
(1777-1854)
General and colonial governor

3736 *See Collections:* Studies for
The Waterloo Banquet at Apsley
House, 1836, by William Salter,
3689-3769

MAJENDIE, Henry William
(1754-1830) Bishop of Bangor

1695(n) *See Collections:* Sketches
for The Trial of Queen Caroline,
1820, by Sir George Hayter,
1695(a-x)

999 *See Groups:* The Trial of
Queen Caroline, 1820, by Sir
George Hayter

MAJOCCHI, Theodore
A witness at the trial of Queen
Caroline

1695(c and **d)** *See Collections:*
Sketches for The Trial of Queen
Caroline, 1820, by Sir George
Hayter, **1695(a-x)**

999 *See Groups:* The Trial of
Queen Caroline, 1820, by Sir
George Hayter

MAKINS, Sir Roger (1904-64)
Diplomat

4529(223-6) *See Collections:*
Working drawings by Sir David
Low, **4529(1-401)**

MALAKOFF, Duc de
See PELISSIER

MALCOLM, Sir John (1769-1833)
Diplomat and writer on India

316a(81) Pencil, two sketches
44.1 x 62.5 ($17\frac{3}{8}$ x $24\frac{5}{8}$)
Sir Francis Chantrey, inscribed
Given by Mrs George Jones, 1871
See Collections: Preliminary
drawings for busts and statues by
Sir Francis Chantrey, **316a(1-202)**

MALET, Sir Thomas (1582-1665)
Judge

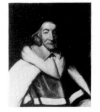

784 Canvas 76.2 x 63.5 (30 x 25)
After an unknown artist (1661)
Bequeathed by Miss Charlotte F.
Gerard, 1888

Piper

MALKIN, Benjamin Heath
(1769-1842) Historian and writer

316a(82) Pencil 45.7 x 27
(18 x 10⅝)
Sir Francis Chantrey, inscribed
Given by Mrs George Jones, 1871
See Collections: Preliminary
drawings for busts and statues by
Sir Francis Chantrey, **316a(1-202)**

MALLORY, George Leigh
(1886-1924) Mountaineer

3918 Pastel 29.2 x 22.9 (11½ x 9)
Simon Bussy, signed, c.1910
Purchased, 1954

MALMESBURY, James Harris, 1st
Earl of (1746-1820) Diplomat

L152(29) Copper 9.5 x 7.6
(3¾ x 3)
Charles Bestland after Sir Thomas
Lawrence, signed and dated 1807,
reduced copy (exh 1806)
Lent by NG (Alan Evans Bequest),
1975

MALMESBURY, James Howard
Harris, 3rd Earl of (1807-89)
Statesman

4893 *See Groups:* The Derby
Cabinet of 1867, by Henry Gales

MALONE, Edmund (1741-1812)
Critic and editor of Shakespeare

709 Canvas 74.9 x 62.2
(29½ x 24½)
Sir Joshua Reynolds, 1778
Given by William Agnew, 1883

MANCHESTER, Charles Montagu,
1st Duke of (1662-1722) Diplomat

3216 Canvas 90.8 x 70.5
(35¾ x 27¾)
Sir Godfrey Kneller, signed in
monogram, c.1710
Kit-cat Club portrait
Given by NACF, 1945.
Beningbrough

Piper

MANCHESTER, William Montagu,
7th Duke of (1823-90) Lord of
the Bedchamber to Prince Albert

2585 Water-colour 33.7 x 20.3
(13¼ x 8)
Sir Leslie Ward, signed *Spy*
(*VF* 28 Dec 1878)
Purchased, 1933

MANCHESTER, Edward Montagu,
2nd Earl of (1602-71) Soldier

4359 Silver badge 3.2 x 2.5
(1¼ x 1)
Unknown artist, c.1643
Purchased, 1964

3678 Canvas 127 x 101.6 (50 x 40)
Sir Peter Lely, inscribed, c.1661-5
Purchased, 1949

1838 Canvas 221 x 128.9
(87 x 50¾)
Studio of Sir Peter Lely, inscribed
Purchased, 1919

Piper

MANGNALL, Richmal (1769-1820)
Schoolmistress, educationalist
and writer

4377 Water-colour 30.2 x 23.8
(11⅞ x 9⅜)
John Downman, signed and dated
1814
Purchased, 1964

MANLEY, Norman Washington
(1893-1969) Premier of Jamaica

4529(227-9) *See Collections:*
Working drawings by Sir David
Low, **4529(1-401)**

MANNERS, Lord Robert William
(1781-1835) Major-General

3737 *See Collections:* Studies for
The Waterloo Banquet at Apsley
House, 1836, by William Salter,
3689-3769

MANNERS, John, Marquess of
Granby *See* GRANBY

MANNERS, John, 7th Duke of
Rutland *See* RUTLAND

MANNERS, John Henry, 5th Duke
of Rutland *See* RUTLAND

MANNERS-SUTTON, Charles
(1755-1828)
Archbishop of Canterbury

1695(t) *See Collections:* Sketches
for The Trial of Queen Caroline,
1820, by Sir George Hayter,
1695(a-x)

999 *See Groups:* The Trial of
Queen Caroline, 1820, by Sir
George Hayter

316a(121) Pencil, two sketches
43.2 x 67 (17 x 26$\frac{3}{8}$)
Sir Francis Chantrey, inscribed
Given by Mrs George Jones, 1871
See Collections: Preliminary
drawings for busts and statues by
Sir Francis Chantrey, **316a(1-202)**

MANNERS-SUTTON, Charles,
1st Viscount Canterbury
See CANTERBURY

MANNING, Frederic (1882-1935)
Novelist and poet

4417 Sanguine and white chalk
39.4 x 29.2 (15½ x 11½)
Sir William Rothenstein, signed
with initials and dated 1921
Purchased, 1964

MANNING, Henry Edward
(1808-92)
Cardinal Archbishop of Westminster

4166 *See Groups:* Charles James
Blomfield, Cardinal Manning and
Sir John Gurney, by George
Richmond

3628 Water-colour 30.2 x 18.1
(11$\frac{7}{8}$ x 7$\frac{1}{8}$)
Carlo Pellegrini, signed *Ape*
(*VF* 25 Feb 1871)
Purchased, 1948

1008 Canvas 90.2 x 69.9
(35½ x 27½)
George Frederic Watts, signed and
dated 1882
Given by the artist, 1895

1589 Plaster cast of bust 87.6
(34½) high
John Adams-Acton, c.1884
Given by the artist's widow, 1910

MANSBRIDGE, Albert (1876-1952)
Founder of the Workers'
Educational Association

3987 Canvas 90.2 x 69.9
(35½ x 27½)
John Mansbridge (his son), signed
and inscribed, 1947
Given by the sitter's widow, 1956

MANSEL, Henry Longueville
(1820-71) Metaphysician

4541(9) *See Collections:* The
Pusey family and their friends,
c.1856, by Clara Pusey, **4541(1-13)**

MANSFIELD, William Murray, 1st Earl of (1705-93) Judge

474 Canvas 74.9 x 62.2 (29½ x 24½) Jean Baptiste van Loo, 1732 Given by the Society of Judges and Serjeants-at-Law, 1877

172 Canvas 223.5 x 146.1 (88 x 57½) John Singleton Copley, signed, exh 1783 Purchased, 1864

MANSFIELD, David William Murray, 3rd Earl of (1777-1840)

999 *See Groups:* The Trial of Queen Caroline, 1820, by Sir George Hayter

MANSFIELD, William David Murray, 4th Earl of (1806-98) MP for Norwich

54 *See Groups:* The House of Commons, 1833, by Sir George Hayter

MANSON, Sir Patrick (1844-1922) Pioneer of tropical medicine

4058 Bronze medal 5.1 (2) diameter John Robert Pinches, inscribed and dated 1922 Given by the artist, 1958

MANVERS, Charles Herbert Pierrepont, 2nd Earl (1778-1860)

999 *See Groups:* The Trial of Queen Caroline, 1820, by Sir George Hayter

MANVERS, Sydney Pierrepont, 3rd Earl (1825-1900) Representative peer

1834(u) *See Collections:* Members of the House of Lords, c.1870-80, by Frederick Sargent, **1834(a-z and aa-hh)**

MANWOOD, Sir Roger (1525-92) Judge

475 Water-colour 24.1 x 20.3 (9½ x 8) George Perfect Harding, signed, copy Given by the Society of Judges and Serjeants-at-Law, 1877

Strong

MARCHESI, Luigi (1755-1829) Italian male soprano

5179 *See Groups:* A Bravura at the Hanover Square Concert, by John Nixon

MARCONI, Marchesi Guglielmo (1874-1937) Italian physicist; pioneer of wireless communication

4529(230) *See Collections:* Working drawings by Sir David Low, **4529(1-401)**

MARGARET Tudor (1489-1541) Queen of Scotland

1173 *See Unknown Sitters I*

MARGARET ROSE, Princess (b.1930) Daughter of George VI

3778 *See Groups:* Conversation Piece at the Royal Lodge, Windsor, 1950, by Sir James Gunn

MARIA Clementina Sobieska (1702-35) Wife of Prince James Francis Edward Stuart

1262 Canvas oval 62.9 x 50.2 (24¾ x 19¾) Unknown Italian artist, c.1719 Purchased, 1900

1686 Bronze medal 4.8 ($1\frac{7}{8}$) diameter Ottone Hamerani, inscribed and dated 1719 Given by Sir Charles Holmes, 1912

Kerslake

MARISCHAL, George Keith, 10th Earl (1693?-1778) Jacobite soldier

552 Copper 44.2 x 32.1 (17⅜ x 12⅝)
Attributed to Placido Costanzi, inscribed, c.1733
Transferred from BM, 1879

Kerslake

MARJORIBANKS, Campbell

316a(83,84) *See Collections:* Preliminary drawings for busts and statues by Sir Francis Chantrey, **316a(1-202)**

MARJORIBANKS, Stewart (1744-1863) MP for Hythe

54 *See Groups:* The House of Commons, 1833, by Sir George Hayter

MARKHAM, William (1719-1807) Headmaster of Westminster School; Archbishop of York

4495 Canvas 76.2 x 63.5 (30 x 25)
Benjamin West, c.1771
Purchased, 1966

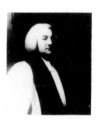

MARKS, Henry Stacy (1829-98) Painter

P94 Photograph: albumen print 19.7 x 16.2 (7¾ x 6⅜)
David Wilkie Wynfield, 1860s
Given by H.Saxe Wyndham,1937
See Collections: The St John's Wood Clique, by David Wilkie Wynfield, **P70-100**

P78 *See Collections:* The St John's Wood Clique, by David Wilkie Wynfield, **P70-100**

2820 *See Groups:* The Royal Academy Conversazione, 1891, by G.Grenville Manton

4245 *See Groups:* Hanging Committee, Royal Academy, 1892, by Reginald Cleaver

MARLBOROUGH, John Churchill, 1st Duke of (1650-1722)
Soldier and statesman

501 Canvas, feigned oval 74.9 x 62.2 (29½ x 24½)
Perhaps by John Closterman after John Riley (c.1685-90)
Purchased, 1878. *Beningbrough*

553 Canvas 125.7 x 104.1 (49½ x 41)
After Sir Godfrey Kneller
Transferred from BM, 1879

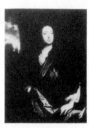

902 Canvas 92.7 x 73.7 (36½ x 29)
Sir Godfrey Kneller, c.1706
Purchased, 1892

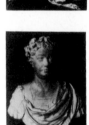

2005 Marble bust 61 (24) high
Studio of (?) John Michael Rysbrack, c.1730
Transferred from BM, 1923

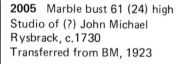

1858 *See Unknown Sitters II*

Piper

MARLBOROUGH, Sarah Churchill, Duchess of (1660-1744)
Wife of 1st Duke of Marlborough and friend of Queen Anne

3634 Canvas 105.4 x 88.9 (41½ x 35)
After Sir Godfrey Kneller (c.1700)
Purchased, 1948

712 *See Unknown Sitters II*

Piper

MARLBOROUGH, George Spencer-
Churchill, 6th Duke of (1793-1857)
MP for Woodstock

54 *See Groups:* The House of Com-
mons, 1833, by Sir George Hayter

MARLBOROUGH, John Churchill,
7th Duke of (1822-83) Politician

4893 *See Groups:* The Derby
Cabinet of 1867, by Henry Gales

MARLBOROUGH, Charles Spencer-
Churchill, 9th Duke of (1871-1934)
Under-Secretary for the Colonies

2965 Water-colour 34.6 x 21.3
($13\frac{5}{8}$ x $8\frac{3}{8}$)
Sir Leslie Ward, signed *Spy*
(*VF* 22 Sept 1898)
Purchased, 1938

MARLBOROUGH, James Ley, 1st
Earl of (1550-1629) Judge

1258 Panel 58.4 x 48.3 (23 x 19)
Unknown artist, inscribed
Purchased, 1900

Strong

MAROCHETTI, Carlo, Baron
(1805-67) Sculptor

1038 Bronze statuette 62.5
($24\frac{5}{8}$) high
Gabriele Ambrosio, incised and
dated 1888
Given by Signora Muratori, 1896

Ormond

MARQUIS, Frederick James, 1st
Earl of Woolton *See* WOOLTON

MARRABLE, Mrs (née Binny)

P6(109,117,122) *See Collections:*
The Hill and Adamson Albums,
1843-8, by David Octavius Hill
and Robert Adamson, **P6(1-258)**

MARRIAGE, Joseph (1807-84)
Slavery abolitionist

599 *See Groups:* The Anti-Slavery
Society Convention, 1840, by
Benjamin Robert Haydon

MARRIOTT, Sir William
(1834-1903)
Lawyer and politician

2586 Water-colour 30.8 x 18.1
($12\frac{1}{8}$ x $7\frac{1}{8}$)
Théobald Chartran, signed *.T.*
(*VF* 24 March 1883)
Purchased, 1933

MARRYAT, Frederick (1792-1848)
Naval captain and novelist

1239 Canvas 76.2 x 63.2
(30 x $24\frac{7}{8}$)
John Simpson, eng 1826
Bequeathed by the sitter's daughter,
Miss Augusta Marryat, 1899

Ormond

MARSDEN, William (1754-1836)
Orientalist and numismatist

4410 Pencil and wash 45.7 x 31.8
(18 x 12½)
George Dance, signed and dated
1794
Given by Christopher Marsden, 1964

316a(85,86) *See Collections:*
Preliminary drawings for busts and
statues by Sir Francis Chantrey,
316a(1-202)

MARSH, Catherine (1818-1912)
Evangelist and social reformer

2365 Water-colour 24.1 x 17.8
(9½ x 7)
Lionel Grimston Fawkes, signed
and dated 1895, and autographed
by sitter (on separate label)
Given by Mrs L.O'Rorke, 1929

MARSH, Sir Edward (1872-1953)
Patron of artists and writers

3945 Canvas 74.3 x 61.6
(29¼ x 24¼)
Sir Oswald Birley, signed and dated
1949
Given by the Contemporary Art
Society, 1955

MARSHALL, Benjamin
(1767?-1835) Painter of animals
and sporting subjects

2787 Pencil 27.9 x 20.3 (11 x 8)
Unknown artist, inscribed
Given by Godfrey Brennan, 1935

2671 Canvas 19.1 x 15.2 (7½ x 6)
Lambert Marshall (his son), c.1825
Purchased, 1934

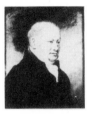

MARSHALL, Sir Frederick
(1829-1900) Lieutenant-General

2587 Water-colour 30.5 x 18.1
(12 x 7⅛)
Carlo Pellegrini, signed *Ape*
(*VF* 16 March 1878)
Purchased, 1933

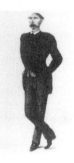

MARSHALL, George (1817-97)
Proctor and Censor of Christ
Church, Oxford

P7(8) *See Collections:* Lewis
Carroll at Christ Church, by Charles
Lutwidge Dodgson, **P7(1-37)**

MARSHALL, John (1797-1836)
MP for Leeds

54 *See Groups:* The House of Com-
mons, 1833, by Sir George Hayter

MARSHALL, Sir William
(1865-1939) Lieutenant-General

1954 *See Groups:* General Officers
of World War I, by John Singer
Sargent

MARTEN, Henry (1602-80)
Regicide

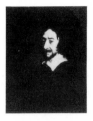

5176 Canvas, feigned oval
74.3 x 61.6 (29¼ x 24¼)
Sir Peter Lely, inscribed
Purchased, 1978

MARTIN, Major

1752 *See Groups:* The Siege of
Gibraltar, 1782, by George Carter

MARTIN, Sir Alec (1884-1971)
Fine art auctioneer and Chairman
of NACF

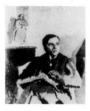

4850 Canvas 91.4 x 81.3 (36 x 32)
John Laviers Wheatley
Given by wish of the sitter, 1971

MARTIN, Basil Kingsley
(1897-1969) Journalist and writer

4529(232-4) *See Collections:*
Working drawings by Sir David
Low, **4529(1-401)**

MARTIN, Evelyn George
(1871-1945) Yachtsman

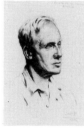

4227 Crayon 34.6 x 24.4
(13⅝ x 9⅝)
Cor Visser, signed, inscribed and
dated 1937
Given by the artist, 1961

MARTIN, Helena Saville (née
Faucit), Lady (1817-98) Actress;
wife of Sir Theodore Martin

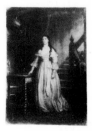

4998 Water-colour 41.3 x 29.8
(16¼ x 11¾)
Thomas Wageman, c.1838
Given by Joseph Klein, 1974

Continued overleaf

1554 Marble bust 71.1 (28) high
John Henry Foley, incised and
dated 1843
Bequeathed by the sitter's husband,
1909

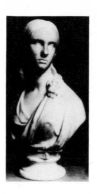

3908 Water-colour 31.4 x 22.9
($12\frac{3}{8}$ x 9)
Unknown artist
Given by Mrs Ernest William
Barnes, 1954

MARTIN, J.H.('Skeets') (b.1875)
American jockey

3009 *See Collections: Vanity
Fair* cartoons, 1869-1910, by
various artists, **2566-2606,** etc

MARTIN, John (1789-1854)
Historical, landscape and biblical
painter

2515(13) *See Collections:*
Drawings of Prominent People,
1823-49, by William Brockedon,
2515(1-104)

958 Panel 26.7 x 21.6 (10½ x 8½)
Henry Warren (his nephew),
exh 1839
Purchased, 1894

Ormond

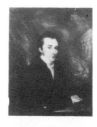

MARTIN, Sir Theodore
(1816-1909) Journalist, writer
and politician

3100 Canvas 72.4 x 62.2
(28½ x 24½)
Robert Herdman, signed in
monogram and dated 1876
Given by James H.Blackwood, 1941

2731 Water-colour 31.8 x 20.3
(12½ x 8)
Sir Leslie Ward, signed *Spy*
(*VF* 7 July 1877)
Purchased, 1934

1555 Canvas 39.4 x 29.8
(15½ x 11¾)
Frank Moss Bennett, signed and
dated 1908
Given by Lord Ronald Sutherland
Gower, 1909

MARTIN, Violet (1862-1915)
Novelist

4655 Panel 21.6 x 13.3 (8½ x 5¼)
Edith Somerville, signed and
inscribed, and signed and dated
1886 on reverse
Purchased, 1968

MARTIN, William (1772-1851)
Inventor and eccentric

1576 Miniature on ivory, oval
8.6 x 6.4 ($3\frac{3}{8}$ x 2½)
George Patten, inscribed
Purchased, 1910

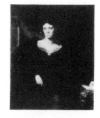

MARTINEAU, Harriet (1802-76)
Social philosopher and writer;
sister of James Martineau

1085 Canvas 127.6 x 101.9
(50¼ x $40\frac{1}{8}$)
Richard Evans, exh 1834
Purchased, 1897

1796 Chalk 62.6 x 47.3
($24\frac{5}{8}$ x $18\frac{5}{8}$)
George Richmond, signed and
dated 1849
Bequeathed by the sitter's niece,
Miss Emily Higginson, 1917

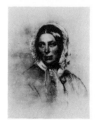

P33 Photograph: albumen print
8.3 x 5.1 (3¼ x 2)
Unknown photographer
Purchased, 1977
See Collections: Prints from two
albums, 1852-60, by Charles
Lutwidge Dodgson and others,
P31-40

Ormond

MARTINEAU, James (1805-1900)
Unitarian divine and writer

1251 Canvas 65.7 x 53.3
(25⅞ x 21)
George Frederic Watts, replica
(1873)
Given by the artist, 1900

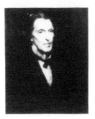

2526 Pencil 17.1 x 12.7 (6¾ x 5)
Clara Martineau (his daughter-in-
law), dated 1887
Given by G.C.Allingham, 1932

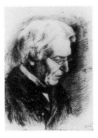

2348 *See Collections:*
Miscellaneous drawings . . . by
Sydney Prior Hall, **2282-2348** and
2370-90

2080 Plaster cast of statuette
35.6 (14) high
Henry Richard Hope-Pinker, incised
and dated 1897
Given by the artist, 1925

Ormond

MARTINELLI, Vincenzo (1702-85)
Italian writer and adventurer

4855(50,52,53) *See Collections:*
The Townshend Album, **4855(1-73)**

MARTIN-HARVEY, Angelita
Helena Margarita, Lady (d.1949)
Wife of Sir John Martin-Harvey

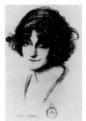

4694A (Companion to no.**4694**,
Sir John Martin-Harvey)
Chalk 53 x 38.7 (20⅞ x 15¼)
Charles Buchel, signed, c.1918
Given by the sitter's daughter,
Miss Muriel Martin-Harvey,1969

MARTIN-HARVEY, Sir John
(1863-1944) Actor-manager

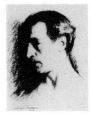

4694 Chalk 53.3 x 38.1 (21 x 15)
Charles Buchel, signed and dated
1918
Given by the sitter's daughter,
Miss Muriel Martin-Harvey, 1969

MARTINEZ, Anna Maria (née
Jenkins) Niece of Thomas Jenkins

5044 *See under* Thomas Jenkins

MARVELL, Andrew (1621-78)
Poet and politician

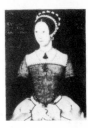

554 Canvas, oval 59.7 x 47
(23½ x 18½)
Unknown artist, c.1655-60
Transferred from BM, 1879

Piper

MARY I (1516-58)
Reigned 1553-8

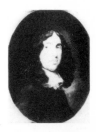

428 Panel 71.1 x 50.8 (28 x 20)
Master John, inscribed and dated
1544
Purchased, 1876

4861 Panel 21.6 x 16.9 (8½ x 6⅝)
Hans Eworth, signed with initials,
1554
Purchased with help from NACF,
Pilgrim Trust, H.M.Government,
Miss Elizabeth Taylor and Richard
Burton, 1972

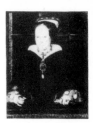

4980(16) *See Collections:* Set of
16 early English Kings and Queens
formerly at Hornby Castle,
Yorkshire, **4980(1-16)**

Continued overleaf

446(1) Electrotype of Medal
6.7 (2⅝) diameter
After Jacopo da Trezzo, signed and
inscribed (c.1555)
Given by Sir George Scharf, 1877

4174 Panel 8.6 x 6.4 (3⅜x 2½)
After Antonio Mor
Given by Edward Peter Jones, 1960

Strong

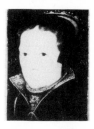

MARY, Queen of Scots (1542-87)
Reigned 1542-87

555 Canvas 71.1 x 53 (28 x 20⅞)
After François Clouet, inscribed
(1560)
Transferred from BM, 1879
(Photographs of the original drawing
by Clouet, and of another drawing
by Clouet, also c.1560, given by Sir
George Scharf in 1889, are nos.
815 and **814**. *Neither is illustrated)*

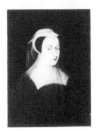

1766 Panel 25.1 x 19.1 (9⅞ x 7½)
After miniature by an unknown
artist (c.1560-5)
Purchased, 1916

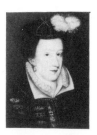

429 Panel 79.1 x 90.2
(31⅛ x 35½)
After Nicholas Hilliard, inscribed,
c.1610 (1578?)
Purchased, 1876

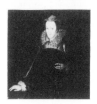

1918 Electrotype of medal
6.7 (2⅝) diameter
After Jacopo Primavera, signed
and inscribed
Given by the BM Department of
Coins and Medals, 1921

96a Electrotype of medal 6.7
(2⅝) diameter
After Jacopo Primavera, inscribed,
18th-century forgery
Given by Albert Way, 1860

307 Electrotype of effigy in
Westminster Abbey 61 (24) high
After Cornelius and William Cure
(1606-c.1616)
Given by John Hosack, 1870

307A Plaster cast of no.**307**
(front of head only) 26.7 (10½) high
Acquired, 1870. *Not illustrated*

307B Plaster cast of no.**307**
(head only) 27.9 (11) high
Acquired, 1870. *Not illustrated*

96 *See Unknown Sitters I*

Strong

MARY of Modena (1658-1718)
Queen of James II

214 Canvas 120.7 x 97.8
(47½ x 38½)
William Wissing, signed, c.1685
Purchased, 1866

Piper

MARY II (1662-94)
Reigned with William III 1688-94

606 Canvas 39.4 x 32.4
(15½ x 12¾)
After William Wissing
Purchased, 1880

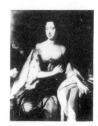

197 Canvas 124.5 x 100.3
(49 x 39½)
After William Wissing
Purchased, 1865

Piper

MARY Victoria of Teck
(1867-1953) Queen of George V

4441 *See Groups:* The Duke and
Duchess of Teck receiving Officers
of the Indian Contingent, 1882, by
Sydney Prior Hall

2089 Miniature on ivory, oval
12.7 x 9.8 (5 x $3\frac{7}{8}$)
Mary Helen Carlisle, signed
Given by the artist's sister, Miss
Sybil Carlisle, 1925

1745 *See Groups:* The Royal
Family at Buckingham Palace,1913,
by Sir John Lavery

4164 Bronze cast of bust 80 (31½)
high
Sir William Reid Dick, incised and
dated 1938
Purchased, 1960

MARY, Princess of Orange
(1631-60) Daughter of Charles I

267 *See Groups:* Five Children of
Charles I, after Sir Anthony van
Dyck

5105 Panel 28.9 x 20 ($11\frac{3}{8}$ x $7\frac{7}{8}$)
Cornelius Johnson, signed with
initials and dated 1639
Purchased, 1976
See Collections: Three eldest
children of Charles I, by Cornelius
Johnson, **5103-5**

MARY Victoria Alexandra Alice
(1897-1965) Princess Royal;
daughter of George V

1745 *See Groups:* The Royal
Family at Buckingham Palace,
1913, by Sir John Lavery

MASEFIELD, John (1878-1967)
Poet Laureate

4568 Etching 52.7 x 37.8
($20\frac{3}{4}$ x $14\frac{7}{8}$)
William Strang, signed below
plate, 1912
Given by the Contemporary
Portraits Fund, 1967

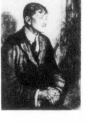

4569 Pencil 30.5 x 22.9 (12 x 9)
Henry Lamb, signed and inscribed
Given by the Contemporary
Portraits Fund, 1967

2053 *See Collections:* Medallions
of Writers, c.1922, by Theodore
Spicer-Simson, **2043-55**

MASHAM, Abigail, Lady (d.1734)
Courtier

1494 *See Unknown Sitters II*

MASKELYNE, Nevil (1732-1811)
Astronomer Royal

1075,1075a and **b** *See Groups:*
Men of Science Living in 1807-8,
by Sir John Gilbert and others

MASON, George Heming (1818-72)
Painter

1295 Canvas 60.6 x 50.2
($23\frac{7}{8}$ x 19¾)
Valentine Cameron Prinsep
Purchased, 1901

MASON, James (1849-1905)
Chess player

3060 *See Groups:* Chess players,
by A.Rosenbaum

MASON, Thomas Monck (1803-89)
Musician, writer and aeronaut

4710 *See Groups:* A Consultation
prior to the Aerial Voyage to
Weilburg, 1836, by John Hollins

MASON, William (1724-97)
Poet and divine; friend and
biographer of Thomas Gray

4806 Canvas 76.2 x 63.2
(30 x 24⅞)
William Doughty, 1778
Purchased, 1970

1393 Miniature on ivory, oval
10.5 x 8.6 (4⅛ x 3⅜)
Attributed to John Plott
Given by the Hon Philip Stanhope,
1905

2690 (design for Mason's
monument in Westminster Abbey)
Pen and pencil 29.8 x 17.8 (11¾ x 7)
John Bacon, signed and inscribed,
c.1797
Acquired, 1934

MASSEREENE, John Clotworthy,
1st Viscount (d.1665)
Irish Presbyterian

2110 Canvas 73 x 61 (28¾ x 24)
Unknown artist, inscribed
Purchased, 1925

Piper

MASSEY, Sir Edward (1619-74)
Soldier

2107 Canvas 73.4 x 61.6
(28⅞ x 24¼)
Unknown artist, incorrectly
inscribed *Sr. Wm. Lewis.*
Purchased, 1925

Piper

MASSEY, William Ferguson
(1856-1925) Prime Minister of
New Zealand; plenipotentiary at
the 1919 Peace Conference

2463 *See Groups:* Statesmen of
World War I, by Sir James Guthrie

2639 Canvas 90.2 x 74.9
(35½ x 29½)
Sir William Orpen, signed and
dated 1919
Given by Viscount Wakefield, 1933

MATHEW, Theobald (1790-1856)
Apostle of temperance

199 Canvas, feigned oval
61 x 50.8 (24 x 20)
Edward Daniel Leahy, 1846
Purchased, 1865

Ormond

MATHEWS, Augusta (née Leighton)
(1835-1919)
Sister of Lord Leighton

2141(b) *See Collections:* Lord
Leighton and his family, by Lord
Leighton and Edward(?) Foster,
2141, 2141 (a-d)

MATHEWS, Charles (1776-1835)
Comedian

3097a Pencil 16.5 x 11.1
(6½ x 4⅜)
George Henry Harlow, signed and
inscribed, 1814
Purchased, 1941

1710 Plaster cast of bust 55.9
(22) high
Samuel Joseph, incised, 1822
Given by C.E.Pym, 1913

1734 Canvas 73 x 61 (28¾ x 24)
Attributed to George Clint
Purchased, 1914

3097(2) Pen and ink 18.4 x 11.4
(7¼ x 4½)
Sir Edwin Landseer, signed and inscribed
Purchased, 1940
See Collections: Caricatures,
c.1825-c.1835, by Sir Edwin
Landseer, **3097(1-10)**

3097(3,4) *See Collections:*
Caricatures, c.1825-c.1835, by Sir
Edwin Landseer, **3097(1-10)**

1524 *See Unknown Sitters IV*

MATHEWS, Charles James
(1803-78) Actor and dramatist;
son of Charles Mathews

1636 Pencil and chalk 41.6 x 29.2
(16⅜ x 11½)
John Frederick Lewis, signed,
inscribed and dated 1827
Purchased, 1911

Ormond

MATHEWS, Sir Charles Willie, Bt
(1850-1920)
Director of Public Prosecutions

3491, 3492 *See Collections:*
Prominent Men, c.1880-c.1910, by
Harry Furniss, **3337-3535** and
3554-3620

MATHEWS, Lucia Elizabeth
(1797-1856) 'Madame Vestris',
actress and singer; wife of Charles
James Mathews

2786 Water-colour 42.5 x 33
(16¾ x 13)
Samuel Lover, c.1826
Purchased, 1935

Ormond

MATTHEW, Tobie (or Tobias)
(1546-1628) Archbishop of York

1048 Panel 54.9 x 44.5
(21⅝ x 17½)
Unknown artist, inscribed and
dated 1616
Purchased, 1896

Strong

MAUD Charlotte Mary Victoria,
Princess (1869-1938) Fifth child
of Edward VII; Queen of Norway

4471 *See Groups:* The three
daughters of Edward VII and Queen
Alexandra, by Sydney Prior Hall

MAUDE, Cyril Francis (1862-1951)
Actor

4095(8) Pen and ink 38.7 x 31.8
(15¼ x 12½)
Harry Furniss, signed with initials,
pub 1905
Purchased, 1959
See Collections: The Garrick Gallery
of Caricatures, 1905, by Harry
Furniss, **4095(1-11)**

MAUDE, Sir Frederick Stanley
(1864-1917) Lieutenant-General

1954 *See Groups:* General Officers
of World War I, by John Singer
Sargent

MAUDSLAY, Henry (1771-1831)
Engineer

1075,1075a and **b** *See Groups:*
Men of Science Living in 1807-8,
by Sir John Gilbert and others

MAUFE, Sir Edward (1883-1974)
Architect

5155 Canvas 91.8 x 71.1
(36⅛ x 28)
John Laviers Wheatley, signed,
exh 1956
Purchased, 1977

MAUGHAM, William Somerset
(1874-1965)
Novelist and playwright

4524 Canvas 68.6 x 56.5
(27 x 22¼)
Philip Steegman, signed and dated
1931
Given by the artist's widow, 1967

4529(235-40) *See Collections:*
Working drawings by Sir David
Low, **4529(1-401)**

MAULE-RAMSAY, Fox, 11th Earl
of Dalhousie *See* DALHOUSIE

MAUREL, Victor (1848-1923)
French singer

4707(17) *See Collections: Vanity
Fair* cartoons, 1869-1910, by
various artists, **2566-2606**, etc

MAURICE, Sir Frederick Barton
(1871-1951) Major-General

4786 Sanguine 46.4 x 34.3
(18¼ x 13½)
Sir William Rothenstein, signed
with initials and dated 1922
Purchased, 1970

MAURICE, Frederick Denison
(1805-72)
Progressive writer and divine

1709 Chalk 45.1 x 32.4
(17¾ x 12¾)
Samuel Laurence, inscribed, c.1846
Given by Sir Michael and Lady
Sadler, 1913

354 Canvas 81.3 x 67 (32 x 26⅜)
Jane Mary Hayward, signed in
monogram and dated 1854
Given by the artist, 1872

1042 Canvas 94 x 84.5
(37 x 33¼)
Samuel Laurence, exh 1871
Bequeathed by the sitter's widow,
1896

1397 Plaster cast of death-mask,
oval 48.9 x 38.1 (19¼ x 15)
Thomas Woolner, 1872
Given by Lowes Dickinson, 1905

Ormond

MAXFIELD, William (1782-1837)
MP for Great Grimsby

54 *See Groups:* The House of Com-
mons, 1833, by Sir George Hayter

MAX-MÜLLER, Friedrich
(1823-1900)
Orientalist and philologist

P7(25) *See Collections:* Lewis
Carroll at Christ Church, by Charles
Lutwidge Dodgson, **P7(1-37)**

1276 Canvas 71.1 x 61 (28 x 24)
George Frederic Watts, 1894-5
Given by the artist, 1900

MAXTON, James (1885-1946)
Socialist politician

4529(241-4) *See Collections:*
Working drawings by Sir David
Low, **4529(1-401)**

5097 Charcoal 54 x 41.6
(21¼ x 16⅜)
Emmanuel Levy, signed and dated
1936
Purchased, 1976

MAXWELL, Henry, 7th Baron
Farnham *See* FARNHAM

MAXWELL, Mary Elizabeth (née Braddon) (1837-1915) Novelist

4478 Canvas 91.4 x 71.8 (36 x 28¼)
William Powell Frith, exh 1865
Given by the sitter's grandson, Henry Maxwell, 1966

MAXWELL, Sir William Stirling, Bt
See STIRLING-MAXWELL

MAY, Sir John (d.1847)
Major-General

3738 *See Collections:* Studies for The Waterloo Banquet at Apsley House, 1836, by William Salter, **3689-3769**

MAY, Philip William (1864-1903)
'Phil May'; cartoonist

3038 Pen and ink 13 x 10.8 ($5\frac{1}{8}$ x 4¼)
Self-portrait, signed, c.1894
Given by Marion Harry Spielmann, 1939

3941 Silhouette on glass 12.7 x 7.6 (5 x 3)
Self-portrait, signed, inscribed and dated 1894
Given by Miss D.Finney, 1955

1184a Pencil 25.4 x 19.7 (10 x 7¾)
Percy F.Seaton Spence, signed, inscribed and dated 1895
Purchased, 1899

1659 With an unknown model
Crayon 53.3 x 68.6 (21 x 27)
Sir Robert Ponsonby Staples, signed and dated 1898
Given by Ernest E.Leggatt, 1912

4149 Pencil 15.9 x 10.2 (6¼ x 4)
Self-portrait, signed, inscribed and dated 1901
Given by F.H.Aitken-Walker,1960

2661 Pencil 36.8 x 17.8 (14½ x 7)
Self-portrait
Given by Miss Jane Harrison, 1934

2751 Pen and ink 10.8 x 8.3 (4¼ x 3¼)
Arthur Collins, inscribed
Given by Rathwell Wilson, 1934

MAY, Thomas Erskine, 1st Baron Farnborough
See FARNBOROUGH

MAYERNE, Sir Theodore Turquet de (1573-1655)
Physician and chemist

1652 Canvas 121.9 x 99.7 (48 x 39¼)
After Sir Peter Paul Rubens (c.1630)
Purchased, 1912

3066 Enamel miniature on gold, oval 4.1 x 3.5 ($1\frac{5}{8}$ x $1\frac{3}{8}$)
Possibly by Jean Petitot
Transferred from BM, 1939

Piper

MAYNARD, Sir John (1602-90)
Lawyer

476 Canvas, feigned oval
75.6 x 62.9 (29¾ x 24¾)
After John Riley(?)
Given by the Society of Judges and
Serjeants-at-Law, 1877

Piper

MAYNWARING, Arthur
(1668-1712)
Politician and journalist

3217 Canvas 91.4 x 71.1 (36 x 28)
Sir Godfrey Kneller, signed in
monogram, c.1705-10
Kit-cat Club portrait
Given by NACF, 1945

Piper

MAYO, Richard Southwell Bourke,
6th Earl of (1822-72) Viceroy and
Governor-General of India

4893 *See Groups:* The Derby
Cabinet of 1867, by Henry Gales

MAYO, John (1761-1818)
Physician

4878 Silhouette on plaster, oval
8.6 x 6.7 (3⅜ x 2⅝)
John Miers
Purchased, 1972

MAYSON, Isabella Mary
See BEETON

MAZARIN, Ortensia Mancini,
Duchess of (1646-99)
Court beauty

1718 *See Unknown Sitters II*

MEAD, Richard (1673-1754)
Physician

4157 Canvas 76.2 x 63.5 (30 x 25)
Jonathan Richardson, c.1738
Purchased,1960. *Beningbrough*

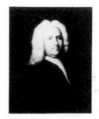

15 Canvas 126.4 x 101
(49¾ x 39¾)
Studio of (?) Allan Ramsay,
inscribed and dated 1740
Purchased, 1857

Kerslake

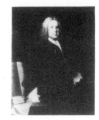

MEADE, Richard, 3rd Earl of
Clanwilliam
See CLANWILLIAM

MEARES, Cecil H.(d.1912)
Linguist and Antarctic explorer

P121 *See under* Lawrence Edward
Grace Oates

MEATH, Reginald Brabazon, Earl
of (1841-1929) Philanthropist

2624 Canvas 101.6 x 86.4
(40 x 34)
Sir William Orpen, signed, exh 1929
Given by the Royal Empire Society,
1933

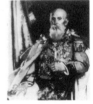

MEICHTON, Ann (née McCandlish)

P6(176,177) *See Collections:* The
Hill and Adamson Albums, 1843-8,
by David Octavius Hill and Robert
Adamson, **P6(1-258)**

MEIKLE, Andrew (1719-1811)
Millwright; invented the thrashing-
machine

5001 Canvas 125.4 x 100.3
(49⅜ x 39½)
A.Reddock, inscribed and dated
1811
Purchased, 1974

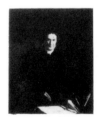

MEISSONIER, Jean Louis Ernest
(1815-91) French painter

4707(18) Water-colour
31.5 x 18.4 (12⅜ x 7¼)
Théobald Chartran, signed .*T.*
(*VF* 1 May 1880)
Purchased, 1938
See Collections: Vanity Fair
cartoons, 1869-1910, by various
artists, **2556-2606,** etc

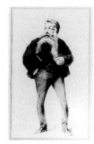

MELBOURNE, William Lamb, 2nd Viscount (1779-1848) Prime Minister

5185 Canvas 75.9 x 63.2 ($29\frac{7}{8}$ x $24\frac{7}{8}$) Sir Thomas Lawrence, c.1805 Purchased, 1978

999 *See Groups:* The Trial of Queen Caroline, 1820, by Sir George Hayter

54 *See Groups:* The House of Commons, 1833, by Sir George Hayter

3050 Panel 59.7 x 43.8 (23½ x 17¼) Sir Edwin Landseer, 1836 Purchased, 1939

4342 (study for *Groups,* 54) Pencil 33 x 23.5 (13 x 9¼) Sir George Hayter, signed, inscribed and dated 1837 Purchased, 1963

316a(87) *See Collections:* Preliminary drawings for busts and statues by Sir Francis Chantrey, **316a(1-202)**

3103 Pencil and wash 37.8 x 30.5 ($14\frac{7}{8}$ x 12) Samuel Diez, signed and dated 1841 Purchased, 1941

941 Canvas 127 x 101.6 (50 x 40) John Partridge, 1844 Given by the 9th Earl of Carlisle, 1893

342,343 *See Groups:* The Fine Arts Commissioners, 1846, by John Partridge

Ormond

MELBOURNE, Frederick James Lamb, 3rd Viscount (1782-1853) Diplomat

3894 Canvas 142.9 x 107.6 (56¼ x $42\frac{3}{8}$) John Partridge, signed and dated 1846 Purchased, 1953

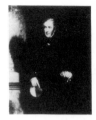

MELCHETT, Alfred Mortiz Mond, 1st Baron (1868-1930) Industrialist, financier and politician

5062 Pen and ink 32.7 x 22.9 ($12\frac{7}{8}$ x 9) Powys Evans, signed *Quiz,* pub 1926 Purchased, 1975

4788 Sanguine 33 x 25.1 (13 x $9\frac{7}{8}$) Sir William Rothenstein, c.1929 Purchased, 1970

MELCOMBE, George Bubb Dodington, Baron (1691-1762) Politician, wit and patron of literature

4855(21,22,24b) *See Collections:* The Townshend Album, **4855(1-73)**

MELDOLA, Raphael (1849-1915) Chemist

2529 Canvas 68.6 x 55.9 (27 x 22) Solomon Joseph Solomon, signed in monogram Bequeathed by the sitter's widow, 1932

Continued overleaf

1943 Bronze plaque, arched top
7.6 x 5.1 (3 x 2)
Frank Bowcher, inscribed,
posthumous
Given by the Society of
Maccabeans, 1922

MÉLINE, Félix Jules (1838-1925)
French politician

4707(19) *See Collections: Vanity
Fair* cartoons, 1869-1910, by
various artists, **2566-2606**, etc

MELLISH, Sir George (1814-77)
Judge

2732 Water-colour 29.2 x 18.1
(11½ x 7⅛)
Sir Leslie Ward, signed *Spy*
(*VF* 30 Dec 1876)
Purchased, 1934

MELLOR, Sir John (1809-87)
Judge

2733 Water-colour 29.2 x 18.1
(11½ x 7⅛)
Sir Leslie Ward, signed *Spy*
(*VF* 24 May 1873)
Purchased, 1934

MELVILL, Hester Jean Frances,
Lady (d.1864)
Wife of Sir James Cosmo Melvill

4825A (Companion to no.4825,
Sir James Cosmo Melvill)
Canvas 127.3 x 102.5 (50⅛ x 40⅜)
John James Napier, c.1858
Given by the sitter's great-great-
grandson, Col M.E.Melvill, 1970

MELVILL, Sir James Cosmo
(1792-1861) Civil servant in India

4825 Canvas 126.7 x 101.9
(49⅞ x 40⅛)
John James Napier, exh 1858
Given by the sitter's great-great-
grandson, Col M.E.Melvill, 1970

Ormond

MELVILLE, Henry Dundas, 1st
Viscount (1742-1811) Statesman

745 *See Groups:* William Pitt
addressing the House of Commons
. . . 1793, by Karl Anton Hickel

746 Canvas 74.9 x 62.2
(29½ x 24½)
Sir Thomas Lawrence, reduced
version (exh 1810)
Purchased, 1885

MELVILLE, Robert Dundas, 2nd
Viscount (1771-1851) Statesman

999 *See Groups:* The Trial of
Queen Caroline, 1820, by Sir
George Hayter

MELVILLE, George John Whyte
See WHYTE-MELVILLE

MENDIP, Welbore Ellis, Baron
(1713-1802) Politician

3993 (study for *Groups,* **745**)
Canvas, feigned oval 59.4 x 49.2
(23⅜ x 19⅜)
Karl Anton Hickel, signed,
inscribed and dated 1793
Purchased, 1956

745 *See Groups:* William Pitt
addressing the House of Commons
. . . 1793, by Karl Anton Hickel

MENNES, Sir John (1599-1671)
Admiral

4097 Canvas 108 x 87.6
(42½ x 34½)
After an unknown artist, incorrectly
inscribed *Ireton* (c.1640?)
Given by A.W.F.Fuller, 1959

Piper

**MENSDORFF-POUILLY-
DIETRICHSTEIN,** Count Albert
(b.1861)
Austro-Hungarian diplomat

4707(20) *See Collections: Vanity
Fair* cartoons, 1869-1910, by
various artists, **2566-2606,** etc

MERCER (afterwards Henderson
Mercer), Douglas (d.1854)
Major-General

3739 *See Collections:* Studies for
The Waterloo Banquet at Apsley
House, 1836, by William Salter,
3689-3769

MEREDITH, George (1828-1909)
Novelist and poet

1543 Canvas 71.8 x 51.4
(28¼ x 20¼)
George Frederic Watts, 1893
Given by wish of the artist, 1909

1981 Bronze medal 5.7 (2¼)
diameter
Sir Charles Holroyd, c.1905
Given by the artist's widow, 1923

1908 Canvas 40 x 29.8
(15¾ x 11¾)
William Strang, signed, inscribed
and dated 1908
Purchased, 1921

1583 Bronze medallion 11.4
(4½) diameter
Theodore Spicer-Simson, inscribed
with initials
Purchased, 1910

MEREWETHER, Henry Alworth
(1780-1864)
Barrister; serjeant-at-law

P120(11) Photograph: albumen
print, arched top 19.7 x 14.6
(7¾ x 5¾)
Maull & Polyblank, inscribed on
mount, 1855
Purchased, 1979
See Collections: Literary and
Scientific Men, 1855, by Maull &
Polyblank, **P120(1-54)**

METCALFE, Philip (1733-1818)
Collector and patron of the arts

2001 Canvas 71.8 x 59.7
(28¼ x 23½)
Pompeo Batoni
Given by Mrs Frances Booth,
1923

METHUEN, Paul Sanford Methuen,
3rd Baron (1845-1932)
Field-Marshal

5017 Canvas 61 x 50.8 (24 x 20)
Paul Ayshford Methuen (his son,
4th Baron), signed, 1920
Bequeathed by the artist, 1975

MEW, Charlotte Mary (1869-1928)
Poet

3550 Water-colour 27.9 x 19.7
(11 x 7¾)
Dorothy Hawksley, signed with
initials, inscribed and dated 1926
Given by the artist, 1947

MEWS, Peter (1619-1706)
Bishop of Winchester

1872 Plumbago on vellum, oval
14 x 11.7 (5½ x 4⅝)
David Loggan, c.1680
Given by Alfred de Pass, 1920

Continued overleaf

637 Engraving 36.2 x 25.7
(14¼ x 10⅛)
David Loggan, signed and inscribed
on plate
Purchased, 1881

Piper

MEYER, Jeremiah (1735-89)
Miniaturist

1437,1437a *See Groups:* The
Academicians of the Royal
Academy, 1771-2, by John Sanders
after Johan Zoffany

MEYERSTEIN, Edward
(1889-1952) Poet

4326 Canvas 61 x 50.8 (24 x 20)
Philip Connard, signed and dated
1928
Bequeathed by the sitter, 1963

MEYNELL, Alice (née Thompson)
(1847-1922)
Poet, essayist and journalist

2221 Pencil 36.2 x 21 (14¼ x 8¼)
John Singer Sargent, signed and
inscribed, 1894
Given by the sitter's husband,
Wilfrid Meynell, 1928

MEYRICK, Sir Samuel Rush
(1783-1848) Antiquary

2515(62) *See Collections:*
Drawings of Prominent People,
1823-49, by William Brockedon,
2515(1-104)

MICHELL, John (1710-66)
Politician

4855(17) *See Collections:* The
Townshend Album, **4855(1-73)**

MIDDLETON, Conyers
(1683-1750) Theologian

626 Canvas 76.2 x 63.2 (30 x 24⅞)
John Giles Eccardt, 1746
Purchased, 1881

Kerslake

MIDDLETON (or Myddelton),
Jane (1645-92) Court beauty

612 *See Unknown Sitters II*

MIDHAT PASHA (1822-84)
Turkish statesman

4707(21) Water-colour
31.4 x 19.3 (12⅜ x 7⅝)
Sir Leslie Ward, signed *Spy*
(*VF* 30 June 1877)
Purchased, 1938
See Collections: Vanity Fair
cartoons, 1869-1910, by various
artists, **2556-2606**, etc

MIERS, Sir Henry Alexander
(1858-1942) Mineralogist

4787 Pencil 35.3 x 25.1
(13⅞ x 9⅞)
Sir William Rothenstein, inscribed
and dated 1917
Purchased, 1970

MIERS, John (1789-1879)
Engineer and botanist

P120(12) Photograph: albumen
print, arched top 19.7 x 14.6
(7¾ x 5¾)
Maull & Polyblank, inscribed on
mount, 1855
Purchased, 1979
See Collections: Literary and
Scientific Men, 1855, by Maull &
Polyblank, **P120(1-54)**

MILDMAY, Paulet St John
(1791-1845) MP for Winchester

54 *See Groups:* The House of Com-
mons, 1833, by Sir George Hayter

MILES, Bernard Miles, Baron
(b.1907) Actor; co-founder
of the Mermaid Theatre

4529(245-9) *See Collections:*
Working drawings by Sir David
Low, **4529(1-401)**

MILFORD-HAVEN, Louis
Alexander Mountbatten, Marquess
of (Prince Louis of Battenburg)
(1854-1921) Admiral of the Fleet

1913 *See Groups:* Naval Officers
of World War I, by Sir Arthur
Stockdale Cope

MILL, John Stuart (1806-73)
Social philosopher

P46 Photograph: albumen print,
partially over-painted in ink-wash,
oval 29.2 x 23.5 (11½ x 9¼)
John and Charles Watkins, 1865
Given by the sitter's sister,
Harriet J.Mill, 1887

1009 Canvas 66 x 53.3 (26 x 21)
George Frederic Watts, 1873, replica
Given by the artist, 1895

Ormond

MILL, William Hodge (1792-1853)
Orientalist

316a(88) Pencil, two sketches
50.4 x 70.2 (19$\frac{7}{8}$ x 27$\frac{5}{8}$)
Sir Francis Chantrey, inscribed
Given by Mrs George Jones, 1871
See Collections: Preliminary
drawings for busts and statues by
Sir Francis Chantrey, **316a(1-202)**

MILLAIS, Euphemia Chalmers
(née Gray), Lady (1828-97)
Wife of John Ruskin and later of
Sir John Everett Millais

5160 Board, arched top 81 x 53
(31$\frac{7}{8}$ x 20$\frac{7}{8}$)
Thomas Richmond, signed and
dated 1851
Given by D.M.McDonald, 1977

MILLAIS, Sir John Everett, Bt
(1829-96) Painter and PRA

1859 Panel 30.5 x 24.8 (12 x 9¾)
Charles Robert Leslie, 1852
Transferred from Tate Gallery, 1957

2914 Pastel and chalk 32.7 x 24.8
(12$\frac{7}{8}$ x 9¾)
William Holman Hunt, signed,
inscribed and dated 1853
Given by L.G.Esmond Morse in
memory of his father, Sydney
Morse, 1937

4959 Plaster plaque, oval
55.9 x 46 (22 x 18$\frac{1}{8}$)
Alexander Munro, incised in
monogram, c.1854
Given by the artist's granddaughter,
Mrs Katherine Macdonald, 1973

1516 Plaster cast of statuette
50.8 (20) high
Sir Joseph Edgar Boehm, incised,
1863
Given by James Donald Milner,
1908

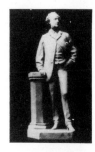

P79 Photograph: albumen print
21 x 16.2 (8¼ x 6$\frac{3}{8}$)
David Wilkie Wynfield, 1860s
Purchased, 1929
See Collections: The St John's
Wood Clique, by David Wilkie
Wynfield, **P70-100**

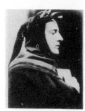

3552 Canvas 64.8 x 52.1
(25½ x 20½)
George Frederic Watts, 1871
Purchased, with help from NACF,
1948

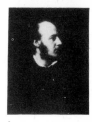

Continued overleaf

2626 Water-colour 30.5 x 24.8
(12 x 9¾)
Carlo Pellegrini, signed *Ape*
(*VF* 13 May 1871, in reverse)
Purchased, 1933

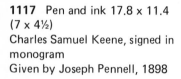

1117 Pen and ink 17.8 x 11.4
(7 x 4½)
Charles Samuel Keene, signed in
monogram
Given by Joseph Pennell, 1898

1833 *See Groups:* Private View of
the Old Masters Exhibition, Royal
Academy, 1888, by Henry Jamyn
Brooks

2820 *See Groups:* The Royal
Academy Conversazione, 1891, by
G.Grenville Manton

4245 *See Groups:* Hanging
Committee, Royal Academy, 1892,
by Reginald Cleaver

1711 Pencil 34.3 x 24.1
(13½ x 9½)
Theodore Blake Wirgman, inscribed
and dated 1896
Given by the artist, 1913

1329 Plaster cast of bust 83.8
(33) high
Edward Onslow Ford
Purchased, 1902. *Not illustrated*

1329a Bronze cast of no.**1329**
Purchased, 1923

MILLAIS, Mary (1860-1944)
Second daughter of Sir John
Everett Millais

1833 *See Groups:* Private View
of the Old Masters Exhibition,
Royal Academy, 1888, by Henry
Jamyn Brooks

MILLER, James (1812-64)
Surgeon

P6(58) Photograph: calotype
19.1 x 14.6 (7½ x 5¾)
David Octavius Hill and Robert
Adamson, 1843-8
Purchased, 1973
See Collections: The Hill and
Adamson Albums, 1843-8, by
David Octavius Hill and Robert
Adamson, **P6(1-258)**

P6(155) *See Collections:* The Hill
and Adamson Albums, by David
Octavius Hill and Robert Adamson,
P6(1-258)

MILLER, James (1837-68)
Eldest son of James Miller (1812-64)

P6(137,166,167) *See Collections:*
The Hill and Adamson Albums,
1843-8, by David Octavius Hill and
Robert Adamson, **P6(1-258)**

MILLER, Jonathan
American slavery abolitionist

599 *See Groups:* The Anti-Slavery
Society Convention, 1840, by
Benjamin Robert Haydon

MILLER, Patrick (1731-1815)
Pioneer of steam navigation

2009 Canvas 74.9 x 62.2
(29½ x 24½)
Sir George Chalmers
Purchased, 1923

1075,1075a and **b** *See Groups:*
Men of Science Living in 1807-8,
by Sir John Gilbert and others

MILLER, Samuel

P6(49) *See Collections:* The Hill and Adamson Albums, 1843-8, by David Octavius Hill and Robert Adamson, **P6(1-258)**

MILLER, Thomas
Uncle of David Octavius Hill

P6(66) *See Collections:* The Hill and Adamson Albums, 1843-8, by David Octavius Hill and Robert Adamson, **P6(1-258)**

MILLER, Thomas
Free Church missionary

P6(138) *See Collections:* The Hill and Adamson Albums, 1843-8, by David Octavius Hill and Robert Adamson, **P6(1-258)**

MILLER, William Henry (1789-1848) Book collector; MP for Newcastle-under-Lyme

54 *See Groups:* The House of Commons, 1833, by Sir George Hayter

MILLES, Jeremiah (1714-84) Antiquary

4590 Water-colour 21.6 x 18.7 (8½ x 7⅜)
John Downman, signed with initials and dated 1785
Purchased, 1967

MILLS, Charles Henry, 1st Baron Hillingdon *See* HILLINGDON

MILLS, John (1789-1871)
MP for Rochester

54 *See Groups:* The House of Commons, 1833, by Sir George Hayter

MILMAN, Archibald John Scott (d.1902)
Clerk of the House of Commons

5256 *See Groups:* The Lobby of the House of Commons, 1886, by Liberio Prosperi

MILLTOWN, Edward Nugent Leeson, 6th Earl of (1835-90) Landowner

4728 Water-colour 30.5 x 18.1 (12 x 7⅛)
Sir Leslie Ward, signed *Spy* (*VF* 24 Nov 1883)
Purchased, 1970

MILMAN, Henry Hart (1791-1868)
Poet and historian

1324 Canvas 64.8 x 52.1 (25½ x 20½)
George Frederic Watts, c.1863
Given by the sitter's sons, 1902

Ormond

MILNE, George Francis Milne, Baron (1866-1948) Field-Marshal

1954 *See Groups:* General Officers of World War I, by John Singer Sargent

MILNE, Agnes

P6(160) With her sister, Ellen *See Collections:* The Hill and Adamson Albums, 1843-8, by David Octavius Hill and Robert Adamson, **P6(1-258)**

MILNE, Alan Alexander (1882-1956)
Writer, playwright and journalist

3493,3494 *See Collections:* Prominent Men, c.1880-c.1910, by Harry Furniss, **3337-3535** and **3554-3620**

4399 Pen and ink 32.1 x 26.7 (12⅝ x 10½)
Powys Evans, inscribed, c.1930
Purchased, 1964

MILNE, Colin (1743-1815)
Divine and botanist

5180 Pastel 61 x 45.7 (24 x 18)
John Russell, signed, inscribed and
dated 1803
Purchased, 1978

MILNER, Alfred Milner, Viscount
(1854-1925) High Commissioner
for South Africa

2135 Canvas 133.4 x 100.3
(52½ x 39½)
Hugh de Twenebrokes Glazebrook,
signed and dated 1901
Given by the artist, 1926

2463 *See Groups:* Statesmen of
World War I, by Sir James Guthrie

MILNER, Sir Frederick George,
7th Bt (1843-1931) Politician

4729 Water-colour 30.8 x 17.8
(12⅛ x 7)
Carlo Pellegrini, signed *Ape*
(*VF* 27 June 1885)
Purchased, 1970

MILNER-GIBSON, Thomas
(1806-84) Statesman

1930 Water-colour, octagonal
25.4 x 20.3 (10 x 8)
Charles Allen Du Val, signed
and dated 1843
Bequeathed by Gery Milner-Gibson-
Cullum, 1922

Ormond

MILNES, Richard Monckton,
1st Baron Houghton
See HOUGHTON

MILTON, John (1608-74)
Poet

4222 Canvas 59.7 x 48.3
(23½ x 19)
Unknown artist, inscribed, c.1629
Purchased, 1961

2102 Plaster cast of bust 27.9 (11)
high
Cast from bust attributed to
Edward Pierce (c.1660?)
Purchased, 1925

1396 Plaster cast of bust 55.9 (22)
high
Horace Montford after bust
attributed to Edward Pierce
(c.1660?)
Given by the artist, 1905

610 Line engraving 18.1 x 13.6
(7⅛ x 5⅜)
William Faithorne, signed, inscribed,
and dated 1670 on plate
Purchased, 1880

3781 Marble bust 45.7 (18) high
Unknown artist, posthumous
Given by Denis Saurat, 1950

695 *See Unknown Sitters II*

Piper

MINTO, Gilbert Eliot, Earl of
(1751-1814)
Governor-General of India

836 Canvas 24.1 x 19.1 (9½ x 7½)
James Atkinson
Given by the artist's son, J.A.
Atkinson, 1890

MINTON, John (1917-57)
Painter and illustrator

4620 Canvas 35.6 x 25.4 (14 x 10)
Self-portrait, c.1953
Purchased, 1968

MIR JAFFIER
Nawab of Murshidabad, 1757-60

5263 *See Groups:* Robert Clive
and Mir Jaffier after the Battle of
Plassey, 1757, by Francis Hayman

MITCHELL, Sir Andrew (1708-71)
Diplomat

2514 Canvas 77.5 x 63.5
(30½ x 25)
After Allan Ramsay (1766)
Purchased, 1931

Kerslake

MITCHELL, Sir Henry (1823-98)
Mayor of Bradford

2989 Water-colour 40 x 24.8
(15¾ x 9¾)
Sir Leslie Ward, signed *Spy*
(*VF* 5 July 1890)
Purchased, 1938

MITCHELL, S.A. (?Silas Weir
Mitchell, 1829-1914)

P106(14) *See Collections:*
Literary and Scientific Portrait
Club, by Maull & Polyblank,
P106(1-20)

MITFORD, Mary Russell
(1787-1855)
Novelist and dramatist

404 Millboard, feigned oval
35.6 x 31.1 (14 x 12¼)
John Lucas, c.1853, after Benjamin
Robert Haydon (1824)
Purchased, 1875

4045 Chalk 37.8 x 29.8
(14$\frac{7}{8}$ x 11¾)
John Lucas, signed, inscribed
and dated 1852
Given by Francis Needham, 1963

Ormond

MITFORD, William (1744-1827)
Historian

1760A Pencil 19.4 x 14.3
(7$\frac{5}{8}$ x 5$\frac{5}{8}$)
After Henry Edridge (eng 1811)
Given by Lord Redesdale, 1915

MOFFAT, Robert (1795-1883)
Missionary in South Africa

3774 Canvas 76.2 x 63.5 (30 x 25)
William Scott, inscribed and dated
1842 on reverse
Purchased, 1950

Ormond

MOHUN, Charles Mohun, Baron
(1677-1712) Soldier and duellist

3218 Canvas 91.4 x 71.1 (36 x 28)
Sir Godfrey Kneller, signed, eng
1707
Kit-cat Club portrait
Given by NACF. *Beningbrough*

Piper

MOIR, Mr

P6(154) *See Collections:* The Hill
and Adamson Albums, 1843-8, by
David Octavius Hill and Robert
Adamson, **P6(1-258)**

MOLESWORTH, Mary Louisa
(1839-1921)
Writer of books for children

4041(3) Pencil and black wash
36.8 x 26 (14½ x 10¼)
Walker Hodgson, signed, inscribed
and dated 1895
Purchased, 1957
See Collections: Drawings, 1891-5,
by Walker Hodgson, **4041(1-5)**

MOLESWORTH, Sir William, Bt
(1810-55) Radical politician

54 *See Groups:* The House of Com-
mons, 1833, by Sir George Hayter

810 Canvas 127 x 101.6 (50 x 40)
Sir John Watson-Gordon, signed
and dated 1854
Bequeathed by the sitter's widow,
1888

1125,1125a *See Groups:* The
Coalition Ministry, 1854, by Sir
John Gilbert

Ormond

MOLINI, Peter (1729/30-1806)
Editor of Ariosto

3089(12) *See Collections:*
Tracings of drawings by George
Dance, **3089(1-12)**

MOLLISON, Amy
See JOHNSON, Amy

MONCK, George, 1st Duke of
Albemarle *See* ALBEMARLE

MONCKTON, Walter Monckton,
Viscount (1891-1965) Statesman

4529(250-2) *See Collections:*
Working drawings by Sir David
Low, **4529(1-401)**

MONCKTON, Edward Philip
(1840-1912)

1833 *See Groups:* Private View of
the Old Masters Exhibition, Royal
Academy, 1888, by Henry Jamyn
Brooks

MONCRIEFF, E., Lady (née Bell)

P6(97) *See Collections:* The Hill
and Adamson Albums, 1843-8, by
David Octavius Hill and Robert
Adamson, **P6(1-258)**

MOND, Alfred Moritz, 1st Baron
Melchett *See* MELCHETT

MOND, Ludwig (1839-1909)
Chemist and art collector

3053 Canvas 127 x 101.6 (50 x 40)
Solomon Joseph Solomon, signed
in monogram, c.1909
Bequeathed by the sitter's son, Sir
Robert Mond, 1939

4511 Bronze plaque 12.1 (4¾)
diameter
Edouard Lanteri, incised, inscribed
and dated 1909
Given by A.V.Winter, 1966

MONKHOUSE, William Cosmo
(1840-1901) Poet and critic

1884 Etching 22.5 x 14.9
($8\frac{7}{8}$ x $5\frac{7}{8}$)
William Strang, signed and dated
1892 on plate, and signed below
plate
Given by the sitter's daughter,
Miss Monkhouse, 1920

1868 Canvas 59.7 x 44.5
(23½ x 17½)
John McLure Hamilton, signed,
exh 1899
Given by the artist, 1920

3592 *See Collections:* Prominent
Men, c.1880-c.1910, by Harry
Furniss, **3337-3535** and **3554-3620**

MONKSWELL, Robert Collier, Baron (1817-86) Judge

2734 Water-colour 29.8 x 18.4 (11¾ x 7¼)
Alfred Thompson, signed *At'n* (*VF* 19 Feb 1870)
Purchased, 1934

MONMOUTH, Robert Carey, 1st Earl of (1560?-1639) Royalist

5246 *See Groups:* 1st Earl of Monmouth and his family, attributed to Paul van Somer

MONMOUTH, Elizabeth (née Trevanion), Countess of (d.1641)
Wife of 1st Earl of Monmouth

5246 *See Groups:* 1st Earl of Monmouth and his family, attributed to Paul van Somer

MONMOUTH, Henry Carey, 2nd Earl of (1596-1661) Translator

5246 *See Groups:* 1st Earl of Monmouth and his family, attributed to Paul van Somer

MONMOUTH AND BUCCLEUCH, James Scott, Duke of (1649-85)
Son of Charles II by Lucy Walter

5225 Canvas, feigned oval 74.3 x 63.8 (29¼ x 25⅛)
Studio of Sir Godfrey Kneller, c.1678
Bequeathed by Mrs I.H.Wilson, 1978

151 Canvas, feigned oval 74.9 x 62.2 (29½ x 24½)
After William Wissing(?) (c.1683)
Purchased, 1862

556 *See Unknown Sitters II*

1566 *See Unknown Sitters II*

Piper

MONOD, Frederic Joel Jean Gerard (1794-1863) Founder of the Free French Reformed Church

P6(61) *See Collections:* The Hill and Adamson Albums, 1843-8, by David Octavius Hill and Robert Adamson, **P6(1-258)**

MONRO, Alexander (1773-1859) Anatomist

P6(15) Photograph: calotype 20.3 x 14.9 (8 x 5⅞)
David Octavius Hill and Robert Adamson, 1843-8
Given by an anonymous donor, 1973
See Collections: The Hill and Adamson Albums, 1843-8, by David Octavius Hill and Robert Adamson, **P6(1-258)**

P6(16) *See Collections:* The Hill and Adamson Albums 1843-8, by David Octavius Hill and Robert Adamson, **P6(1-258)**

MONRO, Harold (1879-1932) Poet, editor and bookseller

4705 Ink and chalk 34 x 17 (13⅜ x 10⅝)
Jacob Kramer, signed, 1923
Purchased, 1970

MONRO, Thomas (1759-1833) Physician and patron of the arts

3117 Pencil and wash 34.3 x 26.7 (13½ x 10½)
Henry Monro (his son)
Given by E.A.Hone, 1942

MONTAGU, John Montagu, 2nd Duke of (1690-1749) Courtier

3219 Canvas 90.8 x 70.5 (35¾ x 27¾)
Sir Godfrey Kneller, signed and dated 1709
Kit-cat Club portrait
Given by NACF, 1945.
Beningbrough

Continued overleaf

2034 *See Groups:* 2nd Duke of Montagu, 2nd Baron Tyrawley and an unknown man, probably by John Verelst

Piper

MONTAGU, Charles, 1st Earl of Halifax *See* HALIFAX

MONTAGU, Charles, 1st Duke of Manchester *See* MANCHESTER

MONTAGU, Edward, 2nd Earl of Manchester *See* MANCHESTER

MONTAGU, Edward, 1st Earl of Sandwich *See* SANDWICH

MONTAGU, Edward Wortley (1713-76) Writer and traveller

3924 *See Groups:* Lady Mary Wortley Montagu with her son and attendants, attributed to Jean Baptiste Vanmour

4573 Canvas 113 x 85.1 (44½ x 33½) Matthew William Peters, signed Purchased, 1967

MONTAGU, Elizabeth (1720-1800) Writer and leader of society

4905 *See Groups:* The Nine Living Muses of Great Britain, by Richard Samuel

MONTAGU, John, 4th Earl of Sandwich *See* SANDWICH

MONTAGU, John William, 7th Earl of Sandwich *See* SANDWICH

MONTAGU, Lady Mary Wortley (1689-1762) Writer of the *Letters*

3924 *See Groups:* Lady Mary Wortley Montagu with her son and attendants, attributed to Jean Baptiste Vanmour

2506 *See Unknown Sitters III*

Kerslake

MONTAGU, William, 7th Duke of Manchester *See* MANCHESTER

MONTAGU-STUART-WORTLEY-MACKENZIE, Edward, 1st Earl of Wharncliffe *See* WHARNCLIFFE

MONTAGUE, Anthony Browne, 1st Viscount (1526-92) Courtier and diplomat

842 Panel 96.2 x 67.6 (37$\frac{7}{8}$ x 26$\frac{5}{8}$) Hans Eworth, inscribed and dated 1569 Purchased, 1890

2398 Water-colour 29.2 x 20.6 (11½ x 8$\frac{1}{8}$) George Perfect Harding, after an unknown artist, signed, inscribed and dated 1848 Purchased, 1929 *See Collections:* Copies of early portraits, by George Perfect Harding and Sylvester Harding, **1492, 1492(a-c)** and **2394-2419**

Strong

MONTEAGLE, Thomas Spring-Rice, Baron (1790-1866) Statesman

54 *See Groups:* The House of Commons, 1833, by Sir George Hayter

MONTEFIORE, Claude Joseph Goldsmid- (1858-1938) Biblical scholar and philanthropist

4789 Sanguine 46.4 x 31.4 (18¼ x 12⅜)
Sir William Rothenstein
Purchased, 1970

MONTEFIORE, Sir Moses Haim, Bt (1784-1885) Philanthropist

2178 Canvas 60.7 x 51.1 (23⅞ x 20⅛)
Henry Weigall, signed in monogram and dated 1881
Given by members of the artist's family, 1928

Ormond

MONTEITH, A. Earle

P6(104) *See Collections:* The Hill and Adamson Albums, 1843-8, by David Octavius Hill and Robert Adamson, **P6(1-258)**

MONTFORT of Horseheath, Henry Bromley, Baron (1705-55) Politician

4855(8) *See Collections:* The Townshend Album, **4855(1-73)**

MONTGOMERY of Alamein, Bernard Law Montgomery, 1st Viscount (1887-1976) Field-Marshal

L165 Canvas 102.2 x 126.7 (40¼ x 49⅞)
Frank O.Salisbury, signed, inscribed and dated 1945
Lent by the sitter's son, Viscount Montgomery, 1977

MONTROSE, Douglas Graham, 5th Duke of (1852-1925) Soldier

2588 Water-colour 30.8 x 18.1 (12⅛ x 7⅛)
Sir Leslie Ward, signed *Spy*
(*VF* 18 March 1882)
Purchased, 1933

MONTROSE, James Graham, 1st Marquess of (1612-50) Soldier

4406 Canvas 78.1 x 64.4 (30¾ x 25⅜)
After Gerard Honthorst
Purchased, 1965

MOORE, Albert Joseph (1841-93) Painter

2375,2379 *See Collections:* Miscellaneous drawings . . . by Sydney Prior Hall, **2282-2348** and **2370-90**

MOORE, George (1852-1933) Novelist

4154 Pencil 28.6 x 24.8 (11¼ x 9¾)
Henry Tonks, pub 1901
Given by Constant Huntington,1960

2565 Pencil 33 x 25.4 (13 x 10)
Sir William Orpen, signed and inscribed
Purchased, 1933

2807 Pastel 50.8 x 36.8 (20 x 14½)
Henry Tonks, c.1920
Given by the artist, 1936

2673 Pencil 37.5 x 27.3 (14¾ x 10¾)
Francis Dodd, signed, inscribed and dated 1932
Given by subscribers, 1934

Continued overleaf

2622 Plaster cast of death-mask
24.1 (9½) long
L.Godon, incised and dated 1933
Given by C.D.Medley, 1933

MOORE, George Edward
(1873-1958) Philosopher

4087 Pencil and chalk 22.9 x 20
(9 x 7$\frac{7}{8}$)
Percy Horton, signed and dated
1947
Given by the sitter's widow, 1958

4135 Chalk, pen and wash
36.2 x 31.1 (14¼ x 12¼)
Percy Horton, signed, 1952
Given by the artist, 1960

MOORE, Sir Graham (1764-1843)
Admiral; brother of Sir John Moore

1129 Canvas 74.9 x 63.5
(29½ x 25)
Sir Thomas Lawrence, exh 1792
Given by the sitter's grand-niece,
Miss Mary Carrick Moore, 1898

MOORE, Henry (b.1898)
Sculptor

4529(256) Pencil 20.3 x 11.7
(8 x 4$\frac{5}{8}$)
Sir David Low, inscribed
Purchased, 1967
See Collections: Working drawings
by Sir David Low, **4529(1-401)**

4529(253-5) *See Collections:*
Working drawings by Sir David Low,
4529(1-401)

4687 Bronze cast of head 31.1
(12¼) high
Marino Marini, 1962
Given by the artist and the sitter,
1969

MOORE, John (1729-1802)
Physician and writer

1148 Pencil 25.4 x 18.4 (10 x 7¼)
George Dance, signed and dated
1794
Purchased, 1898

MOORE, John (1730-1805)
Archbishop of Canterbury

982(e) Etching 27.6 x 17.8
(10$\frac{7}{8}$ x 7)
Robert Dighton, inscribed, and
on plate signed, inscribed and
dated 1803
Acquired before 1896

MOORE, Sir John (1761-1809)
Lieutenant-General; victor of
Corunna

1128 Canvas 74.9 x 62.2
(29½ x 24½)
Sir Thomas Lawrence, c.1800-4
Given by the sitter's grand-niece,
Miss Mary Carrick Moore, 1898

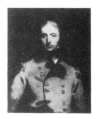

MOORE, Mary
See WYNDHAM, Lady

MOORE, Stephen, Earl Mountcashel
See MOUNTCASHEL

MOORE, Thomas (1779-1852)
Poet and biographer of Byron

1340 Canvas 73.7 x 62.2
(29 x 24½)
Unknown artist
Purchased, 1903

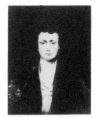

3327 Canvas 88.9 x 69.2
(35 x 27¼)
Sir Martin Archer Shee, c.1817
Lent by Lady Teresa Agnew, 1968

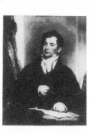

117 Marble bust 61 (24) high
Christopher Moore, incised and
dated 1842
Purchased, 1861

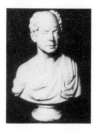

MOORE, Thomas Edward Laws
(1819-72) Rear-Admiral;
Governor of the Falkland Islands

1215 Canvas 38.7 x 32.4
(15¼ x 12¾)
Stephen Pearce, 1860
Bequeathed by John Barrow, 1899
See Collections: Arctic Explorers,
1850-86, by Stephen Pearce,
905-24 and **1209-27**

Ormond

MOORE, Thomas Sturge
(1870-1944)
Poet and wood engraver

4130 Chalk 22.9 x 19.7 (9 x 7¾)
Charles Haslewood Shannon, signed
with initials, inscribed and dated
1925
Given by the Contemporary
Portraits Fund, 1959

MOORE-BRABAZON, John, 1st
Baron Brabazon of Tara
See BRABAZON of Tara

MOORSOM, Constantine Richard
(1792-1861) Vice-Admiral

599 *See Groups:* The Anti-Slavery
Society Convention, 1840, by
Benjamin Robert Haydon

MORAY, Edmund Archibald
Stewart, Earl of (1840-1901)
Landed nobleman

2966 Water-colour 34.9 x 23.5
(13¾ x 9¼)
Sir Leslie Ward, signed *Spy*
(*VF* 9 June 1898)
Purchased, 1938

MORDAUNT, Elizabeth (Carey),
Viscountess (1632/3-79)

3090(4) Water-colour 16.8 x 14.6
(6⅝ x 5¾)
Attributed to George Perfect
Harding after Louise, Princess
Palatine, inscribed and inscribed
below image
Purchased, 1940

MORDAUNT, Charles, 3rd Earl of
Peterborough
See PETERBOROUGH

MORE, Anne (née Cresacre)
(1511-77) Wife of John, only son
of Sir Thomas More

2765 *See Groups:* Sir Thomas
More, his Father, his Household,
and his Descendants, by Rowland
Lockey

MORE, Cresacre (1572-1649)
Great-grandson and biographer of
Sir Thomas More

2765 *See Groups:* Sir Thomas
More, his Father, his Household,
and his Descendants, by Rowland
Lockey

MORE, Hannah (1745-1833)
Religious writer

4905 *See Groups:* The Nine
Living Muses of Great Britain,
by Richard Samuel

Continued overleaf

412 Canvas 125.7 x 89.5
(49½ x 35¼)
Henry William Pickersgill,
inscribed, exh 1822
Purchased, 1875

4501 Silhouette 22.2 x 27.9
(8¾ x 11)
Augustin Edouart, signed and
dated 1827
Purchased, 1966

MORE, Sir John (1451?-1530)
Father of Sir Thomas More

2765 *See Groups:* Sir Thomas
More, his Father, his Household,
and his Descendants, by Rowland
Lockey

MORE, John (1510-47)
Son of Sir Thomas More

2765 *See Groups:* Sir Thomas
More, his Father, his Household,
and his Descendants, by Rowland
Lockey

MORE, John (1557-99?)
Eldest son of Thomas More II

2765 *See Groups:* Sir Thomas
More, his Father, his Household,
and his Descendants, by Rowland
Lockey

MORE, Maria (née Scrope)
(1534-1607)
Wife of Thomas More II

2765 *See Groups:* Sir Thomas
More, his Father, his Household,
and his Descendants, by Rowland
Lockey

MORE, Sir Thomas (1478-1535)
Lord Chancellor, classical scholar
and author of *Utopia;* canonized
1935

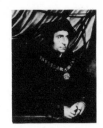

4358 Panel 74.9 x 58.4
(29½ x 23)
After Hans Holbein, inscribed
(1527)
Purchased, 1964. *Montacute*

3543 Panel 55.2 x 42.5
(21¾ x 16¾)
After Hans Holbein (1527)
Purchased, 1947

306 Panel 73 x 59.7
(28¾ x 12½)
After Hans Holbein (1527)
Purchased, 1870

2765 *See Groups:* Sir Thomas
More, his Father, his Household,
and his Descendants, by Rowland
Lockey

Strong

MORE, Thomas, II (1531-1606)
Grandson of Sir Thomas More

2765 *See Groups:* Sir Thomas
More, his Father, his Household,
and his Descendants, by Rowland
Lockey

MORETON, Thomas Reynolds,
1st Earl of Ducie *See* DUCIE

MORGAN, Mr

P22(17) *See Collections:* The
Balmoral Album, 1854-68, by
George Washington Wilson, W.& D.
Downey, and Henry John Whitlock,
P22(1-27)

MORGAN, Charles Langbridge
(1894-1958)
Novelist and dramatist

4472 Chalk 40 x 26.7 (15¾ x 10½)
Augustus John, signed and dated
1944
Given by wish of Commander H.C.
Arnold-Forster, 1965

MORGAN, Frederic Courtenay
(1834-1909) Politician

2976 Water-colour 36.8 x 23.8
(14½ x 9⅜)
Sir Leslie Ward, signed *Spy*
(*VF* 2 Nov 1893)
Purchased, 1938

MORGAN, Sydney, Lady
(1783?-1859) Novelist

1177 Pen and ink 18.4 x 22.9
(7¼ x 9)
William Behnes, inscribed
Given by Francis Draper, 1898

Ormond

MORGAN, Thomas
Slavery abolitionist

599 *See Groups:* The Anti-Slavery
Society Convention, 1840, by
Benjamin Robert Haydon

MORGAN, William
Slavery abolitionist

599 *See Groups:* The Anti-Slavery
Society Convention, 1840, by
Benjamin Robert Haydon

MORILLO, Don Pablo, Comte de
Cartagena *See* CARTAGENA

MORLAND, George (1763-1804)
Painter

422 Canvas 26.7 x 22.9 (10½ x 9)
Self-portrait
Given by William Smith, 1876

1196 Chalk 47 x 33 (18½ x 13)
Self-portrait
Purchased, 1899

4370 Pencil and chalk 14 x 12.7
(5½ x 5)
Sophia Jones, 1805
Given by J.J.Byam Shaw, 1964

3661 *See Unknown Sitters III*

MORLAND, Henry (1730?-97)
Portrait painter

2905 Pencil 27.3 x 19.7
(10¾ x 7¾)
George Morland (his son), inscribed
Purchased, 1936

MORLEY, John Parker, 1st Earl of
(1772-1840) Politician

999 *See Groups:* The Trial of
Queen Caroline, 1820, by Sir
George Hayter

MORLEY of Blackburn, John
Morley, 1st Viscount (1838-1923)
Statesman

2248 *See Collections:* The Parnell
Commission, 1888-9, by Sydney
Prior Hall, **2229-72**

3051 Canvas 73.7 x 61 (29 x 24)
Walter William Ouless, exh 1891
Purchased, 1939

2307,2316,2317 *See Collections:*
Miscellaneous drawings . . . by
Sydney Prior Hall, **2282-2348** and
2370-90

Continued overleaf

2849 *See Collections:* Caricatures of Politicians, by Sir Francis Carruthers Gould, **2825-74**

3399, 3400, 3593 *See Collections:* Prominent Men, c.1880-c.1910, by Harry Furniss, **3337-3535** and **3554-3620**

MORLEY, George (1598-1684)
Prelate

491 Chalk 24.4 x 19.7 (9⅝ x 7¾)
After Sir Peter Lely (c.1660)
Given by Sir George Scharf, 1877

2951 Canvas 125.7 x 102.9
(49½ x 40½)
Studio of Sir Peter Lely, inscribed,
c.1662(?)
Given by Sir George Leon, Bt, 1938

Piper

MORLEY, Samuel (1809-86)
Politician and philanthropist

1303 Plaster cast of statuette
70.5 (27¾) high
James Havard Thomas, c.1885
Given by Francis Draper, 1901

Ormond

MORNINGTON, Anne (née Hill),
Countess of (1742-1831)
Wife of 1st Earl of Mornington and
mother of 1st Duke of Wellington

2665 Pencil 21.6 x 17.5 (8½ x 6⅞)
Sir Thomas Lawrence
Given by H. Henry Farrer, 1861

MORNINGTON, William Wellesley-
Pole, 3rd Earl of (1763-1845)
Politician

5060 Marble bust 68.6 (27) high
Joseph Nollekens, incised and dated
1811
Purchased, 1975

MORRELL, Lady Ottoline
(1873-1938) Patron of the arts

4254 Pencil 31.1 x 24.1
(12¼ x 9½)
Henry Lamb, signed, c.1912
Purchased, 1962

L137 Canvas 31.1 x 29.2
(12¼ x 11½)
Simon Bussy, signed, c.1920
Lent by Tate Gallery, 1967

MORRIS, Edward Patrick Morris,
Baron (1859-1935) Prime Minister

2463 *See Groups:* Statesmen of
World War I, by Sir James Guthrie

MORRIS, Charles (1745-1838)
Song writer

739 Canvas 74.9 x 62.2
(29½ x 24½)
James Lonsdale, inscribed
Given by Augustus Keppel
Stephenson, 1885

MORRIS, Ebenezer Butler
(fl.1833-63) Painter

1456(21) *See under* William Wyon

MORRIS, Jane (née Burden)
(1840?-1914)
Wife of William Morris

3118 *See Unknown Sitters IV*

MORRIS, May (1863-1938)
Craftswoman; daughter of William
Morris

3049 Silver point 31.8 x 24.1
(12½ x 9½)
Sir William Rothenstein, signed
and dated 1897
Given by Robert Steele, 1939

MORRIS, William (1834-96)
Poet, craftsman and socialist

3652 Water-colour 14.3 x 13.3
(5⅝ x 5¼)
Unknown artist
Given by Christopher Hughes,
1949

1078 Canvas 64.8 x 52.1
(25½ x 20½)
George Frederic Watts, 1870
Given by the artist, 1897

1938 Canvas 64.8 x 49.5
(25½ x 19½)
Sir William Blake Richmond
Purchased, 1922

3021 Pencil 28.6 x 22.2
(11¼ x 8¾)
Charles Fairfax Murray, signed
with initials and dated 1896
Transferred from Tate Gallery,
1957

MORRIS, William Richard,
Viscount Nuffield *See* NUFFIELD

MORRISON, Herbert Morrison,
Baron (1888-1965) Statesman

4529(257) *See Collections:*
Working drawings by Sir David
Low, **4529(1-401)**

4559 Chalk 43.2 x 30.2
(17 x 11⅞)
Sir David Low, signed and inscribed
Purchased, 1967

4476 Chalk 48.3 x 31.1 (19 x 12¼)
Juliet Pannett, signed and inscribed,
1961
Purchased, 1966

MORRISON, Alfred (1821-97)
Collector

1833 *See Groups:* Private View of
the Old Masters Exhibition, Royal
Academy, 1888, by Henry Jamyn
Brooks

MORRISON, James (1790-1857)
Merchant and politician

316a(90) Pencil, two sketches
48.9 x 64.8 (19¼ x 25½)
Sir Francis Chantrey, inscribed,
c.1842
Given by Mrs George Jones, 1871
See Collections: Preliminary
drawings for busts and statues by
Sir Francis Chantrey, **316a(1-202)**

Ormond

MORRISON, John
Slavery abolitionist

599 *See Groups:* The Anti-Slavery
Society Convention, 1840, by
Benjamin Robert Haydon

MORRISON, Robert (1782-1834)
Missionary in China

3943 Canvas, oval 13.7 x 11.1
(5⅜ x 4⅜)
Unknown artist
Purchased, 1955

MORTIMER, John Hamilton
(1740-79) History painter

234 With a student
Canvas 73.7 x 61 (29 x 24)
After a self-portrait
Given by Miss Elizabeth Twining,
1867

MORTON, Sholto John Douglas,
20th Earl of (1818-84)
Representative peer

1834(v) *See Collections:* Members
of the House of Lords, c.1870-80,
by Frederick Sargent, **1834(a-z and
aa-hh)**

MORTON, Sir Alpheus Cleophas
(1840-1923)
Architect and politician

2977 Water-colour 34.9 x 26.4
(13¾ x 10⅜)
Sir Leslie Ward, signed *Spy*
(*VF* 15 June 1893)
Purchased, 1938

MORTON, Thomas (1764?-1838)
Dramatist

1540 Chalk 24.1 x 20.3 (9½ x 8)
John Raphael Smith, eng 1804
Given by wish of the sitter's grand-
daughter, Miss Agnes Dunlop, 1909

MOSER, George Michael (1704-83)
Enameller

1437,1437a *See Groups:* The
Academicians of the Royal
Academy, 1771-2, by John Sanders
after Johan Zoffany

MOSLEY, Sir Oswald, Bt
(1785-1871)
MP for Staffordshire North

54 *See Groups:*The House of Com-
mons, 1833, by Sir George Hayter

MOSTYN, Edward Lloyd-Mostyn,
2nd Baron (1795-1884)
MP for Flintshire

54 *See Groups:*The House of Com-
mons, 1833, by Sir George Hayter

MOSTYN, George Charles, 6th
Baron Vaux of Harrowden
See VAUX of Harrowden

MOTT, Charles Grey (1833-1905)
Civil engineer

2456 Water-colour 36.5 x 26.7
(14⅜ x 10½)
Sir Leslie Ward, signed *Spy*
(*VF* 14 June 1894)
Purchased, 1930

MOTT, James
American slavery abolitionist

599 *See Groups:* The Anti-Slavery
Society Convention, 1840, by
Benjamin Robert Haydon

MOTT, Lucretia (1793-1880)
American slavery abolitionist

599 *See Groups:* The Anti-Slavery
Society Convention, 1840, by
Benjamin Robert Haydon

MOTTISTONE, John Edward
Bernard Seely, 1st Baron
(1868-1947) Politician

2967 Water-colour 36.2 x 25.7
(14¼ x 10⅛)
Sir Leslie Ward, signed *Spy*
(*VF* 23 Feb 1905)
Purchased, 1937

MOUNTAIN, Rosoman
(1768?-1841) Actress and singer

760 Miniature on ivory, oval
7.6 x 6.4 (3 x 2½)
Unknown artist after John James
Masquerier, signed *SG* and
dated 1806 and 1812 (eng 1804)
Given by Mrs F.G.Stephens, 1887

MOUNTBATTEN of Burma, Louis
Mountbatten, Earl (1900-79)
Admiral of the Fleet

4617 Canvas 162.6 x 114.3
(64 x 45)
John Ulbricht, signed, 1968
Purchased, 1968

MOUNTBATTEN, Louis Alexander,
1st Marquess of Milford Haven
See MILFORD HAVEN

MOUNTCASHEL, Stephen Moore,
Earl (1825-89) Landowner;
High Sheriff of County Cork

2590 Water-colour 30.8 x 18.1
(12⅛ x 7⅛)
Sir Leslie Ward, signed *Spy*
(*VF* 8 Sept 1883)
Purchased, 1933

MOWBRAY, Sir John Robert, Bt
(1815-99) Judge

2591 Water-colour 30.8 x 18.4
(12⅛ x 7¼)
Sir Leslie Ward, signed *Spy*
(*VF* 8 April 1882)
Purchased, 1933

MUDFORD, William (1782-1848)
Editor of *The Courier*

999 *See Groups:* The Trial of
Queen Caroline, 1820, by Sir
George Hayter

MUGGLETON, Lodowicke
(1609-89) Heresiarch; founder
of Muggletonian sect

4939 Canvas 76.2 x 63.5 (30 x 25)
By or after William Wood, c.1674
Purchased, 1973

557 Canvas, feigned oval
73.7 x 62.2 (29 x 24½)
By or after William Wood, inscribed
and dated 1674
Transferred from BM, 1879

1847 Plaster cast of death-mask
45.7 (18) long
Unknown artist
Given by George Charles
Williamson, 1910

Piper

MUIRHEAD, George (1764-1847)

P6(105) *See Collections:* The Hill
and Adamson Albums, 1843-8,
David Octavius Hill and Robert
Adamson, **P6(1-258)**

MULGRAVE, Henry Phipps, 1st
Earl of (1755-1831)
Soldier and statesman

2630 Water-colour 30.5 x 20.3
(12 x 8)
Attributed to Richard Cosway
Purchased, 1933

MULGRAVE, Constantine John
Phipps, 2nd Baron (1744-92)
Naval commander

1094 Canvas 124.5 x 99.7
(49 x 39¼)
Attributed to Johan Zoffany
Purchased, 1897

966 Water-colour 21 x 17.1
(8¼ x 6¾)
John Downman, 1782
Purchased, 1894

MÜLLER, William James (1812-45)
Landscape painter

1304 Miniature on ivory 7.9 x 7
(3⅛ x 2¾)
Self-portrait
Purchased, 1901

Ormond

MULREADY, William (1786-1863)
Painter and illustrator

1690 Panel 31.1 x 25.4 (12¼ x 10)
John Linnell, signed, inscribed and
dated 1833
Purchased, 1912

4450 Canvas 21.6 x 16.8 (8½ x 6⅝)
Self-portrait, c.1835
Given by Arthur Appleby, 1965

1456(22) Black chalk 10.8 x 9.8
(4¼ x 3⅞)
Charles Hutton Lear, inscribed and
dated 1846
Given by John Elliot, 1907
See Collections: Drawings of
Artists, c.1845, by Charles Hutton
Lear, **1456(1-27)**

2473 *See Collections:* Drawings of
Royal Academicians, c.1858, by
Charles Bell Birch, **2473-9**

3182(5) *See Collections:* Drawings
of Artists, c.1862, by Charles West
Cope, **3182(1-19)**

Ormond

MUNDEN, Joseph Shepherd
(1758-1832) Comedian

1149 Pencil 25.4 x 19.1 (10 x 7½)
George Dance, signed and dated
1798
Purchased, 1898

1283 Canvas 59.1 x 45.1
(23¼ x 17¾)
George Clint
Given by Mrs Charles James Wylie,
1900

MUNDY, Godfrey Charles (d.1860)
Soldier; author of *Pen and Pencil
Sketches in India*

4026(42) *See Collections:*
Drawings of Men about Town,
1832-48, by Alfred, Count D'Orsay,
4026(1-61)

MUNNINGS, Sir Alfred James
(1878-1959) Painter and PRA

4120 Plaster medallion 20.3 (8)
diameter
Frank Kovacs, incised, c.1948
Given by the sitter's widow, 1959

4120a Bronze cast of no.**4120**,
20.3 (8) diameter
Frank Kovacs, incised, c.1948
Given by Sir Charles Wheeler,
1960

4136 Black ink 28.6 x 22.5
(11¼ x 8⅞)
Self-portrait, signed, c.1950
Given by the artist's widow, 1960

MUNRO, Sir Hector (1726-1805)
General

1433 With an attendant
Canvas 124.5 x 96.5 (49 x 38)
Unknown artist, signed *I.W.P.*,
inscribed and dated 1785
Purchased, 1906

MUNRO, Jane (née Campbell),
Lady (d.1850)
Wife of Sir Thomas Munro

3124a (Companion to no.**3124**,
Sir Thomas Munro)
Canvas 76.8 x 64.5 (30¼ x 25⅜)
Sir Martin Archer Shee, 1819
Purchased, 1942

MUNRO, Sir Thomas, Bt
(1761-1827)
Administrator in India

3124 Canvas 73.7 x 61 (29 x 24)
Sir Martin Archer Shee, 1819
Purchased, 1942

MUNTZ, Sir Philip Albert, Bt
(1839-1908) Politician

2978 Water-colour 35.2 x 25.4
(13⅞ x 10)
Sir Leslie Ward, signed *Spy*
(*VF* 23 July 1892)
Purchased, 1938

MURCH, Dr
Slavery abolitionist

599 *See Groups:* The Anti-Slavery
Society Convention, 1840, by
Benjamin Robert Haydon

MURCHISON, Sir Roderick Impey,
Bt (1792-1871) Geologist

P120(10) Photograph: albumen
print, arched top 19.7 x 14.6
(7¾ x 5¾)
Maull & Polyblank, inscribed on
mount, 1855
Purchased, 1979
See Collections: Literary and
Scientific Men, 1855, by Maull &
Polyblank, **P120(1-54)**

906 Canvas 38.7 x 32.4
(15¼ x 12¾)
Stephen Pearce, 1856
Bequeathed by Lady Franklin, 1892
See Collections: Arctic Explorers,
1850-86, by Stephen Pearce,
905-24 and **1209-27**

Ormond

MURDOCK, William (1754-1839)
Inventor of gas lighting

1075,1075a and **b** *See Groups:*
Men of Science Living in 1807-8,
by Sir John Gilbert and others

316a(91) Pencil 43.8 x 32.4
(17¼ x 12¾)
Sir Francis Chantrey, inscribed
Given by Mrs George Jones, 1871
See Collections: Preliminary
drawings for busts and statues by
Sir Francis Chantrey, **316a(1-202)**

316a(92) *See Collections:*
Preliminary drawings for busts and
statues by Sir Francis Chantrey,
316a(1-202)

MURPHY, Arthur (1727-1805)
Writer and actor

10 Canvas 127 x 101.6 (50 x 40)
Nathaniel Dance, 1777
Purchased, 1857

MURPHY, H.

2316 *See Collections:*
Miscellaneous drawings . . . by
Sydney Prior Hall, **2282-2348** and
2370-90

MURPHY, John Patrick
(1831-1907)
One of the Counsel to *The Times*

2231,2239,2250 *See Collections:*
The Parnell Commission, 1888-9,
by Sydney Prior Hall, **2229-72**

MURRAY, Sir John Archibald
Murray, Lord (1779-1859)
Scottish judge

54 *See Groups:* The House of Com-
mons, 1833, by Sir George Hayter

MURRAY, Miss
Sister of John Murray (1808-92)

P6(115) *See Collections:* The Hill
and Adamson Albums, 1843-8, by
David Octavius Hill and Robert
Adamson, **P6(1-258)**

MURRAY, Andrew Graham, 1st
Viscount Dunedin *See* DUNEDIN

MURRAY, David William, 3rd Earl of Mansfield *See* MANSFIELD

MURRAY, Sir George (1772-1846)
General and statesman

4319 Pencil and water-colour
29.8 x 21.6 (11¾ x 8½)
Thomas Heaphy
Purchased, 1963

1818 Chalk 22.9 x 17.8 (9 x 7)
John Linnell
Purchased, 1918
See Collections: Drawings by
John Linnell, **1812-18B**

MURRAY, George (1784-1860)
Bishop of Rochester

4964 Canvas 142.2 x 112.7
(56 x 44⅜)
Samuel Lane, exh 1849
Purchased, 1973

MURRAY, Gilbert (1866-1957)
Classicist and writer

4037 Canvas 60.3 x 75.3
(23¾ x 29⅝)
Lawrence Toynbee, signed with
initials and dated 1950
Purchased, 1957

4170 Chalk 48.3 x 31.1 (19 x 12¼)
Augustus John, signed and dated
1957
Purchased, 1960

MURRAY, Sir Henry (1784-1860)
Major-General

3740 *See Collections:* Studies for
The Waterloo Banquet at Apsley
House, 1836, by William Salter,
3689-3769

MURRAY, James (1719-94)
General and Governor of Canada

3122 Canvas 127 x 101.6 (50 x 40)
Unknown artist
Given by wish of E.R.B.Murray,
1942

MURRAY, Sir John, Bt
(1768?-1827) General

792 *See Groups:* Four studies for
Patrons and Lovers of Art, c.1826,
by Pieter Christoph Wonder, **792-5**

MURRAY, John, 4th Duke of
Atholl *See* ATHOLL

MURRAY, John (1778-1843)
Publisher

2515(83) Pencil and chalk
34.9 x 26.3 (13¾ x 10⅜)
William Brockedon, dated 1837
Lent by NG, 1959
See Collections: Drawings of
Prominent People, 1823-49, by
William Brockedon, **2515(1-104)**

MURRAY, John (1808-92)
Publisher and patron; son of John
Murray (1778-1843)

P6(27) Photograph: calotype
20.3 x 14.6 (8 x 5¾)
David Octavius Hill and Robert
Adamson, 1843-8
Given by an anonymous donor,
1973
See Collections: The Hill and
Adamson Albums, by David
Octavius Hill and Robert Adamson,
P6(1-258)

1885 Canvas 112.1 x 87
(44⅛ x 34¼)
Charles Wellington Furse, c.1891
Given by the sitter's son,
A.H.Hallam Murray, 1920

Ormond

MURRAY, Marian (d.1894)
Wife of John Murray (1808-92)

P6(108) *See Collections:* The Hill and Adamson Albums, 1843-8, by David Octavius Hill and Robert Adamson, **P6(1-258)**

MURRAY, William, 1st Earl of Mansfield *See* MANSFIELD

MURRAY, William David, 4th Earl of Mansfield *See* MANSFIELD

MYDDELTON, Sir Hugh, Bt (1560?-1631)
Projector of the New River scheme

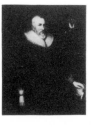

2192 Canvas 127 x 101.6 (50 x 40)
After Cornelius Johnson, inscribed (1628)
Purchased, 1928

Strong

MYERS, Frederic William Henry (1834-1901) Poet and essayist; a founder of the Society for Psychical Research

2928 Canvas 57.2 x 47 (22½ x 18½)
William Clarke Wontner, signed, exh 1896
Given by the sitter's son, Harold H. Myers, 1938

MYERS, Leopold Hamilton (1881-1944) Novelist

4790 Sanguine and black chalk 29.2 x 23.8 (11½ x 9⅜)
Sir William Rothenstein, c.1936
Purchased, 1970

MYLNE, Robert (1734-1811)
Architect and civil engineer

1150 Pencil 26 x 19.1 (10¼ x 7½)
George Dance, signed and dated 1795
Purchased, 1898

1075,1075a and **b** *See Groups:* Men of Science Living in 1807-8, by Sir John Gilbert and others

NAGLE, Sir Edmund (1757-1830)
Admiral

4858 Water-colour 27.9 x 21.9 (11 x 8⅝)
Sir Hilgrove Turner, inscribed
Given by Mrs N.H.Nicholls, 1971

NANINI
Servant of Sir Edwin Landseer

3097(10) *See Collections:* Caricatures, c.1825-c.1835, by Sir Edwin Landseer, **3097(1-10)**

NAOROJI, Dudabhai (1825-1917)
First Indian MP

2307,2329 *See Collections:* Miscellaneous drawings . . . by Sydney Prior Hall, **2282-2348** and **2370-90**

NAPIER of Magdala, Robert Napier, 1st Baron (1810-90)
Field-Marshal

863 Plaster cast of bust 72.4 (28½) high
Sir Joseph Edgar Boehm
Purchased, 1891

NAPIER, Sir Charles (1786-1860)
Admiral

1460 Canvas 30.5 x 25.4 (12 x 10)
E.W.Gill, signed and dated 1854 on reverse
Purchased, 1907

Ormond

NAPIER, Sir Charles James
(1782-1853) Conqueror of Sind

3964 Canvas 35.3 x 28.9
($13\frac{7}{8}$ x $11\frac{3}{8}$)
Attributed to ? Smart
Purchased, 1955

1369 Canvas 54.3 x 47.3
($21\frac{3}{8}$ x $18\frac{5}{8}$)
Edwin Williams, signed, 1849
Purchased, 1904

333 Panel 29.2 x 22.2 (11½ x 8¾)
George Jones, signed, inscribed and
dated 1851
Given by the artist's widow, 1871

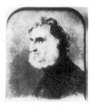

1198 Plaster cast of bust 72.4
(28½) high
George Gammon Adams, incised
and dated 1853
Purchased, 1899

Ormond

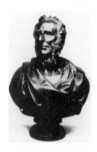

NAPIER, Sir Trevylyan
(1867-1920) Vice-Admiral

1913 *See Groups:* Naval Officers
of World War I, by Sir Arthur
Stockdale Cope

NAPIER, Sir William (1785-1860)
General and historian

1197 Marble bust 68.3 ($26\frac{7}{8}$) high
George Gammon Adams, incised
and dated 1855
Purchased, 1899

Ormond

NAPOLEON BONAPARTE
(1769-1821)
Emperor of France 1804-14

1914(22) *See Collections:*
Peninsular and Waterloo Officers,
1813-14, by Thomas Heaphy,
1914(1-32)

L152(4) *See under* 1st Duke of
Wellington, **L152(3)**

NAPOLÉON, Prince Victor Jerome
Frederic (1862-1926)
Leader of French Bonapartist party

4707(5) *See Collections: Vanity
Fair* cartoons, 1869-1910, by
various artists, **2566-2606**, etc

NARES, Sir George (1831-1915)
Vice-Admiral

1212 Canvas 127 x 101.6 (50 x 40)
Stephen Pearce, signed, and
inscribed and dated 1877 on reverse
Bequeathed by John Barrow, 1899
See Collections: Arctic Explorers,
1850-86, by Stephen Pearce,
905-24 and **1209-27**

Ormond

NASH, Frederick (1782-1856)
Painter of architectural subjects

2688 Water-colour 26 7 x 21.3
($10\frac{1}{2}$ x $8\frac{3}{8}$)
Jules Noguès, signed and dated 1839
Purchased, 1934

Ormond

NASH, John (1752-1835)
Architect

2778 Wax medallion 9.5 (3¾)
diameter
Joseph Anton Couriguer, incised,
c.1820
Purchased, 1935

3097(7) Pen and ink 12.4 x 4.8
$(4\frac{7}{8} \times 1\frac{7}{8})$
Sir Edwin Landseer, inscribed
Purchased, 1940
See Collections: Caricatures,
c.1825-c.1835, by Sir Edwin
Landseer, **3097(1-10)**

NASH, Paul (1889-1946)
Artist

4134 Pencil and pen 37.8 x 27.3
$(14\frac{7}{8} \times 10\frac{3}{4})$
Rupert Lee, 1913
Given by the sitter's widow, 1959

NASH, Richard (1674-1762)
'Beau Nash'; man of fashion

1537 Canvas 76.2 x 62.9
(30 x 24¾)
After William Hoare (c.1761)
Given by Alfred Jones, 1909

Kerslake

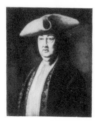

NASMYTH, Alexander (1758-1840)
Painter and scientist

1075, 1075a and **b** *See Groups:*
Men of Science Living in 1807-8,
by Sir John Gilbert and others

NASMYTH, James (1808-90)
Engineer; son of Alexander Nasmyth

P6(28) Photograph: calotype
19.4 x 15.2 $(7\frac{5}{8} \times 6)$
David Octavius Hill and Robert
Adamson, c.1844
Given by an anonymous donor,
1973
See Collections: The Hill and
Adamson Albums, 1843-8, by
David Octavius Hill and Robert
Adamson, **P6(1-258)**

1582 Canvas 36.8 x 30.8
$(14\frac{1}{2} \times 12\frac{1}{8})$
George Bernard O'Neill, 1874
Purchased, 1910

Ormond

NASMYTH, Patrick (1787-1831)
Landscape painter; son of
Alexander Nasmyth

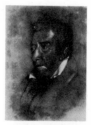

350 Pencil and chalk 45.1 x 34.9
(17¾ x 13¾)
William Bewick, inscribed
Purchased, 1872

NEEDHAM, John Turberville
(1713-81) Roman Catholic divine
and man of science

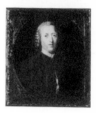

4889 Water-colour, oval 13 x 11.4
$(5\frac{1}{8} \times 4\frac{1}{2})$
Jean Baptiste Garand, inscribed and
dated 1755 on reverse by Charles
Towneley
Purchased, 1972

NEELD, Joseph

316a(93,94) *See Collections:*
Preliminary drawings for busts and
statues by Sir Francis Chantrey,
316a(1-202)

NEILD, James (1744-1814)
Philanthropist

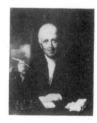

4160 Panel 29.8 x 24.4 $(11\frac{3}{4} \times 9\frac{5}{8})$
Samuel de Wilde, inscribed, 1804
Purchased, 1960

NEILL, Alexander Sutherland
(1883-1973) Child psychologist
and writer

5111 Ink 50.5 x 35.3 $(19\frac{7}{8} \times 13\frac{7}{8})$
Ishbel McWhirter, signed and
inscribed, 1965
Given by Prof J.H.Plumb, 1976

NEILSON, Lilian Adelaide
(1848-80) Actress; real name
Elizabeth Ann Brown

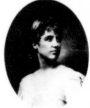

1781B Chalk, oval 42.9 x 33.7
$(16\frac{7}{8} \times 13\frac{1}{4})$ *sight*
Thomas Edward Gaunt after
photograph by Napoleon Sarony,
signed with initials and dated 1880
(1880)
Given by E.E.Leggatt, 1916

NELSON, William Nelson, 1st Earl (1757-1835) Brother of Horatio, Viscount Nelson

2662(21) *See Collections:* Book of sketches, mainly for The Trial of Queen Caroline, 1820, by Sir George Hayter, **2662(1-38)**

999 *See Groups:* The Trial of Queen Caroline, 1820, by Sir George Hayter

NELSON, Horatio Nelson, 3rd Earl (1823-1913) Commissioner of the Royal Patriotic Fund

2592 Water-colour 30.5 x 18.1 (12 x 7$\frac{1}{8}$)
Sir Leslie Ward, signed *Spy*
(*VF* 16 April 1881)
Purchased, 1933

NELSON, Horatio Nelson, Viscount (1758-1805) Vice-Admiral; victor of Trafalgar

394 Canvas 74.9 x 62.2 (29½ x 24½)
Lemuel Francis Abbott, c.1797
Purchased, 1874

L152(32) Enamel miniature 14 x 10.5 (5½ x 4$\frac{1}{8}$)
Henry Pierce Bone after Lemuel Francis Abbott (c.1797)
Lent by NG (Alan Evans Bequest), 1975

5101 With a midshipman
Canvas 222.9 x 168.9 (87¾ x 66½)
Guy Head, 1798-1800
Purchased, 1976

785 Canvas 84.5 x 50.8 (33¼ x 20)
L. Acquarone after Leonardo Guzzardi, 1799-1802 (1799)
Given by the Sultan of Turkey, 1888

2668 Plaster cast of bust 68.6 (27) high
D.Cardosi after Thaler and Ranson, incised (1800)
Purchased, 1934

2767 Plaster squeeze, painted as terracotta 22.9 (9) high
After Thaler and Ranson (1800)
Purchased, 1935

73 Canvas 67.9 x 50.2 (26¾ x 19¾)
Friedrich Heinrich Füger, 1800
Purchased, 1859

L129 Canvas 62.2 x 48.3 (24½ x 19)
Sir William Beechey, 1800-1
Lent by the Leggatt Trustees, 1966

879 Water-colour 31.8 x 22.2
(12½ x 8¾)
Henry Edridge, signed and dated
1802
Purchased, 1891

4309 Marble bust 96.5 (38) high
Sir Francis Chantrey, incised and
dated 1835
Given by the Royal United Service
Institution, 1963

NESFIELD, William Eden
(1835-88) Architect

1193 Pencil 20.3 x 12.7 (8 x 5)
Jacques Emile Edouard Brandon,
signed, inscribed and dated 1858
Given by John Hebb, 1899

4354 Pencil and chalk 44.5 x 31.8
(17½ x 12½)
Sir William Blake Richmond, signed
and inscribed, c.1859
Given by Eric Millar, 1964

NEVILL, Lady Dorothy
(1826-1913) Writer of memoirs

1833 *See Groups:* Private View of
the Old Masters Exhibition, Royal
Academy, 1888, by Henry Jamyn
Brooks

NEVINSON, Evelyn (née Sharp)
(1869-1955) Sociologist and
suffragette; second wife of Henry
Woodd Nevinson

4001 Pencil 22.9 x 17.1 (9 x 6¾)
Sir William Rothenstein, signed
and dated 1933
Given by the sitter's niece, Miss
Joan Sharp, 1956

NEVINSON, Henry Woodd
(1856-1941) Journalist and war
correspondent

3316 Chalk 21.6 x 15.9 (8½ x 6¼)
Sir William Rothenstein, signed and
dated 1919
Given by the sitter's widow, 1946

5193 Sanguine 34.9 x 27.9
(13¾ x 11)
Sir William Rothenstein, signed and
with initials and dated 1924
Given by Sir Bernard de Bunsen,
1978

NEWALL, Cyril Newall, 1st Baron
(1886-1963)
Marshal of the Royal Air Force

4356 Board 50.8 x 40.6 (20 x 16)
Reginald Grenville Eves, signed and
dated 1940
Given by the artist's son, Grenville
Eves, 1964

NEWARK, Charles Evelyn
Pierrepont, Viscount (1805-50)
MP for East Retford

54 *See Groups:* The House of Com-
mons, 1833, by Sir George Hayter

NEWBOLT, Sir Henry John
(1862-1938) Poet

2054 Plasticine medallion 9.8 $(3\frac{7}{8})$
diameter
Theodore Spicer-Simson, incised,
c.1922
Given by the artist, 1924

Continued overleaf

4664 Canvas 112.1 x 101
(44$\frac{1}{8}$ x 39¾)
Meredith Frampton, exh 1931
Purchased, 1969

NEWCASTLE, Thomas Pelham-
Holles, 1st Duke of (1693-1768)
Prime Minister

3215 *See under* 1st Earl of Lincoln

Piper

757 Chalk 61 x 45.7 (24 x 18)
William Hoare, c.1752(?)
Given by the 4th Earl of Chichester,
1887

Kerslake

NEWCASTLE, Henry Clinton, 2nd
Duke of (1720-94) Cofferer of the
Household; nephew of 1st Duke

2504 Canvas 238.8 x 144.8
(94 x 57)
William Hoare, replica
Bequeathed by Miss L.B.Randell,
1931

NEWCASTLE, Henry Clinton, 4th
Duke of (1785-1851) Politician

2789 *See Groups:* Members of the
House of Lords, c.1835, by Isaac
Robert Cruikshank

NEWCASTLE, Henry Clinton, 5th
Duke of (1811-64) Statesman

54 *See Groups:* The House of Com-
mons, 1833, by Sir George Hayter

342,343 *See Groups:* The Fine
Arts Commissioners, 1846, by
John Partridge

4576 Canvas 142.2 x 111.4
(56 x 43$\frac{7}{8}$)
Frederick Richard Say, 1848
Purchased, 1967

1125,1125a *See Groups:* The
Coalition Ministry, 1854, by Sir
John Gilbert

4023 Chalk 61 x 45.4 (24 x 17$\frac{7}{8}$)
George Richmond, signed and
dated 1856
Lent by the Duke of Newcastle,
1957

Ormond

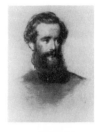

NEWMAN, John Henry (1801-90)
Cardinal

1065 Chalk 41.3 x 33.7
(16¼ x 13¼)
George Richmond, 1844
Purchased, 1896

1668 Plaster cast of bust 69.5 (27$\frac{3}{8}$)
high
Thomas Woolner, incised and dated
1866
Purchased, 1912

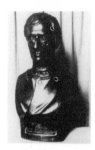

1022 Canvas 111.8 x 89.5
(44 x 35¼)
Emmeline Deane, signed and dated
1889
Given by George Vernon Blunt,
1896

Ormond

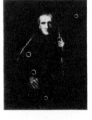

NEWPORT, Mountjoy Blount,
Earl of (1597-1665) Royalist

762 With George Goring, Baron
Goring (right)
Canvas 106 x 126.4 (41¾ x 49¾)
After Sir Anthony van Dyck
(c.1635-40)
Given by the Rev Sir John Tyrwhitt,
1887

Piper

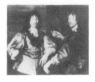

NEWTON, Ann Mary (1832-66)
Portrait painter; daughter of
Joseph Severn

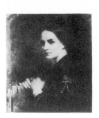

977 61 x 52.1 (24 x 20½)
Self-portrait
Bequeathed by her husband, Sir
Charles Thomas Newton, 1895

Ormond

NEWTON, Sir Charles Thomas
(1816-94) Archaeologist

973 Plaster cast of bust 76.2 (30)
high
Sir Joseph Edgar Boehm, incised
and dated 1863
Given by Miss Amy Frances Yule,
1895

NEWTON, Francis Milner (1720-94)
Portrait painter

1437,1437a *See Groups:* The
Academicians of the Royal
Academy, 1771-2, by John Sanders
after Johan Zoffany

NEWTON, Sir Isaac (1642-1727)
Mathematical scientist

2881 Canvas, feigned oval
75.6 x 62.2 (29¾ x 24½)
Sir Godfrey Kneller, signed,
inscribed and dated 1702
Purchased with help from NACF,
1936

558 Canvas 127 x 148 (50 x 58¼)
Attributed to John Vanderbank,
c.1726
Transferred from BM, 1879

2081 Iron cast of death-mask
19.7 x 14.6 (7¾ x 5¾)
After John Michael Rysbrack (?)
Given by Frank Baxter, 1925

995 Marble bust 71.1 (28) high
Edward Hodges Baily after Louis
François Roubiliac, incised and
dated 1828 (1751)
Transferred from Tate Gallery,
1957. *Beningbrough*

Piper

NIAS, Sir Joseph (1793-1879)
Admiral

P2 Photograph: hand-tinted
ambrotype 10.2 x 7.9 (4 x $3\frac{1}{8}$) *sight*
Unknown photographer
Given by the sitter's daughter,
Miss Nias, 1927

2437 Oil painting over a
photograph 21.3 x 16.2 ($8\frac{3}{8}$ x $6\frac{3}{8}$)
Photograph by Maull & Co.
Given by the sitter's daughter,
Miss Nias, 1927

NICHOLAS, Sir Edward
(1593-1669) Secretary of State

1519 Canvas 124.5 x 100.3
(49 x 39½)
Sir Peter Lely, inscribed, 1662
Purchased, 1908

Piper

NICHOLL, Sir John (1759-1838)
Judge

316a(95) Pencil 50.2 x 32.1
($19\frac{3}{4}$ x $12\frac{5}{8}$)
Sir Francis Chantrey, inscribed
Given by Mrs George Jones, 1871

and

316a(96) Pencil, two sketches
47.6 x 64.5 ($18\frac{3}{4}$ x $25\frac{3}{8}$)
Sir Francis Chantrey, inscribed
Given by Mrs George Jones, 1871
See Collections: Preliminary
drawings for busts and statues by
Sir Francis Chantrey, **316a(1-202)**

NICHOLL, John (1797-1835)
MP for Cardiff

54 *See Groups:* The House of Commons, 1833, by Sir George Hayter

NICHOLLS, Sir George
(1781-1865) Poor Law reformer
and administrator

4807 Canvas 91.8 x 81.6
$(36\frac{1}{8} \times 32\frac{1}{8})$
Ramsay Richard Reinagle, inscribed
and dated 1834 on reverse
Purchased, 1970

Ormond

NICHOLS, Robert (1893-1944)
Poet

3825 Chalk 30.5 x 24.1 (12 x 9½)
Augustus John, signed and dated
1921
Bequeathed by the sitter, 1952

NICHOLSON, Ben (b.1894)
Artist

P42 Photograph: bromide print
20.3 x 16.2 $(8 \times 6\frac{3}{8})$
Humphrey Spender, c.1933
Purchased, 1977

NICHOLSON, Charles (1795-1837)
Flautist and composer

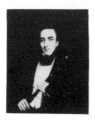

5200 Canvas 76.2 x 66 (30 x 26)
T. Bart, signed, inscribed and dated
1834
Purchased, 1978

NICHOLSON, John (1821-57)
Soldier and administrator

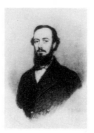

3922 Chalk 35.6 x 25.4 (14 x 10)
William Carpenter, signed, inscribed
and dated 1854
Purchased, 1954

Ormond

NICHOLSON, Peter (1765-1844)
Mathematician and architect

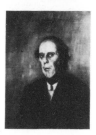

4225 Canvas 75.6 x 63.5
(29¾ x 25)
James Green, c.1816
Given by B.C.Redwood, 1961

NICOLSON, Benedict (1914-78)
Art historian

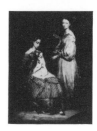

5233 Canvas 81.3 x 63.8
$(32 \times 25\frac{1}{8})$
Rodrigo Moynihan, 1977-8
Purchased with help from NACF,
1978

NIGHTINGALE, Florence
(1820-1910)
Reformer of hospital nursing

3246 With her sister, Frances
Parthenope, afterwards Lady
Verney (right)
Water-colour 45.1 x 34.9
(17¾ x 13¾)
William White, c.1836
Given by Sir Harry L.Stephen, Bt,
1945

3254 Pencil, irregular oval
30.8 x 25.1 $(12\frac{1}{8} \times 9\frac{7}{8})$
Elizabeth, Lady Eastlake, signed
and dated 1846
Given by Sir Harry L. Stephen, Bt,
1945

2939 (study for no.**4305**)
Water-colour 16.2 x 12.1 $(6\frac{3}{8} \times 4\frac{3}{4})$
Jerry Barrett, signed, inscribed and
dated 1856
Purchased, 1938

3303 Pencil and water-colour,
three sketches on two pages, each
16.5 x 10.2 (6½ x 4)
Probably by Jerry Barrett, inscribed
and dated 1856
Given by wish of Miss H.T.Neild,
1946

2939A *See Groups:* Study for Florence Nightingale at Scutari, by Jerry Barrett

4305 *See Groups:* Sketch for Florence Nightingale at Scutari, by Jerry Barrett

1784 Pencil 14 x 7.6 (5½ x 3)
Sir George Scharf, inscribed and dated 1857
Bequeathed by the artist, 1895

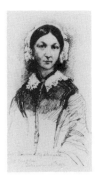

1748 Bronze cast of bust 71.1 (28) high
Sir John Robert Steell, incised and dated 1862
Given by Sir Harry L. and Lady Stephen, 1915

1578 *See Unknown Sitters IV*

NIGRA, Count Constantino (1828-1907) Italian diplomat

4707(22) *See Collections: Vanity Fair* cartoons, 1869-1910, by various artists, **2566-2606**, etc

NOËL, Sir Gerald Noel, Bt (1759-1838) MP for Rutland

54 *See Groups:* The House of Commons, 1833, by Sir George Hayter

NOLLEKENS, Joseph (1737-1823) Sculptor

1437,1437a *See Groups:* The Academicians of the Royal Academy, 1771-2, by John Sanders after Johan Zoffany

30 Canvas 74.9 x 60.3 (29½ x 23¾)
Lemuel Francis Abbott
Given by Henry Labouchere, 1858

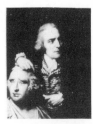

360 Canvas 73.7 x 61 (29 x 24)
James Lonsdale
Given by the artist's son, James John Lonsdale, 1873

NORELE, Mademoiselle

P22(2,24) *See Collections:* The Balmoral Album, 1854-68, by George Washington Wilson, W.& D. Downey, and Henry John Whitlock, **P22(1-27)**

NORFOLK, Thomas Howard, 4th Duke of (1536-72) Plotted to marry Mary, Queen of Scots

1732 *See Unknown Sitters I*

NORFOLK, Henry Howard, 6th Duke of (1628-84) Courtier

613 *See Unknown Sitters II*

NORFOLK, Henry Charles Howard, 13th Duke of (1791-1856)
Lord Steward

54 *See Groups:* The House of Commons, 1833, by Sir George Hayter

NORIE, John William (1772-1843)
Writer on navigation

1131 Water-colour 21 x 19.7 (8¼ x 7¾)
Adam Buck after a miniature by Williams
Given by the sitter's nephew, Henry H.Norie, 1898

NORMANBY, Constantine Henry
Phipps, 1st Marquess of (1797-1863)
Statesman

3139 Pen and ink 21.3 x 13.7
$(8\frac{3}{8} \times 5\frac{3}{8})$
Daniel Maclise, signed *Alfred
Croquis* and inscribed, pub 1835
Purchased, 1943

Ormond

NORMANTON, James Ellis Agar,
3rd Earl of (1818-96)

1833 *See Groups:* Private View of
the Old Masters Exhibition, Royal
Academy, 1888, by Henry Jamyn
Brooks

NORRISS, Bess (Mrs Tait)
(1878-1939)
Water-colourist and miniaturist

4054 Water-colour 23.8 x 18.7
$(9\frac{3}{8} \times 7\frac{3}{8})$
Probably a self-portrait
Acquired, 1958

NORTH, Dudley North, 4th
Baron (1602-77) Courtier

L152(41) Miniature on vellum,
oval 6 x 4.8 $(2\frac{3}{8} \times 1\frac{7}{8})$
John Hoskins, signed in monogram
Lent by NG (Alan Evans Bequest),
1975

NORTH, Christopher
See WILSON, John

NORTH, Sir Dudley (1641-91)
Financier and economist; son of
4th Baron North

4709 Canvas 144.1 x 123.2
$(56\frac{3}{4} \times 48\frac{1}{2})$
Unknown artist, inscribed, c.1680
Purchased, 1970

NORTH, Dudley Long (1748-1829)
Politician

2076 *See Groups:* Whig Statesmen
and their Friends, c.1810, by
William Lane

NORTH, Sir Ford (1830-1913)
Judge

3291 Water-colour 30.8 x 18.4
$(12\frac{1}{8} \times 7\frac{1}{4})$
Sir Leslie Ward, signed *Spy*
(*VF* 29 Oct 1887)
Purchased, 1946

NORTH, Francis, 1st Baron
Guilford *See* GUILFORD

NORTH, Frederick, 2nd Earl of
Guilford *See* GUILFORD

NORTH, Frederick (1800-69)
MP for Hastings

54 *See Groups:* The House of Com-
mons, 1833, by Sir George Hayter

NORTH, John Thomas (1842-96)
Colonel; 'the Nitrate King'

3594 *See Collections:* Prominent
Men, c.1880-c.1910, by Harry
Furniss, **3337-3535** and **3554-3620**

NORTH, Roger (1653-1734)
Lawyer and writer

766 Canvas 74.9 x 62.2
(29½ x 24½)
After Sir Peter Lely (1680)
Purchased, 1887

Piper

NORTHAMPTON, Henry Howard,
1st Earl of (1540-1614)
Lord Warden of the Cinque Ports

665 *See Groups:* The Somerset
House Conference, 1604, by an
unknown Flemish artist

NORTHAMPTON, Spencer
Compton, 2nd Earl of (1601-43)
Royalist soldier

1521 Canvas 124.5 x 102.2
(49 x 40¼)
Henry Paert after Cornelius Johnson
and Sir Anthony van Dyck, inscribed
Purchased, 1908

Piper

NORTHAMPTON, Spencer Joshua
Alwyne Compton, 2nd Marquess of
(1790-1851)
President of the Royal Society

P6(3) Photograph: calotype
20 x 13.7 ($7\frac{7}{8}$ x $5\frac{3}{8}$)
David Octavius Hill and Robert
Adamson, 1844
Given by an anonymous donor,1973
See Collections: The Hill and
Adamson Albums, 1843-8, by
David Octavius Hill and Robert
Adamson, **P6(1-258)**

NORTHBROOK, Francis Baring,
1st Baron (1796-1866) Statesman

1257 (study for *Groups,* **54**)
Millboard 27.9 x 21 (11 x 8¼)
Sir George Hayter, c.1833
Given by the sitter's son, the Earl
of Northbrook, 1900

54 *See Groups:* The House of Com-
mons, 1833, by Sir George Hayter

NORTHCLIFFE, Alfred
Harmsworth, 1st Viscount
(1865-1922) Newspaper proprietor

4101 Copper medallion 10.5 ($4\frac{1}{8}$)
diameter
Edith Anna Bell, incised and dated
1900
Purchased, 1959

NORTHCOTE, Henry Stafford
Northcote, Baron (1846-1911)
Governor-General of Australia

2289 *See Collections:*
Miscellaneous drawings . . . by
Sydney Prior Hall, **2282-2348** and
2370-90

NORTHCOTE, Sir Stafford Henry,
1st Earl of Iddesleigh
See IDDESLEIGH

NORTHCOTE, James (1746-1831)
Painter; pupil and biographer of Sir
Joshua Reynolds

3253 Canvas 73.7 x 61 (29 x 24)
Self-portrait, inscribed and dated
1784 on reverse
Purchased, 1945

4206 Pencil 19.7 x 15.6 ($7\frac{3}{4}$ x $6\frac{1}{8}$)
George Shepheard, inscribed
Given by Iolo A.Williams, 1961

969 Panel 52.1 x 40 (20½ x 15¾)
George Henry Harlow, c.1817
Given by John Carrick Moore, 1894

2515(5) *See Collections:* Drawings
of Prominent People, 1823-49, by
William Brockedon, **2515(1-104)**

147 Canvas 74.9 x 61 (29½ x 24)
Self-portrait, signed and dated 1827
on reverse
Purchased, 1862

3026 Pencil 22.2 x 18.4 (8¾ x 7¼)
Self-portrait, inscribed, c.1829
Given by Marion Harry Spielmann,
1939

2938 *See Unknown Sitters III*

NORTHINGTON, Robert Henley, 1st Earl of (1708?-72) Chancellor

2166 Canvas 124.5 x 99.7 (49 x 39¼)
Studio of Thomas Hudson (exh 1761)
Given by Lord Henley, 1927

NORTHUMBERLAND, John Dudley, Duke of (1502?-53)
Father-in-law of Lady Jane Grey

4165 *See Groups:* Edward VI and the Pope, by an unknown artist

NORTHUMBERLAND, Sir Hugh Percy (originally Smithson), 1st Duke of (1715-86)
Lord-Lieutenant of Ireland

4954 Paste medallion 8.6 (3⅜) high
James Tassie, incised in monogram and dated 1780
Purchased, 1973

NORTHUMBERLAND, Hugh Percy, 3rd Duke of (1785-1847)
Lord-Lieutenant of Ireland

1695(u) *See Collections:* Sketches for The Trial of Queen Caroline, 1820, by Sir George Hayter, **1695(a-x)**

999 *See Groups:* The Trial of Queen Caroline, 1820, by Sir George Hayter

NORTHUMBERLAND, Algernon Percy, 10th Earl of (1602-68)
Statesman and Lord High Admiral

287 61.6 x 50.8 (24¼ x 20)
After Sir Anthony van Dyck, reduced copy
Purchased, 1869

NORTHWICK, John Rushout, 2nd Baron (1770-1859)

999 *See Groups:* The Trial of Queen Caroline, 1820, by Sir George Hayter

NORTHWICK, George Rushout-Bowles, 3rd Baron (1811-87)
Representative peer

1834(w) *See Collections:* Members of the House of Lords, c.1870-80, by Frederick Sargent, **1834(a-z and aa-hh)**

NORTON, Caroline Elizabeth Sarah, afterwards Lady Stirling-Maxwell
See STIRLING-MAXWELL

NORTON, John T.
American slavery abolitionist

599 *See Groups:* The Anti-Slavery Society Convention, 1840, by Benjamin Robert Haydon

NORTON-GRIFFITHS, Sir John, Bt (1871-1930)
Engineer; 'Empire Jack'

4333 Pencil and water-colour 41.3 x 26.7 (16¼ x 10½)
James Kerr-Lawson, posthumous
Given by the sitter's widow, Gwladys, Lady Norton-Griffiths, 1963

NORWICH, Alfred Duff Cooper, 1st Viscount (1890-1950)
Politician, diplomat and writer

4560 With his wife, Diana
Chalk 44.1 x 29.2 (17⅜ x 11½)
Sir David Low, signed, pub 1927
Purchased, 1967

NORWICH, Diana (née Manners), Viscountess (b.1892)
Actress and writer

4560 *See under* 1st Viscount Norwich

NOTTINGHAM, Charles Howard,
1st Earl of (1536-1624)
Lord High Admiral

4434 Canvas 243.9 x 137.2
(96 x 54)
Unknown artist, copy (1602)
Purchased, 1965. *Montacute*

665 *See Groups:* The Somerset
House Conference, 1604, by an
unknown Flemish artist

1931 *See Unknown Sitters I*

Strong

NOTTINGHAM, Heneage Finch,
1st Earl of (1621-82)
Lord Chancellor

1430 Canvas 121.9 x 99.1
(48 x 39)
After Sir Godfrey Kneller (1680?)
Purchased, 1906

Piper

NOTTINGHAM, Daniel Finch,
2nd Earl of *See* WINCHILSEA

NOVELLO, Ivor (1893-1951)
Actor-manager, dramatist and
composer

P65 Photograph: bromide print
37.5 x 29.8 (14¾ x 11¾)
Angus McBean, 1947
Purchased, 1977
See Collections: Prominent people,
c.1946-64, by Angus McBean,
P56-67

NOYES, Alfred (1880-1958)
Poet

3673 Pencil 36.5 x 28.6
(14⅜ x 11¼)
Sir Bernard Partridge, signed
(*Punch* 28 Aug 1929)
Purchased, 1949
See Collections: Mr Punch's
Personalities, 1926-9, by Sir
Bernard Partridge, **3664-6,** etc

NUFFIELD, William Richard
Morris, Viscount (1877-1963)
Industrialist and philanthropist

3674 (With two unidentified
heads)
Pencil 19.1 x 27.6 (7½ x 10⅞)
Sir Bernard Partridge, inscribed
(study for *Punch* 14 Sept 1927)
Purchased, 1949
See Collections: Mr Punch's
Personalities, 1926-9, by Sir
Bernard Partridge, **3664-6,** etc

NUGENT, Lady

316a(97) *See Collections:*
Preliminary drawings for busts and
statues by Sir Francis Chantrey,
316a(1-202)

NUGENT, George Colborne
(1864-1915) Soldier

2999 Water-colour 36.5 x 21.9
(14⅜ x 8⅝)
Sir Leslie Ward, signed *Spy*
(*VF* 12 Aug 1897)
Purchased, 1938

NYTHE, Godfrey
Colonel

883(13) *See Collections:* Studies
for miniatures by Sir George Hayter,
883(1-21)

OATES, Lawrence Edward Grace
(1880-1912) Antarctic explorer

P121 With Cecil H.Meares (left)
Photograph: carbon print
45.7 x 34.3 (18 x 13½)
Herbert G.Ponting, c.1911
Purchased, 1979

OATES, Titus (1649-1705)
Informer

634 Line engraving 22.9 x 15.2
(9 x 6)
Robert White, signed and inscribed
on plate, pub 1679
Purchased, 1881

Piper

O'BRIEN, Eliza Bridgeman
(Willyams) (d.1802)
Wife of James O'Brien, afterwards
3rd Marquess of Thomond

1681A Miniature on ivory, oval
7.9 x 6.4 (3$\frac{1}{8}$ x 2½)
John Cox Dillman Engleheart,
signed, inscribed, and dated 1814
on backing paper
Bequeathed by Miss Ellen Mabel
Dawson, 1912

O'BRIEN, William (1852-1928)
Irish nationalist leader

2979 Water-colour 36.5 x 31.4
(14$\frac{3}{8}$ x 12$\frac{3}{8}$)
Sir Leslie Ward, signed *Spy*
(*VF* 15 May 1907)
Purchased, 1938

O'CASEY, Sean (1880-1964)
Playwright and writer

4402 Ink 35.2 x 25.4 (13$\frac{7}{8}$ x 10)
Powys Evans, signed and inscribed,
pub 1927
Purchased, 1964

OCHTERLONY, Sir David, Bt
(1758-1825) General

1266 Miniature on ivory, oval
5.4 x 4.1 (2$\frac{1}{8}$ x 1$\frac{5}{8}$)
Unknown artist
Given by E.Lennox Boyd, 1900

O'CONNELL, Daniel (1775-1847)
Irish politician

4582 (study for *Groups*, 54)
Millboard 35.6 x 30.5 (14 x 12)
Sir George Hayter, 1834
Purchased, 1967

54 *See Groups:* The House of Commons, 1833, by Sir George Hayter

208 Miniature on ivory, irregular
oval 15.5 x 13.3 (6$\frac{1}{8}$ x 5¼)
Bernard Mulrenin, signed with
initials and dated 1836
Purchased, 1866

599 *See Groups:* The Anti-Slavery
Society Convention, 1840, by
Benjamin Robert Haydon

Ormond

O'CONNOR, Dennis (1794-1847)
MP for County Roscommon

54 *See Groups:* The House of Commons, 1833, by Sir George Hayter

O'CONNOR, John (1850-1928)
Lawyer and MP

2321 *See Collections:*
Miscellaneous drawings . . . by
Sydney Prior Hall, **2282-2348** and
2370-90

O'CONNOR, Thomas Power
(1848-1929)
Journalist and politician

3127 Water-colour 30.5 x 18.1
(12 x 7$\frac{1}{8}$)
Sir Leslie Ward, signed *Spy*
(*VF* 25 Feb 1888)
Purchased, 1942

2297 *See Collections:*
Miscellaneous drawings . . . by
Sydney Prior Hall, **2282-2348** and
2370-90

3401 *See Collections:* Prominent
Men, c.1880-c.1910, by Harry
Furniss, **3337-3535** and **3554-3620**

O'DONNELL, Frank Hugh O'Cahan
(b.1844) Journalist and politician

3280 Water-colour 29.8 x 18.4
(11¾ x 7¼)
Théobald Chartran, signed .T.
(*VF* 28 Aug 1880)
Purchased, 1934

O'DRISCOLL, Florence (d.1939)
Engineer and journalist

2868 *See Collections:*
Caricatures of Politicians, by Sir
Francis Carruthers Gould, **2826-74**

O'FERRALL, Richard More
(1797-1880) Governor of Malta

54 *See Groups:* The House of Com-
mons, 1833, by Sir George Hayter

OFFA (d.796) King of Mercia

4152 Silver penny 1.6 ($\frac{5}{8}$) diameter
Unknown artist, inscribed
Given in memory of Richard Cyril
Lockett, 1960

Strong

OGILVIE-GRANT, Francis William,
6th Earl of Seafield *See* SEAFIELD

OGLE, Chaloner Blake
(c.1765-1857)

999 *See Groups:* The Trial of
Queen Caroline, 1820, by Sir
George Hayter

OGLETHORPE, James Edward
(1696-1785) Founder of Georgia

926 *See Groups:* The Committy
of the House of Commons (the
Gaols Committee), by William
Hogarth

2153a Panel, feigned oval
14 x 11.4 (5½ x 4½)
Alfred Edmund Dyer after William
Verelst, c.1927 (c.1735-6)
Purchased, 1927

Kerslake

O'HARA, James, 2nd Baron
Tyrawley *See* TYRAWLEY

O'KEEFFE, John (1747-1833)
Dramatist

165 Canvas 74.3 x 61 (29¼ x 24)
Thomas Lawranson, inscribed, 1786
Purchased, 1863

OLDFIELD, Anne (1683-1730)
Actress

431 Canvas 72.4 x 61 (28½ x 24)
Unknown artist
Purchased, 1876

Piper

OLIVER, Anne
Wife of Peter Oliver

4853A (reverse of no.**4853**,
Peter Oliver)
Miniature on card, oval 8.6 x 6.7
($3\frac{3}{8}$ x $2\frac{5}{8}$)
Peter Oliver, signed with initials
and inscribed
Given by NACF, 1971

OLIVER, Isaac (c.1565-1617)
Miniaturist

4852 Miniature on vellum, oval
6.4 x 5.1 (2½ x 2)
Self-portrait, c.1590
Purchased with help from H.M.
Government, 1971

OLIVER, Peter (1594-1648)
Miniaturist; eldest son of Isaac
Oliver

4853 (With miniature of his wife
on reverse)
Miniature on card, oval 8.6 x 6.7
($3\frac{3}{8}$ x $2\frac{5}{8}$)
Self-portrait, signed with initials
and inscribed, c.1625-30
Given by NACF, 1971

O'LOGHLEN, Sir Colman Michael,
Bt (1819-77)
Irish lawyer and politician

2735 Water-colour 30.5 x 18.4
(12 x 7¼)
Adriano Cecioni
(*VF* 28 Sept 1872)
Purchased, 1934

O'MALLEY, George (d.1843)
Major-General

3741 *See Collections:* Studies
for The Waterloo Banquet at
Apsley House, 1836, by William
Salter, **3689-3769**

OMAR PASHA (formerly Michael
Lattas) (1806-71) Turkish general

P49 *See Groups:* The Council of
War on the day of the taking of the
Mamelon Quarries, 7 June 1855,
by Roger Fenton

OMMANNEY, Sir Erasmus
(1814-1904) Admiral

1219 Canvas 39 x 32.4
(15⅜ x 12¾)
Stephen Pearce, exh 1861
Bequeathed by John Barrow, 1899
See Collections: Arctic Explorers,
1850-86, by Stephen Pearce,
905-24 and **1209-27**

Ormond

O'NEILL, Eliza *See* BECHER

ONSLOW, George Onslow, 1st Earl
of (1731-1814) Politician

5212 Miniature silhouette, oval
7.6 x 6 (3 x 2⅜) *sight*
John Field
Purchased, 1978

ONSLOW, Arthur (1691-1768)
Speaker of the House of Commons

1940 Canvas 76.2 x 63.5 (30 x 25)
After Hans Hysing (1728)
Transferred from the Speaker's
House, 1922, in exchange for
former NPG no.**559**

926 *See Groups:* The Committy
of the House of Commons (the
Gaols Committee), by William
Hogarth

4855(48) Ink 21.6 x 15.2 (8½ x 6)
George Townshend, 4th Viscount
and 1st Marquess Townshend,
inscribed
Bequeathed by R.W.Ketton-Cremer,
1971
See Collections: The Townshend
Album, **4855(1-73)**

Kerslake

ONSLOW, Denzil Roberts
(1839-1908) MP for Guildford

2269 *See Collections:* The Parnell
Commission, 1888-9, by Sydney
Prior Hall, **2229-72**

OPIE, Amelia (1769-1853)
Novelist and poet; second wife of
John Opie

765 Canvas 74.3 x 62.2
(29¼ x 24½)
John Opie, 1798
Purchased, 1887

1081 Bronze medallion 13.3
(5¼) diameter
Pierre David D'Angers, incised
and dated 1829
Given by Sir Lionel Cust, 1897

599 *See Groups:* The Anti-Slavery
Society Convention, 1840, by
Benjamin Robert Haydon

OPIE, John (1761-1807)
Portrait and history painter

47 Canvas 74.3 x 62.2
(29¼ x 24½)
Self-portrait, 1785
Purchased, 1858

ORAM, Edward (fl.1770-1800)
Landscape painter

3112 Pencil 16.5 x 13.7 (6½ x 5⅜)
John Flaxman, signed and inscribed
Purchased, 1941

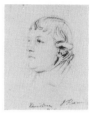

ORANMORE AND BROWNE,
Dominick Browne, 1st Baron
(1787-1860) MP for County Mayo

54 *See Groups:* The House of Commons, 1833, by Sir George Hayter

ORCHARD, William Edwin
(1877-1955) Roman Catholic
priest and theologian

4466 Canvas 101.6 x 76.2
(40 x 30)
Alphaeus Philemon Cole, signed
and dated 1941
Given by the artist, 1965

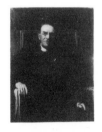

ORCHARDSON, Sir William
Quiller (1832-1910)
Portrait and subject painter

2117 Canvas 69.9 x 54.6
(27½ x 21½)
Henry Weigall, c.1878-81
Purchased, 1926

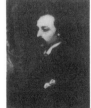

1833 *See Groups:* Private View
of the Old Masters Exhibition,
Royal Academy, 1888, by Henry
Jamyn Brooks

2820 *See Groups:* The Royal
Academy Conversazione, 1891, by
G.Grenville Manton

4245 *See Groups:* Hanging
Committee, Royal Academy, 1892,
by Reginald Cleaver

5005 Water-colour 35.2 x 21
(13⅞ x 8¼)
Sir Leslie Ward, signed *Spy*
(*VF* 24 March 1898)
Purchased, 1974

3166 *See Unknown Sitters IV*

ORDE-POWLETT, William Henry,
3rd Baron Bolton *See* BOLTON

ORFORD, Robert Walpole, 1st
Earl of (1676-1745) Prime Minister

3220 Canvas 91.4 x 71.1 (36 x 28)
Sir Godfrey Kneller, c.1710-15
Kit-cat Club portrait
Given by NACF, 1945

Piper

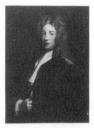

2126 Terracotta bust 66 (26) high
John Michael Rysbrack, incised
and dated 1738
Purchased, 1926

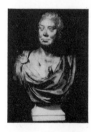

70 Canvas 125.7 x 100.3
(49½ x 39½)
Studio of Jean Baptiste van Loo,
inscribed (1740)
Purchased, 1859. *Beningbrough*

Kerslake

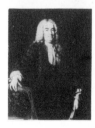

ORFORD, George Walpole, 3rd
Earl of (1730-91)
Rake and eccentric

4855(66) *See Collections:* The
Townshend Album, **4855(1-73)**

ORFORD, Horatio (Horace)
Walpole, 4th Earl of (1717-97)
Writer and collector

988 Canvas 39.4 x 31.8
(15½ x 12½)
John Giles Eccardt, inscribed, 1754
Purchased, 1895

1161 Pencil 24.8 x 18.4 (9¾ x 7¼)
George Dance, signed and dated
1793
Purchased, 1898

3631 Pencil 25.7 x 19.7
($10\frac{1}{8}$ x 7¾)
Sir Thomas Lawrence, 1795
Given by Mrs Maud C.Holland,
1948. *Beningbrough*

116 *See Unknown Sitters III*

ORLEANS, Prince Henri d'
(1867-1901)
Son of Duc de Chartres

4707(23) *See Collections: Vanity
Fair* cartoons, 1869-1910, by
various artists, **2566-2606**, etc

ORLEANS, Henrietta Anne,
Duchess of (1644-70)
Daughter of Charles I

228 Canvas, feigned oval
78.7 x 62.2 (31 x 24½)
After Pierre Mignard (?)
(c.1665-70?)
Purchased, 1867

1606 Enamel miniature on gold
1.9 x 1.6 (¾ x $\frac{5}{8}$)
Attributed to Jean Petitot after
Pierre Mignard (?)
Given by Sir Herbert Henry
Raphael, Bt, 1911

Piper

ORLEANS, Philippe, 9th Duc d'
(1869-1926)
Head of the Bourbon family

4707(24) *See Collections: Vanity
Fair* cartoons, 1869-1910, by
various artists, **2566-2606**, etc

ORMONDE, James Butler, 1st
Duke of (1610-88)
Royalist soldier and statesman

370 Canvas 134 x 108
(52¾ x 42½)
After Sir Peter Lely (c.1665?)
Purchased, 1873

Piper

ORMONDE, James Butler, 2nd
Duke of (1665-1745)
Soldier and Jacobite

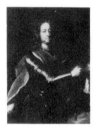

78 Canvas 126.4 x 101.6
(49¾ x 40)
By or after Michael Dahl, 1714
Purchased, 1859

Piper

ORPEN, Sir William (1878-1931)
Painter

5267 Pencil 19.1 x 14.6 (7½ x 5¾)
Self-portrait, inscribed, c.1898
Purchased, 1979

2556 *See Groups:* The Selecting
Jury of the New English Art Club,
1909, by Sir William Orpen

2638 Pencil and wash 33 (13)
diameter
Self-portrait, signed, inscribed and
dated 1910
Given by Mrs C.Philippa Holliday,
1933

ORR, Alexandra Sutherland (née Leighton) (1828-1903)
Sister of Lord Leighton; biographer of Robert Browning

2141(a) Chalk and water-colour 26.7 x 22.6 (10½ x 8⅞)
Frederic Leighton, Baron Leighton, signed, 1845-50
Given by Carolin Nias, in memory of her mother, Lady Nias, 1926
See Collections: Lord Leighton and his family, by Lord Leighton and Edward(?) Foster, **2141** and **2141(a-d)**

ORR, Patricia (née Morris) (d.1854)
Sister of Sophia Finlay

P6(113) *See Collections:* The Hill and Adamson Albums, 1843-8, by David Octavius Hill and Robert Adamson, **P6(1-258)**

ORRERY, Charles Boyle, 4th Earl of (1674-1731) Soldier and scholar

894 Canvas 124.5 x 102.9 (49 x 40½)
After Charles Jervas (?), inscribed (1707)
Purchased, 1892

Piper

ORTON, Arthur (1834-98)
The Tichborne claimant

2173(39) *See Collections:* Book of sketches by Sebastian Evans, **2173(1-70)**

3495 Pen and ink 29.8 x 23.8 (11¾ x 9⅜)
Harry Furniss, signed with initials and inscribed
Purchased, 1947
See Collections: Prominent Men, c.1880-c.1910, by Harry Furniss **3337-3535** and **3554-3620**

OSBORN, Sherard (1822-75)
Rear-Admiral and writer

1224 Canvas 39.4 x 32.7 (15½ x 12⅞)
Stephen Pearce, exh 1847
Bequeathed by John Barrow, 1899
See Collections: Arctic Explorers, 1850-86, by Stephen Pearce, **905-24** and **1209-27**

916 *See Collections:* Arctic Explorers, 1850-86, by Stephen Pearce, **905-24** and **1209-27**

Ormond

OSBORNE, Dorothy
See TEMPLE, Lady

OSBORNE, Francis, 5th Duke of Leeds *See* LEEDS

OSBORNE, John (b.1929)
Playwright and actor

4529(258,258a,259) *See Collections:* Working drawings by Sir David Low, **4529(1-401)**

OSBORNE, Malcolm (1880-1963)
Engraver and teacher

4357 Chalk and water-colour 47 x 36.8 (18½ x 14½)
Dorothy Hawksley, signed and dated 1959
Purchased, 1964

OSBORNE, Thomas, 1st Duke of Leeds *See* LEEDS

O'SHEA, William Henry (1840-1905) Irish politician

2251 *See Collections:* The Parnell Commission, 1888-9, by Sydney Prior Hall, **2229-72**

OSSINGTON, John Denison, 1st Viscount (1800-73) Speaker of the House of Commons

54 *See Groups:* The House of Commons, 1833, by Sir George Hayter

OSSORY, Thomas Butler, Earl of
(1634-80)
Courtier and man of action

371 Canvas 123.2 x 100.3
(48½ x 39½)
Studio of Sir Peter Lely, c.1678
Purchased, 1873

Piper

OSWALD, Richard Alexander
(1771-1841) MP for Ayrshire

54 *See Groups:* The House of Commons, 1833, by Sir George Hayter

OUGHTRED, William (1575-1660)
Mathematician

2906a Water-colour 30.5 x 24.4
(12 x 9⅝)
George Perfect Harding after
engraving by Wenceslaus Hollar,
signed with initials, inscribed on
mount (1644)
Given by Arthur Hutchinson, 1936

Strong

OULESS, Walter William
(1848-1933) Painter

2820 *See Groups:* The Royal
Academy Conversazione, 1891,
by G.Grenville Manton

OUSELEY, Sir Frederick Gore, Bt
(1825-89) Musician and composer

P7(10) Photograph: albumen print
14 x 11.7 (5½ x 4⅝)
Charles Lutwidge Dodgson,
inscribed below image, c.1856
Purchased with help from Kodak
Ltd, 1973
See Collections: Lewis Carroll at
Christ Church, by Charles Lutwidge
Dodgson, **P7(1-37)**

P37 *See Collections:* Prints from
two albums, 1852-60, by Charles
Lutwidge Dodgson and others,
P31-40

OUTRAM, Sir James, Bt (1803-63)
Lieutenant-General

661 Canvas 70.5 x 50.5
(27¾ x 19⅞)
Thomas Brigstocke, c.1863
Purchased, 1882

Ormond

OVERBURY, Sir Thomas
(1581-1613) Poet and courtier

3090(1) Water-colour, oval
11.7 x 9.5 (4⅝ x 3¾)
Sylvester Harding after Marcus
Gheeraerts the Younger, signed
and inscribed below image
Purchased, 1940

2613 *See Unknown Sitters I*

Strong

OWEN, Edward Rodney (b.1856)
Sportsman

3010 Water-colour 34.3 x 23.5
(13½ x 9¼)
Sir Leslie Ward, signed *Spy*
(*VF* 28 Nov 1891)
Purchased, 1937

OWEN, Frank (b.1905)
Journalist, writer and broadcaster

4529(260-2) *See Collections:*
Working drawings by Sir David
Low, **4529(1-401)**

OWEN, Hugh (1784-1861)
Soldier in service of Portugal

975 Miniature on ivory, oval
6.7 x 5.4 (2⅝ x 2⅛)
Unknown artist, 1808
Given by the sitter's son, Hugh
Owen, 1895

Ormond

OWEN, John (1616-83)
Puritan divine

115 Canvas 74.9 x 62.2
(29½ x 24½)
Unknown artist
Purchased, 1860

Piper

OWEN, Sir Richard (1804-92)
Naturalist

938 Canvas 142.9 x 111.8
(56¼ x 44)
Henry William Pickersgill, c.1845
Given by the sitter's daughter-in-
law, Mrs Emily Owen, 1893

2515(98) *See Collections:*
Drawings of Prominent People,
1823-49, by William Brockedon,
2515(1-104)

P106(15) Photograph: albumen
print, arched top 20 x 14.6
(7⅞ x 5¾)
Maull & Polyblank, c.1855
Purchased, 1978
See Collections: Literary and
Scientific Portrait Club, by Maull &
Polyblank, **P106(1-20)**

Ormond

OWEN, Robert (1771-1858)
Pioneer of practical socialism

2507 Water-colour 7.6 x 5.1 (3 x 2)
Auguste Hervieu, signed, inscribed
and dated 1829
Given by Arthur Myers Smith, 1931

943 Canvas 27.3 x 21.6
(10¾ x 8½)
William Henry Brooke, 1834
Given by Mrs H.Dixon, 1893

4521 Water-colour 30.5 x 22.9
(12 x 9)
Ebenezer Morley, signed, inscribed,
and dated 1834 on reverse
Purchased, 1966

602 Bronze medallion, oval
38.1 x 35.6 (15 x 14)
Julian Leverotti after a life-mask by
James S.Deville, incised
Given by Joseph W.Corfield, 1880

328 Chalk 35.6 x 25.4 (14 x 10)
Unknown artist, signed in
monogram *SB*, inscribed and
dated 1851
Purchased, 1871

OWEN, Samuel (1769-1857)
Water-colourist

3129 Water-colour 19.1 x 16.5
(7½ x 6½)
T.Montague, signed and dated 1795
Given by Edward H.Ezard, 1942

OXFORD, Edward de Vere, 17th
Earl of (1550-1604) Courtier

L111 Canvas 74.3 x 63.5
(29¼ x 25)
After a portrait of 1575, inscribed
Lent by the Duke of Portland,
1964. *Montacute*

OXFORD, Henry de Vere, 18th
Earl of (1593-1625)
Hereditary Great Chamberlain

950 Panel, feigned oval
43.5 x 34.3 (17⅛ x 13½)
Unknown artist
Purchased, 1893. *Montacute*

Strong

OXFORD, Aubrey de Vere, 20th
Earl of (1626-1703) Soldier

4941 Canvas 229.9 x 146.1
(90½ x 57½)
Sir Godfrey Kneller, inscribed,
c.1690
Purchased, 1973

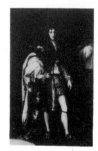

OXFORD, Robert Harley, 1st
Earl of (1661-1724) Politician

624 *See Groups:* Queen Anne and
the Knights of the Garter, 1713, by
Peter Angelis

Continued overleaf

4011 Canvas 243.8 x 148.6
(96 x 58½)
Sir Godfrey Kneller, signed and
dated 1714
Purchased, 1957

16 Canvas 124.5 x 99.1 (49 x 39)
After Sir Godfrey Kneller, reduced
copy (1714)
Purchased, 1857

Piper

OXFORD, Edward Harley, 2nd
Earl of (1689-1741)
Patron of letters and collector

1808 Canvas 75.6 x 62.5
(29¾ x 24$\frac{5}{8}$)
Attributed to Jonathan Richardson
Purchased, 1918. *Beningbrough*

Kerslake

OXFORD AND ASQUITH, Herbert
Henry Asquith, 1st Earl of
(1852-1928) Prime Minister

4945 Water-colour 36.8 x 26.7
(14½ x 10½)
Sir Leslie Ward, signed *Spy*
(*VF* 14 July 1904)
Purchased, 1973

3402 *See Collections:* Prominent
Men, c.1880-c.1910, by Harry
Furniss, **3337-3535** and **3554-3620**

2302,2303,2307 *See Collections:*
Miscellaneous drawings . . . by
Sydney Prior Hall, **2282-2348** and
2370-90

2866a *See Collections:* Caricatures
of Politicians, by Sir Francis
Carruthers Gould, **2826-74**

2463 *See Groups:* Statesmen of
World War I, by Sir James Guthrie

3544 (study for *Groups,* **2463**)
Canvas 48.3 x 35.6 (19 x 14)
Sir James Guthrie
Bequeathed by Sir Frederick
C. Gardiner, 1947

2361 Canvas 86.4 x 62.2
(34 x 24½)
André Cluysenaar, 1919
Purchased with help from Lord
Duveen, 1929

4387 Pencil 38.1 x 25.1 (15 x 9$\frac{7}{8}$)
Frank Dobson, signed and dated
1920
Purchased, 1964

4529(2) *See Collections:* Working
drawings by Sir David Low,
4529(1-401)

OXFORD AND ASQUITH, Emma
(Margot Tennant), Countess of
(1864-1945)
Writer; lady of taste and fashion

1833 *See Groups:* Private View of
the Old Masters Exhibition, Royal
Academy, 1888, by Henry Jamyn
Brooks

4155 Chalk 54.9 x 39.7
(21$\frac{5}{8}$ x 15$\frac{5}{8}$)
John Singer Sargent, signed
Given by Lord Justice Pearce,
1960

P128 Photograph: bromide print
40 x 31.1 (15¾ x 12¼)
Lucia Moholy, 1935
Purchased, 1979
See Collections: Prominent People,
1935-8, by Lucia Moholy, **P127-33**

PAGET, William Paget, 1st Baron
(1505-63) Secretary of State
and Lord Privy Seal

961 Panel 45.1 x 36.2
(17¾ x 14¼)
Attributed to the Master of the
Stätthalterin Madonna, 1549?
Purchased, 1894

Strong

PAGET, Sir Arthur (1771-1840)
Diplomat

4026(43) *See Collections:*
Drawings of Men about Town,
1832-48, by Alfred, Count D'Orsay
4026(1-61)

PAGET, Sir Edward (1775-1849)
General

3247 Miniature on ivory
10.8 x 8.9 (4¼ x 3½)
Robert Home
Purchased, 1945

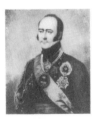

PAGET, Francis (1851-1911)
Bishop of Oxford

3002 Water-colour 36.8 x 26.7
(14½ x 10½)
Sir Leslie Ward, signed *Spy*
(*VF* 22 Nov 1894)
Purchased, 1938

PAGET, Frederick (1807-66)
MP for Beaumaris

54 *See Groups:* The House of Com-
mons, 1833, by Sir George Hayter

PAGET, Henry William,
1st Marquess of Anglesey
See ANGLESEY

PAGET, Sir James, Bt (1814-99)
Surgeon

1635 Chalk 59.1 x 45.1
(23¼ x 17¾)
George Richmond, signed and
dated 1867
Purchased, 1911

PAINE, James, the Younger
(1745-1829) Architect

213 *See under* James Barry

PAINE, Thomas (1737-1809)
Author of *The Rights of Man*

897 Canvas 40.6 x 30.5 (16 x 12)
Auguste Millière after engraving of
1793 by William Sharp after
George Romney, inscribed, c.1880
Given by Henry Willett, 1892

PAKENHAM, Sir Edward
(1778-1815) Major-General

1914(9) Water-colour 19.3 x 16.2
(7⅝ x 6⅜)
Thomas Heaphy
Purchased, 1921
See Collections: Peninsular and
Waterloo Officers, 1813-14, by
Thomas Heaphy, **1914(1-32)**

PAKENHAM, Sir William
(1861-1933) Admiral

1913 *See Groups:* Naval Officers
of World War I, by Sir Arthur
Stockdale Cope

PAKINGTON, Sir John Somerset,
1st Baron Hampton
See HAMPTON

PALEY, William (1743-1805)
Theological writer

3659 Canvas 149.9 x 119.4
(59 x 47)
George Romney, 1789
Purchased, 1949

145 Canvas 73 x 61 (28¾ x 24)
Sir William Beechey after George
Romney, reduced copy (1789)
Purchased, 1862

PALGRAVE, Elizabeth (née Turner), Lady
Wife of Sir Francis Palgrave

2896 With Miss Turner (probably her sister, Eleanor Jane) (right)
Ink 18.4 x 18.1 (7¼ x 7⅛)
Thomas Phillips
Given by Walter Bennett, 1936

PALGRAVE, Sir Francis (born Cohen) (1788-1861) Historian

2069 Plaster cast of medallion 27.6 (10⅞) diameter
Thomas Woolner, incised and dated 1861
Given by the sitter's granddaughters, the Misses Palgrave, 1924

Ormond

PALGRAVE, Francis Turner (1824-97) Poet and critic; son of Sir Francis Palgrave

2070 Chalk and pencil 61.6 x 48.3 (24¼ x 19)
Samuel Laurence, signed and dated 1872
Given by the sitter's daughters, the Misses Palgrave, 1924

PALGRAVE, William Gifford (1826-88) Jesuit and diplomat

2071 Plaster cast of medallion 24.8 (9¾) diameter
Thomas Woolner, incised with initials and dated 1864
Given by the sitter's nieces, the Misses Palgrave, 1924

PALMER, Sir Charles Mark, Bt (1822-1907) Shipowner, ironmaster and politician

4730 Water-colour 30.8 x 18.1 (12⅛ x 7⅛)
Carlo Pellegrini, signed *Ape*
(*VF* 18 Oct 1884)
Purchased, 1970

PALMER, Sir Geoffrey, Bt (1598-1670) Attorney-General

4622 Canvas 125.4 x 102.5 (49⅜ x 40⅜)
Studio of Sir Peter Lely, c.1660
Purchased, 1968

2403 Water-colour 18.9 x 13.8 (7½ x 5⅜)
Sylvester Harding after Sir Peter Lely, signed below image (c.1663)
Purchased, 1929
See Collections: Copies of early portraits, by George Perfect Harding and Sylvester Harding, **1492,1492(a-c)** and **2394-2419**

PALMER, John (1742-1818)
Originator of mail coaches

4929 Pencil 30.5 x 22.5 (12 x 8⅞)
George Dance, signed and dated 1793
Purchased, 1973

PALMER, John (1742?-98)
Actor

2086 Canvas 74.3 x 49.5 (29¼ x 19½)
Henry Walton
Bequeathed by John Lane, 1925

PALMER, John Hinde (1808-84)
Politician

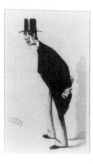

4731 Water-colour 30.8 x 18.1 (12⅛ x 7⅛)
Sir Leslie Ward, signed *Spy*
(*VF* 28 July 1883)
Purchased, 1970

PALMER, Robert (1793-1872)
MP for Berkshire

54 *See Groups:* The House of Commons, 1833, by Sir George Hayter

PALMER, Roundell, 1st Earl of
Selbourne *See* SELBOURNE

PALMER, Samuel (1805-81)
Landscape painter and illustrator

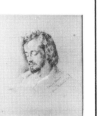

2154 Pencil, pen and ink
23.8 x 20.3 (9$\frac{3}{8}$ x 8)
George Richmond, inscribed,
c.1829
Given by the Misses F.M. and
E.Redgrave, 1927

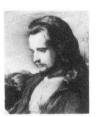

2223 Miniature on ivory 8.3 x 7
(3¼ x 2¾)
George Richmond, inscribed and
dated on back-card, 1829
Purchased, 1928

2155 Pencil 16.5 x 12.4 (6½ x 4$\frac{7}{8}$)
Charles West Cope, inscribed
Given by the Misses F.M. and
E.Redgrave, 1927

Ormond

PALMERSTON, Henry Temple,
3rd Viscount (1784-1865)
Prime Minister

751 Water-colour 26 x 21.6
(10¼ x 8½)
Thomas Heaphy, signed and dated
1802
Given by the Earl of Chichester,
1886

54 *See Groups:* The House of Com-
mons, 1833, by Sir George Hayter

1025 Canvas 94 x 73.7 (37 x 29)
John Partridge, 1844-5
Given by Evelyn Ashley, 1896

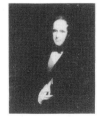

342,343 *See Groups:* The Fine
Arts Commissioners, 1846, by
John Partridge

1125,1125a *See Groups:* The
Coalition Ministry, 1854, by Sir
John Gilbert

3953 Canvas 49.5 x 38.1
(19½ x 15)
Frederick Cruikshank, c.1855
Lent by Earl Mountbatten, 1961

2226 Wax relief, oval 18.4 x 13.3
(7¼ x 5¼)
Richard Cockle Lucas, incised and
dated 1856
Purchased, 1928

4969 *See Groups:* Queen Victoria
Presenting a Bible in the Audience
Chamber at Windsor, by Thomas
Jones Barker

4508 Wedgwood parian-ware bust
44.5 (17½) high
Edward William Wyon, incised,
c.1865
Purchased, 1966

1206 Plaster cast of bust 76.2 (30)
high
George Gammon Adams, c.1867
Purchased, 1899

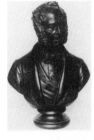

Ormond

PALMERSTON, Emily Mary (née
Lamb), Viscountess (1787-1869)
Whig hostess; wife of 3rd Viscount
Palmerston

3954 Chalk and water-colour
45.7 x 41.3 (18 x 16¼)
Attributed to Ebenezer Butler
Morris
Lent by Earl Mountbatten, 1961

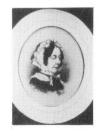

PANIZZI, Sir Anthony (1797-1879)
Principal Librarian of the British
Museum

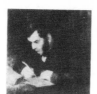

1010 Canvas 75.6 x 75.2
(29¾ x 29⅝)
George Frederic Watts, c.1847
Given by the artist, 1895

2187 Wax medallion, oval
17.1 x 13 (6¾ x 5⅛)
Richard Cockle Lucas, incised and
dated 1850
Purchased, 1928

2736 Pencil, water-colour and
gouache 30.1 x 17.4 (11⅞ x 6⅞)
Carlo Pellegrini, signed *Ape*
(*VF* 17 Jan 1874)
Purchased, 1934

Ormond

PANKHURST, Dame Christabel
(1880-1958) Militant suffragette;
daughter of Emmeline Pankhurst

4207 Pencil 20 x 16.2 (7⅞ x 6⅜)
Jessie Holliday, signed in monogram
Given by wish of Iolo A.Williams,
1961

PANKHURST, Emmeline
(1858-1928)
Militant suffragette

2360 Canvas 78.7 x 61.6
(31 x 24¼)
Georgina Brackenbury, 1927
Given by a Memorial Committee,
1929

PANKHURST, Sylvia (1882-1960)
Militant suffragette; daughter of
Emmeline Pankhurst

4999 Chalk 66.3 x 51.1
(26⅛ x 20⅛)
Self-portrait, inscribed
Given by S.E.Boucher, 1974

4244 Chalk 29.8 x 25.4 (11¾ x 10)
Herbert Cole, signed with initials,
c.1925
Given by the sitter's son, Richard
Pankhurst, 1961

PANMURE, Fox Maule-Ramsay,
2nd Baron *See* DALHOUSIE

PAPILLON, Thomas (1623-1703)
Merchant and politician

5188 Canvas, feigned oval
75.9 x 62.9 (29⅞ x 24¾)
Sir Godfrey Kneller, signed,
inscribed, and dated 1698 on
reverse
Purchased, 1978. *Beningbrough*

PAPWORTH, John Buonarotti
(1775-1847) Architect

2515(53) Pencil 35.9 x 26
(14⅛ x 10¼)
William Brockedon
Lent by NG, 1959
See Collections: Drawings of
Prominent People, 1823-49, by
William Brockedon, **2515(1-104)**

PARK, Mungo (1774-1806)
Explorer

1104 Miniature on ivory, oval
8.3 x 7 (3¼ x 2¾)
After Henry Edridge
Given by L.W.Adamson, 1897

4924 Water-colour 22.9 x 15.2
(9 x 6)
Thomas Rowlandson, inscribed,
c.1805
Purchased, 1972

PARKE, James, Baron Wensleydale
See WENSLEYDALE

PARKER, Sir Gilbert, Rt
(1862-1932) Novelist

3498 *See Collections:* Prominent
Men, c.1880-c.1910, by Harry
Furniss, **3337-3535** and **3554-3620**

PARKER, Henry Perlee
(1795-1873) Painter

4972 Board, oval 34 x 27.6
(13⅜ x 10⅞)
Raphael Hyde Parker (his son)
Given by the sitter's great-grand-
daughter, Dr Kathleen Rutherford,
1974

PARKER, John, 1st Earl of Morley
See MORLEY

PARKER, Joseph (1830-1902)
Congregationalist divine

2073 Plaster cast of bust 38.1 (15)
high
Charles Bell Birch, incised and
dated 1883
Given by the artist's nephew,
George von Pirch, 1924

3496,3497,3595 *See Collections:*
Prominent Men, c.1880-c.1910, by
Harry Furniss, **3337-3535** and
3554-3620

PARKER, Louis Napoleon
(1852-1944)
Musician, playwright and inventor

3499 *See Collections:* Prominent
Men, c.1880-c.1910, by Harry
Furniss, **3337-3535** and **3554-3620**

PARKER, Thomas, 1st Earl of
Macclesfield
See MACCLESFIELD

PARKER, Thomas Augustus
Wolstenholme, 9th Earl of
Macclesfield
See MACCLESFIELD

PARKES, Sir Henry (1815-96)
Australian statesman

1480 Pencil, oval 30.5 x 24.8
(12 x 9¾)
Julian Rossi Ashton, signed and
dated 1891
Purchased, 1907

PARKINSON, Edward (d.1858)
Colonel

3742 *See Collections:* Studies for
The Waterloo Banquet at Apsley
House, 1836, by William Salter,
3689-3769

PARNELL, Charles Stewart
(1846-91)
Irish patriot and politician

5256 *See Groups:* The Lobby of
the House of Commons, 1886, by
Liberio Prosperi

2293 *See Collections:*
Miscellaneous drawings . . . by
Sydney Prior Hall, **2282-2348** and
2370-90

2229,2242-4,2250 *See Collections:*
The Parnell Commission, 1888-9,
by Sydney Prior Hall, **2229-72**

2850 *See Collections:*
Caricatures of Politicians, by Sir
Francis Carruthers Gould, **2826-74**

1087 Plaster cast of bust 74.9
(29½) high
Mary Grant, incised and dated 1892
Purchased, 1897

PARR, Samuel (1747-1825)
Pedagogue and Whig pamphleteer

9 Canvas 90.2 x 69.9 (35½ x 27½)
George Dawe, inscribed, replica,
c.1813
Purchased, 1857

PARR, Thomas (1483?-1635)
Centenarian

385 Canvas 105.4 x 82.6
(41½ x 32½)
After a portrait of c.1635
Purchased, 1873

Piper

PARRATT, Sir Walter (1841-1924)
Composer and organist

4944 Pastel 53.3 x 35.3
(21 x 13⅞)
Miss E.M.Ellison, c.1890
Given by the artist's son, Group
Captain M.O.Richardson, 1973

4791 Sanguine and white
33.7 x 24.1 (13¼ x 9½)
Sir William Rothenstein, c.1921
Purchased, 1970

PARRY, Sir Charles, Bt
(1848-1918) Composer

3877 Pencil 37.5 x 25.4
(14¾ x 10)
Sir William Rothenstein, signed and
dated 1897
Given by the Rothenstein Memorial
Trust, 1953

PARRY, John (1776-1851)
Composer

5152 Pencil 15.9 x 12.1 (6¼ x 4¾)
Abraham Wivell, signed and dated
1830
Given by Hugh S.Pocock, 1977

PARRY, John Humffreys
(1816-80) Serjeant-at-Law

2737 Water-colour 31.8 x 16.2
(12½ x 6⅜)
Sir Leslie Ward, signed *Spy*,
inscribed and dated 1873
(*VF* 13 Dec 1873)
Purchased, 1934

PARRY, Sir William Edward
(1790-1855) Rear-Admiral

5053 Canvas 128 x 101.6
(50⅜ x 40)
Samuel Drummond, eng 1820
Purchased, 1975

912 (study for *Groups,* **1208**)
Canvas 38.4 x 32.4 (15⅛ x 12¾)
Stephen Pearce, 1850
Bequeathed by Lady Franklin,
1892
See Collections: Arctic Explorers,
1850-86, by Stephen Pearce,
905-24 and **1209-27**

1208 *See Groups:* The Arctic
Council, 1851, by Stephen Pearce

Ormond

PARSONS, Alfred William
(1847-1920) Painter and illustrator

2674 Pencil 18.7 x 16.8 (7⅜ x 6⅝)
Self-portrait
Given by Harold Hartley, 1934

PARSONS, James (1705-70)
Physician and antiquary

560 Canvas 76.2 x 63.5 (30 x 25)
Benjamin Wilson, inscribed and
dated 1762 on reverse
Transferred from BM, 1879

Kerslake

PARSONS, Laurence, 4th Earl of
Rosse *See* ROSSE

PARTINGTON, Miles (b.1751)
Apothecary and pioneer of
electricity

4205 Pencil 26 x 19.4 (10¼ x 7⅝)
George Dance, signed and dated
1800
Given by wish of Iolo A.Williams,
1961

PARTRIDGE, Sir Bernard
(1861-1945) Cartoonist

3948 Chalk and wash 27.3 x 21
(10¾ x 8¼)
Self-portrait, signed in monogram,
1894
Given by D.Pepys Whiteley, 1955

4234 Millboard 48.3 x 30.5
(19 x 12)
Ralph Peacock
Bequeathed by the sitter's widow,
1961

PARTRIDGE, Richard (1805-73)
Surgeon

4235 *See Unknown Sitters IV*

PASSFIELD, Sidney Webb, Baron
(1859-1947)
Social reformer and historian

2068 Miniature on ivory, oval
11.4 x 8.9 (4½ x 3½)
Lilian Mary Mayer
Given by the artist's husband,
Sylvain Mayer, 1954

5027 *See Collections:* Miniatures,
1920-30, by Winifred Cécile
Dongworth, **5027-36**

5203 Pencil 38.1 x 29.8
(15 x 11¾)
Eric Gill, signed, inscribed and
dated 1927
Purchased, 1978

PASSFIELD, Beatrice Webb (née
Potter), Lady (1858-1943)
Social reformer and historian

4066 Canvas 52.1 x 41.6
(20½ x 16⅜)
Edward Spilsbury Swinson, signed,
inscribed and dated 1934
Purchased, 1958

PATCH, Thomas (d.1782)
Painter and engraver

4081 Miniature on card 8.6 x 6
(3⅜ x 2⅜)
Unknown artist
Purchased, 1958

PATMORE, Coventry (1823-96)
Poet

1079 Canvas 91.4 x 61 (36 x 24)
John Singer Sargent, signed and
dated 1894
Given by the sitter's widow, 1897

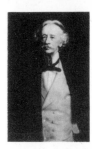

PATON, Mary Ann (Mrs Wood)
(1802-64) Singer

1351 Millboard 61 x 50.5
(24 x 19⅞)
Thomas Sully, 1836
Given by Robert Wood, 1903

Ormond (under Mary Ann Wood)

PATRICK, Simon (1626-1707)
Bishop of Ely

1500 Canvas, feigned oval
74.9 x 62.2 (29½ x 24½)
Sir Peter Lely, c.1668
Purchased, 1908

Piper

PATTI, Adelina (1843-1919)
Singer

3625 Canvas 109.9 x 85.1
(43¼ x 33½)
James Sant, signed in monogram
Bequeathed by the sitter's husband,
Baron O.R.Cederström, 1948

PAULET, Sir Amias (1536?-88)
Keeper of Mary, Queen of Scots

2399　Water-colour 29.2 x 20.3
(11½ x 8)
George Perfect Harding after an
unknown artist, signed, inscribed
and dated 1848
Purchased, 1929
See Collections: Copies of early
portraits, by George Perfect Harding
and Sylvester Harding, **1492, 1492
(a-c)** and **2394-2419**

Strong

PAULET, William, 1st Marquess of
Winchester　*See* WINCHESTER

PAYNE, George (1803-78)
Patron of the turf

2957　With Henry John Rous (right)
Millboard 37.5 x 29.2 (14¾ x 11½)
G. Thompson
Purchased, 1938

4732　Water-colour 30.6 x 18
(12$\frac{1}{8}$ x 7)
Carlo Pellegrini, signed *Ape*
(*VF* 18 Sept 1875)
Purchased, 1970

Ormond

PAYNE, Humfry Gilbert Garth
(1902-36)　Archaeologist

5269　Indian ink and water-colour
64.1 x 30.5 (25¼ x 12) *sight*
Ithell Colquhoun, signed and dated
1934
Purchased, 1979

PAYNE, Roger (1739-97)
Bookbinder

2430　*See Unknown Sitters III*

PEACOCK, Sarah (née Love)
Mother of Thomas Love Peacock

3994B　*See under* Thomas Love
Peacock, **3994**

PEACOCK, Thomas Love
(1785-1866)　Novelist and poet

3994　Miniature on ivory, oval
7.6 x 6 (3 x 2$\frac{3}{8}$)
Roger Jean, signed, c.1805
Purchased, 1956. (Miniatures of the
sitter's mother, Sarah, no.**3394B**,
and of a man in late-18th-century
naval uniform, possibly one the
sitter's uncles, Thomas Love or
Lt Love, no. **3994A**, were acquired
from the same source; both by
unknown artists.)

1432　Millboard 16.5 x 14
(6½ x 5½)
Henry Wallis, dated 1858
Purchased, 1906

Ormond

PEARCE, Stephen (1819-1904)
Painter

1381　Canvas 59.7 x 49.5
(23½ x 19½)
Self-portrait, signed on reverse
Bequeathed by the sitter, 1904

PEARS, Sir Peter (b.1910)
Singer

5136　*See under* Benjamin Britten,
Baron Britten

PEARSALL, Robert Lucas
(1795-1856)　Composer

1785　Canvas, oval 53 x 42.5
(20$\frac{7}{8}$ x 16¾)
Philippa Swinnerton Hughes (his
daughter), replica (1849)
Given by William Barclay Squire,
1917

Ormond

PEARSON, George (1751-1828)
Physician and chemist

316a(98) Pencil 43.5 x 29.2
($17\frac{1}{8}$ x 11½)
Sir Francis Chantrey, inscribed
Given by Mrs George Jones, 1871
See Collections: Preliminary
drawings for busts and statues by
Sir Francis Chantrey, **316a(1-202)**

PEARSON, John (1613-86)
Bishop of Chester

635 Line engraving 29.2 x 20.6
(11½ x $8\frac{1}{8}$)
David Loggan, signed, inscribed,
and dated 1682 on plate
Purchased, 1881

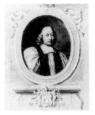

PEASE, Elizabeth
Slavery abolitionist

599 *See Groups:* The Anti-Slavery
Society Convention, 1840, by
Benjamin Robert Haydon

PEASE, Joseph (1772-1846)
Reformer

599 *See Groups:* The Anti-Slavery
Society Convention, 1840, by
Benjamin Robert Haydon

PEASE, Joseph (1799-1872)
Railway projector

54 *See Groups:* The House of Com-
mons, 1833, by Sir George Hayter

PEEK, Sir Henry William, Bt
(1825-98) MP for Mid Surrey

4441 *See Groups:* The Duke and
Duchess of Teck receiving Officers
of the Indian Contingent, 1882, by
Sydney Prior Hall

PEEK, Margaret Maria, Lady
(d.1884)
Wife of Sir Henry William Peek

4441 *See Groups:* The Duke and
Duchess of Teck receiving Officers
of the Indian Contingent, 1882, by
Sydney Prior Hall

PEEK, Richard
Slavery abolitionist

599 *See Groups:* The Anti-Slavery
Society Convention, 1840, by
Benjamin Robert Haydon

PEEL, Arthur Wellesley Peel, 1st
Viscount (1829-1912)
Speaker of the House of Commons

2326 *See Collections:*
Miscellaneous drawings . . . by
Sydney Prior Hall, **2282-2348** and
2370-90

4733 Water-colour 33 x 18.8
(13 x $7\frac{3}{8}$)
Sir Leslie Ward, signed *Spy*
(*VF* 2 July 1887)
Purchased, 1970

4085 Canvas 74.9 x 57.5
(29½ x $22\frac{5}{8}$)
Lance Calkin, signed
Given by the United University
Club, 1958

2851,2852 *See Collections:*
Caricatures of Politicians, by
Sir Francis Carruthers Gould,
2826-74

3403 *See Collections:* Prominent
Men, c.1880-c.1910, by Harry
Furniss, **3337-3535** and **3554-3620**

PEEL, Sir Frederick (1823-1906)
Politician

2980 Water-colour 35.6 x 24.8
(14 x 9¾)
Sir Leslie Ward, signed *Spy*
(*VF* 17 Dec 1903)
Purchased, 1938

PEEL, Sir Robert, Bt
(1788-1850) Prime Minister

795 *See Groups:* Four studies for
Patrons and Lovers of Art, c.1826,
by Pieter Christoph Wonder, **792-5**

54 *See Groups:* The House of Commons, 1833, by Sir George Hayter

316a(99) Pencil, two sketches
48 x 70.2 ($18\frac{7}{8}$ x $27\frac{5}{8}$)
Sir Francis Chantrey, inscribed,
c.1833
Given by Mrs George Jones, 1871
See Collections: Preliminary
drawings for busts and statues by
Sir Francis Chantrey, **316a(1-202)**

2789 *See Groups:* Members of the
House of Lords, c.1835, attributed
to Isaac Robert Cruikshank

772 Panel 45.5 x 37.8
($17\frac{7}{8}$ x $14\frac{7}{8}$)
John Linnell, signed indistinctly
and dated 1838
Purchased, 1887

2772(p.28) *See Collections:* The
Clerk family, Sir Robert Peel,
Samuel Rogers, and others,
1833-57, by Jemima Wedderburn,
2772

342,343 *See Groups:* The Fine
Arts Commissioners, 1846, by
John Partridge

596a Marble bust 42.5 (16¾) high
Matthew Noble, incised and dated
1851, reduced version (1850)
Date of acquisition unknown

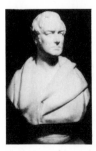

596 Marble bust 78.4 ($30\frac{7}{8}$) high
Matthew Noble, incised and dated
1851
Purchased, 1879

3796 Canvas 240.7 x 147
($94\frac{3}{4}$ x $57\frac{7}{8}$)
Henry William Pickersgill
Given by the 2nd Earl Iveagh,1951

2378 *See Collections:*
Miscellaneous drawings . . . by
Sydney Prior Hall, **2282-2348** and
2370-90

870 *See Unknown Sitters IV*

Ormond

PELHAM, Henry (1695?-1754)
Prime Minister

221 Canvas 127 x 101.6 (50 x 40)
William Hoare, inscribed, 1751(?)
Given by William Jones Lloyd,1866

871 Canvas 123.8 x 102.2
(48¾ x 40¼)
John Shackleton, inscribed,c.1752
Purchased, 1891

Kerslake

PELHAM-HOLLES, Thomas,
1st Duke of Newcastle
See NEWCASTLE

PELISSIER, Aimable Jean Jacques
(Duc de Malakhoff) (1794-1864)
Marshal of France; French
ambassador

P49 *See Groups:* The Council of
War on the day of the taking of the
Mamelon Quarries, 7 June 1855,
by Roger Fenton

PELLEGRINI, Carlo (1839-89)
'Ape'; caricaturist

2933 Water-colour 58.4 x 43.2
(23 x 17)
Attributed to himself, inscribed
and dated 1877
Purchased, 1938

3947 Canvas 38.4 x 29.2
($15\frac{1}{8}$ x 11½)
Sir Henry Thompson, inscribed
Given by Joseph Ceci, 1955

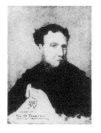

3500,3501 *See Collections:*
Prominent Men, c.1880-c.1910, by
Harry Furniss, **3337-3535** and
3554-3620

PELLEW, Edward, 1st Viscount
Exmouth *See* EXMOUTH

PEMBERTON, Sir Max (1874-1950)
Writer

3502 *See Collections:* Prominent
Men, c.1880-c.1910, by Harry
Furniss, **3337-3535** and **3554-3620**

PEMBROKE, Philip Herbert, 4th
Earl of (1584-1650) Courtier

5187 Canvas 227.5 x 141.9
($89\frac{5}{8}$ x $55\frac{7}{8}$)
Unknown artist, c.1615
Purchased, 1978. *Montacute*

4614 Miniature, oval 3.5 ($1\frac{3}{8}$) high
Attributed to Alexander Cooper
Purchased, 1968

1489 Canvas 52.7 x 43.8
(20¾ x 17¼)
After Sir Anthony van Dyck,
reduced copy (c.1635-40)
Purchased, 1908

Piper

PEMBROKE, Thomas Herbert,
8th Earl of (1656-1733)
Lord High Admiral

5237 Canvas 76.2 x 62.9
(30 x 24¾)
Attributed to John Greenhill,
c.1676
Purchased, 1979

PEMBROKE AND MONTGOMERY,
Ann (Clifford), Countess of
(1590-1676) Landowner

402 Canvas, feigned oval
75.6 x 62.9 (29¾ x 24¾)
Unknown artist, c.1646 or later
Given by Sir George Scharf, 1875

Piper

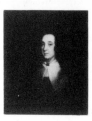

PENDARVES, Edward William
Wynne (1775-1853)
MP for Cornwall West

54 *See Groups:* The House of Com-
mons, 1833, by Sir George Hayter

PENDER, Sir John (1815-96)
Pioneer of submarine telegraphy

2738 Water-colour 30.2 x 18.7
($11\frac{7}{8}$ x $7\frac{3}{8}$)
James Jacques Tissot
(*VF* 28 Oct 1871)
Purchased, 1934

1833 *See Groups:* Private View of
the Old Masters Exhibition, Royal
Academy, 1888, by Henry Jamyn
Brooks

PENDEREL, Humphrey
Royalist; brother of Richard
Penderel

5250 *See Collections:* Charles II's
escape after the Battle of Worcester,
1651, by Isaac Fuller, **5247-51**

PENDEREL, Richard (d.1672)
Royalist

5247,5248 *See Collections:*
Charles II's escape after the Battle
of Worcester, 1651, by Isaac Fuller,
5247-51

PENGELLY, Sir Thomas
(1675-1730)
Chief Baron of the Exchequer

798 *See Groups:* The Court of
Chancery, by Benjamin Ferrers

PENN, Sir William (1621-70)
Admiral

4012 *See Unknown Sitters II*

PENNINGTON, Sir Charles
Richard (1838-1910)
Lieutenant-General

4441 *See Groups:* The Duke and
Duchess of Teck receiving Officers
of the Indian Contingent, 1882,
by Sydney Prior Hall

PENNY, Edward (1714-91)
Portrait and history painter

1437,1437a *See Groups:* The
Academicians of the Royal
Academy, 1771-2, by John Sanders
after Johan Zoffany

PENNY, William (1809-92)
Seaman and explorer

1209 Canvas 127.3 x 100
(50$\frac{1}{8}$ x 39$\frac{3}{8}$)
Stephen Pearce, signed, inscribed
and dated 1853
Bequeathed by John Barrow, 1899
See Collections: Arctic Explorers,
1850-86, by Stephen Pearce,
905-24 and **1209-27**

Ormond

PENRHYN, Edward Douglas-
Pennant, 1st Baron (1800-86)
Politician and landowner

3292 Water-colour 30.8 x 18.1
(12$\frac{1}{8}$ x 7$\frac{1}{8}$)
Sir Leslie Ward, signed *Spy*
(*VF* 25 March 1882)
Purchased, 1934

PENTLAND, John Sinclair, 1st
Baron (1860-1925)
Governor of Madras

3408 *See Collections:* Prominent
Men, c.1880-c.1910, by Harry
Furniss, **3337-3535** and **3554-3620**

PENZANCE, James Wilde, Baron
(1816-99) Judge

2739 Water-colour 30.8 x 18.7
(12$\frac{1}{8}$ x 7$\frac{3}{8}$)
Carlo Pellegrini
(*VF* 18 Dec 1869)
Purchased, 1934

PEPUSCH, John Christopher
(1667-1752) Composer and teacher

2063 Canvas 127 x 102.2
(50 x 40¼)
Thomas Hudson
Purchased, 1924. *Beningbrough*

Kerslake

PEPYS, Charles Christopher,
1st Earl of Cottenham
See COTTENHAM

PEPYS, Elizabeth (1640-69)
Wife of Samuel Pepys

4824 Plaster cast of bust 74.9
(29½) high
After marble attributed to John
Bushnell (1672)
Purchased, 1970

PEPYS, Samuel (1633-1703)
Diarist and naval administrator

211 Canvas 75.6 x 62.9
(29¾ x 24¾)
John Hayls, inscribed, 1666
Purchased, 1866

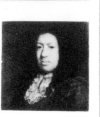

2100 Canvas, oval 73.7 x 58.4
(29 x 23)
John Closterman, c.1690-1700
Given by James Donald Milner,
1925. *Beningbrough*

2092 Canvas 45.7 x 45.1
(18 x 17¾)
Unknown artist
Purchased, 1925

Piper

PERCEVAL, Alexander
(1787-1858) Serjeant-at-Arms

54 *See Groups:* The House of Commons, 1833, by Sir George Hayter

PERCEVAL, John, 1st Earl of
Egmont *See* EGMONT

PERCEVAL, John, 2nd Earl of
Egmont *See* EGMONT

PERCEVAL, Spencer (1762-1812)
Prime Minister

1657 Marble bust 66 (26) high
Studio of Joseph Nollekens based
on death-mask by Nollekens, c.1812
Given by the sitter's great-granddaughter, Mrs F.C. Holland, 1912

1031 Canvas 139.7 x 110.5
(55 x 43½)
George Francis Joseph after death-mask by Joseph Nollekens, signed,
inscribed and dated 1812
Bequeathed by the sitter's granddaughter, Miss Anna Jane Perceval,
1896

4 Canvas 73.7 x 61 (29 x 24)
George Francis Joseph after death-mask by Joseph Nollekens, signed,
inscribed and dated 1812
Given by wish of Sir Robert Harry
Inglis, Bt, 1857

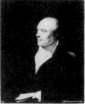

PERCY, Algernon, 10th Earl of
Northumberland
See NORTHUMBERLAND

PERCY (originally Smithson), Sir
Hugh, 1st Duke of Northumberland
See NORTHUMBERLAND

PERCY, Hugh, 3rd Duke of
Northumberland
See NORTHUMBERLAND

PERCY, Thomas (1560-1605)
Organiser of the 'Gunpowder Plot'

334A *See Groups:* The Gunpowder
Plot Conspirators, 1605, by an
unknown artist

PERING, Richard (1767-1858)
Inventor

2515(17) *See Collections:*
Drawings of Prominent People,
1823-49, by William Brockedon,
2515(1-104)

PERKIN, Sir William Henry
(1838-1907)
Invented synthetic dyes

1892 Canvas 124.5 x 92.7
(49 x 36½)
Sir Arthur Stockdale Cope, signed
and dated 1906
Given by a Memorial Committee,
1921

PERKINS, Jacob (1766-1849)
American inventor

2515(7) *See Collections:*
Drawings of Prominent People,
1823-49, by William Brockedon,
2515(1-104)

PERRY, Sir Thomas Erskine
(1806-82) Judge in India

1817 Pencil and red and white
chalk 26 x 31.1 (10¼ x 12¼)
John Linnell, inscribed
Purchased, 1918
See Collections: Drawings by
John Linnell, **1812-18B**

Ormond

PERTH, James Drummond,
4th Earl of (1648-1716)
Lord Chancellor of Scotland

2153 Miniature on cardboard, oval
12.1 x 9.5 (4¾ x 3¾)
After John Riley (c.1680-4)
Bequeathed by William Barclay
Squire, 1927

Piper

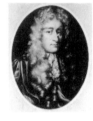

PERY, Edmund Henry, 1st Earl of
Limerick *See* LIMERICK

PERYAM, Sir William (1534-1604)
Judge

477 Water-colour 21.9 x 20.3
(8⅝ x 8)
After an unknown artist (c.1600)
Given by the Society of Judges and
Serjeants-at-Law, 1877

Strong

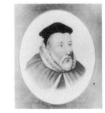

PETERBOROUGH, Charles
Mordaunt, 3rd Earl of (1658-1735)
Soldier

624 *See Groups:* Queen Anne and
the Knights of the Garter, 1713, by
Peter Angelis

PETERKIN, Ishbel Allan (b.1903)
Daughter of James Ramsay
MacDonald

5035 *See Collections:* Miniatures,
1920-30, by Winifred Cécile
Dongworth, **5027-36**

PETERS, Matthew William
(1742-1814) Painter and
Chaplain to the Prince Regent

2169 With Robert West (left)
Charcoal 40.6 x 54.6 (16 x 21½)
Self-portrait, signed and dated 1758
Purchased, 1927

PETHICK-LAWRENCE, Frederick
Pethick-Lawrence, 1st Baron
(1871-1961)
Politician and women's suffragist

4275 Canvas 93 x 72.7
(36⅝ x 28⅝)
Henry Coller, signed, 1933
Given by Miss Esther Knowles,
1962

4280 Wooden head 33 (13) high
Albin Moroder, signed and dated
1949
Given by Miss Theresa Garnett,
1962

PETRE, Sir William (1505?-72)
Secretary of State

3816 Panel 92.4 x 71.1
(36¾ x 28)
Steven van der Meulen, inscribed
and dated 1567
Purchased, 1952. *Montacute*

Strong

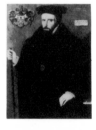

PETRIE, Sir William Matthew
Flinders (1853-1942) Archaeologist

3959 Canvas 69.2 x 61.9
(27¼ x 24⅜)
George Frederic Watts, 1900
Given under the terms of the
artist's will, 1955

4007 Canvas 90.2 x 59.4
(35½ x 23⅜)
Philip de Laszlo, signed and dated
1934
Given by the artist's son, John de
Laszlo, 1956

PETT, Peter (1610-70)
Shipbuilder

1270 Canvas 141 x 156.2
(55½ x 61½)
After Sir Peter Lely (?)
Purchased, 1900

Piper

PETT, Phineas (1570-1647)
Shipbuilder; first Master of the
Shipwrights' Company

2035 Panel 118.7 x 99.7
(46¾ x 39¼)
Unknown Dutch artist, inscribed,
c.1612
Purchased, 1924

Piper

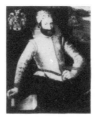

PETTIE, John (1839-93)
Painter

2820 *See Groups:* The Royal
Academy Conversazione, 1891, by
G.Grenville Manton

4245 *See Groups:* Hanging
Committee, Royal Academy, 1892,
by Reginald Cleaver

PETTY, Henry, Earl of Shelburne
See SHELBURNE

PETTY, William 1st Marquess of
Lansdowne *See* LANSDOWNE

PETTY, Sir William (1623-87)
Political economist

2924 Canvas 124.5 x 100.3
(49 x 39½)
Isaac Fuller, c.1640-51
Purchased, 1937

Piper

PETTY-FITZMAURICE, Henry,
3rd Marquess of Lansdowne
See LANSDOWNE

PETTY-FITZMAURICE, Henry,
5th Marquess of Lansdowne
See LANSDOWNE

PETTY-FITZMAURICE, William
Thomas, Earl of Kerry
See KERRY

PETYT, Sylvester (d.1719)
Lawyer

719 Canvas 124.5 x 100.3
(49 x 39½)
Richard van Bleeck, signed and
inscribed, c.1700
Given by Barnard's Inn, 1884

Piper

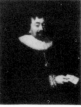

PHELIPS, Sir Robert (1586?-1638)
Parliamentarian

3790 Canvas 83.2 x 70.5
(32¾ x 27¾)
Attributed to Hendrik Gerritsz Pot,
inscribed, 1632
Given by Charles E.Russell, 1951
Montacute

Piper

PHELPS, Richard (d.1785)
Portrait painter

1797A Chalk 31.8 x 26
(12½ x 10¼)
Self-portrait, inscribed and dated
1771 on reverse
Given by Francis Wellesley, 1917

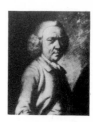

PHELPS, Samuel (1804-78)
Actor

3015 Sepia and grisaille wash
54.6 x 36.8 (21½ x 14½)
Alfred Bryan
Purchased, 1939

Continued overleaf

3503, 3596 *See Collections:*
Prominent Men, c.1880-c.1910,
by Harry Furniss, **3337-3535** and
3554-3620

Ormond

PHILIP II, King of Spain (1527-98)
Husband of Mary I

4175 Miniature on wood 8.6 x 6.4
($3\frac{3}{8}$ x 2½)
After Titian, dated 1555
Given by Edward Peter Jones, 1960

446(2) Electrotype of medal 6.7 ($2\frac{5}{8}$)
diameter
After Jacopo da Trezzo, signed and
inscribed (1555)
Given by Sir George Scharf, 1877

347 Canvas 184.2 x 104.1
(72½ x 41)
Unknown artist, c.1580
Purchased, 1872

Strong

PHILIP, Prince, Duke of Edinburgh
(b.1921) Consort of Elizabeth II

5268 Bronze cast of head 32.1
($12\frac{5}{8}$) high
Franta Belsky, incised and dated
1979
Purchased, 1979

PHILIPPA of Hainault (1314?-69)
Queen of Edward III

346 Electrotype of effigy in
Westminster Abbey 43.8 (17¼) high
After Jean de Liège (c.1367)
Purchased, 1872

Strong

PHILIPS, Francis Charles
(1849-1921)
Novelist and dramatist

4632 Water-colour 30.8 x 18.1
($12\frac{1}{8}$ x $7\frac{1}{8}$)
Carlo Pellegrini, signed *Ape*
(*VF* 7 July 1888)
Purchased, 1968

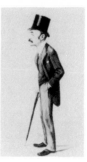

PHILIPS, Sir George, Bt
(1766-1847)
MP for Warwickshire South

54 *See Groups:* The House of Com-
mons, 1833, by Sir George Hayter

PHILIPS, John (1676-1709)
Poet

1763 Canvas, oval 33.7 x 28.6
(13¼ x 11¼)
Unknown artist, c.1700
Purchased, 1915

Piper

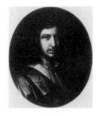

PHILLIMORE, Sir Robert Joseph
(1810-85) Judge

P118 Photograph: 9th plate
daguerreotype 5.1 x 3.8 (2 x 1½)*sight*
Studio of Richard Beard, 1840s
Purchased, 1979

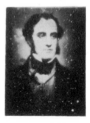

PHILLIP, Arthur (1738-1814)
Vice-Admiral; first Governor of
New South Wales

1462 Canvas 90.2 x 69.2
(35½ x 27¼)
Francis Wheatley, signed with
initials and dated 1786
Bequeathed by Mrs Elizabeth
Gayton, 1907

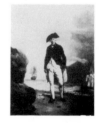

PHILLIP, John (1817-67)
Portrait and subject painter

3335 Canvas 52.1 x 57.2
(20½ x 22½)
Attributed to himself
Purchased, 1947

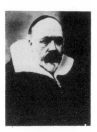

P80 Photograph: albumen print
21 x 16.2 (8¼ x 6⅜)
David Wilkie Wynfield, 1860s
Purchased, 1979
See Collections: The St John's
Wood Clique, by David Wilkie
Wynfield, **P70-100**

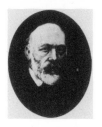

2446 Water-colour, gouache and
oil, oval 45.7 x 36.8 (18 x 14½)
Attributed to Sir Daniel Macnee
Given by H.Campbell Johnson, 1929

Ormond

PHILLIPPS, Sir Thomas, Bt
(1792-1872)
Antiquary and bibliophile

3094 Water-colour, two sketches
24.1 x 34 (9½ x 13⅜)
Sir Henry Dryden, inscribed and
dated 1853 on reverse
Purchased, 1940

Ormond

PHILLIPS, Sir Claude (1846-1924)
Art critic

2431 Silverpoint 30.2 x 20.6
(11⅞ x 8⅛)
Alphonse Legros, signed and dated
1890
Bequeathed by the sitter, 1924

2432 Silverpoint 31.5 x 22.9
(12⅜ x 9)
Alphonse Legros, signed and dated
1890
Bequeathed by the sitter, 1924

PHILLIPS, Henry (1801-76)
Singer

1962(f) *See Collections:* Opera
singers and others, c.1804-c.1836,
by Alfred Edward Chalon, **1962(a-l)**

Ormond

PHILLIPS, Henry Wyndham
(1820-68) Painter

P81 Photograph: albumen print
22.9 x 16.2 (8½ x 6⅜)
David Wilkie Wynfield, 1860s
Purchased, 1929
See Collections: The St John's Wood
Clique, by David Wilkie Wynfield,
P70-100

PHILLIPS, Molesworth (1755-1832)
Soldier

2515(4) Chalk 38.4 x 27.3
(15⅛ x 10¾)
William Brockedon, dated 1825
Lent by NG, 1959
See Collect ns: Drawings of
Prominent People, 1823-49, by
William Brockedon, **2515(1-104)**

PHILLIPS, Sir Richard (1767-1840)
Writer, bookseller and publisher

944 Canvas 74.9 x 61.6
(29½ x 24¼)
James Saxon, signed, inscribed and
dated 1806
Bequeathed by the sitter's daughter,
Miss Louisa Antonia Phillips, 1893

PHILLIPS, Stephen (1864-1915)
Poet and dramatist

4338 Water-colour 30.5 x 25.4
(12 x 10)
Percy Anderson, signed in
monogram and dated 1902
Purchased, 1963

PHILLIPS, Thomas (1770-1845)
Portrait painter

1601 Canvas 73.7 x 61 (29 x 24)
Self-portrait, 1802
Purchased, 1911

2515(70) Chalk and pencil
35.6 x 26.7 (14 x 10½)
William Brockedon, dated 1834
Lent by NG, 1959
See Collections: Drawings of
Prominent People, 1823-49, by
William Brockedon, **2515(1-104)**

PHILLIPS, Wendell (1811-84)
American slavery abolitionist

599 *See Groups:* The Anti-Slavery
Society Convention, 1840, by
Benjamin Robert Haydon

PHILPOT, Annie Wilhelmina
(1854-1930)

P18(29) *See Collections:* The
Herschel Album, by Julia Margaret
Cameron, **P18(1-92b)**

PHILPOT, Glyn (1884-1937)
Painter

4681 Canvas 91.4 x 71.1 (36 x 28)
Self-portrait, signed and dated 1908
Purchased, 1969

3651 Canvas 100.3 x 74.9
(39½ x 29½)
Sir Oswald Birley, signed and
dated 1920
Given by the sitter's sister, Miss
Daisy Philpot, 1949

PHIPPS, Lieutenant-Colonel

1752 *See Groups:* The Siege of
Gibraltar, 1782, by George Carter

PHIPPS, Constantine Henry,
1st Marquess of Normanby
See NORMANBY

PHIPPS, Constantine John, 2nd
Baron Mulgrave *See* MULGRAVE

PHIPPS, Edmund (1760-1837)
General; son of 1st Baron Mulgrave

4026(44) *See Collections:*
Drawings of Men about Town,
1832-48, by Alfred, Count D'Orsay,
4026(1-61)

4918 *See Collections:* Caricatures
of Prominent People, 1832-5, by
Sir Edwin Landseer, **4914-22**

PHIPPS, Edmund (1808-57)
Writer and barrister

4026(45) Pencil and black chalk
29.2 x 22.9 (11½ x 9)
Alfred, Count D'Orsay, signed and
dated 1848, autographed by sitter
Purchased, 1957
See Collections: Drawings of Men
about Town, 1832-48, by Alfred,
Count D'Orsay, **4026(1-61)**

Ormond

PHIPPS, Henry, 1st Earl of Mulgrave
See MULGRAVE

PHIPPS, Maria-Louisa (née
Campbell) (d.1888)
Married first Charles F.Norton,
second Edmund Phipps (1808-57)

1916 *See Groups:* Samuel Rogers,
Mrs Norton and Mrs Phipps, by
Frank Stone, c.1845

PICKERING, Ferdinand
(1811-c.1882) History painter

3182(15,16) *See Collections:*
Drawings of Artists, c.1862, by
Charles West Cope, **3182(1-19)**

PICKERSGILL, Frederick Richard
(1820-1900)
Historical and genre painter;
nephew of Henry William Pickersgill

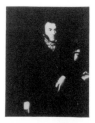

5183 Canvas 127.3 x 101.6
(50⅛ x 40)
Self-portrait, c.1850
Purchased, 1978

P82 Photograph: albumen print
20.7 x 16.2 (8⅛ x 6⅜)
David Wilkie Wynfield, 1860s
Purchased, 1929
See Collections: The St John's
Wood Clique, by David Wilkie
Wynfield, **P70-100**

PICKERSGILL, Henry William
(1782-1875) Painter

3097(1) Pen and ink 22.9 x 18.4
(9 x 7¼)
Sir Edwin Landseer, inscribed
Purchased, 1940
See Collections: Caricatures,
c.1825-c.1835, by Sir Edwin
Landseer, **3097(1-10)**

1456(23) Black chalk 8.6 x 7.6
(3⅜ x 3)
Charles Hutton Lear, dated 1848
Given by John Elliot, 1907
See Collections: Drawings of
Artists, c.1845, by Charles Hutton
Lear, **1456(1-27)**

3182(9) *See Collections:* Drawings
of Artists, c.1862, by Charles West
Cope, **3182(1-19)**

Ormond

PICKLES, Wilfred (1904-78)
Radio actor

4529(263-6) *See Collections:*
Working drawings by Sir David
Low, **4529(1-401)**

PICTET, Baby (b.1861)

P18(19) *See Collections:* The
Herschel Album, by Julia Margaret
Cameron, **P18(1-92b)**

PICTON, Major-General

1752 *See Groups:* The Siege of
Gibraltar, 1782, by George Carter

PICTON, Sir Thomas (1758-1815)
Lieutenant-General

126 Canvas 74.3 x 62.2
(29¼ x 24½)
Sir Martin Archer Shee, eng 1812
Purchased, 1861

PIERREPONT, Charles Evelyn,
Viscount Newark *See* NEWARK

PIERREPONT, Charles Herbert,
2nd Earl Manvers
See MANVERS

PIERREPONT, Evelyn, 1st Duke of
Kingston and Marquess of
Dorchester *See* KINGSTON

PIERREPONT, Sydney, 3rd Earl
Manvers *See* MANVERS

PIGGOTT, Edward Frederick
Smyth (1820-95)
Examiner of stage plays

2992 Water-colour 37.5 x 26
(14¾ x 10¼)
Jean de Paleologu, signed *PAL*
(*VF* 11 Jan 1890)
Purchased, 1937

PIGOT, George Pigot, Baron
(1719-77) Governor of Madras

3837 Canvas, feigned oval
67.3 x 56.5 (26½ x 22¼)
George Willison, signed and dated
1777
Purchased, 1952

PIGOTT, Richard (1828?-89)
Irish journalist and forger

2234 Pencil 25.4 x 19.7 (10 x 7¾)
Sydney Prior Hall, inscribed and
dated *Feb 21* (1889)
Given by the artist's son, Harry
Reginald Holland Hall, 1928
See Collections: The Parnell
Commission, 1888-9, by Sydney
Prior Hall, **2229-72**

PINCHES, Thomas
Slavery abolitionist

599 *See Groups:* The Anti-Slavery
Society Convention, 1840, by
Benjamin Robert Haydon

PINERO, Sir Arthur Wing
(1855-1934) Playwright

2761 Canvas 125.1 x 100.3
(49¼ x 39½)
Joseph Mordecai, signed, exh 1891
Bequeathed by the sitter, 1935

4095(9) Pen and ink 38.7 x 31.8
(15¼ x 12½)
Harry Furniss, signed with initials
Purchased, 1959
See Collections: The Garrick Gallery
of Caricatures, 1905, by Harry
Furniss, **4095(1-11)**

3675 Pencil, chalk, and wash
37.5 x 27.6 (14¾ x 10⅞)
Sir Bernard Partridge, signed
(*Punch* 28 Sept 1927)
Purchased, 1949
See Collections: Mr Punch's
Personalities, 1926-9, by Sir
Bernard Partridge, **3664-6,** etc

PINNEY, William (1806-98)
MP for Lyme Regis

54 *See Groups:* The House of Com-
mons, 1833, by Sir George Hayter

PINWELL, George John (1842-75)
Water-colourist and illustrator

4496 Pencil and crayon 11.1 x 8.3
(4⅜ x 3¼)
Eyre Crowe, signed and inscribed
Purchased, 1966

PIOZZI, Gabriel (1741-1809)
Musician; married Mrs Thrale

1152 Pencil 24.8 x 19.1 (9¾ x 7½)
George Dance, signed and dated
1793
Purchased, 1898

761(a) *See Unknown Sitters III*

PIOZZI, Hester Lynch (Mrs Thrale)
(1741-1821)
Writer and friend of Dr Johnson

4942 Canvas 75.6 x 62.9
(29¾ x 24¾)
Italian school, c.1785
Purchased, 1973

1151 Pencil 24.8 x 19.1 (9¾ x 7½)
George Dance, signed and dated
1793
Purchased, 1898

PIPER, John (b.1903)
Painter and writer

4529(268) Pencil 25.1 x 19.1
(9⅞ x 7½)
Sir David Low, inscribed
Purchased, 1967
See Collections: Working drawings
by Sir David Low, **4529(1-401)**

4529(267,269) *See Collections:*
Working drawings by Sir David
Low, **4529(1-401)**

PISSARRO, Lucien (1863-1944)
Painter, engraver and printer

4103 Etching 17.5 x 14.9
(6⅞ x 5⅞)
Camille Pissarro (his father), signed
with initials, numbered 3, inscribed,
and dated 1890 below plate
Purchased, 1959

PITMAN, Sir Isaac (1813-97)
Inventor of Pitman's shorthand

1509 Canvas 125.7 x 100.3
(49½ x 39½)
Sir Arthur Stockdale Cope, signed
with initials and inscribed,
posthumous
Given by a Memorial Committee,
1908

PITT, George, 2nd Baron Rivers
See RIVERS

PITT, John, 2nd Earl of Chatham
See CHATHAM

PITT, William (1759-1806)
Prime Minister

135a Water-colour 22.9 x 17.1
(9 x 6¾)
James Gillray, signed, 1789
Given by H.W.Martin, 1861

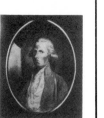

2103B Pencil 30.8 x 21.3
($12\frac{1}{8}$ x $8\frac{3}{8}$)
Isaac Cruikshank, inscribed on
reverse
Given by Alfred Jones, 1925

745 *See Groups:* William Pitt
addressing the House of Commons
. . . 1793, by Karl Anton Hickel

697 Canvas 141 x 108
(55½ x 42½)
John Hoppner, replica (1805)
Lent by Tate Gallery, 1954

120 Marble bust 71.1 (28) high
Joseph Nollekens, incised and
dated 1808
Given by Earl Granville, 1861

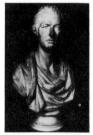

1240 Marble bust 71.1 (28) high
Dominick Andrew Olivieri after
Joseph Nollekens
Bequeathed by Mrs Sarah Ann
Elizabeth FitzGerald, 1899

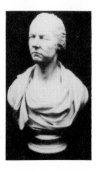

1747 Wax medallion 10.2 (4)
diameter
Peter Rouw, incised and dated 1809
Given by Francis Wellesley, 1915

PITT, William, 1st Earl of Chatham
See CHATHAM

PIX, Mary (1666-1720?)
Dramatist

4554 Canvas, feigned oval
76.2 x 63.5 (30 x 25)
Unknown artist
Purchased, 1967

PLACE, Francis (1771-1854)
Political and social reformer

1959 Canvas 91.4 x 71.4
(36 x $28\frac{1}{8}$)
Samuel Drummond, exh 1833
Given by the sitter's great-grandson,
Sir Henry Miers, 1922

PLAYFAIR, Lyon Playfair, 1st
Baron (1818-98) Chemist,
scientific adviser and politician

5216 Enamel miniature, oval
5.1 x 4.1 (2 x $1\frac{5}{8}$)
John Haslem, incised and dated
1854 on reverse
Purchased, 1854

P120(7) Photograph: albumen
print, arched top 19.7 x 14.6
(7¾ x 5¾)
Maull & Polyblank, inscribed on
mount, 1855
Purchased, 1979
See Collections: Literary and
Scientific Men, 1855, by Maull &
Polyblank, **P120(1-54)**

PLAYFAIR, John (1748-1819)
Mathematician and geologist

1075,1075a *See Groups:* Men of
Science Living in 1807-8, by Sir
John Gilbert and others

840 Canvas 126.4 x 100.3
(49¾ x 39½)
Sir Henry Raeburn
Purchased, 1890

PLAYFAIR, Sir Nigel (1874-1934)
Actor-manager

3504 *See Collections:* Prominent
Men, c.1880-c.1910, by Harry
Furniss, **3337-3535** and **3554-3620**

PLIMSOLL, Samuel (1824-98)
Champion of seamen's rights

4734 Water-colour 29.5 x 17.5
(11$\frac{5}{8}$ x 6$\frac{7}{8}$)
W.Vine, signed in monogram
(*VF* 15 March 1873)
Purchased, 1970

PLOMER, William (1903-73)
Librettist, poet and writer

5172 Canvas 141.9 x 99.4
(55$\frac{7}{8}$ x 39$\frac{1}{8}$)
Edward Wolfe, signed, 1926
Purchased, 1977

PLOWDEN, Edwin Noel Plowden,
Baron (b.1907) Economist

4529(270,271) *See Collections:*
Working drawings by Sir David
Low, **4529(1-401)**

PLOWDEN, Alfred Chichele
(1844-1914) Magistrate

2993 Water-colour 32.7 x 20.6
(12$\frac{7}{8}$ x 8$\frac{1}{8}$)
A.G.Witherby, signed *w.a.g.*
(*VF* 11 April 1901)
Purchased, 1938

2994 Water-colour 49.5 x 35.9
(19½ x 14$\frac{1}{8}$)
Sir Leslie Ward, signed *Spy*
(*VF* 16 Dec 1908)
Purchased, 1938

PLUMER, Herbert Plumer, 1st
Viscount (1857-1932)
Field-Marshal

3000 Water-colour 36.5 x 26.7
(14$\frac{3}{8}$ x 10½)
Sir Leslie Ward, signed *Spy*
(*VF* 13 Nov 1902)
Purchased, 1938

1954 *See Groups:* General Officers
of World War I, by John Singer
Sargent

PLUMPTRE, John Pemberton
(1791-1864) MP for Kent East

54 *See Groups:* The House of Com-
mons, 1833, by Sir George Hayter

PLUNKET, David Robert, 1st Baron
Rathmore *See* RATHMORE

PLUNKET, Oliver (1629-81)
Roman Catholic Archbishop of
Armagh

262 Canvas 52.1 x 44.5
(20½ x 17½)
By or after Garrett Morphey (?after
Edward Lutterel, 1681)
Purchased, 1868

Piper

PLUNKETT, Edward John Moreton
Drax, 18th Baron Dunsany
See DUNSANY

PLUNKETT, Sir Horace Curzon (1854-1932) Irish statesman

3878 Chalk 34 x 22.9 (13⅜ x 9)
Sir William Rothenstein, signed, 1921
Given by the Rothenstein Memorial Trust, 1953

POCOCK, Sir George (1706-92) Admiral

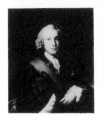

1787 Canvas 75.6 x 62.9 (29¾ x 24¾)
After Thomas Hudson (c.1761)
Purchased, 1917

Kerslake

POEL, William (1852-1934) Actor and writer

3072(11) Pencil 34 x 25.7 (13⅜ x 10⅛)
Henry Tonks, inscribed
Given by Charles Henry Collins Baker, 1937
See Collections: Sketches and studies by Henry Tonks, **3072(1-18)**

3072(8-10, 12-18) *See Collections:* Sketches and studies by Henry Tonks, **3072(1-18)**

2762 Canvas 74.9 x 62.2 (29½ x 24½)
Henry Tonks, signed with initials and dated 1932
Given by subscribers, 1935

POLAND, Sir Harry Bodkin (1829-1928) Lawyer

3505 *See Collections:* Prominent Men, c.1880-c.1910, by Harry Furniss, **3337-3535** and **3554-3620**

POLANYI, Michael (1891-1976) Physical chemist and sociologist

P133 *See Collections:* Prominent People, 1935-8, by Lucia Moholy, **P127-33**

POLE, Margaret, Countess of Salisbury *See* SALISBURY

POLE, Reginald (1500-58) Cardinal and Archbishop of Canterbury

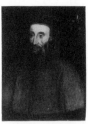

220 Panel 47 x 36.8 (18½ x 14½)
Unknown artist, after 1556
Given by William Smith, 1866

Strong

POLIDORI, John William (1795-1821)
Physician and writer

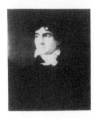

991 Canvas 58.4 x 48 (23 x 18⅞)
F.G.Gainsford
Given by the sitter's nephew, William Michael Rossetti, 1895

POLLARD, Robert (1755-1838) Painter and engraver

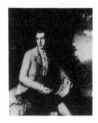

1020 Canvas 123.8 x 99.1 (48¾ x 39)
Richard Samuel, signed and dated 1784
Given by Thomas Humphry Ward, 1895

POLLOCK, Sir Charles (1823-97) Judge

3598 *See Collections:* Prominent Men, c.1880-c.1910, by Harry Furniss, **3337-3535** and **3554-3620**

POLLOCK, Sir Frederick, Bt (1845-1937) Jurist and historian

3599 *See Collections:* Prominent Men, c.1880-c.1910, by Harry Furniss, **3337-3535** and **3554-3620**

3835 Canvas 56.5 x 46.4 (22¼ x 18¼)
Reginald Grenville Eves, signed, c.1926
Purchased, 1952

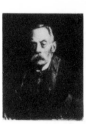

POLLOCK, Sir George, Bt
(1786-1872) Field-Marshal

364 Marble bust 67.9 (26¾) high
Joseph Durham, incised and dated
1870
Given by the executors of Lady
Pollock, 1873

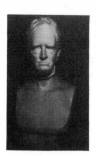

2459 Pencil 25.1 x 21.6 (9⅞ x 8½)
Lionel Grimston Fawkes, signed
with initials and dated 1872,
autographed by sitter
Given by the artist, 1930

Ormond

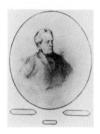

POLLOCK, Sir Jonathan Frederick,
Bt (1783-1870) Judge

54 *See Groups:* The House of Com-
mons, 1833, by Sir George Hayter

758 Canvas 139.1 x 110.5
(54¾ x 43½)
Samuel Laurence, exh 1842
Given by the sitter's son, Sir
William Frederick Pollock, Bt,
1887

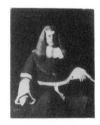

732 Black and white chalk
53.7 x 37.5 (21⅛ x 14¾)
Samuel Laurence, signed and dated
1863
Given by Anne, Lady Ritchie, 1885

Ormond

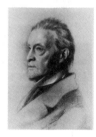

POMFRET, George Fermor, 3rd
Earl of (1768-1830)

1695(j) *See Collections:* Sketches
for The Trial of Queen Caroline,
1820, by Sir George Hayter,
1695(a-x)

999 *See Groups:* The Trial of
Queen Caroline, 1820, by Sir
George Hayter

PONSOMBY, Colonel (possibly Sir
Henry Ford Ponsonby, 1825-95)

P22(2) *See Collections:* The
Balmoral Album, 1854-68, by
George Washington Wilson, W.& D.
Downey, and Henry John Whitlock,
P22(1-27)

PONSOMBY, Mrs

P22(24) *See Collections:* The
Balmoral Album, 1854-68, by
George Washington Wilson, W.& D.
Downey, and Henry John Whitlock,
P22(1-27)

PONSONBY, Arthur Ponsonby,
1st Baron (1871-1946)
Politician and writer

4792 Sanguine 34.3 x 20.3
(13½ x 8)
Sir William Rothenstein, inscribed
and dated 1925
Purchased, 1970

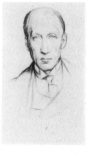

PONSONBY, Sir Frederic
(1783-1837) Major-General

1914(10) Water-colour and pencil
18.4 x 16.2 (7¼ x 6⅜)
Thomas Heaphy
Purchased, 1921
See Collections: Peninsular and
Waterloo Officers, 1813-14, by
Thomas Heaphy, **1914(1-32)**

PONSONBY, Frederick, 3rd Earl of
Bessborough *See* BESSBOROUGH

PONSONBY, John, 5th Earl of
Bessborough *See* BESSBOROUGH

PONSONBY, John William, 4th Earl
of Bessborough
See BESSBOROUGH

PONSONBY, William, 1st Baron de
Mauley *See* DE MAULEY

POOLE, John (1786?-1872)
Dramatist and writer

3807 Canvas, feigned oval
76.2 x 63.5 (30 x 25)
Henry William Pickersgill, eng 1827
Purchased, 1951

2515(25) *See Collections:*
Drawings of Prominent People,
1823-49, by William Brockedon,
2515(1-104)

Ormond

POOLE, Paul Falconer (1807-79)
Historical painter

2532 Canvas 61 x 50.8 (24 x 20)
Frank Holl, signed with initials,
inscribed and dated 1879
Given by the artist's sister-in-law,
Mrs Ellen Holl, 1932

Ormond

POPE, Alexander (1688-1744)
Poet

112 With a female attendant
Canvas 177.8 x 127 (70 x 50)
Attributed to Charles Jervas
Purchased, 1860. *Beningbrough*

4132 Canvas 76.2 x 63.5 (30 x 25)
Studio of Michael Dahl, c.1727
Purchased, 1959

1179 Canvas 61.3 x 45.7 (24$\frac{1}{8}$ x 18)
Attributed to Jonathan Richardson,
c.1737
Given by Alfred A. de Pass, 1898

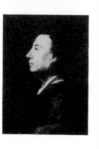

561 Canvas 44.1 x 36.5 (17$\frac{3}{8}$ x 14$\frac{3}{8}$)
Attributed to Jonathan Richardson,
c.1738
Transferred from BM, 1879

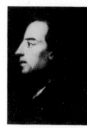

2483 Plaster cast of bust 65.1
(25$\frac{5}{8}$) high
After Louis François Roubiliac,
incised (c.1738)
Purchased, 1930

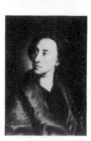

299 Pastel 60.7 x 45.1
(23$\frac{7}{8}$ x 17¾)
William Hoare
Bequeathed by Charles Townsend,
1870. *Beningbrough*

873 Red chalk 16.8 x 11.4
(6$\frac{5}{8}$ x 4½) *sight*
William Hoare, signed and inscribed
on mount
Purchased, 1891

Kerslake

POPE-HENNESSY, Sir John
(1834-91) Colonial governor

3267 Water-colour 30.5 x 17.8
(12 x 7)
Carlo Pellegrini, signed *Ape*
(*VF* 27 March 1875)
Purchased, 1946

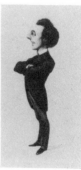

POPHAM, Sir Home Riggs
(1762-1820) Rear-Admiral

811 Canvas 189.2 x 120.7
(74½ x 47½)
Mather Brown
Given by G.F.Popham Blyth, 1888

POPHAM, Sir John (1531?-1607)
Lord Chief Justice; Speaker of the
House of Commons

2405 Water-colour 22.9 x 17.8
(9 x 7)
George Perfect Harding after an
unknown artist, signed and inscribed
Purchased, 1929
See Collections: Copies of early
portraits, by George Perfect
Harding and Sylvester Harding,
1492,1492(a-c) and **2394-2419**

Strong

POPHAM, William (d.1821)
Lieutenant-General

812 Canvas 139.7 x 107.3
(55 x 42¼)
Sir Martin Archer Shee
Given by G.F.Popham Blyth, 1888

PORSON, Richard (1759-1808)
Greek scholar

673 Plaster bust from a death-mask
68.6 (27) high
Giovanni Domenico Gianelli,
incised and dated 1809
Given by wish of the sitter's niece,
Mrs Chuter, 1883

673a Electrotype of head of
no.**673,** 38.1 (15) high
Purchased, 1883

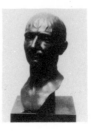

PORTER, Anna Maria (1780-1832)
Novelist

1109 Pencil 24.1 x 19.1 (9½ x 7½)
George Henry Harlow, signed with
initials and inscribed
Purchased, 1897

PORTER, Endymion (1587-1649)
Poet and courtier

615 *See Unknown Sitters II*

PORTER, George, 6th Baron de
Hochepied *See* DE HOCHEPIED

PORTER, Jane (1776-1850)
Novelist; sister of Anna Maria
Porter

1108 Pencil 21.6 x 17.1 (8½ x 6¾)
George Henry Harlow, signed with
initials and inscribed
Purchased, 1897

PORTEUS, Beilby (1731-1808)
Bishop of London

735 Chalk and water-colour
40.6 x 30.5 (16 x 12)
Adam Buck
Purchased, 1885

PORTLAND, William Cavendish
Scott-Bentinck, 4th Duke of
(1768-1854)

999 *See Groups:* The Trial of
Queen Caroline, 1820, by Sir
George Hayter

PORTLAND, Richard Weston, 1st
Earl of (1577-1635) Statesman

1344 *See Unknown Sitters II*

PORTLAND, William Bentinck, 1st Earl of (1649-1709) Friend and agent of William III

1968 Canvas 139.7 x 117.5 (55 x 46¼) Studio of Hyacinthe Rigaud, inscribed, 1698-9 Purchased, 1922

Piper

PORTMAN, Edward Portman, 1st Viscount (1799-1888) Politician

54 See Groups: The House of Commons, 1833, by Sir George Hayter

PORTSMOUTH, Louise de Kéroualle, Duchess of (1649-1734) Mistress of Charles II

497 Canvas 120.7 x 95.3 (47½ x 37½) Pierre Mignard, signed, inscribed and dated 1682 Purchased, 1878

Piper

PORTSMOUTH, Isaac Newton Wallop, 5th Earl of (1825-91) Landowner

4735 Water-colour 30.8 x 17.8 (12⅛ x 7) Sir Leslie Ward, signed Spy (VF 1 July 1876) Purchased, 1970

1834(x) See Collections: Members of the House of Lords, c.1870-80, by Frederick Sargent, **1834(a-z and aa-hh)**

PORTSMOUTH, Newton Wallop, 6th Earl of (1856-1917) Politician and landowner

3506 See Collections: Prominent Men, c. 1880-c.1910, by Harry Furniss, **3337-3535 and 3554-3620**

POST, Jacob (1774-1855) Quaker

599 See Groups: The Anti-Slavery Society Convention, 1840, by Benjamin Robert Haydon

POTTER, Beatrix (Mrs Heelis) (1866-1943) Writer and illustrator of books for children

3635 Canvas 74.9 x 62.2 (29½ x 24½) Delmar Banner, signed, 1938 Given by the artist, 1948

POTTER, Richard (1778-1842) Politician

54 See Groups: The House of Commons, 1833, by Sir George Hayter

POTTER, Stephen (1900-69) Writer

4529(273) Pencil 17.5 x 13.3 (6⅞ x 5¼) Sir David Low Purchased, 1967 See Collections: Working drawings by Sir David Low, **4529(1-401)**

4529(272,274-6) See Collections: Working drawings by Sir David Low, **4529(1-401)**

POULETT, John Poulett, 1st Earl (1663-1743) First Lord of the Treasury

624 See Groups: Queen Anne and the Knights of the Garter, 1713, by Peter Angelis

POULTER, John Sayer (d.1847) MP for Shaftesbury

54 See Groups: The House of Commons, 1833, by Sir George Hayter

POWELL, Anthony (b.1905) Writer

5093 Pencil 40.3 x 33 (15⅞ x 13) H.Andrew Freeth, signed Purchased, 1976

POWELL, Sir John (1633-96)
Judge

479 Canvas 90.2 x 69.9
(35½ x 27½)
After an unknown artist
Given by the Society of Judges and
Serjeants-at-Law, 1877

Piper

POWELL, John Allan (d.1859)
Solicitor; law agent for Lord
Blessington

999 *See Groups:* The Trial of
Queen Caroline, 1820, by Sir
George Hayter

4026(46) *See Collections:*
Drawings of Men about Town,
1832-48, by Alfred, Count D'Orsay,
4026(1-61)

POWELL, Michael (1905-71)
Film director and writer

4529(277-9) *See Collections:*
Working drawings by Sir David
Low, **4529(1-401)**

POWER, John O'Connor (b.1846)
Politician

3293 Water-colour 32.1 x 18.4
(12⅝ x 7¼)
Sir Leslie Ward, signed *Spy*
(*VF* 25 Dec 1886)
Purchased, 1934

POWERSCOURT, Richard
Wingfield, 6th Viscount (1815-44)

4026(47) *See Collections:*
Drawings of Men about Town,
1832-48, by Alfred, Count D'Orsay
4026(1-61)

POWERSCOURT, Mervyn
Wingfield, 7th Viscount
(1836-1904) Collector

1833 *See Groups:* Private View of
the Old Masters Exhibition, Royal
Academy, 1888, by Henry Jamyn
Brooks

POWIS, Edward Herbert, 2nd Earl
of (1785-1848) Politician

54 *See Groups:* The House of Com-
mons, 1833, by Sir George Hayter

POWYS, John Cowper (1872-1963)
Writer and poet

4668 Chalk 52.7 x 35.6 (20¾ x 14)
Augustus John
Purchased, 1969

POWYS, Theodore Francis
(1876-1953) Novelist

4461 Pen and ink 45.7 x 35.6
(18 x 14)
Powys Evans, pub 1929
Purchased, 1965

POYNTER, Sir Edward, Bt
(1836-1919) Painter

1833 *See Groups:* Private View of
the Old Masters Exhibition, Royal
Academy, 1888, by Henry Jamyn
Brooks

1951 Canvas 84.5 x 59.7
(33¼ x 23½)
Sir Philip Burne-Jones, signed with
initials and dated 1909
Purchased, 1922

POYNTZ, William Stephen
(c.1769-1840) MP for Ashburton

54 *See Groups:* The House of Com-
mons, 1833, by Sir George Hayter

PRAED, Winthrop Mackworth
(1802-39) Poet

3030 Water-colour and pencil
29.8 x 22.9 (11¾ x 9)
Daniel Maclise
Given by Marion Harry Spielmann,
1939

Ormond

PRATT, Charles, 1st Earl of Camden
See CAMDEN

PRATT, Hodgson (1824-1907)
Advocate of peace and promoter
of industrial cooperative movement

2032 Canvas 74.9 x 61.6
(29½ x 24¼)
Felix Moscheles, signed, inscribed
and dated 1891
Given by a Memorial Committee,
1924

PRATT, Sir John (1657-1725)
Lord Chief Justice

480 Canvas 90.8 x 71.1
(35¾ x 28)
After Michael Dahl (?)
Given by the Society of Judges and
Serjeants-at-Law, 1877

Piper

PRATT, John Jeffreys, 1st Marquess
of Camden *See* CAMDEN

PRATT, John Tidd

P120(9) *See Collections:* Literary
and Scientific Men, 1855, by Maull
& Polyblank, **P120(1-54)**

PRATT, S. P.

P120(26) *See Collections:* Literary
and Scientific Men, 1855, by Maull
& Polyblank, **P120(1-54)**

PRESCOD, Samuel J.
Slavery abolitionist from Barbados

599 *See Groups:* The Anti-Slavery
Society Convention, 1840, by
Benjamin Robert Haydon

PRESCOTT, Robert (1725-1816)
Governor of Canada

3963 Miniature on ivory, oval
3.5 x 2.9 (1⅜ x 1⅛)
John Bogle, signed with initials and
dated 1776
Purchased, 1955

PRESTON, Isaac (1711-68)
Barrister

4855(56) *See Collections:* The
Townshend Album, **4855(1-73)**

PRICE, Francis (1704?-53)
Architect

1960 Canvas, feigned oval
76.2 x 63.5 (30 x 25)
George Beare, signed, inscribed
and dated 1747
Given by Martin Leggatt, 1922.
Beningbrough

Kerslake

PRICE, James (1752-83) Chemist

1942 Pastel, oval 59.7 x 44.5
(23½ x 17½)
John Russell
Purchased, 1922

PRICE, Thomas
Slavery abolitionist

599 *See Groups:* The Anti-Slavery
Society Convention, 1840, by
Benjamin Robert Haydon

PRICE, William Lake
(1810-after 1896) Water-colourist

2538 Chalk 16.5 x 20 (6½ x 7⅞)
Alfred Edward Chalon, inscribed,
c.1844
Given by Iolo A. Williams, 1932

Ormond

PRIDEAUX, Walter (1806-89)
Lawyer and poet

4170 *See Groups:* A Consultation
prior to the Aerial Voyage to
Weilburg, 1836, by John Hollins

PRIESTLEY, John Boynton
(b. 1894) Writer

5109 Pen and ink 36.8 x 27.3
(14½ x 10¾)
Powys Evans, signed
Given by R.N.Ricks, 1976

4529(280-5, 283a) *See Collections:*
Working drawings by Sir David
Low, **4529(1-401)**

PRIESTLEY, Joseph (1733-1804)
Theologian and scientist

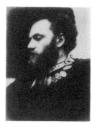

175a Medallion 5.1 (2) diameter
Phipson, inscribed, c.1795
Given by James Yates, 1864

175b Medallion 5.1 (2) diameter
Thomas Halliday, inscribed
Given by James Yates, 1864

175 Pastel 21.6 x 17.1 (8½ x 6¾)
Ellen Sharples
Given by James Yates, 1864

2904 Pastel, irregular oval
24. 1 x 19.1 (9½ x 7½)
Ellen Sharples
Given by T.H.Russell and Mrs
Alexander Scott, 1936

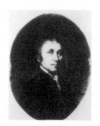

PRIME, Sir Samuel (1701-77)
Lawyer

4855(45) *See Collections:*
The Townshend Album,
4855(1-73)

PRIMROSE, Archibald John, 4th
Earl of Rosebery *See* ROSEBERY

PRIMROSE, Archibald Philip, 5th
Earl of Rosebery *See* ROSEBERY

PRINCE, G.K.
Slavery abolitionist

599 *See Groups:* The Anti-Slavery
Society Convention, 1840, by
Benjamin Robert Haydon

PRINSEP, Valentine Cameron
(1838-1904) Artist

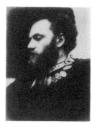

P83 Photograph: albumen print
21.3 x 16.2 (8⅜ x 6⅜)
David Wilkie Wynfield, 1860s
Purchased, 1979
See Collections: The St John's
Wood Clique, by David Wilkie
Wynfield, **P70-100**

P95 *See Collections:* The St
John's Wood Clique, by David
Wilkie Wynfield, **P70-100**

PRIOR, Sir James (1790?-1869)
Naval surgeon and writer

2515(43) *See Collections:*
Drawings of Prominent People,
1823-49, by William Brockedon,
2515(1-104)

Ormond

PRIOR, Matthew (1664-1721)
Poet, politician and diplomat

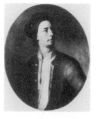

3682 Canvas, oval 76.2 x 63.5
(30 x 25)
Attributed to Michael Dahl,
inscribed and dated 1713 on reverse
Purchased, 1949

L152(10) Staffordshire plaque, oval
9.5 x 8 (3¾ x 3⅛)
After Antoine Coysevox (1714)
Lent by NG (Alan Evans Bequest),
1974

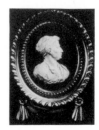

91 Canvas 124.5 x 99.1 (49 x 39)
Tom Wright after Jonathan
Richardson (c.1718)
Given by the Earl of Derby, 1860

562 Canvas 101.6 x 86.4 (40 x 34)
Thomas Hudson after Jonathan
Richardson (c.1718)
Transferred from BM, 1879.
Beningbrough

Piper

PRIOR, Richard Chandler
Alexander (1809-1902) Botanist

P106(16) Photograph: albumen
print, arched top 20 x 14.6
($7\frac{7}{8}$ x 5¾)
Maull & Polyblank, c.1855
Purchased, 1978
See Collections: Literary and
Scientific Portrait Club, c.1855,
by Maull & Polyblank, **P106(1-20)**

PROBYN, John Hopkins (1703-73)
Lawyer and politician

4855(18) *See Collections:* The
Townshend Album, **4855(1-73)**

PROCTER, Adelaide Ann (1825-64)
Poet and hymn writer; eldest child
of Bryan Waller Procter

789 Canvas, feigned oval
95. 3 x 78.7 (37½ x 31)
Emma Gaggiotti Richards, signed
with initials
Bequeathed by the sitter's mother,
Mrs Anne Procter, 1888

Ormond

PROCTER, Bryan Waller
(1787-1874) Poet and biographer
of Charles Lamb; sometimes wrote
as 'Barry Cornwall'

2515(23) Black and red chalk
36.8 x 27 (14½ x $10\frac{5}{8}$)
William Brockedon, dated 1830
Lent by NG, 1959
See Collections: Drawings of
Prominent People, 1823-49, by
William Brockedon, **2515(1-104)**

4026(48) *See Collections:*
Drawings of Men about Town,
1832-48, by Alfred, Count D'Orsay
4026(1-61)

788 Marble bust 72.4 (28½) high
John Henry Foley, incised
Bequeathed by the sitter's widow,
Mrs Anne Procter, 1888

Ormond

PROUT, Samuel (1783-1852)
Water-colourist

1618 Canvas, feigned oval
76.2 x 63.8 (30 x $25\frac{1}{8}$)
John Jackson, inscribed and dated
1823 on reverse
Bequeathed by the sitter's son,
Samuel Gillespie Prout, 1911

2515(12) *See Collections:*
Drawings of Prominent People,
1823-49, by William Brockedon,
2515(1-104)

1245 Grisaille pastel 34 x 27.6
($13\frac{3}{8}$ x $10\frac{7}{8}$)
Charles Turner, inscribed, c.1836
Purchased, 1899

Ormond

PROUT, Thomas Jones (1823-1909)
Divine and college constitution
reformer

P7(7) *See Collections:* Lewis
Carroll at Christ Church, by Charles
Lutwidge Dodgson, **P7(1-37)**

PROWSE, Elizabeth (née Sharp)
(d.1810) Sister of Granville
and William Sharp

L169 *See Groups:* The Sharp
Family, by Johan Zoffany, 1779-81

PRYDE, James Ferrier (1866-1941)
Painter and designer

4006 Miniature on ivory 7 x 5.7
(2¾ x 2¼)
John William Brooke, signed in
monogram
Given by Miss Florence M.Wood,
1956

PRYNNE, William (1600-69)
Puritan pamphleteer

2692 Water-colour, feigned oval
22.2 x 19.4 (8¾ x 7⅝)
George Perfect Harding after an
unknown artist, inscribed below
image
Purchased, 1934

PUGIN, Augustus Welby Northmore
(1812-52)
Architect and ecclesiologist

1404 Canvas 61.3 x 50.8
(24⅛ x 20)
Unknown artist, inscribed, c.1840
Purchased, 1905

Ormond

PULESTON, Sir John Henry
(1830-1908) Politician

2593 Water-colour 30.8 x 18.4
(12⅛ x 7¼)
Sir Leslie Ward, signed *Spy*
(*VF* 14 Oct 1882)
Purchased, 1933

PULTENEY, William 1st Earl
of Bath *See* BATH

PULTENEY, Sir William Pulteney
(1861-1941) Lieutenant-General

4236 Canvas 80.6 x 58.4
(31¾ x 23)
Philip de Laszlo, signed and dated
1917
Given by the sitter's sister, Miss
Isabel Pulteney, 1961

PURCELL, Daniel (1660?-1717)
Musician; brother of Henry Purcell

1463 *See Unknown Sitters II*

PURCELL, Henry (1659-95)
Composer

2150 Canvas, oval 58.4 x 53.3
(23 x 21)
Unknown artist, inscribed
Bequeathed by William Barclay
Squire, 1927

4994 Black chalk 38.1 x 28.6
(15 x 11¼)
Attributed to John Closterman,
inscribed
Purchased with help from the
Pilgrim Trust and the Worshipful
Company of Musicians, 1974

1352 Canvas, oval 73.7 x 61
(29 x 24)
By or after John Closterman, 1695
Purchased, 1903

Piper

PURVES, John Home
Soldier; nephew of Lady Blessington

4026(49) *See Collections:*
Drawings of Men about Town,
1832-48, by Alfred, Count D'Orsay
4026(1-61)

PUSEY, Edward Bouverie (1800-82)
A leader of the Oxford Movement

4541(4,7,9) *See Collections:* The
Pusey family and their friends,
c.1856, by Clara Pusey, **4541(1-13)**

2594 Water-colour 30.5 x 17.8
(12 x 7)
Carlo Pellegrini, signed *Ape*
(*VF* 2 Jan 1875)
Purchased, 1933

1059 Black and white chalk
71.8 x 55.9 (28¼ x 22)
George Richmond, c.1890
Purchased, 1896

Ormond

PYE, Henry James (1745-1813)
Poet Laureate

4253 Canvas 76.2 x 63.5 (30 x 25)
Samuel James Arnold, eng 1801
Given by A.O.Elmhirst, 1962

PYE, John (1782-1874) Engraver

2190 Plaster cast of bust 71.4
(28⅛) high
Henry Behnes Burlowe, incised
and dated 1831
Given by the executors of the
sitter's great-niece, Miss Edith
M.Walker, 1928

Ormond

PYM, John (1584-1643)
Statesman

1425 Woodcut 9.5 x 7.6 (3¾ x 3)
After Edward Bower, inscribed and
dated 1641 on plate
Purchased, 1905

Piper

QUARLES, Frances (1592-1644)
Poet

288 *See Unknown Sitters II*

QUEENSBERRY, Catherine
(Hyde), Duchess of (1700-77)
Eccentric beauty and patron of
writers

238 Canvas 127 x 101 (50 x 39¾)
Attributed to Charles Jervas
Purchased, 1867

Kerslake

QUEENSBERRY, William Douglas,
4th Duke of (1724-1810)
Rake and patron of the turf

4849 Canvas 76.5 x 63.2
(30⅛ x 24⅞)
Attributed to John Opie
Given by F.K.Huber, 1971

QUEENSBERRY, John Sholto
Douglas, 8th Marquess of
(1844-1900) Patron of boxing

3174 Silhouette 17.8 x 11.4
(7 x 4½)
Phil May, signed, inscribed and
dated 1889
Purchased, 1944

QUICK, John (1748-1831)
Comedian

1355 Canvas 73.7 x 61 (29 x 24)
Thomas Lawranson, eng 1789
Purchased, 1904

QUILLER-COUCH, Sir Arthur
(1863-1944) 'Q'; writer, novelist
and literary scholar

4272 With various characters from
his books
Water-colour 36.8 x 26.7
(14½ x 10½)
Louis Paul, inscribed and dated 1920
Given by the sitter's daughter, Miss
Foy Quiller-Couch, 1962

Continued overleaf

4262 Pencil and chalk 47.3 x 35.6
($18\frac{5}{8}$ x 14)
Henry Lamb, 1938
Purchased, 1962

QUILTER, Roger (1877-1953)
Composer

3904 Canvas 110.5 x 74.9
($43\frac{1}{2}$ x $29\frac{1}{2}$)
Wilfred Gabriel de Glehn, signed
and dated 1920
Given by the artist's widow, 1954

P110 Photograph: bromide print
18.1 x 23.9 ($7\frac{1}{8}$ x $9\frac{3}{8}$)
Herbert Lambert, inscribed on print
Given by the photographer's
daughter, Mrs Barbara Hardman,
1978
See Collections: Musicians and
Composers, by Herbert Lambert
P107-11

RADCLIFFE, John (1650-1714)
Physician

1626 *See Unknown Sitters II*

RADCLIFFE, Robert, 3rd Earl of
Sussex *See* SUSSEX

RADSTOCK, Granville Augustus
William Waldegrave, 3rd Baron
(1833-1913) Evangelist

2595 Water-colour 30.5 x 18.1
(12 x $7\frac{1}{8}$)
Adriano Cecioni
(*VF* 17 Aug 1872)
Purchased, 1933

RAE, John (1813-93)
Arctic explorer; surgeon

1213 Millboard 38.4 x 33.7
($15\frac{1}{8}$ x 13¼)
Stephen Pearce, exh 1853
Bequeathed by John Barrow, 1899
See Collections: Arctic Explorers,
1850-86, by Stephen Pearce,
905-24 and **1209-27**

Ormond

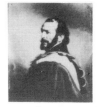

RAFFLES, Sir Thomas Stamford
Bingley (1781-1826)
Colonial governor and zoologist

84 Canvas 139.7 x 109.2 (55 x 43)
George Francis Joseph, signed,
inscribed and dated 1817
Given by the sitter's nephew,
W.C.Raffles Flint, 1859

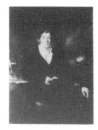

RAGLAN, Fitzroy Somerset, 1st
Baron (1788-1855)
Commander in the Crimea

1914(11) Water-colour and pencil
21.3 x 18.4 ($8\frac{3}{8}$ x 7¼) *sight*
Thomas Heaphy, 1813-14
Purchased, 1921
See Collections: Peninsular and
Waterloo Officers, 1813-14, by
Thomas Heaphy, **1914(1-32)**

3743 Canvas 51.8 x 41.6
($20\frac{3}{8}$ x $16\frac{3}{8}$) *sight*
William Salter
Bequeathed by W.D.MacKenzie,
1950
See Collections: Studies for The
Waterloo Banquet at Apsley House,
1836, by William Salter

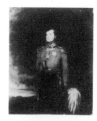

P19 Photograph: salt print
20 x 12.4 ($7\frac{7}{8}$ x $4\frac{7}{8}$)
Roger Fenton, 1855
Purchased, 1975

P49 *See Groups:* The Council of
War on the day of the taking of the
Mamelon Quarries, 7 June 1855, by
Roger Fenton

RAGLAN, Richard Henry Fitzroy, 2nd Baron (1817-84)
Representative peer

1834(y) *See Collections:* Members of the House of Lords, c.1870-80, by Frederick Sargent, **1834(a-z and aa-hh)**

RAIKES, Henry Cecil (1838-91)
Postmaster-General

2596 Water-colour 30.5 x 18.1 (12 x $7\frac{1}{8}$)
Carlo Pellegrini, signed *Ape* (*VF* 17 April 1875)
Purchased, 1933

RAIKES, Robert (1735-1811)
Journalist and promoter of Sunday Schools

1551 Canvas 123.8 x 98.4 (48¾ x 38¾)
George Romney, 1785-8
Purchased, 1909

2548 Paste medallion, oval 7.6 x 5.7 (3 x 2¼)
William Tassie, incised
Purchased, 1932

RAIMBACH, Abraham (1776-1843)
Engraver

775 Panel 25.4 x 21 (10 x 8¼)
Sir David Wilkie, inscribed and dated 1818 on reverse
Bequeathed by the sitter's son, Michael Thomson Scott Raimbach, 1887

RAINSFORD, Sir Richard (1605-80) Judge

643 Canvas, feigned oval 75.6 x 62.2 (29¾ x 24½)
After Gerard Soest (1678)
Purchased, 1881

Piper

RALEIGH (or Ralegh), Sir Walter (1552?-1618)
Soldier, sailor, poet and writer

4106 Miniature on vellum, oval 4.8 x 4.1 ($1\frac{7}{8}$ x $1\frac{5}{8}$)
Nicholas Hilliard, c.1585
Purchased with help from NACF and the Pilgrim Trust, 1959

7 Panel 91.4 x 74.6 (36 x $29\frac{3}{8}$)
Attributed to the monogrammist 'H', inscribed and dated 1588
Purchased, 1857. *Montacute*

3914 With his eldest son, Walter
Panel 199.4 x 127.3 (78½ x $50\frac{1}{8}$)
Unknown artist, inscribed and dated 1588
Given by the Lennard family, 1954

Strong

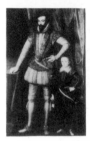

RALEIGH, Walter (1593-1618)
Eldest son of Sir Walter Raleigh

3914 *See under* Sir Walter Raleigh

RAMBERT, Dame Marie (Marie Dukes) (b.1888)
A founder of British ballet

4866 Bronze cast of bust 47.6 (18¾) high
Astrid Zydower, incised with initials and dated 1970
Given by the artist, 1972

RAMSAY, Allan (1713-84)
Portrait painter

3311 Canvas, oval 61 x 46.4 (24 x 18¼)
Self-portrait, c.1739
Purchased, 1946

Continued overleaf

1660 Red chalk 28.9 x 21.6
$(11\frac{3}{8} \times 8\frac{1}{2})$
Self-portrait, inscribed and dated
1776 on reverse
Purchased, 1912

Kerslake

RAMSAY, James (1733-89)
Divine and philanthropist

2559 Canvas 88.9 x 68.6 (35 x 27)
Carl Frederik von Breda, signed,
inscribed and dated 1789
Given by Sir Edmund Phipps, 1933

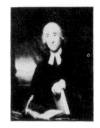

RAMSAY, James, 10th Earl and
1st Marquess of Dalhousie
See DALHOUSIE

RAMSAY, William
Fisherman

P6(215) *See Collections:* The Hill
and Adamson Albums, 1843-8, by
David Octavius Hill and Robert
Adamson, **P6(1-258)**

RAMSBOTTOM, John (d.1845)
MP for Windsor

54 *See Groups:* The House of Com-
mons, 1833, by Sir George Hayter

RAMSDEN, John Charles
(1788-1837) MP for Malton

54 *See Groups:* The House of Com-
mons, 1833, by Sir George Hayter

RANCLIFFE, Elizabeth Mary,
Lady (1786-1852)
Wife of 2nd Baron Rancliffe

883(16) *See Collections:* Studies
for miniatures by Sir George Hayter,
883(1-21)

RANELAGH, Thomas Heron Jones,
7th Viscount (1812-85) Rake

4736 Water-colour 30.5 x 17.8
(12 x 7)
Carlo Pellegrini, signed *Ape*
(*VF* 25 June 1870)
Purchased, 1970

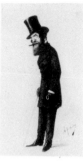

RASCH, Sir Frederic Carne, Bt
(1847-1914) Politician

2981 Water-colour 36.2 x 24.8
$(14\frac{1}{4} \times 9\frac{3}{4})$
Sir Leslie Ward, signed *Spy*
(*VF* 1 April 1896)
Purchased, 1937

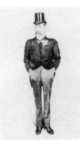

RAS MAKONNEN, Sir
Abyssinian envoy

4707(16) *See Collections: Vanity
Fair* cartoons, 1869-1910, by
various artists, **2566-2606,** etc

RASSAM, Christian Anthony
(d.1872)
Nestorian Christian and explorer;
British vice-consul at Mosul

2515(89) *See Collections:*
Drawings of Prominent People,
1823-49, by William Brockedon,
2515(1-104)

RATHBONE, Eleanor Florence
(1872-1946) Social reformer;
daughter of William Rathbone

4133 Canvas 89.5 x 69.9
$(35\frac{1}{4} \times 27\frac{1}{2})$
Sir James Gunn, signed
Given by B.L.Rathbone, 1959

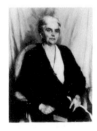

RATHBONE, Richard
Slavery abolitionist

599 *See Groups:* The Anti-Slavery
Society Convention, 1840, by
Benjamin Robert Haydon

RATHBONE, William (1819-1902)
Pioneer organiser of nursing services

4018 Bronze medallion 14.9 (5⅞)
diameter
Charles John Allen, inscribed and
dated 1899
Given by the artist's family, 1957

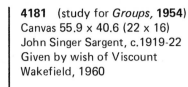

RATHMORE, David Robert, 1st
Baron (1838-1919) Politician;
first Commissioner of Works

3597 *See Collections:* Prominent
Men, c.1880-c.1910, by Harry
Furniss, **3337-3535** and **3554-3620**

RATTIGAN, Sir Terence (1911-77)
Playwright

4529(286-93) *See Collections:*
Working drawings by Sir David
Low, **4529(1-401)**

RAVEN-HILL, Leonard
(1867-1942)
Artist, illustrator and cartoonist

3046 Pencil 31.4 x 21.3
(12⅜ x 8⅜)
Self-portrait, signed with initials
Given by Marion Harry Spielmann,
1939

RAWLINSON, Henry Seymour
Rawlinson, Baron (1864-1925)
Soldier

4039(4) Water-colour and pencil
29.5 x 24.1 (11⅝ x 9½)
Inglis Sheldon-Williams, signed,
inscribed and dated 1900,
autographed by sitter
Purchased, 1957
See Collections: Boer War Officers,
1900, by Inglis Sheldon-Williams,
4039(1-7)

2908(2,14,15) *See Collections:*
Studies, mainly for General Officers
of World War I, by John Singer
Sargent, **2908(1-18)**

4181 (study for *Groups,* **1954**)
Canvas 55.9 x 40.6 (22 x 16)
John Singer Sargent, c.1919-22
Given by wish of Viscount
Wakefield, 1960

1954 *See Groups:* General
Officers of World War I, by
John Singer Sargent

RAWLINSON, Sir Henry Creswicke,
Bt (1810-95) Soldier, diplomat
and Assyriologist

1714 Wax medallion, irregular
oval 17.1 x 12.7 (6¾ x 5)
Richard Cockle Lucas, incised and
dated 1850
Purchased, 1913

4737 Water-colour 31.1 x 16.5
(12¼ x 6½)
Sir Leslie Ward, signed *Spy*
(*VF* 12 July 1873)
Purchased, 1970

RAWSON, Mrs
Slavery abolitionist

599 *See Groups:* The Anti-Slavery
Society Convention, 1840, by
Benjamin Robert Haydon

RAY, John (1627-1705)
Naturalist

563 Canvas, feigned oval
76.2 x 63.5 (30 x 25)
Unknown artist
Transferred from BM, 1879

Piper

RAYLEIGH, John Strutt, Baron
(1842-1919)
Mathematician and physicist

3879 Crayon and pencil
34.9 x 25.4 (13¾ x 10)
Sir William Rothenstein, signed
with initials and dated 1916
Given by the Rothenstein Memorial
Trust, 1953

READ, Clare Sewell (1826-1905)
Agriculturalist

2597 Water-colour 30.2 x 18.1
($11\frac{7}{8}$ x $7\frac{1}{8}$)
Carlo Pellegrini, signed *Ape*
(*VF* 5 June 1875)
Purchased, 1933

READ, Sir Herbert (1893-1968)
Critic and writer on art

P13 Photograph: bromide print
38.4 x 25.1 ($15\frac{1}{8}$ x $9\frac{7}{8}$)
Felix H. Man, 1940
Given by the photographer, 1975
See Collections: Prominent men,
c.1938-43, by Felix H. Man,
P10-17

4654 Canvas 76.2 x 63.5 (30 x 25)
Patrick Heron, signed and dated
1950
Given by Dame Barbara Hepworth
and Henry Moore, 1968

READ, John Francis Holcombe
Stockbroker

2598 Water-colour 31.8 x 19.7
(12½ x 7¾)
Liberio Prosperi, signed *Lib*
(*VF* 28 April 1888)
Purchased, 1933

READE, Charles (1814-84)
Novelist and dramatist

2281 Canvas 109.9 x 140.3
(43¼ x 55¼)
Attributed to Charles Mercier
Given by T.Chatto, 1929

1633 Plaster cast of bust 83.8 (33)
high
Percy Fitzgerald
Given by the artist, 1911

READING, Rufus Isaacs, Marquess
of (1860-1935) Lord Chief Justice,
diplomat and Viceroy of India

4180 Canvas 91.4 x 61 (36 x 24)
Sir William Orpen, signed and dated
1919
Given by wish of Viscount
Wakefield, 1960

3643 Bronze cast of bust 43.2 (17)
high
Kathleen Scott, incised, 1925
Given by the artist's husband,
Lord Kennet, 1948

2880 Sanguine, black and white
chalk 40.6 x 29.5 (16 x $11\frac{5}{8}$)
Sir William Rothenstein, signed
with initials and dated 1925
Given by the Rothenstein Memorial
Trust, 1936

REDDING, Mr

P6(159) *See Collections:* The Hill
and Adamson Albums, 1843-8, by
David Octavius Hill and Robert
Adamson, **P6(1-258)**

REDESDALE, John Freeman-Mitford, Baron (1748-1830)
Speaker of the House of Commons

745 *See Groups:* William Pitt addressing the House of Commons . . . 1793, by Karl Anton Hickel

1265 Canvas 140.3 x 109.2 (55¼ x 43)
Sir Martin Archer Shee
Given by Algernon Freeman-Mitford, Baron Redesdale, 1900

REDESDALE, Algernon Freeman-Mitford, Baron (1837-1916)
Diplomat and writer

3860 Water-colour 34.3 x 24.8 (13½ x 9¾)
Sir Leslie Ward, signed *Spy*
(*VF* 16 June 1904)
Purchased, 1953

REDGRAVE, Richard (1804-88)
Painter and pioneer organiser of art education

2464 Canvas 17.8 x 15.2 (7 x 6)
Self-portrait
Given by his son, Gilbert Redgrave, 1930

4486 Brown wash 14.9 x 11.4 (5⅞ x 4½)
Sir Francis Grant, inscribed and dated 1872
Purchased, 1966

Ormond

REDMOND, John Edward (1856-1918) Irish political leader

2982 Water-colour 35.2 x 25.1 (13⅞ x 9⅞)
Sir Leslie Ward, signed *Spy*
(*VF* 12 Nov 1892)
Purchased, 1938

2983 Water-colour 36.5 x 26.4 (14⅜ x 10⅜)
Sir Leslie Ward, signed *Spy*
(*VF* 7 July 1907)
Purchased, 1938

5123 Sanguine 47.3 x 36.8 (18⅝ x 14½)
Harold Speed, signed and dated 1907, autographed by sitter
Purchased, 1977

2916a Etching 23.5 x 18.4 (9¼ x 7¼)
John George Day, signed with symbol, 1913
Purchased, 1937

2855 *See Collections:* Caricatures of Politicians, by Sir Francis Carruthers Gould, **2826-74**

REDMOND, William Hoey Kearney (1861-1917) Irish nationalist

2286 *See Collections:* Miscellaneous drawings . . . by Sydney Prior Hall, **2282-2348** and **2370-90**

REDPATH, Anne (1895-1965)
Painter

5171 Canvas 72.7 x 60 (28⅝ x 23⅝)
Leszek Muszynski, signed and dated 1948
Given by the artist, 1977

REES, Abraham (1743-1825)
Encyclopaedist

564 Canvas 74.9 x 62.2
(29½ x 24½)
James Lonsdale
Transferred from BM, 1879

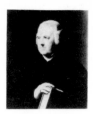

REEVE, Henry (1813-95)
Journalist and writer

4372 Pencil and wash 27.9 x 21.6
(11 x 8½)
Alfred, Count D'Orsay, signed and
dated 1839, autographed by sitter
Given by W.Reeve Wallace, 1964

REEVE, John (1783-1864)
Colonel

3744 *See Collections:* Studies for
The Waterloo Banquet at Apsley
House, 1836, by William Salter,
3689-3769

REEVES, John (1752-1829)
King's printer

2633 Canvas 40.6 x 30.5 (16 x 12)
After Thomas Hardy, inscribed
(exh 1792)
Given by E.Culme Seymour, 1933

REEVES, John Sims (1818-1900)
Singer

1962(g) Water-colour and pencil
20.6 x 14.9 (8⅛ x 5⅞)
Alfred Edward Chalon
Purchased, 1922
See Collections: Opera singers and
others, c.1804-c.1836, by Alfred
Edward Chalon, **1962(a-l)**

2764 Canvas 240 x 148
(94½ x 58¼)
Alessandro Ossani, signed and dated
1863
Purchased, 1935

Ormond

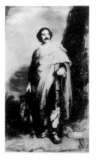

REID, Sir John Rae, Bt (1781-1867)
MP for Dover

54 *See Groups:* The House of Com-
mons, 1833, by Sir George Hayter

REID, Robert Threshie, Earl
Loreburn *See* LOREBURN

REID, Sir Thomas Wemyss
(1842-1905)
Journalist and biographer

2257 *See Collections:* The Parnell
Commission, 1888-9, by Sydney
Prior Hall, **2229-72**

REINAGLE, Ramsay Richard
(1775-1862) Painter

3025 *See Unknown Sitters IV*

REITH, John Reith, Baron
(1889-1971)
First Director of the BBC

4529(294-7) *See Collections:*
Working drawings by Sir David
Low, **4529(1-401)**

4566 Chalk 48.9 x 34 (19¼ x 13⅜)
Sir David Low, signed and inscribed,
pub 1933
Purchased, 1933

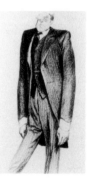

4648 Sanguine and white chalk
41.6 x 28.2 (16⅜ x 11⅛)
Sir William Rothenstein, pub 1937
Given by the Rothenstein Memorial
Trust, 1968

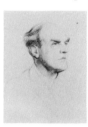

RENNELL, James Rennell Rodd,
1st Baron (1858-1941)
Diplomat and scholar

5127 Water-colour 37.5 x 26.7
(14¾ x 10½)
Sir Leslie Ward, signed *Spy*
(*VF* 7 Jan 1897)
Purchased, 1977

RENNELL, James (1742-1830)
Geographer

1153 Pencil 25.4 x 19.1 (10 x 7½)
George Dance, signed and dated
1794
Purchased, 1898

896 Marble bust 54.6 (21½) high
Unknown artist
Bequeathed by the sitter's grandson,
Major James Rennell Rodd, 1892

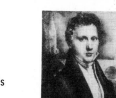

RENNIE, George (1791-1866)
Civil engineer

3683 Miniature on ivory
12.1 x 8.9 (4¾ x 3½)
John Linnell, signed with initials
and dated 1824
Purchased, 1949

Ormond

RENNIE, John (1761-1821)
Civil engineer

1154 Pencil 25.4 x 19.1 (10 x 7½)
George Dance, signed and dated
1803
Purchased, 1898

316a(100) Pencil 40.6 x 25.7
(16 x 10⅛)
Sir Francis Chantrey, inscribed
Given by Mrs George Jones, 1871
See Collections: Preliminary
drawings for busts and statues by
Sir Francis Chantrey, **316a(1-202)**

1075,1075a and **b** *See Groups:*
Men of Science Living in 1807-8,
by Sir John Gilbert and others

649 Marble bust 77.5 (30½) high
Sir Francis Chantrey, incised and
dated 1818
Given by the sitter's grandson, John
Keith Rennie, 1881

679 Bronze medallion 6.4 (2½)
diameter
W.Bain after Sir Francis Chantrey,
inscribed, c.1823(1818)
Given by the sitter's grandson, John
Keith Rennie, 1883

REPTON, Humphry (1752-1818)
Landscape gardener

4247 *See Unknown Sitters III*

RESZKE, Jean de (1850-1925)
Polish singer

4707(25) *See Collections: Vanity
Fair* cartoons, 1869-1910, by
various artists, **2566-2606,** etc

REUTER, Paul Julius, Baron
(1816-99) Founder of Reuter's
Telegraph Agency

3275 Water-colour 30.5 x 18.4
(12 x 7¼)
Melchiorre Delfico
(*VF* 14 Dec 1872)
Purchased, 1934

REYNELL, Sir Thomas

3745 *See Collections:* Studies for The Waterloo Banquet at Apsley House, 1836, by William Salter, **3689-3769**

REYNOLDS, John Hamilton (1796-1852) Poet; friend and correspondent of John Keats

5052 Miniature on ivory 9.9 x 7.3 ($3\frac{7}{8}$ x $2\frac{7}{8}$)
Joseph Severn, signed and dated 1818 on backing card
Bequeathed by Miss M.P.Sichel, 1975

REYNOLDS, Joseph (1769-1859)
Slavery abolitionist

599 *See Groups:* The Anti-Slavery Society Convention, 1840, by Benjamin Robert Haydon

REYNOLDS, Sir Joshua (1723-92)
Painter and first PRA

41 Canvas 63.5 x 74.3 (25 x 29¼)
Self-portrait, c.1747
Purchased, 1858

1437, 1437a *See Groups:* The Academicians of the Royal Academy, 1771-2, by John Sanders after Johan Zoffany

987 *See Groups:* Sir Joshua Reynolds, Sir William Chambers and Joseph Wilton, 1782, by John Francis Rigaud

927 *See Unknown Sitters III*

1761b *See Unknown Sitters III*

REYNOLDS, Richard (1735-1816)
Philanthropist and industrialist

4674 Wax bust 19.1 x 15.2 (7½ x 6)
Samuel Percy, c.1817
Purchased, 1969

REYNOLDS, Samuel William (1773-1835)
Mezzotint engraver and painter

1320 Panel 42.5 x 34.9 (16¾ x 13¾)
John Opie
Purchased, 1902

4989 Canvas 76.5 x 63.8 ($30\frac{1}{8}$ x $25\frac{1}{8}$)
Self-portrait, c.1820-5
Purchased, 1974

2123 Miniature on ivory, oval 8.6 x 7 ($3\frac{3}{8}$ x 2¾)
Elizabeth Walker (his daughter)
Given by Bernard Falk, 1926

RHODES, Cecil John (1853-1902)
Imperialist and statesman in South Africa

1407 Canvas 85.7 x 67.9 (33¾ x 26¾)
George Frederic Watts, 1898
Given by the artist's executors, 1905

4151 Bronze cast of bust 45.1 (17¾) high
Sydney March, incised and dated 1901
Purchased, 1960

2853,2854 *See Collections:* Caricatures of Politicians, by Sir Francis Carruthers Gould, **2826-74**

3404 *See Collections:* Prominent Men, c.1880-c.1910, by Harry Furniss, **3337-3535** and **3554-3620**

1730 Plaster cast of death-mask
24.8 (9¾) long
John Tweed
Given by the artist, 1914

4200 Pastel 73.3 x 53.3
($28\frac{7}{8}$ x 21)
Henry Tonks, signed and dated 1917
Bequeathed by Dr Dorothy Day,
1961

2545 Plaster cast of bust 64.8
(25½) high
Henry Pegram, posthumous
Given by the artist, 1932

RICH, Henry, 1st Earl of Holland
See HOLLAND

RICH, John (1826-1913)
Honorary Canon of Bristol
Cathedral

P7(11) *See Collections:* Lewis
Carroll at Christ Church, by Charles
Lutwidge Dodgson, **P7(1-37)**

RHYS, Ernest (1859-1946)
Writer and editor

P131 Photograph: bromide print
40 x 31.1 (15¾ x 12¼)
Lucia Moholy, 1938
Purchased, 1979
See Collections: Prominent People,
1935-8, by Lucia Moholy, **P127-33**

RICHARD II (1367-1400)
Reigned 1377-99

1676 Canvas 226.1 x 113
(89 x 44½)
J.Randall after painting by an
unknown artist in Westminster
Abbey
Lent by Victoria & Albert Museum,
1912

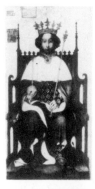

RHYS, Sir John (1840-1915)
Celtic scholar

4697 Canvas 68.6 x 55.9 (27 x 22)
Solomon Joseph Solomon, signed
in monogram
Purchased, 1969

565 Panel 60.3 x 45.7 (23¾ x 18)
Unknown artist, inscribed, reduced
copy
Transferred from BM, 1879

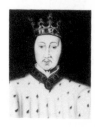

RICE, Francis William, 5th Baron
Dynevor *See* DYNEVOR

RICE, George, 4th Baron Dynevor
See DYNEVOR

4980(8) *See Collections:* Set of 16
early English Kings and Queens
formerly at Hornby Castle,
Yorkshire, **4980(1-16)**

RICE, James (1843-82) Novelist

2280 *See under* Sir Walter Besant

330 Electrotype of effigy in
Westminster Abbey 78.7 (31) high
After Nicholas Broker and Godfrey
Prest (c.1395-7)
Purchased, 1871

RICH, Alfred William (1856-1922)
Water-colourist

2556 *See Groups:* The Selecting
Jury of the New English Art Club,
1909, by Sir William Orpen

Strong

RICHARD III (1452-85)
Reigned 1483-5

148 Panel 63.8 x 47 ($25\frac{1}{8}$ x 18½)
Unknown artist, inscribed
Given by James Gibson Craig, 1862

4980(12) Panel 56.8 x 44.8
($22\frac{3}{8}$ x $17\frac{5}{8}$)
Unknown artist, inscribed
Purchased, 1974
See Collections: Set of 16 early
English Kings and Queens formerly
at Hornby Castle, Yorkshire,
4980(1-16)

Strong

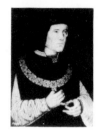

RICHARDOT, Jean
President of the Privy Council

665 *See Groups:* The Somerset
House Conference, 1604, by an
unknown Flemish artist

RICHARDS, Ceri (1903-71)
Painter

4909 Composition board
76.2 x 63.5 (30 x 25)
Self-portrait, signed with initials
and dated 1934
Purchased, 1972

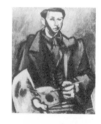

RICHARDS, Sir George Henry
(1820-96) Admiral and
hydrographer to the Admiralty

923 Canvas 38.7 x 32.4
(15¼ x 12¾)
Stephen Pearce, 1865
Bequeathed by Lady Franklin,
1892
See Collections: Arctic Explorers,
1850-86, by Stephen Pearce,
905-24 and **1209-27**

Ormond

RICHARDS, Sir Gordon (b.1904)
Jockey, trainer and racing manager

P17 *See Collections:* Prominent
men, c.1938-43, by Felix H. Man,
P10-17

RICHARDS, John Inigo (d.1810)
Landscape and scene painter

1437,1437a *See Groups:* The
Academicians of the Royal
Academy, 1771-2, by John Sanders
after Johan Zoffany

RICHARDSON, Sir John
(1787-1865)
Arctic explorer and naturalist

888 Plaster cast of medallion
20.3 (8) diameter
Bernhard Smith, incised, 1842
Given by Sir Joseph Dalton Hooker,
1892

909 (study for *Groups,* **1208**)
Millboard 37.8 x 31.8 ($14\frac{7}{8}$ x 12½)
Stephen Pearce, 1850
Bequeathed by Lady Franklin,
1892
See Collections: Arctic Explorers,
1850-86, by Stephen Pearce,
905-24 and **1209-27**

1208 *See Groups:* The Arctic
Council, 1851, by Stephen Pearce

Ormond

RICHARDSON, Jonathan
(1665-1745) Portrait painter

706 Canvas 73.7 x 62.9 (29 x 24¾)
Self-portrait, dated 1729
Purchased, 1883. *Beningbrough*

1831 Pencil on vellum 15.6 x 12.7
($6\frac{1}{8}$ x 5)
Self-portrait, dated 1730
Given by Richard Budgett, 1918

1693 Black and red chalk
39.7 x 25.7 ($15\frac{5}{8}$ x $10\frac{1}{8}$)
Self-portrait, stamped *JR*
Purchased, 1913

3779 Black chalk 32.7 x 26.7
($12\frac{7}{8}$ x 10½)
Self-portrait, inscribed and dated
1735
Transferred from the Fleming
Collection, 1950

3023 Pen and pencil 16.2 x 11.4
($6\frac{3}{8}$ x 4½)
Self-portrait, inscribed and dated
1736
Given by Marion Harry Spielmann,
1939

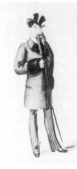

1576D Pencil 11.7 x 8.9
($4\frac{5}{8}$ x 3½)
By or after himself
Given by George Tite, 1910

Kerslake

RICHARDSON, Sir Ralph (b.1902)
Actor

P66 *See Collections:* Prominent
people, c.1946-64, by Angus
McBean, **P56-67**

RICHARDSON, Robert
(1779-1847)
Traveller and physician

2515(26) *See Collections:*
Drawings of Prominent People,
1823-49, by William Brockedon,
2515(1-104)

Ormond

RICHARDSON, Samuel
(1689-1761) Novelist

161 Canvas 75.6 x 62.9
(29¾ x 24¾)
Joseph Highmore, inscribed,
reduced version (1747)
Purchased, 1863. *Beningbrough*

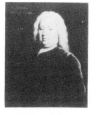

1036 Canvas 52.7 x 36.8
(20¾ x 14½)
Joseph Highmore, signed, inscribed
and dated 1750
Purchased, 1896

Kerslake

RICHARDSON-GARDNER,
Robert (b.1827) Politician

3294 Water-colour 39.4 x 21.6
(15½ x 8½)
Sir Leslie Ward, signed *Spy*
(*VF* 17 Feb 1877)
Purchased, 1934

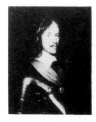

RICHMOND, Lodovick Stuart, 1st
Duke of, and 2nd Duke of Lennox
(1574-1624) Statesman

3063 Water-colour on parchment,
heart-shaped 5.7 x 4.4 (2¼ x 1¾)
Isaac Oliver, c.1605
Transferred from BM, 1939

Strong

RICHMOND, James Stuart, 1st
Duke of, and 4th Duke of Lennox
(1612-55) Royalist

4518 Canvas 73.7 x 59.7
(29 x 23½)
Attributed to Theodore Russel
Purchased, 1966

RICHMOND, Mary, Duchess of
(1622-85) Daughter of 1st Duke
of Buckingham and wife of 1st
Duke of Richmond

711 *See Groups:* The Duke of
Buckingham and his Family,
1628, after Gerard Honthorst

RICHMOND, Charles Henry
Gordon-Lennox, 6th Duke of, and
1st Duke of Gordon (1818-1903)
Statesman

4893 *See Groups:* The Derby
Cabinet of 1867, by Henry Gales

RICHMOND, George (1809-96)
Portrait painter and draughtsman

2157 Plaster cast of bust 66 (26)
high
Joseph Denham, incised, c.1834
Given by the sitter's daughter,
Lady Kennedy, 1927

2157a Electrotype in bronze of
no.**2157**, 65.4 (25¾) high
After Joseph Denham (c.1834)
Purchased, 1927

2509 Millboard 35.2 x 27.3
(13⅞ x 10¾)
Self-portrait, inscribed and dated
1853 on backboard
Given by wish of the sitter's son,
Walter Richmond, 1931

1833 *See Groups:* Private View of
the Old Masters Exhibition, Royal
Academy, 1888, by Henry Jamyn
Brooks

Ormond

RICHMOND, Sir William Blake
(1842-1921)
Painter; son of George Richmond

2065 Chalk 45.1 x 34.3
(17¾ x 13½)
George Phoenix, signed and dated
1893
Given by W.H.I.Winter, 1924

2779A Canvas 52.7 x 40.6
(20¾ x 16)
Unknown artist
Purchased, 1935. *Damaged, not
illustrated*

RICHMOND AND LENNOX,
Charles Lennox, 1st Duke of
(1672-1723) Courtier

3221 Canvas 91.4 x 71.1
(36 x 28)
Sir Godfrey Kneller, signed, c.1710
Kit-cat Club portrait
Given by NACF, 1945.
Beningbrough

Piper

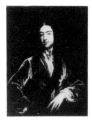

RICHMOND AND LENNOX,
Frances Theresa Stuart, Duchess of
(1647-1702) Famous beauty; wife
of 3rd Duke of Richmond and 6th
Duke of Lennox

1681 Silver medal 7 (2¾) diameter
John Roettier, modern strike from
die of c.1667
Purchased, 1912

4996 Canvas 213 x 129.5
(84⅞ x 51)
William Wissing and Jan van der
Vaart, signed and dated 1687
Purchased, 1974

Piper

RICHMOND AND LENNOX,
Charles Lennox, 3rd Duke of
(1735-1806)
Soldier, diplomat and politician

4877 Canvas 81.3 x 68.6 (32 x 27)
George Romney, 1776
Purchased, 1972

RICHMOND AND LENNOX,

Charles Lennox, 4th Duke of
(1764-1819) Soldier; Governor-
General of British North America

4943 Miniature on ivory, oval
7.6 x 6.4 (3 x 2½)
Attributed to Simon Jacques
Rochard
Purchased, 1973

RICHMOND AND LENNOX,

Charles Gordon-Lennox, 5th Duke
of (1791-1860)
Soldier and politician

1914(12) Water-colour 19.1 x 16.2
(7½ x 6⅜)
Thomas Heaphy
Purchased, 1921
See Collections: Peninsular and
Waterloo Officers, 1813-14, by
Thomas Heaphy, **1914(1-32)**

999 *See Groups:* The Trial of
Queen Caroline, 1820, by Sir
George Hayter

54 *See Groups:* The House of Com-
mons, 1833, by Sir George Hayter

3746 *See Collections:* Studies for
The Waterloo Banquet at Apsley
House, 1836, by William Salter,
3689-3769

RICKETTS, Charles (1866-1931)
Painter and designer

3106 Canvas 95.3 x 99.1
(37½ x 39)
Charles Haslewood Shannon, signed
and dated 1898
Given by NACF, 1942

2631 Chalk 29.8 x 19.7
(11¾ x 7 ¾)
Charles Haslewood Shannon, signed
with initials and dated 1899
Purchased, 1933

3108 Pencil 26.7 x 21.3 (10½ x 8⅜)
Laura Anning-Bell, signed
Bequeathed by Lady Davis, 1942

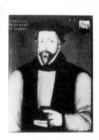

RICKMAN, John (1771-1840)
Statistician

54 *See Groups:* The House of Com-
mons, 1833, by Sir George Hayter

RIDDELL, George Riddell, Baron
(1865-1934) Newspaper proprietor

4529(298) *See Collections:*
Working drawings by Sir David
Low, **4529(1-401)**

RIDDING, George (1828-1904)
Bishop of Southwell

2369 *See Groups:* The Education
Bill in the House of Lords, by
Sydney Prior Hall

RIDLEY, Nicholas (1500?-55)
Bishop of London

296 Panel 55.9 x 43.2 (22 x 17)
Unknown artist, inscribed and dated
1555
Purchased, 1870

Strong

RIDLEY-COLBORNE, Nicholas
William, 1st Baron Colborne
See COLBORNE

RIGBY, Anne (née Palgrave)
(1777-1872) Wife of Edward Rigby

P6(126-8,132-4) *See Collections:*
The Hill and Adamson Albums,
1843-8, by David Octavius Hill and
Robert Adamson, **P6(1-258)**

RIGBY, Sir John (1834-1903)
Solicitor-General

2995 Water-colour 36.2 x 26.7
(14¼ x 10½)
(Possibly H.C.Sepping) Wright,
signed *STUFF*
(*VF* 31 Aug 1893)
Purchased, 1938

RINTOUL,Robert Stephen
(1787-1858) Journalist, editor and
founder of *The Spectator*

P6(79) Photograph: calotype
19.7 x 14.9 (7¾ x 5⅞)
David Octavius Hill and Robert
Adamson, 1843-8
Given by an anonymous donor, 1973
See Collections: The Hill and
Adamson Albums, 1843-8, by David
Octavius Hill and Robert Adamson,
P6(1-258)

RIPON, Frederick John Robinson,
1st Earl of (1782-1859)
Prime Minister

4875 Canvas 92.1 x 71.1
(36¼ x 28)
Sir Thomas Lawrence, c.1824
Purchased, 1972

54 *See Groups:*The House of Com-
mons, 1833, by Sir George Hayter

RIPON, George Robinson, 1st
Marquess of (1827-1909)
Viceroy of India

5116 *See Groups:* Gladstone's
Cabinet of 1868, by Lowes Cato
Dickinson

1553 Canvas 74.9 x 62.2
(29½ x 24½)
George Frederic Watts, 1895
Given by wish of the artist, 1909

2856, 2857 *See Collections:*
Caricatures of Politicians, by Sir
Francis Carruthers Gould, **2826-74**

3405 *See Collections:* Prominent
Men, c.1880-c.1910, by Harry
Furniss, **3337-3535** and **3554-3620**

RIPPON, Cuthbert
MP for Gateshead

54 *See Groups:*The House of Com-
mons, 1833, by Sir George Hayter

RISHTON, Mrs (née McCandlish)

P6(116) *See Collections:* The Hill
and Adamson Albums, 1843-8, by
David Octavius Hill and Robert
Adamson, **P6(1-258)**

RITCHIE, Alexander Handyside
(1804-70) Sculptor

P6(33) Photograph: calotype
17.8 x 14.6 (7 x 5¾)
David Octavius Hill and Robert
Adamson, 1843-8
Given by an anonymous donor,
1973
See Collections: The Hill and
Adamson Albums, 1843-8, by David
Octavius Hill and Robert Adamson,
P6(1-258)

P6(24,98) *See Collections:* The
Hill and Adamson Albums, 1843-8,
by David Octavius Hill and Robert
Adamson, **P6(1-258)**

RITCHIE, Isabella Anne, Lady
(1837-1919) Novelist; daughter
of William Makepeace Thackeray

P53 Photograph: albumen print
30.2 x 23.2 (11⅞ x 9⅛)
Julia Margaret Cameron, inscribed
below print, c.1867
Given by Mrs E.Norman-Butler,
1976

RIVERS, George Pitt, 2nd Baron
(1751-1828)

999 *See Groups:* The Trial of
Queen Caroline, 1820, by Sir
George Hayter

RIVIERE, Briton (1840-1920)
Painter

2820 *See Groups:* The Royal
Academy Conversazione, 1891, by
G.Grenville Manton

ROBENS of Woldingham, Alfred
Robens, Baron (b.1910)
Administrator and writer

4529(299-301) *See Collections:*
Working drawings by Sir David
Low, **4529(1-401)**

ROBERT, Duke of Normandy
(1054?-1134)
Eldest son of William I

440 Electrotype of painted wooden
effigy in Gloucester Cathedral
177.8 (70) long
Unknown artist (c.1280)
Purchased, 1877

Strong

ROBERTS, Frederick Sleigh
Roberts, 1st Earl (1832-1914)
Field-Marshal

1996 Water-colour 30.5 x 18.1
(12 x 7$\frac{1}{8}$)
Unknown artist, signed in
monogram *GWR* (?)
(*VF* 10 April 1880)
Purchased, 1923

1744 Canvas 74.3 x 61.6
(29¼ x 24¼)
George Frederic Watts, 1898
Given by wish of the artist, 1914

4039(5) Water-colour and pencil
29.5 x 24.1 (11$\frac{5}{8}$ x 9½)
Inglis Sheldon-Williams, signed and
dated 1900, autographed by sitter
Purchased, 1957
See Collections: Boer War Officers,
1900, by Inglis Sheldon-Williams,
4039(1-7)

3927 Canvas 161.9 x 102.9
(63¾ x 40½)
John Singer Sargent, signed, 1904
Bequeathed by the sitter's daughter,
Countess Roberts, 1955

ROBERTS, Sir Abraham
(1784-1873) General; father
of 1st Earl Roberts

3928 Canvas 76.2 x 62.2
(30 x 24½)
Unknown artist
Given by Sir Ewan Miller, 1955

Ormond

ROBERTS, Arthur (1852-1933)
Comedian

2362 Pencil 39.7 x 30.5
(15$\frac{5}{8}$ x 12)
Augustus John, signed and dated
1895
Given by the artist, 1929

ROBERTS, David (1796-1864)
Painter

P6(90) Photograph: calotype
21 x 15.6 (8¼ x 6$\frac{1}{8}$)
David Octavius Hill and Robert
Adamson, 1843-8
Given by an anonymous donor,
1973
See Collections: The Hill and
Adamson Albums, 1843-8, by David
Octavius Hill and Robert Adamson,
P6(1-258)

1371 Chalk 35.6 x 23.2 (14 x 9$\frac{1}{8}$)
Unknown artist, inscribed
Purchased, 1904

3182(7) *See Collections:* Drawings
of Artists, c.1862, by Charles West
Cope, **3182(1-19)**

Ormond

ROBERTS, John

4529(302,303) *See Collections:*
Working drawings by Sir David Low,
4529(1-401)

ROBERTS, William (1895-1980)
Painter

5063 Pencil and water-colour
38.1 x 27.9 (15 x 11)
Self-portrait, signed, c.1965
Purchased, 1975

ROBERTSON, Brian Robertson,
1st Baron (1896-1974) Military
commander and administrator

4529(304-6) *See Collections:*
Working drawings by Sir David Low,
4529(1-401)

ROBERTSON, Patrick Robertson,
Lord (1794-1855) Scottish judge

P6(74) Photograph: calotype
20.6 x 14.9 ($8\frac{1}{8}$ x $5\frac{7}{8}$)
David Octavius Hill and Robert
Adamson, 1843-8
Given by an anonymous donor,
1973
See Collections: The Hill and
Adamson Albums, 1843-8, by David
Octavius Hill and Robert Adamson,
P6(1-258)

ROBERTSON, Dr

P22(24) *See Collections:* The
Balmoral Album, 1854-68, by
George Washington Wilson, W.& D.
Downey, and Henry John Whitlock,
P22(1-27)

ROBERTSON, John (1801-66)

P6(67) *See Collections:* The Hill
and Adamson Albums, 1843-8, by
David Octavius Hill and Robert
Adamson, **P6(1-258)**

ROBERTSON, Sir Johnston Forbes-
(1853-1937) Actor-manager

3008 Water-colour 37.5 x 26.7
(14¾ x 10½)
Sir Leslie Ward, signed *Spy*
(*VF* 8 May 1895)
Purchased, 1938

3642 Plaster cast of bust 50.8 (20)
high
Emil Fuchs, c.1902
Given by the sitter's widow, 1948

4095(4) Pen and ink 38.7 x 31.8
(15¼ x 12½)
Harry Furniss, signed with initials
Purchased, 1959
See Collections: The Garrick
Gallery of Caricatures, 1905, by
Harry Furniss, **4095(1-11)**

4529(307) *See Collections:*
Working drawings by Sir David Low,
4529(1-401)

ROBERTSON, P.

P22(17) *See Collections:* The
Balmoral Album, 1854-68, by
George Washington Wilson, W.& D.
Downey, and Henry John Whitlock,
P22(1-27)

ROBERTSON, Walford Graham
(1866-1948) Painter, illustrator,
costume designer and playwright

P47 Photograph: platinum print
14.6 x 10.2 (5¾ x 4)
Frederick Hollyer, early 1890s
Purchased, 1977

ROBERTSON, Sir William Robert, Bt (1860-1933) Field-Marshal

1954 *See Groups:* General Officers of World War I, by John Singer Sargent

ROBEY, Sir George (George Edward Wade) (1869-1954) Comedian

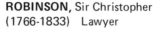

5082 Pen and ink 8.3 x 7 (3¼ x 2¾) Self-portrait, signed and inscribed, 1944
Given by J.Vassall Adams, 1976

3939, 3939a Pen and ink, two sketches, each 14 x 8.6 (5½ x 3⅜) Self-portraits, signed and inscribed
Given by the sitter's widow, 1955

4323 Pen and ink 15.9 x 14.9 (6¼ x 5⅞) Self-portrait, signed
Purchased, 1963

ROBIDA, Alessandro
Senator of Milan; a delegate at the Somerset House Conference

665 *See Groups:* The Somerset House Conference, 1604, by an unknown Flemish artist

ROBINS, Arthur (1834-99)
Chaplain to the Household Brigade

3003 Water-colour 38.1 x 23.8 (15 x 9⅜)
Sir Leslie Ward, signed *Spy* (*VF* 23 Dec 1897)
Purchased, 1938

ROBINSON, Sir Christopher (1766-1833) Lawyer

1695(h) *See Collections:* Sketches for The Trial of Queen Caroline, 1820, by Sir George Hayter, **1695(a-x)**

999 *See Groups:* The Trial of Queen Caroline, 1820, by Sir George Hayter

ROBINSON, Frederick John, 1st Earl of Ripon *See* RIPON

ROBINSON, George, 1st Marquess of Ripon *See* RIPON

ROBINSON, George Richard (1781-1850) MP for Worcester

54 *See Groups:* The House of Commons, 1833, by Sir George Hayter

ROBINSON, Henry Crabb (1775-1867) Journalist and diarist

1347 Miniature 15.2 x 12.1 (6 x 4¾)
Henry Darvall
Given by T.Smith Osler, 1903

ROBINSON, Sir John (1824-1913) Connoisseur and collector

2543 Canvas 71.1 x 55.9 (28 x 22) John James Napier
Given by the sitter's son, F.J.Robinson, 1932

1833 *See Groups:* Private View of the Old Masters Exhibition, Royal Academy, 1888, by Henry Jamyn Brooks

ROBINSON, Mary (1758-1800) 'Perdita'; writer, actress and mistress of George, Prince of Wales (later George IV)

5264 Pencil, pen and brown ink 25.4 x 20.3 (10 x 8)
Sir Joshua Reynolds, inscribed, c.1782
Purchased, 1979

Continued overleaf

1254 Pencil 26 x 21 (10¼ x 8¼)
George Dance, c.1793
Purchased, 1900

ROBINSON, Mathew (c.1694-1778)
Artist

1384 *See Groups:* A Conversation
of Virtuosis . . . at the Kings Armes
(A Club of Artists), by Gawen
Hamilton

ROBINSON, Sir Robert
(1886-1975) Chemist

5112 Canvas 91.4 x 71.1 (36 x 28)
Alfred Kingsley Lawrence, signed,
c.1950
Given by the artist's family, 1976

ROBINSON, Thomas, 1st Baron
Grantham *See* GRANTHAM

ROBINSON, Sir Thomas, Bt
(1700?-77) Colonial governor
and amateur architect

5275 Canvas 126.7 x 101.9
(49⅞ x 40⅛)
Frans van der Mijn (or Myn),
signed, inscribed and dated 1750
Purchased, 1979

ROBSON, William Snowden
Robson, 1st Baron (1852-1918)
Attorney-General

2996 Water-colour 36.5 x 26.7
(14⅜ x 10½)
Sir Leslie Ward, signed *Spy*
(*VF* 25 Jan 1906)
Purchased, 1938

ROBSON, Thomas Frederick
(1822?-64) Actor

1877 Chalk 36.5 x 27.3
(14⅜ x 10¾)
Arthur Miles, signed and dated
1861
Purchased, 1920

Ormond

ROCHE, William (1775-1850)
MP for Limerick

54 *See Groups:* The House of Com-
mons, 1833, by Sir George Hayter

ROCHESTER, Laurence Hyde, 1st
Earl of (1641-1711) Politician

4033 Canvas 220.3 x 148.6
(86¾ x 58½)
Sir Godfrey Kneller, signed and
dated 1685
Purchased, 1957

819 Canvas 121.9 x 100.3
(48 x 39½)
After William Wissing (c.1685-7)
Purchased, 1889

Piper

ROCHESTER, John Wilmot, 2nd
Earl of (1647-80)
Poet and libertine

804 Canvas 127 x 99.1 (50 x 39)
After Jacob Huysmans(?),
(c.1665-70)
Purchased, 1888

Piper

ROCKINGHAM, Charles Watson-
Wentworth, 2nd Marquess of
(1730-82) Prime Minister

406 Canvas, feigned oval
69.2 x 55.9 (27¼ x 22)
Studio of Sir Joshua Reynolds,
reduced version
Given by Ralph Maude, 1875

RODD, James Rennell, 1st Baron
Rennell *See* RENNELL

RODEN, Robert Jocelyn, 4th Earl
of (1846-80) Soldier and courtier

4738 Water-colour 27.3 x 18.4
(10¾ x 7¼)
Sir Leslie Ward, signed *Spy*
(*VF* 20 May 1876)
Purchased, 1970

RODNEY, George Brydges Rodney,
1st Baron (1719-92) Admiral

1398 Canvas 99.1 x 79.4
(39 x 31¼)
After Sir Joshua Reynolds (1761)
Purchased, 1905

RODNEY, George Rodney, 7th
Baron (1857-1909) Soldier

4739 Water-colour 32.4 x 19.1
(12¾ x 7½)
Liberio Prosperi, signed *Lib*
(*VF* 10 Nov 1888)
Purchased, 1970

ROE, Sir Thomas (1581-1644)
Diplomat

1354 Panel, feigned oval
72.4 x 59.7 (28½ x 23½)
After Michael Jansz. van Miereveldt,
inscribed (c.1640)
Purchased, 1904. *Montacute*

Piper

ROEBUCK, John Arthur (1801-79)
Politician

1777 Canvas 76.2 x 62.9
(30 x 24¾)
Unknown artist
Purchased, 1916

54 *See Groups:* The House of Com-
mons, 1833, by Sir George Hayter

2695 Water-colour 29.8 x 17.8
(11¾ x 7)
Carlo Pellegrini, signed *Ape*
(*VF* 11 April 1874)
Purchased, 1934

Ormond

ROGERS, Sir Edward
(1498?-1567?) Esquire of the
Body of Henry VIII

3792 Panel 67.9 x 52.7
(26¾ x 20¾)
Unknown artist, inscribed and
dated 1567
Purchased, 1951. *Montacute*

2409 *See Collections:* Copies of
early portraits, by George Perfect
Harding and Sylvester Harding,
1492, 1492(a-c) and **2394-2419**

Strong

ROGERS, Frederic, Baron Blachford
See BLACHFORD

ROGERS, Samuel (1763-1855)
Poet, banker and connoisseur

1155 Pencil 24.8 x 19.1 (9¾ x 7½)
George Dance, signed and dated
1795
Purchased, 1898

763 Canvas, oval 76.2 x 64.8
(30 x 25½)
Thomas Phillips, c.1817
Purchased, 1887

Continued overleaf

400 Chalk 74.3 x 61.9 (29¼ x 24⅜)
Sir Thomas Lawrence, c.1825
Given by the sitter's nephew, Henry
Rogers, 1875

3888 Plaster caricature bust
31.1 (12¼) high
Jean Pierre Dantan, incised, 1833
Given by Dr Philip Gosse, 1953

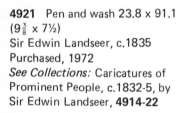

4921 Pen and wash 23.8 x 91.1
(9⅜ x 7½)
Sir Edwin Landseer, c.1835
Purchased, 1972
See Collections: Caricatures of
Prominent People, c.1832-5, by
Sir Edwin Landseer, **4914-22**

4919, 4920 *See Collections:*
Caricatures of Prominent People,
c.1832-5, by Sir Edwin Landseer,
4914-22

2772(p.28) *See Collections:* The
Clerk family, Sir Robert Peel,
Samuel Rogers, and others, 1833-57,
by Jemima Wedderburn, **2772**

1916 *See Groups:* Samuel Rogers,
the Hon Caroline Norton and Mrs
Phipps, c.1845, by Frank Stone

342,343 *See Groups:* The Fine
Arts Commissioners, 1846, by
John Partridge

1044 Chalk 60.3 x 47.6
(23¾ x 18¾)
George Richmond, signed and
dated 1848
Bequeathed by the artist, 1896

ROGET, Peter Mark (1779-1869)
Physician and savant; author of
*Thesaurus of English Words
and Phrases*

2515(79) Black and red chalk
36.2 x 26.7 (14¼ x 10½)
William Brockedon, dated 1835
Lent by NG, 1959
See Collections: Drawings of
Prominent People, 1823-49, by
William Brockedon, **2515(1-104)**

Ormond

ROLFE, Robert Monsey, Baron
Cranworth *See* CRANWORTH

ROLLE, John Rolle, Baron
(1750-1842) Politician

999 *See Groups:* The Trial of
Queen Caroline, 1820, by Sir
George Hayter

ROLLESTON, George (1829-81)
Physician

1933 Pencil and chalk 63.5 x 47
(25 x 18½)
William Edwards Miller, signed and
dated 1877
Given by the sitter's son, Sir
Humphry Davy Rolleston, 1922

ROLLIT, Sir Albert (1842-1922)
Politician

2694 Water-colour 31.8 x 18.4
(12½ x 7¼)
Sir Leslie Ward, signed *Spy*
(*VF* 9 Oct 1886)
Purchased, 1934

ROMAINE, William (1714-95)
Evangelical divine

2036 Canvas 124.5 x 99.1
(49 x 39)
Francis Cotes, signed and dated 1758
Purchased, 1924

ROMER, Isabella Frances (d.1852)
Miscellaneous writer

4026(50) Pencil and chalk
30.5 x 22.6 (12 x $8\frac{7}{8}$)
Alfred, Count D'Orsay, signed and
dated 1847, autographed by sitter
Purchased, 1957
See Collections: Drawings of Men
about Town, 1832-48, by Alfred,
Count D'Orsay, **4026(1-61)**

Ormond

ROMILLY, Sir Samuel
(1757-1818) Solicitor-General
and law reformer

3325 Canvas 73.7 x 61 (29 x 24)
John Hoppner, inscribed
Lent by Lady Teresa Agnew, 1968

1171 Canvas 74.9 x 62.2
(29½ x 24½)
Sir Thomas Lawrence, c.1810
Lent by Tate Gallery, 1954

ROMNEY, Henry Sidney, Earl of
(1641-1704) Politician

1722 *See Unknown Sitters II*

ROMNEY, George (1734-1802)
Portrait painter

2814 Pencil 14.6 x 10.2 (5¾ x 4)
Self-portrait
Purchased, 1936

959 Canvas 125.7 x 99.1
(49½ x 39)
Self-portrait, 1782
Purchased, 1894

1881 Miniature on ivory, oval
7.3 x 5.7 ($2\frac{7}{8}$ x 2¼)
Mary Barret
Given by Ernest E.Leggatt, 1920

ROMNEY, Peter (1743-77)
Painter

1882 Canvas 11.4 x 10.2 (4½ x 4)
George Romney (his brother)
Given by Ernest E.Leggatt, 1920

RONALD, Sir Landon (1873-1938)
Musician and conductor

3676 Pencil 36.8 x 30.1
(14½ x $11\frac{7}{8}$)
Sir Bernard Partridge, signed and
inscribed
(*Punch* 27 March 1929)
Purchased, 1949
See Collections: Mr Punch's
Personalities, 1926-9, by Sir
Bernard Partridge, **3664-6,** etc

4975(13) Pencil 26.3 x 20
($10\frac{3}{8}$ x $7\frac{7}{8}$)
Ernest Procter, 1929
Purchased, 1974
See Collections: Rehearsals for
A Mass of Life, 1929, by Ernest
Procter, **4975(1-36)**

RONALDS, Sir Francis (1788-1873)
Electrician and meteorologist

1075, 1075a and **b** *See Groups:*
Men of Science Living in 1807-8,
by Sir John Gilbert and others

1095 Canvas 61.6 x 50.8
(24¼ x 20)
Hugh Carter (his nephew), signed in
monogram, c.1870
Given by the artist, 1897

Ormond

RONNEY, W.

316a(101) *See Collections:* Preliminary drawings for busts and statues by Sir Francis Chantrey, **316a(1-202)**

ROOKE, Sir George (1650-1709)
Admiral

1992 Canvas, oval 72.4 x 59.7 (28½ x 23½)
Studio of Michael Dahl
Purchased, 1923

Piper

ROOKE, Sir Henry Willoughby (1783-1869)

3747 *See Collections:* Studies for The Waterloo Banquet at Apsley House, 1836, by William Salter, **3689-3769**

ROPER, Margaret (1505-44)
Daughter of Sir Thomas More

2765 *See Groups:* Sir Thomas More, his Father, his Household and his Descendants, by Rowland Lockey

ROSCOE, William (1753-1831)
Banker, historian and collector

963 Canvas 76.2 x 62.2 (30 x 24½)
Attributed to John Williamson
Given by the sitter's grandson, Sir Henry Enfield Roscoe, 1894

4147 Marble bust 21.6 (8½) high
Attributed to William Spence, incised
Given by Ernest Galinsky, 1960

ROSCOMMON, Wentworth Dillon, 4th Earl of (1633?-85)
Poet and translator of Horace

2396 Water-colour 9.8 x 7.8 ($3\frac{7}{8}$ x $3\frac{1}{8}$)
Attributed to George Perfect Harding after Carlo Maratti
Purchased, 1929
See Collections: Copies of early portraits, by George Perfect Harding and Sylvester Harding, **1492, 1492(a-c)** and **2394-2419**

ROSE, George (1744-1818)
Statesman

367 Canvas 90.2 x 69.9 (35½ x 27½)
Sir William Beechey, signed in monogram and dated 1802
Given by the sitter's grandsons, Lord Strathnairn and Sir W.Rose, 1873

ROSE, Hugh Henry, Baron Strathnairn *See* STRATHNAIRN

ROSEBERY, Archibald Primrose, 4th Earl of (1783-1868)
MP and FRS

999 *See Groups:* The Trial of Queen Caroline, 1820, by Sir George Hayter

ROSEBERY, Archibald Philip Primrose, 5th Earl of (1847-1929)
Prime Minister

3845 *See Groups:* Dinner at Haddo House, 1884, by Alfred Edward Emslie

2858-60 *See Collections:* Caricatures of Politicians, by Sir Francis Carruthers Gould, **2826-74**

3406,3406a,3600 *See Collections:* Prominent Men, c.1880-c.1910, by Harry Furniss, **3337-3535** and · **3554-3620**

ROSEBERY, Hannah (née Rothschild), Countess of (d.1890) Wife of 5th Earl of Rosebery

3845 *See Groups:* Dinner at Haddo House, 1884, by Alfred Edward Emslie

ROSENBAUM, Anthony (d.1888) Painter

3060 *See Groups:* Chess players, by A. Rosenbaum

ROSENBERG, Isaac (1890-1918) Painter and poet

4129 Panel 29.5 x 22.2 ($11\frac{5}{8}$ x 8¾) Self-portrait, 1915 Given by his sister, Mrs Wynick, 1959

ROSS, Sir Edward Denison (1871-1940) Orientalist

4203b (study for no.**4203**) Pencil 18.1 x 12.7 ($7\frac{1}{8}$ x 5) Frank Kovacs, signed, c.1939 Given by the artist, 1961

4203a (original plaster of no. **4203**) Frank Kovacs, incised, c.1939 Purchased, 1961. *Not illustrated*

4203 Bronze medallion 12.7 (5) diameter Frank Kovacs, incised, c.1939 Purchased, 1961

3981 Pencil 22.5 x 16.2 ($8\frac{7}{8}$ x $6\frac{3}{8}$) Helen McDougall Campbell, signed, inscribed and dated 1939 Given by George S.Sandilands, 1956

4529(308,309) *See Collections:* Working drawings by Sir David Low, **4529 (1-401)**

ROSS, Sir Hew Dalrymple (1779-1868) Field-Marshal

1914(13) Water-colour and pencil 19.1 x 15.2 (7½ x 6) *sight* Thomas Heaphy Purchased, 1921 *See Collections:* Peninsular and Waterloo Officers, 1813-14, by Thomas Heaphy, **1914(1-32)**

3748 Canvas 49.5 x 41.9 (19½ x 16½) William Salter Bequeathed by W.D.MacKenzie, 1950 *See Collections:* Studies for The Waterloo Banquet at Apsley House, 1836, by William Salter, **3689-3769**

ROSS, Sir James Clark (1800-62) Rear-Admiral and Arctic explorer

887 Plaster cast of medallion 20.3 (8) diameter Bernhard Smith, incised, 1843 Given by Sir Joseph Dalton Hooker, 1892

2515(99) *See Collections:* Drawings of Prominent People, 1823-49, by William Brockedon, **2515(1-104)**

913 (study for *Groups,* **1208**) Millboard 38.4 x 32.4 ($15\frac{1}{8}$ x 12¾) Stephen Pearce, 1850 Bequeathed by Lady Franklin, 1892 *See Collections:* Arctic Explorers, 1850-86, by Stephen Pearce, **905-24** and **1209-27**

1208 *See Groups:* The Arctic Council, 1851, by Stephen Pearce

Ormond

ROSS, Sir John (1777-1856) Rear-Admiral and Arctic explorer

314 Canvas 132.1 x 111.1 (52 x 43¾) James Green, 1833 Purchased, 1870

Continued overleaf

P120(25) Photograph: albumen print, arched top 19.7 x 14.6 (7¾ x 5¾)
Maull & Polyblank, 1855
Purchased, 1979
See Collections: Literary and Scientific Men, 1855, by Maull & Polyblank, **P120(1-54)**

Ormond

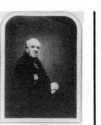

ROSS,Robert Baldwin (1869-1918) Writer and connoisseur

L168(6) *See Collections:* Prominent Men, 1895-1930, by Sir William Rothenstein, **L168(1-11)**

ROSS, Sir Ronald (1857-1932) Discoverer of the mosquito cycle in malaria

3646 Bronze plaque 17.1 x 14.6 (6¾ x 5¾)
Frank Bowcher, incised and dated 1929
Purchased, 1948

ROSS, Sir William Charles (1794-1860) Miniaturist

1946 Miniature on ivory 12.7 x 9.8 (5 x 3$\frac{7}{8}$)
Hugh Ross (his brother), exh 1843
Purchased, 1922

Ormond

ROSSE, Laurence Parsons, 4th Earl of (1840-1908) Astronomer

1834(z) Pencil 20.3 x 12.6 (8 x 5)
Frederick Sargent, inscribed
Given by A.C.R.Carter, 1919
See Collections: Members of the House of Lords, c.1870-80, by Frederick Sargent, **1834(a-z and aa-hh)**

ROSSETTI, Christina Georgina (1830-94) Poet

P56 *See Groups:* The Rossetti family, by Charles Lutwidge Dodgson

990 With her mother, Frances Mary Lavinia Rossetti (right)
Chalk 42.5 x 48.3 (16¾ x 19)
Dante Gabriel Rossetti (her brother), 1877
Given by the sitter's brother, William Michael Rossetti, 1895

ROSSETTI, Dante Gabriel (1828-82) Painter and poet

857 Pencil 19.7 x 17.8 (7¾ x 7)
Self-portrait, dated 1847
Purchased, 1891

P29 Photograph: albumen print 14.6 x 12.1 (5¾ x 4¾)
Charles Lutwidge Dodgson, 1863
Purchased, 1977

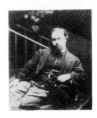

P56 *See Groups:* The Rossetti family, by Charles Lutwidge Dodgson

1510 Facsimile of drawing 21.3 x 16.5 (8$\frac{3}{8}$ x 6½)
After Simeon Solomon, c.1864
Bequeathed by Mrs G.C.W.Warr, 1908

3033 Etching 9.8 x 7.9 (3$\frac{7}{8}$ x 3$\frac{1}{8}$)
Self-portrait, signed in monogram on plate, 1870
Given by Marion Harry Spielmann, 1939

1011 Canvas 64.8 x 51.4 (25½ x 20¼)
George Frederic Watts, signed, c.1871
Given by the artist, 1895

3048 Pencil 9.5 x 7.6 (3¾ x 3)
Self-portrait
Given by Robert Steele, 1939

3022 With Theodore Watts-
Dunton (right)
Water-colour 54 x 81.9 (21¼ x 32¼)
Henry Treffry Dunn, signed and
dated 1882
Purchased, 1939

1699 Plaster cast of head
incorporating death-mask 33 (13)
high
D.Brucciani & Co, incised and
dated 1882
Given by Miss Alice M.Chambers,
1913

ROSSETTI, Frances Mary Lavinia
(née Polidori) (1800-86) Mother
of Dante Gabriel, William Michael
and Christina Rossetti

P56 *See Groups:* The Rossetti
family, by Charles Lutwidge
Dodgson

990 *See under* Christina Georgina
Rossetti

ROSSETTI, William Michael
(1829-1919) Critic and writer

P56 *See Groups:* The Rossetti
family, by Charles Lutwidge
Dodgson

P126 Photograph: albumen print
25.3 x 20.3 (10 x 8)
Julia Margaret Cameron, c.1866
Acquired, 1979. *Not illustrated*

2485 Canvas 59.7 x 49.5
(23½ x 19½)
Sir William Rothenstein, c.1909
Given by the sitter's daughters,
Mrs Helen Rossetti Angeli and
Miss Mary Rossetti, 1931

ROSSLYN, Alexander Wedderburn,
1st Earl of (Lord Loughborough)
(1733-1805) Lord Chancellor

392 Canvas 142.2 x 114.3
(56 x 45)
William Owen
Purchased, 1874

ROSSLYN, James St Clair-Erskine,
2nd Earl of (1762-1837) General

999 *See Groups:* The Trial of
Queen Caroline, 1820, by Sir
George Hayter

54 *See Groups:* The House of Com-
mons, 1833, by Sir George Hayter

ROSTAND, Edmond Eugène Alexis
(1868-1918) French dramatist

4707(26) *See Collections: Vanity
Fair* cartoons, 1869-1910, by
various artists, **2566-2606,** etc

ROTHA, Paul (b.1907)
Film producer and director

4529(310-13) *See Collections:*
Working drawings by Sir David
Low, **4529(1-401)**

ROTHENSTEIN, Sir John (b.1901)
Art historian

4529(314-20) *See Collections:*
Working drawings by Sir David
Low, **4529(1-401)**

ROTHENSTEIN, Sir William
(1872-1945)
Artist and teacher of art

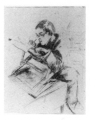

4414 Lithograph 56.8 x 44.1
(22$\frac{3}{8}$ x 17$\frac{3}{8}$)
John Singer Sargent, 1897
Given by the sitter's son, Sir
John Rothenstein, 1964

2556 *See Groups:* The Selecting
Jury of the New English Art Club,
1909, by Sir William Orpen

Continued overleaf

4433 Pencil 26.7 x 16.8
(10½ x 6⅝)
Self-portrait, signed with initials
and dated 1916
Given by Daniel Shackleton, 1965

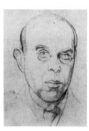

3880 Sanguine, black and white
chalk 38.7 x 28.9 (15¼ x 11⅜)
Self-portrait, c.1930
Given by the Rothenstein Memorial
Trust, 1953

5000 Canvas 61.6 x 51.4
(24¼ x 20¼)
Self-portrait, signed with initials
and dated 1930
Given by his son, Sir John
Rothenstein, 1974

ROTHSCHILD, Alfred Charles de
(1842-1918) Banker

1833 *See Groups:* Private View of
the Old Masters Exhibition, Royal
Academy, 1888, by Henry Jamyn
Brooks

ROTHSCHILD, Ferdinand James
de (1830-98) Art collector

1833 *See Groups:* Private View of
the Old Masters Exhibition, Royal
Academy, 1888, by Henry Jamyn
Brooks

ROTHSCHILD, Lionel Nathan de
(1808-79)
Banker and philanthropist

3838 Canvas 50.2 x 38.1
(19¾ x 15)
Moritz Daniel Oppenheim, signed
and dated 1835
Purchased, 1952

Ormond

ROTHWELL, Richard (1800-68)
Painter

3182(8) Pen and ink and black
chalk 8.9 x 8.6 (3½ x 3⅜)
Charles West Cope, inscribed, c.1862
Purchased, 1944
See Collections: Drawings of
Artists, c.1862, by Charles West
Cope, **3182(1-19)**

Ormond

ROUBILIAC, Louis François
(1705?-1762) Sculptor

2145 Marble bust 64.8 (25½) high
Attributed to Joseph Wilton,
c.1761
Given by NACF, 1927

303 Canvas 125.7 x 100.3
(49½ x 39½)
Adrien Carpentiers, signed and
dated 1762
Purchased, 1870. *Beningbrough*

Kerslake

ROUS, Henry John (1795-1877)
Admiral and sportsman

2957 *See under* George Payne

Ormond

ROUS, John Edward Cornwallis,
2nd Earl of Stradbroke
See STRADBROKE

ROWAN, Sir Charles (c.1782-1852)
Lieutenant-Colonel; first Chief
Commissioner of Police

3749 *See Collections:* Studies for
The Waterloo Banquet at Apsley
House, 1836, by William Salter,
3689-3769

ROWE, Nicholas (1674-1718)
Poet Laureate and dramatist

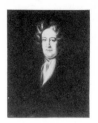

1512 Canvas 74.9 x 62.2
(29½ x 24½)
Unknown artist (c.1718?)
Bequeathed by Joshua Brooking
Rowe, 1908

Piper

ROWLANDSON, Thomas
(1757-1827) Satirical draughtsman

2813 Pencil and chalk 23.5 x 19.7
(9¼ x 7¾)
George Henry Harlow, signed with
initials, inscribed and dated 1814
Purchased, 1936

2198 Pencil 24.1 x 19.1 (9½ x 7½)
John Jackson, signed and inscribed,
c.1815
Purchased, 1928

ROXBURGHE, John Ker, 3rd Duke
of (1740-1804) Bibliophile

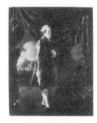

724 Canvas 65.4 x 52.1
(25¾ x 20½)
Thomas Patch, c.1761
Given by Sir Richard Wallace, Bt,
1884. *Beningbrough*

RUMFORD, Sir Benjamin
Thompson, Count von (1753-1814)
Scientist and founder of the Royal
Institution

1332 Canvas, feigned oval
71.1 x 58.4 (28 x 23)
After Moritz Kellerhoven (1792)
Purchased, 1902

1075, 1075a and **b** *See Groups:*
Men of Science Living in 1807-8,
by Sir John Gilbert and others

RUNCIMAN, Walter Runciman, 1st
Viscount (1870-1949) Statesman;
son of 1st Baron Runciman

5157 Drypoint and engraving
39.7 x 30.2 (15⅝ x 11⅞)
William Strang, signed below
plate, 1913
Given by the sitter's son, 2nd
Viscount Runciman, 1977

5141 Ink and wash 36.2 x 21.9
(14¼ x 8⅝)
Matt, signed and dated 1924
Given by the sitter's son, 2nd
Viscount Runciman, 1977

RUNCIMAN, Walter Runciman,
1st Baron (1847-1937) Shipowner

3407 *See Collections:* Prominent
Men, c.1880-c.1910, by Harry
Furniss, **3337-3535** and **3554-3620**

RUPERT, Prince, Count Palatine
(1619-82)
Soldier and patron of science

L124 Canvas 215.9 x 133.4
(85 x 52½)
Ascribed to studio of Sir Anthony
van Dyck (c.1637)
Lent by NG, 1965

4519 Panel, feigned oval
74.3 x 59.1 (29¼ x 23¼)
Attributed to Gerard Honthorst,
inscribed, c.1641-2
Purchased, 1966

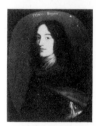

233 Miniature on vellum, oval
7.9 x 6.4 (3⅛ x 2½)
After Sir Peter Lely (c.1665-70)
Purchased, 1867

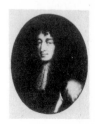

Continued overleaf

608 Canvas 105.4 x 80
(41½ x 31½)
Studio of Sir Peter Lely, c.1670
Purchased, 1883

Piper

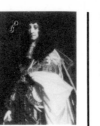

RUSHOUT, John, 2nd Baron
Northwick *See* NORTHWICK

RUSHOUT-BOWLES, George, 3rd
Baron Northwick
See NORTHWICK

RUSKIN, John (1819-1900)
Writer, artist and social reformer

1058 Chalk 43.2 x 35.6 (17 x 14)
George Richmond, c.1843
Purchased, 1896

P50 Photograph: albumen print
9.2 x 5.7 ($3\frac{5}{8}$ x 2¼)
Charles Lutwidge Dodgson, c.1875
Given anonymously, 1973

1336 Water-colour 73.7 x 48.3
(29 x 19)
Sir Hubert von Herkomer, signed
with initials and dated 1879
Given by the artist, 1903

1053 Plaster cast of bust 62.2
(24½) high
Sir Joseph Edgar Boehm, incised,
1881
Given by the Earl of Carlisle, 1896

3035 Pencil 26.7 x 34.3
(10½ x 13½)
Theodore Blake Wirgman, signed
and inscribed, c.1886
Given by Marion Harry Spielmann,
1939

2030 Bronze cast of bust 15.2 (6)
high
Conrad Dressler, incised and dated
1888
Given by Alfred Jones, 1924

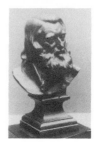

1833 *See Groups:* Private View of
the Old Masters Exhibition, Royal
Academy, 1888, by Henry Jamyn
Brooks

RUSSELL, Lord John Russell, 1st
Earl (1792-1878) Prime Minister

999 *See Groups:* The Trial of
Queen Caroline, 1820, by Sir
George Hayter

678 Marble bust 69.9 (27½) high
John Francis, incised and dated 1832
Given by the Duke of Bedford, 1883

54 *See Groups:* The House of Com-
mons, 1833, by Sir George Hayter

342,343 *See Groups:* The Fine
Arts Commissioners, 1846, by John
Partridge

895 Canvas 45.1 x 38.1 (17¾ x 15)
George Frederic Watts, c.1851
Given by the artist, 1892

2635 Chalk 61 x 50.8 (24 x 20)
George Frederic Watts, signed,
c.1852
Bequeathed by the sitter's daughter,
Lady Agatha Russell, 1933

1121 Canvas 201.3 x 111.8
(79¼ x 44)
Sir Francis Grant, 1853
Given by the Duke of Bedford,
1898

1125,1125a *See Groups:* The
Coalition Ministry, 1854, by Sir
John Gilbert

5222 Canvas 80.6 x 62.2
(31¾ x 24½)
Lowes Cato Dickinson, signed with
initials, inscribed and dated
1855/1867
Purchased, 1978

4969 *See Groups:* Queen Victoria
Presenting a Bible in the Audience
Chamber at Windsor, c.1861, by
Thomas Jones Barker

4291 Terracotta head 6.4 (2½) high
Sir Joseph Edgar Boehm,c.1880
Given by Miss Flora Russell, 1962

Ormond

RUSSELL, Bertrand Russell, 3rd
Earl (1872-1970) Philosopher

4832 Canvas 54 x 45.1
(21¼ x 17¾)
Roger Fry, c.1923
Purchased, 1970

4529(321) *See Collections:*
Working drawings by Sir David
Low, **4529(1-401)**

RUSSELL of Killowen, Charles
Russell, 1st Baron (1832-1900)
Lord Chief Justice

2740 Water-colour 31.1 x 18.1
(12¼ x 7⅛)
François Verheyden, inscribed
(*VF* 5 May 1883)
Purchased, 1934

2230, 2239-41, 2250, 2251
See Collections: The Parnell
Commission, 1888-9, by Sydney
Prior Hall, **2229-72**

2295,2318 *See Collections:*
Miscellaneous drawings . . . by
Sydney Prior Hall, **2282-2348**

1907 Canvas 85.1 x 71.1
(33½ x 28)
John Singer Sargent, signed,
replica (1900)
Given by a Memorial Committee,
1921

3601 *See Collections:* Prominent
Men, c.1880-c.1910, by Harry
Furniss, **3337-3535** and **3554-3620**

RUSSELL, Lord Charles James
Fox (1807-94)
MP for Bedfordshire

54 *See Groups:* The House of Commons, 1833, by Sir George Hayter

RUSSELL, Lord Edward (b.1551)
Eldest son of 2nd Earl of Bedford

2410 Water-colour 30.5 x 23.5
(12 x 9¼)
George Perfect Harding after an
unknown artist, signed and inscribed
(1573)
Purchased, 1929
See Collections: Copies of early
portraits, by George Perfect Harding
and Sylvester Harding, **1492,
1492(a-c)** and **2394-2419**

Strong

RUSSELL, Lord Francis (d.1585)
Third son of 2nd Earl of Bedford

2411 Water-colour 30.5 x 23.5
(12 x 9¼)
George Perfect Harding after an
unknown artist, signed and
inscribed (c.1573)
Purchased, 1929
See Collections: Copies of early
portraits, by George Perfect Harding
and Sylvester Harding, **1492,
1492(a-c)** and **2394-2419**

Strong

RUSSELL, Lord George William
(1790-1846) Major-General

999 *See Groups:* The Trial of
Queen Caroline, 1820, by Sir
George Hayter

RUSSELL, William Russell, Lord
(1639-83) Politician

L152(16) Miniature on vellum,
oval 6.4 x 5.1 (2½ x 2)
Attributed to Thomas Flatman
Lent by NG (Alan Evans Bequest),
1975

202 *See Unknown Sitters II*

Piper

RUSSELL, Lord William (1800-40)
Grandson of 4th Duke of Bedford

883(17) *See Collections:* Studies
for miniatures by Sir George
Hayter, **883(1-21)**

RUSSELL, Sir Andrew Hamilton
(1868-1960) Major-General

1954 *See Groups:* General
Officers of World War I, by John
Singer Sargent

RUSSELL, Charles (1786-1856)
MP for Reading

54 *See Groups:* The House of Com-
mons, 1833, by Sir George Hayter

RUSSELL, Sir Charles, 3rd Bt
(1826-83) Soldier and politician

4740 Water-colour 30.5 x 18.1
(12 x 7⅛)
Carlo Pellegrini, signed *Ape*
(*VF* 2 Feb 1878)
Purchased, 1970

RUSSELL, Hon Sir Charles, Bt
(1863-1928) Solicitor

2997 Water-colour 49.5 x 35.2
(19½ x 13⅞)
Sir Leslie Ward, signed *Spy*
(*VF* 10 April 1907)
Purchased, 1938

RUSSELL, Francis, 5th Duke
of Bedford *See* BEDFORD

RUSSELL, Francis, 7th Duke of
Bedford *See* BEDFORD

RUSSELL, Sir George, 4th Bt
(1828-98) Judge

4741 Water-colour 30.8 x 18.1
($12\frac{1}{8}$ x $7\frac{1}{8}$)
Sir Leslie Ward, signed *Spy*
(*VF* 2 March 1889)
Purchased, 1970

RUSSELL, George William
(1867-1935) Irish poet,
economist and journalist

3980 Lithograph 26 x 20.6
(10¼ x $8\frac{1}{8}$)
Mary Duncan, signed on plate
Purchased, 1955

3926 Bronze cast of bust 36.2
(14¼) high
Jeanette Hare, incised
Given by the artist's husband,
Irving H.Hare, 1955

RUSSELL, Sir Henry, 1st Bt
(1751-1836) Judge

316a(102,103) Pencil, two
sketches 46 x 32.4 ($18\frac{1}{8}$ x 12¾) and
45.7 x 32.7 (18 x $12\frac{7}{8}$)
Sir Francis Chantrey, inscribed,
c.1822
Given by Mrs George Jones, 1871
See Collections: Preliminary
drawings for busts and statues by
Sir Francis Chantrey, **316a(1-202)**

RUSSELL, Herbrand Arthur, 11th
Duke of Bedford *See* BEDFORD

RUSSELL, John (1745-1806)
Portrait painter and pastellist

3907 Chalk 33.3 x 22.2
($13\frac{1}{8}$ x 8¾)
Self-portrait
Bequeathed by Miss Eleanor
Mabel Freeman Wood, 1954

3160 *See Unknown Sitters IV*

RUSSELL, John, 4th Duke of
Bedford *See* BEDFORD

RUSSELL, John, 6th Duke of
Bedford *See* BEDFORD

RUSSELL, John, 1st Earl of
Bedford *See* BEDFORD

RUSSELL, Sir Thomas Wallace, Bt
(1841-1920) Politician

3295 Water-colour 31.8 x 18.1
(12½ x $7\frac{1}{8}$)
Sir Leslie Ward, signed *Spy*
(*VF* 24 March 1888)
Purchased, 1934

2869 *See Collections:* Caricatures
of Politicians, by Sir Francis
Carruthers Gould, **2826-72**

RUSSELL, William, 1st Duke of
Bedford *See* BEDFORD

RUSSELL, William, 8th Duke of
Bedford *See* BEDFORD

RUSSELL, William Congreve
(1778-1850)
MP for Worcestershire East

54 *See Groups:* The House of Com-
mons, 1833, by Sir George Hayter

RUSSELL, Sir William Howard
(1820-1907)
War correspondent

3268 Water-colour 30.5 x 17.8
(12 x 7)
Carlo Pellegrini, signed *Ape*
(*VF* 16 Jan 1875)
Purchased, 1934

3602 *See Collections:* Prominent
Men, c.1880-c.1910, by Harry
Furniss, **3337-3535** and **3554-3620**

RUTHERFORD, Ernest
Rutherford, Baron (1871-1937)
Physicist

4793 Sanguine and pencil
21 x 30.2 (8¼ x 11⅞)
Sir William Rothenstein, inscribed,
c.1925
Purchased, 1970

2935 Canvas 76.2 x 63.5 (30 x 25)
Sir James Gunn, signed and dated
1932
Given by the Contemporary
Portraits Fund, 1938

4426 Chalk 38.1 x 27.9 (15 x 11)
Francis Dodd, signed, inscribed and
dated 1934
Purchased, 1964

RUTHERFORD, Alex
Fisherman

P6(215) *See Collections:* The Hill
and Adamson Albums, 1843-8, by
David Octavius Hill and Robert
Adamson, **P6(1-258)**

RUTHERFORD, Daniel
(1749-1819)
Physician and botanist

1075, 1075a and **b** *See Groups:*
Men of Science Living in 1807-8,
by Sir John Gilbert and others

RUTHERFORD, Dame Margaret
(1892-1972) Actress

4937 Pencil 34.9 x 26.7
(13¾ x 10½)
Michael Noakes, signed and dated
1970
Given by the Royal Academy (under
the terms of the Annie Hugill
Fund), 1973

RUTHVEN, James Ruthven, 6th
Baron (1777-1853)

P6(22) *See Collections:* The Hill
and Adamson Albums, 1843-8, by
David Octavius Hill and Robert
Adamson, **P6(1-258)**

RUTHVEN, Mary (née Campbell),
Lady (1789-1885)
Wife of 6th Baron Ruthven

P6(114) *See Collections:* The Hill
and Adamson Albums, 1843-8, by
David Octavius Hill and Robert
Adamson, **P6(1-258)**

RUTLAND, John Henry Manners,
5th Duke of (1778-1857)

999 *See Groups:* The Trial of
Queen Caroline, 1820, by Sir
George Hayter

RUTLAND, John Manners, 7th
Duke of (1818-1906) Politician

4893 *See Groups:* The Derby
Cabinet of 1867, by Henry Gales

2679 Chalk 57.8 x 47
(22¾ x 18½)
Henry Tanworth Wells, signed and
dated 1872
Given by Walter E.Manners, 1934

2945 Canvas 126.4 x 101
(49¾ x 39¾)
Walter William Ouless, signed and
dated 1886
Given by Viscount Hambleden,
1938

RUTLAND, Violet, Duchess of
(d.1937)
Artist; wife of 8th Duke of Rutland

1833 *See Groups:* Private View of
the Old Masters Exhibition, Royal
Academy, 1888, by Henry Jamyn
Brooks

RYCAUT, Sir Paul (1628-1700)
Diplomat and writer

1874 Canvas 74.9 x 62.2
(29½ x 24½)
After Sir Peter Lely (c.1679-80)
Purchased, 1920

2691 *See Unknown Sitters II*

Piper

RYDER, Dudley, 1st Earl of
Harrowby *See* HARROWBY

RYDER, Dudley, 2nd Earl of
Harrowby *See* HARROWBY

RYDER, Dudley, 3rd Earl of
Harrowby *See* HARROWBY

RYLANDS, Peter (1820-87)
Politician

4742 Water-colour 30.5 x 17.8
(12 x 7)
Sir Leslie Ward, signed *Spy*
(*VF* 25 Jan 1879)
Purchased, 1970

RYLE, Gilbert (1900-76)
Philosopher

5092 Sepia and water-colour
37.2 x 33 (14⅝ x 13)
H.Andrew Freeth, signed and
dated 1952
Purchased, 1976

RYLE, John Charles (1816-1900)
Bishop of Liverpool

4743 Water-colour 30.2 x 17.8
(11⅞ x 7)
Carlo Pellegrini, signed *Ape*
(*VF* 26 March 1881)
Purchased, 1970

RYSBRACK, John Michael
(1693-1770) Sculptor

1802 Canvas 125.7 x 100.3
(49½ x 39½)
John Vanderbank, c.1728
Purchased, 1918. *Beningbrough*

1384 *See Groups:* A Conversation
of Virtuosis at the Kings Armes
(A Club of Artists), by Gawen
Hamilton

Kerslake

SABINE, Sir Edward (1788-1883)
General, scientist and President of
the Royal Society

907 (study for *Groups,* **1208**)
Millboard 37.8 x 32.1 (14⅞ x 12⅝)
Stephen Pearce, 1850
Bequeathed by Lady Franklin, 1892
See Collections: Arctic Explorers,
1850-86, by Stephen Pearce,
905-24 and **1209-27**

1208 *See Groups:* The Arctic
Council, 1851, by Stephen Pearce

Ormond

SACKVILLE, George Sackville
Germain, 1st Viscount (1716-85)
Soldier and statesman

4910 Miniature on ivory, oval
3.5 x 2.9 (1⅜ x 1⅛)
Nathaniel Hone, signed with initials
and dated 1760
Purchased, 1972

SACKVILLE, Charles Sackville-
West, 4th Baron (1870-1962)
Major-General

4649 Canvas 91.4 x 76.2 (36 x 30)
Sir William Orpen, signed and dated
1919
Given by wish of Viscount
Wakefield, 1968

SACKVILLE, Charles, 6th Earl of
Dorset *See* DORSET

SACKVILLE, Lionel, 1st Duke of
Dorset *See* DORSET

SACKVILLE, Thomas, 1st Earl of
Dorset *See* DORSET

SACKVILLE-WEST, George John,
5th Earl Delawarr
See DELAWARR

SADLER, James (1753-1828)
Aeronaut

4955 Canvas 146.7 x 113
(57¾ x 44½)
Unknown artist
Purchased, 1973

SADLER, Michael Thomas
(1780-1835) Social reformer

2907 Canvas 91.4 x 72.4
(36 x 28½)
William Robinson, eng 1830
Given by the sitter's granddaughter,
Miss Emily Sadler, 1937

SADLER, Walter Dendy
(1854-1923) Genre painter

4405 *See Groups:* Primrose Hill
School, 1893, by an unknown artist

4404 *See Groups:* The St John's
Wood Arts Club, 1895, by Sydney
Prior Hall

ST ALBANS, William Beauclerk,
8th Duke of (1766-1825)

999 *See Groups:* The Trial of
Queen Caroline, 1820, by Sir
George Hayter

ST ALBANS, Harriot (Mellon),
Duchess of (1777?-1837) Actress;
wife of 9th Duke of St Albans

1915 Canvas 238.8 x 147.3
(94 x 58)
Sir William Beechey
Bequeathed by W.L.A.Burdett
Coutts, 1921

ST ALBANS, William Aubrey de
Vere Beauclerk, 10th Duke of
(1840-98) Representative peer

1834(aa) *See Collections:* Members
of the House of Lords, c.1870-80,
by Frederick Sargent, **1834(a-z and
aa-hh)**

ST ALBANS, Viscount *See* BACON

ST ALDWYN, Michael Hicks-
Beach, 1st Earl (1837-1916)
Statesman

2320 *See Collections:*
Miscellaneous drawings . . . by
Sydney Prior Hall, **2282-2348** and
2370-90

2948 Canvas 127.6 x 92.1
(50¼ x 36¼)
Sir Arthur Stockdale Cope, signed
and dated 1906
Given by Viscount Hambleden,
1938

2864 *See Collections:* Caricatures
of Politicians, by Sir Francis
Carruthers Gould, **2826-74**

SAINT-ÉVREMOND, Charles de
Marquetel de (1613?-1703)
Wit and courtier

566 Canvas, feigned oval
74.9 x 62.2 (29½ x 24½)
James Parmentier(?), c.1701
Transferred from BM, 1879

Piper

ST GERMANS, John Eliot,
1st Earl of (1761-1823)

999 *See Groups:* The Trial of
Queen Caroline, 1820, by Sir
George Hayter

ST HELENS, Alleyne Fitzherbert,
Baron (1753-1839) Diplomat

999 *See Groups:* The Trial of
Queen Caroline, 1820, by Sir
George Hayter

ST JOHN, Oliver St John, Baron
(d.1582) Sat in judgement on
Duke of Norfolk, 1572

2408 Water-colour 23.2 x 17.8
($9\frac{1}{8}$ x 7)
George Perfect Harding after
Arnold van Brounckhorst, signed
(1578)
Purchased, 1929
See Collections: Copies of early
portraits, by George Perfect
Harding and Sylvester Harding,
1492,1492(a-c) and **2394-2419**

Strong

ST JOHN, St Andrew St John,
13th Baron (1759-1817)

2076 *See Groups:* Whig Statesmen
and their Friends, c.1810, by
William Lane

ST JOHN, Henry, 1st Viscount
Bolingbroke *See* BOLINGBROKE

ST JOHN, Oliver (1598?-1673)
Chief Justice

4978 Canvas 220 x 156.8
($86\frac{5}{8}$ x $61\frac{3}{4}$)
Pieter Nason, signed and dated 1651
Purchased, 1974

ST MAUR, Algernon Percy Banks,
14th Duke of Somerset
See SOMERSET

ST VINCENT, John Jervis, Earl of
(1735-1823) Admiral

2026 Canvas 125.7 x 100.3
($49\frac{1}{2}$ x $39\frac{1}{2}$)
Francis Cotes, signed and dated
1769
Purchased with help from NACF,
1949

167a Pencil and water-colour
30.5 x 21.6 (12 x $8\frac{1}{2}$)
Bouch, signed, inscribed and dated
1797
Given by Mrs Lucretia Kay, 1863

936 Canvas 60.3 x 50.8 ($23\frac{3}{4}$ x 20)
Studio of Lemuel Francis Abbott,
eng 1798
Purchased, 1892

2222 Canvas 74.9 x 62.2
($29\frac{1}{2}$ x $24\frac{1}{2}$)
Studio of Sir William Beechey, eng
1809
Purchased, 1928

SALA, George Augustus Henry
(1828-96) Journalist

2260 Pencil 19.7 x 25.1 ($7\frac{3}{4}$ x $9\frac{7}{8}$)
Sydney Prior Hall, inscribed and
dated *March 1* (1889)
Given by the artist's son, Harry
Reginald Holland Hall, 1928
See Collections: The Parnell
Commission, 1888-9, by Sydney
Prior Hall, **2229-72**

2261 *See Collections:* The Parnell
Commission, 1888-9, by Sydney
Prior Hall, **2229-72**

Continued overleaf

1689A Ink 17.1 x 12.4 (6¾ x 4⅞)
Pollie Vernay, signed and dated
1894, autographed by sitter
Given by Ernest E.Leggatt, 1912

3507 *See Collections:* Prominent
Men, c.1880-c.1910, by Harry
Furniss, **3337-3535** and **3554-3620**

SALISBURY, Margaret Pole,
Countess of (1473-1541) Daughter
of George, Duke of Clarence

2607 *See Unknown Sitters I*

SALISBURY, Robert Cecil, 1st
Earl of (1563-1612) Statesman

107 Panel 90.2 x 73.4
(35½ x 28⅞)
John de Critz the Elder, inscribed
and dated 1602
Given by David Laing, 1860

1115 Panel, oval 23.5 x 18.7
(9¼ x 7⅜)
After John de Critz the Elder
Given by Sir Henry Hoyle Howarth,
1898

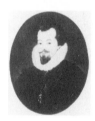

665 *See Groups:* The Somerset
House Conference, 1604, by an
unknown Flemish artist

Strong

SALISBURY, Mary Amelia Hill,
1st Marchioness of (1750-1835)
Daughter of 1st Marquess of
Downshire

L160 *See Groups:* 1st Marquess of
Downshire and his family, c.1760,
by Arthur Devis

SALISBURY, Robert Gascoyne-
Cecil, 3rd Marquess of (1830-1903)
Prime Minister

1349 Canvas 64.8 x 52.1
(25½ x 20½)
George Frederic Watts, 1882
Given by the artist, 1903

3242 Canvas 127.3 x 93.3
(50⅛ x 36¾)
Sir John Everett Millais, signed in
monogram
Given by Viscount Hambleden,
1945

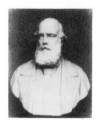

2012 Marble bust 66 (26) high
Unknown artist, incised
Given by the sitter's niece,
Viscountess Ullswater, 1924

1610 Pen and ink 24.8 x 15.9
(9¾ x 6¼)
Phil May, signed, inscribed and
dated 1893
Given by Messrs E.Brown & Phillips,
1911

5004 Water-colour 36.5 x 22.2
(14⅜ x 8¾)
Sir Leslie Ward, signed *Spy* and
inscribed
(related to *VF* cartoon of 20 Dec
1900)
Purchased, 1974

2339-42 *See Collections:*
Miscellaneous drawings . . . by
Sydney Prior Hall, **2282-2348** and
2370-90

3409-11,3603 *See Collections:*
Prominent Men, c.1880-c.1910, by
Harry Furniss, **3337-3535** and
3554-3620

2861,2862,2873 *See Collections:*
Caricatures of Politicians, by Sir
Francis Carruthers Gould, **2826-74**

SALMON, John Drew (1802?-59)
Botanist; manager of Wenham Lake
Ice Company

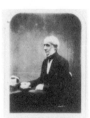

P120(23) Photograph; albumen
print, arched top 19.7 x 14.6
(7¾ x 5¾)
Maull & Polyblank, inscribed on
mount, 1855
Purchased, 1979
See Collections: Literary and
Scientific Men, 1855, by Maull &
Polyblank, **P120(1-54)**

SALTER, James

P120(3) *See Collections:* Literary
and Scientific Men, 1855, by Maull
& Polyblank, **P120(1-54)**

SALTING, George (1835-1909)
Art collector and benefactor

1790 Pencil 29.2 x 18.7 (11½ x 7⅜)
Joseph Oppenheimer, signed,
inscribed and dated 1905
Given by Maurice Rosenheim, 1917

SALTOUN, Alexander Fraser, 16th
Baron (1785-1853)
Lieutenant-General

3750 *See Collections:* Studies for
The Waterloo Banquet at Apsley
House, 1836, by William Salter,
3689-3769

SAMBOURNE, Edward Linley
(1845-1910)
Cartoonist and designer

3034 Pen and ink 17.8 x 15.2 .
(7 x 6)
Self-portrait, signed and dated
1891
Given by Marion Harry Spielmann,
1939

3508,3509,3619 *See Collections:*
Prominent Men, c.1880-c.1910, by
Harry Furniss, **3337-3535** and
3554-3620

SAMS, Joseph (1784-1860)
Orientalist

599 *See Groups:* The Anti-Slavery
Society Convention, 1840, by
Benjamin Robert Haydon

SAMSON, George
See ALEXANDER, Sir George

SANCROFT, William (1617-93)
Archbishop of Canterbury

636 Line engraving 37.1 x 25.4
(14⅝ x 10)
David Loggan, signed, inscribed and
dated 1680 on plate
Purchased, 1881

301 Chalk 30.5 x 25.1 (12 x 9⅞)
Edward Lutterel, signed in
monogram, c.1688
Purchased, 1870

79,152a *See Groups:* The Seven
Bishops Committed to the Tower,
1688, by an unknown artist and
George Bower
Piper

SANDBY, Paul (1730/1-1809)
Water-colourist and engraver

1437,1437a *See Groups:* The
Academicians of the Royal
Academy, 1771-2, by John Sanders
after Johan Zoffany

1379 Canvas 73.7 x 62.2
(29 x 24½)
Sir William Beechey, exh 1789
Bequeathed by Walter Arnold
Sandby, 1904

SANDBY, Thomas (1723-98)
Architect; brother of Paul Sandby

1437,1437a *See Groups:* The
Academicians of the Royal
Academy, 1771-2, by John Sanders
after Johan Zoffany

1380 Canvas 89.5 x 69.9
(35¼ x 27½)
Sir William Beechey, signed with
initials and dated 1792
Bequeathed by Walter Arnold
Sandby, 1904

SANDERSON, Thomas Sanderson,
1st Baron (1841-1923)
Under-Secretary of State

2968 Water-colour 35.6 x 25.1
(14 x 9⅞)
Sir Leslie Ward, signed *Spy*
(*VF* 10 Nov 1898)
Purchased, 1938

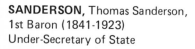

SANDFORD, Alexina Nesbit (née
Lindsay) (d.1851)
Wife of Thomas Hugh Sandford

3791 *See under* Catherine
Hepburne Lindsay

SANDFORD, Charles Waldegrave
(1828-1903) Bishop of Gibraltar

P7(20) *See Collections:* Lewis
Carroll at Christ Church, by Charles
Lutwidge Dodgson, **P7(1-37)**

SANDFORD, Francis (1630-94)
Herald

4311 Pencil 14.6 x 10.2 (5¾ x 4)
George Vertue after unknown artist,
inscribed on mount (c.1680)
Purchased, 1963

SANDWICH, Edward Montagu,
1st Earl of (1625-72) Admiral

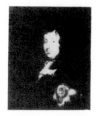

609 Canvas 74.9 x 62.2
(29½ x 24½)
After Sir Peter Lely (c.1660)
Purchased, 1880

Piper

SANDWICH, John Montagu, 4th
Earl of (1718-92)
First Lord of the Admiralty

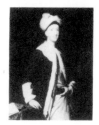

1977 Canvas 121.9 x 91.4
(48 x 36)
Joseph Highmore, signed and dated
1740
Given anonymously, 1923

4855(23) *See Collections:* The
Townshend Album, **4855(1-73)**

182 Canvas, feigned oval 73.7 x 61
(29 x 24)
After Johan Zoffany, reduced copy
(c.1763)
Purchased, 1864

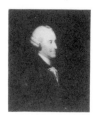

SANDWICH, John William
Montagu, 7th Earl of (1811-84)
Representative peer

1834(bb) *See Collections:*
Members of the House of Lords,
c.1870-80, by Frederick Sargent,
1834(a-z and **aa-hh)**

SANDYS, Arthur Moyses William
Sandys, 2nd Baron (1792-1860)
Lieutenant-General; politician

54 *See Groups:* The House of Com-
mons, 1833, by Sir George Hayter

3751 *See Collections:* Studies for
The Waterloo Banquet at Apsley
House, 1836, by William Salter,
3689-3769

SANDYS, Arthur Marcus Cecil
Sandys, 3rd Baron (1798-1863)
MP for Newry

54 *See Groups:* The House of Com-
mons, 1833, by Sir George Hayter

SANDYS, Cicely (née Wilford)
Second wife of Edwin Sandys

1268 *See under* Edwin Sandys

SANDYS, Edwin (1516?-88)
Archbishop of York

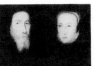

1268 With his second wife,
Cicely
Canvas 31.8 x 45.1 (12½ x 17¾)
Unknown artist, after a portrait of
1571
Given by Thomas Myles Sandys,
1900

Strong

SANDYS, Frederick (1829-1904)
Painter

1741 Millboard 17.1 x 13.3
(6¾ x 5¼)
Anthony Sands (his father), 1848
Purchased, 1914

SANFORD, Edward Ayshford
(1794-1871) MP for Somerset West

54 *See Groups:* The House of Commons, 1833, by Sir George Hayter

SANT, James (1820-1916)
Painter

4093 Canvas 59.1 x 44.1
(23¼ x 17⅜)
Self-portrait, signed in monogram
Given by his grandchildren, James
A. and Sylvia Gye, 1959

2820 *See Groups:* The Royal
Academy Conversazione, 1891,
by G.Grenville Manton

SARDOU, Victorien (1831-1908)
French dramatist

4707(27) *See Collections: Vanity
Fair* cartoons, 1869-1910, by
various artists, **2566-2606,** etc

SARGENT, Sir Malcolm
(1895-1967) Conductor

4657 Lithograph 33 x 20
(13 x 7⅞)
Albert W.M.Rissik, signed on stone
with initials, 1930
Given by the artist, 1967

4529(324) Pencil 22.5 x 13.6
(8⅞ x 5⅜)
Sir David Low
Purchased, 1967
See Collections: Working drawings
by Sir David Low, **4529(1-401)**

4529(322,323,325-7)
See Collections: Working drawings
by Sir David Low, **4529(1-401)**

SASS, Henry (1788-1844)
Painter

1456(24) Pencil 5.1 x 5.7 (2 x 2¼)
Charles Hutton Lear, inscribed,
c.1839
Given by John Elliot, 1907
See Collections: Drawings of
Artists, c.1845, by Charles Hutton
Lear, **1456(1-27)**

Ormond

SAUNDERS (c.1682-1732?)
Portrait draughtsman

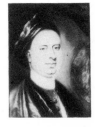

3135 Pastel 46 x 35.6 (18⅛ x 14)
Self-portrait, inscribed, 1732(?)
Purchased, 1943

Kerslake

SAUNDERS, George (1762-1839)
Architect

316a(106) Pencil, two sketches
48.9 x 64.1 (19¼ x 25¼)
Sir Francis Chantrey, inscribed
Given by Mrs George Jones, 1871
See Collections: Preliminary
drawings for busts and statues by
Sir Francis Chantrey, **316a(1-202)**

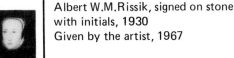

SAUNDERS, William Wilson
(1809-79) Entomologist

P120(4) Photograph: albumen
print, arched top 19.7 x 14.6
(7¾ x 5¾)
Maull & Polyblank, inscribed on
mount, 1855
Purchased, 1979
See Collections: Literary and
Scientific Men, 1855, by Maull &
Polyblank, **P120(1-54)**

SAVILE, John Lumley-Savile, 2nd
Baron (1853-1931)
Diplomat and sportsman

4608 Water-colour 54 x 37.5
(21¼ x 14¾)
Sir Leslie Ward, signed *Spy*
(*VF* 15 April 1908)
Purchased, 1968

SAVILE, George, Marquess of
Halifax *See* HALIFAX

SAVILE, Thomas, 1st Earl of
Sussex *See* SUSSEX

SAY, Jean Baptiste Léon
(1826-96)
French ambassador in London

4707(28) *See Collections: Vanity
Fair* cartoons, 1869-1910, by
various artists, **2566-2606,** etc

SAY, William (1768-1834)
Mezzotint engraver

1836 Canvas 73.7 x 58.4 (29 x 23)
James Green
Purchased, 1919

SAYERS, Dorothy Leigh
(1893-1957) Novelist

5146 Canvas 76.2 x 66.7
(30 x 26¼)
Sir William Hutchison
Purchased, 1977

SAYERS, Tom (1826-65)
Pugilist

2465 Plaster cast of statuette
30.2 (11⅞) high
A.Bezzi, incised
Given by wish of Charles Whibley,
1930

2465a Bronze cast of no.**2465,**
28.2 (11⅛) high
Purchased, 1960

Ormond

SCALES, Thomas
Slavery abolitionist

599 *See Groups:* The Anti-Slavery
Society Convention, 1840, by
Benjamin Robert Haydon

SCARBOROUGH, Richard Lumley,
2nd Earl of (1688?-1740) Soldier

3222 Canvas 91.4 x 71.1 (36 x 28)
Sir Godfrey Kneller, signed in
monogram and dated 1717
Kit-cat Club portrait
Given by NACF, 1945.
Beningbrough

Piper

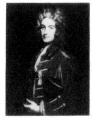

SCARLETT, Sir James Yorke
(1799-1871) General

807 Plaster cast of bust 74.9 (29½)
high
Matthew Noble, incised, c.1873
Given by the artist's widow, 1888

Ormond

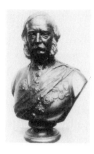

SCHANCK, John (1740-1823)
Admiral

1923 Canvas 73.7 x 61.6
(29 x 24¼)
John James Masquerier, eng 1799
Given by wish of H.A.Schank,1921

SCHARF, Sir George (1820-95)
Art historian; first Director of the
National Portrait Gallery

3863 Water-colour 55.9 x 38.1
(22 x 15)
Self-portrait
Bequeathed by himself, 1895

3864 Water-colour 50.5 x 37.1
(19⅞ x 14⅝)
Self-portrait
Bequeathed by himself, 1895

3865 Water-colour 50.2 x 37.8
(19¾ x 14⅞)
Self-portrait, signed with initials
and dated 1872
Bequeathed by himself, 1895

4583 Chalk 35.6 x 25.4 (14 x 10)
A.Langdon, inscribed
Acquired, 1967

985 Canvas 90.2 x 69.9
(35½ x 27½)
Walter William Ouless, signed,
inscribed and dated 1885
Given by a number of friends,
1886

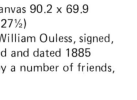

1833 *See Groups:* Private View
of the Old Masters Exhibition,
Royal Academy, 1888, by Henry
Jamyn Brooks

SCHEEMAKERS, Peter
(1691-1781) Sculptor

2675 Canvas 62.9 x 48.9
(24¾ x 19¼)
André Bernard de Quertenmont,
1776
Purchased, 1934

Kerslake

SCHNADHORST, Francis
(1840-1900) Founder of the
National Liberal Association

1774a Water-colour 36.2 x 24.8
(14¼ x 9¾)
(Possibly H.C.Sepping) Wright,
signed *STUFF,* inscribed
(*VF* 2 July 1892)
Given by Ernest E.Leggatt, 1916

SCHOMBURGK, Sir Robert
Hermann (1804-65) Explorer

2515(91) Black and red chalk
37.1 x 27.3 (14⅝ x 10¾)
William Brockedon, dated 1840
Lent by NG, 1959
See Collections: Drawings of
Prominent People, 1823-49, by
William Brockedon, **2515(1-104)**

Ormond

SCHOUVALOFF, Count
Russian ambassador in London

4707(29) *See Collections: Vanity
Fair* cartoons, 1869-1910, by
various artists, **2566-2606,** etc

SCHREPPERGILL, Colonel

1752 *See Groups:* The Siege of
Gibraltar, 1782, by George Carter

SCOBELL, Henry (d.1660)
Clerk of the Parliament

4363 Gold medal 3.5 (1⅜) diameter
Thomas Simon, inscribed, 1649
Purchased, 1964

SCOBLE, John
Slavery abolitionist

599 *See Groups:* The Anti-Slavery Society Convention, 1840, by Benjamin Robert Haydon

SCOTT, Charles Prestwich (1846-1932) Journalist

3997 Etching 25.1 x 17.5 ($9\frac{7}{8}$ x $6\frac{7}{8}$)
Francis Dodd, signed and dated 1916 on plate, signed below plate
Purchased, 1956

SCOTT, David (1806-49)
Religious and historical painter

P6(144) *See Collections:* The Hill and Adamson Albums, 1843-8, by David Octavius Hill and Robert Adamson, **P6(1-258)**

SCOTT, Sir Edward Dolman, Bt (1793-1851) MP for Lichfield

54 *See Groups:* The House of Commons, 1833, by Sir George Hayter

SCOTT, Sir George Gilbert (1811-78) Architect

2475 Pencil 11.7 x 8.9 ($4\frac{5}{8}$ x 3½)
Charles Bell Birch, inscribed and dated 1859
Given by the artist's nephew, George von Pirch, 1930
See Collections: Drawings of Royal Academicians, c.1858, by Charles Bell Birch, **2473-9**

1061 Chalk 47 x 31.8 (18½ x 12½)
George Richmond, signed, inscribed and dated 1877
Purchased, 1896

Ormond

SCOTT, Sir Giles Gilbert (1880-1960) Architect; grandson of Sir George Gilbert Scott

4398 Pen and ink 35.6 x 25.4 (14 x 10)
Powys Evans, pub 1927
Purchased, 1964

4171 Canvas 61 x 50.8 (24 x 20)
Reginald Grenville Eves, 1935
Purchased, 1960

4162 Chalk 30.5 x 26 (12 x 10¼)
Robin Guthrie, signed and inscribed, 1937
Given by the artist, 1960

SCOTT, H.

883(18) *See Collections:* Studies for miniatures by Sir George Hayter, **883(1-21)**

SCOTT, James, Duke of Monmouth and Buccleuch *See* MONMOUTH AND BUCCLEUCH

SCOTT, James (1770-1848)
Surgeon

316a(107) *See Collections:* Preliminary drawings for busts and statues by Sir Francis Chantrey, **316a(1-202)**

SCOTT, James Winter (1799-1873)
MP for Hampshire North

54 *See Groups:* The House of Commons, 1833, by Sir George Hayter

SCOTT, John, 1st Earl of Eldon
See ELDON

SCOTT, Sir Percy Moreton, Bt
(1853-1924) Admiral

2998 Water-colour 36.5 x 26.7
($14\frac{3}{8}$ x 10½)
Sir Leslie Ward, signed *Spy*,
inscribed
(*VF* 17 Sept 1903)
Purchased, 1938

SCOTT, R.

P6(53, 89) *See Collections:* The
Hill and Adamson Albums, 1843-8,
by David Octavius Hill and Robert
Adamson, **P6(1-258)**

SCOTT, Robert Falcon (1868-1912)
Antarctic explorer

2079 Canvas 151.1 x 100.3
(59½ x 39½)
Daniel Albert Wehrschmidt, signed
and dated 1905
Lent by the sitter's son, Sir Peter
Scott, 1924

1726 Canvas 53.3 x 41.9
(21 x 16½)
C.Percival Small, posthumous,
based on photographs of 1910
Given by Sir Courtauld Thomson,
1914

P23 Photograph: carbon print
35.6 x 45.7 (14 x 18)
Herbert Ponting, 1911
Purchased, 1976

SCOTT, Samuel (1702?-72)
Painter

1683 Canvas 59.7 x 50.2
(23½ x 19¾)
Unknown artist
Given by F.A.White, 1912

Kerslake

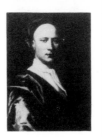

SCOTT, Thomas

P6(40) *See Collections:* The Hill
and Adamson Albums, 1843-8, by
David Octavius Hill and Robert
Adamson, **P6(1-258)**

SCOTT, Sir Walter, Bt (1771-1832)
Novelist and poet

993 Marble bust 76.2 (30) high
Sir Francis Chantrey, incised and
dated 1841 (1820)
Transferred from Tate Gallery, 1957

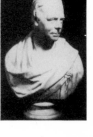

2811 Pen and ink, two sketches
17.1 x 13.3 (6¾ x 5¼)
Sir Edwin Landseer, signed with
initials
Purchased, 1936

391 Panel 29.2 x 24.1 (11½ x 9½)
Sir Edwin Landseer, c.1824
Given by Albert Grant, 1874

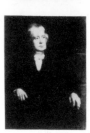

240 Canvas 109.2 x 83.8 (43 x 33)
John Graham Gilbert, c.1829
Given by the artist's widow, 1867

2515(30) *See Collections:*
Drawings of Prominent People,
1823-49, by William Brockedon,
2515(1-104)

1638 Silhouette 24.1 x 11.4
(9½ x 4½)
Augustin Edouart, 1831
Purchased, 1911

Continued overleaf

2646 (study for no.**321**)
Pencil and chalk 24.8 x 21
(9¾ x 8¼)
Sir William Allan
Purchased, 1933

321 Canvas 81.3 x 63.5 (32 x 25)
Sir William Allan, 1832
Purchased, 1871

1650 *See Unknown Sitters IV*

SCOTT, William, 1st Baron Stowell
See STOWELL

SCOVELL, Sir George (1774-1861)
General

1914(14) Water-colour 19.1 x 16.2
(7½ x 6⅜)
Thomas Heaphy, 1813-14
Purchased, 1921
See Collections: Peninsular and
Waterloo Officers, 1813-14, by
Thomas Heaphy, **1914(1-32)**

3752 Canvas 51.4 x 41.3
(20¼ x 16¼) *sight*
William Salter, 1834-40
Bequeathed by W.D.Mackenzie
(d.1928), 1950
See Collections: Studies for The
Waterloo Banquet at Apsley House,
1836, by William Salter, **3689-3769**

SCROGGS, Sir William (1623-83)
Judge

1850 Canvas 124.5 x 100.3
(49 x 39½)
Unknown artist (?after John
Michael Wright, 1678), inscribed
Purchased, 1919

Piper

SCROPE, Adrian (1601-60)
Regicide

4435 Canvas 127 x 101.6 (50 x 40)
By or after Robert Walker, inscribed
Purchased, 1965

SCROPE, Richard Le (1350?-1405)
Archbishop of York

845 Water-colour 47.6 x 25.4
(18¾ x 10) *sight*
D.J.Powell, based on window in
York Minster, inscribed and dated
1819 on reverse
Given by George H.Jackson, 1890

SCUDAMORE, Mary (née
Throckmorton), Lady (d.1632)
Wife of Sir James Scudamore

64 Panel 114.3 x 82.6 (45 x 32½)
Marcus Gheeraerts the Younger,
inscribed and dated 1614-15
Purchased, 1859. *Montacute*

Strong (under Countess of
Pembroke)

SEAFIELD, Francis William Ogilvie-
Grant, 6th Earl of (1778-1853)
MP for Elgin and Nairn

54 *See Groups:* The House of Com-
mons, 1833, by Sir George Hayter

SEARLE, Henry
Oarsman

3011 Water-colour 35.3 x 24.5
(13⅞ x 9⅝)
Sir Leslie Ward, signed *Spy* and
dated 1889
(*VF* 7 Sept 1889)
Purchased, 1937

SEATON, John Colborne, 1st
Baron (1778-1863) Field-Marshal

982b Millboard 27.9 x 22.9
(11 x 9)
George Jones, signed and inscribed,
1860-3
Given by the artist's widow, 1871

1205 Plaster cast of bust 81.3 (32) high
George Gammon Adams, incised and dated 1863
Purchased, 1899

Ormond

SEBRIGHT, Sir John, Bt (1767-1846)
Politician and agriculturalist

54 *See Groups:* The House of Commons, 1833, by Sir George Hayter

SECKER, Thomas (1693-1768)
Archbishop of Canterbury

850 Canvas 76.2 x 63.8 (30 x 25⅛)
After Sir Joshua Reynolds, reduced copy (1764-5)
Purchased, 1890

Kerslake

SEDGWICK, Adam (1785-1873)
Geologist

4502 Silhouette 27.9 x 18.4 (11 x 7¼)
Augustin Edouart, signed, inscribed and dated 1828
Purchased, 1966

1669 Plaster cast of bust 66 (26) high
Thomas Woolner, incised, c.1860
Purchased, 1912

Ormond

SEDGWICK, Edward
Secretary to 2nd Earl of Halifax

3328 *See Groups:* Lord Halifax and his secretaries, attributed to Daniel Gardner, after Hugh Douglas Hamilton

SEDGWICK, Obadiah (1600?-58)
Puritan divine

2452 Water-colour 29.5 x 20.3 (11⅝ x 8)
T. Athow after an unknown artist, signed and inscribed below image
Purchased, 1930

SEELY, John Edward Bernard, 1st Baron Mottistone
See MOTTISTONE

SEEMANN, Berthold Carl (1825-71)
Botanist and traveller

P120(22) Photograph: albumen print, arched top 19.7 x 14.6 (7¾ x 5¾)
Maull & Polyblank, inscribed on mount, 1855
Purchased, 1979
See Collections: Literary and Scientific Men, 1855, by Maull & Polyblank, **P120(1-54)**

SEGUIER, William (1771-1843)
Artist; first Keeper of the National Gallery

2644 Card 45.7 x 39.4 (18 x 15½)
Attributed to John Jackson
Given by Mrs Herbert George Haines, 1933

SELBORNE, Roundell Palmer, 1st Earl of (1812-95)
Lord Chancellor

2138 Pencil 19.7 x 14.6 (7¾ x 5¾)
Horace William Petherick, signed and dated 1884
Given by the artist's daughters, Mrs A.Gibson and the Misses Petherick, 1926

1448 Canvas 74.9 x 62.2 (29½ x 24½)
James Malcolm Stewart after Miss E.M.Busk, signed, inscribed and dated 1906 (1889)
Given by the sitter's son, the Earl of Selborne, 1906

SELDEN, John (1584-1654)
Jurist, politician and scholar

3052 Canvas 43.2 x 38.1 (17 x 15)
Unknown artist
Purchased, 1939

76 Canvas 74.9 x 62.9
(29½ x 24¾)
After an unknown artist, inscribed
reduced copy
Purchased, 1859

Piper

SELFRIDGE, Harry Gordon
(1858-1947) Man of business;
founder of 'Selfridges'

5224(1) Ink and pencil 35.6 x 25.4
(14 x 10)
Robert Stewart Sherriffs, signed,
and inscribed below image
Purchased, 1978
See Collections: Cartoons,
c.1928-c.1936, by Robert Stewart
Sherriffs, **5224(1-9)**

SELIGMAN, Charles Gabriel
(1873-1940) Ethnologist

4833 Pencil 34 x 27.9 (13$\frac{3}{8}$ x 11)
Sir William Rothenstein
Purchased, 1970

SELOUS, Frederick Courtenay
(1851-1917) Hunter and explorer

2795 Pastel 45.1 x 35.6 (17¾ x 14)
Olivia Mary Bryden, signed,
posthumous
Purchased, 1935

SELOUS, Henry Courtney
(1811-90) Painter and lithographer

4848 Canvas 53.3 x 43.2 (21 x 17)
Self-portrait, signed with initials
and dated 1871
Acquired, 1971

SELWYN, George Augustus
(1809-78) Bishop of Lichfield

2780 Oil over photograph, oval
21.6 x 17.5 (8½ x 6$\frac{7}{8}$) *sight*
Photograph by Mason & Co, c.1867
Given by Mrs J.S.Hall, 1912

SENDALL, Sir Walter (1832-1904)
Colonial governor

4859 Marble bust 75.5 (29¾) high
Edouard Lanteri, incised and dated
1902
Given by the West India Committee,
1971

SERRES, Dominic (1722-93)
Marine painter

1437, 1437a *See Groups:* The
Academicians of the Royal
Academy, 1771-2, by John Sanders
after Johan Zoffany

1909 Miniature on ivory
10.8 x 8.3 (4¼ x 3¼)
Philip Jean, signed and dated on
backing paper 1788
Purchased, 1921

650a Wash and pencil 16.5 x 12.1
(6½ x 4¾)
By or after Paul Sandby, inscribed,
1792
Given by William Hudson, 1881

SEVERN, Joseph (1793-1879)
Painter; friend of John Keats

3091 Pencil 25.4 x 17.8 (10 x 7)
Self-portrait, c.1820
Given by Maurice Buxton Forman,
1940

3944(18,20) *See Collections:*
Artists, 1825, by John Partridge,
3944(1-55)

Ormond

SEWARD, Anna (1742-1809)
Writer and poet

2017 Canvas 73.7 x 62.2
(29 x 24½)
Tilly Kettle, signed, inscribed
and dated 1762
Purchased, 1924. *Beningbrough*

SEWARD, William (1747-99)
Writer

1157 Pencil 24.1 x 19.1 (9½ x 7½)
George Dance, signed and dated
1793
Purchased, 1898

SEXTON, Thomas (1848-1932)
Irish politician

3620 *See Collections:* Prominent
Men, c.1880-c.1910, by Harry
Furniss, **3337-3535** and **3554-3620**

SEYMOUR, Thomas Seymour,
Baron (1508?-49)
Lord High Admiral; son of 1st
Duke of Somerset

4571 Panel 53.3 x 41.9 (21 x 16½)
Unknown artist, inscribed
Purchased, 1967

Strong

SEYMOUR, Charles, 6th Duke of
Somerset *See* SOMERSET

SEYMOUR, Digby
Counsellor

2235 *See Collections:* The Parnell
Commission, 1888-9, by Sydney
Prior Hall, **2229-72**

SEYMOUR, Edward, 1st Duke of
Somerset *See* SOMERSET

SEYMOUR, Edward, 11th Duke of
Somerset *See* SOMERSET

SEYMOUR, Henry (c.1776-1843)
Serjeant-at-Arms

54 *See Groups:* The House of Commons, 1833, by Sir George Hayter

SEYMOUR, William, 2nd Duke of
Somerset *See* SOMERSET

SHACKLETON, Sir Ernest Henry
(1874-1922) Antarctic explorer

2608 Canvas 61 x 50.8 (24 x 20)
Reginald Grenville Eves, signed and
dated 1921
Given by a Memorial Committee,
1933

SHADWELL, Thomas (1642?-92)
Dramatist and Poet Laureate

4143 Canvas 76.5 x 63.5
(30⅛ x 25)
Unknown artist, inscribed and
dated 1690
Purchased, 1960

Piper

SHAFTESBURY, Anthony Ashley-
Cooper, 1st Earl of (1621-83)
Statesman

3893 Canvas 127 x 99.7
(50 x 39¼)
After John Greenhill, inscribed
(c.1672-3?)
Purchased, 1953

Piper

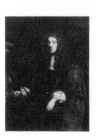

SHAFTESBURY, Cropley Ashley
Cooper, 6th Earl of (1768-1851)

999 *See Groups:* The Trial of
Queen Caroline, 1820, by Sir
George Hayter

SHAFTESBURY, Anthony Ashley-
Cooper, 7th Earl of (1801-85)
Philanthropist and social reformer

54 *See Groups:* The House of Commons, 1833, by Sir George Hayter

Continued overleaf

1012 Panel 60.6 x 50.2
(23$\frac{7}{8}$ x 19¾)
George Frederic Watts, 1862
Given by the artist, 1895

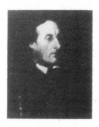

862 Plaster cast of bust 69.2 (27¼)
high
Sir Joseph Edgar Boehm, incised
and dated 1875
Purchased, 1891

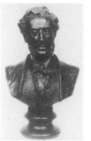

1728 Canvas 127 x 101.6 (50 x 40)
John Collier, 1877
Given by wish of James Wilkes, 1914

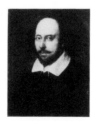

1834(cc) *See Collections:* Members
of the House of Lords, c.1870-80,
by Frederick Sargent, **1834(a-z and
aa-hh)**

Ormond

SHAKESPEARE, William
(1564-1616) Dramatist and poet

1 Canvas, feigned oval 55.2 x 43.8
(21¾ x 17¼)
Unknown artist
Given by the Earl of Ellesmere, 1856

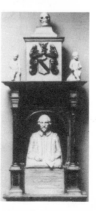

1281 Coloured plaster copy of
tomb at Stratford-upon-Avon
81.3 x 68.6 (32 x 27)
After Gerard Johnson, reduced
copy (c.1620)
Given by Mrs Charles James Wylie
in memory of her husband, 1900

1735 Plaster copy of effigy at
Stratford-upon-Avon 80.6 (31¾)
high
After Gerard Johnson (c.1620)
Purchased, 1914

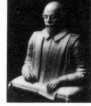

185a Plaster copy of head only of
no.**1735**, 30.5 (12) long
After Gerard Johnson (c.1620)
Given by Albert Way (d.1874)

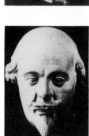

185 Engraving 19.1 x 15.9
(7½ x 6¼)
Martin Droeshout, signed and
inscribed below image
Purchased, 1864

Strong

SHAND, Alexander Burns Shand,
1st Baron (1828-1904) Judge

2969 Water-colour 31.1 x 26.4
(12¼ x 10$\frac{3}{8}$)
Sir Leslie Ward, signed *Spy*
(*VF* 22 July 1903)
Purchased, 1938

SHANNON, Richard Boyle, 2nd
Viscount (1675-1740) Soldier

3235 Canvas 91.4 x 71.1 (36 x 28)
Sir Godfrey Kneller, eng 1733
Kit-cat Club portrait
Given by NACF, 1945

Piper

SHANNON, Charles Haslewood
(1863-1937)
Painter and lithographer

3107 Canvas 92.7 x 96.5
(36½ x 38)
Self-portrait, signed and dated 1897
Given by NACF, 1942

3081 Lithograph 24.1 x 23.5
(9½ x 9¼)
Self-portrait, signed with initials
and dated 1918 on stone
Purchased, 1940

SHANNON, Sir James Jebusa
(1862-1923) Painter

4412 Canvas 95.3 x 69.9
(37½ x 27½)
Self-portrait, c.1919
Given by his daughter, Mrs
Keigwin, 1964

SHARP, Anna Jemima
Daughter of John Sharp

L169 *See Groups:* The Sharp
Family, by Johan Zoffany, 1779-81

SHARP, Catherine (née Barwick)
Wife of William Sharp (1729-1820)

L169 *See Groups:* The Sharp
Family, by Johan Zoffany, 1779-81

SHARP, Catherine
Daughter of James Sharp

L169 *See Groups:* The Sharp
Family, by Johan Zoffany, 1779-81

SHARP, Cecil (1859-1924)
Musician and collector of folk-songs

2517 Chalk 29.2 x 22.9 (11½ x 9)
Esther Blaikie Mackinnon, signed
and dated 1921
Given by the artist, 1931

2518 Pencil 21.6 x 19.1 (8½ x 7½)
Esther Blaikie Mackinnon, signed
and dated 1921
Given by the artist, 1931

SHARP, Frances
Sister of Granville and William
Sharp

L169 *See Groups:* The Sharp
Family, by Johan Zoffany, 1779-81

SHARP, Granville (1753-1813)
Scholar and philanthropist

L169 *See Groups:* The Sharp
Family, by Johan Zoffany, 1779-81

1158 Pencil 24.8 x 18.4 (9¾ x 7¼)
George Dance, signed and dated
1794
Purchased, 1898

SHARP, James
Ironmaster; brother of William
and Granville Sharp

L169 *See Groups:* The Sharp
Family, by Johan Zoffany, 1779-81

SHARP, Mrs James (née Lodge)

L169 *See Groups:* The Sharp
Family, by Johan Zoffany, 1779-81

SHARP, John (d.1792)
Archdeacon of Northumberland

L169 *See Groups:* The Sharp
Family, by Johan Zoffany, 1779-81

SHARP, Judith
Sister of Granville Sharp

L169 *See Groups:* The Sharp
Family, by Johan Zoffany, 1779-81

SHARP, Mary (née Dering)
Wife of John Sharp

L169 *See Groups:* The Sharp
Family, by Johan Zoffany, 1779-81

SHARP, William (1729-1820)
Surgeon to George III

L169 *See Groups:* The Sharp
Family, by Johan Zoffany, 1779-81

SHARP, William (1749-1824)
Engraver

25 Canvas 124.5 x 99.1 (49 x 39)
James Lonsdale
Purchased, 1859

SHARPE, Daniel (1806-56)
Geologist

P120(19) Photograph: albumen
print, arched top 19.7 x 14.6
(7¾ x 5¾)
Maull & Polyblank, 1855
Purchased, 1979
See Collections: Literary and
Scientific Men, 1855, by Maull &
Polyblank, **P120(1-54)**

SHARPE, Matthew (d.1845)
MP for Dumfries

54 *See Groups:* The House of Com-
mons, 1833, by Sir George Hayter

SHARPE, Samuel (1799-1881)
Egyptologist

1476 Canvas 60.3 x 50.8
(23¾ x 20)
Matilda Sharpe (his daughter),
inscribed and dated 1868
Given by the artist and her sister,
Miss Emily Sharpe, 1907

Ormond

SHARPEY, William (1802-80)
Physiologist

P120(21) Photograph: albumen
print, arched top 19.7 x 14.6
(7¾ x 5¾)
Maull & Polyblank, inscribed on
mount, 1855
Purchased, 1979
See Collections: Literary and
Scientific Men, 1855, by Maull &
Polyblank, **P120(1-54)**

SHARPEY-SCHAFER, Sir Edward
(1850-1935) Physiologist

4581 Bronze medal 5.1 (2) diameter
Charles d'Orville Pilkington
Jackson, inscribed
Given by the sitter's daughter, Miss
G.M.Sharpey-Schafer, 1967

SHAW, Sir Frederick, Bt
(1799-1876) Irish politician

54 *See Groups:* The House of Com-
mons, 1833, by Sir George Hayter

SHAW, George Bernard
(1856-1950) Playwright

4229 Water-colour 26.7 x 18.4
(10½ x 7¼)
Sir Bernard Partridge, signed and
dated 1894
Purchased, 1961

P113 Photograph: platinum print
13.3 x 9.8 (5¼ x $3\frac{7}{8}$)
Frederick Henry Evans, 1896
Given by Dr Robert Steele, 1939

3510-12, 3604 *See Collections:*
Prominent Men, c.1880-c.1910, by
Harry Furniss, **3337-3535** and
3554-3620

4228 Water-colour 38.1 x 26.7
(15 x 10½)
Sir Bernard Partridge, signed, c.1925
Purchased, 1961

4047 Bronze cast of bust 45.7 (18) high
Sir Jacob Epstein, incised, 1934
Purchased, 1958

SHAW, Norton

P120(2) *See Collections:* Literary and Scientific Men, 1855, by Maull & Polyblank, **P120(1-54)**

SHAWCROSS, Hartley William Shawcross, Baron (b.1902) Attorney-General

4529(328-33) *See Collections:* Working drawings by Sir David Low, **4529(1-401)**

SHAW-LEFEVRE, Charles, 1st Viscount Eversley
See EVERSLEY

SHAW-LEFEVRE, Sir John (1797-1879)
Civil Service Commissioner

2741 Water-colour 29.8 x 18.7 (11¾ x 7⅜)
Carlo Pellegrini, signed *Ape* (*VF* 1 July 1871)
Purchased, 1934

Ormond

SHEE, Sir Martin Archer (1769-1850)
Portrait painter and PRA

1093 Canvas 76.2 x 62.9 (30 x 24¾)
Self-portrait, 1794
Purchased, 1897

3153 Black chalk and water-colour 24.4 x 21 (9⅝ x 8¼)
John Jackson, c.1815
Purchased, 1943

Ormond

SHEFFIELD, John Holroyd, 1st Earl of (1735-1821) Statesman

2185 Pencil and wash 27.3 x 18.4 (10¾ x 7¼)
Henry Edridge, signed and dated 1798
Purchased, 1928

SHEFFIELD, Anne (North), Countess of (1764-1832) Third wife of 1st Earl of Sheffield

2185a Pencil and wash 26.7 x 18.4 (10½ x 7¼)
Henry Edridge, signed and dated 1798
Purchased, 1928

SHEFFIELD, John, Duke of Buckingham and Normanby
See BUCKINGHAM AND NORMANBY

SHEIL, Richard Lalor (1791-1851) Politician and dramatist

54 *See Groups:* The House of Commons, 1833, by Sir George Hayter

SHELBURNE, Henry Petty, Earl of (1675-1751) Politician

4855(15) *See Collections:* The Townshend Album, **4855(1-73)**

SHELBURNE, William Petty, Earl of *See* LANSDOWNE

SHELDON, Gilbert (1598-1677) Archbishop of Canterbury

1837 Canvas 121.9 x 99.1 (48 x 39)
Studio of Sir Peter Lely, c.1665
Purchased, 1919

Piper

SHELLEY, Sir John, 4th Bt (1692-1771) Politician

4855(44) *See Collections:* The Townshend Album, **4855(1-73)**

SHELLEY, Sir John, Bt
(1772-1852)

883(19) *See Collections:* Studies
for miniatures by Sir George Hayter,
883(1-21)

SHELLEY, Mary Wollstonecraft
(1797-1851) Novelist; wife of
Percy Bysshe Shelley

1235 Canvas 73.7 x 61 (29 x 24)
Richard Rothwell, exh 1840
Bequeathed by the sitter's daughter-
in-law, Jane, Lady Shelley, 1899

1719 *See Unknown Sitters IV*

SHELLEY, Percy Bysshe
(1792-1822) Poet

1234 Canvas 59.7 x 47.6
(23½ x 18¾)
Amelia Curran, 1819
Bequeathed by the sitter's daughter-
in-law, Jane, Lady Shelley, 1899

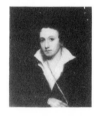

1271 Canvas 59.7 x 49.5
(23½ x 19½)
Alfred Clint after Amelia Curran
and Edward Ellerker Williams
Purchased, 1900

2683 Plaster cast of medallion
22.2 (8¾) diameter
Attributed to Marianne Leigh Hunt,
posthumous
Given by Maurice Buxton Forman,
1934

SHENSTONE, William (1714-63)
Poet and landscape gardener

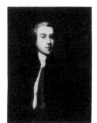

4386 Canvas, feigned oval
75.9 x 56.5 (29$\frac{7}{8}$ x 22¼)
Thomas Ross, signed and dated 1738
Purchased, 1964

263 Canvas 150.8 x 99.7
(59$\frac{3}{8}$ x 39¼)
Edward Alcock, 1760
Purchased, 1868

Kerslake

SHEPPARD, Hugh Richard (Dick)
(1880-1937) Dean of Canterbury

4529(34) *See Collections:*
Working drawings by Sir David
Low, **4529(1-401)**

SHEPPARD, John (1702-24)
Criminal

4313 Chalk and pencil 32.4 x 25.1
(12¾ x 9$\frac{7}{8}$)
Attributed to Sir James Thornhill,
c.1724
Purchased, 1963. *Beningbrough*

Kerslake

SHERBROOKE, Robert Lowe,
1st Viscount (1811-92)
Chancellor of the Exchequer

5116 *See Groups:* Gladstone's
Cabinet of 1868, by Lowes Cato
Dickinson

5106 Terracotta statuette 43.8
(17¼) high
Carlo Pellegrini, incised and dated
1873
Purchased, 1976

1013 Canvas 64.8 x 52.1
(25½ x 20½)
George Frederic Watts, c.1874
Given by the artist, 1895

3605, 3606 *See Collections:*
Prominent Men, c.1880-c.1910, by
Harry Furniss, **3337-3535** and
3554-3620

SHERIDAN, Elizabeth Ann (Linley)
(1754-92) Singer; first wife of
R.B.Sheridan

4905 *See Groups:* The Nine
Living Muses of Great Britain, by
Richard Samuel

SHERIDAN, Richard Brinsley
(1751-1816)
Dramatist and parliamentary orator

651 Pastel, oval 59.7 x 44.5
(23½ x 17½)
John Russell, signed and dated 1788
Purchased, 1881

745 *See Groups:* William Pitt
addressing the House of Commons
. . . 1793, by Karl Anton Hickel

SHERRINGTON, Sir Charles Scott
(1857-1952) Physiologist

3829 Charcoal 57.2 x 37.5
(22½ x 14¾)
Reginald Grenville Eves, signed and
dated 1927
Given by the artist, 1952

3828 Canvas 75.6 x 62.2
(29¾ x 24½)
Reginald Grenville Eves, c.1927
Purchased, 1952

SHIELD, William (1748-1829)
Composer

1159 Pencil 24.8 x 18.4 (9¾ x 7¼)
George Dance, signed and dated
1798
Purchased, 1898

5221 Water-colour 19.7 x 16.5
(7¾ x 6½)
John Jackson, inscribed, eng 1822
Purchased, 1978

2515(11) *See Collections:*
Drawings of Prominent People,
1823-49, by William Brockedon,
2515(1-104)

SHORE, John, 1st Baron
Teignmouth *See* TEIGNMOUTH

SHORT, Sir Frank (1857-1945)
Etcher and engraver

3776 Chalk 69.9 x 52.1
(27½ x 20½)
Albert Wallace Peters, signed and
inscribed, c.1914
Given by H.E.Palfrey, 1950

4804 Lithographic chalk
30.8 x 24.1 ($12\frac{1}{8}$ x 9½)
Sir William Rothenstein, 1921
Purchased, 1970

SHORTT, Edward (1862-1935)
Home Secretary

4368a Pencil 9.2 x 6 ($3\frac{5}{8}$ x $2\frac{3}{8}$)
Reginald Grenville Eves, signed and
dated 1922
Given by the artist's son, Grenville
Eves, 1964

4368b Pencil 9.2 x 6 ($3\frac{5}{8}$ x $2\frac{3}{8}$)
Reginald Grenville Eves, signed and
dated 1922
Given by the artist's son, Grenville
Eves, 1964

SHOVELL, Sir Clowdisley
(1650-1707) Admiral

797 Canvas 222.3 x 142.2
(87½ x 56)
Michael Dahl, c.1702
Purchased, 1888

Piper

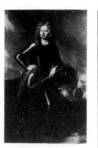

SHREWSBURY, Charles Talbot,
1st Duke of (1660-1718) Politician

1424 Canvas, feigned oval
74.9 x 62.2 (29½ x 24½)
After Sir Godfrey Kneller (c.1685)
Purchased, 1905

624 *See Groups:* Queen Anne and
the Knights of the Garter, 1713, by
Peter Angelis

Piper

SHREWSBURY, George Talbot,
6th Earl of (1528?-90)
Custodian of Mary, Queen of Scots

2822 Water-colour 24.8 x 17.5
(9¾ x 6⅞)
Unknown artist, after a portrait of
1580, inscribed
Purchased, 1936

Strong

SHREWSBURY, Elizabeth Talbot,
Countess of (1518-1608)
'Bess of Hardwick'; wife of 6th
Earl of Shrewsbury

203 Canvas 98.8 x 78.7 (38⅞ x 31)
Unknown artist
Purchased, 1865. *Montacute*

Strong

SHREWSBURY, Anna Maria
(Brudenell), Countess of
(1642-1702) Notorious beauty;
wife of 11th Earl of Shrewsbury

280 Canvas, feigned oval
74.9 x 62.2 (19½ x 24½)
Sir Peter Lely, inscribed, c.1670
Purchased, 1869

Piper

SIBTHORP, Humphry (1713-97)
Botanist

4408 Miniature on ivory, oval
7 x 5.4 (2¾ x 2⅛)
Unknown artist
Given by the Hon Mrs Dudley
Pelham, 1964

SIBTHORP, John (1758-96)
Botanist; son of Humphry Sibthorp

4409 Miniature on ivory, oval
7.6 x 6.4 (3 x 2½)
Unknown artist
Given by the Hon Mrs Dudley
Pelham, 1964

SICHEL, Walter (1855-1933)
Biographer

3513 *See Collections:* Prominent
Men, c. 1880-c.1910, by Harry
Furniss, **3337-3535** and **3554-3620**

SICKERT, Walter Richard
(1860-1942) Painter

3142 Canvas 59.7 x 29.8
(23½ x 11¾)
Philip Wilson Steer, signed, pub 1894
Given by NACF, 1943

4761 Canvas 80.9 x 64.8
(31⅞ x 25½)
Jacques-Emile Blanche, signed and
dated 1898
Purchased, 1970

2556 *See Groups:* The Selecting
Jury of the New English Art Club,
1909, by Sir William Orpen

3134 Canvas 68.6 x 25.4 (27 x 10)
Self-portrait, 1930s
Given by Sir Alec Martin, 1943

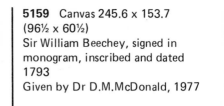

3547 Pen and ink 31.4 x 20
($12\frac{3}{8}$ x $7\frac{7}{8}$)
Edmond Xavier Kapp, signed,
inscribed and dated 1940
Given by Sir Alec Martin, 1947

SIDDONS, Henry (1774-1815)
Actor; son of Sarah Siddons

4879 Miniature on ivory, oval
7.9 x 6.4 ($3\frac{1}{8}$ x 2½)
Samuel John Stump, incised,
exh 1807
Purchased, 1972

SIDDONS, Sarah (1755-1831)
Actress

50 Canvas 74.9 x 62.2
(29½ x 24½)
Gilbert Stuart, c.1785
Given by John Thadeus Delane,
1858

2651 Chalk, oval 20.3 x 17.1
(8 x 6¾)
John Downman, signed and dated
1787
Given by Mrs D.E.Knollys, 1934

5159 Canvas 245.6 x 153.7
(96½ x 60½)
Sir William Beechey, signed in
monogram, inscribed and dated
1793
Given by Dr D.M.McDonald, 1977

642 Marble relief 116.8 x 95.3
(46 x 37½)
Thomas Campbell
Given by James Thomson Gibson-
Craig, 1881

2425 *See Unknown Sitters IV*

SIDMOUTH, Henry Addington, 1st
Viscount (1757-1844)
Prime Minister

745 *See Groups:* William Pitt
addressing the House of Commons
. . . 1793, by Karl Anton Hickel

3917 Marble bust 77.5 (30½) high
William Behnes, incised and dated
1831
Purchased, 1954

5 Water-colour 59.7 x 38.7
(23½ x 15¼)
George Richmond, signed and
dated 1833
Given by the executors of Sir
Robert Harry Inglis, Bt, 1857

SIDNEY Algernon (1622-83)
Republican

568 Canvas 45.7 x 38.1
(18 x 15)
After Justus van Egmont (1663)
Transferred from BM, 1879

Piper

SIDNEY, Sir Henry (1529-86)
Soldier and statesman

1092 Panel 67.6 x 52.5
$(26\frac{5}{8} \times 20\frac{5}{8})$
Unknown artist, inscribed and
dated 1573
Purchased, 1897. *Montacute*

2823 Oil on paper 30.5 x 27.9
(12 x 11)
Unknown artist
Purchased, 1936

Strong

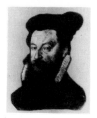

SIDNEY, Henry, Earl of Romney
See ROMNEY

SIDNEY, Sir Philip (1544-86)
Soldier, statesman and poet

2096 Canvas 115.2 x 82.3
$(45\frac{3}{8} \times 32\frac{3}{8})$
After an unknown artist
Given by Viscount Dillon in
memory of Julia, Viscountess
Dillon, 1925

2412 *See Unknown Sitters I*

Strong

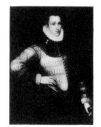

SIDNEY, Robert, 1st Earl of
Leicester *See* LEICESTER

SIEMENS, Sir William (1823-83)
Metallurgist and electrician

2632 Canvas 91.4 x 71.1
(36 x 28)
Rudolph Lehmann, signed in
monogram and dated 1882
Bequeathed by Joseph Gordon
Gordon, 1933

SIMMONS, Sir John (1821-1903)
Field-Marshal

3269 Water-colour 30.5 x 17.8
(12 x 7)
Carlo Pellegrini, signed *Ape*
(*VF* 1 Dec 1877)
Purchased, 1946

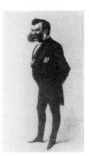

SIMMS, F.W.(?Frederick Walter
Simms, 1803-65)

P120(8) *See Collections:* Literary
and Scientific Men, 1855, by Maull
& Polyblank, **P120(1-54)**

SIMON, Abraham (1617-92)
Medallist and modeller

1642 Canvas 43.8 x 34.9
(17¼ x 13¾)
Attributed to himself, c.1670-80
Purchased, 1912

Piper

SIMPSON, Mr
Gardener

P22(14) With his wife
See Collections: The Balmoral
Album, 1854-68, by George
Washington Wilson, W.& D.Downey,
and Henry John Whitlock, **P22(1-27)**

SIMPSON, John (1751-1817)

1485 Canvas 73.7 x 61 (29 x 24)
Angelica Kauffmann, signed, c.1777,
reduced version
Given by Charles Davis, 1908

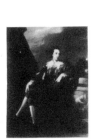

SIMS, George Robert (1847-1922)
Journalist and playwright

3514 *See Collections:* Prominent
Men, c.1880-c.1910, by Harry
Furniss, **3337-3535** and **3554-3620**

SINCLAIR, Sir George, Bt
(1790-1868) Politician and writer

54 *See Groups:* The House of Com-
mons, 1833, by Sir George Hayter

SINCLAIR, James, 14th Earl of Caithness *See* CAITHNESS

SINCLAIR, Sir John, Bt (1754-1835) Agriculturalist

454 Canvas 123.2 x 98.4 (48½ x 38¾) Sir Henry Raeburn, inscribed Purchased, 1877

SINCLAIR, John, 1st Baron Pentland *See* PENTLAND

SINCLAIR, Sir John Gordon, Bt (1790-1863)

883(20) *See Collections:* Studies for miniatures by Sir George Hayter, **883(1-21)**

SITWELL, Dame Edith (1887-1964) Poet

4464 Pencil 38.7 x 28.6 (15¼ x 11¼) Wyndham Lewis, signed, inscribed and dated 1921 Given by the sitter's brother, Sir Osbert Sitwell, Bt, 1965

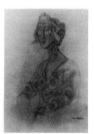

4465 Pencil and wash 40 x 28.9 (15¾ x 11$\frac{3}{8}$) Wyndham Lewis, signed and dated 1923 Given by the sitter's brother, Sir Osbert Sitwell, Bt, 1965

SITWELL, Sir Osbert, Bt (1892-1969) Poet and novelist

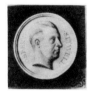

5009 Pencil and water-colour 14.9 x 14.9 (5$\frac{7}{8}$ x 5$\frac{7}{8}$) Rex Whistler, inscribed, 1935 Bequeathed by the Dowager Lady Aberconway, 1974

SLACK, Jack (d.1778) Boxer

4855(30) *See Collections:* The Townshend Album, **4855(1-73)**

SLATIN, Rudolf Carl von Slatin, Baron and Pasha (1857-1932) Administrator in the Sudan

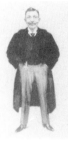

3001 Water-colour 33.7 x 22.9 (13¼ x 9) Sir Leslie Ward, signed *Spy* (*VF* 15 June 1899) Purchased, 1938

SLEIGH, Sir James Wallace (1780-1865) Major-General

3753 *See Collections:* Studies for The Waterloo Banquet at Apsley House, 1836, by William Salter, **3689-3769**

SLOANE, Sir Hans, Bt (1660-1753) Physician and collector

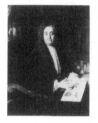

569 Canvas 125.7 x 101 (49½ x 39¾) Stephen Slaughter, signed, inscribed and dated 1736 Transferred from BM, 1879

Kerslake

SMALLEY, George Washburn (1833-1916) American journalist

3845 *See Groups:* Dinner at Haddo House, 1884, by Alfred Edward Emslie

SMALLWOOD, Thomas Pugilist

4855(31,34) *See Collections:* The Townshend Album, **4855(1-73)**

SMART, Christopher (1722-71) Poet

3780 Canvas, feigned oval 72.4 x 59.4 (28½ x 23$\frac{3}{8}$) Unknown artist Purchased, 1950

Kerslake

SMART, Sir George Thomas
(1776-1867) Musician

1326 Canvas 73.7 x 61 (29 x 24)
William Bradley, signed with initials,
inscribed and dated 1829
Purchased, 1902

SMART, John (1741-1811)
Miniaturist

3817 Canvas 89.2 x 68.9
($35\frac{1}{8}$ x $27\frac{1}{8}$)
Attributed to Lemuel Francis
Abbott
Purchased, 1952

SMEAL, William (1792-1877)
Slavery abolitionist

599 *See Groups:* The Anti-Slavery
Society Convention, 1840, by
Benjamin Robert Haydon

SMEATON, John (1724-92)
Civil engineer

80 Canvas 74.9 x 62.2
(29½ x 24½)
Geroge Romney after Rhodes
Purchased, 1859

SMETHAM, James (1821-89)
Painter and essayist

4487 Chalk and wash 14.9 x 12.4
($5\frac{7}{8}$ x $4\frac{7}{8}$)
Self-portrait, c.1845
Purchased, 1966

SMILES, Samuel (1812-1904)
Social reformer; author of *Self Help*

1377 Canvas 62.2 x 45.7
(24½ x 18)
Sir George Reid, signed .R.
Given by members of the sitter's
family, 1904

1856 Chalk 59.7 x 49.5
(23½ x 19½)
Louise Jopling-Rowe, signed
Given by the artist, 1920

SMIRKE, Robert (1752-1845)
Painter and illustrator

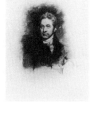

2672 Water-colour 21.6 x 17.8
(8½ x 7)
John Jackson after Miss Smirke,
eng 1814
Purchased, 1934

4525 Plaster cast of bust 61 (24)
high
Attributed to Edward Hodges Baily,
1828
Purchased, 1967

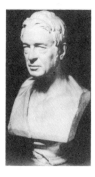

SMITH, Adam (1723-90)
Political economist

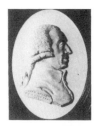

1242 Plaster cast of medallion,
oval 9.5 x 7 (3¾ x 2¾)
James Tassie, incised and dated 1787
Given by Sir James Caw, 1899

3237 Paste medallion, oval
8.9 x 6.4 (3½ x 2½)
James Tassie, incised and dated 1787
Purchased, 1945

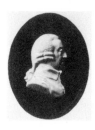

SMITH, Arthur Lionel (1850-1924)
Historian; Master of Balliol College,
Oxford

3996 Etching 24.5 x 18.4
($9\frac{5}{8}$ x 7¼)
Francis Dodd, signed and dated 1915
on plate, and signed below plate
Purchased, 1956

SMITH, Benjamin Leigh
(1828-1913) Explorer

924 Millboard 38.1 x 31.1
(15 x 12¼)
Stephen Pearce, inscribed, 1886
Bequeathed by Lady Franklin, 1892
See Collections: Arctic Explorers,
1850-86, by Stephen Pearce,
905-24 and **1209-27**

Ormond

SMITH, Charles Hamilton
(1776-1859) Soldier and naturalist

2515(22) *See Collections:*
Drawings of Prominent People,
1823-49, by William Brockedon,
2515(1-104)

Ormond

SMITH, Edward
Slavery abolitionist

599 *See Groups:* The Anti-Slavery
Society Convention, 1840, by
Benjamin Robert Haydon

SMITH, Frederick Edwin,
1st Earl of Birkenhead
See BIRKENHEAD

SMITH, George (1713-76)
Landscape painter and poet

4117 With his brother, John (right)
Canvas 62.9 x 75.2 (24¾ x 29⅝)
Self-portraits, inscribed
Purchased, 1959

Kerslake

SMITH, George (1824-1901)
Publisher and founder of the
Dictionary of National Biography

1620 Canvas 59.7 x 49.5
(23½ x 19½)
John Collier, signed, posthumous
Given by a group of the sitter's
friends, 1911

SMITH, Sir Harry, Bt (1787-1860)
General

1945 Miniature on ivory
15.9 x 12.4 (6¼ x 4⅞)
Unknown artist, after 1848
Purchased, 1922

1255 Plaster cast of bust 75.6
(29¾) high
George Gammon Adams, c.1849
Purchased, 1900

Ormond

SMITH, Henry (1826-83)
Mathematician

787 Terracotta bust 76.2 (30) high
Sir Joseph Edgar Boehm
Given by the artist, 1888

SMITH, Horatio ('Horace')
(1779-1849) Poet and novelist

4578 Pencil and wash 49.5 x 34.3
(19½ x 13½)
Edward Matthew Ward, signed,
inscribed and dated 1835
Given by K.M. Guichard, 1967

2200 Water-colour 19.1 x 16.5
(7½ x 6½)
Unknown artist
Bequeathed by the sitter's grandson,
John Horace Round, 1928

SMITH, J.

P22(17) *See Collections*: The
Balmoral Album, 1854-68, by
George Washington Wilson, W. & D.
Downey, and Henry John Witlock,
P22(1-27)

SMITH, James (1775-1839)
Writer and humorist; brother of
Horatio Smith

1415 Canvas 125.7 x 69.9
(49½ x 27½)
James Lonsdale
Purchased, 1905

SMITH, Sir James Edward
(1759-1828) Botanist

316a(108) Pencil 42.9 x 34
(16⅞ x 11⅜)
Sir Francis Chantrey, inscribed

and

316a(109) Pencil, two sketches
44.8 x 65.1 (17⅝ x 25⅝)
Sir Francis Chantrey, inscribed
Given by Mrs George Jones, 1871
See Collections: Preliminary
drawings for busts and statues by
Sir Francis Chantrey, **316a(1-202)**

SMITH, John (1717-64)
Landscape painter

4117 *See under* George Smith

SMITH, John Raphael (1752-1812)
Portrait painter, engraver and
pastellist

981 Pastel 24.1 x 20.3 (9½ x 8)
Self-portrait
Purchased, 1895

SMITH, John Thomas (1766-1833)
Draughtsman and antiquary

2515(34) Chalk 37.5 x 27
(14¾ x 10⅝)
William Brockedon, dated 1832
Lent by NG, 1959
See Collections: Drawings of
Prominent People, 1823-49, by
William Brockedon, **2515(1-104)**

SMITH, Julia

1962(k) With Miss Smith
See Collections: Opera singers and
others, c.1804-c.1836, by Alfred
Edward Chalon, **1962(a-l)**

SMITH, Matilda (née Rigby)
Daughter of Edward and Anne
Rigby

P6(129, 131, 135) *See Collections:*
The Hill and Admson Albums,
1843-8, by David Octavius Hill and
Robert Adamson, **P6(1-258)**

SMITH, Sir Matthew (1879-1959)
Painter

4190 Canvas 41.3 x 33 (16¼ x 13)
Self-portrait, signed in monogram,
inscribed, and dated 1932 on
reverse
Given by Alden Brooks, 1961

4161 Canvas 90.5 x 70.2
(35⅝ x 27⅝)
Cathleen Mann, signed and dated
1952
Given by the artist's son, the
Marquess of Queensberry, 1960

SMITH, Robert, 1st Baron
Carrington *See* CARRINGTON

SMITH, Robert Vernon, 1st Baron
Lyveden *See* LYVEDEN

SMITH, Samuel (1798-1868)
Free Church minister

P6(65) *See Collections:* The Hill
and Adamson Albums, 1943-8, by
David Octavius Hill and Robert
Adamson, **P6(1-258)**

SMITH, Samuel (1836-1906)
Politician and philanthropist

2984 Water-colour 36.5 x 26.4
(14⅜ x 10⅜)
Sir Leslie Ward, signed *Spy*
(*VF* 4 Aug 1904)
Purchased, 1938

SMITH, Sydney (1771-1845)
Wit and Canon of St Paul's

1475 Canvas 127.6 x 102.2
(50¼ x 40¼)
Henry Perronet Briggs, inscribed
and dated 1840 (1833)
Given by Viscount Knutsford, 1907

2887 Ink and wash 16.5 x 11.4
(6½ x 4½)
Sir Edwin Landseer, signed, c.1835
Purchased, 1936

4917 *See Collections*: Caricatures
of Prominent People, c.1832-5, by
Sir Edwin Landseer, **4914-22**

5147 Pencil 13.3 x 8 (5¼ x 3⅛)
John Marshall, inscribed and dated
1839
Given by the artist's daughter, Ada
Blanche Marshall, 1927

SMITH, Thomas Southwood
(1788-1861) Physician and
sanitary reformer

339 Marble bust 66 (26) high
Joel T. Hart, incised and dated
1856
Given by a Committee, 1872

Ormond

SMITH, William (1769-1839)
Geologist and engineer

1075a, 1075b *See Groups*: Men of
Science Living in 1807-8, by Sir
John Gilbert and others

SMITH, William (1808-76)
Print-seller and antiquary

1692 Canvas 76.2 x 63.5 (30 x 25)
Margaret Sarah Carpenter, signed
and dated 1856
Bequeathed by the sitter's brother,
George Smith, 1913

Ormond

SMITH, William

316a(110) *See Collections*:
Preliminary drawings for busts and
statues by Sir Francis Chantrey,
316a(1-202)

SMITH, William Henry (1825-91)
Statesman

2322 *See Collections*:
Miscellaneous drawings . . . by
Sydney Prior Hall, **2282-2348**
and **2370-90**

1742 Plaster cast of bust 77.5
(30½) high
Frederick Winter, incised and dated
1891
Purchased, 1914

3607 *See Collections*: Prominent
Men, c.1880-c.1910, by Harry
Furniss, **3337-3535** and **3554-3620**

SMITH, Sir William Sidney
(1764-1840) Admiral

832 Canvas 237.5 x 144.8
(93½ x 57)
John Eckstein, 1800-2
Purchased, 1890

SMITHSON (afterwards Percy),
Sir Hugh, 1st Duke of
Northumberland
See NORTHUMBERLAND

SMOLLETT, Tobias George
(1721-71) Novelist

1110 Canvas 68.6 x 52.7
(27 x 20¾)
Unknown artist, c.1770
Purchased, 1897

Kerslake

SMUTS, Jan Christian (1870-1950)
Statesman and Field-Marshal

4187 (study for *Groups,* **1954**)
Canvas 80.6 x 65.4 (31¾ x 25¾)
John Singer Sargent, c.1919-22
Given by wish of Viscount
Wakefield, 1960

1954 *See Groups*: General
Officers of World War I, by John
Singer Sargent

4645 Sanguine and white chalk
39.7 x 28.9 ($15\frac{5}{8}$ x $11\frac{3}{8}$)
Sir William Rothenstein, 1923
Given by the Rothenstein Memorial
Trust, 1968

4004 Bronze cast of bust 48.3
(19) high
Moses Kottler, incised, 1949
Purchased, 1956

SMYTH, Dame Ethel Mary
(1858-1944) Composer

3243 Black chalk 59.7 x 46
(23½ x $18\frac{1}{8}$)
John Singer Sargent, signed and
inscribed, 1901
Given by the sitter's nieces,
Mrs Elwes, Mrs Williamson and
Lady Grant Lawson, 1944

SMYTH, William Henry
(1788-1865)
Admiral and scientific writer

2515(85) Black and red chalk
35.6 x 25.7 (14 x $10\frac{1}{8}$)
William Brockedon, dated 1838
Lent by NG, 1959
See Collections: Drawings of
Prominent People, 1823-49, by
William Brockedon, **2515(1-104)**

P120(33) Photograph: albumen
print, arched top 19.7 x 14.6
(7¾ x 5¾)
Maull & Polyblank, 1855
Purchased, 1979
See Collections: Literary and
Scientific Men, 1855, by Maull &
Polyblank, **P120(1-54)**

Ormond

SNOWDEN, Philip Snowden,
Viscount (1864-1937) Statesman

5028 *See Collections*: Miniatures,
1920-30, by Winifred Cécile
Dongworth, **5027-36**

4529(335) *See Collections*:
Working drawings by Sir David
Low, **4529(1-401)**

4563 Chalk 45.1 x 29.2
(17¾ x 11½)
Sir David Low, signed, pub 1927
Purchased, 1967

SOAMES, Mr

2256 *See Collections*: The
Parnell Commission, 1888-9, by
Sydney Prior Hall, **2229-72**

SOANE, Sir John (1753-1837)
Architect

4913(3) *See Collections*: Four
studies from a sketchbook, by
Thomas Cooley, **4913(1-4)**

701 Canvas 74.9 x 62.2
(29½ x 24½)
John Jackson, 1828
Transferred from Tate Gallery,
1957

316a(111) Pencil, two sketches
47.3 x 64.5 ($18\frac{5}{8}$ x $25\frac{3}{8}$)
Sir Francis Chantrey, inscribed
Given by Mrs George Jones, 1971
See Collections: Preliminary
drawings for busts and statues by
Sir Francis Chantrey, **316a(1-202)**

2515(76) *See Collections*:
Drawings of Prominent People,
1823-49, by William Brockedon
2515(1-104)

SOBIESKA, Maria Clementina
See MARIA

SOLLY, R.H.

P120(24) *See Collections*:
Literary and Scientific Men, 1855,
by Maull & Polyblank, **P120(1-54)**

SOLOMON, Solomon Joseph
(1860-1927) Painter

3044 Pen and ink 22.2 x 18.4
(8¾ x 7¼)
Self-portrait
Given by Marion Harry Spielmann,
1939

3515 Pen and ink 16.5 x 18.1
(6½ x $7\frac{1}{8}$)
Harry Furniss, signed with initials,
inscribed
Purchased, 1947
See Collections: Prominent Men,
c.1880-c.1910, by Harry Furniss,
3337-3535 and **3554-3620**

SOMERS, John Somers Cocks,
2nd Earl (1788-1852)
MP for Reigate

54 *See Groups*:The House of Com-
mons, 1833, by Sir George Hayter

SOMERS, Charles Somers Cocks,
3rd Earl (1819-83)
Representative peer

1834(dd) *See Collections*:
Members of the House of Lords,
c.1870-80, by Frederick Sargent,
1834(a-z and aa-hh)

SOMERS, John Somers, Baron
(1651-1716) Lord Chancellor

3658 Miniature on vellum
7.9 x 6.7 ($3\frac{1}{8}$ x $2\frac{5}{8}$)
Unknown artist, 1690-1700
Purchased, 1949

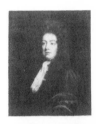

490 Canvas 91.4 x 71.1 (36 x 28)
Sir Godfrey Kneller, signed in
monogram, inscribed, c.1700-10
Given by Earl Somers, 1877

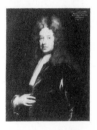

3223 Canvas 90.8 x 70.5
(35¾ x 27¾)
Sir Godfrey Kneller, signed and
inscribed, c.1700-10
Kit-cat Club portrait
Given by NACF, 1945

Piper

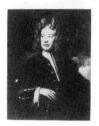

SOMERSET, Edward Seymour,
1st Duke of (1506?-52)
'The Protector'; statesman

4165 *See Groups*: Edward VI and
the Pope, by an unknown artist

1375 *See Unknown Sitters I*

Strong

SOMERSET, William Seymour,
2nd Duke of (1588-1660)
Soldier and politician

1645B Water-colour, feigned oval
24.5 x 21.9 (9⅝ x 8⅝)
George Perfect Harding after
Robert Walker, signed and inscribed
Given by Joseph Cahn, 1912

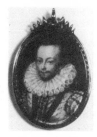

SOMERSET, Charles Seymour,
6th Duke of (1662-1748)
Politician

3224 Canvas 91.4 x 71.1 (36 x 28)
Sir Godfrey Kneller, signed, c.1703
Kit-cat Club portrait
Given by NACF, 1945

Piper

SOMERSET, Elizabeth (Percy),
Duchess of (1667-1722) Heiress;
wife of 6th Duke of Somerset

1753 Chalk 31.8 x 27
(12½ x 10⅝)
After Sir Peter Lely (c.1679)
Purchased, 1915

Piper

SOMERSET, Edward Seymour,
11th Duke of (1775-1855)
Mathematician

999 *See Groups:* The Trial of
Queen Caroline, 1820, by Sir
George Hayter

SOMERSET, Algernon Percy Banks
St Maur, 14th Duke of (1813-94)
Landowner

2970 Water-colour 36.8 x 22.9
(14½ x 9)
Sir Leslie Ward, signed *Spy*
(*VF* 27 April 1893)
Purchased, 1937

SOMERSET, Robert Carr (or Ker),
Earl of (c.1587-1645)
Favourite of James I

4260 Miniature on vellum, oval
4.4 x 3.5 (1¾ x 1⅜)
Manner of Nicholas Hilliard, c.1611
Purchased, 1962

Strong

1114 Panel 24.1 x 18.4 (9½ x 7¼)
After John Hoskins (c.1625-30)
Given by Sir Henry Howorth, 1898

Piper

SOMERSET, Frances (Howard),
Countess of (1590-1632)
Famous beauty

1955 Panel, feigned oval
57.5 x 43.8 (22⅝ x 17¼)
Attributed to William Larkin,
c.1615
Purchased, 1922

Strong

SOMERSET, Lord Granville
(1792-1848) Politician

54 *See Groups:* The House of Com-
mons, 1833, by Sir George Hayter

SOMERSET, Lord Henry Arthur
George (1851-1926)
Soldier and sportsman

2600 Water-colour 31.8 x 18.4
(12½ x 7¼)
Sir Leslie Ward, signed *Spy*
(*VF* 19 Nov 1887)
Purchased, 1933

SOMERSET, Lord John
(1787-1846) Lieutenant-Colonel

3755 *See Collections:* Studies for
The Waterloo Banquet at Apsley
House, 1836, by William Salter,
3689-3769

SOMERSET, Lord Robert Edward
Henry (1776-1842) General

1914(15) Water-colour 19.4 x 16.2
($7\frac{5}{8}$ x $6\frac{3}{8}$)
Thomas Heaphy, 1813-14
Purchased, 1921
See Collections: Peninsular and
Waterloo Officers, 1813-14, by
Thomas Heaphy, **1914(1-32)**

3754 Canvas 51.8 x 40.9
($20\frac{3}{8}$ x $16\frac{1}{8}$) *sight*
William Salter, 1834-40
Bequeathed by W.D. Mackenzie
(d.1928), 1950
See Collections: Studies for The
Waterloo Banquet at Apsley House,
1836, by William Salter, **3689-3769**

SOMERSET, Charles, 1st Earl of
Worcester *See* WORCESTER

SOMERSET, Fitzroy, 1st Baron
Raglan *See* RAGLAN

SOMERSET, Henry, 2nd Duke of
Beaufort *See* BEAUFORT

SOMERSET, Henry, 7th Duke of
Beaufort *See* BEAUFORT

SOMERSET, Henry Charles,
6th Duke of Beaufort
See BEAUFORT

SOMERSET, Isabella Caroline
(née Somers), Lady (1851-1921)
Wife of Lord Henry Somerset

P18(34) *See Collections*: The
Herschel Album, by Julia Margaret
Cameron, **P18(1-92b)**

SOMERSET, William, 3rd Earl of
Worcester *See* WORCESTER

SOMERVILLE, Mary (1780-1872)
Scientific writer; wife of William
Somerville (1771-1860)

316a(114, 115) Pencil, two
sketches 48.6 x 65.1 ($19\frac{1}{8}$ x $25\frac{5}{8}$)
Sir Francis Chantrey, inscribed and
dated 1832
Given by Mrs George Jones, 1871
See Collections: Preliminary
drawings for busts and statues by
Sir Francis Chantrey, **316a(1-202)**

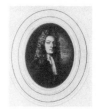

690 Chalk, irregular oval
69.2 x 60.7 ($27\frac{1}{4}$ x $23\frac{7}{8}$)
James Rannie Swinton, signed and
dated 1848
Bequeathed by the sitter's
daughter, Miss Martha Somerville,
1883

Ormond

SOMERVILLE, William
(1675-1742) Poet

1873 *Identity uncertain*
Pencil on vellum, oval 11.1 x 8.6
($4\frac{3}{8}$ x $3\frac{3}{8}$)
George White, signed and dated
1709
Given by Alfred A. de Pass, 1920

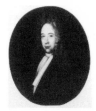

1308 Canvas, oval 75.6 x 63.5
(29¾ x 25)
Unknown artist
Given by Mrs Charles Pigott, 1902

Kerslake

SOMERVILLE, William
(1771-1860) Physician

316a(112) Pencil 51.1 x 34.3
($20\frac{1}{8}$ x 13½)
Sir Francis Chantrey, inscribed

and

Continued overleaf

316a(113) Pencil 50.8 x 34
(20 x 13⅜)
Sir Francis Chantrey, inscribed
Given by Mrs George Jones, 1871
See Collections: Preliminary
drawings for busts and statues by
Sir Francis Chantrey, **316a(1-202)**

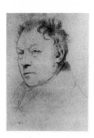

SOPHIA, Princess, Electress of
Hanover (1630-1714)
Mother of George I; granddaughter
of James I

4520 Marble bust 73.7 (29) high
Unknown artist, incised *F.M.R.*
and dated 1648
Purchased, 1967

SOPHIA DOROTHEA, Queen of
Prussia (1685-1757)
Daughter of George I

489 Copper, oval 15.9 x 14
(6¼ x 5½)
After Johann Leonhard
Hirschmann (c.1706)
Purchased, 1877

Kerslake

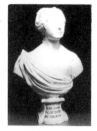

SORLEY, Charles Hamilton
(1895-1915) Poet

5012 Chalk 46 x 35.2
(18⅛ x 13⅞)
Cecil Jameson, signed and dated
1916
Given by the sitter's sister, Mrs J.L.
Bickersteth, 1974

SOTHEBY, William (1757-1833)
Poet and classicist

3955 Chalk on canvas, feigned
oval 66 x 54.6 (26 x 21½)
Sir Thomas Lawrence, c.1807
Purchased, 1955

SOUL, Joseph
Slavery abolitionist

599 *See Groups:* The Anti-
Slavery Society Convention, 1840,
by Benjamin Robert Haydon

SOUTH, Sir James (1785-1867)
Astronomer

P120(20) Photograph: albumen
print, arched top 19.7 x 14.6
(7¾ x 5¾)
Maull & Polyblank, inscribed on
mount, 1855
Purchased, 1979
See Collections: Literary and
Scientific Men, 1855, by Maull &
Polyblank, **P120(1-54)**

SOUTHAMPTON, Henry
Wriothesley, 3rd Earl of
(1573-1624) Patron of Shakespeare

L114 Canvas 204.5 x 121.9
(80½ x 48)
Unknown artist, c.1600
Lent by the Duke of Portland,
1964. *Montacute*

52 Canvas, feigned oval
88.9 x 68.6 (35 x 27)
After Daniel Mytens, inscribed
Purchased, 1858

Strong

SOUTHAMPTON, Elizabeth
(Vernon), Countess of
(1572?-1648?)
Wife of 3rd Earl of Southampton

570 Panel 73.3 x 52.1 (28⅞ x 20½)
Unknown artist, c.1620
Transferred from BM, 1879.
Montacute

Strong

SOUTHAMPTON, Thomas
Wriothesley, 4th Earl of (1608-67)
Lord High Treasurer

681 Canvas 71.8 x 58.4 (28¼ x 23)
After Sir Peter Lely, inscribed
(c.1661)
Purchased, 1883

4360 Silver medal 4.1 (1⅝)
diameter
Thomas Simon, inscribed and dated
1664
Purchased, 1964

Piper

SOUTHCOTT, Joanna (1750-1814)
Religious fanatic

1402 Pencil 22.9 x 18.4 (9 x 7¼)
William Sharp, eng 1812
Purchased, 1905

SOUTHEY, Reginald (1835-99)
Physician; nephew of Robert
Southey

P7(23) *See Collections*: Lewis
Carroll at Christ Church, by Charles
Lutwidge Dodgson, **P7(1-37)**

SOUTHEY, Robert (1774-1843)
Poet Laureate

193 Canvas 54.6 x 44.5
(21½ x 17½)
Peter Vandyke, 1795
Purchased, 1865

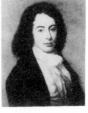

451 Pencil and water-colour
17.1 x 14.6 (6¾ x 5¾)
Robert Hancock, 1796
Purchased, 1877

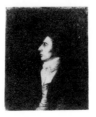

119 Pencil, chalk and wash
28.2 x 22.5 (11⅛ x 8⅞)
Henry Edridge, signed and dated
1804
Purchased, 1861

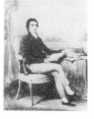

4071 Pencil 19.1 x 16.2 (7½ x 6⅜)
Dionysius Aguirre after Thomas
Phillips, signed and inscribed
(1815)
Given by A.C. Sewter, 1958

4028 Miniature on ivory
13.6 x 10.2 (5⅜ x 4)
Edward Nash, 1820
Bequeathed by the sitter's great-
granddaughter, Mrs E.A. Boult,
1957

3956 Marble bust 76.2 (30) high
Sir Francis Chantrey, incised and
dated 1832
Purchased, 1955

2681 Wax medallion 8.3 (3¼)
diameter
Edward William Wyon, 1835
Given by Maurice Buxton Forman,
1934

841 Marble bust 78.7 (31) high
John Graham Lough, incised and
dated 1845
Bequeathed by the sitter's niece,
Miss Emma Southey, 1890

SOUTHWELL, Edward, 18th Baron
de Clifford *See* DE CLIFFORD

SOUTHWELL, Sir Richard
(1504-64) Courtier and official

4912 Panel 45.7 x 35.6 (18 x 14)
After Hans Holbein, inscribed
(1536)
Purchased, 1972

SOYER, Alexis Benoit (1809-58)
Cook, and writer of cookery books

2939A *See Groups:* Study for
Florence Nightingale at Scutari,
by Jerry Barrett

4305 *See Groups:* Sketch for
Florence Nightingale at Scutari,
by Jerry Barrett

SPALDING, Jack
Ex-lancer; gambler

4026(51) *See Collections:*
Drawings of Men about Town,
1832-48, by Alfred, Count D'Orsay,
4026(1-61)

SPARKE, Bowyer Edward
(c.1760-1836) Bishop of Ely

2662(12) *See Collections:* Book
of sketches, mainly for The Trial of
Queen Caroline, 1820, by Sir
George Hayter, **2662(1-38)**

999 *See Groups:* The Trial of
Queen Caroline, 1820, by Sir
George Hayter

SPEARS, Sir Edward (1886-1974)
Soldier and politician

5099 Canvas 60.7 x 50.5
($23\frac{7}{8}$ x $19\frac{7}{8}$)
Mary Borden (Lady Spears)
Purchased, 1976

SPEDDING, James (1808-81)
Editor of the works of Francis
Bacon

2059 Chalk 50.2 x 32.1
($19\frac{3}{4}$ x $12\frac{5}{8}$)
George Frederic Watts, c.1853
Given by the sitter's niece, Miss
Isabel Spedding, 1924

P18(10) Photograph: albumen
print 28.6 x 21 ($11\frac{1}{4}$ x $8\frac{1}{4}$)
Julia Margaret Cameron, May 1864
Purchased with help from public
appeal, 1975
See Collections: The Herschel
Album, by Julia Margaret Cameron,
P18(1-92b)

Ormond

SPEED, John (1552?-1629)
Historian and cartographer

571 *See Unknown Sitters I*

Strong

SPEKE, John Hanning (1827-64)
African explorer; discovered source
of the Nile

1739 Plaster cast of bust 81.9
(32¼) high
Louis Gardie, incised and dated
1864
Given by Alfred Jones, 1914

Ormond

SPELMAN, Sir Henry (1564?-1641)
Historian and philologist

962 Canvas 75.6 x 55.2
(29¾ x 21¾)
After Cornelius Johnson (1628?)
Purchased, 1894

Piper

SPENCER, George Spencer, 2nd
Earl (1758-1834)
First Lord of the Admiralty

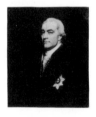

1487 Canvas, feigned oval
73.7 x 61 (29 x 24)
John Singleton Copley, c.1800
Purchased, 1908

316a(116) Pencil 45.4 x 32.1
($17\frac{7}{8}$ x $12\frac{5}{8}$)
Sir Francis Chantrey, inscribed
Given by Mrs George Jones, 1871
See Collections: Preliminary
drawings for busts and statues by
Sir Francis Chantrey, **316a(1-202)**

SPENCER, John Spencer, 3rd Earl
(1782-1845) Whig statesman

54 *See Groups:* The House of Com-
mons, 1833, by Sir George Hayter

1318 Chalk 44.5 x 34.3
(17½ x 13½)
Charles Turner
Purchased, 1902

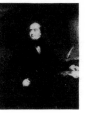

SPENCER, Frederick Spencer,
4th Earl (1798-1857)
MP for Midhurst

54 *See Groups:* The House of Commons, 1833, by Sir George Hayter

SPENCER, John Spencer, 5th Earl
(1835-1910) Viceroy of Ireland

1833 *See Groups:* Private View of
the Old Masters Exhibition, Royal
Academy, 1888, by Henry Jamyn
Brooks

2874 Chalk and pencil 51.8 x 38.4
(20$\frac{3}{8}$ x 15$\frac{1}{8}$)
Sir Francis Carruthers Gould,
signed with initials
Purchased, 1936
See Collections: Caricatures of
Politicians, by Sir Francis
Carruthers Gould, **2826-74**

2346 *See Collections:*
Miscellaneous drawings . . . by
Sydney Prior Hall, **2282-2348** and
2370-90

3412, 3608 *See Collections:*
Prominent Men, c.1880-c.1910, by
Harry Furniss, **3337-3535** and
3554-3620

SPENCER, Charlotte, Countess
(1835-1903)
Wife of 5th Earl Spencer

1833 *See Groups:* Private View of
the Old Masters Exhibition, Royal
Academy, 1888, by Henry Jamyn
Brooks

SPENCER, Charles Robert Spencer,
6th Earl (1857-1922) Politician

5256 *See Groups:* The Lobby of
the House of Commons, 1886, by
Liberio Prosperi

SPENCER, Lord Robert (d.1831)
Third son of 3rd Duke of
Marlborough

2076 *See Groups:* Whig Statesmen
and their Friends, c.1810, by
William Lane

SPENCER, Herbert (1820-1903)
Philosopher

1358 Canvas 116.8 x 95.3
(46 x 37½)
John Bagnold Burgess, 1872
Bequeathed by the sitter, 1904

2601 Water-colour 30.5 x 20
(12 x 7$\frac{7}{8}$)
Sir Francis Carruthers Gould,
signed *CG*
(*VF* 26 April 1879)
Purchased, 1933

1359 Marble bust 71.1 (28) high
Sir Joseph Edgar Boehm, incised,
c.1884
Bequeathed by the sitter, 1904

4092 Canvas 44.5 x 56.5
(17½ x 22¼)
John McLure Hamilton, signed,
c.1895
Given by Messrs James Bourlet,
1959

3609 *See Collections:* Prominent
Men, c.1880-c.1910, by Harry
Furniss, **3337-3535** and **3554-3620**

SPENCER, Sir Stanley (1891-1959)
Painter

4306 Pencil 35.6 x 22.9 (14 x 9)
Self-portrait, signed and dated 1919
Bequeathed by Wilfred Ariel Evill,
1963

Continued overleaf

4527 Canvas 50.8 x 40.6 (20 x 16)
Henry Lamb, signed and dated
1928
Purchased, 1967

SPENCER-CHURCHILL,
Clementine Ogilvy Spencer-
Churchill, Baroness (1885-1977)
Society beauty and hostess; wife of
Sir Winston Churchill

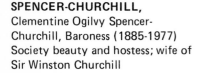

5184 With her daughter, Sarah
Canvas 25.1 x 35.3 ($9\frac{7}{8}$ x $13\frac{7}{8}$)
Sir John Lavery, c.1915
Purchased, 1978

SPENCER-CHURCHILL, Charles,
9th Duke of Marlborough
See MARLBOROUGH

SPENCER-CHURCHILL, George,
6th Duke of Marlborough
See MARLBOROUGH

SPENDER, Stephen (b.1909)
Poet and critic

4529(336-9) *See Collections:*
Working drawings by Sir David
Low, **4529(1-401)**

SPIELMANN, Marion Harry
(1858-1948) Art historian

2820 *See Groups:* The Royal
Academy Conversazione, 1891, by
G.Grenville Manton

4352 Canvas 61 x 50.8 (24 x 20)
John Henry Frederick Bacon, 1904
Given by wish of the sitter's son,
Percy Edwin Spielmann, 1964

3047 *See Groups:* Group including
Marion Harry Spielmann, 1907, by
John Henry Amschewitz

3516 *See Collections:* Prominent
Men, c.1880-c.1910, by Harry
Furniss, **3337-3535** and **3554-3620**

SPIERS, Robert Cunningham
Graham (1797-1847)

P6(8,139) *See Collections:* The
Hill and Adamson Albums, 1843-8,
by David Octavius Hill and Robert
Adamson, **P6(1-258)**

SPINETO, Marchese di
(c.1774-1849) Interpreter

1695(i) *See Collections:* Sketches
for The Trial of Queen Caroline,
1820, by Sir George Hayter,
1695(a-x)

999 *See Groups:* The Trial of
Queen Caroline, 1820, by Sir
George Hayter

SPODE, Josiah, I (1733-97)
Potter

4586 Miniature on ivory, oval
7.6 x 6 (3 x $2\frac{3}{8}$)
Unknown artist
Purchased, 1967

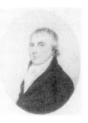

SPODE, Josiah, II (1754-1827)
Potter to George III; son of Josiah
Spode I

4587 Miniature on ivory, oval
7.6 x 6.4 (3 x 2½)
Unknown artist
Purchased, 1967

SPOONER, William Archibald
(1844-1930)
Warden of New College, Oxford;
originator of 'Spoonerism'

2377 *See Collections:*
Miscellaneous drawings . . . by
Sydney Prior Hall, **2282-2348**
and **2370-90**

SPRING-RICE, Thomas, 1st Baron
Monteagle *See* MONTEAGLE

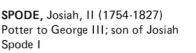

SPURGEON, Charles Haddon
(1834-92) Baptist preacher

2641 Canvas 127 x 101.6 (50 x 40)
Alexander Melville, 1885
Purchased, 1933

3517, 3610 *See Collections:*
Prominent Men, c.1880-c.1910, by
Harry Furniss, **3337-3535** and
3554-3620

SQUIRE, Sir John Collings
(1884-1958)
Poet, critic and journalist

4794 Sanguine 40 x 24.5
($15\frac{3}{4}$ x $9\frac{5}{8}$)
Sir William Rothenstein, c.1920
Purchased, 1970

4110 Canvas 62.2 x 74.9
($24\frac{1}{2}$ x $29\frac{1}{2}$)
John Mansbridge, signed, 1932-3
Purchased, 1959

STABLES, Edward
Clerk of the House of Commons

926 *See Groups:* The Committy
of the House of Commons (the
Gaols Committee), by William
Hogarth

STACEY, George (1787-1857)
Slavery abolitionist

599 *See Groups:* The Anti-Slavery
Society Convention, 1840, by
Benjamin Robert Haydon

STAFFORD, William Howard,
1st Viscount (1614-80)
Implicated in Popish plot

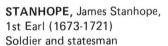

2015 Miniature on vellum, oval
5.? x 4.8 ($2\frac{1}{4}$ x $1\frac{7}{8}$)
Unknown artist, c.1670
Purchased, 1924

Piper

STAIR, John Dalrymple, 8th Earl
of (1771-1853) General

54 *See Groups:* The House of Com-
mons, 1833, by Sir George Hayter

STANDISH, Charles (1790-1863)
Politician and sportsman

4026(52) *See Collections:*
Drawings of Men about Town,
1832-48, by Alfred, Count D'Orsay,
4026(1-61)

STANFIELD, Clarkson (1783-1867)
Marine and landscape painter

2637 Canvas 76.5 x 63.5
($30\frac{1}{8}$ x 25)
Attributed to John Simpson, c.1829
Given by the sitter's granddaughter,
Mrs Harriet Bicknell, 1933

2515(40) *See Collections:*
Drawings of Prominent People,
1823-49, by William Brockedon,
2515(1-104)

Ormond

STANFORD, Sir Charles Villiers
(1852-1924) Composer

4067 Black and white chalk
37.5 x 27.3 ($14\frac{3}{4}$ x $10\frac{3}{4}$)
Sir William Rothenstein, signed,
c.1920
Purchased, 1958

STANHOPE, James Stanhope,
1st Earl (1673-1721)
Soldier and statesman

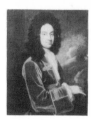

3225 Canvas 91.4 x 71.1 (36 x 28)
Sir Godfrey Kneller, signed,
c.1705-10
Kit-cat Club portrait
Given by NACF, 1945.
Beningbrough

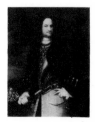

6 Canvas 111.8 x 91.4 (44 x 36)
Attributed to Johan van Diest,
c.1718(?)
Given by Earl Stanhope, c.1870

Piper

STANHOPE, Charles Stanhope,
3rd Earl (1753-1816)
Politician and scientist

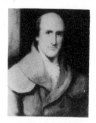

380 Chalk 59.1 x 48.9
(23¼ x 19¼)
Ozias Humphry, 1796
Given by Earl Stanhope, 1873

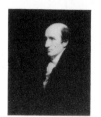

3324 Canvas 73.7 x 61.6
(29 x 24¼)
John Opie, exh 1803
Lent by Lady Teresa Agnew, 1968

1075,1075a and **b** *See Groups:*
Men of Science Living in 1807-8,
by Sir John Gilbert and others

STANHOPE, Philip Henry
Stanhope, 4th Earl (1781-1855)
Man of affairs

2789 *See Groups:* Members of
the House of Lords, c.1835,
attributed to Isaac Robert
Cruikshank

STANHOPE, Philip Stanhope,
5th Earl (1805-75) Historian and
a founder of the National Portrait
Gallery

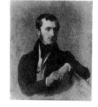

4336 (study for *Groups,* **54**)
Millboard 34.9 x 29.8 (13¾ x 11¾)
Sir George Hayter, signed, inscribed
and dated 1834
Given by wish of the sitter's great-
granddaughter, Miss Cicely
Stanhope, 1963

54 *See Groups:* The House of Com-
mons, 1833, by Sir George Hayter

342,343 *See Groups:* The Fine
Arts Commissioners, 1846, by
John Partridge

499 Marble bust 74.9 (29½) high
Henry Hugh Armstead after
Lawrence Macdonald (1854)
Given by the sitter's son, Earl
Stanhope, 1878

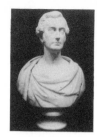

955 Plaster cast of medallion 26
(10¼) diameter
Frederick Thomas, c.1894
Given by Sir George Scharf, 1894

Ormond

STANHOPE, John Roddam Spencer
(1829-1908) Pre-Raphaelite painter

P7(15) *See Collections:* Lewis
Carroll at Christ Church, by Charles
Lutwidge Dodgson, **P7(1-37)**

STANHOPE, Lincoln (1781-1840)
Soldier; son of 3rd Earl of
Harrington

4026(53) *See Collections:*
Drawings of Men about Town,
1832-48, by Alfred, Count D'Orsay,
4026(1-61)

STANHOPE, Lovell (d.1783)
Secretary to 2nd Earl of Halifax

3328 *See Groups:* Lord Halifax
and his secretaries, attributed to
Daniel Gardner, after Hugh Douglas
Hamilton

STANHOPE, Philip Dormer,
4th Earl of Chesterfield
See CHESTERFIELD

STANHOPE, William, 1st Earl of
Harrington *See* HARRINGTON

STANLEY of Alderley, Edward
Stanley, 2nd Baron (1802-69)
Statesman

54 *See Groups:* The House of Com-
mons, 1833, by Sir George Hayter

STANLEY, Arthur Penrhyn
(1815-81) Dean of Westminster;
son of Edward Stanley

P35 *See Collections:* Prints from
two albums, 1852-60, by Charles
Lutwidge Dodgson and others,
P31-40

1536 Canvas 26 x 21.6 (10¼ x 8½)
Lowes Cato Dickinson
Purchased, 1909

4701 Chalk 67.9 x 50.8 (26¾ x 20)
Emily J. Harding, exh 1877
Given by Anthony Blunt, 1970

1072 Miniature on ivory, oval
6.7 x 6 ($2\frac{5}{8}$ x $2\frac{3}{8}$)
Unknown artist
Given by Lord Weardale, 1896

867 Plaster cast of monument in
Westminster Abbey 175.3 (69) long
Sir Joseph Edgar Boehm
Purchased, 1891

STANLEY, Edward (1779-1849)
Bishop of Norwich

4242 Canvas 76.2 x 63.5 (30 x 25)
James Green, signed and dated
1803
Purchased, 1961

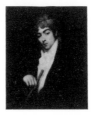

STANLEY, Edward, 14th Earl of
Derby *See* DERBY

STANLEY, Edward, 15th Earl of
Derby *See* DERBY

STANLEY, Edward, 17th Earl of
Derby *See* DERBY

STANLEY, Edward Smith,
12th Earl of Derby *See* DERBY

STANLEY, Ferdinand Charles
(1871-1935) Brigadier-General

4039(6) Water-colour and pencil
29.8 x 24.1 (11¾ x 9½)
Inglis Sheldon-Williams, signed,
inscribed, and dated by artist and
sitter, 1900
Purchased, 1957
See Collections: Boer War Officers,
1900, by Inglis Sheldon-Williams,
4039(1-7)

STANLEY, Henry, 4th Earl of
Derby *See* DERBY

STANLEY, Sir Henry Morton
(1841-1904)
Explorer and journalist

3857 Ink and wash 16.5 x 12.4
($6\frac{1}{2}$ x $4\frac{7}{8}$)
Sir Max Beerbohm, signed *Max,*
inscribed, 1897
Purchased, 1953
See Collections: Caricatures,
1897-1932, by Sir Max Beerbohm,
3851-8

STANLEY, James, 7th Earl of
Derby *See* DERBY

STANLEY, James, Lord Strange
See STRANGE

STANLEY, Thomas (1625-78)
Scholar and humanist

166 Canvas 74.9 x 62.9
(29½ x 24¾)
Gerard Soest, inscribed, c.1660
Purchased, 1863

Piper

STANTON, Arthur Henry
(1839-1913) Anglo-Catholic divine

3830 Plaster cast of bust 71.1 (28)
high
Frederick Lessore
Bequeathed by the artist, 1952

STANTON, Henry B.
Slavery abolitionist

599 *See Groups:* The Anti-Slavery
Society Convention, 1840, by
Benjamin Robert Haydon

STANYAN, Abraham (1669?-1732)
Diplomat

3226 Canvas 91.4 x 71.1 (36 x 28)
Sir Godfrey Kneller, signed in
monogram, c.1710(?)
Kit-cat Club portrait
Given by NACF, 1945.
Beningbrough

Piper

STAPLEDON, Walter de
(1261-1326) Bishop of Exeter

2781 Water-colour 36.8 x 34.6
(14½ x 13⅝)
D.J.Powell, signed and inscribed
Given by George H.Jackson, 1894

STAPLETON, Sir Philip (1603-47)
Parliamentarian

2397 Water-colour 13.8 x 11.4
(5⅜ x 4½)
Attributed to George Perfect
Harding, copy
Purchased, 1929
See Collections: Copies of early
portraits, by George Perfect
Harding and Sylvester Harding, **1492,
1492(a-c)** and **2394-2419**

STAPLYTON, Anne (Waller), Lady
(1718/19-91) Wife of Sir Miles
Staplyton, Bt

2505 Canvas 126.7 x 100.3
(49⅞ x 39½)
Attributed to Andrea Soldi
Bequeathed by Lillie Belle Randell,
1931

Kerslake

STARK, James (1794-1859)
Landscape painter

1562 Water-colour and chalk
26.7 x 21 (10½ x 8¼)
Horace Beevor Love, signed and
dated 1830
Purchased, 1910

Ormond

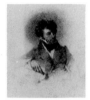

STAUNTON, Sir George Leonard,
Bt (1737-1801) Diplomat

329 *See under* George Macartney,
Earl Macartney

STAUNTON, Sir George Thomas, Bt
(1781-1859)
MP for Hampshire South

54 *See Groups:* The House of Com-
mons, 1833, by Sir George Hayter

STAVELEY, Thomas Kitchingman
(1791-1860) MP for Ripon

54 *See Groups:* The House of Com-
mons, 1833, by Sir George Hayter

STAWALL, Samson (d.1849)
Colonel

3756 *See Collections:* Studies for
The Waterloo Banquet at Apsley
House, 1836, by William Salter,
3689-3769

STEAD, William Thomas
(1849-1912) Journalist

2250,2257 *See Collections:* The
Parnell Commission, 1888-9, by
Sydney Prior Hall, **2229-72**

2288 *See Collections:*
Miscellaneous drawings . . . by
Sydney Prior Hall, **2282-2348** and
2370-90

STEANE, Edward
Slavery abolitionist

599 *See Groups:* The Anti-Slavery
Society Convention, 1840, by
Benjamin Robert Haydon

STEBBING, Henry (1687-1763)
Divine

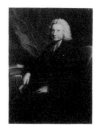

572 Canvas 127 x 99.1 (50 x 39)
Joseph Highmore, signed and dated
1757
Transferred from BM, 1879.
Beningbrough

Kerslake

STEELE, Eugene (1712-23)
Son of Sir Richard Steele

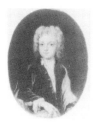

1506c Miniature on ivory, oval
8.3 x 6.4 (3¼ x 2½)
Unknown artist, c.1720
Given by George Harland Peck,
1908

Piper (under Sir Richard Steele)

STEELE, Mary (b.1713)
Daughter of Sir Richard Steele

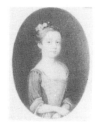

1506d Miniature on ivory, oval
8.6 x 6 (3⅜ x 2⅜)
Unknown artist, c.1720
Given by George Harland Peck,
1908

Piper (under Sir Richard Steele)

STEELE, Sir Richard (1672-1729)
Dramatist and essayist

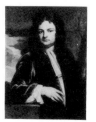

3227 Canvas 91.4 x 71.1 (36 x 28)
Sir Godfrey Kneller, signed and
dated 1711
Kit-cat Club portrait
Given by NACF, 1945

5067 Canvas 126.4 x 101.9
(49⅞ x 40⅛)
Jonathan Richardson, inscribed,
1712
Purchased, 1976

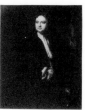

160 Canvas 74.9 x 62.2
(29½ x 24½)
Jonathan Richardson, inscribed,
1712
Purchased, 1863

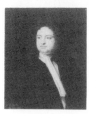

1506a Miniature on ivory, oval
8.3 x 6 (3¼ x 2⅜)
Unknown artist, c.1720
Given by George Harland Peck,
1908

Piper

STEELL, Sir John Robert (1804-91)
Sculptor

P6(52) Photograph: calotype
18.8 x 13.6 (7⅜ x 5⅜)
David Octavius Hill and Robert
Adamson, 1843-8
Given by an anonymous donor, 1973
See Collections: The Hill and
Adamson Albums, 1843-8, by
David Octavius Hill and Robert
Adamson, **P6(1-258)**

STEER, John (1780-1856)
Slavery abolitionist

599 *See Groups:* The Anti-Slavery
Society Convention, 1840, by
Benjamin Robert Haydon

STEER, Philip Wilson (1860-1942)
Painter

3116 Canvas 90.2 x 59.7
(35½ x 23½)
Walter Richard Sickert, signed,
c.1890
Bequeathed by the sitter, 1942

Continued overleaf

2556 *See Groups:* The Selecting Jury of the New English Art Club, 1909, by Sir William Orpen

3072(3a) Pencil 30.8 x 22.9 $(12\frac{1}{8}$ x 9)
Henry Tonks
Given by Charles Henry Collins Baker, 1937
See Collections: Sketches and studies by Henry Tonks, **3072(1-18)**

3072(1,6) *See Collections:* Sketches and studies by Henry Tonks, **3072(1-18)**

5088 Pencil 15.9 x 14.9 $(6\frac{1}{4}$ x $5\frac{7}{8})$
Henry Tonks, signed
Bequeathed by William George Constable, 1976

2663 *See Groups:* Some Members of the New English Art Club, by Donald Graeme MacLaren

4643 Chalk 36.8 x 31.1 $(14\frac{1}{2}$ x $12\frac{1}{4})$
Sir William Rothenstein, signed with initials and dated 1928
Given by the Rothenstein Memorial Trust, 1968

STEEVENS, George (1736-1800)
Commentator on Shakespeare

1160 Pencil 29.2 x 22.9 $(11\frac{1}{2}$ x 9)
George Dance, signed and dated 1793
Purchased, 1898

STEIN, Sir Aurel (1862-1943)
Scholar, explorer and archaeologist

3881 Chalk 40 x 28.6 $(15\frac{3}{4}$ x $11\frac{1}{4})$
Sir William Rothenstein, signed and dated 1920
Given by the Rothenstein Memorial Trust, 1963

STEINTZ, Wilhelm (1836-1900)
Austrian chess player

3060 *See Groups:* Chess players, by A. Rosenbaum

STEPHEN (1097?-1154)
Reigned 1135-54

4980(3) *See Collections:* Set of 16 early English Kings and Queens formerly at Hornby Castle, Yorkshire, **4980(1-16)**

STEPHEN, Sir James (1789-1859)
Historian and colonial under-secretary

1029 Marble bust 74 $(29\frac{1}{8})$ high
Carlo, Baron Marochetti, 1858
Given by the sitter's grandson, Sir Herbert Stephen, Bt, 1896

Ormond

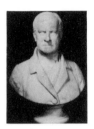

STEPHEN, Sir James Fitzjames, Bt (1829-94)
Judge; son of Sir James Stephen

3076 Coloured chalk 61 x 45.7 (24 x 18)
George Frederic Watts, c.1855
Given by the sitter's son, Sir Herbert Stephen, Bt, 1939

STEPHEN, Julia (née Jackson), Lady (1846-95) Wife of Sir Leslie Stephen and mother of Virginia Woolf and Vanessa Bell

P18(90) Photograph: albumen print 32.7 x 26.3 $(12\frac{7}{8}$ x $10\frac{3}{8})$
Julia Margaret Cameron, April 1867
Purchased with help from public appeal, 1975
See Collections: The Herschel Album, by Julia Margaret Cameron, **P18(1-92b)**

P18(5,24,31,59,67,68,79)
See Collections: The Herschel Album, by Julia Margaret Cameron, **P18(1-92b)**

STEPHEN, Sir Leslie (1832-1904)
Writer, philosopher and
mountaineer; first editor of the
Dictionary of National Biography

2098 Chalk 17.8 x 12.7 (7 x 5)
Sir William Rothenstein, c.1903
Purchased, 1925

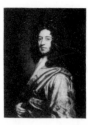

STEPHENS, Frederic George
(1828-1907) Pre-Raphaelite
painter and art critic

2363 Pencil 21.6 x 15.2 (8½ x 6)
Sir John Everett Millais, signed,
inscribed and dated 1853
Given by the sitter's son, Holman
Stephens, 1929

STEPHENS, James (1882-1950)
Poet and novelist

3989 Lithograph 28.6 x 22.2
(11¼ x 8¾)
Mary Duncan, signed, c.1915
Given by the artist, 1956

STEPHENSON, George (1781-1848)
Inventor of the railway-engine

410 Canvas 111.8 x 87 (44 x 34¼)
Henry William Pickersgill
Purchased, 1875

261 Marble bust 75.2 (29⅝) high
Joseph Pitts, incised and dated 1846
Purchased, 1868

STEPHENSON, Robert (1803-59)
Civil engineer; son of George
Stephenson

5079 Marble bust 77.5 (30½) high
Charles H. Mabey after Edward
William Wyon, incised and dated
1897 (c.1856)
Purchased, 1976

STEPNEY, George (1663-1707)
Diplomat

3228 Canvas 91.4 x 71.1 (36 x 28)
Sir Godfrey Kneller, signed, c.1705
Kit-cat Club portrait
Given by NACF, 1945

Piper

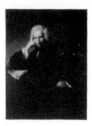

STERNE, Laurence (1713-68)
Writer and divine; author of
Tristram Shandy

5019 Canvas 127.3 x 100.3
(50⅛ x 39½)
Sir Joshua Reynolds, signed,
inscribed and dated 1760
Purchased with help from an
anonymous benefactor, NACF,
Pilgrim Trust, H.M.Government,
and the results of a public appeal,
1975

2785 Water-colour 26.3 x 17.5
(10⅜ x 6⅞)
Louis Carrogis ('Louis de
Carmontelle')?, c.1762
Purchased, 1935

1891 Marble bust 39.4 (15½) high
Joseph Nollekens, incised, c.1766
Given by G.B.Croft-Lyons, 1920

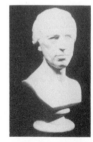

2022 Canvas 43.5 x 34.6
(17⅛ x 13⅝)
Unknown artist, inscribed
Purchased, 1924. *Beningbrough*

Kerslake

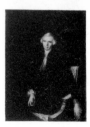

STERRY, Henry (1803-69)
Slavery abolitionist

599 *See Groups:* The Anti-Slavery
Society Convention, 1840, by
Benjamin Robert Haydon

STERRY, Richard (1785-1865)
Slavery abolitionist

599 *See Groups:* The Anti-Slavery
Society Convention, 1840, by
Benjamin Robert Haydon

STEUART, Robert (c.1806-42)
MP for Haddington

54 *See Groups:* The House of Com-
mons, 1833, by Sir George Hayter

STEVENS, Alfred (1818-75)
Sculptor and designer

1526 Pencil 28.9 x 22.9 (11$\frac{3}{8}$ x 9)
Self-portrait, c.1835-40
Purchased, 1908

1413 Plaster cast of death-mask
37.5 (14¾) long
Reuben Townroe, incised in
monogram, 1875
Purchased, 1905

Ormond

STEVENS, John (1793-1868)
Sculptor

P6(93) Photograph: calotype
19.4 x 14 (7$\frac{5}{8}$ x 5½)
David Octavius Hill and Robert
Adamson, 1843-8
Given by an anonymous donor, 1973
See Collections: The Hill and
Adamson Albums, 1843-8, by
David Octavius Hill and Robert
Adamson, **P6(1-258)**

P6(57) *See Collections:* The Hill
and Adamson Albums, 1843-8, by
David Octavius Hill and Robert
Adamson, **P6(1-258)**

STEVENSON, Joseph (1806-95)
Historian and archivist

982 Plaster cast of medallion
14 (5½) diameter
Charles Matthew, incised
Given by Everard Green, 1895

STEVENSON, Robert Louis
(1850-94) Novelist and essayist

1028 Canvas 71.1 x 53.3 (28 x 21)
Sir William Blake Richmond, 1887
Given by the artist, 1896

2349 Bronze relief 43.8 x 43.2
(17¼ x 17)
Augustus St Gaudens, inscribed
and dated 1887
Given by Lady Gosse and family,
1928

1184 Pencil 25.4 x 21.6 (10 x 8½)
Percy F. Seaton Spence, inscribed
and dated 1893
Purchased, 1899

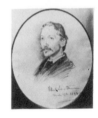

2454 Bronze cast of bust 47
(18½) high
Allen Hutchinson, incised and
dated 1893
Given by Mrs How, 1930

3518 Pen and ink 9.9 x 19.4
(3$\frac{7}{8}$ x 7$\frac{5}{8}$)
Harry Furniss, signed with initials,
inscribed
Purchased, 1947
See Collections: Prominent Men,
c.1880-c.1910, by Harry Furniss,
3337-3535 and 3554-3620

2687 *See Unknown Sitters IV*

STEWARD, Richard (1593?-1651)
Dean designate of St Paul's
Cathedral and Westminster

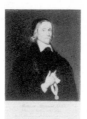

2415 Water-colour 12.3 x 10.5
($4\frac{7}{8}$ x $4\frac{1}{8}$)
George Perfect Harding after
painting attributed to Cornelius
Neve, signed, inscribed and dated
1822
Purchased, 1929
See Collections: Copies of early
portraits, by George Perfect Harding
and Sylvester Harding, **1492,
1492(a-c)** and **2394-2419**

STEWART, Alan, 10th Earl of
Galloway *See* GALLOWAY

STEWART, Alexander (1830-72)
Whaling officer

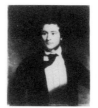

1220 Canvas 38.1 x 32.4
(15 x 12¾)
Stephen Pearce, exh 1854
Bequeathed by John Barrow, 1899
See Collections: Arctic Explorers,
1850-86, by Stephen Pearce,
905-24 and **1209-27**

Ormond

STEWART (afterwards Vane-),
Charles William, 3rd Marquess of
Londonderry
See LONDONDERRY

STEWART, Donald

P22(10,27) *See Collections:* The
Balmoral Album, 1843-68, by
George Washington Wilson, W. & D.
Downey, and Henry John Whitlock,
P22(1-27)

STEWART, Mrs Donald

P22(26) *See Collections:* The
Balmoral Album, 1854-68, by
George Washington Wilson, W. & D.
Downey, and Henry John Whitlock,
P22(1-27)

STEWART, Sir Donald Martin, Bt
(1824-1900) Field-Marshal

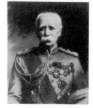

1622 Canvas 73.7 x 61 (29 x 24)
Frank Brooks, signed and dated
1903
Given by Donald Stewart Memorial
Fund, 1911

STEWART, Dugald (1753-1828)
Philosopher

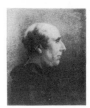

1428 Pencil and chalk 17.1 x 14
(6¾ x 5½)
John Henning, signed and dated
1811
Given by Mrs Katharine M.Lyell,
1906

STEWART, Edmund Archibald,
Earl of Moray *See* MORAY

STEWART, Frederick William
Robert, 4th Marquess of
Londonderry
See LONDONDERRY

STEWART, George, 8th Earl of
Galloway *See* GALLOWAY

STEWART, Robert, 2nd Marquess
of Londonderry
See LONDONDERRY

STILLINGFLEET, Edward
(1635-99) Bishop of Worcester

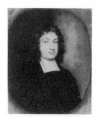

2516 Chalk 28.6 x 22.9 (11¼ x 9)
Unknown artist, c.1670
Purchased, 1931

1389 Canvas 126.4 x 101.6
(49¾ x 40)
Attributed to Mary Beale, inscribed,
c.1690
Purchased, 1904

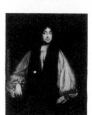

Piper

STIRLING-MAXWELL, Caroline,
Lady (m.1st G.C.Norton) (1808-77)
Novelist and poet

4918 *See Collections:* Caricatures
of Prominent People, c.1832-5, by
Sir Edwin Landseer, **4914-22**

1916 *See Groups:* Samuel Rogers,
Mrs Norton and Mrs Phipps, c.1845,
by Frank Stone

729 Plaster cast of bust 54.9
(21⅝) high
Francis John Williamson, incised
and dated 1873
Given by the artist, 1884

Ormond

STIRLING-MAXWELL, Sir William,
Bt (1818-78) Historian,
connoissseur and collector

728 Plaster cast of bust 57.2 (22½)
high
Francis John Williamson, incised
and dated 1873
Given by the artist, 1884

Ormond

STODDART, Charles (1806-42)
Soldier and diplomat

2515(74) Black and red chalk
36.5 x 26.7 (14⅜ x 10½)
William Brockedon, dated 1835
Lent by NG, 1959
See Collections: Drawings of
Prominent People, 1823-49, by
William Brockedon, **2515(1-104)**

Ormond

STODDART, Stephen (1763-1812)
Major; father of Charles Stoddart

931 Miniature on ivory, oval
7 x 5.7 (2¾ x 2¼)
Unknown artist
Bequeathed by the sitter's daughter,
Miss Frances Agnes Stoddart, 1892

STOKES, Edward (1823-63)
Divine

P7(6) *See Collections:* Lewis
Carroll at Christ Church, by Charles
Lutwidge Dodgson, **P7(1-37)**

STOKES, Sir George Gabriel, Bt
(1819-1903)
Mathematician and physicist

2758 Bronze medallion 24.8
(9¾) diameter
George William de Saulles,
inscribed, 1899
Given by Arthur Hutchinson, 1935

STONE, Sir John Benjamin
(1838-1914)
Politician and photographer

2985 Water-colour 36.2 x 23.2
(14¼ x 9⅛)
Sir Leslie Ward, signed *Spy*
(*VF* 20 Feb 1902)
Purchased, 1938

STONE, Marcus (1840-1921)
Painter

1833 *See Groups:* Private View of
the Old Masters Exhibition, Royal
Academy, 1888, by Henry Jamyn
Brooks

2820 *See Groups:* The Royal
Academy Conversazione, 1891, by
G.Grenville Manton

STONE, William (1857-1958)
'The Squire of Piccadilly'

4095(10) Pen and ink 38.7 x 31.8
(15¼ x 12½)
Harry Furniss, signed with initials
Purchased, 1959
See Collections: The Garrick
Gallery of Caricatures, 1905, by
Harry Furniss, **4095(1-11)**

STOPES, Marie Carmichael
(1880-1959) Palaeobotanist;
pioneer and advocate of birth
control

4529(340,341) *See Collections:*
Working drawings by Sir David
Low, **4529(1-401)**

4111 Canvas 72.4 x 85.7
(28½ x 33¾)
Sir Gerald Kelly, signed and
dated 1953
Bequeathed by the sitter, 1959

STOPFORD, Sir Robert
(1768-1847) Admiral

1774 Oil on metal 22.2 x 15.9
(8¾ x 6¼)
Unknown artist, dated 1840
Purchased, 1916

STOREY, George Adolphus
(1834-1919) Painter

3519,3520 *See Collections:*
Prominent Men, c.1880-c.1910, by
Harry Furniss, **3337-3535** and
3554-3620

STORKS, Sir Henry Knight
(1811-74) Lieutenant-General

2939A *See Groups:* Study for
Florence Nightingale at Scutari, by
Jerry Barrett

4305 *See Groups:* Sketch for
Florence Nightingale at Scutari, by
Jerry Barrett

2602 Water-colour 29.8 x 17.8
(11¾ x 7)
Carlo Pellegrini, signed *Ape*
(*VF* 24 Dec 1870)
Purchased, 1933

STOTHARD, Thomas (1755-1834)
Painter and illustrator

1096 Pencil 17.8 x 17.8 (7 x 7)
John Flaxman, c.1800
Given by Miss Mary Sharpe, 1897

2 Canvas 74.9 x 62.2 (29½ x 24½)
James Green, signed and dated 1830
Given by J.H.Anderson, 1857

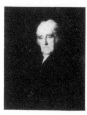

STOVEL, Charles
Baptist minister and slavery
abolitionist

599 *See Groups:* The Anti-Slavery
Society Convention, 1840, by
Benjamin Robert Haydon

STOWELL, William Scott, Baron
(1745-1836) Judge

1156 Pencil 25.4 x 19.1 (10 x 7½)
George Dance, signed and dated
1803
Purchased, 1898

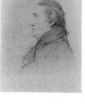

999 *See Groups:* The Trial of
Queen Caroline, 1820, by Sir
George Hayter

125 Marble bust 73.7 (29) high
William Behnes, incised and dated
1824
Purchased, 1861

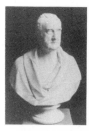

STRACHEY, Giles Lytton
(1880-1932) Critic and biographer;
son of Sir Richard Strachey

4595 Pastel 53.3 x 43.2 (21 x 17)
Simon Bussy, 1904
Given by Mrs A.S.Strachey, 1967

Continued overleaf

2215 Chalk 40.6 x 16.5 (16 x 6½)
Nina Hamnett, signed with initials
Given by Lady Gosse and family,
1928

STRACHEY, John (1901-63)
Statesman; son of John St Loe
Strachey

4529(342,343,343a,344)
See Collections: Working drawings
by Sir David Low, **4529(1-401)**

4567 Chalk 52.7 x 35.9
(20¾ x 14⅛)
Sir David Low, signed and inscribed
Purchased, 1967

STRACHEY, John St Loe
(1860-1927) Journalist

4795 Sanguine, black and white
chalk 40.3 x 28.9 (15⅞ x 11⅜)
Sir William Rothenstein, signed
with initials, inscribed and dated
1924
Purchased, 1970

STRACHEY, Sir Richard
(1817-1908) Lieutenant-General;
scientist and engineer

4596 Pastel 45.7 x 50.8 (18 x 20)
Simon Bussy
Given by Mrs A.S.Strachey, 1967

STRADBROKE, John Edward
Cornwallis Rous, 2nd Earl of
(1794-1886) Soldier and politician

4744 Water-colour 30.5 x 17.8
(12 x 7)
Carlo Pellegrini, signed *Ape*
(*VF* 31 July 1875)
Purchased, 1970

STRAFFORD, Thomas Wentworth,
1st Earl of (1593-1641)
Statesman

1077 Canvas 128.3 x 101.6
(50½ x 40)
After Sir Anthony van Dyck
(c.1633)
Purchased, 1896

2960 Canvas 124.5 x 108
(49 x 42½)
After Sir Anthony van Dyck,
inscribed (c.1633)
Given by Lord Craigmyle, 1938

4531 Canvas 138.4 x 108
(54½ x 42½)
Studio of Sir Anthony van Dyck,
c.1636
Given by Sir Gyles Isham, Bt,
1967

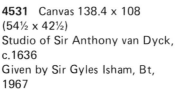

L152(9) Miniature on vellum, oval
6.4 x 5.1 (2½ x 2)
Unknown artist, signed *H*
Lent by NG (Alan Evans Bequest),
1974

Piper

STRAFFORD, John Byng, 1st
Earl of (1772-1860)
Field-Marshal and politician

54 *See Groups:* The House of Com-
mons, 1833, by Sir George Hayter

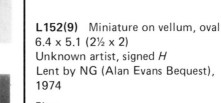

3757 *See Collections:* Studies for The Waterloo Banquet at Apsley House, 1836, by William Salter, **3689-3769**

STRAFFORD, George Stevens Byng, 2nd Earl of (1806-86) Politician

54 *See Groups:* The House Commons, 1833, by Sir George Hayter

STRAFFORD, George Henry Charles Byng, 3rd Earl of (1830-98) Politician

3272 Water-colour 30.5 x 18.1 (12 x 7$\frac{1}{8}$) Adriano Cecioni (*VF* 14 Sept 1872) Purchased, 1946

STRAHAN, William (1715-85) Printer and publisher

4202 Canvas 91.4 x 71.1 (36 x 28) Sir Joshua Reynolds, exh 1783 Purchased, 1960

STRANG, William (1859-1921) Painter and etcher

2927 Chalk 38.7 x 24.8 (15¼ x 9¾) Self-portrait, signed and dated 1902 Purchased, 1937

4533 Canvas 52.1 x 44.5 (20½ x 17½) Self-portrait, signed with initials and dated 1917 Bequeathed by his son, David Strang, 1967

STRANGE, James Stanley, Lord (1716/17-71) Son of 11th Earl of Derby

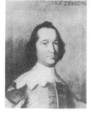

2424 Water-colour and pencil 20.3 x 15.9 (8 x 6¼) William Derby after Thomas Hudson, inscribed, reduced copy Acquired, 1929

STRANGWAYS, Arthur Henry Fox (1859-1948) Music critic

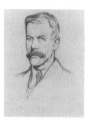

L168(5) Pencil 32.1 x 23.8 (12$\frac{5}{8}$ x 9$\frac{3}{8}$) Sir William Rothenstein, c.1916 Lent by the artist's son, Sir John Rothenstein, 1977 *See Collections:* Prominent men, 1895-1939, by Sir William Rothenstein, **L168(1-11)**

STRATFORD DE REDCLIFFE, Stratford Canning, Viscount (1786-1880) Diplomat

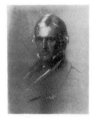

1513 Chalk 61.6 x 47.9 (24¼ x 18$\frac{7}{8}$) George Richmond, signed and dated 1853 Bequeathed by the sitter's daughter, the Hon Louisa Canning, 1908

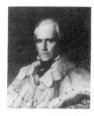

684 Panel 61 x 50.8 (24 x 20) George Frederic Watts, signed, 1856-7 Given by the artist, 1883

791 Plaster cast of bust 63.5 (25) high Sir Joseph Edgar Boehm, incised and dated 1864 Given by the executors of Miss Mary Anne Talbot, 1888

Ormond

STRATHNAIRN, Hugh Henry
Rose, Baron (1801-85)
Field-Marshal

1331 Plaster cast of bust 63.2
($24\frac{7}{8}$) high
Edward Onslow Ford, c.1895
Purchased, 1902

Ormond

STRATON, Sir Joseph (d.1841)
Major-General

3758 *See Collections:* Studies
for The Waterloo Banquet at
Apsley House, 1836, by William
Salter, **3689-3769**

STREET, Mrs
Daughter of Henry Tanworth Wells

1833 *See Groups:* Private View of
the Old Masters Exhibition, Royal
Academy, 1888, by Henry Jamyn
Brooks

STRETTON, Sempronius (d.1842)
Colonel

3759 *See Collections:* Studies for
The Waterloo Banquet at Apsley
House, 1836, by William Salter,
3689-3769

STRICKLAND, Agnes (1796-1874)
Historian

2923 Chalk 25.4 x 20.3 (10 x 8)
Charles L.Gow, signed, inscribed
and dated 1844
Given by Wilfrid Partington, 1937

403 Canvas 92.1 x 71.8
(36¼ x 28¼)
John Hayes, 1846
Bequeathed by the sitter, 1875

Ormond

STRICKLAND (later Cholmley),
Sir George, Bt (1782-1874)
MP for Yorkshire West Riding

54 *See Groups:* The House of Com-
mons, 1833, by Sir George Hayter

STRICKLAND, Walter (d.1676)
Politician

5235 Canvas 213.7 x 151.5
($84\frac{1}{8}$ x $59\frac{5}{8}$)
Pieter Nason, inscribed, 1651
Purchased, 1979

STRODE, John
Colonel; Governor of Dover Castle

3090(5) Sepia and wash
26.4 x 17.1 ($10\frac{3}{8}$ x 6¾)
F.R.Nixon (?Francis Russell Nixon)
after an unknown artist
Purchased, 1940

STRONG, Leonard Alfred George
(1896-1958) Writer

5143 Pencil and wash 31.4 x 25.1
($12\frac{3}{8}$ x $9\frac{7}{8}$)
Wyndham Lewis, signed, inscribed
and dated 1932
Given by the sitter's widow, 1977

4529(345-8) *See Collections:*
Working drawings by Sir David
Low, **4529(1-401)**

STRONG, Sandford Arthur
(1863-1904) Orientalist

3633 Pencil 15.6 x 24.5 ($6\frac{1}{8}$ x $9\frac{5}{8}$)
Sir Charles Holroyd, posthumous,
1904
Given by the sitter's sister-in-law,
Mrs C.Leigh-Smith, 1948

STRONG, Thomas Banks
(1861-1944)
Bishop of Ripon and Oxford

4805 Pencil 38.4 x 28.2
($15\frac{1}{8}$ x $11\frac{1}{8}$)
Sir William Rothenstein, 1916
Purchased, 1970

STRUTHERS, Sir John (1857-1925)
Educationalist and civil servant

3141 Canvas 114.3 x 96.5
(45 x 38)
Maurice Greiffenhagen, signed and
dated 1922
Bequeathed by the sitter's widow,
1943

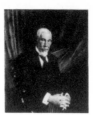

STRUTT, John, 3rd Baron
Rayleigh *See* RAYLEIGH

STRUTT, Joseph (1749-1802)
Engraver and antiquary

323 Pastel 49.5 x 43.2 (19½ x 17)
Ozias Humphry
Given by the sitter's grandson,
H.I.Strutt, 1871

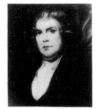

STUART, Lord Dudley Coutts
(1803-54) Advocate of Polish
independence

54 *See Groups:* The House of Com-
mons, 1833, by Sir George Hayter

STUART, Lady Arabella
(1575-1615) Cousin of James I

1723 *See Unknown Sitters I*

STUART, Charles
Slavery abolitionist from Jamaica

599 *See Groups:* The Anti-Slavery
Society Convention, 1840, by
Benjamin Robert Haydon

STUART, Charles (1810-92)
MP for Bute

54 *See Groups:* The House of Com-
mons, 1833, by Sir George Hayter

STUART, Elizabeth (1762-99)
Second wife of James Stuart

55B Miniature on ivory, oval
5.7 x 4.8 (2¼ x 1⅞)
Attributed to Philip Jean
Given by the sitter's son, James
Stuart, 1858

STUART, Frances Theresa,
Duchess of Richmond and Lennox
See RICHMOND AND LENNOX

STUART, Henry, Lord Darnley
See DARNLEY

STUART, James (1713-88)
Painter and architect

55A Miniature on ivory, oval
5.4 x 4.4 (2⅛ x 1¾)
Attributed to Philip Jean
Given by the sitter's son, James
Stuart, 1858

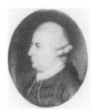

STUART, James, 1st Duke of
Richmond and 4th Duke of Lennox
See RICHMOND

STUART, John, 3rd Earl of Bute
See BUTE

STUART, Lodovick, 1st Duke of
Richmond and 2nd Duke of Lennox
See RICHMOND

STUART-WORTLEY, Charles
Stuart-Wortley, 1st Baron
(1851-1926) Politician

4627 Water-colour 32.4 x 18.4
(12¾ x 7¼)
Sir Leslie Ward, signed *Spy*
(*VF* 11 Sept 1886)
Purchased, 1968

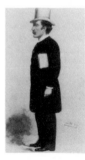

STUART-WORTLEY, James
Archibald (1805-81)
Solicitor-General

P6(23,102) *See Collections:* The
Hill and Adamson Albums, 1843-8,
by David Octavius Hill and Robert
Adamson, **P6(1-258)**

STUART-WORTLEY, Jane (née
Beilby) (d.1900) Wife of James
Archibald Stuart-Wortley

P6(102) *See Collections:* The
Hill and Adamson Albums, 1843-8,
by David Octavius Hill and Robert
Adamson, **P6(1-258)**

STUART-WORTLEY-MACKENZIE,
James, 1st Baron Wharncliffe
See WHARNCLIFFE

STUBBS, George (1724-1806)
Painter and anatomist

4575 Enamel on Wedgwood
plaque, oval 67.6 x 51.1
($26\frac{5}{8}$ x $20\frac{1}{8}$)
Self-portrait, signed and dated 1781
Purchased with help from NACF,
1967

1399 Water-colour 50.8 x 40
(10 x 15¾)
Ozias Humphry
Purchased, 1905

STUBBS, William (1825-1901)
Historian; Bishop of Chester and
Oxford

2469 Chalk 61 x 45.7 (24 x 18)
H. Aitchison, signed and dated 1884
Given by the sitter's son, Sir
Reginald Stubbs, 1930

STUKELEY, William (1687-1765)
Antiquary and physician

4266 Pencil, ink and wash
28.9 x 19.7 ($11\frac{3}{8}$ x 7¾)
Sir Godfrey Kneller, inscribed and
dated 1721
Given by Sir Alan Barlow, Bt, 1962

Kerslake

STURDEE, Sir Frederick, Bt
(1859-1925) Admiral

1913 *See Groups:* Naval Officers
of World War I, by Sir Arthur
Stockdale Cope

STURGE, John
Slavery abolitionist

599 *See Groups:* The Anti-Slavery
Society Convention, 1840, by
Benjamin Robert Haydon

STURGE, Joseph (1793-1859)
Quaker and philanthropist

599 *See Groups:* The Anti-Slavery
Society Convention, 1840, by
Benjamin Robert Haydon

STURT, Charles (1795-1869)
Explorer

3302 Canvas 141.6 x 111.1
(55¾ x 43¾)
John Michael Crossland, inscribed,
c.1853, replica
Given by the sitter's grandson,
Geoffrey C.N.Sturt, 1946

Ormond

SUCKLING, Sir John (1609-42)
Poet

448 Panel 34.3 x 28.6 (13½ x 11¼)
After Sir Anthony van Dyck
(c.1640)
Purchased, 1877

Piper

SUCKLING, Maurice (1725-78)
Comptroller of the Navy; uncle
of Nelson

2010 Canvas 125.7 x 100.3
(49½ x 39½)
Thomas Bardwell, signed, inscribed
and dated 1764
Bequeathed by Thomas Suckling,
1924

SUFFOLK, Charles Brandon, 1st
Duke of (d.1545)
Soldier and statesman

516 Panel 87.9 x 74.9
($34\frac{5}{8}$ x 29½)
Unknown artist
Purchased, 1879

Strong

SUFFOLK, Thomas Howard,
1st Baron Howard de Walden and
1st Earl of (1561-1626)
Lord High Treasurer

4572 Panel, feigned oval
77.5 x 64.8 (30½ x 25½)
Unknown artist, inscribed
Purchased, 1967. *Montacute*

Strong

SUFFOLK, Henrietta Howard,
Countess of (1681-1767)
Wife of 9th Earl of Suffolk;
mistress of George II

2451 Water-colour 20.3 x 16.5
(8 x 6½)
Attributed to John Harris after
painting attributed to Michael Dahl,
inscribed (c.1715-25)
Purchased, 1930

3891 Canvas 97.8 x 118.1
(38½ x 46½)
Attributed to Charles Jervas
Lent by Ian Hope-Morley, 1963

Kerslake

SULLIVAN, Sir Arthur (1842-1900)
Composer; collaborated with
W.S. Gilbert

1325 Canvas 115.6 x 87
(45½ x 34¼)
Sir John Everett Millais, signed in
monogram and dated 1888
Bequeathed by the sitter, 1902

SULLIVAN, Sir Edward Robert, Bt
(1826-99) Journalist and writer

3270 Water-colour 30.1 x 17.8
($11\frac{7}{8}$ x 7)
Carlo Pellegrini, signed *Ape*
(*VF* 13 June 1885)
Purchased, 1934

SUMMERSKILL, Edith
Summerskill, Baroness (1901-80)
Labour politician

4529(349-52) *See Collections:*
Working drawings by Sir David
Low, **4529(1-401)**

SUMNER, John Andrew Hamilton,
Viscount (1859-1934) Judge

2760 Canvas 76.2 x 63.5 (30 x 25)
Sir William Orpen, signed, 1919
Given by Viscount Wakefield, 1935

SUMNER, John Bird (1780-1862)
Archbishop of Canterbury

2467 Chalk 61 x 47 (24 x 18½)
George Richmond, eng 1849
Bequeathed by the sitter's grand-
daughter, Miss Elizabeth Sumner,
1930

3975 Canvas 81.3 x 65.7
($32 x 25\frac{7}{8}$)
Margaret Sarah Carpenter, c.1852
Given by Ronald Carter, husband
of the sitter's great-granddaughter,
1956

1207 Plaster cast of bust 45.1
(17¾) high
George Gammon Adams, incised
and dated 1863
Purchased, 1899

Ormond

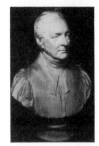

SUNDERLAND, Anne (Churchill),
Countess of (1683-1716) Beauty;
wife of 3rd Earl of Sunderland

803 Canvas 125.7 x 101.6
(49½ x 40)
Sir Godfrey Kneller, signed, c.1710
Given by the Earl of Chichester,
1888

Piper

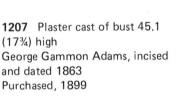

SURREY, Henry Howard, Earl of
(1517?-47) Poet

4952 Panel 48 x 30.1 (18$\frac{7}{8}$ x 11$\frac{7}{8}$)
After William Scrots, reduced copy
(1545)
Purchased, 1973

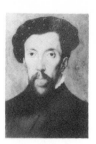

611 Panel 41.9 x 28.6 (16½ x 11¼)
After William Scrots, reduced copy
(1546)
Given by Thomas Stainton, 1880.
Montacute

Strong

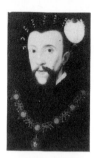

SUSSEX, Augustus Frederick,
Duke of (1773-1843)
Son of George III

648 Canvas 94.6 x 80 (37¼ x 31½)
Guy Head, 1798
Bequeathed by Lord Hatherley,
1881

316a(119) Pencil 42.9 x 34
(16$\frac{7}{8}$ x 13$\frac{3}{8}$)
Sir Francis Chantrey, inscribed
Given by Mrs George Jones, 1871

and

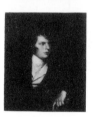

316a(120) Pencil 42.9 x 35.6
(16$\frac{7}{8}$ x 14)
Sir Francis Chantrey, inscribed
Given by Mrs George Jones, 1871
See Collections: Preliminary
drawings for busts and statues by
Sir Francis Chantrey, **316a(1-202)**

982j Bronze medal 3.8 (1½)
diameter
William Joseph Taylor after C. Henry
Weigall, inscribed
Acquired, 1895

4026(54) *See Collections:*
Drawings of Men about Town,
1832-48, by Alfred, Count D'Orsay,
4026(1-61)

1576(b) *See Unknown Sitters III*

SUSSEX, Thomas Savile, 1st Earl
of (1590?-1658?) Politician

3090(3) Water-colour 16.2 x 13.7
(6$\frac{3}{8}$ x 5$\frac{3}{8}$)
George Perfect Harding after an
unknown artist, signed
Purchased, 1940

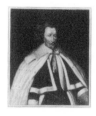

SUSSEX, Thomas Radcliffe,
3rd Earl of (1526?-83)
Soldier and courtier

105 Panel 49.2 x 37.5 (19$\frac{3}{8}$ x 14¾)
Unknown artist, after a painting of
c.1565
Purchased, 1860. *Montacute*

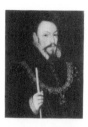

312 Panel 59.1 x 50.8 (23¼ x 20)
Unknown artist, after a painting of
c.1565
Purchased, 1870

Strong

SUTHERLAND, George Granville
Leveson-Gower, 1st Duke of
(1758-1833)
Diplomat and magnate

1298 Canvas 72.4 x 58.4
(28½ x 23)
Thomas Phillips, 1805
Given by Samuel Ashton
Thompson-Yates, 1901

1695(j) *See Collections:* Sketches
for The Trial of Queen Caroline,
1820, by Sir George Hayter,
1695(a-x)

999 *See Groups:* The Trial of
Queen Caroline, 1820, by Sir
George Hayter

794 *See Groups:* Four studies
for Patrons and Lovers of Art,
c.1826, by Pieter Christoph Wonder,
792-5

316a(117,118) *See Collections:*
Preliminary drawings for busts and
statues by Sir Francis Chantrey,
316a(1-202)

SUTHERLAND, George Granville
Sutherland-Leveson-Gower, 2nd
Duke of (1786-1861)
President of the British Institution

999 *See Groups:* The Trial of
Queen Caroline, 1820, by Sir
George Hayter

342, 343a-c *See Groups:* The Fine
Arts Commissioners, 1846, by
John Partridge

SUTHERLAND, Harriet (Howard),
Duchess of (1806-68)
Mistress of the Robes and friend
of Queen Victoria; wife of 2nd
Duke of Sutherland

808 Plaster cast of bust 69.2
(27¼) high
Matthew Noble, incised and dated
1869
Given by the artist's widow, 1888

Ormond

SUTHERLAND, Graham (1903-80)
Painter

4529(356) Pencil, two sketches
18.1 x 13 ($7\frac{1}{8}$ x $5\frac{1}{8}$)
Sir David Low
Purchased, 1967
See Collections: Working drawings
by Sir David Low, **4529(1-401)**

4529(354, 355, 357)
See Collections: Working drawings
by Sir David Low, **4529(1-401)**

SUTHERLAND, Sir Thomas
(1834-1922) Chairman of P & O
Steamship Company

2603 Water-colour 30.8 x 17.8
($12\frac{1}{8}$ x 7)
Carlo Pellegrini, signed *Ape*
(*VF* 22 Oct 1887)
Purchased, 1933

SUTRO, Alfred (1863-1933)
Playwright

3521 *See Collections:* Prominent
Men, c.1880-c.1910, by Harry
Furniss, **3337-3535** and **3554-3620**

SWAIN, Charles (1801-74)
Poet

4014 Panel 32.7 x 24.4
($12\frac{7}{8}$ x $9\frac{5}{8}$)
William Bradley, c.1833
Purchased, 1957

Ormond

SWAN, Sir Joseph Wilson
(1828-1914)
Chemist and electrical inventor

1781c Pencil 17.8 x 14.3 (7 x $5\frac{5}{8}$)
Minnie Agnes Cohen, signed,
inscribed and dated 1894
Given by the artist, 1916

SWAN, Thomas
Slavery abolitionist

599 *See Groups:* The Anti-Slavery
Society Convention, 1840, by
Benjamin Robert Haydon

SWETTENHAM, Sir Frank
(1850-1946)
Colonial administrator

4837 Canvas 170.8 x 110.5
(67¼ x 43½)
John Singer Sargent, signed and
dated 1904
Bequeathed by the sitter, 1971

SWIFT, Jonathan (1667-1745)
Satirist and divine

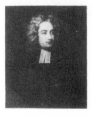

4407 Canvas, feigned oval
76.2 x 63.5 (30 x 25)
By or after Charles Jervas, 1709-10
Bequeathed by Sir Harold Williams,
1964

Continued overleaf

278 Canvas 123.2 x 97.2
(48½ x 38¼)
Charles Jervas, inscribed, c.1718
Purchased, 1869

Piper

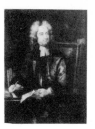

SWINBURNE, Algernon Charles
(1837-1909) Poet

1762 *See Groups:* Swinburne and
his sisters, by George Richmond

1511 Facsimile of drawing
24.4 x 18.1 ($9\frac{5}{8}$ x $7\frac{1}{8}$)
After Simeon Solomon (c.1864-5)
Bequeathed by Mrs G.C.W.Warr,
1908. *Faded; not illustrated*

1542 Canvas 64.8 x 52.1
(25½ x 20½)
George Frederic Watts, 1867
Given by wish of the artist, 1909

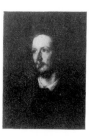

2216 Water-colour 30.5 x 17.8
(12 x 7)
Carlo Pellegrini, signed *Ape*
(*VF* 21 Nov 1874)
Given by Lady Gosse and family,
1928

3016 Sepia 37.5 x 27.3
(14¾ x 10¾)
Alfred Bryan, signed with initials
Purchased, 1939

2217 Chalk 39.4 x 29.2
(15½ x 11½)
Sir Robert Ponsonby Staples,
signed in monogram and dated 1900
Given by Lady Gosse and family,
1928

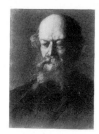

4002 Canvas 46.7 x 34
($18\frac{3}{8}$ x $13\frac{3}{8}$)
Robert M.B.Paxton, 1909
Given by the artist's daughter,
Miss Peggy Paxton, 1956

3611 *See Collections:* Prominent
Men, c.1880-c.1910, by Harry
Furniss, **3337-3535** and **3554-3620**

SWINBURNE, Alice (d.1903)
Sister of A.C.Swinburne

1762 *See Groups:* Swinburne and
his sisters, by George Richmond

SWINBURNE, Edith (d.1863)
Sister of A.C.Swinburne

1762 *See Groups:* Swinburne and
his sisters, by George Richmond

SYDENHAM, Charles Poulett-
Thomson, Baron (1799-1841)
Governor-General of Canada

54 *See Groups:* The House of Com-
mons, 1833, by Sir George Hayter

SYDENHAM, Thomas (1624-89)
Physician

3901 Canvas 76.2 x 61 (30 x 24)
Mary Beale, inscribed and dated
1688
Given by the Earl of Ilchester, 1953

Piper

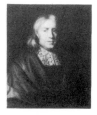

SYDNEY: Algernon, Sir Henry and
Sir Philip *See* SIDNEY

SYDNEY, John Thomas Townshend,
2nd Viscount (1764-1831)
Ranger of Hyde Park and St James's
Park

999 *See Groups:* The Trial of
Queen Caroline, 1820, by Sir
George Hayter

SYDNEY, John Robert Townshend,
3rd Viscount (1810-90) Politician

L152(38) Miniature on ivory, oval
8.6 x 7.3 ($3\frac{3}{8}$ x $2\frac{7}{8}$)
William Egley, 1836
Lent by NG (Alan Evans Bequest),
1975

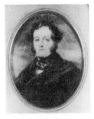

SYDNEY, Emily (Paget),
Viscountess (1810-93)
Wife of 3rd Viscount Sydney

L152(39) (Companion to no.
L152(38), 3rd Viscount Sydney
Miniature on ivory, oval 8.6 x 7.3
($3\frac{3}{8}$ x $2\frac{7}{8}$)
William Egley, signed and dated
1836
Lent by NG (Alan Evans Bequest),
1975

SYKES, Sir Tatton, Bt (1772-1863)
Landed gentleman and sportsman

3102 Millboard, feigned oval
12.1 x 9.5 (4¾ x 3¾)
Unknown artist
Purchased, 1941

Ormond

SYMINGTON, William (1763-1831)
Engineer

1075, 1075a and **b** *See Groups:*
Men of Science Living in 1807-8,
by Sir John Gilbert and others

SYMONDS, John Addington
(1840-93) Writer

1427 Chalk 55.9 x 45.7 (22 x 18)
Carlo Orsi, signed
Given by Mrs Henry J. Ross, 1906

SYMONS, Arthur William
(1865-1945)
Poet, translator, critic and editor

P104 Photograph: sepia platinum
print 19.7 x 13.3 (7¾ x 5¼)
Frederick Henry Evans, blind stamp
Purchased, 1978

4172 Tempera on canvas
61 x 50.8 (24 x 20)
Rudolf Helmut Sauter, signed and
dated 1935
Purchased, 1960

SYMONS, Mary

P22(15) *See Collections:* The
Balmoral Album, 1854-68, by
George Washington Wilson, W. & D.
Downey, and Henry John Whitlock,
P22(1-27)

SYMONS, Victoria-Alice

P22(15) *See Collections:* The
Balmoral Album, 1854-68, by
George Washington Wilson, W. & D.
Downey, and Henry John Whitlock,
P22(1-27)

SYNGE, John Millington
(1871-1909) Dramatist

4676 *See Groups:* Lady Gregory,
Sir Hugh Lane, J.M.Synge and
W.B.Yeats, by Sir William Orpen

TABRUM, Mr

1818A *See Collections:* Drawings
by John Linnell, **1812-18B**

TAGLIONI, Marie (1809-84)
Ballerina

1962(I) Water-colour 29.8 x 23.2
(11¾ x 9⅛)
Alfred Edward Chalon, inscribed,
c.1831
Purchased, 1922
See Collections: Opera singers and
others, c.1804-c.1836, by Alfred
Edward Chalon, **1962(a-I)**

Ormond

TAIT, Archibald Campbell
(1811-82)
Archbishop of Canterbury

4580 Canvas 132.1 x 107.3
(52 x 42¼)
James Sant, c.1865
Given by the sitter's great-grand-
daughter, Mrs E.H.Colville, 1967

1431 Chalk 59.7 x 47.6
(23½ x 18¾)
Lowes Cato Dickinson, signed in
monogram and dated 1867
Purchased, 1906

2352 Plaster cast of death-mask
34.3 (13½) long
Unknown artist
Given by Archbishop Lord
Davidson, 1929

859 Plaster cast of bust 81.3 (32)
high
Sir Joseph Edgar Boehm, incised
and dated 1883
Purchased, 1891

TALBOT of Hensol, Charles
Talbot, Baron (1685-1737)
Lord Chancellor

42 Canvas 140.7 x 124.5
(55⅜ x 49)
After John Vanderbank (c.1733-9)
Given by the Hon Mrs John
Chetwynd Talbot, 1858

Kerslake

TALBOT, Charles, Duke of
Shrewsbury *See* SHREWSBURY

TALBOT, Christopher Rice Mansel
(1803-90) Politician

54 *See Groups:* The House of Com-
mons, 1833, by Sir George Hayter

4026(55) *See Collections:*
Drawings of Men about Town,
1832-48, by Alfred, Count D'Orsay,
4026(1-61)

TALBOT, Edward Stuart
(1844-1934) Bishop of Winchester

2369 *See Groups:* The Education
Bill in the House of Lords, by
Sydney Prior Hall

3004 Water-colour 36.5 x 22.5
(14⅜ x 8⅞)
Sir Leslie Ward, signed *Spy*
(*VF* 21 April 1904)
Purchased, 1938

TALBOT, Elizabeth, Countess of
Shrewsbury *See* SHREWSBURY

TALBOT, George, Earl of
Shrewsbury *See* SHREWSBURY

TALBOT, Richard, Duke of
Tyrconnell *See* TYRCONNELL

TALBOT DE MALAHIDE, James
Talbot, 4th Baron (1805-83)
Politician and President of the
Archaeologicial Society

54 *See Groups:* The House of Commons, 1833, by Sir George Hayter

1834(ee) Pencil 20.3 x 12.7 (8 x 5)
Frederick Sargent, inscribed
Given by A.C.R.Carter, 1919
See Collections: Members of the
House of Lords, c.1870-80, by
Frederick Sargent, **1834(a-z** and
aa-hh)

Ormond

TALFOURD, Sir Thomas Noon
(1795-1854) Judge, poet and critic

417 Canvas 141 x 110.5
(55½ x 43½)
Henry William Pickersgill
Purchased, 1876

Ormond

TAN che-qua (fl.1769)
Chinese artist

1473, 1473a *See Groups:* The
Academicians of the Royal
Academy, 1771-2, by John Sanders
after Johan Zoffany

TANKERVILLE, Charles Augustus
Bennet, 6th Earl of (1810-99)
Man of affairs

4026(56) *See Collections:*
Drawings of Men about Town,
1832-48, by Alfred, Count D'Orsay,
4026(1-61)

TANNER, Jack (1889-1965)
President of Amalgamated
Engineering Union

4529(358) *See Collections:*
Working drawings by Sir David
Low, **4529(1-401)**

TANNER, Thomas (1718-86)
Divine

4855(12) *See Collections:* The
Townshend Album, **4855(1-73)**

TATE, George

883(21) *See Collections:* Studies
for miniatures by Sir George Hayter,
883(1-21)

TATTERSALL, Richard (1724-95)
Horse auctioneeer

2357 Ink and wash, irregular oval
15.2 x 12.4 (6 x $4\frac{7}{8}$)
Unknown artist, known as *JCB*,
1788
Purchased, 1929

TATTERSALL, Richard
(1785-1859) Horse auctioneer

4026(57) *See Collections:*
Drawings of Men about Town,
1832-48, by Alfred, Count D'Orsay,
4026(1-61)

TAUNTON, Henry Labouchere,
Baron (1798-1869) Statesman

54 *See Groups:* The House of Commons, 1833, by Sir George Hayter

TAVISTOCK, Adeline (Somers),
Marchioness of (1852-1920)

P18(34) *See Collections:* The
Herschel Album, by Julia Margaret
Cameron, **P18(1-92b)**

TAWNEY, Richard Henry
(1880-1962) Economist

4258 Pencil 46.4 x 62.2
(18¼ x 24½)
John Mansbridge, signed and
dated 1953
Given by the artist, 1962

TAYLOR, Ann (Martin)
(1757-1830) Writer; wife of
Isaac Taylor (1759-1829)

1248 *See Groups:* The Taylor
family, by Isaac Taylor

TAYLOR, Ann (Mrs Gilbert)
(1782-1866) Writer of children's
poetry; daughter of Ann and
Isaac Taylor

1248 *See Groups:* The Taylor
family, by Isaac Taylor

TAYLOR, Brook (1685-1731)
Mathematician

1920 Miniature on vellum, oval
9.8 x 7.6 ($3\frac{7}{8}$ x 3)
Louis Goupy(?), inscribed
Purchased, 1921

Kerslake

TAYLOR, Edward (1784-1863)
Musician

4217 Pencil 12.1 x 8.6 ($4\frac{3}{4}$ x $3\frac{3}{8}$)
George Harlow White, signed,
inscribed and dated 1845
Given by Ernest E.Leggatt, 1910
See Collections: Drawings, c.1845,
by George Harlow White, **4216-18**

Ormond

TAYLOR, George Watson (d.1841)
Collector

792 *See Groups:* Four studies for
Patrons and Lovers of Art, c.1826,
by Pieter Christoph Wonder, **792-5**

TAYLOR, Sir Henry (1800-86)
Poet, essayist and civil servant

2619 Marble bust 69.9 (27½) high
Lawrence Macdonald, incised and
dated 1843
Given by the sitter's granddaughter,
Lady Trowbridge, 1933

P18(7) Photograph: albumen print
27 x 21 ($10\frac{5}{8}$ x 8¼)
Julia Margaret Cameron, 1864
Purchased with help from public
appeal, 1975
See Collections: The Herschel
Album, by Julia Margaret Cameron,
P18(1-92b)

P18(21, 61, 62, 70, 71, 75, 77)
See Collections: The Herschel
Album, by Julia Margaret Cameron,
P18(1-92b)

1014 Canvas 61 x 50.8 (24 x 20)
George Frederic Watts
Given by the artist, 1895

Ormond

TAYLOR, Sir Herbert (1775-1839)
Lieutenant-General

2878 Canvas 76.2 x 63.5 (30 x 25)
Unknown artist
Given by Ernest Taylor, 1936

TAYLOR, Isaac (1759-1829)
Nonconformist divine, writer and
engraver

1248 *See Groups:* The Taylor
family, by Isaac Taylor

TAYLOR, Isaac (1787-1865)
Writer and artist; eldest son of Ann
and Isaac Taylor

1248 *See Groups:* The Taylor
family, by Isaac Taylor

884 Chalk 54.9 x 42.2
($21\frac{5}{8}$ x $16\frac{5}{8}$)
Josiah Gilbert (his nephew), signed
and dated 1862, replica
Given by the artist, 1892

Ormond

TAYLOR, Jane (1783-1824)
Writer of children's poetry;
daughter of Ann and Isaac Taylor

1248 *See Groups:* The Taylor
family, by Isaac Taylor

TAYLOR, Jefferys (1792-1853)
Writer for children; youngest son
of Ann and Isaac Taylor

1248 *See Groups:* The Taylor
family, by Isaac Taylor

TAYLOR, John (1781-1864)
Publisher and writer

1808A Wax medallion 9.2 ($3\frac{5}{8}$) diameter
Unknown artist
Given by Robert F.Norton, 1918

TAYLOR, Leonard Campbell (1874-1969) Artist

4936 Charcoal 39.4 x 29.2 (15½ x 11½)
Brenda Moore, signed, exh 1966
Given by the artist, the sitter's widow, 1973

TAYLOR, Martin (1788-1867)
Son of Ann and Isaac Taylor

1248 *See Groups:* The Taylor family, by Isaac Taylor

TAYLOR, Michael Angelo (1757-1834) Politician

54 *See Groups:* The House of Commons, 1833, by Sir George Hayter

TAYLOR, Sir Robert (1714-88)
Architect

1323 Water-colour 21 x 17.8 (8¼ x 7)
Unknown artist
Purchased, 1902

TAYLOR, Thomas (1758-1835)
Platonist

374 Canvas 33.7 x 26.7 (13¼ x 10½)
Richard Evans after Sir Thomas Lawrence, inscribed, reduced copy (exh 1812)
Given by Sir George Scharf, 1873

TAYLOR, Thomas William (1782-1854) Colonel

3760 *See Collections:* Studies for The Waterloo Banquet at Apsley House, 1836, by William Salter, **3689-3769**

TECK, Francis, Prince and Duke of (1837-1900) Major-General

4441 *See Groups:* The Duke and Duchess of Teck receiving Officers of the Indian Contingent, 1882, by Sydney Prior Hall

TECK, Mary Adelaide, Duchess of (1833-97) Mother of Queen Mary

4441 *See Groups:* The Duke and Duchess of Teck receiving Officers of the Indian Contingent, 1882, by Sydney Prior Hall

TEESDALE, Sir Christopher Charles (1833-93) Soldier

P22(2,24) *See Collections:* The Balmoral Album, 1854-68, by George Washington Wilson, W. & D. Downey, and Henry John Whitlock, **P22(1-27)**

TEIGNMOUTH, John Shore, 1st Baron (1751-1834)
Governor-General of India

4986 Wax medallion 8 ($3\frac{1}{8}$) high
Thomas R.Poole, incised and dated 1818
Purchased, 1974

5145 Water-colour 36.2 x 26.4 (14¼ x $10\frac{3}{8}$)
George Richmond, signed and dated 1832
Purchased, 1977

TELFORD, Thomas (1757-1834)
Engineer

1075,1075a and **b** *See Groups:* Men of Science Living in 1807-8, by Sir John Gilbert and others

Continued overleaf

2515(67) Pencil and chalk
35.2 x 26.4 (13$\frac{7}{8}$ x 10$\frac{3}{8}$)
William Brockedon, dated 1834
Lent by NG, 1959
See Collections: Drawings of
Prominent People, 1823-49, by
William Brockedon, **2515(1-104)**

TEMPEST, Dame Marie
(1864-1942) Actress

5191 Canvas 110.5 x 105.1
(43½ x 41$\frac{3}{8}$)
Sir William Nicholson, signed and
dated 1903
Purchased, 1978

TEMPLE, Ann (Chambers),
Countess (1709-77) Poet; wife
of 2nd Earl Temple

246 Pastel, oval 24.1 x 19.1
(9½ x 7½)
Hugh Douglas Hamilton, signed and
dated 1770
Purchased, 1867

TEMPLE, Richard Grenville-
Temple, 2nd Earl (1711-79)
Statesman

258 Canvas 125.7 x 100.3
(49½ x 39½)
William Hoare, inscribed and dated
1760
Purchased, 1868

TEMPLE, Dorothy (née Osborne),
Lady (1627-95) Letter writer;
wife of Sir William Temple

3813 Canvas 47.6 x 38.7
(18¾ x 15¼)
Gaspar Netscher, signed and dated
1671
Purchased, 1951

Piper

TEMPLE, Frederick (1821-1902)
Archbishop of Canterbury

2870, 2871 *See Collections:*
Caricatures of Politicians, by Sir
Francis Carruthers Gould, **2826-74**

3522 *See Collections:* Prominent
Men, c.1880-c.1910, by Harry
Furniss, **3337-3535** and **3554-3620**

2369 *See Groups:* The Education
Bill in the House of Lords, by
Sydney Prior Hall

TEMPLE, Henry, 3rd Viscount
Palmerston *See* PALMERSTON

TEMPLE, Richard, 1st Viscount
Cobham *See* COBHAM

TEMPLE, Sir William, Bt (1628-99)
Diplomat and writer

152 Canvas 74.9 x 63.5 (29½ x 25)
By or after Sir Peter Lely, inscribed,
c.1660
Purchased, 1862

3812 Canvas 52.1 x 43.2
(20½ x 17)
Gaspar Netscher, signed and dated
1675
Purchased, 1951

Piper

TENISON, Thomas (1636-1715)
Archbishop of Canterbury

1525 Canvas 125.7 x 100.3
(49½ x 39½)
After an engraving by Robert White
(c.1695-1702)
Purchased, 1908

Piper

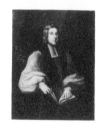

TENNANT, Charles (1768-1838)
Manufacturing chemist

1075, 1075a and **b** *See Groups:*
Men of Science Living in 1807-8,
by Sir John Gilbert and others

TENNANT, Sir Charles, Bt
(1823-1906) Manufacturer,
politician and patron of art

4745 Water-colour 31.4 x 18.1
($12\frac{3}{8}$ x $7\frac{1}{8}$)
François Verheyden
(*VF* 9 June 1883)
Purchased, 1970

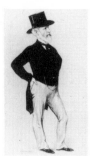

1833 *See Groups:* Private View
of the Old Masters Exhibition,
Royal Academy, 1888, by Henry
Jamyn Brooks

TENNIEL, Sir John (1820-1914)
Cartoonist and illustrator

2002 Pencil 15.2 x 12.7 (6 x 5)
Unknown artist, signed *G.J.R.* and
dated 1844
Purchased, 1936

1596 Canvas 60.3 x 47.6
(23¾ x 18¾)
Frank Holl
Bequeathed by Sir William Agnew,
Bt, 1911

2818 Pen and ink 20.3 x 15.2
(8 x 6)
Self-portrait, signed in monogram
and dated 1889
Purchased, 1936

3525-7, 3612 *See Collections:*
Prominent Men, c.1880-c.1910,
by Harry Furniss, **3337-3535** and
3554-3620

TENNYSON, Alfred Tennyson, 1st
Baron (1809-92) Poet Laureate

3940 Pencil 19.7 x 14 (7¾ x 5½)
Attributed to James Spedding,
inscribed, c.1831
Purchased, 1955

2460 Canvas 67.9 x 57.8
(26¾ x 22¾)
Samuel Laurence, c.1840
Transferred from Tate Gallery,
1957

3847 Plaster cast of medallion 26
(10¼) diameter
Thomas Woolner, incised and dated
1856
Purchased, 1953

947 Marble bust 72.4 (28½) high
Mary Grant after Thomas Woolner,
incised and dated 1893 (1857)
Given by the sitter's son, Lord
Tennyson, 1893

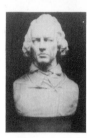

P34 Photograph: albumen print
7.6 x 5.7 (3 x 2¼)
Possibly by Cundall & Downes
Purchased, 1977
See Collections: Prints from two
albums, 1852-60, by Charles
Lutwidge Dodgson and others,
P31-40

1015 Canvas 61.3 x 51.4
($24\frac{1}{8}$ x 20¼)
George Frederic Watts, c.1863-4
Given by the artist, 1895

970 Chalk, oval 62.5 x 50.2
($24\frac{5}{8}$ x 19¾)
M. Arnault after a photograph by
John Mayall of 1864
Given by the sitter's widow, 1894

Continued overleaf

P18(73) Photograph: albumen print 25.1 x 20 (9$\frac{7}{8}$ x 7$\frac{7}{8}$)
Julia Margaret Cameron, May 1865
Purchased with help from public appeal, 1975
See Collections: The Herschel Album, by Julia Margaret Cameron, **P18(1-92b)**

P18(3, 6, 72, 74, 76, 84)
See Collections: The Herschel Album, by Julia Margaret Cameron, **P18(1-92b)**

P9 Photograph: albumen print 28.9 x 24.8 (11$\frac{3}{8}$ x 9¾)
Julia Margaret Cameron, 3 June 1869
Purchased, 1974

P124 Photograph: albumen print 30.5 x 25.4 (12 x 10)
Julia Margaret Cameron, 3 June 1869
Given by Miss Hipkins, 1930

1667 Plaster cast of bust 71.8 (28¼) high
Thomas Woolner, incised and dated 1873
Purchased, 1912

4343 Water-colour 32.7 x 24.1 (12$\frac{7}{8}$ x 9½)
William Henry Margetson after a photograph by William Barraud, signed with initials, 1891 (1882)
Given by J.B.Hodgson, 1963

1178 Plaster cast of bust 88.9 (35) high
Francis John Williamson, incised and dated 1893
Given by the artist, 1898

Ormond

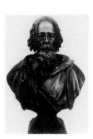

TENNYSON, Hallam Tennyson, 2nd Baron (1852-1928)
First son and biographer of Alfred, Lord Tennyson

P40 *See Collections:* Prints from two albums, 1852-60, by Charles Lutwidge Dodgson and others, **P31-40**

TENNYSON, Lionel (1854-86)
Second son of Alfred, Lord Tennyson

P18(26) *See Collections:* The Herschel Album, by Julia Margaret Cameron, **P18(1-92b)**

TENTERDEN, Charles Abbott, 1st Baron (1762-1832)
Lord Chief Justice

481 Canvas 139.7 x 109.2 (55 x 43)
John Hollins after William Owen, signed and dated 1850 (exh 1819)
Given by the Society of Judges and Serjeants-at-Law, 1877

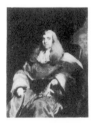

TERRY, Dame Alice Ellen (1847-1928) Actress

5048 Known as 'Choosing'
Panel 48 x 35.2 (18$\frac{7}{8}$ x 13$\frac{7}{8}$)
George Frederic Watts (her first husband), c.1864
Accepted by H.M.Treasury, in lieu of death duties, from the Estate of Kerrison Preston, and allocated, 1975

2274 Canvas 59.7 x 59.7 (23½ x 23½)
George Frederic Watts, c.1864-5
Purchased, 1928

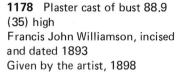

3789 Canvas 59.7 x 49.5
(23½ x 19½)
Sir Johnston Forbes-Robertson,
signed and dated 1876
Given by the artist's widow, 1951

2273 Grisaille 85.1 x 71.1
(33½ x 28)
John Singer Sargent, signed and
inscribed, 1889
Purchased, 1928

2820 *See Groups:* The Royal
Academy Conversazione, 1891, by
G.Grenville Manton

3132 Canvas 119.4 x 73.7 (47 x 29)
Walford Graham Robertson, signed,
inscribed and dated 1922
Given by the artist, 1943

3662 Chalk 60.3 x 43.5
(23¾ x 17⅛)
Cyril Roberts, signed, inscribed and
dated 1923
Given by friends of the artist, 1948

3657 Plaster cast of death-mask
22.5 (8⅞) long
Unknown artist
Given by Miss Clare Atwood, 1949

TEWSON, Sir Harold Vincent
(b.1898) Trade unionist

4529(359-61) *See Collections:*
Working drawings by Sir David
Low, **4529(1-401)**

THACKERAY, Isabella Anne
See RITCHIE

THACKERAY, William Makepeace
(1811-63) Novelist

620 Plaster cast of bust 50.8 (20)
high
Sir Joseph Edgar Boehm after
James S.Deville (1824-5)
Given by Sir Leslie Stephen, 1881

620a Electrotype of no.**620** by
Elkington & Co
Commissioned, 1881. *Not illustrated*

4210 Canvas 61 x 50.8 (24 x 20)
Frank Stone, c.1839
Bequeathed by the sitter's grand-
daughter, Mrs Richard Thackeray
Fuller, 1961

4209 Pencil 20.3 x 13.3 (8 x 5¼)
Daniel Maclise, c.1840
Bequeathed by the sitter's grand-
daughter, Mrs Richard Thackeray
Fuller, 1961

3925 Pen and ink and wash
11.7 x 9.8 (4⅝ x 3⅞)
Sir Edwin Landseer, inscribed and
dated 1857 on backboard by Sir
Francis Grant
Purchased, 1955

725 Canvas 75.6 x 62.9
(29¾ x 24¾)
Samuel Laurence, c.1864,
unfinished version (1862)
Purchased, 1884

Continued overleaf

1501 Plaster cast of death-mask 33 (13) long, and right hand 19.4 (7⅝) long
D.Brucciani & Co, 1863
Given by the makers, 1890

495 Plaster cast of bust 83.8 (33) high
Joseph Durham, incised and dated 1864
Given by H.Graves & Co, 1878

495a Terracotta cast of no.495, 76.2 (30) high
Sir Joseph Edgar Boehm after Joseph Durham (1864)
Commissioned, 1878. *Not illustrated*

1282 Plaster cast of statuette 53.3 (21) high
Sir Joseph Edgar Boehm, incised and dated 1864
Given by Mrs Charles John Wylie, 1900

738 Marble bust 43.8 (17¼) high
Nevill Northey Burnard, c.1867
Given by Sir Theodore Martin, 1885

Ormond

THANET, Sackville Tufton, 9th Earl of (1769-1825) Gambler

999 *See Groups:* The Trial of Queen Caroline, 1820, by Sir George Hayter

THELWALL, John (1764-1834) Reformer and elocutionist

2163 Canvas 74.9 x 62.2 (29½ x 24½)
Attributed to William Hazlitt
Purchased, 1927

THESIGER, Frederick, 1st Baron Chelmsford *See* CHELMSFORD

THICKNESSE, Philip (1719-92) Writer and eccentric

4192 Miniature on enamel, oval 2.8 x 2.5 (1⅛ x 1)
Nathaniel Hone, signed in monogram and dated 1757
Purchased, 1960

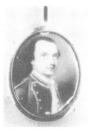

THOMAS, Arthur Goring (1850-92) Composer

1316 Chalk 17.8 x 12.7 (7 x 5)
Francis Inigo Thomas, signed with initials, inscribed and dated 1889
Given by the artist, 1902

THOMAS, Bert (Herbert Samuel) (1883-1966) Cartoonist

4510 Board 35.6 x 26 (14 x 10¼)
Unknown artist, 1913
Given by the sitter's widow, 1966

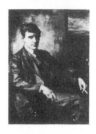

THOMAS, Dylan (1914-53) Poet

4334 Pencil 24.8 x 17.1 (9¾ x 6¾)
Mervyn Levy, signed, inscribed and dated 1938
Purchased, 1963

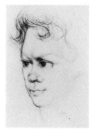

4284 Canvas 45.7 x 30.5 (18 x 12)
Rupert Shephard, signed and dated
1940
Purchased, 1962

4285 Board 35.6 x 25.4 (14 x 10)
Rupert Shephard, signed and dated
1940
Purchased, 1962

4089 Charcoal 39.4 x 29.8
(15½ x 11¾)
Michael Ayrton, signed, inscribed
and dated 1945
Purchased, 1958

4335 Pencil 42.2 x 32.1
(16⅝ x 12⅝)
Mervyn Levy, signed and dated
1950
Purchased, 1963

4274 Canvas 49.5 x 38.1 (19½ x 15)
Gordon Thomas Stuart, signed with
initials and dated 1953
Given by the artist, 1962

THOMAS, Edward (1878-1917)
Poet and critic

2892 Pencil 27.3 x 17.8 (10¾ x 7)
Ernest Henry Thomas (his brother),
signed with initials and dated 1905
Given by their brother, Julian
Thomas, 1936

4459 Pencil 29.8 x 24.1
(11¾ x 9½)
John Laviers Wheatley, 1916
Purchased, 1916

THOMAS, Hugh Owen (1834-91)
Surgeon

3167 Canvas 44.5 x 34.3
(17½ x 13½)
H.Fleury, signed, c.1890
Given by Maxwell Wimpole, 1943

THOMAS, James Havard
(1854-1921) Sculptor

2115 Pencil 33 x 25.4 (13 x 10)
James Kerr-Lawson
Purchased, 1926

THOMAS, James Henry
(1874-1949)
Trade union leader

4529(362) *See Collections:*
Working drawings by Sir David
Low, **4529(1-401)**

4564 Chalk 44.8 x 29.8
(17⅝ x 11¾)
Sir David Low, signed and inscribed,
pub 1926
Purchased, 1967

THOMAS, John (1826-1913)
Harpist

2380 *See Collections:*
Miscellaneous drawings . . . by
Sydney Prior Hall, **2282-2348**
and **2370-90**

THOMAS, Matthew Evan
(1788-1830) Architect

999 *See Groups:* The Trial of
Queen Caroline, 1820, by Sir
George Hayter

THOMAS, Sidney Gilchrist
(1850-85) Metallurgist

2615 Chalk 53.3 x 45.7 (21 x 18)
Unknown artist
Given by the sitter's sister,
Mrs L. Gilchrist Thompson, 1933

THOMAS, William (fl.1722-37)
Architect

1384 *See Groups:* A Conversation
of Virtuosis . . . at the Kings Armes
(A Club of Artists), by Gawen
Hamilton, 1735

THOMASON, Sir Edward
(1769-1849) Inventor

2515(73) Black and red chalk
34.9 x 25.1 (13¾ x 9⅞)
William Brockedon, dated 1834
Lent by NG, 1959
See Collections: Drawings of
Prominent People, 1823-49, by
William Brockedon, **2515(1-104)**

Ormond

THOMPSON, Sir Benjamin, Count
von Rumford *See* RUMFORD

THOMPSON, Francis (1859-1907)
Poet

5271 Plaster cast of life-mask
25.1 (9⅞) long
Everard Meynell
Given by Miss Alice Meynell in
memory of her parents, Everard
and Grazia Meynell, 1979

2940 Chalk 35.6 x 25.4 (14 x 10)
Neville Lytton (3rd Earl of Lytton),
1907
Lent by the artist's daughter, Lady
Anne Lytton, 1961

THOMPSON, George (1804-78)
Slavery abolitionist

599 *See Groups:* The Anti-Slavery
Society Convention, 1840, by
Benjamin Robert Haydon

3523 *See Collections:* Prominent
Men, c.1880-c.1910, by Harry
Furniss, **3337-3535** and **3554-3620**

Ormond

THOMPSON, Sir James (1835-1906)
Manager of Caledonian Railway

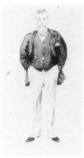

2991 Water-colour 38.1 x 26.7
(15 x 10½)
Sir Leslie Ward, signed *Spy*
(*VF* 15 Aug 1895)
Purchased, 1937

THOMPSON, Theophilus (1807-60)
Physician

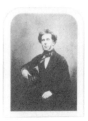

P120(32) Photograph: albumen
print, arched top 19.7 x 14.6
(7¾ x 5¾)
Maull & Polyblank, inscribed on
mount, 1855
Purchased, 1979
See Collections: Literary and
Scientific Men, 1855, by Maull &
Polyblank, **P120(1-54)**

THOMPSON, William (1811-89)
Pugilist

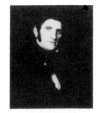

4191 Canvas 61 x 51.1 (24 x 20⅛)
Thomas Earl, signed and dated 1850
Purchased, 1960

THOMPSON, William Hepworth
(1810-86) Classical scholar

1743 Chalk 50.8 x 36.2
(20 x 14¼)
Samuel Laurence, signed and dated
1841
Purchased, 1914

Ormond

THOMSON, Christopher Birdwood Thomson, Baron (1875-1930) Soldier and politician

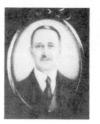

5031 Miniature on ivory, oval 5.1 x 3.8 (2 x 1½) *sight* Winifred Cécile Dongworth, signed Bequeathed by the sitter, 1975 *See Collections:* Miniatures, 1920-30, by Winifred Cécile Dongworth, **5027-36**

THOMSON of Fleet, Roy Thomson, 1st Baron (1894-1976) Newspaper magnate

4529(363-5) *See Collections:* Working drawings by Sir David Low, **4529(1-401)**

THOMSON, Alexander

P6(68) *See Collections:* The Hill and Adamson Albums, 1843-8, by David Octavius Hill and Robert Adamson, **P6(1-258)**

THOMSON, Charles Poulett, 1st Baron Sydenham *See* SYDENHAM

THOMSON, Henry (1773-1843) Painter and illustrator

3156 Water-colour 21.6 x 17.8 (8½ x 7) John Jackson, eng 1817 Purchased, 1943

THOMSON, James (1700-48) Poet

11 Canvas, feigned oval 76.2 x 63.5 (30 x 25) After John Patoun (c.1746) Given by the sitter's great-niece, Miss Elizabeth Bell, 1857

4896 Marble medallion, oval 53.3 x 45.7 (21 x 18) Unknown artist, incised, posthumous Purchased, 1972

Kerslake

THOMSON, James (1786-1849) Mathematician; father of William Thomson, Baron Kelvin

1708(b) Pencil 20 x 16.2 ($7\frac{7}{8}$ x $6\frac{3}{8}$) Agnes Gardner King after Elizabeth King (1847) Given by Agnes Gardner King, 1913 *See Collections:* Lord Kelvin and members of his family, by Elizabeth King and Agnes Gardner King, **1708(a-h)**

THOMSON, James (1822-92) Engineer; brother of William Thomson, Baron Kelvin

1707(e) Pencil 23 x 19.1 ($9\frac{1}{8}$ x 7½) Agnes Gardner King after Elizabeth King, dated 1838 Given by Agnes Gardner King, 1913 *See Collections:* Lord Kelvin and members of his family, by Elizabeth King and Agnes Gardner King, **1708(a-h)**

1708(a) *See Collections:* Lord Kelvin and members of his family, by Elizabeth King and Agnes Gardner King, **1708(a-h)**

THOMSON, Sir Joseph John (1856-1940) Physicist

4796 Pencil 35.6 x 25.1 (14 x $9\frac{7}{8}$) Sir William Rothenstein, 1915 Purchased, 1970

3256 Pencil 39.4 x 30.5 (15½ x 12) Sir Walter Thomas Monnington, 1932 Given by the Contemporary Portraits Fund, 1945

THOMSON, Thomas (1773-1852) Chemist

1075, 1075a and **b** *See Groups:* Men of Science Living in 1807-8, by Sir John Gilbert and others

THOMSON, Thomas (1817-78)
Naturalist; son of Thomas Thomson
(1773-1852)

P120(31) Photograph: albumen
print, arched top 19.7 x 14.6
(7¾ x 5¾)
Maull & Polyblank, inscribed on
mount, 1855
Purchased, 1979
See Collections: Literary and
Scientific Men, 1855, by Maull &
Polyblank, **P120(1-54)**

THOMSON, William, Baron Kelvin
See KELVIN

THORBURN, Joseph (1799-1854)
Free Church minister

P6(76) *See Collections:* The Hill
and Adamson Albums, 1843-8, by
David Octavius Hill and Robert
Adamson, **P6(1-258)**

THORNBOROUGH, John
(1551-1641) Bishop of Worcester

5234 Canvas 203.2 x 123.5
(80 x 48⅝)
Unknown artist, inscribed and
dated 163(1?)
Purchased, 1979. *Montacute*

THORNHILL, Sir James
(1675-1734) Decorative painter
and politician; father-in-law of
Hogarth

4688 Canvas, oval 45.7 x 40.6
(18 x 16)
Self-portrait, c.1707
Given by Douglas H.Gordon, 1969

926 *See Groups:* The Committy
of the House of Commons (the
Gaols Committee), by William
Hogarth

Kerslake

3962 Canvas, feigned oval
76.2 x 63.5 (30 x 25)
Jonathan Richardson, c.1730-4
Purchased, 1955

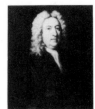

1261 *See Unknown Sitters II*

Piper

THORNTON, Sir Edward
(1817-1906) Diplomat

2742 Water-colour 30.5 x 18.1
(12 x 7⅛)
Carlo Pellegrini, signed *Ape*
(*VF* 27 March 1886)
Purchased, 1934

THORNYCROFT, Mary (1814-95)
Sculptor

4065 Bronze cast of bust 51.4
(20¼) high
Mary Alyce Thornycroft (her
daughter), c.1892
Given by the sitter's granddaughter,
Mrs Herbert Farjeon, 1958

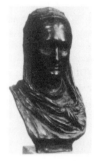

THORNYCROFT, Sir William
Hamo (1850-1925) Sculptor; son
of Mary Thornycroft

2218 Pen and ink 15.9 x 19.7
(6¼ x 7¾)
Theodore Blake Wirgman, signed
and dated 1880
Given by Lady Gosse and family,
1928

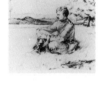

3933 Water-colour 33.7 x 22.5
(13¼ x 8⅞)
Sir Leslie Ward, signed *Spy*
(*VF* 20 Feb 1892)
Purchased, 1955

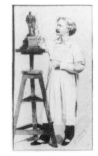

4245 *See Groups:* Hanging Committee, Royal Academy, 1892, by Reginald Cleaver

THOROLD, Anthony Wilson (1825-95) Bishop of Rochester

4746 Water-colour 30.8 x 18.1 ($12\frac{1}{8}$ x $7\frac{1}{8}$)
Sir Leslie Ward, signed *Spy*
(*VF* 20 Jan 1885)
Purchased, 1970

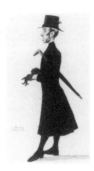

THRALE, Hester Lynch
See PIOZZI

THROCKMORTON, Sir Nicholas (1515-71) Diplomat

3800 Panel 89.8 x 72.4 ($35\frac{3}{8}$ x 28½)
Unknown artist, inscribed, c.1562
Purchased, 1951. *Montacute*

1492a *See Collections:* Copies of early portraits, by George Perfect Harding and Sylvester Harding, **1492,1492(a-c)** and **2394-2419**

Strong

THURLOE, John (1616-68)
Secretary of State

1033 Canvas 124.5 x 101 (49 x 39¾)
Unknown artist
Given by William Henry Alexander, 1896

4248 Water-colour 17.8 x 12.1 (7 x 4¾)
John Bullfinch, inscribed below image
Purchased, 1961

Piper

THURLOW, Edward Thurlow, Baron (1731-1806)
Lord Chancellor

395 Canvas 63.5 x 54 (25 x 21¼)
Attributed to Richard Evans
Purchased, 1874

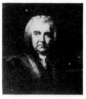

1264 Canvas 124.5 x 99.1 (49 x 39)
Thomas Phillips, 1806
Given by Lawrence J.Baker, 1900

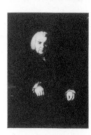

249 Canvas 73.7 x 61 (29 x 24)
Thomas Phillips, 1806
Purchased, 1867

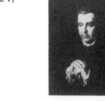

5238 Artificial stone bust 50.8 (20) high
John Charles Felix Rossi, incised, 1809
Purchased, 1979

THYNNE, Lord Henry Frederick (1832-1904)
Politician and courtier

4747 Water-colour 34.6 x 18.7 ($13\frac{5}{8}$ x $7\frac{3}{8}$)
Sir Leslie Ward, signed *Spy*
(*VF* 26 May 1877)
Purchased, 1970

THYNNE, Sir Thomas, 1st Viscount Weymouth *See* WEYMOUTH

THYNNE, Thomas, 2nd Marquess of Bath *See* BATH

TIDCOMB, John (1642-1713)
Soldier

3229 Canvas 91.4 x 71.1 (36 x 28)
Sir Godfrey Kneller, signed, c.1710
Kit-cat Club portrait
Given by NACF, 1945.
Beningbrough

Piper

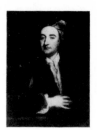

TIERNEY, George (1761-1830)
Statesman

999 *See Groups:* The Trial of
Queen Caroline, 1820, by Sir
George Hayter

173 Marble bust 67.3 (26½) high
William Behnes, incised and dated
1822
Given by the sitter's son, George
Tierney, 1864

TIERNEY, Sir Matthew John, Bt
(1776-1845) Physician

2175a Water-colour, oval
22.9 x 19.7 (9 x 7¾)
Unknown artist
Given by Mrs Frances J. W. Booth,
1927

TIGHE, Mary (1770-1810)
Poet

1629 Miniature on ivory 8.6 x 7.6
(3⅞ x 3)
Unknown artist after George
Romney
Purchased, 1911

TILLOTSON, John (1630-94)
Archbishop of Canterbury

94 Canvas 90.8 x 70.5
(35¾ x 27¾)
After Sir Godfrey Kneller
(c.1691-4)
Purchased, 1860

Piper

TIMBS, John (1801-75)
Writer

5011 Miniature on ivory
31.1 x 22.9 (12¼ x 9)
Thomas John Gullick, eng 1855
Purchased, 1974

TINDAL, Sir Nicholas Conyngham
(1776-1846)
Chief Justice of Common Pleas

999 *See Groups:* The Trial of
Queen Caroline, 1820, by Sir
George Hayter

482 Canvas 141 x 111.1
(55½ x 43¾)
Thomas Phillips, inscribed, 1840
Given by the Society of Judges and
Serjeants-at-Law, 1877

TINSLEY, William (1831-1902)
Publisher

3524 *See Collections:* Prominent
Men, c.1880-c.1910, by Harry
Furniss, **3337-3535** and **3554-3620**

TOLSTOY, Count Leo (1828-1910)
Russian novelist

4707(30) Water-colour 36.5 x 25.1
(14⅜ x 9⅞)
Signed *SNAPP* and inscribed
(*VF* 24 Oct 1901)
Purchased, 1938
See Collections: Vanity Fair
cartoons, 1869-1910, by various
artists, **2556-2606**, etc

TOMLINSON, Henry Major
(1873-1958) Writer

4597 Board 29.8 x 24.8
(11¾ x 9¾)
Richard Murry, signed and dated
1927
Given by the artist's sister-in-law,
Mrs Middleton Murry, 1968

TOMS, Peter (d.1777)
Painter and herald

1437, 1437a *See Groups:* The
Academicians of the Royal
Academy, 1771-2, by John Sanders
after Johan Zoffany

TONKS, Henry (1862-1937)
Painter and teacher

3072(5) Pencil 36.2 x 26
(14¼ x 10¼)
Self-portrait
Given by Charles Henry Collins
Baker, 1937
See Collections: Sketches and
studies by Henry Tonks, **3072(1-18)**

3072(7) Pencil 36.2 x 26
(14¼ x 10¼)
Self-portrait
Given by Charles Henry Collins
Baker, 1937
See Collections: Sketches and
studies by Henry Tonks, **3072(1-18)**

3072(6) *See Collections:* Sketches
and studies by Henry Tonks,
3072(1-18)

2556 *See Groups:* The Selecting
Jury of the New English Art Club,
1909, by Sir William Orpen

2663 *See Groups:* Some Members
of the New English Art Club, by
Donald Graeme MacLaren

3137a With two heads of Percy
Grainger (right)
Pencil 27.3 x 24.1 (10¾ x 9½)
George Washington Lambert, signed
with initials and inscribed
Given by the artist's widow, 1942

5089 With another drawing of
Tonks on reverse (no.**5089A**)
Ink and wash 27.3 x 21 (10¾ x 8¼)
Ernest Heber Thompson, signed
and dated 1923
Bequeathed by William George
Constable, 1976

TONSON, Jacob, I (1655-1736)
Publisher and Secretary of the
Kit-cat Club

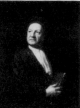

3230 Canvas 91.4 x 71.1 (36 x 28)
Sir Godfrey Kneller, signed,
inscribed and dated 1717
Kit-cat Club portrait
Given by NACF, 1945

Piper

TONSON, Jacob, II (d.1735)
Publisher; nephew of Jacob
Tonson I

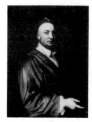

4091 Canvas 90.8 x 70.2
(35¾ x 27$\frac{5}{8}$)
Sir Godfrey Kneller, signed in
monogram, c.1720(?)
Given by Sir Alec and Lady Martin
through NACF, 1959

Piper

TOOKE, John Horne (1736-1812)
Radical politician and philologist

1944 *See Groups:* John Glynn,
John Wilkes and John Horne Tooke,
by Richard Houston

13 Canvas 74.9 x 62.2
(29½ x 24½)
Thomas Hardy, eng 1791
Purchased, 1857

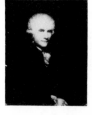

316a(122) Ink 36.8 x 27.6
(14½ x 10$\frac{7}{8}$)
Sir Francis Chantrey, inscribed
Given by Mrs George Jones, 1871
See Collections: Preliminary
drawings for busts and statues by
Sir Francis Chantrey, **316a(1-202)**

TOOKE, William (1777-1863)
President of the Society of Arts

54 *See Groups:*The House of Com-
mons, 1833, by Sir George Hayter

TOOLE, John Lawrence
(1830-1906) Actor

3074 Chalk 34.9 x 24.1
(13¾ x 9½)
Alfred Bryan, signed
Purchased, 1939

2264 *See Collections:* The Parnell
Commission, 1888-9, by Sydney
Prior Hall, **2229-72**

3528 *See Collections:* Prominent
Men, c.1880-c.1910, by Harry
Furniss, **3337-3535** and **3554-3620**

TOPLADY, Augustus Montague
(1740-78) Divine and hymn writer

3138 Pencil and gouache
30.8 x 23.8 (12⅛ x 9⅜)
After John Raphael Smith,
inscribed (eng 1777)
Purchased, 1943

TORRINGTON, George Byng,
Viscount (1663-1733) Admiral

14 Canvas 200.7 x 142.2 (79 x 56)
Attributed to Jeremiah Davison,
inscribed, c.1725
Given by Viscount Torrington, 1857

Piper

TOSTI, Sir Francesco Paolo
(1847-1916) Song writer

3137 Pencil 22.9 x 18.1 (9 x 7⅛)
George Washington Lambert,
signed with initials
Given by the artist's widow, 1942

TOTNES, George Carew, Earl of
(1555-1629) Statesman

409 Canvas 127 x 102.9
(50 x 40½)
Unknown artist, after a portrait
of c.1615-20
Purchased, 1875

Strong

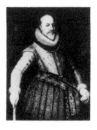

TOTTENHAM, Arthur Loftus
(1838-87) Politician

4748 Water-colour 30.8 x 18.1
(12⅛ x 7⅛)
Sir Leslie Ward, signed *Spy*
(*VF* 15 April 1882)
Purchased, 1970

TOVEY, Sir Donald (1875-1940)
Musician

5277 Sanguine and pencil
38.4 x 28.6 (15⅛ x 11¼)
Sir William Rothenstein, c.1936
Purchased, 1979

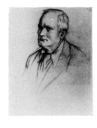

TOWNSHEND, George Townshend,
2nd Marquess (1755-1811)
Archaeologist and antiquary

2076 *See Groups:* Whig Statesmen
and their Friends, c.1810, by
William Lane

TOWNSHEND, John Townshend,
5th Marquess (1831-99)
Politician and landowner

2604 Water-colour 29.8 x 17.8
(11¾ x 7)
Alfred Thompson
(*VF* 26 Feb 1870)
Purchased, 1933

TOWNSHEND, Charles Townshend,
2nd Viscount (1675-1738)
Statesman and agriculturalist

3623 Canvas 243.6 x 146.1
(95½ x 57½)
Sir Godfrey Kneller, signed and
dated 17(04?), inscribed
Purchased, 1947

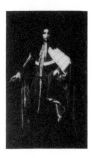

1363 Canvas 125.7 x 100.3
(49½ x 39½)
Studio of (?) Sir Godfrey Kneller,
inscribed
Purchased, 1904

1755 Canvas 125.7 x 101
(49½ x 39¾)
After Sir Godfrey Kneller,
(c.1715-20)
Purchased, 1915

Piper

TOWNSHEND, Charles (1725-67)
Chancellor of the Exchequer

1756 Wax medallion, oval
11.1 x 8.6 (4$\frac{3}{8}$ x 3$\frac{3}{8}$)
Attributed to Isaac Gosset
Purchased, 1915

Kerslake

TOWNSHEND, Charles Powlett, 2nd
Baron Bayning *See* BAYNING

TOWNSHEND, Sir Horatio George
Powys (1780-1843) Colonel

3761 *See Collections:* Studies for
The Waterloo Banquet at Apsley
House, 1836, by William Salter,
3689-3769

TOWNSHEND, John Robert, 3rd
Viscount Sydney *See* SYDNEY

TOWNSHEND, John Thomas, 2nd
Viscount Sydney *See* SYDNEY

TOYNBEE, Arnold (1852-83)
Economist and social reformer

2486 Plaster cast of medallion
42.5 (16¾) diameter
Sir Joseph Edgar Boehm,
posthumous
Bequeathed by the sitter's widow,
1931

TOYNBEE, Arnold Joseph
(1889-1975) Historian; nephew
of Arnold Toynbee

5208 Wax medallion 9.5 (3¾)
diameter, *sight*
Effie Stillman, inscribed and dated
1893
Given by the sitter's widow, 1978

TRADESCANT, John, the Younger
(1608-62) Gardener and collector

1089 Canvas 80 x 61 (31½ x 24)
Attributed to Emmanuel de Critz,
1652
Purchased, 1897

Piper

TRAILL, Henry Duff (1842-1900)
Journalist and writer

3529 *See Collections:* Prominent
Men, c.1880-c.1910, by Harry
Furniss, **3337-3535** and **3554-3620**

TREBY, Sir George (1644?-1700)
Judge

638 Line engraving 39 x 28.2
(15$\frac{3}{8}$ x 11$\frac{1}{8}$)
Robert White, signed, inscribed,
and dated 1700 on plate
Purchased, 1881

TREE, Sir Herbert Beerbohm
(1852-1917) Actor-manager

2263 *See Collections:* The Parnell
Commission, 1888-9, by Sydney
Prior Hall, **2229-72**

4095(11) Pen and ink 38.7 x 31.8
(15¼ x 12½)
Harry Furniss, signed with initials
Purchased, 1959
See Collections: The Garrick
Gallery of Caricatures, 1905, by
Harry Furniss, **4095(1-11)**

Continued overleaf

2392 Plaster cast of death-mask
24.1 (9½) long
Sir George Frampton, incised in
monogram and dated 1918 on
support
Given by the sitter's widow, 1929

TREFUSIS, Robert Cotton St John,
18th Baron Clinton *See* CLINTON

TREFUSIS, Violet (1894-1972)
Writer

5229 Canvas 117.1 x 89.5
(46$\frac{1}{8}$ x 35¼)
Jacques-Emile Blanche, signed,
inscribed and dated 1926
Bequeathed by Philippe Julian, 1978

TRELAWNY, Edward John
(1792-1881) Writer and adventurer

2882 Pencil 10.2 x 8.9 (4 x 3½)
Bryan Edward Duppa, signed and
inscribed
Purchased, 1936

2883 Pencil 17.1 x 10.2
(6¾ x 4)
Bryan Edward Duppa, signed
and inscribed
Purchased, 1936

2886 Pencil 14 x 11.4 (5½ x 4½)
Sir Edwin Landseer
Purchased, 1936

2132 Pen and ink 15.2 x 15.2
(6 x 6)
Joseph Severn, signed and dated
1838
Given by the sitter's son-in-law,
C.F.Call, 1926

TRELAWNY, Sir Jonathan, Bt
(1650-1721) Bishop of Winchester

79, 152a *See Groups:* The Seven
Bishops Committed to the Tower in
1688, by an unknown artist and
George Bower

TRELOAR, Sir William Purdie, Bt
(1843-1923)
Manufacturer and philanthropist

3613 *See Collections:* Prominent
Men, c.1880-c.1910, by Harry
Furniss, **3337-3535** and **3554-3620**

TRENCH, Power le Poer
(1770-1839) Archbishop of Tuam

999 *See Groups:* The Trial of
Queen Caroline, 1820, by Sir
George Hayter

TRENCH, Richard Chenevix
(1807-86) Archbishop of Dublin,
poet and philologist

1685 Chalk 48 x 35.2
(18$\frac{7}{8}$ x 13$\frac{7}{8}$)
Samuel Laurence, c.1841
Given by Ernest E.Leggatt, 1912

Ormond

TRENCH, Richard le Poer, 2nd
Earl of and 1st Viscount Clancarty
See CLANCARTY

TRENCHARD, Hugh Montague Trenchard, Viscount (1873-1956) Marshal of the Royal Air Force

3677 Pencil and wash 37.8 x 26.7 (14$\frac{7}{8}$ x 10½)
Sir Bernard Partridge, signed and inscribed
(*Punch* 2 March 1927)
Purchased, 1949
See Collections: Mr Punch's Personalities, 1926-9, by Sir Bernard Partridge, **3664-6,** etc

TREVELYAN, Sir Charles Philip, 3rd Bt (1870-1958) Politician; son of Sir George Otto Trevelyan

4797 Sanguine, black and white chalk 36.8 x 35.2 (14½ x 13$\frac{7}{8}$)
Sir William Rothenstein, 1924
Purchased, 1970

TREVELYAN, Sir George Otto, 2nd Bt (1838-1928)
Statesman and historian; nephew of Lord Macaulay

2743 Water-colour 29.5 x 12.1 (11$\frac{5}{8}$ x 4¾)
Sir Leslie Ward, signed *Spy* and inscribed
(*VF* 2 Aug 1873)
Purchased, 1934

2224 Water-colour 24.1 x 19.1 (9½ x 7½)
Fanny, Lady Holroyd, signed and dated 1911
Given by the sitter's son, Sir Charles Philip Trevelyan, Bt, 1928

TREVELYAN, George Macaulay (1876-1962) Historian; son of Sir George Otto Trevelyan

4286 Sanguine, black and white chalk 35.2 x 30.1 (13$\frac{7}{8}$ x 11$\frac{7}{8}$)
Sir William Rothenstein, c.1924
Given by the Rothenstein Memorial Trust, 1962

4287 Pencil 37.8 x 28.3 (14$\frac{7}{8}$ x 11$\frac{1}{8}$)
Francis Dodd, signed and dated 1933
Given by the Contemporary Portraits Fund, 1962

TREVES, Sir Frederick, Bt (1853-1923) Surgeon

2917 Canvas 47 x 34.3 (18½ x 13½)
Sir Luke Fildes, signed and dated 1896, reduced replica
Given by the sitter's widow, 1937

TREVITHICK, Richard (1771-1833) Engineer and inventor

1075, 1075a and **b** *See Groups:* Men of Science Living in 1807-8, by Sir John Gilbert and others

TREVOR, Elizabeth (Steele), Lady (1709-48)
Daughter of Sir Richard Steele

1506b Miniature on ivory, oval 8 x 6 (3$\frac{1}{8}$ x 2$\frac{3}{8}$)
Unknown artist, c.1720
Given by George Harland Peck, 1908

Piper (under Sir Richard Steele)

TREVOR, Leo (1865?-1927)
Dramatist and amateur actor

3012 Water-colour 36.5 x 26.7 (14$\frac{3}{8}$ x 10½)
Sir Leslie Ward, signed *Spy*
(*VF* 2 Nov 1905)
Purchased, 1937

TRIGG, Colonel

1752 *See Groups:* The Siege of Gibraltar, 1782, by George Carter

TRIMMER, Sarah (1741-1810)
Writer for children

796 Canvas 90.2 x 68.6 (35½ x 27)
Henry Howard, inscribed, exh 1798
Purchased, 1888

TROLLOPE, Anthony (1815-82)
Novelist

P18(32) Photograph: albumen
print 25.1 x 21.3 ($9\frac{7}{8}$ x $8\frac{3}{8}$)
Julia Margaret Cameron, October
1864
Purchased with help from public
appeal, 1975
See Collections: The Herschel
Album, by Julia Margaret Cameron,
P18(1-92b)

1680 Canvas 59.7 x 50.2
(23½ x 19¾)
Samuel Laurence, c.1864
Purchased, 1912

3915 Water-colour 29.5 x 18.4
($11\frac{5}{8}$ x 7¼)
Sir Leslie Ward, inscribed
(Study for *VF* 5 April 1873)
Given by D.Pepys Whiteley, 1954

3906(b) *See Unknown Sitters IV*

TROLLOPE, Frances (1780-1863)
Novelist; mother of Anthony
Trollope

3906 Canvas 15.2 x 12.7 (6 x 5)
Auguste Hervieu, c.1832
Bequeathed by the sitter's great-
granddaughter, Miss Muriel Rose
Trollope, 1954

Ormond

TROLLOPE, Thomas Adolphus
(1810-92) Writer

3906(a) *See Unknown Sitters IV*

TROUGHTON, Edward
(1753-1835)
Scientific instrument maker

1075a and **b** *See Groups:* Men of
Science Living in 1807-8, by
Sir John Gilbert and others

316a(123) Pencil 44.5 x 34
(17½ x $13\frac{3}{8}$)
Sir Francis Chantrey, inscribed and
dated 1822
Given by Mrs George Jones, 1871

and

316a(124) Pencil, two sketches
46 x 62.6 ($18\frac{1}{8}$ x $24\frac{5}{8}$)
Sir Francis Chantrey, inscribed and
dated 1822
Given by Mrs George Jones, 1871
See Collections: Preliminary
drawings for busts and statues by
Sir Francis Chantrey, **316a(1-202)**

TRURO, Thomas Wilde, 1st Baron
(1782-1855) Lord Chancellor

1695(i,o) *See Collections:*
Sketches for The Trial of Queen
Caroline, 1820, by Sir George
Hayter, **1695(a-x)**

999 *See Groups:* The Trial of
Queen Caroline, 1820, by Sir
George Hayter

483 Canvas 139.7 x 109.2
(55 x 43)
Thomas Youngman Gooderson
after Sir Francis Grant (1850)
Given by the Society of Judges and
Serjeants-at-Law, 1877

Ormond

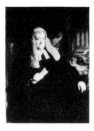

TRURO, Charles Robert Claude Wilde, 2nd Baron (1816-91)
Lawyer

4749 Water-colour 31.1 x 18.1 (12¼ x 7⅛)
Carlo Pellegrini, signed *Ape*, inscribed
(*VF* 1 Jan 1887)
Purchased, 1970

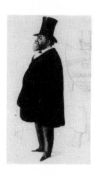

TUCKER, Abraham (1705-74)
Philosopher

3942 Canvas, feigned oval 75.6 x 62.2 (29¾ x 24½)
Enoch Seeman, signed, inscribed and dated 1739
Purchased, 1955

Kerslake

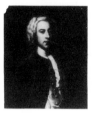

TUFTON, Sackville, 9th Earl of Thanet *See* THANET

TULLOCH, John (1823-86)
Theologian; Principal of St Andrews University

3845 *See Groups:* Dinner at Haddo House, 1884, by Alfred Edward Emslie

TUPPER, Martin Farquhar (1810-89)
Poet, writer and barrister

4381 Water-colour 34.3 x 24.8 (13½ x 9¾)
François Theodore Rochard, signed and dated 1846
Purchased, 1964

Ormond

TURNER, Miss (probably Eleanor Jane)

2896 *See under* Elizabeth, Lady Palgrave

TURNER, Sir Ben (1863-1942)
Trade unionist

4529(366,367) *See Collections:* Working drawings by Sir David Low, **4529(1-401)**

TURNER, Charles (1774-1857)
Engraver

2515(59) *See Collections:* Drawings of Prominent People, 1823-49, by William Brockedon, **2515(1-104)**

1317 Chalk on canvas 76.1 x 63.2 (30 x 24⅞)
Self-portrait, signed and dated 1850
Purchased, 1902

Ormond

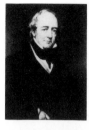

TURNER, Francis (1638?-1700)
Bishop of Ely

573 Canvas, feigned oval 74.9 x 62.2 (29½ x 24½)
Attributed to Mary Beale, inscribed, c.1683-8
Transferred from BM, 1879

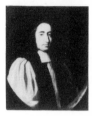

79,152a *See Groups:* The Seven Bishops Committed to the Tower in 1688, by an unknown artist and George Bower

Piper

TURNER, Joseph Mallord William (1775-1851) Landscape painter

1314 Water-colour, oval 9.5 x 7 (3¾ x 2¾)
Self-portrait, c.1790
Given in memory of Cosmo Monkhouse, 1902

4913(1) *See Collections:* Four studies from a sketchbook, by Thomas Cooley, **4913(1-4)**

4084 Pencil 10.8 x 8.6 (4¼ x 3⅜)
Charles Robert Leslie, inscribed, 1816
Given by the artist's granddaughter, Miss L. Leslie, 1958

Continued overleaf

2943 With two unidentified figures (right)
Oil on card 15.9 x 13 (6¼ x 5⅛)
Charles West Cope, c.1828
Given by the artist's son, Sir Arthur Stockdale Cope, 1938

L157 Canvas 46 x 38.4
(18⅛ x 15⅛)
John Linnell, 1838
Lent by the Hon Colin Tennant, 1975

1182 Chalk 34.3 x 24.8 (13½ x 9¾)
Charles Turner, signed with initials and dated 1842
Purchased, 1898

1483 Pencil 37.1 x 26 (14⅝ x 10¼)
Charles Martin, inscribed, 1844
Given by Miss Alice Balfour, 1907

1456(25) Pencil 10.8 x 11.1
(4¼ x 4⅜) *sight*
Charles Hutton Lear, inscribed, c.1847
Given by John Elliot, 1907
See Collections: Drawings of Artists, c.1845, by Charles Hutton Lear, **1456(1-27)**

1717 Water-colour 30.8 x 23.8
(12⅛ x 9⅜)
John Phillip, signed, c.1850
Given by W.G.Rawlinson, 1913

1664 Plaster cast of death-mask
25.4 (10) long
Probably by Thomas Woolner, 1851
Purchased, 1912

TURNER, Sharon (1768-1847)
Historian

1848 Canvas 74.3 x 61.6
(29¼ x 24¼)
Sir Martin Archer Shee
Given by the sitter's grandson, Sharon Grote Turner, 1919

TURPIN DE CRISSÉ, Launcelot Théodore, Count (1781-1852)
French painter

2515(50) *See Collections:*
Drawings of Prominent People, 1823-49, by William Brockedon, **2515(1-104)**

TUSSAUD, Marie (1760-1850)
Modeller in wax

2031 Chalk 38.1 x 27.9 (15 x 11)
Attributed to Francis Tussaud
(her son)
Given by the sitter's great-grandson, John Theodore Tussaud, 1924

TWEEDDALE, William Montagu Hay, 10th Marquess of (1826-1911)
Landowner

4750 Water-colour 30.8 x 18.1
(12⅛ x 7⅛)
Carlo Pellegrini, signed *Ape*
(*VF* 12 Dec 1874)
Purchased, 1970

TWEEDSMUIR, John Buchan, Baron (1875-1940)
Novelist and Governor-General of Canada

3636 Bronze cast of bust 35.6 (14) high
Thomas John Clapperton, incised, 1935
Purchased with help from the sitter's widow and son, 1948

TYERMAN, Donald (b.1908)
Journalist

4529(368-72) *See Collections:* Working drawings by Sir David Low, **4529(1-401)**

TYLDESLEY, Sir Thomas (1596-1651) Royalist general

1571 *See Unknown Sitters II*

TYLER, William (d.1801)
Sculptor and architect

1437,1437a *See Groups:* The Academicians of the Royal Academy, 1771-2, by John Sanders after Johan Zoffany

TYLOR, Sir Edward Burnett (1832-1917) Anthropologist

1912 Chalk and pastel 60.3 x 50.8 (23¾ x 20)
George Bonavia, 1860
Given by the sitter's nieces, Mrs John Tyndall, Mrs Sydney Morse and Miss Dorothy Tylor, 1921

TYNDALE, William (d.1536)
Translator of the Bible

1592, 3180 *See Unknown Sitters I*

TYNDALL, John (1820-93)
Scientist

1287 Canvas 45.7 x 61 (18 x 24)
John McLure Hamilton, 1893
Given by the sitter's widow, 1901

3530,3614 *See Collections:* Prominent Men, c.1880-c.1910, by Harry Furniss, **3337-3535** and **3554-3620**

TYNTE, Charles John Kemeys (1800-82) MP for Somerset West

54 *See Groups:* The House of Commons, 1833, by Sir George Hayter

TYRAWLEY, James O'Hara, 2nd Baron (1682?-1773)
Soldier and diplomat

2034 *See Groups:* 2nd Duke of Montagu, 2nd Baron Tyrawley, and an unknown man, probably by John Verelst

TYRCONNEL, Frances Jennings, Duchess of (1647/9-1730)
Famous beauty

5095 Miniature on vellum, oval 7.3 x 6.1 (2⅞ x 2⅜)
Samuel Cooper, signed in monogram, c.1665
Purchased, 1976

TYRCONNEL, Richard Talbot, Earl of (1630-91) Soldier

1466 Canvas 115.6 x 88.9 (45½ x 35)
Unknown French artist, 1690
Purchased, 1907

TYRELL, Sir John Tyssen, Bt (1795-1877)
MP for Essex North

54 *See Groups:* The House of Commons, 1833, by Sir George Hayter

TYRWHITT, Sir Reginald Yorke (1870-1951) Admiral

1913 *See Groups:* Naval Officers of World War I, by Sir Arthur Stockdale Cope

TYRWHITT, Richard St John
(1827-95) Writer on art

P7(17) Photograph: albumen
print 14.6 x 12.1 (5¾ x 4¾)
Charles Lutwidge Dodgson, c.1856
Purchased with help from Kodak
Ltd, 1973
See Collections: Lewis Carroll at
Christ Church, by Charles Lutwidge
Dodgson, **P7(1-37)**

TYRWHITT, Thomas (1730-86)
Classical commentator

2942 Canvas 74.9 x 62.2
(29½ x 24½)
Unknown artist
Given by wish of H.M.Tyrwhitt,
1938

TYRWHITT, Sir Thomas
(c.1762-1839) Gentleman Usher
of the Black Rod

999 *See Groups:* The Trial of
Queen Caroline, 1820, by Sir
George Hayter

TYRWHITT-WILSON, Gerald
Hugh, 14th Baron Berners
See BERNERS

TYTLER, Patrick Fraser
(1791-1849) Scottish historian

226 Canvas 91.4 x 74 (36 x 29⅛)
Margaret Sarah Carpenter, inscribed,
exh 1845
Purchased, 1867

Ormond

ULLSWATER, James William
Lowther, Viscount (1855-1949)
Speaker of the House of Commons

4610 Water-colour 40.6 x 25.4
(16 x 10)
Sir Leslie Ward, signed *Spy*
(*VF* 19 Dec 1891)
Purchased, 1968

3615 *See Collections:* Prominent
Men, c.1880-c.1910, by Harry
Furniss, **3337-3535** and **3554-3620**

UNDERWOOD, Leon (1890-1975)
Artist

4798 Black chalk 37.8 x 28.6
(14⅞ x 11¼)
Sir William Rothenstein, signed
with initials and dated 1922
Purchased, 1970

UNTON, Sir Henry (1557?-96)
Soldier and diplomat

710 With scenes from his life
Panel 74 x 163.2 (29⅛ x 64¼)
Unknown artist, c.1596
Purchased, 1884

Strong

UPPER OSSORY, John Fitzpatrick,
2nd Earl of (1745-1818)

2076 *See Groups:* Whig Statesmen
and their Friends, c.1810, by
William Lane

URE, Andrew (1778-1857)
Chemist and scientific writer

2876 Water-colour 21.6 x 17.8
(8½ x 7)
Unknown artist, inscribed
Purchased, 1936

USSHER, James (1580-1656)
Archbishop of Armagh

574 Canvas 78.1 x 65.4
(30¾ x 25¾)
After Sir Peter Lely
Transferred from BM, 1879

Piper

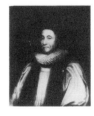

USTINOV, Peter (b.1921)
Actor, dramatist and film director

4529(373-6) *See Collections:*
Working drawings by Sir David
Low, **4529(1-401)**

UWINS, Thomas (1782-1857)
Painter

3944(14) Pencil 23.8 x 18.4
($9\frac{3}{8}$ x 7¼)
John Partridge, signed and dated
1825
Purchased, 1955
See Collections: Artists, 1825, by
John Partridge and others,
3944(1-55)

4231 Millboard 25.1 x 20
($9\frac{7}{8}$ x $7\frac{7}{8}$)
John Partridge, 1836
Bequeathed by the widow of the
artist's nephew, Sir Bernard
Partridge, 1961

1456(12) Chalk 7 x 7.6 (2¾ x 3)
Charles Hutton Lear, inscribed and
dated 1845
Given by John Elliot, 1907
See Collections: Drawings of Artists,
c.1845, by Charles Hutton Lear,
1456(1-27)

4218 Pencil 8.3 x 5.7 (3¼ x 2¼)
George Harlow White, inscribed,
c.1845
Given by Ernest E.Leggatt, 1910
See Collections: Drawings, c.1845,
by George Harlow White, **4216-18**

Ormond

VACHELL, Horace Annesley
(1861-1955)
Novelist and playwright

3531,3616 *See Collections:*
Prominent Men, c.1880-c.1910, by
Harry Furniss, **3337-3535** and
3554-3620

VALLOTTOR, Major

1752 *See Groups:* The Siege of
Gibraltar, 1782, by George Carter

VANBRUGH, Dame Irene
(1872-1949) Actress

4102 Lithograph 39.7 x 27.3
($15\frac{3}{8}$ x 10¾)
Flora Lion, signed, inscribed and
dated 1913
Purchased, 1959

VANBRUGH, Sir John (1664-1726)
Architect and dramatist

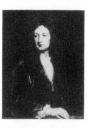

3231 Canvas 91.4 x 71.1 (36 x 28)
Sir Godfrey Kneller, signed in
monogram, c.1704-10(?)
Kit-cat Club portrait
Given by NACF, 1945

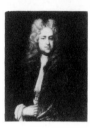

1568 Canvas 90.2 x 69.9
(35½ x 27½)
Attributed to Thomas Murray,
c.1718(?)
Purchased, 1910. *Beningbrough*

Piper

VANCOUVER, George (1758-98)
Explorer

503 *See Unknown Sitters III*

VANDELEUR, Sir John Ormsby
(1763-1849) General

3762 *See Collections:* Studies for
The Waterloo Banquet at Apsley
House, 1836, by William Salter,
3689-3769

VANDERBANK, John
(1694?-1739) Portrait painter

3647 Pen and ink 32.4 x 19.1
(12¾ x 7½)
Self-portrait, signed with initials
and dated 1738
Purchased, 1948. *Beningbrough*

Kerslake

VAN DER DOORT, Abraham
(d.1640) Artist and Keeper
of Charles I's collections

1569 Canvas 48.3 x 43.8
(19 x 17¼)
Unknown artist, perhaps after
William Dobson
Purchased, 1910

Piper

VAN DYCK, Sir Anthony
(1599-1641) Painter

1291 Canvas 57.2 x 49.5
(22½ x 19½)
After a self-portrait, reduced copy
(c.1621)
Lent by NG, 1901

Piper

VANE, Sir Henry, the Elder
(1589-1655) Secretary of State

1118 Panel 64.1 x 55.9
(25¼ x 22)
After Michael Jansz. van Miereveldt
(?), inscribed
Purchased, 1898

Piper

VANE, Sir Henry, the Younger
(1613-62) Revolutionary

575 *See Unknown Sitters II*

VANE, Henry, 2nd Duke of
Cleveland *See* CLEVELAND

VANE, William Harry, 1st Duke
of Cleveland *See* CLEVELAND

VANE-STEWARD, Charles William,
3rd Marquess of Londonderry
See LONDONDERRY

VANE-TEMPEST, George,
5th Marquess of Londonderry
See LONDONDERRY

VANE-TEMPEST-STEWART,
Charles, 7th Marquess of
Londonderry
See LONDONDERRY

VANE-TEMPEST-STEWART,
Charles Stewart, 6th Marquess of
Londonderry
See LONDONDERRY

VAN MILDERT, William
(1765-1836) Bishop of Durham

999 *See Groups:* The Trial of
Queen Caroline, 1820, by Sir
George Hayter

VANSITTART, Nicholas, Baron
Bexley *See* BEXLEY

VAN VOORST, John

P106(17) *See Collections:*
Literary and Scientific Portrait
Club, by Maull & Polyblank,
P106(1-20)

VARLEY, John (1778-1842)
Landscape painter

1194 Pencil 27.9 x 19.7 (11 x 7¾)
William Blake, inscribed
Given by Godfrey E.P.Arkwright,
1899

1529 Panel 8.9 x 7.6 (3½ x 3)
William Mulready
Purchased, 1909

VAUGHAN, Henry Halford
(1811-85) Historian

P18(20) *See Collections:* The
Herschel Album, by Julia Margaret
Cameron, **P18(1-92b)**

VAUGHAN, John, 3rd Earl of
Carbery *See* CARBERY

VAUGHAN, William (1752-1850)
Merchant and writer

4934 Marble bust 61 (24) high
Sir Francis Chantrey, incised and
dated 1811
Purchased, 1973

VAUGHAN WILLIAMS, Ralph
(1872-1958) Composer

5022 Water-colour and pencil
20.3 x 16.8 (8 x 6⅝)
Sibella Bonham Carter, signed with
initials and dated 1926 (*sic*), 1928
Given by the artist, 1975

4086 Pencil and chalk 35.6 x 29.2
(14 x 11½)
Joyce Finzi, signed *F* and dated
1947
Given by wish of the artist's
husband, Gerald Finzi, 1958

4762 Bronze cast of bust 40.6 (16)
high
Sir Jacob Epstein, incised, 1950
Purchased, 1970

4073 Chalk 28.6 x 24.1
(11¼ x 9½)
Juliet Pannett, signed by artist and
sitter, 1957
Purchased, 1958

4088 Bronze cast of head 31.8
(12½) high
David McFall, incised
Purchased, 1958

4074 Chalk 31.8 x 25.4 (12½ x 10)
Juliet Pannett, signed by artist and
sitter, 1958
Purchased, 1958

4829 Canvas 106.7 x 88.9
(42 x 35)
Sir Gerald Kelly, signed and dated
1958-61
Given by the sitter's widow, Mrs
Ursula Vaughan Williams, 1970

VAUX of Harrowden, George
Charles Mostyn, 6th Baron
(1804-83) Representative peer

1834(ff) *See Collections:* Members
of the House of Lords, c.1870-80,
by Frederick Sargent, **1834(a-z and
aa-hh)**

VENN, Henry (1725-97)
Evangelical divine

3161 Pastel 59.7 x 44.5
(23½ x 17½)
John Russell, signed and dated
1787
Bequeathed by Mrs E.H.Elliott,
widow of the sitter's great-great-
grandson, 1943

VERE of Tilbury, Horace Vere,
Baron (1565-1635) Soldier

818 Panel 87 x 64.1 (34¼ x 25¼)
Attributed to Michael Jansz. van
Miereveldt, inscribed and dated
1629
Purchased, 1889. *Montacute*

Piper

VERE, Aubrey de, 20th Earl of
Oxford *See* OXFORD

VERE, Sir Charles Broke
(1779-1843) Major-General

3763 *See Collections:* Studies for
The Waterloo Banquet at Apsley
House, 1836, by William Salter,
3689-3769

VERE, Edward de, 17th Earl of
Oxford *See* OXFORD

VERE, Sir Francis (1560-1609)
Soldier

L112 Canvas, feigned oval
61 x 48.3 (24 x 19)
Unknown artist, inscribed
Lent by the Duke of Portland,
1964. *Montacute*

VERE, Henry de, 18th Earl of
Oxford *See* OXFORD

VEREYKEN, Louis
Audencier of Brussels

665 *See Groups:* The Somerset
House Conference, 1604, by an
unknown Flemish artist

VERMIGLI, Pietro (1500-62)
'Peter Martyr'; reformer

195 Canvas, transferred from
panel 59.7 x 54.6 (23½ x 21½)
Hans Asper, inscribed and dated
1560
Purchased, 1865

Strong

VERNER, Sir William, Bt
(1782-1871)
MP for County Armagh

54 *See Groups:* The House of Com-
mons, 1833, by Sir George Hayter

VERNEY, Frances Parthenope,
Lady (d.1890) Sister of Florence
Nightingale; second wife of Sir
Harry Verney, Bt

3246 *See under* Florence
Nightingale

VERNEY, Sir Harry, Bt (1801-94)
Soldier, traveller and MP

54 *See Groups:* The House of Com-
mons, 1833, by Sir George Hayter

VERNEY, Richard Greville,
19th Baron Willoughby de Broke
See WILLOUGHBY DE BROKE

VERNON, George Vernon, Baron
(1803-66)
Commentator on Dante

54 *See Groups:* The House of Com-
mons, 1833, by Sir George Hayter

VERNON, Edward (1684-1757)
Admiral

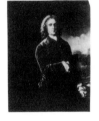

881 Canvas 126.4 x 103.8
(49¾ x 40⅞)
Thomas Gainsborough, c.1753
Purchased, 1891. *Beningbrough*

Kerslake

VERNON, George Granville
Venables (1785-1861)
MP for Lichfield

999 *See Groups:* The Trial of
Queen Caroline, 1820, by Sir
George Hayter

VERNON, James (1646-1727)
Secretary of State

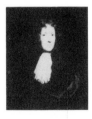

2963 Canvas, feigned oval
74.9 x 62.2 (29½ x 24½)
Sir Godfrey Kneller, 1677
Purchased, 1938. *Beningbrough*

5226 Canvas 75.6 x 63.5
(29¾ x 25)
Studio of Sir Godfrey Kneller
(1677)
Bequeathed by Mrs I.H.Wilson,
1978

Piper

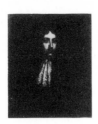

VERNON, Robert (1774-1849)
Patron and art collector

4513 Panel 76.2 x 62.9 (30 x 24¾)
George Jones and Henry Collen,
inscribed and dated 1848 on reverse
Purchased, 1967

VERRIO, Antonio (1639?-1707)
Decorative painter

2890 Canvas, feigned oval
76.2 x 63.5 (30 x 25)
Self-portrait, c.1700
Purchased, 1936. *Beningbrough*

Piper

VERTUE, George (1683-1756)
Engraver and antiquary

576 Canvas, feigned oval
74.9 x 62.2 (29½ x 24½)
Jonathan Richardson, 1733
Transferred from BM, 1879

1384 *See Groups:* A Conversation
of Virtuosis at the Kings Armes
(A Club of Artists), by Gawen
Hamilton

4876 Pencil and red chalk
23.5 x 14 (9¼ x 5½)
Self-portrait, signed, inscribed and
dated 1741
Purchased, 1972. *Beningbrough*

Kerslake

VERULAM, James Walter
Grimston, 1st Earl of (1775-1845)

999 *See Groups:* The Trial of
Queen Caroline, 1820, by Sir
George Hayter

VERULAM, James Walter
Grimston, 2nd Earl of (1809-95)
MP for Hertfordshire

54 *See Groups:* The House of Com-
mons, 1833, by Sir George Hayter

VESEY, Elizabeth (1715?-91)
Blue-stocking and hostess

3131 Chalk 22.2 x 18.4 (8¾ x 7¼)
Unknown artist
Given by G.F.Gilmour, 1942

VESTRIS, Madame
See MATHEWS

VIAUD, Julien (1850-1923)
'Pierre Loti'; French novelist

4707(15) *See Collections: Vanity
Fair* cartoons, 1869-1910, by
various artists, **2566-2606**, etc

VICTORIA, Queen (1819-1901)
Reigned 1837-1901

1250 Canvas 285.8 x 179
(112½ x 70½)
Sir George Hayter, signed and dated
1863, replica (1838)
Given by Queen Victoria, 1900

1891A Water-colour 20.6 x 15.9
($8\frac{1}{8}$ x 6¼)
W.Warman after Thomas Sully,
reduced copy (1838)
Given by Ernest E. Leggatt, 1920

316a(125) Pencil 50.8 x 41.3
(20 x 16¼)
Sir Francis Chantrey, inscribed,
c.1839
Given by Mrs George Jones, 1871

and

Continued overleaf

316a(126) Pencil 49.5 x 43.8
(19½ x 17¼)
Sir Francis Chantrey, c.1839
Given by Mrs George Jones, 1871
See Collections: Preliminary
drawings for busts and statues by
Sir Francis Chantrey, **316a(1-202)**

1716 Marble bust 70.5 (27¾) high
Sir Francis Chantrey, incised and
dated 1841, replica (1839)
Purchased with help from G.Harland
Peck, 1913

1297 Pen and ink and water-colour
23.2 x 15.2 (9⅛ x 6)
Sir David Wilkie, c.1840
Given by Lord Ronald Sutherland
Gower, 1901

4108 Water-colour, feigned oval
34.9 x 26.7 (13¾ x 10½)
Aaron Edwin Penley, signed, c.1840
Given by John Steegman, 1959

5164 Marble bust 57.2 (22½) high
Robert Physick, incised and dated
1851
Given by Queen Elizabeth Military
Hospital, 1977

P26 *See Groups:* The Royal
Family . . . , by L.Caldesi

4969 *See Groups:* Queen Victoria
Presenting a Bible in the Audience
Chamber at Windsor, by Thomas
Jones Barker

P27 *See Groups:* Royal mourning
group, 1862, by W.Bambridge

2954 Pencil and water-colour
31.4 x 20 (12⅜ x 7⅞)
George Housman Thomas, c.1863
Purchased, 1938

P22(1,2,3) *See Collections:* The
Balmoral Album, by George
Washington Wilson, W.& D.
Downey, and Henry John Whitlock,
P22(1-27)

P22(4) With John Brown
Photograph: albumen print
14 x 9.8 (5½ x 3⅞)
W. & D. Downey, June 1868
Purchased, 1975
See Collections: The Balmoral
Album, by George Washington
Wilson, W. & D.Downey, and Henry
Whitlock, **P22(1-27)**

2023A(1,2) *See Collections:*
Queen Victoria, Prince Albert and
members of their family, by Susan
D.Durant, **2023A(1-12)**

708 Water-colour 145.7 x 97.8
(57⅜ x 38½)
Lady Julia Abercromby after
Heinrich von Angeli, signed in
monogram, inscribed and dated
1883 (1875)
Given by Lady Abercromby, 1883

858 Plaster cast of bust 86.4 (34)
high
Sir Joseph Edgar Boehm, c.1887
Purchased, 1891

4042 Pencil 37.5 x 25.1
(14¾ x 9⅞)
Adolphe de Bathe, inscribed, c.1890
Purchased 1956

2088 Miniature on ivory, oval
8.3 x 10.2 (3¼ x 4)
Mary Helen Carlisle
Given by the artist's sister, Miss
Sybil Carlisle, 1925

P51 With her Indian servant at
Frogmore
Photograph: carbon print 45.7 x 60
(18 x 23⅝)
Hills & Saunders, July 1893
Acquired before 1972

4536 *See Groups:* Four
Generations . . . , by Sir William
Quiller Orchardson

1252 Canvas 118.1 x 91.4
(46½ x 36)
Bertha Müller after Heinrich von
Angeli, signed and inscribed, 1900
(1899)
Purchased, 1900

Ormond

VICTORIA Adelaide Mary Louise,
Princess Royal (1840-1901)
Eldest child of Queen Victoria;
Empress of Germany

P26 *See Groups:* The Royal
Family . . . , by L.Caldesi

P27 *See Groups:* Royal mourning
group, 1862, by W.Bambridge

2023A(5,6) *See Collections:*
Queen Victoria, Prince Albert and
members of their family, by Susan
D.Durant, **2023A(1-12)**

4430 Canvas 35.6 x 30.5 (14 x 12)
Joseph Mordecai after a photograph
of c.1900
Given by wish of the artist's widow,
1965

VICTORIA Alexandra Olga Mary,
Princess (1868-1935)
Second daughter of Edward VII

4471 *See Groups:* The three
daughters of Edward VII and
Queen Alexandra, by Sydney Prior
Hall

VICTORIA Eugénie Julia Ena of
Battenberg, Princess (1887-1969)
Granddaughter of Queen Victoria;
Queen of Alfonso XIII of Spain

4043 Pencil 37.8 x 25.1
(14⅞ x 9⅞)
Adolphe de Bathe, signed and
inscribed
Purchased, 1956

VIGORS, Nicholas Aylward
(1785-1840) Zoologist

54 *See Groups:* The House of Com-
mons, 1833, by Sir George Hayter

VILLA MEDIANA, Juan de Tassis,
Count of
A delegate at the Somerset House
Conference

665 *See Groups:* The Somerset
House Conference, 1604, by an
unknown Flemish artist

VILLIERS, Augustus (1810-47)
Soldier; son of 5th Earl of Jersey

4026(58) *See Collections:*
Drawings of Men about Town,
1832-48, by Alfred, Count D'Orsay,
4026(1-61)

VILLIERS, George, 1st Duke of
Buckingham *See* BUCKINGHAM

VILLIERS, George, 2nd Duke of
Buckingham *See* BUCKINGHAM

VILLIERS, George, 4th Earl of
Clarendon *See* CLARENDON

VILLIERS, George Augustus
Frederick Child-, 6th Earl of
Jersey *See* JERSEY

VILLIERS, George Child-, 5th Earl
of Jersey *See* JERSEY

VILLIERS, Victor Child-, 7th Earl
of Jersey *See* JERSEY

VINCENT, Edgar, Viscount
D'Abernon *See* D'ABERNON

VINCENT, George (1796-1836?)
Landscape painter

1822 Water-colour 24.8 x 19.1
(9¾ x 7½)
John Jackson
Purchased, 1918

VINCENT, Sir Howard (1849-1908)
First Director of Criminal
Investigation

2744 Water-colour 30.8 x 18.1
$(12\frac{1}{8} \times 7\frac{1}{8})$
Sir Leslie Ward, signed *Spy*
(*VF* 22 Dec 1883)
Purchased, 1934

VINCENT, William (1739-1815)
Dean of Westminster

1434 Pencil and water-colour
22.9 x 17.8 (9 x 7)
Henry Edridge, eng 1810
Purchased, 1906

2418 Water-colour 12.4 x 10.7
$(4\frac{7}{8} \times 4\frac{1}{4})$
George Perfect Harding after
William Owen, signed, and inscribed
on mount, eng 1822, reduced copy
(exh 1811)
See Collections: Copies of early
portraits, by George Perfect
Harding and Sylvester Harding,
1492,1492(a-c) and 2394-2419

VINER (VYNER), Sir Thomas
(1588-1665) Banker and
Lord Mayor of London

4509 Canvas 108.6 x 103.5
(42¾ x 40¾)
Unknown artist, inscribed
Given by Oscar Klein, 1966

VIVIAN, Richard Hussey Vivian,
Baron (1775-1842)
Lieutenant-General

54 *See Groups:* The House of Com-
mons, 1833, by Sir George Hayter

3764 *See Collections:* Studies for
The Waterloo Banquet at Apsley
House, 1836, by William Salter,
3689-3769

VIVIAN, George (1798-1873)
Connoisseur

342,343c *See Groups:* The Fine
Arts Commissioners, 1846, by John
Partridge, **342** and **343(a-c)**

VIVIAN, John Henry (1785-1855)
MP for Swansea

54 *See Groups:* The House of Com-
mons, 1833, by Sir George Hayter

VIZARD, William (1774-1859)
Solicitor to Queen Caroline

999 *See Groups:* The Trial of
Queen Caroline, 1820, by Sir
George Hayter

VOYSEY, Charles Francis Annesley
(1857-1941) Architect

4404 *See Groups:* The St John's
Wood Arts Club, 1895, by Sydney
Prior Hall

4116 Chalk 41.3 x 29.5
$(16\frac{1}{4} \times 11\frac{5}{8})$
Harold Speed, signed, inscribed and
dated 1896
Given by the executors of Sir
W.Essex, 1959

5140 Canvas 48 x 39 (18$\frac{7}{8}$ x 15$\frac{3}{8}$)
Harold Speed, signed and dated 1905
Purchased, 1977

WADE, George (1673-1748)
Field-Marshal

1594 Canvas, oval 75.6 x 62.5
(29$\frac{3}{4}$ x 24$\frac{5}{8}$)
Attributed to Johann van Diest,
c.1731(?)
Purchased, 1911

Kerslake

WADE, George Edward
See ROBEY, Sir George

WAGHORN, Thomas (1800-50)
Pioneer of the overland route to
India

974 Canvas 76.2 x 63.5 (30 x 25)
Sir George Hayter
Bequeathed by Mrs Mary V.
Wheatley, 1895

Ormond

WAKE, William (1657-1737)
Archbishop of Canterbury

22 Canvas 124.5 x 100.3
(49 x 39½)
Unknown artist, c.1730(?)
Purchased, 1857

Piper

WAKEFIELD, Edward Gibbon
(1796-1862) Colonial statesman

1561 Miniature on ivory, oval
8.6 x 7 (3$\frac{3}{8}$ x 2$\frac{3}{4}$)
Unknown artist
Given by Mrs J. Storr, 1910

Ormond

WAKEFIELD, Robert

P120(29) *See Collections:*
Literary and Scientific Men, 1855,
by Maull & Polyblank, **P120(1-54)**

WALDEGRAVE, James Waldegrave,
1st Earl (1685-1741) Diplomat

1875 Pastel 69.2 x 54.3
(27¼ x 21$\frac{3}{8}$)
Unknown artist
Purchased, 1920

Kerslake

WALDEGRAVE, William Frederick
Waldegrave, 9th Earl (1851-1930)
Representative peer

1834(gg) *See Collections:* Members
of the House of Lords, c.1870-80,
by Frederick Sargent, **1834(a-z**
and **aa-hh)**

WALDEGRAVE, Granville
Augustus William, 3rd Baron
Radstock *See* RADSTOCK

WALE, Samuel (d.1786)
History painter

1437,1437a *See Groups:* The
Academicians of the Royal
Academy, 1771-2, by John Sanders
after Johan Zoffany

WALERAN, William Hood Walrond,
1st Baron (1849-1925)
Politician and sportsman

3279 Water-colour 31.4 x 18.4
(12$\frac{3}{8}$ x 7¼)
Liberio Prosperi, signed *Lib*
(*VF* 17 July 1886)
Purchased, 1934

WALEY, Arthur (1889-1966)
Poet and translator

4598 Pencil 29.8 x 24.1
(11¾ x 9½)
Rex Whistler, inscribed
Purchased, 1968

WALKER, Adam (1731-1821)
Inventor and writer

1106 *See Groups:* Adam Walker
and his family, by George Romney

WALKER, Adam John
Divine; second son of Adam Walker

1106 *See Groups:* Adam Walker
and his family, by George Romney

WALKER, David (1837-1917)
Surgeon and naturalist

922 Canvas 39.4 x 32.7
(15½ x 12⅞)
Stephen Pearce, exh 1860
Bequeathed by Lady Franklin,
1892
See Collections: Arctic Explorers,
1850-86, by Stephen Pearce,
905-24 and **1209-27**

Ormond

WALKER, Deane Franklin
(1778-1865) Astronomer;
youngest son of Adam Walker

1106 *See Groups:* Adam Walker
and his family, by George Romney

WALKER, Sir Edward (1612-77)
Garter King-at-Arms

1961 *See under* Charles I

WALKER, Eleanor
Wife of Adam Walker

1106 *See Groups:* Adam Walker
and his family, by George Romney

WALKER, Frederick (1840-75)
Painter and illustrator

P84 Photograph: albumen print
20.7 x 15.2 (8⅛ x 6)
David Wilkie Wynfield, 1860s
Purchased, 1929
See Collections: The St John's
Wood Clique, by David Wilkie
Wynfield, **P70-100**

1498 Water-colour 15.2 x 11.4
(6 x 4½)
Self-portrait, c.1865
Given by wish of Geoffrey Marks,
1939

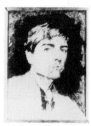

WALKER, George (1645?-90)
Soldier and divine

2038 Canvas 126.4 x 101
(49¾ x 39¾)
Unknown artist, inscribed
Given by Lady Ardilaun, 1924

Piper

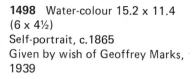

WALKER, George (1803-79)
Chess player and columnist

3060 *See Groups:* Chess
players, by A.Rosenbaum

WALKER, Sir George Townshend,
Bt (1764-1842) General

1914(16) Water-colour
16.8 x 15.9 (6⅝ x 6¼)
Thomas Heaphy
Purchased, 1921
See Collections: Peninsular and
Waterloo Officers, 1813-14, by
Thomas Heaphy, **1914(1-32)**

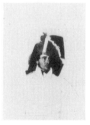

WALKER, Robert (1599-1658)
Painter

753 Canvas 73.7 x 61 (29 x 24)
Self-portrait
Purchased, 1886

WALKER, Thomas (1698-1744)
Actor

2202 *See Unknown Sitters III*

WALKER, William (1767?-1816)
Astronomer; eldest son of Adam
Walker

1106 *See Groups:* Adam Walker
and his family, by George Romney

WALL, Charles Baring (1795-1853)
MP for Guildford

54 *See Groups:* The House of Commons, 1833, by Sir George Hayter

WALLACE, Alfred Russel
(1823-1913) Naturalist

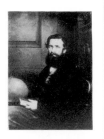

1765 Oil over a photograph
28.9 x 22.5 ($11\frac{3}{8}$ x $8\frac{7}{8}$)
Photograph by Thomas Sims,
c.1863-6
Given by the sitter's children,
W.G. and Violet Wallace, 1916

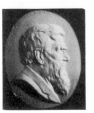

1764 Plaster cast of medallion,
oval 27.9 x 23.2 (11 x $9\frac{1}{8}$)
Albert Bruce-Joy, inscribed and
dated 1906
Given by the sitter's children, W.G.
and Violet Wallace, 1916

WALLACE, Sir Richard, Bt
(1818--90)
Connoisseur and collector

1833 *See Groups:* Private View of
the Old Masters Exhibition, Royal
Academy, 1888, by Henry Jamyn
Brooks

WALLER, Edmund (1606-87)
Poet

4494 Plumbago on vellum, oval
14 x 11.1 ($5\frac{1}{2}$ x $4\frac{3}{8}$)
David Loggan, signed and dated
1685
Purchased, 1966

144 Canvas, feigned oval
52.1 x 40.6 (20½ x 16)
After John Riley (c.1685)
Purchased, 1862

Piper

WALLER, Sir William (1597-1668)
Parliamentary general

2108 Canvas 69.9 x 59.1
(27½ x 23¼)
Unknown artist, inscribed
Purchased, 1925

577 *See Unknown Sitters II*

Piper

WALLIS, John (1616-1703)
Mathematician

639 Line engraving 24.1 x 18.4
(9½ x 7¼)
David Loggan, signed, inscribed and
dated 1678 on plate
Purchased, 1881

578 Canvas, feigned oval
74.9 x 62.9 (29½ x 24¾)
After Sir Godfrey Kneller (1701)
Transferred from BM, 1879

Piper

WALLOP, Isaac Newton, 5th Earl
of Portsmouth *See* PORTSMOUTH

WALLOP, Newton, 6th Earl of
Portsmouth *See* PORTSMOUTH

WALPOLE of Wolterton, Horatio
Walpole, 1st Baron (1678-1757)
Diplomat

1535 *See Unknown Sitters III*

WALPOLE, George, 3rd Earl of
Orford *See* ORFORD

WALPOLE, Horace, 4th Earl of
Orford *See* ORFORD

WALPOLE, Sir Hugh (1884-1941)
Novelist

4529(377,378) *See Collections:*
Working drawings by Sir David
Low, **4529(1-401)**

Continued overleaf

4282 Bronze cast of head 39.4 (15½) high
David Evans, incised and dated 1929
Given by the artist's widow, 1962

3841 Canvas 74.3 x 62.2 (29¼ x 24½)
Stephen Bone, signed
Given by the sitter's sister and brother, Dorothea and Robert Henry Walpole, 1952

WALPOLE, Robert, 1st Earl of Orford *See* ORFORD

WALPOLE, Sir Spencer (1839-1907)
Historian and civil servant; son of Spencer Horatio Walpole

3632 Chalk 51.4 x 40 (20¼ x 15¾)
Hugh Goldwin Riviere, c.1903
Given by the sitter's daughter, Mrs Maud C.Holland, 1948

WALPOLE, Spencer Horatio (1806-98) Politician

4893 *See Groups:* The Derby Cabinet of 1867, by Henry Gales

2745 Water-colour 30.5 x 18.1 (12 x $7\frac{1}{8}$)
Adriano Cecioni
(*VF* 10 Feb 1872)
Purchased, 1934

5215 Plaster relief 25.4 (10) diameter
Conrad Dressler, incised and dated 1882
Purchased, 1978

WALROND, William Hood, 1st Baron Waleran *See* WALERAN

WALSH, William (1663-1708)
Poet and critic

3232 Canvas 91.4 x 71.1 (36 x 28)
Sir Godfrey Kneller, c.1708
Kit-cat Club portrait
Given by NACF, 1945.
Beningbrough

Piper

WALSH, William J. (1841-1921)
Roman Catholic Archbishop of Dublin

2229 *See Collections:* The Parnell Commission, 1888-9, by Sydney Prior Hall, **2229-72**

WALSINGHAM, Thomas de Grey, 6th Baron (1843-1919)
Natural historian and sportsman

4636 Water-colour 32.4 x 17.5 (12¾ x $6\frac{7}{8}$)
Théobald Chartran, signed .*T*.
(*VF* 9 Sept 1882)
Purchased, 1968

WALSINGHAM, Sir Francis (1530-90) Statesman

1807 Panel 76.2 x 63.5 (30 x 25)
Attributed to John de Critz the Elder
Purchased, 1917

1704 Panel 37.5 x 29.8
(14¾ x 11¾)
After John de Critz the Elder(?)
Purchased, 1913. *Montacute*

Strong

WALSINGHAM, Ursula, Lady
(d.1602)
Second wife of Sir Francis
Walsingham

1705 *See Unknown Sitters I*

WALTER, Bruno (1876-1962)
Conductor

5040(1) *See Collections:* Studies
for portraits of Kathleen Ferrier
singing, by Bernard Dunstan,
5040(1-8)

WALTER, John (1776-1847)
Chief proprietor of *The Times*

54 *See Groups:* The House of Com-
mons, 1833, by Sir George Hayter

WALTON, Izaak (1593-1683)
Author of *The Compleat Angler*

1168 Canvas 77.5 x 64.8
(30½ x 25½)
Jacob Huysmans, signed with
initials and inscribed, c.1672
Transferred from Tate Gallery, 1957

Piper

WALTON, Sir William (b.1902)
Composer

P55 Photograph: bromide print
28.9 x 23.8 ($11\frac{3}{8}$ x $9\frac{3}{8}$)
Sir Cecil Beaton, 1926
Purchased, 1978

4640 Pencil 27.9 x 23.5 (11 x 9¼)
Rex Whistler, signed, inscribed and
dated 1929
Given by Sir Osbert Sitwell, Bt, 1968

5138 Canvas 61.3 x 91.5
($24\frac{1}{8}$ x 36)
Michael Ayrton, signed, 1948
Purchased, 1977

WANDESFORDE, Christopher
(1592-1640)
Lord Deputy of Ireland

2407 *See Collections:* Copies of
early portraits, by George Perfect
Harding and Sylvester Harding,
1492,1492(a-c) and **2394-2419**

WANLEY, Humphrey (1672-1726)
Librarian and antiquary

579 Canvas, feigned oval
76.2 x 63.5 (30 x 25)
Thomas Hill, inscribed and dated
1717
Transferred from BM, 1879

Piper

WANTAGE, Robert Loyd-Lindsay,
Baron (1832-1901)
Soldier and politician

1833 *See Groups:* Private View of
the Old Masters Exhibition, Royal
Academy, 1888, by Henry Jamyn
Brooks

WANTAGE, Harriet Sarah, Lady
(1837-1920)
Writer; wife of Baron Wantage

1833 *See Groups:* Private View of
the Old Masters Exhibition, Royal
Academy, 1888, by Henry Jamyn
Brooks

WARBURTON, Henry (1785-1858)
Philosophical radical

54 *See Groups:* The House of Com-
mons, 1833, by Sir George Hayter

WARBURTON, William
(1698-1779) Bishop of
Gloucester, critic and writer

23 Canvas 125.4 x 100.3
(49⅜ x 39½)
Charles Philips, inscribed, c.1737
Purchased, 1857

Kerslake

WARD, Barbara *See* JACKSON
of Lodsworth, Baroness

WARD, Edward Matthew (1816-79)
History painter

2072 Chalk 61 x 46.4 (24 x 18¼)
George Richmond, signed and
dated 1859
Bequeathed by the sitter's widow,
1924

3182(10) *See Collections:*
Drawings of Artists, c.1862, by
Charles West Cope, **3182(1-19)**

2746 Water-colour 30.5 x 17.1
(12 x 6¾)
Sir Leslie Ward (his son), signed *Spy*
(*VF* 20 Dec 1873)
Purchased, 1934

WARD, Sir Henry George
(1797-1860) Colonial governor

54 *See Groups:* The House of Com-
mons, 1833, by Sir George Hayter

WARD, Humphry (1845-1926)
Journalist and writer

1833 *See Groups:* Private View of
the Old Masters Exhibition, Royal
Academy, 1888, by Henry Jamyn
Brooks

WARD, James (1769-1859)
Engraver and painter of animals

1684 Panel 53.3 x 41.9 (21 x 16½)
Self-portrait, signed with initials
and dated 1834
Given by F.A.White, 1912

309 Canvas 61.6 x 52.7
(24¼ x 20¾)
Self-portrait, inscribed and dated
1848
Given by the sitter's son,
G.R.Ward, 1870

WARD, John (1679?-1758)
Biographer and antiquary

590 Canvas 59.7 x 47.6
(23½ x 18¾)
Unknown artist
Transferred from BM, 1879

Kerslake

WARD, Sir Joseph, Bt (1856-1931)
Prime Minister of New Zealand

2640 Canvas 74.9 x 62.2
(29½ x 24½)
Sir William Orpen, signed, 1919
Given by Viscount Wakefield, 1933

WARD, Sir Leslie (1851-1922)
'Spy'; caricaturist; son of Edward
Matthew Ward

3007 Water-colour 31.8 x 18.4
(12½ x 7¼)
Jean de Paleologu, signed *PAL*
(*VF* 23 Nov 1889)
Purchased, 1938

WARD, Mary Augusta (1851-1920)
Mrs Humphry Ward; novelist

P69 Photograph: albumen print
13 x 11.4 (5⅛ x 4½)
Charles Lutwidge Dodgson, 1872
Purchased, 1978

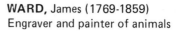

2650 Canvas 44.5 x 35.6
(17½ x 14)
Julian Russell Story, signed and
dated 1889
Given by the sitter's daughter, Miss
Dorothy Ward, 1934

WARD, Nathaniel

P120(30) *See Collections:* Literary
and Scientific Men, 1855, Maull &
Polyblank, **P120(1-54)**

WARD, Nathaniel Bagshaw
(1791-1868) Botanist

P106(18) Photograph: albumen
print, arched top 20 x 14.6
($7\frac{7}{8}$ x 5¾)
Maull & Polyblank, c.1855
Purchased, 1978
See Collections: Literary and
Scientific Portrait Club, by Maull &
Polyblank, **P106(1-20)**

WARD, Seth (1617-89)
Bishop of Salisbury

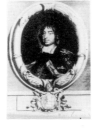

644 Line engraving 36.8 x 25.7
(14½ x $10\frac{1}{8}$)
David Loggan, signed, inscribed,
and dated 1678 on plate
Purchased, 1881

WARDLE, Gwyllym Lloyd
(1762?-1833)
Soldier and politician

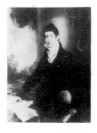

4265 Canvas 46.4 x 36.2
(18¼ x 14¼)
Arthur William Devis, inscribed,
1809
Purchased, 1962

WARE, Isaac (c.1707?-66)
Architect

4982 Marble bust 50.5 ($19\frac{7}{8}$) high
Louis François Roubiliac, c.1741
Purchased with help from NACF,
1974 . *Beningbrough*

Kerslake

WARHAM, William (1450?-1532)
Archbishop of Canterbury

2094 Panel 82.2 x 66.3 ($32\frac{3}{8}$ x $26\frac{1}{8}$)
After Hans Holbein, inscribed
(1527)
Given by Viscount Dillon in
memory of Julia, Viscountess
Dillon, 1925

Strong

WARLOCK, Peter
See HESELTINE, Philip Arnold

WARREN, Edward R.

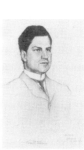

2927A Chalk 41.6 x 26.7
($16\frac{3}{8}$ x 10½)
William Strang, signed, inscribed
and dated 1904
Purchased, 1937

WARREN, Sir Peter (1703-52)
Vice-Admiral

5158 Canvas 135.9 x 132.1
(53½ x 52)
Thomas Hudson, c.1747
Given by D.M.McDonald, 1977.
Beningbrough

WARREN, Samuel (1807-77)
Lawyer and novelist

1441 Canvas 91.4 x 70.8
(36 x $27\frac{7}{8}$)
Attributed to John Linnell,
c.1835-40
Purchased, 1906

Ormond

WARTER, Edith May (1804-71)
Daughter of Robert Southey;
married John Wood Warter

4029 *See under* Sara Coleridge

WARTON, Charles Nicholas
(b.1832) Politician

3271 Water-colour 30.8 x 18.1
($12\frac{1}{8}$ x $7\frac{1}{8}$)
Carlo Pellegrini, inscribed
(*VF* 10 May 1884)
Purchased, 1934

WARWICK, Guy Dudley, Earl of

2491 *See Unknown Sitters I*

WARWICK, Henry Richard Greville,
3rd Earl of (1779-1853)

999 *See Groups:* The Trial of
Queen Caroline, 1820, by Sir
George Hayter

WASHINGTON, George (1732-99)
First President of USA

2903 Pastel, oval 24.1 x 19.1
(9½ x 7½)
After James Sharples
Given by T.H.Russell and Mrs
Alexander Scott, 1936

174 Pastel 21.6 x 16.5 (8½ x 6½)
After James Sharples
Given by James Yates, 1864

2041 Canvas 73 x 60.3
(28¾ x 23¾)
Gilbert Stuart, replica
Given by Edward S.Harkness,
1924

774 Canvas 71.1 x 49.5 (28 x 19½)
After Gilbert Stuart, reduced copy
(1797)
Purchased, 1887

WATERFORD, Louisa (Stuart),
Marchioness of (1818-91)
Artist and illustrator

3176 Canvas 90.2 x 57.2
(35½ x 22½)
Sir Francis Grant
Purchased, 1944

WATERLOW, Sir Ernest Albert
(1850-1919)
Landscape and animal painter

4405 *See Groups:* Primrose Hill
School, 1893, by an unknown
artist

WATERS, Sir John (1774-1842)
Major-General

3765 *See Collections:* Studies for
The Waterloo Banquet at Apsley
House, 1836, by William Salter,
3689-3769

WATERTON, Charles (1782-1865)
Naturalist

2014 Canvas 61.3 x 51.4
($24\frac{1}{8}$ x 20¼)
Charles Willson Peale, inscribed and
dated 1824 on reverse
Purchased, 1924

1621 Pen and ink 7.9 x 9.8
($3\frac{1}{8}$ x $3\frac{7}{8}$)
Percy Fitzgerald, inscribed, 1860
Given by the artist, 1911

Ormond

WATKINS, John Lloyd Vaughan
(1802-65) MP for Brecon

54 *See Groups:* The House of Com-
mons, 1833, by Sir George Hayter

WATSON, Miss

P6(221) *See Collections:* The Hill
and Adamson Albums, 1843-8, by
David Octavius Hill and Robert
Adamson, **P6(1-258)**

WATSON, John Dawson (1832-92)
Artist

P85 Photograph: albumen print
21 x 16.2 (8¼ x 6⅜)
David Wilkie Wynfield, 1860s
Purchased, 1929
See Collections: The St John's
Wood Clique, by David Wilkie
Wynfield, **P70-100**

WATSON, Mary (née Hill)
Sister of David Octavius Hill

P6(106) *See Collections:* The Hill
and Adamson Albums, 1843-8, by
David Octavius Hill and Robert
Adamson, **P6(1-258)**

WATSON, Richard (1737-1816)
Cleric and chemist

1075a and **b** *See Groups:* Men of
Science Living in 1807-8, by Sir
John Gilbert and others

WATSON, Richard (1800-52)
MP for Canterbury

54 *See Groups:* The House of Commons, 1833, by Sir George Hayter

WATSON, Sir William (1858-1935)
Poet and critic

3839 Canvas 87 x 63.5 (34¼ x 25)
Reginald Grenville Eves, signed and
dated 192(9?)
Purchased, 1952

WATSON-WENTWORTH, Charles,
2nd Marquess of Rockingham
See ROCKINGHAM

WATT, James (1736-1819)
Engineer

186a Canvas 125.7 x 100.3
(49½ x 39½)
Carl Frederik von Breda, signed
and dated 1792
Given by M.P. Watt Boulton, 1865

183 Wax medallion 9.5 (3¾)
diameter
Peter Rouw, 1802
Purchased, 1864

1075, 1075a and **b** *See Groups:*
Men of Science Living in 1807-8,
by Sir John Gilbert and others

663 Panel 19.1 x 14.6 (7½ x 5¾)
Henry Howard
Given by Sir Theodore Martin, 1882

WATTS, Alaric Alexander
(1797-1864) Poet and journalist

2515(51) Chalk 37.8 x 28.2
(14⅞ x 11⅛)
William Brockedon, dated 1825
Lent by NG, 1959
See Collections: Drawings of
Prominent People, 1823-49, by
William Brockedon, **2515(1-104)**

Ormond

WATTS, George Frederic
(1817-1904) Painter

1378 Canvas 90.2 x 64.1
(35½ x 25¼)
Henry Wyndham Phillips
Given by Henry Wagner, 1904

P68 Photograph: albumen print
20.6 x 13.6 (8⅛ x 5⅜)
James Soame, inscribed and dated
1858 on back of mount
Purchased, 1978

Continued overleaf

5087 Panel 61 x 50.2 (24 x 19¾)
Self-portrait, c.1860
Purchased, 1976

P96 Photograph: albumen print
21.3 x 16.2 (8⅜ x 6⅜)
David Wilkie Wynfield, 1860s
Given by H.Saxe Wyndham, 1937
See Collections: The St John's
Wood Clique, by David Wilkie
Wynfield, **P70-100**

P86 *See Collections:* The St John's
Wood Clique, by David Wilkie
Wynfield, **P70-100**

P18(38) Photograph: albumen
print 26 x 20.6 (10¼ x 8⅛)
Julia Margaret Cameron, inscribed
on mount, 1864
Purchased with help from public
appeal, 1975
See Collections: The Herschel
Album, by Julia Margaret Cameron,
P18(1-92b)

P18(8,9) *See Collections:* The
Herschel Album, by Julia Margaret
Cameron, **P18(1-92b)**

P125 Photograph: albumen print
25.4 x 19.7 (10 x 7¾)
Julia Margaret Cameron, c.1863-8
Given by H.Saxe Wyndham, 1939

1406 Canvas 63.5 x 50.8 (25 x 20)
Self-portrait, c.1879
Given by his executors, 1905

1833 *See Groups:* Private View
of the Old Masters Exhibition,
Royal Academy, 1888, by Henry
Jamyn Brooks

5223 Canvas 91.4 x 72.4
(36 x 28½)
Louis Deuchars after a photograph
of 1897 by George Andrews, signed
Purchased, 1978

1980 Bronze medal 9.5 (3¾)
diameter
Sir Charles Holroyd, inscribed,
c.1897
Given by the artist's widow, 1923

2480 Bronze statuette 58.4 (23)
high
Henry Poole
Purchased, 1930

WATTS, Isaac (1674-1748)
Hymn writer

640 Mezzotint, feigned oval
35.2 x 24.8 (13⅞ x 9¾)
George White, signed, inscribed
and dated 1727 on plate
Purchased, 1881

264 Canvas, feigned oval
74.3 x 64.1 (29¼ x 25¼)
Unknown artist
Purchased, 1868

Kerslake

WATTS-DUNTON, Theodore
(1832-1914)
Critic, novelist and poet

4888 Pastel 63.8 x 54.6
(25⅛ x 21½)
Dante Gabriel Rossetti, signed
in monogram and dated 1874
Given by the sitter's nieces, the
Misses Watts, 1972

3022 *See under* Dante Gabriel Rossetti

WAUGH, Benjamin (1839-1908)
Philanthropist

3909 Canvas 36.8 x 31.8
(14½ x 12½)
Edna Clarke, Lady Hall (his daughter)
Given by the artist, 1954

WAUGH, Evelyn (1903-66)
Writer

P14 Photograph: bromide print
38.7 x 29.5 (15¼ x 11⅝)
Felix H.Man, c.1943
Given by the photographer, 1975
See Collections: Prominent men,
c.1938-43, by Felix H.Man,
P10-17

5218 *See Unknown Sitters IV*

WAVERLEY, John Anderson,
1st Viscount (1882-1958)
Administrator and statesman

5025 Chalk 61 x 45.1 (24 x 17¾)
Augustus John, signed and dated
1944
Bequeathed by the sitter's widow,
Ava, Viscountess Waverley, 1975

WAVERLEY, Ava, Viscountess
(1895-1974) Second wife of
1st Viscount Waverley

5026 Panel 30.5 x 24.8 (12 x 9¾)
Napoleone Parisani, signed in
monogram and dated 1902
Bequeathed by the sitter, 1975

WAYLETT, Harriet (1798-1851)
Actress

3097(9) *See Collections:*
Caricatures, c.1825-c.1835, by Sir
Edwin Landseer, **3097(1-10)**

WEBB, Sir Aston (1849-1930)
Architect and PRA

2489 Canvas 90.2 x 72.4
(35½ x 28½)
Solomon Joseph Solomon, signed
in monogram, c.1906
Given by the sitter's son and
daughter, 1931

WEBB, Martha Beatrice, Lady
Passfield *See* PASSFIELD

WEBB, Matthew (1848-83)
Swimmer

4751 Water-colour 30.5 x 17.8
(12 x 7)
Carlo Pellegrini, signed *Ape*
(*VF* 9 Oct 1875)
Purchased, 1970

WEBB, Philip Barker (1793-1854)
Botanist and traveller

4327 Canvas 38.1 x 26.7
(15 x 10½)
Lalogero di Bernardis, signed and
dated 1820
Purchased, 1963

Ormond

WEBB, Philip Speakman
(1831-1915) Architect

4310 Wash 31.4 x 25.4
(12⅜ x 10)
Charles Fairfax Murray, signed,
inscribed and dated 1873
Given by wish of Sir Sydney
Cockerell, 1963

WEBB, Richard D.
Slavery abolitionist

599 *See Groups:* The Anti-Slavery
Society Convention, 1840, by
Benjamin Robert Haydon

WEBB, Sidney, Baron Passfield
See PASSFIELD

WEBSTER, Jane (née Binny)

P6(109, 111, 117, 122)
See Collections: The Hill and
Adamson Albums, 1843-8, by
David Octavius Hill and Robert
Adamson, **P6(1-258)**

WEBSTER, Richard Everard,
Viscount Alverstone
See ALVERSTONE

WEBSTER, Thomas (1800-86)
Painter and etcher

2879 Pencil 12.4 x 8.6 (4$\frac{7}{8}$ x 3$\frac{3}{8}$)
Edward Matthew Ward, inscribed
and dated 1862
Given by Walter Bennett, 1936

Ormond

WEDDERBURN, Alexander, 1st
Earl of Rosslyn *See* ROSSLYN

WEDGWOOD, Ernest Hensleigh

1841B *See Groups:* Four men at
cards, by Fred Walker

WEDGWOOD, Josiah (1730-95)
Potter

1948 Wedgwood medallion, oval
12.7 x 10.2 (5 x 4)
William Hackwood, modern cast
(1779)
Given by Josiah Wedgwood & Sons,
1922

WELCH, Maurice Denton (1915-48)
Novelist and painter

4080 Hardboard 47.6 x 40.3
(18¾ x 15$\frac{7}{8}$)
Self-portrait
Given by subscribers, 1958

WELD, Thomas (1773-1837)
Cardinal

5260 Pencil 14.6 x 12.4 (5¾ x 4$\frac{7}{8}$)
George Jones, inscribed and dated
1830
Purchased, 1979

WELD-FORESTER, George Cecil
Weld, 3rd Baron Forester
See FORESTER

WELLDON, James Edward Cowell
(1854-1937) Divine; headmaster
of Dulwich College and Harrow

2347 *See Collections:*
Miscellaneous drawings . . . by
Sydney Prior Hall, **2282-2348** and
2370-90

WELLESLEY, Richard Colley
Wellesley, Marquess (1760-1842)
Governor-General of India;
brother of Wellington

745 *See Groups:* William Pitt
addressing the House of Commons
. . . 1793, by Karl Anton Hickel

992 Marble bust 62.2 (24½) high
John Bacon the Younger, incised
Transferred from Tate Gallery, 1957

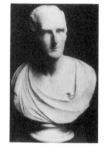

847 Water-colour 20.3 x 16.5
(8 x 6½)
J.Pain Davis
Given by the executors of the
artist's widow, 1900

846 Canvas 51.4 x 40.6 (20¼ x 16)
J.Pain Davis
Bequeathed by the artist's widow,
1900

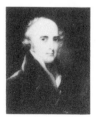

WELLESLEY, Arthur, 1st Duke of
Wellington *See* WELLINGTON

WELLESLEY, Frederick Arthur (1844-1931) Soldier and diplomat

4752 Water-colour 30.8 x 18.1 ($12\frac{1}{8}$ x $7\frac{1}{8}$)
Carlo Pellegrini, signed *Ape* (*VF* 25 May 1878)
Purchased, 1970

WELLESLEY-POLE, William, 3rd Earl of Mornington
See MORNINGTON

WELLINGTON, Arthur Wellesley, 1st Duke of (1769-1852)
Field-Marshal and Prime Minister

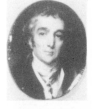

741 Miniature on ivory 8.6 x 6.7 ($3\frac{3}{8}$ x $2\frac{5}{8}$)
Unknown artist, 1804
Given by Edward Cock, 1885

1471 Canvas 74.9 x 62.2 (29½ x 24½)
Robert Home, 1804-6
Transferred from Tate Gallery, 1957

4176 Water-colour 57.2 x 40.6 (22½ x 16)
Thomas Heaphy, c.1813
Given by Edward Peter Jones, 1960

1914(17,18) *See Collections:* Peninsular and Waterloo Officers, 1813-14, by Thomas Heaphy, **1914(1-32)**

308 Water-colour 33 x 24.8 (13 x 9¾)
Juan Bauzil, eng 1817
Given by William Smith, 1870

4670 Chalk on canvas 63.5 x 52.1 (25 x 10½)
Sir Thomas Lawrence, c.1820
Purchased, 1969

999 *See Groups:* The Trial of Queen Caroline, 1820, by Sir George Hayter

L152(35) Enamel miniature, oval 5.1 x 4.1 (2 x $1\frac{5}{8}$)
Henry Pierce Bone after Sir Thomas Lawrence, signed and dated 1845 on reverse, reduced copy (exh 1822)
Lent by NG (Alan Evans Bequest), 1975

1614 Canvas 125.7 x 100.3 (49½ x 39½)
John Jackson, c.1827
Purchased, 1911

54 *See Groups:* The House of Commons, 1833, by Sir George Hayter

2789 *See Groups:* Members of the House of Lords, c.1835, attributed to Isaac Robert Cruikshank

3766 *See Collections:* Studies for The Waterloo Banquet at Apsley House, 1836, by William Salter, **3689-3769**

L152(3) Canvas 76.2 x 63.5 (30 x 25)
Benjamin Robert Haydon, 1839
Lent by NG (Alan Evans Bequest), 1974. (A companion portrait of Napoleon Bonaparte by Haydon is no.**L152(4)**)

316a(127-40) *See Collections:* Preliminary drawings for busts and statues by Sir Francis Chantrey, **316a(1-202)**

Continued overleaf

405 Canvas 135.2 x 104.1
(53¼ x 41)
Alfred, Count D'Orsay, signed and
dated 1845
Bequeathed by Charles Vickers,
1875

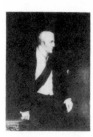

218 Marble bust 78.7 (31) high
John Francis, incised and dated
1852
Purchased, 1866

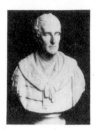

2667 Pencil 19.7 x 32.4
(7¾ x 12¾)
Thomas Milnes
Given by Francis Wellesley, 1931

2155a Plaster cast of death-mask
23.8 (9⅜) long
Unknown artist
Given by Sir Herbert Richmond,
1927

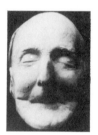

WELLINGTON, Henry Wellesley,
3rd Duke of (1846-1900)
Soldier and politician

4630 Water-colour 31.1 x 18.4
(12¼ x 7¼)
Carlo Pellegrini, signed *Ape*
(*VF* 3 Jan 1885)
Purchased, 1968

WELLS, Henry Tanworth
(1828-1903) Portrait painter

2820 *See Groups:* The Royal
Academy Conversazione, 1891, by
G.Grenville Manton

WELLS, Herbert George
(1866-1946) Writer

4644 Pencil 40.3 x 31.1
(15⅞ x 12¼)
Sir William Rothenstein, signed
and dated 1912
Given by the Rothenstein Memorial
Trust, 1968

5071 Charcoal and wash 27 x 17.1
(10⅝ x 6¾)
Claud Lovat Fraser, signed and
inscribed
Purchased, 1976

2055 *See Collections:* Medallions
of Writers, c.1922, by Theodore
Spicer-Simson, **2043-55**

4529(384,385) *See Collections:*
Working drawings by Sir David Low,
4529(1-401)

5224(2,3) *See Collections:*
Cartoons, c.1928-c.1936, by Robert
Stewart Sherriffs, **5224(1-8)**

WELSH, David (1793-1845)
Scottish divine and writer

P6(14) Photograph: calotype
14.6 x 11.4 (5¾ x 4½)
David Octavius Hill and Robert
Adamson, 1843-5
Given by an anonymous donor,
1973
See Collections: The Hill and
Adamson Albums, 1843-8, by
David Octavius Hill and Robert
Adamson, **P6(1-258)**

P6(104) *See Collections:* The Hill
and Adamson Albums, 1843-8, by
David Octavius Hill and Robert
Adamson, **P6(1-258)**

WEMYSS, Francis Wemyss-Charteris-Douglas, 10th Earl of (1818-1914) Politician

P6(17) Photograph: calotype 20.2 x 14.9 (8 x 5⅞)
David Octavius Hill and Robert Adamson, 1843-8
Given by an anonymous donor, 1973
See Collections: The Hill and Adamson Albums, 1843-8, by David Octavius Hill and Robert Adamson, **P6(1-258)**

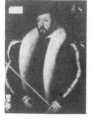

WEMYSS, Rosslyn Erskine, Baron Wester Wemyss
See WESTER WEMYSS

WENLOCK, Beilby Lawley, 3rd Baron (1849-1912)
Governor of Madras

2971 Water-colour 39.1 x 27.9 (15⅜ x 11)
Signed *Bint*
(*VF* 28 Jan 1893)
Purchased, 1938

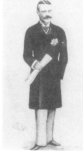

WENSLEYDALE, James Parke, 1st Baron (1782-1868) Judge

1695(h) *See Collections:* Sketches for The Trial of Queen Caroline, 1820, by Sir George Hayter, **1695(a-x)**

999 *See Groups:* The Trial of Queen Caroline, 1820, by Sir George Hayter

2028 Pencil 22.5 x 17.1 (8⅞ x 6¾)
George Howard, 9th Earl of Carlisle (his grandson), c.1863
Given by the sitter's grandson, Viscount Ullswater, 1924

Ormond

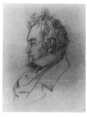

WENTWORTH, Thomas Wentworth, 1st Baron (1501-51)
Lord Chamberlain

1851 Panel 77.1 x 73.4 (30⅜ x 28⅞)
Attributed to John Bettes, inscribed, 1549
Purchased, 1919

Strong

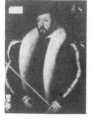

WENTWORTH, Thomas Wentworth, 2nd Baron (1525-84)
Last Captain of Calais

1852 Panel 99.1 x 72.1 (39 x 28⅜)
Attributed to Steven van der Meulen, inscribed and dated 1568
Purchased, 1919. *Montacute*

Strong

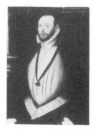

WENTWORTH, Thomas, 1st Earl of Strafford *See* STRAFFORD

WENTWORTH, William Charles (1793-1872) Advocate of colonial self-government

1671 Bronze cast of medallion 7.6 (3) diameter
Thomas Woolner, incised, c.1854
Purchased, 1912

Ormond

WESKER, Arnold (b.1912)
Playwright

4529(386-9) *See Collections:* Working drawings by Sir David Low, **4529(1-401)**

WESLEY, John (1703-91)
Methodist leader

135 Canvas 125.7 x 99.7 (49½ x 39¼)
Nathaniel Hone, c.1766
Purchased, 1861

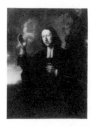

Continued overleaf

317 Canvas 128 x 101.9
(50⅜ x 40⅛)
William Hamilton, signed and
dated 1788
Given by James Milbourne, 1871

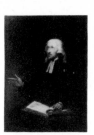

2366 Canvas 74.9 x 62.9
(29½ x 24¾)
After George Romney (1789)
Bequeathed by Miss Mary Stringer
Rowe, 1929

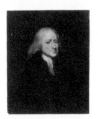

271 Marble bust 50.8 (20) high
Unknown artist
Purchased, 1868

Kerslake

WESLEY, Samuel (1766-1837)
Composer and organist; nephew of
John Wesley

2040 Canvas 57.8 x 47.6
(22¾ x 18¾)
John Jackson
Purchased, 1924

WEST, Sir Algernon Edward
(1832-1921) Chairman of the
Board of Inland Revenue

2986 Water-colour 35.3 x 24.1
(13⅞ x 9½)
Sir Leslie Ward, signed *Spy*
(*VF* 13 Aug 1892)
Purchased, 1938

WEST, Benjamin (1738-1820)
History painter and PRA

1649 Chalk 41.9 x 31.8
(16½ x 12½)
Angelica Kauffmann, signed,
inscribed and dated 1763
Given by Percy Fitzgerald, 1912

1437, 1437a *See Groups:* The
Academicians of the Royal
Academy, 1771-2, by John Sanders
after Johan Zoffany

L152(2) Copper, oval 21.6 x 17.8
(8½ x 7)
John Downman, inscribed
Lent by NG (Alan Evans Bequest),
1974

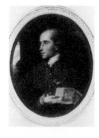

349 Canvas 90.2 x 69.9
(35½ x 27½)
Gilbert Stuart, inscribed, 1786
Purchased, 1872

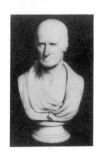

607 Marble bust 64.8 (25½) high
Sir Francis Chantrey, incised and
dated 1818
Purchased, 1880

1456(26) Pencil 17.1 x 14.3
(6¾ x 5⅝)
Charles Hutton Lear, inscribed
Given by John Elliot, 1907
See Collections: Drawings of
Artists, c.1845, by Charles Hutton
Lear, **1456(1-27)**

WEST, Richard (d.1726)
Lawyer and playwright

17 Canvas 127 x 101.6 (50 x 40)
Attributed to Jonathan Richardson,
c.1725
Purchased, 1857

Piper

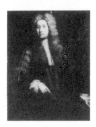

WEST, Robert (d.1770)
Irish painter

2169 *See under* Matthew William Peters

WEST, Mrs W.

1962(i) *See Collections:* Opera singers and others, c.1804-c.1836, by Alfred Edward Chalon, **1962(a-l)**

WESTBURY, Richard Bethell, 1st Baron (1800-73)
Lord Chancellor

1941 Canvas 61.9 x 49.9 (24$\frac{3}{8}$ x 19$\frac{5}{8}$)
Michele Gordigiani
Purchased, 1922

Ormond

WESTER WEMYSS, Rosslyn Erskine Wemyss, Baron (1864-1933)
Admiral of the Fleet

1913 *See Groups:* Naval Officers of World War I, by Sir Arthur Stockdale Cope

4182 Canvas 91.4 x 76.2 (36 x 30)
Sir William Orpen, signed, 1919
Given by wish of Viscount Wakefield, 1960

WESTLAKE, John (1828-1913)
Jurist

4847 Panel 33.7 x 26 (13¼ x 10¼)
Alice Westlake (his wife), c.1896-7
Acquired, 1971

1890 Panel 19.1 x 13.3 (7½ x 5¼)
Marianne Stokes, signed with initials and dated 1902
Given by the sitter's widow, 1920

WESTMACOTT, Sir Richard (1775-1856) Sculptor

731 Chalk 22.2 x 17.1 (8¾ x 6¾)
Charles Benazech
Given by wish of the sitter's daughter, Miss Louisa Margaret Westmacott, 1884

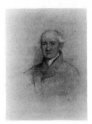

2515(95) Chalk and pencil 36.2 x 26.7 (14¼ x 10½)
William Brockedon, dated 1844
Lent by NG, 1959
See Collections: Drawings of Prominent People, 1823-49, by William Brockedon, **2515(1-104)**

1456(27) *See Collections:* Drawings of Artists, c.1845, by Charles Hutton Lear, **1456(1-27)**

WESTMACOTT, Richard (1799-1872) Sculptor; son of Sir Richard Westmacott

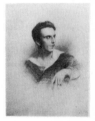

3944(4) Pencil 24.1 x 18.4 (9½ x 7¼)
John Partridge, signed and dated 1825
Purchased, 1955
See Collections: Artists, 1825, by John Partridge and others, **3994(1-55)**

4026(59) *See Collections:* Drawings of Men about Town, 1832-48, by Alfred, Count D'Orsay, **4026(1-61)**

Ormond

WESTMINSTER, Robert Grosvenor, 1st Marquess of (1767-1845)
Patron of art and the turf

999 *See Groups:* The Trial of Queen Caroline, 1820, by Sir George Hayter

794 *See Groups:* Four studies for Patrons and Lovers of Art, c.1826, by Pieter Christoph Wonder, **792-5**

Continued overleaf

316a(60) Pencil, two sketches
44.8 x 58.4 (17⅝ x 23)
Sir Francis Chantrey, inscribed
Given by Mrs George Jones, 1871

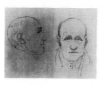

and

316a(61) Pencil, two sketches
42.2 x 59.1 (16⅝ x 23¼)
Sir Francis Chantrey, inscribed
Given by Mrs George Jones, 1871
See Collections: Preliminary
drawings for busts and statues by
Sir Francis Chantrey, **316a(1-202)**

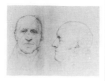

WESTMORLAND, John Fane,
10th Earl of (1759-1841)
Lord-Lieutenant of Ireland

999 *See Groups:* The Trial of
Queen Caroline, 1820, by Sir
George Hayter

WESTMORLAND, John Fane,
11th Earl of (1784-1859)
Soldier, diplomat and musician

3886 Pencil and wash 22.9 x 16.8
(9 x 6⅝)
After Sir Thomas Lawrence
Purchased, 1953

WESTON, Dame Agnes Elizabeth
(1840-1918)
Nautical philanthropist

4437 Board, oval 50.2 x 40.6
(19¾ x 16)
Unknown artist
Given by the sitter's great-nephew,
Robert Wyndham Ketton-Cremer,
1965

WESTON, Richard, 1st Earl of
Portland *See* PORTLAND

WEYLAND, Richard (1780-1864)
MP for Oxfordshire

54 *See Groups:* The House of Com-
mons, 1833, by Sir George Hayter

WEYMOUTH, Sir Thomas Thynne,
1st Viscount (1640-1714)
Statesman

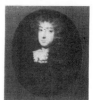

L152(17) Miniature on vellum,
oval 5.7 x 4.8 (2¼ x 1⅞)
Attributed to Nicholas Dixon
after Sir Peter Lely, reduced copy
Lent by NG (Alan Evans Bequest),
1975

WHARNCLIFFE, Edward Montagu-
Wortley-Mackenzie, 1st Earl of
(1827-99) Railway chairman,
politician and collector

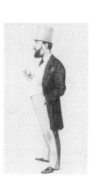

4699 Water-colour 30. 5 x 17.8
(12 x 7)
Carlo Pellegrini, signed *Ape*
(*VF* 14 Aug 1875)
Acquired, 1969

1833 *See Groups:* Private View of
the Old Masters Exhibition, Royal
Academy, 1888, by Henry Jamyn
Brooks

WHARNCLIFFE, Susan, Countess
of (d.1927)
Wife of 1st Earl of Wharncliffe

1833 *See Groups:* Private View of
the Old Masters Exhibition, Royal
Academy, 1888, by Henry Jamyn
Brooks

WHARNCLIFFE, James Stuart-
Wortley-Mackenzie, 1st Baron
(1776-1845) Statesman

2789 *See Groups:* Members of the
House of Lords, c.1835, attributed
to Isaac Robert Cruikshank

WHARTON, Thomas Wharton,
1st Marquess of (1648-1716)
Politician

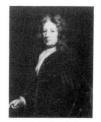

3233 Canvas 91.4 x 71.1 (36 x 28)
Sir Godfrey Kneller, signed, c.1710
Kit-cat Club portrait
Given by NACF, 1945

Piper

WHARTON, Philadelphia, Lady
(1594-1654)
Daughter of 1st Earl of Monmouth

5246 *See Groups:* 1st Earl of
Monmouth and his family,
attributed to Paul van Somer

WHARTON, Sir William
(1843-1905) Hydrographer

1497 Canvas 74.9 x 62.2
(29½ x 24½)
Harry Allen, posthumous
Given by a Memorial Committee,
1908

WHEATLEY, Francis (1747-1801)
Painter

5037 Pencil and water-colour, oval
16.8 x 14.6 (6⅝ x 5¾)
William Hamilton
Purchased, 1975

1278 *See Unknown Sitters III*

WHEATSTONE, Sir Charles
(1802-75) Scientist and inventor

2515(84) Chalk 36.2 x 25.7
(14¼ x 10⅛)
William Brockedon, dated 1837
Lent by NG, 1959
See Collections: Drawings of
Prominent People, 1823-49, by
William Brockedon, **2515(1-104)**

726 Chalk 72.1 x 52.1 (28⅜ x 20½)
Samuel Laurence, inscribed, 1868
Purchased, 1884

Ormond

WHEELER, Sir Charles (1892-1974)
Sculptor and PRA

5132 Lead bust 27 (10⅝) high
Muriel, Lady Wheeler (his wife),
incised and dated 1931
Given by the artist, 1973

WHEELER, Samuel (1776-1858)
Slavery abolitionist

599 *See Groups:* The Anti-Slavery
Society Convention, 1840, by
Benjamin Robert Haydon

WHEWELL, William (1794-1866)
Mathematician and philosopher

1390 Plaster cast of bust 72.1
(28⅜) high
Edward Hodges Baily, incised and
dated 1851
Purchased, 1904

Ormond

WHIBLEY, Charles (1859-1930)
Scholar, critic and journalist

4395 Pen and ink 31.1 x 24.8
(12¼ x 9¾)
Powys Evans, inscribed, pub 1929
Purchased, 1964

WHISTLER, James Abbott McNeill
(1834-1903) Painter and etcher

1700 Water-colour 34.9 x 21
(13¾ x 8¼)
Sir Leslie Ward, signed and dated
1878
(Study for *VF* 12 Jan 1878)
Purchased, 1913

Continued overleaf

4497 Canvas 90.8 x 71.1
(35¾ x 28)
Walter Greaves, signed
Purchased, 1966

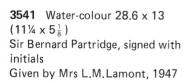

3541 Water-colour 28.6 x 13
(11¼ x 5⅛)
Sir Bernard Partridge, signed with
initials
Given by Mrs L.M.Lamont, 1947

2188 Chalk, two heads 17.1 x 21.6
(6¾ x 8½)
Sir Robert Ponsonby Staples,
signed, inscribed and dated 1901
Purchased, 1928

3617,3618 *See Collections:*
Prominent Men, c.1880-c.1910, by
Harry Furniss, **3337-3535** and
3554-3620

WHISTLER, Reginald John (Rex)
(1905-44) Painter and designer

4124 Canvas 36.8 x 26
(14½ x 10¼)
Self-portrait
Purchased, 1959

WHISTON, William (1667-1752)
Mathematician and divine

243 Canvas 54.6 x 40 (21½ x 15¾)
After Sarah Hoadly, inscribed
(c.1720?)
Purchased, 1867

733 Miniature wooden head
8.3 (3¼) high
Unknown artist
Given by Arthur Gore, 1885

Piper

WHITBREAD, Samuel Charles
(1796-1879)
MP for Middlesex

999 *See Groups:* The Trial of
Queen Caroline, 1820, by Sir
George Hayter

WHITE, Edward
Connoisseur and friend of Charles
Lamb

3182(11) *See Collections:*
Drawings of Artists, c.1862, by
Charles West Cope, **3182(1-19)**

WHITE, Henry (1836-90)
Clergyman

4634 Water-colour 30.2 x 17.8
(11⅞ x 7)
Carlo Pellegrini, signed *Ape*
(*VF* 26 Dec 1874)
Purchased, 1968

WHITE, Henry Hopley (1790-1876)
Lawyer

2515(58) *See Collections:*
Drawings of Prominent People,
1823-49, by William Brockedon,
2515(1-104)

WHITE, Henry Kirke (1785-1806)
Poet

493 Pencil 24.1 x 19.7 (9½ x 7¾)
Unknown artist
Purchased, 1877

3248 Millboard 24.1 x 17.8
(9½ x 7)
Sylvanus Redgate after unknown
artist, signed
Purchased, 1945

93 Plaster medallion, oval
38.1 x 30.5 (15 x 12)
Sir Francis Chantrey
Given by Francis Boott, 1860

WHITE, Joseph Blanco (1775-1841)
Theological writer

3788 Pencil and wash 19.7 x 15.9
(7¾ x 6¼)
Joseph Slater, signed, inscribed and
dated 1812
Given by R.Heath, 1951

WHITE, Luke (d.1854)
MP for County Longford

54 *See Groups:* The House of Com-
mons, 1833, by Sir George Hayter

WHITE, Samuel (d.1854)
MP for County Leitrim

54 *See Groups:* The House of Com-
mons, 1833, by Sir George Hayter

WHITE, Thomas (1628-98)
Bishop of Peterborough

79, 152a *See Groups:* The Seven
Bishops Committed to the Tower
in 1688, by an unknown artist
and George Bower

WHITEFIELD, George (1714-70)
Methodist leader

131 With a congregation of five
Canvas 82.9 x 66 (32⅝ x 26)
John Wollaston, c.1742
Purchased, 1861

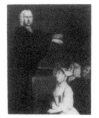

1792 Canvas, oval 17.5 x 13.6
(6⅞ x 5⅜)
John Russell, 1770(?)
Given by the artist's great-grandson,
Francis H.Webb, 1917

Kerslake

WHITEFOORD, Caleb (1734-1810)
Diplomat

1400 Canvas, feigned oval,
74.3 x 62.2 (29¼ x 24½)
Studio of Sir Joshua Reynolds,
1773-4
Purchased, 1905

WHITEHEAD, Sir Edgar (1905-71)
Prime Minister of Southern
Rhodesia

4529(390,391) *See Collections:*
Working drawings by Sir David
Low, **4529(1-401)**

WHITEHEAD, Paul (1710-74)
Satirist

1679 *See Unknown Sitters III*

Kerslake

WHITEHORNE, James
Slavery abolitionist

599 *See Groups:* The Anti-Slavery
Society Convention, 1840, by
Benjamin Robert Haydon

WHITELOCKE, Bulstrode
(1605-76) Diplomat and lawyer

4499 Canvas 76.2 x 63.5 (30 x 25)
Unknown artist, inscribed and
dated 1634
Purchased, 1966

254 Canvas, feigned oval
75.6 x 62.2 (29¾ x 24½)
Unknown artist, inscribed and
dated 1650
Purchased, 1867

Piper

WHITELOCKE, Sir James
(1570-1632) Judge

4498 Panel 66 x 52.1 (26 x 20½)
Unknown artist, inscribed, c.1632
Purchased, 1966

WHITGIFT, John (1530?-1604)
Archbishop of Canterbury

660 Panel 38.7 x 29.5
(15¼ x 11$\frac{5}{8}$)
Unknown artist, inscribed
Purchased, 1882

Strong

WHITLEY, John Henry
(1866-1935)
Speaker of the House of Commons

4799 Sanguine and black crayon
51.4 x 34.9 (20¼ x 13¾)
Sir William Rothenstein, signed and
dated 1924
Purchased, 1970

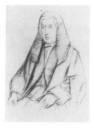

WHITTAKER, Sir Edmund Taylor
(1873-1956) Mathematician

4299 Canvas 55.5 x 45.4
(21$\frac{7}{8}$ x 17$\frac{7}{8}$)
Trevor Haddon, signed and dated
1933
Given by the sitter's widow, 1963

WHITWORTH, Charles Whitworth,
Earl (1752-1825) Diplomat

999 *See Groups:* The Trial of
Queen Caroline, 1820, by Sir
George Hayter

WHYTE-MELVILLE, George John
(1821-78) Novelist

3836 Marble bust 72.4 (28½) high
Sir Joseph Edgar Boehm, incised
and dated 1879
Purchased, 1952

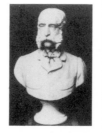

WIFFEN, Jeremiah Holmes
(1792-1836)
Poet; translator of Tasso

2515(18) Chalk 34.9 x 25.7
(13¾ x 10$\frac{1}{8}$)
William Brockedon, dated 1830
Lent by NG, 1959
See Collections: Drawings of
Prominent People, 1823-49, by
William Brockedon, **2515(1-104)**

Ormond

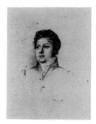

WIGAN, John (1696-1739)
Physician and writer

4588 Canvas 125.1 x 100.3
(49¼ x 39½)
Unknown artist, inscribed
Purchased, 1967

Kerslake

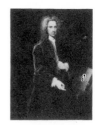

WIGHT, Robert (1796-1872)
Botanist

P120(28) Photograph: albumen
print, arched top 19.7 x 14.6
(7¾ x 5¾)
Maull & Polyblank, inscribed on
mount, 1855
Purchased, 1979
See Collections: Literary and
Scientific Men, 1855, by Maull &
Polyblank, **P120(1-54)**

WIGNEY, Isaac Newton
(c.1795-1844) MP for Brighton

54 *See Groups:*The House of Com-
mons, 1833, by Sir George Hayter

WILBERFORCE, Samuel(1805-73)
Bishop; son of William Wilberforce

4541(9,11) *See Collections:* The
Pusey family and their friends,
c.1856, by Clara Pusey, **4541(1-13)**

1054 Oil on paper 44.5 x 33.3
(17½ x 13$\frac{1}{8}$)
George Richmond, c.1864
Purchased, 1896

4974 Charcoal and chalk
56.8 x 41.9 (22⅜ x 16½)
George Richmond, signed with
initials, inscribed and dated 1868
Purchased, 1974

1993 Water-colour 30.5 x 18.1
(12 x 7⅛)
Carlo Pellegrini, signed *Ape*
(*VF* 24 July 1869)
Purchased, 1923

Ormond

WILBERFORCE, William
(1759-1833)
Philanthropist and reformer

759 Canvas 28.6 x 24.1
(11¼ x 9½)
John Russell, signed and dated 1770
Bequeathed by the sitter's son-in-
law, John James, 1887

745 *See Groups:* William Pitt
addressing the House of Commons
. . . 1793, by Karl Anton Hickel

3 Canvas 96.5 x 109.2 (38 x 43)
Sir Thomas Lawrence, 1828
Given by the executors of Sir
Robert Harry Inglis, Bt, 1857

4997 Water-colour 43.8 x 33
(17¼ x 13)
George Richmond, signed and
dated 1833
Purchased, 1974

WILBRAHAM, George (1779-1852)
MP for Cheshire South

54 *See Groups:* The House of Com-
mons, 1833, by Sir George Hayter

WILCOCKS, Joseph (1673-1756)
Dean of Westminster; Bishop of
Rochester

2417 Water-colour 12.4 x 11.1
(4⅞ x 4⅜)
George Perfect Harding after an
unknown artist, inscribed below
image, eng 1822
Purchased, 1929
See Collections: Copies of early
portraits, by George Perfect
Harding and Sylvester Harding,
1492, 1492(a-c) and **2394-2419**

WILDE, Charles Robert Claude,
2nd Baron Truro *See* TRURO

WILDE, James, Baron Penzance
See PENZANCE

WILDE, Oscar (1856-1900)
Wit and dramatist

P24 Photograph: albumen 'panel'
print 30.5 x 18.4 (12 x 7¼)
Napoleon Sarony, 1882
Purchased, 1976

P25 Photograph: albumen 'panel'
print 30.5 x 18.4 (12 x 7¼)
Napoleon Sarony, 1882
Purchased, 1976

3653 Water-colour 30.8 x 17.8
(12⅛ x 7)
Carlo Pellegrini, signed *Ape*
(*VF* 24 May 1884)
Purchased, 1949

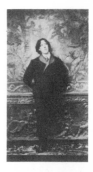

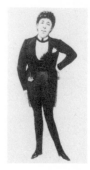

Continued overleaf

2265 *See Collections:* The Parnell Commission, 1888-9, by Sydney Prior Hall, **2229-72**

WILDE, Thomas, Baron Truro
See TRURO

WILKES, John (1727-97)
Politician and agitator

1944 *See Groups:* John Glynn, John Wilkes and John Horne Tooke, by Richard Houston

284 Pencil 34.3 x 24.8 (13½ x 9¾)
Richard Earlom
Given by William Smith, 1869

1702 Silver medal 5.7 (2¼) diameter
Unknown artist, inscribed
Purchased, 1913

WILKIE, Sir David (1785-1841)
Painter

2770 Water-colour 12.7 x 9.2 (5 x 3⅝)
William Henry Hunt, signed, c.1809
Given by Thomas Lowinsky, 1935

3154 Pencil and chalk 24.8 x 21 (9¾ x 8¼)
John Jackson, c.1810
Purchased, 1943

53 Panel 14.3 x 9.8 (5⅝ x 3⅞)
Self-portrait, 1813
Purchased, 1858

2423 Pencil 45.7 x 35.6 (18 x 14)
Benjamin Robert Haydon, signed, inscribed and dated 1816
Given by Sir W.B.Hardy, 1921

795 *See Groups:* Four studies for Patrons and Lovers of Art, c.1826, by Pieter Christoph Wonder, **792-5**

WILKINSON, George Howard (1833-1901) Bishop of St Andrews

4753 Water-colour 29.8 x 18.1 (11¾ x 7⅛)
Sir Leslie Ward, signed *Spy*
(*VF* 26 Dec 1885)
Purchased, 1970

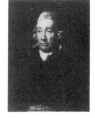

WILKINSON, John (1728-1808)
Ironmaster

3785 Canvas 73.7 x 61.6 (29 x 24¼)
Lemuel Francis Abbott
Purchased, 1951

WILKINSON, Sir John Gardner (1797-1875)
Explorer and Egyptologist

2515(86) Chalk 36.2 x 26.4 (14¼ x 10⅜)
William Brockedon, dated 1838
Lent by NG, 1959
See Collections: Drawings of Prominent People, 1823-49, by William Brockedon, **2515(1-104)**

4026(28) *See Collections:* Drawings of Men about Town, 1832-48, by Alfred,Count D'Orsay, **4026(1-61)**

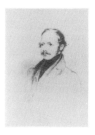

Ormond

WILLES, Sir John (1685-1761)
Judge

484 Canvas 135.2 x 102.2
(53¼ x 40¼)
Thomas Hudson, inscribed, eng 1744
Given by the Society of Judges and
Serjeants-at-Law, 1877

Kerslake

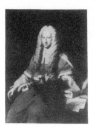

WILLIAM I (1027-87)
'The Conqueror'; reigned 1066-87

4051 Silver penny 1.9 (¾) diameter
From a die attributed to Theodoric,
inscribed, 1068(?)
Purchased, 1958

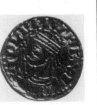

4052 Silver penny 1.9 (¾) diameter
From a die attributed to Theodoric,
inscribed, 1068-71
Purchased, 1958

4980(1) *See Collections:* Set of
16 early English Kings and Queens
formerly at Hornby Castle,
Yorkshire, **4980(1-16)**

Strong

WILLIAM III (1650-1702)
Reigned 1689-1702

272 Canvas 74.9 x 55.9
(29½ x 22)
After Cornelius Johnson (1657)
Purchased, 1868

L152(7) Canvas 82.6 x 66.7
(32½ x 26¼)
Jan de Baen, c.1668
Lent by NG (Alan Evans Bequest),
1974

1902 Canvas 124.5 x 101
(49 x 39¾)
After Sir Peter Lely (1677)
Purchased, 1921

580 Canvas, feigned oval
74.9 x 62.9 (29½ x 24¾)
After William Wissing (?)
Transferred from BM, 1879

4153 Canvas 247.7 x 163.8
(85½ x 64½)
Unknown artist, c.1690
Given by Mme Georges Forest-
Colcombet, 1960

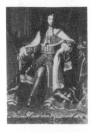

1026 Canvas 216.2 x 174.6
(85½ x 68¾)
Unknown artist, c.1690
Given by Henry Yates Thompson,
1896. *Beningbrough*

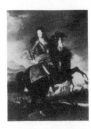

1737 Enamel miniature, oval
3.5 x 2.5 ($1\frac{3}{8}$ x 1)
Charles Boit, signed on reverse,
1690-9
Purchased, 1914

Piper

WILLIAM IV (1765-1837)
Reigned 1830-7

2199 Canvas 221 x 149.9 (87 x 59)
Sir Martin Archer Shee, c.1800
Purchased, 1928

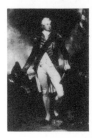

1695(j) *See Collections:* Sketches
for The Trial of Queen Caroline,
1820, by Sir George Hayter,
1695(a-x)

999 *See Groups:* The Trial of
Queen Caroline, 1820, by Sir
George Hayter

Continued overleaf

1632 *Identity uncertain*
Pencil 31.1 x 20.3 (12¼ x 8)
Attributed to Sir George Hayter,
c.1825-8
Given by Mrs Mary A. Sadler, 1911

316a(141) Pencil 43.5 x 33.3
(17⅛ x 13⅛)
Sir Francis Chantrey, inscribed and
dated 1837, tracing (1830)
Given by Mrs George Jones, 1871

and

316a(142) Pencil 43.5 x 33.3
(17⅛ x 13⅛)
Sir Francis Chantrey, inscribed,
1830
Given by Mrs George Jones, 1871
See Collections: Preliminary
drawings for busts and statues by
Sir Francis Chantrey, **316a(1-202)**

316a(34-7) *See Collections:*
Preliminary drawings for busts and
statues by Sir Francis Chantrey,
316a(1-202)

1163 Water-colour 28.6 x 22.9
(11¼ x 9)
After Henry Dawe (c.1830)
Purchased, 1898

2920 Wax medallion, oval 6 x 5.4
(2⅜ x 2⅛)
John de Veaux, embossed
Given by R.M.Holland-Martin, 1937

3767 *See Collections:* Studies for
The Waterloo Banquet at Apsley
House, 1836, by William Salter,
3689-3769

4703 Water-colour 20.7 x 15.2
(8⅛ x 6)
Reginald Easton, signed
Purchased, 1970

Ormond

WILLIAM I (1772-1844)
King of Holland, 1815-40

3768 *See Collections:* Studies for
The Waterloo Banquet at Apsley
House, 1836, by William Salter,
3689-3769

WILLIAM II (1792-1849)
King of Holland, 1840-9)

1914(20) *See Collections:*
Peninsular and Waterloo Officers,
1813-14, by Thomas Heaphy,
1914(1-32)

WILLIAM of Nassau (1626-50)
Prince of Orange; father of
William III

964 Canvas 69.2 x 53.3 (27¼ x 21)
After Sir Anthony van Dyck (?)
Given by Viscount Cobham, 1894

Piper

WILLIAM, Prince, of Gloucester
(1941-72) Cousin of Elizabeth II

L153 Pastel 60.6 x 50.8
(23⅞ x 20)
Nicholas Egon, signed and dated
1972
Lent by the British Schools
Exploring Society, 1974

WILLIAM, Duke of Gloucester
See GLOUCESTER

WILLIAM Augustus, Duke of
Cumberland *See* CUMBERLAND

WILLIAM Frederick, 2nd Duke of Gloucester *See* GLOUCESTER

WILLIAM, F.
Doorkeeper of the House of Commons

54 *See Groups:* The House of Commons, 1833, by Sir George Hayter

WILLIAMS, Bransby (Bransby William Pharez) (1870-1961)
Music-hall performer

2750A Pen and ink 10.8 x 7.9 (4¼ x 3⅛)
Self-portrait, signed, inscribed and dated 1907
Given by Rathmell Wilson, 1934

WILLIAMS, Sir Charles Hanbury (1708-59)
Satirical writer and diplomat

383 Canvas 91.1 x 71.4 (35⅞ x 28⅛)
Attributed to John Giles Eccardt, inscribed, c.1746
Given by Mrs Charles Richard Fox, 1873. *Beningbrough*

Kerslake

WILLIAMS, Emlyn (b.1905)
Actor, dramatist and director

P59 *See Collections:* Prominent people, c.1946-64, by Angus McBean, **P56-67**

WILLIAMS, Sir George (1821-1905)
Founder of YMCA

2140 Canvas 61 x 50.8 (24 x 20)
John Collier, signed, reduced replica (1887)
Given by the sitter's son, Howard Williams, 1927

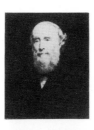

WILLIAMS, Hugh William (1773-1829) Landscape painter

965 Canvas 74.9 x 62.2 (29½ x 24½)
Sir Henry Raeburn
Given by Sir Charles Tennant, Bt, 1894

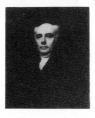

WILLIAMS, John (1636?-1709)
Bishop of Chichester

2419 *See Collections:* Copies of early portraits, by George Perfect Harding and Sylvester Harding, **1492,1492(a-c)** and **2394-2419**

WILLIAMS, John (1761-1818)
'Anthony Pasquin'; satirist

4204 Pencil, water-colour and wash 32.1 x 23.5 (12⅝ x 9¼)
Unknown artist, inscribed
Given by Iolo A. Williams, 1961

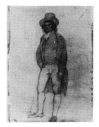

WILLIAMS, Sir John (1777-1846)
Judge

999 *See Groups:* The Trial of Queen Caroline, 1820, by Sir George Hayter

WILLIAMS, John (1796-1839)
Missionary

4956 Colour print 26.7 x 21 (10½ x 8¼)
George Baxter, inscribed and dated 1843 on plate
Purchased, 1973

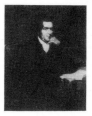

WILLIAMS, Owen Lewis Cope (1836-1904) Lieutenant-General

2291 *See Collections:* Miscellaneous drawings . . . by Sydney Prior Hall, **2282-2348** and **2370-90**

WILLIAMS-BULKELEY, Sir Richard Bulkeley, Bt (1801-75)
MP for Anglesey

54 *See Groups:* The House of Commons, 1833, by Sir George Hayter

WILLIAMSON, Sir Bedworth, Bt (1797-1861)
MP for County Durham North

54 *See Groups:* The House of Commons, 1833, by Sir George Hayter

WILLIAMSON, Henry (1895-1977)
Writer and journalist

5110 Pen and ink 29.2 x 23.8
(11½ x 9⅜)
Powys Evans, inscribed and dated
1928
Given by R.N.Ricks, 1976

WILLIAMSON, Sir Joseph
(1633-1701) Secretary of State

1100 Canvas, feigned oval
75.6 x 62.2 (29¾ x 24½)
Unknown artist, inscribed
(c.1660-70)
Purchased, 1897

Piper

WILLIAMS-WYNN, Charles
Watkin (1822-96) Politician

2605 Water-colour 30.5 x 18.4
(12 x 7¼)
Sir Leslie Ward, signed *Spy*
(*VF* 28 June 1879)
Purchased, 1933

WILLIAMS-WYNN, Sir Watkin, Bt
(1820-85)
Landowner and politician

2606 Water-colour 31.8 x 17.8
(12½ x 7)
Sir Leslie Ward, signed *Spy*
(*VF* 14 June 1873)
Purchased, 1933

WILLIAMS-WYNN, Sir Watkin,
7th Bt (1860-1944)
Soldier and landowner

1833 *See Groups:* Private View of
the Old Masters Exhibition, Royal
Academy, 1888, by Henry Jamyn
Brooks

WILLINK, Sir Henry (1894-1973)
Politician

4529(392-5) *See Collections:*
Working drawings by Sir David Low,
4529(1-401)

WILLIS, Francis (1718-1807)
Physician

2186 Pastel 60.3 x 44.5
(23¾ x 17½)
John Russell, signed and dated
1789
Purchased, 1928

WILLOUGHBY, Sir John
Christopher, 5th Bt (1859-1918)
Soldier

4754 Water-colour 28.9 x 16.8
(11⅜ x 6⅝)
Sir Leslie Ward, signed *Spy*
(*VF* 6 Sept 1884)
Purchased, 1970

WILLOUGHBY DE BROKE,
Richard Greville Verney, 19th
Baron (1869-1923)
Huntsman and politician

4946 Water-colour 36.8 x 26.7
(14½ x 10½)
Sir Leslie Ward, signed *Spy*
(*VF* 23 Nov 1905)
Purchased, 1973

WILLOUGHBY DE ERESBY,
Peter Robert Drummond-
Willoughby, 19th Baron
(1782-1865) Politician

342,343(a-c) *See Groups:* The
FineArts Commissioners, 1846,
by John Partridge

WILLSHIRE, Sir Thomas, Bt
(1789-1862) General

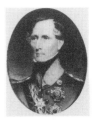

2008 Miniature on ivory, oval
8.3 x 6.4 (3¼ x 2½)
Unknown artist
Purchased, 1923

Ormond

WILMINGTON, Spencer Compton, Earl of (1673-1743) Statesman

3234 Canvas 91.4 x 71.1 (36 x 28)
Sir Godfrey Kneller, signed, c.1710
Kit-cat Club portrait
Given by NACF, 1945

Piper

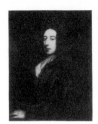

WILMOT, John, 2nd Earl of
Rochester *See* ROCHESTER

WILMOT, Sir John Eardley
Eardley-, 1st Bt (1783-1847)
Slavery abolitionist

599 *See Groups:* The Anti-Slavery
Society Convention, 1840, by
Benjamin Robert Haydon

WILMOT, Sir John Eardley
Eardley-, 2nd Bt (1810-92)
Barrister and politician

3296 Water-colour 30.8 x 17.8
$(12\frac{1}{8} \times 7)$
Sir Leslie Ward, signed *Spy*
(*VF* 9 May 1885)
Purchased, 1934

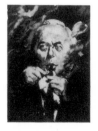

WILSON, Captain

1752 *See Groups:* The Siege of
Gibraltar, 1782, by George Carter

WILSON, Cyllina Margaret
(1852-83) Adopted daughter of
Julia Margaret Cameron

P18(45,52,57,58) *See Collections:*
The Herschel Album, by Julia
Margaret Cameron, **P18(1-92b)**

WILSON, Sir Harold (b.1916)
Prime Minister

5047 Canvas 51.1 x 38.1
$(20\frac{1}{8} \times 15)$
Ruskin Spear, signed, exh 1974
Purchased, 1975

WILSON, Sir Henry Hughes, Bt
(1864-1922) Field-Marshal

4039(7) Water-colour and pencil
29.8 x 24.1 (11¾ x 9½)
Inglis Sheldon-Williams, signed and
dated 1900 by artist and sitter
Purchased 1975
See Collections: Boer War Officers,
1900, by Inglis Sheldon-Williams,
4039(1-7)

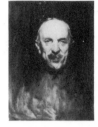

2908(13) *See Collections:* Studies,
mainly for General Officers of
World War I, by John Singer
Sargent, **2908(1-18)**

2889 (study for *Groups,* 1954)
Canvas 54.6 x 39.4 (21½ x 15½)
John Singer Sargent
Given by Viscount Wakefield, 1936

1954 *See Groups:* General Officers
of World War I, by John Singer
Sargent

4183 Canvas 91.4 x 76.2 (36 x 30)
Sir William Orpen, signed and dated
1919
Given by wish of Viscount
Wakefield, 1960

WILSON, Horace Hayman
(1786-1860) Orientalist

2748 Canvas 76.2 x 63.5 (30 x 25)
Unknown artist
Bequeathed by the sitter's grandson,
Alexander Wilson, 1934

826 Water-colour 14 x 11.1
$(5\frac{1}{2} \times 4\frac{3}{8})$
James Atkinson, inscribed and
dated 1821
Given by the artist's son,
J.A.Atkinson, 1889

Continued overleaf

316a(143) Pencil, two sketches
47.6 x 65.1 (18¾ x 25⅝)
Sir Francis Chantrey, inscribed,
c.1837
Given by Mrs George Jones, 1871
See Collections: Preliminary
drawings for busts and statues by
Sir Francis Chantrey, **316a(1-202)**

Ormond

WILSON, Sir James (1805-60)
Political economist

2189 Canvas 127.3 x 101.6
(50⅛ x 40)
Sir John Watson-Gordon, signed
and dated 1858
Given by the sitter's daughter, Mrs
Russell Barrington, 1928

Ormond

WILSON, Jeanie

P6(200,207) *See Collections:* The
Hill and Adamson Albums, 1843-8,
by David Octavius Hill and Robert
Adamson, **P6(1-258)**

WILSON, John (1785-1854)
'Christopher North'; essayist and
journalist

187 Canvas 90.2 x 69.9
(35½ x 27½)
Sir John Watson-Gordon, eng 1833
Given by the artist's brother,
H.G.Watson, 1865

P6(4) Photograph: calotype
19.4 x 14.3 (7⅝ x 5⅝)
David Octavius Hill and Robert
Adamson, 1843
Given by an anonymous donor, 1973
See Collections: The Hill and
Adamson Albums, 1843-8, by
David Octavius Hill and Robert
Adamson, **P6(1-258)**

WILSON, Sir Leslie Orme
(1876-1955)
Lieutenant-Colonel and MP

3532 *See Collections:* Prominent
Men, c.1880-c.1910, by Harry
Furniss, **3337-3535** and **3554-3620**

WILSON, Richard (1714-82)
Landscape painter

1803 Canvas 74.9 x 62.2
(29½ x 24½)
After Anton Raphael Mengs (1752)
Given by Richard Ford, 1917

1305 Canvas 59.7 x 48.9
(23½ x 19¼)
After Anton Raphael Mengs (1752)
Purchased, 1901

1437,1437a *See Groups:* The
Academicians of the Royal
Academy, 1771-2, by John Sanders
after Johan Zoffany

1327 *See Unknown Sitters III*

WILSON, Thomas (1525?-81)
Secretary of State and scholar

3799 Panel 108 x 82.6
(42½ x 32½)
Unknown Flemish artist, inscribed
and dated 1575
Exchanged with the Ministry of
Works for no.**592** (a later copy of
the same portrait), 1951
Montacute
Strong

WILSON, William
Slavery abolitionist

599 *See Groups:* The Anti-Slavery
Society Convention, 1840, by
Benjamin Robert Haydon

WILSON-PATTEN, John, 1st
Baron Winmarleigh
See WINMARLEIGH

WILTON, Joseph (1722-1803)
Sculptor

4810 Canvas 76.2 x 59.7
(30 x 23½)
Sir Joshua Reynolds, 1752
Purchased, 1970

1437,1437a *See Groups:* The Academicians of the Royal Academy, 1771-2, by John Sanders after Johan Zoffany

4314 Chalk 13.6 x 11.4 (5⅜ x 4½) Charles Grignion, inscribed, c.1773 Purchased, 1963

987 *See Groups:* Sir Joshua Reynolds, Sir William Chambers and Joseph Wilton, 1782, by John Francis Rigaud

WIMBLEDON, Edward Cecil, Viscount (1572-1638) Naval and military commander

L164 Panel 62.2 x 50.8 (24½ x 20) Michael Jansz. van Miereveldt, inscribed and dated 1610 Lent by Mrs D.Yeats Brown, in memory of her father, George Anson, 1977

4514 Panel 68 x 58.7 (26⅞ x 23⅛) Michael Jansz. van Miereveldt, signed, inscribed and dated 1631 Given by NACF, 1966

WINCHESTER, William Paulet (Pawlet or Poulet), 1st Marquess of (1485-1572) Statesman

65 Panel 90.5 x 67.6 (35⅝ x 26⅝) Unknown artist Purchased, 1859

Strong

WINCHESTER, Charles Ingoldsby Burroughs-Paulet, 13th Marquess of (1765-1843)

999 *See Groups:* The Trial of Queen Caroline, 1820, by Sir George Hayter

WINCHILSEA, Daniel Finch, 2nd Earl of Nottingham and 7th Earl of (1647-1730) Statesman

3910 Canvas, three heads 78.7 x 104.1 (31 x 41) Sir Godfrey Kneller, inscribed, c.1720(?) Given by Sir Alec and Lady Martin, 1954. *Beningbrough*

3622 Canvas 125.1 x 101 (49¼ x 39¾) Attributed to Jonathan Richardson, inscribed and dated 1726 Purchased, 1948

Piper

WINCHILSEA, Anne Finch, Countess of (d.1720) Poet; wife of 7th Earl of Winchilsea

4692 Miniature on vellum, oval 7.6 x 6.4 (3 x 2½) Lawrence Crosse, signed in monogram Purchased, 1969

3622A (Companion to no.**3622**, 7th Earl of Winchilsea) Canvas 125.1 x 101 (49¼ x 39¾) Attributed to Jonathan Richardson, inscribed Purchased, 1948

WINCHILSEA, Daniel Finch, 8th Earl of (1689-1769) Politician

4855(24,24b) *See Collections:* The Townshend Album, **4855(1-73)**

WINCHILSEA, George Finch-Hatton, 11th Earl of (1815-87)

4026(60) *See Collections:* Drawings of Men about Town, 1832-48, by Alfred, Count D'Orsay, **4026(1-61)**

WINDHAM, William (1750-1810)
Statesman

704 Canvas 74.9 x 62.2
(29½ x 24½)
Sir Joshua Reynolds, exh 1788
Transferred from Tate Gallery,
1957

38 Canvas 73.7 x 61 (29 x 24)
Sir Thomas Lawrence, inscribed,
c.1803, reduced version
Purchased, 1858

WINDSOR, Edward, Duke of
(Edward VIII) (1894-1972)
Reigned 1936

4536 *See Groups:* Four
Generations . . . , by Sir William
Quiller Orchardson

1745 *See Groups:* The Royal
Family at Buckingham Palace,
1912, by Sir John Lavery

4534 Silhouette 30.5 x 11.4
(12 x 4½)
Harry Lawrence Oakley, signed,
inscribed and dated 1919
Given by wish of John Bowyer
Oakley, 1967

4169 Chalk 58.4 x 45.7 (23 x 18)
Reginald Grenville Eves, c.1920
Given by the artist's son, Grenville
Eves, 1960

4138 Miniature 7.9 x 6 ($3\frac{1}{8}$ x $2\frac{3}{8}$)
Reginald Grenville Eves, c.1920
Purchased, 1960

4908 Lithograph 52.1 x 39.4
(20½ x 15½)
Edmond Xavier Kapp, initialled *K*
on stone, and signed, inscribed and
numbered 28/50
Purchased, 1972

5051 Bronze medal 9.8 ($3\frac{7}{8}$)
diameter
Fred Kormis, incised with initials,
1936
Given by the artist, 1975

P136 Photograph: sepia bromide
print 37.5 x 29.8 (14¾ x 11¾)
Hugh Cecil, 1936
Purchased, 1979

4949 Board 45.7 x 35.6 (18 x 14)
Sir James Gunn, 1954
Purchased, 1973

WINGFIELD, Mervyn, 7th Viscount
Powerscourt *See* POWERSCOURT

WINGFIELD, Richard, 6th Viscount
Powerscourt *See* POWERSCOURT

WINMARLEIGH, John Wilson-Patten, Baron (1802-92) Politician

54 *See Groups:* The House of Commons, 1833, by Sir George Hayter

WINN, Charles Mark Allanson, 4th Baron Headley *See* HEADLEY

WINNINGTON, Sir Francis (1634-1700) Lawyer

305 Miniature on vellum, oval 4.8 x 4.1 ($1\frac{7}{8}$ x $1\frac{5}{8}$)
Unknown artist
Given by the sitter's descendant, Sir Thomas E. Winnington, Bt, 1870

Piper

WINNINGTON, Thomas (1696-1746) Politician; grandson of Sir Francis Winnington

85 Enamel miniature, oval 4.4 x 3.8 ($1\frac{3}{4}$ x $1\frac{1}{2}$)
Christian Frederick Zincke
Given by the sitter's descendant, Sir Thomas E.Winnington, Bt, 1859

WINNINGTON-INGRAM, Arthur Foley (1858-1946)
Bishop of London

2369 *See Groups:* The Education Bill in the House of Lords, by Sydney Prior Hall

5021 Canvas 150.5 x 102.2 (59¼ x 40¼)
Frank O. Salisbury, signed, 1918
Given by the executors of Canon S.A.Alexander, 1975

4970 Charcoal, pen and wash 36.8 x 27.9 (14½ x 11)
Sir Bernard Partridge, signed
(*Punch* 21 Nov 1928)
Given by D.Pepys-Whiteley, 1974

WINTER, Robert (d.1606)
Conspirator

334A *See Groups:* The Gunpowder Plot Conspirators, 1605, by an unknown artist

WINTER, Thomas (1572-1606)
Conspirator; brother of Robert Winter

334A *See Groups:* The Gunpowder Plot Conspirators, 1605, by an unknown artist

WINWOOD, Sir Ralph (1563?-1617)
Secretary of State

40 *See Unknown Sitters I*

WISEMAN, Nicholas Patrick Stephen (1802-65)
Cardinal-Archbishop of Westminster

2074 Black and white chalk 55.2 x 41.9 (21¾ x 16½)
Attributed to Henry Edward Doyle
Given by Cardinal Bourne, 1924

4237 Chalk 46.7 x 32.1 ($18\frac{3}{8}$ x $12\frac{5}{8}$)
Henry Edward Doyle, signed
Purchased, 1961

4619 Pen and ink 27 x 19.1 ($10\frac{5}{8}$ x 7½)
Attributed to Richard Doyle, inscribed
Purchased, 1968

Ormond

WITHERINGTON, William Frederick (1785-1865) Painter

3182(6,9) *See Collections:* Drawings of Artists, c.1862, by Charles West Cope, **3182(1-19)**

Ormond

WODEHOUSE, John, 1st Earl of
Kimberley *See* KIMBERLEY

WOFFINGTON, Margaret
(1714?-60)
'Peg Woffington'; actress

650 Canvas 90.2 x 106.7
(35½ x 42)
Unknown artist, c.1758
Given by Sir Theodore Martin,
1881. *Beningbrough*

2177 *See Unknown Sitters III*

Kerslake

WOLCOT, John (1738-1819)
'Peter Pindar'; physician and satirist

830 Canvas 49.5 x 39.4
(19½ x 15½)
John Opie
Purchased, 1890

156 Miniature on ivory 11.4 x 8.6
(4½ x 3⅜)
Walter Stephens Lethbridge
Purchased, 1864

WOLFE, Humbert (1886-1940)
Poet and civil servant

L168(10,11) *See Collections:*
Prominent men, 1895-1930, by Sir
William Rothenstein, **L168(1-11)**

4529(396) *See Collections:*
Working drawings by Sir David
Low, **4529(1-401)**

WOLFE, James (1727-59)
General; conqueror of Quebec

688 Pencil and water-colour
19.7 x 12.1 (7¾ x 4¾)
Elizabeth, Duchess of Devonshire,
inscribed
Given by Lord Ronald Sutherland
Gower, 1883

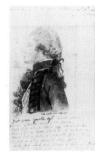

48 Canvas 52.7 x 43.2 (20¾ x 17)
Attributed to J.S.C.Schaak
Given by Leopold I, King of the
Belgians, 1858

713a Pencil tracing 19.7 x 14.6
(7¾ x 5¾)
Harold Dillon (afterwards 17th
Viscount Dillon) after drawing
attributed to Sir Harvey Smyth
Given by Viscount Dillon, 1884.
Beningbrough

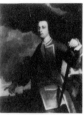

1111 Canvas 124.5 x 98.4
(49 x 38¾)
Unknown artist
Purchased, 1897

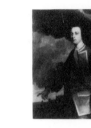

4415 Plaster cast of bust 75.6
(29¾) high
Joseph Wilton, c.1760
Purchased, 1964

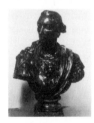

2225 Bronze cast of bust 75.6
(29¾) high
After Joseph Wilton (c.1760)
Given by Sir Robert Leicester
Harmsworth, Bt, 1928.
Beningbrough

Kerslake

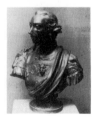

WOLLASTON, William Hyde
(1766-1828) Physiologist,
chemist and physicist

1075,1075a and **b** *See Groups:*
Men of Science Living in 1807-8,
by Sir John Gilbert and others

1703 Pencil 31.8 x 24.8
(12½ x 9¾)
John Jackson
Purchased, 1913

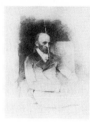

2515(10) *See Collections:*
Drawings of Prominent People, by
William Brockedon, **2515(1-104)**

316a(144) Pencil, two sketches
42.9 x 63.8 (16⅞ x 25⅛)
Sir Francis Chantrey, inscribed
Given by Mrs George Jones, 1871
See Collections: Preliminary
drawings for busts and statues by
Sir Francis Chantrey, **316a(1-202)**

WOLMARK, Alfred (1877-1961)
Artist

4884 Pen and ink 33.3 x 31.4
(13⅛ x 12⅜)
Self-portrait, signed and dated 1926
Purchased, 1972

WOLSELEY, Garnet Joseph
Wolseley, 1st Viscount (1833-1913)
Field-Marshal

1789 Canvas 201.9 x 152.4
(79½ x 60)
Paul Albert Besnard, signed and
dated 1880
Given by the sitter's widow, 1917

1840 Bronze cast of bust 71.1 (28)
high
Sir Joseph Edgar Boehm, incised
and dated 1883
Given by the sitter's widow, 1919

4059 Chalk 46.4 x 33.7
(18¼ x 13¼)
William Strang, signed, inscribed
and dated 1908
Purchased, 1958

WOLSEY, Thomas (1475?-1530)
Cardinal and statesman

32 Panel, arched top 83.8 x 55.9
(33 x 22)
Unknown artist, inscribed
Purchased, 1858

Strong

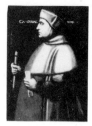

WOLVERHAMPTON, Henry
Fowler, Viscount (1830-1911)
Statesman

3533 *See Collections:* Prominent
Men, c.1880-c.1910, by Harry
Furniss, **3337-3535** and **3554-3620**

WOMBWELL, Sir George, Bt
(1792-1855)

4026(61) *See Collections:*
Drawings of Men about Town,
1832-48, by Alfred, Count D'Orsay,
4026(1-61)

WONDER, Pieter Christoph
(1780-1852) Painter

792 *See Groups:* Four studies
for Patrons and Lovers of Art,
c.1826, by Pieter Christoph Wonder,
792-5

WOOD, Charles, 1st Viscount
Halifax *See* HALIFAX

WOOD, Charles
Jockey

4755 Water-colour 31.4 x 18.7
(12⅜ x 7⅜)
Liberio Prosperi, signed *Lib*
(*VF* 22 May 1866)
Purchased, 1970

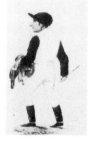

WOOD, Charles Lindley, 2nd
Viscount Halifax *See* HALIFAX

WOOD, Edward, 1st Earl of
Halifax *See* HALIFAX

WOOD, Francis Derwent
(1871-1926) Sculptor

4416 Canvas 61 x 50.8 (24 x 20)
George Washington Lambert, signed
and dated 1906
Purchased, 1964

WOOD, Sir George Adam
(1767-1831) Major-General

3990 Canvas 59.7 x 49.9
(23½ x 19⅝)
Attributed to S.Cole, c.1815
Purchased, 1956

5258 Pencil, two sketches
10.8 x 10.5 (4¼ x 4⅛)
George Jones, inscribed and dated
1817
Purchased, 1979

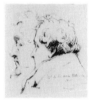

WOOD, Sir Henry Evelyn
(1838-1919) Field-Marshal

4756 Water-colour 31.4 x 18.1
(12⅜ x 7⅛)
Sir Leslie Ward, signed *Spy*
(*VF* 15 Nov 1879)
Purchased, 1970

3949 Lithograph 34.3 x 26
(13½ x 10¼)
Flora Lion, signed on stone, and
inscribed and dated 1915
Purchased, 1955

WOOD, Sir Henry Joseph
(1869-1944) Conductor

L168(7) *See Collections:*
Prominent men, 1895-1930, by
William Rothenstein, **L168(1-11)**

4078 Pen and ink 21 x 15.6
(8¼ x 6⅛)
William Kerridge Haselden, signed *H.*
and inscribed
(*Punch* 23 Aug 1933)
Given by D.Pepys Whiteley, 1958

3818 Pencil 22.9 x 16.5 (9 x 6½)
Hilda E.Wiener, signed *W*, 1938
Given by the artist's sister, Miss
Evelyn Samuel, 1952

3688 Canvas 109.5 x 83.2
(43⅛ x 32¾)
Frank O.Salisbury, signed, 1943
Given by Lady Jessie Wood, 1950

WOOD, J. Julius (1800-77)
Scottish divine

P6(45) *See Collections:* The Hill
and Adamson Albums, 1843-8, by
David Octavius Hill and Robert
Adamson, **P6(1-258)**

WOOD, John (1825-91)
Surgeon

2477 *See Collections:* Drawings of
Royal Academicians, c.1858, by
Charles Bell Birch, **2473-9**

WOOD, Mary Ann (née Paton)
See PATON

WOOD, Sir Matthew, Bt
(1768-1843)
Lord Mayor of London

1481 Canvas 74.9 x 62.2
(29½ x 24½)
Arthur William Devis, eng 1817
Purchased, 1907

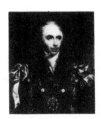

999 *See Groups:* The Trial of
Queen Caroline, 1820, by Sir
George Hayter

WOOD, Robert (1716-71)
Classical archaeologist, traveller
and politician

4868 Canvas 99.1 x 74.9
(39 x 29½)
Allan Ramsay, signed and dated
1755
Purchased, 1972. *Beningbrough*

Kerslake

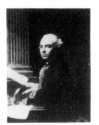

WOOD, Thomas (1777-1860)
MP for Breconshire

54 *See Groups:* The House of Commons, 1833, by Sir George Hayter

WOOD, William, Baron Hatherley
See HATHERLEY

WOODALL, William (1832-1901)
Philanthropist

2987 Water-colour 34.6 x 26
(13⅝ x 10¼)
Sir Leslie Ward, signed *Spy*
(*VF* 15 Oct 1896)
Purchased, 1938

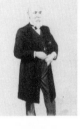

WOODFALL, William (1746-1803)
Journalist and dramatic critic

169 Canvas 74.9 x 62.9
(29½ x 24¾)
Thomas Beach, signed, inscribed
and dated 1782
Given by the sitter's great-nephew,
H.D.Woodfall, 1864

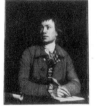

WOODMARK, John
Slavery abolitionist

599 *See Groups:* The Anti-Slavery
Society Convention, 1840, by
Benjamin Robert Haydon

WOODS, Margaret Louisa (née
Bradley) (1856-1945)
Writer and poet

P18(27) *See Collections:* The
Herschel Album, by Julia Margaret
Cameron, **P18(1-92b)**

WOOLF, Leonard Sidney
(1880-1969)
Journalist and publisher

4695 Canvas 81.3 x 64.8
(32 x 25½)
Vanessa Bell, 1940
Given by Mrs Ian Parsons, 1969

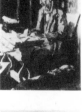

4938 Cold-cast bronze head
41.9 (16½) high
Charlotte Hewer, incised and dated
1968
Purchased, 1973

WOOLF, Virginia (1882-1941)
Novelist and critic; wife of Leonard
Woolf

3802 Chalk 20.3 x 16.5 (8 x 6½)
Francis Dodd, signed and dated 1908
Given by the artist, 1951

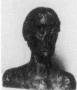

3882 Lead cast of bust 40.6 (16)
high
Stephen Tomlin, c.1935
Purchased, 1953

WOOLMORE, Captain

316a(145) *See Collections:*
Preliminary drawings for busts and
statues by Sir Francis Chantrey,
316a(1-202)

WOOLNER, Thomas (1825-92)
Sculptor and poet

3848 Pencil, hexagonal
15.5 x 14.6 (6⅛ x 5¾)
Dante Gabriel Rossetti, dated 1852
Purchased, 1953

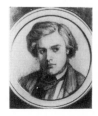

WOOLTON, Frederick James
Marquis, 1st Earl of (1883-1964)
Statesman

4529(397) *See Collections:*
Working drawings by Sir David Low,
4529(1-401)

WOOTTON, John (1686?-1765)
Painter of sporting subjects and
landscapes

1384 *See Groups:* A Conversation
of Virtuosis at the Kings Armes
(A Club of Artists), by Gawen
Hamilton

WORCESTER, Charles Somerset,
1st Earl of (1460?-1526) Natural
son of 3rd Duke of Somerset

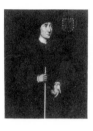

1492 Water-colour 20.6 x 16.5
(8½ x 6½)
George Perfect Harding after an
unknown artist, signed
Bequeathed by H.C.Brunning, 1908
See Collections: Copies of early
portraits, by George Perfect Harding
and Sylvester Harding, **1492,
1492(a-c)** and **2394-2419**

Strong

WORCESTER, William Somerset,
3rd Earl of (1526-89) Courtier

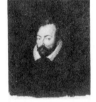

2400 Water-colour 27.3 x 20
(10¾ x 7⅞)
George Perfect Harding after a
portrait of 1569, inscribed
Purchased, 1929
See Collections: Copies of early
portraits, by George Perfect Harding
and Sylvester Harding, **1492,
1492(a-c)** and **2394-2419**

Strong

WORDSWORTH, John (1843-1911)
Bishop of Salisbury; grand-nephew
of William Wordsworth

2369 *See Groups:* The Education
Bill in the House of Lords, by
Sydney Prior Hall

WORDSWORTH, William
(1770-1850) Poet Laureate

450 Pencil and chalk 16.5 x 14
(6½ x 5½)
Robert Hancock, 1798
Purchased, 1877

2020 Plaster cast of life-mask
24.1 (9½) long
Benjamin Robert Haydon, 1815
Given by Sir George Buckston
Browne, 1924

3687 Chalk 54.6 x 41.9
(21½ x 16½)
Benjamin Robert Haydon, signed,
inscribed and dated 1818
Given by Mrs Silvia St Hill, 1950

316a(146) *See Collections:*
Preliminary drawings for busts and
statues by Sir Francis Chantrey,
316a(1-202)

4211 Panel 40.6 x 29.8 (16 x 11¾)
Sir William Boxall, signed and
inscribed, 1831
Bequeathed by Miss Catherine
Ouless, 1961

104 Canvas 217.2 x 133.4
(85½ x 52½)
Henry William Pickersgill, c.1850,
related to a portrait of 1833
Purchased, 1860

2680 Wax medallion 8.3 (3¼)
diameter
Edward William Wyon, 1835
Given by Maurice Buxton Forman,
1934

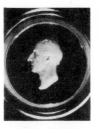

1857 Canvas 124.5 x 99.1
(49 x 39)
Benjamin Robert Haydon, 1842
Bequeathed by John Fisher
Wordsworth, 1920

WOTTON, Sir Henry (1568-1639)
Diplomat and poet

1482 Canvas 124.5 x 99.1
(49 x 39)
Unknown artist, inscribed
Purchased, 1907

Piper

WRAY, Sir Christopher (1524-92)
Judge

1484 Canvas 61 x 48.3 (24 x 19)
Unknown artist, after a portrait of
1582
Bequeathed by William Thomas
Snosswell, 1908

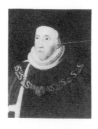

WREN, Sir Christopher (1632-1723)
Architect and scientist

113 Canvas 124.5 x 100.3
(49 x 39½)
Sir Godfrey Kneller, signed,
inscribed and dated 1711
Purchased, 1860

4500 Ivory medallion, oval
12.7 x 9.2 (5 x 3⅝)
David le Marchand, c.1723
Purchased, 1966

Piper

WRIGHT, Sir Almroth Edward
(1861-1947) Bacteriologist

4127 Pencil 37.5 x 27.3
(14¾ x 10¾)
Francis Dodd, signed, inscribed and
dated 1932
Given by Leonard Colebrook, 1959

WRIGHT, Christopher
(1570?-1605) Conspirator

334A *See Groups:* The Gunpowder
Plot Conspirators, 1605, by an
unknown artist

WRIGHT, John (1568?-1605)
Conspirator; brother of Christopher
Wright

334A *See Groups:* The Gunpowder
Plot Conspirators, 1605, by an
unknown artist

WRIGHT, Joseph (1734-97)
'Wright of Derby'; painter

4090 Canvas 62.2 x 52.7
(24½ x 20¾)
Self-portrait, c.1784(?)
Purchased, 1959

29 *See Unknown Sitters III*

WRIGHT, Thomas (1789-1875)
Prison philanthropist

1016 Chalk 61 x 50.8 (24 x 20)
George Frederic Watts, c.1850-1
Given by the artist, 1895

Ormond

WRIGHT, W.
Doorkeeper

999 *See Groups:* The Trial of
Queen Caroline, 1820, by Sir
George Hayter

WRIGHT, Whitaker (1845-1904)
Company promoter

3534 *See Collections:* Prominent
Men, c.1880-c.1910, by Harry
Furniss, **3337-3535** and **3554-3620**

WRIOTHESLEY, Henry, 3rd Earl
of Southampton
See SOUTHAMPTON

WRIOTHESLEY, Thomas, 4th Earl
of Southampton
See SOUTHAMPTON

WROTTESLEY, John Wrottesley,
1st Baron (1771-1841) Politician

54 *See Groups:* The House of Commons, 1833, by Sir George Hayter

WROTTESLEY, Arthur Wrottesley,
3rd Baron (1824-1910)
Philanthropist in Staffordshire

1834(hh) Pencil 20.3 x 12.7
(8 x 5)
Frederick Sargent, signed by artist
and sitter
Given by A.C.R.Carter, 1919
See Collections: Members of the
House of Lords, c.1870-80, by
Frederick Sargent, **1834(a-z** and
aa-hh)

2972 Water-colour 40 x 24.1
(15¾ x 9½)
(Possibly H.C.Sepping) Wright,
signed *STUFF*
(*VF* 20 June 1895)
Purchased, 1938

WYATT, James (1746-1813)
Architect

344 Bronze cast of bust 50.8 (20)
high
John Charles Felix Rossi, incised,
exh 1797
Given by Sir Matthew Digby Wyatt,
1872

WYATT, Richard James
(1795-1850) Sculptor; grandson
of James Wyatt

3944(19) Pencil 23.8 x 18.4
(9⅜ x 7¼)
John Partridge, 1825
Purchased, 1955
See Collections: Artists, 1825,
by John Partridge and others,
3944(1-55)

WYATT, Sir Thomas (1503?-42)
Poet

1035 Panel 47 (18½) diameter
After Hans Holbein, inscribed
Purchased, 1896

2809 Panel 36.2 (14¼) diameter
After Hans Holbein
Purchased, 1936. *Montacute*

Strong

WYATT, Sir Thomas (1521?-54)
Conspirator; son of Sir Thomas
Wyatt (1503?-42)

3331 Panel, feigned circle
34.3 x 33 (13½ x 13)
Unknown artist
Purchased, 1947

Strong

WYATVILLE, Sir Jeffry
(1766-1840) Architect; nephew
of James Wyatt

316a(148) Pencil 47.6 x 37.1
(18¾ x 14⅝)
Sir Francis Chantrey, inscribed
Given by Mrs George Jones, 1871

and

316a(149) Pencil 47. x 27.9
(18½ x 11)
Sir Francis Chantrey
Given by Mrs George Jones, 1871
See Collections: Preliminary
drawings for busts and statues by
Sir Francis Chantrey, **316a(1-202)**

316a(147) *See Collections:*
Preliminary drawing for busts and
statues by Sir Francis Chantrey,
316a(1-202)

WYCHE, Sir Cyril (1632?-1707)
Statesman and scientist

1422 Canvas 127 x 101.6 (50 x 40)
Unknown artist, 1693(?)
Given by the sitter's lineal
descendant, Cyril Wyche, 1905

Piper

WYCHERLEY, William
(1640-1716) Dramatist

880 Canvas 66.7 x 57.8
(26¼ x 22¾)
After(?) Sir Peter Lely, signed *PL* in
monogram (c.1668)
Purchased, 1891

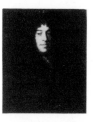

L152(18) Miniature on vellum,
oval 6.4 x 5.1 (2½ x 2)
Attributed to Lawrence Crosse,
signed *LC* in monogram
Lent by NG (Alan Evans Bequest),
1975

Piper

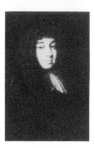

WYKE, Sir Charles Lennox
(1815-97) Diplomat

4757 Water-colour 29.8 x 17.8
(11¾ x 7)
Carlo Pellegrini: signed *Ape*
(*VF* 9 Feb 1884)
Purchased, 1970

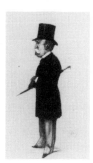

WYNDHAM, Charles, 2nd Earl of
Egremont *See* EGREMONT

WYNDHAM, Sir Charles
(1837-1919) Actor-manager

2373 *See Collections:*
Miscellaneous drawings . . . by
Sydney Prior Hall, **2282-2348** and
2370-90

3535 Pen and ink 38.7 x 31.8
(15¼ x 12½)
Harry Furniss, signed with initials,
pub 1905
Purchased, 1947
See Collections: Prominent Men,
c.1880-c.1910, by Harry Furniss,
3337-3535 and **3554-3620**

WYNDHAM, George, 3rd Earl of
Egremont *See* EGREMONT

WYNDHAM, George (1863-1913)
Statesman and writer

3814 Plaster cast of death-mask
36.8 (14½) long
Unknown artist, 1913
Given by the sitter's step-daughter,
the Countess of Shaftesbury, 1952

WYNDHAM, Sir Henry
(1790-1860) Major-General

3769 *See Collections:* Studies
for The Waterloo Banquet at
Apsley House, 1836, by William
Salter, **3689-3769**

WYNDHAM, Mary, Lady
(1861-1931) 'Mary Moore';
actress and theatre-manager

2370-2 *See Collections:*
Miscellaneous drawings . . . by
Sydney Prior Hall, **2282-2348**
and **2370-90**

WYNDHAM, Percy Scawen
(1835-1911)
Landowner and connoisseur

4758 Water-colour 30.5 x 18.1
(12 x 7⅛)
Sir Leslie Ward, signed *Spy*
(*VF* 30 Oct 1880)
Purchased, 1970

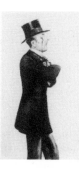

WYNDHAM, Sir William, Bt
(1687-1740) Politician and
Chancellor of the Exchequer

4447 Canvas 128.3 x 101.6
(50½ x 40)
Jonathan Richardson, inscribed,
1713-14
Purchased, 1965

WYNFIELD, David Wilkie
(1837-87)
Painter and photographer

P97 Photograph: albumen print
21.3 x 16.2 (8$\frac{3}{8}$ x 6$\frac{3}{8}$)
Self-portrait, 1860s
Given by H.Saxe Wyndham, 1937
See Collections: The St John's
Wood Clique, by David Wilkie
Wynfield, **P70-100**

P87 *See Collections:* The St
John's Wood Clique, by David
Wilkie Wynfield, **P70-100**

WYNN, Charles Watkin Williams
(1775-1850) Politician; grandson
of Sir Watkin Williams Wynn, Bt

54 *See Groups:* The House of Com-
mons, 1833, by Sir George Hayter

WYNN, Sir Watkin Williams, Bt
(1692-1749) Jacobite

2614 Canvas 126.4 x 101.6
(49¾ x 40)
After Michael Dahl, inscribed
(c.1729?)
Purchased, 1933

Kerslake

WYNN-CARRINGTON, Charles,
3rd Baron and Earl Carrington
See CARRINGTON

WYN-CARRINGTON, Charles
Robert,1st Marquess of Lincolnshire
See LINCOLNSHIRE

WYON, William (1795-1851)
Medallist

2515(8) Pencil and chalk
38.7 x 27.9 (15¼ x 11)
William Brockedon, dated 1825
Lent by NG, 1959
See Collections: Drawings of
Prominent People, 1823-49, by
William Brockedon, **2515(1-104)**

1456(21) With Ebenezer Butler
Morris (left)
Chalk 8.3 x 13 (3¼ x 5$\frac{1}{8}$)
Charles Hutton Lear, inscribed,
c.1845
Given by John Elliot, 1907
See Collections: Drawings of
Artists, c.1845, by Charles
Hutton Lear, **1456(1-27)**

Ormond

WYSE, Sir Thomas (1791-1862)
Diplomat

342,343(a-c) *See Groups:* The
Fine Arts Commissioners, 1846, by
John Partridge

YARRELL, William (1784-1856)
Zoologist

P120(27) Photograph: albumen
print, arched top 19.7 x 14.6
(7¾ x 5¾)
Maull & Polyblank, inscribed on
mount, 1855
Purchased, 1979
See Collections: Literary and
Scientific Men, 1855, by Maull &
Polyblank, **P120(1-54)**

YATES, Edmund (1831-94)
Novelist

4546 Water-colour 27.6 x 19.4
(10$\frac{7}{8}$ x 7$\frac{5}{8}$)
Unknown artist, signed *HHE* (?),
pub 1884
Given by A.Yakovleff, 1967

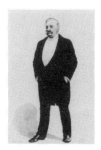

YEAMES, William Frederick
(1835-1918) Painter

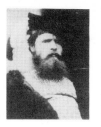

P98 Photograph: albumen print
21.3 x 16.2 ($8\frac{3}{8}$ x $6\frac{3}{8}$)
David Wilkie Wynfield, 1860s
Given by H.Saxe Wyndham, 1937
See Collections: The St John's
Wood Clique, by David Wilkie
Wynfield, **P70-100**

P88 *See Collections:* The St John's
Wood Clique, by David Wilkie
Wynfield, **P70-100**

2820 *See Groups:* The Royal
Academy Conversazione, 1891, by
G.Grenville Manton

YEATS, John Butler (1839-1922)
Painter

4104 Chalk 50.2 x 38.1 (19¾ x 15)
Self-portrait, signed, inscribed and
dated 1920
Purchased, 1959

YEATS, William Butler (1865-1939)
Poet and dramatist; son of John
Butler Yeats

3061 Etching 17.8 x 12.7 (7 x 5)
Augustus John, signed and dated
1907 on plate, and signed below
plate
Purchased, 1959

3644 Plaster cast of mask 44.5
(17½) high
Kathleen Scott, 1907
Given by the artist's husband,
Lord Kennet, 1948

3644a Bronze cast of no.**3644**
Purchased, 1955. *Not illustrated*

4676 *See Groups:* Lady Gregory,
Sir Hugh Lane, J.M.Synge and
W.B.Yeats, by Sir William Orpen

4105 Pencil and wash 34.3 x 19.1
(13½ x 7½)
Augustus John, signed, c.1910
Purchased, 1910

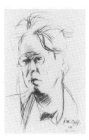

3965 Chalk 47 x 30.5 (18½ x 12)
Ivan Opffer, signed, inscribed and
dated 1935(?)
Purchased, 1955

YEO, Richard (d.1779)
Medallist

1437,1437a *See Groups:* The
Academicians of the Royal
Academy, 1771-2, by John Sanders
after Johan Zoffany

YONGE, Charlotte Mary
(1823-1901) Novelist and writer
of books for children

2193 Water-colour and chalk
51.1 x 32.7 ($20\frac{1}{8}$ x $12\frac{7}{8}$)
George Richmond, signed and
dated 1844
Purchased, 1928

YONGE, Sir George, Bt
(1731-1812)
Governor of Cape of Good Hope

745 *See Groups:* William Pitt
addressing the House of Commons
. . . 1793, by Karl Anton Hickel

YONGE, John (1467-1516)
Diplomat

1585 Plaster cast from head of the
monument now in Public Record
Office 30.5 (12) high
After Pietro Torrigiano (c.1516)
Given by Alfred Peachey, 1910

Strong

YORK, Anne Hyde, Duchess of
(1637-71) Mother of Mary II
and Queen Anne

5077 *See under* James II

241 Canvas, feigned carved oval
74.3 x 62.9 (29¼ x 24¾)
After Sir Peter Lely (?), (c.1670)
Purchased, 1867

Piper

YORK, Henry Benedict Maria
Clement Stuart, Cardinal
(1725-1807) Son of Prince James
Francis Edward Stuart

435 Canvas, feigned oval
65.4 x 49.2 (25¾ x 19⅜)
Studio of Antonio David, c.1732
Purchased, 1876

129 Canvas 73.7 x 61.6 (29 x 24¼)
After Pompeo Batoni (?)
Purchased, 1861

378 Pastel 24.4 x 21.6 (9⅝ x 8½)
Attributed to Hugh Douglas
Hamilton, c.1786
Purchased, 1873. *Beningbrough*

2784 Silver medal 5.4 (2⅛)
diameter
Gioacchimo Hamerani, signed,
inscribed and dated 1788
Given by Reginald Stubbs, 1935

Kerslake

YORK AND ALBANY, Edward
Augustus, Duke of (1739-67)
Son of Frederick, Prince of Wales

1165 *See Groups:* Francis
Ayscough with the Prince of Wales
and the Duke of York and Albany,
by Richard Wilson

YORK AND ALBANY, Frederick,
Duke of (1763-1827) Son of
George III; Commander-in-Chief
of the Army

3308 *See under* George IV

1695(t) *See Collections:* Sketches
for The Trial of Queen Caroline,
1820, by Sir George Hayter,
1695(a-x)

2662(21) *See Collections:* Book
of sketches, mainly for The Trial of
Queen Caroline, 1820, by Sir
George Hayter, **2662(1-38)**

999 *See Groups:* The Trial of
Queen Caroline, 1820, by Sir
George Hayter

1563 Millboard 29.8 x 22.9
(11¾ x 9)
G.Swendale after Sir Thomas
Lawrence, inscribed and dated
1829 on reverse (exh 1822)
Purchased, 1910

2936 Panel 59.1 x 52.1
(23¼ x 20½)
Sir David Wilkie, signed and dated
1823
Purchased, 1938

1615 Canvas, feigned oval
74.9 x 62.2 (29½ x 24½)
After John Jackson (eng 1825)
Purchased, 1911

1691a *See under* George IV

2921 Wax medallion, oval
5.7 x 5.1 (2¼ x 2)
John de Veaux, signed
Given by R.M.Holland-Martin,1937

YORKE, Charles Philip, 4th Earl of Hardwicke *See* HARDWICKE

YORKE, Charles Philip, 5th Earl of Hardwicke *See* HARDWICKE

YORKE, Philip, 1st Earl of Hardwicke *See* HARDWICKE

YOUNG, Sir Allen William (1827-1915) Sailor and explorer

920 Canvas 39.4 x 33 (15½ x 13) Stephen Pearce, signed and dated 1876
Bequeathed by Lady Franklin, 1892
See Collections: Arctic Explorers, 1850-86, by Stephen Pearce, **905-24** and **1209-27**

Ormond

YOUNG, Arthur (1741-1820) Agriculturalist, traveller and writer

1162 Pencil 25.4 x 19.1 (10 x 7½) George Dance, signed and dated 1794
Purchased, 1898

YOUNG, Brook
Son of Sir William Young, 1st Bt (1725-88)

L170 *See Groups:* Brook, John and Harry Young, by Johan Zoffany

YOUNG, Charles Mayne (1777-1856) Actor and comedian

999 *See Groups:* The Trial of Queen Caroline, 1820, by Sir George Hayter

1814 Chalk 34.9 x 44.5 (13¾ x 17½)
John Linnell
Purchased, 1918
See Collections: Drawings by John Linnell, **1812-18B**

YOUNG, Edward (1683-1765) Poet

1244 *See Unknown Sitters III*

YOUNG, Edward Hilton, 1st Baron Kennet *See* KENNET

YOUNG, George Frederick (1791-1870) MP for Tynemouth

54 *See Groups:* The House of Commons, 1833, by Sir George Hayter

YOUNG, George Malcolm (1882-1959) Historian

4255 Pencil 51.1 x 35.6 $(20\frac{1}{8} \times 14)$
Henry Lamb, c.1935
Purchased, 1962

4292 Pencil 45.7 x 35.6 (18 x 14) Henry Lamb, signed and dated 1938
Given by the Warden and Fellows of All Souls College, 1962

YOUNG, Harry
Son of Sir William Young, 1st Bt (1725-88)

L170 *See Groups:* Brook, John and Harry Young, by Johan Zoffany

YOUNG, John
Youngest son of Sir William Young, 1st Bt (1725-88)

L170 *See Groups:* Brook, John and Harry Young, by Johan Zoffany

YOUNG, John, 1st Baron Lisgar *See* LISGAR

YOUNG, Mary
Daughter of Sir William Young, 1st Bt (1725-88)

L171 *See under* Sir William Young, 2nd Bt

YOUNG, Thomas (1773-1829)
Physician, physicist and
Egyptologist

1075,1075a and **b** *See Groups:*
Men of Science Living in 1807-8,
by Sir John Gilbert and others

YOUNG, Sir William, 2nd Bt
(1749-1815)
Governor of Tobago

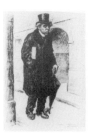

L171 With his sister, Mary
Canvas 63.5 x 49.5 (25 x 19½)
Johan Zoffany, c.1766
Lent by Sir William Young, Bt,
1978

YOUNGHUSBAND, Sir Francis
Edward (1863-1942)
Soldier, explorer and mystic

3184 Canvas 69.2 x 58.4
(27¼ x 23)
Sir William Quiller Orchardson,
signed with initials and dated 1906
Given by the sitter's widow and
daughter, Helen and Eileen
Younghusband, 1944

YPRES, John French, 1st Earl of
(1852-1925) Field-Marshal

2908(11) *See Collections:* Studies,
mainly for General Officers of
World War I, by John Singer
Sargent, **2908 (1-18)**

2654 (study for *Groups*, **1954**)
Canvas 54.6 x 39.4 (21½ x 15½)
John Singer Sargent
Given by Viscount Wakefield, 1934

1954 *See Groups:* General Officers
of World War I, by John Singer
Sargent

ZANGWILL, Israel (1864-1926)
Novelist

3318 Canvas 34.9 x 45.1
(13¾ x 17¾)
C.Polowetski, signed and dated
1909
Bequeathed by the sitter's widow,
1947

2808 Pen and ink 33.7 x 23.5
(13¼ x 9¼)
Alfred Wolmark, signed and dated
1925
Given by the Ben Uri Gallery, 1936

4003 Chalk 36.8 x 26.7
(14½ x 10½)
Sir Bernard Partridge, inscribed
Given by D.Pepys Whiteley, 1956

ZOFFANY, Johan (1733-1810)
Painter of portraits and
conversation pieces

1437,1437a *See Groups:* The
Academicians of the Royal
Academy, 1771-2, by John Sanders
after Johan Zoffany

2536 Pencil 15.2 (6) diameter
Self-portrait
Given by Iolo A.Williams, 1932

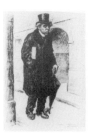

399 *See Unknown Sitters III*

ZOUCHE, Robert Curzon, 14th
Baron (1810-73) Diplomat

P116 Photograph: 9th plate
daguerreotype 5.1 x 3.8 (2 x 1½)
sight
Studio of Richard Beard, 1840s
Purchased, 1979

ZOUCHE, Richard (c.1590-1661)
Judge

5056 Panel, feigned oval
67.3 x 52.1 (26½ x 20½)
Attributed to Cornelius Johnson,
dated 1620
Purchased, 1975

ZUCCARELLI, Francesco
(1702-88) Landscape painter

1437,1437a *See Groups:* The
Academicians of the Royal
Academy, 1771-2, by John Sanders
after Johan Zoffany

ZUKERTORT, Johannes Hermann
(1842-88) Chess player

3060 *See Groups:* Chess players,
by A.Rosenbaum

Groups

Note: The entries in this section are arranged numerically under Gallery register number, beginning with non-prefixed numbers, followed by numbers with the prefix P (photograph) and then by numbers with the prefix L (loan).

The House of Commons, 1833

54 Canvas 300.3 x 497.8 (118¼ x 196)
Sir George Hayter, signed and dated 1833-43
Nearly four hundred figures
Given by H.M.Government, 1858

The following, listed alphabetically, are represented:

George Hamilton Gordon, 4th Earl of Aberdeen (1784-1860)
Montagu Bertie, 6th Earl of Abingdon (1808-84)
Sir Charles Adam (1780-1853)
Edward Hamlyn Adams (1777-1842)
Henry Aglionby Aglionby (1790-1854)
Sir Andrew Agnew, Bt (1793-1849)
Ernest Augustus Charles Brudenell-Bruce, 3rd Marquess of
 Ailesbury (1811-86)
Henry William Paget, 1st Marquess of Anglesey (1768-1854)
Sir George Anson (1769-1849)
George Anson (1797-1857)
Hugh Arbuthnot (1780-1868)
Alexander Baring, 1st Baron Ashburton (1774-1848)
William Bingham Baring, 2nd Baron Ashburton (1799-1864)
Anthony Henry Ashley-Cooper (1807-58)
Thomas Attwood (1783-1856)
Gilbert John Heathcote, 1st Baron Aveland (1795-1867)

William John Bankes (c.1784-1855)
Sir Alexander Bannerman (1788-1864)
Henry Bingham Baring (1804-69)
Charles James Barnett (c.1797-1882)
Sir Henry Winston Barron, Bt (1795-1872)
Sir Robert Bateson, Bt (1782-1863)
George Henry Bathurst, 4th Earl Bathurst (1790-1866)
Henry Beauchamp Lygon, 4th Earl Beauchamp (1784-1863)
Francis Russell, 7th Duke of Bedford (1788-1861)
John Russell, 6th Duke of Bedford (1766-1839)
William Russell, 8th Duke of Bedford (1809-72)

John Benett (1773-1852)
Sir John Poo Beresford, Bt (1766-1844)
George Charles Grantley FitzHardinge Berkeley (1800-81)
Ralph Bernal (d.1854)
John William Ponsonby, 4th Earl of Bessborough (1781-1847)
Richard Bethell (1772-1864)
Thomas Bish (1780-1843)
William Seymour Blackstone (1809-81)
John Campbell, 2nd Marquess of Breadalbane (1796-1862)
Frederick William Hervey, 2nd Marquess of Bristol (1800-64)
William Bird Brodie (1780-1863)
Joseph Brotherton (1783-1857)
William Brougham, 2nd Baron Brougham and Vaux
 (1795-1886)
John Cam Hobhouse, 1st Baron Broughton de Gyfford
 (1786-1869)
Richard Grenville, 2nd Duke of Buckingham and Chandos
 (1797-1861)
Sir Francis Burdett, Bt (1770-1844)
Sir Thomas Fowell Buxton, Bt (1786-1845)
George Byng (1764-1847)

John Hales Calcraft (1796-1880)
John Campbell, 1st Baron Campbell (1779-1861)
Charles Manners-Sutton, 1st Viscount Canterbury (1780-1845)
James Thomas Brudenell, 7th Earl of Cardigan (1797-1868)
George Frederick William Howard, 7th Earl of Carlisle
 (1802-64)
Robert John Smith (later Carrington), 2nd Baron Carrington
 (1796-1868)
William Ralph Cartwright (1771-1847)
Edward Stillingfleet Cayley (1802-62)
Sir George Cayley, Bt (1773-1857)
Charles William Bury, 2nd Earl of Charleville (1801-51)
Charles Compton Cavendish, 1st Baron Chesham (1793-1863)
William Fawkener Chetwynd (1788-1873)
John Walbanke Childers (1789-1886)

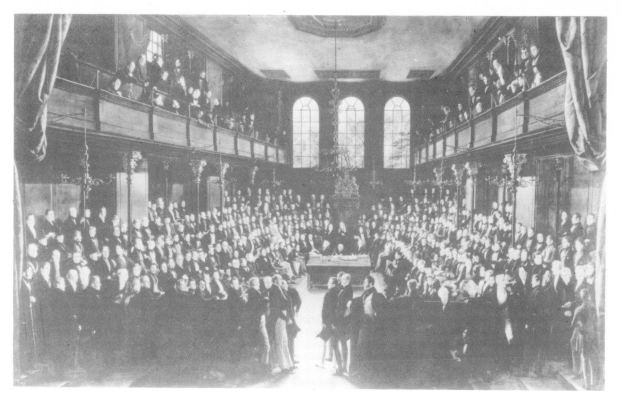

Richard Hobart FitzGibbon, 3rd Earl of Clare (1793-1864)
Sir William Clay, Bt (1791-1869)
Sir William Robert Clayton, Bt (1786-1866)
Henry Vane, 2nd Duke of Cleveland (1788-1864)
Edward Bolton Clive (after 1763-1845)
Robert Henry Clive (1789-1854)
William Cobbett (1762-1835)
Sir Charles Cockerell, Bt (1755-1837)
Sir Edward Codrington (1770-1851)
Arthur Henry Cole (1780-1844)
Edmund Michael Conolly (1786-1848)
Sir Charles Henry Coote, Bt (1802-64)
Henry Thomas Lowry Corry (1803-73)
Charles Christopher Pepys, 1st Earl of Cottenham (1781-1851)
Thomas Francis Fremantle, 1st Baron Cottesloe (1798-1890)
Joseph Cripps (1765-1847)
Charles Lennox Cumming-Bruce (1790-1875)

Sir George Henry Dashwood, Bt (1790-1862)
William Francis Spencer Ponsonby, 1st Baron De Mauley
 (1787-1855)
Edward Stanley, 14th Earl of Derby (1799-1869)
William Cavendish, 7th Duke of Devonshire (1808-91)
Charles Tennyson D'Eyncourt (1784-1861)
Quintin Dick (1777-1858)
Lewis Weston Dillwyn (1778-1855)
George Rice Rice-Trevor, 4th Baron Dinevor (1795-1869)
Edward Divett (1797-1864)
George Hamilton Chichester, 3rd Marquess of Donegall
 (1797-1883)
Sir Rufane Shaw Donkin (1773-1841)
William Stratford Dugdale (1800-71)
Sir James Whitely Deans Dundas (1785-1862)
Sir Robert Lawrence Dundas (1780-1844)
James Abercromby, 1st Baron Dunfermline (1776-1858)
Fretchville Lawson Ballantine Dykes (1800-66)

Robert Grosvenor, 1st Baron Ebury (1801-93)
Edward Ellice (1781-1863)
Sir George Elliott (1784-1863)
William Willoughby Cole, 3rd Earl of Enniskillen (1807-86)
Ralph Etwall (1804-82)
Charles Shaw-Lefevre, 1st Viscount Eversley (1794-1888)
William Ewart (1798-1869)

Charles St John Fancourt (1804-75)
Henry Maxwell, 7th Baron Farnham (1799-1868)
John Nicholas Fazakerley (1787-1852)
Sir William Feildon, Bt (1772-1859)
John Fenton (c.1791-1863)
Robert Ferguson (before 1773-1840)
Sir Ronald Craufurd Ferguson (1773-1841)
Robert Cutlar Fergusson (1768-1838)
William Duncombe, 2nd Baron Feversham (1798-1867)
John Fielden (1784-1849)
George Finch (1794-1870)
Sir Peter Hesketh Fleetwood, Bt (1801-66)
Charles Elphinstone Fleming (1774-1840)
Sir William John Henry Browne Folkes, Bt (1786-1860)
John George Weld-Forester, 2nd Baron Forester (1801-74)
George Cecil Weld-Forester, 3rd Baron Forester (1807-86)
Hugh Fortescue, 2nd Earl Fortescue (1783-1861)
Charles Richard Fox (1796-1873)
Sackville Walter Lane Fox (1800-74)
Fitzstephen French (1801-73)

Daniel Gaskell (1782-1875)
James Milnes Gaskell (1810-73)
Sir Thomas Gladstone, Bt (1804-89)
William Ewart Gladstone (1809-98)
Sir Stephen Richard Glynne, Bt (1807-74)
William Gordon (1784-1858)
Henry Goulburn (1784-1856)
Sir James Robert George Graham, Bt (1792-1861)

Continued overleaf

Sir Robert Grant (1779-1838)
Thomas Greene (1794-1872)
Sir Charles John Greville (1780-1836)
Charles Grey, 2nd Earl Grey (1764-1845)
Henry George Grey, 3rd Earl Grey (1802-94)
Rees Howell Gronow (1794-1865)
George Grote (1794-1871)
Sir Josiah John Guest, Bt (1785-1852)
John Gully (1783-1863)

Charles Wood, 1st Viscount Halifax (1800-85)
Lord Douglas Gordon Hallyburton (1777-1841)
Charles Hamilton
John Hanmer, 1st Baron Hanmer (1809-81)
George Granville Harcourt (1785-1861)
Henry Hardinge, 1st Viscount Hardinge (1785-1856)
Charles Philip Yorke, 4th Earl of Hardwicke (1799-1873)
John Hardy (1773-1855)
William Charles Harland (1804-63)
Dudley Ryder, 2nd Earl of Harrowby (1798-1882)
Daniel Whittle Harvey (1786-1863)
Jacob Astley, 16th Baron Hastings (1797-1859)
Edward John Littleton, 1st Baron Hatherton (1791-1863)
Sir Andrew Leith Hay (1785-1862)
Sir John Hay, Bt (1788-1838)
Sir Edmund Samuel Hayes, Bt (1806-60)
Sir George Hayter (1792-1871)
George Fieschi Heneage (1800-64)
John Henniker-Major, 4th Baron Henniker (1801-70)
Sidney Herbert, 1st Baron Herbert (1810-61)
Sir Robert Heron, Bt (1765-1854)
John Charles Herries (1778-1855)
Rowland Hill, 2nd Viscount Hill (1800-75)
Thomas Law Hodges (1776-1857)
Henry Richard Vassall Fox, 3rd Baron Holland (1773-1840)
Sir William Horne (1774-1860)
Beaumont Hotham, 3rd Baron Hotham (1794-1870)
Philip Henry Howard (1801-83)
William Howley (1766-1848)
Thomas Hudson (1772-1852)
Joseph Hume (1777-1855)
John Humphery (1794-1863)
William George Hylton Jolliffe, 1st Baron Hylton (1800-76)

Robert Ingham (1793-1875)
Sir Robert Harry Inglis, Bt (1786-1855)
William James (1791-1861)
Francis Jeffrey, Lord Jeffrey (1773-1850)
George Child-Villiers, 5th Earl of Jersey (1773-1859)
George Augustus Frederick Child-Villiers, 6th Earl of Jersey
 (1808-59)
Sir John Vanden Bempde Johnstone, Bt (1799-1869)

Thomas Read Kemp (1782-1844)
Thomas Francis Kennedy (1788-1879)
Sir Edward Kerrison, Bt (1774-1853)
William Thomas Petty-Fitzmaurice, Earl of Kerry (1811-36)
Edward Bolton King (1800-78)
Sir Edward Knatchbull, Bt (1781-1849)

William Gore Langton (1760-1847)
Henry Petty-Fitzmaurice, 3rd Marquess of Lansdowne
 (1780-1863)
Anthony Lefroy (1800-90)
Thomas Langlois Lefroy (1776-1869)
Benjamin Lester Lester (c.1780-1838)
John Henry Ley (d.1850)
William Ley (c.1817-47)
John Young, 1st Baron Lisgar (1807-76)
James Loch (1780-1855)
Wadham Locke (1779-1835)

Frederick William Robert Stewart, 4th Marquess of
 Londonderry (1805-72)
Sir Ralph Lopes, Bt (1788-1854)
Henry Cecil Lowther (1790-1867)
John Singleton Copley, Baron Lyndhurst (1772-1863)
Robert Vernon Smith, 1st Baron Lyveden (1800-73)

Thomas Babington Macaulay, 1st Baron Macaulay (1800-59)
Roderick Macleod (1768-1853)
John Madocks (1786-1837)
William David Murray, 4th Earl of Mansfield (1806-98)
Stewart Marjoribanks (1774-1863)
George Spencer-Churchill, 6th Duke of Marlborough
 (1793-1857)
John Marshall (1797-1836)
William Maxfield (1782-1837)
William Lamb, 2nd Viscount Melbourne (1779-1848)
Paulet St John Mildmay (1791-1845)
William Henry Miller (1789-1848)
John Mills (1789-1871)
Sir William Molesworth, Bt (1810-55)
Thomas Spring-Rice, 1st Baron Monteagle (1790-1866)
Sir Oswald Mosley, Bt (1785-1871)
Edward Mostyn Lloyd-Mostyn, 2nd Baron Mostyn (1795-1884)
Sir John Archibald Murray, Lord Murray (1779-1859)

Charles Evelyn Pierrepont, Viscount Newark (1805-50)
Henry Clinton, 5th Duke of Newcastle (1811-64)
John Nicholl (1797-1853)
Sir Gerald Noël Noël, Bt (1759-1838)
Henry Charles Howard, 13th Duke of Norfolk (1791-1856)
Frederick North (1800-69)
Francis Thornhill Baring, 1st Baron Northbrook (1796-1866)

Daniel O'Connell (1775-1847)
Dennis O'Connor (1794-1847)
Richard More O'Ferrall (1797-1880)
Dominick Browne, 1st Baron Oranmore and Browne
 (1787-1860)
John Evelyn Denison, 1st Viscount Ossington (1800-73)
Richard Alexander Oswald (1771-1841)

Frederick Paget (1807-66)
Robert Palmer (1793-1872)
Henry John Temple, 3rd Viscount Palmerston (1784-1865)
Joseph Pease (1799-1872)
Sir Robert Peel, Bt (1788-1850)
Edward William Wynne Pendarves (1775-1853)
Alexander Perceval (1787-1858)
Sir George Philips, Bt (1766-1847)
William Pinney (1806-98)
John Pemberton Plumptre (1791-1864)
Sir Jonathan Frederick Pollock, Bt (1783-1870)
Edward Berkeley Portman, 1st Viscount Portman (1799-1888)
Richard Potter (1778-1842)
John Sayer Poulter (d.1847)
Edward Herbert, 2nd Earl of Powis (1785-1848)
William Stephen Poyntz (c.1769-1840)

John Ramsbottom (d.1845)
John Charles Ramsden (1788-1837)
Sir John Rae Reid, Bt (1791-1867)
Charles Gordon-Lennox, 5th Duke of Gordon and Lennox
 (1791-1860)
John Rickman (1771-1840)
Frederick John Robinson, 1st Earl of Ripon (1782-1859)
Cuthbert Rippon
George Richard Robinson (1781-1850)
William Roche (1775-1850)
John Arthur Roebuck (1801-79)
James St Clair Erskine, 2nd Earl of Rosslyn (1762-1837)

John Russell, 1st Earl Russell (1792-1878)
Lord Charles James Fox Russell (1807-94)
Charles Russell (1786-1856)
William Congreve Russell (1788-1850)

Arthur Moyses William Hill, 2nd Baron Sandys (1792-1860)
Arthur Marcus Cecil Hill, 3rd Baron Sandys (1798-1863)
Edward Ayshford Sanford (1794-1871)
Sir Edward Dolman Scott, Bt (1793-1851)
James Winter Scott (1799-1873)
Francis William Ogilvie-Grant, 6th Earl of Seafield (1778-1853)
Sir John Saunders Sebright, Bt (1767-1846)
Henry Seymour (c.1776-1843)
Anthony Ashley-Cooper, 7th Earl of Shaftesbury (1801-85)
Matthew Sharpe (d.1845)
Sir Frederick Shaw, Bt (1799-1876)
Richard Lalor Sheil (1791-1851)
Sir George Sinclair, Bt (1790-1868)
John Somers Cocks, 2nd Earl Somers (1788-1852)
Lord Granville Charles Henry Somerset (1792-1848)
John Charles Spencer, 3rd Earl Spencer (1782-1845)
Frederick Spencer, 4th Earl Spencer (1798-1857)
John Hamilton Macgill Dalrymple, 8th Earl of Stair (1771-1853)
Philip Henry Stanhope, 5th Earl Stanhope (1805-75)
Edward John Stanley, 2nd Baron Stanley (1802-69)
Sir George Thomas Staunton, Bt (1781-1859)
Thomas Kitchingman Staveley (1791-1860)
Robert Steuart (c.1806-42)
John Byng, 1st Earl of Strafford (1772-1860)
George Stevens Byng, 2nd Earl of Strafford (1806-86)
Sir George Strickland, Bt (1782-1874)
Lord Dudley Coutts Stuart (1803-54)
Charles Stuart (1810-92)
Charles Edward Poulett Thomson, 1st Baron Sydenham (1799-1841)

Christopher Rice Mansel Talbot (1803-90)
James Talbot, 4th Baron Talbot de Malahide (1805-83)
Henry Labouchere, 1st Baron Taunton (1789-1869)
Michael Angelo Taylor (1757-1834)
William Tooke (1777-1863)
Charles John Kemeys Tynte (1800-82)
Sir John Tyssen Tyrell, Bt (1795-1877)

Sir William Verner, Bt (1782-1871)
Sir Harry Verney, Bt (1801-94)
George John Venables-Vernon, 5th Baron Vernon (1803-66)
James Walter Grimston, 2nd Earl of Verulam (1809-95)
Nicholas Aylward Vigors (1785-1840)
Richard Hussey Vivian, 1st Baron Vivian (1775-1842)
John Henry Vivian (1785-1855)

Charles Baring Wall (1795-1853)
John Walter (1776-1847)
Henry Warburton (1785-1858)
Sir Henry George Ward (1797-1860)
John Lloyd Vaughan Watkins (1802-65)
Richard Watson (1800-52)
Arthur Wellesley, 1st Duke of Wellington (1769-1852)
Richard Weyland (1780-1864)
Luke White (d.1854)
Samuel White (d.1854)
Isaac Newton Wigney (c.1795-1844)
George Wilbraham (1779-1852)
F.William
Sir Richard Bulkeley Williams-Bulkeley, Bt (1801-75)
Sir Hedworth Williamson, Bt (1797-1861)
John Wilson Patten, 1st Baron Winmarleigh (1802-92)
Thomas Wood (1777-1860)

John Wrottesley, 1st Baron Wrottesley (1771-1841)
Charles Watkin Williams Wynn (1775-1850)

George Frederick Young (1791-1870)

1103 Sheet of three studies, showing Hayter at work on this picture. *See under* HAYTER

3073 Sketch of the Interior of the House of Commons
Pencil 32.1 x 45.1 ($12\frac{5}{8}$ x 17¾)
Sir George Hayter
Given by P.C.I.B.McNalty, 1939. *Not illustrated*

Ormond

The Seven Bishops Committed to the Tower in 1688

79 Canvas 96.5 x 83.8 (38 x 33)
Unknown artist, inscribed, c.1688
Seven figures in ovals
Purchased, 1859
The sitters are (left to right, from top):
William Lloyd (1627-1717)
Francis Turner (1638?-1700)
John Lake (1624-89)
William Sancroft (1617-93)
Thomas Ken (1637-1711)
Thomas White (1628-98)
Sir Jonathan Trelawny, Bt (1650-1721)

Continued overleaf

152a Silver medal 3.5 (1⅜) diameter
George Bower, signed with initials and dated 1688
Given by John Ashton Bostock, 1862

Obverse:
William Sancroft

Reverse (left to right, from top):
William Lloyd
Francis Turner
John Lake
Henry Compton (1632-1713)
Thomas Ken
Thomas White
Sir Jonathan Trelawny, Bt

Piper

The Seven Bishops Committed to the Tower in 1688

152a *See under Groups,* **79**

Five Children of Charles I

267 Canvas 108 x 174.6 (42½ x 68¾)
After Sir Anthony van Dyck (1637)
Five figures
Purchased, 1868

The sitters are (left to right):
Princess Mary (1631-60)
James, Duke of York (afterwards James II) (1633-1701)
Charles (afterwards Charles II) (1630-85)
Princess Elizabeth (1635-50)
Princess Anne (1636-40)

Piper

The Gunpowder Plot Conspirators, 1605

334A Engraving 20 x 20.6 (7⅞ x 8⅛)
Unknown artist, inscribed on plate
Given by H.M.Stationery Office, 1871

The sitters are (left to right):
Thomas Bates (d.1606)
Robert Winter (d.1606)
Christopher Wright (1570?-1605)
John Wright (1568?-1605)
Thomas Percy (1560-1605)
Guy Fawkes (1570-1606)
Robert Catesby (1573-1605)
Thomas Winter (1572-1606)

The Fine Arts Commissioners, 1846

342 Canvas 188 x 372.8 (74 x 145)
John Partridge, c.1846-53
Twenty-eight figures
Given by the artist, 1872
Obliterated by bitumen. *Not illustrated*

The following, listed alphabetically, are represented:
George Hamilton Gordon, 4th Earl of Aberdeen (1784-1860)
Albert, Prince Consort (1819-61)
Alexander Baring, 1st Baron Ashburton (1774-1848)
Sir Charles Barry (1795-1860)
Charles John Canning, Earl Canning (1812-62)
George William Frederick Howard, 7th Earl of Carlisle
 (1802-64)
Nicholas William Ridley-Colborne, 1st Baron Colborne
 (1779-1854)
Sir Charles Lock Eastlake (1793-1865)
Charles Shaw-Lefevre, Viscount Eversley (1794-1888)
Sir James Graham, Bt (1792-1861)
Henry Hallam (1777-1859)
Sir Benjamin Hawes (1797-1862)
Sir Robert Harry Inglis, Bt (1786-1855)
Henry Gally Knight (1786-1846)
Henry Petty-Fitzmaurice, 3rd Marquess of Lansdowne
 (1780-1863)
John Singleton Copley, Baron Lyndhurst (1772-1863)
Thomas Babington Macaulay, 1st Baron Macaulay (1800-59)
William Lamb, 2nd Viscount Melbourne (1779-1848)
Henry Clinton, 5th Duke of Newcastle (1811-64)
Henry John Temple, 3rd Viscount Palmerston (1784-1865)
Sir Robert Peel, Bt (1788-1850)
Samuel Rogers (1763-1855)

John Russell, 1st Earl Russell (1792-1878)
Philip Stanhope, 5th Earl Stanhope (1805-75)
George Granville Sutherland-Leveson-Gower, 2nd Duke of
 Sutherland (1786-1861)
George Vivian (1798-1873)
Peter Robert Drummond-Willoughby, 19th Baron Willoughby
 de Eresby (1782-1865)
Sir Thomas Wyse (1791-1862)

343a Study for no.**342**
Oil on paper 47.6 x 86 (18¾ x 33⅞)
John Partridge, c.1846
Twenty-five figures
Given by the artist, 1872
The same sitters as in no. **342**, but omitting Sir Benjamin
Hawes, Henry Gally Knight and George Vivian

343b Sketch for no.**342**
Pencil 12.1 x 19.4 (4¾ x 7⅝)
Prince Albert, c.1846
Twenty-six figures
Given by Mrs John Partridge, 1872
Faded through excessive exposure. *Not illustrated*

343c Key to no. **342**
Pen and ink wash 46.7 x 102.5 (18⅜ x 40⅜)
John Partridge, inscribed and dated 1846
Twenty-eight figures
Given by the artist, 1872

Ormond

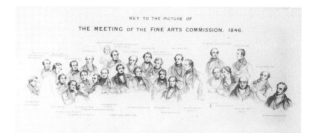

KEY TO THE PICTURE OF
THE MEETING OF THE FINE ARTS COMMISSION. 1846.

The Anti-Slavery Society Convention, 1840

599 Canvas 297.2 x 383.6 (117 x 151)
Benjamin Robert Haydon, signed, inscribed and dated
1841
One hundred and thirty-six figures
Given by the British and Foreign Anti-Slavery Society,
1880

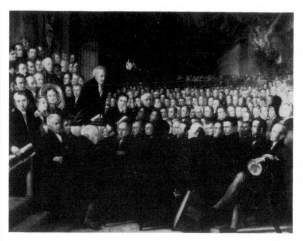

The following, listed alphabetically, are represented:
Professor Adam
Edward Adey
George William Alexander (1802-90)
Richard Allen (1787-1873)
Stafford Allen (1806-89)
William Allen (1770-1843)

Sir Edward Baines (1800-90)
Edward Baldwin
Saxe Bannister (1790-1877)
Edward Barrett
Richard Barrett
Isaac Bass (1782-1855)
Abraham Beaumont (1782-1848)
John Beaumont (1788-1862)
Mrs John Beaumont (1790-1853)
William Beaumont (1790-1869)
Henry Beckford
George Bennett
William Bevan
Thomas Binney (1798-1874)
James Gillespie Birney (1792-1857)
John Birt
Jonathan Blackhouse
W.T.Blair
William Boultbee
Samuel Bowly
Sir John Bowring (1792-1872)
George Bradburn
William Brock (1807-75)
Thomas Bulley
John Burnet
Sir Thomas Fowell Buxton (1786-1845)
Lady Byron (1792-1860)

Tapper Cadbury (1768-1860)
James Carlile (1784-1854)
Peter Clare (1781-1851)
Thomas Clarkson (1760-1846)

Continued overleaf

Thomas Clarkson
Mary Clarkson
Nathaniel Colver
Josiah Conder (1789-1855)
Joseph Cooper (1800-81)
Francis Augustus Cox (1783-1853)
Isaac Crewdson (1780-1844)
William Dillworth
John Cropper

William Dawes
James Dean

Joseph Eaton (1793-1858)
John Ellis (1789-1862)

William Fairbank (1771-1846)
Josiah Forster (1782-1870)
Robert Forster (1792-1873)
William Forster (1784-1854)
Samuel Fox (1781-1868)

Eton Galusha
B.Godwin
Robert Kaye Greville (1794-1866)
Cyrus Pitt Grosvenor
Samuel Gurney (1786-1856)

George Head Head
John Howard Hinton (1791-1873)
Isaac Hodgson (1783-1847)

M.M.Isambert
John Angell James (1785-1859)
William James
Sir John Jeremie (1795-1841)
J.H.Johnson

William Kay
John Keep
Joseph Ketley
William Knibb (1803-45)
Ann Knight (1792-1860)

William Leatham (1783-1842)
L.C.Lecesne
C.Edwards Lester
M.L'Instant
Samuel Lucas
Stephen Lushington (1782-1873)

T.M.McDonnell
Richard Robert Madden (1798-1886)
Joseph Marriage (1807-84)
Jonathan Miller
Constantine Richard Moorsom (1792-1861)
Thomas Morgan
William Morgan
John Morrison
James Mott
Lucretia Mott (1793-1880)
Dr Murch

John T.Norton

Daniel O'Connell (1775-1847)
Amelia Opie (1769-1853)

Joseph Pease (1772-1846)
Elizabeth Pease
Richard Peek
Wendell Phillips (1811-84)
Thomas Pinches
Jacob Post (1774-1855)
Samuel J.Prescod

Thomas Price
G.K.Prince

Richard Rathbone
Mrs Rawson
Joseph Reynolds (1769-1859)

Joseph Sams (1784-1860)
Thomas Scales
John Scoble
William Smeal (1792-1877)
Edward Smith
Joseph Soul
George Stacey (1787-1857)
Henry B.Stanton
Edward Steane
John Steer (1780-1856)
Henry Sterry (1803-69)
Richard Sterry (1785-1865)
Charles Stovel
Charles Stuart
John Sturge
Joseph Sturge (1793-1859)
Thomas Swan

William Tatum (1783-1862)
Henry Taylor
William Taylor
George Thompson (1804-78)
J.Harfield Tredgold
Mrs Tredgold
Henry Tuckett
David Turnbull

Richard D.Webb
Samuel Wheeler (1776-1858)
James Whiteborne
Sir John Eardley Eardley Wilmot, Bt (1783-1847)
William Wilson
John Woodwark

Ormond

Queen Anne and the Knights of the Garter

624 Canvas 62.2 x 74.9 (24½ x 29½)
Peter Angelis, signed and indistinctly dated, c.1713
Over thirty figures
Purchased, 1881. *Beningbrough*

None of the sitters can be identified with certainty, except for Queen Anne. Presumably also present are the Lord Chamberlain, Charles Talbot, Duke of Shrewsbury (1660-1718) and the following new Knights:
Henry Somerset, 2nd Duke of Beaufort (1684-1714)

Henry Grey, 1st Duke of Kent (1664-1740)
Robert Harley, 1st Earl of Oxford (1661-1724)
Charles Mordaunt, 3rd Earl of Peterborough (1658-1735)
John Poulett, 1st Earl Poulett (1663-1743)

Piper

Groups associated with the Moravian Church

624A Canvas 49.5 x 61.3 (19½ x 24$\frac{1}{8}$)
Attributed to Johann Valentin Haidt, c.1752-4
Nine figures
Purchased, 1881
None of the sitters, mostly foreign, has been identified
with certainty

1356 Canvas 53 x 62.6 (20$\frac{7}{8}$ x 24$\frac{5}{8}$)
Attributed to Johann Valentin Haidt, c.1752-4
Ten figures
Purchased, 1904
Except for George II (4th from left) none of the
sitters, mostly foreign, has been identified with
certainty

Kerslake

The Somerset House Conference, 1604

665 Canvas 205.7 x 268 (81 x 105½)
Signed *Juan pantoxa* (Pantoja de la Cruz), but probably
by an unknown Flemish artist, 1604
Eleven seated figures
Purchased, 1882

Left, from the window, the Hispano-Flemish delegation:
Juan de Velasco, Duke of Frias, Constable of Castile
Juan de Tassis, Count of Villa Mediana
Alessandro Robida, Senator of Milan
Charles de Ligne, Count of Aremberg
Jean Richardot, President of the Privy Council
Louis Vereyken, *Audencier* of Brussels

Right, from the window, the English delegates:
Thomas Sackville, Earl of Dorset
Charles Howard, Earl of Nottingham
Charles Blount, Earl of Devonshire
Henry Howard, Earl of Northampton
Robert Cecil, Viscount Cranborne (later 1st Earl of Salisbury)

Strong

A Review of Troops in Phoenix Park, Dublin, 1781

682 Canvas 236.2 x 175.2 (93 x 69)
Francis Wheatley, signed and dated 1781
Five figures
None of the sitters has positively been identified; the right-hand figure (wearing the Order of the Bath) may be Sir John Irwin (1728-88)

The Duke of Buckingham and his Family, 1628

711 Canvas 145.4 x 198.1 (57¼ x 78)
After Gerard Honthorst (1628)
Purchased, 1884. *Montacute*

The sitters are (left to right):
Mary (afterwards Lady Herbert and Duchess of Richmond) (1622-85)
George (afterwards 2nd Duke of Buckingham) (1628-87)
Katharine, Duchess of Buckingham (d.1649)
George Villiers, 1st Duke of Buckingham (1592-1628)

Piper (under 1st Duke of Buckingham)

William Pitt addressing the House of Commons on the French declaration of war, 1793

745 Canvas 322.6 x 449.6 (127 x 177)
Karl Anton Hickel
Ninety-seven figures
Given by the Emperor of Austria, 1885

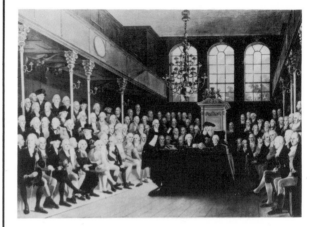

The following sitters have been identified:
Richard Pepper Arden, 1st Baron Alvanley (1764-1840)
Alexander Hood, 1st Viscount Bridport (1726-1814)
John Jeffreys Pratt, 1st Marquess of Camden (1759-1840)
George Canning (1770-1827)
George Porter, 6th Baron de Hochepied (1760-1828)
Thomas Erskine, 1st Baron Erskine (1750-1823)
Charles James Fox (1749-1806)
Henry Edward Fox (1755-1811)
Dudley Ryder, 1st Earl of Harrowby (1762-1847)
John Hatsell (1743-1820)
Samuel Hood, 1st Viscount Hood (1724-1816)
Robert Jenkinson, 2nd Earl of Liverpool (1770-1828)
William Mainwaring
Henry Dundas, 1st Viscount Melville (1742-1811)
Welbore Ellis, Baron Mendip (1713-1802)
William Pitt (1759-1806)
John Freeman-Mitford, Baron Redesdale (1748-1830)
Richard Brinsley Sheridan (1751-1816)
Henry Addington, 1st Viscount Sidmouth (1757-1844)
Richard Cooley Wellesley, Marquess Wellesley (1760-1842)
William Wilberforce (1759-1833)
Sir George Yonge, Bt (1731-1812)

Four studies for Patrons and Lovers of Art, c.1826
(painting not in NPG)

792 Canvas 62.2 x 47 (24½ x 18½)
Pieter Christoph Wonder, c.1826
Four figures
Given by Edward Joseph, 1888

The sitters are (left to right):
George Watson Taylor (1771-1841)
William Howell-Carr (1758-1830)
Sir John Murray, Bt (1768?-1827)
Pieter Christoph Wonder (1780-1852)

793 Canvas 54.6 x 57.8 (21½ x 22¾)
Pieter Christoph Wonder, inscribed, c.1826
Three figures
Given by Edward Joseph, 1888

The sitters are (left to right):
Charles Long, 1st Baron Farnborough (1760-1838)
Sir Abraham Hume, Bt (1749-1838)
George Hamilton Gordon, 4th Earl of Aberdeen (1784-1860)

794 Canvas 61.3 x 45.7 (24⅛ x 18)
Pieter Christoph Wonder, inscribed, c.1826
Two figures
Given by Edward Joseph, 1888

Left: George Agar-Ellis, 1st Baron Dover (1797-1833)
Right: Robert Grosvenor, 1st Marquess of Westminster
(1767-1845)

795 Canvas 54.9 x 48.3 (21⅝ x 19)
Pieter Christoph Wonder, inscribed, c.1826
Three figures
Given by Edward Joseph, 1888

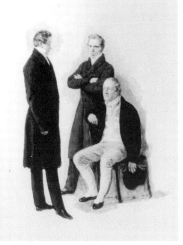

The sitters are (left to right):
Sir Robert Peel, Bt (1788-1830)
Sir David Wilkie (1785-1841)
George Wyndham, 3rd Earl of Egremont (1751-1837)

Ormond (nos. **793** and **795** only, under Aberdeen and Peel
respectively)

The Court of Chancery during the reign of George I

798 Canvas 75.6 x 63.2 (29¾ x 24⅞)
Benjamin Ferrers, c.1725
Over fifty figures
Purchased, 1888

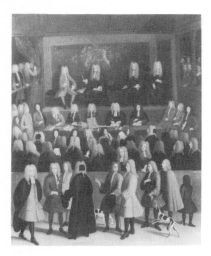

None of the figures has positively been identified;
those on the bench should be Thomas Parker, 1st
Earl of Macclesfield (1666-1732), Philip Yorke,
1st Earl of Hardwicke (1690-1764), and Sir Thomas
Pengelly (1675-1730)

Kerslake

The Misses Mary, Harriet and Louisa Gardiner
Daughters of Colonel Thomas Gardiner

883(11) *See Collections:* Studies for miniatures
by Sir George Hayter, **883(1-21)**

The Committy of the house of Commons (the Gaols Committee)

926 Canvas 51.1 x 68.6 (20⅛ x 27)
William Hogarth, c.1729
Seventeen figures round a table
Given by the 9th Earl of Carlisle, 1892

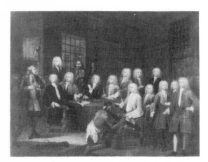

No identifications are certain, but the following have been
suggested:
James Edward Oglethorpe (1696-1785) as chairman
Arthur Onslow (1691-1768) seated next to him
John Perceval, 1st Earl of Egmont (1683-1748) next, seated,
face turned towards
Edward Stables
Sir Archibald Grant (1696-1778) 3rd from right, standing
William Hucks (d.1740) seated, before kneeling prisoner

Kerslake

Sir Joshua Reynolds, Sir William Chambers and Joseph Wilton

987 Canvas 118.1 x 143.5 (46½ x 56½)
John Francis Rigaud, signed and dated 1782
Three figures
Purchased, 1895

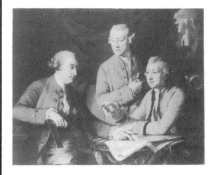

The sitters are (left to right):
Sir William Chambers (1726-96)
Joseph Wilton (1772-1803)
Sir Joshua Reynolds (1723-92)

(See also Groups, **3186**)

The House of Lords, 1820, The Trial of Queen Caroline

999 Canvas 233 x 266.2 (91¾ x 140¼)
Sir George Hayter, 1823
One hundred and eighty-six figures
Given by NACF, 1912

The following, listed alphabetically, are represented:
William Adams (1751-1839)
Charles Brudenell-Bruce, 2nd Earl and 1st Marquess of Ailesbury
(1773-1856)
William Charles Keppel, 4th Earl of Albemarle (1772-1849)
William Arden, 2nd Baron Alvanley (1789-1849)
William Pitt Amherst, 1st Earl Amherst of Arracan (1773-1857)
Henry William Paget, 1st Marquess of Anglesey (1768-1854)
George Anson (1797-1857)
Charles Arbuthnot (1767-1850)
George William Campbell, 6th Duke of Argyll (1768-1839)
George Ashburnham, 3rd Earl of Ashburnham (1760-1830)
John Murray, 4th Duke of Atholl (1755-1830)
George Eden, 1st Earl of Auckland (1784-1849)
Heneage Finch, 5th Earl of Aylesford (1786-1859)

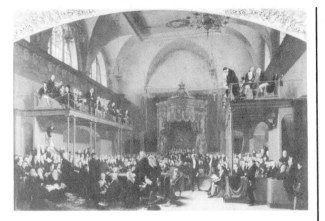

William Bagot, 2nd Baron Bagot (1773-1856)
Thomas Barnes (1785-1841)
Shute Barrington (1734-1826)
Thomas Thynne, 2nd Marquess of Bath (1765-1837)
Henry Bathurst, 3rd Earl Bathurst (1762-1837)
Charles Powlett Townshend, 2nd Baron Bayning (1785-1823)
Henry Charles Somerset, 6th Duke of Beaufort (1766-1835)
Henry Somerset, 7th Duke of Beaufort (1792-1853)
John Russell, 6th Duke of Bedford (1766-1839)
Frederick Ponsonby, 3rd Earl of Bessborough (1758-1844)
Charles John Gardiner, Earl of Blessington (1782-1829)
Orlando Bridgeman, 2nd Baron and 1st Earl of Bradford
 (1762-1825)
John William Egerton, 7th Earl of Bridgewater (1753-1823)
Henry Peter Brougham, 1st Baron Brougham and Vaux
 (1778-1868)
John Cust, 1st Earl Brownlow (1779-1853)
George Robert Hobart, 5th Earl of Buckinghamshire
 (1789-1849)
Sir Francis Burdett, Bt (1770-1844)
Thomas Burgess (1756-1837)

George Gough-Calthorpe, 3rd Baron Calthorpe (1787-1851)
John Jeffreys Pratt, 1st Marquess Camden (1759-1840)
George William Frederick Howard, 7th Earl of Carlisle
 (1802-64)
Henry George Herbert, 2nd Earl of Carnarvon (1772-1833)
Queen Caroline (1768-1821)
Robert Smith, 1st Baron Carrington (1752-1838)
Robert John Carrington, 2nd Baron Carrington (1796-1868)
John Pitt, 2nd Earl Chatham (1756-1835)
Richard Meade, 3rd Earl of Clanwilliam (1795-1879)
John Fitzgibbon, 2nd Earl of Clare (1792-1851)
Henry Welbore Ellis, 2nd Viscount Clifden (1761-1836)
Robert Cotton St John Trefusis, 18th Baron Clinton
 (1787-1832)
Sir Charles Cockerell, Bt (1755-1837)
John Colville, 10th Baron Colville (1768-1849)
Folliott Herbert Walker Cornewall (1754-1831)
Charles Cornwallis, 2nd Marquess Cornwallis (1774-1823)
George William Coventry, 7th Earl of Coventry (1758-1831)
George William Coventry, 8th Earl of Coventry (1784-1843)
Peter Nassau Cowper, 5th Earl Cowper (1778-1837)
Henry Cowper (1758-1840)
Benjamin Currey

Thomas Brand, 20th Baron Dacre (1774-1851)
Sir Robert Dallas (1756-1824)
John Bligh, 4th Earl of Darnley (1767-1831)
William Legge, 4th Earl of Dartmouth (1784-1853)
Edward Southwell, 18th Baron De Clifford (1767-1832)
Thomas Philip de Grey, Earl de Grey (1781-1859)

George John Sackville-West, 5th Earl Delawarr (1791-1869)
William Francis Spencer Ponsonby, 1st Baron De Mauley
 (1787-1855)
William Basil Percy Fielding, 7th Earl of Denbigh (1796-1865)
Thomas Denman, 1st Baron Denman (1779-1854)
Edward Smith-Stanley, 12th Earl of Derby (1752-1834)
William Cavendish, 6th Duke of Devonshire (1790-1859)
Edward Digby, 2nd Earl Digby (1773-1856)
Richard Hely-Hutchinson, 1st Earl of Donoughmore
 (1756-1825)
George Agar-Ellis, 1st Baron Dover (1797-1833)
Arthur Trumbull Hill, 3rd Marquess of Downshire (1788-1845)
Thomas Reynolds Moreton, 1st Earl of Ducie (1776-1840)
John George Lambton, 1st Earl of Durham (1792-1840)

Kenneth Howard, 1st Earl of Effingham (1767-1845)
George Wyndham, 3rd Earl of Egremont (1751-1837)
John Scott, 1st Earl of Eldon (1751-1838)
Edward Law, 1st Earl of Ellenborough (1790-1871)
John Willoughby Cole, 2nd Earl of Enniskillen (1768-1840)
Thomas Erskine, 1st Baron Erskine (1750-1823)
George Capel-Coningsby, 5th Earl of Essex (1758-1839)
Brownlow Cecil, 2nd Marquess of Exeter (1795-1867)
Edward Pellew, 1st Viscount Exmouth (1757-1833)

Edward Boscawen, 1st Earl of Falmouth (1787-1841)
Charles Long, 1st Baron Farnborough (1761-1838)
Lord John Edward Fitzroy (1785-1856)
Hugh Fortescue, 1st Earl Fortescue (1753-1841)
George Lane Fox (c.1790-1848)

George Stewart, 8th Earl of Galloway (1768-1834)
Sir William Garrow (1760-1840)
Robert Gifford, 1st Baron Gifford (1779-1826)
William Frederick, 2nd Duke of Gloucester (1776-1834)
George Gordon, 5th Duke of Gordon (1770-1836)
Archibald Acheson, 2nd Earl of Gosford (1776-1849)
George Henry Fitzroy, 4th Duke of Grafton (1760-1844)
Granville Leveson-Gower, 1st Earl Granville (1773-1846)
William Wyndham Grenville, Baron Grenville (1759-1834)
Charles Grey, 2nd Earl Grey (1764-1845)
William Brodie Gurney (1777-1855)
Peter Robert Drummond-Burrell, 2nd Baron Gwydyr
 (1782-1865)

Alexander Hamilton, 10th Duke of Hamilton (1767-1852)
Lady Anne Hamilton (1766-1846)
Thomas Hampden, 2nd Viscount Hampden (1746-1824)
William Harcourt, 3rd Earl Harcourt (1743-1830)
Edward Harcourt (1757-1847)
Henry Lascelles, 2nd Earl of Harewood (1767-1841)
Dudley Ryder, 1st Earl of Harrowby (1762-1847)
Charles Hayter (1761-1835)
Sir George Hayter (1792-1871)
Henry Fleming Lea Devereux, 14th Viscount Hereford
 (1777-1843)
Rowland Hill, 1st Viscount Hill (1772-1842)
William Howley (1766-1848)
George Gordon, 9th Marquess of Huntly (1761-1853)

George Child-Villiers, 5th Earl of Jersey (1773-1859)

George Kenyon, 2nd Baron Kenyon (1776-1855)
Peter King, 7th Baron King (1775-1833)
Douglas James William Kinnaird (1788-1830)

Henry Petty-Fitzmaurice, 3rd Marquess of Lansdowne
 (1780-1863)
James Maitland, 8th Earl of Lauderdale (1759-1839)
George Henry Law (1761-1845)
Augustus Frederick Fitzgerald, 3rd Duke of Leinster
 (1791-1874)

Continued overleaf

Edmond Henry Pery, 1st Earl of Limerick (1758-1844)
Robert Jenkinson, 2nd Earl of Liverpool (1770-1828)
Robert Stewart, 2nd Marquess of Londonderry (1769-1822)
William Kerr, 6th Marquess of Lothian (1763-1824)
Stephen Lushington (1782-1873)
John Luxmoore (1756-1830)
John Singleton Copley, Baron Lyndhurst (1772-1863)

William Gordon MacGregor (d.1840)
Henry William Majendie (1754-1830)
Theodore Majocchi
Charles Manners-Sutton (1755-1828)
David William Murray, 3rd Earl of Mansfield (1777-1840)
Charles Herbert Pierrepont, 2nd Earl Manvers (1778-1860)
William Lamb, 2nd Viscount Melbourne (1779-1848)
Robert Saunders-Dundas, 2nd Viscount Melville (1771-1851)
John Parker, 1st Earl of Morley (1772-1840)
William Mudford (1782-1848)

William Nelson, 1st Earl Nelson (1757-1835)
Hugh Percy, 3rd Duke of Northumberland (1785-1847)
John Rushout, 2nd Baron Northwick (1770-1859)

Chaloner Blake Ogle

George Fermor, 3rd Earl of Pomfret (1768-1830)
William Cavendish Scott-Bentinck, 4th Duke of Portland
 (1768-1854)

Charles Gordon-Lennox, 5th Duke of Richmond and Lennox
 (1791-1860)
George Pitt, 2nd Baron Rivers (1751-1828)
Sir Christopher Robinson (1766-1833)
John Rolle, Baron Rolle (1750-1842)
Archibald Primrose, 4th Earl of Rosebery (1783-1868)
James St Clair-Erskine, 2nd Earl of Rosslyn (1762-1837)
John Russell, 1st Earl Russell (1792-1878)
Lord George William Russell (1790-1846)
John Henry Manners, 5th Duke of Rutland (1778-1857)

William Beauclerk, 8th Duke of St Albans (1766-1825)
John Eliot, 1st Earl of St Germans (1761-1823)
Alleyne Fitzherbert, Baron St Helens (1753-1839)
Cropley Ashley Cooper, 6th Earl of Shaftesbury (1768-1851)
Henry Addington, 1st Viscount Sidmouth (1757-1844)
Edward Seymour, 11th Duke of Somerset (1775-1855)
Bowyer Edward Sparke (d.1836)
Spineti
William Scott, 1st Baron Stowell (1745-1836)
George Granville Sutherland-Leveson-Gower, 2nd Duke of
 Sutherland (1786-1861)
John Thomas Townshend, 2nd Viscount Sydney (1764-1831)

Sackville Tufton, 9th Earl of Thanet (1767-1825)
Matthew Evan Thomas (1788-1830)
George Tierney (1761-1830)
Sir Nicholas Conyngham Tindal (1776-1846)
Power le Poer Trench (1770-1839)
Thomas Wilde, Baron Truro (1782-1855)
Sir Thomas Tyrwhitt (c.1762-1839)

William Van Mildert (1765-1836)
George Granville Venables Vernon (1785-1861)
James Walter Grimston, 1st Earl of Verulam (1775-1845)
William Vizard (1774-1859)

Henry Richard Greville, 3rd Earl of Warwick (1779-1853)
Arthur Wellesley, 1st Duke of Wellington (1769-1852)
James Parke, Baron Wensleydale (1782-1868)
Robert Grosvenor, 1st Marquess of Westminster (1767-1845)
John Fane, 10th Earl of Westmorland (1759-1841)
Samuel Charles Whitbread (1796-1879)
Charles Whitworth, Earl Whitworth (1752-1825)
William IV (1765-1837)

Sir John Williams (1777-1846)
Charles Ingoldsby Burroughs-Paulet, 13th Marquess of
 Winchester (1765-1843)
Sir Matthew Wood, Bt (1768-1843)
W.Wright

Frederick, Duke of York and Albany (1763-1827)
Charles Mayne Young (1777-1856)

(*See also Collections*, **1695** and **2662**)

Men of Science Living in 1807-8

1075 Pencil and wash 64.8 x 128.3 (25½ x 50½)
Sir John Gilbert (grouping), Frederick John Skill
(figures), and William and Elizabeth Walker
(design and finish), 1855-8
Forty-eight figures
Purchased, 1896

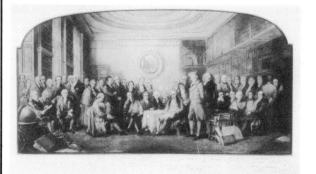

The following, listed alphabetically, are represented:
William Allen (1770-1843)
Francis Bailey (1774-1844)
Sir Joseph Banks, Bt (1743-1820)
Sir Samuel Bentham (1757-1831)
Matthew Boulton (1728-1809)
Joseph Bramah (1748-1814)
Robert Brown (1773-1858)
Sir Marc Isambard Brunel (1769-1849)
Edmund Cartwright (1743-1823)
Henry Cavendish (1731-1810)
Sir William Congreve, Bt (1772-1828)
Samuel Crompton (1753-1827)
John Dalton (1766-1844)
Sir Humphry Davy, Bt (1778-1829)
Peter Dolland (1730-1820)
Bryan Donkin (1768-1855)
Archibald Cochrane, 9th Earl of Dundonald (1749-1831)
Henry Fourdrinier (1766-1854)
Davies Gilbert (formerly Giddy) (1767-1839)
Charles Hatchett (1765-1847)
William Henry (1774-1836)
Sir William Herschel (1738-1822)
Edward Charles Howard (1774-1816)
Joseph Huddart (1741-1816)
Edward Jenner (1749-1823)
William Jessop (1745-1814)
Henry Kater (1777-1835)
Sir John Leslie (1766-1832)
Nevil Maskelyne (1732-1811)
Henry Maudslay (1771-1831)
Patrick Miller (1731-1815)

William Murdock (1754-1839)
Robert Mylne (1734-1811)
Alexander Nasmyth (1758-1840)
John Playfair (1748-1819)
John Rennie (1761-1821)
Sir Francis Ronalds (1788-1873)
Sir Benjamin Thompson, Count von Rumford (1753-1814)
Daniel Rutherford (1749-1819)
Charles Stanhope, 3rd Earl Stanhope (1753-1816)
William Symington (1763-1831)
Thomas Telford (1757-1834)
Charles Tennant (1768-1838)
Thomas Thomson (1773-1852)
Richard Trevithick (1771-1833)
James Watt (1736-1819)
William Hyde Wollaston (1766-1828)
Thomas Young (1773-1829)

1075a Engraving after no.**1075**
62.9 x 108.9 (24¾ x 42⅞)
William Walker and George Zobel, plate dated 1862
Fifty-one-figures
Purchased, 1896

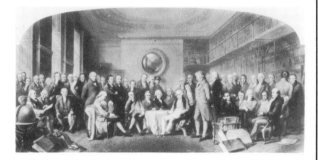

Almost the same sitters as no.**1075**, but omitting:
9th Earl of Dundonald
Henry Fourdrinier
and adding:
William Chapman (1749-1832)
William James Frodsham (1778-1850)
William Smith (1769-1839)
Edward Troughton (1753-1835)
Richard Watson (1737-1816)

1075b Key to no.**1075a**
Engraving 27.3 x 43.5 (10¾ x 17⅛)
William Walker, plate dated 1862
Fifty-one figures
Purchased, 1896

1383a Two sketches for no.**1075**
Pencil and wash 20.7 x 35.3 (8⅛ x 13⅞) and
27.6 x 36.5 (10⅞ x 14⅜)
Sir John Gilbert, signed and inscribed
Over forty figures in each
Purchased, 1904

Sheet of three studies by Sir George Hayter

1103 *See under* HAYTER, *and also Groups,* **54**

Adam Walker and his family

1106 Canvas 135.2 x 165.7 (53¼ x 65¼)
George Romney, c.1796-1801
Six figures
Bequeathed by Adam Walker's granddaughter,
Miss Ellen Elizabeth Gibson, 1897

The sitters are (left to right):
William Walker (1767?-1816)
Eleanor Walker
Adam John Walker
Deane Franklin Walker (1778-1865)
Eliza Gibson (née Walker) (d.1856)
Adam Walker (1731-1821)

The Coalition Ministry 1854

1125 Pencil, pen and ink and wash 44.5 x 68.6
(17½ x 27)
Sir John Gilbert, signed and dated 1855
Fifteen figures
Purchased, 1898

The sitters are (left to right):
Charles Wood, 1st Viscount Halifax (1800-85)
Sir James Graham, Bt (1792-1861)
Sir William Molesworth, Bt (1810-55)
William Ewart Gladstone (1809-98)
George Douglas Campbell, 8th Duke of Argyll (1823-1900)
George Villiers, 4th Earl of Clarendon (1800-70)
Henry Petty-Fitzmaurice, 3rd Marquess of Lansdowne
 (1780-1863)
John Russell, 1st Earl Russell (1792-1878)
Granville Leveson-Gower, 2nd Earl Granville (1815-91)
George Hamilton Gordon, 4th Earl of Aberdeen (1784-1860)
Robert Monsey Rolfe, Baron Cranworth (1790-1868)
Henry Temple, 3rd Viscount Palmerston (1784-1865)
Sir George Grey, Bt (1799-1882)
Sidney Herbert, 1st Baron Herbert of Lea (1810-61)
Henry Clinton, 5th Duke of Newcastle (1811-64)

1125a Engraving after no.**1125**
52.7 x 72.1 (20¾ x 28⅜)
William Walker after Sir John Gilbert, signed, inscribed,
and dated 1857 on plate
Purchased, 1898

Ormond

Francis Ayscough with the Prince of Wales (later George III) and the Duke of York and Albany

1165 Canvas 207 x 257.8 (81½ x 101½)
Richard Wilson, c.1749
Three figures
Given by Thomas Agnew & Sons, 1900. *Beningbrough*

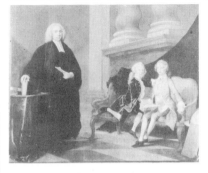

The sitters are (left to right):
Francis Ayscough (1700-63)
The Prince of Wales (later George III) (1738-1820)
Edward Augustus, Duke of York and Albany (1739-67)

Kerslake

The Arctic Council planning a search for Sir John Franklin

1208 Canvas 117.5 x 183.3 (46¼ x 72⅛)
Stephen Pearce, signed and dated 1851
Ten figures
Bequeathed by John Barrow, 1899

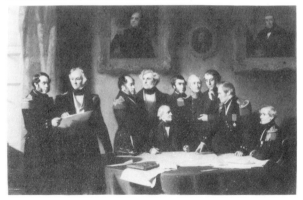

The sitters are (left to right):
Sir George Back (1796-1887)
Sir William Parry (1790-1855)
Edward Joseph Bird (1799-1881)
Sir James Clark Ross (1800-62)
Sir Francis Beaufort (1774-1857)
John Barrow (1808-98)
Sir Edward Sabine (1788-1883)
William Baillie Hamilton (1803-81)
Sir John Richardson (1787-1865)
Frederick Beechey (1796-1856)

(*See also Collections*, **905-24** and **1209-27**)

Ormond

The Taylor family

1248 Canvas 45.1 x 34.3 (17¾ x 13½)
Isaac Taylor, 1792
Seven figures
Given by Mrs Josiah Gilbert, daughter-in-law of
Ann Taylor (Mrs Gilbert), 1900

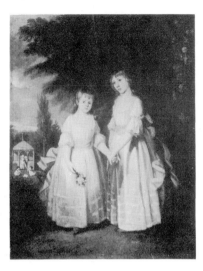

The sitters are, foreground, left to right:
Jane Taylor (1783-1824)
Ann Taylor (Mrs Gilbert) (1782-1866)

Background, left to right:
Martin Taylor (1788-1867)
Ann Taylor (1757-1830) holding
Jefferys Taylor (1792-1853)
Isaac Taylor (1759-1829)
Isaac Taylor (1787-1865)

Group associated with the Moravian Church

1356 *See under Groups,* **624A**

Men of Science Living in 1807-8

1383a *See under Groups,* **1075**

A Conversation of Virtuosis . . . at the Kings Arms (A Club of Artists)

1384 Canvas 87.6 x 111.5 (34½ x 43⅞)
Gawen Hamilton, inscribed, 1735
Thirteen figures
Purchased, 1904

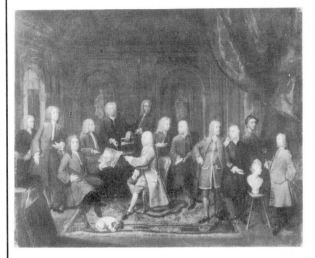

The sitters are (left to right):
George Vertue (1683-1756)
Hans Hysing (1678-1752/3)
Michael Dahl (1656-1743)
William Thomas (fl.1722-37)
James Gibbs (1682-1754)
Joseph Goupy (d.before 1782)
Mathew Robinson (c.1694-1778)
Charles Bridgeman (d.1738)
Bernard Baron (1696-1762)
John Wootton (c.1686-1765)
John Michael Rysbrack (1693?-1770)
Gawen Hamilton (1698-1737)
William Kent (1684-1748)

Kerslake

The Academicians of the Royal Academy, 1771-2

1437 Water-colour 18.8 x 27 (7⅜ x 10⅝)
John Sanders after Johan Zoffany, signed, inscribed
and dated 1773 and (97)
Thirty-six figures
Given by Alfred Jones, 1906

The following, listed alphabetically, are represented:
George Barret (1728?-84)
Francesco Bartolozzi (1727-1815)
Edward Burch (fl.1771)
Agostino Carlini (d.1790)
Charles Catton (1728-98)
Mason Chamberlin (d.1787)
Sir William Chambers (1726-96)
Giovanni Battista Cipriani (1727-85)
Richard Cosway (1740-1821)
John Gwynn (d.1786)

Continued overleaf

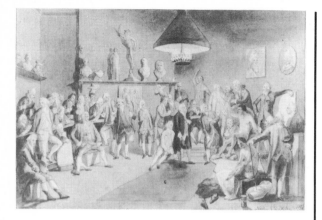

Francis Hayman (1708-76)
William Hoare (1707?-92)
Nathaniel Hone (1718-84)
William Hunter (1718-83)
Jeremiah Meyer (1735-89)
George Michael Moser (1704-83)
Francis Milner Newton (1720-94)
Joseph Nollekens (1737-1823)
Edward Penny (1714-91)
Sir Joshua Reynolds (1723-92)
John Inigo Richards (d.1810)
Paul Sandby (1730/1-1809)
Thomas Sandby (1723-98)
Dominic Serres (1722-93)
Tan-che-qua (fl.1769)
Peter Toms (d.1777)
William Tyler (d.1801)
Samuel Wale (d.1786)
Benjamin West (1738-1820)
Richard Wilson (1714-82)
Joseph Wilton (1722-1803)
Richard Yeo (d.1779)
Johan Zoffany (1733-1810)
Francesco Zuccarelli (1702-88)
Two male models

1437a Sketch for no.**1437**
Pencil 19.1 x 27 (7½ x 10⅝)
John Sanders after Johan Zoffany, inscribed, c.1773
Thirty-six figures
Given by Alfred Jones, 1906

**Frederick, Prince of Wales, and his sisters
(The Music Party)**

1556 Canvas 45.1 x 57.8 (17¾ x 22¾)
Philip Mercier, signed and dated 1733
Four figures
Purchased, 1909

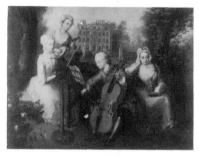

The sitters are (left to right):
?Anne, Princess Royal (1709-59)
?Princess Caroline (1713-57)
Frederick, Prince of Wales (1707-51)
?Princess Amelia (1711-86)

Kerslake

**William Adams, 1st Baron Wensleydale, and
Sir Christopher Robinson**

1695(h) *See Collections:* Sketches for The Trial of
Queen Caroline, 1820, by Sir George Hayter,
1695(a-x)

**Group including 1st Baron Gifford, Stephen Lushington,
Baron Lyndhurst, Marchese di Spineto and
Baron Truro**

1695(i) *See Collections:* Sketches for The Trial of
Queen Caroline, 1820, by Sir George Hayter,
1695(a-x)

**Group including Henry William Majendie, Folliott
Herbert Walker Cornewall, George Henry Law,
5th Earl of Aylesford and 10th Baron Colville**

1695(n) *See Collections:* Sketches for The Trial of
Queen Caroline, 1820, by Sir George Hayter,
1695(a-x)

**Group including Frederick, Duke of York, Charles
Manners-Sutton and Edward Harcourt**

1695(t) *See Collections:* Sketches for The Trial of
Queen Caroline, 1820, by Sir George Hayter,
1695(a-x)

Group including 2nd Baron Bayning, 7th Earl of Denbigh, 3rd Duke of Northumberland, 1st Earl of Ducie and 5th Earl of Jersey

1695(u) *See Collections:* Sketches for The Trial of Queen Caroline, 1820, by Sir George Hayter, **1695(a-x)**

Baron Kelvin with his brother and sister

1708(a) *See Collections:* Lord Kelvin and members of his family, by Elizabeth King and Agnes Gardner King, **1708(a-h)**

The Brontë Sisters

1725 Canvas 90.2 x 74.6 (35½ x 29⅜)
Patrick Branwell Brontë (their brother), c.1834
Purchased, 1914

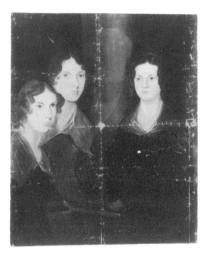

The sitters are (left to right):
Anne Brontë (1820-49)
Emily Brontë (1818-48)
Charlotte Brontë (1816-55)

Ormond

The Royal Family at Buckingham Palace, 1913

1745 Canvas 340.3 x 271.8 (134 x 107)
Sir John Lavery, signed, 1913
Four figures
Given by William Hugh Spottiswoode, 1913

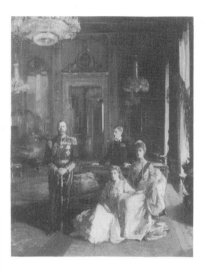

The sitters are (standing, left to right):
George V (1865-1936)
Duke of Windsor (1894-1972)
(seated, left to right):
Princess Mary Victoria Alexandra Alice (1897-1965)
Queen Mary (1867-1953)

The Siege of Gibraltar, 1782

1752 Millboard 41.9 x 55.9 (16½ x 22)
George Carter, 1784
Over twenty-four figures
Given by Alfred Jones, 1915

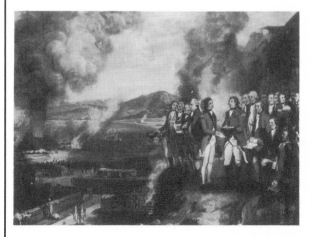

The identified sitters are (on the high ground, left to right):
Colonel Schreppergill
Colonel Hugo
Colonel Hellst

Continued overleaf

Major-General de la Motte
Sir Robert Lloyd (1710-94)
Captain Wilson
Major Vallottor
George Eliott, Baron Heathfield (1717-90)
Colonel Cochrane
Major-General Picton
Sir William Green, Bt (1725-1811)
Sir Charles Holloway (1749-1827)

(next to him, top row):
Colonel Trigg
Lieutenant-Colonel Phipps
Colonel P.Craig
Major Lloyd
Major Grove
Colonel Gladstone
Lieutenant-Colonel Mackintosh

(below Holloway):
Lieutenant-Colonel Lewis
Major Eyre
Colonel Mackenzie (in kilt)
Major Martin
Colonel Daikenhausen

Swinburne and his sisters

1762 Water-colour 52.7 x 57.2 (20¾ x 22½)
George Richmond, signed and dated 1843
Three figures
Bequeathed by the sitters' sister, Miss Isabel Swinburne,
1915

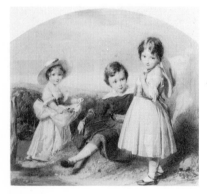

The sitters are (left to right):
Edith Swinburne (d.1863)
Algernon Charles Swinburne (1837-1909)
Alice Swinburne (d.1903)

Private View of the Old Masters Exhibition, Royal Academy, 1888

1833 Canvas 152.4 x 406.4 (60 x 160)
Henry Jamyn Brooks, signed and dated 1889
Sixty-five figures
Given by the artist, 1919

The sitters are (left to right):
Sir Watkin Williams-Wynn, Bt (1860-1944)
Henrietta Blanche, Countess of Airlie (1830-1921)
Charles Drury Fortnum (1820-99)

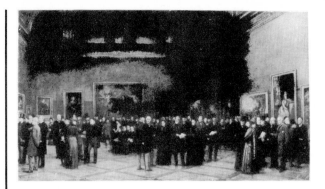

Unknown man (hat only)
Sir Frederick William Burton (1816-1900)
Alfred Morrison (1821-97)
Lady Dorothy Nevill (1826-1913)
Sir John Everett Millais, Bt (1829-96)
(Sir) Philip Burne-Jones (1861-1926)
Lady Marjorie Manners (afterwards Marchioness of Anglesey)
 (d.1946)
Sir John Pender (1815-96)
Violet, Marchioness of Granby (afterwards Duchess of Rutland)
 (d.1937)
Ferdinand de Rothschild (1839-98)
Unknown woman (back of head only)
Humphry Ward (1845-1926)
George Richmond (1809-96)
Edward Philip Monckton (1840-1912)
Unknown woman
William Powell Frith (1819-1909)
(Sir) Lawrence Alma-Tadema (1836-1912)
John Evan Hodgson (1831-95)
Unknown woman
Frank Holl (1845-88)
Susan, Countess of Wharncliffe (d.1927)
Charles Butler (1822-1910)
James Ellis Agar, 3rd Earl of Normanton (1818-96)
Unknown woman
Charles Henry Mills, 1st Baron Hillingdon (1830-98)
Edward Montagu Stuart-Wortley, 1st Earl of Wharncliffe
 (1827-99)
(Sir) Edward Poynter (1836-1919)
Mrs (afterwards Lady) Alma-Tadema (d.1909)
Robert James Lindsay (afterwards Loyd-Lindsay), 1st Baron
 Wantage (1832-1901)
Sir Richard Wallace, Bt (1818-90)
Henry Edward Doyle (1827-92)
Sir John Robinson (1824-1913)
Margaret Elizabeth, Countess of Jersey (1849-1945)
Philip Hermogenes Calderon (1833-98)
Mary Millais (1860-1944)
(Sir) William Quiller Orchardson (1835-1910)
Sir Frederic Leighton (afterwards Baron Leighton) (1830-96)
Alfred de Rothschild (1842-1918)
Henry Jamyn Brooks (d.1925)
Mervyn Wingfield, 7th Viscount Powerscourt (1836-1904)
Unknown man (hat only)
Harriet Sarah, Lady Wantage (1837-1920)
John Stuart Bligh, 6th Earl of Darnley (1827-96)
(Sir) George Scharf (1820-95)
(Sir) Joseph Edgar Boehm (1834-90)
Victor Child-Villiers, 7th Earl of Jersey (1845-1915)
William Holman Hunt (1827-1910)
Mrs Street (daughter of Henry Tanworth Wells)
Henry Tanworth Wells (1828-1903)
John Spencer, 5th Earl Spencer (1835-1910)

Sir Charles Tennant, Bt (1823-1906)
Charlotte, Countess Spencer (1835-1903)
Margot Tennant (afterwards Countess of Oxford and Asquith)
 (1864-1945)
William Ewart Gladstone (1809-98)
Michael Arthur Bass, 1st Baron Burton (1837-1909)
Marcus Stone (1840-1921)
(Sir) William Agnew (1825-1910)
John Callcott Horsley (1817-1903)
George Frederic Watts (1817-1904)
Ayscough Fawkes (1831-99)
(Sir) Frederick Eaton (1838-1913)

Four men at cards

1841B Pen and ink 11.4 x 15.9 (4½ x 6¼)
Frederick Walker, signed with initials
Four figures
Given by Mrs Wedgwood in memory of her son,
Allen Wedgwood, 1919

The sitters (presumably from left to right) are said to be:
Sir Henry Turner Irving (1833-1923)
Ernest Hensleigh Wedgwood
Sidney Cooper
R.MacDonald

Naval Officers of World War I

1913 Canvas 264.1 x 516.2 (104 x 202½)
Sir Arthur Stockdale Cope, signed, 1921
Twenty-two figures
Given by Sir Abe Bailey, Bt, 1921

The sitters are (left to right):
Sir Edwyn Sinclair Alexander-Sinclair (1865-1945)
Sir Walter Henry Cowan (1871-1958)
Sir Osmond de Beauvoir Brock (1869-1947)

Sir William Edmund Goodenough (1867-1945)
Sir Robert Keith Arbuthnot, Bt (1864-1916)
Sir Montague Edward Browning (1863-1947)
Sir Christopher Cradock (1862-1914)
Sir Horace Hood (1870-1916)
Sir John Michael De Robeck, Bt (1862-1928)
Sir William Pakenham (1861-1933)
Sir Reginald Yorke Tyrwhitt (1870-1951)
Roger Keyes, 1st Baron Keyes (1872-1945)
Sir Cecil Burney, Bt (1858-1929)
David Beatty, 1st Earl Beatty (1871-1936)
Sir Trevylyan Napier (1867-1920)
Louis Alexander Mountbatten, Marquess of Milford-Haven
 (1854-1921)
Sir Hugh Evan-Thomas (1862-1928)
Sir Frederick Sturdee, Bt (1859-1925)
Sir Arthur Cavenagh Leveson (1868-1929)
Sir Charles Edward Madden, Bt (1862-1935)
John Rushworth Jellicoe, 1st Earl Jellicoe (1859-1935)
Rosslyn Erskine Wemyss, Baron Wester Wemyss (1864-1933)

Samuel Rogers, Mrs Norton (later Lady Stirling-Maxwell) and Mrs Phipps

1916 Canvas 62.2 x 74.6 (24½ x 29⅜)
Frank Stone, c.1845
Given by the 2nd Marquess of Crewe, 1921

The sitters are (left to right):
Mrs Maria-Louisa Phipps (d.1888)
Samuel Rogers (1763-1855)
Mrs Caroline Norton (later Lady Stirling-Maxwell) (1808-77)

Ormond

John Glynn, John Wilkes and John Horne Tooke

1944 Canvas 52.7 x 75.6 (20¾ x 29¾)
Richard Houston, inscribed, eng 1769
Three figures
Given by NACF, 1922

The sitters are (left to right):
John Glynn (1722-79)
John Wilkes (1727-97)
John Horne Tooke (1736-1812)

General Officers of World War I

1954 Canvas 299.7 x 528.3 (118 x 208)
John Singer Sargent, signed, 1922
Twenty-two figures
Given by Sir Abe Bailey, Bt, 1922

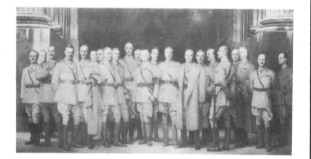

The sitters are (left to right):
William Riddell Birdwood, 1st Baron Birdwood (1865-1951)
Jan Christian Smuts (1870-1950)
Louis Botha (1862-1919)
Julian Byng, 1st Viscount Byng of Vimy (1862-1935)
Henry Seymour Rawlinson, Baron Rawlinson (1864-1925)
Sir Henry Timson Lukin (1860-1925)
Sir John Monash (1865-1931)
Henry Sinclair Horne, Baron Horne (1861-1929)
George Francis Milne, Baron Milne (1866-1948)
Sir Henry Hughes Wilson, Bt (1864-1922)
Sir Andrew Hamilton Russell (1868-1960)
Herbert Plumer, 1st Viscount Plumer (1857-1932)
Sir John Steven Cowans (1862-1921)
Douglas Haig, 1st Earl Haig (1861-1928)
John French, 1st Earl of Ypres (1852-1925)
Sir William Robert Robertson, Bt (1860-1933)
Sir Frederick Stanley Maude (1864-1917)
Edmund Allenby, 1st Viscount Allenby (1861-1936)
Sir William Marshall (1865-1939)

Sir Arthur William Currie (1875-1933)
Frederick Lambart, 10th Earl of Cavan (1865-1946)
Sir Charles Macpherson Dobell (1869-1954)

(*See also Collections*, **2908(1-18)**)

2nd Duke of Montagu, 2nd Baron Tyrawley, and an unknown man

2034 Canvas 144.8 x 176.5 (57 x 69½)
Probably by John Verelst, signature damaged, dated 1712
Given by the 7th Duke of Buccleuch, 1924

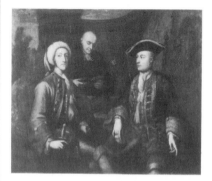

The sitters are (left to right):
John Montagu, 2nd Duke of Montagu (1690-1749)
Unknown man
James O'Hara, 2nd Baron Tyrawley (1682?-1773)

Piper (under Montagu)

Whig Statesmen and their Friends, c.1810

2076 Chalk 53.3 x 69.9 (21 x 27½)
William Lane
Twelve figures
Purchased, 1924

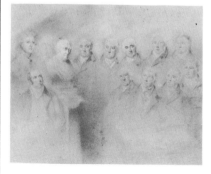

The sitters are (left to right):
William Cavendish, 5th Duke of Devonshire (1748-1811)
Henry Richard Vassall Fox, 3rd Baron Holland (1773-1840)
William Wentworth Fitzwilliam, 2nd Earl Fitzwilliam
 (1748-1833)
(bust of Charles James Fox)
John Crewe, 1st Baron Crewe (1742-1829)

Frederick Ponsonby, 3rd Earl of Bessborough (1758-1844)
John Fitzpatrick, 2nd Earl of Upper Ossory (1745-1818)
Dudley Long North (1748-1829)
Richard Fitzpatrick (1748-1813)
George James Cholmondeley, 1st Marquess Cholmondeley (1749-1827)
George Townshend, 2nd Marquess Townshend (1755-1811)
Lord Robert Spencer (d.1831)
St Andrew St John, 13th Baron St John (1759-1817)

Group including Charles Stewart Parnell and William J. Walsh

2229 *See Collections:* The Parnell Commission, 1888-9, by Sydney Prior Hall, **2229-72**

Thomas Miller Beach, John Patrick Murphy, Sir Henry James and Sir Charles Russell

2239 *See Collections:* The Parnell Commission, 1888-9, by Sydney Prior Hall, **2229-72**

Group including Charles Stewart Parnell and H.Campbell

2242 *See Collections:* The Parnell Commission, 1888-9, by Sydney Prior Hall, **2229-72**

Group including Charles Stewart Parnell and Sir George Henry Lewis

2243 *See Collections:* The Parnell Commission, 1888-9, by Sydney Prior Hall, **2229-72**

Charles Stewart Parnell, Sir George Henry Lewis and Thomas Miller Beach

2244 *See Collections:* The Parnell Commission, 1888-9, by Sydney Prior Hall, **2229-72**

Group including John Patrick Murphy, Sir Henry James, Sir Charles Russell, Sir George Henry Lewis, William Thomas Stead, Michael Davitt and Charles Stewart Parnell

2250 *See Collections:* The Parnell Commission, 1888-9, by Sydney Prior Hall, **2229-72**

Group including Joseph William Comyns Carr, William Hoey Kearney Redmond and H.Campbell

2286 *See Collections:* Miscellaneous drawings . . . by Sydney Prior Hall, **2282-2348** and **2370-90**

Owen Lewis Cope Williams and others

2291 *See Collections:* Miscellaneous drawings . . . by Sydney Prior Hall, **2282-2348** and **2370-90**

Debate on the Indian Cotton Duties

2307 *See Collections:* Miscellaneous drawings . . . by Sydney Prior Hall, **2282-2348** and **2370-90**

The Education Bill in the House of Lords

2369 Water-colour 41.3 x 30.5 (16¼ x 12)
Sydney Prior Hall, signed
(*Graphic* 13 Dec 1902)
Eleven bishops and other members of the House of Lords
Given by the artist's son, Henry Reginald Holland Hall, 1930

The bishops are (left to right):
George Wyndham Kennion (1845-1922)
George Ridding (1828-1904)
Francis John Jayne (1845-1921)
Edward Stuart Talbot (1895-1934)
Frederick Temple (1821-1902)
Lord Alwyne Compton (1825-1906)
Edgar Jacob (1844-1920)
William Dalrymple Maclagan (1826-1910)
Randall Thomas Davidson, Baron Davidson of Lambeth (1848-1930)
Arthur Foley Winnington-Ingram (1858-1946)
John Wordsworth (1843-1911)

658 *2463-2689*

Statesmen of World War I

2463 Canvas 395.2 x 335.5 (156 x 132)
Sir James Guthrie, 1924-30
Seventeen figures
Given by Sir Abe Bailey, Bt 1930

The sitters are (standing, left to right):
The Maharaja of Bikaner (1880-1943)
Louis Botha (1862-1919)
George Nicoll Barnes (1859-1940)
Sir Robert Laird Borden (1854-1937)
Arthur James Balfour, 1st Earl of Balfour (1848-1930)
Sir Eric Campbell Geddes (1875-1937)
Andrew Bonar Law (1858-1923)
Edward Patrick Morris, Baron Morris (1859-1935)
Horatio Herbert Kitchener, 1st Earl Kitchener of Khartoum
 (1850-1916)
(seated, left to right):
Sir Joseph Cook (1860-1947)
William Morris Hughes (1864-1952)
David Lloyd George, 1st Earl Lloyd-George (1863-1945)
Alfred Milner, Viscount Milner (1854-1925)
William Ferguson Massey (1865-1925)
Sir Winston Spencer Churchill (1874-1965)
Edward Grey, 1st Viscount Grey of Fallodon (1862-1933)
Herbert Henry Asquith, 1st Earl of Oxford and Asquith
 (1852-1928)

The Selecting Jury of the New English Art Club, 1909

2556 Canvas 69.9 x 90.2 (27½ x 35½)
Sir William Orpen, signed, inscribed and dated 1909
Eleven figures
Purchased, 1932

The sitters are (left to right):
Dugald Sutherland MacColl (1859-1948)
Alfred William Rich (1856-1922)
Unidentified attendant
Frederick Brown (1851-1941)
Ambrose McEvoy (1878-1927)
Sir William Rothenstein (1872-1945)
Sir William Orpen (1787-1931)
Walter Richard Sickert (1860-1942)
Philip Wilson Steer (1860-1942)
Augustus John (1878-1961)
Henry Tonks (1862-1937)

Some members of the New English Art Club

2663 Water-colour 24.1 x 19.1 (9½ x 7½)
Donald Graeme MacLaren, signed
Purchased, 1934

The sitters are (left to right):
Arthur Ambrose McEvoy (1878-1927)
Frederick Brown (1851-1941)
Henry Tonks (1862-1937)
Augustus John (1878-1961)
Unidentified man
Philip Wilson Steer (1860-1942)
Dugald Sutherland MacColl (1859-1948)

The Funeral of Lord Macaulay

2689 Pen and ink 24.8 x 38.1 (9¾ x 15)
Sir George Scharf, signed, inscribed and dated 1860
Over seventy figures
Given by Earl Stanhope, 1934
None of the sitters can be identified

Sir Thomas More, his Father, his Household and his Descendants

2765 Canvas 227.4 x 330.2 (89½ x 130)
Rowland Lockey, inscribed, 1593, partly after
Hans Holbein
Eleven figures
Bequeathed by Emslie John Horniman, 1935

The sitters are (left to right):
Sir John More (1451?-1530)
Anne More (née Cresacre) (1511-77)
Sir Thomas More (1478-1535)
John More (1509?-47)
Cicely Heron (née More) (b.1507)
Elizabeth Dauncey (née More) (1506-64)
Margaret Roper (née More) (1505-44)
John More (1557-99?)
Thomas More (1531-1606)
Cresacre More (1572-1649)
Maria More (née Scrope) (1534-1607)

Strong

Breakfast at Mr Rogers

2772(p.28) *See Collections:* The Clerk family,
Sir Robert Peel, Samuel Rogers and others, 1833-57,
by Jemima Wedderburn, **2772**

Sir Robert Peel showing his pictures

2772(p.28) *See Collections:* The Clerk family,
Sir Robert Peel, Samuel Rogers and others, 1833-57,
by Jemima Wedderburn, **2772**

Members of the House of Lords, c.1835

2789 Pencil and sepia wash 22.3 x 18.7 (8¾ x 7⅜)
Attributed to Isaac Robert Cruikshank, inscribed,
c.1835
Thirteen sketches
Given by Godfrey Brennan, 1935

The sitters are (from top left):
Charles William Vane-Stewart, 3rd Marquess of Londonderry
　(1778-1854)
Same sitter, head only
Philip Henry Stanhope, 4th Earl Stanhope (1781-1855)
Henry Clinton, 4th Duke of Newcastle (1785-1851)
Unidentified, possibly 4th Duke of Newcastle
George Hamilton Gordon, 4th Earl of Aberdeen (1784-1860)
James Stuart-Wortley-Mackenzie, 1st Baron Wharncliffe
　(1776-1845)
Unidentified, possibly 1st Duke of Wellington
Edward Law, 1st Earl of Ellenborough (1790-1871)
Edward Stanley, 14th Earl of Derby (according to
　G.M.Trevelyan); possibly 1st Earl of Ellenborough
Arthur Wellesley, 1st Duke of Wellington (1769-1852)
Sir Robert Peel, Bt (1788-1850)
Unidentified, possibly Peel

Ormond

The Royal Academy Conversazione, 1891

2820 Water-colour 43.8 x 60.3 (17¼ x 23¾)
G.Grenville Manton, signed and dated 1891
Thirty-eight figures
Purchased, 1936

The sitters are (left to right):
John Seymour Lucas (1849-1923)
(Dame) Ellen Terry (1847-1928)
(Sir) William Quiller Orchardson (1832-1910)
Rachel Gurney (afterwards Countess of Dudley) (d.1920)
Marcus Stone (1840-1921)
Henry Stacey Marks (1829-98)
(Sir) Henry Irving (1838-1905)
Unknown man
Unknown man
Sir John Everett Millais, Bt (1829-96)

Continued overleaf

William Charles Thomas Dobson (1817-98)
Unknown woman
James Sant (1820-1916)
William Powell Frith (1819-1909)
(Sir) Hubert von Herkomer (1849-1914)
Unknown woman
Briton Riviere (1840-1920)
Unknown man
John Pettie (1839-93)
(Sir) Lawrence Alma-Tadema (1836-1912)
Sir Frederic (afterwards Baron) Leighton (1830-96)
Philip Hermogenes Calderon (1833-98)
Walter William Ouless (1848-1933)
Thomas Faed (1826-1900)
Robert Walker Macbeth (1848-1910)
Edward Onslow Ford (1852-1901)
William Frederick Yeames (1835-1918)
Unknown woman
(Sir) Edward Burne-Jones (1833-98)
Unknown man
Mary Anderson (1859-1940)
Unknown man
Unknown woman
Unknown man
Henry Tanworth Wells (1828-1903)
Unknown woman
Marion Harry Spielmann (1858-1948)
Unknown woman

1st Earl St Aldwyn, 1st Earl of Balfour and Joseph Chamberlain

2864 *See Collections:* Caricatures of Politicians, by Sir Francis Carruthers Gould, **2826-74**

Archibald Forbes and others

2931 Pencil 32.7 x 24.8 ($12\frac{7}{8}$ x 9¾)
Frederic Villiers, signed
Over eleven figures
Given by George A. Romilly Shaw, 1938
Forbes (1839-1900) in the foreground; the rest unidentified

Study for Florence Nightingale at Scutari
(painting not in NPG)

2939A Pen and ink 22.2 x 30.1 (8¾ x $11\frac{7}{8}$)
Jerry Barrett, signed and inscribed, c.1856
Twenty-six figures
Purchased, 1938

The following figures have been identified:
(extreme left, under archway, from left):
Sir William Linton (1801-80)
Alexis Benoit Soyer (1809-58)
Sir Henry Knight Storks (1811-74)
(centre, below window):
Florence Nightingale (1820-1910)

Sketch for Florence Nightingale at Scutari
(painting not in NPG)

4305 Canvas 40.6 x 61 (16 x 24)
Jerry Barrett, signed and inscribed, c.1856
Over thirty-four figures
Purchased, 1963

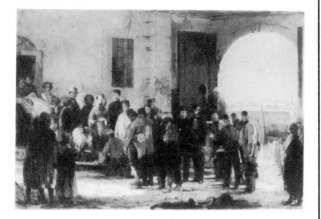

The following figures have been identified:
(extreme left, under archway, from left):
Sir William Linton (1801-80)
Sir Henry Knight Storks (1811-74)
(below and left of window):
Florence Nightingale (1820-1910)
(second next, to her left):
Alexis Benoit Soyer (1809-58)

Group including Marion Harry Spielmann

3047 Pen and ink 44.1 x 32.4 (17⅜ x 12¾)
John Henry Amschewitz, signed *Ponim* and dated 1907
Given by Marion Harry Spielmann, 1939
Spielmann (1858-1948) 4th from left; the rest
unidentified

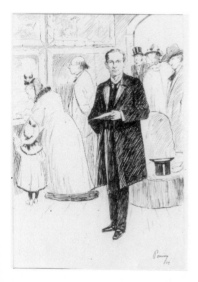

Chess players

3060 Canvas 81.3 x 152.4 (32 x 60)
Anthony Rosenbaum, signed and dated 1880 (began
1874) Forty-six figures
Given by F.G.Hamilton-Russell, 1939

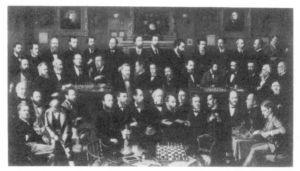

The sitters are believed to include the following:
Henry Edward Bird (1830-1908)
Joseph Henry Blackburne (1841-1924)
Richard Dawson, 1st Earl of Dartrey (1817-97)
Charles Godfrey Gumpel
Berhard Howritz (1807-85)
Johann Jakob Lowenthal (1810-76)
George Alcock MacDonnell (1830-99)
James Mason (1849-1905)
Anthony Rosenbaum (d.1888)
Wilhelm Steintz (1836-1900)
George Walker (1803-79)
Johannes Hermann Zukertort (1842-88)

Sketch of the Interior of the House of Commons

3073 *See under Groups,* 54

The Opening of the Royal Albert Infirmary at Bishop's Waltham, 1865

3083 Canvas 83.8 x 114.3 (33 x 45)
Unknown artist, signed *F.W.*
Fourteen figures
Purchased, 1940

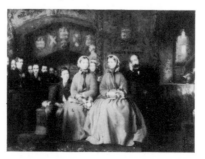

The sitters include (seated, from left):
Prince Arthur, 1st Duke of Connaught and Strathearn
 (1850-1942)
Princess Helena (1846-1923)
Princess Louise (1848-1939)
(behind Princess Louise, right):
Sir Arthur Helps (1813-75)

Francesco Bartolozzi, Giovanni Battista Cipriani and Agostino Carlini

3186 Canvas 100.3 x 125.7 (39½ x 49½)
John Francis Rigaud, signed and dated 1777
Three figures
Given by Miss M.H.Turner, 1944

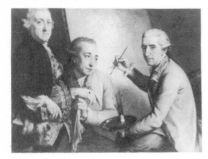

The sitters are (left to right):
Agostino Carlini (d.1790)
Francesco Bartolozzi (1727-1815)
Giovanni Battista Cipriani (1727-85)

(*See also Groups*, **987**)

Mrs Hewlett, Mrs Kerr-Lawson and Maurice Hewlett

3264 Pencil 19.4 x 25.4 (7⅝ x 10)
James Kerr-Lawson, c.1904
Three figures
Given by the artist's widow, before 1945

According to NPG records, the sitters are (left to right):
Hilda Beatrice Hewlett
Caterina Kerr-Lawson
Maurice Hewlett (1861-1923)

Lord Halifax and his secretaries

3328 Gouache 70.5 x 96.5 (17¾ x 38)
Attributed to Daniel Gardner, after Hugh Douglas Hamilton, inscribed, c.1765-7
Three figures
Purchased, 1947

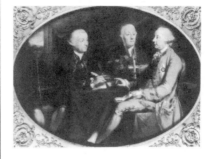

Right: George Montagu Dunk, 2nd Earl of Halifax (1716-71)
Left: Edward Sedgwick and Lovell Stanhope (d.1783), his secretaries (which is which is not known)

Kerslake

Arthur William a Beckett, Edwin Linley Sambourne and Thomas Anstey Guthrie

3619 *See Collections:* Prominent Men, c.1880-c.1910, by Harry Furniss, **3337-3535** and **3554-3620**

Timothy Michael Healy, Justin McCarthy and Thomas Sexton

3620 *See Collections:* Prominent Men, c.1880-c.1910, by Harry Furniss, **3337-3535** and **3554-3620**

Conversation Piece: Hilaire Belloc, G.K.Chesterton and Maurice Baring

3654 Canvas 151.1 x 110.5 (59½ x 43½)
Sir James Gunn, signed, 1932
Three figures
Given by Mrs George Balfour, 1960

The sitters are (left to right):
Gilbert Keith Chesterton (1874-1936)
Maurice Baring (1874-1945)
Hilaire Belloc (1870-1953)

Conversation piece at the Royal Lodge, Windsor, 1950

3778 Canvas 151.1 x 100.3 (59½ x 39½)
Sir James Gunn, 1950
Four figures
Purchased, 1950

The sitters are (left to right):
George VI (1895-1952)
Queen Elizabeth (The Queen Mother) (b.1900)
Princess Elizabeth (later Elizabeth II) (b.1926)
Princess Margaret (b.1930)

The Audience of the Grand Signor (A Sultan of Turkey receiving a British Ambassador)

3797 Water-colour 51.7 x 74.6 (20⅜ x 29⅜)
Attributed to Francis Smith, c.1764
Twenty figures
Bequeathed by Lt-Col W.A.Moore, 1950
None of the sitters has been identified

Dinner at Haddo House, 1884

3845 Canvas 36.2 x 57.8 (14¼ x 22¾)
Alfred Edward Emslie, signed
Nineteen figures (six undistinguishable)
Given by Marjorie, Lady Pentland, 1953

The sitters are (clockwise, from left):
Archibald Philip Primrose, 5th Earl of Rosebery
 (1847-1929)
Lady Harriet Lindsay
Edward Carr Glyn (1843-1928)
Maybird Hogg
Henry Drummond (1851-97)
Constance, Countess of Elgin (d.1909)
John Tulloch (1823-86)
Mrs Catherine Gladstone (d.1900)
John Campbell Gordon, 1st Marquess of Aberdeen
 and Temair (1847-1934)
Andrew Cant (piper)
The next six are undistinguishable:
George Washburn Smalley (1833-1916)
Helen Gladstone (1849-1925)
Peter Esslemont
Robert Farquharson (1836-1918)
Lady Mary Glyn (d.1947)
Victor Alexander Bruce, 9th Earl of Elgin (1849-1917)]
Hannah, Countess of Rosebery (d.1890)
William Ewart Gladstone (1809-98)
Ishbel Maria, Marchioness of Aberdeen and Temair (1857-1939)

Lady Mary Wortley Montagu with her son and attendants

3924 Canvas 68.6 x 90.2 (27 x 35½)
Attributed to Jean Baptiste Vanmour, c.1717
Four figures
Purchased, 1958

The sitters are (left to right):
An attendant
Edward Wortley Montagu (1713-76)
Lady Mary Wortley Montagu (1689-1762)
An attendant

Kerslake (under Lady Mary Wortley Montagu)

Edward VI and the Pope

4165 Canvas 62.2 x 90.8 (24½ x 35¾)
Unknown artist, c.1548-9
Thirteen figures
Purchased, 1960

The following sitters have been identified (back row, left to right):
Henry VIII (1491-1547)
Edward VI (1537-53)
Edward Seymour, 1st Duke of Somerset (1506?-52)
?John Dudley, Duke of Northumberland (1502?-53)
Thomas Cranmer, Archbishop of Canterbury
 (1489-1556)

Strong

Charles James Blomfield, Cardinal Manning and Sir John Gurney

4166 Pen and ink 22.7 x 19 (9 x 7½)
George Richmond, inscribed, c.1840-5
Given by Sir Geoffrey Keynes, 1960

The sitters are (left to right):
Sir John Gurney (1768-1845)
Charles James Blomfield (1786-1857)
Henry Edward Manning (1808-92)

Ormond (under Blomfield)

Hanging Committee, Royal Academy, 1892

4245 Pen and ink 27.3 x 25.4 (10¾ x 10)
Reginald Cleaver, signed and inscribed
Thirteen figures
Purchased, 1961

The sitters are (left to right):
Two porters (unidentified)
John Callcott Horsley (1817-1903)
Henry Stacy Marks (1829-98)
Sir Lawrence Alma-Tadema (1836-1912)
Sir Thomas Brock (1847-1922)

Frederic Leighton, Baron Leighton (1830-96)
Sir John Everett Millais, Bt (1829-96)
Sir William Hamo Thornycroft (1850-1925)
James Clarke Hook (1819-1907)
Sir Frederick Eaton (1838-1913)
Sir William Quiller Orchardson (1832-1910)
John Pettie (1839-93)

Sketch for Florence Nightingale at Scutari

4305 *See under Groups,* **2939A**

The St John's Wood Arts Club, 1895

4404 Chalk and wash 39.1 x 28.6 (15$\frac{3}{8}$ x 11¼)
Sydney Prior Hall, signed with initials, and inscribed
(outside image)
Nine figures
Given by Col A.C.B.Clayton on behalf of the St John's
Wood Arts Club, 1964

The sitters are (clockwise, from figure on steps):
Sir Lawrence Alma-Tadema (1836-1912)
Arthur Hacker (1858-1919)
A waiter?
Arthur Hopkins (1848-1930)
John Collier (1850-1934)
Charles Francis Annesley Voysey (1857-1941)
Edward Onslow Ford (1852-1901)
Probably John Bagnold Burgess (1830-97)
Walter Dendy Sadler (1854-1923)

Primrose Hill School

4405 Chalk 54.6 x 69.5 (21½ x 27$\frac{3}{8}$)
Unknown artist, inscribed and dated 1893
Ten figures
Given by Col A.C.B.Clayton on behalf of the St John's
Wood Arts Club, 1964

The following sitters have been identified (from 2nd
figure, left to right, seated round platform):
Sir Ernest Albert Waterlow (1850-1919)
Walter Dendy Sadler (1854-1923)
Maurice William Greiffenhagen (1862-1931)
Sydney Prior Hall (1842-1922)
Unknown woman
Arthur Hopkins (1848-1930)

The Duke and Duchess of Teck receiving officers of the Indian Contingent, 1882

4441 Canvas 76.8 x 114.3 (30¼ x 45)
Sydney Prior Hall, signed and dated 1883
Sixteen figures in the foreground
Given by Mrs Montagu Bernard, 1965

The sitters are (left to right):
Mrs William Edgar
Sir Henry Bartle Frere, Bt (1815-84)
The Duke of Teck (1837-1900)
Colonel (afterwards Sir) Charles Richard Pennington
(1838-1910)

Continued overleaf

One of the younger sons of the Duke of Teck (Francis,
 b.1870; or Alexander, later Earl of Athlone,
 1874-1957)
Mary Victoria (later Queen Mary) (1867-1953)
Mary Adelaide, Duchess of Teck (1833-97)
Margaret Maria, Lady Peek (d. 1884)
Sir Henry William Peek, Bt (1825-98)
Seven officers of the Indian Contingent

The three daughters of Edward VII and Queen Alexandra

4471 Canvas 45.7 x 61 (18 x 24)
Sydney Prior Hall, signed and dated 1883
Bequeathed by Rupert Gunnis, 1965

The sitters are (left to right):
Victoria Alexandra Olga Mary (1868-1935)
Maud Charlotte Mary Victoria (1869-1938)
Louise Victoria Alexandra Dagmar (1867-1931)

Four Generations: Queen Victoria, Edward VII, George V and the Duke of Windsor

4536 Canvas 53.3 x 71.1 (21 x 28)
Sir William Quiller Orchardson, c.1897
Four figures
Purchased, 1967

The sitters are (left to right):
Queen Victoria (1819-1901)
Edward VII (1841-1910)
Duke of Windsor (1894-1972)
George V (1865-1936)

Ormond (under Victoria)

Lady Gregory, Sir Hugh Lane, J.M.Synge and W.B.Yeats

4676 Pen and ink 20.3 x 14 (8 x 5½)
Sir William Orpen, 1907
Four figures
Given by Gibbs Proprietaries, 1969

The sitters are (left to right):
Sir Hugh Lane (1875-1915)
John Millington Synge (1871-1909)
William Butler Yeats (1865-1939)
Isabella Augusta, Lady Gregory (1852-1932)

Mr and Mrs George Henry Lewes with Thornton Leigh Hunt

4686 Pencil 15.5 x 12.7 ($6\frac{1}{8}$ x 5)
William Makepeace Thackeray, signed *Smithers* and
with part of artist's head
Three figures
Purchased, 1969

The sitters are (left to right):
Agnes Lewes (d.1902)
George Henry Lewes (1817-78)
Thornton Leigh Hunt (1810-73)

A Consultation prior to the Aerial Voyage to Weilburgh, 1836

4710 Canvas 147.3 x 206.4 (58 x 81½)
John Hollins, c.1836-8
Six figures
Purchased, 1970

The sitters are (left to right):
Walter Prideaux (1806-89)
John Hollins (1798-1855)
Sir William Milbourne James (1807-81)
Robert Hollond (1808-77)
Thomas Monck Mason (1803-89)
Charles Green (1785-1870)

Ormond

The Capel Family

4759 Canvas 160 x 259.1 (63 x 102)
Cornelius Johnson, c.1640
Seven figures
Purchased with help from NACF, 1970

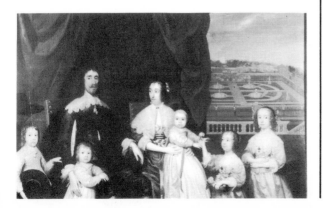

The sitters are (seated):
Arthur Capel, 1st Baron Capel (1604-49)
Elizabeth (Morrison), Lady Capel (d.1661)
(on Lady Capel's lap) Henry Capel, 2nd Baron Capel
 (d.1696)

(standing, left to right):
Arthur Capel, Earl of Essex (1631-83)
Charles Capel (d.1656-7)
Mary (Capel), Duchess of Beaufort (1630-1715)
Elizabeth (Capel), Countess of Carnarvon (1633-78)

The Derby Cabinet of 1867: at which the expedition to Abyssinia in 1868 was decided upon

4893 Water-colour 76.2 x 120.7 (30 x 47½)
Henry Gales, signed and dated 1868
Fifteen figures
Purchased, 1972

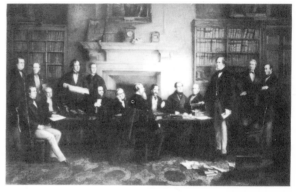

The sitters are (left to right):
Richard Southwell Bourke, 6th Earl of Mayo (1822-72)
Edward Henry Stanley, 15th Earl of Derby (1826-93)
Gathorne Gathorne-Hardy, 1st Earl of Cranbrook (1814-1906)
John Somerset Pakington, 1st Baron Hampton (1799-1880)
Benjamin Disraeli, Earl of Beaconsfield (1804-81)
Charles Henry Gordon-Lennox, 6th Duke of Richmond and
 1st Duke of Gordon (1818-1903)
Richard Grenville, 3rd Duke of Buckingham and Chandos
 (1823-89)
John Churchill, 7th Duke of Marlborough (1822-83)
Stafford Henry Northcote, 1st Earl of Iddesleigh (1818-87)
James Howard Harris, 3rd Earl of Malmesbury (1807-89)
Frederick Thesiger, 1st Baron Chelmsford (1794-1878)
Spencer Horatio Walpole (1806-98)
Edward George Stanley, 14th Earl of Derby (1799-1869)
John Manners, 7th Duke of Rutland (1818-1906)
Henry Thomas Lowry Corry (1803-73)

The Nine Living Muses of Great Britain: portraits in the characters of the Muses in the Temple of Apollo

4905 Canvas 132.1 x 154.9 (52 x 61)
Richard Samuel, signed, exh 1779
Nine figures
Purchased, 1972

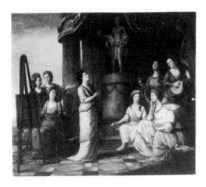

The sitters are (standing, left to right):
Elizabeth Carter (1717-1806)
Anna Letitia Barbauld (1743-1825)
Elizabeth Anne Sheridan (née Linley) (1754-92)
Hannah More (1745-1833)
Charlotte Lennox (1720-1804)

(seated, left to right):
Angelica Kauffmann (1741-1807)
Catharine Macaulay (1731-91)
Elizabeth Montagu (1720-1800)
Elizabeth Griffith (1720?-93)

3rd Baron Holland, Lady Holland and Mrs Brown

4914 *See Collections:* Caricatures of Prominent People, c.1832-5, by Sir Edwin Landseer, **4914-22**

General Phipps, Mrs Norton and 2nd Baron Alvanley at the theatre

4918 *See Collections:* Caricatures of Prominent People, c.1832-5, by Sir Edwin Landseer, **4914-22**

Queen Victoria presenting a Bible in the Audience Chamber at Windsor

4969 Canvas 167.6 x 213.8 (66 x 84$\frac{1}{8}$)
Thomas Jones Barker, signed in monogram, c.1861
Six figures
Purchased, 1974

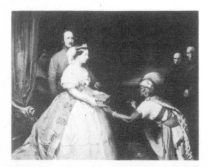

The sitters are (left to right):
Lady-in-waiting (unidentified)
Prince Albert (1819-61)
Queen Victoria (1819-1901)
African chief (unidentified)
Henry Temple, 3rd Viscount Palmerston (1784-1865)
John Russell, 1st Earl Russell (1792-1878)

Group including Frederick Delius and Philip Arnold Heseltine

4975(8) *See Collections:* Rehearsals for *A Mass of Life,* 1929, by Ernest Procter, **4975(1-36)**

Kathleen Ferrier at a Concert

5043 Board 18.4 x 22.9 (7¼ x 9)
Bernard Dunstan
Over sixteen figures
Purchased, 1975
Only the singer, Kathleen Ferrier (1912-53), has been identified

Gladstone's Cabinet of 1868

5116 Canvas 204.5 x 317.5 (80½ x 125)
Lowes Cato Dickinson, signed and dated *1869.1874*
Fifteen figures
Purchased, 1977

The sitters are (left to right):
Robert Lowe, Viscount Sherbrooke (1811-92)
Spencer Cavendish, 8th Duke of Devonshire (1833-1908)
John Bright (1811-89)
George Douglas Campbell, 8th Duke of Argyll (1823-1900)
Chichester Samuel Fortescue (afterwards Parkinson-Fortescue),
 Baron Carlingford (1823-98)
George Villiers, 4th Earl of Clarendon (1800-70)
Henry Austin Bruce, 1st Baron Aberdare (1815-95)
William Wood, Baron Hatherley (1801-81)
George Robinson, 1st Marquess of Ripon (1827-1909)
William Ewart Gladstone (1809-98)
Edward Cardwell, Viscount Cardwell (1813-86)
Hugh Culling Eardley Childers (1827-96)
Granville Leveson-Gower, 2nd Earl Granville (1815-91)
John Wodehouse, 1st Earl of Kimberley (1826-1902)
George Goschen, 1st Viscount Goschen (1831-1907)

A Bravura at the Hanover Square Concert

5179 Pen and ink and brown wash 23.5 x 16.8
(9¼ x 6⅝)
John Nixon, signed in monogram, inscribed and dated
1789
Purchased, 1978

The sitters are (musicians):
Left: James Cervetto (1747-1837)
Right: Luigi Marchesi (1755-1829)

(audience):
centre possibly Henry Frederick, Duke of Cumberland and
Strathearn (1725-90); others unknown

1st Earl of Monmouth and his family

5246 Canvas 227.3 x 216.5 (89½ x 85¼)
Attributed to Paul van Somer, c.1617
Five figures
Purchased, 1979. *Montacute*

The sitters are (left to right):
Henry Carey, 2nd Earl of Monmouth (1596-1661)
Elizabeth (née Trevanion), Countess of Monmouth (d.1641)
Robert Carey, 1st Earl of Monmouth (1560?-1639)
Philadelphia, Lady Wharton (1594-1654)
Thomas Carey (1597-1634)

Charles II at Boscobel Wood

5248 *See Collections:* Charles II's escape after the
Battle of Worcester, 1651, by Isaac Fuller, **5247-51**

The Lobby of the House of Commons, 1886

5256 Canvas 33 x 48.9 (13 x 19¼)
Liberio Prosperi, signed *Lib*
(*VF* Christmas Supplement, 1886)
Seventeen figures
Purchased, 1979

Continued overleaf

The sitters are (left to right):
Inspector Denning
Archibald John Scott Milman (d.1902)
John Bright (1811-89)
Sir William Harcourt (1827-1904)
Ralph Allen Gossett
Henry du Pré Labouchere (1831-1912)
Charles Bradlaugh (1833-91)
Joseph Chamberlain (1836-1914)
Charles Stewart Parnell (1846-91)
William Ewart Gladstone (1809-98)
Lord Randolph Churchill (1849-94)
Spencer Cavendish, 8th Duke of Devonshire (1833-1908)
Henry Chaplin, 1st Viscount Chaplin (1840-1923)
Sir George Leveson Gower (1858-1951)
Charles Robert Spencer, 6th Earl Spencer (1857-1922)
Lord Arthur William Hill (1846-1931)
Mr Hansard

Robert Clive and Mir Jaffier after the Battle of Plassey, 1757

5263 Canvas 100.3 x 127 (39½ x 50)
Francis Hayman, inscribed, c.1760
Seventeen figures
Purchased with help from NACF, 1979
Clive (1725-74) and Mir Jaffier in the centre (arms outstretched); the rest unidentified

Greyfriars Churchyard, Edinburgh: group including David Octavius Hill

P6(2) *See Collections:* The Hill and Adamson Albums, 1843-8, by David Octavius Hill and Robert Adamson, **P6(1-258)**

George William Bell, Lady Moncrieff (née Bell) and Thomas Blizzard Bell

P6(97) *See Collections:* The Hill and Adamson Albums, 1843-8, by David Octavius Hill and Robert Adamson, **P6(1-258)**

The Torso: John Henning, Alexander Handyside Ritchie and David Octavius Hill

P6(98) *See Collections:* The Hill and Adamson Albums, 1843-8, by David Octavius Hill and Robert Adamson, **P6(1-258)**

Free Church Committee: Marquess of Breadalbane, Sir David Brewster, David Welsh, John Hamilton and A.Earle Monteith

P6(104) *See Collections:* The Hill and Adamson Albums, 1843-8, by David Octavius Hill and Robert Adamson, **P6(1-258)**

Study for . . . the first General Assembly of the Free Church: George Muirhead, William Cunningham, James Begg, Thomas Guthrie and John Hamilton

P6(105) *See Collections:* The Hill and Adamson Albums, 1843-8, by David Octavius Hill and Robert Adamson, **P6(1-258)**

Jane Webster, Mrs Marrable and Justine Gallie

P6(117) *See Collections:* The Hill and Adamson Albums, 1843-8, by David Octavius Hill and Robert Adamson, **P6(1-258)**

James Fillans with his two daughters

P6(120) *See Collections:* The Hill and Adamson Albums, 1843-8, by David Octavius Hill and Robert Adamson, **P6(1-258)**

Thomas Miller and his family

P6(138) *See Collections:* The Hill and Adamson Albums, 1843-8, by David Octavius Hill and Robert Adamson, **P6(1-258)**

Graham Fyvie, Robert Cadell and Robert Cunningham Graham Spiers

P6(139) *See Collections:* The Hill and Adamson Albums, 1843-8, by David Octavius Hill and Robert Adamson, **P6(1-258)**

Dundee Free Church Presbytery

P6((140) *See Collections:* The Hill and Adamson Albums, 1843-8, by David Octavius Hill and Robert Adamson, **P6(1-258)**

Edinburgh Ale: James Ballantine, George William Bell and David Octavius Hill

P6(141) *See Collections:* The Hill and Adamson Albums, 1843-8, by David Octavius Hill and Robert Adamson, **P6(1-258)**

A Discussion: James Ballantine, David Octavius Hill and George William Bell

P6(143) *See Collections:* The Hill and Adamson Albums, 1843-8, by David Octavius Hill and Robert Adamson, **P6(1-258)**

Fishermen Ashore: Alex Rutherford, William Ramsay and John Liston

P6(215) *See Collections:* The Hill and Adamson Albums, 1843-8, by David Octavius Hill and Robert Adamson, **P6(1-258)**

The Monks of Kennaquhair: William Borthwick Johnstone, William Leighton Leitch and David Scott

P6(144) *See Collections:* The Hill and Adamson Albums, 1843-8, by David Octavius Hill and Robert Adamson, **P6(1-258)**

The Adamson family: Alexander Adamson, John Adamson and his wife, Mrs Bell, Melville Adamson and Robert Adamson

P6(153) *See Collections:* The Hill and Adamson Albums, 1843-8, by David Octavius Hill and Robert Adamson, **P6(1-258)**

The Minnow Pool: children of Charles Finlay

P6(171) *See Collections:* The Hill and Adamson Albums, 1843-8, by David Octavius Hill and Robert Adamson, **P6(1-258)**

James Linton and his children

P6(199) *See Collections:* The Hill and Adamson Albums, 1843-8, by David Octavius Hill and Robert Adamson, **P6(1-258)**

The Letter: Marion Finlay, Margaret Dryburgh and Grace Finlay

P6(202) *See Collections:* The Hill and Adamson Albums, 1843-8, by David Octavius Hill and Robert Adamson, **P6(1-258)**

Marion Finlay, Margaret Dryburgh, Grace Finlay and others

P6(204) *See Collections:* The Hill and Adamson Albums, 1843-8, by David Octavius Hill and Robert Adamson, **P6(1-258)**

The Pastor's Visit: group including James Fairbairn

P6(206) *See Collections:* The Hill and Adamson Albums, 1843-8, by David Octavius Hill and Robert Adamson, **P6(1-258)**

Sir Robert Dennistoun's Tomb: group including David Octavius Hill

P6(220) *See Collections:* The Hill and Adamson Albums, 1843-8, by David Octavius Hill and Robert Adamson, **P6(1-258)**

The Nasmyth Tomb: David Octavius Hill and three other men

P6(230) *See Collections:* The Hill and Adamson Albums, 1843-8, by David Octavius Hill and Robert Adamson, **P6(1-258)**

Edinburgh Castle: group probably including George Meikle Kemp

P6(234) *See Collections:* The Hill and Adamson Albums, 1843-8, by David Octavius Hill and Robert Adamson, **P6(1-258)**

Lord Henry Cockburn, his family, David Octavius Hill and John Henning

P6(237,238) *See Collections:* The Hill and Adamson Albums, 1843-8, by David Octavius Hill and Robert Adamson, **P6(1-258)**

Sir Gordon Richards at Newmarket

P17 *See Collections:* Prominent men, c.1938-43, by Felix H. Man, **P10-17**

Heaven: Mary Ann Hillier, Elizabeth Keown? and Alice Jessie Keown

P18(36) *See Collections:* The Herschel Album, by Julia Margaret Cameron, **P18(1-92b)**

Love: Mary Ann Hillier, Elizabeth Keown and Alice Jessie Keown

P18(43) *See Collections:* The Herschel Album, by Julia Margaret Cameron, **P18(1-92b)**

Faith: Mary Ann Hillier, Elizabeth Keown? and Alice Jessie Keown

P18(53) *See Collections:* The Herschel Album, by Julia Margaret Cameron, **P18(1-92b)**

The Return after 3 days: Mary Kellaway?, Mary Ann Hillier, William Frederick Gould, and Mary, Lady Cotton

P18(55) *See Collections:* The Herschel Album, by Julia Margaret Cameron, **P18(1-92b)**

The Holy Family: Cyllina Margaret Wilson, Percy Seymour Keown? and Alice Jessie Keown

P18(57) *See Collections:* The Herschel Album, by Julia Margaret Cameron, **P18(1-92b)**

Holy Family (other study): Cyllina Margaret Wilson, Percy Seymour Keown? and Alice Jessie Keown

P18(58) *See Collections:* The Herschel Album, by Julia Margaret Cameron, **P18(1-92b)**

King Ahasuerus & Queen Esther in Apocrypha: Sir Henry Taylor, Mary, Lady Cotton, and Mary Kellaway

P18(77) *See Collections:* The Herschel Album, by Julia Margaret Cameron, **P18(1-92b)**

The Minstrel Group: Mary, Lady Cotton, Kate Keown and Elizabeth Keown

P18(86) *See Collections:* The Herschel Album, by Julia Margaret Cameron, **P18(1-92b)**

Queen Victoria, Princess Louise and Princess Beatrice driving

P22(1) *See Collections:* The Balmoral Album, 1854-68, by George Washington Wilson, W. & D. Downey, and Henry John Whitlock, **P22(1-27)**

Group of fifteen including Queen Victoria and others

P22(2) *See Collections:* The Balmoral Album, 1854-68, by George Washington Wilson, W. & D. Downey, and Henry John Whitlock, **P22(1-27)**

The Gillies ball, 1868

P22(3) *See Collections:* The Balmoral Album, 1854-68, by George Washington Wilson, W. & D. Downey, and Henry John Whitlock, **P22(1-27)**

Stag shot by the Prince

P22(10) *See Collections:* The Balmoral Album, 1854-68, by George Washington Wilson, W. & D. Downey, and Henry John Whitlock, **P22(1-27)**

John Grant and his family

P22(12) *See Collections:* The Balmoral Album, 1854-68, by George Washington Wilson, W.& D. Downey, and Henry John Whitlock, **P22(1-27)**

Children of John Grant

P22(16) *See Collections:* The Balmoral Album, 1854-68, by George Washington Wilson, W. & D. Downey, and Henry John Whitlock **P22(1-27)**

D.Kennedy, J.Smith, Willy Stewart, John Brown, F.Farquarson, Morgan, Charlie Coutts, P.Robertson and John Grant

P22(17) *See Collections:* The Balmoral Album, 1854-68, by George Washington Wilson, W. & D. Downey, and Henry John Whitlock, **P22(1-27)**

Group of eleven, including the Duchess of Atholl

P22(24) *See Collections:* The Balmoral Album, 1854-68, by George Washington Wilson, W. & D. Downey, and Henry John Whitlock, **P22(1-27)**

Mrs Donald Stewart and her children

P22(26) *See Collections:* The Balmoral Album, 1854-68, by George Washington Wilson, W. & D. Downey, and Henry John Whitlock, **P22(1-27)**

The Royal Family on the terrace of Osborne House

P26 Photograph: albumen print 15.9 x 21.3 (6¼ x 8⅜)
L.Caldesi, 1857
Eleven figures
Purchased, 1977

The sitters are (left to right):
Prince Alfred, Duke of Edinburgh (1844-1900)
Prince Albert (1819-61)
Princess Helena Augusta Victoria (1846-1923)
Prince Arthur, Duke of Connaught and Strathearn (1850-1942)
 (in front)
Princess Alice Maud Mary (1843-78)
Queen Victoria (1819-1901) with, in her lap,
Princess Beatrice (1857-1944)
Princess Victoria Adelaide Mary Louise (1840-1901)
Princess Louise Caroline Alberta (1848-1939)
Prince Leopold, Duke of Albany (1853-84)
Prince Edward (later Edward VII) (1841-1910)

Royal mourning group, 1862

P27 Photograph: albumen print, oval 16.8 x 13 (6⅝ x 5⅛)
W.Bambridge, 28 March 1862
Four figures
Purchased, 1977

The sitters are (left to right):
Princess Victoria Adelaide Mary Louise (1840-1901)
Princess Alice Maud Mary (1843-78)
Queen Victoria (1819-1901)
Prince Alfred, Duke of Edinburgh (1844-1900)

Charles Dodgson and his family at Croft Rectory

P32 *See Collections:* Prints from two albums, 1852-60, by Charles Lutwidge Dodgson and others, **P31-40**

The Council of War on the day of the taking of the Mamelon Quarries, 7 June 1855

P49 Photograph: salt print 18.7 x 15.9 (7⅜ x 6¼)
Roger Fenton, 7 June 1855
Given by the Rev Collins Odgers, 1923

The sitters are (left to right):
Fitzroy Somerset, 1st Baron Raglan (1788-1855)
Omar Pasha (1806-71)
Aimable Jean Jacques Pelissier (Duc de Malakhoff)
 (1794-1864)

The Rossetti family

P56 Photograph: albumen print 17.5 x 22.2
(6⅞ x 8¾)
Charles Lutwidge Dogson, 7 October 1863
Four figures
Given by Miss Helen Macgregor, 1978

The sitters are (left to right):
Dante Gabriel Rossetti (1828-82)
Christina Georgina Rossetti (1830-94)
Frances Mary Lavinia Rossetti (née Polidori) (1800-86)
William Michael Rossetti (1829-1919)

Hugh ('Binkie') Beaumont, Angela Baddeley and Emlyn Williams

P59 *See Collections:* Prominent People, c.1946-64,
by Angus McBean, **P56-67**

Plenipotentiaries of Britain, Holland, Prussia and Russia signing the Treaty of 1791

L152(1) Water-colour, oval 14.9 x 20.3 (5⅞ x 8)
Edward Dayes, 1791
Four figures
Lent by NG (Alan Evans Bequest), 1974
None of the sitters, whose features are interchangeable,
can be identified

1st Marquess of Downshire and his family

L160 Canvas 63.5 x 76.8 (25 x 30¼)
Arthur Devis, inscribed, c.1760
Four figures
Lent by the Marchioness of Downshire Discretionary
Trust, 1975

The sitters are (left to right):
Lady Mary Amelia Hill (afterwards 1st Marchioness of
 Salisbury) (1750-1835)
Margaretta, Countess of Hillsborough (1729-66)
Arthur Hill (afterwards 2nd Marquess of Downshire)
 (1753-1801)
Wills Hill, 1st Marquess of Downshire (1718-93)

The Sharp family

L169 Canvas 115.6 x 125.7 (45½ x 49½)
Johan Zoffany, 1779-81
Fifteen figures
Lent by the executors of the late Miss Olive Lloyd-Baker, 1978

The sitters are (left to right):
Top level:
William Sharp (1729-1820)
Anna Jemima Sharp

Middle level:
Mrs James Sharp (née Lodge)
Catherine Sharp (née Barwick), holding in her lap
Mary Sharp (afterwards Mrs Thomas Lloyd-Baker) (d.1812)
Judith Sharp

Lower level:
Cabin boy
Bargemaster
James Sharp
Catherine Sharp
Granville Sharp (1753-1813)
Elizabeth Prowse (née Sharp) (d.1810)
Frances Sharp
John Sharp (d.1792)
Mary Sharp (née Dering)

Brook, John and Harry Young

L170 Canvas 86.4 x 63.5 (34 x 25)
Johan Zoffany, inscribed, c.1766
Four figures
Lent by Sir William Young, Bt, 1978. *Beningbrough*

The sitters are (left to right):
Brook Young
John Young
Negro page
Harry Young

Collections

Note: The entries in this section are arranged numerically under Gallery register number, beginning with non-prefixed numbers, followed by numbers with the prefix P (photograph) and then by numbers with the prefix L (loan).

Preliminary drawings for busts and statues

316a(1-202) Pencil studies made with a camera lucida, mainly life-size
Sir Francis Chantrey, c.1807-c.1840
Given by Mrs George Jones, 1871
The sitters, listed alphabetically, are as follows: those marked with an asterisk are catalogued separately in the section
Single and Double Portraits:
* **104,105** Duchess of Abercorn (when Lady Louisa Jane Russell) (1812-1902)
* **1** Sir Thomas Dyke Acland, Bt (1787-1871)
* **2** William Keppel, 4th Earl of Albemarle (1772-1849)

* **3,4** Shute Barrington (1734-1826)
* **5** Sir William Blizard (1743-1835)
* **13b** Henry Bone (1755-1834)
* **6** Sir Benjamin Collins Brodie, Bt (1783-1862)
 7 Mr Burton

* **8** Sir Augustus Wall Callcott (1799-1844)
* **9** John Jeffreys Pratt, 1st Marquess of Camden (1759-1840)
* **10** George Canning (1770-1827)
 64 Sir Benjamin Hallowell Carew (1760-1834)
* **11, 12** Sir James Rivett Carnac, Bt (1785-1846)
 15 Sir Charles Mansfield Clarke, Bt (1782-1857)
* **16** Sir Charles Mansfield Clarke, Bt
* **17** William Henry Vane, 1st Duke of Cleveland (1766-1842)
* **18** Henry Cline (1750-1827)
* **19** Henry Thomas Colebrooke (1765-1837)
* **20** Sir Astley Paston Cooper, Bt (1768-1841)
 21 Sir Astley Paston Cooper, Bt
 22 Capt. Cotton
* **23** Henry Cowper (1758-1840)
* **24a** and **b** George Crabbe (1754-1832)
* **25, 26** Sir William Curtis, Bt (1752-1829)

27, 28, 30 John Dalton (1766-1844)
* **29** John Dalton
 31 Mr Davis Barking Church/Mont. by Roubiliac
 32 Mrs Davis Roman Villa near/Cheltenham
* **33** Sir Howard Douglas, Bt (1776-1861)
* **39** Thomas Dundas, 1st Baron Dundas (1741-1820)
* **38** Sir David Dundas (1735-1820)
* **40** Robert Dundas of Arniston (1758-1819)
 41 James Dunlop (1769?-1841)

* **42** Sir Edward Hyde East, Bt (1764-1847)
* **43** George Wyndham, 3rd Earl of Egremont (1751-1837)
 44 Mr Ellis (Frederick Augustus Ellis)
 45 Charles Ellis
 46 Mr Elwin
 47 Lady Errol

* **79, 80** Charles Long, 1st Baron Farnborough (1761-1838)
* **48** Sir Ronald Craufurd Ferguson (1773-1841)
* **49** Sir Charles Forbes, Bt (1774-1849)
 50 C.Forbes Esqr
 51 John Hookham Frere (1769-1846)
 52 John Fuller

53, 55 George IV (1762-1830)
* **54** George IV
 56, 57 Sketches of ornamentation on George IV's robe
 58 Sir Sandford Graham, Bt (1788-1852)
* **59** Charles Grey, 2nd Earl Grey (1764-1845)

* **62** Basil Hall (1788-1844)
 63 Mrs Basil Hall (formerly Margaret Hunter, d.1876)
* **65** Charles Hatchett (1765?-1847)
 66, 67 Mr Hazledine/Shrewsbury (probably William Hazledine, 1763-1840)
 68 Sir T.Heathcote

* 69 Sir Benjamin Hobhouse, Bt (1757-1831)
* 70 Sir Everard Home, Bt (1756-1832)
 71 Christopher Hughes

 72 John Ireland (1761-1842)
73, 74 Dr Philip Jones
 75 G.R.Kinnersley
 76 Mr Kinnersley

77, 78 Thomas William Coke, 1st Earl of Leicester
 (1752-1842)
 64a Sir John Leslie (1766-1832)
* 13a, 14 Robert Stewart, 2nd Marquess of Londonderry
 (1769-1822)

* 81 Sir John Malcolm (1769-1833)
* 82 Benjamin Heath Malkin (1769-1842)
* 121 Charles Manners-Sutton (1755-1828)
83, 84 Campbell Marjoribanks
85, 86 William Marsden (probably the orientalist and
 numismatist, 1754-1836)
 87 William Lamb, 2nd Viscount Melbourne (1779-1848)
 89 Mr Miles
* 88 William Hodge Mill (1792-1853)
* 90 James Morrison (1790-1857)
* 91 William Murdock (1754-1839)
 92 William Murdock

93, 94 Josh. Neeld
* 95, 96 Sir John Nicholl (1759-1838)
 97 Lady Nugent

* 98 George Pearson (1751-1828)
* 99 Sir Robert Peel, Bt (1788-1850)

 100 John Rennie (1761-1821)
 101 W.Ronney
*102, 103 Sir Henry Russell, Bt (1751-1836)

* 106 George Saunders (1762-1839)
 107 James Scott (1770-1848)
* 108, 109 Sir James Edward Smith (1759-1828)
 110 Wm. Smith
* 111 Sir John Soane (1753-1837)
* 114, 115 Mary Somerville (1780-1872)
* 112, 113 William Somerville (1771-1860)
* 116 George Spencer, 2nd Earl Spencer (1758-1834)
* 119, 120 Augustus Frederick, Duke of Sussex (1773-1843)
 117, 118 George Granville Leveson-Gower, 1st Duke of
 Sutherland (1758-1833)

* 122 John Horne Tooke (1736-1812)
* 123, 124 Edward Troughton (1753-1835)

* 125, 126 Queen Victoria (1819-1901)

 127-40 Arthur Wellesley, Duke of Wellington (1769-1852)
 60, 61 Robert Grosvenor, 1st Marquess of Westminster
 (1767-1845)
 34-7 William IV (1765-1837)
* 141, 142 William IV
* 143 Horace Hayman Wilson (1786-1860)
* 144 William Hyde Wollaston (1766-1828)
 145 Capt. Woolmore
 146 William Wordsworth (1770-1850)
 147 Sir Jeffry Wyatville (1766-1840)
* 148, 149 Sir Jeffry Wyatville

 150-202 Unknown sitters

Four studies for Patrons and Lovers of Art
by Pieter Christoph Wonder, c.1826

792-5 *See Groups*

Studies for miniatures

883(1-21) Pencil, pen, ink and wash 17.5 x 13
($6\frac{7}{8}$ x $5\frac{1}{8}$) or less
Sir George Hayter
Purchased, 1891

The sitters, listed alphabetically, are as follows; those marked
with an asterisk are catalogued separately in the section
Single and Double Portraits:
* 1 Henry Bathurst (1744-1837)
 2 Lord Frederick Beauclerk (1808-65)
* 3 John Russell, 6th Duke of Bedford (1766-1839)
* 4, 5 Georgina, Duchess of Bedford (1781-1853)
 6 Mr Burdett
 7 Charles Clavering
 8 Sir William John Codrington (1804-84) and his brother
 Edward (1803-19)
 9 Lady Ellenborough (probably Anne, 1761-1843, wife of
 1st Baron)
* 10 Jane Elizabeth, Lady Ellenborough (1807-81)
 11 The Misses Mary, Harriet and Louisa Gardiner
 12 Lady Elizabeth Harcourt (née Bingham) (d.1838)
 13 Colonel Godfrey Nythe
 14 Sarah Sophia, Countess of Jersey (d.1867)
* 15 William Henry Lyttelton (1782-1837)
 16 Elizabeth Mary, Lady Rancliffe (1786-1840)
 17 Lord William Russell (1800-40)
 18 H.Scott
 19 Sir John Shelley, Bt (1772-1852)
 20 Sir John Gordon Sinclair, Bt (1790-1863)
 21 George Tate

Arctic Explorers, 1850-86

905-24, 1209-27 Canvas or board 124.5 x 99.1
(49 x 39) or less
Stephen Pearce
Nos. 905-24 bequeathed by Lady Franklin, 1892;
nos. 1209-27 bequeathed by John Barrow, 1899

The sitters, listed alphabetically, are as follows; those marked
with an asterisk are catalogued separately in the section
Single and Double Portraits:
* 1218 Sir Horatio Thomas Austin (1801-65)
* 905 John Barrow (1808-98)
* 918 Sir Francis Beaufort (1774-1857)
* 911 Frederick William Beechey (1796-1856)
* 1217 Sir Edward Belcher (1799-1877)
* 1227 Joseph René Bellot (1826-52)
* 1221 Sir Richard Collinson (1811-83)
 914 Replica of no. **1221**
* 908 William Alexander Baillie Hamilton (1803-81)
 910 William Robert Hobson (1831-65)
* 1223 Sir Edward Augustus Inglefield (1820-94)
 921 Replica of no. **1223**
* 1222 Sir Henry Kellett (1806-75)
 915 Replica of no. **1222**
* 1225 William Kennedy (1813-90)
 917 Replica of no. **1225**

Continued overleaf

* **1211** Sir Francis Leopold McClintock (1819-1907)
 1226 Sir Francis Leopold McClintock
 919 Replica of no.**1226**
* **1210** Sir Robert McClure (1807-73)
* **1216** Robert McCormick (1800-90)
* **1214** Rochfort Maguire (d.1857)
* **1215** Thomas Edward Laws Moore (1819-72)
* **906** Sir Roderick Impey Murchison (1792-1871)
* **1212** Sir George Strong Nares (1831-1915)
* **1219** Sir Erasmus Ommanney (1814-1904)
* **1224** Sherard Osborn (1822-75)
 916 Replica of no.**1224**
* **912** Sir William Edward Parry (1790-1855)
* **1209** William Penny (1809-92)
* **1213** John Rae (1813-93)
* **923** Sir George Henry Richards (1820-96)
* **909** Sir John Richardson (1787-1865)
* **913** Sir James Clark Ross (1800-62)
* **907** Sir Edward Sabine (1788-1883)
* **924** Benjamin Leigh Smith (1828-1913)
* **1220** Alexander Stewart (1830-90)
* **922** David Walker (1837-1917)
* **920** Sir Allen William Young (1827-1915)

See also Groups, **1208**

Ormond

Drawings of Artists, c.1845

1456(1-27) Pencil 16.5 x 14 (6½ x 5½) or less
Charles Hutton Lear
Given by John Elliot, 1907

The sitters, listed numerically, are as follows; those marked
with an asterisk are catalogued separately in the section
Single and Double Portraits:
* **1** Edward Hodges Baily (1788-1867)
* **2** Abraham Cooper (1787-1868)
* **3** Joshua Cristall (1767-1847)
* **4** George Haydock Dodgson (1811-80)
* **5** Augustus Leopold Egg (1816-63)
* **6** William Etty (1787-1849)
 7, 8 William Etty
* **9** Solomon Alexander Hart (1806-81)
* **10** John Rogers Herbert (1810-90)
* **11** William Hilton (1786-1839)
* **12** Thomas Uwins (1782-1857)
* **13** James Clarke Hook (1819-1907)
* **14** George Jones (1786-1869)
* **15** Charles Robert Leslie (1794-1859)
 16 Linnell (a son of John Linnell)
 17 Linnell (another son of John Linnell)
* **18** William Long (fl.1821-55)
* **19, 20** Daniel Maclise (1806-70)
* **21** Ebenezer Butler Morris (f.1833-63) and William
 Wyon (1795-1851) (catalogued separately under
 Wyon)
* **22** William Mulready (1786-1863)
* **23** Henry William Pickersgill (1782-1875)
* **24** Henry Sass (1788-1844)
* **25** James Mallord William Turner (1775-1851)
* **26** Benjamin West (1738-1820)
 27 Sir Richard Westmacott (1775-1856)

Ormond

Copies of early portraits

1492, 1492(a-c) and **2394-2419** Water-colour
23.2 x 20 ($9\frac{1}{8}$ x $7\frac{7}{8}$) or less
George Perfect Harding and Sylvester Harding
Nos.1492 and 1492(a-c) bequeathed by Henry Callcott
Brunning, 1908; nos.2394-2419 purchased, 1929

The sitters, listed alphabetically, are as follows; those marked
with an asterisk are catalogued separately in the section
Single and Double Portraits:
* **2416** Samuel Bradford (1652-1731)
* **2401** Edward Bruce, 1st Baron Bruce of Kinloss
 (1549?-1611)
 2394 Sir Samuel Egerton Brydges, Bt (1762-1837)
* **2402** Sir Charles Caesar (1590-1642)
* **1492(c)** George Clifford, 3rd Earl of Cumberland
 (1558-1605)
 1492(b) Sir William Drury (1527-79)
* **2404** Sir John Finet (1571-1641)
* **2414** Gabriel Goodman (1529?-1601)
* **2413** Sir Christopher Hatton (1540-91)
 2406 Called Charles Gerard, 1st Earl of Macclesfield
 (1620?-94)
* **2398** Anthony Browne, 1st Viscount Montague (1526-92)
* **2403** Sir Geoffrey Palmer, Bt (1598-1670)
* **2399** Sir Amias Paulet (1536?-88)
* **2405** Sir John Popham (1531?-1607)
 2409 Sir Edward Rogers (1498?-1567)
* **2396** Wentworth Dillon, 4th Earl of Roscommon
 (1633?-85)
* **2410** Lord Edward Russell (b.1551)
* **2411** Lord Francis Russell (b.1585)
* **2048** Oliver St John, Baron St John (d.1582)
 2412 Called Sir Philip Sidney (1554-86)
* **2397** Sir Philip Stapleton (1603-47)
* **2415** Richard Steward (1593?-1651)
 1492(a) Sir Nicholas Throckmorton (1515-71)
* **2418** William Vincent (1739-1815)
 2407 Christopher Wandesforde (1592-1640)
* **2417** Joseph Wilcocks (1673-1756)
 2419 John Williams (1636?-1709)
* **1492** Charles Somerset, 1st Earl of Worcester (1460?-1526)
* **2400** William Somerset, 3rd Earl of Worcester (1526-89)
 2395 Unknown man

Sketches for The Trial of Queen Caroline, 1820
(*Groups,* **999**)

1695(a-x) Pen, pencil or wash 33 x 20.3 (13 x 8)
or less
Sir George Hayter, 1820
Purchased, 1913

The sitters, in letter order, are as follows:
a and **b** Queen Caroline (1768-1821)
c and **d** Theodore Majocchi
e Robert Gifford, 1st Baron Gifford (1779-1826)
f Thomas Denman, 1st Baron Denman (1779-1854)
g Henry Richard Vassall Fox, 3rd Baron Holland (1773-1840)
h William Adams (1772-1851), James Parke, 1st Baron
 Wensleydale (1782-1868), and Sir Christopher Robinson
 (1766-1833)
i 1st Baron Gifford, Stephen Lushington (1782-1873), John
 Singleton Copley, Baron Lyndhurst (1772-1863), Marchese
 di Spineto (c.1774-1849), and Thomas Wilde, Baron Truro
 (1782-1855)

j Sketches of William IV (1765-1837), George Granville Leveson-Gower, 1st Duke of Sutherland (1758-1833), George Fermor, 3rd Earl of Pomfret (1768-1830), and others

k and l John Scott, 1st Earl of Eldon (1751-1838)

m Sketch of Robert Jenkinson, 2nd Earl of Liverpool (1770-1828), and others

n Group including Henry William Majendie (1754-1830), Folliott Herbert Walker Cornewall (1754-1831), George Henry Law (1761-1845), Heneage Finch, 5th Earl of Aylesford (1786-1859), and John Colville, 10th Baron Colville (1768-1849)

o Baron Truro

p Henry Lascelles, 2nd Earl of Harewood (1767-1841)

q Group including some Members of the House of Commons

r A member of the Council

s Sketches of 1st Earl of Eldon, Sir William Garrow (1760-1840), 2nd Earl of Liverpool, and a group

t Group including Frederick, Duke of York (1763-1827), Charles Manners-Sutton (1755-1828), and Edward Harcourt (1757-1847)

u Group including Charles Powlett Townshend, 2nd Baron Bayning (1785-1823), William Feilding, 7th Earl of Denbigh (1796-1865), Hugh Percy, 3rd Duke of Northumberland (1785-1847), Thomas Reynolds Moreton, 1st Earl of Ducie (1776-1840), and George Child-Villiers, 5th Earl of Jersey (1773-1859)

v Group in the left gallery

w Group of Members of the House of Commons

x Group for right niche (not used in the painting)

See also Collections, 2662

Lord Kelvin and members of his family

1708(a-h) Chalk or pencil 51.8 x 35.6 (20$\frac{3}{8}$ x 14) or less

Elizabeth King and Agnes Gardner King, 1838-1907

Given by Agnes Gardner King, 1913

Unless otherwise stated, all the drawings are by Elizabeth King. The sitters are as follows; those marked with an asterisk are catalogued separately in the section *Single and Double Portraits:*

a Baron Kelvin (1824-1907), Elizabeth King (1818-96), and James Thomson (1822-92) by Agnes Gardner King

*b James Thomson (1786-1849) by Agnes Gardner King after Elizabeth King

c Elizabeth King (née Thomson) (1818-96)

d Anna Bottomley (née Thomson) (1820-56)

*e James Thomson (1822-92) by Agnes Gardner King after Elizabeth King

*f William Thomson, Baron Kelvin (1824-1907)

*g David King (1806-83)

h Eliza King (née Young) (1786?-1847)

Drawings by John Linnell

1812-18, 1818A, 1818B Water-colour, crayon or pencil 43.8 x 34.9 (17¼ x 13¾) or less

John Linnell

Purchased, 1918

Except for nos. 1818A and 1818B all the sitters are catalogued separately in the section *Single and Double Portraits.* The sitters are:

1812, 1813 William Crotch (1775-1847)
1814 Charles Mayne Young (1777-1856)
1815 Francis Jeffrey, Lord Jeffrey (1773-1850)
1816 Samuel Bagster (1772-1851)
1817 Sir Thomas Erskine Perry (1806-82)
1818 Sir George Murray (1772-1846)
1818A Mr Tabrum
1818B Harvey Aston (d.1839)

Members of the House of Lords, c.1870-80

1834(a-z and aa-hh) Pencil 20.6 x 13 (8$\frac{1}{8}$ x 5$\frac{1}{8}$) or less

Frederick Sargent

Given by A.C.R.Carter, 1919

The sitters, listed alphabetically, are as follows; those marked with an asterisk are catalogued separately in the section *Single and Double Portraits:*

*a James Hamilton, 1st Duke of Abercorn (1811-85)

b William Henry Orde-Powlett, 3rd Baron Bolton (1818-95)

*c James Sinclair, 14th Earl of Caithness (1821-81)

*d George Frederick William Charles, 2nd Duke of Cambridge (1819-1904)

e Edward Cardwell, Viscount Cardwell (1813-86)

f Richard Handcock, 4th Baron Castlemaine (1826-92)

*g Frederick Thesiger, 1st Baron Chelmsford (1794-1878)

h Charles John Colville, 1st Viscount Colville (1818-1903)

i Richard Edmund St Lawrence Boyle, 9th Earl of Cork (1829-1904)

j Rudolph William Feilding, 8th Earl of Denbigh (1823-92)

k Francis William Rice, 5th Baron Dynevor (1804-78)

l William Ernest Duncombe, 1st Earl of Feversham (1829-1915)

m George Weld-Forester, 3rd Baron Forester (1807-86)

*n John Hanmer, Baron Hanmer (1809-81)

*o Charles Philip Yorke, 5th Earl of Hardwicke (1836-97)

p Edward Richard Littleton, 2nd Baron Hatherton (1815-88)

q John Henniker-Major, 5th Baron Henniker (1842-1902)

*r Victor Child-Villiers, 7th Earl of Jersey (1845-1915)

s Edward Bootle-Wilbraham, 1st Earl of Lathom (1837-98)

t James Hewitt, 4th Viscount Lifford (1811-87)

u Sydney Pierrepont, 3rd Earl Manvers (1825-1900)

v Sholto John Douglas. 20th Earl of Morton (1818-84)

w George Rushout-Bowles, 3rd Baron Northwick (1811-87)

x Isaac Newton Wallop, 5th Earl of Portsmouth (1825-91)

y Richard Henry Fitzroy, 2nd Baron Raglan (1817-84)

*z Laurence Parsons, 4th Earl of Rosse (1840-1908)

aa William Aubrey de Vere Beauclerk, 10th Duke of St Albans (1840-98)

bb John William Montagu, 7th Earl of Sandwich (1811-84)

cc Anthony Ashley-Cooper, 7th Earl of Shaftesbury (1801-85)

dd Charles Somers Cocks, 3rd Earl Somers (1819-83)

*ee James Talbot, 4th Baron Talbot de Malahide (1805-83)

ff George Charles Mostyn, 6th Baron Vaux of Harrowden (1804-83)

gg William Frederick Waldegrave, 9th Earl Waldegrave (1851-1930)

*hh Arthur Wrottesley, 3rd Baron Wrottesley (1824-1910)

Peninsular and Waterloo Officers, 1813-14

1914(1-32) Water-colour 23.2 x 19.4 (9$\frac{1}{8}$ x 7$\frac{5}{8}$) or less
Thomas Heaphy
Purchased, 1921

Nos.1914(1-18,20 and 23) are presumably studies for Heaphy's Wellington giving orders to the Generals previous to a general action (painting not in NPG). The following sitters (listed numerically) have been identified; those marked with an asterisk are catalogued separately in the section *Single and Double Portraits:*

* * 1 Sir Charles, Count von Alten (1764-1840)
* * 2 Sir Edward Barnes (1776-1838)
* 3 Sir Edward Barnes
* 4 William Carr Beresford, Viscount Beresford (1768-1854)
* * 5 Sir John Fox Burgoyne, Bt (1782-1871)
* * 6 Rowland Hill, 1st Viscount Hill (1772-1842)
* 7 Rowland Hill, 1st Viscount Hill
* * 8 Sir James McGrigor (1771-1858)
* * 9 Sir Edward Pakenham (1778-1815)
* *10 Sir Frederic Ponsonby (1783-1837)
* *11 Fitzroy Somerset, 1st Baron Raglan (1788-1855)
* *12 Charles Gordon-Lennox, 5th Duke of Richmond and Lennox (1791-1860)
* *13 Sir Hew Dalrymple Ross (1799-1868)
* *14 Sir George Scovell (1774-1861)
* *15 Lord Robert Edward Henry Somerset (1776-1842)
* *16 Sir George Townshend Walker, Bt (1764-1842)
* 17, 18 Arthur Wellesley, 1st Duke of Wellington (1769-1852)
* *19 Princess Charlotte (1796-1817)
* 20 William II of Holland (1792-1849)
* 22 Napoleon Bonaparte (1769-1821)
* 23 Don Pablo Morillo, Comte de Cartagena (1777-1838)

Opera singers and others, c.1804-c.1836

1962(a-l) Water-colour, pen, and ink 29.8 x 23.2 (11¾ x 9$\frac{1}{8}$) or less
Alfred Edward Chalon
Purchased, 1922

The sitters, in letter order, are as follows; those marked with an asterisk are catalogued separately in the section *Single and Double Portraits:*

* * a Angelica Catalani (1780-1849)
* b Maria Theresa Kemble (née De Camp) (1774-1838)
* * c Maria Dickons (1770?-1833)
* d a Kemble
* * e Robert Lindley (1776-1855)
* f Henry Phillips (1801-76)
* * g John Sims Reeves (1818-1900)
* h Unknown woman
* i Mrs W. West
* j Miss H.Cawse and Miss Betts
* k Julia Smith and Miss Smith
* * l Maria Taglioni (1809-84)

Queen Victoria, Prince Albert, and members of their family

2023A(1-12) Metal medallions and medallions in ormolu 10.5 x 8.3 (4$\frac{1}{8}$ x 3¼) or less
Susan D.Durant, c.1861-c.1872
Given by Sir Henry Paul Harvey, 1924

The sitters are as follows:
1,2 Queen Victoria (1819-1901)
3,4 Prince Albert (1819-61)
5,6 Princess Victoria Adelaide Mary Louise (1840-1901)
7-9 Princess Alice Maud Mary (1843-78)
10 Princess Alice Maud Mary (on reverse: Prince Louis, 1837-92)
11,12 Princess Helena Augusta Victoria (1846-1923)

Medallions of writers, c.1922

2043-55 Plasticine 11.4 (4½) or less diameter
Theodore Spicer-Simson
Given by the artist, 1924

The sitters, listed alphabetically, are as follows; those marked with an asterisk are catalogued separately in the section *Single and Double Portraits:*

2043	Arnold Bennett (1867-1931)
*2044	Robert Bridges (1844-1930)
2045	Gilbert Keith Chesterton (1874-1936)
2046	William Henry Davies (1871-1940)
*2047	Walter de la Mare (1873-1956)
*2048	Edward John Moreton Drax Plunkett, 18th Baron Dunsany (1878-1957)
*2049	St John Greer Ervine (1883-1971)
2050	Thomas Hardy (1840-1928)
2051	Alfred Edward Housman (1859-1936)
2052	William Henry Hudson (1841-1922)
2053	John Masefield (1878-1967)
*2054	Sir Henry Newbolt (1862-1938)
2055	Herbert George Wells (1866-1946)

Lord Leighton and his family

2141, 2141(a-d) Pencil, chalk or water colour 26.8 x 22.6 (10½ x 8$\frac{7}{8}$) or less
Frederick Leighton, Baron Leighton, and Edward(?) Foster, 1834-c.1850
Given by Carolin Nias, in memory of her mother, Lady Nias, 1926

The sitters are as follows; those marked with an asterisk are catalogued separately in the section *Single and Double Portraits:*

*2141	Frederic Leighton, Baron Leighton (1830-96), self-portrait
*2141a	Alexandra Sutherland Orr (née Leighton) (1828-1903) by Lord Leighton
2141b	Augusta Mathews (née Leighton) (1835-1919) by Lord Leighton
2141c	Frederic Septimus Leighton (1800-92) by Edward(?) Foster
2141d	Augusta Leighton (née Nash) (1804-65) by Edward(?) Foster

Book of sketches, including members of Bench and Bar

2173(1-70) Pencil, pen and ink 30 x 24.1 (12 x 9½) or less
Sebastian Evans, c.1848-c.1883
Given by George Hubbard, 1927

The following sitters, listed alphabetically, have been identified; those marked with an asterisk are catalogued separately in the section *Single and Double Portraits:*

* **3** Sir James Bacon (1798-1895)
 20, 21 George Elwes Corrie (1793-1885)
* **46** Gathorne Gathorne-Hardy, 1st Earl of Cranbrook (1814-1906)
 9 Sir John Walter Huddleston (1815-90)
 45 Sir Edward Ebenezer Kay (1822-97)
* **14** Sir Rupert Alfred Kettle (1817-94)
* **7** Henry Charles Lopes, 1st Baron Ludlow (1828-99)
 39 Arthur Orton (1834-98)

The Parnell Commission, 1888-9

2229-72 Pencil 48.3 x 33.3 (19 x 13⅛) or less
Sydney Prior Hall, 1888-9
Given by the artist's son, Harry Reginald Holland Hall, 1928

The sitters are as follows, listed numerically, with publication dates of drawings reproduced in *The Graphic;* those marked with an asterisk are catalogued separately in the section *Single and Double Portraits:*

2229 Group including Charles Stewart Parnell (1846-91) and William J.Walsh (1841-1921)
2230 Sir Charles Russell (afterwards Baron Russell of Killowen) (1832-1900) (*Graphic* 2 Feb 1889)
2231 John Patrick Murphy (1831-1907) (*Graphic* 8 June 1889)
2232 Sir James Hannen (afterwards Baron Hannen) (1821-94) (*Graphic* 17 Nov 1888)
2233 Sir Richard Everard Webster (afterwards Viscount Alverstone) (1842-1915)
*__2234__ Richard Pigott (1828-89) (*Graphic* 2 March 1889)
2235 Digby Seymour
2236 Thomas Miller Beach (1841-94), two sketches (*Graphic* 16 Feb 1889)
*__2237__ Thomas Miller Beach (*Graphic* 9 Feb 1889)
2238 Thomas Miller Beach (*Graphic* 23 Feb 1889)
2239 Thomas Miller Beach, John Patrick Murphy, Sir Henry James (afterwards Baron James of Hereford, 1828-1911), and Sir Charles Russell (*Graphic* 16 Feb 1889)
2240, 2241 Sir Charles Russell (*Graphic* 2 March 1889)
2242 Group including Charles Stewart Parnell and H.Campbell (*Graphic* 16 Feb 1889)
2243 Group including Charles Stewart Parnell and Sir George Henry Lewis (1833-1911) (*Graphic* 2 March 1889)
2244 Charles Stewart Parnell, Sir George Henry Lewis and Thomas Miller Beach (*Graphic* 16 Feb 1889)
*__2245__ Sir Courtenay Peregrine Ilbert (1841-1924) (*Graphic* 2 Feb 1889)
2246 Joseph R.Cox (*Graphic* 2 Feb 1889)
*__2247__ Sir James Taylor Ingham (1805-90) (*Graphic* 23 Feb 1889)
2248 John Morley, 1st Viscount Morley (1838-1923), and Henry du Pré Labouchere (1831-1912) (*Graphic* 2 March 1889)

2249 James Bryce (afterwards Viscount Bryce) (1838-1922) and Sir John Day (1826-1908) (*Graphic* 2 March 1889)
2250 Group including John Patrick Murphy, Sir Henry James, Sir Charles Russell, Sir George Henry Lewis, William Thomas Stead (1849-1912), Michael Davitt (1846-1906) and Charles Stewart Parnell (*Graphic* 2 March 1889)
2251 Group including William Henry O'Shea (1840-1905) and Sir Charles Russell (*Graphic* Special Number 11 March 1889)
2252 Mr Cunninghame (*Graphic* 26 Jan 1889)
2253 Sir Frank Lockwood (1846-97) (*Graphic* 2 Feb 1889)
2254 Sir Henry James and a counsellor; another unknown man (*Graphic* 2 Feb 1889)
2255 Mr Louden (*Graphic* 2 Feb 1889)
2256 Mr Soames (*Graphic* 2 March 1889)
2257 (Sir) Thomas Wemyss Reid (1842-1905) and William Thomas Stead (1849-1912) (*Graphic* 2 March 1889)
*__2258__ Sir George Henry Lewis (*Graphic* 2 March 1889)
2259 Dr A.Commyns (*Graphic* 2 March 1889)
*__2260__ George Augustus Henry Sala (1828-96) (*Graphic* 16 March 1889)
2261 George Augustus Henry Sala
2262 Frederic Leighton, Baron Leighton (1830-96), and Clifford Lloyd (*Graphic* 16 Feb 1889)
2263 Sir Herbert Beerbohm Tree (1852-1917) and Joseph Williams Comyns Carr (1849-1916) (*Graphic* 23 Feb 1889)
2264 John Lawrence Toole (1830-1906) (*Graphic* 16 Feb 1889)
2265 Oscar Wilde (1856-1900)
2266, 2267 Unknown man
2268 Mr Louden and Mat Harris
2269 Denzil Roberts Onslow (1839-1908) (*Graphic* 16 Feb 1889)
2270 Unknown man
2271 William Francis Littleton (1847-89) and George Charles Brodrick (1831-1903)
2272 Group including Sir Henry James

Miscellaneous drawings: The Parnell Commission, Members of the House of Lords and the House of Commons, etc, c.1886-1903

2282-2348, 2370-90 Pencil 53.6 x 36.8 (21⅛ x 14½) or less
Sydney Prior Hall
Given by the artist's son, Harry Reginald Holland Hall, 1929

The drawings are as follows, listed numerically, with publication dates of those reproduced in *The Graphic:*

2282 Joseph Gillis Biggar (1828-90), Sir George Henry Lewis (1833-1911) and four other members of the Council (*Graphic* 11 March 1889, omitting Lewis)
2283 Henry du Pré Labouchere (1831-1917)
2284 Henry du Pré Labouchere and Justin McCarthy (1830-1912)
2285 Sir John Day (1826-1908)
2286 Group including Joseph William Comyns Carr (1849-1916), William Hoey Kearney Redmond (1861-1917) and H.Campbell
2287 Sir Edward Coley Burne-Jones, Bt (1833-98) (*Graphic* 20 April 1889)
2288 William Thomas Stead (1849-1912)
2289 Henry Stafford Northcote, Baron Northcote (1846-1911)

Continued overleaf

2290	John Burns (1858-1943)
2291	Owen Lewis Cope Williams (1836-1904), his wife(?), and an unknown man
2292	Sir George Henry Lewis
2293	Charles Stewart Parnell (1846-91) and others
2294	William Graham (1838-c.1900) (related to *Graphic* 22 Sept 1888)
2295	Charles Russell, Baron Russell of Killowen (1832-1900)
2296	Sir John Day and James Hannen, Baron Hannen (1821-94)
2297	Thomas Power O'Connor (1848-1929)
2298	Sir Frank Lockwood (1847-97)
2299	Sir George Henry Lewis
2300	Richard Everard Webster, Viscount Alverstone (1842-1915)
2301	Robert Threshie Reid, Earl Loreburn (1846-1923)
2302	Herbert Henry Asquith, 1st Earl of Oxford and Asquith (1852-1928) (*Graphic* 23 Feb 1889)
2303	1st Earl of Oxford and Asquith
2304	Edward Spencer Beesly (1831-1915)
2305	James Hannen, Baron Hannen
2306	Sir Frank Lockwood
2307	Debate on the Indian Duties: group including 1st Viscount Goschen (1831-1907), Sir Henry James (1828-1911), Sir Frank Lockwood, Dudabhai Naoroji (1825-1917), Joseph Chamberlain (1836-1914), 1st Viscount Morley of Blackburn (1838-1923), Sir William Harcourt (1827-1904), and 1st Earl of Oxford and Asquith (*Graphic* 2 March 1895)
2308-12	William Ewart Gladstone (1809-98)
2313, 2314	Charles Bradlaugh (1833-91)
2315	Sir William Harcourt
2316	Three sketches: Charles Bradlaugh, 1st Viscount Morley of Blackburn, and H.Murphy
2317	Sir William Harcourt and 1st Viscount Morley of Blackburn
2318	William Ewart Gladstone and Baron Russell of Killowen
2319	Timothy Michael Healy (1855-1931) and William Ewart Gladstone
2320	Michael Hicks-Beach, 1st Earl St Aldwyn (1837-1916)
2321	John O'Connor (1850-1928) and Leonard Courtney, 1st Baron Courtney of Penwith (1832-1918)
2322	William Henry Smith (1825-91) and John Bright (1811-89)
2323-5	William Ewart Gladstone
2326	Arthur Wellesley Peel, 1st Viscount Peel (1829-1912)
2327	Robert William Hanbury (1845-1903)
2328	Hugh Oakeley Arnold-Foster (1855-1909)
2329	Dudabhai Naoroji
2330	Joseph Chamberlain
2331	Arthur James Balfour, 1st Earl of Balfour (1843-1930)
2332	Charles Bradlaugh and others
2333, 2334	Sir Henry William Lucy (1845-1924)
2335	Spencer Cavendish, 8th Duke of Devonshire (1833-1908)
2336	Hardinge Stanley Giffard, 1st Earl of Halsbury (1823-1921)
2337	Herbrand Arthur Russell, 11th Duke of Bedford (1858-1940)
2338	George Douglas Campbell, 8th Duke of Argyll (1823-1900)
2339-42	Robert Gascoyne Cecil, 3rd Marquess of Salisbury (1830-1903)
2343-5	Farrer Herschel, Baron Herschel (1837-99)
2346	John Spencer, 5th Earl Spencer (1835-1910)
2347	James Edward Cowell Welldon (1854-1937)
2348	James Martineau (1805-1900)
2370-2	Mary Moore, Lady Wyndham (1861-1931)
2373	Sir Charles Wyndham (1837-1919)

2374	David James (1839-93)
2375	?Albert Joseph Moore (1841-93)
2376	Charles Lindley Wood, 2nd Viscount Halifax (1839-1934)
2377	William Archibald Spooner (1844-1930)
2378	Sir Robert Peel, Bt (1788-1850)
2379	?Albert Joseph Moore
2380	John Thomas (1826-1913)
2381	The Rao of Kutch
2382	Sir Wilfred Laurier (1841-1919)
2383	William Booth (1829-1912)
2384, 2385	Edward Onslow Ford (1852-1901)
2386	Harry Furniss (1854-1925) (*Graphic* 20 April 1889)
2387	Justin McCarthy (1830-1902)
2388	Justin McCarthy (*Graphic* 9 March 1889)
2389	Benjamin Jowett (1817-93) (*Graphic* 9 Dec 1893)
2390	? Sir Edwin Hughes (1832-1904)

Copies of early portraits, by George Perfect Harding and Sylvester Harding

2394-2419 *See under Collections*, **1492, 1492(a-c)**

Drawings of Royal Academicians, c.1858

2473-9 Pencil and water-colour, 16.5 x 9.5 (6½ x 3¾) or less

Charles Bell Birch

Given by the artist's nephew, George von Pirch, 1930

The sitters, listed numerically, are as follows; those marked with an asterisk are catalogued separately in the section *Single and Double Portraits:*

2473	William Mulready (1786-1863)
*2474	Edwin Longsden Long (1829-91)
*2475	Sir George Gilbert Scott (1811-78)
2476	Daniel Maclise (1806-70) and Solomon Alexander Hart (1806-81)
*2477	Heads of Sir Charles Lock Eastlake (1793-1865), George Dunlop Leslie (1835-1921) and John Wood (1825-91)
2478	Sir Charles Lock Eastlake
*2479	Solomon Alexander Hart

Ormond

Drawings of Prominent People, 1823-49

2515(1-104) Pencil and chalk 38.1 x 27.9 (15 x 11) or less

William Brockedon

Lent by NG, 1959

The sitters, listed numerically, are as follows; those marked with an asterisk are catalogued separately in the section *Single and Double Portraits:*

*	1	Giovanni Baptista Belzoni (1778-1823)
	2	Antonio Canova (1757-1822)
	3	Dominique Vivant, Baron Denon (1747-1825)
*	4	Molesworth Phillips (1799-1832)
	5	James Northcote (1746-1831)
*	6	Washington Irving (1783-1859)
	7	Jacob Perkins (1766-1849)
*	8	William Wyon (1795-1851)
*	9	Arthur Aikin (1773-1854)

10 William Hyde Wollaston (1766-1828)
11 William Shield (1748-1829)
12 Samuel Prout (1783-1852)
* 13 John Martin (1789-1854)
* 14 William Kitchener (1775?-1827)
* 15 George Bidder (1806-78)
16 Sir Charles Eastlake (1793-1865)
17 Richard Pering (1767-1858)
* 18 Jeremiah Holmes Wiffen (1792-1836)
19 Giovanni Aldini (1762-1834)
20 Sir Alexander Burnes (1805-41)
* 21 Sir Thomas Lawrence (1769-1830)
22 Charles Hamilton Smith (1776-1859)
* 23 Bryan Waller Procter (1787-1874)
24 Michael Faraday (1791-1867)
25 John Poole (1786?-1872)
26 Robert Richardson (1779-1847)
* 27 Prince Hoare (1755-1834)
28 Sir Marc Isambard Brunel (1769-1849)
29 William Godwin (1756-1836)
30 Sir Walter Scott (1771-1832)
31 George Croly (1780-1860)
32 John Flaxman (1755-1826)
33 Charles Babbage (1792-1871)
* 34 John Thomas Smith (1766-1833)
35 Robert H.Froude (1771?-1859)
36 Francis Vyvyan Jago Arundell (1780-1846)
* 37 John Galt (1779-1839)
38 Friedrich Heinrich Alexander, Baron Humboldt (1769-1859)
39 Allan Cunningham (1784-1842)
40 Clarkson Stanfield (1793-1867)
* 41 James Hogg (1770-1835)
42 Sir John Carr (1772-1832)
43 Sir James Prior (1790?-1869)
* 44 John Britton (1771-1857)
* 45 Charles Joseph Latrobe (1801-75)
* 46 Sir George Back (1796-1878)
47 Richard Lemon Lander (1804-34)
48 James Baillie Fraser (1783-1856)
49 Agricole, Marquis de Fortia D'Urbain (1756-1843)
50 Launcelot Théodore, Count Turpin De Crisse (1781-1852)
* 51 Alaric Alexander Watts (1797-1864)
52 Foulis
* 53 John Buonarotti Papworth (1775-1847)
54 John Fuller (1756-1834)
55 Joseph Chessborough Dyer (1780-1871)
56 Sir John Bowring (1792-1872)
57 Marie Joseph, Marquis de Lafayette (1757-1834)
58 Henry Hopley White (1790-1876)
59 Charles Turner (1774-1857)
60 Charles Macfarlane (d.1858)
61 Countess Teresa Guiccioli (1801-73)
62 Sir Samuel Meyrick (1783-1848)
63 Franz Andreas Bauer (1758-1840)
* 64 John Lander (1807-39)
65 F.(probably Baron Felix) Feuillet de Couche (1798-1887)
66 John Dalton (1766-1844)
* 67 Thomas Telford (1757-1834)
68 William Allen (1793-1864)
* 69 James Holman (1786-1857)
* 70 Thomas Phillips (1770-1845)
* 71 Anne Bray (1790-1883)
* 72 John Anthony Cramer (1793-1848)
* 73 Sir Edward Thomason (1769-1849)
* 74 Charles Stoddart (1806-42)
75 Camille, Count Cavour (1810-61)

76 Sir John Soane (1753-1837)
77 Barras
78 De Luc (probably Jean André, 1763-1847)
* 79 Peter Mark Roget (1779-1869)
80 Arthur Howe Holdsworth (1780-1860)
81 Sir John Franklin (1786-1847)
* 82 Thomas Frederick Colby (1784-1852)
* 83 John Murray (1778-1843)
* 84 Sir Charles Wheatstone (1802-75)
* 85 William Henry Smyth (1788-1865)
* 86 Sir John Gardner Wilkinson (1797-1875)
87 William Buckland (1784-1856)
* 88 Davies Gilbert (1767-1839)
89 Christian Anthony Rassam (d.1847)
* 90 Sir Francis Beaufort (1774-1857)
* 91 Sir Robert Hermann Schomburgk (1804-65)
92 Manockjee Cursetjee (1808-87)
* 93 Thomas Campbell (1777-1844)
94 Sir Henry Thomas De La Beche (1796-1855)
* 95 Sir Richard Westmacott (1775-1856)
* 96 John Gibson (1790-1866)
* 97 Sir Charles Fellows (1799-1860)
98 Sir Richard Owen (1804-92)
99 Sir James Clark Ross (1800-62)
*100 Robert Brown (1773-1858)
101 Theodore Edward Hook (1788-1841)
*102 Albert James Bernays (1823-92)
*103 Sir Austen Henry Layard (1817-94)
104 Charles Enderley (1797-1876)

Ormond

Vanity Fair cartoons, 1869-1910
Water-colour 30.5 x 17.8 (12 x 7) on average
Various artists
2566-2606 Purchased, 1933
2698-2746 Purchased, 1934
2964-3012 Purchased, 1937
3265-3300 Purchased, 1934
4605-4611 Purchased, 1968
4627-4636 Purchased, 1968
4707(1-30) Purchased, 1938
4711-4758 Purchased, 1970
All English sitters are catalogued individually in the section *Single and Double Portraits*. All foreign sitters are listed alphabetically as follows; those marked with an asterisk are catalogued separately in the section *Single and Double Portraits*:
*4707(1) Abdul Aziz (1830-76) by James Jacques Tissot
*4707(2) Alexander II (1818-81) by James Jacques Tissot
4707(3) Henri d'Orleans, Duc d'Aumale (1822-97) by Jean Baptiste Guth
4714 Marchese d'Azeglio by Carlo Pellegrini
4707(4) Friedrich Ferdinand, Count von Beust (1808-86) by Carlo Pellegrini
4635 Chevalier Carlo Cadorna by Carlo Pellegrini
*4707(6) Don Carlos (1848-1909) by Sir Leslie Ward
4707(7) Sadi Carnot (1837-94) by Jean de Paleologu
4707(8) Jean Paul Pierre Casimir-Perier (1847-1907) by Jean Baptiste Guth
2699 Cetewayo (or Cettiwayo) (d.1883) by Sir Leslie Ward
4707(9) Charles Louis de Saulces Freycinet (1828-1923) by Jean Baptiste Guth
4707(10) John Gennadius by Sir Leslie Ward
4707(11) Jules Grévy (1807-91) by Théobald Chartran

Continued overleaf

4707(12) Albert Auguste Gabriel Hanotaux (1853-1944)
 by Jean Baptiste Guth
4707(13) Viscount Tadasu Hayashi (1850-1913) by Sir
 Leslie Ward
2580 Sir Salar Jung (1829-83) by Sir Leslie Ward
*4707(14) Kuo Sung Tao (d.1887) by Sir Leslie Ward
3009 J.H.Martin ('Skeets') (b.1875) by L'Estrange
4707(17) Victor Maurel (1848-1923) by Sir Leslie Ward
*4707(18) Jean Louis Ernest Meissonier (1815-91) by
 Théobald Chartran
4707(19) Félix Jules Méline (1838-1925) by Jean Baptiste
 Guth
4707(20) Count Albert Mensdorff-Pouilly-Dietrichstein
 (b.1861) by Sir Leslie Ward
*4707(21) Midhat Pasha (1822-84) by Sir Leslie Ward
4707(5) Prince Victor Jerome Frederic Napoleon
 (1862-1926) by Jean Baptiste Guth
4707(22) Count Constantino Nigra (1828-1907) by Carlo
 Pellegrini
4707(23) Prince Henri d'Orleans (1867-1901) by Jean
 Baptiste Guth
4707(24) Philippe, 9th Duc d'Orleans (1869-1926) by Jean
 Baptiste Guth
4707(16) Sir Ras Makonnen by Sir Leslie Ward
4707(25) Jean de Reszke (1850-1925) by Sir Leslie Ward
4707(26) Edmond Eugène Alexis Rostand (1868-1918)
 by Jean Baptiste Guth
4707(27) Victorien Sardou (1831-1908) by Jean Baptiste
 Guth
4707(28) Jean Baptiste Leon Say (1826-96) by Carlo
 Pellegrini
4707(29) Count Schouvaloff by Carlo Pellegrini
*4707(30) Count Leo Tolstoy (1828-1910) by Snapp
4707(15) Julien Viaud ('Pierre Loti') (1850-1923) by Jean
 Baptiste Guth

Ormond *VF*

Book of sketches, mainly for The Trial of Queen Caroline, 1820 *(Groups, 999)*

2662(1-38) Pencil, pen or wash 26.7 x 20.3 (10½ x 8)
or less
Sir George Hayter, c.1820
Purchased, 1934

(Nos. 33, 35 and 36 are architectural sketches, and nos. 9 and
38 are unconnected with the painting.) The following have
been identified:

1-6, 8 Queen Caroline (1768-1821)
7 Head of John Singleton Copley, Baron Lyndhurst
 (1772-1863), and two other heads
10 William Adams (1772-1851)
12 Bowyer Edward Sparke (c.1760-1836) and other figures
14 Charles Arbuthnot (1767-1850)
20 Various heads including 7th Baron King (1775-1833),
 1st Earl Granville (1773-1846), 5th Earl Delawarr
 (1791-1869), and 1st Earl Amherst (1773-1857)
21 Various heads including William Nelson, 1st Earl Nelson
 (1757-1835), and Frederick, Duke of York (1763-1827)
29 Various heads including, Richard Hely-Hutchinson,
 1st Earl of Donoughmore (1756-1825)

See also Collections, **1695(a-x)**

The Clerk family, Sir Robert Peel, Samuel Rogers, and others, 1833-57

2772 Album of c. 150 sketches, mostly water-colour,
various sizes
Jemima Wedderburn
Given by Mary and Jane Clerk, 1935

Besides sketches of the Clerk family, and of animals, which are
outside the Gallery's terms of reference, the album includes
the following:

p. 28 Sir Robert Peel showing his pictures: group including
 Sir Robert Peel (1788-1850) and Henry Brougham,
 1st Baron Brougham and Vaux (1778-1868)
p.28 Samuel Rogers (1763-1855) in a group: Breakfast at
 Mr Rogers
p.33 Charles John Kean (1811?-68) as Richard III
 (2 drawings)

Ormond

Caricatures of Politicians

2826-74 Pen or pencil 43.2 x 30.5 (17 x 12) or less
Sir Francis Carruthers Gould (mostly for *Pall Mall
Gazette*)
Purchased, 1936

The sitters, listed numerically, are as follows; those marked
with an asterisk are catalogued separately in the section *Single
and Double Portraits:*

2826 John Burns (1858-1943)
2827 Edgar Algernon Robert Gascoyne-Cecil, 1st Viscount
 Cecil (1864-1958)
2828 Henry Chaplin, 1st Viscount Chaplin (1840-1923)
2829 Joseph Chamberlain (1836-1914)
2830-2 Sir Henry Campbell-Bannerman (1836-1908)
2833, 2834 Spencer Cavendish, 8th Duke of Devonshire
 (1833-1908)
2835 John Dillon (1851-1927)
2836 Robert Finlay, 1st Viscount Finlay (1842-1929)
2837 David Lloyd George, 1st Earl Lloyd-George
 (1863-1945)
2838 George Goschen, 1st Viscount Goschen (1831-1907)
2839 Sir John Eldon Gorst (1835-1911)
2840 Richard Burdon Haldane, Viscount Haldane
 (1856-1928)
2841-3, 2845 Sir William Harcourt (1827-1904)
*2844 Sir William Harcourt
2846 James Keir Hardie (1856-1915)
2847 Andrew Bonar Law (1858-1923)
2848 Henry du Pré Labouchere (1831-1912)
2849 John Morley, 1st Viscount Morley of Blackburn
 (1838-1923)
2850 Charles Stewart Parnell (1846-91)
2851 Arthur Wellesley Peel, 1st Viscount Peel (1829-1912),
 and an unidentified man
2852 1st Viscount Peel
2853 Cecil John Rhodes (4 heads) (1853-1902)
2854 Cecil John Rhodes (3 heads)
2855 John Edward Redmond (1856-1918)
2856, 2857 George Robinson, 1st Marquess of Ripon
 (1827-1909)
2858-60 Archibald Philip Primrose, 5th Earl of Rosebery
 (1847-1929)
2861, 2862 Robert Gascoyne-Cecil, 3rd Marquess of Salisbury
 (1830-1903)
2863 Randall Thomas Davidson, Baron Davidson of
 Lambeth (1848-1930), and 1st Earl Lloyd-George

2864 Michael Hicks-Beach, 1st Earl St Aldwyn (1837-1916),
 Arthur James Balfour, 1st Earl of Balfour (1848-1930),
 and Joseph Chamberlain
2864a 1st Earl of Balfour
2865 1st Viscount Cecil
2866 1st Earl of Balfour and Sir Henry Campbell-Bannerman
2867 Henry du Pré Labouchere
2868 Charles Bradlaugh (1833-91) and Florence O'Driscoll
 (d.1939)
2869 Sir Thomas Wallace Russell, Bt (1841-1920)
2870, 2871 Edward White Benson (1829-96) and Frederick
 Temple (1821-1902)
*2872 John Dillon
2873 3rd Marquess of Salisbury
*2874 John Spencer, 5th Earl Spencer (1835-1910)

Studies, mainly for General Officers of World War I
(*Groups,* 1954)

2908(1-18) Pencil 35.6 x 21.6 (14 x 8½) or less
John Singer Sargent, c.1922 (except no.18)
Given by the artist's sister, Mrs Violet Ormond, 1937

The sitters, listed numerically, are:
1 William Riddell Birdwood, 1st Baron Birdwood
 (1865-1951)
2 Henry Seymour Rawlinson, Baron Rawlinson (1864-1925)
3 Frederick Lambart, 10th Earl of Cavan (1865-1946)
4 Henry Sinclair Horne, Baron Horne (1861-1929)
5 Julian Byng, 1st Viscount Byng of Vimy (1862-1935)
6, 7 Sir Charles Macpherson Dobell (1869-1954)
8 Louis Botha (1862-1919)
9 10th Earl of Cavan
10 Edmund Allenby, 1st Viscount Allenby (1861-1936)
11 John French, 1st Earl of Ypres (1852-1925)
12 1st Viscount Allenby
13 Sir Henry Hughes Wilson, Bt (1864-1922)
14, 15 Baron Rawlinson
16 Unidentified (de Luca?)
17 Douglas Haig, 1st Earl Haig (1861-1928)
18 Study for Thou Shalt Not Steal, 1918

Sketches and studies by Henry Tonks

3072(1-18) Pen or pencil 33 x 27.9 (13 x 11) or less
Henry Tonks
Given by Charles Henry Collins Baker, 1937
The sitters are as follows; those marked with an asterisk are
catalogued separately in the section *Single and Double
Portraits:*
1 Philip Wilson Steer (1860-1942)
2 Back view of unknown artist painting portrait of a woman
3 Unknown woman (2 studies)
*3a Philip Wilson Steer
4 Henry Tonks (1862-1937)
*5 Henry Tonks
6 Philip Wilson Steer
*7 Henry Tonks
8-10 William Poel (1852-1934)
*11 William Poel
12-18 William Poel

Drawings by Sir George Hayter, illustrating his riding accident in 1821

3082(1-2, 4-7) Pen and ink 25.4 x 13.3 (10 x 5¼)
or less
Given by Iolo A.Williams, 1940

3082(3) Pen and ink 13.3 x 24.4 (5¼ x $9\frac{5}{8}$)
Given by John Woodward, 1943

Ormond (under Hayter)

Tracings of drawings by George Dance

3089(1-12) Pencil 25.7 x 20 ($10\frac{1}{8}$ x $7\frac{7}{8}$) or less
William Daniell after George Dance
Purchased, 1940
The sitters, listed alphabetically, are as follows; those marked
with an asterisk are catalogued separately in the section
Single and Double Portraits;
* 1 Joseph Bonomi (1739-1808)
 2 Bonomi
* 3 Hugh Carleton, Viscount Carleton (1739-1826)
* 4 John Crosdill (1751-1825)
* 5 Sir James Earle (1755-1817)
* 6 John Fisher (1748-1825)
* 7 Gavin Hamilton (1730-97)
 8 Sir Richard Hardinge, Bt (1756-1826)
 9 John Hoole (1727-1803)
*10 William Knyvett (1779-1856)
*11 Samuel Lysons (1763-1819)
 12 Peter Molini (1729/30-1806)

Caricatures, c.1825-c.1835

3097(1-10) Pen and ink and pencil 22.9 x 18.4
(9 x 7¼) or less
Sir Edwin Landseer
Purchased, 1940
The sitters, listed numerically, are as follows; those marked
with an asterisk are catalogued separately in the section
Single and Double Portraits:
* 1 Henry William Pickersgill (1782-1875)
* 2 Charles Mathews (1776-1835)
 3, 4 Charles Mathews
 5 Duchess of Cannizzaro (d.1841)
 6 George Capel-Coningsby, 5th Earl of Essex (1757-1839)
* 7 John Nash (1752-1835)
 8 Joseph Boruwlaski (1739-1837)
 9 Harriet Waylett (1798-1851)
 10 Nanini

Drawings of Artists, c.1862

3182(1-19) Pen, charcoal or pencil 21 x 13.3
(8¼ x 5¼) or less
Charles West Cope
Purchased, 1944

The sitters, listed numerically, are as follows; no.8 is
catalogued separately in the section *Single and Double
Portraits:*

1 Abraham Cooper (1787-1868)
2 John Callcott Horsley (1817-1903)
3 Solomon Alexander Hart (1806-81) and Samuel Cousins
 (1801-87)
4 Charles Robert Leslie (1794-1859)
5 William Mulready (1786-1863) and Charles Robert
 Leslie (on reverse: Sir Charles Eastlake)
6 John Prescott Knight (1803-81) and William Frederick
 Witherington (1785-1865)
7 David Roberts (1796-1864)
8 Richard Rothwell (1800-68)
9 Henry William Pickersgill (1782-1875) and William
 Frederick Witherington
10 Edward Matthew Ward (1816-79)
11 Edward White
12 Sir Charles Eastlake (1793-1865)
13 Two unidentified heads
14 Unidentified art students at work, including Ferdinand
 Pickering (1811-c.1882)
16 Ferdinand Pickering
17 Unidentified art students at work
18 A sculptor at work
19 Abraham Cooper

Ormond

The Kit-cat Club Portraits

3193-3235 Canvas, mostly 91.4 x 71.1 (36 x 28)
Sir Godfrey Kneller, c.1697-1717
Given by NACF, 1945

The sitters, listed numerically and (except no.3235)
alphabetically, are as follows; all are catalogued separately
in the section *Single and Double Portraits:*

3193 Joseph Addison (1672-1719)
3194 William Pulteney, 1st Earl of Bath (1684-1764)
3195 James Berkeley, 3rd Earl of Berkeley (1680-1736)
3196 John Vaughan, 3rd Earl of Carbery (1639-1713)
3197 Charles Howard, 3rd Earl of Carlisle (1669-1738)
3198 Richard Temple, 1st Viscount Cobham (1675-1749)
3199 William Congreve (1670-1729)
3200 Charles Cornwallis, 4th Baron Cornwallis (1675-1722)
3201 Charles Dartiquenave (1664-1737) (after Kneller)
3202 William Cavendish, 2nd Duke of Devonshire
 (1673-1729)
3203 John Dormer (1669-1719)
3204 Charles Sackville, 6th Earl of Dorset (1638-1706)
3205 Lionel Sackville, 1st Duke of Dorset (1688-1765)
3206 Edmund Dunch (1657-1719)
3207 Algernon Capel, 2nd Earl of Essex (1670-1710)
3208 Sir Samuel Garth (1661-1719)
3209 Francis Godolphin, 2nd Earl of Godolphin
 (1678-1766)
3210 Charles Fitzroy, 2nd Duke of Grafton (1683-1757)
3211 Charles Montagu, 1st Earl of Halifax (1661-1715)
3212 Thomas Hopkins (d.1720)
3213 Evelyn Pierrepont, 1st Duke of Kingston and Marquess
 of Dorchester (1665-1726)

3214 Sir Godfrey Kneller (1646-1723)
3215 Henry Clinton, 7th Earl of Lincoln (1684-1728), and
 Thomas Pelham-Holles, 1st Duke of Newcastle
 (1693-1768)
3216 Charles Montagu, 1st Duke of Manchester (1662-1722)
3217 Arthur Maynwaring (1668-1712)
3218 Charles Mohun, Baron Mohun (1677-1712)
3219 John Montagu, 2nd Duke of Montagu (1690-1749)
3220 Robert Walpole, 1st Earl of Orford (1676-1745)
3221 Charles Lennox, 1st Duke of Richmond and Lennox
 (1672-1723)
3222 Richard Lumley, 2nd Earl of Scarborough
 (1688?-1740)
3223 John Somers, Baron Somers (1651-1716)
3224 Charles Seymour, 6th Duke of Somerset (1662-1748)
3225 James Stanhope, 1st Earl Stanhope (1673-1721)
3226 Abraham Stanyan (1669?-1732)
3227 Sir Richard Steele (1672-1729)
3228 George Stepney (1663-1707)
3229 John Tidcomb (1642-1713)
3230 Jacob Tonson I (1655-1736)
3231 Sir John Vanbrugh (1644-1726)
3232 William Walsh (1663-1708)
3233 Thomas Wharton, 1st Marquess of Wharton
 (1648-1716)
3234 Spencer Compton, Earl of Wilmington (1674-1716)
3235 Richard Boyle, 2nd Viscount Shannon (1675-1740)

Piper

Prominent Men, c.1880-c.1910

3337-3535, 3554-3620 Pen and ink 38.1 x 30.5
(15 x 12) or less
Harry Furniss
(Drawn for *Punch, Black and White, The Garrick
Gallery of Caricatures, Some Victorian Men, etc.)*
Purchased, 1947 and 1948

The sitters are listed alphabetically as follows, followed by two
groups (nos.3619 and 3620); those marked with an asterisk
are catalogued separately in the section *Single and Double
Portraits:*

3413 Sir William Agnew, Bt (1825-1910)
*3414 Henry Hinchliffe Ainley (1879-1945)
3415 Sir Edmund Avory (1851-1935)
3416 Allan Aynesworth (Edward Abbot-Anderson)
 (1864-1959)

3337, 3338 Arthur James Balfour, 1st Earl of Balfour
 (1848-1930)
3417 Sir Robert Stawell Ball (1840-1913)
3418 George Playdell Bancroft (1868-1956)
3419 Frederick Barnard (1846-96)
3431 Barnett Isaacs Barnato (1852-97)
*3420 Sir James Matthew Barrie, Bt (1860-1937)
3421 Sir Dunbar Plunkett Barton, Bt (1853-1937)
3339-42 Benjamin Disraeli, Earl of Beaconsfield (1804-81)
3422 Arnold Bennett (1867-1931)
3343, 3344 Augustine Birrell (1850-1933)
3554 Dion Boucicault (1820-90)
3555 Charles Bradlaugh (1833-91)
3466 Henry Hawkins, 1st Baron Brampton (1817-1907)
3345 John Bright (1811-89)
3556 Lionel Brough (1836-1909)
3425, 3557 James Bryce, 1st Viscount Bryce (1838-1922)
3426, 3427 Stanley Owen Buckmaster, 1st Viscount
 Buckmaster (1861-1934)
3428 Frederick Gustavus Burnaby (1842-85)

3429, 3430 Sir Francis Cowley Burnand (1836-1917)
3432 Sir Edward Coley Burne-Jones, 1st Bt (1833-98)
3433 Edward Levy-Lawson, 1st Baron Burnham (1833-1916)
3346 John Burns (1858-1943)

3434-6 Sir Hall Caine (1853-1931)
3437 Dion Clayton Calthorp (1878-1937)
*3558 Thomas Carlyle (1795-1881)
3438 Joseph William Comyns Carr (1849-1916)
3347 Edward Carson, 1st Baron Carson (1854-1935)
3348-50 Joseph Chamberlain (1836-1914)
3439, 3440 Henry Chaplin, 1st Viscount Chaplin (1840-1923)
3351, 3352, 3559 Lord Randolph Churchill (1849-95)
3441 Sir Casper Purdon Clarke (1846-1911)
3442 Sir Edward George Clarke (1841-1931)
3443 William Leonard Courtney (1850-1928)
3560 Harold Cox (1859-1936)
3353 Gathorne Gathorne-Hardy, 1st Earl of Cranbrook (1814-1906)
3354 Robert Crewe-Milnes, 1st Marquess of Crewe (1858-1945)
3561 William Crooks (1852-1921)
*3355 George Curzon, Marquess Curzon of Kedleston (1859-1925)

3356 Edward Stanley, 15th Earl of Derby (1826-93)
3562 Victor Cavendish, 9th Duke of Devonshire (1868-1938)
3445, 3446, 3563-6 Charles Dickens (1812-70)
3357 Sir Charles Wentworth Dilke, Bt (1843-1911)
3567 Charles Lutwidge Dodgson (1832-98) and Harry Furniss (1854-1925)
3568, 3569 George du Maurier (1834-96)

3447 Frederick William Farrar (1831-1903)
3570 Sir Luke Fildes (1843-1927)
3571 Percy Fitzgerald (1834-1925)
*3572 James Staats Forbes (1823-1904)
3358 William Edward Forster (1818-86)
3448, 3449 James Anthony Froude (1818-94)
3450 Frederick James Furnivall (1825-1910)

*3451 Richard Garnett (1835-1906)
3573 Sir John Gilbert (1817-97)
3452, 3453, 3574 Sir William Schwenk Gilbert (1836-1911)
3359-87, 3575 William Ewart Gladstone (1809-98)
3454 Algernon Borthwick, 1st Baron Glenesk (1830-1908)
3576 Charles George Gordon (1833-85)
3577 George Goschen, 1st Viscount Goschen (1831-1907)
3444 Robert Bontine Cunningham Graham (1852-1936)
3455 Richard Corney Grain (1844-95)
3388, 3578 Edward Grey, 1st Viscount Grey of Fallodon (1862-1933)
3456, 3457 George Grossmith (1847-1912)
3458 Weedon Grossmith (d.1919)

3459-61 Sir Henry Rider Haggard (1856-1925)
3462 Sir Edward Marshall Hall (1858-1929)
3393, 3394 Hardinge Stanley Giffard, 1st Earl of Halsbury (1823-1921)
3389 Lewis Harcourt, 1st Viscount Harcourt (1863-1922)
3390-2 Sir William Harcourt (1827-1904)
3579 James Keir Hardie (1856-1915)
3463, 3464, 3580-2 Thomas Hardy (1840-1928)
3583 Thomas Hardy and T.H.Tilley
3584 Sir Augustus Harris (1852-96)
3465 Sir Anthony Hope Hawkins (1863-1933)
3585 Charles Mark Allanson Winn, 4th Baron Headley (1845-1913)
3586 William Ernest Henley (1849-1903)

3467 George Alfred Henty (1832-1902)
3468 Sir Edward Seymour Hicks (1871-1949)
3469 Sir Henry Hoyle Howorth (1842-1923)

3396 Stafford Henry Northcote, 1st Earl of Iddesleigh (1818-97)
3470 James Lyle Mackay, 1st Earl of Inchcape (1852-1932)
3471 Sir Henry Irving (1838-1905)
3472 William Wymark Jacobs (1863-1943)
3473 Sir Harry Hamilton Johnston (1858-1927)
3474 Henry Arthur Jones (1851-1929)
3475 Benjamin Jowett (1817-93)

3476, 3477 Charles Samuel Keene (1823-91)
3587 William Thomson, Baron Kelvin (1824-1907)
3395 William Nicholas Keogh (1817-78)
3478, 3588 Rudyard Kipling (1865-1936)
3479, 3480 Joseph Knight (1829-1907)
3481 Edward Knoblock (1874-1945)

3589 Henry du Pré Labouchere (1831-1912)
3482, 3483 Andrew Lang (1844-1912)
3590 Henry Petty-Fitzmaurice, 5th Marquess of Lansdowne (1845-1927)
3484 Frederic Leighton, Baron Leighton (1830-96)
3397, 3398 David Lloyd George, 1st Earl Lloyd-George (1863-1945)
3485, 3486 William John Locke (1863-1930)
3487 Sir Frank Lockwood (1846-97)
3615 James Lowther (1840-1904)
3488 Edward Bulwer-Lytton, 1st Earl of Lytton (1831-91)

3591 Justin McCarthy (1830-1912)
3489 Stephen McKenna (1888-1967)
3490 Sir Alexander Campbell Mackenzie (1847-1935)
3491, 3492 Sir Charles Willie Mathews, Bt (1850-1920)
3493, 3494 Alan Alexander Milne (1882-1956)
3592 William Cosmo Monkhouse (1840-1901)
3399, 3400, 3593 John Morley, 1st Viscount Morley of Blackburn (1838-1923)

3594 John Thomas North (1841-96)

3401 Thomas Power O'Connor (1848-1929)
*3495 Arthur Orton (1834-98)
3402 Herbert Henry Asquith, 1st Earl of Oxford and Asquith (1852-1928)

3498 Sir Gilbert Parker, Bt (1862-1932)
3496, 3497 Joseph Parker (1830-1902)
3499 Louis Napoleon Parker (1852-1944)
3403 Arthur Wellesley Peel, 1st Viscount Peel (1829-1912)
3500, 3501 Carlo Pellegrini (1839-89)
3502 Sir Max Pemberton (1874-1950)
3408 John Sinclair, 1st Baron Pentland (1860-1925)
3503, 3596 Samuel Phelps (1804-78)
3504 Sir Nigel Playfair (1874-1934)
3505 Sir Harry Bodkin Poland (1829-1928)
3598 Sir Charles Pollock (1823-97)
3599 Sir Frederick Pollock, Bt (1845-1937) and Harry Furniss
3506 Newton Wallop, 6th Earl of Portsmouth (1856-1917)
3597 David Robert Plunket, 1st Baron Rathmore (1838-1919)
3404 Cecil John Rhodes (1853-1902)
3405 George Robinson, 1st Marquess of Ripon (1827-1909)
3406, 3406a, 3600 Archibald Philip Primrose, 5th Earl of Rosebery (1847-1929)
3407 Walter Runciman, 1st Baron Runciman (1847-1937)
3601 Charles Russell, Baron Russell of Killowen (1832-1900)
3602 Sir William Howard Russell (1820-1907)

3507 George Augustus Henry Sala (1828-96)

Continued overleaf

3409-11, 3603 Robert Gascoyne-Cecil, 3rd Marquess of
 Salisbury (1830-1903)
3508, 3509 Edwin Linley Sambourne (1844-1910)
3510-12, 3604 George Bernard Shaw (1856-1950)
3605, 3606 Robert Lowe, Viscount Sherbrooke (1811-92)
3513 Walter Sichel (1855-1933)
3514 George Robert Sims (1847-1922)
3607 William Henry Smith (1825-91)
*3515 Solomon Joseph Solomon (1860-1927)
3412, 3608 John Spencer, 5th Earl Spencer (1835-1910)
3609 Herbert Spencer (1820-1903)
3516 Marion Harry Spielmann (1858-1948)
3517, 3610 Charles Haddon Spurgeon (1834-92)
*3518 Robert Louis Stevenson (1850-1919)
3519, 3520 George Adolphus Storey (1834-1919)
3521 Alfred Sutro (1863-1933)
3611 Algernon Charles Swinburne (1837-1909)

3522 Frederick Temple (1821-1902)
3525-7, 3612 Sir John Tenniel (1820-1914)
3523 George Thompson (1804-78)
3524 William Tinsley (1831-1902)
3528 John Lawrence Toole (1830-1906)
3529 Henry Duff Traill (1842-1900)
3613 Sir William Purdie Treloar, Bt (1843-1923)
3530, 3614 John Tyndall (1820-93)

3531, 3616 Horace Annesley Vachell (1861-1955)

3617, 3618 James Abbott McNeill Whistler (1834-1903)
3532 Sir Leslie Orme Wilson (1876-1955)
3533 Henry Fowler, Viscount Wolverhampton (1830-1911)
3534 Whitaker Wright (1845-1904)
*3535 Sir Charles Wyndham (1837-1919)

3619 Arthur William a Beckett (1844-1909), Edwin Linley
 Sambourne and Thomas Anstey Guthrie (1856-1934)
3620 Timothy Michael Healy (1855-1931), Justin McCarthy
 and Thomas Sexton (1848-1932)

See also Collections, **4095(1-11)**

Mr Punch's Personalities, 1926-9

3664-6, 3668-77, 4075-7 Pencil, ink, black chalk and
water-colour 38.1 x 27.9 (15 x 11) or less
Sir Bernard Partridge
Purchased, 1949, except for nos. 4075-7, given by
D.Pepys Whiteley, 1958

The sitters, listed alphabetically, are as follows: all are
catalogued separately in the section *Single and Double
Portraits*:
3664 Hilaire Belloc (1870-1953)
4075 Arnold Bennett (1867-1931)
3665 Sir William Sefton Brancker (1877-1930)
3666 Julian Byng, 1st Viscount Byng of Vimy (1862-1935)
3668 Sir Arthur Conan Doyle (1859-1930)
3669 Sir George Frampton (1860-1928)
3670 James Louis Garvin (1868-1947)
4076 Sir Alfred Gilbert (1854-1934)
3671 Sir John Lavery (1856-1941)
4077 Sir Oliver Joseph Lodge (1851-1940)
3672 Sir Edwin Lutyens (1869-1944)
3673 Alfred Noyes (1880-1958)
3674 William Richard Morris, Viscount Nuffield (1877-1963)
3675 Sir Arthur Wing Pinero (1855-1934)
3676 Sir Landon Ronald (1873-1938)
3677 Hugh Montague Trenchard, Viscount Trenchard
 (1873-1956)

Studies for The Waterloo Banquet at Apsley House, 1836 (painting not in NPG)

3689-3769 Canvas 49.5 x 41.9 (19½ x 16½)
William Salter, 1834-40
Bequeathed by W.D.Mackenzie (d.1928), 1950

The sitters, listed alphabetically, are as follows; those marked
with an asterisk are catalogued separately in the section
Single and Double Portraits:
3689 Sir Frederick Adam (1781-1853)
3690 Stephen Galway Adye (d.1838)
3691 Don Miguel Alava
3692 Charles Allix (1787-1862)
3693 Henry William Paget, 1st Marquess of Anglesey
 (1768-1854)
3694 Sir Henry Askew (1775-1847)
3695 Sir Andrew Barnard (1773-1855)
*3696 Sir Edward Barnes (1776-1838)
3697 Henry Bathurst, 3rd Earl Bathurst (1762-1834)
3699 Count Pozzo di Borgo
3700 Sir Edward Bowater (1787-1861)
3701 Felix Calvert (1790-1857)
3702 Sir Colin Campbell (1776-1847)
3703 Prince Castel-Cicala
3704 Sir Arthur Clifton (1772-1869)
3706 Sir Charles Webb Dance (d.1844)
3707 F.Dawkins (1796-1847)
3705 George Lionel Dawson Damer (1788-1856)
3708 Sir Robert Dick (1785?-1846)
3709 Sir Alexander Dickson (1777-1840)
3710 Henry D'Oyly (1780-1855)
3711 Berkeley Drummond (1796-1860)
3712 Richard Egerton (1783-1854)
3713 Sir John Elley (d.1839)
3714 William Elphinstone (1782-1842)
3715 John Fremantle
3716 Sir Robert William Gardiner (1781-1864)
3717 Sir William Maynard Gomm (1784-1875)
3718 James Grant (d.1852)
3719 John Gurwood (1790-1845)
3720 Sir Colin Halkett (1774-1856)
3721 Henry Hardinge, 1st Viscount Hardinge (1785-1856)
3722 William George Harris, 2nd Baron Harris (1782-1845)
3723 James Hay (d.1854)
3724 Rowland Hill, 1st Viscount Hill (1772-1842)
3725 Clement Hill (1781-1845)
3726 Sir George Charles Hoste (1786-1845)
3727 Beaumont Hotham, 3rd Baron Hotham (1794-1870)
3698 Thomas Hunter-Blair (d.1849)
3728 Sir James Kempt (1764-1854)
3729 Sir Edward Kerrison (1774-1853)
3730 Charles King (d.1844)
3731 Sir John Lambert (1772-1847)
3732 Sir Richard Lluellyn (1783-1867)
3733 Edward Pyndar Lygon (c.1786-1860)
3734 Reginald Ranald Macdonald (d.1845)
3735 Sir James Macdonnel (d.1857)
3736 Sir Peregrine Maitland (1777-1854)
3737 Lord Robert William Manners (1781-1835)
3738 Sir John May (d.1847)
3739 Douglas Mercer (afterwards Henderson Mercer)
 (d.1854)
3740 Sir Henry Murray (1784-1860)
3741 George O'Malley (d.1843)
3742 Edward Parkinson (d.1858)
*3743 Fitzroy Somerset, 1st Baron Raglan (1788-1855)
3744 John Reeve (1783-1864)
3745 Sir Thomas Reynell
3746 Charles Gordon-Lennox, 5th Duke of Richmond and
 Lennox (1791-1860)

3747 Sir Henry Willoughby Rooke (1783-1869)
*3748 Sir Hew Dalrymple Ross (1779-1868)
3749 Sir Charles Rowan (c.1782-1852)
3750 Alexander Fraser, 16th Baron Saltoun (1785-1853)
3751 Arthur Moyses William Sandys, 2nd Baron Sandys (1792-1860)
*3752 Sir George Scovell (1744-1861)
3753 Sir James Wallace Sleigh (1780-1865)
3755 Lord John Somerset (1787-1846)
*3754 Lord Robert Edward Henry Somerset (1776-1842)
3756 Samson Stawell (d.1849)
3757 John Byng, 1st Earl of Strafford (1772-1860)
3758 Sir Joseph Straton (d.1841)
3759 Sempronius Stretton (d.1842)
3760 Thomas William Taylor (1782-1854)
3761 Sir Horatio George Powys Townshend (1780-1843)
3762 Sir John Ormsby Vandeleur (1763-1849)
3763 Sir Charles Broke Vere (1779-1843)
3764 Richard Hussey Vivian, Baron Vivian (1775-1842)
3765 Sir John Waters (1774-1842)
3766 Arthur Wellesley, 1st Duke of Wellington (1769-1852)
3767 William IV (1765-1837)
3768 William I of Holland (1772-1844)
3769 Sir Henry Wyndham (1790-1860)

Caricatures, 1897-1932

3851-8 Pencil, ink and water-colour 32.1 x 21 (12⅝ x 8¼) or less
Sir Max Beerbohm
Purchased, 1953

The sitters, listed alphabetically, are as follows; all are catalogued separately in the section *Single and Double Portraits:*
3851 John Burns (1858-1943)
3852 Edward Carson, 1st Baron Carson (1854-1935)
3853 Henry Chaplin, 1st Viscount Chaplin (1840-1923)
3858 Roger Fry (1866-1934)
3854 George Goschen, 1st Viscount Goschen (1831-1907)
3855 Richard Burdon Haldane, Viscount Haldane (1856-1928)
3856 Sir Oliver Joseph Lodge (1851-1940)
3857 Sir Henry Morton Stanley (1841-1904)

Artists, 1825

3944(1-55) Pencil, ink, water-colour and wash 23.8 x 18.4 (9⅜ x 7¼) or less
John Partridge and others
Purchased, 1955

The drawings, which are by Partridge unless otherwise stated, are listed numerically as follows; those marked with an asterisk are catalogued separately in the section *Single and Double Portraits:*
1 Inscriptions by Clementina Partridge
2 St Peter's, Rome, attributed to Sir Charles Eastlake
3 Woman of Genzano, by Joseph Severn
* 4 Richard Westmacott (1799-1872)
5 Girl with a bird, attributed to Richard Westmacott
6 Neapolitan fisher-boy, attributed to Thomas Uwins
7 Neapolitan girl, possibly by Partridge
8 Neapolitan scene, possibly by Partridge
9 Unknown man
10 Monk with Neapolitan woman, possibly by Partridge
11 Unknown man in Vandyck costume
12 River scene, attributed to Partridge

13 Artist saved from the devil, by an unknown artist
*14 Thomas Uwins (1782-1857)
15 Blank
16 Tuning, by Richard James Wyatt
17 Italian fisher-boy, attributed to Mrs Westmacott
18 Possibly Joseph Severn (1793-1879)
*19 Richard James Wyatt (1795-1850)
20 Probably Joseph Severn
21 Classical ruins at Selimonte, attributed to Partridge
*22 Sir Charles Eastlake (1793-1865)
23, 24 Blank
25 Neapolitan mother and child
26 Unknown man
27-9 Blank
*30 William Dyce (1806-64)
31 A putto pursuing a butterfly, by John Gibson
*32 John Gibson (1790-1866)
33, 34 Blank
35 Rustic archway with figures, attributed to Partridge
36-8 Blank
39 Verso, seated man, attributed to Partridge
40-54 Blank
55 Probably Joshua Cristall (1767-1847), by an unknown artist

Ormond

Drawings of Men about Town, 1832-48

4026(1-61) Pencil and chalk 30.5 x 22.9 (12 x 9) or less
Alfred, Count D'Orsay
Purchased, 1957

The sitters. listed numerically, are as follows; those marked with an asterisk are catalogued separately in the section *Single and Double Portraits:*
1, 2 Joshua William Allen, 6th Viscount Allen (1781-1845)
3 Sir Andrew Francis Barnard (1773-1855)
4 George William Barrington, 7th Viscount Barrington (1824-86)
5 Henry Somerset, 7th Duke of Beaufort (1792-1853)
* 6 John Ponsonby, 5th Earl of Bessborough (1809-80)
7 John Bushe
8, 9 Frederick Byng
10 Thomas Campbell (1777-1844)
11 Charles Manners Sutton, 1st Viscount Canterbury (1780-1845)
12 Charles Bury, 2nd Earl of Charleville (1801-51)
*13 Henry Fothergill Chorley (1808-72)
14 Ulick de Burgh, 1st Marquess of Clanricarde (1802-74)
15 Sir Willoughby Cotton (1783-1860)
16 Charles Spencer Cowper (1816-79)
17 William Craven, 2nd Earl of Craven (1809-66)
*18 Keppel Craven (1779-1851)
19 Mrs Thomas Jenkins, Baroness de Calabrella
20 Thomas Slingsby Duncombe (1796-1861)
21 Edwardes (either William, Lord Kensington, 1801-72, or one of his brothers, George, 1802-79, Richard, 1807-66, Charles, 1813-81, or Thomas, 1819-96)
22 John Fairlie
23 Lord Frederick Fitzclarence (1799-1855)
24 George Forester, 3rd Baron Forester (1807-86)
25 Charles Robert Weld Forester (1811-52) and 3rd Baron Forester
26 Henry Fox, 4th Baron Holland (1802-59)
27 Alan Legge Gardner, 3rd Baron Gardner (1810-83)
28 Sir John Gardner Wilkinson (1797-1875)
29 Sir Henry James Goodricke (d.1833)

Continued overleaf

30, 31 Robert Gore (1810-54)
*32 William (1800-44) or Thomas (1799-1882) Grieve
33 George Rawdon-Hastings, 2nd Marquess of Hastings (1808-44)
34 George Herbert (1812-38)
35 Seymour Ball Hughes
*36 Edward Ball Hughes (d.1863)
*37 John Heneage Jesse (1815-74)
38 Robert Jocelyn, Viscount Joycelyn (1816-54)
39 Rainald Knightley, 1st Baron Knightley (1819-95)
40 John Lyster (d.1840)
*41 Richard Robert Madden (1798-1886)
42 Godfrey Charles Mundy (d.1860)
43 Sir Arthur Paget (1771-1840)
44 Edmund Phipps (1760-1837)
*45 Edmund Phipps
46 John Allan Powell
47 Richard Wingfield, 6th Viscount Powerscourt (1815-44)
48 Bryan Waller Procter (1787-1874)
49 John Home Purves
*50 Isabella Frances Romer (d.1852)
51 Jack Spalding
52 Charles Standish (1790-1863)
53 Lincoln Stanhope (1781-1840)
54 Augustus, Duke of Sussex (1773-1843)
55 Christopher Rice Mansel Talbot (1803-90)
56 Charles Augustus Bennet, 6th Earl of Tankerville (1810-99)
57 Richard Tattersall (1785-1859)
58 Augustus Villiers (1810-47)
59 Richard Westmacott (1799-1872)
60 George Finch-Hatton, 11th Earl of Winchilsea (1815-87)
61 Sir George Wombwell, Bt (1792-1855)

Ormond

Boer War Officers, 1900

4039(1-7) Water-colour and pencil 29.8 x 24.1 (11¾ x 9½) or less
Inglis Sheldon-Williams, signed, inscribed, and dated by artist and sitter 1900
Purchased, 1957

The sitters are as follows; all are catalogued separately in the section *Single and Double Portraits:*
1 Henry Vivian Cowan (1854-1918)
2 Edward Stanley, 17th Earl of Derby (1865-1948)
3 Sir Ian Hamilton (1853-1947)
4 Henry Seymour Rawlinson, Baron Rawlinson (1864-1925)
5 Frederick Sleigh Roberts, 1st Earl Roberts (1832-1914)
6 Ferdinand Charles Stanley (1871-1935)
7 Sir Henry Hughes Wilson, Bt (1864-1922)

Drawings, 1891-5

4041(1-5) Pencil, wash and water-colour 43.2 x 30.5 (17 x 12) or less
Walker Hodgson
Purchased, 1957

The sitters are as follows; all are catalogued separately in the section *Single and Double Portraits:*
1 Myles Birket Foster (1825-99)
2 William McTaggart (1835-1910)
3 Mary Louisa Molesworth (1839-1921)
4 Ford Madox Brown (1821-93)
5 Sir Frank Brangwyn (1867-1956)

Mr Punch's Personalities, 1926-9 by Sir Bernard Partridge

4075-7 *See under Collections,* **3664-6,** etc

The Garrick Gallery of Caricatures, 1905

4095(1-11) Pen and ink, each 38.7 x 31.4 (15¼ x 12⅜)
Harry Furniss
Purchased, 1959

The sitters, listed alphabetically, are as follows; all are catalogued separately in the section *Single and Double Portraits:*
1 Sir George Alexander (George Samson) (1858-1918)
2 Sir Squire Bancroft Bancroft (1841-1926)
3 Sir Gerald du Maurier (1873-1934)
4 Sir Johnston Forbes-Robertson (1853-1937)
5 Sir John Hare (1844-1921)
6 Sir Henry Irving (1838-1905)
7 Henry Brodribb Irving (1870-1919)
8 Cyril Francis Maude (1862-1951)
9 Sir Arthur Wing Pinero (1855-1934)
10 William Stone (1857-1958)
11 Sir Herbert Beerbohm Tree (1852-1917)

See also Collections, **3337-3535** and **3554-3620**

Drawings, c.1845

4216-18 Pencil, pen and ink 14.6 x 12.1 (5¾ x 4¾) or less
George Harlow White
Given by E.E.Leggatt, 1910

The sitters are as follows; all are catalogued separately in the section *Single and Double Portraits:*
4216 Samuel Drummond (1765-1844)
4217 Edward Taylor (1784-1863)
4218 Thomas Uwins (1782-1857)

Ormond

George Cruikshank and others

4259 Sketches on seven sheets of MS fragments, pencil, pen and ink 31.1 x 20 (12¼ x 7⅞) or less
George Cruikshank
Given by S.Hodgson, 1962

The sketches are of:
George Cruikshank (1792-1878)
Isaac Robert Cruikshank (1789-1856)
Eliza Cruikshank
William Hone (1780-1842)

Ormond (under Cruikshank)

Working drawings

4529(1-401) Pencil 20.3 x 15.2 (8 x 6) on average
Sir David Low
Purchased, 1967

The sitters, listed numerically (and with a few exceptions alphabetically) are as follows; those marked with an asterisk are catalogued separately in the section *Single and Double Portraits:*

1	William Adamson (1863-1936)
2	Herbert Henry Asquith, 1st Earl of Oxford and Asquith (1852-1928)
3-6	David Astor (b.1912)
7-11	Nigel Balchin (1908-70)
12	Stanley Baldwin, 1st Earl Baldwin (1867-1947)
13-15	Sir Gerald Barry (1898-1968)
*16	Herbert Ernest Bates (1905-74)
17-19	Herbert Ernest Bates
*20	Brendan Behan (1923-64)
21, 22	Brendan Behan
23	Aneurin Bevan (1897-1960)
24-7	Cyril Kenneth Bird (1887-1964)
28-31	William Norman Birkett, 1st Baron Birkett (1883-1962)
32	Augustine Birrell (1850-1933)
33	Sir Basil Phillott Blackett (1882-1935)
34-9	Patrick Maynard Stuart Blackett, 1st Baron Blackett (1897-1974)
40-2	Sir Michael Blundell (b.1907)
43, 44	Robert Bolt (b.1924)
45-51	James Bone (1872-1962)
52-5	Sir James Bowman (1898-1978)
56, 57	Brendan Bracken, Viscount Bracken (1901-58)
58-61	Benjamin Britten, Baron Britten (1913-76)
*62	Benjamin Britten, Baron Britten
63-6	Peter Brook (b.1925)
*67	Ernest Brown (1881-1962)
68-71	Sir William Butlin (1899-1980)
72	Valentine Browne, 6th Earl of Kenmare (1891-1943)
73	Arthur Neville Chamberlain (1869-1940)
74-7	Sir Christopher Chancellor (b.1904)
78, 79	Oliver Lyttelton, 1st Viscount Chandos (1893-1972)
80-3	Gilbert Keith Chesterton (1874-1936)
84, 85	Sir Winston Spencer Churchill (1874-1965)
86	Willie Clarkson
87-9	Lionel Leonard Cohen, Baron Cohen (1888-1973)
90-2	Norman Richard Collins (b.1907)
93, 94	Joseph Conrad (1857-1924)
95-7	Jack Cotton (1903-64)
98-108	Percy Cudlipp (1905-62)
109	Sir Edward Guy Dawber and Sir William Arbuthnot Lane, Bt (1856-1943)
110-15	Arthur Deakin (1890-1955)
116-19	George A. Drew
120-2	Robert Anthony Eden, 1st Earl of Avon (1897-1977)
*123	St John Greer Ervine (1883-1971)
124	Sir Luke Fawcett (1881-1960)
125, 126	Gerard Fay (1913-68)
127-31	Michael Foot (b.1913)
132-40	John Galsworthy (1867-1933)
141	Sir Edmund Gosse (1849-1928)
142-4	Sir Hugh Carlton Greene (b.1910)
145, 146, 148-51	Graham Greene (b.1904)
*147	Graham Greene
152-5	Joseph (Jo) Grimond (b.1913)
156-60	Sir Alec Guinness (b.1914)

161, 161a and b, 162	William Malcolm Hailey, 1st Baron Hailey (1872-1969)
163, 164	Sir Peter Hall (b.1930)
165-7	Henry John Heinz (b.1908)
168-70	Sir Philip Hendy (1900-80)
171	Gordon Hewart, 1st Viscount Hewart (1870-1943)
172	Sir Anthony Hope Hawkins (1863-1933)
173,174,176	Aldous Huxley (1894-1963)
*175	Aldous Huxley
177-80	Jack Hylton (1892-1965)
181,182	William Ralph Inge (1860-1954)
183,184	John Rushworth Jellicoe, 1st Earl Jellicoe (1859-1935)
185	Augustus John (1878-1961)
*186	Sir Gerald Kelly (1879-1972)
187,188	Sir Gerald Kelly
189-91	John Maynard Keynes, Baron Keynes (1883-1946)
192-5	Cecil Harmsworth King (b.1901)
196	William Stephen Richard King-Hall, Baron King-Hall (1893-1966)
197	David Kirkwood, 1st Baron Kirkwood (1872-1955)
198,199	Arthur Koestler (b.1905)
200-4	Sir Allen Lane (1902-70)
205,205a,206	Harold Laski (1893-1950)
207	Philip de Laszlo (1869-1937)
208,209	David Lean (b.1908)
210	Charles Vane-Tempest-Stewart, 7th Marquess of Londonderry (1878-1949)
211-14	Sir Bernard Lovell (b.1913)
215-20	Sir Robert Lusty (b.1909)
221	Robert Lynd (1879-1949)
222	James Ramsay Macdonald (1866-1937)
223-6	Sir Roger Makins (1904-64)
227-9	Norman Washington Manley (1893-1969)
230	Marchese Guglielmo Marconi (1874-1937)
231	Walter de la Mare (1873-1956)
232-4	Basil Kingsley Martin (1897-1969)
235-240	William Somerset Maugham (1874-1965)
241-4	James Maxton (1885-1946)
245-9	Bernard Miles, Baron Miles (b.1907)
250-2	Walter Monckton, Viscount Monckton (1891-1965)
253-5	Henry Moore (b.1898)
*256	Henry Moore
257	Herbert Morrison, Baron Morrison (1888-1965)
258,258a,259	John Osborne (b.1929)
260-2	Frank Owen (b.1905)
263-6	Wilfred Pickles (1904-78)
267,269	John Piper (b.1903)
*268	John Piper
270,271	Edwin Noel Plowden, Baron Plowden (b.1907)
272,274-6	Stephen Potter (1900-69)
*273	Stephen Potter
277-9	Michael Powell (1905-71)
280-5,283a	John Boynton Priestley (b.1894)
286-93	Sir Terence Rattigan (1911-77)
294-7	John Reith, Baron Reith (1889-1971)
298	George Riddell, Baron Riddell (1865-1934)
299-301	Alfred Robens, Baron Robens of Woldingham (b.1910)
302,303	John Roberts
304-6	Brian Robertson, 1st Baron Robertson (1896-1974)
307	Sir Johnston Forbes-Robertson (1853-1937)
308	Sir Edward Denison Ross (1871-1940)
309	Sir Edward Denison Ross and William Wymark Jacobs (1863-1943)

Continued overleaf

310-13 Paul Rotha (b.1907)
314-20 Sir John Rothenstein (b.1901)
321 Bertrand Russell, 3rd Earl Russell (1872-1970)

322,323,325-7 Sir Malcolm Sargent (1895-1967)
***324** Sir Malcolm Sargent
328-33 Hartley William Shawcross, Baron Shawcross (b.1902)
334 Hugh Richard (Dick) Sheppard (1880-1937)
335 Philip Snowden, Viscount Snowden (1864-1937)
336-9 Stephen Spender (b.1909)
340 Marie Stopes (1880-1958)
342,343,343a,344 John Strachey (1901-63)
345-8 Leonard Alfred George Strong (1896-1958)
349-53 Edith Summerskill, Baroness Summerskill (1901-80)
354,355,357 Graham Sutherland (1903-80)
***356** Graham Sutherland

358,358a and b Jack Tanner (1889-1965)
359-61 Sir Harold Vincent Tewson (b.1898)
362 James Henry Thomas (1874-1949)
363-5 Roy Thomson, 1st Baron Thomson of Fleet (1894-1976)
366,367 Sir Ben Turner (1863-1942)
368-72 Donald Tyerman (b.1908)

373-6 Peter Ustinov (b.1921)

377,378 Sir Hugh Walpole (1884-1941)
379-83 Barbara Jackson, Baroness Jackson of Lodsworth (b.1914)
384,385 Herbert George Wells (1866-1946)
386-9 Arnold Wesker (b.1932)
390,391 Sir Edgar Whitehead (1905-71)
392-5 Sir Henry Willink (1894-1973)
396 Humbert Wolfe (1886-1940)
397 Frederick James Marquis, 1st Earl of Woolton (1883-1964)

398 Edward Hilton Young, 1st Baron Kennet (1879-1960)

399-401 Unknown sitters

The Pusey family and their friends, c.1856

4541(1-13) Pen and ink and water-colour 18.1 x 22.6
($7\frac{1}{8}$ x $8\frac{7}{8}$) or less
Clara Pusey
Purchased, 1967

Over fifty drawings stuck down on both sides of thirteen sheets of paper. With the exception of the following, most are either outside the Gallery's terms of reference or unidentifiable:

9 verso Group including Richard Lynch Cotton (1794-1880)
9 verso Group at a lunch or dinner party, including Henry Longueville Mansel (1820-71)
4 recto Edward Bouverie Pusey (1800-82) with his family at breakfast
7 recto Edward Bouverie Pusey preaching (2 sketches)
9 recto Samuel Wilberforce (1805-73) with Edward Bouverie Pusey and others
11 recto Samuel Wilberforce preaching

Ormond

Drawings, 1899-1938

4763-4805 Sanguine, pencil and chalk, various sizes
Sir William Rothenstein
Purchased, 1970

See under individual sitters

The Townshend Album

4855(1-73) Pencil, ink or water-colour 33 x 20.5
(13 x $9\frac{5}{8}$) or less
George Townshend, 4th Viscount and 1st Marquess
Townshend, 1751-8
Bequeathed by R.W.Ketton-Cremer, 1971

Folio volume of seventy-three caricatures and portrait sketches of which seven (nos.67-73) are of North American Indians and twenty-two are unidentifiable. The rest, listed numerically, are as follows; those marked with an asterisk are catalogued separately in the section *Single and Double Portraits*:

1 Davy Durrant (1704-59)
2 George II (1683-1760)
4 Matthew Fortescue, 2nd Baron Fortescue (1719-85)
***5** George II
6 James Johnston (1721-97)
7 George William Hervey, 2nd Earl of Bristol (1721-75)
8 Henry Bromley, Baron Montfort of Horseheath (1705-55)
9 Michel Descazeaux du Hally (1710-75)
12 Thomas Tanner (1718-86)
13 Thomas Evans (d.1767)
14 Mrs E. Lascelles
15 Henry Petty, Earl of Shelburne (1675-1751)
16 Robert Leeke (d.1762)
17 John Michell (1710-66)
18 John Hopkins Probyn (1703-73)
21,22 George Bubb Dodington, Baron Melcombe (1691-1762)
23 John Montagu, 4th Earl of Sandwich (1718-92)
24 Daniel Finch, 8th Earl of Winchilsea (1689-1769)
24a Etching: The Recruiting Serjeant or Brittanniais Happy Prospect (1757)
24b Etching: George Bubb Dodington, Baron Melcombe, and Daniel Finch, 8th Earl of Winchilsea (plate dated 1781)
29 Jack Broughton (1705-89)
30 Jack Slack (d.1778)
31 Thomas Smallwood(?)
34 Thomas Smallwood
36 Possibly August George, Margrave of Baden (1706-71)
37-9 William Augustus, Duke of Cumberland (1721-65)
41 Philip Burlton (d.1790)
43 John Jones (1705-69)
44 Sir John Shelley, 4th Bt (1692-1771)
45 Sir Samuel Prime (1701-77)
46,47 Sir John Cope (?) (1690-1760)
***48** Arthur Onslow (1691-1768)
49 George Lyttelton, 1st Baron Lyttelton (1709-73)
50,52,53 Vincenzo Martinelli (1702-85)
54 Riches Repps Brown (d.1767)
56 Isaac Preston (1711-68)
57,59 Dodo Heinrich Freiherr von Knyphausen (1729-89)
60 George Haldane (1722-59)
66 George Walpole, 3rd Earl of Orford (1730-91)

Harris

Four studies from a sketchbook

4913(1-4) Pencil 21.6 x 12.7 (8½ x 5)
Thomas Cooley, signed, inscribed and dated 1810
Purchased, 1972

The sitters are:
1,2 Recto: Joseph Mallord William Turner (1775-1851)
 and Henry Fuseli (1741-1825)
3,4 Verso: Sir John Soane (1753-1837) and John
 Flaxman (1755-1826)

Caricatures of Prominent People, c.1832-5

4914-22 Pen and wash 23.8 x 19.1 (9$\frac{3}{8}$x 7½) or less
Sir Edwin Landseer
Purchased, 1972

The sitters, listed numerically, are as follows; those marked
with an asterisk are catalogued separately in the section
Single and Double Portraits:
4914 3rd Baron Holland (1773-1840), Elizabeth, Lady
 Holland (1770-1845), and her maid and housekeeper,
 Mrs Brown
***4915** 4th Earl of Bessborough (1781-1847)
***4916** 6th Duke of Devonshire (1790-1858) at the opera
4917 Sydney Smith (1771-1845) with allegorical figures of
 the Church and the Devil
4918 General Edmund Phipps (1760-1837), Mrs Caroline
 Norton (afterwards Lady Stirling-Maxwell, 1808-77)
 and 2nd Baron Alvanley (1789-1849) at the theatre
4919 Samuel Rogers (1763-1855) having a bath
4920 Samuel Rogers scrubbing his back
***4921** Samuel Rogers with a monkey
4922 Alfred, Count D'Orsay (1801-52)

Rehearsals for *A Mass of Life* at the Queen's Hall, 1929

4975(1-36) Pencil 36.8 x 26.7 (14½ x 10½) or less
Ernest Procter, 1929
Purchased, 1974

The following have been identified; those marked with an
asterisk are catalogued in the section *Single and Double
Portraits:*
*** 1** Frederick Delius (1862-1934)
2-7 Frederick Delius
8 Group including Frederick Delius and Philip Arnold
 Heseltine ('Peter Warlock') (1894-1930)
9,10 Sir Thomas Beecham (1879-1961)
***11** Sir Thomas Beecham
12 Sir Landon Ronald (1873-1938)
***13** Sir Landon Ronald

Set of 16 early English Kings and Queens formerly at Hornby Castle, Yorkshire

4980(1-16) Panels 58.1 x 45.1(22$\frac{7}{8}$ x 17¾) or less
Unknown artists, 17th century
Purchased, 1974. *Montacute*
The sitters, listed numerically, are as follows; those marked
with an asterisk are catalogued separately in the section
Single and Double Portraits:
1 Called William the Conqueror (1027-87)
2 Called Henry I (1068-1135)
3 Called Stephen (1097?-1154)

4 Called Henry II (1133-89)
5 Called John (1167?-1216)
6 Called Henry III (1207-72)
*** 7** Edward III (1327-77)
8 Richard II (1367-1400)
9 Called Henry IV (1367-1413)
***10** Edward IV (1442-83)
11 Called Edward V (1470-83)
***12** Richard III (1452-85)
***13** Henry VII (1457-1509)
14 Henry VIII (1491-1547)
15 Anne Boleyn (1507-36)
16 Mary I (1516-58)

Miniatures, 1920-30

5027-36 Miniatures on ivory, various sizes
Winifred Cécile Dongworth
Bequeathed by the artist, 1975

The sitters, listed alphabetically, are as follows; those marked
with an asterisk are catalogued separately in the section
Single and Double Portraits:
5036 Mary and Ann Casson
5030 Stanley Baldwin, 1st Earl Baldwin (1867-1947)
5034 Lucy, Lady Bladwin (née Ridsdale) (d.1945)
***5032** Lily Brayton (1876-1953)
5033 Lily Brayton
5029 James Ramsay MacDonald (1866-1937)
5027 Sidney Webb, Baron Passfield (1859-1947)
5035 Ishbel Allan Peterkin (née MacDonald) (b.1903)
5028 Philip Snowden, Viscount Snowden (1864-1937)
***5031** Christopher Birdwood Thomson, Baron Thomson
 (1875-1930)

Studies for portraits of Kathleen Ferrier singing

5040(1-8) Pencil 30.2 x 21.6 (11$\frac{7}{8}$ x 8½)
Bernard Dunstan, 1950
Given by the artist, 1975

1 Kathleen Ferrier (1912-53) and Bruno Walter (1876-1962)
2-8 Various studies of Kathleen Ferrier; no.3 is catalogued
 separately in the section *Single and Double Portraits*

Three eldest children of Charles I

5103-5 Panel, each 28.9 x 20 (11$\frac{3}{8}$ x 7$\frac{7}{8}$)
Cornelius Johnson, 1639
Purchased, 1976

The sitters, as follows, are all catalogued separately in the
section *Single and Double Portraits:*
5103 Charles II when Prince of Wales (1630-85)
5104 James II when Duke of York (1633-1701)
5105 Mary, Princess of Orange (1631-60)

Cartoons, c.1928-c.1936

5224(1-9) Ink and pencil 39.1 x 28.2 (15$\frac{5}{8}$ x 11$\frac{1}{8}$)
or less
Robert Stewart Sherriffs
Purchased, 1978

The sitters, listed alphabetically, are as follows; those marked with an asterisk are catalogued separately in the section *Single and Double Portraits:*

 4 Frederick Edwin Smith, 1st Earl of Birkenhead
 (1872-1930)
 *9 Sir Charles Chaplin (1889-1977)
 5 Sir Charles Blake Cochran (1872-1951)
 6 Edward Gordon Craig (1872-1966)
 7 George Grossmith (1874-1935)
 *8 Sir Jack Hobbs (1872-1951)
 *1 Harry Gordon Selfridge (1858-1947)
 2,3 Herbert George Wells (1866-1946)

Charles II's escape after the Battle of Worcester, 1651

5247-51 Canvas 206.1 x 315 (83¼ x 124) or less
Isaac Fuller, c.1660-70
Purchased, 1979

The paintings, listed numerically, are as follows; no.5247 is catalogued separately in the section *Single and Double Portraits* (under Charles II):

 5247 Charles II (1630-85) with Richard Penderel
 (d.1672) at Whiteladies
 5248 Charles II in Boscobel Wood. Left to right: Richard
 Penderel, William Carlos (d.1689) and Charles II
 5249 Charles II and William Carlos in the Royal Oak
 5250 Charles II on Humphrey Penderel's mill horse, with
 Humphrey Penderel leading
 5251 Charles II and Jane Lane (afterwards Lady Fisher,
 d.1689) riding to Bristol

The Hill and Adamson Albums

P6(1-258) Photographs: calotypes 38.4 x 29.5
(15$\frac{1}{8}$ x 11$\frac{5}{8}$) or less
David Octavius Hill and Robert Adamson, 1843-8
Given by an anonymous donor, 1973

Excluding unidentified subjects or purely scenic views, the photographs, listed numerically, are as follows; those marked with an asterisk are catalogued separately in the section *Single and Double Portraits:*

 *1 David Octavius Hill (1802-70)
 2 Greyfriars Churchyard, Edinburgh: group including
 David Octavius Hill

*	3	Spencer Joshua Alwyne Compton, 2nd Marquess of Northampton (1790-1851)
*	4	John Wilson (1785-1854)
	5	Thomas Chalmers (1780-1847)
*	6	Thomas Chalmers
*	7	William Etty (1787-1849)
	8	Robert Cunningham Graham Spiers (1797-1847)
*	9	Sir William Allan (1782-1850)
*	10	Sir David Brewster (1781-1868)
*	11	Sir John McNeill (1795-1883)
*	12	Alexander Keith (1791-1880)
	13	George Cook (1772-1845)
*	14	David Welsh (1793-1845)
*	15	Alexander Monro (1773-1859)
	16	Alexander Monro
*	17	Francis Wemyss-Charteris-Douglas, 10th Earl of Wemyss (1818-1914)
	18	Robert Liston (1794-1847)
*	19	Robert Liston
	20	Thomas Duncan (1807-45)
	21	Henry Roberts, 3rd Baron Rossmore (1792-1860)
	22	James Ruthven, 6th Baron Ruthven (1777-1853)
	23	James Archibald Stuart-Wortley (1805-81)
	24	John Henning (1771-1851) and Alexander Handyside Ritchie (1804-70)
*	25	Sir Francis Grant (1803-78)
*	26	Abraham Capadose (1795-1874)
*	27	John Murray (1808-92)
*	28	James Nasmyth (1808-90)
*	29	Thomas Guthrie (1803-73)
	30	Alexander Keith
	31	John Henning
*	32	John Henning
*	33	Alexander Handyside Ritchie
*	34	James Drummond (1816-77)
	35	Sir William Allan
	36	James Aytoun
	37	James Inglis (1813-51)
	38	Robert Bryson (1778-1852)
	39	D.T.K.Drummond (1799-1888)
	40	Thomas Scott
*	41	George Buist (1805-60)
	42	John Gibson (1799-1871)
	43	Sir William Carmichael Anstruther, Bt (1793-1869)
	44	George Gunn (d.1859)
	45	Julius Wood (1800-77)
	46	Jabez Bunting (1779-1858)
*	47	Jabez Bunting
	48	Alexander Keith
	49	Samuel Miller (1810-81)
	50	James Glencairn Burns (1794-1865)
*	51	Alexander Campbell Fraser (1819-1914)
*	52	Sir John Steell (1804-91)
	53	R.Scott
	54	James Brewster (1777-1847)
	55	Sir William Allan
	56	John Duncan
	57	John Stevens (1793-1868)
*	58	James Miller (1812-64)
	59	Andrew Sutherland (d.1867)
	60	David Laing (1793-1878)
	61	Frederic Joel Jean Gerard Monod (1794-1863)
	62	William Govan (1804-75)
	64	Thomas Blizzard Bell (1815-66)
	65	Samuel Smith (1798-1868)
	66	Thomas Miller
	67	John Robertson (1801-66)
	68	Alexander Thomson (1798-1868)
	69	John Duncan

70 George William Bell
71 John Harden (1772-1847)
72 Thomas Duncan
73 Thomas Henshaw Jones (1796-1860)
* 74 Patrick Robertson, Lord Robertson (1794-1855)
75 J.Finlay McAllister (1805-66)
76 Joseph Thorburn (1799-1854)
* 77 David Irving (1788-1860)
78 George Gunn
* 79 Robert Stephen Rintoul (1787-1858)
80 Robert Bryson (1778-1852)
81 David Maitland McGill Crichton (1801-44?)
* 82 James Ballantine (1808-77)
83 Peter Jones ('Kahkewaquonaby') (1802-56)
* 84 Thomas Duncan
85 Andrew Gray (1805-61)
86 William Hamilton Burns (1779-1859)
* 87 George Combe (1788-1858)
* 88 Henry Duncan (1774-1846)
89 R.Scott
* 90 David Roberts (1796-1864)
91 Robert Liston
92 John Henning
* 93 John Stevens
94 Peter Jones
95 James Ballantine
96 Finlay of Colonsay
97 George William Bell, E. Lady Moncrieff (nee Bell), and Thomas Blizzard Bell
98 The Torso: John Henning, Alexander Handyside Ritchie and David Octavius Hill
99 George Lewis (1803-79)
100 David Octavius Hill and William Borthwick Johnstone (1804-68)
*101 Kenneth Macleay (1802-78)
102 James Stuart-Wortley and his wife
103 David Octavius Hill
104 Free Church Committee: John Campbell, 2nd Marquess of Breadalbane (1796-1862), Sir David Brewster, David Welsh, John Hamilton (1799-1851) and A.Earle Monteith
105 Study for ... the first General Assembly of the Free Church: George Muirhead (1764-1847), William Cunningham (1805-61), James Begg (1808-83), Thomas Guthrie and John Hamilton
106 Mary Watson (née Hill)
107 Grizel Baillie (1822-91)
108 Marian Murray (d.1894)
109 Jane Webster (née Binny) and her sister, Mrs Marrable
110 Justine Gallie (née Monro)
111 Jane Webster
*112 Anna Brownell Jameson (née Murphy) (1794-1860)
113 Patricia Orr (née Morris) (d.1854)
114 Mary, Lady Ruthven (1789-1885)
115 Miss Murray
116 Mrs Rishton (née McCandlish)
117 Jane Webster, Mrs Marrable and Justine Gallie (née Monro)
118 Sophia Finlay (née Morris)
119 Mrs Bell
120 James Fillans (1808-52) with his two daughters
121 Miss Kemp
122 Jane Webster (née Binny) and her sister, Mrs Marrable
123 Mrs Barker (?Jane Sophia Barker, née Harden)
*124 Elizabeth, Lady Eastlake (née Rigby) (1809-93)
125 Elizabeth, Lady Eastlake
126-8 Anne Rigby (née Palgrave) (1777-1872)
129 Matilda Smith (née Rigby)
130 Elizabeth, Lady Eastlake

131 Matilda Smith
132,133 Anne Rigby
134 Anne Rigby and Lady Eastlake
135 Matilda Smith
136 Elizabeth, Lady Eastlake
137 James Miller (1837-68)
138 Thomas Miller and his family
139 Graham Fyvie, Robert Cadell (1788-1849) and Robert Cunningham Graham Spiers
140 Dundee Free Church Presbytery
141 Edinburgh Ale: James Ballantine, George William Bell, and David Octavius Hill
142 James and Thomas Duncan
143 A Discussion: James Ballantine, David Octavius Hill and George William Bell
144 The Monks of Kennaquhair: William Borthwick Johnstone, William Leighton Leitch (1804-83) and David Scott (1806-49)
145 Peter Jones
146 Patrick Byrne (1797?-1863)
147 William Leighton Leitch
148 Patrick Byrne
149 ?John Lane
150 Patrick Byrne
151 Edie Ochiltree: John Henning and Miss Cockburn
152 Patrick Byrne
153 The Adamson family: Alexander Adamson, John Adamson and his wife, Mrs Bell, Melville Adamson and Robert Adamson
154 John Gibson and Mr Moir
155 David Octavius Hill and James Miller
156 Edie Ochiltree: John Henning
157 ?John Lane
158 Study in Bonaly: John Henning and Miss Cockburn
159 Mr Lane and Mr Redding
160 Agnes and Ellen Milne
161 Sophia Finlay and Annie Farney
162 Annie Farney and her sister
163 Elizabeth, Lady Eastlake
165 Sophia Finlay and Annie Farney
166,167 James Miller
168 The Misses Grierson
169 Elizabeth Logan (1811-62)
170 Miss Bell
171 The Minnow Pool: children of Charles Finlay
172 Elizabeth Logan
173 The Misses Grierson
174 John Hope Finlay (1839-1907)
175 Charlotte Dagleish (née Hill) (1839-62)
176,177 Margaret Arkley (née McCandlish) and Ann Meichton (née McCandlish)
178 Elizabeth Logan
179 Master Grierson
*181 Robert Adamson
193,195 Elizabeth Johnstone
196,197 Barbara Flucker
199 James Linton and his children
200 Jeanie Wilson and Annie Linton
202 The Letter: Marion Finlay, Margaret Dryburgh and Grace Finlay
203 Elizabeth Johnstone
204 Marion Finlay, Margaret Dryburgh, Grace Finlay and others
206 The Pastor's Visit: group including James Fairbairn
207 Jeanie Wilson
215 Fishermen Ashore: Alex Rutherford, William Ramsay and John Liston
217 Willie Liston
220 Sir Robert Dennistoun's Tomb: group including David Octavius Hill

Continued overleaf

221 The Covenanters' Tomb: David Octavius Hill and a Miss Watson?

227 The Nasmyth Tomb: Thomas Duncan and David Octavius Hill

228 McKenzie's Tomb: David Octavius Hill and another man

230 The Nasmyth Tomb: David Octavius Hill and three other men

234 Edinburgh Castle: group probably including George Meikle Kemp (1795-1844)

237 Bonaly, near Edinburgh: Lord Henry Cockburn, his family, David Octavius Hill and John Henning

238 Lord Henry Cockburn, his family, David Octavius Hill and John Henning

Ford *Album*

Lewis Carroll at Christ Church

P7(1-37) Photographs: albumen prints 14.6 x 12.1 (5¾ x 4¾) or less
Charles Lutwidge Dodgson ('Lewis Carroll') (except no.26, possibly by Reginald Southey), c.1856
Purchased with help from Kodak Ltd, 1973

The identified sitters, listed alphabetically, are as follows; those marked with an asterisk are catalogued separately in the section *Single and Double Portraits:*

18 Thomas Vere Bayne (1829-1908)
*13 Richard Meux Benson (1824-1915)
3 Thomas Chamberlain (1810-92)
* 9 Charles William Corfe (1814-83)
*26 Charles Lutwidge Dodgson (1832-98) (possibly by Reginald Southey)
16 Robert Godfrey Faussett (1827-1908)
* 5 Osborne Gordon (1813-83)
4 Edward Hill (1809-1900)
* 1 William Jacobson (1803-84)
12 Frederick Pigott Johnson (1826-82)
*14 George William Kitchin (1827-1912)
2 Jacob Ley (1803-81)
*22 Henry Parry Liddon (1829-90)
8 George Marshall (1817-97)
25 Friedrich Max-Müller (1827-1900)
*10 Sir Frederick Gore Ouseley, Bt (1825-89)
7 Thomas Jones Prout (1823-1909)
11 John Rich (1826-1913)
20 Charles Waldegrave Sandford (1828-1903)
23 Reginald Southey (1835-99)
15 John Roddam Spencer Stanhope (1829-1908)
6 Edward Stokes (1823-1909)
*17 Richard St John Tyrwhitt (1827-95)

Ford *Carroll*

Prominent men, c.1938-43

P10-17 Photographs: bromide prints 38.7 x 30.5 (15¼ x 12) or less
Felix H. Man
Given by the photographer, 1975

The sitters, listed numerically, are as follows; those marked with an asterisk are catalogued separately in the section *Single and Double Portraits:*

*P10 David Lloyd George, 1st Earl Lloyd-George (1863-1945)

P11 William Henry Beveridge, 1st Baron Beveridge (1879-1963)
*P12 Ernest Bevin (1881-1951)
*P13 Sir Herbert Read (1893-1968)
*P14 Evelyn Waugh (1903-66)
*P15 Sir Jacob Epstein (1880-59) and Hewlett Johnson (1874-1966) (catalogued separately under Epstein)
P16 Clement Attlee, 1st Earl Attlee (1883-1967), and Arthur Greenwood (1880-1954)
P17 Sir Gordon Richards (b.1904) with two unidentified men

The Herschel Album

P18(1-92b) Photographs: albumen prints 33.4 x 27.9 (13⅛ x 11) or less
Julia Margaret Cameron, c.1864-7
Purchased with help from a public appeal, 1975

The photographs, listed numerically, are as follows; those marked with an asterisk are catalogued separately in the section *Single and Double Portraits:*

* 1 Sir John Herschel (1792-1871)
* 2 Thomas Carlyle (1795-1881)
3 Alfred Tennyson, Baron Tennyson (1809-92)
4 Thomas Carlyle
5 Julia, Lady Stephen (née Jackson) (1846-95)
6 Alfred Tennyson, Baron Tennyson
* 7 Sir Henry Taylor (1800-86)
8,9 George Frederic Watts (1817-1904)
*10 James Spedding (1808-81)
*11 William Holman Hunt (1827-1910)
12 La Madonna Adorata: Mary Ann Gilbert (née Hillier, 1847-1936) and Alice Jessie Keown? (b.1861)
13 St Agnes: Mary Ann Gilbert
14 Paul and Virginia: William Frederick Gould (b.1861) and Elizabeth Keown (b.1859)
*15 Aubrey Thomas de Vere (1814-1902)
16 Alice du Cane (b.1860)
17 William Henry Brookfield (1809-74)
18 John Jackson (1804-87)
19 Baby 'Pictet' (b.1861)
20 Henry Halford Vaughan (1811-85)
21 Sir Henry Taylor
22 Ewen Wrottesley Hay Cameron (1843-85)
23 William Holman Hunt
24 Julia, Lady Stephen
25 The Dialogue: Mary Ann Gilbert and Mary Emily Hichens (née Prinsep) (1853-1931)
26 Lionel Tennyson (1854-86)
27 Daisy: Margaret Louisa Woods (née Bradley) (1855-1945)
28 The May Queen: Mary, Lady Cotton (née Ryan, 1848-1914), and Caroline Hawkins
29 Annie Wilhelmina Philpot (1854-1930)
30 Connor of the Royal Artillery: Gunner Patrick Connors?
31 Julia, Lady Stephen
*32 Anthony Trollope (1815-82)
33 The Grand Mother: Sarah Groves (1772-1865) and an unidentified girl
34 Isabel and Adeline Somers: Isabella Caroline, Lady Somerset (1851-1921), and Adeline, Marchioness of Tavistock (1852-1920)
35 Suspense: Kate Dore
36 Heaven: Mary Ann Gilbert, Elizabeth Keown? and Alice Jessie Keown
37 St Agnes: Mary Ann Gilbert
*38 George Frederic Watts

39 Prayer: William Frederick Gould
40 La Madonna Aspettante: Mary Ann Gilbert and William Frederick Gould
41 Cherub and Seraph: William Frederick Gould and Elizabeth Keown?
42 Ernest and Maggie (unidentified)
43 Love: Mary Ann Gilbert, Elizabeth Keown and Alice Jessie Keown
44 Goodness: Mary Ann Gilbert and Alice Jessie Keown
45 From life Teachings from the Elgin Marbles: Cyllina Margaret Wilson (1851-83) and Mary Ann Gilbert
46 La Madonna Riposata: Mary Ann Gilbert and Percy Seymour Keown (b.1864)
47 The Flower Girl: Mary Ann Gilbert
48 After the Manner of Perugino: Mary, Lady Cotton
49 Acting Grandmama: Mary Emily Hichens
50 La Beata: Mary Ann Gilbert and William Frederick Gould
51 A Study after the manner of Francia: Mary, Lady Cotton, and Elizabeth Keown
52 2d Version of Study after the Elgin Marbles: Cyllina Margaret Wilson and Mary Ann Gilbert
53 Faith: Mary Ann Gilbert, Elizabeth Keown? and Alice Jessie Keown
54 2d Version The Dialogue: Mary Ann Gilbert and Mary Emily Hichens
55 The Return after 3 days: Mary Kellaway?, Mary Ann Gilbert, William Frederick Gould and Mary, Lady Cotton
56 The Red & White Roses: Kate Keown (b.1857) and Elizabeth Keown
57 The Holy Family: Cyllina Margaret Wilson, Percy Seymour Keown? and Alice Jessie Keown
58 Holy Family (other study): Cyllina Margaret Wilson, Percy Seymour Keown? and Alice Jessie Keown
59 Julia, Lady Stephen
60 Young Astyanax: William Frederick Keown
61 Friar Laurence and Juliet: Sir Henry Taylor and Mary Ann Gilbert
62 Other version of Friar Laurence & Juliet: Sir Henry Taylor and Mary Ann Gilbert
63 The Neapolitan: Mary Emily Hichens
64 Your Carry: Caroline, Lady Hamilton-Gordon (née Herschel) (1830-1909)
65 Romeo and Juliet: Sir Henry James Stedman Cotton (1845-1917) and Mary, Lady Cotton?
66 The Gardener's Daughter: Mary, Lady Cotton
67,68 Julia, Lady Stephen
69 Iago Study from an Italian: Alessandro Colrossi?
70 King David: Sir Henry Taylor
71 Sir Henry Taylor
72,74 Alfred Tennyson, Baron Tennyson
*73 Alfred Tennyson, Baron Tennyson
75 Prospero Study of Henry Taylor: Sir Henry Taylor
76 Alfred Tennyson, Baron Tennyson
77 King Ahasuerus & Queen Esther In Apocrypha: Sir Henry Taylor, Mary, Lady Cotton, and Mary Kellaway
78 The Wild Flower: Annie Cameron (née Chinery)
79 Julia, Lady Stephen
80 Group from Sordello by Browning: Sir Henry James Stedman Cotton and Mary, Lady Cotton
81 William Frederick Gould
82 The Mountain Nymph Sweet Liberty (unidentified)
83 Study of the Beatrice Cenci from May Prinsep: Mary Emily Hichens
84 Alfred Tennyson, Baron Tennyson
85 Francis Charteris (1844-70)
86 The Minstrel Group: Mary, Lady Cotton, Kate Keown and Elizabeth Keown
87 The Contadina: Mary Emily Hichens

88 Sir Henry James Stedman Cotton as King Cophetua
89 Eugene Hay Cameron (1840-85)
*90 Julia, Lady Stephen
91 Adolphus George Charles Liddell (1846-1920)
92 Mary, Lady Cotton
92a Mary Catherine, Lady Humphery (née Alderson)
92b William Frederick Gould and an unidentified child

Ford *Herschel*

The Balmoral Album

P22(1-27) Photographs: albumen prints 20.3 x 15 ($8 \times 5\frac{7}{8}$) or less
George Washington Wilson, W.& D.Downey, and Henry John Whitlock, 1854-68
Purchased, 1975

The photographs, listed numerically, are as follows; those marked with an asterisk are catalogued separately in the section *Single and Double Portraits*:

1 Queen Victoria (1819-1901), Princess Louise (1848-1939) and Princess Beatrice (1857-1944) driving (group of five in a carriage) (by Whitlock, October 1867)
2 Group of fifteen: Queen Victoria, Prince of Wales (later Edward VII, 1841-1910), Princess Louise, Prince Arthur (1st Duke of Connaught and Strathearn, 1850-1942) Prince Leopold (1853-84), Princess Beatrice, Anne, Duchess of Atholl (1814-97), Miss MacGregor, Mrs Ponsomby (?Ponsonby), Mademoiselle Norele, Sir Christopher Charles Teesdale (1833-93), Col Elphinstone (?Sir Howard Crawfurd Elphinstone, 1829-90), Col Ponsomby (?Sir Henry Ford Ponsonby, 1825-95), Dr Hoffmeister, Mr Collins (by Downey, 25 May 1868)
3 The Gillies ball, 1868: group of over thirty including Queen Victoria, Prince Edward, Duchess of Atholl, Princess Louise, Princess Beatrice, Prince Leopold, and Prince Arthur (1st Duke of Connaught and Strathearn) (by Downey, 25 May 1868)
*4 Queen Victoria with John Brown (1826-83) (by Downey, June 1868)
*5 Edward, Prince of Wales (by Downey, 25 May 1868)
*6 Princess Louise (by Downey, May 1868)
7 Princess Louise and Prince Leopold (by Downey, May 1868)
*8 Princess Beatrice (by Downey, May 1868)
9 John Brown (by Downey, May 1868)
10 Stag shot by the Prince. Group of ten: J.Kennedy, Charlie Coutts, Wiily Stewart, Peter Farquarson, J.Mackenzie, John Grant, Macdonald, Donald Stewart, C.Campbell, and Gordon of Bevaglie (by Wilson, 1854)
11 Macdonald & the Stag shot by the Prince . . . (by Wilson, 7 October 1854)
12 John Grant and his family (by Wilson, 1861)
13 John Grant & the same Stag (by Wilson, 7 October 1854)
14 The old gardener Simpson . . . and his wife (by Wilson, October 1857)
15 Victoria-Alice and Mary Symons (by Wilson, September 1857)
16 Children of John Grant (by Wilson, 1857)
17 D.Kennedy, J.Smith, Willy Stewart, John Brown, F.Farquarson, Morgan, Charlie Coutts, P.Robertson and John Grant (by Wilson, October 1857)
18 Peter Farquarson (by Wilson, 1860)
19 Mrs Grant (by Wilson, 29 September 1857)
20 Jammie Gow (by Wilson, September 1861)

Continued overleaf

21 Mrs Duncan and her children (by Wilson, 1861)
22 Royal Stag shot by the Prince (by Wilson, 13 October 1858)
23 Macdonald & the Stag shot by the Prince . . . (by Wilson, 6 October 1854)
24 Group of eleven: Duchess of Atholl, Miss MacGregor, Miss Cathcart, Sir Christopher Charles Teesdale, Col Elphinstone (?Sir Howard Crawfurd Elphinstone), Dr Hoffmeister, Charles Grey (1804-70), Mr Collins, Dr Robertson, Mademoiselle Norêle and Mrs Ponsomby (?Ponsonby) (by Downey 25 May 1868)
25 John Grant (by Downey, May 1868)
26 Mrs Donald Stewart and her children (by Wilson, 1861)
27 Donald Stewart & the same Stag (by Wilson, 7 October 1854)

Prints from two albums, 1852-60

P31-40 Photographs: albumen prints, various sizes
Charles Lutwidge Dodgson ('Lewis Carroll') unless otherwise stated
Purchased, 1977

The photographs, listed numerically, are as follows; those marked with an asterisk are catalogued separately in the section *Single and Double Portraits:*

P31 Charles Dodgson (1800-68)
P32 Charles Dodgson and his family at Croft Rectory (probably by Skeffington Lutwidge)
*P33 Harriet Martineau (1802-76) (by unknown photographer)
*P34 Alfred Tennyson, 1st Baron Tennyson (1809-92) (possibly by Cundall & Downes)
P35 Arthur Penrhyn Stanley (1815-81)
*P36 George MacDonald (1824-1905) (possibly by Dodgson)
P37 Sir Frederick Arthur Gore Ouseley, Bt (1825-89) (by unknown photographer)
*P38 Charles Lutwidge Dodgson ('Lewis Carroll', 1832-98) (by unknown photographer)
P39 Charles Lutwidge Dodgson (by unknown photographer)
P40 Hallam Tennyson, 2nd Baron Tennyson (1852-1928)

Prominent people, c.1946-64

P57-67 Photographs: bromide prints 60.3 x 50.2 (23¾ x 19¾) or less
Angus McBean
Purchased, 1977

The sitters, listed numerically, are as follows: those marked with an asterisk are catalogued separately in the section *Single and Double Portraits:*

*P57 Ivor Brown (1891-1974)
P58 Peter Brook (b.1925)
P59 Hugh ('Binkie') Beaumont (1908-73), Angela Baddeley (1904-76) and Emlyn Williams (b.1905)
*P60 Sir John Gielgud (b.1904)
*P61 Robert Helpmann (b.1909)
*P62 Vivien Leigh (1913-67)
P63 Constance Cummings (b.1910)
P64 Dame Edith Evans (1888-1976)
*P65 Ivor Novello (1893-1951)
P66 Sir Ralph Richardson (b.1902)
P67 Christopher Fry (b.1907)

The St John's Wood Clique

P70-100 Photographs: albumen prints 21.6 x 16.2 (8½ x 6⅜) or less
David Wilkie Wynfield, 1860s
Nos.P70-88 purchased, 1929; nos.P89-100 given by H.Saxe Wyndham, 1937

The sitters, listed alphabetically, are as follows: those marked with an asterisk are catalogued separately in the section *Single and Double Portraits:*

P70 Richard Ansdell (1815-85)
*P89 Richard Ansdell
P71 Thomas Oldham Barlow (1824-98)
*P90 Thomas Oldham Barlow
*P72 Philip Hermogenes Calderon (1833-98)
*P73 Thomas Faed (1826-1900)
*P99 Myles Birket Foster (1825-99)
*P100 William Gale (1823-1909)
*P74 John Evan Hodgson (1831-95)
P91 John Evan Hodgson
*P75 William Holman Hunt (1827-1910)
P76 Charles Samuel Keene (1823-91)
*P92 Charles Samuel Keene
P77 Frederic Leighton, Baron Leighton (1830-96)
*P93 Frederic Leighton, Baron Leighton
P78 Henry Stacy Marks (1829-98)
*P94 Henry Stacy Marks
*P79 Sir John Everett Millais (1829-96)
*P80 John Phillip (1817-67)
*P81 Henry Wyndham Phillips (1820-1900)
*P82 Frederick Richard Pickersgill (1820-1900)
*P83 Valentine Cameron Prinsep (1838-1904)
P95 Valentine Cameron Prinsep
*P84 Frederick Walker (1840-75)
*P85 John Dawson Watson (1832-92)
P86 George Frederic Watts (1817-1904)
*P96 George Frederic Watts
P87 David Wilkie Wynfield (1837-87)
*P97 David Wilkie Wynfield
P88 William Frederick Yeames (1835-1918)
*P98 William Frederick Yeames

Rupert Brooke, 1913

P101(a-g) Photographs: glass positives, each 30.5 x 25.4 (12 x 10)
Sherrill Schell, c.1918 (from negatives of 1913)
Given by Emery Walker Ltd, 1956

Nos. b and f are catalogued separately in the section *Single and Double Portraits.*

Literary and Scientific Portrait Club

P106(1-20) Photographs: albumen prints, arched top, each 20 x 14.6 (7⅞ x 5¾)
Maull & Polyblank, c.1855
Purchased, 1978

The sitters, listed numerically, are as follows; those marked with an asterisk are catalogued separately in the section *Single and Double Portraits:*

1 Prof Anderson
* 2 William Borrer (1781-1862)
3 William Borrer, junior

* 4 James Scott Bowerbank (1797-1877)
 5 Woodyerill Buckton
* 6 Hugh Cuming (1791-1865)
* 7 Charles Robert Darwin (1809-82)
* 8 John Peter Gassiot (1797-1877)
 9 Thomas Graham (1805-69)
*10 Charles Cardale Babington (1808-95)
*11 James Holman (1786-1857)
*12 Sir Joseph Dalton Hooker (1817-1911)
 13 Robert Hudson
 14 S.W.Mitchell (?Silas Weir Mitchell, 1829-1914)
*15 Sir Richard Owen (1804-92)
*16 Richard Chandler Alexander Prior (1809-1902)
 17 John van Voorst
*18 Nathaniel Bagshaw Ward (1791-1868)
 19, 20 Two unknown women

Musicians and Composers

P107-11 Photographs: bromide prints 18.1 x 23.8
($7\frac{1}{8}$ x $9\frac{3}{8}$) or less
Herbert Lambert
Given by the photographer's daughter, Mrs Barbara
Hardman, 1978

The sitters, listed numerically, are as follows; all are catalogued
separately in the section *Single and Double Portraits*:
P107 Sir Edward Elgar, Bt (1857-1934)
P108 Arnold Dolmetsch (1858-1940)
P109 Gustav Theodore Holst (1874-1934)
P110 Roger Quilter (1877-1953)
P111 Rutland Boughton (1878-1960)

Literary and Scientific Men, 1855

P120(1-54) Photographs: albumen prints, arched
top 19.7 x 14.6 ($7\frac{3}{4}$ x $5\frac{3}{4}$)
Maull & Polyblank, 1855
Purchased, 1979

The sitters, listed numerically, are as follows; those marked
with an asterisk are catalogued separately in the section
Single and Double Portraits:
 1 James Scott Bowerbank (1797-1877)
 2 Norton Shaw
 3 James Salter
* 4 William Wilson Saunders (1809-79)
 5 T.B.Curling
 6 J.Barlow
* 7 Lyon Playfair, 1st Baron Playfair (1818-98)
 8 F.W.Simms (?Frederick Walter Simms, 1803-65)
 9 John Tidd Pratt
*10 Sir Roderick Impey Murchison, Bt (1792-1871)
*11 Henry Alworth Merewether (1780-1864)
*12 John Miers (1789-1879)
*13 Sir Charles Lyell, Bt (1797-1875)
 14 Dr Lee
*15 Edwin Lankester (1814-74)
*16 John Gwyn Jeffreys (1809-85)
*17 Joshua Alder (1792-1867)
 18 Dr Booth
*19 Daniel Sharpe (1806-56)
*20 Sir James South (1785-1867)
*21 William Sharpey (1802-80)
*22 Berthold Carl Seeman (1825-71)
*23 John Drew Salmon (1802?-59)

 24 R.H.Solly
*25 Sir John Ross (1777-1856)
 26 S.P.Pratt
*27 William Yarrell (1784-1856)
*28 Robert Wight (1796-1872)
 29 Robert Wakefield
 30 Nathaniel Ward
*31 Thomas Thomson (1817-78)
*32 Theophilus Thompson (1807-60)
*33 William Henry Smyth (1788-1865)
 34 J.A.Hankey (?John Alexander Hankey, d.1882)
*35 William Benjamin Carpenter (1813-85)
*36 John Curtis (1791-1862)
 37 H. Deane
*38 Warren De la Rue (1815-89)
*39 Sir Philip de Malpas Grey-Egerton (1806-81)
 40 J.Gaskoin
*41 Robert Brown (1773-1858)
*42 Thomas Bell (1792-1880)
*43 John Hutton Balfour (1808-84)
*44 Frederick William Beechey (1796-1856)
*45 William Thomas Brande (1788-1866)
 46 T.C.Janson (?Thomas Corbyn Janson, 1809-63)
 47 Dr Hamilton (?James Hamilton, 1814-67)
 48 John Harris
*49 Arthur Henfrey (1819-59)
*50 John Hogg (1800-69)
*51 Philip Henry Gosse (1810-88)
*52 John Edward Gray (1800-75)
*53 James Glaisher (1809-1903)
*54 Thomas Graham (1805-1869)

Prominent People, 1935-8

P127-33 Photographs: bromide prints 40 x 31.1
($15\frac{3}{4}$ x $12\frac{1}{4}$)
Lucia Moholy
Purchased, 1979

The sitters, listed numerically, are as follows; those marked
with an asterisk are catalogued separately in the section
Single and Double Portraits:
 P127 Patrick Maynard Stuart Blackett, 1st Baron Blackett
 (1897-1974)
***P128** Emma, Countess of Oxford and Asquith (1864-1945)
***P129** Ruth Fry (1878-1962)
***P130** Sir Alfred Hopkinson (1851-1939)
***P131** Ernest Rhys (1859-1946)
***P132** Edward Garnett (1868-1937)
 P133 Michael Polanyi (1891-1976)

Gerald Brenan Album

P134(1-25) Photographs: platinum and bromide
prints 11.1 x 7.9 ($4\frac{3}{8}$ x $3\frac{1}{8}$)
John Hope-Johnstone, c.1922
Purchased, 1979

The following sitters are within the Gallery's terms of reference;
nos. 21 and 25 are catalogued separately in the section
Single and Double Portraits:
20, 21 Gerald Brenan (b.1894)
10,18,25 Augustus John (1878-1961)

Prominent men, 1895-1930

L168(1-11) Canvas, chalk or pencil 76.5 x 63.5
(30⅛ x 25) or less
Sir William Rothenstein
Lent by the artist's son, Sir John Rothenstein, 1977

The sitters, listed alphabetically, are as follows; those marked
with an asterisk are catalogued separately in the section
Single and Double Portraits:
*1 Hercules Brabazon Brabazon (1821-1906)
 8 Geoffrey Dawson (1874-1944)
*9 John Drinkwater (1882-1937)
*2 Sir James George Frazer (1854-1941)
 4 Sir William Hale-White (1857-1949)
 3 James Thomas ('Frank') Harris (1856-1931)
 6 Robert Baldwin Ross (1869-1918)
*5 Arthur Henry Fox Strangways (1859-1948)
 10,11 Humbert Wolfe (1886-1940)
 7 Sir Henry Wood (1869-1944)

Unknown Sitters

The portraits are arranged chronologically in four groups, and in numerical order within each group. Where applicable, the names formerly attached to the sitters are given. Many of the portraits are discussed in the various NPG catalogues raisonnés, as indicated (ie Strong, Piper, Kerslake and Ormond).

I : 16th CENTURY AND EARLIER

40 *Called* Sir Ralph Winwood (1563?-1617)
Canvas 75.6 x 62.9 (29¾ x 24¾)
Unknown artist
Purchased, 1858

Strong

72 *Called* John Knox (1505-72)
Panel 66.7 x 53.3 (26¼ x 21)
Unknown artist
Given by the Duke of Buccleuch, 1859

Strong

96 *Called* Mary, Queen of Scots (1542-87)
Canvas 96.2 x 70.2 (37$\frac{7}{8}$ x 27$\frac{5}{8}$)
Unknown artist, c.1560
Purchased, 1860

Strong

310 *Called* Henry IV (1367-1413)
Panel 58.7 x 45.7 (23$\frac{1}{8}$ x 18)
Unknown artist, inscribed
Purchased, 1870

Strong

401 *Called* Mary Douglas, Countess of Lennox (1515-78)
Panel 40.3 x 32.1 (15$\frac{7}{8}$ x 12$\frac{5}{8}$)
Unknown artist, c.1560-5
Given by Hugh Diamond, 1874

Strong

461 *Called* Sir Nicholas Hyde (d.1631)
Canvas 76.8 x 64.8 (30¼ x 25½)
Unknown artist, inscribed
Given by the Society of Judges and Serjeants-at-Law, 1877

Strong

527 *Called* Sir Julius Ceasar (1558-1636)
Canvas 74.9 x 61 (29½ x 24)
Unknown artist
Transferred from BM, 1879

Strong

571 *Called* John Speed (1552?-1629)
Panel 60.3 x 44.1 (23¾ x 17$\frac{3}{8}$)
Unknown artist
Transferred from BM, 1879

Strong

764 *Called* Lady Jane Dudley (1537-54)
Panel 16.5 (6½) diameter
Unknown artist, 1555-60
Purchased, 1887

Strong

776 *Called* Michael Drayton (1563-1631)
Panel 59.7 x 45.7 (23½ x 18)
Unknown artist, inscribed and dated 1599
Given by T.H.Woods, 1888

Strong

844 *Called* Richard Hooker (1554?-1600)
Panel 51.1 x 33 (20⅛ x 13)
Unknown artist
Given by John Neale Dalton, 1890

Strong

1119 *Called* Catherine Howard (d.1542)
Panel 73.7 x 49.5 (29 x 19½)
After Hans Holbein, inscribed
Purchased, 1898

Strong

1173 *Called* Margaret Tudor (1489-1541)
Panel 44.1 x 35.6 (17⅜ x 14)
Jean Perréal, c.1520
Purchased, 1898

Strong

1195 *Called* William Drummond (1585-1649)
Panel 21.1 x 19.7 (8⅜ x 7¾)
Unknown artist
Purchased, 1899

Strong

1306 *Called* John Gerard (1545-1612)
Panel 46 x 35.6 (18⅛ x 14)
Unknown artist, inscribed and dated 1587
Purchased, 1901

Strong

1375 *Called* Edward Seymour, 1st Duke of Somerset
(1506?-52)
Panel 45.4 x 35.2 (17⅞ x 13⅞)
Unknown artist
Purchased, 1904

Strong

1488 *Called* Lady Margaret Beaufort (1443-1509)
Panel 44.5 x 31.8 (17½ x 12½)
Unknown artist
Purchased, 1908

Strong

1592 *Called* William Tyndale (d.1536)
Canvas 115.6 x 86 (45½ x 33⅞)
Unknown artist, inscribed
Purchased, 1910

Strong

1705 *Called* Ursula, Lady Walsingham (d.1602)
Panel 39.4 x 34 (15½ x 13⅜)
Unknown artist, 1583
Purchased, 1913

Strong

1723 *Called* Lady Arabella Stuart (1575-1615)
Panel 18.7 x 13.3 (7⅜ x 5¼)
Unknown artist
Purchased, 1914

Strong

1732 *Called* Thomas Howard, 4th Duke of Norfolk
(1536-72)
Panel 54.3 x 40.6 (21⅜ x 16)
Unknown artist
Purchased, 1914

Strong

1931 *Called* Charles Howard, 1st Earl of Nottingham
(1536-1624)
Canvas, feigned oval 91.4 x 71.1 (36 x 28)
Unknown artist, inscribed
Given by G.Milner-Gibson-Cullum, 1924

Strong

2039 *Called* Catherine (Fitzgerald), Countess of
Desmond (d.1604)
Canvas 75.2 x 62.9 (29⅝ x 24¾)
Unknown artist, inscribed
Given by Lady Ardilaun, 1924

Strong

2412 *Called* Sir Philip Sidney (1544-86)
Water-colour 20.3 x 11.4 (8 x 4½)
Attributed to George Perfect Harding, 1818, copy
Purchased, 1929
See Collections: Copies of early portraits, by George
Perfect Harding and Sylvester Harding, **1492,1492(a-c)**
and **2394-2419**

Strong

2421 *Called* Catherine of Aragon (1485-1536)
Water-colour 28.6 x 14.6 (11¼ x 5¾)
Wilfred Drake, signed and dated 1921
Given by the artist, 1921

Strong

2491 *Called* Guy Dudley, Earl of Warwick, or John
Lumley, 5th/6th Baron Lumley (1493-1544)
Water-colour 21.6 x 16.2 (8½ x 6⅜)
Attributed to George Perfect Harding, copy
Bequeathed by Frederick Louis Lucas, 1931

2607 *Called* Margaret Pole, Countess of Salisbury
(1473-1541)
Panel 62.9 x 48.9 (24¾ x 19¼)
Unknown artist
Given by NACF, 1931

Strong

2613 *Called* Sir Thomas Overbury (1581-1613)
Panel 47.6 x 34.6 (18¾ x 13⅝)
Unknown artist, c.1590-1600
Purchased, 1933

Strong

2693 *Called* John Lumley, 5th/6th Baron Lumley
(1493-1544)
Water-colour 21 x 15.9 (8¼ x 6¼)
George Perfect Harding, signed, copy
Purchased, 1934

Strong

2824 Unknown divine
Water-colour 15.9 x 13 (6¼ x 5⅛)
Unknown artist
Purchased, 1936

Strong

2825 *Called* Elizabeth I (1533-1603)
Pencil and water-colour 15.2 x 18.4 (6 x 7¼)
Unknown artist, c.1595
Purchased, 1936

Strong

3180 *Called* William Tyndale (d.1536)
Canvas 68.2 x 55.2 (26⅞ x 21¾)
Unknown artist, dated 1534
Given by the executors of C.J.S.Thompson, 1944

Strong

4270 *Called* Sir Robert Bruce Cotton (1571-1631)
Canvas, feigned oval 61.3 x 51.4 (24⅛ x 20¼)
Unknown artist
Given by Mary C. Annesley, 1962

Strong

4873 *Called* John Bull (1563?-1628)
Panel 36.8 x 26.7 (14½ x 10½)
Unknown artist
Bequeathed by Prof R. Thurston Dart, 1971

II : 17th CENTURY

33 *Called* Henry Ireton (1611-51)
Canvas, feigned oval 76.2 x 62.2 (30 x 24½)
Unknown artist, inscribed
Purchased, 1858

Piper

146 *Called* John Hampden (1594?-1643)
Terracotta bust 53.3 (21) high
Attributed to Peter Scheemakers, incised
Purchased, 1862

Piper

202 *Called* William Russell, Lord Russell (1639-83)
Canvas, feigned oval 73 x 60.3 (28¾ x 23¾)
After Sir Godfrey Kneller (?) (c.1680)
Purchased, 1865

Piper

253 *Called* Mary Davis (fl.1663-9)
Canvas 125.7 x 101.6 (49½ x 40)
After Sir Peter Lely (c.1665-70)
Purchased, 1867

Piper

288 *Called* Francis Quarles (1592-1644)
Canvas 85.1 x 67.9 (33½ x 26¾)
William Dobson, c.1642-4
Purchased, 1869. *Montacute*

Piper

418 *Called* Thomas Blood (1618-80)
Canvas 58.4 x 45.7 (23 x 18)
Attributed to Gerard Soest, c.1670-80
Purchased, 1876

Piper

509 *Called* Elizabeth (Hamilton), Countess of
Grammont (1641-1708)
Canvas 141 x 139.7 (55½ x 55)
Attributed to John Greenhill, c.1665
Purchased, 1878

Piper

556 *Called* James Scott, Duke of Monmouth and
Buccleuch (1649-85)
Canvas 124.5 x 101.6 (49 x 40)
After Sir Peter Lely, inscribed (c.1670)
Transferred from BM, 1879

Piper

575 *Called* Sir Henry Vane the Younger (1613-62)
Canvas, feigned oval 76.2 x 63.5 (30 x 25)
Attributed to Gerard Soest, inscribed, c.1650
Transferred from BM, 1879

Piper

577 *Called* Sir William Waller (1597-1668)
Canvas 68.6 x 53.3 (27 x 21)
Unknown artist
Transferred from BM, 1879

Piper

612 *Called* Jane Middleton (or Myddelton) (1645-92)
Canvas 121.3 x 99.7 (47¾ x 39¼)
Gerard Soest, c.1670
Purchased, 1880

Piper

613 *Called* Henry Howard, 6th Duke of Norfolk
(1628-84)
Canvas, feigned oval 74.3 x 61 (29¼ x 24)
After (?) Sir Peter Lely (c.1680)
Purchased, 1880

Piper

615 *Called* Endymion Porter (1587-1649), *but
possibly* Sir Thomas Aylesbury (1576-1651)
Canvas 125.7 x 99.1 (49½ x 39)
William Dobson, inscribed, c.1642-6
Purchased, 1880

Piper

618 *Called* William Faithorne
(1616?-91)
Canvas 96.5 x 78.7 (38 x 31)
Attributed to Robert Walker, c.1650
Purchased, 1880

Piper

622 *Called* John Gay (1685-1732)
Canvas 34.3 x 26.7 (13½ x 10½)
Attributed to Sir Godfrey Kneller
Purchased, 1881. *Beningbrough*

Piper

623 *Called* Catherine of Braganza (1638-1705)
Canvas 97.8 x 83.8 (38½ x 33)
Attributed to Benedetto Gennari
Purchased, 1881

Piper

659 *Called* Abraham Cowley (1618-67)
Canvas 53.3 x 45.1 (21 x 17¾)
Attributed to Mary Beale
Purchased, 1882

Piper

695 *Called* John Milton (1608-74)
Canvas 71.1 x 59.7 (28 x 23½)
Pieter van der Plas, c.1650(?)
Lent by NG, 1883

Piper

712 *Called* Sarah Churchill, Duchess of Marlborough
(1660-1744)
Canvas, oval 74.9 x 62.9 (29½ x 24¾)
Michael Dahl, c.1695-1700(?)
Purchased, 1884

Piper

982(g) *Called* Oliver Cromwell (1599-1658) and
his daughter
Canvas 78.7 x 67.3 (31 x 26½)
Unknown artist
Acquired before 1896

982(h) *Called* John Lambert (1619-83)
Canvas, oval 74.9 x 61.9 (29½ x 24⅜)
Unknown artist
Acquired before 1896

982(i) *Called* Matthew Henry (1662-1714)
Canvas, oval 74.9 x 62.2 (29½ x 24½)
Unknown artist
Acquired before 1896

1124 *Called* Montague Bertie, 2nd Earl of
Lindsey (1608-66)
Canvas, oval 67.3 x 54 (26½ x 21¼)
Unknown (?French) artist, c.1660
Given by Sir Coutts Lindsay, Bt, 1898

Piper

1181 *Called* Sir George Rooke (1650-1709)
Canvas 75.6 x 61 (29¾ x 24)
Unknown artist
Purchased, 1898

Piper

1243 *Called* John Ashburnham (1603-71)
Canvas 30.5 x 24.8 (12 x 9¾)
Unknown artist, dated 1647
Purchased, 1899

Piper

1261 *Called* Sir James Thornhill (1675-1734)
Canvas, feigned oval 74.9 x 61.6 (29½ x 24¼)
Unknown artist
Purchased, 1900

Piper

1334 *Called* Richard Cromwell (1626-1712)
Canvas 66 x 49.5 (26 x 19½)
Unknown artist
Purchased, 1902

Piper

1344 *Called* Richard Weston, 1st Earl of Portland
(1577-1635)
Panel, feigned oval 73.7 x 61 (29 x 24)
Cornelius Johnson, signed with initials and dated 1627
Purchased, 1903

Piper

1346 *Called* George Villiers, 1st Duke of Buckingham
(1592-1628)
Canvas 64.1 x 59.7 (25¼ x 23½)
Cornelius de Neve, signed and dated 1627
Purchased, 1903

Piper

1365 *Called* Sir Godfrey Kneller (1646-1723)
Canvas 58.4 x 52.1 (23 x 20½)
Unknown artist, c.1700
Purchased, 1904

Piper

1463 *Called* Daniel Purcell (1660?-1717)
Canvas 55.9 x 47 (22 x 18½)
Attributed to John Closterman
Given by Charles Burney, 1907

Piper

1494 *Called* Abigail (Hill), Lady Masham (d.1734)
Canvas, oval 73.7 x 62.2 (29 x 24½)
Unknown artist, c.1700
Purchased, 1908

Piper

1517 *Called* Oliver Cromwell (1599-1658)
Plaster cast of wax mask in BM
21.6 (8½) long
Unknown artist
Given by Brucciani & Co, 1908

Piper

1566 *Called* James Scott, Duke of Monmouth and
Buccleuch (1649-85)
Canvas 56.5 x 66.7 (22¼ x 26¼)
Unknown artist
Purchased, 1910

Piper

1571 *Called* Sir Thomas Tyldesley (1596-1651)
Canvas 76.2 x 63.5 (30 x 25)
Unknown artist, c.1645-50
Bequeathed by S.M.Milne, 1910

Piper

1591 *Called* Jeffrey Hudson (1619?-82)
Canvas 124.5 x 81.3 (49 x 32)
Unknown artist
Purchased, 1910

Piper

1600 *Called* John Hampden (1594-1643)
Canvas 73.7 x 61 (29 x 24)
Attributed to Robert Walker
Given by T.W.Bacon, 1911

Piper

1617 *Called* Wenceslas Hollar (1607-77)
Canvas 91.4 x 77.5 (36 x 30½)
Unknown artist, c.1650
Purchased, 1911

Piper

1626 *Called* John Radcliffe (1650-1714)
Canvas 51.4 x 38.7 (20¼ x 15¼)
Unknown artist
Purchased, 1911

Piper

1674 *Called* Queen Anne (1665-1714)
Canvas, oval 45.1 x 33.7 (17¾ x 13¼)
Unknown artist
Purchased, 1912

Piper

1718 *Called* Ortensia Mancini, Duchess of Mazarin
(1646-99)
Oil on copper 27.3 x 20.7 (10¾ x $8\frac{1}{8}$)
Unknown artist, c.1675
Purchased, 1913

Piper

1722 *Called* Henry Sidney, Earl of Romney
(1641-1704)
Canvas, feigned oval 74.9 x 62.2 (29½ x 24½)
Sir Godfrey Kneller, dated 1700
Purchased, 1914

Piper

1771 *Called* Elizabeth Cromwell (née Steward)
(d.1654)
Canvas 116.8 x 92.1 (46 x 36¼)
S.J.Dügy, inscribed and dated 1620
Bequeathed by Luke Owen Pike, 1916

1858 *Called* John Churchill, 1st Duke of Marlborough
(1650-1722)
Canvas, feigned oval 77.5 x 62.9 (30½ x 24¾)
After Sir Godfrey Kneller (c.1740)
Purchased, 1920

Piper

1887 *Called* Cornelius Johnson (1593-1661)
Canvas 76.8 x 62.2 (30¼ x 24½)
Cornelius Johnson, signed with initials and dated 1636
Purchased, 1920

Piper

1910 *Called* Charles I (1600-49)
Canvas 76.2 x 63.5 (30 x 25)
Unknown artist, inscribed, c.1645(?)
Bequeathed by Mrs A.H.S.Wodehouse, 1921

Piper

1927 *Called* George Monck, 1st Duke of Albemarle
(1608-70)
Miniature on copper, oval 5.1 x 4.4 (2 x 1¾)
Unknown artist
Bequeathed by G.Milner-Gibson-Cullum, 1922

Piper

2131 *Called* John Bradshaw (1602-59)
Miniature on vellum, oval 4.8 x 3.8 ($1\frac{7}{8}$ x 1½)
Unknown artist
Given by H. Bradshaw-Isherwood, 1926

Piper

2406 *Called* Charles Gerard, 1st Earl of Macclesfield
(d.1694)
Water-colour 19.7 x 13.6 (7¾ x $5\frac{3}{8}$)
George Perfect Harding, signed and dated 1827, copy
Purchased, 1929
See Collections: Copies of early portraits, by George
Perfect Harding and Sylvester Harding, **1492,1492(a-c)**
and **2394-2419**

2444 *Called* Sir William Lockhart (1621-76)
Oil on brass, oval 7.9 x 7 ($3\frac{1}{8}$ x 2¾)
Unknown artist, signed *A.G.S.* and inscribed
Purchased, 1929

Piper

2496 *Called* Eleanor (Nell) Gwyn (1650-87)
Canvas, feigned oval 76.2 x 63.5 (30 x 25)
Simon Verelst, signed, c.1690
Bequeathed by John Neale, 1931

Piper

2691 *Called* Sir Paul Rycaut (1628-1700)
Water-colour 12.7 x 9.5 (5 x 3¾)
Unknown artist
Purchased, 1934

4012 *Called* Sir William Penn (1621-70)
Water-colour 11.1 x 8.9 ($4\frac{3}{8}$ x 3½)
Unknown artist
Bequeathed by Henry Nicholas Ridley, 1957

III : 18th CENTURY

29 *Called* Joseph Wright (1734-97)
Canvas 72.4 x 60.3 (28½ x 23¾)
Unknown artist
Given by William Michael Rossetti, 1858

95 *Called* William Huntington (1745-1813)
Canvas 74.3 x 61 (29¼ x 24) *sight*
Unknown artist
Purchased, 1860

116 *Called* Horatio (Horace) Walpole,
4th Earl of Orford (1717-97)

Canvas 58.4 x 48.9 (23 x 19¼)
Nathaniel Hone
Purchased, 1861

377 *Called* Louisa of Stolberg-Gedern, Countess of Albany (1753-1824)
Canvas 24.1 x 21.6 (9½ x 8½)
Attributed to Hugh Douglas Hamilton, c.1785
Purchased, 1873

Kerslake

399 *Called* Johan Zoffany (1733-1810)
Canvas 52.7 x 41.3 (20¾ x 16¼)
Unknown artist, falsely signed *Zoffany* and dated 1761
Purchased, 1875

503 *Called* George Vancourver (1757-98)
Canvas 109.9 x 85.1 (43¼ x 33½)
Unknown artist
Purchased, 1878

761(a) *Called* Gabriel Piozzi (1741-1809)
Canvas 74.3 x 62.2 (29¼ x 24½)
Unknown artist
Given by Dr Whyatt, 1887

813 *Called* Edward Daniel Clarke (1769-1822)
Millboard 42.5 x 38.1 (16¾ x 15)
John Opie
Given by Henry Willett, 1889

927 *Called* Sir Joshua Reynolds (1723-92)
Canvas 19.7 x 17.1 (7¾ x 6¾)
Attributed to Sir Joshua Reynolds
Given by Lord Ronald Sutherland-Gower, 1892

928 *Called* Thomas Gainsborough (1727-88)
Canvas, feigned oval 14.3 x 11.1 ($5\frac{5}{8}$ x $4\frac{3}{8}$)
After Thomas Gainsborough
Given by Lord Ronald Sutherland-Gower, 1892

972 *Called* William Cowper (1731-1800)
Canvas 42.5 x 36.8 (16¾ x 14½)
George Romney
Given by Sir George Scharf, 1894

1244 *Called* Edward Young (1683-1765)
Panel, irregular oval 26 x 20.6 (10¼ x $8\frac{1}{8}$)
Unknown artist
Purchased, 1899

Kerslake

1278 *Called* Francis Wheatley (1747-1801)
Canvas 38.1 x 31.8 (15 x 12½)
Unknown artist
Purchased, 1900

1327 *Called* Richard Wilson (1713?-82)
Canvas 76.2 x 63.5 (30 x 25)
Unknown artist
Given by Sir Hugh Percy Lane, 1902

1339 *Called* Christopher Anstey (1724-1805)
Canvas, oval 43.2 x 35.6 (17 x 14)
Attributed to John Raphael Smith
Purchased, 1903

1382 *Called* Henry Richard Vassall Fox, 3rd Baron Holland (1773-1840)
Canvas 66.7 x 50.2 (26¼ x 19¾)
Louis Gauffier, signed and dated 1796
Purchased, 1904

1414 *Called* James Cook (1728-79)
Canvas 90.2 x 68.6 (35½ x 27)
Unknown artist, inscribed
Purchased, 1905

1535 *Called* Horatio Walpole, 1st Baron Walpole of Wolterton (1678-1757)
Canvas 125.1 x 100.3 (49¼ x 39½)
Unknown artist, inscribed
Purchased, 1909

1576(b) *Called* Augustus Frederick, Duke of Sussex (1773-1843)
Pencil and water-colour 22.2 x 17.8 (8¾ x 7)
Unknown artist
Given by Lord De Mauley, 1910

1580 *Called* Ralph Allen (1694-1763)
Canvas 43.8 x 34.3 (17¼ x 13½)
Unknown artist
Given by Alfred Jones, 1910

Kerslake

1679 *Called* Paul Whitehead (1710-74)
Canvas 75.6 x 63.8 (29¾ x $25\frac{1}{8}$)
John Downman, signed and dated 1770
Given by the Hon E.Charteris, 1912

Kerslake

1754 *Called* John Aislabie (1670-1742)
Canvas 42.5 x 38.7 (16¾ x 15¼)
Unknown artist
Purchased, 1915

Kerslake

1761b *Called* Sir Joshua Reynolds (1723-92)
Oil on copper, oval 6.4 x 5.7 (2½ x 2¼)
Unknown artist
Given by Lord Weardale, 1915

1929 *Called* Prince Charles Edward Stuart (1720-88)
Canvas 109.2 x 60.3 (43 x 23¾)
Unknown artist, inscribed
Given by G.Milner-Gibson-Cullum, 1922

Kerslake

2007 *Called* Philip Doddridge (1702-51)
Canvas 89.5 x 71.8 (35¼ x 28¼)
Unknown artist
Given by W.C.Edwards, 1923

Kerslake

2085 *Called* Maurice Green (1695-1755)
Canvas, feigned oval 73.7 x 61 (29 x 24)
Unknown artist
Given by Sir Alan Garrett Anderson, 1925

Kerslake

2177 *Called* Margaret Woffington (1714?-60)
Canvas 62.2 x 44.8 (24½ x 17⅝)
Attributed to Francis Hayman
Purchased, 1928

Kerslake

2202 *Called* Thomas Walker (1698-1744)
Canvas 63.5 x 49.5 (25 x 19½)
Unknown artist
Given by Viscount Bearsted, 1928

2351 *Called* Thomas Coram (1668?-1751)
Canvas, feigned oval 74.9 x 62.2 (29½ x 24½)
Unknown artist
Purchased, 1929

Kerslake

2430 *Called* Roger Payne (1739-97)
Water-colour 32.1 x 23.1 (12⅝ x 9⅛)
Unknown artist
Given by Percy Fitzgerald, before 1925

2506 *Called* Lady Mary Wortley Montagu (1689-1762)
Canvas 123.8 x 92.1 (48¾ x 36¼)
Studio of Charles Jervas
Bequeathed by Lillie Belle Randell, 1931

Kerslake

2938 *Called* James Northcote (1746-1831)
Panel 19.7 x 17.1 (7¾ x 6¾)
Sir David Wilkie
Given by Dudley Leggatt, 1937

3024 *Called* Joseph Baretti (1719-89)
Chalk 26.3 x 35.6 (10⅜ x 14)
Unknown artist
Given by Marion Harry Spielmann, 1939

3661 *Called* George Morland (1763-1804)
Pastel 25.4 x 21.6 (10 x 8½)
John Raphael Smith
Given by Dudley Leggatt, 1949

4247 *Called* Humphry Repton (1752-1818)
Water-colour 13 x 10.8 (5⅛ x 4¼)
Samuel Shelley, inscribed
Purchased, 1961

IV : 19th CENTURY AND LATER

870 *Called* Sir Robert Peel (1788-1850)
Canvas 50.8 x 38.1 (20 x 15)
Unknown artist
Purchased, 1891

Ormond

971 *Called* Thomas Bewick (1753-1828)
Canvas 55.9 x 44.5 (22 x 17½)
Thomas Sword Good
Given by A.A.Isaacs, 1894

1099 *Called* Edward Bulwer-Lytton, 1st Baron Lytton (1803-73)
Canvas 47 x 33.7 (18½ x 13¼)
Attributed to Alfred Edward Chalon
Purchased, 1897

Ormond

1293 *Called* Benjamin Disraeli, Earl of Beaconsfield (1804-81)
Miniature on ivory 10.8 x 8.3 (4¼ x 3¼)
Attributed to Kenneth Macleay, c.1835
Purchased, 1901

1444 *Called* Charlotte Brontë (1816-55)
Water-colour 31.1 x 23.5 (12¼ x 9¼)
Unknown artist, signed *Paul Héger,* and dated 1850
Purchased, 1906

1450 *Called* Michael William Balfe (1808-70)
Canvas 111.8 x 85.7 (44 x 33¾)
Attributed to Richard Rothwell, c.1840
Purchased, 1906

Ormond

1474 *Called* Charles George Gordon (1833-85)
Canvas 50.8 x 38.1 (20 x 15)
Leo Diet, signed, inscribed and dated 1884
Purchased, 1907

1502 *Called* Felicia Dorothea Hemans (1793-1835)
Canvas 74.9 x 62.2 (29½ x 24½)
Attributed to George Henry Harlow
Purchased, 1908

1524 *Called* Charles Mathews (1776-1835)
Canvas 73.7 x 61 (29 x 24)
Unknown artist
Purchased, 1908

1578 *Called* Florence Nightingale (1820-1910)
Panel 17.1 x 10.8 (6¾ x 4¼)
Augustus Leopold Egg
Given by Mrs W. Rathbone, 1910

1650 *Called* Sir Walter Scott (1771-1832)
Pen and ink 12.7 x 8.3 (5 x 3¼)
Attributed to Sir Edwin Landseer, inscribed and
dated 1821
Given by Percy Fitzgerald, 1912

1719 *Called* Mary Wollstonecraft Shelley (1797-1851)
Canvas 125.7 x 100.3 (49½ x 39½)
Samuel John Stump, signed and dated 1831
Purchased, 1913

1836a *Called* Richard Dighton (fl.1795-1880)
Water-colour 27.6 x 16.2 ($10\frac{7}{8}$ x $6\frac{3}{8}$)
Attributed to Richard Dighton, signed *Dighton*
Purchased, 1919

Ormond

2210 *Called* Mary Ann Cross (1819-80)
Pencil, two sketches 54.3 x 45.1 ($21\frac{3}{8}$ x 17¾)
Sir Frederick William Burton, inscribed
Given by Lady Gosse, 1928

2425 *Called* Sarah Siddons (1755-1831)
Pencil 20.3 x 27.6 (8 x $10\frac{7}{8}$)
Unknown artist, inscribed
Acquired, 1929

2434 Unknown man
Chalk and pencil 63.5 x 50.2 (25 x 19¾)
Samuel Laurence
Given by Henrietta Maria, Lady Stanley of Alderley,
1884

2435 Unknown man
Chalk and pencil 61 x 48.6 (24 x $19\frac{1}{8}$)
Samuel Laurence
Given by Henrietta Maria, Lady Stanley of Alderley,
1884

2440 Unknown man
Chalk 62.2 x 50.5 (24½ x $19\frac{7}{8}$)
Unknown artist
Acquired before 1929

2687 *Called* Robert Louis Stevenson (1850-94)
Chalk, oval 60 x 43.8 ($23\frac{5}{8}$ x 17¼) *sight*
Unknown artist, signed *JR*, inscribed and dated 1880
Acquired, 1934

2782 Unknown man
Charcoal 27 x 20.6 ($10\frac{5}{8}$ x $8\frac{1}{8}$)
Huet Villiers, signed and dated 1803
Given by Sir Richard Wallace, Bt, 1884

2888 Unknown man
Pencil and water-colour 25.4 x 17.5 (10 x $6\frac{3}{8}$)
Unknown artist, inscribed
Purchased, 1936

2927B Unknown man
Chalk 41.6 x 26.7 ($16\frac{3}{8}$ x 10½)
William Strang, signed and dated 1904
Purchased, 1937

3025 *Called* Ramsay Richard Reinagle (1775-1862)
Chalk 13 x 10.5 ($5\frac{1}{8}$ x $4\frac{1}{8}$)
Attributed to Ramsay Richard Reinagle
Given by Marion Harry Spielmann, 1939

Ormond

3118 *Called* Jane Morris (1804?-1914), with an
unknown lady and sketch of head of a man
Pen and ink 12.7 x 19.7 (5 x 7¾)
Richard Doyle
Given by Sir John Rothenstein, 1942

3160 *Called* John Russell (1745-1806)
Wash 24.5 x 20.6 ($9\frac{5}{8}$ x $8\frac{1}{8}$)
Unknown artist
Purchased, 1943

3166 *Called* Sir William Quiller Orchardson
(1832-1910)
Canvas 27.9 x 21.6 (11 x 8½)
Sir William Quiller Orchardson
Given by Mrs Katharine Kay, 1943

3174A Unknown man
Pen and ink 16.8 x 11 ($6\frac{5}{8}$ x $4\frac{3}{8}$)
Phil May, signed
Purchased, 1943

3260 *Called* Alfred Edward Chalon (1780-1860)
Pastel 17.5 x 12.7 (6$\frac{7}{8}$ x 5)
Unknown artist, inscribed
Given by Iolo A.Williams, 1942

3843 *Called* John Clare (1793-1864)
Water-colour 31.4 x 22.5 (12$\frac{3}{8}$ x 8$\frac{7}{8}$)
William Henry Hunt
Given by Sir Leonard Woolley, 1952

3906(a) *Called* Thomas Adolphus Trollope (1810-92)
Water-colour 15.9 x 12.4 (6¼ x 4$\frac{7}{8}$)
Auguste Hervieu, signed and dated 1832
Purchased, 1954

3906(b) *Called* Anthony Trollope (1815-82)
Water-colour 8.9 x 6.7 (3½ x 2$\frac{5}{8}$)
Auguste Hervieu, signed and dated 1832
Purchased, 1954

4219 *Called* George Henry Harlow (1787-1819)
Silhouette 18.1 x 13 (7$\frac{1}{8}$ x 5$\frac{1}{8}$)
Unknown artist, inscribed on mount
Given by Ernest E.Leggatt, 1910

Ormond

4235 *Called* Richard Partridge (1805-73)
Panel 20.6 x 18.4 (8$\frac{1}{8}$ x 7¼)
John Partridge, c.1840
Bequeathed by Lady Partridge, 1961

4318 *Called* Lord Charles Fitzroy
Water-colour 12.7 x 11.7 (5 x 4$\frac{5}{8}$)
Thomas Heaphy, c.1813
Purchased, 1963

4321 *Called* Sir John Fox Burgoyne (1782-1871)
Water-colour 15.9 x 12.7 (6¼ x 5)
Thomas Heaphy, c.1813
Purchased, 1963

4368c Unknown man
Pencil 9.2 x 6 (3$\frac{5}{8}$ x 2$\frac{3}{8}$)
Reginald Grenville Eves
Given by the artist's son, Grenville Eves, 1964

4503 *Called* Benjamin Disraeli, Earl of Beaconsfield (1804-81)
Water-colour 21.6 x 17.1 (8½ x 6¾)
Charles Bone, signed and dated 1828
Purchased, 1966

5074 Unknown man
Water-colour 28.6 x 15.5 (11¼ x 6$\frac{1}{8}$)
Carlo Pellegrini, signed
Acquired, 1976

5075 Unknown man
Water-colour 37.5 x 27.3 (14¾ x 10¾)
Unknown artist
Acquired, 1976

5076 Unknown man
Water-colour 29.5 x 18.4 (11$\frac{5}{8}$ x 7¼)
Unknown artist
Acquired, 1976

5218 *Called* Evelyn Waugh (1903-66)
Canvas 42.5 x 27 (16¾ x 10$\frac{5}{8}$)
Unknown artist, signed *EW* and dated 191(8 or 9)
Purchased, 1978

Index of Artists, Engravers and Photographers

Anderson, Percy (1851?-1928)
Conrad, Joseph 1985
Phillips, Stephen 4338

Anderson, Stanley (1884-1966)
Halifax, 1st Earl of 4214

Andrews, Mrs E. W.
See Harding, Emily J.

Andrews, George
Watts, George Frederic 5223 (after)

Angeli, Heinrich von (1840-1925)
Victoria, Queen 708 (after),1252 (after)

Angelis, Peter (1685-1734)
Groups: Queen Anne and Knights of the
 Garter 624

Annan & Sons, T. & R. (Thomas, 1829-87; James Craig, 1864-1946)
Belloc, Hilaire P21

Annigoni, Pietro (b.1910)
Elizabeth II 4706, 4830

Anning-Bell, Laura (1867-1950)
Guthrie, Thomas Anstey 4507
Ricketts, Charles 3108

Anthony, Charles (early 17th century)
Elizabeth I L155 (attributed to)

'Ao'
See L'Estrange

'Ape'
See Pellegrini, Carlo

Argyll, Duchess of
See Louise Caroline Alberta, Princess

Arikha, Avigdor (b.1929)
Beckett, Samuel 5100

Armfield, Maxwell (1881-1972)
Kauffer, Edward McKnight 4947, 4947A

Armstead, Henry Hugh (1828-1905)
Stanhope, 5th Earl 499 (copy by)

Arnald, George (1763-1841)
Self-portrait 5254

Arnault, M. (fl.1880)
Tennyson, 1st Baron 970 (copy by)

Arnold, Samuel James (fl.1800)
Pye, Henry James 4253

Arnold-Forster, William Edward (1885-1951)
Bateson, William 2417

Artaud, William (1763-1823)
Self-portraits 4862, 4863

Ashton, Julian Rossi (1851-1942)
Parkes, Sir Henry 1480

Ashton, Winifred
See Dane, Clemence

Asper, Hans (1499-1571)
Vermigli, Pietro 195

Athow, T. (fl.1806-22)
Sedgwick, Obadiah 2452 (copy by)

Atkinson, James (1780-1852)
Self-portrait 930
Bentinck, Lord William Cavendish 848
Conolly, Arthur 825
Cotton, Sir Willoughby 824
Flaxman, John 823
Hastings, 1st Marquess of 837
Macnaghten, Sir William Hay, Bt 749
Minto, Earl of 836
Wilson, Horace Hayman 826

Atkinson, Thomas Lewis
Jacob, John 2186A

'Atñ'
See Thompson, Alfred

Austen, Cassandra (1773-1845)
Austen, Jane 3630

Ayrton, Michael (1921-75)
Douglas, Norman 4146
Thomas, Dylan 4089
Walton, Sir William 5138

'JCB'
Tattersall, Richard 2357

'SB'
Owen, Robert 328

Bachardy, Don (b. 1934)
Auden, Wystan Hugh 4677

Bacon, John, the Elder (1740-99)
Chamberlin, Mason 2653
Mason, William 2690

Bacon, John, the Younger (1777-1859)
Knight, Richard Payne 4887
Wellesley, Marquess 992

Bacon, John Henry Frederick (1868-1914)
Spielmann, Marion Harry 4352

Bacon, Sir Nathaniel (1585?-1627)
Self-portrait 2142

Baen, Jan de (1633-1702)
William III L152(7)

Baily, Edward Hodges (1788-1867)
Beechey, Sir William 5169
Herschel, Sir John, Bt 4056
Jerrold, Douglas William 942

Johnson, Samuel 996 (copy by)
Lawrence, Sir Thomas 239,1507
 (after), 4278 (after)
Lonsdale, James 770
Newton, Sir Isaac 995 (copy by)
Smirke, Robert 4525 (attributed to)
Whewell, William 1390

Bain, W. (fl.1825-62)
Rennie, John 679 (copy by)

Baldry, Alfred Lys (1858-1939)
Boughton, George Henry 2612

Baldwin, B. (fl. 1841-5)
Abbott, Sir James 4532

Ball, Percival (fl. 1865-82)
Edwards, Amelia Ann 929

Ballantyne, John (1815-97)
Ballantyne, Robert Michael 4128
Grant, Sir Francis 5239
Hunt, William Holman 2555
Landseer, Sir Edwin 835

Bambridge, W. (of Windsor) (fl. 1850-60)
Groups: Royal mourning group P27

Banks, Thomas (1735-1805)
Hastings, Warren 209

Banner, Delmar (b. 1896)
Potter, Beatrix 3635

Bardwell, Thomas (1704-67)
Argyll, 2nd Duke of 3110
Suckling, Maurice 2010

Barker, C.F. (fl. 1845)
Lee, Sir William 471 (copy by)

Barker, Thomas Jones (1815-82)
Bancroft, Marie Effie, Lady 2122
Groups: Queen Victoria presenting
 Bible 4969

Barlin, Frederick Benjamin (fl. 1802-7)
Hirschel, Solomon 1343

Barnett, Mrs M.A. (fl. 1908-27)
Edward VII 3967

Barraud, William (fl. 1880-90)
Tennyson, 1st Baron 4343 (after)

Barret, Mary (d. 1836)
Romney, George 1881

Barrett, Jerry (1814-1906)
Nightingale, Florence 2929, 3303
 (probably by)
Groups: Study for Florence Nightingale
 at Scutari 2939A
Groups: Sketch for Florence Nightingale
 at Scutari 4305

Barry, James (1741-1806)
Self-portrait, with James Paine and
 Dominique Lefevre 213
Burke, Edmund 854 *(after)*
Johnson, Samuel 1185

Bart, T. (fl. 1816-34)
Nicholson, Charles 5200

Bartolini, Lorenzo (1777-1850)
Byron, 6th Baron 1367

Bartolozzi, Francesco (1727-1815)
Arne, Thomas Augustine 1130 *(after)*
Cheesman, Thomas 780
Gainsborough, Thomas 1107 *(copy by)*

Barton (a member of the family)
Hill, Octavia 3804

Basire, James (1730-1802)
Gray, Thomas 425 *(copy by)*

Bastien-Lepage, Jules (1848-84)
Irving, Sir Henry 1560

Bate, William (fl.1799-1845)
Bacon, John L152 (27) *(copy by)*

Batoni, Pompeo (1708-87)
Grafton, 3rd Duke of 4899
Metcalfe, Philip 2001
York, Henry Stuart, Cardinal
 129 *(after?)*

Baugniet, Charles (1814-86)
Barnett, John 1587

Baumann, Hans
See Man, Felix H.

Bauzil (or Bauziel), Juan (fl. 1800-12)
Wellington, 1st Duke of 308

Baxter, Frank (b. 1865)
Gairdner, James 2021, 2021a

Baxter, George (1804-67)
Knibb, William 4957
Williams, John 4956

Beach, Thomas (1738-1806)
Self-portrait 3143
Woodfall, William 169

Beale, Mary (1633-99)
Beale, Charles, the Elder 1279
Self-portrait 1687
Halifax, Marquess of 2962
 (attributed to)
Stillingfleet, Edward 1389
 (attributed to)
Sydenham, Thomas 3901
Turner, Francis 573
 (attributed to)
Unknown Sitters II 659
 (attributed to)

Beard, Richard (1801/2-85)
Canning, Earl P119 *(studio of)*

Edgeworth, Maria P5 *(studio of)*
Harris, 3rd Baron P117 *(studio of)*
Phillimore, Sir Robert Joseph P118
 (studio of)
Zouche, 14th Baron P116 *(studio of)*

Beare, George (fl. 1741-7)
Chubb, Thomas 1122
Price, Francis 1960

Beaton, Sir Cecil (1904-80)
Walton, Sir William P55

**Bedford, Helen Catherine (née Carter)
(1874-1949)**
Clodd, Edward 2749

Beechey, Sir William (1753-1839)
Adelaide, Queen 1533
Self-portraits 614, 3158 *(after)*
Beresford, Viscount 1180 *(after)*
Boulton, Matthew 1595 *(after)*
Bourgeois, Sir Peter Francis 231
Boydell, John 934 *(attributed to)*
Carr, John 4062
George III 2502 *(studio of)*
Halford, Sir Henry, Bt 1068
Hope, Thomas 4574
Hutton, Henry 2768
Kent and Strathearn, Duke of 647
Nelson, Viscount L129
Paley, William 145 *(copy by)*
Rose, George 367
St Albans, Duchess of 1915
St Vincent, Earl of 2222 *(studio of)*
Sandby, Paul 1379
Sandby, Thomas 1380
Siddons, Sarah 5159

**Beerbohm, Sir Max (Henry Maximilian)
(1872-1956)**
Self-portrait 5107
Lloyd-George, 1st Earl 3252
Macdonald, James Ramsay 4665
Collections: Caricatures 3851-8

Behnes, William (1794-1864)
Arnold, Thomas 168
Bunting, Jabez 4880
Cruikshank, George 1300
Macready, William Charles 1504
Morgan, Sydney, Lady 1177
Sidmouth, 1st Viscount 3917
Stowell, Baron 125
Tierney, George 173

Bell, Edith Anna (fl. 1896-1912)
Northcliffe, 1st Viscount 4101

Bell, Vanessa (1879-1961)
Woolf, Leonard Sidney 4695

Bell, William (1740?-1804?)
Harrison, Robert 4898

Belle, Alexis Simon (1674-1734)
Bolingbroke, 1st Viscount 593
 (attributed to)

James Francis Edward Stuart, Prince
 273 *(after)*, 348 *(studio of*
Law, John 191 *(attributed to)*

Belsky, Franta (b. 1921)
Day-Lewis, Cecil 5068
Philip, Prince 5268

Benazech, Charles (1767-94)
Westmacott, Sir Richard 731

Bennett, Frank Moss (1874-1953)
Martin, Sir Theodore 1555

Bennett, Mary, Lady
See Edis, Mary

Bentley, Nicolas Clerihew (1907-78)
Hastings, Sir Patrick 4339

**Beresford, E. (probably Elizabeth)
(fl.c. 1814)**
Beresford, Viscount 1180 *(copy by)*

Beresford, George Charles (1864-1938)
Hardie, James Keir 2542 *(after)*

Bernadis, Lalogero di (fl. 1820)
Webb, Philip Barker 4327

Besnard, Paul Albert (1849-1934)
Wolseley, 1st Viscount 1789

Bestland, Charles (fl. 1783-1837)
Malmesbury, 1st Earl of L152(29)
 (copy by)

**Bettes, John, the Elder (fl. 1531;
d. before 1576)**
Wentworth, 1st Baron 1851
 (attributed to)

Bevan, Robert Polhill (1865-1925)
Self-portrait 5201
Bevan, Stanislawa 5202

Bevis, Leslie Cubitt (b.c. 1891)
Gaitskell, Hugh 4530

Bewick, William (1795-1866)
Hazlitt, William 2697
Nasmyth, Patrick 350

Bezzi, A. (fl. 1850-3)
Sayers, Tom 2465, 2465a

Bindon, Francis (c.1700-65)
Boulter, Hugh 502 *(after)*

Bingguely-Lejeune, Ginette (fl. 1937-40)
Kipling, Rudyard 2955

'Bint' (Vanity Fair cartoonist)
Wenlock, 3rd Baron 2971

Birch, Charles Bell (1832-93)
Carlyle, Thomas 2520
Foley, John Henry 1541
Grant, Sir Francis, and Sir Edwin
 Landseer 2521

Continued overleaf

Macdonald, Sir John Alexander 1550
Parker, Joseph 2073
Collections: Royal Academicians
 2473-9

Birley, Sir Oswald (1880-1952)
Birkenhead, 1st Earl of 2552
George V 4013
Marsh, Sir Edward 3945
Philpot, Glyn 3651

Bishop, Henry (1868-1939)
Carpenter, Edward 3832

Blackburn, Mrs Hugh
See Wedderburn, Jemima

Blake, William (1757-1827)
Varley, John 1194

Blanche, Jacques-Emile (1861-1942)
Beardsley, Aubrey 1991
Granville-Barker, Harley 3842
Joyce, James 3883
Sickert, Walter Richard 4761
Trefusis, Violet 5229

Blandy, Louise Virenda (fl.1880-94)
Mackinlay, Antoinette 2774

Blondeau, Peter (fl.1656-64)
Cromwell, Oliver 4068

Blyenberch, Abraham van (fl.1617-22)
Charles I 1112 (attributed to)
Jonson, Benjamin 363 (after), 2752
 (after)

Boeckhorst, Johann (fl.1659)
Gloucester, Duke of 1932 (after)

Boehm, Sir Joseph Edgar, Bt (1834-90)
Beaconsfield, Earl of 860,1760
Bright, John 868
Carlyle, Thomas 658,1623 (after)
Cole, Sir Henry 865
Darwin, Charles Robert 761
Gordon, Charles George 864
Hughes, Thomas L122
Iddesleigh, 1st Earl of 861
Johnson, Samuel 621, 621a
Lawrence, 1st Baron 786
Lecky, William Edward Hartpole 1360
Leech, John 866
Millais, Sir John Everett, Bt 1516
Napier of Magdala, 1st Baron 863
Newton, Sir Charles Thomas 973
Ruskin, John 1053
Russell, 1st Earl 4291
Shaftesbury, 7th Earl of 862
Smith, Henry 787
Spencer, Herbert 1359
Stanley, Arthur Penrhyn 867
Stratford de Redcliffe, Viscount 791
Tait, Archibald Campbell 859
Thackeray, William Makepeace 495a
 (copy by), 620 (copy by), 620a
 (copy by), 1282
Toynbee, Arnold 2486
Victoria, Queen 858

Whyte-Melville, George John 3836
Wolseley, 1st Viscount 1840

Bogle, John (c. 1746-1803)
Prescott, Robert 3963

Bogle, William Lockhart (d.1950)
Beaconsfield, Earl of 925 (copy by)

Boit, Charles (1662-1727)
Anne, Queen L152(20)
William III 1737

Boldini, Giovanni (1842-1931)
Campbell, Lady Colin 1630

Bomberg, David (1890-1957)
Self-portraits 4522, 4821

Bonavia, George (fl.1851-76)
Tylor, Sir Edward Burnett 1912

Bone, Charles (fl.1828)
Unknown Sitters IV 4503

Bone, Henry (1755-1834)
Bloomfield, Robert 1644 (copy by)
Charlotte Sophia of Mecklenburg-Strelitz
 L152(28)

Bone, Henry Pierce (1779-1855)
Nelson, Viscount L152(32) (copy by)
Wellington, 1st Duke of L152(35)
 (copy by)

Bone, Stephen (1904-58)
Walpole, Sir Hugh 3841

Bonham Carter, Sibella (b.1899)
Vaughan Williams, Ralph 5022

Bonington, Richard Parkes (1801-28)
Self-portrait 1729

Bonomi, Joseph (1796-1878)
Livingstone, David 386

Boonham, Nigel (living)
Keynes, Sir Geoffrey 5182

Borden, Mary (Lady Spears) (1886-1968)
Spears, Sir Edward 5099

Borrow, John Thomas (1800-33)
Borrow, George 1651

Bouch (fl.1797)
St Vincent, Earl of 167a

Bourdelle, Emile Antoine (1861-1929)
Frazer, Sir James George 2099

Bourdon, Sebastien (1616-72)
Chiffinch, Thomas 816 (attributed to)

Bowcher, Frank (1864-1938)
Hooker, Sir Joseph Dalton
 2033, 2276

Meldola, Raphael 1943
Ross, Sir Ronald 3646

Bower, Edward (fl.1635-67)
Pym, John 1425 (after)

Bower, George (1650-90)
Groups: Seven Bishops 152a

Bowles, James (fl.1852-73)
Gomm, Sir William Maynard 1071

Boxall, Sir William (1800-79)
Cox, David 1986
Cubitt, Lewis 4099
Fielding, Antony Vandyke Copley 601
Lewis, John Frederick 1470
Wordsworth, William 4211

Brackenbury, Georgina (d.1949)
Dillon, 17th Viscount 2623
Pankhurst, Emmeline 2360

Bradley, William (1801-57)
Smart, Sir George Thomas 1326
Swain, Charles 4014

Bramley, Frank (1857-1915)
Abel, Sir Frederick Augustus 4926

Brandon, Jacques Emile Edouard (1831-97)
Nesfield, William Eden 1193

Brangwyn, Sir Frank (1867-1956)
East, Sir Alfred 4826

Bray, Caroline (1814-1905)
Cross, Mary Ann 1232
Evans Robert 1232a (copy by)

Breda, Carl Frederik von (1759-1818)
Clarkson, Thomas 235
Ramsay, James 2559
Watt, James 186a

Brett, Hon Dorothy Eugénie (1883-1977)
Lawrence, David Herbert 4015

Bridell, Eliza Florence (née Fox and afterwards Mrs Fox) (d.1904)
Fox, William Johnson 1374

Bridgford, Thomas (1812-78)
Mahon, Charles James Patrick 4584
 (probably by)

Briggs, Henry Perronet (1793-1844)
Cayley, Sir George, Bt 3977
Codrington, Sir Edward 721
Harding, James Duffield 1781
Smith, Sydney 1475

Bright, Beatrice (1861-1940)
Canning, Sir Samuel 4925
Comper, Sir John Ninian 4808

Brigstocke, Thomas (1809-81)
Holland, Sir Henry, Bt 1656

Cohen, Minnie Agnes (b.1864)
Ashton, William George 1775
Law, Andrew Bonar 2358
Swan, Sir Joseph Wilson 1781c

'Coidé'
See Tissot, James Jacques

Cole, Alpheus Philemon (1876-c.1967)
Arnold, Sir Edwin 2455
Orchard, William Edwin 4466

Cole, Herbert (1867-1930)
Pankhurst, Sylvia 4244

Cole, S. (fl.1815)
Wood, Sir George Adam 3990
(attributed to)

Collen, Henry (b.1798)
Avery, John 1893 (attributed to)
Langdale, Baron 1773
Vernon, Robert 4513

Coller, Henry (fl.1933)
Pethick-Lawrence, 1st Baron 4275

Collier, John (1850-1934)
Burns, John 3170
Chirol, Sir Ignatius Valentine 4271
Clifford, John 2037
Clifford, William Kingdon 1231
Darwin, Charles Robert 1024
Foster, Sir Michael 1869
Huggins, Sir William 1682
Huxley, Thomas Henry 3168
Inglefield, Sir Edward 2500
Shaftesbury, 7th Earl of 1728
Smith, George 1620
Williams, Sir George 2140

Collier, Marian (née Huxley) (1859-87)
Burton, Sir Richard Francis 3148
Darwin, Charles Robert 3144
Huxley, Thomas Henry 3145, 3147
Lecky, William Edward Hartpole 3146

Collins, Mrs (fl.c.1801)
Austen, Jane 3181 (perhaps by)

Collins, Arthur
May, Philip William (Phil) 2751

Collins, Charles Allston (1828-73)
Collins, William 1643

Colquhoun, Ithell (b.1906)
Payne, Humfry Gilbert Garth 5269

Colquhoun, Robert (1914-62)
Self-portrait 4872

Colson, Jean François (1733-1803)
Foote, Samuel 4904

Colte, Maximilian (fl.1596-1641)
Elizabeth I 357 (after)

Conder, Charles (1868-1909)
Self-portrait 4556
Dowson, Ernest 2209

Connard, Phillip (1875-1958)
Self-portrait 4702
Meyerstein, Edward 4326

Conner, Angela (living)
Macmillan, Harold 5133

Constable, John (1776-1837)
Self-portrait 901

Cooke, George
Cobbett, William 1549 (possibly by)

Cooke, John (d.1932)
Curzon of Kedleston, Marquess 2534
(copy by)

Cooley, Thomas (1795-1872)
Collections: Sketchbook studies
4913(1-4)

Cooper, Alexander (c.1605-60)
Pembroke, 4th Earl of 4614
(attributed to)

Cooper, Alexander Davis (fl.1837-88)
Cockburn, Sir Alexander, Bt 933

Cooper, Alfred Egerton (1883-1974)
Brabazon of Tara, 1st Baron 4442

Cooper, Alfred William (fl.1850-1901)
Keene, Charles Samuel 2771

Cooper, Robert (fl.1795-1836)
Dancer, Daniel 4369 (attributed to)

Cooper, Samuel (1609-72)
Albemarle, 1st Duke of 154 (after)
Self-portrait 2891 (after)
Cromwell, Oliver 514 (after),
588 (after), 2426 (after drawing
attributed to), 3065, 5274
(attributed to)
Fleetwood, George 1925
Ireton, Henry 3301 (after)
Lauderdale, 1st Duke of 4198
Lenthall, William 2766
Tyrconnel, Duchess of 5095

Cooper, Thomas George (fl.1844-98)
Leslie, Henry David 2522

Cope, Sir Arthur Stockdale (1857-1940)
Carpenter, Alfred Francis Blakeney
3971
Chaplin, 1st Viscount 4865
Knutsford, 1st Viscount 2947
Perkin, Sir William Henry 1892
Pitman, Sir Isaac 1509
St Aldwyn, 1st Earl 2948
Groups: Naval Officers 1913

Cope, Charles West (1811-90)
Palmer, Samuel 2155
Turner, Joseph Mallord William 2943
Collections: Artists 3182(1-19)

Copley, John Singleton (1737-1815)
Heathfield, Baron 170

Mansfield, 1st Earl of 172
Spencer, 2nd Earl 1487

Corbould, Walton
Keene, Charles Samuel 1337

Cornish, John (fl.1750)
Granger, James 2961

Corvus, Johannes (fl.1528-45)
Foxe, Richard 874 (after)

Costa, James D. (fl.1891)
Fitzpatrick, Sir Dennis 4038

Costanzi, Placido (c.1690-1759)
Marischal, 10th Earl 552 (attributed to)

Cosway, Richard (1742-1821)
Bloomfield, Robert 1644 (after)
Self-portraits 304, 1678
Damer, Anne Seymour 5236
Hamilton, Emma, Lady 2941
Hastings, Warren L152(24)
Mulgrave, 1st Earl of 2630
(attributed to)

Cotes, Francis (1725?-70)
Hamilton and Argyll, Duchess of 4890
Romaine, William 2036
St Vincent, Earl of 2026

Couriguer, Joseph Anton (1750-1830)
Nash, John 2778

Cousins, Samuel (1801-87)
Kean, Edmund 1829

Couzens, Charles (fl.1838-75)
A Beckett, Gilbert Abbott 1362
(attributed to)

Covell, Miss S. E. (fl.1812)
Jay, William 1793

Coxeter, Mrs H.
See Gee, Lucy

Coysevox, Antoine (1640-1720)
Prior, Matthew L152(10) (after)

Crosse, Lawrence (1650-1724)
Brett, Henry L152(43)
Dorchester, Countess of 1696
Winchilsea, Countess of 4692
Wycherley, William L152(18)
(attributed to)

Crossland, John Michael (1800-58)
Sturt, Charles 3302

Crowe, Eyre (1824-1910)
Pinwell, George John 4496

Crowhurst of Brighton
George IV, and Duke of York and Albany
1691a

Cruikshank, Frederick (1800-68)
Palmerston, 3rd Viscount 3953

Cruikshank, George (1792-1878)
Collections: George Cruikshank and
 others 4259

Cruikshank Isaac (1756-1810)
Pitt, William 2103B

Cruikshank, Isaac Robert (1789-1856)
Charlotte Sophia of Mecklenburg-Strelitz
 2788
Groups: Members of House of Lords
 2789 *(attributed to)*

**Cruikshank, William Cumberland
(1745-1800)**
Johnson, Samuel 498A *(after)*, 498B
 (after), 4685 *(after)*

Cundall, Downes & Co (Cundall & Co)
Collections: Prints from two albums
 P31-40

Cure, Cornelius and William (fl.1606-16)
Mary, Queen of Scots 307 *(after)*,
 307A *(after)*, 307B *(after)*

Curran, Amelia (d.1847)
Shelley, Percy Bysshe 1234, 1271
 (after)

Custodis, Hieronimo (fl.1589)
Fleming, Sir Thomas 1799 *(circle of)*
Harrington, Sir John 3121
 (attributed to)

'F.T.D'
See Dalton, F. T.

'M.D.' or 'Montbard'
See Loye, Charles Auguste

Dadd, Richard (1817-86)
Self-portrait 5181

Dahl, Michael (1656-1743)
Addison, Joseph 714
Self-portrait 3822
George of Denmark, Prince 4163
 (by or after)
Hardwicke, 1st Earl of 872 *(studio of?)*
Locke, John 114
Ormonde, 2nd Duke of 78 *(by or after)*
Pope, Alexander 4132 *(studio of)*
Pratt, Sir John 480 *(after?)*
Prior, Matthew 3682 *(attributed to)*
Rooke, Sir George 1992 *(studio of)*
Shovell, Sir Clowdisley 797
Suffolk, Countess of 2451
 (after painting attributed to)
Wynn, Sir Watkin Williams, Bt 2614
Unknown Sitters II 712

Dalton, F. T. ('F.T.D.') (fl.1890)
Creighton, Mandell 2706
Farwell, Sir George 3273
Leach, Sir George Archibald 2974
Londonderry, 6th Marquess of 2964

Damer, Anne Seymour (1749-1828)
Derby, Countess of 4469

Dance, George (1741-1825)
Abernethy, John 1253
Arnold, Samuel 1135
Bannister, John 1136
Beaumont, Sir George Howland, Bt
 1137
Bligh, William 1138
Boswell, James 1139
Burney, Charles 1140
Cobb, James 3900
Combe, William 2029
Self-portrait 2812
Dance, William 3058
Englefield, Sir Henry, Bt 1142
Hoole, John 1143
Hull, Thomas 3899
Inchbald, Elizabeth 1144
Incledon, Charles 1145
Jekyll, Joseph 1146
Jessop, William 1147
Londonderry, 2nd Marquess of 1141
Marsden, William 4410
Moore, John 1148
Munden, Joseph Shepherd 1149
Mylne, Robert 1150
Orford, 4th Earl of 1161
Palmer, John 4929
Partington, Miles 4205
Piozzi, Gabriel 1152
Piozzi, Hester Lynch 1151
Rennell, James 1153
Rennie, John 1154
Robinson, Mary 1254
Rogers, Samuel 1155
Seward, William 1157
Sharp, Granville 1158
Shield, William 1159
Steevens, George 1160
Stowell, Baron 1156
Young, Arthur 1162
Collections: Tracing of drawings
 3089(1-12) *(after)*

**Dance, Nathaniel (Sir Nathaniel
Dance-Holland) (1735-1811)**
Brown, Lancelot 1490, L107
Camden, 1st Earl 336
Clive, 1st Baron 39 *(studio of?)*
Self-portrait 3626
Garrick, David 3639
Garrick, Eva Maria 3640
Guilford, 2nd Earl of 276 *(after)*, 3627
Le Despencer, 15th Baron 1345
 (attributed to)
Murphy, Arthur 10

Dandridge, Bartholomew (1691-c.1754)
Frederick Lewis, Prince, and his groom
 of the bedchamber 1164
Hooke, Nathaniel 68
Kent, William 1557

**Dane, Clemence (Winifred Ashton)
(d.1965)**
Coward, Sir Noel 4950, 4951

Daniell, William (1769-1837)
Collections: Tracings of drawings
 3089(1-12)

Danloux, Henri Pierre (1753-1809)
Duncan, 1st Viscount 1084

Danton, Jean-Pierre (1800-69)
Cumberland, Duke of, and 2nd Duke of
 Gloucester L167
Rogers, Samuel 3888

Darvall, Henry (fl.1848-89)
Robinson, Henry Crabb 1347

David, Antonio (1684?-1750)
Charles Edward Stuart, Prince 434
 (studio of)
York, Henry Stuart, Cardinal 435
 (studio of)

David D'Angers, Pierre Jean (1788-1856)
Bowring, Sir John 1082
Opie, Amelia 1081

Davis, J. Pain ('Pope Davis') (1784-1862)
Wellesley, Marquess 846, 847

Davis, Joseph Barnard (1861-1943)
Goodall, Frederick 3257

Davison, Jeremiah (c.1695-after 1750)
Forbes of Culloden, Duncan 61 *(after)*
Torrington, Viscount 14 *(attributed to)*

Davison, William (fl.1813-43)
Kenyon, 1st Baron 469 *(copy by)*
Lindley, Robert 1952

Dawe, George (1781-1829)
Charlotte Augusta, Princess 1530 *(after)*
Charlotte Augusta, Princess, and Prince
 Leopold 51
Cumberland, Duke of 3309
Parr, Samuel 9

Dawe, Henry (1790-1848)
William IV 1163 *(after)*

Day, John George (1854-1931)
Carson, 1st Baron 2916
Redmond, John Edward 2916a

Day, Thomas (c.1732-1807?)
Fox, Charles James L152(30)

Dayes, Edward (1763-1804)
Self-portrait 2091
Groups: Plenipotentiaries L152(1)

Deane, Emmeline (d.1944)
Newman, John Henry 1022

De Baen, Jan
See Baen, Jan de

De Bathe, Adolphe (fl.1890)
Victoria, Queen 4042
Victoria Eugénie Julia Ena of Battenberg,
 Princess 4043

De Brie, Anthony (fl.1912)
Halifax, 1st Viscount 1677 *(copy by)*

De Coning, Daniel (1660-after 1720)
King of Ockham, 1st Baron 470

De Critz, Emmanuel (1605?-65)
Tradescant, John, the Younger 1089
 (attributed to)

De Critz, John, the Elder (c.1555-1641)
Dorset, 1st Earl of 4024 *(attributed to)*
James I 548 *(after)*
Salisbury, 1st Earl of 107, 1115 *(after)*
Walsingham, Sir Francis 1704 *(after?)*,
 1807 *(attributed to)*

De Glehn, Wilfred Gabriel (1870-1951)
Quilter, Roger 3904

**De Laszlo, Philip (Philip Alexius László
de Lombos) (1869-1937)**
Balfour, 1st Earl of 2497
Byng, 1st Viscount 3786
Fildes, Sir Luke 4960
Haldane, Viscount 2364
Henschel, Sir George 4935
Inge, William Ralph 4856
Jerome, Jerome Klapka 4491
Lansdowne, 5th Marquess of 2180
Petrie, Sir William Matthew 4007
Pulteney, Sir William Pulteney 4236

Delfico, Melchiorre (1825-95)
Galloway, 10th Earl of 3274
Reuter, Baron 3275

De La Tour, Maurice Quentin
See La Tour, Maurice Quentin de

De Liege, Jean (fl.1367)
Philippa of Hainault 346 *(after)*

**De Lisle, Edith Fortunée Tita
(1866-1911)**
Lardner, Dionysius 1039

**De Loutherbourg, Philip James
(1740-1812)**
Self-portrait 2493

Demanet, Victor (b.1895)
Chamberlain, Arthur Neville 4268

De Neve, Cornelius (1612?-78?)
Unknown Sitters II 1346

Denham, Joseph (1803-54)
Richmond, George 2157, 2157a

Denner, Balthasar (1685-1749)
Handel, George Frederick 1976
 (attributed to)

Derby, William (1786-1847)
Strange, Lord 2424 *(copy by)*

De Saulles, George William (1862-1903)
Stokes, Sir George Gabriel, Bt 2758

Des Granges, David (1611/13-75?)
Charles I 1924 *(copy by)*
Charles II L152(14) *(copy by)*

De Strobl, Sigismund (1884-1975)
Chamberlain, Sir Joseph Austen 5059

Detmold, Charles Maurice (1883-1908)
Detmold, Edward Julius 3037

Detmold, Edward Julius (1883-1957)
Detmold, Charles Maurice 3036

Deuchars, Louis (1870-1927)
Watts, George Frederic 5223 *(copy by)*

De Vaere, John (1755-1830)
Duncan, 1st Viscount L152(8)
Howe, 1st Earl 3313 *(after)*

Devas, Anthony (1911-58)
Hayward, John 4475

De Veaux, John (fl.1821-36)
William IV 2920
York and Albany, Duke of 2921

Deville, James S. (1776-1846)
Blake, William 1809, 1809a
Owen, Robert 602 *(after)*
Thackeray, William Makepeace 620
 (after), 620a *(after)*

Devis, Arthur (1708-87)
Burrow, Sir James 3090(8) *(after)*
Groups: Downshire family L160

Devis, Arthur William (1763-1822)
Amherst, 1st Earl 1546 *(after)*
Herbert, John 547
Wardle, Gwyllym Lloyd 4265
Wood, Sir Matthew, Bt 1481

**Devonshire, Elizabeth, Duchess of
(d.1824)**
Wolfe, James 688

De Wilde, Samuel (1748-1832)
Neild, James 4160

Dick, Sir William Reid (1879-1961)
Blomfield, Sir Reginald 3929
Duveen, Baron 3062
George VI 4114
Mary Victoria of Teck 4164

Dickinson, Lowes Cato (1819-1908)
Cobden, Richard 316
Cross, Mary Ann 4961
Dickinson, Goldsworthy Lowes 4293
Hare, Thomas 1819
Kingsley, Charles 2525
Lyell, Sir Charles, Bt 1387
Russell, 1st Earl 5222
Stanley, Arthur Penrhyn 1536
Tait, Archibald Campbell 1431
Groups: Gladstone's Cabinet 5116

Diet, Leo (b. 1857)
Unknown Sitters IV 1474

Diez, Samuel (1803-73)
Melbourne, 2nd Viscount 3103

Digby, Simon (d. 1720)
Hough, John 3685

Dighton, Joshua (fl. 1820-40)
Bentinck, Lord Henry William 3553

Dighton, Richard (1795-1880)
Braham, John 1637
Denham, Sir James Steuart, Bt 2756
Keate, John 1116
Unknown Sitters IV 1836a
 (attributed to)

Dighton, Robert (1752?-1814)
Self-portrait 2815
Dundas, Sir David 982(d)
Moore, John 982(e)

**Dillon, Harold (17th Viscount Dillon)
(1844-1932)**
Wolfe, James 713a *(copy by)*

Dixon, Nicholas (fl.1660-1708)
Cutts, Baron L152(19)
Weymouth, 1st Viscount L152(17)
 (copy attributed to)

Dobson, Frank (1888-1963)
Oxford and Asquith, 1st Earl of 4387

Dobson, Henry Raeburn (b.1901)
Gregory, Sir Richard Arman 5117

Dobson, William (1610-46)
Self-portrait 302 *(after)*
Gage, Sir Henry 2279 *(perhaps after)*
Van der Doort, Abraham 1569
 (perhaps after)
Unknown Sitters II 288, 615

Dodd, Daniel (fl.1763-c.1791)
Lewis, Sir Watkin 2439 *(by or after)*

Dodd, Francis (1874-1949)
Alexander, Samuel 4422
Baker, Charles Henry Collins 4355
Baldwin, 1st Earl 4425
Barnett, Samuel Augustus 4419
Bone, Sir Muirhead 3079, 3079a, 4028
Booth, William 1783A
Cave, Viscount 4421
D'Abernon, 1st Viscount 3862
Don, Alan Campbell 4539
Evans, Sir Arthur John 3540
Fisher, 1st Baron 3080
Henley, William Ernest 4420
Holden, Charles 4173, 4427
Housman, Alfred Edward 3075
Lee, Sir Sidney 4423
MacColl, Dugald Sutherland 4424
Moore, George 2673
Rutherford, Baron 4426
Scott, Charles Prestwich 3997
Smith, Arthur Lionel 3996
Trevelyan, George Macaulay 4287
Woolf, Virginia 3802
Wright, Sir Almroth Edward 4127

Dodgson, Charles Lutwidge ('Lewis Carroll') (1832-98)
Rossetti, Dante Gabriel P29
Ruskin, John P50
Ward, Mary Augusta P69
Groups: Rossetti family P56
Collections: Lewis Carroll at Christ Church P7(1-37)
Collections: Prints from two albums P31-40

Donald-Smith, Helen (fl.1883-1930)
Grove, Sir William Robert 1478
Mackay, Mary 4891

Dongworth, Winifred Cécile (1893-1975)
Collections: Miniatures 5027-36

D'Orsay, Alfred, Count (1801-52)
D'Israeli, Isaac 3772
Self-portrait 3548
Greville, Charles Cavendish Fulke 3773
Lind, Johanna Maria 2204
Reeve, Henry 4372
Wellington, 1st Duke of 405
Collections: Men about Town 4026(1-61)

Doughty, William (1757-82)
Self-portrait 2513
Mason, William 4806

Douglas, Sir William Fettes (1822-91)
Faed, Thomas 4840

Downey, W. & D. (fl.1850s)
Hughes, Arthur P30 *(possibly by)*
Collections: Balmoral Album P22(1-27)

Downman, John (1750-1824)
Cole, Thomas 1719A
Derby, Countess of 2652
D'Israeli, Isaac 4079
Mangnall, Richmal 4377
Milles, Jeremiah 4590
Mulgrave, 2nd Baron 966
Siddons, Sarah 2651
West, Benjamin L152(2)
Unknown Sitters III 1679

Doyle, Henry Edward (1827-92)
Doyle, John 2130
Wiseman, Nicholas Patrick Stephen 2074 *(attributed to)*, 4237

Doyle, Richard (1824-83)
Wiseman, Nicholas Patrick Stephen 4619 *(attributed to)*
Unknown Sitters IV 3118

Drake, Wilfred
Unknown Sitters I 2421

Dressler, Conrad (1856-1940)
Ruskin, John 2030
Walpole, Spencer Horatio 5215

Droeshout, Martin (1601-50?)
Shakespeare, William 185

Drummond, Rose Myra (fl.1832-49)
Kean, Charles John 2524 *(attributed to)*

Drummond, Samuel (1765-1844)
Brunel, Sir Marc Isambard 89
Ellenborough, 1st Baron 1123
Fry, Elizabeth 118
Gully, John 4817
Parry, Sir William Edward 5053
Place, Francis 1959

Dryden, Sir Henry, Bt (1818-99)
Phillipps, Sir Thomas, Bt 3094

Dugdale, Thomas Cantrell (1880-1952)
Bevin, Ernest 3921
Self-portrait 3919

Dügy, S.J.
Unknown Sitters II 1771

Du Maurier, George (1834-96)
Ainger, Alfred 2660
Self-portrait 3656

Dunbar, David (1792-1866)
Darling, Grace 998

Duncan, Mary (1885-1968)
Russell, George William 3980
Stephens, James 3989

Duncan, Thomas (1807-45)
Dalhousie, 11th Earl of 2537

Dunkarton, Robert (1744-1811?)
Henderson, John 1919

Dunn, Henry Treffry (1838-99)
Rossetti, Dante Gabriel, and Theodore Watts-Dunton 3022

Dunstan, Bernard (b.1920)
Groups: Kathleen Ferrier at a Concert 5043
Collections: Studies of Kathleen Ferrier 5040(1-8)

Duplessis, Joseph Siffred (1725-1802)
Franklin, Benjamin 327 *(after)*

Dupont, Gainsborough (1754-97)
Lewis, William Thomas 5148

Duppa, Bryan Edward (fl.1832-53)
Trelawny, Edward John 2882, 2883

Dupré, Augustin (1748-1833)
Jones, John Paul 4022 *(copy by)*

Durade, François D'Albert (1804-86)
Cross, Mary Ann 1405

Durand, André (b.1942)
Bowen, Elizabeth 5134

Durant, Susan D. (d.1873)
Collections: Queen Victoria and family 2023A(1-12)

Durham, Joseph (1814-77)
Knight, Charles 393
Pollock, Sir George, Bt 364
Thackeray, William Makepeace 495, 495a *(after)*

Du Val, Charles Allen (1808-72)
Milner-Gibson, Thomas 1930

Dyce, William (1806-64)
Cole, Sir Galbraith Lowry 946

Dyer, Alfred Edmund (fl.1927)
Oglethorpe, James Edward 2153a *(copy by)*

Earl, Ralph (1751-1801)
Kempenfelt, Richard 1641

Earl, Thomas (fl.1836-85)
Thompson, William 4191

Earlom, Richard (1742/3-1822)
Wilkes, John 284

Eastlake, Elizabeth (née Rigby), Lady (1809-93)
Nightingale, Florence 3254

Easton, Reginald (1807-93)
Guthrie, George James 932
William IV 4703

Eccardt, John Giles (d.1779)
Grammont, Countess of 20 *(copy by)*
Gray, Thomas 989
Holland, 1st Baron 2078 *(copy by)*
Middleton, Conyers 626
Orford, 4th Earl of 988
Williams, Sir Charles Hanbury 383 *(attributed to)*

Eckstein, John (c.1770-after 1803)
Smith, Sir William Sidney 832

Eddis, Eden Upton (1812-1901)
Chantrey, Sir Francis 1731
Hook, Theodore Edward 37

Edis, Mary (Lady Bennett) (d.1976)
Despard, Charlotte 5007

Edmeads, Louisa (née Grimaldi) (1795-1873)
Grimaldi, William 3114 *(after)*

Edouart, Augustin (1789-1861)
Liston, John 3098 *(by or after)*
More, Hannah 4501
Scott, Sir Walter, Bt 1638
Sedgwick, Adam 4502

Edridge, Henry (1769-1821)
Anglesey, 1st Marquess of 313
Auckland, 1st Baron 122
Bentham, Samuel 3069
Bloomfield, Robert 2926
Chalmers, George 2196

Coke, Thomas 1434a
Farnborough, 1st Baron 4046
Fellowes, Robert L152(36)
Foley, Sir Thomas 1459
Frere, John Hookham 1473
Gwynn, Mary 3152
Mitford, William 1706A *(after)*
Nelson, Viscount 879
Park, Mungo 1104 *(after)*
Sheffield, 1st Earl of 2185
Sheffield, Countess of 2185a
Southey, Robert 119
Vincent, William 1434

Egg, Augustus Leopold (1816-63)
Unknown Sitters IV 1578

Egley, William (1798-1870)
Sydney, 3rd Viscount L152(38)
Sydney, Viscountess L152(39)

Egmont, Justus van (1601-74)
Sidney, Algernon 568 *(after)*

Egon, Nicholas
William, Prince, of Gloucester L153

Elkington & Co
Thackeray, William Makepeace 620a
 (copy by)

Elliot & Fry (founded 1864)
Cruikshank , George 3150 *(after)*

Ellison, Miss E. M. (1863-1954)
Parratt, Sir Walter 4944

Emslie, Alfred Edward (1848-1918)
Gladstone, William Ewart 3898
Groups: Dinner at Haddo House 3845

Engleheart, George (1752-1829)
Self-portrait 2753

Engleheart, John Cox Dillman (1783-1862)
Self-portrait 2754
O'Brien, Eliza Bridgeman 1681A

Engleheart, Thomas (1745-86)
Kent and Strathearn, Duke of 207

Epstein, Sir Jacob (1880-1959)
Conrad, Joseph 4159
Davies, William Henry 3885
Eliot, Thomas Stearns 4440
Self-portrait 4126
Freud, Lucian 5199
Graham, Robert Bontine Cunninghame 4220
John, Augustus 4295
Macdonald, James Ramsay 2934
Shaw, George Bernard 4047
Vaughan Williams, Ralph 4762

Evans, Mrs D. T.
See Hewer, Charlotte

Evans, David (1894-1959)
Ashby, Thomas 4281

Galsworthy, John 4208
Walpole, Sir Hugh 4282

Evans, Frederick Henry (1852-1943)
Beardsley, Aubrey P114, P115
Shaw, George Bernard P113
Symons, Arthur William P104

Evans, Powys (b.1899)
Bax, Sir Arnold 4400
Cochran, Sir Charles 4460
Darwin, Bernard 4462
Davies, William Henry 4396
Epstein, Sir Jacob 4397
Greaves, Walter 4394
Holmes, Sir Charles John 3307
Knox, Ronald Arbuthnot 4403
Lamb, Henry 4401
Melchett, 1st Baron 5062
Milne, Alan Alexander 4399
O'Casey, Sean 4402
Powys, Theodore Francis 4461
Priestley, John Boynton 5109
Scott, Sir Giles Gilbert 4398
Whibley, Charles 4395
Williamson, Henry 5110

Evans, Richard (1784-1871)
Bradshaw, George 2201
Canning, George 1338 *(completed by)*
Lawrence, Sir Thomas 260 *(copy by)*
Martineau, Harriet 1085
Taylor, Thomas 374 *(copy by)*
Thurlow, Baron 395 *(attributed to)*

Evans, Sebastian (1830-1909)
Collections: Book of Sketches
 2173(1-70)

Evans, William (fl.1797-1856)
Barry, James 441
Beechey, Sir William 3158 *(copy by)*

Eves, Reginald Grenville (1876-1941)
Auchinleck, Sir Claude 4639
Baldwin, 1st Earl 3551
Beerbohm, Sir Max 4000
Benson, Sir Frank Robert 3777
Chatfield, 1st Baron 4602
Elizabeth, Queen 4145
Self-portrait 3826
George VI 4144
Hardy, Thomas 2498
Howard, Leslie 3827
Jellicoe, 1st Earl 2799
Newall, 1st Baron 4356
Pollock, Sir Frederick, Bt 3835
Scott, Sir Giles Gilbert 4171
Shackleton, Sir Ernest Henry 2608
Sherrington, Sir Charles Scott
 3828, 3829
Shortt, Edward 4368a, 4368b
Watson, Sir William 3839
Windsor, Duke of 4138, 4169
Unknown Sitters IV 4368c

Ewald, Clara (1859-1948)
Brooke, Rupert 4911

Eworth, Hans (fl.1540-73)
Heath, Nicholas 1388

Mary I 4861
Montague, 1st Viscount 842

'Eye'
See Hodgson, W. W.

Faber, John (1684-1756)
Haselden, Thomas 4122 *(after)*

Fabre, François Xavier (1766-1837)
Holland, 3rd Baron 3660

Fagnani, Giuseppe (1819-73)
Cobden, Richard 201
Dalling and Bulwer, Baron 852

Fairfield, A. R. (1861-87)
Dobson, Austin 2208

Faiththorne, William (1616-91)
Fairfax of Cameron, 3rd Baron 3624
Milton, John 610

Faulkner, Benjamin Rawlinson (1787-1849)
Children, John George 5151

Faulkner, Robert (fl.1845-62)
Landor, Walter Savage 2658

Fawkes, Lionel Grimston (1849-1931)
Marsh, Catherine 2365
Pollock, Sir George, Bt 2459

Felici, Vincenzo (fl.1701-7)
Egmont, 1st Earl of 1956

Fenton, Roger (1819-69)
Clyde, 1st Baron P20
Raglan, 1st Baron P19
Groups: Council of War P49

Fergusson, John Duncan (1874-1961)
Harris, James Thomas ('Frank') 4883

Ferrers, Benjamin (d.1732)
Groups: Court of Chancery 798

Field, John (1771-1841)
Bentham, Jeremy 3068
Magee, William 5213
Onslow, 1st Earl of 5212

Field, Robert (1769-1819)
Inglis, Charles 1023

Fildes, Sir Luke (1843-1927)
Alexandra, Queen 1889
Edward VII 1691
Fildes, Sir Paul 4843
Treves, Sir Frederick, Bt 2917

Finzi, Joyce
Vaughan Williams, Ralph 4086

Fischer, Paul (1786-1875)
George IV L152(33)

Gardner, Daniel (1750-1805)
Self-portrait 1971
Groups: Lord Halifax and his secretaries
3328 *(copy attributed to)*

Garland, H. (fl.1867-83)
Alexandra, Queen 3059

Gates, Henry L. (fl.1927-41)
Doyle, Sir Arthur Conan 4115

Gaudier-Brzeska, Henri (1891-1915)
Self-portrait 4814

Gauffier, Louis (1761-1801)
Unknown Sitters III 1382

Gaunt, Thomas Edward (fl.1880-92)
Neilson, Lilian Adelaide 1781B
(copy by)

Gaywood, Richard (1630?-1711)
Cocker, Edward 274 *(after)*
Harvey, William 60
(after etching attributed to)

Geddes, Andrew (1783-1844)
Jeffrey, Francis, Lord 1628
Lindsay, Catherine Hepburne, and
Alexina Sandford 3791

**Gee, Lucy (Mrs H. Coxeter)
(fl.1896-1930)**
Gunther, Albert 4965

Gennari, Benedetto (1633-1710)
Unknown Sitters II 623 *(attributed to)*

Gertler, Mark (1892-1939)
Darwin, Sir George Howard 1999

**Gheeraerts, Marcus, the Younger
(fl.1561; d.1635)**
Burghley, 1st Baron 362 *(attributed to)*
Camden, William 528 *(by or after)*
Elizabeth I 2561
Essex, 2nd Earl of 180 *(after)*, 4985
Henry, Prince of Wales 2562
Overbury, Sir Thomas 3090(1) *(after)*
Scudamore, Mary, Lady 64

**Gianelli, Giovanni Domenico
(1775-1820)**
Porson, Richard 673, 673a

Gibson, Edward (1668-1701)
Self-portrait 1880

Gibson, John (1790-1866)
Eastlake, Sir Charles Lock 953
Jameson, Anna Brownell 689
Kemble, John Philip 149
Landor, Walter Savage 1950, 2127
(after)

Gilbert, Sir Alfred (1854-1934)
Carlyle, Thomas 1361

Gilbert, Donald (1900-61)
Baird, John Logie 4125

Gilbert, Sir John (1817-97)
Groups: Men of Science 1075, 1383a
Groups: Coalition Ministry 1125

Gilbert, John Graham (1794-1866)
Scott, Sir Walter, Bt 240

Gilbert, Josiah (1814-92)
Gilbert, Sir Joseph Henry 2472
Taylor, Isaac 884

**Giles, Margaret May (Mrs Jenkin)
(1868-1949)**
Kelvin, Baron 1896, 1896a
Lister, Baron 1897, 1897a

Gill, E. W. (fl.1843-68)
Napier, Sir Charles 1460

Gill, Eric (1882-1940)
Coster, Howard 5196
Self-portrait 4661
Passfield, Baron 5203

Gillies, Margaret (1803-87)
Adams, Sarah Flower 1514 *(after)*
Horne, Richard Henry 2168
Hunt, James Henry Leigh 1267

Gillray, James (1757-1815)
George III L152(26) *(possibly by)*
Self-portrait 83
Pitt, William 135a

Gilroy, John (b.1898)
Alexander, Earl 4689

Gimond, Marcel (1894-1961)
Bell, Vanessa 4349

Ginner, Charles (1878-1952)
Self-portrait 4992

Ginnett, Louis (1875-1946)
Brangwyn, Sir Frank 5194

Gladstones, Thomas (1803-32)
Gladstone, Sir John 5042

Glassby, Robert Edward (d.1892)
Beaconsfield, Earl of 2655

**Glazebrook, Hugh de Twenebrokes
(1855-1937)**
Milner, Viscount 2135

Glehn, Wilfred Gabriel de
See De Glehn

Gliddon, Anne (fl.1840)
Lewes, George Henry 1373

Goblet, L. Alexander (fl.1799-1822)
Catalani, Angelica 5039

Godon, L.
Moore, George 2622

Goedecker, F. (fl.1884-5)
Herkomer, Sir Hubert von 2720

Gogin, Charles (1844-1931)
Butler, Samuel 1599

Good, Thomas Sword (1789-1872)
Unknown Sitters IV 971

Goodall, Frederick (1822-1904)
Havelock, Sir Henry, Bt 4835
Kitchener, 1st Earl 1782
(background by)

Goodall, John Edward (fl.1877-1911)
Froude, James Anthony 1439

**Gooderson, Thomas Youngman
(fl.1846-60)**
Truro, 1st Baron 483 *(copy by)*

Gordigiani, Michele (1830-1909)
Browning, Elizabeth Barrett 1899
Browning, Robert 1898
Westbury, 1st Baron 1941

Gordon, Sir John Watson- (1788-1864)
Baird, Sir David, Bt 2195
(attributed to)
Brewster, Sir David 691
Dalhousie, 10th Earl 188
De Quincey, Thomas 189
Molesworth, Sir William 810
Wilson, Sir James 2189
Wilson, John 187

Gore, Spencer Frederick (1878-1914)
Self-portrait 4981

Gosse, Sylvia (1881-1968)
Dobson, Austin 1964
Lansbury, George 3775

Gosse, William (fl.1814-40)
Gosse, Philip Henry 2367

Gosset, Isaac (1713-99)
Conway, Henry Seymour 1757
Edwards, George 1576A *(after)*
Townshend, Charles 1756
(attributed to)

**Gould, Sir Francis Carruthers ('F.C.G.')
(1844-1925)**
Bourke, Henry Lorton 3276
Campbell-Bannerman, Sir Henry 3537
Farmer-Atkinson, Henry John 3536
Irving, Sir Henry 3538
Spencer, Herbert 2601
Collections: Caricatures 2826-74

Goupy, Louis (c.1700-47)
Taylor, Brook 1920 *(probably by)*

Gow, Charles L. (fl.1844-72)
Strickland, Agnes 2923

Gower, George (c.1540-96)
Coningsby, Sir Thomas 4348
(attributed to)
Elizabeth I 541 *(by or after)*

**Gower, Lord Ronald Sutherland
(1834-1916)**
Beaconsfield, Earl of 652

Gowing, Lawrence (b.1918)
Fleck, Baron 4662

Graef, Gustav (1821-95)
Galton, Sir Francis 1997

Graham Gilbert, John
See Gilbert

Grant, Duncan (1885-1978)
Bell, Vanessa 4331
Self-portrait 5131
MacCarthy, Sir Desmond 4468, 4842,
5024

Grant, Sir Francis (1803-78)
Brooke, Sir James 1559
Campbell, 1st Baron 460
Clyde, 1st Baron 619
Gooch, Sir Daniel 5080
Gough, 1st Viscount 805
Self-portrait 1286
Grant, Sir James Hope 783
Hardinge of Lahore, 1st Viscount
437, 508
Herbert of Lea, 1st Baron 1639
Landseer, Sir Edwin 436, 834,
1018
Macaulay, Baron 453
Redgrave, Richard 4486
Russell, 1st Earl 1121
Truro, 1st Baron 483 *(after)*
Waterford, Marchioness of 3176

Grant, James Ardern (1885-1973)
Birch, Lamorna 5084
Fleming, Sir Alexander 5085

Grant, Mary (1831-1908)
Fawcett, Henry 1086
Grant, Sir Francis 1088
Parnell, Charles Stewart 1087
Tennyson, 1st Baron 947 *(copy by)*

Gray, Reginald
Bacon, Francis 5135

Greaves, Walter (1846-1930)
Whistler, James Abbott McNeill 4497

Green, George Pycock (d.1893)
Green, Mary Ann Everett 1438

Green, James (1771-1834)
Nicholson, Peter 4225
Ross, Sir John 314
Say, William 1836
Stanley, Edward 4242
Stothard, Thomas 2

Green, Kenneth (b.1905)
Britten, Baron, and Sir Peter Pears
5136

Greenhill, John (1644?-76)
Locke, John 3912

Pembroke, 8th Earl of 5237
(attributed to)
Shaftesbury, 1st Earl of 3893 *(after)*
Unknown Sitters II 509 *(attributed to)*

**Greenwood, Sydney Earnshaw
(1887-c.1949)**
Hanley, James 5231

Gregory, Edward John (1850-1909)
Self-portrait 2621

Greiffenhagen, Maurice (1862-1931)
Struthers, Sir John 3141

Grignion, Charles (1754-1804)
Farmer, George 2149
Wilton, Joseph 4314

Grimaldi, Mary (fl.1832)
Grimaldi, William 3114 *(copy by)*

Grimaldi, William (1751-1830)
Bedford, 5th Duke of L152(34)
(copy by)

Gullick, Thomas John (fl.1851-84)
Timbs, John 5011

Gunn, Sir James (1893-1964)
Amery, Leopold Stennett 4300
Chesterton, Gilbert Keith 3984, 3985
Crawford, 27th Earl of 3088
Rathbone, Eleanor Florence 4133
Rutherford, Baron 2935
Windsor, Duke of 4949
Groups: Conversation Piece 3654
Groups: Conversation Piece, Windsor
3778

Gush, William (fl.1833-74)
Curwen, John 1066

**Guth, Jean Baptiste ('GUTH')
(fl.1883-1921)**
Collections: *Vanity Fair* cartoons
2566-2606, etc

Guthrie, Sir James (1859-1930)
Grey, 1st Viscount 3545
Oxford and Asquith, 1st Earl of 3544
Groups: Statesmen of World War I 2463

Guthrie, Robin (1902-71)
Dunedin, 1st Viscount 3935
Lloyd-George, 1st Earl 3261
Lucas, Edward Verrall 3934
MacCarthy, Sir Desmond 3936
Scott, Sir Giles Gilbert 4162

Guzzardi, Leonardo (fl.1799)
Nelson, Viscount 785 *(after)*

Gwynne-Jones, Allan (b.1892)
Ismay, 1st Baron 4537

'H' (monogrammist) (fl.1588)
Raleigh, Sir Walter 7 *(attributed to)*

'G.R.H.'
Kitchener of Khartoum, 1st Earl 4549

Hackwood, William (fl.1780; d.1836)
Wedgwood, Josiah 1948

Haddon, Trevor (1864-1941)
Whittaker, Sir Edmund Taylor 4299

Haidt, Johann Valentin (1700-80)
Groups: Moravian Church 624A, 1356
(attributed to)

Hailstone, Bernard (b.1910)
Churchill, Sir Winston Spencer 4458

Halford, Sir Henry, Bt (1766-1844)
Charles I 2189A

Halkett, George Roland (1865-1918)
Gladstone, William Ewart 3183

Hall, Edna Clarke, Lady (1879-1979)
Waugh, Benjamin 3909

Hall, Sydney Prior (1842-1922)
Alma-Tadema, Sir Lawrence 4388
Balfour, 1st Earl of, and Joseph
Chamberlain 5114
Collier, John 4390
Gladstone, William Ewart 2227, 3641
Hacker, Arthur 4389
Groups: Education Bill 2369
Groups: St John's Wood Arts Club
4404
Groups: Duke and Duchess of Teck
4441
Groups: Three daughters of Edward VII
4471
Collections: Parnell Commission
2229-72
Collections: Miscellaneous drawings
2282-2348, 2370-90

Halliday, Thomas (fl.1810-54)
Priestley, Joseph 175b

Halls, John James (fl.1791-1834)
Denman, 1st Baron 372

Hamerani, Gioacchimo (fl.1775-1800)
York, Cardinal 2784

Hamerani, Ottone (1694-1761)
Maria Clementina Sobieska, Princess
1686

Hamilton, Gawen (1697?-1737)
Groups: Club of Artists 1384

Hamilton, Hugh Douglas (c.1739-1808)
Charles Edward Stuart, Prince 376
Fitzgerald, Lord Edward 3815
(studio of)
Ireland, Samuel 4302
Temple, Countess 246
York, Henry Stuart, Cardinal 378
(attributed to)

Holland, George Herbert Buckingham (b.1901)
Bantock, Sir Granville 4457
Holmes, Sir Charles John 3549

Hollar, Wenceslas (1607-77)
Oughtred, William 2906a *(after)*

Holliday, Jessie (c.1920)
Pankhurst, Dame Christabel 4207

Hollins, John (1798-1855)
Tenterden, 1st Baron 481 *(copy by)*
Groups: Aerial Voyage 4710

Hollyer, Frederick (1837-1933)
Robertson, Walford Graham P47

Holmes, James (1777-1860)
Blessington, 1st Earl of 1523

Holroyd, Sir Charles (1861-1917)
Meredith, George 1981
Strong, Sandford Arthur 3633
Watts, George Frederic 1980

Holroyd, Fanny, Lady (d.1924)
Trevelyan, Sir George Otto, 2nd Bt 2224

Home, Robert (1752-1834)
Self-portrait 3162
Paget, Sir Edward 3247
Wellington, 1st Duke of 1471

Hondius, Jodocus (1563-1611)
Drake, Sir Francis 1627 *(after engraving attributed to)*, 3905 *(attributed to)*

Hone, Horace (1756-1825)
Self-portrait 1879
Edgeworth, Richard Lovell 5069

Hone, Nathaniel (1718-84)
Collinson, Peter L152(21)
Fielding, Sir John 3834
Fisher, Catherine Maria 2354
Self-portraits 177, 1878
Sackville, 1st Viscount 4910
Thicknesse, Philip 4192
Wesley, John 135
Unknown Sitters III 116

Honthorst, Gerard (1590-1656)
Charles I 4444
Elizabeth, Queen of Bohemia 511 *(studio of)*, L123
Elizabeth, Princess Palatine 340 *(after)*
Frederick V of Bohemia 1973
Montrose, 1st Marquess 4406 *(after)*
Rupert, Prince 4519 *(attributed to)*
Groups: Duke of Buckingham and Family 711 *(after)*

Hoogstraeten, Samuel van (1627-78)
Knatchbull, Sir Thomas, Bt 3090(7) *(after)*

Hope-Johnstone, John (d.1970)
Collections: Gerald Brenan Album P134(1-25)

Hope-Pinker, Henry Richard (1849-1927)
Fawcett, Henry 1418
Liddell, Henry George 1871
Martineau, James 2080

Hopkins, Anne Eleanor (fl.1859)
Hopkins, Gerard Manley 4264

Hoppé, Emil Otto (1878-1972)
Clodd, Edward P103

Hoppner, John (1758-1810)
Abercromby, Sir Ralph 1538 *(after)*
Beaumont, Sir George Howland, Bt 3157 *(after)*
Bedford, 5th Duke of L152(34) *(after)*
Buckinghamshire, 4th Earl of 3892
Colchester, 1st Baron 1416
Duncan, 1st Viscount 1839
Gifford, William 1017
Grenville, 1st Baron 318
Jordan, Dorothy L174
Pitt, William 697
Romilly, Sir Samuel 3325

Hornebolte, Lucas (d.1544)
Catherine of Aragon 4682 *(attributed to)*

Horsfall, Charles Mendelssohn (1865-1942)
Despard, Charlotte 4345 *(attributed to)*
Kitchener, 1st Earl 1780

Horsley, John Callcott (1817-1903)
Brunel, Isambard Kingdom 979

Horton, Percy (1897-1970)
Moore, George Edward 4087, 4135

Horwitz, Emanuel Henry (fl.1886-1935)
Aumonier, Stacy 2777

Hoskins, John (c.1595-1665)
Capel, 1st Baron L152(13) *(probably after)*
Charles I 1924 *(after)*
Falkland, 2nd Viscount L152(42) *(attributed to)*
North, 4th Baron L152(41)
Somerset, Earl of 1114 *(after)*

Hosmer, Harriet (1830-1908)
Browning, Elizabeth Barrett, and Robert 3165

Houdon, Jean Antoine (1741-1828)
Jones, John Paul 4022 *(after)*

Houston, Richard (1721?-75)
Groups: John Glynn and others 1944

Howard, Charlotte E. (Mrs Lugard) (fl.1885-94)
Lugard, !st Baron 3305

Howard, George (9th Earl of Carlisle) (1843-1911)
Burne-Jones, Sir Edward Coley, Bt 5276

Wensleydale, 1st Baron 2028

Howard, Henry (1769-1847)
Collingwood, Baron 1496
Davy, Sir Humphry, Bt 4591
Flaxman, Anne 675
Flaxman, John 674
Hayley, William 662
Trimmer, Sarah 796
Watt, James 663

Howlett, Robert (d.1858)
Brunel, Isambard Kingdom P112

Hubrecht, Maria (1865-1950)
Lawrence, David Herbert 5098

Hudson, Henry John (fl.1881-1912)
Lyall, Sir Alfred Comyn 2170 *(copy by)*

Hudson, Thomas (1701-79)
Bradley, James 1073 *(after)*
Cibber, Susannah Maria 4526
Egmont, 2nd Earl of 2481
George II 670
Hales, Stephen 1861 *(studio of?)*
Handel, George Frederick 8 *(after)*, 3970
Herring, Thomas 4895 *(attributed to)*
Northington, 1st Earl of 2166 *(studio of)*
Pepusch, John Christopher 2063
Pocock, Sir George 1787 *(after)*
Prior, Matthew 562 *(copy by)*
Strange, Lord 2424 *(after)*
Warren, Sir Peter 5158
Willes, Sir John 484

Hughes, Arthur (1832-1915)
Self-portrait 2759

Hughes, Edward Robert (1851-1914)
Callow, William 2937

Hughes, Philippa Swinnerton (née Pearsall) (1824-1917)
Pearsall, Robert Lucas 1785

Humphry, Ozias (1742-1810)
Carnac, John L152(22)
Haward, Francis 1233
Stanhope, 3rd Earl 380
Strutt, Joseph 323
Stubbs, George 1399

Hunn, Thomas H. (fl.1878-1908)
Lucas, David 1353 *(copy by)*

Hunt, Marianne Leigh (1788-1857)
Shelley, Percy Bysshe 2683 *(attributed to)*

Hunt, William Henry (1790-1864)
Self-portraits 768, 2636
Wilkie, Sir David 2770
Unknown Sitters IV 3843

Hunt, William Holman (1827-1910)
Lushington, Stephen 1646
Millais, Sir John Everett, Bt 2914

Hunt, William S.
Kingsley, Charles 1284 *(copy by)*
Kingsley, Henry 1285 *(copy by)*

Hutchinson, Allen (1855-1929)
Stevenson, Robert Louis 2454

Hutchinson, J.
(?Joseph Hutchinson, 1747-1830)
Holland, Charles L152(25)

Hutchinson, Robert (fl.1773)
Cromwell, Oliver 2426 *(copy by)*

Hutchison, Sir William (1889-1970)
Sayers, Dorothy Leigh 5146

Huysman, Jacob (1633?-96)
Catherine of Braganza 597 *(studio of?)*
Cholmley, John 2105 *(attributed to)*
Lauderdale, 1st Duke of 2084
Legge, William 505 *(after)*
Rochester, 2nd Earl of 804 *(after?)*
Walton, Isaak 1168

Hysing, Hans (1678-1752/3)
Onslow, Arthur 1940 *(after)*

Ibbetson, Julius Caesar (1759-1817)
Ibbetson, Bella L152(6)
Self-portrait L152(5)

Ingles, David N. (fl.1913-23)
Booth, William 2042

Iocetel
Edward the Confessor 4049

JEJ (fl.1885)
Gell, Frederick 4550

Jackson, Charles d'Orville Pilkington (1887-1973)
Lugard, 1st Baron 4289, 4289A
Sharpey-Schaffer, Sir Edward 4581

Jackson, G. (fl.1822)
Herring, John Frederick 4902

Jackson, Gilbert (fl.1622-40)
Bankes, Sir John 1069 *(after?)*

Jackson, John (1778-1831)
Barrow, Sir John, Bt 886
Bone, Henry 3155
Davy, Sir Humphry, Bt 1794
Essex, Countess of 702
Harlow, George Henry 782 *(copy by)*
Hunter, John 77 *(copy by)*
Self-portraits 443, L152(37) *(after)*

Macready, William Charles 1503
Prout, Samuel 1618
Rowlandson, Thomas 2198
Seguier, William 2644 *(attributed to)*
Shee, Sir Martin Archer 3153
Shield, William 5221
Smirk, Robert 2672 *(copy by)*
Soane, Sir John 701
Thomson, Henry 3156
Vincent, George 1822
Wellington, 1st Duke of 1614
Wesley, Samuel 2040
Wilkie, Sir David 3154
Wollaston, William Hyde 1703
York and Albany, Duke of 1615
 (after)

Jacomb-Hood, George Percy (1857-1929)
Haden, Sir Francis Seymour 1826

Jameson, Cecil (b.1883)
Sorley, Charles Hamilton 5012

Jameson, Middleton (1851-1919)
Jameson, Sir Leander Starr, Bt 2804

Janvry, H. de (fl.1793-1800)
George IV 1761

Jean, Philip (1755-1802)
De Saumarez, 1st Baron 2549
Serres, Dominic 1909
Stuart, Elizabeth 55B *(attributed to)*
Stuart, James 55A *(attributed to)*

Jean, Roger (c.1783-1828)
Peacock, Thomas Love 3994

Jefferys, James (1751-84)
Self-portrait 4669

Jenkin, Margaret May
See Giles, Margaret May

Jervas, Charles (1675?-1739)
Caroline of Brandenburg-Ansbach 369
 (studio of)
Cumberland, Duke of 802
George II 368 *(studio of)*
Orrery, 4th Earl of 894 *(after?)*
Pope, Alexander 112 *(attributed to)*
Queensberry, Duchess of 238
 (attributed to)
Suffolk, Countess of 3891
 (attributed to)
Swift, Jonathan 278, 4407 *(by or after)*
Unknown Sitters III 2506 *(studio of)*

John, Master (fl.1544-5)
Dudley, Lady Jane 4451 *(attributed to)*
Mary I 428

John, Augustus (1878-1961)
Barker, Sir Herbert Atkinson 4189
Davies, William Henry 3149
De la Mare, Walter 4473
Epstein, Sir Jacob 4119
Firbank, Ronald 4600
Self-portrait 4577

Lawrence, Thomas Edward 2910,
 3187, 3188
McEvoy, Ambrose 3056
Morgan, Charles Langbridge 4472
Murray, Gilbert 4170
Nichols, Robert 3825
Powys, John Cowper 4668
Roberts, Arthur 2362
Waverley, 1st Viscount 5025
Yeats, William Butler 3061, 4105

John, Gwen (Gwendolen Mary)
(1876-1939)
Self-portrait 4439

Johnson (or Jonson), Cornelius
(1593-1661)
Cotton, Sir Robert Bruce 534 *(after)*
Coventry, 1st Baron 716 *(after)*,
 4815
Myddelton, Sir Hugh, Bt 2192 *(after)*
Northampton, 2nd Earl of 1521 *(after)*
Spelman, Sir Henry 962 *(after)*
William III 272 *(after)*
Zouche, Richard 5056 *(attributed to)*
Groups: Capel Family 4759
Collections: Three Eldest Children of
 Charles I 5103-5
Unknown Sitters II 1344, 1887

Johnson, Ernest Borough (1866-1949)
Herkomer, Sir Hubert von 3175

Johnson, Gerard (fl.1616-23)
Shakespeare, William 185a *(after)*,
 1281 *(after)*, 1735 *(after)*

Johnson, Henry (fl.1824-47)
Ferneley, John 2024

Johnson, Thomas (fl.1710-20)
Bullock, William 2540 *(after)*

Jones, George (1786-1869)
Barnard, Sir Andrew Francis 982a
Berry, Sir Edward 5259
Grant, Colquhoun 5261
Light, William 982c
Napier, Sir Charles James 333
Seaton, 1st Baron 982b
Vernon, Robert 4513
Weld, Thomas 5260
Wood, Sir George Adam 5258

Jones, Helena G. de Courcy (fl.1814)
Flinders, Matthew 1844 *(copy by)*

Jones, Sophia (fl.1805)
Morland, George 4370

Jopling, Joseph Middleton (1831-84)
Lindsay, Sir Coutts, 2nd Bt 2729

Jopling-Rowe, Louise (1843-1933)
Smiles, Samuel 1856

Joseph, George Francis (1764-1846)
Perceval, Spencer 4 *(copy by)*, 1031
 (copy by)

Continued overleaf

Collections: Kit-cat Club 3193-3235
(listed individually, see above)
Unknown Sitters II 202 *(after?)*,
622 *(attributed to)*, 1722, 1858
(after)

Knight, Harold (1874-1961)
Self-portrait 4831

Knight, John Prescott (1803-81)
Barry, Sir Charles 1272

Knight, Dame Laura (1877-1970)
Freeman, John 4040
Self-portrait, with model 4839

Knight, W. Milner (d.1961)
Bondfield, Margaret Grace 3966

**Knighton-Hammond, Arthur Henry
(1875-1970)**
Brangwyn, Sir Frank 4373, 4374
Johnston, Edward 4375

Koberwein, George (1820-76)
Blore, Edward 3163

Kokoschka, Oskar (1886-1980)
Self-portrait 5156

Kolitz, Louis (fl.1877)
Crowe, Sir Joseph Archer 4329

Kormis, Fred (b.1896)
Windsor, Duke of 5051

Kottler, Moses
Smuts, Jan Christian 4004

Kovacs, Frank
Fleming, Sir Alexander 4238
Munnings, Sir Alfred James 4120,
4120a
Ross, Sir Edward Denison 4203, 4203a,
4203b

Kramer, Jacob (1892-1962)
Self-portrait 4871
Munro, Harold 4705

Kyte, Francis (fl.1710-45)
Handel, George Frederick 2152
(copy by)

Lacey, Edward Hill (1892-1967)
Hyndman, Henry Mayers 1947

Laguerre, Louis (1663-1721)
Cadogan, 1st Earl 18 *(attributed to)*

Lamb, Henry (1883-1960)
Bowra, Sir Maurice 4667
Chamberlain, Arthur Neville 4279
Self-portraits 4256, 4257, 4432
Lynd, Robert 4666
Masefield, John 4569
Morrell, Lady Ottoline 4254
Quiller-Couch, Sir Arthur 4262

Spencer, Sir Stanley 4527
Young, George Malcolm 4255, 4292

Lambda, Peter
Bevan, Aneurin 4993

**Lambert, George Washington
(1873-1930)**
Graham, Robert Bontine Cunninghame
4846
Self-portrait 3115
Tonks, Henry, and Percy Grainger 3137a
Tosti, Sir Francesco Paolo 3137
Wood, Francis Derwent 4416

Lambert, Herbert (1881-1936)
Ireland, John P105
Collections: Musicians and Composers
P107-11

Lance, George (1802-64)
Self-portrait 1713

Landseer, Charles (1799-1879)
Landseer, Thomas 1120

Landseer, Sir Edwin (1802-73)
Allen, John 384
Burdett, Sir Francis, Bt 3140
Callcott, Sir Augustus Wall 3336
Self-portrait 4267
Landseer, John 1843
Melbourne, 2nd Viscount 3050
Scott, Sir Walter, Bt 391, 2811
Smith, Sydney 2887
Thackeray, William Makepeace 3925
Trelawny, Edward John 2886
Collections: Caricatures 3097(1-10),
4914-22
Unknown Sitters IV 1650
(attributed to)

Lane, Clara S. (fl.1850-9)
Buckingham, James Silk 2368
Lane, Edward William 3099

Lane, Richard James (1800-72)
Barham, Richard Harris 2922
D'Orsay, Alfred, Count 4540
Lane, Edward William 940

Lane, Samuel (1780-1859)
Bentinck, Lord George Cavendish 1515
Murray, George 4964

Lane, William (1746-1819)
Bedford, 5th Duke of 1830
Groups: Whig statesmen and friends
2076

Langdon, A.
Scharf, Sir George 4583

Lanteri, Edouard (1848-1917)
Boehm, Sir Joseph Edgar, Bt 5273
Mond, Ludwig 4511
Sendall, Sir Walter 4859

Lapthorn, Mabel D. (1889-1975)
Frith, William Powell 5058

Largillière, Nicolas de (1656-1746)
James Francis Edward Stuart, Prince,
and his sister Louisa Maria 976

Larkin, William (fl.1610-20)
Anne of Denmark 4656 *(attributed to)*
Buckingham, 1st Duke of 3840
(attributed to)
Somerset, Countess of 1955
(attributed to)

Laszlo de Lombos, Philip
See De Laszlo, Philip

La Tour, Maurice Quentin de (1704-88)
Charles Edward Stuart, Prince 2161
(after)

Lauder, Robert Scott (1803-69)
Hill, David Octavius 5049

Laurence, Samuel (1812-84)
Babbage, Charles 414
Bourchier, Sir Thomas 720
Carlyle, Jane Baillie 1175
Cole, Sir Henry 1698
Derby, 15th Earl of 948
Dickens, Charles 5207
Higgins, Matthew James 2433
Hunt, James Henry Leigh 2508
Kenney, James 4263
Maurice, Frederick Denison 1042, 1709
Palgrave, Francis Turner 2070
Pollock, Sir Jonathan Frederick, Bt
732, 758
Tennyson, 1st Baron 2460
Thackeray, William Makepeace 725
Thompson, William Hepworth 1743
Trench, Richard Chenevix 1685
Trollope, Anthony 1680
Wheatstone, Sir Charles 726
Unknown Sitters 2434, 2435

Lavery, Sir John (1856-1941)
Kelly, James Fitzmaurice 2018
Macdonald, James Ramsay 2959
Spencer-Churchill, Baroness, and Sarah
Churchill 5184
Groups: Royal Family 1745

Lawranson, Thomas (fl.1733-86)
O'Keeffe, John 165
Quick, John 1355

Lawranson, William (fl.1774-80)
Hall, John 3992 *(attributed to)*

Lawrence, Alfred Kingsley (1893-1975)
Robinson, Sir Robert 5112

Lawrence, Sir Thomas (1769-1830)
Banks, Sir Joseph, Bt 853
Baring, Sir Francis, Bt 1256 *(after)*
Bloomfield, 2nd Baron 1408
Boswell, James 2755
Brougham and Vaux, 1st Baron 3136
Bunbury, Henry William 4696
Burdett, Sir Francis, Bt 3820
(begun by)

Burdett, Sophia, Lady 3821 *(begun by)*
Callcott, Maria, Lady 954
Campbell, Thomas 198
Canning, George 1338, 1832
Caroline of Brunswick 244
Carter, Elizabeth 28
Davy, Sir Humphry, Bt 1573 *(after)*
Eldon, 1st Earl of 464 *(studio of)*
Fawcett, John 692 *(begun by)*
George IV 123, 2503 *(after)*
Grant, Sir William 671
Grey, 2nd Earl 1190 *(after)*
Hastings, Warren 390, 3823
Impey, Sir Elijah 821
Kemble, John Philip 2616
 (attributed to)
Self-portrait 260 *(after)*
Liverpool, 2nd Earl of 1804
Londonderry, 2nd Marquess of 891
Lysons, Samuel 5078
Mackintosh, Sir James 45
Malmesbury, 1st Earl of L152(29)
 (after)
Melbourne, 2nd Viscount 5185
Melville, 1st Viscount 746
Moore, Sir Graham 1129
Moore, Sir John 1128
Mornington, Countess of 2665
Orford, 4th Earl of 3631
Ripon, 1st Earl of 4875
Rogers, Samuel 400
Romilly, Sir Samuel 1171
Sotheby, William 3955
Taylor, Thomas 374 *(after)*
Wellington, 1st Duke of 4670, L152(35)
 (after)
Westmorland, 11th Earl of 3886 *(after)*
Wilberforce, William 3
Windham, William 38
York and Albany, Duke of 1563 *(after)*

Lawson, Francis Wilfrid (1842-1935)
Lawson, Cecil Gordon 2797
Lawson, Malcolm Leonard 2798

Leahy, Edward Daniel (1797-1875)
Mathew, Theobald 199

Leakey, James (1775-1865)
Cousins, Samuel 1447

Lear, Charles Hutton (1818-1903)
Brougham and Vaux, 1st Baron 1457a,
 1457b
Collections: Artists 1456(1-27)

Lear, Edward (1812-88)
Self-portrait 4351

Ledoux, Philippe (fl.1930-6)
Dick, Sir William Reid 4809

Ledru, Hilaire (1769-1840)
Green, Charles 2557

Lee, Rupert (1887-1959)
Nash, Paul 4134

Legros, Alphonse (1837-1911)
MacColl, Dugald Sutherland 4857
Phillips, Sir Claude 2431, 2432

Lehmann, Rudolph (1819-1905)
Browning, Robert 839
Collins, William Wilkie 3333
Siemens, Sir William 2632

Leighton, Charles Blair (1823-55)
Hume, Joseph 1098

**Leighton, Frederic Leighton, Baron
(1830-96)**
Burton, Sir Richard Francis 1070
Collections: Lord Leighton and family
 2141, 2141(a-d)

Lely, Sir Peter (1618-80)
Albemarle, 1st Duke of 423 *(studio of)*
Arlington, 1st Earl of 1853 *(after)*
Brouncker, 2nd Viscount 1567 *(after?)*
Brouncker, 3rd Viscount 1590 *(after)*
Buckingham, 2nd Duke of 279
Charles II 153 *(after)*
Cleveland, Duchess of 387 *(after)*, 2564
 (after)
Clifford, 1st Baron 204 *(after)*
Compton, Sir William 1522 *(after)*
Cowley, Abraham 74 *(after)*, 4215
Dorchester, Countess of 36 *(studio of)*
Fox, Sir Stephen 2077
Gibson, Richard 1975 *(after)*
Grafton, 1st Duke of 2915 *(after?)*
Grammont, Countess of 20 *(after)*
Gwyn, Nell 3811 *(after)*, 3976
 (studio of)
Harman, Sir John 1419 *(studio of)*
Harrington, James 4109 *(after)*
James II 5211
James II and Anne Hyde 5077
Leeds, 1st Duke of 1472 *(studio of)*
Self-portraits 951 *(after)*, 3897
Long, Sir Robert 4637 *(after)*
Manchester, 2nd Earl of 1838
 (studio of), 3678
Marten, Henry 5176
Morley, George 491 *(after)*, 2951
 (studio of)
Nicholas, Sir Edward 1519
North, Roger 766 *(after)*
Ormonde, 1st Duke of 370 *(after)*
Ossory, Earl of 371 *(studio of)*
Palmer, Sir Geoffrey, Bt 2403 *(after)*,
 4622 *(studio of)*
Patrick, Simon 1500
Pett, Peter 1270 *(after?)*
Rupert, Prince 233 *(after)*, 608
 (studio of)
Rycaut, Sir Paul 1874 *(after)*
Sandwich, 1st Earl of 609 *(after)*
Sheldon, Gilbert 1837 *(studio of)*
Shrewsbury, Countess of 280
Somerset, Countess of 1753 *(after)*
Southampton, 4th Earl of 681 *(after)*
Temple, Sir William, Bt 152
Ussher, James 574 *(after)*
Weymouth, 1st Viscount L152(17)
 (after)

William III 1902 *(after)*
Wycherley, William 880 *(after?)*
York, Duchess of 241 *(after?)*
Unknown Sitters II 253 *(after)*, 556
 (after), 613 *(after)*

Le Marchand, David (1674-1726)
Wren, Sir Christopher 4500

Lenbach, Franz Seraph von (1836-1904)
Acton, 1st Baron 4083

Leno, Dan
See Galvin, George

Lens, Bernard (1622-1740)
Fleetwood, William 5118, 5119
Folkes, Martin 1926
Self-portrait 1624

Leoni, Lodovico (1542-1612)
Cheke, Sir John 1988
 (after medal attributed to)

Leslie, Charles Robert (1794-1859)
Cottenham, 1st Earl of 5149
Fry, Elizabeth 898 *(after)*
Holland, 3rd Baron 382 *(after)*
Self-portrait 2618
Millais, Sir John Everett, Bt 1859
Turner, Joseph Mallord William 4084

Lessore, Emile Aubert (1805-76)
Boys, Thomas Shotter 4820

Lessore, Frederick (1879-1951)
Stanton, Arthur Henry 3830

**L'Estrange ('Ao', Vanity Fair cartoonist)
(fl.1903-7)**
Collections: *Vanity Fair* cartoons
 2566-2606, etc

Le Sueur, Hubert (c.1580-1670)
Charles I 297 *(after?)*

Lethbridge, Walter Stephens (1771-1831)
Horsley, Samuel 155
Wolcot, John 156

Leverotti, Julian (1844-1915)
Owen, Robert 602 *(copy by)*

Le Vieux, Lucien (fl.1790)
Cook, James 984

Levy, Emmanuel (b.1900)
Blackett, 1st Baron 5010
Maxton, James 5097

Levy, Mervyn (b.1915)
Thomas, Dylan 4334, 4335

Lewis, E. Goodwyn (fl.1860-72)
Kean, Charles John 1307
Lawrence, 1st Baron 2610

Lewis, Frederick (fl.1915-59)
Haweis, Hugh Reginald 4107

Lewis, John Frederick (1805-76)
Mathews, Charles James 1636

Lewis, Wyndham (1882-1957)
Self-portrait 4528
Sitwell, Dame Edith 4464, 4465
Strong, Leonard Alfred George 5143

'Lib'
See Prosperi, Liberio

Liège, Jean de (fl.1364-7)
Philippa of Hainault 346 (after)

Linnell, John (1792-1882)
Austin, Sarah 672
Blake, William 2146
Hunt, Robert 4523
King of Ockham, 7th Baron 4020
Self-portrait 1811
Mulready, William 1690
Peel, Sir Robert, Bt 772
Rennie, George 3683
Turner, Joseph Mallord William L157
Warren, Samuel 1441 (attributed to)
Collections: Drawings 1812-18, 1818A,
 1818B

Lion, Flora (1876-1958)
Alma-Tadema, Sir Lawrence 3946
German, Sir Edward 3951
Gregory, Isabella Augusta, Lady 3950
Horniman, Annie Elizabeth Fredericka
 3973
Lehmann, Liza 4118
Mackenzie, Sir Alexander Campbell
 3972
Vanbrugh, Dame Irene 4102
Wood, Sir Henry Evelyn 3949

Little, Leon (1862-1941)
Haggard, Sir Henry Rider 2350

Livesay, Richard (d.1823)
Charlemont, 1st Earl of 176

Lochée, John Charles (b.1751)
Herschel, Sir William 4055

Lock, Beatrice (Mrs Fripp) (1880-1913)
Maitland, Frederic William 1966

Lockey, Nicholas (fl.1620)
King, John 657 (attributed to)

Lockey, Rowland (fl.1593-1616)
James I 63 (copy attributed to)
Groups: Sir Thomas More and family
 2765 (copy by)

Loggan, David (c.1635-92)
Albemarle, 1st Duke of 833
Allstree, Richard 629
Argyll, 9th Earl of 630
Barrow, Isaac 1876
Clarendon, 1st Earl of 645
Guilford, 1st Baron 632
Lloyd, William 633
Mews, Peter 637, 1872
Pearson, John 635

Sancroft, William 636
Waller, Edmund 4494
Wallis, John 639
Ward, Seth 644

Long, Edwin (1829-91)
Churchill, Lord Randolph 5113
Iddesleigh, 1st Earl of 820, 2944

Longstaff, Sir John (1862-1941)
Johnson, Amy 4201

Lonsdale, James (1777-1839)
Bolland, Sir William 730
Brougham and Vaux, 1st Baron 361,
 5038
Caroline of Brunswick 498
Congreve, Sir William, Bt 982f
Francis, Sir Philip 334
Heath, James 771
Self-portrait 1854
Morris, Charles 739
Nollekens, Joseph 360
Rees, Abraham 564
Sharp, William 25
Smith, James 1415

Lough, John Graham (1798-1876)
Collingwood, Baron 1296
 (attributed to)
Forbes, Edward 1609 (after)
Southey, Robert 841

Louise, Princess Palatine
Craven, 1st Earl of 4517 (attributed to)
Mordaunt, Viscountess 3090(4) (after)

**Louise Caroline Alberta, Princess
(1848-1939)**
Self-portrait 4455

Love, Horace Beevor (1800-38)
Cotman, John Sell 1372
Stark, James 1562

Lover, Samuel (1797-1868)
Lifford, 1st Viscount 4249 (copy by)
Mathews, Lucia Elizabeth 2786

Low, Sir David (1891-1963)
Barrie, Sir James Matthew, Bt 4557
Bennett, Arnold 4561
Bevin, Ernest 4558
Blackett, 1st Baron 4565
Chamberlain, Sir Joseph Austen 4562
Self-portrait 4512
Morrison, Baron 4559
Norwich, 1st Viscount and Viscountess
 4560
Reith, Baron 4566
Snowden, Viscount 4563
Strachey, John 4567
Thomas, James Henry 4564
Collections: Working drawings
 4529(1-401)

**Loye, Charles Auguste
('M.D' or. Montbard') (1841-1905)**
Binney, Thomas 2182
Capel, Thomas John 2567

Lucas, John (1807-74)
Mitford, Mary Russell 404 (copy by),
 4045

Lucas, John Seymour (1849-1923)
Alverstone, Viscount 4337
Self-portrait 3040

Lucas, Richard Cockle (1800-83)
Anglesey, 1st Marquess of 5270
Garnier, Thomas 4844
Hallam, Henry 3119
Holmes, John 1781A (after)
Self-portraits 1651B, 1783
Madden, Sir Frederic 1979
Palmerston, 3rd Viscount 2226
Panizzi, Sir Anthony 2187
Rawlinson, Sir Henry Creswicke, Bt
 1714

Lucchesi, Andrea Carlo (1860-1924)
Franklin, Sir John 1230

Ludovici, Albert (1820-94)
Crookes, Sir William 1846

Lugard, Charlotte E. (née Howard)
See Howard, Charlotte E.

Lutterel, Edward (1650?-1723?)
Bedford, 1st Duke of 1824
Butler, Samuel 248
Plunket, Oliver 262 (after?)
Sancroft, William 301

Lutwidge, Skeffington
Collections: Prints from two albums
 P31-40

Lutyens, Robert (b.1950)
Lutyens, Sir Edwin 4481

**Lytton, Neville (3rd Earl of Lytton)
(1879-1951)**
Thompson, Francis 2940

'VM' (fl.1634-7)
Backhouse, Sir John 2183

Mabey, Charles H. (fl.1863-97)
Stephenson, Robert 5079 (copy by)

McBean, Angus (b.1904)
Collections: Prominent people P57-67

McBey, James (1883-1959)
Graham, Robert Bontine Cunninghame
 4626

Macdonald, Daniel (1821-53)
Jesse, Edward 2453

Macdonald, Lawrence (1799-1878)
Stanhope, 5th Earl 499 (after)
Taylor, Sir Henry 2619

Macdonald, Somerled (1869-1948)
Blackie, John Stuart 2670

MacDougald, George D. (fl.1910)
Dewar, Sir James 2119

MacDowell, Patrick (1799-1870)
Carnac, Sir James Rivett 5128

McEvoy, Ambrose (1878-1927)
Alcock, Sir John William 1894
Self-portrait 2790

McFall, David (b.1919)
Attlee, 1st Earl 4601
Vaughan Williams, Ralph 4088

Mackinnon, Esther Blaikie (1885-1935)
Sharp, Cecil 2517, 2518

MacLaren, Andrew (b.1883)
Chamberlain, Arthur Neville 4413

MacLaren, Donald Graeme (1886-1917)
Groups: New English Art Club 2663

Macleay, Kenneth (1802-78)
Unknown Sitters IV 1293
 (attributed to)

Maclise, Daniel (1806-70)
Ainsworth, William Harrison 3655
Beaconsfield, Earl of 3093 *(by or after)*
Buckstone, John Baldwin 2087
Constable, John 1458
Cruikshank, George 5170
Dickens, Charles 1172
D'Israeli, Isaac 3092 *(after)*
Dunlop, William 3029
Jerdan, William 3028
Landon, Letitia Elizabeth 1953
Macready, William Charles 3329
 (attributed to)
Normanby, 1st Marquess of 3139
Praed, Winthrop Mackworth 3030
Thackeray, William Makepeace 4209

Macnee, Sir Daniel (1806-82)
Jerrold, Douglas William 292
McCulloch, John Ramsay 677
Phillip, John 2446 *(attributed to)*

McWhirter, Ishbel (b.1927)
Klein, Melanie 5108
Neill, Alexander Sutherland 5111

McWilliam, Frederick Edward (b.1909)
De Valois, Dame Ninette 4679

Magnus, Eduard (1799-1872)
Lind, Johanna Maria 3801

Man, Felix H. (Hans Baumann) (b.1893)
Collections: Prominent men P10-17

Mann, Cathleen (1896-1959)
Smith, Sir Matthew 4161

Mansbridge, John
Cecil, 1st Viscount 4112
Gore, Charles 2611
Mansbridge, Albert 3987

Squire, Sir John Collings 4110
Tawney, Richard Henry 4258

Manton, G. Grenville (1855-1932)
Groups: Royal Academy Conversazione
 2820

Manwine
Edward the Confessor 4048

Manzini, Camille (fl.1832-42)
Grenville, Thomas 517

Maratti, Carlo (1625-1713)
Roscommon, 4th Earl of 2396 *(after)*

March, Sydney (fl.1901-34)
Edward VII 2019
Rhodes, Cecil John 4151

Marchand, Jean (1883-1941)
Fry, Roger 4570

Margetson, William Henry (1861-1940)
Tennyson, 1st Baron 4343 *(copy by)*

Marini, Marino (1901-80)
Moore, Henry 4687

Marochetti, Carlo, Baron (1805-67)
Macaulay, Baron 257
Stephen, Sir James 1029

Marshall, John (1818-91)
Smith, Sydney 5147

Marshall, Lambert (1810-70)
Marshall, Benjamin 2671

Marstrand, Wilhelm Nicolai (1810-73)
Lear, Edward 3055

Martin, Captain (George Mathew?) (fl.1856-61)
Cubbon, Sir Mark 4250
Grant, Sir Patrick 4251

Martin, Charles (1820-1906)
Blessington, Countess of 1645a
Cunningham, Peter 1645
Turner, Joseph Mallord William 1483

Martineau, Clara (née Fell) (fl.1887)
Martineau, James 2526

Mason & Co
Selwyn, George Augustus 2780 *(after)*

Mason, Arnold (1885-1963)
Glyn, Elinor 4283

Mason, William (1724-97)
Gray, Thomas 425 *(after)*

Masquerier, John James (1788-1855)
Becher, Eliza 445
Mountain, Rosoman 760 *(after)*
Schanck, John 1923

Master of the Stätthalterin Madonna (fl.1549)
Paget, 1st Baron 961 *(attributed to)*

Matarrese, Georgio (fl.1894)
Lacaita, Sir James Philip 5272

'Matt' (cartoonist)
Runciman, 1st Viscount 5141

Matthew, Charles (d.1916)
Stevenson, Joseph 982

Maubert, James (d.1746)
Dryden, John 1133

Maull & Co (Maull & Fox, Maull & Polyblank) (fl.1850s)
Beeton, Isabella Mary P3
Grant, Sir Patrick 1454 *(after)*
Nias, Sir Joseph 2437
Collections: Literary and Scientific
 Portrait Club P106(1-20)
Collections: Literary and Scientific Men
 P120(1-54)

May, Phil (Philip William) (1864-1903)
Astley, Sir John Dugdale, Bt 3173,
 3173A
Brangwyn, Sir Frank 4057
Chamberlain, Joseph 3020
Chilston, 1st Viscount 4991
Churchill, Lord Randolph 3032
Corbould, Alfred Chantrey 2463
Gladstone, William Ewart 2819
Irving, Sir Henry 1611, 3679, 3680,
 3681
Longstaff, Sir John 4392
Self-portrait 2661, 3038, 3941, 4149
Queensberry, 8th Marquess of 3174
Salisbury, 3rd Marquess of 1610
Unknown Sitters IV 3174A

Mayall, John Jabez (1810-1901)
Tennyson, 1st Baron 970 *(after)*

Mayer, Lilian Mary (d.1945)
Henderson, Arthur 2067
Macdonald, James Ramsay 2066
Passfield, Baron 2068

Mazzotti, Pellegrino (1785?-1870?)
Crome, John 1900

Melilli, Cernigliari (fl.1906)
Dewar, Sir James 2118

Melville, Alexander (fl.1846-85)
Spurgeon, Charles Haddon 2641

Mengs, Anton Raphael (1728-79)
Wilson, Richard 1305 *(after)*, 1803
 (after)

Mercier, Charles (1834-after 1893)
Reade, Charles 2281 *(attributed to)*

Mercier, Philip (1689-1760)
Frederick Lewis, Prince 2501
Groups: Music Party 1556

Methuen, Paul Ayshford Methuen, 4th Baron (1886-1974)
Methuen, 3rd Baron 5017

Meyer, Henry Hoppner (1782?-1847)
Lamb, Charles 1312 *(after)*

Meyer, Jeremiah (1735-89)
Chambers, Sir William 4044
Gage, Thomas 4070

Meynell, Everard (1882-1926)
Thompson, Francis 5271

Miereveldt, Michael Jansz. van (1567-1641)
Borlase, Sir John 4933
Carleton, Anne, Lady 111 *(studio of)*
Dorchester, Viscount 110 *(studio of)*, 3684
Elizabeth, Queen of Bohemia 71 *(studio of)*
Roe, Sir Thomas 1354 *(after)*
Vane, Sir Henry, the Elder 1118 *(after?)*
Vere of Tilbury, Baron 818 *(attributed to)*
Wimbledon, Viscount 4514, L164

Miers, John (1756-1821)
Mayo, John 4878

Mignard, Pierre (1612-95)
Orleans, Duchess of 228 *(after?)*, 1606 *(after?)*
Portsmouth, Duchess of 497

Mijn (or Myn), Frans van der (1719-83)
Robinson, Sir Thomas, Bt 5275

Miles, Arthur (fl.1851-79)
Robson, Thomas Frederick 1877

Millais, Sir John Everett, Bt (1829-96)
Beaconsfield, Earl of 925 *(after)*, 3241
Carlyle, Thomas 968
Collins, William Wilkie 967
Gladstone, William Ewart 3637
Irving, Sir Henry 1453 *(after)*
Leech, John 899
Salisbury, 3rd Marquess of 3242
Stephens, Frederic George 2363
Sullivan, Sir Arthur 1325

Millar, James (fl.1771-90)
Baskerville, John 1394 *(after)*

Miller, Alec (1879-1961)
Housman, Laurence 4816

Miller, William Edwards (fl.1873-1929)
Rolleston, George 1933

Millière, Auguste (fl.1876-96)
Paine, Thomas 897 *(copy by)*

Milnes, Thomas (1813-88)
Wellington, 1st Duke of 2667

Minton, John (1917-57)
Self-portrait 4620

Mitchell, Thomas (fl.1798-1830)
Hastings, 1st Marquess of L152(31)

Moholy, Lucia (b.1900)
Collections: Prominent People P127-33

Monnington, Sir Walter Thomas (1902-76)
Barrie, Sir James Matthew, Bt 3539
Thomson, Sir Joseph John 3256

Monro, Henry (1791-1814)
Hearne, Thomas 1653
Monro, Thomas 3117

Montague, T. (fl.1794)
Owen, Samuel 3129

'Montbard' or 'M.D.'
See Loye, Charles Auguste

Montford, Horace (d.1912?)
Darwin, Charles Robert 1395
Milton, John 1396 *(copy by)*

Moore, Brenda (Mrs Campbell Taylor) (fl.1925-64)
Taylor, Leonard Campbell 4936

Moore, Christopher (1790-1863)
Moore, Thomas 117

Moore, Ernest (1865-1940)
Bryce, 1st Viscount 1970
Ellis, Sir William Henry 4927

Moore-Park, Carton (1877-1956)
Jacobs, William Wymark 3178

Mor, Antonio (1519-75)
Lee, Sir Henry 2095
Mary I 4174 *(after)*

Mordecai, Joseph (1851-1940)
Pinero, Sir Arthur Wing 2761
Victoria Adelaide Mary Louise, Princess 4430 *(copy by)*

Morgan, Howard (b.1949)
Howells, Herbert 5209

Morier, David (1705?-70)
Cumberland, Duke of 537 *(studio of)*

Morland, George (1763-1804)
Self-portrait 422, 1196
Morland, Henry 2905

Morland, Henry (c.1730-97)
Coote, Sir Eyre 124

Morley, Ebenezer (fl.1834)
Owen, Robert 4521

Moroder, Albin (fl.1949)
Pethick-Lawrence, 1st Baron 4280

Morphey, Garrett (d.1716)
Plunket, Oliver 262 *(by or after)*

Morris, Ebenezer Butler (fl.1833-63)
Palmerston, Viscountess 3954 *(attributed to)*

Mortimer, John Hamilton (1740-79)
Self-portrait 234 *(after)*

Mortimore, Constance (Mrs Kirk) (fl.1896-9)
Baring-Gould, Sabine 4353

Morton, Andrew (1802-45)
Keating, Sir Henry Sheehy 1895

Moscheles, Felix (1833-1917)
Pratt, Hodgson, 2032

Moseley, Henry (fl.1842-66)
Edwardes, Sir Herbert 1391

Moses, Henry (c.1782-1870)
Englefield, Sir Henry, Bt 2000 *(attributed to)*

Moynihan, Rodrigo (b.1910)
Gowing, Lawrence 5266
Nicolson, Benedict 5233

Mukhina, Vera (b.1889)
Johnson, Hewlett 4585

Müller, Bertha (1848-1925)
Victoria, Queen 1252 *(copy by)*

Müller, Heinrich (fl.1821-39)
Gladstone, William Ewart 4034

Müller, William James (1812-45)
Self-portrait 1304

Mulready, William (1786-1863)
Jackson, John L152(37) *(copy by)*
Self-portrait 4450
Varley, John 1529

Mulrenin, Bernard (1803-68)
O'Connell, Daniel 208

Munnings, Sir Alfred (1878-1959)
Self-portrait 4136

Munro, Alexander (1825-71)
Millais, Sir John Everett, Bt 4959

Murphy, Denis Brownell (d.1842)
Crome, John 2061

Murray, Charles Fairfax (1849-1919)
Morris, William 3021
Webb, Philip Speakman 4310

Murray, John Somerset (b.1904)
Hitchens, Ivon P135

Murray, Thomas (1663-1734)
Dampier, William 538

Vanbrugh, Sir John 1568
(attributed to)

Murry, Richard (b.1902)
Tomlinson, Henry Major 4597

Muss, Charles (1779-1824)
Baring, Sir Francis, Bt 1256 *(copy by)*

Muszynski, Leszek (b.1923)
Redpath, Anne 5171

Myers, Eveleen (née Tennant) (d.1937)
Gladstone, William Ewart P54

Mytens, Daniel (1590-1648?)
Charles I 1246
Edmondes, Sir Thomas 4652
Essex, 3rd Earl of L115 *(attributed to)*
Holland, 1st Earl of 3770 *(studio of)*
James I 109
Southampton, 3rd Earl of 52 *(after)*

Nanteuil, Robert (1623?-78)
Evelyn, John 3258

Napier, John James (fl.1856-76)
Melvill, Hester Jean Frances, Lady
4825A
Melvill, Sir James Cosmo 4825
Robinson, Sir John 2543

Nash, Edward (1778-1821)
Coleridge, Sara, and Edith May Warter
4029
Southey, Robert 4028

Nasmyth, Alexander (1758-1840)
Burns, Robert 46

Nason, Pieter (1612-90)
St John, Oliver 4978
Strickland, Walter 5235

Nast, Thomas (1840-1902)
Lawson, Sir Wilfrid, Bt 2728

Nemon, Oscar (b.1906)
Asquith, Baroness 4963

Netscher, Gaspar (1639-84)
Temple, Dorothy, Lady 3813
Temple, Sir William, Bt 3812

Neve, Cornelius (1612?-78?)
Steward, Richard 2415 *(after painting attributed to)*

Newman, Arnold (b.1918)
Delaney, Shelagh P45
Macmillan, Harold P44

Newton, Ann Mary (née Severn) (1832-66)
Self-portrait 977

Newton, Gilbert Stuart (1795-1835)
Hallam, Henry 2810 *(attributed to)*

Nicholson, Sir William (1872-1949)
Beerbohm, Sir Max 3850
Davies, William Henry 4194
Jekyll, Gertrude 3334
Tempest, Dame Marie 5191

Nightingale, W. H. (fl.1836-40)
Angelo, Henry Charles 2009A

Nini, Jean Baptiste (1717-86)
Franklin, Benjamin 722

Nixon, F. R. (Francis Russell?) (1803-79)
Strode, John 3090(5) *(copy by)*

Nixon, James (c.1741-82)
Farington, Joseph L152(44)

Nixon, John (1760-1818)
Abel, Carl Friedrich 5178
Groups: Hanover Square Concert 5179

Noakes, Michael (b.1933)
Rutherford, Dame Margaret 4937

Noble, Matthew (1818-76)
Ellesmere, 1st Earl of 2203
Etty, William 595
Peel, Sir Robert, Bt 596, 596a
Scarlett, Sir James Yorke 807
Sutherland, Duchess of 808

Noguès, Jules (b.1809)
Nash, Frederick 2688

Nollekens, Joseph (1737-1823)
Fox, Charles James 139, 3887
Johnson, Samuel 996 *(after)*
Mornington, 3rd Earl of 5060
Perceval, Spencer 4 *(after)*, 1031 *(after)*,
1657 *(studio of)*
Pitt, William 120, 1240 *(after)*
Sterne, Laurence 1891

Norris, Arthur (b.1889)
Inge, William Ralph 3920

Norriss, Bess (Mrs Tait) (1878-1939)
Self-portrait 4054 *(probably)*

Northcote, James (1746-1831)
Brunel, Sir Marc Isambard 978
Exmouth, 1st Viscount 140
Fuseli, Henry L173
Godwin, William 1236
Hanway, Jonas 4301
Jenner, Edward 62
Self-portraits 147, 3026, 3253

Oakley, Harry Lawrence (1882-1960)
Windsor, Duke of 4534

Oakley, Octavius (1800-67)
Galton, Sir Francis 3923

Oliver, Archer James (1774-1842)
Children, George 5150

Oliver, Isaac (c.1565-1617)
Anne of Denmark 4010
Charles I 3064 *(studio of)*
Cork, 1st Earl of 2494
Derby, 4th Earl of L152(40)
Donne, John 1849 *(after)*
Essex, 2nd Earl of 4966
Henry, Prince of Wales 407 *(after)*,
1572 *(studio of)*
Herbert of Cherbury, 1st Baron 487
(perhaps after)
Self-portrait 4852
Richmond, 1st Duke of 3063

Oliver, Peter (1594-1648)
Digby, Sir Kenelm L152(12)
Oliver, Anne 4853A
Self-portrait 4853

Olivieri, Dominick Andrew (fl.1820-33)
Pitt, William 1240 *(copy by)*

O'Neill, George Bernard (1828-1917)
Nasmyth, James 1582

Opffer, Ivan (d.1980)
Yeats, William Butler 3965

Opie, John (1761-1807)
Bartolozzi, Francesco 222
Betty, William Henry West 1392
Bone, Henry 869
Delany, Mary 1030
Fuseli, Henry 744
Girtin, Thomas 882
Godwin, Mary 1237
Holcroft, Thomas 512, 3130
Johnson, Samuel 1302 *(after)*
Macklin, Charles 1319
Opie, Amelia 765
Self-portrait 47
Queensbury, 4th Duke of 4849
(attributed to)
Reynolds, Samuel William 1320
Stanhope, 3rd Earl 3324
Wolcot, John 830
Unknown Sitters III 813

Oppenheim, Moritz Daniel (1800-82)
Rothschild, Lionel Nathan de 3838

Oppenheimer, Joseph (1876-1967)
Salting, George 1790

Orchardson, Sir William Quiller (1832-1910)
Younghusband, Sir Francis Edward
3184
Groups: Four Generations 4536
Unknown Sitters IV 3166

Orde, Cuthbert Julian (1888-1968)
Benson, Stella 3321

Orpen, Sir William (1878-1931)
Bikaner, The Maharaja of 4188
Birrell, Augustine 2791
Cecil, 1st Viscount 4184
Derby, 17th Earl of 4185
De Wiart, Sir Adrian Carton 4651

Continued overleaf

Politi, Giuseppe (fl.1807)
Collingwood, Baron 1496 *(after)*

Pollen, Daphne (née Baring) (b.1904)
Belloc, Hilaire 4008

Pollock, Courtenay (1877-1943)
Chamberlain, Joseph 3096

Polowetski, C. (fl.1909)
Zangwill, Israel 3318

Polunin, Elizabeth (née Hart) (b.1887)
Constable, William George 5090

Ponting, Herbert G. (1870-1935)
Oates, Lawrence Edward Grace, and
 Cecil H. Meares P121
Scott, Robert Falcon P23

Ponzone, Francesco (fl.1741)
James Francis Edward Stuart, Prince
 4535 *(by or after)*

Poole, Henry (1873-1928)
Ball, Albert 2277
Watts, George Frederic 2480

Poole, Thomas R. (fl.1791-1814)
Burke, Edmund 1607
George IV and Duke of York and
 Albany 3308
Hall, Robert 5066
Teignmouth, 1st Baron 4986

**Pot, Hendrik Gerritsz
(before 1585-1657)**
Phelips, Sir Robert 3790 *(attributed to)*

Powell, D. J. (fl.1819)
Scrope, Richard Le 845
Stapledon, Walter de 2781

Praetorius, Charles J. (fl.1888-1914)
Best, William Thomas 1455
Franks, Sir Augustus Wollaston 1584

Prest, Godfrey (fl.1377-95)
Anne of Bohemia 331 *(after)*
Richard II 330 *(after)*

Primavera, Jacopo (fl.1568-85)
Mary, Queen of Scots 96a *(after)*, 1918
 (after)

Prinsep, Valentine Cameron (1838-1904)
Mason, George Heming 1295

Procter, Ernest (1886-1935)
Delius, Frederick 3861
Collections: *A Mass of Life* 4975(1-36)

Prosperi, Liberio ('Lib') (fl.1886-1903)
Gould, Sir Francis Carruthers 3278
Kennard, Howard John 2988
Read, John Francis Holcombe 2598
Rodney, 7th Baron 4739
Waleran, 1st Baron 3279
Wood, Charles 4755

Groups: Lobby of House of Commons
 5256

Pusey, Clara (fl.1856)
Collections: Pusey family and friends
 4541(1-13)

**Quertenmount, André Bernard de
(1750-1835)**
Scheemakers, Peter 2675

'F.M.R.' (fl.1648)
Sophia, Princess 4520

'G.J.R.' (fl.1844)
Tenniel, Sir John 2002

'GWR' (?) (Vanity Fair cartoonist)
Roberts, 1st Earl 1996

'JR'
Unknown Sitters IV 2687

Radclyffe, William (1813-46)
Cox, David 1403

Raeburn, Sir Henry (1756-1823)
Home, John 320
Horner, Francis 485
Mackenzie, Henry 455
Playfair, John 840
Sinclair, Sir John, Bt 454
Williams, Hugh William 965

Ramsay, Allan (1713-84)
Burgoyne, John 4158 *(after)*
Charlotte Sophia of Mecklenburg-Strelitz
 224 *(studio of)*
Chesterfield, 4th Earl of 533
George III 223 *(studio of)*
Mead, Richard 15 *(studio of?)*
Mitchell, Sir Andrew 2514 *(after)*
Self-portraits 1660, 3311
Wood, Robert 4868

Ramsay, James (1786-1854)
Bewick, Thomas 319

Randall, J. (fl.1864-74)
Richard II 1676 *(copy by)*

Ranson, Matthias
See Thaler and Ranson

Raven, Samuel (1775?-1847)
Emery, John 1661

Raven-Hill, Leonard (1867-1942)
Self-portrait 3046

**Raverat, Gwendolen (Gwen, née Darwin)
(1885-1957)**
Darwin, Sir George Howard 2101
Keynes, Baron 4553

Reddock, A. (fl.1811)
Meikle, Andrew 5001

Redgate, Sylvanus (1827-1907)
White, Henry Kirke 3248 *(copy by)*

Redgrave, Richard (1804-88)
Self-portrait 2464

Reed, Edward Tennyson (1860-1933)
Dilke, Sir Charles Wentworth, Bt 5154

Reed, Stanley (b.1908)
Downey, Richard Joseph 5023

Reid, Sir George (1841-1913)
Frere, Sir Henry Bartle, Bt 2669
Froude, James Anthony 4990
Lodge, Sir Oliver Joseph 3952
MacDonald, George 2011
Smiles, Samuel 1377

Reid, John Robertson (1851-1926)
Campbell, John 2523

Reid, Stephen (1873-1948)
Booth, William 2275

Reinagle, Ramsay Richard (1775-1862)
Constable, John 1786
Harris, Sir William Cornwallis 4098
 (attributed to)
Nicholls, Sir George 4807
Unknown Sitters IV 3025
 (attributed to)

Reynolds, Sir Joshua (1723-92)
Anson, 1st Baron 518 *(after)*
Ashburton, 1st Baron 102 *(studio of)*
Bath, 1st Earl of 35 *(after)*, 337
Blackstone, Sir William 388
 (attributed to)
Boscawen, Edward 44 *(after)*
Boswell, James 1675 *(studio of)*, 4452
Bristol, 3rd Earl of 1835 *(after)*
Burke, Edmund 655 *(studio of)*
Burney, Charles 3884
Bute, 3rd Earl of 3938
Camden, 1st Earl 459 *(after)*
Chambers, Sir William 27, 3159 *(after)*
Colman, George 1364 *(studio of)*
Cumberland, Duke of 229 *(after)*,
 625 *(studio of)*
Damer, Anne Seymour 594 *(studio of)*
Devonshire, Duchess of 1041
Fitzherbert, Maria Anne L162
Garrick, David 4504 *(after)*
Goldsmith, Oliver 130 *(studio of)*,
 828 *(after)*
Granby, Marquess of 1186 *(after)*
Haldimand, Sir Frederick 4874
 (studio of)
Hamilton, Sir William 680 *(studio of)*
Hastings, Warren 4445
Holland, 1st Baron 2075 *(after)*
Hunter, John 77 *(after)*
Johnson, Samuel 1445 *(after)*, 1597,
 L142
Keppel, Viscount 179 *(studio of)*
Lansdowne, 1st Marquess of 43 *(after)*
Macardell, James 3123
Macpherson, James 983 *(after)*
Malone, Edmund 709

Self-portrait 41
Robinson, Mary 5264
Rockingham, 2nd Marquess of 406
 (studio of)
Rodney, 1st Baron 1398 *(after)*
Secker, Thomas 850 *(after)*
Sterne, Laurence 5019
Strahan, William 4202
Whitefoord, Caleb 1400 *(studio of)*
Wilton, Joseph 4810
Windham, William 704
Unknown Sitters II 927 *(attributed to)*

Reynolds, Samuel William (1773-1835)
Self-portrait 4989

Rhodes (d.1790)
Smeaton, John 80 *(after)*

Richards, Ceri (1903-71)
Self-portrait 4909

Richards, Emma Gaggiotti (1825-1912)
Procter, Adelaide Ann 789

Richardson, Jonathan (1665-1745)
Bolingbroke, 1st Viscount 1493
 (attributed to)
Burlington, 3rd Earl of 4818
 (attributed to)
Cheselden, William 4995
Cowper, 1st Earl 736 *(by or after)*
Mead, Richard 4157
Oxford, 2nd Earl of 1808
 (attributed to)
Pope, Alexander 561 *(attributed to)*,
 1179 *(attributed to)*
Prior, Matthew 91 *(after)*, 562 *(after)*
Self-portraits 706, 1576D *(by or after)*,
 1693, 1831, 3023, 3779
Steele, Sir Richard 160, 5067
Thornhill, Sir James 3962
Vertue, George 576
West, Richard 17 *(attributed to)*
Winchilsea, 7th Earl 3622
 (attributed to)
Winchilsea, Countess of 3622A
 (attributed to)
Wyndham, Sir William, Bt 4447

Richmond, George (1809-96)
Avebury, 1st Baron 4869
Balfour, 1st Earl of 2497
Brontë, Charlotte 1452
Butler, Josephine Elizabeth L172
Canning, Earl 1057
Cardwell, Viscount 767
Cotton, Sir Henry 4240
Cranbrook, 1st Earl of 1449
Cranworth, Baron 285
Cureton, William 3164
Edward VII 5217
Gaskell, Elizabeth Cleghorn 1720
Granville, 2nd Earl 4900
Halifax, 1st Viscount 1677 *(after)*
Hallam, Henry 5139
Harrowby, 3rd Earl of 4226
Hatherley, Baron 646
Helps, Sir Arthur 2027
Hill, 1st Viscount 1055

Houghton, 1st Baron 3824
Inglis, Sir Robert, Bt 1062
Kater, Henry 2165
Keble, John 1043
Lewis, Sir George Cornewall, Bt 1063
Liddon, Henry Parry 1060
Longley, Charles Thomas 1056
Lyell, Sir Charles, Bt 1064
Lyndhurst, Baron 2144
Martineau, Harriet 1796
Newcastle, 5th Duke of 4023
Newman, John Henry 1065
Paget, Sir James, Bt 1635
Palmer, Samuel 2154, 2223
Pusey, Edward Bouverie 1059
Self-portrait 2509
Rogers, Samuel 1044
Ruskin, John 1058
Scott, Sir George Gilbert 1061
Sidmouth, 1st Viscount 5
Stratford de Redcliffe, Viscount 1513
Sumner, John Bird 2467
Teignmouth, 1st Baron 5145
Ward, Edward Matthew 2072
Wilberforce, Samuel 1054, 4974
Wilberforce, William 4997
Yonge, Charlotte Mary 2193
Groups: Swinburne and his sisters
 1762
Groups: Charles James Blomfield and
 others 4166

Richmond, Thomas (1802-74)
Millais, Euphemia Chalmers, Lady 5160

**Richmond, Sir William Blake
(1842-1921)**
Gladstone, William Ewart 3319
Hullah, John Pyke 1348
Hunt, William Holman 1901, 2803
Morris, William 1938
Nesfield, William Eden 4354
Stevenson, Robert louis 1028

Richter, Christian (1678-1732)
Duck, Stephen 4493 *(attributed to)*

Rigaud, Hyacinthe (1659-1743)
Portland, 1st Earl of 1968 *(studio of)*

Rigaud, John Francis (1742-1810)
Groups: Sir Joshua Reynolds and others
 987
Groups: Francesco Bartolozzi and others
 3186

Riley, John (1646-91)
Ashmole, Elias 1602 *(after)*
Burnet, Gilbert 159 *(after)*
Charles II 3798 *(studio of)*
Chiffinch, William 1091 *(after)*
Dartmouth, 1st Baron 664 *(after)*
George of Denmark, Prince 326 *(after)*
Guilford, 1st Baron 4708
 (attributed to)
Marlborough, 1st Duke of 501 *(after)*
Maynard, Sir John 476 *(after)*
Perth, 4th Earl of 2153 *(after)*
Waller, Edmund 144 *(after)*

Rissik, Albert W. M. (fl.1922-67)
Sargent, Sir Malcolm 4657

Ritchie, Alexander Handyside (1804-70)
Cockburn, Lord 4700

Rivett-Carnac, Eva, Lady (d.1939)
Fitzgerald, Edward 1342 *(copy by)*

Riviere, Briton (1840-1920)
Dobell, Sidney Thompson 2060

Riviere, Hugh Goldwin (1869-1956)
Bancroft, Sir Squire Bancroft 2121
Bentley, Edmund Clerihew 4931
Walpole, Sir Spencer 3632

Roberts, Cyril (1871-1949)
Terry, Dame Alice Ellen 3662

Roberts, William (1895-1980)
Self-portrait 5063

Robertson, Charles John (b.1779?)
Beale, William 5265

**Robertson, Sir Johnston Forbes-
(1853-1937)**
Terry, Dame Alice Ellen 3789

**Robertson, Walford Graham
(1867-1948)**
Farren, Ellen 3133
Terry, Dame Alice Ellen 3132

**Robey, Sir George (George Edward
Wade) (1869-1954)**
Self-portraits 3939, 3939a, 4323, 5082

Robinson, Boardman (1876-1952)
Bryce, 1st Viscount 4551

Robinson, William (1799-1839)
Sadler, Michael Thomas 2907

**Roch(e) Sampson Towgood
(1759-1847)**
Beddoes, Thomas 5070

**Rochard, François Théodore
(1798-1858)**
Tupper, Martin Farquhar 4381

Rochard, Simon Jacques (1788-1872)
Richmond and Lennox, 4th Duke of
 4943 *(attributed to)*

Roddon, Guy Lindsay
Ireland, John 4290

Rodin, Auguste (1840-1917)
Henley, William Ernest 1697

Roe, Fred (1864-1947)
Dawber, Sir Edward Guy 4168
Edward VII 4367
Grove, Sir Coleridge 2420

Roettier, John (1639-1707)
Lauderdale, 1st Duke of 4362

Continued overleaf

Richmond and Lennox, Duchess of 1681

Roffe, F. (fl.1822-36)
Lyndhurst, Baron 4121

Rogers, Claude (1907-79)
Fry, Sara Margery 5240

Romilly, Amélie (1788-1875)
Franklin, Jane, Lady 904

Romney, George (1734-1802)
Cowper, William 1423
Cumberland, Richard 19
Flaxman, John, and Thomas Alphonso Hayley 101
Hamilton, Emma, Lady 294, 4448
Kenyon, 1st Baron 469 *(after)*
Liverpool, 1st Earl of 5206
Paine, Thomas 897 *(after)*
Paley, William 145 *(after)*, 3659
Raikes, Robert 1551
Richmond and Lennox, 3rd Duke of 4877
Self-portraits 959, 2814
Smeaton, John 80 *(copy by)*
Tighe, Mary 1629 *(after)*
Wesley, John 2366 *(after)*
Groups: Walker family 1106
Unknown Sitters III 972

Room, Henry (1802-50)
Cunningham, Allan 1823

Rosenbaum, Anthony (d.1888)
Groups: Chess players 3060

Rosenberg, Isaac (1890-1918)
Self-portrait 4129

Ross, Hugh (1800-73)
Ross, Sir William Charles 1946

Ross, Thomas (fl.1738)
Shenstone, William 4386

Ross, Sir William Charles (1794-1860)
Burdett, Sir Francis, Bt 2056
Burdett-Coutts, Baroness 2057
Erskine, 1st Baron 960
Evans, Sir George de Lacy 2158

Rossetti, Dante Gabriel (1828-82)
Brown, Ford Madox 1021
Rossetti, Christina Georgina, and her mother, Mary Lavinia 990
Self-portraits 857, 3033, 3048
Watts-Dunton, Theodore 4888
Woolner, Thomas 3848

Rossi, John Charles Felix (1762-1839)
Thurlow, Baron 5238
Wyatt, James 344

Rothenstein, Sir William (1872-1945)
Allen, Charles Grant Blairfindie 3998
Baker, Sir Herbert 4763
Baldwin, 1st Earl 3866
Bateson, William 4379

Beerbohm, Sir Max 4141
Berners, 14th Baron 4380
Blomfield, Sir Reginald 4764
Blunden, Edmund 4977
Booth, Charles 4765
Brodsky, Adolf 4766
Brooke, Stopford Augustus 4767, 4774
Butler, Henry Montagu 4768
Casement, Roger David 3867, 3867a
Cecil, 1st Viscount 4769
Chambers, Sir Edmund Kerchever 4139
Clutton-Brock, Arthur 4770
Colvin, Sir Sidney 3999
Conder, Charles 2558
Conrad, Joseph 2097, 2207
Crawford, 27th Earl of 4771
Crewe, 1st Marquess of 4772
Cullen of Ashbourne, 1st Baron 4773
De la Mare, Walter 4142
Devonshire, 9th Duke of 4775
Dixon, Richard Watson 3171
Dolmetsch, Arnold 4641, 4642
Eddington, Sir Arthur 4646
Elgar, Sir Edward, Bt 3868
Ellis, Havelock 3177
Furnivall, Frederick James 3172
Gill, Eric 4647
Girdlestone, Gathorne Robert 4801
Gosse, Sir Edmund 2359
Gough, Sir Hubert 4776
Greaves, Walter 3179
Grey of Fallodon, 1st Viscount 3869
Guedalla, Philip 4802
Gwynn, Stephen Lucius 4777
Haden, Sir Francis Seymour 3870
Hamilton, Sir Ian 3871
Hammond, John Lawrence Le Breton 4778
Hewlett, Maurice 2213
Hooker, Sir Joseph Dalton 4199
Hopkinson, Sir Alfred 4779
Hornby, Charles Harry St John 3872
Housman, Alfred Edward 3873
Hudson, William Henry 1965
John, Augustus 4246
Jones, Thomas 4780
Keith, Sir Arthur 4140
Kennet, 1st Baron 4800
Ker, William Paton 4803
Kipling, Rudyard 3874
Lankester, Sir Edwin Ray 4378, 4781
Leaf, Walter 4782
Lodge, Sir Oliver Joseph 3875
Lutyens, Sir Edwin 3876
Lyttelton, Edward 4783
Lytton, 3rd Earl of 4784
Mackinder, Sir Halford John 4785
Manning, Frederic 4417
Maurice, Sir Frederick Barton 4786
Melchett, 1st Baron 4788
Miers, Sir Henry Alexander 4787
Montefiore, Claude Joseph Goldsmid - 4789
Morris, May 3049
Myers, Leopold Hamilton 4790
Nevinson, Evelyn 4001

Nevinson, Henry Woodd 3316, 5193
Parratt, Sir Walter 4791
Parry, Sir Charles 3877
Plunkett, Sir Horace Curzon 3878
Ponsonby, 1st Baron 4792
Rayleigh, Baron 3879
Reading, Marquess of 2880
Reith, Baron 4648
Rossetti, William Michael 2485
Self-portraits 3880, 4433, 5000
Rutherford, Baron 4793
Seligman, Charles Gabriel 4833
Short, Sir Frank 4804
Smuts, Jan Christian 4645
Squire, Sir John Collings 4794
Stanford, Sir Charles Villiers 4067
Steer, Philip Wilson 4643
Stein, Sir Aurel 3881
Stephen, Sir Leslie 2098
Strachey, John St Loe 4795
Strong, Thomas Banks 4805
Thomson, Sir Joseph John 4796
Tovey, Sir Donald 5277
Trevelyan, Sir Charles Philip, 3rd Bt 4797
Trevelyan, George Macaulay 4286
Underwood, Leon 4798
Wells, Herbert George 4644
Whitley, John Henry 4799
Collections: Prominent men L168(1-11)

Rothwell, Richard (1800-68)
Beresford, Viscount 300
Farren, William 1440
Huskisson, William 21
Shelley, Mary Wollstonecraft 1235
Unknown Sitters IV 1450 *(attributed to)*

Roty, Oscar (1846-1911)
Dilke, Sir Charles Wentworth, Bt 1883

Roubiliac, Louis François (1705?-62)
Garrick, David 707a *(attributed to)*
Hogarth, William 121
Ligonier, 1st Earl 2013
Newton, Sir Isaac 995 *(after)*
Pope, Alexander 2483 *(after)*
Ware, Isaac 4982

Rouw, Peter (1771-1852)
Bridgewater, 3rd Duke of 4276
Charlotte Augusta Matilda, Princess 2174 *(attributed to)*
Hastings, Warren 5065
Pitt, William 1747
Watt, James 183

Rowe, Cosmo (fl.1933)
Hardie, James Keir 2542 *(copy by)*

Rowlandson, Thomas (1756-1827)
Park, Mungo 4924

Rowse, Samuel (1822-1901)
Clough, Arthur Hugh 3314

Schell, Sherrill (1877-1964)
Collections: Rupert Brooke　P101(a-g)

Schiött, Heinrich August Georg (1823-95)
Delane, John Thadeus　1593

Schwabe, Randolph (1885-1948)
Birrell, Augustine　4431
Bragg, Sir William Henry　3255
Davies, Randall Robert Henry　3621

Scott, Kathleen (Lady Kennet) (1878-1947)
Reading, Marquess of　3643
Yeats, William Butler　3644, 3644a

Scott, Walter (fl.1850)
Cooper, Thomas Sidney　3236

Scott, William (fl.1842)
Moffat, Robert　3774

Scougall, David (fl.1654-66)
Argyll, 1st Marquess　3109 *(after)*

Scrots, William (d.c.1544)
Edward VI　442 *(studio of)*, 1299
Surrey, Earl of　611 *(after)*, 4952 *(after)*

Seeman, Enoch (1694-1744)
Tucker, Abraham　3942

Seeman, Isaac (d.1751)
Cork and Orrery, 5th Earl of　4621
　(attributed to)

Selous, Henry Courtney (1811-90)
Self-portrait　4848

Severn, Joseph (1793-1879)
Keats, John　58, 194 *(after)*, 1605
Reynolds, John Hamilton　5052
Self-portrait　3091
Trelawny, Edward John　2132

Shackleton, John (d.1767)
Pelham, Henry　871

Shackleton, Kathleen (fl.1936)
Deeping, Warwick　5142

Shannon, Charles Haslewood (1863-1937)
Beerbohm, Sir Max　4330
Bottomley, Gordon　4150
Furnivall, Frederick James　1577
Legros, Alphonse　2551
Moore, Thomas Sturge　4130
Ricketts, Charles　2631, 3106
Self-portraits　3081, 3107

Shannon, Sir James Jebusa (1862-1923)
Elsie, Lily　4322
Lyall, Sir Alfred Comyn　2170 *(after)*
Self-portrait　4412

Sharp, William (1749-1824)
Paine, William　897 *(after)*
Southcott, Joanna　1402

Sharpe, Matilda (1830-1915)
Bonomi, Joseph, the Younger　1477
Davidson, Samuel　1539
Sharpe, Samuel　1476

Sharples, Ellen (1769-1849)
Priestley, Joseph　175, 2904

Sharples, George (c.1787-c.1849)
Esdaile, William　4660

Sharples, James (1751?-1811)
Washington, George　174 *(after)*, 2903
　(after)

Shee, Sir Martin Archer (1769-1850)
Burdett, Sir Francis, Bt　432
Denman, 1st Baron　463
Follett, Sir William　1442
Frere, John Hookham　3326
Kenyon, 1st Baron　469 *(after)*
Moore, Thomas　3327
Munro, Jane, Lady　3124a
Munro, Sir Thomas, Bt　3124
Picton, Sir Thomas　126
Popham, William　812
Redesdale, Baron　1265
Self-portrait　1093
Turner, Sharon　1848
William IV　2199

Sheldon-Williams, Inglis (1870-1940)
Collections: Boer War Officers
　4039(1-7)

Shelley, Samuel (c.1750-1808)
Unknown Sitters III　4247

Shephard, Rupert (b.1909)
Huxley, Sir Julian　5041
Thomas, Dylan　4284, 4285

Shepheard, George (1770?-1842)
Northcote, James　4206

Sheppard, William (fl.1641-60)
Killigrew, Sir Thomas　3795

Sherlock, William (1796-1806)
Gilpin, Sawrey　4328

Sherriffs, Robert Stewart (1906-60)
Collections: Cartoons　5224(1-9)

Sherwin, John Keyse (1751-90)
Garrick, David　1187

Sickert, Walter Richard (1860-1942)
Beardsley, Aubrey　1967
Beaverbrook, 1st Baron　5173
Bradlaugh, Charles　2206
Churchill, Sir Winston Spencer　4438
Harrison, Frederic　2214
Holyoake, George Jacob　1810
Self-portrait　3134
Steer, Philip Wilson　3116

Sidley, Samuel (1829-96)
Colenso, John William　1080

Simon, Abraham (1617-92)
Self-portrait　1642 *(attributed to)*

Simon, Thomas (1618-65)
Clarendon, 1st Earl of　4361
Cromwell, Oliver　747 *(after)*, 1486
　(after), 4068 *(after)*, 4365, 4366
Fairfax of Cameron, 3rd Baron　4624
Hotham, Sir John, Bt　4364
　(probably by)
Scobell, Henry　4363
Southampton, 4th Earl of　4360

Simpson, John (1782-1847)
Holland, 3rd Baron　382 *(copy by)*
Marryat, Frederick　1239
Stanfield, Clarkson　2637
　(attributed to)

Simpson, Joseph (1879-1939)
Halsbury, 1st Earl of　4547

Sims, Thomas (fl.1860s)
Wallace, Alfred Russel　1765

Simson, William (1800-47)
Burnet, John　935

Singleton, Henry (1766-1839)
Howe, 1st Earl　75

Sittow, Michiel (c.1469-1525)
Henry VII　416

Skaife, Thomas (fl.1840-52)
Lingard, John　4304

Skill, Frederick John (1824-81)
Groups: Men of Science　1075

Slater, Joseph (c.1779-1837)
Gambier, 1st Baron　1982
Hastings, 16th Baron　3645
Irving, David　424
White, Joseph Blanco　3788

Slaughter, Stephen (1697?-1765)
Sloane, Sir Hans, Bt　569

Slocombe, Shirley (fl.1887-1916)
Baden-Powell, 1st Baron　4100

Small, C. Percival (fl.1901-12)
Scott, Robert Falcon　1726

Smart
Napier, Sir Charles James　3964
　(attributed to)

Smart, John (1742/3-1811)
Bligh, William　4317
Bruce, James　5008
Cornwallis, 1st Marquess　4316
Duncan, 1st Viscount　4315

Smetham, James (1821-89)
Self-portrait　4487

Smibert, John (1688-1751)
Berkeley, George　653

Smirke, Miss
Smirke, Robert 2672 *(after)*

Smith, Bernhard (1820-85)
Richardson, Sir John 888
Ross, Sir James Clark 887

Smith, Edwin Dalton (1800-after 1866)
Buckingham, James Silk 5003

Smith, George (1713-76)
Self-portrait, with John Smith 4117

Smith, Francis (c.1705-c.1779)
Groups: Audience of the Grand Signor
 3797 *(attributed to)*

Smith, Mrs Graham (fl.1891-1920)
Haig, 1st Earl 1801A

Smith, Joachim (fl.1760-1813)
Bentley, Thomas 1949

Smith, John (1717-64)
Self-portrait, with George Smith 4117

Smith, John Raphael (1752-1812)
Morton, Thomas 1540
Self-portrait 981
Toplady, Augustus Montague 3138
 (after)
Unknown Sitters III 1339
 (attributed to), 3661

Smith, John Thomas (1766-1833)
Arnald, George 1967a

Smith, Sir Matthew (1879-1959)
Self-portrait 4190

Smith, W. Thomas (1865-1936)
Durand, Sir Henry Mortimer 2128

Smyth, Coke
Eastlake, Elizabeth, Lady 2533

Smyth, Sir Harvey, Bt (1734-1811)
Wolfe, James 713a *(after drawing
 attributed to)*

'SNAPP' (Vanity Fair cartoonist)
Collections: *Vanity Fair* cartoons
 2566-2606, etc

Soame, James (fl.1850-70)
Watts, George Frederic P68

Soest, Gerard (1600?-81)
Butler, Samuel 2468
Cartwright, Thomas 1090 *(after)*
Fairfax of Emley, 3rd Viscount, and his
 wife Elizabeth 754
Rainsford, Sir Richard 643 *(after)*
Stanley, Thomas 166
Unknown Sitters II 418 *(attributed to)*,
 575 *(attributed to)*, 612

Soldi, Andrea (1703-c.1761)
Staplyton, Anne, Lady 2505
 (attributed to)

Solomon, Simeon (1840-1905)
Rossetti, Dante Gabriel 1510 *(after)*
Swinburne, Algernon Charles 1511
 (after)

Solomon, Solomon Joseph (1860-1927)
Jerome, Jerome Klapka 4492
Macdonald, James Ramsay 3890
Meldola, Raphael 2529
Mond, Ludwig 3053
Rhys, Sir John 4697
Self-portrait 3044
Webb, Sir Ashton 2489

Somerville, Edith (1858-1949)
Martin, Violet 4655

Sorolla y Bastida, Joaquin (1863-1923)
Beatrice, Princess 5166

Spear, Ruskin (b.1911)
Herbert, Sir Alan Patrick 4894
Wilson, Sir Harold 5047

Spears, Mary, Lady
See Borden, Mary

Spedding, James (1808-81)
Tennyson, 1st Baron 3940

Speed, Harold (1872-1957)
Burns, John 5124
Campbell-Bannerman, Sir Henry 5120
Carrington, Earl 5121
Dilke, Sir Charles Wentworth, Bt 5122
Grey of Fallodon, 1st Viscount 3120
Redmond, John Edward 5123
Voysey, Charles Francis Annesley
 4116, 5140

Spence, Percy F. Seaton (1868-1933)
May, Philip William (Phil) 1184a
Stevenson, Robert Louis 1184

Spence, William (1793-1849)
Roscoe, William 4147 *(attributed to)*

Spencer, Sir Stanley (1891-1959)
Bone, Sir Muirhead 4453
Self-portrait 4306

Spender, Humphrey (b.1910)
Isherwood, Christopher P41
Nicholson, Ben P42

Spicer-Simson, Theodore (1871-1959)
Galsworthy, John 3649
Hodgson, Ralph 4704, 4704A
Meredith, George 1583
Collections: Medallions of writers
 2043-55

'Spy'
See Ward, Sir Leslie

Stanfield, Clarkson (1793-1867)
Brockedon, William 4653

**Staples, Sir Robert Ponsonby, Bt
(1853-1943)**
May, Philip William (Phil) 1659

Swinburne, Algernon Charles 2217
Whistler, James Abbott McNeill 2188

Steegman, Philip (1903-52)
Maugham, William Somerset 4524

Steell, Sir John Robert (1804-91)
De Quincey, Thomas 822
Nightingale, Florence 1748

Steenwyck, Hendrik van (c.1580-1649)
Henrietta Maria 1247
 (background probably by)

Steer, Philip Wilson (1860-1942)
Brown, Frederick 2816
Sickert, Walter Richard 3142

Stermann, H.H. (fl.1935)
Campbell, Sir Malcolm 4195

Stevens, Alfred (1818-75)
Self-portrait 1526

Stevens, John (1793?-1868)
Bell, Sir Charles 446a

Stewardson, Thomas (1781-1859)
Grote, George 365

Stewart, James Malcolm (1829-1916)
Selborne, 1st Earl of 1448 *(copy by)*

Stillman, Effie (fl.1892-1907)
Toynbee, Arnold Joseph 5208

Stokes, Marianne (1855-1927)
Westlake, John 1890

Stone, Frank (1800-59)
Thackeray, William Makepeace 4210
Groups: Samuel Rogers and others
 1916

Stone, Richard (b.1951)
Bliss, Sir Arthur 5055
Boult, Sir Adrian 4906

Stoop, Dirk (c.1610-c.1686)
Catherine of Braganza 353 *(after)*,
 2563 *(by or after)*

Story, Julian Russell (1857-1919)
Ward, Mary Augusta 2650

Story, Waldo (1855-1915)
Harcourt, Sir William 1461

Strang, Ian (1886-1952)
Innes, James Dickson 4382

Strang, William (1859-1921)
Binyon, Laurence 3185
Bridges, Robert 2773
Dilke, Sir Charles Wentworth, Bt 3819
Hardy, Thomas 1922, 2929
Kipling, Rudyard 2919
Masefield, John 4568
Meredith, George 1908

Continued overleaf

Monkhouse, William Cosmo 1884
Runciman, 1st Viscount 5157
Self-portraits 2927, 4533
Warren, Edward R. 2927A
Wolseley, 1st Viscount 4059
Unknown Sitters IV 2927B

Ströhling, Peter Eduard (1768-1826)
Acton, Sir John Francis Edward 4082
Horn, Charles Edward 5189

Stuart, Gilbert (1755-1828)
Barré, Isaac 1191
Copley, John Singleton 2143
Hall, John 693
Kemble, John Philip 49
Siddons, Sarah 50
Washington, George 774 *(after)*,
 2041
West, Benjamin 349

Stuart, Gordon Thomas
Beecham, Sir Thomas L106
Thomas, Dylan 4274

Stubbs, George (1724-1806)
Self-portrait 4575

Stuckey, George (1822-72)
Barnes, William 3332

'STUFF', 'Stuff Gownsman' or 'Stuff G.'
See Wright, (possibly H.C. Sepping)

Stump, Samuel John (1778-1863)
Kean, Charles John 1249
Siddons, Henry 4879
Unknown Sitters IV 1719

Sullivan, Edward Joseph (1869-1933)
Du Maurier, George 2899
Furniss, Harry 2900

Sully, Thomas (1783-1872)
Paton, Mary Ann 1351
Victoria, Queen 1891A *(after)*

Summers, Charles (1827-78)
Horne, Richard Henry 2682

Sutherland, Graham (1903-80)
Beaverbrook, 1st Baron 5195
Clark, Baron 5243, 5244

Swendale (or Swandale), G. (fl.1824-44)
York and Albany, Duke of 1563
 (copy by)

Swinson, Edward Spilsbury (1871-1958)
Passfield, Beatrice Webb, Lady 4066

Swinton, James Rannie (1816-88)
Somerville, Mary 690

Symons, William Christian (1845-1911)
Bentley, John Francis 4479

'.T.'
See Chartran, Théobald

Talfourd, Field (1815-74)
Browning, Elizabeth Barrett 322
Browning, Robert 1269

Tassie, James (1735-99)
Adam, John 4612
Black, Joseph 3238
Gordon, Lord George 4603
Harrison, John 4599
Hume, David 4897
Northumberland, 1st Duke of 4954
Smith, Adam 1242, 3237

Tassie, William (1777-1860)
Raikes, Robert 2548

Tatham, Frederick (1805-78)
Eldon, 1st Earl of 181

Taverner, Jeremiah (fl.1706)
Defoe, Daniel 3960 *(after)*

Tayler, William (1808-92)
Everest, Sir George 2553
 (attributed to)

Taylor, Isaac (1759-1829)
Groups: Taylor family 1248

Taylor, William Joseph (1802-85)
Sussex, Duke of 982(j) *(copy by)*

Temple, Vere (or Vera) (fl.1902-39)
John, Prince 5144

Tenniel, Sir John (1820-1914)
Self-portrait 2818

Thackeray, William Makepeace (1811-63)
Groups: Mr and Mrs George Henry Lewis
 with Thornton Leigh Hunt 4686

Thaler and Ranson (fl.1800)
Nelson, Viscount 2668 *(after)*, 2767
 (after)

Theed, William (1804-91)
Gibson, John 1795
Holland, Sir Henry, Bt 1067

Theodoric (fl.1065-71)
Edward the Confessor 4048, 4049
Harold, King 4050 *(attributed to)*
William I 4051 *(attributed to)*, 4052
 (attributed to)

Theweneti, Laurence (fl.1824-31)
Harding, James Duffield 3125

Thomas, Ernest Henry (1880-1947)
Thomas, Edward 2892

Thomas, Francis Inigo (fl.1889-1929)
Thomas, Arthur Goring 1316

Thomas, Frederick (fl.1892-1901)
Stanhope, 5th Earl 955

Thomas, George Housman (1824-68)
Victoria, Queen 2954

Thomas, James Havard (1854-1921)
Brooke, Rupert 2448
Morley, Samuel 1303

Thomas, Margaret (d.1929)
Jefferies, Richard 1097

Thomas, William (fl.1819)
Hickey, William 3249

Thompson, Alfred (Atñ) (fl.1862-76)
Hampton, John Somerset 2628
Monkswell, Baron 2734
Townshend, 5th Marquess 2604

Thompson, Ernest Heber (1891-1971)
Tonks, Henry 5089

Thompson, G. (fl.1870)
Payne, George, and John Rous 2957

Thompson, Sir Henry (1820-1904)
Pellegrini, Carlo 3947

Thompson, Joyce Wansey (fl.1935)
Drinkwater, John 4094

Thornhill, Alan
Grieve, Christopher Murray 5230

Thornhill, Sir James (1675-1734)
Bentley, Richard 851 *(after)*
Sheppard, John 4313 *(attributed to)*
Self-portrait 4688

Thornycroft, Mary Alyce (1844-1906)
Thornycroft, Mary 4065

Thornycroft, Sir William Hamo (1850-1925)
Beaconsfield, Earl of 4671
Hardy, Thomas 2156

Tidey, Alfred (1808-92)
Conroy, Sir John, Bt 2175

Tilt, F.A. (fl.1866-8)
Erle, Sir William 464a

Tissot, James Jacques (1836-1902)
Collections: *Vanity Fair* cartoons
 2566-2606, etc

Titian (d.1576)
Philip II of Spain 4175 *(after)*

Tittle, Walter (1883-1966)
Bennett, Arnold 2664
Conrad, Joseph 2220, 2482
Duveen, Baron 2484
Jones, Henry Arthur 4239

Tomlin, Stephen (1901-37)
Woolf, Virginia 3882

Tonkiss, Samuel
Lowry, Laurence Stephen 5091

Tonks, Henry (1862-1937)
Moore, George 2807, 4154

Varley, Cornelius (1781-1873)
Gell, Sir William 5086

Verelst, Herman (1641?-90?)
Locke, John 3846

Verelst, John (fl.1698-1731)
Groups: 2nd Duke of Montagu and
 others 2034 *(probably by)*

Verelst, Simon (c.1644-c.1710)
Unknown Sitters II 2496

Verelst, William (d.after 1756)
Dean, John 949
Oglethorpe, James Edward 2153a
 (after)

Verheyden, François (fl.1878-97)
Alverstone, Viscount 2698
Russell of Killowen, 1st Baron 2740
Tennant, Sir Charles, Bt 4745

Verhych, Jamé (fl.1719)
Clarke, Samuel 4838

Vernay, Pollie (fl.1894)
Sala, George Augustus Henry 1689A

Verrio, Antonio (1639?-1707)
Self-portrait 2890

Vertue, George (1684-1756)
Drake, Sir Francis 3905 *(finished by)*
Drayton, Michael 2528 *(attributed to)*
Johnson, Maurice 4684
Sandford, Francis 4311 *(copy by)*
Self-portrait 4876

Villiers, Frederic (1852-1922)
Groups: Archibald Forbes and others
 2931

Vine, W. (fl.1873)
Karslake, Sir John Burgess 2581
Plimsoll, Samuel 4734

Vinter, John Alfred (1828?-1905)
Hill, Sir Rowland 838 *(copy by)*

Visser, Cor (b.1903)
Martin, Evelyn George 4227

Voet, Ferdinand (1639-1700?)
Burnet, Thomas 526 *(probaby by)*

Voigt, Carl Friedrich (1800-74)
Gilchrist, John Borthwick 4064

'EW'
Unknown Sitters IV 5218

'F.W.' (fl.1865)
Groups: Royal Albert Infirmary 3083

Wade, George Edward
See Robey, Sir George

Wageman, Thomas Charles (1787-1863)
Hunt, James Henry Leigh 4505
Kean, Edmund 4623 *(attributed to)*
Martin, Helena Saville, Lady 4998

Walker, Elizabeth (née Reynolds) (1800-76)
Reynolds, Samuel William 2123
Groups: Men of Science 1075

Walker, Fred (fl.1919)
Groups: Four men at cards 1841B

Walker, Frederick (1840-75)
Self-portrait 1498

Walker, Robert (1599-1658)
Cromwell, Oliver 536
Evelyn, John L166
Fairfax of Cameron, 3rd Baron 3624
 (after)
Ireton, Henry 3301 *(copy attributed to)*
Lambert, John 252 *(after)*
Scrope, Adrian 4435 *(by or after)*
Somerset, 2nd Duke of 1645B *(after)*
Self-portrait 753
Unknown Sitters II 618 *(attributed to)*,
 1600 *(attributed to)*

Walker, William (1791-1867)
Groups: Men of Science 1075,
 1075a and b
Groups: Coalition Ministry 1125a

Waller, Mary Lemon (née Fowler) (1851-1931)
Armstrong, Baron L161

Wallis, Henry (1830-1916)
Peacock, Thomas Love 1432

Walshe, Christina (fl.1911)
Boughton, Rutland 4932

Walton, Henry (1746-1813)
Gibbon, Edward 1443
Gilpin, William 4418
Lansdowne, 3rd Marquess of 178
Palmer, John 2086

Walton, John Whitehead (fl.1834-65)
Hume, Joseph 713

Ward, Edward Matthew (1816-79)
Carlyle, Thomas 2894
Macaulay, Baron 4882
Maclise, Daniel 616
Smith, Horatio 4578
Webster, Thomas 2879

Ward, James (1769-1859)
Self-portraits 309, 1684

Ward, Sir Leslie ('Spy') (1851-1922)
Aird, Sir John 5014
Albany, Duke of 4711
Ancaster, 1st Earl of 4712
Ashbourne, 1st Baron 3932
Austin, Alfred 1768, 4845
Balfour, Jabez Spencer 4606

Ball, Sir Robert Stawell 4544
Bhownaggree, Sir Mancherjee Merwanjee
 4241
Biddulph, Sir Michael Anthony Shrapnel
 3931
Birrell, Augustine 3126
Bourne, Francis Alphonsus 4592
Carden, Sir Robert Walter, Bt 2568
Clarke, Sir Edward George 2700
Cleasby, Sir Anthony 2701, 2897
Coleridge, 2nd Baron 3281
Colonsay and Oronsay, Baron 2627
Cooper, Sir Alfred 5013
Cottesloe, 1st Baron 3190
Cotton, Sir Henry 2704
Cotton, Sir William 3282
Crawford, 26th Earl of 2705
Crealock, Henry Hope 2898
Dalglish, Robert 3283
Danesfort, Baron 2657
Darling, 1st Baron 2708
Davidson of Lambeth, Baron 2956
Deane, Sir Henry Bargrave 3284
De Keyser, Sir Polydore 2570
Devonshire, 8th Duke of 3191
Dickens, Sir Henry Fielding 3285
Doran, John 1648
Doyle, Sir Charles Hastings 2709
Doyle, Sir Francis, Bt 2710
Du Maurier, George 2711
Ellenborough, 3rd Baron 3286
Field, Baron 2713
Fordham, George 2629
Forestier-Walker, Sir Frederick 4716
Fraser, James Keith 2572
Gardner, 3rd Baron 3287
Gent-Tharp, William Montagu 2990
Gladstone, 1st Viscount 3288
Gladstone, William Ewart 5057
Gladstone, William Henry 3289
Gomm, Sir William Maynard 2715
Goodford, Charles Old 2716
Grenville, 2nd Baron 2576
Grove, Sir William Robert 2717
Haldane, Viscount 5125
Halsbury, 1st Earl of 3290
Hamilton, Sir Ian 4609
Hardie, James Keir 4456
Hargreaves, John 4718
Heneage, 1st Baron 4719
Herschell, 1st Baron 2721
Holker, Sir John 2722
Hornby, James John 3105
Hunter, Sir Archibald 5126
Hutchinson, Henry Doveton 4607
Innes-Ker, Lord Charles John 4721
Jackson, Frederick George 4611
Jenkins, John Edward 2578
Joachim, Joseph 4930
Kay, Sir Edward Ebenezer 2727
Kelvin, Baron 3005
Kenealy, Edward Vaughan Hyde 2685
Kenmare, 4th Earl of 4720
Kennaway, Sir John Henry, Bt 2582
Kingscote, Sir Robert Nigel Fitzhardinge
 4723
Kintore, 9th Earl of 4722
Kitchener of Khartoum, 1st Earl
 2684
Lankester, Sir Edwin Ray 3006

Warin, Claude (d.1654)

Warman, W. (fl.1830s)

Warren, Henry (1794-1879)

Watkins, John and Charles (fl.1857-76)

Watson-Gordon, Sir John
See Gordon, Sir John Watson-

Watts, George Frederic (1817-1904)

Webber, John (1750-93)

**Wedderburn, Jemima
(Mrs Hugh Blackburn) (1823-1909)**

Weekes, Henry (1807-77)

Wehrschmidt, Daniel Albert (1861-1932)

Weigall, C. Henry (1800?-83)

Weigall, Henry (1829-1925)

Weiss, Felix (b.1907)

Welch, Maurice Denton (1915-48)

Wells, Henry Tanworth (1828-1903)

West, Benjamin (1738-1820)
Leeds, 5th Duke of 801 *(attributed to)*
Markham, William 4495

Westall, Richard (1765-1836)
Byron, 6th Baron 1047 *(by or after)*,
4243

Westlake, Alice (née Hare) (1840-1923)
Hare, Thomas 1820
Westlake, John 4847

Wheatley, Francis (1747-1801)
Grattan, Henry 790
Phillip, Arthur 1462
Groups: Review of Troops 682

Wheatley, John Laviers (1892-1955)
Martin, Sir Alec 4850
Maufe, Sir Edward 5155
Thomas, Edward 4459

Wheeler, Sir Charles (1892-1974)
Bodkin, Thomas 5015
Lawrence, Thomas Edward 5016

Wheeler, Muriel, Lady (d.1979)
Wheeler, Sir Charles 5132

Whistler, Rex (Reginald John) (1905-44)
Berners, 14th Baron 5050
Sitwell, Sir Osbert, Bt 5009
Waley, Arthur 4598
Walton, Sir William 4640
Self-portrait 4124

White, Clarence
Hore-Belisha, Baron 4860

White, George (1684?-1732)
Somerville, William 1873
Watts, Isaac 640

White, George Harlow (d.1887)
Collections: Drawings 4216-18

White, Robert (1645-1703)
Baxter, Richard 521 *(after)*, 875
(after)
Browne, Sir Thomas 1969 *(after)*
Fleetwood, William 5118 *(after)*
Leeds, 1st Duke of 631
Oates, Titus 634
Tenison, Thomas 1525 *(after)*
Treby, Sir George 638

White, William (fl.1835-40)
Nightingale, Florence, and her sister
Frances Parthenope (afterwards
Lady Verney) 3246

Whiting, Frederic (d.1962)
George V 5094

Whitlock, Henry John (fl.1867)
Collections: Balmoral Album P22(1-27)

Wiche, J. (fl.1811-27)
Hunt, Henry 957

Wiener, Hilda E. (d.1940)
Wood, Sir Henry Joseph 3818

Wilczynski, Katerina (1894-1978)
Cary, Joyce 4822

Wilde, Samuel de (1748-1832)
Neild, James 4160

Wilkie, Sir David (1785-1841)
Baird, Sir David, Bt 1825
Haydon, Benjamin Robert 1505
Raimbach, Abraham 775
Victoria, Queen 1297
Self-portrait 53
York and Albany, Duke of 2936
Unknown Sitters III 2938

Williams
Norie, John William 1131 *(after)*

Williams, Bransby (Bransby William Pharez) (1870-1961)
Self-portrait 2750A

Williams, Edward Ellerker (1793-1822)
Shelley, Percy Bysshe 1271 *(after)*

Williams, Edwin (fl.1844-75)
Napier, Sir Charles James 1369

Williams, John Michael (1710-c.1780)
Gibbs, James 504

Williamson, Francis John (1833-1920)
Stirling-Maxwell, Caroline, Lady 729
Stirling-Maxwell, Sir William 728
Tennyson, 1st Baron 1178

Williamson, John (1751-1818)
Roscoe, William 963 *(attributed to)*

Willison, George (1741-97)
Adam, Robert 2953 *(attributed to)*
Pigot, Baron 3837

Wilson, Benjamin (1721-88)
Parsons, James 560

Wilson, George Washington (1823-93)
Collections: Balmoral Album P22(1-27)

Wilson, Helen (1903-71)
Mackenzie, Sir Compton 4948

Wilson, Richard (1714-82)
Groups: Francis Ayscough, Prince of
Wales, and the Duke of York and
Albany 1165

Wilton, Joseph (1722-1803)
Roubiliac, Louis François 2145
(attributed to)
Wolfe, James 2225 *(after)*, 4415

Winter, Frederick (d.1924)
Smith, William Henry 1742

Winterhalter, Francis Xavier (1806-73)
Albert, Prince 237
Kent and Strathearn, Duchess of 2554

Wirgman, Theodore Blake (1848-1925)
Graham, Robert Bontine Cunninghame
2212
Huxley, Thomas Henry 1528
Johnston, Sir Harry Hamilton 2902
Millais, Sir John Everett, Bt 1711
Ruskin, John 3035
Thornycroft, Sir William Hamo 2218

Wissing, William (1656-87)
Cutts, Baron 515 *(ater)*
Mary of Modena 214
Mary II 197 *(after)*, 606 *(after)*
Monmouth and Buccleuch, Duke of
151 *(after?)*
Richmond and Lennox, Duchess of
4996
Rochester, 1st Earl of 819 *(after)*
William III 580 *(after)*

Witherby, A. G. ('w.a.g.') (fl.1894-1901)
Plowden, Alfred Chichele 2993
Baker, William 3300

Wivell, Abraham (1786-1849)
Parry, John 5152

Wolfe, Edward (b.1897)
Plomer, William 5172

Wolfsfeld, Erich (1884-1956)
John, Sir William Goscombe 5102

Wollaston, John (b.c.1672)
Britton, Thomas 523

Wollaston, John (d.c.1770)
Whitefield, George 131

Wolmark, Alfred (1877-1961)
Ford, Ford Madox 4454
Hawkins, Sir Anthony Hope 3974
Huxley, Aldous 4485
Jones, Henry Arthur 4482
Lane, Sir William Arbuthnot, Bt 4484
Self-portrait 4884
Zangwill, Israel 2808

Wonder, Pieter Christoph (1780-1852)
Groups: Patrons and Lovers of Art
792-5

Wontner, William Clarke (fl.1879-c.1922)
Myers, Frederic William Henry 2928

Wood, Christopher (1901-30)
Lambert, Constant 4443

Wood, Francis Derwent (1871-1926)
McEvoy, Ambrose 2958

Wood, John (1801-70)
Beechey, Sir William 614
Britton, John 667